LORENZO GHIBERTI

PRINCETON MONOGRAPHS
IN ART AND ARCHAEOLOGY
XXXI

PUBLISHED FOR THE
DEPARTMENT OF ART AND ARCHAEOLOGY
PRINCETON UNIVERSITY

LORENZO GHIBERTI

BY RICHARD KRAUTHEIMER

IN COLLABORATION WITH

TRUDE KRAUTHEIMER-HESS

PRINCETON, NEW JERSEY

PRINCETON UNIVERSITY PRESS

Published by Princeton University Press, 41 William Street,
Princeton, New Jersey 08540
In the U.K.: Princeton University Press, Oxford

L.C. Card 81-47999
ISBN 0-691-03979-8
ISBN 0-691-00336-X pbk.
Second Printing, with corrections and new preface, 1970
First Princeton Paperback printing,
with new preface and bibliography, 1982

Second paperback printing, 1990
8 7 6 5 4 3 2

PUBLICATION OF THIS BOOK HAS BEEN AIDED

BY GRANTS FROM

THE BOLLINGEN FOUNDATION AND THE JOHN SIMON GUGGENHEIM MEMORIAL FOUNDATION

PRINTED IN THE UNITED STATES OF AMERICA

BY PRINCETON UNIVERSITY PRESS, PRINCETON, NEW JERSEY

PREFACE TO THE FIRST PRINTING

THIS somewhat weighty volume sprang from modest beginnings. Early in 1933 the Institute for the History of Art at Marburg University, where I was then teaching, planned to publish, as part of a series on Medieval Bronze Doors, a portfolio on the North Door of the Baptistery in Florence, for which I was to write a short introductory text. Political events and my subsequent coming to the United States brought that project to nought. But my interest had been aroused and Ghiberti and Ghibertiana accompanied me from Louisville, Kentucky, to Vassar College and to the Institute of Fine Arts of New York University.

Ghiberti is the only major sculptor and almost the only major artist of the early Renaissance not deemed worthy so far of an exhaustive monograph. His art has always been considered attractive, but he was overshadowed during the age of the great monographs, roughly 1880 to 1915, by the powerful figures of Donatello, Masaccio, and Brunelleschi. His entire *œuvre* was well documented. It consisted in a few great works, the two bronze doors at the Baptistery, the statues at Or San Michele, the reliefs on the Siena Font. No discoveries were likely to be made. His work was viewed, understandably so in the aesthetic climate of the late Victorian Age, as a last offshoot of Gothic art, static and only peripherically affected by the new Renaissance movement. Hence his art seemed to be of minor interest. Ghiberti the writer, Ghiberti the collector, Ghiberti the historian of art, not Ghiberti the artist, were indeed the topics which Julius von Schlosser approached in his superb studies.

But after all, by his contemporaries and for centuries afterwards Ghiberti was reckoned among the leading artists of the fifteenth century. His position had to be clarified if the status of Florentine art in the early Renaissance was to be understood, and this apparently could not be done by focusing exclusively or indeed primarily on his own development. To be sure, the changes of his art, from the Competition Relief to the Gates of Paradise, presented a number of fascinating problems. Being at the same time an artist and a writer and autobiographer, Ghiberti seemed singularly well fitted to demonstrate the change of a personality in a period of change. Yet the man, so it seemed, could be understood only if his art and character were viewed within broader contexts: the art of Western Europe around and shortly after 1400; the art of Florence from 1410 to 1450 and beyond; the goldsmith craft; and finally Ghiberti's personality, inventive, receptive, nimble and sober and very Florentine.

These were, more or less, the topics of a series of essays that I planned near the end of the war to assemble in a little book. Then, new problems turned up: Ghiberti and antiquity; Ghiberti and humanism; the pictorial relief; the place of Alberti in early Quattrocento art. Both my wife and I began to work on these questions and for almost ten years it was Ghiberti and little else. Thus the book grew and grew. Whether we have achieved in any way what we intended to do, we cannot tell. We do know a number of points where we have failed. We did not discuss the peripheral work of Ghiberti, be it the terracotta reliefs or the stained glass windows. We did not go seriously into the question of his impact on the Florentine artists of the later Quattro-

cento. Nor did we perhaps place sufficient emphasis on the links between Ghiberti's art and contemporary painting. Each of these problems demands further study. We do hope to have succeeded in bringing out a new picture of Ghiberti and of his art within the framework of his time.

The division of labor between author and collaborator is at this point hard to trace. By and large the text is my responsibility, the appendices, except for Appendix B, my wife's. But obviously, every sentence in the text and every word in the appendices has been fought over by both of us. As a rule of thumb, overstatements throughout the book should be blamed on me, understatements on my wife.

There is hardly an aspect of Ghiberti's which we have not discussed over these last ten years with friends and colleagues, and our warm thanks go to all of them. From Erwin Panofsky I have had patient and invaluable advice on questions of perspective and textual interpretation, and he was good enough to read and criticize Chapter XVI. Millard Meiss has lent me the benefit of his immense knowledge on Trecento and Quattrocento painting and has given me criticism and read several chapters in the manuscript. Among my colleagues and friends at the Institute of Fine Arts of New York University, I want to mention especially H. W. Janson and Karl Lehmann. The former has been an unselfish source of information on anything faintly related to Donatello and of invaluable help in procuring seemingly unobtainable photographs. In determining the antique sculptures known to Ghiberti and exploited by him, we have been fortunate enough to draw on the advice of Karl Lehmann and Mrs. Phyllis Bober, whose "Census of Antiques known to the Renaissance" at the Institute of Fine Arts, New York University, forms an indispensable basis for any work in that field. Cornelius Vermeule, now at Bryn Mawr College, kindly allowed us to peruse his catalogue of the Dal Pozzo drawings. Ulrich Middeldorf, helpful as always, provided not only photographs hard to obtain, but placed at our disposal his own notes, which on a number of points confirmed our own opinions on various aspects of Ghiberti's work. Our friends Enrico de' Negri and Rudolf Wittkower have been helpful in interpreting difficult passages in fifteenth century texts. Last but not least, I have profited from the students with whom I discussed Ghiberti problems in two seminars, one taught at Yale University in 1951-1952, the other at the Institute of Fine Arts of New York University in the spring of 1953.

Officials and colleagues in Italy have gone out of their way to facilitate our studies. Our special thanks go to Professor Sartini, the director of the Archivio di Stato in Florence and his collaborator, Mrs. Giulia Camerani; to Professor Filippo Rossi of the Sopraintendenza ai Monumenti who removed all possible obstacles for studying and photographing Ghiberti's works in Florence; to Professor Ugo Procacci, whose immense knowledge of *documenti artistici* preserved in the Florentine archives proved invaluable. A special word of gratitude is due to Cavaliere Bruno Bearzi, the master who carried through the cleaning of the Baptistery doors, and who was ever ready to help, and let himself be plied with questions on the technical aspects of bronze founding, both ancient and modern.

Warm thanks go also to those who have provided me with illustrations: to Signor

Malanotti, who for the firm of Giacomo Brogi di Laurati executed the great majority of the photographs of Ghiberti's work; and to Mrs. Rollie McKenna, who was good enough to supply some particularly beautiful details. Mr. Alfred Frazer kindly executed the drawings for the diagrams included in Chapter XVI. I am particularly indebted to the German Archaeological Institute in Rome and the Warburg Institute of London University for supplying other photographs. It would be impossible at this point to thank individually the many museums and scholars who have been good enough to provide photographs of objects under their care.

A number of friendly hands have attempted to remove from our English text awkward expressions and plain mistakes: Miss Dorothea Nyberg, Miss Elaine Loeffler, Miss Mary Ann Graeve, and Miss Marie Alexander. Our very sincere thanks go to all of them and particularly to the two last-named who have carried the bulk of the burden. Miss Alexander has taken upon herself also the formidable task of typing the manuscript, assisted by Miss Gustina Scaglia, and of laying the groundwork for the index.

Neither the preparation of this book nor its publication could have been carried through without the generous support, financial and moral, of a number of scholarly institutions. Vassar College gave me a research leave and subsidized through its Lucy Salmon Fund a photographic campaign in 1950-1951. The John Simon Guggenheim Memorial Foundation granted me that same year a fellowship to carry on my studies in Florence and added further subsidies, one towards revising and typing the manuscript, another towards the publication. The Bollingen Foundation supported the publication with a sizable grant in aid. Finally the Department of Art and Archaeology of Princeton University has done me the honor of welcoming the volume into its series of Monographs on Art and Archaeology and through a generous subsidy has made possible its publication. My sincere thanks go to all four institutions. They go most warmly to the late Professor E. Baldwin Smith, then Chairman of the Department in Princeton, who generously supported the publication; and to Dr. Henry Allen Moe, the Secretary of the Guggenheim Foundation, whose humane interest in humanistic studies remains a constant source of encouragement.

I am equally grateful to the Princeton University Press, particularly to its director, Mr. Herbert S. Bailey, Jr., and to Miss Harriet Anderson, for care and infinite patience in preparing and carrying through the publication.

RICHARD KRAUTHEIMER
Institute of Fine Arts, New York University

Rome, May 16, 1956

Acknowledgement for photographs is made as follows:

Prof. Bernard Ashmole: Fig. 105.
Dr. H. Goldkuhle: Fig. 90.
Prof. H. W. Janson: Figs. 20, 30, 43.

Prof. Clarence C. Kennedy: Pls. 2a, 2b, 26a.

Prof. Richard Offner: Fig. 85.

Prof. Cornelius Vermeule: Figs. 130, 139, 140.

Albertina, Vienna: Pl. 46.

Biblioteca Laurenziana, Florence: Fig. 65.

Bibliothèque Nationale, Paris: Fig. 18.

British Museum, London: Fig. 127.

County Museum, Los Angeles: Fig. 132.

Gabinetto dei Disegni, Uffizi, Florence: Fig. 98.

Metropolitan Museum of Art, New York: Fig. 108.

Musée, Dijon: Fig. 23.

Musées Royaux, Archives Centrales Photographiques, Brussels: Fig. 103.

Museum of Fine Arts, Boston: Fig. 29.

National Gallery, London: Fig. 25.

National Gallery of Art, Washington, D.C.: Fig. 15.

Vassar College Collection, Poughkeepsie, N.Y.: Fig. 24.

Warburg and Courtauld Institutes, London University: Figs. 66, 125, 126, 133, 138, 142, 145, 146.

Alinari, Florence: Pls. 1, 6, 57d, 72, 73, 75, 77a, 77b; Figs. 1, 2, 5, 6, 7, 8, 12, 13, 19, 21, 26, 31, 36, 39, 40, 42, 49, 59, 60, 61, 63, 67, 68, 69, 70, 72, 73, 74, 75, 77, 78, 83, 84, 86, 87, 88, 93, 104.

Anderson, Rome: Figs. 52, 76, 79, 80, 88, 89, 100, 101, 102, 106, 112, 119, 120, 131.

Archives Photographiques, Monuments Historiques, Paris: Pl. 15; Figs. 9, 16, 17, 27.

Osvaldo Boehm, Venice: Fig. 58.

Deutsches Archaeologisches Institut, Rome: Figs. 91, 109, 110, 111, 113, 121, 122, 123, 124, 129, 134, 137, 141, 143, 144.

J. Felbermeyer, Rome: Figs. 115, 116, 117, 118.

Gabinetto Fotografico della Sopraintendenza alle Gallerie, Florence: Pls: 4, 9a, 9b, 10a, 76; Figs. 3, 4, 28, 32, 33, 55, 71, 92, 96, 134.

Gabinetto Fotografico Nazionale, Rome: Fig. 135.

Giraudon, Paris: Fig. 34.

Kunsthistorisches Institut, Universität Marburg: Pls. 57e, 69b, 76; Figs. 54a, 54b, 128.

Logi, S. Gimignano: Figs. 81, 82.

Mas, Barcelona: Figs. 37, 38.

Rollie McKenna, New York (Copyrights, Rollie McKenna): Pls. 23, 24, 55b, 59d, 59e, 59f, 60a, 60c, 60d, 60e, 60f, 61a, 63b, 64b, 69a, 69c, 69d, 74, 96b, 104b, 106b, 110, 111b, 114b, 115, 118, 121b, 134b, 134c, 134d, 134f, 137a, 137b, 137c, 138b; Figs. 10, 46, 47, 48, 50, 51, 94, 95, 99.

Photo-Roseman, Paris: Fig. 14.

C. Pineider, Florence: Fig. 45.

For all the remaining photographs acknowledgement is made to Giacomo Brogi di Laurati, except for Figs. 11, 22, 41, 44 which are the author's property.

PREFACE TO THE SECOND PRINTING

IN writing this book, fifteen years ago, we attempted to present Lorenzo Ghiberti in a broad context: as an artist and craftsman, a citizen and the head of a large workshop, a businessman, a writer with scholarly aspirations, standing on the fringe of the humanist circles of fifteenth century Florence. Given this perhaps overly broad approach, it was only natural that in the intervening years much should have been written on the multifaceted figure of Lorenzo and that many questions should have arisen in the minds of the authors and their readers. A new preface to this new printing offers the welcome opportunity to correct obvious errors in the original publication, to list new publications, beginning in 1955, to add freshly discovered material, and to sum up and give a critical review of recent research. More important, it gives us the chance for a self-appraisal; we can try to find out whether the views held in 1955 are still tenable in 1970, in the face of the criticisms proffered by some of the reviewers of our book, of new findings, and of our own critical judgment. Had our views changed radically, through recent research or new insight on our part, this new printing would not be justified, and the book would have to be written anew. Fortunately, this is not the case. The needed additions and corrections as well as the statement of the author's present position can be incorporated here and in supplementary corrigenda, bibliography, and digests of documents. Any item preceded by an asterisk in this preface may be found in these supplementary lists.

NEW DOCUMENTS

The only sizable contributions made in the past fifteen years concern not Ghiberti's *œuvre* but his life and his many interests as seen through newly discovered documentary evidence.

The most important of these documents dates only a few days before Lorenzo's death when, on November 26, 1455, he made his last will. Fortunately for us, this will forty years later led to a mare's nest of quarrels between Ghiberti's son Vittòrio and Vittorio's three sons from two subsequent marriages.[1] The will, still known to Baldinucci,[2] remains lost. But the ensuing disagreements were recorded in October 1496 in a diary[3] of Buonaccorso Ghiberti, Vittorio's son from his first marriage and the only grandson born before Lorenzo's death; they are also reflected in two arbitration proceedings[4] which incorporate phrases or quotations of parts of Lorenzo's will. From these and the accompanying comments, it appears that, contrary to previous assumptions,[5] Lorenzo named as sole heir not his son Vittorio but his grandson Buonaccorso, then just four years old. Vittorio, as his son's legal guardian, accepted the will in 1459, and had only the usufruct of the estate. Another document,[6] highly fragmentary, suggests that legacies went to Buonaccorso's three small sisters.

None of these legal niceties would concern us, were it not for the fact that the

[1] Krautheimer-Hess, bibl. *31.
[2] bibl. 35, p. 351, note; see also below, p. 421.
[3] bibl. *31, 318ff and *passim*; dig. 303.
[4] *ibid.*, 320f and *passim*; dig. 303.
[5] see below, p. 8.
[6] dig. 293a.

arbitration proceedings provide us with some knowledge of the contents of the work-shop at the time of Lorenzo's death, still preserved in 1496. Along with tools for the working of bronze and stone, for goldsmith work, painting and engineering, are listed precious stones, cut and uncut, *roba di ingegneria*, books and writings, drawings and *intagli* in bronze and marble. The precious stones suggest that the shop handled considerable jewelry work. The books and writings presumably comprised Ghiberti's diaries, in part still known to Baldinucci;[7] perhaps a copy of the *Commentarii* and voluminous reading notes; and presumably some works of classical writers, such as Pliny and Vitruvius. To the *roba di ingegneria* we shall have to return. The *intagli* in bronze and marble were presumably reliefs, but whether ancient or modern remains undecided. Still, a number were certainly antiques, and one of these, a ring with a putto on a horse, is specifically listed in Buonaccorso's diary as having belonged to his grandfather.[8] The drawings remain unspecified. But Vasari[9] reports having bought from Buonaccorso's son, Vittorio II, a number of drawings from Lorenzo's collection; among them were several he believed to be by Giotto, while others he attributed to old Bartolo di Michele and to Lorenzo himself.[10] Of Ghiberti's, Vasari mentions by name only an evangelist. However, Degenhart and Schmitt[11] suggest that Vasari like-wise owned the Louvre drawing for the Stephen.[12]

Another block of drawings from the workshop, still extant in 1496, presumably represented machinery for construction work and other mechanical apparatus.[13] Scaglia has convincingly demonstrated that these engineering drawings to a large extent were originals of Brunelleschi's or copies thereafter and that they were copied by Buonaccorso Ghiberti in his *zibaldone*.[14] It seems possible that in Lorenzo's workshop these engineering drawings were supplemented by wooden or bronze models and by tools and parts of machinery, the *roba di ingegneria*, mentioned in the paraphrased fragments from Lorenzo's last will. As suggested by Gustina Scaglia, Lorenzo may have assembled these materials, together with excerpts from Vitruvius and drawings after Roman architectural details also incorporated in the *zibaldone*,[15] in preparation for the architectural treatise he planned to write (*Commentarii*, II, 23).[16]

Further evidence regarding Ghiberti's activities and those of his family was un-covered by Fr. Mendes Atanasio,[17] likewise in the Innocenti archives. A ledger of the Cambini bank[18] records payments made to Lorenzo and a number of helpers for their work in repairing and building furnaces and in casting parts of the second door, as well as payments to the merchants involved in providing the bronze from Flanders.[19] The imprecise indications of the Strozzi excerpts[20] regarding the casting of the frame are thus pinned down. These documents also show that Lorenzo's son Tommaso was

[7] bibl. 35, I, pp. 354f; see below, p. 11.
[8] dig. 304; bibl. *31.
[9] bibl. 533, II, p. 249.
[10] bibl. *31, p. 316, see also dig. 303.
[11] bibl. *14, pt. 1, vol. 2, pp. 293f.
[12] below, pp. 97ff.
[13] bibl. *53, *54, *55.
[14] Florence, B.N., BR 228.
[15] bibl. *54.
[16] bibl. 178, I, p. 50; bibl. *55, p. 96.
[17] bibl. *2.
[18] dig. 255a.
[19] dig. 255a.
[20] docs. 19, 41; digs. 254, 255.

very active in this phase of the work, and Mendes Atanasio may well be right in suggesting that he was a specialist in large-scale casting.[21] However, while still active in the workshop, he had formed, apparently in November 1445, a separate partnership with one Matteo di Giovanni, another member of the Ghiberti shop, and had executed with him the tabernacle for Michelozzo's Baptist on the silver altar of the Baptistery.[22] Finally, another document in the Innocenti archive corrects our guess[23] that Tommaso died in 1447. He was still alive in July 1455,[24] but it remains unknown whether or not he survived at the time of his father's death, the end of November of that year. Yet, contrary to Mendes Atanasio we can see the style of Lorenzo's workshop only remotely reflected in the small figures on the silver tabernacle; and we strongly doubt that the younger portrait head on the frame of the Gates of Paradise represents Tommaso rather than Vittorio.[25] And most certainly Vittorio does not disappear[26] from the documents after 1443.

Finally, a few scattered documents supplement those already known regarding Lorenzo's work in the twenties. The statue of Saint Stephen was already in its niche in the summer of 1433; but it still lacked the gilding of the embroidery,[27] presumably on the hem and the collar of the garment. Also, a number of entries in three ledgers of the Opera del Duomo in Siena, previously unknown to us and dating from 1418, 1425, and 1427, have been communicated to us through the kindness of John T. Paoletti. They all concern payments made to Lorenzo for two reliefs for the Font and, barring two items previously unknown,[28] they merely confirm entries already published from other account books.[29]

THE ŒUVRE

Some factual material, though not overly much, has been added in the last fifteen years to our knowledge of the activities of Ghiberti's workshop if not to our knowledge of his own *œuvre*.

One criticism leveled against our book[30] concerned the short shrift we had given to the designs for stained-glass windows prepared for S. Maria del Fiore by Ghiberti and his shop. This criticism we must accept. Indeed, save the *Assumption* oculus in the nave façade, 1404-1405, which supported our dating of the early reliefs on the North Door, we barely alluded to this side of Ghiberti's activities. Such summary treatment at the time seemed to us justifiable: the windows all through the cathedral are hard to see; good photographs were, then, unobtainable; the designs, as transposed in the medium of stained glass, reveal but dimly Ghiberti's style; and the majority of the cartoons, particularly those for the late windows in the triconch and drum of the cathedral (1435-1443 and 1443-1445 respectively), belong to the workshop rather

[21] bibl. *2, p. 95.
[22] dig. 255b.
[23] below, pp. 8, 166.
[24] dig. 292a.
[25] bibl. *2, p. 96.
[26] bibl. *2, p. 93f.
[27] "cum brustis aureis," dig. 179a.
[28] dig. 119a.
[29] dig. 120.
[30] Steingräber, bibl. *63; Clark, bibl. *9; Geza von Österreich, bibl. *15.

than to the master's hand.[31] The gap has meanwhile been closed: first by Marchini's preliminary remarks[32] and the accompanying illustrations, and lately by Geza von Österreich's doctoral dissertation.[33] Yet, these publications—and we see this confirmed by Geza von Österreich's conclusions—leave us again with the feeling that certainly the cartoons designed in the thirties and forties only complement our picture of the workshop: indeed, more often than not they make use of compositions done by Ghiberti thirty years before and transpose such remainders into even more traditional formulas; as witness, the *Mount of Olives* of 1443-1444, as against its counterpart on the North Door, ca. 1407.

On the other hand, the early oculi on the façade—they are, along with the *Assumption* window, the oculi in the aisle façades showing SS. Stephen and Lawrence, 1412-1415—would have warranted a more extensive treatment; not so much because they support the dating of the reliefs on the North Door but because they might throw light on young Ghiberti's style as a painter and its presumable roots in Tuscan tradition. Since the *Assumption* window dates from right after the competition, it should give us a clue and, indeed, Salmi[34] has pointed to Mariotto di Nardo as a possible source of its style. Geza von Österreich,[35] instead of seeing the direct sources of the early style in this minor master or, as we did, in Bartolo di Fredi,[36] finds them in the workshop of Agnolo Gaddi. Salmi has also suggested[37] a possible attribution to Ghiberti of two paintings, a *Saint Anthony* at Zagreb and a female saint in the Uffizi, formerly at S. Apollonia in Florence, without suggesting any dates. As long as no painting of Ghiberti's is known and since the stained-glass windows reflect his style only indirectly, we remain skeptical—the more so since we do not see traces of late Trecento painting anywhere in Ghiberti's early reliefs. But we leave the decision in the hands of those competent in the field of painting.

Nothing, it seems to us, need be added to Ghiberti's *œuvre* as a bronze caster, sculptor, goldsmith, and draughtsman, as we attempted to draw it up fifteen years ago. Nor need anything be dropped. An attempt has been made to place in his early years, before 1401-1402, three sculptures in the Marche: a bronze relief of the Assumption at S. Maria dei Servi in S. Angelo a Vado; a terracotta Virgin and Child, seated, also in high relief, in the Urbino museum; and a seated Virgin Annunciate in wood, at S. Filippo also in S. Angelo a Vado.[38] To us, the three pieces seem to be by the hands of quite different masters, the first two, we fear, far inferior in quality to Lorenzo, and by local rather than Florentine artists. The wooden Annunciate, on the other hand, is no doubt the work of a first-rate sculptor; but in our judgment, this is not Ghiberti's either. Were we to place it, we would suggest one of the Sienese woodcarvers active in the twenties. As it is, we regret to say that none of the three sculptures in the Marche recalls to us Ghiberti's earliest style, as known from the competition plaque. Nor can we accept the proposal made some years ago to see reflected in a well-

[31] below, p. 203, note 1.

[32] bibl. *37, p. 43ff.

[33] bibl. *42.

[34] bibl. *51.

[35] bibl. *42, p. 47.

[36] below, p. 54.

[37] bibl. *52.

[38] Marchini, bibl. *38; also Brunetti, bibl. *5, p. 9.

known fifteenth century painting, the missing morse "con un Cristo che segna" which Ghiberti wrought for Martin V.[39] The suggestion[40] has been to identify the morse with the one worn by St. Martin, clearly a portrait of Martin V, on Masolino's altar wing in the Johnson Collection in Philadelphia. This morse, however, shows an *imago pietatis* instead of Christ Blessing, and Vayer suggests bridging the difficulty by giving "segnare" the archaic meaning "to bleed," a "bleeding Christ." As used by Ghiberti, however, as an intransitive, "segnare" means only "to bless"; with the meaning "to bleed," it occurs only as a transitive, "to bleed somebody."[41]

Likewise, it seems, little can be added regarding Ghiberti's architectural activities. Marchini, who long ago was the first to suggest convincingly a possible link between Ghiberti's style and the architectural vocabulary of the Strozzi chapel at S. Trinità,[42] datable 1418-1423, has recently called attention to a portal with similar features at S. Francesco in Urbania.[43] Since Ghiberti's presence in the Marche after 1420, the presumable *terminus ad* or *post* of the portal at Urbania, is unlikely, the only possible explanation is that a design from the workshop of S. Trinità found its way into that province. On the other hand, a series of documents discovered by Wundram[44] have led him to attribute both the execution and, cautiously, also the design of the niche of the Baptist at Or San Michele to the stone mason Albizzo di Piero. This is very possible, and we gladly withdraw our equally cautious suggestion[45] that Ghiberti may have had a hand in the design. All told, we hold to our opinion that Ghiberti as a practicing architect counted little; he should never have claimed, as he did,[46] to have built the *cupolone* jointly with Brunelleschi—and we are glad to find our opinion shared by Chastel.[47] We maintain that his importance as an architect rests with the settings designed for the Gates of Paradise.

The traditional doubts regarding the authenticity of the *Flagellation* drawing in the Albertina apparently were not quite laid to rest by our discussion.[48] Nevertheless, we remain convinced that it is by Ghiberti's own hand and we feel comforted in this opinion by the support received from the most authoritative recent work on early Italian drawings.[49] The authors also share our view that the *Saint Stephen* in the Louvre is a presentation drawing[50] although perhaps closer to the master himself than we had thought.

The extent of Ghiberti's *œuvre* remains fundamentally unchanged. How far the work of assistants went in his large enterprises will always remain debatable; certainly we shall not insist on the workshop's rather than the master's having designed this or that detail; the quatrefoils of the *Last Supper, Christ in the Storm,* and the *Arrest of Christ,* which we attributed to assistants, may have been modeled wholly or in

[39] *Commentarii*, II, 21; bibl. 178, I, p. 47, and below p. 13.
[40] bibl. *66.
[41] *Vocabulario della Crusca Compendiato*, II, Florence, 1717, 291.
[42] bibl. 298, pp. 37ff; see also below, p. 261 and note 16.
[43] bibl. *38, pp. 188f. [44] bibl. *69.
[45] below, p. 260, note 15. [46] *Commentarii*, II, 23, bibl. 178, I, p. 51.
[47] bibl. *9, p. 962. [48] Steingräber, bibl. *63.
[49] Degenhart and Schmitt, bibl. *13, pt. I, 2, pp. 289ff.
[50] *ibid.*, pt. I, vol. 2, pp. 293f.

part by Ghiberti himself;[51] if so, he must have done them in his weaker moments. On the other hand, a successful beginning has been made in clarifying the long debated and vexing question of the large *œuvre* presumably designed by Ghiberti but surely executed by anonymous artists for commercial use. Based on his own words, *Commentarii*, II, 23,[52] that he prepared "very many models (*provedimenti*) in wax and clay for painters, sculptors, and *statuarii*," it has long been suggested that among such *provedimenti* were moulds for terracotta sculptures. Among such terracottas surviving, a number of half-figures of the Virgin and Child have long been and are indeed closely linked to Ghiberti's style;[53] one such group, obviously Ghibertesque, was apparently designed prior to 1427, when it was copied by Bartolommeo Buon on a well-head in the Cà d'Oro in Venice.[54] Other groups, equally clearly, were done under Ghiberti's influence, but not in his shop; while still others have nothing whatever in common with him. When writing our book, we decided, wisely we feel, to keep out of the area of terracotta sculptures and of the inseparable jumble of attributions and the inherent booby traps of originals, replicas, early and late copies, and forgeries. Since, John Pope-Hennessy with discriminating connoisseurship has begun to undo this Gordian knot, to distinguish a number of hands, and thus to shed some light on these by-products of Lorenzo's activity.[55]

STYLE AND DEVELOPMENT

All this new information supplements our knowledge of Ghiberti only to a minor degree. None of it provides new insights into the origins and development or the character of Ghiberti's art, or to his position among the artists and patrons of Florence. Such broader questions, discussed in our volume, have nonetheless remained in our mind; they have been asked by some of our critics; and they have come to the fore, if only by implication, in recent writings dealing with Ghiberti, his contemporaries, or with the art of the fifteenth century more generally. Outstanding among these latter are John Pope-Hennessy's *Italian Gothic Sculpture* and Seymour's Pelican volume.

The absolute chronology of Ghiberti's *œuvre* is too well established to allow for major argument. What can be disputed are minor deviations in the relative chronology of the reliefs or of the figures and heads on the frames of his two Baptistery Doors—and, more notably, the changes in his style and their sequence. As we still see him, Ghiberti stands within a field of artistic and intellectual forces that span ancient Rome, fourteenth century France, and contemporary Florence. From this broad spectrum he successively derives inspiration; rooted in a sound knowledge of his craft and an innate sense of grace and balance, he integrates such concepts and idioms into a style firmly his own; and within his own language, he creates with perfect freedom. By and large, the same view has been taken by Seymour,[56] modified obviously by his need to place Ghiberti's art into the chronological scheme of a history of

[51] Kurz, bibl. *32, p. 364; Seymour, bibl. *57, p. 227, note 12.
[52] bibl. 178, I, p. 50. [53] Krautheimer, bibl. *29. [54] *ibid.*
[55] bibl. *47, pt. 1, pp. 58, 215f; bibl. *46, nos. 51-55.
[56] bibl. *57, passim.

fifteenth century sculpture. Divergencies in presentation and interpretation are, on the whole, minor and will be dealt with later. The differences of opinion between Pope-Hennessy's view[57] and ours are more fundamental. Where we, and we think Seymour, see a Ghiberti genuinely one of the founding fathers of the Early Renaissance, Pope-Hennessy views him as a basically Gothic artist, suspect even in his mature work of only imitating the thought processes and the idiom of the new style.[58] It is, after all, not by chance that John Pope-Hennessy discusses Ghiberti as the closing figure in the volume on Gothic Sculpture. Notwithstanding our respect for the sensitive connoisseurship of the author, we see no way to bridge this fundamental divergence of views.

Nor do we see any reason to alter our thesis regarding Ghiberti's origins. His art is rooted primarily in the ambient of the goldsmiths working at and for the royal and ducal courts of France during the last decades of the fourteenth century. Known to craftsmen and collectors all over Europe, such precious metalwork was represented to Ghiberti by the *œuvre* of Master Gusmin. Renewed attempts to identify that still mysterious Northerner with Claus Sluter and to postulate a link between Sluter's style and that of Florentine goldsmith work around 1400[59] seem to us as inconclusive as ever. Nor can we go along with the often repeated proposal to view Ghiberti's early style as growing from the tradition of large-scale sculpture, in stone or bronze, of the early and high Trecento in Tuscany.[60] True enough, later in life Ghiberti was deeply impressed by Sienese painting of the fourteenth century. But everything speaks against his early art being tied to that of the Pisani or of Lorenzo Maitani: his background in the goldsmiths' craft; the apparent death by 1350 of the tradition established by the sculptors and, incidentally, the painters of the early Trecento in Tuscany;[61] and, finally, the brief treatment given in the *Commentarii* to the sculptors of the Tuscan past. Giovanni Pisano is listed with but three works; Nicola only as Giovanni's father; Giotto's *campanile* reliefs appear with a question mark; and Lorenzo Maitani is altogether omitted. Only Andrea Pisano, obviously because a bronze caster, receives an *œuvre* catalogue and is called *bonissimo*. But we fail to see in Ghiberti's work, early or late, any trace of Giovanni Pisano's, Andrea Pisano's or, indeed, Lorenzo Maitani's style. True, the graceful curves, the slender figures, the fine heads, and the sweeping draperies as they appear in Ghiberti's work from the start recall, at first glance, Maitani's Orvieto reliefs.[62] But such elements, in our opinion, derive from a common source: French art of the early fourteenth century, transmitted, we presume, to Maitani either directly or by way of Siena; to Ghiberti by way of a tradition still surviving in France among goldsmiths at the end of the century. Nor can we see any notable impact exerted on Ghiberti's early style by Florentine stone sculpture of the waning Trecento. Evidently, the jambs of the Porta della Mandorla and the *Annunciation* in the Museo del Opera del Duomo mark the milieu in which young Ghiberti

[57] bibl. *47, pt. 1. [58] bibl. *47, pt. 1, pp. 44f, 206.

[59] Parronchi, bibl. *44.

[60] Gombrich, bibl. *21; Steingräber, bibl. *62.

[61] Chastel, bibl. *9, p. 967. [62] Gombrich, bibl. *21.

first encountered the art of antiquity reflected; but stylistically it told him little except, perhaps, through the delicate handling of the body of Hercules on the Porta della Mandorla, copied as it was from a Roman bronze. Meanwhile we await with hopeful anticipation the outcome of the controversy regarding the masters active in that group.[63]

When writing our chapters on the origins of Ghiberti, we desperately looked for possible sources in local goldsmith work. But we found no stylistic resemblance to even the best Tuscan pieces, such as the angel choirs crowning the Pistoia *Silver Altar* or the *Croce dei Pisani* in Lucca, recently attributed—unconvincingly we fear—to Brunelleschi.[64] Notwithstanding authoritative voices[65] which suggest stylistic links between the Pistoia angels and the reliefs of young Ghiberti, we feel that these works share less an Italian sense of beauty than technical skill, precise finishing, and refined elegance of design. After all, the training young Lorenzo received from his stepfather Bartolo di Michele—possibly the "valente orafo Bartolo" called upon in 1395 to assess the terminal work on the Pistoia altar[66]—was that current in the goldsmiths' shops at the time. Work of the past, even including Andrea Pisano's bronze door, superior though it was to his own in casting skill, apparently exerted less impact on the formation of his technique than did contemporary goldsmith work, whether Tuscan or French; and stylistically, we repeat, we see no links in his early *œuvre* to the former.

The large lines of our proposals regarding the development of Ghiberti's art from the Competition relief through the panels of the Gates of Paradise seem to have found general acceptance: the earliest phase is followed between 1407 and 1415—dates suggested but loosely!—by his version of the International Style, marked by the Baptist from Or San Michele and the corresponding reliefs and heads from the North Door; this in turn gives way to the increasingly classical vocabulary of the later reliefs and the *Saint Matthew*; in the twenties he vastly enlarges his classical idiom and evolves his interpretation both of elegant, classical figures and concepts of composition and of his version of a pictorial relief; the thirties, finally, witness the maturing of classical free creations in the major panels of the East Door. Disagreements only occasionally touch upon essential points: Seymour[67] views the formulas of the International Style as merely grafted onto a fundamentally geometrical-classical substratum of Ghiberti's. This seems arguable to us. But on the whole, differences of opinion are limited to the relative chronology of the reliefs in both the North Door and the Gates of Paradise; differences depending obviously on both the stylistic and documentary criteria employed. Wundram, in his doctoral thesis[68]—it came to our knowledge only in 1956 or 1957—based his dating of the quatrefoils of the North Door on stylistic grounds only. We view with some skepticism the resulting proposal of a continuous stylistic sequence parallel to that of the biblical tale, starting with the *Annunciation*

[63] Seymour, bibl. *56; *57; Wundram, bibl. *70, *72.
[64] Parronchi, bibl. *44, p. 175.
[65] Seymour, bibl. *62, pp. 271f; Ragghianti, bibl. *50; Pope-Hennessy, bibl. *47, pt. 1, pp. 38f.
[66] bibl. *62, p. 271. [67] bibl. *57, pp. 45f. [68] bibl. *70.

and ending with *Pentecost*.[69] But we gladly concede the possibility of a relative chronology somewhat different from that suggested by us. No grouping suggested can ever be rigid: in a shop as large and busy as Ghiberti's, the modeling in wax of twenty-eight reliefs containing some hundred figures cannot have proceeded in strict chronological order. Master and assistants must have gone back and forth, sketching, revising, and remodeling groups and individual figures. Our proposed sequence was intended to provide only loose *termini ante* and *ad quos* for larger groups rather than for single reliefs. Variations envisaged in this sequence will always remain debatable. However, we see little sense in quibbling over the question whether the earliest group of reliefs on the North Door, because of its resemblance to the *Assumption* window, was modeled in 1404-1405[70] rather than between 1404 and 1407. Similarly, the amount of assistants' work in the modeling and finishing of the quatrefoils is bound to remain controversial.[71]

The order in which the ten panels of the Gates of Paradise were modeled can likewise be debated. Wundram, first in his thesis and again more recently,[72] has chosen as stylistic criteria the gradual disappearance of the front stage and of full-round foreground figures and the development of what he calls centrally ordered compositions. Thus he arrives at a sequence, proceeding from the *Isaac* and *Cain and Abel* panels to *Genesis, Abraham, Noah* and *Joseph*; then he ends, as we did, with the remaining four reliefs, *Moses, Joshua, David*, and the *Queen of Sheba*. Our argument was based on the increasing unification of both the narrative and the relief space from the *Genesis* to the *Joseph* panels, and on the subsequent flattening of the relief and the coterminous loss of depth and volume. On this basis we would still view the *Isaac* and *Joseph* panels as closely related and would place them in the middle of the series, on the watershed, as it were. We cannot see, by any means, an increasing depth and unity of space in the last panels.[73] Given the documentary evidence, any rearrangement in terms of an absolute chronology would involve differences of only a year or two, if not just a few months. We can only restate our view: both the *terminus post* for the beginning of the modeling in wax of all ten panels (1428 or 1429) and the *terminus ante*, April 1437 (if not 1436), when all ten had been cast, remain fixed. Attempts[74] to place after 1439 the modeling of five reliefs not listed in July of that year as "finished wholly or in part (*finite*)"[75] are still as unconvincing as they were in 1955. These unfinished, supposedly late, reliefs are, by extrapolation, the *Genesis, Noah, Abraham, Joshua* and *David*; and indeed four of these, again unnamed, recur as *non finite* in 1444. But *finire* in fifteenth century usage always means the chasing and finishing of the rough cast, a process requiring a great deal of time: from April 1437 to June 1447, as documented. Steingräber,[76] an authority on metalwork, if any, has pointed to the comparable length of time used by Sansovino to chase the Sacristy

[69] *ibid.*, pp. 28ff.
[70] Geza von Österreich, bibl. *42, pp. 75ff.
[71] Kurz, bibl. *32, p. 364; Seymour, bibl. *57, p. 227, note 12.
[72] bibl. *70, pp. 202ff; bibl. *73, pp. 11f.
[73] bibl. *70, pp. 109f; bibl. *73, pp. 20ff.
[74] Mendes Atanasio, bibl. *2, pp. 96f; bibl. *6.
[75] below, p. 163; docs. 23, 24.
[76] Steingräber, bibl. *63.

Doors at S. Marco in Venice. We leave it open whether Wundram[77] is right to explain such slowness in this phase of the work compared to Andrea Pisano's speed by the higher quality of the latter's rough casts and the resulting ease of chasing. But are not Andrea's reliefs also far less ornate?

Few of these questions appear to be of major importance. However, the sequence assigned to the panels, and in particular to the last group and their date prior to 1437, has more serious implications. Fifteen years ago we hinted at these questions[78] without being quite aware of their import. No doubt, some elements are part of the chasing stage and thus postdate July 1439 or indeed June 1444; these are the overabundant decoration and the negligent handling of human features in the last panels. But the figure style, the over-all composition, and the presentation of space are part of the initial phase of designing in wax and thus antedate April 1437. We can only agree[79] that seven or eight years are an uncomfortably short span to explain the stylistic differences among the *Cain and Abel*, the *Isaac*, and the *David* panels. The crowding of the *David* with figures and props, the tapestry effect of the flattened relief, and the denial of both the individuality of three dimensional figures and the intelligibility of space, are after all a reversal of the principles that had guided Ghiberti's relief style from the Siena Font to the *Isaac* panel.

The reasons for this change lie in part with external factors.[80] In 1436 or 1437, Ghiberti, then in his fifties and an old man in Quattrocento terms,[81] was under heavy pressure of work. Shortcuts in design would naturally be chosen, and the workshop would be drafted into helping with the modeling as well as the finishing. Still, a new style resulted. The tapestry effect and the denial of measurable bodies and space, forecast Gozzoli's murals in the Medici Palace fifteen years later. This we pointed out. But we did not stress that this tapestry effect also looks like a throwback to the pictorial concepts of the International Style, as present for instance in Gentile da Fabriano; nor did we point out the contemporary parallels, such as Pisanello's frescoes or Filarete's main panels on the doors of St. Peter's in Rome. One even wonders, whether Donatello, in the Padua reliefs (1447-1448), did not move somewhat in the same direction. The *David* panel then would seem to occupy a key position within the "drift from the humanist style of the thirties to the crowded, decorative style of the mid-century. Must we then suppose that Ghiberti anticipated this trend by a decade?"[82] But the low quality of the design raises the possibility that they were done largely by a member of the workshop, representing a current surviving all the time alongside Ghiberti's classical style; a current resisted by will all along and breaking to the fore— we refer again to Kenneth Clark—as Ghiberti's will slackened. Were we to revise our book, the style of the last panels on the Gates of Paradise, their place within Ghiberti's own *œuvre*, and their presumable impact on contemporary and later work is the one major point we would rethink and perhaps reformulate.

Another point, of lesser impact, causes us minor pangs of conscience when looking back to the East Door. We treated the figures on its frame rather shortly. True, a great

[77] bibl. *73, p. 10.
[78] below, p. 202.
[79] Clark, bibl. *10.
[80] see below, pp. 202ff.
[81] Gilbert, bibl. *17.
[82] Clark, bibl. *10, p. 177.

number, perhaps a majority, are workshop products, at times derived from formulas coined years and decades before. But a few stand out and the best may have been modeled by the master, or at least under his supervision, perhaps in the early thirties. In spite of their small size, they are of monumental beauty; these few lines must make amends for a sin of omission.

SCHOLARLY AND HUMANIST AMBITIONS

Nearly half our book deals with questions beyond the confines of Ghiberti's *œuvre* and the development of his art. First among such broader considerations is his involvement in the rise of humanism, his relation to the scholarly carriers of the new faith, his scientific approach to rendering space and volume and the human figure, finally his encounter with the rediscovered world of antiquity. The question is ultimately whether Ghiberti wholeheartedly participated in the new movement as an equal or near equal of the humanist scholars, sharing the company of Niccolo Niccoli and Ambrogio Traversari;[83] or whether he stood only on the fringe of that learned circle, aspiring to be and to be accepted as one of them but never attaining his goal. The answer, I think, rests with the realization that scholars and artists stood in different camps. Even though, about 1420, the camps began to talk together and to evolve a common language, the differences remained.

Where Ghiberti can rely on his eye and his sure taste, he manages with ease the encounter with the new world, including that of antiquity reborn. He progressively absorbs a vocabulary purloined from Roman sarcophagi; he gradually assimilates the language of antiquity in both form and content; he assimilates principles derived from the art of Rome, and he ends up by freely inventing designs inspired by the world of the ancients. In these last stages, the communication between Ghiberti and the humanist scholars of Florence increases, and an understanding is for the first time evident.

Within this broad context of a full integration of antiquity into Ghiberti's art, the question of specific sources is essentially of minor importance. Ghiberti draws on a wide variety of inspirations, from Roman reliefs and sarcophagi to the rich vocabulary of classical elements transmitted by the painters of the Sienese Trecento. Still, we wanted to avoid the kind of loose confrontations, all too customary, of Quattrocento works with their presumed models, whether Roman, or indeed, Greek. Hence, our self-imposed limitation to ancient works of art demonstrably known at Ghiberti's time in places he had visited, and the compilation of a corresponding list. The tediousness of this task seems to us justified by the clearer view gained of the ways the fifteenth century met antiquity;[84] and the risk of being suspected of pedantry because of such rigor in method we would bear gladly had we succeeded in initiating an approach both precise and cautious to the study of antique motifs and concepts absorbed by fifteenth century artists. Alas, vagueness still prevails far too often.[85]

We would still rather err on the side of strictness. Only occasionally would we

[83] Gombrich, bibl. *20. [84] see also Degenhart and Schmitt, bibl. *13.

[85] Vermeule, bibl. *67.

broaden the list of possible sources by including elements so omnipresent in antiquity that acquaintance with them in the fifteenth century may be reasonably assumed: small bronzes of widely known type that are known to us in the Renaissance only through sparse inventory entries; sarcophagi of a class widespread; gems and coins such as those of the Empress Sabina, reflected in the *Moses* plaque as well as in the *Queen of Sheba*.[86] Etruscan or Early Christian and Byzantine works, while presumably known to Donatello,[87] apparently meant little to Ghiberti.

However, we did overlook one possible source for the impact of antiquity on Renaissance artists: descriptions in Roman writings of works of art. Gombrich, in a paper published only in 1955[88] and unfortunately unknown to us at the time of writing, suggested that Ghiberti's Adam and Eve in the *Genesis* panel may have been designed under the impact of Lysippus' figure style as described by Pliny,[89] with "heads smaller than older sculptors (had done them) and more elegant and slimmer bodies . . . ," a passage paraphrased by Ghiberti in the *Commentarii*, I, 16.[90] This seems to us likely.

The import of the Pliny passage has been taken to mean that, like Lysippus, Ghiberti consciously set out to better the work of his elders and to perfect himself continuously in the image of antiquity, as did his peers among the humanist philologists and *literati*; and that this constitutes proof of his having been in "contact with the humanist idea of artistic progress."[91] We would not go that far: certainly he strove to outdo his elders, but Lysippus' example in that respect meant so little to him that in paraphrasing Pliny he rendered the key words, "than older sculptors," as "than the other ancient sculptors," and thus eliminated from his text the very idea of progress. Ghiberti's misinterpretation seems, to us, significant indication of his unsureness in approaching the path that led his learned contemporaries to the world of antiquity. He was an intellectual only by ambition, and in learned questions he wanted advice. In composing the *Commentarii*, as Schlosser had contended before us,[92] Ghiberti aimed at nothing so much as to emulate the *vilumi e commentarii* of the ancients, the lost theoretical and autobiographical writings he believed to have formed an integral part in the lifework of the major Greek and Roman artists. Except when telling of himself and his artistic ancestry in the *Second Commentary*,[93] his language is shot through with terms intended to render in the *volgare* a technical and often unintelligible vocabulary found in ancient authors: terms frequently transposed from their original meaning and, as a rule, hard to interpret. *Misure, lineamenti, ragione*, are the best known in his humanist vocabulary. The meaning of at least the first two is still debated.[94] Today we would render *lineamenti*, as used by Ghiberti, strictly as outlines of representation; the other terms we believe to have interpreted correctly. *Statua, statuario, arte statuaria*, and *colosso* have recently come under scrutiny as other such humanist terms.[95] However, little of this terminology was ingrained in

[86] Carandini, bibl. *6, pp. 267f.
[87] Janson, bibl. *27.
[88] bibl. *20.
[89] *H. N.*, xxxiv, x, 64.
[90] bibl. 178, p. 18.
[91] Gombrich, bibl. *20, *21.
[92] bibl. 178, vol. 2, p. 11; see also below, pp. 310ff.
[93] When writing our book, we had quite forgotten a pertinent essay we had published twenty-five years before, bibl. *30, and the oversight was kindly pointed out to us by Erwin Panofsky.
[94] Boskovits, bibl. *4, p. 253 and note 131.
[95] Seymour, bibl. *57; Smith, bibl. *59.

Ghiberti; it was grafted on. He wrote with ease only when disregarding such learned pretensions; at the same time, he loved that borrowed splendor. The frustrated humanist in Ghiberti is in eternal conflict with the wide-awake artist and the down-to-earth craftsman.

This conflict, while obvious in his writing, comes to the fore in his art when, in the *Isaac* and *Joseph* panels, he seeks new ways to represent space to allow for the easy movement of figures. His experiments in linear perspective construction stand out so markedly that it seemed to us of primary importance to focus on them and on their place within the development of fifteenth century perspective theory and practice. Our conclusion was that Ghiberti's experiments reflected the theory and method expounded in Alberti's *Treatise on Painting*. We have reread our chapter of Ghiberti's perspective and have tried to keep up with the pertinent spate of publications. Over the last fifteen years, the discussion has become even more complex and ever new queries have been raised: the roots of Brunelleschi's perspective;[96] artificial and natural perspective;[97] one-point and two-point linear perspective;[98] monocular and binocular perspective;[99] the contrast between or the identity of Brunelleschi's and Alberti's approaches and methods;[100] finally, the clarification of Alberti's procedure through a newly discovered text.[101] The entire area has become so cluttered that it is hard to keep a sense of perspective—pun intended!—despite two excellent summaries.[102] By and large, we still believe in a basic difference, in both method and approach, between Brunelleschi and Alberti, the more so since Erwin Panofsky[103] and M. Boskovits[104] shared this view. Within the restricted area of Ghiberti's use of linear perspective, in any event, a few salient points stand out. One, Ghiberti's experiment in linear perspective is limited to the *Isaac* and *Joseph* panels; in the *Queen of Sheba*, the fleeting moment has already passed. Two, he designs an intelligible space for the movements and actions of figures by building up an architectural setting, a *casamento*.[105] This setting is constructed, based on a square-tiled floor which in turn is proportionate to the height of a human figure placed on it. Three, the procedure is inapplicable to non-architectural, landscape settings. Four, method and approach in the architectural panels coincide with those laid down in Alberti's *Della Pittura*: size and proportion of the human figure envisaged by the artist determine all relationships and render the picture space intelligible. This, Alberti's fundamental concept, is new; whether or not his construction (as distinguished from his concept) merely codifies Brunelleschi's, is tangential. These fundamental points require no change, and we remain unconvinced by contentions[106] that Ghiberti's panels were designed in terms of binocular *misure dell'occhio* and reflect optical theories deliberately non-Albertian.

However, our thesis might need some modification and amplification. Seymour is probably right to suggest[107] that Ghiberti manipulated linear perspective so as to adjust it to the position of the panels on the door and to render it applicable to a

[96] Sanpaolesi, bibl. 469; White, bibl. *68.
[97] Parronchi, bibl. *45.
[98] Gioseffi, bibl. *18, *19.
[99] Parronchi, bibl. *44.
[100] Boskovits, bibl. *4; Panofsky, bibl. *43.
[101] Grayson, bibl. *23.
[102] Boskovits, bibl. *4; Dalai, bibl. *11.
[103] bibl. *43.
[104] bibl. *4.
[105] Bloom, bibl. *3.
[106] Parronchi, bibl. *45.
[107] bibl. *57.

high relief rather than to a flat picture plane. But we regretfully must refuse to see all the panels on the Gates of Paradise as adjusted to the spectator's point of view *da sotto in su* or *da su in sotto*.[108] None of this, alas, answers the question of how and whether Ghiberti constructed space in reliefs with a pure landscape background. It has been proposed[109] that in these reliefs too, Ghiberti employed a rigid system: a workshop formula, dividing the height of the panel into zones, each determined by the measurable size of the figures and thus suggesting depth. As presented, the formula appears to lack consistency, but a similar workshop rule of thumb may well have been used. Also, we feel as bothered as ever[110] by Ghiberti's claims, *Commentarii*, II, 22,[111] that all ten panels were in *casamenti*; that in all the figures stood on *piani*; and that all were filled with many figures. We cannot accept the translation of *casamenti* as "non-scientific perspective organization";[112] to us, *casamenti* still means architectural settings. *Rebus sic stantibus* we must fall back on our original suggestion: Ghiberti, writing in retrospect, transferred to all ten panels the most outstanding features used in any of them. But this is not a neat solution.

Be that as it may, Ghiberti employed a consistent linear perspective only in the *Isaac* and *Joseph* panels, and it is based on an Albertian approach. He abandoned this approach as unexpectedly as he had taken it up, and we leave it open whether or not such reversion was caused by Alberti's departure in 1436 from Florence.[113] In any event, the transitoriness of Ghiberti's "perspective moment" shows how weak was his hold on the scientific basis of space representation. He depended on advice, and this was so in all his learned endeavors. He collected ancient art, and this avocation he shared with some of the humanists. But his approach was visual, not intellectual; and, as we see it, he stood only on the edge of that "codex-swapping crowd,"[114] and in scholarly matters depended on the advice of its members. Hence, we view with considerable doubt the proposition that he himself drew up the final program of the Gates of Paradise.[115] We still believe that advice on this program, if not the program itself, originated with Traversari and possibly, Niccolo Niccoli.

Whomever Ghiberti drew on for advice in matters theological, it was, in our opinion, Alberti on whom he relied most closely in the thirties. When bringing up Alberti's name in the context of Ghiberti's scholarly aspirations and of his mature work, we presented a hypothesis, based on the parallels in rendering movement, intelligible space, and action (*storia*) between the Gates of Paradise and *Della Pittura*. We considered it a plausible, and on many points the only possible, explanation, as did some of our critics.[116] We may, in discussing the architectural design in the panels of the Gates, occasionally have gone a bit far,[117] but on the whole, we have not changed our mind. Our own criticism would be that in the last chapters of our book we were driven by a subconscious desire of long standing: to write a book on Alberti.

[108] Parronchi, bibl. *45.

[109] Bloom, bibl. *3.

[110] below, pp. 231ff.

[111] bibl. 178, I, pp. 48f.

[112] Bloom, bibl. *3, p. 168, note 27.

[113] Clark, bibl. *10, p. 178.

[114] Gombrich, bibl. *20.

[115] Gilbert, bibl. *16, p. 84, note 40.

[116] Clark, bibl. *10, p. 178; Chastel, bibl. *9.

[117] Chastel, bibl. *9, p. 971.

GHIBERTI'S PLACE

It has never been easy to assess Ghiberti's place among the artists and patrons of fifteenth century Florence and to determine the character of his art. The view established by Vasari, of Lorenzo's moving from Gothic formulas to the new art of the Renaissance, dies hard; today he is still occasionally presented as a "Renaissance artist within the context of Gothic and a Gothic artist in the context of the Renaissance."[118] The flaw in this view lies in a misconception, not so much of Ghiberti as of the character and modern nomenclature of the styles current North and South of the Alps through the fourteenth century and the early part of the fifteenth. Prevailing opinion frequently has it that both the Gothic and the Early Renaissance are fundamentally monolithic. But this is not so. Both the "realism" of the late fourteenth century, as represented by Peter Parler or Claus Sluter, or, indeed, Gusmin, and its subsequent reversal in the International Style break with the Gothic past: the one through pitiless exploration of nature and its ugly side; the other through an overlay of lyricism on an essentially "realistic" core. Hence, we consider the term "International Gothic" as misleading, and while well aware of the confusion inherent in the term "realism,"[119] we still cannot find a better one. Ghiberti's early art then, while rooted successively in the late fourteenth century realism of Gusmin and in the International Style, does not make him a Gothic artist. Nor does it make him a conservative. Hindsight makes it easy to perceive that neither of these currents was to prevail in Florence. But in the first decade of the fifteenth century, these were the most progressive forces, just penetrating from North of the Alps into Italy. Ghiberti at that time was no conservative.

The difficulty in seeing him as the progressive he was lies to a large degree with his innate sense of balance and moderation. Where Brunelleschi in his Competition piece loudly proclaims the newness and boldness of his realism and his discovery of antiquity, Ghiberti quietly integrates similar features into the melodious linearism natural to him. Such unobtrusive absorption of revolutionary features and their full integration with a lifelong personal style is apt to interfere with an immediate recognition of their newness. Soft voices are hard to hear.

Until about 1412, Ghiberti was the leading artist in Florence—the progressive champion of the International Style, the *dernier cri* among internationally minded civic leaders, progressive also in fusing into his work a vocabulary *all'antico*, and the only capable bronze caster. Donatello and Nanni di Banco were just coming to the fore, and they were stone sculptors to boot. They became Ghiberti's true competitors only after 1412 or 1415, and the argument can only be whether Ghiberti retained his leading position in the rising tide of the representatives of the new style—Donatello, Masaccio, Nanni, and Brunelleschi. Of course, one wants to understand that in the late teens and for some time thereafter, each of these masters had his own answers to the newly proposed questions—the nude, the draped figure, movement, convincing space, expressiveness, and the encounter with antiquity. The Renaissance, then and probably always, was not monolithic; and Ghiberti's solutions, from the *Matthew* and

[118] bibl. *47, pt. 1, p. 39. [119] bibl. *1.

the Siena *Baptism* to the panels of the East Door and the Shrine of St. Zenobius, are as fully Renaissance as anybody's. But obviously he fused both the new tasks and the heritage of classical antiquity with that constant personal note of his—grace and elegance, balance and moderation, and perfection of both technique and detail. These were the elements he sought in antiquity, and they are his contribution to the formation of the new style in the twenties and thirties. It is misleading to identify elegance and linear beauty with either the heritage of the International Style or with easy prettiness.[120]

As a force within the history of fifteenth century sculpture Ghiberti is as decisive and as progressive as any of his contemporaries; but this does not impair Donatello's greatness.[121] Among Florentine sculptors, Donatello was the most monumental, inventive, and imaginative; he was the most powerful, bold, ever ready to go to extremes. He was a genius. We are not sure that Ghiberti was. On the contrary, we tried to view him as an anti-hero of sorts and to take an attitude as objective as any historian can without losing a hold on his subject. Naturally in a large and broad monograph, the anti-hero can hardly help being tainted here and there by the stroke of a heroic brush. But we strove hard to avoid this. We think of Master Lorenzo as a superb artist, as a craftsman satisfied with nothing less than perfection, as the head of the most efficient team of bronze casters in Florence, as a shrewd businessman and good citizen—a square in present-day terminology. He was far less totally engaged than Donatello, less bold, less outspoken, and never brutal. Certainly, this lesser degree of involvement, the cautious moderation of his approach were essential elements of his success with the business community in charge of commissioning works of art. Committees dislike being shocked. But none of this should distract us from seeing his art as it is: of the highest quality, superb in both design and execution, immensely refined, elegant, and intricate. Nothing is ever obvious; the excellence of his art is tied up in its quiet balance; in short he's got style.

A purgatory of sorts awaits scholars in their late years—re-editing their old books. The author believes that he remembers them accurately, having perused them on occasions over the years. When the new edition comes along, he relies on a dim memory and starts reading what colleagues and friends, no synonyms by any means, have written on the subject—critical and uncritical praise and trivia alike. In the end, in despair, the author returns to his own book, to read it carefully and, for the first time in long years, to assess both details and broad scope. If he is lucky, he heaves a sigh of relief. Purgatory is over.

In preparing and writing this preface, I have had the help of two students of our Institute: Laurie Smith, who took upon herself the weary task of reading and digesting the reams of publications on Ghiberti and his time; and Constance Lowenthal, who has helped me in coining the right phrase at the right moment. My old friend, Mrs. Meg Licht in Florence, has spent endless hours tracking wayward photographs; my warmest thanks go to her.

New York, May 25, 1970

RICHARD KRAUTHEIMER
Institute of Fine Arts, New York University

[120] bibl. *9, pp. 971f. [121] bibl. *1; bibl. *9, pp. 970ff.

PREFACE TO THE THIRD PRINTING

WE have some qualms as would anyone about reprinting a work first published a quarter of a century ago and conceived in part some time before. But we are told *Lorenzo Ghiberti* is still needed and that it has become a classic; and that therefore it should be reissued and must be reissued as it stands. Nor would we want to change the text. The basic conceits regarding Ghiberti's personality, his *œuvre* and his place in fifteenth-century art remain those we held at the time of writing. But additional points are coming to the fore in papers and discussions and the extent of his *œuvre* is being enlarged and disputed here and there. Thus we feel obliged to give in this preface as we did in the Preface to the Second Printing an account, if brief, of new finds and new interpretations published since 1970, when that printing appeared, and where necessary to take a stand for or against; we also want to use this occasion to state briefly our view on the frame of the South door of the Baptistery, a work produced by the Ghiberti shop after Lorenzo's death.

The preface will be subdivided as was the one to the Second Printing under a number of headings: *The Oeuvre; Style and Development; Iconography; Ghiberti architetto; Writings and Humanist Ambitions.* The publications discussed will be found listed as *Additional Bibliography Since 1970* and are marked in the footnotes with two asterisks.

THE ŒUVRE

Major additions to Ghiberti's *œuvre* were hardly to be hoped for. Still, Ulrich Middeldorf in 1971 was able to bring to light a number of tombstones in Florentine churches, apparently designed by Ghiberti and executed under his supervision.[1] Outstanding among them is the Lenzi slab at Ognissanti with the exquisite bronze plaque of a bull's head, assigned by Middeldorf, rightly it seems to us, to Ghiberti himself. The attribution to him of the design for the sarcophagus of Onofrio Strozzi in the Sacristy of S. Trinita has met with some skepticism.[2] On the other hand, Middeldorf's proposal to see Ghiberti rather than Donatello[3] as the designer of the sarcophagus for Maso degli Albizzi in S. Pierino is convicing; the superb relief of a dog on the front plaque, as pointed out by Middeldorf, persuasively recalls the animals in Ghiberti's *Noah* panel on the *Gates of Paradise.* Just this resemblance, however, raises the question whether the sarcophagus was done right after Maso's death in 1417 or a decade or two later. In the latter case its lettering *all'antica* would not be surprising, either.

A few pieces of goldsmith work, too, have been newly attributed to Ghiberti or his workshop. A beautiful bronze pommel, formed of three heads and hence identified as *Prudentia,* was acquired in 1973 by the Bayerisches Nationalmuseum in Munich; it is close in style to the heads projecting from the clipei on the North door of the

[1] Middeldorf, bibl. **52. [2] Lisner, bibl. **42, note 110.
[3] bibl. **42, p. 171.

Baptistery. Two other such triple-headed pommels, possibly cast from the same mold, have been recognized, one at the Fitzwilliam Museum in Cambridge, the other then in the art market.[4] The body of the reliquary at Città di Castello whose figures have long been identified as produced by the master's workshop has likewise been convincingly attributed to his shop.[5] The discussion in this context of a well-known drawing preparatory for a piece of goldsmith work has led Giulia Brunetti to bring out the characteristics of the architectural vocabulary used by Florentine goldsmiths and in particular that idiosyncratic to Ghiberti's shop.[6] The number of stucco and terracotta Madonnas fondling the Child, half– or full figures, which go under his name has been increased and their authenticity, whether produced by the master or by collaborators or imitators or, indeed, modern forgers investigated: one group so far unknown is in the Hermitage;[7] and three more, one at Detroit convincingly given to Ghiberti himself, have been discussed in the coda to an important paper by Sir John Pope-Hennessy, more of which later; in passing, the author also confirms our suggestion that the production of such groups increased after 1437, when Vittorio entered the firm as a junior partner.[8] Finally, a number of such groups in terracotta and stucco, formerly attributed to Ghiberti or Quercia has been persuasively given to Nanni di Bartolo.[9]

On the other hand, we remain unpersuaded, notwithstanding Ulrich Middeldorf's nodding approval,[10] by the proposal to remove from Ghiberti's holograph *œuvre* the Albertina drawing for the Flagellation and to give it to Masolino instead.[11] To us that forceful sketch reveals a hand far stronger than Masolino's in the *sinopie* in Empoli and at S. Clemente in Rome; and given the close correspondence of the figures to those in the relief on the North door, that hand can only be Ghiberti's. Nor are we persuaded by the proposition, based largely on the attribution to Masolino of the Albertina sheet, to assign a number of fifteenth–century drawings contained in a codex of the Laurentian Library to the Ghiberti workshop;[12] unless, that is, the shop is viewed quite broadly so as to include collaborators of very different background.

Nothing new has been or indeed could be expected to be said regarding the techniques of casting or chasing employed by Ghiberti and his workshop. We have been criticized[13] for translating *ottone*, the material used for the Baptistery doors, as bronze instead of brass.[14] Technically, this criticism is correct; *ottone* is indeed brass, an alloy of copper and zinc, while bronze is an alloy of copper and tin. However, everybody since the fifteenth century has spoken of Ghiberti's bronze doors[15] and we shall just go along with the tradition instead of switching to 'brass doors.'

The organization of Ghiberti's shop and of his collaborators has been discussed

[4] Anonymous, bibl. **5.

[5] Brunetti, bibl. **17, p. 232ff., and Marchini, bibl. **49, p. 19.

[6] bibl. **17, p. 225ff. [7] Androssov, bibl. **4.

[8] Pope-Hennessy, bibl. **60, p. 68. [9] Schlegel, bibl. **72.

[10] Conti, bibl. **20, p. 148, note 4. [11] Bellosi, bibl. **12.

[12] Conti, bibl. **20. [13] Euler-Künsemüller, bibl. **26, p. 97.

[14] see below, p. 369, Docs. 27, 30, and *passim*. [15] see below, p. 374, Docs. 61, 65, and *passim*.

again, if only in part.[16] Uccello's apprenticeship with Ghiberti has been persuasively dated into the years from 1412 to 1416.[17] Michelozzo, as last suggested by Harriet Kaplow,[18] may well have been employed as a specialist in chasing when in the shop, either as a partner in the early twenties or later as a collaborator. To single out his work on either door or in the *Saint Matthew* seems to us impossible. Likewise the attempt to distinguish on the second door the hands of Ghiberti's sons, Tommaso and Vittorio, is forbiddingly difficult, notwithstanding a recent attempt.[19] The old man apparently ruled his crew with an iron hand—better a bronze hand. Individualities had but a poor chance of coming to the fore. When they did, as was the case we think in the *David, Moses*, and *Joshua* panels, they cannot be identified, since their handwriting in attributable works remains either unknown or, as is the case with Tommaso's work on the niche of the Baptist on the altar of Saint John in the *Opera*, simply lacks a character of its own.

Nor, we fear, will the frame of the Andrea Pisano door, commissioned in 1453 to the firm of Lorenzo Ghiberti and Son and executed under Vittorio's supervision from 1456 to 1464, yield many clues toward identifying Vittorio's hand. Based on comparisons with that frame some of the prophet figures on the *Gates of Paradise* and some heads from its frame have been attributed to Vittorio.[20] We cannot agree with these attributions. As we see it today, more clearly than we did twenty-five years ago,[21] the frame is the work not of Vittorio, as we then thought, but of an *équipe*, largely composed of young artists, obviously supervised but not directed by Vittorio. Whether or not Antonio Pollaiuolo and Verrocchio were among these young forces, it is the generation born in the twenties and thirties which in our view is responsible for the innovative freshness and extraordinary beauty of the frame: the exuberant, deeply undercut foliage; the putti heads on the architrave; the rushes and palm fronds; the palmettoes and the candelabra *all'antica* on the inner jambs. Nor could Vittorio, it seems to us, have modelled the figures at the bottom of the frame—not Adam and Eve, as we formerly had it, but satyr and bacchante. Both are derived from the Bacchic sarcophagus, then at S. Maria Maggiore in Rome, seen by Lorenzo and presumably drawn in his sketchbook.[22] But stylistically they are no longer akin to the figures on the *Gates of Paradise*, panels or frame. The superbly refined Eve in the *Genesis* story, the fine-boned boys in the *Joseph* and *Moses* plaques on the one hand, the bacchante on the frame, slim but bony, the wrestling fat urchins, the expressionless faces on the other, are miles—better, a generation—apart. The team working on the frame on the whole is no longer, it seems to us, the same as that active under the old man on the *Gates of Paradise*; except that a few members may have been retained. Vittorio's hand in our present opinion cannot be seen anywhere on the frame. What little is known of his work is conservative, indeed far behind the times. The *pietra dura* casket, once attributed to him,[23] has been removed from his

[16] Ciardi Dupré, bibl. **18, p. 245ff., and *Catalogo*, 392ff.
[17] Beck, bibl. **11. [18] Kaplow, bibl. **39.
[19] see above, note 16. [20] see above, note 16.
[21] see below, p. 212f. [22] see below, pp. 344, 348.
[23] Steingräber, bibl. **74.

œuvre on good grounds[24] and reattributed tentatively to the workshop of Pasquino da Montepulciano.[25] The only documented work that remains is a reliquary bust at S. Domenico below Fiesole dated 1457 and thus contemporary with work on the frame.[26] The head was replaced in the sixteenth century, but the rest survives: a bust covered by a pluviale, covered with thorny tendrils and cufic script and conservative in the extreme.

As we see Vittorio, his place in Florentine art rested primarily on his having inherited the largest bronze foundry in the city, the only one capable of handling an object as huge as the frame; when taken over by his son Buanoccorso in the last decades of the fifteenth century it became a canon foundry.[27] In the middle of the century, after Lorenzo's death, the foundry naturally would attract the young forces among sculptors, eager to learn the techniques of casting and chasing. Vittorio aside from being the owner may have been a skilled technician. It is not he, however, but younger forceful artists who were responsible for the forward looking style of the frame around the Andrea Pisano door.

STYLE AND DEVELOPMENT

Discussion as was to be expected continues about the formation of Ghiberti's early style and his activities as a painter prior to 1402. *Primizie* in that field have again been suggested; we must leave the decision to expert opinion.[28] Likewise, as was to be expected, the links postulated by us of Ghiberti's beginnings with contemporary or slightly earlier French goldsmith work, known to him through the *œuvre* of Master Gusmin, are being questioned.[29] We ourselves wish more precise evidence were forthcoming regarding that enigmatic master; in its absence we can only point again to the obvious resemblances of young Ghiberti's first works to French goldsmith work of the 1380s and thereafter. Against this our view, the "Florentine faction" points to Tuscan precedents for Ghiberti's early *œuvre*, both stone sculpture and goldsmith work.[30] As to the former, there has never been nor is there any argument: young Ghiberti was obviously impressed by the new way of handling a human body under the impact of antique models as it had come to the fore at the Porta della Mandorla, in particular in the work of the "Hercules Master" be he or not Giovanni d'Ambrogio. However, we never could nor can we now discern any

[24] G. Brunetti, as quoted by Ciardi Dupré, bibl. **18, p. 248, note 11.

[25] bibl. **18, p. 249. [26] Mather, bibl. 308.

[27] Krautheimer-Hess, bibl. *33. [28] Marchini, bibl. **48.

[29] The figure of Charlemagne atop the Sceptre of Charles V (below, p. 64 and fig. 17) has been pronounced a fake dating from 1804 (O. Kurz, *Falsi e falsari*, transl. L. Ragghianti Collobi, Venice, 1961, 240f., based on his *Fakes*, New Haven, 1948; however, the author omitted the passage from the revised second English edition, New York, 1967). If so, the statuette is a fairly exact copy or, I would suggest, a reworking of the original as reproduced by B. de Montfaucon, *Les Monuments de la Monarchie Française*, I, Paris, 1729, pl. 3 and described *ibid.*, p. xxv; except that the handling of the face, now that it has been pointed out by H. Swarzenski, "The niello cover of the Gospel Book of the Sainte-Chapelle . . .," *Gesta* 20 (1981), 207ff., esp. 210, begins to arouse my own suspicions—now, *après vingt-cinq ans.*

[30] Kreytenberg, bibl. **41.

stylistic kinship between the Competition relief or the earliest quatrefoils on the one hand and the Pistoia silver altar or that of the Baptist in the Opera del Duomo on the other. It goes without saying that Ghiberti had obviously acquired his technical skill in a Florentine goldsmith shop, presumably that of Bartolo di Michele. Discussion will no doubt continue.

An intriguing question has been raised regarding the penetration into Florence of the International Style.[31] The carrier, rather than Ghiberti or Lorenzo Monaco, as we thought, was Starnina, it is being proposed; he would have brought the new fashion from Spain as early as 1403 and thus four or five years before it penetrated the work of either of the two. Florentine painting of the first years of the Quattrocento is a sealed book to the present writers. If the connoisseurs in that area concur with the suggestion and with the proposed identification of Starnina with the Maestro del Bambino Vispo, we shall be glad to modify our earlier position.

A recent doctoral dissertation takes an analysis of the reliefs on the North Door as the springboard for a critique of the approach to Ghiberti's art and personality chosen by us.[32] The author attacks our attempt to present the quatrefoils as reflecting a gradual development of Ghiberti's style during the first fifteen years of his activity. She would rather view the entire door in terms of a unity of style and interpret the obvious differences between the individual quatrefoils as resulting from "a dialectic based on the artistic development of the collaborators as against that of the master." There is a kernel of truth in this criticism in that the activity of collaborators already on the North Door was presumably more incisive than it was brought out by us twenty-five years ago; but it remains as difficult as ever to determine such cooperation, the more so since Ghiberti's contract so clearly stipulated that he was to work with his own hand the difficult parts in every single relief.[33] Altogether, however, our critic feels that an analysis of the quatrefoils and by implication of Ghiberti's entire œuvre ought to start from the narrative as transposed into visual form. In brief her approach is antihistorical, aimed at conveying an impression of the artistic personality "beyond time and space." It is an attempt, as the author makes clear, to revive the approach pursued successfully on a high intellectual level seventy years ago by Julius von Schlosser; an approach we parted ways with because of Schlosser's heroization of the artist in *Leben und Meinungen*[34] and concomitant avoidance, much in contrast to his other work, of historical perspective. Schlosser in that book did not want to write history; nor does our new opponent. Hence we cannot argue with her. There are fundamentally different ways of looking at an artist's œuvre. We have chosen ours.

Not to stray from our path, the place in Ghiberti's œuvre of the statue of *Saint Stephen* and the development of his style in the twenties should be reconsidered. It has been claimed recently that the presentation drawing for this work in the Louvre follows a pattern of proportions for the human figure described around 1400 by

[31] Van Waadenoijen, bibl. **77; see also *idem*, bibl. **78.
[32] Euler-Künsemüller, bibl. **26. [33] see below, p. 368, Doc. 26.
[34] Schlosser, bibl. 477.

Cennini while the statue as designed and cast in 1426-27 is laid out according to a system based, so the author, on both Vitruvius' rules and on those recommended by Alberti in *De statua*.[35] Hence, it is maintained, the *Saint Stephen* should be seen as a decisive step forward in the development of Ghiberti's style. We are only half convinced by the argument. There is no reason to doubt that indeed different canons of proportions underlie the design of the drawing on the one hand, of the statue on the other. But we question the validity of conclusions drawn for Ghiberti's style and development from a comparison between the Louvre drawing and the statue as it stands at Or San Michele. The drawing, while done for Ghiberti, is by the hand of either an assistant or of a painter of his acquaintance;[36] and in any event by a craftsman trained in the tradition of a Trecento painter's shop. It was intended, as such presentation drawings were, to give the commissioning body, the Arte della Lana in this case, an overall idea of the work proposed, in particular size and attributes; suffice it to recall Quercia's presentation drawing for the Fonte Gaia. In no way does it reflect Ghiberti's personal style. The statue on the contrary as executed is his; and the canon of proportions used *does* reflect his exploration of new artistic formulas in the second decade of the fifteenth century. Indeed, the *Saint Matthew*, as sustained in a thesis dealing with the proportions of Ghiberti's large scale sculptures and in a subsequent paper,[37] is still based on the canon of proportions recommended by Cennini. Ghiberti, then, would have broken with that Trecento canon between 1419-20 and 1426-27, the dates when the *Saint Matthew* and the *Saint Stephen* respectively were designed. (If the niche of the *Saint Matthew* indeed was designed according to the canon of musical proportions developed in Plato's *Timaeus*,[38] Ghiberti would have shifted to a canon *all'antica* as early as 1422.) In any event, the canons of proportion for the human figure employed by Ghiberti, given all-too short shrift in our text twenty-five years ago, should be taken into account in assessing the development of his style. Nonetheless, the "advanced" proportional canon, if that it is, of the *Stephen*, leaves unresolved the obvious contrast between the classical forward looking posture of the *Matthew* and that ever so much more tradition-bound pose of the *Stephen*, eight years later, just a few years before work started on designing the plaques of the *Gates of Paradise*.

Both the absolute and the relative chronology of these plaques, so central in Ghiberti's late *œuvre*, have been called into question. Their dates, however, are, we believe, too well documented to allow for any doubt regarding the chronology of casting and finishing: all ten reliefs were cast by April 1437—or possibly, though less likely, April 1436; and the list of July 1439 of two panels finished, three more in different stages of chasing—this and nothing else is the meaning of *finito*—leaves five more plaques waiting for the nettoyage to be started.[39] Doubts ever reiterated[40] cannot change evidence that clear. On the other hand, no documentation refers to

[35] Morselli, bibl. **55.
[36] see below, p. 97, note 19.
[37] Zervas, bibl. **81 and **80.
[38] Zervas, bibl. **80, p. 38.
[39] see below, p. 368, Docs. 23 and 24.
[40] Ciardi Dupré, bibl. **18, and Gioseffi, bibl. **32, p. 403, *nota aggiuntiva*.

the sequence in which the plaques were designed and modelled in wax; except, that is, the *terminus post*, after 1428-29 when a pattern of twenty-four rather than ten panels was still envisaged, as witness the back frame of the door, and the *terminus ante* of April 1437 when the panels had been cast. Within this maximum span of eight years the panels were modelled; as we proposed, in the sequence of the biblical narrative, moving from the upper to the bottom plaques. Starting with *Genesis* and ending with the *David* story, then, designing and modelling would have proceeded from a narrative with several events—*effetti* in Ghiberti's language—represented in each panel, all given nearly equal weight, to panels all filled by one dominant *effetto*. Concomitantly we saw (and still see) Ghiberti's style changing: from a relief, which gradually recedes from full-round figures front stage to a less voluminous middle ground and further to delicate background scenes, he shifts towards a *rilievo schiacciato* with rapid transitions from shallow foreground scenes to the farthest distance. Correspondingly in these panels near the bottom of the door the individual figures are swallowed up by swirling crowds while in the upper registers in each panel the individuality of figures and events is underscored. In the Preface to the Second Printing we have already stressed in answer to a question of Kenneth Clark's how the style of these, in our view the last panels to be modelled, defies easy explanation, reverting it seems to the International Style of the twenties while at the same time apparently anticipating Donatello's Paduan plaques and their *schiacciato* relief.

This thesis of a development of Ghiberti's relief style, proceeding from the upper to the lower panels on the *Gates of Paradise*, has been challenged in what seems to us the most significant contribution made over the past ten years to the Ghibertian debate.[41] Sir John Pope-Hennessy starts by outlining the creative procedure presumably followed by Ghiberti in designing the reliefs on both his doors, starting with sketches, such as the Albertina sheet, followed by careful working drawings and by models of figures and groups in clay or wax, perhaps arranged on a tiny stage— the latter a suggestion made by our critic in his inaugural speech at the 1978 Congress—and ending with the final modelling of the relief in wax. In this context, Sir John persuasively brings out the interlocking of painting and sculpture in Quattrocento art in general and in Ghiberti's *œuvre* in particular. Indeed, both in composition and in the presentation of the narrative, the latter in the author's opinion Ghiberti's main concern, the panels—in particular the upper ones, I would specify— and the stained glass windows of the Cathedral designed in the thirties are closely related. We can only agree and we gladly concede the need to stress more strongly than we did in formulating our text the importance both of these windows in tracing Ghiberti's style in the thirties and of the overall narrative motivation of Ghiberti's design: perhaps even to the point of viewing his use of perspective as serving the creation "of an illusion of space for the sake of narrative lucidity." We also gladly accept the suggestion to view the landscape grounds in the *Gates of Paradise* as being based on an experimental rather than an Albertian perspective, a view not too far different from our own.

41 Pope-Hennessy, bibl. **60.

We part ways with Sir John, however, in his proposal for a new relative chronology of the panels in the designing stage. He views as the guiding principle in Ghiberti's development in the *Gates of Paradise* an increasing commitment to "narrative lucidity"; and since the stories in the upper registers of the doors, from the *Genesis* to the *Isaac* panel, are more lucidly told than those of the *Moses, Joshua,* or *David* in the lower registers, he places these latter at the start, the former at the end of the planning phase. Ghiberti, then, would have proceeded from narrative confusion to ever greater clarity. Concomitantly Pope-Hennessy links the relief style of the lower panels, such as the *Joshua* or *David*, to that of Ghiberti's *Baptism* on the Siena Font. A mainstay in this argument is the resemblance in composition—a center group flanked by wings of bystanders—between the *Solomon* panel and the main plaque of the Zenobius shrine, the *Miracle of the Boy Resurrected.* The contract for that shrine, one recalls, was signed in 1432; but work was long delayed and the main plaque was not cast before 1439.[42] The modelling of that plaque—and we stand corrected as to its subject matter; rather than being a Strozzi, the boy is unnamed, left by his mother in the care of the Saint—we assumed to have taken place in 1437, because of the correspondence of figures and draperies to the *Joshua, David,* and *Solomon* panels, late in our opinion and presumably modelled in 1435 and 1436. Pope-Hennessy on the contrary argues that the Zenobius relief "must have existed at least in graphic form when the plan of the shrine was approved early in 1432." To corroborate this early date he points to Fra Angelico's *Last Judgement* of 1431 which indeed anticipates the compositional pattern of the relief.

A presentation drawing for the main plaque of the Zenobius shrine may well have existed early in 1432. However, presentation drawings notoriously differ from the final design—suffice it to point to the Louvre drawing for the *Saint Stephen.* The final version for the Zenobius miracle as it was cast in 1439 or 1440, in any event, need not have been modelled in 1432; if not in 1437, a date not provable either, it could have been modelled in the mid-thirties and thus more or less contemporaneously with the modelling of what we believe to be the late group of panels on the *Gates of Paradise.* But of course, since Pope-Hennessy dates that very group early, the argument moves in a circle.

Nonetheless, we remain unpersuaded by Sir John's proposal to reverse *in toto* the sequence in which the plaques on the door were designed. The relief style in the upper panels, *Genesis, Cain and Abel, Noah,* or even the *Isaac* story, receding as it does from full-round foreground groups to shallower middle ground and backdrop scenes and settings, seems to us today, as it did twenty-five years ago, evolved from that developed by Ghiberti certainly by 1424 or, as we now think, a few years before, in the *Baptism* on the Siena Font. In fact, in a noteworthy essay, easily overlooked because published in a daily paper,[43] it has been suggested that the "transformation of ground into space" so evident in the Siena *Baptism* and in the upper panels on the *Gates of Paradise* could be traced back to the latest quatrefoils on the North Door. As we see it the relief style of the *Genesis* panel and those related is a more

[42] see below, pp. 412, 415, Digs. 167, 207. [43] Wundram, bibl. **79.

sophisticated version of that evolved by Ghiberti in the early twenties. Conversely, we cannot see Ghiberti proceeding from that solution, as Pope-Hennessy would have it, straight to the *David*, the *Joshua*, or indeed the *Solomon* panel. Nor are we persuaded by the second argument adduced to reverse the sequence in which the panels were modelled. The narrative, to be sure, is presented with maximum clarity in the upper registers of the doors. But the contention that Ghiberti's narrative style moves from the unclear telling of the story in the overcrowded *David* or *Joshua* panels—only the *Solomon* story is straightway intelligible—towards ever greater clarity, fails to convince us. As we see it, the lucidity of narrative exposition in the upper registers of the doors rests on the story's being told as a sequence of *effetti*, each single one recounted succinctly, like those on the Siena Font and in the quatrefoils of the North Door. Assembled in one panel, these single *effetti*, succeeding one another in the narrative, are distributed over the stage, embedded in a setting, scenery or architecture. Such telling of a story is after all good Trecento tradition, from Maso di Banco's Sylvester cycle at S. Croce and Traini's murals at Pisa to Spinello Aretino's Saint Benedict cycle at S. Miniato; and it is the narrative technique reflected in Ghiberti's enthusiastic recounting of Ambrogio Lorenzetti's murals. Transposed into a new idiom, this tradition, we maintain, is taken up in the upper registers of the *Gates of Paradise*: the eye is led from one event to the next, nearly all of equal importance, until the whole story has been told. In the mid-thirties, as we see it, Ghiberti breaks with this tradition and shifts towards a new narrative technique. In this, one event dominates or, indeed, it tells the entire story as witness the *Solomon* relief. However, such concentration on one single key event occurs in Ghiberti's work only once more —in the front plaque of the Zenobius shrine. More frequently, the event that stands out in the panel, rather than being the key to the story, is mere by-play, while the key event has been pushed far back as in the *Moses* panel; or else, the key event, the *Slaying of Goliath*, gets drowned by the battling crowd; and in either case the story loses its lucidity.

How this new narrative technique came to the fore in the panels of the *Gates of Paradise* still needs an explanation. Some few paintings in the late twenties and early thirties had anticipated it—Masaccio in the *Tribute Money*, Masolino in the *Miracle of the Snow*. They remain isolated. But by the mid-thirties they would have exerted their impact on Ghiberti. Concomitantly, Alberti's conceit of *storia* as expounded in *De pictura* in 1435 codified the technique of telling a story by focussing on one single event and reinforced it by the precedent of antiquity. The writing and publication of Alberti's treatise, then, would have coincided, if our thesis holds, exactly with the modelling by Ghiberti of the bottom panels of his Second Door. That he did not quite go along with Alberti's conceit, but rather obscured the key event through subordinate *effetti* or through by-play, marks his position between Trecento tradition and new concepts.

ICONOGRAPHY

Only the iconography of the *Gates of Paradise* has received attention in recent years. One suggestion made in passing tentatively, if not persuasively, identifies the

two prophets flanking the *Joseph* panel as Elijah and Elisha;[44] but one wonders about the links between just these two prophets and the story of Joseph. Another paper[45] in a broader context has investigated possible typological references in a number of panels on the door based on the interpretation of Old Testament stories as antitypes of Christ, the Virgin, and the Church as codified by the *Bible Moralisée* and commonly accepted by the fifteenth century. The analogies adduced are isolated and hard to follow. Indeed, the only contribution towards a coherent interpretation of the program of the *Gates of Paradise*, both of the panels and the prophets on the frame, has been made by Frederick Hartt.[46] Reiterating a proposal of his made at the time the present volume was in preparation, but disallowed by us in a lengthy footnote,[47] he has now elaborated on and reinforced it. His argument is that the choice of Old Testament subjects rather than being based on Ambrose's exegetical writings as interpreted by Ambrogio Traversari was drawn from Saint Antonine's *Summa Theologica* and his *Opus Chronicorum*; and that in its entirety it is meant to forecast the mission of Christ. The correspondence between the selection of biblical events in these writings as brought out by Professor Hartt and those represented in the panels is indeed close at times. Moreover, his careful reading of these *effetti* provides interpretations so far overlooked and sets right former misreadings: Esau standing before his father may in fact represent, rather than the start of his wild game chase, his return and the Negation of the Blessing; and the signs on the boards of the Ark are of course Roman numerals giving height, width, and length of the Ark, rather than carpenter's marks as we obtusely maintained. However, is the overall selection of the biblical events on the door really so much closer to the writings of Saint Antonine than to those of Ambrose which we had proposed? In particular, is their elaboration in detail—and this is what counts—closer to one than to the other? Some such details in fact recall Antonine's exegesis, but others correspond to that of Ambrose. But few really dovetail; and while we remain but half-convinced of Antonine's impact on the program, neither do we insist quite as strongly as we once did on Ambrose's. Our impression is more and more that exegetical writing starting with the Church Fathers and elaborated in ever new variants, by the fifteenth century was instantaneously and permanently present in countless variations to the mind of any good theologian; and that in formulating a program—whether or not the author was Traversari—any number of variants would strike his mind, like the numberless notes (to quote a Carolingian poet) vibrating when a tuning fork is struck. There is no need, it seems to us now, to insist as we did in our note on the date of Antonine's writings as being some time after the panels of the door were cast; nor is there any need to assume with Professor Hartt that Antonine, when putting his exegesis on paper, rewrote ideas formulated twenty years before. Whatever exegetical variants, however, underlie the program, they would have provided no more than a guideline to Ghiberti. There is after all a fundamental difference between a theologian's exegesis and the interpretation of the biblical event by an artist, in particular one with

[44] Rose, bibl., **64.

[46] Hartt, bibl. **35.

[45] Mielke, bibl. **53.

[47] see below, p. 187f., note 77.

xxxiv

Ghiberti's gusto and gift for telling a story. In fact, a fascinating by-product of Professor Hartt's study is the evidence that Ghiberti in describing the doors in the *Commentarii* not only forgot some of the *effetti* represented, but misnamed others and, most remarkably, listed biblical events not shown in the panels. The subjects and certainly their typological meaning, we feel, meant little to him. They meant, we do not doubt, a great deal to the author of the program—a theologian, we are sure—and possibly to the supervisory committee. But we are not sure they need mean as much to us as long as we are dealing with Ghiberti.

As must be clear from these lines, we have no quarrel with the proposition formulated by one of our critics[48] that Ghiberti saw the *storie* on the *Gates of Paradise* and in particular the *Meeting of the Queen of Sheba with Solomon* "as a richly embroidered dramatic narrative" which to him had no meaning, typological or topical. On rereading our text, it seems to us we were of just this view. However, contrary to Professor Gombrich we maintained, and still do so, that the program for the Doors did have meaning for its author, whoever he was. Bruni, in the letter accompanying his abortive proposal, lays down, after all, two requirements for the *storie*, ". . . l'uno che siano illustri l'altro che siano significanti . . . ," that is, "degni di memoria." Such commemorative value, we grant our critic, might be purely historical, an important event in the history of the chosen people; but biblical history ever since the Church Fathers and far into modern times was after all understood in typological terms. Why then should the program for the *Gates* have departed from this rule?—a point we, incidentally, never stressed as much as our critic makes out. Nor do we see any reason for withdrawing the proposal proffered as a likely hypothesis that the scene of the *Meeting* had a particular topical significance to the author and the supervisory committee in that it referred to the hoped-for reconciliation of the Greek and Latin Churches; and that it was introduced into the program by Ambrogio Traversari who in 1425 voiced his concern about Bruni's program. The proposition that his letter meant to question the allocation of the *Doors* to Ghiberti seems to us untenable; were it so, Traversari would have written, "Quid de tertia illa porta senties," rather than "de historiis tertiae illi portae insculpendis. . . ." Nor does the lack of any reference to Traversari in the context of the *Gates* after 1425 carry much weight; nobody else is mentioned in that connection either. We likewise remain unpersuaded by the arguments proffered to counter an interpretation of the *Meeting* as forecasting the union of the Western and Eastern Churches. The union, it is agreed, took place in 1439, two years after the *Meeting* was cast; and it ended in failure. Negotiations, however, had been underway since the twenties, long before the panel was modelled, and Traversari from the start was involved. No doubt, as Professor Gombrich points out, the Latins viewed the reconciliation as implying the submission of the Greeks to the Roman Church rather than an encounter of equals. But then I Kings X: 1-7 does not depict the Queen as Solomon's equal either: "she came to prove him with riddles . . . and Solomon taught her all the words she had proposed . . . " and she submitted to his wisdom. However, would not any diplomat on the Latin side worth

[48] Gombrich, bibl. **33.

his salt conceal as long as possible this *de facto* inequality and his ultimate aim of subjugating and ultimately absorbing the Eastern Church and pretend instead equality between the Queen, representing the Greeks, and Solomon, standing for Rome? Clearly, Ghiberti would have been indifferent to that or any interpretation; but the author of the program, we think, would have had it in mind—why else would he have introduced the scene, missing from Bruni's proposal, to crown the sequence?

Granted, the entire program could be seen, as Professor Gombrich does, as simply presenting the historical sequence starting with the Creation and ending with the *Meeting* which allowed for so much splendor to be displayed. In that case, however, why would the committee in charge of the Baptistery bother to ask Leonardo Bruni and perhaps others to prepare a program of "significant" events? The concept of such a program void of significance seems to us unlikely in the fifteenth century; the more so in the face of what seem to us valid clues pointing to just such significance. We thought we had better attempt an interpretation of these clues at least as a working hypothesis—and a likely one, we still think.

Scholarly interest seems to have shifted to a considerable extent from the discussion of Ghiberti the craftsman and artist to exploring those activities of his in which, notwithstanding his best efforts, he was perhaps not entirely successful. Presumably in the past too much has been written on his sculptural *œuvre*—its origins, development, characteristics and style. Recently, on the contrary, a large part of the scholarly production dealing with Ghiberti has turned towards his activity as an architect and architectural designer; toward his writings and their sources; and toward his theories on art, in particular on optics, proportions, and perspective, as manifest both in his writings and his practice.

GHIBERTI ARCHITETTO

More than a tenth of the *Catalogo* of 1978 has been devoted to a reassessment of Ghiberti's buildings and architectural designs.[49] Likewise, in the *Atti* ten papers, nearly one third of the total, were given over to *Ghiberti architetto*.[50] Confirming Marchini's hunch forty years ago,[51] the design of the Strozzi Sacristy at S. Trinità and of its furnishings as well as the sculpted arms and *impresa* of Palla Strozzi has been firmly attributed to the master through a review of known and the publication of new documents, through new visual evidence and through comparison with the architectural vocabulary employed in the quatrefoils of the North Door.[52] The attempt at reconstructing the original placing in the sacristy and the adjoining small chapel of the tomb of Onofrio Strozzi and the two altar pieces, one by Gentile da Fabriano, the other by Fra Angelico, and at devising an iconological program does not persuade us,[53] but Ghiberti does not enter into that problem. Likewise, other architectural designs have been persuasively assigned to Ghiberti: the upper win-

[49] bibl. **2. [50] bibl. **3.
[51] Marchini, bibl. 298.
[52] Sale, bibl. **66, Jones, bibl. **38; see also Sanpaolesi, bibl. **67, Marchini, bibl. **49, p. 22.
[53] Davisson, bibl. **22.

dows in the East exedra of the Cathedral, their jambs beautifully inlaid;[54] the West portal of Or San Michele;[55] and two portals in the Palazzo di Parte Guelfa.[56] Whether the remains now in the cloister of S. Francesco at Urbania are works of his *ante litteram* requires further study.[57] Most of this work is decorative in character and conservative in vocabulary, strikingly so in the Florence of the twenties and early thirties alongside Brunelleschi's buildings. But Ghiberti, it would seem, designed these portals and other details to be farmed out for execution to run-of-the-mill master builders, as plausibly brought out on the basis of newly published documents.[58]

Altogether Ghiberti appears to have acted, rather than as a builder, as an architectural designer and consultant. This nature of his activity seems to throw light also on the question of his part in the designing and building of the *chupolone*. Franco Borsi takes up the cudgels in defense of the thesis[59] that Ghiberti in the preparatory phase of designing that dome bore equal responsibility with Brunelleschi; while in the final technological phase of actual construction the latter alone carried the responsibility. If confirmed, this thesis would supersede the view, held also by us, that Ghiberti's rôle, once his model had been eliminated, was representative and administrative rather than active.[60] In fact it seems by now certain that there never existed a "compromise model" designed jointly by Ghiberti and Brunelleschi.[61] Nonetheless Ghiberti seems to have cooperated with Brunelleschi into the twenties on the *chupolone* at least on one level. This is suggested, it seems to us, by the drawings of engines devised for constructing the dome and copied in the *Zibaldone* of Ghiberti's grandson Buonaccorso.[62] Their inclusion in that copybook is best explained by assuming that the original drawings, by Buonaccorso's time still in the workshop, had served for the casting in Lorenzo's foundry of the metal parts of the engines.[63] The invention of the machinery, as documented, was Brunelleschi's. But in the initial phase of work and perhaps later as new engines had to be devised, Ghiberti would seem to have collaborated on a technical as well as an administrative level. Indeed, payments, overlooked by us, were made to him for parts of machinery in 1420 and 1425.[64] It cannot be decided whether or not in the phase of actual building he also participated in solving problems of construction or design. The documents are not specific enough, and in our opinion the technological difficulties encountered in the building of the dome were beyond his capabilities.

If the two ever collaborated on the architectural level proper, they may have done so also on the Torre del Marzocco in the harbor of Livorno.[65] The tower, a sketch of which is found in the *Zibaldone* of Buonaccorso, is a fascinating piece of architectural

[54] Marchini, bibl. **49, p. 17f.
[55] bibl. **49, p. 18.
[56] bibl. **49, p. 23f.
[57] bibl. **49, p. 17.
[58] Quinterio, bibl. **61.
[59] Borsi, bibl. **14.
[60] Saalman, bibl. **65.
[61] bibl. **65, p. 438.
[62] Scaglia, bibl. **68 and bibl. **69.
[63] bibl. **68 and **69; see also Bove and others, bibl. **16.
[64] Guasti, bibl., 119, items 50, 141; see also Scaglia, bibl. **68.
[65] Scaglia, bibl. **70; see also Marchini, bibl. **49, p. 30f.

engineering. But whether it was built by Brunelleschi[66] or Ghiberti[67] or in collaboration by both, remains anybody's guess.

A distinction should be made, we feel, between designs prepared for actual building as Ghiberti undoubtedly produced them and those for architectural props and settings as they abound in the reliefs of both the North Door and the *Gates of Paradise*. The props employed in the quatrefoils of the North Door stand in a Trecento tradition; but rather than a builder's tradition, it is the tradition of architectural props as handed down in the painters' shops, using a painter's rather than an architect's vocabulary. Likewise the architectural settings in the *Gates of Paradise* should be seen fundamentally, we feel, in the context of a painter's architecture. Its link to the concept of a space constructed by means of perspective is as obvious as its function to provide a credible stage for credible human action; and in this respect the temple in the *Solomon* panel remains close to Ambrogio Lorenzetti's *Presentation in the Temple*. Concomitantly, it is pointed out, the construction of space in these panels is interwoven with his technique of narration by successive *effetti*.[68] On a different plane, it has been suggested to view the background architectures in the *Gates of Paradise* as illustrating a history of man and his buildings as sketched by Vitruvius (II.i.1) progressing from the thatched hut of the first parents to Noah's Ark, Solomon's temple and the cityscape in the David story.[69] The proposal seems to us worth considering, the more so in the context of the Vitruvius excerpts in Italian translation copied in Buonaccorso's *Zibaldone*, more of which later;[70] a few lines of Vitruvius' sketch of primitive architecture are in fact included among these excerpts. However, Vitruvius in that chapter dealt only with the origins of human habitation, rather than with tents, pyramids or temples, as they appear in successive panels.

Less elusive and more central is a question raised by Howard Burns in a paper read at the Ghiberti *convegno* in 1978 but regrettably not submitted for publication in the *Atti*. A study of the architectural vocabulary employed by Ghiberti in the architectural settings of the *Gates of Paradise* led him to propose that all details, in particular the Corinthian capitals, the entablatures and their profiles are akin rather than to Alberti's, to Brunelleschi's architectural language. We are convinced by the comparisons shown, in particular those with the architectural frame of Masaccio's Trinity fresco at S. Maria Novella attributed on good grounds—our former doubts have been dispelled—to Brunelleschi. Indeed, that frame shows that the arch and lintel motif contrary to our previous hesitation is part of Brunelleschi's vocabulary. Nonetheless we fear that Ghiberti's architectural settings, both in detail and overall concept, leave many questions to be answered. Unfluted pilasters, windows framed by aediculae, superimposed orders are features pointing ever so much more strongly towards the second half of the Quattrocento than Brunelleschi ever went; the purism of unadorned orders and surfaces is as contrary to his practice; as are the *piazze*,

[66] bibl. **70; bibl. **49, p. 30f.

[67] bibl. **70; bibl. **49, p. 30f. [68] Ray, bibl. **61.

[69] Morelli, bibl. **54, especially p. 617; also Pacciano, bibl. **57, p. 639f.

[70] Scaglia, bibl. **71.

delimited by "Renaissance" palaces and churches, as in the *Solomon* panel and on the Zenobius shrine; finally the city views and their colosseums, triumphal columns, *Tempio di Marte*-Baptisteries go so far beyond anything that Brunelleschi ever designed that we still suspect other forces at work. All these features belong, it seems to us, to a dream architecture *all'antica* which emerges in Florence in the generation after Brunelleschi and for that matter after Ghiberti. This is why we thought of Alberti, not as the designer of the settings, but as the clever young humanist, in Florence just as the panels of the *Gates of Paradise* were designed, who talking, guided Ghiberti towards an architectural vision and ten or fifteen years later put on paper the principles of that new architecture. Indeed we consider it unlikely for Ghiberti to have dreamt up all by himself the all-embracing concept of an architecture *all'antica* in his settings and passed it on to Alberti. We still see Alberti's mind guiding Ghiberti's hand. But we qualify the position we took twenty-five years ago, in that we see with Howard Burns, the actual vocabulary of capitals, cornices, entablatures, and bases drawn straight from Brunelleschi's language as it marked progressive Florentine building ever since 1419.

WRITINGS AND HUMANIST AMBITIONS

A variety of new contributions deal with Ghiberti's literary work, the *Commentarii* in the first place, but not only these.

A *collectanea* of excerpts from the first six books of Vitruvius' *De architectura* in Italian translation was copied by Buonaccorso Ghiberti in his *Zibaldone*.[71] A comparison of wording and phrasing with those occurring in the Vitruvian passages in the *Commentarii* leads the author to assign persuasively to Lorenzo Ghiberti the original of this translation. The choice of excerpts, the misunderstandings of and the few additions to Vitruvius' text reveal, it seems to us, little about Ghiberti's attitude regarding either architecture or antiquity beyond what is already known so far. But they say a lot about his humanist ambitions and achievements. The translation is based on guesswork as much as on his knowledge, quite limited it appears, of Latin. Be it added, by the way, that the Carolingian Vitruvius used by Ghiberti contained marginal illustrations, copied from late antique originals, of architectural details, misnamed and misunderstood; and that Ghiberti apparently copied faithfully some of these illustrations in his translation whence they migrated into Buonaccorso's copy.

The *Commentarii*, one recalls, are preserved only in a defective copy, full of misreadings and omissions, from single words to entire lines and sentences. Professor Murray is preparing a new edition of the Second Book of the *Commentarii*, the original text of which he feels can be reconstructed with great plausibility, based on the surviving copy, and on two more manuscripts now lost, but known to and used the one by Vasari when writing the 1568 edition of the *Vite* and by the Anonimo Magliabecchiano, the other by Gelli. Both versions seem to have differed among themselves and from the surviving copy. The corrupt passages convincingly re-

[71] bibl. **71.

constructed in a preliminary report[72] elucidate Ghiberti's meaning and should help to further clarify his terminology and his overall approach to works of art, his own and those of others.

How far this approach at the time he wrote the Second Book of the *Commentarii* was determined by humanist concepts rather than by humanist ambitions, seems to us still as moot a question as ten years ago when we wrote the Preface to the Second Printing. We still doubt that he saw himself as a second Lysippus—notwithstanding the slim bodies and small heads in the *Genesis* panel, but only there—and as the champion of a humanist art, based on the idea of progress.[73] To be sure, he was one of the Fathers of the new art; but he saw himself also as grown from the tradition of the Trecento and as a craftsman, first and foremost. Nor can we believe that his descriptions of Ambrogio Lorenzetti's murals were written under the impact of the tradition of Late Byzantine *ekphraseis*.[74] That this tradition just then reached Italy through Chrysoloras has been conclusively demonstrated.[75] But in our opinion Ghiberti knew nothing of it. Nor do we think that in discoursing on Lorenzetti's murals he had in mind Alberti's definition of *composizione*.[76] We feel he used what God had given him—his eyes, his bright intelligence, his lively imagination and his Tuscan tongue.

An English translation of the Second Book with commentary published as a thesis is unfortunately wanting in many respects.[77]

Some of the vexing questions concerning the Third Commentary seem to have come closer to solution. A reconstruction of the text, difficult though it would be, seems as desirable as ever. However, Corrado Maltese has provided the first analysis known to us in which the fragments on optics and light scattered through the Third Book become intelligible as a coherent theory.[78] He has also persuasively suggested that the many misspellings and misunderstandings of words may have been caused by Ghiberti's having dictated the text. Among the sources used by Ghiberti for these sections on optics and identified in part by Schlosser and more fully by Doesschate, Alhazen's *De aspectibus* has always been known. As early as 1965 but unknown to us in 1970 a thorough study[79] had established the existence of an Italian translation presumably of fourteenth century date, based on a Latin translation of the Arabic original; the paper, little changed, was read at the *convegno* of 1978.[80] A comparison of long passages from the Third Commentary with their counterparts in the Italian Alhazen (Vat. lat. 4595) proves convincingly, for these parts anyhow, Ghiberti's source. A question raised by the author remains; whether Ghiberti used his further sources in optics—John Peckham, Roger Bacon, Witelo, all preserved only in Latin —likewise in translations, perhaps supplied by humanist friends, or in the original. The Vitruvius excerpts he translated show him valiantly proceeding by guess as much

[72] Murray, bibl. **56.

[74] Ercoli, bibl. **25, p. 330f.

[76] Van Veen, bibl. **76.

[78] Maltese, bibl. **44.

[80] *idem*, bibl. **28.

[73] Gombrich, bibl. *21 and *22.

[75] Baxandall, bibl. **6, p. 78ff.

[77] Fengler Knapp, bibl. **29.

[79] Federici Vescovini, bibl. **27.

as by latinity. We think it quite possible that with equal valor he attacked the Latin medieval treatises on optics. In any event, the scientific tradition on which Ghiberti based himself, in optics anyhow and, it seems, in anatomy as well was solidly medieval, much in contrast to his humanist ambitions.[81] Medieval scientists were authorities, not more nor less than Pliny, whom he excerpted for the First Commentary, or Vitruvius, both here and there misunderstood and reinterpreted by him.

The *Commentarii* have always been viewed as fragmentary and composed of disparate parts: the First and Second Books more or less complete, the Third as a jumble of sections in the drafting stage—those on optics, for instance—and of half-digested reading notes. A recent counterproposal[82] maintains that on the contrary the entire work should be seen as a unit, carefully structured into ten topics, each introduced by a preface culled from one of the prefaces to the ten books of Vitruvius' *De architectura*: four topics to Commentary One—the disciplines of human knowledge, *disegno*, ancient bronze statuary, ancient painting; two topics to Commentary Two—Trecento art and Ghiberti's autobiography; and four topics to Commentary Three—optics, anatomy, human proportions and—again human proportions. Evidently the calculation does not quite tally, be it only because the manuscript breaks off at this point. But we feel a step has been attempted in a new direction; whether it is the right direction, we are not entirely persuaded. The picture of a Ghiberti structuring the outline of the *Commentarii* like a scholar, humanist or traditional, and following it up rigidly is not quite our picture of the man: an artist first and foremost, a superb craftsman, ambitious to prove himself a humanist but always falling short of that aim and reverting to his own intelligent and common sense self.

[81] see, however, Vagnetti, bibl. **75, especially p. 424.
[82] Hurd, bibl. **36 and **37.

CONTENTS

PREFACE TO THE FIRST PRINTING v

PREFACE TO THE SECOND PRINTING ix

PREFACE TO THE THIRD PRINTING xxv

LIFE AND RENOWN 1

Chapter I. Ghiberti's Biography 3

Chapter II. Ghiberti's Fame 16

THE BEGINNINGS 29

Chapter III. The Competition 31

Chapter IV. The Competition Reliefs:

Ghiberti and Brunelleschi 44

Chapter V. Ghiberti's Origins 50

THE BRONZES AT OR SAN MICHELE 69

Chapter VI. *Saint John* and the International Style 71

Chapter VII. *Saint Matthew* and *Saint Stephen* 86

THE NORTH DOOR OF THE BAPTISTERY 101

Chapter VIII. Documents and Progress of Work 103

Chapter IX. The Quatrefoils and Heads 113

THE NEW STYLE 135

Chapter X. Pictorial Relief 137

THE GATES OF PARADISE 157

Chapter XI. Documents and Progress of Work 159

Chapter XII. The Program 169

Chapter XIII. The Panels 189

Chapter XIV. The Late Workshop 203

Chapter XV. Ghiberti and the Trecento 214

CONTENTS

RENAISSANCE PROBLEMS 227

 Chapter XVI. Linear Perspective 229

 Chapter XVII. Ghiberti architetto 254

 Chapter XVIII. Ghiberti and Antiquity 277

 Chapter XIX. Humanists and Artists 294

 Chapter XX. Ghiberti the Writer 306

 Chapter XXI. Ghiberti and Alberti 315

APPENDICES 335

 Appendix A. Handlist of Antiques 337

 Appendix B. The Olympiads 353

 Appendix C. Sources 359

 1. Analysis of Documents 360

 2. Transcript of Documents 366

 3. Digest of Documents 402

 4. Digest of New Documents 422

BIBLIOGRAPHY 425

ADDITIONAL BIBLIOGRAPHY 439

ADDITIONAL BIBLIOGRAPHY SINCE 1970 441

INDEX 445

ADDENDA AND CORRIGENDA 461

CONTENTS

TEXT DIAGRAMS

1. Schema of the North Door 104

2. Schema of the Gates of Paradise 160

3. Bruni, Program for the Gates of Paradise 170

4. Brunelleschi, Perspective Construction, Piazza del Duomo 239

5. Masolino, Perspective Construction, *Disputation and Miracle of Saint Catherine* 243

6. Alberti, Perspective Construction 246

7. Ghiberti, Perspective Construction, *Isaac*, Gates of Paradise 250

PLATES

following page

Works of Ghiberti, Plates 1-137 461

Collateral Material, Figures 1-146

LIFE AND RENOWN

CHAPTER I

GHIBERTI'S BIOGRAPHY

THE life of Lorenzo Ghiberti seems, at first glance, to have run a smooth course, much like that of any prosperous businessman of fifteenth century Italy. Yet confusion surrounds even his birth date: in his *Portate al Catasto*, his tax declarations, it is first listed as 1381, only to change in 1442 to 1378 (Dig. 1; Docs. 81-86). Such irregularities are frequent in fourteenth and fifteenth century documents, but Ghiberti's lapse of memory may not have been unintentional, for apparently the legitimacy of his birth was in doubt (Digs. 247-249; Doc. 120). His mother, Mona Fiore, daughter of a farm laborer from Val di Sieve married Cione Paltami Ghiberti at Pelago near Florence in 1370. Cione was the son of a notary, ser Buonaccorso and thus of a respectable family, but he was accounted "a thoroughly useless person, a sorry wretch nearly out of his mind." Mona Fiore left Cione and went to Florence where she lived as the common-law wife of the goldsmith Bartolo di Michele, called Bartoluccio, whom she married only after Cione's death in 1406. Lorenzo grew up in Bartolo's shop and evidently did not keep in touch with Cione. Throughout his early and mature years he called himself simply Lorenzo, as seen in his inscription on the North Door of the Baptistery and on his *Saint John* for Or San Michele. In private life and in legal documents he used the names of Lorenzo di Bartolo, Lorenzo di Bartoluccio or Lorenzo di Bartolo Michele, which suggest that he may have considered himself, and was obviously believed to be, Bartolo's son. This general belief must have been the stronger since he paid taxes in Bartolo's name after 1413 and as his son and heir after 1422 when he entered upon Bartolo's inheritance. For several years after Cione's death in 1406 Ghiberti's right to the latter's fortune was apparently contested by his relatives and not until 1413 did Lorenzo reach a compromise, recovering a small part of the inheritance, although he did not bother even then to pay the taxes due on it. Ghiberti, in brief, tried to enjoy the advantages of being the son of both Cione and Bartolo. Trouble was bound to arise from this confusion, and in fact in 1444, after serving as one of the Twelve, to which office he had been elected, Ghiberti was denounced in two separate briefs as ineligible to hold public office because of illegitimate birth. Moreover, one of the denunciations correctly pointed out that if Ghiberti insisted on his legitimacy, he would be ineligible on two other counts, first because Cione had never paid taxes in Florence and second because Ghiberti himself had not done so under what was presumably his real name, Lorenzo di Cione; certainly he had not done so for thirty years, as prescribed by law. The legal dilemma was inescapable, and Ghiberti was fined five hundred florins for illegal tenure of office. Given his sense of justice and his eye for economy, however, he objected and in a long rebuttal submitted to the *Signoria* he asked that the fine be rescinded. He admitted, on the one hand, that he had paid taxes only under the name of Lorenzo di Bartolo, and only since Bartoluccio's death in 1422, but, on the other hand, he stood firm in claiming not only that he was Cione's legitimate son, born in 1378 while his mother was

still living with her husband, but also that Cione had paid taxes in Florence in 1375. The *Signoria* granted both points by a large majority vote, and contented themselves with a small fine of fifty lire because Ghiberti had not paid taxes under his legal name for thirty years. His right to hold office, either under his legal name or under the name of Lorenzo di Bartolo, was specifically confirmed; in brief, Ghiberti's name was at least officially cleared. Perhaps trouble had started brewing even earlier, for in 1442 Ghiberti had begun changing his signature to Lorenzo di Cione di Ser Buonaccorso Ghiberti, adding for mere identification "chiamato Lorenzo di Bartoluccio"; his tax declarations (Digs. 237, 258, 276), the inscription on the Gates of Paradise, even his own account books (Dig. 224) bear the full name. Thus it is at least possible that beginning in 1442 Ghiberti pushed back the date of his birth to support his claim to legitimacy. In any case, the family, son and grandson, carried on the family name and he has remained Lorenzo Ghiberti throughout history.

The exact truth cannot be discovered now, but it is irrelevant. The important fact is that, whatever his paternity, Ghiberti grew up in Bartoluccio's workshop and was trained as a goldsmith and, apparently, as a painter. He also learned the three R's and while he was never a scholar he knew Latin and evidently read the ancient writers to some extent. He may have had some difficulty spelling and writing antique script, for in signing his Gates of Paradise, he reversed the capital N's and had to correct the spelling of *FABRICATUM*. His account books, however, were carefully kept and he wrote a beautiful hand, as these and his autograph tax declarations show;[1] his style is among the most lively of the century.

Born in the shadow of the *cupolone*—still a mere project—Ghiberti remained Florentine throughout his life. There he came into the limelight suddenly and almost as a child prodigy. In 1400, when he was about twenty, he had gone with a painter to Pesaro,[2] but the competition for the new bronze door of the Baptistery brought him back to Bartolo's workshop: and when the *Arte di Calimala*, the most important guild in Florence, awarded them the commission, theirs automatically became the city's outstanding bronze foundry. The business was still in Bartolo's hands when the contract for the door was signed in 1403, but it was expanded by Lorenzo when he took over six years later upon his matriculation in the goldsmiths' guild (Dig. 28). For some years he had served with other leading painters, goldsmiths, masons, and sculptors, as an architectural consultant to the *Opera* of the Cathedral and since 1404 he had branched out into designing cartoons for the Cathedral's stained glass windows. Around 1412 or 1413 the *Calimala* gave him another big commission for a statue of their patron saint, John the Baptist, to stand in the common sanctuary of the guilds at Or San Michele. A few years later he was called outside Florence, for the first and only time, to work on the baptismal font at Siena. In addition to these major commissions were minor ones, like the designs for goldsmith work to be executed by other Florentine workshops. It was about this time that Lorenzo married Marsilia, daughter of the woolcarder Bartolommeo di Luca. She was a young thing, barely sixteen years old at

[1] Mather, bibl. 308, fig. 2.
[2] In the following paragraphs specific reference will be made only to documents concerning Ghiberti's civil status.

the time. His two sons were born shortly afterwards, Tomaso in 1417 and Vittorio in 1418 (Digs. 58, 63). Bartolo di Michele, for many years retired from the firm, seems to have died in or shortly before 1422, the year when Lorenzo began paying taxes in his own name (Doc. 120). His death found Lorenzo not yet forty, the head of a family and of an excellent business which had both local and out-of-town connections, in fact, a well-established master whose word was respected by the great guilds in all matters of art.

Business continued to flourish and expand in the 1420's. Following the *Calimala's* example, two other guilds of almost equal importance ordered large bronze statues from Ghiberti, to be set up at Or San Michele: the *Saint Matthew* for the *Cambio*, the bankers' guild, and the *Saint Stephen* for the *Lana*, the wool guild. Thus three of the major guilds had turned to his workshop and most of the important commissions in bronze sculpture were in his hands; the *Parte Guelfa* alone entrusted its statue, *Saint Louis*, to Donatello. Through his work on the *Saint Matthew*, Lorenzo came into contact with Cosimo Medici who was one of the members of the supervising committee, and in 1426 Cosimo and his brother Lorenzo commissioned Ghiberti to design and execute a shrine for the convent of S. Maria degli Angeli to hold the relics of the Saints Protus, Hyacinth, and Nemesius. Probably at the same time he mounted an ancient cornelian with Apollo and Marsyas for a member of the Medici family. But his connections with the Medici were never close, nor did he ever do more than minor work for other important families, and then it was not executed by his own hand. He worked only once for a religious order, when casting the tomb plaque of the General of the Dominican friars, Lorenzo Dati, and even this commission came from the order in conjunction with the city of Florence. Throughout his life the majority of Ghiberti's commissions issued from the great guilds, given in either their own name or in that of the city. Like his first door for the Baptistery, his second, the Porta del Paradiso, was designed, cast and finished for the *Calimala*; a shrine for the relics of the patron of Florence, Saint Zenobius, was executed for the *Opera* of the Cathedral, which was to all practical intent and purpose an organ of both the city administration and the *Arte della Lana*. From the same body came the commission to supervise, in conjunction with Brunelleschi, the construction of the dome of the Cathedral. The extent to which this commission was based on Ghiberti's architectural knowledge remains open to question. His technical ability was hardly up to the difficult task; but certainly his excellent standing with the leading circles in Florence had something to do with the commission. At times Ghiberti seems to appear in the role of semi-official artist of the city; when such dignitaries as the Popes Martin V and Eugene IV were honored guests of Florence, it was Ghiberti who redesigned the papal apartment for the city and wrought gold and jeweled mitres and morses at the Popes' requests.

The years between 1415 and 1430 mark the peak of Ghiberti's life. Therein fell his only large work outside Florence, the Siena reliefs, and his only prolonged absences from his native city. A visit to Venice in the winter of 1424-1425 was followed possibly by another in 1430 (Digs. 107, 161).[3] More important are the trips which apparently

[3] A trip of Ghiberti's to Venice in 1430 is mentioned by Fiocco (bibl. 160, p. 346) with a specific

led him at least twice to Rome: one prior to 1416, as attested to by the impact of Roman sculpture on his work; a second one, falling into the 440th olympiad, he has mentioned in the *Commentarii*.[4] The date would correspond to the years 1425-1430, and indeed, the late fall of 1429 and the late spring, summer, and fall of 1430 are free from any documented activities which would have kept Ghiberti at home. But throughout his life he remained settled and active in Florence. From 1425, or shortly thereafter, he was working on his second bronze door, the last of three for the Baptistery, and the keystone of the triad adorning the *bel San Giovanni*, the crowning triumph of his life. In the thirties he met with a number of reverses. His appointment as supervisor of construction for the dome of the Cathedral was terminated in 1436; his model for the lantern of the dome was not accepted, nor was his design for a choir submitted to the *Opera del Duomo* in 1438; a design of Donatello's was given preference in a competition for a large stained glass window in 1434; the commission for the Shrine of Saint Zenobius, which he had been awarded in 1432, was canceled in 1437. Still this eclipse seems to have been temporary, for in 1439 he won a new contract for the Shrine of Saint Zenobius, and throughout the whole period his work on the east gates of the Baptistery was sustained. The ten reliefs and the frame occupied him without interruption during the 1430's and 1440's. For years he had built up around his person a crew of assistants which expanded and contracted as business demanded. In the thirties both of his sons entered the workshop and although Tomaso is mentioned only occasionally in the documents (Dig. 250; Doc. 217), the younger Vittorio, beginning in 1437, occupied a more and more prominent position, first as his father's assistant and after 1444, as junior partner. Michelozzo, who had worked on the *Saint Matthew*, was hired again, for a short while at least, to assist in the finishing of the second door. For the same task Benozzo Gozzoli joined them a little later for a three-year period. During these years the firm was branching out in various directions; in the late 1420's it had designed two marble tombstones for members of Florentine families at S. Croce, and although Ghiberti certainly sent these designs out for carving (Dig. 145), he had to join the masons' guild in 1426 (Dig. 126). Similarly the design for the frame of Fra Angelico's Linaiuoli Altar was drawn in the workshop in 1432 and executed by outside woodcarvers and stonemasons (Dig. 174). The same interest in taking on outside commissions shows in Ghiberti's increased eagerness to design cartoons for stained glass windows, and possibly for this reason he registered with the *Compagnia de' Pittori*, the painters' guild, as early as 1423 (Dig. 103). Requests for such cartoons came regularly from the *Opera* of the Cathedral. For about a decade between 1434 and 1443 he had practically a monopoly on the designing of windows for the apses and the drum of the dome.

Despite temporary reverses, then, Ghiberti's workshop remained one of Florence's leading centers of activity in nearly all branches of ecclesiastical art during the thirties

reference to his having been in contact with the goldsmith family Sesto. In a brief communication Mr. Fiocco has been good enough to give as his source a statement made to him by the late Osvaldo Paoletti, who apparently had found documentary proof so far unpublished.

[4] Regarding Ghiberti's first Roman trip, see below pp. 284f and 320; regarding his second, see Ghiberti-Schlosser (bibl. 178, I, p. 47) and below App. B, pp. 357f.

and forties. Even the annoyance, in 1444 of the denunciations regarding his alleged illegitimacy, though professionally most embarrassing, did not seriously hamper his activity. His own guild, the *Arte della Seta*, had canceled Ghiberti's name and that of his son Tomaso as the result, ironically, of his having cleared his status (Dig. 250). Since legally he was no longer the son of a goldsmith, his matriculation in 1409 without fee and without a waiting period had been obtained under false pretenses and hence invalidated. He was forced to reapply, pay a fee of five florins and wait two years for his rematriculation.[5] Still the firm survived this shock. Work on the large commissions continued and also, apparently, a good deal of minor work. He mentions in his autobiography that ". . . he rendered great services to painters, sculptors and architects [and] made very many sketches in wax and clay. . . ."[6] A large group of terracotta madonnas from Florentine and possibly other Tuscan workshops does in fact reflect his style, predominantly that of the mature and late years. His position as a leader in the realm of Florentine art and art trade—the two are very closely interwoven—and as a very substantial citizen was established more and more definitely. The sum of 200 florins which he received annually from the *Calimala* as an advance for his own personal work (*fatica e magisterio*) on the bronze doors for the Baptistery is extraordinarily high. True, this was the amount paid for full-time work and as a rule Ghiberti worked less than that, but still it compares favorably with the compensations of his fellow artists. Brunelleschi, as supervisor of the dome of Florence Cathedral, drew first only 36, later 100 florins per year.[7] Donatello was paid roughly 100 florins for a marble statue, which would take about one year to carve.[8] When in the 1440's and later, the bronze doors were commissioned for the sacristies of the Cathedral, the total amount promised Luca della Robbia and his partners, was 1,100 florins for three years' working time; but apparently they had to take care of the wages of the shop crew.[9] Hence, Ghiberti's nominal annual income from the *Calimala* is far higher. It corresponds roughly to the salary of a branch manager of the Medici bank.[10] This, of course, does not include his outside earnings which were quite considerable, certainly in the years when he executed such work as the statues for Or San Michele. Bronze founders, it seems, were in the same economic class with bankers.

Accordingly Ghiberti's tax declarations show him as a man of substantial and ever increasing wealth. The *Catasto* of 1427, the first year of the new assessment and levy, shows him the owner of a house and workshop in town, a piece of land with a vineyard

[5] From the *matricula* of the *Arte della Seta* it appears that the sons of guild members were often matriculated the same day they took the oath and always free of charge; others paid a fee and had to wait, the period varying, but never less than six months. See *Statuti dell'Arte di Por Santa Maria, seconda parte*, Florence, 1580, p. 7; and for comparison F. Sartini, bibl. 470, pp. 76, 128, 233f.

[6] Ghiberti-Schlosser, bibl. 178, I, pp. 50f.

[7] Guasti, bibl. 198, docs. 71ff, 75, 84 and the correction, p. 188.

[8] Poggi, bibl. 413, docs. 23, 280 *passim*.

[9] The contract of February 28, 1446, for example, between the *Opera del Duomo* and Luca della Robbia, Michelozzo, and Maso for the bronze doors of the sacristy in the Cathedral (Marquand, bibl. 302, pp. 196f, doc. 5) stipulates only the payment of a total amount to the masters and the obligation of the *Opera* to provide material, thus by implication devolving the wages of the assistants onto the masters-entrepreneurs.

[10] I am greatly indebted to Mr. Raymond de Roover, Boston University, for this neat piece of information.

in the parish of S. Donato di Fronzano, and with a respectable deposit of over 700 florins on the *Monte* or, as we would put it, in government bonds, as against a debt of 100 florins (Dig. 138). By 1431 the deposit had risen to 1,307 florins, and Ghiberti had acquired a flock of sheep in the Val d'Elsa (Dig. 162). His debts, as listed at this time as well as in all his later *Portate al Catasto*, are those to be expected in a big business enterprise. His assets, in both land and securities, are very much greater than those of any contemporary artist with the one exception of Brunelleschi, who was the wealthy son and heir of a notary. Ghiberti's property clearly places him among the well-to-do within the semi-urban, semi-agricultural early capitalist society of fifteenth century Florence. In 1431 he added a farm at Careggi to his possessions, leasing it from the *Arte di Calimala* for the duration of his lifetime and that of his family against payment of 370 florins and an annual rent (Dig. 179). At the same time he cut down his investment on the *Monte*, and had invested the money in some land at Monte Piano and at S. Donato di Fronzano; most important, in 1442 he purchased from the Biliotti family an estate with a manor house in the parish of S. Giuliano at Settimo (Digs. 224, 237). The transaction and the successive improvements on this *podere* he, and after him his son Vittorio, recorded in an expense book which came to light some years ago.[11] In 1444 and 1446 he added to the land at Settimo and bought a piece of property at S. Cervazzo (Dig. 258). The small holding at Monte Piano had apparently been sold. In town he was also expanding his real estate holdings; to his residence he added an adjoining house in 1438 (Dig. 237) and he bought another house with a druggist's shop prior to 1446 as security for his daughter-in-law's dowry (Dig. 258). In order to acquire all this property he and Vittorio sold their accounts on the *Monte*, 1,307 florins prior to 1442 and another 530 florins by 1446 (Digs. 237, 258). Finally in 1452, he and Vittorio —that is, the firm of Lorenzo Ghiberti and son—accepted from the *Calimala* as part payment for their work on the second door the workshop and house where the doors had been cast (Dig. 287) "with gardens, courtyards and porticoes, with a well, a hall and bedrooms."[12] The change of Ghiberti's investments from government bonds to landed property tallies with what may have been a policy widespread among well-to-do Florentines, possibly as a safeguard against inflation.[13] But Ghiberti's emphasis on the seigniorial character of his property at Settimo "with a tower, a manor house, a moat all around, walls and a drawbridge"[14] also shows clearly his pride in being able to emulate the old established patricians in the neighborhood.

At the same time this shift coincided with his gradual retirement from business in the late forties. The amount of work around the shop was decidedly shrinking. The Shrine of Saint Zenobius was completed by 1443, the reliefs of the second door were finished by 1447. What remained to be done—friezes and jambs of the doors—could be handled by a reduced crew, more and more under the supervision of the heir, Vittorio; Tomaso, the elder son, disappears from the documents after 1447 and nothing further

[11] The book was still known to Baldinucci, bibl. 35, I, pp. 373ff. Regarding its contents see Krautheimer, bibl. 249, pp. 79f, and Ginori-Conti, bibl. 181, the present owner who has published the manuscript in full.

[12] Arbitration between Vittorio and his sons, October 5, 1496, after Baldinucci, bibl. 35, I, p. 372.

[13] Doren, bibl. 134, I, p. 448. [14] Ginori-Conti, bibl. 181, p. 302.

is known of him. Vittorio came increasingly to the fore. Ghiberti himself seems to have lived in his late years, at least part of the time, on his manor at Settimo. Still, nominally at least, the old man remained at the wheel. The bronze jambs for the South Door of the Baptistery, the door of Andrea Pisano, were jointly commissioned from him and his son and even the payments for such minor commissions as the small bronze shutter for the altar tabernacle at S. Maria Nuova in 1452 were made out to Lorenzo, although they were receipted by Vittorio. Until his death Ghiberti appears in the documents as the head of the firm.

Ghiberti made his will on November 26, 1455 (Dig. 293), died on December 1, and was buried among the patricians he strove to emulate, in a tomb he had bought at S. Croce, apparently as early as 1430 (Doc. 82). Mona Marsilia, his wife, survived him, and Vittorio, for many years to all intent and purpose a junior partner, fell heir to his father's business and possessions as is evident from his tax declaration of 1457.[15] He apparently designed and completed the bronze jambs of the South Door of the Baptistery, remarkable in beauty and craftsmanship, along lines different from those of his father. Although he carried on the firm and supplied ecclesiastical bronze and goldsmith work until his death in 1496, he never attained his father's stature as an artist.

All data regarding Lorenzo Ghiberti point to a man of more than common caliber, a man of singular energy, and excellent business sense, with an instinct for negotiations. This last gift of his is proved by what remains of his business correspondence: a series of letters written to the *Operaio* of the Cathedral of Siena and to the goldsmith Giovanni Turini, designed to explain away the endless delays in finishing the two reliefs for the Siena Baptistery. Beyond question, the man who managed to keep not a single deadline and still remain in the good graces of the contracting parties, who managed to pay none of the stipulated fines, yet never to lose a commission, or to fail to recover it after temporary loss, who managed to harvest ever new orders and to juggle three or four major jobs at the same time—this man can only have been a supreme negotiator. His enemies may have felt that at times this skill in negotiating commissions made him a trifle pushing. Certainly this is the impression the biographer of Brunelleschi, the so-called Manetti, attempted to give in the 1480's when elaborating on the tensions that existed between his hero and the archfiend Ghiberti.[16] Inimical voices there must have been. Indeed, it is strange that Ghiberti's fellow citizens only once elected him to public office. Perhaps the circumstances surrounding his birth were the reason for their reluctance to nominate him, or for his reluctance to accept. The latter was, as a matter of fact, what the denunciations of 1444 maintained regarding his refusal to serve as consul of the *Arte della Seta* in which the goldsmiths were organized. But it is also possible that he was not displeased to keep out of politics, and preferred to mind his own business. In any case, those who are not convinced of his character by the documents need only look at the two self-portraits, that on the North Door, done when he was about forty (Pl. 136a), and the late one, on the Gates of Paradise, which shows him at seventy or thereabouts (Pl. 136b). That they represent the same man is beyond

[15] Mather, bibl. 308, p. 59, doc. 7. [16] See below, pp. 35f and note 24.

doubt: it is the same squarish face, younger here, older there, the same broad nose and small slanted eyes set far apart—a very intelligent and a very Florentine face, with clever eyes and a thin mouth, the face of a man who is cautious and deliberate in making decisions. That the two are self-portraits is proven by this very resemblance; tradition, since Gelli,[17] has confirmed it. In the old age portrait the master has grown into an even more shrewd, witty, and worldly-wise man, amused by a world he had observed for seven decades and had learned to handle.

All this concerns Ghiberti, the citizen and businessman. It does not seem to touch his art. But the businessman, the citizen, and the artist are in Ghiberti so closely intertwined that any attempt to separate them is doomed to failure and a study of his art must at least sketch the various facets of his personality. It must equally touch upon his literary endeavors. Indeed, the *Commentarii*, Ghiberti's literary work, are proof of his intelligence, his high sense of quality, and his independent judgment, in matters not only of art. They show likewise that he was no intellectual. A discussion of the *Commentarii* belongs properly in a later chapter.[18] Yet nowhere does his personality stand out with greater clarity than in the autobiography with which he concludes the second book of this, his great literary work.

The value of this autobiography has long been recognized. Since the sixteenth century, it has been exploited by historians of art. The last 150 years have brought forth translations and a number of editions. Outstanding remains Schlosser's standard edition of the entire work, which for the first time presented the complete text.[19] Schlosser was also the one to point out that it would be decidedly misleading to interpret these biographical chapters as an attempt on Ghiberti's part to write history *sine ira et studio*, and to criticize him, as did Vasari, for failing to achieve this end. On the contrary, Ghiberti's autobiography is a highly personal document, an attempt to give an account of his work and to see himself as one of the artists who, beginning with Giotto, had contributed to the birth of a new art, as one who carried on the work of his artistic ancestors and as the crowning figure in the development. If, then, Ghiberti's autobiography is history, it is indeed highly personal history. However there is nothing sophisticated in the look Ghiberti takes at himself. He never attempts to analyze his "artistic" achievements or to sound the resemblances or the differences between his own art and that of his predecessors. He simply assumes that he continues in his own way, in terms of his personal style, what they had done in their various ways. As he had enumerated their works with only an occasional characterization or word of praise, so he concludes with a list of his own works. The exact and artless sequence in which the works are enumerated chronologically and the precision with which cost, weight, and measurements are given suggest that in writing this autobiography Ghiberti made use of notes, possibly diaries in which he had entered his daily business. In fact, a passage in his autobiography seems to prove that Ghiberti used such diaries as a basis: "Ancora apparisce una cassa di bronzo in sancta Maria degli Angnoli" (there appears also a bronze shrine in S. Maria degli Angeli), clearly needs supplementing by "in my notes" or "in my diaries." What, except the existence of such notes would induce him to in-

[17] Gelli, bibl. 175, pp. 49f. [18] See below, pp. 306ff. [19] Ghiberti-Schlosser, bibl. 178.

clude in his account, at exactly the right point, even mediocre workshop productions which could hardly be of any great significance to him? We know that such diaries did exist; Filippo Baldinucci saw and perused a "journal of Lorenzo di Cione di Ser Buonaccorso Ghiberti from Florence, goldsmith," in which Ghiberti stated: "I shall write down all my business from day to day . . . beginning May 1, 1403 signed A . . ." (Doc. 163). This particular volume went at least as far as December 1414.[20] It is needless to stress what a boon it would be to find this volume or, for that matter, any other volume of the diaries, for the subscript (A) makes it obvious that the journal was but the first of a series which either existed or was intended. The heading of the journal, by the way, makes it likely that either the title was added by a later owner of the manuscript or else that Ghiberti corrected the title at a time when he had dropped the patronym Lorenzo di Bartolo in favor of his official name. Indeed, the wording corresponds exactly to the one which in 1442 he used in his autograph expense book for the estate in Settimo.

Despite its chronological arrangement, however, the autobiography in the *Commentarii* is anything but a colorless transcript from personal journals and other notes and the seemingly artless presentation does not deprive it of its character as a personal document. Ghiberti describes his achievements exactly in the terms which had been used throughout the Middle Ages: first and foremost the material, especially where precious stones or metals are concerned; second, size and weight; third, workmanship, the diligence of the execution, the love with which details have been carried out, the technique (*disciplina*) of the execution. Only rarely will he complement such craftsmanlike terms with a word about new problems of design—such as perspective, architectural settings, means to create an illusion of reality—as they permeate his late work. In these portions the language of the late medieval craftsman-artist gives way to newfangled terms from the language of the humanists.

Ghiberti wrote his autobiography in retrospect, apparently in the winter of 1447-1448.[21] The date is implied by his statement that at the time of writing the friezes of the Gates of Paradise were cast, while the twenty-four heads and the jambs were still in the planning stage, a situation which corresponds to the contract of January 28, 1448. As a man of seventy or so, who had made a place for himself in Florence as an artist and a citizen, he could look back on his life with some pride. At the same time it becomes manifest from this record of his life that Ghiberti thought of himself as a master in two directions: on one hand as a goldsmith, on the other as the creator of a new type of pictorial relief in bronze. To the three statues for Or San Michele, each one and a half times life-size, he devotes only one or two lines each. Goldsmith work and jewelry he described lovingly in every detail, down to the wings of the dragon and the ivy leaves in the mounting of the Medici Cornelian, and the pearls, rubies, sapphires, and emeralds of the mitres and morses for the two visiting popes. Yet, fully aware of the events which he considered incisive for his development, he would carefully distribute his emphasis and insert, if necessary, an explanatory phrase. The competition which, indeed, established his reputation as the leading bronze founder of his native city, is told with all the

[20] Baldinucci, bibl. 35, I, pp. 354f. [21] See below, p. 307.

relevant detail, but with the obvious intention of explaining the decision of the jury and justifying the award of the prize to himself. At the same time his outlook on his life work was naturally determined by the concepts of his last years regarding the requirements and essentials of a work of art. Under the impact of these late concepts he appears to emphasize, in the account of his earlier *œuvre*, the first work in which he had evolved a shallow relief, the Dati tomb. Likewise he stresses the antique lettering of the inscriptions on the same tomb and on the two bronze shrines for S. Maria degli Angeli and for the Cathedral. Thus his first door is described in bare outlines while he discusses the Gates of Paradise in every detail, giving attention to the narrative with the many scenes in each of the ten reliefs and to the presentation with its large number of figures, distributed into depth on receding planes. To have developed a pictorial relief in which a number of events were presented in a unified composition was in Ghiberti's eyes his proudest achievement. We cannot do better than to terminate this chapter with this *vita*, rendered as far as possible in its own lively and personal style.[22]

In my youth in the year of Christ 1400 I left Florence because of the corruption of the air and the bad state of the city. I left with an eminent painter whom the Lord Malatesta of Pesaro had summoned; he had us do a room which we painted with the greatest diligence. My mind was largely turned to painting; the reason thereof was the works which the lord promised us, and also the partner with whom I stayed continually showed me the honor and the advantage which we would acquire. However, at this moment it was written to me by my friends that the Regents of the Temple of S. Giovanni Battista were sending for masters who should be skilled, of whose work they wanted to see proof. From all the lands of Italy a great many skilled masters came to submit to this trial and contest. I asked leave of the lord and my partner. When the lord heard of the matter he immediately gave me leave; together with the other sculptors we came before the Committee of said temple. To each were given four plaques of bronze. As a trial piece the Committee and the Regents of that temple wanted each of us to make one story for this door; the story that they chose was the Sacrifice of Isaac and each of the contestants was to make the same story. These trial pieces should be carried out within one year and the prize would be given to him who won. The contestants were these: Filippo di Ser Brunellesco, Simone da Colle, Niccolo d'Arezzo, Jacopo della Quercia from Siena, Francesco di Valdambrino, Niccolo Lamberti. We were six[23] taking part in this competition, which was a demonstration of many aspects of the art of statuary. To me the palm of victory was conceded by all the experts and by all those who competed with me. To me was universally conceded the glory without any exception. At that time, after long deliberation and examination by the experts, it seemed to all that I had surpassed every one of the others. The committee of the Regents wanted their [the experts'] judgment written by their own hand; they were men highly experienced among painters, goldsmiths, silversmiths and sculptors. The judges were thirty-four from the city and from other neighboring places; by all the declaration of victory was given in writing in my favor, by the Consuls and the Committee and the entire body of the merchants' guild which has in its charge the temple of S. Giovanni Battista. It was conceded to me and determined that I should make this bronze door for this temple. This I executed with great diligence. And this is the first work: it amounted, with the decoration around it, to about

[22] Ghiberti-Schlosser, bibl. 178, i, pp. 45ff. Recent translations into English are found in Holt (bibl. 218, pp. 87ff) and Goldwater-Treves (bibl. 187, pp. 29f). We have used in places the translation in Mrs. Holt's volume, which is by and large excellent; but we have tried throughout to render the text as literally as possible and to preserve the old-fashioned flavor of its style.

[23] Ghiberti forgets to mention himself. There were really seven contestants; see also Ghiberti-Schlosser, bibl. 178, ii, p. 168, note 4.

twenty-two thousand florins. Also in this door are twenty-eight compartments. In twenty there are stories of the New Testament and at the bottom four Evangelists and four Doctors, with a great number of human heads around. This work is executed diligently with great love, with frames and ivy leaves, and with door jambs of very rich ornament of leaves of many kinds. The weight of this work was thirty-four thousand [pounds]. It was executed with the greatest ingenuity and proficiency. At that time the statue of Saint John the Baptist was made which was four and a third braccie; in 1414 it was set up, of fine bronze.

I was commissioned two stories by the community of Siena; they are in the Baptistery, the story [that shows] how Saint John baptizes Christ and the other story [that shows] how Saint John is led a prisoner before Herod. Also I produced with my own hand the statue of Saint Matthew; it was four and a half braccie, of bronze. I also made in bronze the tomb of Messere Leonardo Dati, the general of the Dominican Friars; he was a very learned man whom I portrayed from nature; the tomb is in low relief, it has an epitaph at the bottom. Moreover I caused to be made in marble the tomb[s] of Lodovico degli Obiz[z]i and Bartolomeo Valori who are buried at the Franciscan Friars. Also there appears [in my diaries?] a shrine of bronze in S. Maria degli Angeli, where Benedictine Brothers live; in this shrine are the bones of three martyrs: Protus, Hyacinth, and Nemesius. On the front are sculptured two little angels; they hold in their hands a wreath of olive leaves within which is written an inscription with their names. At that time I set in gold a cornelian of the size of a nut with its shell, on which three figures had been carved most beautifully by the hands of a very excellent ancient master. For a stem I made a dragon with its wings a little open and its head lowered; he lifts his neck in the middle, and the wings formed the handle of the seal; this dragon, I mean to say serpent,[24] was [placed] between ivy leaves. Around these figures there were cut, by my hand, antique letters giving the name of Nero, which I made with great diligence. The figure in this cornelian was an old man, seated on a rock on which was a lion skin, and bound with his hands behind him to a dead tree. At his feet was a putto kneeling on one foot and watching a youth who held in his right hand a scroll and in his left a zither. It seemed that the putto was asking instruction from the youth. These three figures were made to represent our ages [the three ages of man]. Certainly they were either from the hand of Pirgotile or else of Policreto. Perfect they were as anything I have ever seen carved in intaglio.

Pope Martin came to Florence [and] commissioned me to make a golden mitre and a morse for a cope. On it [the mitre] I made eight half figures in gold, and on the morse I made a figure of Our Lord blessing. Pope Eugene came to live in the city of Florence; he had me make a mitre of gold which weighed fifteen pounds, the gold alone; the stones weighed five and a half pounds. They were estimated by jewelers of our city at thirty-eight thousand florins; they were balas rubies, sapphires, emeralds, and pearls. There were in this mitre six pearls large as filberts. It was decorated with many figures and with a great many ornaments, and in the front [is] a throne with many small angels around, and in the middle our Lord; similarly in the back [is] a figure of Our Lady with the same small angels around the throne. There are also the four Evangelists in quatrefoils of gold and there are a great many small angels in the frieze which runs at the bottom. It is made with great splendor. I took on [a commission] from the Regents of the wool guild to make a statue of bronze of four and a half braccie; they set it up at the oratory of Or San Michele. This statue is made to represent the martyr Saint Stephen which, like all my works, I made with great diligence. The Committee of S. Maria del Fiore commissioned me to make, for the body of Saint Zenobius, a sepulchre of bronze, three and a half braccie in length, on which are sculptured stories of the said Saint Zenobius. On the front is [shown] how he revives the boy whom the mother left in his care until she should return from a pilgrimage; and how the boy died while the woman was on her way, and the woman is seen claiming him from Saint Zenobius; and how he revives him and, how another boy was killed by a cart. And also there is [shown]

[24] Schlosser (bibl. 178, II, p. 177) assumed erroneously that serpent and dragon were two different animals used in the mounting.

how he revives one of the two servants whom Saint Ambrose sent him: he died on the mountain; and [it is shown] how the companion mourns his death and Saint Zenobius said: "Go, he went to sleep, you will find him alive"; and how this one went and found him alive. On the back are six small angels; they hold a wreath of elm leaves; carved into it is an epitaph in antique lettering in honor of the Saint.

I was commissioned the other door, that is the third door of S. Giovanni, and I was given a free hand to execute it in whatever way I thought it would turn out most perfect and most ornate and richest. I began this work in panels which were one and a third braccia in size. These stories, very abundant in figures, were from the Old Testament: in them I strove to observe with all the scale and proportion (*misura*), and to endeavor to imitate Nature in them as much as I might be capable; and with all the principles (*liniamenti*) which I could lay bare in it and with excellent compositions and rich with very many figures. In some stories I placed a hundred figures, in some less and in some more. I conducted this work with the greatest diligence and with the greatest love. There were ten stories, all in architectural settings (*casamenti*) in the relation with which the eye measures them, and real to such a degree that if one stands far from them they seem to stand out in high relief (*appariscono rilevati*). [However] they have very low relief and on the standing planes (*piani*) one sees the figures which are near appear larger, and those that are far off smaller, as reality shows it. And I have carried through this whole work these said rules [of measurement and proportion]. There are ten stories. The first is the Creation of Man and Woman and how they disobeyed the Creator of All Things. Also in this same story [is shown] how they are driven from Paradise for the sin they committed; this then contains four stories, that is, events (*effetti*). In the second panel is [shown] how Adam and Eve have begotten Cain and Abel, small children. There is [shown] how they bring a sacrifice, and Cain sacrificed the meanest and vilest things he had, and Abel the best and the noblest he had. His sacrifice was very acceptable to the Lord and that of Cain was quite the contrary. There was [shown] how Cain slays Abel out of envy; in that panel Abel watched his flock and Cain tilled the soil. Also there was [shown] how the Lord appears to Cain and asks him about his brother whom he has slain; thus in each panel appear the events of four stories. In the third panel is [shown] how Noah leaves the ark with his sons and daughters-in-law and his wife and all the birds and the animals, and there with his whole clan he brings a sacrifice. There is [shown] how he plants the vine and how he gets drunk and Ham his son mocks him and how his other two sons cover him up. In the fourth panel is [shown] how three Angels appear to Abraham, and how he worships one, and how the servants and the ass remain at the foot of the mountain, and how he has stripped Isaac and wants to sacrifice him, and the Angel takes his hand with the knife and shows him the ram. In the fifth panel is [shown] how Esau and Jacob are born to Isaac and how he sent Esau to hunt and how the mother instructs Jacob and gives him the kid and the skin, and fastens it on his neck and tells him he should ask the blessing from Isaac, and how Isaac probes his neck and finds it hairy and gives him the blessing. In the sixth panel is [shown] how Joseph is thrown in the well by his brothers, and how they sell him and how he is given to Pharaoh, the king of Egypt. Through the dream it was revealed that a great famine was to come over Egypt; and the remedy which Joseph proposed [is shown] and all the lands and provinces were spared; they had what they needed; and how he was greatly honored by Pharaoh. [There is shown] how Jacob sent his sons and Joseph recognized them; and how he told them that they should come back with Benjamin, their brother, otherwise they would get no grain. They came back with Benjamin and he gave them a banquet and had the cup placed in the sack of Benjamin; and [there is shown] how it was found and he was brought before Joseph and how he made himself known to his brothers. In the seventh panel is [shown] how Moses received the tablets on top of the mountain and how Joshua remained halfway up the mountain and how the people marvel at the earthquakes, lightnings, and thunders, and how the people stay at the foot of the mountain all stunned. In the eighth panel is [shown] how Joshua went to Jericho, came and halted at the Jordan and pitched twelve tents, how he went around Jericho, sounding the

trumpets and how at the end of seven days the walls fell and they took Jericho. In the ninth panel is [shown] how David slays Goliath and how they, the people of the Lord, break the Philistines, and how he returns with the head of Goliath in his hand and how the people come to meet him, making music and singing and saying: "Saul percussit mille et David decem milia" (Saul hath slain his thousand and David his ten thousands). In the tenth panel is [shown] how the Queen of Sheba comes to visit Solomon with great company; she is adorned, with many people about. There are twenty-four figures in the frieze that surrounds these stories; between one frieze and the other a head is placed. There are twenty-four heads, executed with the greatest assiduousness and proficiency. Of [all] my works this is the most outstanding one which I have created and it has been completed with all craftsmanship and measure and ingenuity. On the outer frieze which is on the door jambs, and on the architrave, a decoration of leaves and birds and small animals goes in a way becoming to such a decoration. There is also to be a bronze frame. Likewise on the inner side of the door jambs there is a decoration in low relief made with the highest craftsmanship. And so is the threshold below; this decoration is of fine bronze.

But in order not to tire the readers I shall leave aside a great many works of art created by me. I know that one cannot get pleasure out of such matter. Nevertheless I ask pardon from all the readers and may they all have patience. Also for many painters, sculptors and stone-carvers I provided the greatest honors in their works [for] I have made very many models in wax and clay and for the painters I have designed very many things. Moreover to those who had to make figures larger than life size, I have given the rules for executing them on perfect scale. I designed on the façade of S. Maria del Fiore in the round window in the center the Assumption of Our Lady, and I designed the others [windows] which are on the sides. I designed in that church very many [stained] glass windows. In the dome there are three round windows designed by my hand. In one is [shown] how Christ ascends to Heaven, in another how He prays in the garden; in the third is [shown] how [He] is presented in the Temple. Few things of importance were made in our city that were not designed or devised by my hand. And especially in the building of the dome, Filippo and I were competitors for eighteen years at the same salary; thus we executed said dome. We shall write a treatise on architecture and deal with this matter. This ends the second commentary. We shall now come to the third.

CHAPTER II

GHIBERTI'S FAME

NEITHER contemporaries nor succeeding generations have added much to the data of Ghiberti's life and art. But what they do have to say gives a clear picture of the esteem in which the master was held in his own day and still more vividly mirrors the changes in opinion over the centuries regarding the quality of his work, its interpretation and significance.[1]

By the time the East Door of the Baptistery was set in place in 1452, Ghiberti's fame in Florence was solidly rooted and for the next half century spread far and wide throughout Italy. Even a local and pedestrian chronicler like Domenico Boninsegni, writing in the fifties, notes as among the time's major and minor events the completion of both the first and second doors: the former evidently cited from memory as an afterthought, hence with the mistaken date of 1421; the second correctly noted at the time of its being placed on the Baptistery gate with the added remarks that it had taken the master fifty years from the start of the first door until the finish of the second and that a sculptor of Ghiberti's calibre had not existed in many centuries.[2] Later in the Quattrocento Giovanni Cambi gives in his *Istorie* the correct date of April 19, 1424, for the setting-in-place of Ghiberti's first door, presumably drawing his information from older chronicles. His added remark, "Lavorolle Lorenzo di Bartolucci anni 44," makes no sense, unless he meant to imply that Ghiberti at the time was forty-four years old.[3]

Of greater significance than these chroniclers' notices is that in the fifties the humanist literati also began to mention Ghiberti and his works. Matteo Palmieri incorporates Boninsegni's remarks, including the mistaken date for the first door, into his ambitious work, *De temporibus suis*,[4] a world chronicle of decidedly Florentine bias. Fra Domenico di Giovanni in the seventies praises Lorenzo's doors with the words that "nothing like them had been done before on the globe and through them the name of man shines everywhere."[5] However, as often as not praise was intended for the city that had given rise to these wonders rather than for the artist himself. Indeed, Ugolino Verini, writing about 1485, refers to the sculptor as only a son "of Sulla's town, worthy of the ancient Pelasgians."[6] Or else praise takes on a moral twist, as when Gianozzo Manetti points out great artists of the past, from Zeuxis and Phidias to Giotto and Ghiberti, as exemplifying the excellent and admirable virtues inherent in man.[7] Between 1450 and 1455 Ghiberti's fame must have reached courtiers and humanists everywhere in Italy. Bartolommeo Fazio of the court of Naples names him one of seven artists worthy of mention among illustrious men of the age,[8] the whole lot including

[1] Schlosser (bibl. 476 *passim*, reprinted in bibl. 477, pp. 69ff) has given a superb analysis of Ghiberti's renown, which is mainly concentrated on nineteenth century criticism. The reader will notice for himself the basic difference of this chapter from the approach of Schlosser.

[2] Boninsegni, bibl. 62, p. 17. [3] Cambi, bibl. 85, p. 160. [4] Palmieri, bibl. 377, pp. 122f.

[5] Frater Dominicus Joannis, bibl. 132, pp. 100ff.

[6] Verini, bibl. 536, Lib. II, p. 46. [7] Manetti, bibl. 295, pp. 101f. [8] Fazio, bibl. 156, p. 50.

four painters, Gentile da Fabriano, Pisanello, Jan van Eyck, and Roger van der Weyden, and three sculptors, Ghiberti, his son Vittorio, and Donatello. The overall choice, two Flemings, one North Italian, one Umbro-Venetian, with the three sculptors representing the only Florentines, was clearly dictated by a taste for what is now known as the "International Style." This makes it even more noteworthy that at such a distance from Florence these principal works of Ghiberti were known: the two doors of the Baptistery, "executed with indescribable workmanship," the Shrine of Saint Zenobius in the Cathedral and the *Saint John* and *Saint Stephen*—but not the *Saint Matthew*—at Or San Michele.

The second book of the *Commentarii* leaves no doubt but that Ghiberti himself considered his second door of the Baptistery, the East Door, the crowning achievement of his life. In keeping with this self-estimation, his own generation and the next based Ghiberti's renown primarily and emphatically on this door: witness a letter of 1475, written in the best panegyric style of Quattrocento humanism by Piero Cennini, son of Bernardo, a goldsmith and one-time assistant to Ghiberti:[9] "[Strangers] passing through Florence view them [the East Door] eagerly; they are captured by a desire to see, looking carefully at the details and the day slips quietly by. But who would not be captured by the sight of such wonders? Who would not stand transfixed almost out of his mind when confronted with those men of action and those diverse deeds so convincingly rendered?" To have worked on this miracle of a door became a title of honor bestowed on every major artist of the time. Hence Piero Cennini lists among Ghiberti's assistants not only Michelozzo and his own father, both of whom were actually employed on the chasing of the gates, but Donatello, who worked solely on the first door, and Luca della Robbia, whose activity in Ghiberti's shop has never been otherwise demonstrable. Until the last generation of the fifteenth century, Ghiberti remained the great son of Florence, the man who had wrought a miracle out of bronze which all the world came to see and who had trained the best sculptors of the century in their craft. To this list of helpers composed by Cennini the sixteenth century added not only the name of Ghiberti's chief antagonist, Filippo Brunelleschi, but also, in ever-changing combinations, those of various masters of the last part of the Quattrocento: the two Rossellinos, Piero and Antonio Pollaiuolo, Desiderio da Settignano, Maso Finiguerra, Verrocchio.[10] No doubt some did work on the Gates of Paradise, but since most of them were mere youngsters at the time of Ghiberti's death, if they assisted at all, it could only have been to help Vittorio Ghiberti with completing the frame of Andrea Pisano's door of the Baptistery. This ever increasing list of names only reflects the ever growing Ghiberti legend among the people of Florence. A few years after the Gates of Paradise had been set in place, the foundry where they were cast became known simply as *le porte*.[11] All this, then, represents local popular opinion in Florence

[9] Mancini, bibl. 290, pp. 220ff.

[10] (Anonimo Magliabecchiano), bibl. 22, p. 73; Billi, bibl. 52, pp. 71f. Sanpaolesi (bibl. 467, p. 42, note 13) refers to an alleged statement of Manetti that "Brunellesco, Donatello . . . and perhaps Nanni di Banco . . . helped in the chasing of the doors." No such statement appears in either the *Uomini singholari* (bibl. 293) or in the Brunelleschi biography (bibl. 294).

[11] The term appears first in Vittorio Ghiberti's tax declaration of 1457 (Mather, bibl. 308, p. 59).

which art critics, Florentine and otherwise, picked up and carried far into the sixteenth century. In distant Padua, Gauricus in 1502 indicated that Ghiberti was indeed the fountainhead of "modern sculpture," the teacher of Donatello and therefore indirectly of Verrocchio, Bellano, and even Leonardo.[12] Albertini, writing in Florence in 1510, paid more attention to the works of Ghiberti and his son Vittorio than to those of any other sculptor, laboriously compiling a list of all of them from the Baptistery doors to the three statues of Or San Michele.[13]

Out of this mood of legendary admiration for the works of Ghiberti grew the anecdote that Michelangelo, stunned by the beauty of the doors, christened them the "Gates of Paradise." If Bocchi and Migliori are to be believed, Michelangelo meant the doors of both the East and North gates, but if Vasari's word is preferred, he meant the East Door alone.[14] The term Porte del Paradiso could easily have been applied to the main door of the Baptistery, not by Michelangelo, but rather by common parlance, and not because beauty deemed them worthy to serve as the "Gates of Paradise," but simply because they opened onto the *paradisus*, the atrium in front of the Cathedral.[15] Just when and by whom the term was played on and reinterpreted nobody can tell. Nor is it precisely known when the famous quatrain was composed in which the anecdote is poetically paraphrased:

> *Dum cernit valvas aurato ex aere nitentes*
> *In Templo Michael Angelus obstupuit*
> *Attonitusque diu sua alta silentia rupit*:
> *Oh divinum opus, oh janua digna polo.*

The term was first alluded to in 1549, and the 1550 edition of Vasari contains both the Michelangelo anecdote and its paraphrase. That Michelangelo was the author is unlikely. Hardly would he have stared in stunned wonder at a door before which he had played hide-and-seek as a child; aside from which, both taste and training drew him more toward Donatello's forceful stone figures than toward Ghiberti's melodious bronze reliefs. Still the phrase in itself and its attribution to the "divino Buonarotti" reflect the public's still prevalent admiration for Ghiberti and his doors in the sixteenth century. Varchi, about 1540, in a context quite foreign to art criticism, calls Ghiberti's doors "a work certainly miraculous and perhaps unique on earth."[16] In 1591 Francesco Bocchi sums up general feeling,[17] saying that both doors "are constructed with such singular . . . craftsmanship (*artifizio*) that they are famous and miraculous rather than rare. . . . If one saw them once in a while, instead of every hour, they would rank beyond any doubt among the most highly praised wonders of the world. . . ."

In the midst of these loud praises, harsh notes of criticism begin to sound from the late fifteenth century on. A goodly amount of ill feeling may even have been aroused during Ghiberti's lifetime as a result of his obvious skill in negotiating commissions.

[12] Gauricus, bibl. 172, f. g 7v. [13] Albertini, bibl. 13, pp. 7f, 15.
[14] Bocchi-Cinelli, bibl. 56, p. 11; Migliori, bibl. 332, pp. 90f; Vasari-Milanesi, bibl. 533, II, p. 242.
[15] Paatz, bibl. 375, II, p. 246, note 129. [16] Varchi, bibl. 530, p. 330.
[17] Bocchi-Cinelli, bibl. 56, p. 11.

At any rate, attacks on his character are openly and emphatically scored in the anonymous Brunelleschi biography of the 1480's.[18] More important, these attacks went beyond the limits of character, being gauged to cast doubt on Ghiberti's reputation both as a sculptor and architect. It seems that studio gossip in these years played a major part in this criticism. Donatello was apparently attributed in the late 1470's with the crack, "the best thing Ghiberti ever did was sell Lepriano," allegedly a *podere* which Ghiberti owned.[19] These more or less open aspersions seem to have stemmed ultimately from the almost personal grudge which Brunelleschi's nameless biographer held against Ghiberti as the antagonist of his hero. But even if launched singlehanded, they soon found fertile soil in the Brunelleschi revival of the last two decades of the fifteenth century. At the same time, renewed enthusiasm for the work of Donatello created an atmosphere decidedly unfavorable for the melodious beauty of Ghiberti. Since he was more and more viewed as Donatello's logical counterpart, his rating as Florence's leading sculptor automatically dropped in proportion to the rise of Donatello's popularity in the Cinquecento. From the early sixteenth century on, these elements seem to have tipped the scales toward strongly ambivalent and skeptical overtones in the evaluation of Ghiberti's work. The Anonimo Magliabecchiano,[20] around 1505, is overtly full of praise for the master's achievements, but stresses a little too strongly the collaboration of others on the doors, of Donatello, Luca della Robbia, Bernardo, and Antonio Rossellino: "whoever has insight into this craft . . . will be able to see what was done by these excellent masters." He makes a specific attribution to Antonio Pollaiuolo of a quail, "very delicately wrought," on the jambs of the East gate. In another passage he singles out Brunelleschi who, despite his defeat in the competition, "could not refrain from working on these doors," together with other masters who also joined in "because of a desire they had to see the work brought to perfection. . . ." In other words, the group of assistants named by Piero Cennini in 1475 was then transformed into a bevy of collaborators. They all helped out because otherwise, it is implied, Ghiberti by himself could never have achieved so perfect a work. Around 1520, Antonio Billi, takes up these unfavorable overtones, using practically the same words as the Magliabecchiano, except that he sharpens their bite by maintaining that without Brunelleschi's help, "it would have been impossible to terminate [the doors] in perfection." Characteristically enough, Billi also attributes the most classical of Ghiberti's statues, the *Saint Matthew*, to Michelozzo.[21] Bandinelli, writing shortly after the middle of the century, gives a list of Ghiberti's collaborators with the purpose of proving that the panels "at the bottom [of the Gates of Paradise] were the first done and very poor . . . though in the end the youngsters grew more skilled." The finishing is attributed *in toto* to assistants, while Ghiberti is pictured in

[18] (Manetti), bibl. 294 *passim*; see below, p. 35, note 24.

[19] The anecdote was pointed out to me by H. W. Janson who found it in a collection of *facetiae*, published anonymously in 1548, but apparently written in the late 1470's and republished with the misleading attribution to Angelo Poliziano by Wesselski, bibl. 551, p. 27, note 42.

[20] (Anonimo Magliabecchiano), bibl. 22, pp. 65, 73, 81. Frey dates the original manuscript in the years 1500-1507.

[21] Billi, bibl. 52, pp. 44f, 60. Frey has established that Billi's *libro* was composed between 1516 and 1525.

the role of merely "the very skilled designer."[22] Cellini's criticism takes still another track. As a goldsmith he is full of sympathetic understanding for Ghiberti, the accomplished craftsman, but he stresses his skill in casting small as opposed to large figures.[23]

A second reason for growing ambivalence in the appraisal of Ghiberti was an ever stronger dependence on Ghiberti's literary work in the approach of art critics and connoisseurs of the Cinquecento. The *Commentarii* had evidently become better known; in 1550 Cosimo Bartoli, one of the leading historiographers of art of the time, owned the now only surviving copy.[24] Thus it happened that in discussions of his *œuvre*, Ghiberti's autobiography often became a preferred source of reference over the works themselves. The Anonimo Magliabecchiano already based his chapter on Ghiberti on verbatim excerpts to which he added only a few remarks. Between 1540 and 1550 Gelli copied the autobiography nearly word for word in his *Vite d'artisti*.[25] The immediate and lively impressions held of Ghiberti by an earlier generation were replaced by a somewhat colorless, bookish image of him based on his own account, and in the process some coolness developed toward his work. Naturally the Gates of Paradise still received praise, but a praise waxed slightly conventional, unable to conceal a certain indifference. True, no one else went so far as Doni who in an abbreviated guidebook of Florence, written in the form of a letter in 1549,[26] constantly suppresses any favorable mention of Ghiberti's works, while praising Donatello to the skies. His use of the term "Gates of Purgatory" was obviously not meant as a silly journalistic pun, but in dead seriousness.[27]

Both increased emphasis on Ghiberti's literary work and decreased emphasis on his eminence in Florentine sculpture are manifest in Vasari's *Vite* of 1550.[28] Vasari contributes little to the data of Ghiberti's life and art. The works were known and could neither be decreased nor increased in number. Information on the life came mainly from the *Commentarii*; Vasari was familiar with the copy then in Cosimo Bartoli's library. At the same time, he leaned heavily on the anonymous biography of Brunelleschi with its underhanded attacks against Ghiberti's character and achievements. As a result, Vasari's chapter on Ghiberti is but a confused secondary source. The confusion was no doubt partly due to the dilemma facing Vasari when he tried to reconcile these two conflicting versions of Ghiberti. Moreover, as all through the *Vite*, facts, invented details, psychological and aesthetic interpretations of historical situations are indissolubly tangled. The value of Vasari's life of Ghiberti does not lie in factual material, but instead in his attempt to rationalize the uncertainty felt by the Cinquecento in trying to evaluate Ghiberti's work and its relation to the art which, in Vasari's eyes, was modern art. As an art historian Vasari was able to work out reasons for this uncertainty in historical terms. To him Ghiberti's work did not present itself as a unit, equally superb in all its phases and parts. As he saw it, Ghiberti had started out with a design for the first door in which "the draperies still hold some to the old man-

[22] Bottari-Ticozzi, bibl. 64, I, pp. 71f.
[23] Cellini, bibl. 92, p. 7.
[24] Ghiberti-Schlosser, bibl. 178, II, p. 7.
[25] Gelli, bibl. 175, pp. 49f.
[26] Bottari-Ticozzi, bibl. 64, III, p. 343.
[27] See however, Schlosser, bibl. 477, pp. 70, 77.
[28] Vasari-Ricci, bibl. 531, I, pp. 257ff.

ner of Giotto's time, even though there is a general tendency that inclines toward the manner of the moderns." Only in the *Saint John*, according to a comment inserted into the 1568 edition, "is there to be seen the beginning of the good modern manner in the head, the arm and the flesh. [Ghiberti] was the first to imitate the works of the ancient Romans. . . ." Finally, apropos of the second door, because ". . . it is perfect in every way and because the purity (*saldezza*) of casting, it can be called the most beautiful work ever seen on earth, whether ancient or modern. . . ."

Vasari, then, was the first to interpret Ghiberti's position in art as a gradual development from what we know as the Gothic style to Renaissance solutions. He casts him in the role of a transitional figure. Only at the end, with the last work, the East Gate of the Baptistery, does Vasari feel that the admiration accorded Ghiberti by previous generations was justified. Obviously such wholehearted admiration could not very well be disregarded and Vasari had no such intention. But it seemed to him inappropriate to apply the apocryphal Michelangelo epithet, with which he concludes his account, to both doors as Bocchi had done; the East Door alone had a right to the title, Gates of Paradise, and so, accordingly, does Vasari recount the anecdote.

This bilateral approach, the result of seeing Ghiberti's work as a bridge between the Middle Ages and Renaissance, and at the same time allotting praise to the late style, set the pattern for the opinions of the entire seventeenth and eighteenth centuries. Ghiberti and his work were obviously going to remain objects of pride for every Florentine and of wonder for every visitor. But in time pride and wonder were by and large confined to the East Gate and expressed, more often than not, in vague and trite phrases based on the "Michelangelo" *bon mot*. In 1681 Baldinucci published what was to be the most valuable biography of the master. Kept independent of Vasari's presentation of the facts of Ghiberti's life and art, it is based almost entirely on previously unknown documentary material culled from private and public archives.[29] But to Baldinucci, as to Vasari, Ghiberti began as a fundamentally "Gothic" artist, pupil of Starnina, and only in the Gates of Paradise did he create not merely a great work of art, but a new style that made him one of the founding fathers of the Renaissance. Local antiquarians of the eighteenth century followed the same line. To Richa, after 1750, the first door, "while . . . worthy of high praise, is nevertheless judged by recognized authorities (*professori*) as less refined than and far inferior to the second . . . which because of its perfection and diligence in craftsmanship deserves greater praise."[30]

But more often than not even the Gates of Paradise were accorded only perfunctory praise. Nobody made an effort to see them for what they really are, and an occasional passing stranger might even have coolly ignored or condemned them along with the rest of Ghiberti's work. President De Brosses in 1739 thought little enough of the Baptistery doors, even doubting, glib heretic that he was, Michelangelo's authorship of the term Gates of Paradise, and its applicability to Ghiberti's work: "Ce n'est pas la seule sottise qu'on lui fasse dire."[31] Volkmann, author of the most famous German guide-

[29] Baldinucci, bibl. 35, I, pp. 347ff. [30] Richa, bibl. 443, v, p. xxi.
[31] De Brosses, bibl. 70, I, p. 278.

book of the eighteenth century, condescended in 1770 to make only a few remarks.[32] Goethe, passing through Florence in 1786, did not even glance at the Baptistery doors; but then he looked at nothing in Florence. The low opinion into which Ghiberti had fallen was summed up in 1772 by the director of the Granducal Gallery, Raimondo Cocchi. In answer to a request to have the Gates of Paradise cleaned, submitted by Anton Raphael Mengs, among others, he called them "more remarkable as a monument of the history of art which is flattering to the Florentines than as a perfect example," declaring himself skeptical as to whether "one would study Ghiberti's statues if one were interested in reviving the art of sculpture which is wanting in Florence."[33]

Nevertheless, the interest which Mengs took in the doors proves that still another change was about to take place in public opinion. Ghiberti's *œuvre* became more interesting just because of the contrast between the early and late gates. Indeed, in the eyes of eighteenth and nineteenth century Classicists this contrast reflected one of the burning questions: the *paragone* between sculpture and painting, the problem of boundaries between the arts. The early door was thought purely sculptural in approach, while the Gates of Paradise stood for pictorial relief. The question of whether such relief was legitimate or transgressed the "eternal boundaries" of the arts became basic to both classicistic and romantic criticism from the time it was first posed in the anti-Baroque climate of the late eighteenth century.[34] At the same time, the narrative and its presentation invited still another comparison between the doors, equally vital to the period. The first doors were looked upon as imbued with a simple, yet deep sentiment, the second as reflecting a more balanced, though not necessarily more profound beauty. The contrast between Ghiberti's early and late style, first established by Vasari, was then transposed from the historical to the critical plane. Yet it did not entirely lose its historical connotation. Just because of the contrast, Ghiberti was hailed the harbinger of a new art. The Gates of Paradise were viewed as the first work of the *rinascita*. The connoisseur, Antonio Cocchi, under the pseudonym Thomas Patch, and the engraver Ferdinando Gregori published in 1774 a lavish tome on the doors, incorporating Strozzi's excerpts from the *Libro della seconda e terza porta*;[35] both the engravings and title of the publication limit the subject to the main door, and the line drawings which represent the reliefs clearly express a classicistic interpretation of Ghiberti's work. It is of some significance that Cocchi used an English pseudonym and that the book appeared in two editions, one with an English title page, the other with an Italian one. The idea was a frank catering to the taste of English tourists who were at that time on the verge of discovering the beauties of Italian primitives—albeit primitives in classicistic disguise. Shortly thereafter, Seroux d'Agincourt[36] opened his chapter on the rebirth of sculpture in the fifteenth century with two plates, one of which illustrates the East Gates of the Baptistery (*un des plus précieux monuments de l'art moderne*), the other the Cassa di S. Zenobio, thus indicating that Ghiberti's two

[32] Volkmann, bibl. 542, I, p. 531.

[33] Quoted by Rossi, bibl. 452, pp. 339ff.

[34] Venturi, bibl. 535, pp. 233ff.

[35] Patch-Gregori, bibl. 392.

[36] Seroux d'Agincourt, bibl. 3, I, pls. XLI, XLII; II, pp. 76ff. The text was written prior to 1789.

latest works had initiated a new age. His earlier works, including the North Door, are not even mentioned.

In his sparkling chapter on Ghiberti's fame, Schlosser[37] discusses the nineteenth century's meandering views on Ghiberti's art. As he sees it, variances of opinion were due more to differences of personality among critics than to shifts of taste in the stylistic *ambiente*. Yet these changes in critical attitude were fundamentally determined by issues which, at the end of the eighteenth century, had suddenly forced Ghiberti into the limelight: questions of sculpture versus pictorial relief and sentiment versus perfection. Throughout the nineteenth century these issues were nourished on the period's own interweaving and opposing movements: the continued battle against the Baroque, the rising opposition to the classicism of the early part of the century, the rediscovery of "primitives" by the Pre-Raphaelites and Nazarenes. To all these issues Ghiberti's *œuvre*, rent by the contrast between his early and late style, lent a fitting battleground. Cicognara in some of the best pages ever written in art history,[38] gives a splendid analysis of one of the reliefs on the first door, the *Lazarus* plaque. Contrary to all previous opinion, he rates it far above the *Genesis* panel on the Gates of Paradise. Classicist *and* Romantic that he was, he was impressed by the clarity and simplicity of both the competition relief and the *Lazarus* plaque, by their "attic purity," their contrasting dark and light masses, variety of expression and deep religious feeling—all of which he describes in the terminology of both the Greek revivalists and Pre-Raphaelites. In this spirit and by the same tokens, he perceived in Ghiberti, as represented in his early style, an artist far greater than either Brunelleschi or Donatello. To the *Genesis* panel he relates sweetness of movement and depth of feeling; yet in his discussion of this relief and even more of the Cassa di S. Zenobio he points out the "difficulties" bound to beset pictorial relief: multiplicity of planes, contrasts between full and shallow relief, crowding of figures. From the point of view of his time, Cicognara had asserted a critical truth; for to the entire nineteenth century it appeared that the late style of Ghiberti—in the pictorial character of its relief, as well as in its large scale compositions, its narrative and the slow dignified movements of its figures—forecast not only Raphael, whom Cicognara and others of his taste could easily admire, but beyond this, the compositional principles of the hated Seicento. Rumohr in 1829[39] began like Cicognara by basing his arguments on the fundamental issue of pictorial relief; but by reasoning along complex lines, he reversed Cicognara's judgments. Ghiberti's second door seemed to him far superior to the first. Like Cicognara he is decidedly hostile to the tradition of pictorial relief. But Ghiberti, in Rumohr's eyes fundamentally a painter, was the genius who made the impossible possible, who transformed pictorial form into pure lines and outlines and thus achieved large scale compositions easy to comprehend. He visualized the reliefs of the Gates of Paradise as paintings, his descriptions of them reminding one of the Nazarenes, the German

[37] Schlosser, bibl. 476 *passim*, reprinted in bibl. 477, pp. 69ff.

[38] Cicognara, bibl. 99, IV, pp. 169ff, pls. XX, XXI.

[39] Rumohr, bibl. 454, II, pp. 232ff. A comparable romantic-classicistic view of Ghiberti is reflected in such publications as Gaye (bibl. 174), and that charming mystification of a chronicle allegedly written by Ghiberti (Hagen, bibl. 204, first published in 1831).

Pre-Raphaelites, who, mostly converts like Rumohr himself, were at that time paint-
ing large murals in the Casino Massimi in Rome. It is as a Nazarene that Ghiberti
is presented to Rumohr's readers, classicistic and melodious in form, Christian and
sweet in subject matter. This combined classicistic-Nazarene image of Ghiberti sur-
vived late into the nineteenth century, together with the concept that genius may,
without punishment, transgress the natural laws of art. However, Charles Perkins,
first director of the Boston Museum of Fine Arts, who generally approves of the
opinions of Cicognara and Rumohr, says that the first door is based on a twofold in-
spiration of nature and antiquity, while the second door is, instead, a "pictorial
debauche," and that "despite [Ghiberti's] enormous success his infraction of discipline
deserves severe censure." In short, Perkins made none of the allowances for genius
which would permit a transgression of "the natural boundaries of sculpture."[40]

In any case, it was not the lingering classicistic theories of art, but romantic criticism
which finally sized up the contrast between the doors, bringing it to what must neces-
sarily have seemed a logical conclusion. Historically minded as the Romantics were,
they saw the contrast as primarily an issue of an historical nature. Ghiberti was once
more looked upon as an artist hovering between Gothic and Renaissance. But while
Vasari's conception has him moving slowly toward a liberation from medieval art,
emerging victorious at the end as one of the great artists of the Renaissance, the nine-
teenth century reversed this decision. To the Romantics Ghiberti was first and fore-
most a Gothic sculptor whose true art reveals itself in the first door and in the cor-
respondingly early *Saint John*. They frowned upon the second door as an aberration
from his natural talent, a half-truth brought about by illegitimate concessions. Among
the first to propound this point of view was Burckhardt in the first edition of the
Cicerone in 1855.[41] Burckhardt's *bête noire* was the newly rediscovered realism of the
fifteenth century represented by Donatello. Ghiberti, he felt, withstood this realism
in his early *œuvre* in which "the spirit of the fourteenth and fifteenth centuries (as
represented by Andrea Pisano) fuses with a . . . free beauty that flourishes most fully
in the sixteenth century. Giotto and Raphael join hands across [the period of] realism."
In contrast, then, to the reliefs of the first door and *Saint John*, the pictorial panels of
the late door "have fallen victim to realism." But Burckhardt is too sensitive to a great
work of art to submit to the narrowness of his categories. He stresses "the new-born
beauty of detail. The narrow Gothic form gives way not to an equally narrow realism,
but to a new idealism [and] the charm of both the panels and the statues speaks power-
fully to everyone's eyes. . . ."

Burckhardt, despite his criticism, saw in all of Ghiberti's work the hand of a master.
After him, well into the twentieth century, the tendency was to focus on Ghiberti's
early period. As late as 1923, it formed the criterion for Lionello Venturi's critical
analysis. The change of style was still for Venturi a qualitative change: the first door
is coherent, a rich phantasy lives in its lines, the "sentimental reactions" are unfailing,
the effects of light dominated by "an imperfect yet consistent impressionism." The

40 Perkins, bibl. 394, pp. 457ff; *idem*, bibl. 393 *passim*.
41 Burckhardt, bibl. 82, pp. 553ff.

Gates of Paradise, he complains, represent an attempt on Ghiberti's part to break with his own past and adjust to the classicism of his contemporaries; consequently, he lost spontaneity and his large panels lack the "visual unity" of Donatello's Paduan reliefs.[42]

During the decades of realism in art and literature, the period between 1860 and 1890, interest (Schlosser brings out)[43] was by and large centered on Donatello, the "powerful naturalist," the individualist, the true sculptor who was, it was generally agreed, "far superior to the goldsmith Ghiberti, the minstrel of grace . . . who lacks grandeur."[44] However, there was probably also an external factor involved in the formation of this opinion. Ghiberti's works were known, all solidly anchored in the major churches of Florence. Nothing much of importance was likely to appear on the market that could enrich the public and private sculpture collections which, during the middle and late Victorian era, were just in the making. Still, there were exceptions to this indifference. Taine, for example, during a visit to Florence in April 1864,[45] made his brief but incisive remarks about Ghiberti's figures which "through the simplicity and quiet development of their poses seem Athenian masterpieces. . . . Eve a primitive nymph, virginal and naive. . . . Even when the muscles are raised, the faces drawn by passion . . . he subordinates expression to beauty. . . . The School of Athens, the *loggie* . . . seem of the same school as the door of the Baptistery and to achieve the resemblance, Ghiberti handled the bronze as a painter." An equally remarkable commentary of the time is a long paper by Toschi,[46] a critique both of Ghiberti's work and nineteenth century writings on it. Like Taine, he adopts Burckhardt's concept that Ghiberti foreshadowed the sixteenth century. He sees him as neither a Gothic laggard nor as a Pre-Raphaelite of classic form and medieval spirit. Instead, Toschi puts Ghiberti at one with his contemporaries, Quercia, Brunelleschi, and Donatello, in their rediscovery of nature, except that he went beyond them in being able to subordinate "the somewhat crude truth . . . to the ideal," that is, the ideal of antiquity. He distinguishes Ghiberti as having achieved an art marked by careful and elegant selection (*ricercatezza*) comparable to the Cinquecento, "a fruit ripened before its time." Nevertheless, despite its mature quality, Toschi finds flaws in this art, such as heads of a traditional type or S-curved and insecure stances that "no Greek sculptor would ever have made." But his conviction remains secure that Ghiberti in both his first and second doors surpasses the efforts of his contemporaries. Pictorial relief is at last judged admissible, not just because of Ghiberti's exceptional creativity, but as a legitimate form of sculptural relief.

Both Taine and Toschi, then, turned against the aesthetic tenets of realism. They stand for classicism, but not the old classicism of the eighteenth and early nineteenth centuries. Their criterion is a new classicism, elegant, *recherché*, and pictorial such as

[42] Venturi, bibl. 535, pp. 233ff. To Morisani (bibl. 179, pp. viiff and bibl. 348, pp. 20ff) even more than to Venturi, Ghiberti remains a split personality: a follower of Andrea Pisano, traditional throughout his life and one who never absorbed into his work the "spiritual values" of ancient art; fundamentally superficial and intent on assimilating, only as external elements into his technique rather than into his art, the new problems of the Renaissance, the rendering of space, the movement of figures, and perspective.

[43] Schlosser, bibl. 477, pp. 69ff.

[44] Reymond, bibl. 438, pp. 125ff.

[45] Taine, bibl. 516, II, pp. 109ff.

[46] Toschi, bibl. 525, pp. 449ff, 624ff.

comes to the fore at the end of the century, playing a decisive role in the rise of *art nouveau*. To this new style Ghiberti's work presented an ideal, perhaps *the* ideal prototype. Hence, in the decades between 1895 and 1915, a flood of new literature on Ghiberti issued forth, writings by Reymond,[47] an essay by Carocci,[48] and another by A. G. Meyer[49]—all general in character, published in widely read magazines and handbooks, clearly designed for popular consumption. These more or less popularized accounts were accompanied by scholarly publications, varied in scope: papers by Schmarsow,[50] an important volume by Brockhaus,[51] Doren's superb publication of the account book for the statue of Saint Matthew,[52] Bode's and Sirén's attributions to Ghiberti of the terracotta Madonnas scattered throughout the major and minor collections of Europe and the United States[53] and last, but not least, Schlosser's study of Ghiberti the collector.[54] The whole lively renewal of interest in Ghiberti is finally crowned by Schlosser's masterful edition of the *Commentarii*.[55]

The rediscovery of Ghiberti during these years is best observed within the framework of the *art nouveau*. Just as the Romantics, in the light of their own preference, had seen Ghiberti even in his last works as having retained a medieval flavor, so too did those around 1900 imagine him as representative of an art akin to their own. They stressed the free ornament "imitated from nature rather than from the cold lotus leaves . . . of Greek art,"[56] his "grace and elegance, the feminization of form," his love of "youth and beauty," his pretended lack of interest in historical forms, including the antique, the floating and dancing movements of his figures,[57] his feeling for "whatever is agreeable to the eye," his "graceful nobility," his stage-like compositions and "jubilant pleasure of living."[58] Such attributes would naturally attract a generation trained to like the decorative architectural designs of Horta, the medals of Roty and illustrations of Beardsley, a generation, moreover, wont to set its art against a historical perspective, preferably affiliating it with the art either of Japan or of fourteenth century France. In fact, Reymond presents Ghiberti's work as influenced by the sculptures of the Cathedral of Strasbourg and even a somewhat pedantic analysis like Schmarsow's *Kompositiongesetze* stems from the same approach.[59] Ghiberti's first door is now seen as stamped with a character of design comparable to Gothic stained glass windows, though at the same time as pure and abstract, without the slightest reference to representation or narrative. Where the reliefs do not fit this concept, the critic conveniently rearranges them. A linear pattern is assumed to underlie the entire composition and every form is seen in terms of circles, triangles, diagonals, and horizontals. The "harmony of flowing lines" is claimed as Ghiberti's principal aim. No doubt these

[47] Reymond, bibl. 438, pp. 125ff; bibl. 440, II, pp. 50ff.
[48] Carocci, bibl. 88, pp. 69ff. [49] Meyer, bibl. 326, pp. 17ff.
[50] Schmarsow, bibl. 485, p. 48; bibl. 482, pp. 1ff.
[51] Brockhaus, bibl. 69. [52] Doren, bibl. 133.
[53] Bode, bibl. 58; Sirén, bibl. 497 and bibl. 495.
[54] Schlosser, bibl. 479, reprinted bibl. 477, pp. 123ff.
[55] Ghiberti-Schlosser, bibl. 178. [56] Carocci, bibl. 88, pp. 69ff.
[57] Reymond, bibl. 440, II, pp. 50ff. [58] Meyer, bibl. 326, pp. 17ff.
[59] Schmarsow, bibl. 482, and Schlosser's brilliant critique of that paper (bibl. 476, pp. 27ff).

observations contain more than a grain of truth, but they could only have been made by a generation intent upon finding corroborative historical precedents.

Schlosser's work on Ghiberti covered four decades, from 1903 until the end of his life. The *Antiken*, the *Prolegomena*, and the *Commentarii* are all magnificent studies.[60] Written by a humanist and great scholar they are broad, learned, large in scope. However, they were not meant to raise questions of Ghiberti's style or his place in fifteenth century art. Where Ghiberti the artist as a historical phenomenon is concerned, Schlosser's pages had best be read as an *apologia*. He was up in arms against the disparaging attitude of the previous generation, the generation of Bode, of realism and unlimited admiration for Donatello. At times one cannot help but suspect that Schlosser draws an implicit comparison between Bode and Donatello, the "brutally aggressive naturalist" and individualist, and that consequently he half-consciously identifies himself with his own hero, Ghiberti.

We chose the word hero not without intention. Indeed, in Schlosser's eyes Ghiberti was a hero in a tragedy of slanders that had already started in his lifetime and immediately after his death. The accusations about his illegitimate birth and those contained in the Brunelleschi biography were, according to Schlosser, but the beginning of a long line of misrepresentation. Simultaneously, with this heroization of "the master," Schlosser consistently opposes all earlier efforts to explain Ghiberti's *œuvre* within the light of history; on this account, he censures both Vasari and Baldinucci, though letting them share the blame with some more recent authors. He refuses to let his hero be seen within the history of either fifteenth century art or, *sub specie*, the development of his personal style. He is suspicious of any attempt at what he calls philological criticism such as trying to enlarge upon Ghiberti's repertory by new attributions (the *bête noire* is again obviously Bode with his terracotta Madonnas) or differentiating the hands of Ghiberti from his assistants'. Finally, he objects to interpreting him in historico-psychological terms as Lionello Venturi has tried to do. The reason for Schlosser's aversion to all these methods of approach, though never explicitly stated, is obvious: heroes should not and cannot be explained, lest they cease to be heroes.

Schlosser's own approach, then, is consciously antihistorical. He wants to gain immediate insight into the true essence of Ghiberti. His target is not the artist in time and space, but a spirit free of historical bonds, an autonomous phenomenon which, by its own nature, demands autonomous description. Again and again he refers to a supposed Burckhardt saying, "Ghiberti remains always himself." This approach, based on hero worship, appears linked to the principle of art for art's sake, a basic tenet of *art nouveau*. Passages in which he speaks of Ghiberti's "beautiful curves," the importance of pure outline and theatrical composition in the East Door recall almost word for word descriptions of these panels made at the turn of the nineteenth century. Schlosser's picture of Ghiberti fits perfectly with the ideal image of the artistic personality in which *art nouveau* delighted: a craftsman "whose thoughtful persistence and neatness" are basic to his being and a poet in whom the essential trait is musicality. Musical terms, so fundamental to this analysis with its stress on sensitivity and "finger

[60] Schlosser, bibl. 479, 478, 178; see also bibl. 477.

tips," are likewise effectively used in Schlosser's interpretation of Ghiberti the collector and lover of antique sculptures.

Since "inner experience" is the key, the artist is placed in the sharpest possible contrast to the theoretician who, in Schlosser's mind, is represented by Paolo Ucello and more so by Leone Battista Alberti, "half artists," "bloodless," and Alberti, at least, "alien to the workshop." By this definition the artist is anti-intellectual. Yet Schlosser magnificently portrays Ghiberti as a historian of art. No contradiction is involved in this attitude, for to Schlosser the "true historian" is much less an intellectual than a poet.

Schlosser's conception of Ghiberti the artist and historical figure is highly personal and it is dated. Where he deals with the intellectual *ambiente* in which Ghiberti moved and thought, he is superb. In the edition of the *Commentarii* and the *Prolegomena* his vast knowledge of ancient sources and of medieval and humanist thought, is an infallible instrument for interpretation, laying bare the meaning and origin of Ghiberti's every sentence. He traces the roots of Ghiberti's nomenclature back to the terminology of medieval workshops and carefully analyzes its Trecento features together with those taken from the master's reinterpretation, as well as misinterpretation, of his beloved ancient authors. The place of the *Commentarii* in the historiography of art is precisely determined against a broad background extending from Dante and Filippo Villani to Giorgio Vasari. In the *Antiken* Schlosser traces with meticulous care the history of a small number of Roman sculptures, known to and in part owned by Ghiberti and on the basis of the sculptor's own descriptions analyzes his evaluation of antique works of art. He establishes Ghiberti's approach to antiquity and his mania for collecting within a large historical framework of collections and passion for great works, leading from Ristoro d'Arezzo and Petrarch to the cabinet of antiquities owned by Rudolph II of Hapsburg.

No matter how personal, Schlosser's remains the last great endeavor to view Ghiberti the artist and humanist.

THE BEGINNINGS

CHAPTER III

THE COMPETITION

GHIBERTI first steps into the light of history at roughly the age of twenty. In the winter of 1400-1401 he returned from Pesaro to Florence in order to enter the competition announced by the *Arte di Calimala* for the commission of the new bronze door of the Baptistery.

The Baptistery had long been the pride of Florentines. By the thirteenth century it had been forgotten that this splendid example of Tuscan proto-Renaissance architecture was designed and built between 1059 and 1150;[1] legend had arisen, instead, that it dated as early as the mid-sixth century and had been designed as a copy of and built to emulate the foremost baptistery of Christendom, S. Giovanni in Fonte at the Lateran in Rome, the octagonal *batesimo di Ghostantino*. Late in the thirteenth or perhaps early in the fourteenth century another conjecture came to the fore: the Baptistery was believed to be a real Roman building, a temple of Mars rededicated to the Baptist. This may or may not have been connected with the fact that a number of the Baptistery's architectural features are undeniably linked to the Pantheon.[2] This tradition is first reflected, it would seem, in Dante[3] and stated *expressis verbis* before the middle of the fourteenth century by Giovanni Villani.[4] The claim that the Baptistery was the foremost and oldest, indeed the only Roman building in Florence, was thus made definite and final. The chapters in Villani's chronicle pertinent to this argument show clearly the association of ideas: Florentines, he says, were always close to the Romans; indeed, Florence was a small Rome and hence, he concludes, the citizens commemorated the victory of the Romans over Fiesole by building this temple of Mars designed by Roman workmen. In short, to a Florentine of the fourteenth and fifteenth centuries, the Baptistery was the supreme witness of his city's noble past.

Any undertaking in connection with the Baptistery therefore was an event of major importance in the eyes of the citizenry. The construction proper was terminated in 1150, but for centuries after there was continuous endeavor to give the building a decoration worthy of its reputed origin. The choir was added; its mosaics are dated 1225. From about 1271 until after 1301 a large scale cycle of mosaics was added inside the huge dome.[5] Between 1309 and 1321 marble statues were placed outside, above the entrances, the largest sculpture group of its kind yet to be seen in Florence.[6] Finally, in 1329 Andrea Pisano was asked to design a bronze door,[7] meant no doubt to compete in

[1] Horn (bibl. 219, pp. 100ff) and Paatz (bibl. 375, II, pp. 173ff) where also the history of the Baptistery and of its legendary origins have been summed up.

[2] Horn, bibl. 219, pp. 126ff.

[3] *Divina Commedia, Paradiso*, Canto XVI, vv. 22ff, bibl. 114, p. 126.

[4] Villani, bibl. 538, Book I, chapter I.

[5] Vasari-Frey, bibl. 532, pp. 329ff, docs. 7, 13 [henceforth quoted as Frey]; Paatz, bibl. 375, II, p. 200, notes 149ff.

[6] Paatz, bibl. 375, II, p. 206 and note 177.

[7] For the history of the Andrea Pisano door see Paatz (bibl. 375, II, p. 95 and notes 123ff) and Falk (bibl. 151, pp. 40ff).

splendor with the doors of the Cathedral of Pisa, the old rival of Florence (Fig. 35). Its twenty-eight panels, four rows by seven, are framed by metal strips decorated with rosettes and diamonds and with lion heads at the corners. In the quatrefoils contained within each panel of the two bottom rows are seated figures of the cardinal virtues; the five upper rows present the story of Saint John the Baptist. Figures, setting and frame are gilded. Since no crew of trained workers was available in Florence or nearby, a group of Venetians was sent for to assist in the casting. When the door was completed in 1338 it was, according to one tradition, set up on the gate opposite the Cathedral.[8] But it is more likely that it occupied from the first its present place in the south portal which was then the most important of the three Baptistery gates because it alone faced the city: the east portal, certainly originally intended for the main entrance, still faced a disorderly building site upon which the Cathedral had hardly begun to take form; before the north portal lay the suburbs, an area as yet not built up. For the next two generations Andrea's door remained the last great work to be erected in honor of S. Giovanni.

For a long time it had been the custom in Florence to entrust the supervision of work on important public buildings to the seven Greater Guilds.[9] Without necessarily financing the work, a particular guild acted in the capacity of deputy for communal administration and trustee for the funds assigned to the building in its charge. Nothing could have been more suitable than that the decoration of S. Giovanni should be put in the hands of the most influential and affluent guild in town: the *Arte dei Mercatanti di Calimala*. From time immemorial they had stood under the patronage of Saint John the Baptist. When first established in the twelfth century the *Calimala* was the guild of big business, comprising not only the dealers and refiners of foreign cloth and the wool importers, but also importers of silk, brocade, jewels, and other precious materials from the Levant, as well as bankers, all of whose activities were closely knit within Florentine economy.[10] Toward the end of the twelfth century the bankers withdrew to form an independent guild of their own, the *Arte del Cambio*, though the limits between the financial dealings of the two guilds remained elastic.[11] Some years later the *Arte Por S. Maria* or *della Seta* was formed by retail dealers; they were joined in 1247 by the importers of silk and other goods from the Levant and still later by the silk weavers, embroiderers, and goldsmiths.[12] In 1371 or possibly some years earlier, the wool importers and cloth manufacturers, wanting to promote the local product, separated from the importers and refiners of foreign cloth and established the *Arte della Lana*, almost exclusively a manufacturing guild.[13] The development of the local wool industry, protected as it was by high tariffs, the increase of Levant trade and the coincidental resurgence of the Florentine international banking houses—all of which took place in the last third of the fourteenth century—made the wool, silk, and banking guilds the lead-

[8] Falk (bibl. 151, p. 57) assumes, though with reservations, that the door was originally placed opposite the Cathedral.

[9] The importance of the guilds in the art life of Florence was first pointed out by Doren (bibl. 135) and later by Wackernagel (bibl. 543).

[10] Doren, bibl. 135 *passim*. [11] *ibid.*, I, pp. 20ff. [12] Pieri, bibl. 398 *passim*.

[13] Doren, bibl. 135, I, pp. 407ff; Agnoletti, bibl. 4 *passim*.

ing business groups of Florence.[14] The *Calimala* changed its character without losing its importance. Its members ceased to rely on the outdated business of importing and refining foreign cloth. After the mid-fourteenth century they made their fortunes as wool importers, exporters of Florentine cloth, in shipping and selling foreign cloth from the Flemish and French markets to the Near East and as international financiers. The *coup d'état* of 1393 made the *Calimala* the bastion of the ruling aristocratic party, the *optimati*, represented then by the Albizzi, the Strozzi, the Uzzano families. To the activities characteristic of a big business organization and a political machine, the *Calimala* adjoined those of a society for the betterment of the poor and the promotion of the arts.[15] These two latter functions had been traditional with the *Calimala* since the twelfth and thirteenth centuries. Probably from 1180 and certainly from 1228 the guild had taken care of completing and later repairing the church of S. Miniato. In 1192 it was put in charge of the hospital of S. Eusebio. In 1360 the guild added to its cares the administration of the hospital of S. Gallo. In 1388 it undertook the trusteeship of the Convent of S. Croce and in 1441 that of the church. From 1405 to 1426 it supervised the construction and decoration of the chapel of Niccolo Acciaiuolo which adjoins the cloister of S. Maria Novella and in 1418 the completion of the church of S. Domenico in Fiesole. In 1427 the guild acted as executor of the will of Pippo Spano and in this capacity supervised the building of S. Maria degli Angeli from 1434 until 1437. In number, if not in importance, these tasks far surpassed those of other guilds with the possible exception of the *Arte della Lana* which had in its charge after 1331 a single project, but that the largest artistic enterprise in town, the building and decoration of the Cathedral.

Of all the tasks undertaken in the social and cultural fields by the *Calimala* the most important was the supervision of the Baptistery of S. Giovanni. Possibly from the year 1157 and certainly by 1182 the guild had been made responsible for the maintenance of the building, and for the completion of its decoration.[16] Acting through a committee, the *Officiali del Musaico*, it directed work on the mosaics of the dome, the repairs and decoration of the building, and the completion of its furnishings.[17] Up until 1400 the guild's greatest glory had been the commissioning and supervising of Andrea's door, between the years 1329 and 1336.

The decision to give Andrea's door one or two companion pieces was not made suddenly. Drawings were in preparation for at least one more door as early as 1338-1339.[18] But the project was effectively squashed by a series of disasters: the economic crash lasting from 1339 to 1346; the ensuing dictatorship of the Duke of Athens and finally the pestilence of 1348 with all its dire consequences. A generation later bronze was purchased for the purpose of either covering the existent wooden doors or replacing them

[14] Doren, bibl. 135, I, p. 403.

[15] For the following see *ibid.*, II, pp. 702ff, particularly pp. 704f; Wackernagel, bibl. 543, pp. 218ff; Paatz, bibl. 375 *passim*, and the documentary evidence quoted below.

[16] Davidsohn, bibl. 118, I, pp. 145f.　　　　[17] Documents in Frey, bibl. 532, pp. 328ff.

[18] The document was published by Frey, bibl. 532, p. 353, doc. 31; Oertel, bibl. 367, pp. 266f, has rightly concluded that the drawing was a large-scale sketch on a wall. See also Paatz, bibl. 375, II, p. 244, note 122.

with bronze doors.[19] Once again the plan came to naught, but it seems to have been revived in the last years of the fourteenth century. In fact, plans this time appear to have progressed far and must have seemed of the utmost importance to the *Calimala*. The consuls may have reached a decision more easily since Gian Galeazzo Visconti, then a constant threat to Florence, had been temporarily appeased by the treaty with Venice of March 1400.[20] Not even the epidemic that ravaged the city in the summer of 1400, reportedly killing 30,000 people and driving others to seek refuge across the Apennines,[21] put a halt to the plans. In the winter of that same year the consuls of the guild opened the contest for the new bronze door.

The combination of all these elements—the Baptistery of S. Giovanni, the *Arte di Calimala*, the doors of Andrea Pisano—forms an impressive background to the competition which drew Ghiberti back from Pesaro. The most important group of patrons in Florence called for a trial piece for the new bronze door which would eventually decorate the most illustrious building in the city and which would, besides, have the privilege of standing alongside the only important bronze sculpture theretofore produced in Florence.

Indeed, at the close of the competition and even before work had started on the new door, it was assigned the center position of the portal opposite the Cathedral (Dig. 7; Doc. 60). By 1400 this portal had become the most prominent entrance to the Baptistery. The nave of the Cathedral and the decoration of its portals were by that time completed. The large sculptures of the façade were about to be commissioned and the dome over the crossing was under discussion. Soon, opposite the new façade, the new bronze gate of the Baptistery would confront the main doors of the Cathedral, and when they were open, the High Altar. On high festivals the processions would file out of the Cathedral, enter the Baptistery through the east gate and leave it through the north portal.[22] Thus the east gate became the focus, as it were, for the entire body of sacred buildings on the border between the old and new parts of town. From this standpoint alone can the contest for the East Door be estimated in its true proportions: it promised to be the most important of all contests ever held in the realm of sculpture, certainly more important than anything that had taken place in Florence for over seventy years. In material terms the winner would be assured a brilliant future. The *Calimala* would probably back him further. Professionally he would be recognized *ipso facto* as one of the outstanding sculptors of his time and an equal of the most eminent bronze founder of the past, Andrea Pisano.

So much for the general background of the competition. The particulars of its preparation, progress and final award are less clear. Strozzi's excerpts (App. C1), valuable though they are for the work done on the actual door, are almost completely silent about the contest. They are limited to recording only a few bare facts. In 1402 or pos-

[19] Frey, bibl. 532, p. 340, doc. 59, with the date March 1, 1365.

[20] The political situation in Florence during the first third of the fifteenth century has been brilliantly analyzed by Baron, bibl. 39.

[21] Bruni, bibl. 77, pp. 920f.

[22] The route which the procession took is illustrated in an engraving in Zocchi, bibl. 563, pl. XXI.

sibly early in 1403 the decision was made to entrust the door to Ghiberti (Dig. 4; Doc. 1); the continued improvement in the political situation in Florence after the death of Gian Galeazzo Visconti in September 1402 may have led the members of the *Calimala* to approach in earnest the problem of making a choice among the contestants. A payment of 30 florins to "Nencio di Bartoluccio" made at the same time (Dig. 5; Doc. 80), and thus before the signing of the first contract, may refer to the purchase of the competition relief and to its gilding. Indeed, the amount is quite considerable. The scarcity of documentary material is to some degree compensated for by two nearly contemporary accounts of the competition, Ghiberti's own report in the *Commentarii* and that of the anonymous writer of the *Vita di Brunellesco*. Needless to say, both must be taken with a grain of salt, since both are prejudiced; even so, they are much more revealing than has often been thought. In fact, both are sources of prime importance and of far greater interest than Vasari's later remarks.

Ghiberti's own account in the *Commentarii* seems factually more or less reliable.[23] He speaks of the announcement of the competition and the summoning of seven contesting artists before the *Operai*, the committee in charge of S. Giovanni; he tells of the selection of the specific task for the competition, a panel with the Sacrifice of Isaac; he mentions the amount of bronze given to each of the seven artists and the deadline set for the end of the contest. He enumerates the contestants by name and origin of birth and mentions the jury of thirty-four experts that awarded him the palm of victory. He refers to a written report submitted by the jury to the consuls of the guild and the *Operai*, but differentiates this report from the final commission for the door, which was made by the "consuls and the *Operai* and the entire membership of the guild." Of course, his account of the event is colored, but the details of procedure and the machinery of its operation could not be described with greater precision.

If the account in the *Commentarii* is favorably slanted, the *Vita di Brunellesco* is downright defamatory in regard to Ghiberti. It matters little to us whether or not Antonio di Tuccio Manetti (1423-1497) is really the author of this pamphlet.[24] What is important is that in its present form it was written after 1471[25] and before 1497 and therefore that it must have been partly based on hearsay, although the author "knew (Brunelleschi) and spoke to him"; it is important to us, too, that it was intended to

[23] Ghiberti-Schlosser, bibl. 178, I, p. 46, and above p. 12.

[24] The biography survives in two copies, both incomplete. The first is in the Biblioteca Nazionale in Florence (Magl. Cl. II. II. 325; Mazzatinti, bibl. 313, IX, p. 95) and was published in the early nineteenth century by Moreni, appended to Baldinucci, bibl. 36, pp. 291ff. It is contained in a codex comprised of Manetti's *Uomini singholari* and writings by other authors, all transcribed, no doubt, by Manetti's own hand. But since Manetti is not the author of the entire codex, he need not have composed the *Vita di Brunellesco*. In fact, the second copy, discovered in Pistoia by Chiapelli (bibl. 95, pp. 241ff) and given by him to the Biblioteca Nazionale in Florence, while equally fragmentary, continues the biography after the Magliabecchiana copy breaks off. Our quotations are from a reprint of the Chiapelli copy, published by E. Toesca, bibl. 294.

[25] *Termini post* are the following: mention of a fire in S. Spirito as occurring in 1471; reference to the removal of sculptures from Rome "by popes and cardinals, Roman and others," which obviously was effected in the second half of the fifteenth century; and the "post-Albertian" tenor of the whole pamphlet. The footnote to the translation in Holt, bibl. 218, pp. 45ff, does not explain the dating of the pamphlet "only a few years after Brunellesco's death." A *terminus ante* is furnished by the death in 1497 of Antonio Manetti who wrote the Florentine copy.

glorify its hero as the founder of modern art and Florence as its fountainhead and that in the process Ghiberti is presented as the lifelong antagonist of Brunelleschi and the incompetent antagonist to boot. Consequently, this account of the competition pictures Ghiberti as the villain in a plot to cheat Brunelleschi out of his well-deserved first prize. The tale reads like a typological forewarning of the other competition to follow years later for the dome of the Cathedral in which the same two protagonists participated. With regard to facts, the author is not nearly so well informed as Ghiberti. He knows little of the machinery governing the competition. He does not distinguish between the various organs of the *Calimala* concerned, the consuls, the committee in charge of the Baptistery and the membership at large. He maintains that the *Operai* in searching for the best bronze casters could find them only among Florentines. Since Florence represents, in his mind, the hub of the world, he speaks not of seven contestants, but of two only, "both Florentines," Filippo and Lorenzo di Bartolo "whose name is inscribed on the doors as Lorenzo di Cione Ghiberti, for he is the son of Cione," a deliberate jab at Ghiberti's sensitive birthright. He suggests that they were the only artists to model and cast competition pieces. He concludes with a story about an indecisive report submitted to the *Operai* by the jury which stated in effect that Ghiberti and Brunelleschi should share the work, and describes Brunelleschi's angry retreat. The facts, then, are riddled with some confusion. Yet, prejudiced and tendentious though it is, or perhaps just because it is so partisan, the Brunelleschi *Vita* is full of implications about the emotional climate stirred up by the competition and its impression on contemporaries.

Vasari's account of the contest is contained in the respective *Vite* of Ghiberti and Brunelleschi.[26] According to Vasari's own words, it is based on both the *Commentarii* and the *Vita di Brunellesco* with the result that it takes over the two contradictory versions of the competition and its outcome without reconciling them. Moreover, the whole story is embroidered with all kinds of anecdotal embellishments: not just "friends," but old Bartoluccio himself called Ghiberti back to Florence, then assisted his foster son in the contest; opinion was divided among the jury; the plaques of all seven were put on public exhibition. Donatello, then in his teens, is erroneously named among the contestants, while two others, Niccolo Spinelli d'Arezzo and Niccolo Lamberti are merged into one person because of the similarity of their names. Throughout, then, Vasari imaginatively mingles fact with fiction. But despite all this, Vasari added a few valuable observations of his own of a technical, stylistic, and critical nature.

From all these sources there emerges a fairly clear picture of the competition as it originated and developed. The *Commentarii* and the *Vita di Brunellesco* concur on the date of 1401 for the opening of the competition, and Ghiberti's description of the proceedings corresponds by and large with what apparently became standard procedure thirty years later. When in 1432 the *Arte della Lana* prepared the way for commissioning the Shrine of Saint Zenobius, the consuls and standing committee of the Cathedral, the *Operai*, jointly established the general conditions of the envisaged work (Dig.

[26] Vasari-Milanesi, bibl. 533, II, pp. 223ff; pp. 334ff.

165).[27] They first selected an advisory group composed of "outstanding laymen, experienced artists and learned theologians . . ."; their idea was "that the first group through their *prudentia*, the second through their art, the third through their religious knowledge, should all together be so well equipped for the matter that, conducted according to their judgment, no one could blame or reproach it." *Prudentia* in this context means, of course, nothing else than common sense and it is very much in the spirit of early and later capitalism that businessmen should be credited with this quality in contrast to artists and scholars. This committee then drew up a report for the consuls and *Operai* on the general lines to be followed: the selection of the chapel, the decoration of walls and windows, the transfer of relics, the celebration of the anniversary. The consuls and *Operai*, after they had accepted the report, appointed a small subcommittee of *deputati* consisting of the chairman of the *Operai* and some outstanding members of the guild. Their duty was to inspect drawings and models submitted in the course of a public competition and to discover the opinions of a jury of artists and connoisseurs: "sculptors, painters, architects and others learned in such matters." The *deputati* reported the jury's choice back to the consuls of the guild and the *Operai*, who, in turn, commissioned the winner to do the work. But this was not the end of the matter. Upon signing the contract, the *Operai* appointed a new executive committee, consisting of two or three of their members, "to collaborate continuously with Lorenzo in this work." This executive committee was to work out the precise details of the shrine, the ornament, and exact subject-matter of the reliefs, to approve Ghiberti's requests for materials and to act in general as liaison between the master and the *Operai*. In the event of special questions coming up during the course of work, the executive committee continued to turn to experts for advice, as when Leonardo Bruni was asked to compose the inscription of the shrine.

Roughly this same procedure seems to have applied in the competition for the new door of the Baptistery in 1401, although it is doubtful that at this point the complex system of advisors had been devised.[28] The committee which the *Calimala* had put in charge of the Baptistery, the *Officiali del Musaico* or as it was popularly called the *Operai* or *Governatori*,[29] very likely set up the general conditions of the contest, presumedly with the approval of the consuls of the guild, and allotted the funds necessary for the occasion. To assure themselves of having a competent master they decided to announce a contest, inviting "skilled masters from all the lands of Italy" to participate. In order to prepare for and supervise the competition properly, the *Officiali del Musaico* held a consultation with an advisory jury of thirty-four members on questions of technical and artistic conduct. The committee must have been responsible for the rules of the contest and obviously determined the general scheme of the door which in the

[27] Poggi, bibl. 413, docs. 905ff, from whence the quotations in the following paragraph are taken; see also Doren, bibl. 133, pp. 8f.

[28] The organization of the *Officiali del Musaico* into a committee appointed by the consuls of the *Arte di Calimala* is confirmed for the year 1370 by the inscription on the Baptismal Fount of S. Giovanni: ". . . *factus est ipse Fons . . . ab officialibus istius operis deputatis a Consulibus Artis Kalimale . . .*" (Befani, bibl. 44, p. 71).

[29] Ghiberti himself uses the term *operai di detto governo*; see Ghiberti-Schlosser, bibl. 178, I, p. 46.

end was to be commissioned to the winner as an award: like Andrea's, it was to be divided into twenty-eight panels, each a *braccio* wide and containing a quatrefoil. The committee selected the general subject matter and possibly, though not necessarily, determined the sequence of scenes and individual figures thereof. Certainly it was the committee that decided upon the subject for the competition panel and set the deadline for its completion.

The competition, proceeding by and large along these lines, was not without its difficulties. During the contest or shortly thereafter, just before work began, the program of the door was changed. At the commencement of the competition, the projected subject matter was the Old Testament; Ghiberti writes that the committee insisted on making every competitor design "one story of this door . . . the Sacrifice of Isaac." Later, "it was decided to place the New Testament on this door" and to save the prize-winning relief of the Sacrifice of Isaac "for the other door, if there the Old Testament should be represented" (Dig. 6; Doc. 33).

Since a cycle of the Old Testament was planned, the choice of the competition panel obviously had to be a scene common to Old Testament cycles, for it would only be sensible to incorporate the winning relief into the final scheme. The Sacrifice of Isaac was the outstanding typological prefiguration of the Crucifixion and as such formed throughout the Middle Ages part and parcel of all large Old Testament cycles. To choose this theme for the competition was then the natural thing to do.

But the committee of the *Operai*, instead of simply prescribing this subject, apparently went further and drew up a specific set of requirements; for it can hardly be by chance that the competition reliefs of both Brunelleschi and Ghiberti contain the same number of figures and exceed the limits of the Sacrifice proper. Alongside the traditional elements of the subject—Abraham, Isaac, the angel appearing from heaven, the ram and thicket—there are two servants at the foot of the rock and an ass drinking from the fountain. The appearance of this particular combination of figures in both reliefs is so remarkable a coincidence as strongly to suggest that the committee of the *Calimala* requested it. The combination is not traditional. As a rule, the Sacrifice and the waiting servants form two different scenes as, indeed, they are described in Genesis 22.[30]

[30] Throughout the Middle Ages scenes of the Sacrifice were limited to the principal actors: Isaac kneels on the altar; Abraham lifts the sword; the hand of God or of an angel appears from heaven; and the ram is hidden in the bush. Such scenes appear first in fourth century sarcophagi and pyxides and continue as late as the thirteenth and fourteenth centuries, represented in the *Psalter of Saint Louis* (Paris, Bibl. Nat., lat. 10525; Omont, bibl. 373, pl. x), in Torriti's fresco in Assisi (Van Marle, bibl. 301, I, fig. 109) and in Giusto da Menabuoi's frescoes in Padua. Throughout medieval art the ass and servants seem never to be shown in the same scene as the Sacrifice proper; they are accessories, fully developed or abbreviated, but always distinct from the main scene. In the ninth century *Cosmas Indicopleustes* the servants are shown walking with the ass, led by Abraham and Isaac, the latter carrying the fagot (Vat. Gr. 699, f. 59; Stornaiolo, bibl. 507, pl. 22); in another scene on this page the Sacrifice is represented. At about the same time (880-886) the *Homilies of Gregory of Nazianz* (Paris, Bibl. Nat., gr. 510, f. 174; Omont, bibl. 372, pl. 37) shows Abraham bidding the servants to wait with their beast of burden, while Isaac with the fagot precedes him up the hill; the Sacrifice as always is depicted in another scene. The two scenes remain clearly separated until the High and Late Middle Ages. In the *Bible of Jean de Sy, ca.* 1356 (Paris, Bibl. Nat., fr. 15397) Abraham is shown bidding the servants to wait; on f. 36v they wait, while their ass drinks from the fountain and Abraham and Isaac ascend the mountain

Very rarely are the two scenes fused into one. In the Hamilton Bible and related Neapolitan manuscripts of *ca.* 1360,[31] Abraham, accompanied by Isaac, is seen in a lower tier addressing *one* servant who is seated in the right corner next to his ass; in an upper tier, raised on a mountain ledge, the scene of the sacrifice is shown. Here, then, is a combination of the two scenes which forecasts the selection made for the competition panel. In fact, the overall design is somewhat comparable to that of Brunelleschi. Since the Hamilton Bible was Medici property, at least by 1515, and possibly much earlier, it is tempting to suggest it as the inspirational source of the advisors to the committee for combining the Sacrifice of Isaac with the scene of the waiting servants. Still, even if this speculation should prove true, one cannot help feeling that the committee may have had special reasons for enjoining the recommendation of its advisors. Was it merely considerations of the contrast between drama and genre, evident in the Biblical account, that prompted the choice? Vasari suggests that the story was selected because it could test the artists' ability to present several aspects of reality at once and their mastery of relief techniques; for, so he says, the scene of the sacrifice (in combination with that of the servants waiting) required the contestants to cope with "the difficulties of art," by which he means the representation of "scenery, nudes, draped figures and animals and the use of full, half and shallow relief."[32] Vasari's words are not to be trusted when value judgments enter his account. Not only is his emphasis on relief planes probably based on categorical distinctions made by sixteenth century art criticism, but it does not apply to the competition reliefs. In neither Brunelleschi's nor Ghiberti's are half or shallow relief employed to any significant extent. On the other hand, Vasari's reference to "scenery, nudes, draped figures and animals" is not an allusion entirely of his own invention. It closely coincides with words used by the more reliable Anonimo Magliabecchiano in declaring that the subject was chosen for its "many figures, old and young, animals, mountains and trees."[33] That these terms may derive from documents concerning the competition is suggested by their appearance in Strozzi's excerpts from the two contracts made with Ghiberti for the door: the agreement of 1403 (Dig. 8; Doc. 26) states that Ghiberti "must work with his own hand the figures, trees and similar things in the quatrefoils"; the 1407 agreement (Dig. 22; Doc. 27) stipulates that "he must work . . . particularly on those parts which require the greatest perfection such as hair, nudes and so forth." Since these elements are mentioned in the contracts, they were clearly considered of importance by the committee supervising the execution of the door. It is thus quite likely that their presence in the

(Martin, bibl. 306, fig. LXI, pl. 45; fig. LXII, pl. 46). Usually Isaac carries the fagot (Franco-Flemish Bible, Lille, Witter Coll., late thirteenth century; psalter of Queen Isabeau, Munich, Staatsbibliothek, gall. 16, f. 29v; a French psalter, fourteenth century, Oxford, Bodl., Auct. D. 44; James, bibl. 230, pl. 27b). Needless to say, this motif serves as a typological parallel to Christ bearing the Cross in the *Biblia Pauperum* and the *Speculum Humanae Salvationis* of the late Middle Ages (Cornell, bibl. 106 *passim*; Lutz-Perdrizet, bibl. 284, pp. 170, 214; pl. 43).

[31] Berlin, Kupferstichkabinett, 78 E 3, f. 4 (Wescher, bibl. 550, pp. 54ff), see also Vienna, Nationalbibliothek, cod. 1191 (Theol. 53), (Hermann, bibl. 210, pp. 250ff). The manuscript is represented in Raphael's portrait of Leo X in the Pitti Palace, see Wescher, *loc.cit.*

[32] Vasari-Milanesi, bibl. 533, p. 224. The particular passage is inserted into Vasari's second edition and is thus somewhat suspect; see also Ghiberti-Schlosser, bibl. 178, II, p. 169.

[33] (Anonimo Magliabecchiano) bibl. 22, p. 274.

Sacrifice of Isaac weighed in its choice by the committee as a subject matter for the competition.

The committee in charge of the contest apparently selected the participants as well. The sources, in truth, disagree somewhat on the procedure used here. The *Vita di Brunellesco* maintains that only Brunelleschi and Ghiberti were asked to compete, but this assertion was obviously dictated by a desire to single out Florence as the most important city of the time.[34] Ghiberti, in the *Commentarii*, likewise suggests that the competitors were chosen by invitation of the committee, who "sent for masters who should be skilled and of whose work they wanted to see proof," but evidently additional candidates, like Ghiberti himself, could also apply at the suggestion of "friends in Florence."[35] The first large group may have been narrowed down by the committee; in any case, the final run included only seven: Filippo di Ser Brunellesco, Simone da Colle, Niccolo di Luca Spinelli, known as Niccolo d'Arezzo, Jacopo della Quercia, Francesco da Valdambrino, Niccolo di Piero Lamberti and Lorenzo Ghiberti.[36] It was a most remarkable selection. The origin of the contestants, their age and training, were probably all discussed and criticized by committee and outsiders alike, and such criticism is, indeed, reflected in the *Vita di Brunellesco*. The contest was not limited to Florentines and although the seven were not "from all over Italy," they did come from various parts of Tuscany. Only two, Brunelleschi and Ghiberti, were sons of Florentine citizens. One, Simone da Colle, was from the old Florentine territory of Val d'Elsa. Niccolo Lamberti, though settled in Florence, came from an Aretine family. Niccolo di Luca Spinelli apparently resided in Arezzo which, just sixteen years before, had been purchased by the republic of Florence, thus making Spinelli a Florentine subject, but not a citizen. The group was further broadened by the admittance of two artists, Jacopo della Quercia and Francesco da Valdambrino, who actually came from the old arch enemy of Florence, Siena. Florentine *campanilismo* must have winced. The disparity of age between the competitors was no doubt a point for an issue of much argument. Except for Niccolo di Luca Spinelli, apparently about fifty, and Jacopo della Quercia, about forty, all were young. Niccolo di Piero Lamberti was just over thirty and Francesco da Valdambrino about the same. Brunelleschi and Ghiberti were the youngest, twenty-three and about twenty respectively. Diversity of training among the contestants must also have led to objections: Niccolo d'Arezzo and Brunelleschi were in good standing as goldsmiths; Simone da Colle later gained fame as a cannon founder; Quercia and Francesco da Valdambrino were sculptors and woodcarvers together with Niccolo di Piero Lamberti, another respected member of the guild for woodcarvers

[34] (Manetti), bibl. 294, p. 14.

[35] Ghiberti-Schlosser, bibl. 178, I, pp. 45f.

[36] The most recent and authoritative monograph on Quercia is Bacci's, bibl. 31. Bacci has also published the only monograph in existence on Francesco da Valdambrino, bibl. 30. The identities of Niccolo Lamberti and Niccolo di Luca Spinelli have been definitely established by Procacci, bibl. 427, pp. 300ff. Thus, the personality of only one of the competitors, Simone da Colle, remains obscure.

Vasari (Vasari-Milanesi, bibl. 533, II, pp. 226, 335) adds to this list of competitors the name of Donatello, quite arbitrarily it would seem. The date of his birth, probably 1386, precludes his participation.

and stonecutters; young Ghiberti, though probably trained as a goldsmith, up until then had worked only as a painter.

The outcome of the competition is known. Late in 1402, *stile fiorentino*, that is prior to March 25, 1403, one and a half or two years after its opening, the consuls of the *Calimala* decided to entrust the execution of the door to Ghiberti, the youngest competitor (Dig. 4; Doc. 1). Shortly afterwards, prior to March 1403, a first payment of 30 florins was made to "Nencio di Bartoluccio," possibly for the purchase of the competition relief and for the gilding (Digs. 5, 6; Docs. 80, 33). The decision of the consuls was apparently based on a report drawn up by the *Operai* and this in turn rested upon a written declaration requested by them of the jury "the committee of regents wanted their [the experts'] judgment written in their own hand." Yet it appears that the consuls also invited the opinion of rank and file members of the guild, for Ghiberti explicitly states that everyone approved his victory, "consuls and *Operai* and the entire body of the *Arte Mercatoria*." The procedure seems unusual, but then Ghiberti's words can hardly be disregarded.[37]

It is understandable that the committee of regents, the *Operai*, may have wanted to protect its final actions by a written declaration as evidence of the jury's verdict. The jury of experts was composed of persons as diverse in training and origin as the seven contestants, being "painters, gold and silversmiths and sculptors . . . from the city and other neighboring places." Yet despite all the precautions taken to arrive at a disinterested verdict, the situation remained delicate and to have the judgment down in black and white could do no harm. Already the choice of the final seven, many of them young and not even trained as metal workers, had been open to attack. Now the first prize fell to the youngest of all, a lad of twenty, and, worse, he was not a member of the goldsmiths' or sculptors' guilds; it is not even certain that he was matriculated in the *Medici e Spetiali*, the guild in which, as a painter, he should have enrolled. Most shocking of all, he was not yet a master. Brunelleschi, but a few years his senior, had by 1398 applied for registration as a goldsmith and could expect to matriculate as a master simply by payment of a few florins, as indeed he did in 1404.[38] Ghiberti on the other hand, had to work in the name of the firm of his stepfather, Bartolo di Michele; if a contract were signed, it had to be worded in such a way as to make Bartoluccio, as a master of good standing in the *Arte della Seta*, undertake legal responsibility. A situation of this sort was almost certain to give rise to accusations of unfairness, preferential treatment, and discrimination.

In fact, there is more than just slight evidence of accusations of this kind. By the time Ghiberti wrote his *Commentarii*, forty years later, such recriminations may have been more vocal and they became rampant in the *Vita di Brunellesco*. Of course, the particulars, as the *Vita* handles them, are distorted. Filippo is constantly presented as the young independent genius who went about his task disdaining favors and asking advice from no one. Ghiberti, on the other hand, is accused of scheming, underhanded methods such as apple-polishing the jury by asking their advice and remodeling his

[37] Ghiberti-Schlosser, bibl. 178, I, p. 46; II, pp. 168ff.
[38] *ASF, Arti, Seta, Matricola*, vol. VII, c.68v; quoted by Fabriczy, bibl. 148, p. 5.

relief in response to their suggestions. But, according to the *Vita*, despite all Ghiberti's maneuvers, the experts turned in a report which appointed first prize to both Ghiberti and Brunelleschi. They were asked to design and cast the door jointly and only because Brunelleschi refused to share the honor was Ghiberti left the sole victor.[39] Studio gossip in Florence in the last quarter of the century clearly persisted in the rumor that at the time of the contest opinion had been sharply divided. Perhaps such gossip did not arise before the thirties or forties. The bronze door which Ghiberti executed as a result of his triumph, while still admired by laymen, was then considered by *cognoscenti* obsolete and far surpassed by the new door, the Gates of Paradise. In this Ghiberti himself agreed by implication with the younger generation, the leaders of the *Calimala*, who in 1452 moved his first door to the less conspicuous North Gate. Brunelleschi, meanwhile, had achieved the difficult feat of vaulting the dome of the Cathedral, the pride of all Florentines, and had set up all over town buildings in a new and bold style, thus earning himself the status of the grand old man of modern architecture. His early defeat in the competition had somehow to be satisfactorily explained away, a wish and sentiment all too clearly reflected in the *Vita*.

Yet, the fact that opinion was later divided does not preclude the possibility that dissension existed at the time of the competition, dissension which only grew more bitter with time. It is sharply brought out in the *Vita di Brunellesco* that even in 1420 "the city still smelled from the bile of the bronze doors" (la città teneva dello umore delle porte del bronzo). Ghiberti himself, in discussing the contest in the *Commentarii* shortly before 1450, seems rather anxious to justify the final judgment in his favor. He is insistent about the fact that the opinion of the jury was declared in writing and puts great stress on the agreement reached by all ranks of the *Calimala* as to his worthiness, repeating three times in succession that the jury, the officials of the guild, the rank and file and "even those who competed against me"[40] were unanimously in his favor. He underscores the differences among the judges in background and profession. All this reiteration betrays a sense of uneasiness on the old master's part, undoubtedly aroused by some clash of opinion in wider art circles. His qualifying phrase, "at that time," meaning that he received unanimous approval at the time of the competition, suggests that when writing the *Commentarii* he was aware of and resented a growing opposition to his early work.

Several scraps of evidence, circumstantial it is true, tend to support the claim that the competition once ended in a tie. In the first place, the precautions taken by the various organs of the *Calimala* in order to justify their final choice seem quite extraordinary. It was unprecedented to secure a written declaration of opinion from the jury and furthermore to take recourse in the opinions of the rank and file. It would seem that such motions were specially devised on this occasion, so as to give added weight to the final decision. Secondly, of all the reliefs entered in the contest, only two survive, Ghiberti's and Brunelleschi's (Pl. 1; Fig. 1). Naturally Ghiberti's would be preserved, since it was prize-winner and intended for use in the other door, "if there the Old Testament should be represented." The members of the *Calimala*

[39] (Manetti), bibl. 294, p. 42. [40] Ghiberti-Schlosser, bibl. 178, 1, p. 46.

were, after all, shrewd businessmen who would not be more wasteful than necessary. By the same token, it seems strange that Brunelleschi's competition entry was not melted down as presumably the rest of the losers' were. If his plaque was deliberately saved, despite the sheer waste of seventy-five pounds of good bronze, there must have been a reason for it and the likeliest is that the jury wished to keep it as evidence in support of its own split choice in the final decision.

Ghiberti's relief went to the audience hall of the *Arte di Calimala*; Brunelleschi's, after 1421, was inserted in the back slab of the altar in the Old Sacristy of S. Lorenzo,[41] allegedly presented as a gift by the master to Cosimo di Medici. Both plaques entered the Bargello in 1859 by way of the Uffizi. Of the reliefs of the other contestants, nothing is known. Probably none survived and Vasari's vague suggestions to the contrary must be discarded as unreliable.[42]

[41] (Manetti), bibl. 294, p. 15.

[42] In his first edition Vasari says only that Ghiberti's and Brunelleschi's reliefs were the best, Donatello's good, Quercia's on a par with Donatello's and Francesco's, Simone's and Niccolo's the worst (Vasari-Ricci, bibl. 531, I, p. 261). In the second edition he elaborates on this statement (Vasari-Milanesi, bibl. 533, II, p. 226), going so far as to say that Donatello's relief had been given to the *Arte del Cambio*, and thereby intimating that he, Vasari, was acquainted with it (Vasari-Milanesi, bibl. 533, II, p. 335). But he clearly never saw such a relief and, indeed, omits any mention of it in Donatello's Vita (*ibid.*, II, pp. 395ff). Scattered throughout the Vite of Ghiberti, Brunelleschi, Quercia, and Niccolo d'Arezzo, are descriptions of the other competition reliefs, but they are kept general and are obviously based on Vasari's actual or pretended knowledge of the styles of the respective masters (*ibid.*, II, pp. 113, 226f, 335). Probably Vasari was just giving his imagination free rein; see also Ghiberti-Schlosser, bibl. 178, II, p. 169.

An engraving, dating *ca.* 1460-70, of the Sacrifice of Isaac (Uffizi 27) has been believed to reproduce one of the competition panels (Kristeller, bibl. 255, pp. 277ff), but the hypothesis is doubtful, to say the least. See also Hind, bibl. 213, I, p. 27; II, pl. 5, and Ghiberti-Schlosser, bibl. 178, II, p. 170.

CHAPTER IV

THE COMPETITION RELIEFS:
GHIBERTI AND BRUNELLESCHI

A DIVISION of opinion would seem not only justified but almost forced upon the experts when they were confronted with the reliefs of Ghiberti and Brunelleschi: two artists could hardly be more different in style, technique, personality, and background. Together they vividly illuminate the divergent artistic trends in Florence at the beginning of the fifteenth century. Opinions were bound to clash among the members of the jury and their disagreement no doubt had repercussions in talk all over town.[1]

Brunelleschi approaches the Abraham and Isaac story with dramatic force (Fig. 1). He divides the plaque horizontally into two registers. In the upper, much larger tier, Abraham rushes from the right towards Isaac. The boy kneels on the altar, his right leg forward, his head bent back, his body moving quickly away from the threatening knife. The father's left hand presses Isaac's chin upwards to free his throat for the blow; the knife, in his right hand, is touching the boy's skin. But the angel rushes down from a massive cloud on the left; his left arm shoots forth to grab Abraham's wrist, forcing it back from Isaac's throat—one feels the resistance of the surprised patriarch. The ram, below the angel, is very much in evidence; so is the cliff to the right behind Abraham, surmounted by a small tree that is almost covered by the fluttering cloak of the old man. Abraham, Isaac, and the ram form what appears to be almost an isosceles triangle. In the lower tier, forming its base, spread across the width of the foreground, are the two servants, one in each corner, utterly unconcerned with the main event. The ass between them drinks from the spring at the right. All the figures are in the round; their draperies are heavy, with deep, massive folds. The faces are strong, with broad planes, crowned by heavy wiglike masses of hair. The figures are set against an empty blank ground, parallel to the front plane, on two superimposed narrow stages. No attempt is made to convey depth within the relief. On the contrary, the two servants in the foreground jut forth frontwise and sideways beyond the frame. The scenery is confined to a few props: a steep, sharply cut cliff, two dwarfed trees with scanty, fan-shaped twigs. Every corner of the plaque is painstakingly filled: the upper left lobe by the angel, the upper right lobe by the cliff, the lower ones each by one of the servants; the left corner of the quatrefoil contains the ram, the right corner, an end of Abraham's mantle and a spur of the cliff, the one at the bottom the donkey's right foreleg. The entire plaque is covered by figures and objects, in a *horror vacui*.

At first glance the relief appears strikingly new and exciting, and a good number of the judges, artists and laymen, must have been impressed. It is the work of a young man, awkward in places. But it is brimming over with the impetuosity and the endless

[1] Comparisons between Ghiberti's and Brunelleschi's reliefs are legion. We refer only to the most recent one, Shapley-Kennedy, bibl. 492.

curiosity of youth; it teems with an experimenter's love of difficult problems and intricate solutions. The story is told in the most violent language. Every movement, every detail is designed to impress, every gesture meant to shock. The dramatic force of the narrative and the abundance of realistic detail were bound to arouse admiration. Such admiration is indeed reflected in the *Vita di Brunellesco*. The author praises just those surprising and shocking effects: "that finger under the (victim's) chin;" the angel, "how he seizes Abraham's hand," the servant "who pulls a splinter from his foot and the other who bends down to drink." No less impressive to some certainly was the central scene: the gawky boniness of Isaac's adolescent torso, the bent-up toes of both his feet, the muscles and tendons of his thighs and calves, the mouth open in a half-choked cry; Abraham's bald pate surrounded by long disorderly coils of hair, the veins and tendons in his left hand, the uncouth butcher knife, and the flames spitting from the altar. Not even the circumcision of Isaac's membrum is forgotten. The foreground is almost completely filled by the donkey. His legs are far apart, his neck strained towards the fountain, two thin threads of water drip from his mouth. The joints, bones and tendons of his legs and rump are sharply outlined, the short mane shaggy and bristling, the knees of the forelegs are marred by deep roundish scars. A knotted rope dangles from behind his right ear, the saddle is worn through, showing the straw filling; one can almost smell the sweat and dirt of the leather. Likewise the ram scratching an ear with a hindleg must have pleased a public which admired this stark but rather obvious realism in the presentation of a narrative so colorful and exciting in itself.

It is a bold realism, delighting in experiments. The two servants are antithetic studies in movement, body, and drapery. The thornpicker to the left sits straight with only head and shoulders bent, his body barely shown through the heavy cloak, his skull hidden under a rich crop of curls. The servant at the right edge crouches low, his whole body nearly bent double. His jerkin is so tight that it almost bursts at the seams from the violent movement; his shaven head (or is it a leather cap?) brings out the form of his skull. Legs and arms cross and overlap in different combinations in each figure. Isaac kneels, his feet pointing left, his chest *en face*, his head violently turned upward and right.

Brunelleschi, then, sets up, as it were, a series of experiments; he carefully selects a number of positions enabling him to inquire into the nature of movement, the interplay of limbs and body and the relation between body and garment. This spirit of inquiry is the very essence of his design. Various elements borrowed from antiquity, scattered as they are throughout the relief, form part and parcel of this approach. They were used not merely because they were obviously rare tidbits for humanist connoisseurs, but because the figures *all'antica*, seated, kneeling, crouching, bent and double-bent, were bold experiments in, and useful tools for, the study of movement.[2] All this makes a daring and aggressive competition piece; but it does not necessarily make a great piece of sculpture. Indeed, the entire relief is full of strange inconsistencies. Alongside the genuine discovery of reality as a means of forceful artistic expression and antiquity as a tool for its realization, stands a bulky and conservative figure design

[2] See also below, pp. 281f.

and composition. Certainly the result proves that the jury did not consider these revolutionary and experimental aspects a decisive factor in their final judgment. Perhaps the majority were more aware of the awkwardness of composition, its somewhat trite plan, the overloading with detail, the incongruencies between traditional types and dramatically new additions. The conservative taste of some jurors may well have been shocked by Brunelleschi's experiments.

The goldsmiths on the jury were probably struck by the technical deficiency of Brunelleschi's competition piece. Instead of casting the relief in one piece, as did Ghiberti, he cast a solid plaque, approximately 5 mm thick and soldered onto it the individual pieces of his composition, cast solid and fastened down with crude pegs for greater safety. One large piece comprises the block of rock in the foreground, the ass and ram to the left, the altar and possibly the body of Isaac,[3] the figure of Abraham, together with the rock behind him and the left hand of the angel. Four smaller, individual pieces are added: the two servants, the angel, and the tree on the rock rising behind Abraham. The rock, again in contrast to Ghiberti, is roughened not by casting but by the traditional method of stippling. This method of casting the relief in several pieces, fastening them onto a solid plaque, must have weighed heavily in the jury's adverse decision, for practical as well as technical reasons. If the entire relief were cast in one hollow sheet, as Ghiberti's was, minor failings could be easily corrected by soldering small pieces onto the back of the relief. But if the figures were cast solid, such corrections would be made impossible.[4] Secondly, Brunelleschi's relief was much heavier than Ghiberti's, 25.5 kg as against 18.5 kg (76⅔ Florentine pounds vs. 55⅔ pounds).[5] The twenty-eight reliefs of the North door, if cast by Brunelleschi, would thus have required an additional 600 Florentine pounds of bronze. No doubt the *prudentes viri* of the *Calimala* thought twice before agreeing to raise the cost of the reliefs even by roughly 60 florins[6] for additional materials alone. True, within the final overall cost of the door 60 florins made little difference. But in 1402 and 1403 the enormous total cost of 16,000 florins could hardly have been foreseen even by the most far-sighted committee members.

Nothing could be more in contrast to Brunelleschi's relief than Ghiberti's (Pls. 1, 2a, 2b). Technically it was infinitely superior. Only the figure of Isaac was cast separately, together with Abraham's left hand and a small piece of the rock underneath; all the rest was cast in one piece, forming a strong sheet of bronze, an average of 9 mm thick, and hollow, save for the solid top, right edges, and lower left lobe of the quatrefoil. Minor failings in the casting had been repaired and weak spots reinforced, notably behind the figure of Isaac and behind the foreleg of the donkey. The lesser weight and the ease with which such recasting could be carried out made Ghi-

[3] Even after repeated rechecking, I am not certain whether the body of Isaac was cast separately or together with this large piece.

[4] I am indebted for this and many other observations on the technique of Ghiberti's works to Cavaliere Bruno Bearzi.

[5] I am most grateful to the *Sopraintendenza ai Monumenti* in Florence and especially to Dr. Filippo Rossi, for giving me permission to take the two competition reliefs off their wooden frames.

[6] The standard price for bronze fluctuated from 6½ to 7 *soldi* per *libra*; see Docs. 19, 121 and Dig. 78.

berti's relief the more economical. Also an exceedingly fine job of finishing was done throughout. The tiny flaws in the surface are hardly visible and every detail has been gone over with chisel and file: the faces are worked, down to the smallest wrinkle; the little snail-like curls reveal every strand of hair; Abraham's toes are visible through the stockings, the embroidered details of his garment are clear down to the tiniest twig and flower.

The contrast is equally marked in design and narrative. True, Ghiberti also divides the quatrefoil into two sections corresponding to the two parts of the narrative. But he is careful not to cut it up horizontally into two tiers. Instead, he presents the story in two groups which are both separated and connected by a diagonal rocky ridge running from upper left to lower right. To the left, underneath the rocky dividing line, stand the two servants, looking at each other and talking with reticent gestures across the back of the donkey. To the right, above the ridge, Abraham bends over Isaac. The ram is perched above him high on top of the cliff to the left; the angel floats down from the upper right. The quatrefoil serves merely as a frame; much different from Brunelleschi's, it is not scrupulously filled up in all its lobes and corners. The figures fall into clear small groups, separated by scenery. They are set off against rock or placed against carefully balanced stretches of blank ground. The pause, as it were, has been turned into a dynamic feature of creative design.

Also, in contrast to Brunelleschi's design, the groups in Ghiberti's relief do not run parallel to the front plane. Two or three figures are crowded together. They frequently turn into the relief or half out of it in poses that stress three-quarter views, half-lost profiles or movements that twist slightly from one pose to the other. The young servant to the left pivots on his feet; Isaac turns in a clockwise move from right to left, his left thigh facing right, his chest parallel to the picture plane, his head thrown sharply upwards and to the left. Abraham pushes back into the relief with his right hip, only to thrust forward his head, his right arm and his left leg. Within the groups figures face or move in opposite directions, creating "space caves" in which to stand and by which to hint at depth. The space around the group of servants is not identical with that around Abraham and Isaac, nor is either area completely unified within itself. Thus it happens that the top part of the older servant's body protrudes from the rock almost in the round, while his legs are but faintly marked as if much further away. But space is intimated, the back plaque suggesting atmosphere rather than blank ground. The two servants are enclosed in the cavity of the rock. They face each other and in the gap that separates them the donkey thrusts forward, his neck bent and craned. Thus the narrow space to which the figures are confined is filled by a multitude of gestures and movements. An intricate network of directional forces is established. Abraham and Isaac are separated by a deep gap and again space seems an active force spreading out and enveloping the figures of father and son.

Every movement hints at depth. The figures do not, as in Brunelleschi's relief take violent, yet frozen poses: Abraham in a beautifully swaying, almost protective curve, bends over his son and the boy's body follows the curve of his father's stance. The angel above, the cloak below, continue the movement of the patriarch, closing the half circle

and completing the rhythm of the group. In a counter-movement, the servants swing out towards the left in a slight curve. Every gesture is sure, yet delicate and nervous. The figures rest lightly on their feet: the young servant drawing one leg back, lifts his heel barely and touches the ground with his toes; Abraham thrusts his leg forward, the knee hardly bent, yet clearly marked through his garment. His arm is tense and muscular, yet incredibly fine. No part, no movement is ever violent. The draperies, thin and light, follow the motions of the figures in long-drawn curves.

Every detail aims at supporting this melodious, yet not prettified beauty. The modeling of the heads is built up from the bone structure; the cheekbones protrude strongly, brows and the foreheads overshadow deep-set eyes. Faces are rendered in small nervous planes, noses thin, and nostrils appearing to vibrate. Small particulars are modeled with the utmost sharpness and precision, but they blend with the entity of the face. Heads dominate bodies, and their movements and glances replace dramatic action. In the torso of Isaac the skin seems silky, the bones are well padded with flesh. Hands and fingers are long and thin, veins and tendons distinct under the skin. Hair throughout is rendered in tiny light and soft curls, including the fur of the ram and the mane of the donkey. Cloaks are richly embroidered along the hems; Abraham's garment is distinguished by two large panels of embroidery running along the chest and skirt. A few long curved folds are raised above the surface, accompanied and countered by a wealth of short, slightly curved intervening grooves. The entire drapery is lively and articulate, whereas in Brunelleschi's design a few strong folds are separated by wide empty gaps. Light and shade flicker over the surface in tempered contrasts of light and dark, with highlights on shoulders, thighs, ribs and arms, on the ridges of the folds in the cloaks, on brows and cheekbones, creating a network of relationships that leads the eye quickly from figure to figure and ties the composition into a perfect, yet lightly held unit.

The narrative, while clearly intelligible, merely hints at the events. It does not present them with brutal directness as does Brunelleschi. Abraham has raised the knife, but hesitates to strike; his left arm is placed lovingly around Isaac's shoulder. The boy looks at his father, full of confidence; the angel floats down leisurely, sure to arrive in good time. The servants, to the left, talk to each other and the older appears to indicate the mountain where the miracle takes place. Although avoiding dramatic gestures, they are not wholly unconcerned like Brunelleschi's waiting servants, but participate from afar as supporting actors in the drama of the Sacrifice, fulfilling a role not unlike the choir in a Greek tragedy. All the participants of the drama communicate with each other by glances and slight gestures. Even the beholder is made to feel at one with them. His eye enters the scene by way of the beckoning back of the young servant. From there it glides easily over the donkey to the older servant and is hence led by his gesture to the main group. From Abraham's head it wanders along his arm to the face of Isaac, then to the angel and finally back down to the servant. The interplay of movements and glances, the psychological differentiations, are incredibly complex. But they are presented with the greatest possible ease.

As one would expect of any work done between the years 1390 and 1410, realistic

details heighten the credibility of the scene: the donkey stands with his forelegs apart, drinking from the fountain; its saddle is shabby and worn through like the one in Brunelleschi's relief. Logs are heaped on the altar. A lizard scurries across the rock in the foreground. But such elements are few, employed with reticence. Very much in contrast to Brunelleschi, the conquest of reality through experimentation is not a final aim to Ghiberti. His figures are not set up as studies in movement or in the relation between body and drapery. He does not attempt to take the beholder by surprise, to attract attention by shocking gestures or intricate and intriguing poses. Reality is not signified to him by the extraordinary event or movement, the drama, the loud outcry. Indeed, he strives for credibility rather than for realism: credibility based on the perceptive handling of a face and body, instead of on a few striking movements; on the subtle interplay of glances and gestures rather than on ferocious dramatization. Like Brunelleschi, Ghiberti draws time and again on the art of antiquity. Isaac's torso is taken from an antique; a Roman acanthus scroll fills the front slab of the altar. But none of these motifs sticks out obtrusively. Ghiberti merges all elements into a consistent and unified atmosphere, with no attempt to overwhelm the beholder; he convinces him instead by the very ease and perfect sureness of his presentation.

Ghiberti's relief in its complete mastery of means is of almost uncanny perfection; superbly finished in every detail, a great feat of craftsmanship and in its sureness hardly credible as the work of a young man just past twenty. It lacks the freshness and vehemence of Brunelleschi's relief; it shows none of the love of experiment or the rebellious violence which made Brunelleschi's piece both awkward and intriguing. Yet the very absence of rebellious elements in Ghiberti's relief may have been one of its great virtues in the eyes of part of the jury. The perfect ease of the design, the convincing yet forceful quiet of the composition and narrative and, last not least, its infinitely superior technical perfection were decisive, one would suppose, in obtaining the much coveted award for the young goldsmith Ghiberti.

CHAPTER V

GHIBERTI'S ORIGINS

WHEN in 1402 the competition reliefs of Brunelleschi and Ghiberti came before the jury both were startlingly new sights for Florentine eyes. They stood for widely divergent approaches in the period's past and present and they opened up widely divergent paths leading into its future. Their differences, while not always envisaged with clarity, have been frequently noticed, the reticence of Ghiberti's design being interpreted, more often than not, as a sign of a fundamental conservatism, just as Brunelleschi's bold experimental approach is usually taken for progressiveness.[1] The situation, however, is more complex. Ghiberti's relief is in its own way as progressive as Brunelleschi's. The bold and exciting innovations of Brunelleschi, on the other hand, are coupled with fundamentally traditional features. The dramatic presentation of the narrative—Abraham pouncing on Isaac, the youth naked and kneeling on the altar, his legs in profile—was forecast in medieval art and survived in Florence well into the fourteenth century.[2] The style of the figures and draperies, and the entire composition are linked to a Florentine tradition. It would have reached Brunelleschi by way of a group of silversmith shops which collaborated in executing the reliefs of the legend of San Jacopo for the altar in Pistoia (1361-1367) and, slightly later, the eight stories of Saint John on the *frontale* of the altar for the Baptistery of Florence (1367-1387)[3] (Fig. 2). The overall compositions of the two altars anticipate many a feature of Brunelleschi's relief. The plaques are crowded with figures and props; the actors move across a shallow stage, pushing forward from a slightly tilted front; the bodies are fully in the round, the relief hardly gradated; occasionally the scene is divided into an upper and a lower tier. At times the vocabulary is specifically suggestive of Brunelleschi's idiom: the steep cliffs with indentations and overhangings, the dwarfed trees with fanlike foliage, the heavy draperies and facial types, the old men with their large pates and long coils of hair. All these resemblances are not surprising, since not only did work on the two altars continue past the fourteenth century and into the fifteenth, but Brunelleschi himself in his early years worked on the altar at Pistoia. Two half figures of prophets have been attributed to his hand since the days of Vasari at least, and recently some of the seated and standing church fathers have been assigned to him.[4] (Figs. 3, 4, 10)

[1] Middeldorf, bibl. 330, p. 583.

[2] The *Sacrifice of Isaac*, in the border medallion beneath the huge mural of the Crucifixion in the Sacristy of S. Croce, offers a surprisingly close example. The fresco is attributed by Offner (bibl. 369, p. 238) to Taddeo Gaddi and assistants, by van Marle (bibl. 301, III, p. 614) to Niccolo di Pietro Gerini.

[3] The documents for the altar of S. Jacopo, first collected by Ciampi (bibl. 98, pp. 136ff) and Beani (bibl. 43, pp. 11ff), have been fully analyzed by Bacci (bibl. 32, I, pp. 109ff). The documents for the altar in Florence have been gathered by Poggi, bibl. 410, pp. 65ff.

[4] The anonymous biographer of Brunelleschi (Manetti), mentions that the artist had made "certain important silver figures" for the S. Jacopo Altar (bibl. 294, p. 8). The first to identify the two prophets with Brunelleschi's work were Gelli (bibl. 175, p. 4) and Vasari (bibl. 533, II, p. 330). The

This Florentine silversmith tradition is just one of many factors contributing to the formation of Brunelleschi's style. It may not even be the most decisive element, being overshadowed by other features new to Florence: the violent and explosive movements of the figures, the lifelike rendering of a face with deep-set eyes or a hand, bony and slim with the tendons and veins clearly marked, and experimental poses based on a vocabulary *all'antica*. If anywhere, similar features can only be found in art of the late fourteenth century north of the Apennines; but in Brunelleschi's case these elements are grafted onto a traditional Florentine vocabulary.

Ghiberti's relief, on the other hand, is not linked to the style of Florentine gold-smith shops in the last third of the fourteenth century. This is all the more remarkable in view of the close association with his stepfather, the goldsmith Bartolo di Michele. No work of Bartolo is known, but since he matriculated as a goldsmith in 1376, he presumably received his training in one of the Florentine workshops at the time the two silver altars were under way.[5] It is likely that it was he who trained Ghiberti in his craft. Indeed, Ghiberti's entire lifework reveals the hand of a trained goldsmith in its delicacy of execution, its perfection of casting and its neatness of chasing. However, even if Bartolo belonged to this tradition of Florentine goldsmith shops, neither his style nor that of his contemporaries made much impression on his foster son. The *Commentarii*, at any rate, waste no words on the *œuvre* of Florentine goldsmiths.

Nor was Ghiberti greatly impressed by the output of local painters in the last genera-tion of the Trecento. This is also strange, since he started out as a painter, going to-gether with another painter, presumably a Florentine, to work in Pesaro just before the advent of the competition. In his late recollections he gives no clue as to the identity of that *egregio pittore*, his early companion.[6] Yet, despite this youthful venture, Ghi-berti in the *Commentarii* remains altogether and eloquently silent on the subject of Florentine painting in the late Trecento and, evidently, not without intention: "There have been in our city many other painters who might be listed among the outstanding (this follows upon his account of Orcagna and his brothers) . . . but to me it does not

documents mention a goldsmith Pippo di Ser Benincasa di Firenze and it is likely that a notary's mistake accounts for the different patronym.

Despite the obvious high quality of the two prophets and their close relation in style to Brunel-leschi's competition relief, modern scholars have been slow to acknowledge his authorship. The first to take up Gelli's and Vasari's suggestion was A. Chiapelli (bibl. 96, p. 461). In a paper writ-ten in 1949, but as yet unpublished, Clarence C. Kennedy attributed to Brunelleschi further figures from the Pistoia Altar. Meanwhile, Sanpaolesi (bibl. 466, pp. 225ff) has come to similar, though not identical conclusions. He convincingly assigns one seated and one standing church father of the altar to Brunelleschi.

[5] The known facts regarding Bartolo di Michele are few. In 1376 he was matriculated in the *Arte della Seta* (Doc. 114). From about 1375 or 1378 he lived in common-law marriage with Ghiberti's mother, whom he married after the death of her legal husband (Doc. 120). In 1394 he evaluated for the *Opera* of S. Maria del Fiore a sculpture executed by Piero di Giovanni Tedesco (Poggi, bibl. 413, doc. 104). He may be identical with the Maestro Bartolo orafo di Firenze who in 1395 was called to Pistoia to give his opinion on Giovanni di Bartolomeo Cristiani's design for the top part of the silver altar of S. Jacopo (Bacci, bibl. 32, p. 18). He signed the contract for Ghiberti's first door in 1403 (Doc. 26) and continued to work in his son's shop after 1407 (Doc. 31), where he was still active in 1416 (Doc. 131). In 1422, or shortly before, he apparently died (Doc. 120).

[6] Ghiberti-Schlosser, bibl. 178, I, p. 45; II, p. 167.

seem that I should place theirs among these." Ghiberti's unfavorable opinion, even if personal, is understandable. Little in Florentine painting at the turn of the century resembled, at least no more than faintly, the masterful unity, yet complexity of his competition plaque with its lithe figures, with their elegant swing, firm stance, smooth flow of draperies and the delicacy of narrative. Whatever differences existed between individual masters and workshops of the time, they were one in the fact that none shaped Ghiberti's early style in any of its essentials: their figures are massive and solidly outlined, they move and stand stiffly, are displayed on narrow stages placed either against a scenic backdrop of isolated rock formations or within a spidery architectural setting. Only on occasion does a motif from one of these Trecento workshops slip into Ghiberti's design. Usually it is merely a stage prop like the rocky spur that runs diagonally across Ghiberti's competition relief or the iconographical formula or the architectural setting.[7]

One workshop in Florence, however, not a painter's but a sculptor's, apparently exerted a strong impact on the art of young Ghiberti. Time and again his competition relief brings to mind, in one way or another, the art of the Porta della Mandorla. The jambs and lintel of this door (Figs. 5, 6), the second on the north side of the Cathedral, were designed and executed by a Florentine workshop between 1391 and 1396, the archivolt following after 1405.[8] The identities of the individual sculptors or the parts assigned to each is of less importance to the present discussion than the motifs *all'antica* which, intertwined with double curved acanthus candelabra, are scattered over the jambs of the portal. For both the overall design and the figures the artists drew on classical prototypes. But these were selected not primarily for the sake of their inherent sculptural qualities. They are embedded in the predominantly medieval context of the portal as markedly alien elements, and the contrast between their unwonted subject matter and their harsh Trecento idiom is striking. They must have represented to the majority of masters working on the Porta della Mandorla no more than marginal notes.

However, one master of this workshop treated motifs *all'antica* with a refinement lacking in the others. In the figure of Hercules with the lion skin (Fig. 6) the soft planes are lovingly brought out with a feeling for the play of light and shade, the plastic values of the design and flowing movement. This sculptor, the Hercules Master, was manifestly intrigued not only by the subject matter of his prototype, but also by its forceful and easy stance and the rendering of the body in small rippling planes. Whatever specific Hercules he used as a model, he caught the intrinsic values of antique sculpture.[9] Besides the figures *all'antica*, the peculiar style of this master dominates the

[7] See below, pp. 214f.

[8] The documents (Poggi, bibl. 413, docs. 348ff) refer to four masters, Giovanni d'Ambrogio, Niccolo Lamberti, Piero di Giovanni Tedesco, and Jacopo di Piero Guidi, as working on the jambs. Hence, the field has been wide open for speculation, particularly since Schmarsow (bibl. 486) and Wulff (bibl. 560), introduced the name of Nanni di Banco. Regarding more recent views on the problem, see Kauffmann (bibl. 237, pp. 216ff), Brunetti (bibl. 72 and 73) and the refreshingly clear summary of Paatz (bibl. 375, III, pp. 366f and notes 221f). Illustrations in Venturi, bibl. 534, IV, pp. 609ff.

[9] Regarding the place of the Porta della Mandorla within the humanist movement of Florence at the turn of the fourteenth century, see below, pp. 279f and note 10.

neighboring half figures of angels and, it would seem, the Virgin with the head of an athlete and the angel of the Annunciation now in the Museo dell'Opera. The Hercules Master adds his own distinct note to the general picture of Florentine sculpture in the last decade of the Trecento. In fact, he is unique.[10]

Whoever he was, the Hercules Master finds a strong echo in Ghiberti's earliest work. Like the figures *all'antica* on the jambs of the Porta della Mandorla, the antiquish figure of Isaac forms a dominant note in Ghiberti's competition relief and imparts a classical tone to the entire design. No doubt the adolescent body is derived from some antique model (App. A, 1), and like the Hercules Master, only more so, Ghiberti rivets his attention on the softness of the body, the tactile values of small planes, delicate transitions which reveal themselves to the eye, to paraphrase Ghiberti's own words, only when the sculpture is bathed in a temperate light or to the touch of fingertips.[11] These are the elements he transferred to the body of Isaac and to the head with its soft curls of long S-curved locks. Nothing could be more indicative than the contrast between Ghiberti's and Brunelleschi's handling of an antique model. Brunelleschi looked upon antique prototypes through an overlay of medieval tradition, transforming their smooth movements into jerky gestures. He exploited antique models for the sake of their scientific or pseudo-scientific solutions to problems of reality and their dramatic and convincing portrayals. But to the Hercules Master and even more to young Ghiberti antiquity meant, on the contrary, fluid movements, easy stances, silky surfaces of skin and gentle transitional planes. Later in his life Ghiberti never alluded to the sculptors of the Porta della Mandorla, not even to the Hercules Master, and at first glance it may seem strange that he kept as silent about these formative influences as about earlier silversmith work and painting which did not impress him. However, in the *Commentarii* Ghiberti abides by the principle of avoiding discussion of contemporaries, and the Hercules Master, whoever he was, was not much older than Ghiberti.

About masters of the more distant past Ghiberti could be very eloquent when he wished. The painting of the Sienese, both before and after the middle of the Trecento, occupies a large space in the *Commentarii*. For this reason and because Sienese art like

[10] The extent of the work of the Hercules Master on the Porta della Mandorla and his identity with the Master of the Annunciation have been agreed upon by and large in recent discussions (Kauffmann, *op.cit.*; Paatz, *loc.cit.*; more recently Brunetti, bibl. 75 and 76). Minor points, such as the inclusion of the violin-playing Apollo in the master's work (Kauffmann and Brunetti, *op.cit.*) are in my opinion still open to question. Certainly agreement is far from general regarding the identity of the master. The older identification with Niccolo Lamberti (Venturi, bibl. 534, IV, p. 757) or with Nanni di Banco (Wulff, bibl. 560, p. 130; Brunetti, bibl. 73) can probably be dismissed. But neither is Kauffmann's identification with Giovanni d'Ambrogio (bibl. 237, pp. 224ff) convincing; see also Paatz, bibl. 375, III, pp. 487f, note 222.

One principal difficulty in assigning the four parts which can be stylistically differentiated in the Porta della Mandorla (summary in Paatz, bibl. 375, III, pp. 487f, note 222) is that it need not have been executed in its entirety by the four masters to whom payments were effected, namely, Jacopo di Piero Guidi, Piero di Giovanni Tedesco, Giovanni d'Ambrogio, Niccolo Lamberti (Poggi, bibl. 413, docs. 88ff, 348ff). Any of them may have employed a younger master in his workshop and, indeed, Brunetti (bibl. 75 and 76) has suggested that the Hercules Master be identified with young Jacopo della Quercia. I do not want to take any position regarding this proposal, tempting as it may seem.

[11] Ghiberti-Schlosser, bibl. 178, I, pp. 61f.

his own is traditionally supposed to have remained "Gothic," Ghiberti's style has been linked time and again with Siena. Simone Martini in particular is named a source of his inspiration. Certainly Sienese painters of the early Trecento held a fascination for Ghiberti. But what he claims most attracted him is not so much Simone Martini, elegant and "graceful . . . whom the Sienese painters like best," as the dramatic art of Ambrogio Lorenzetti.[12] Still, despite this expressed preference of his later years, Ghiberti's early work in many ways recalls the melodious qualities of Simone Martini. However, the elements he shares in common with the gentle Sienese, the suavity of line and sway of lithe bodies, he shares not alone with him.

To begin with, traits of Simone Martini's style survived far into the second half of the fourteenth century in the work of Bartolo di Fredi, among others. In fact, Ghiberti apparently used as a model for his glass window design of the *Assumption* for the façade of the Cathedral (Fig. 7) Bartolo's *Assumption* on the pinnacle of the Montalcino Altar of 1388 (Fig. 8). Simone Martini's style, then, insofar as it shaped the early work of Ghiberti, did so indirectly through later derivations. It is of equal importance that Simone Martini shared some essential traits with French art of the early fourteenth century. This point can hardly be stressed too strongly. Nor can it be overstressed that whatever is "Gothic" in Ghiberti's competition relief recalls this French art as generally and inconclusively as it recalls the Sienese masters.

The origin of Ghiberti's style can only be understood against a background that goes beyond Florentine or Sienese art, to include Northern art as well, specifically that of fourteenth century France.[13] From the 1320's on a new style, was being shaped in France, combining volume with elegant linear form. In manuscript painting, saturated with Italian influences, largely from the circle of Duccio, this style was primarily set by Jean Pucelle and his Paris workshop. But it also came to the fore, though perhaps a decade later, in goldsmith work and stone sculpture, as witness the silver *Madonna* of Jeanne d'Evreux (1339) from St. Denis, now in the Louvre, and the *Vierge Blanche* at Notre Dame in Paris (*ca.* 1340). About 1360 this style was invaded by still another and very different art; its ultimate aim was to transcribe literally, sometimes in commonplace fashion, the principal visual, tactile, and psychological aspects of human appearance and action. Art became a means of exploring reality.[14] Through this new

[12] Ghiberti-Schlosser, bibl. 178, I, pp. 40ff; see also below, pp. 218ff.

[13] In a splendid chapter, Panofsky (bibl. 380, pp. 21ff) has recently clarified the history of French fourteenth century art, especially of book illumination. I am happy that his book came into my hands before I terminated the last draft of this and the following chapter. I have gained from it far more than a new insight into the development of illuminated manuscripts. Differences in emphasis are, to a large extent, due to differences of focus on book illumination, and on sculpture and goldsmith work respectively.

[14] The ultimate roots of this literal, descriptive realism still remain hidden. In book illumination, it is doubtless carried on by the Flamands working in France and shaped largely under the influence of Sienese pathos formulas (Panofsky, bibl. 378, p. 42 and *passim*). In the realm of large-scale stone sculpture one wonders if it is also linked with either a survival or revival of the importance given emotional realism one generation before both north of the Alps in the early Pietàs and Crucifixes of the Lower Rhenish regions and south in the *ambiente* of Pisa and Siena in the *œuvre* of Giovanni Pisano. See also Garger, bibl. 170, p. 37; Pinder, bibl. 400, I, pp. 30ff.

Keller (bibl. 240) has pointed out the part played by portrait sculpture in the development of fourteenth century realism.

movement the art of Central Europe, broken up into regional styles shortly after 1300, became once more united. The unifying agent of this super-regional style was not the Church, but the powerful courts of Central Europe from Paris and Dijon to Vienna and Prague. Flanders and the Netherlands, including Cologne at one end and Upper Italy at the other, produced the artists: Jean Bondol, alias Hennequin de Bruges (the *Maitre aux Boqueteaux*), the Parlers, and Tomaso da Modena. Out of this atmosphere grew the sculpture which was to prevail in Central Europe from one end to the other from the sixties through the nineties: the life-sized statues of Charles V and Jeanne de Bourbon from the Quinze-Vingts in Paris (Fig. 16); the story of Saint Paul and the figures of Rudolph IV and his wife at the Singertor at St. Stephen, and the figures of other princes of the Austrian house, now at the Rathaus Museum in Vienna; the portrait busts of the Imperial family in the Cathedral of Prague (1374-1385); Claus Sluter's powerful statue of the Virgin and the true-to-life figures of the donors on the portal of the Chartreuse in Dijon (1389-1396).[15] Throughout the emphasis is on realistic likenesses, individuality of features and vividness of expression and costume. The urge to create realistic royal portraiture amounted to what seems almost an obsession for picturing the privileged few at their ugliest best, beards and hair unkempt, eyes protruding, jowls flabby, not a mole or wrinkle forgotten. Correspondingly, the scriptures and legends of the saints were also rendered with a new immediacy in the repulsiveness of the enemies of Christ, the ferociousness of the executioners, the un-inhibited wildness of grief. Humanity, whether from out of the Holy Scriptures or everyday life, is generally depicted with heavy ugly physiognomies, in fashionable costumes, and often as blocky forms. At the same time, Christ and his saints and also allegorical figures are, as a rule, represented in an elegant style with delicate features and clad in the same flowing draperies that had been theirs for centuries. Much in contrast to figures from daily life, they sway slightly in beautiful curves not so different from the slim sculptural shapes so cherished a generation before by artists and connoisseurs. The dichotomy is evident in the *Parament de Narbonne* (*ca.* 1376) where the corporeally massive donors, Charles V and Jeanne de Bourbon, kneel beneath elegant personifications of the Church and Synagogue accompanied by equally elegant prophets (Fig. 9).[16] No doubt the boundaries were sometimes felt as fluid, and saints

[15] The statues of Charles V and his wife in the guise of Saint Louis and Queen Marguerite (Paris, Louvre) formerly believed to have come from the portal of the Célestines, have been assigned by Huard (bibl. 222) to their correct origin, the church of the Quinze-Vingts with a date after 1377, and possibly after 1380.

The sculptures of St. Stephen have been discussed by Ernst and Garger, bibl. 140, and by Tietze, bibl. 518, pp. 138ff, 154ff, 473ff, and 521ff. No doubt all are linked to the Parler workshop and its activity in Prague, but their date is uncertain. Ernst and Garger favor a date between 1365 and 1375. Tietze proposes a date in the eighties for the *Conversion of Saint Paul* and the princely statues at the Singertor and an even later date, 1390-1400, for the tomb of Rudolph IV and the princely figures from the tower of Saint Stephen, now in the Rathaus Museum. However, the early date, 1365-1375, seems more likely on the grounds of both stylistic and historical considerations, for instance the presence on the Tower of a statue of Charles IV at a relatively young age. For the statuary of Prague, see the recent publication of Swoboda (bibl. 515, pp. 28ff).

Claus Sluter's *œuvre* is best presented in the excellent monograph of Liebreich (bibl. 275).

[16] Swoboda (bibl. 515, p. 38), in discussing the sculptures of Prague Cathedral, has convincingly brought out the contrast between the realistic portraits of the imperial family and their household

did not always escape the impact of the new descriptive realism; they often feature the expressive heads, gestures and costumes suggested by everyday reality. But, by and large, when realism intrudes upon the supernatural, it is embedded in decorative patterns.

The stress on decorative elegance is even stronger in what is generally, if improperly, called the minor arts, book illumination, goldsmith work and tapestries. This is only natural. The ateliers which since the sixties and seventies had produced priceless treasures for the princely courts of France, worked in the most precious materials to satisfy the taste of progressive yet tradition-bound seigneurs. Hence patrons and artists, while tempted to play around with realism, tended to tone down its starker aspects, embedding realistic traits and sculptural volumes in an elegant linear framework. A fresh Italianate wave brought with it into this art motifs coming largely from Barna da Siena and Simone Martini. In many respects the illuminated manuscripts of Jean Bondol, the tapestries of Angers and the Golden Scepter of Charles V recall Gothic elements of a generation past. Indeed, Jean Bondol apparently reverted to both Italian artists, as well as to Jean Pucelle.[17] Thus the lifelike appearances, the sculptural bodies that press against tautly drawn garments, become combined with rich draperies overhung with long curvilinear folds and flanked by cascades, their hems rolling, curving, overlapping. A credible and tangible reality is still the principal aim; but as presented within a framework of calligraphic patterns evocative of a lyrical nature, this aim is partly counteracted. An element of heterogeneity is inherent in these products of the *enlumineurs* and goldsmiths just as it is in representations of the supernatural. Toward the end of the century realism for its own sake is even further played down. The plastic value of the body gradually disappears beneath garments of decorative linearism. The first phase of what is generally called the International Style announces itself upon the scene.

Within the art of the last third of the fourteenth century in all Central and Western Europe, an exploration into the tactile, visual, and psychological facets of reality proves the pivotal element, whether the reality appears in its starker aspects or embedded in decorative patterns. Contrary to general belief, Italy did not remain aloof from this interest. Certainly the regions north of the Apennines, both Lombardy and the Veneto, give evidence, if not of an influence from, at least of close analogies to, the new realistic trends in art north of the Alps.

In Venice the movement was carried on by the brothers Masegne in whose hands it met up with the last echoes of Giovanni Pisano's art which had survived in the form of tomb *gisants* by the De Sanctis school in Padua.[18] Under the Masegne, particularly

in the lower triforium (1374-1376) and the idealized representations of Christ and his saints in the upper (before 1385).

[17] Panofsky, bibl. 380, pp. 35ff and *passim*.

[18] For the *œuvre* of the Masegne workshop see Planiscig, bibl. 406, pp. 177ff; *idem*, in: Thieme-Becker, bibl. 517, XXIV, pp. 200ff; Krautheimer, bibl. 252; Gnudi, bibl. 184 and 185. Gnudi, in his earlier publication, had corrected my previous assumption of a common Masegne style and differentiated the work of the two brothers, the more conservative Pier Paolo and the progressive Jacobello. In his recent article, while still maintaining the essential differences between the two mas-

Jacobello, a realistic interpretation of the visual world became a decisive factor in Venetian and Bolognese sculpture. A relief from the tomb of a professor Legnano at Bologna (1383) gives a true-to-life picture of a lecture, down to the last button on the student's costumes and the attentive or sleepy expressions on their faces. The statue of the kneeling Doge at the Museo Correr (1382-1400) is no less lifelike, the parchment-like skin drawn tightly across the cheekbones, the beard sparse, the hands knotty and venose (Fig. 11). A few years later, in the figures of the apostles on the rod-screen of Saint Mark's in Venice (after 1394), reality is viewed in a language slightly more dramatic and expressive (Fig. 12). The bodies are stocky, heavily sculptural. They jerk violently, their facial expressions are ferocious. But such dramatizing traits are tucked between half traditional elements that permeate the overall design along much the same lines as in the conservative factions of French, South, and East German art of the seventies. Finally, still within the Masegne *ambiente*, but possibly a variant of their style, linear elements grow ever more decorative, flattening the body, while faces remain as true to nature as a death mask: a perfect example is the Tomb of Andrea Manfredi (d. 1396) in S. Maria de' Servi in Bologna. On the whole, the development parallels that taken by French and Austrian sculpture from the seventies through the nineties.

Sculpture in Milan during the last years of the fourteenth century is certainly not comparable in quality with the products of Venetian and Bolognese studios, not to mention those of Paris and Vienna. Still, a relief like Jacopo da Campione's *Salvator Mundi in His Glory* over the north sacristy door of the Milan Cathedral (1391-1395) shows, despite the crudeness of its execution, surprising boldness in spatial experimentation (Fig. 13): patriarchs, saints, and apostles are placed at the bottom of the relief, partly cut off by the frame, their heads drawn back in unexpected foreshortenings as they look upwards and inwards; the Savior supported in back by cherubims, floats fully in the round within a space undefined, yet deep; an angelic host at the top protrudes far beyond the frame.[19] The origins of such sculpture and its ties with art on the other side of the Alps, is as yet far from clarified. But the problem of translating reality into a visual media, which had so attracted French and Austrian artists a decade or two before, now caught the attention of sculptors and painters from the Milanese *ambiente*. The library of Gian Galeazzo Visconti, one of the finest in fourteenth century Europe, contained dozens of French manuscripts; local workshops were as preoccupied as any in Europe with interpreting the manifold facets of reality through their art.[20] Chivalresque romances are presented in contemporary costume, the cour-

ters, he recognizes more strongly the existence of common features and revises his earlier statements in favor of a less rigid division between them.

[19] For the sculpture of Milan at the turn of the fifteenth century, see bibl. 335, I, and Appendix I *passim*; Nebbia, bibl. 360; and on a broader basis and more recently, Baroni, bibl. 40.

The standard work for illuminated manuscripts and altar painting in Lombardy and Piedmont, remains Toesca, bibl. 520, supplemented more recently by van Schendel, bibl. 472.

[20] Toesca, bibl. 520, pp. 311ff and van Schendel, bibl. 472, p. 4. For the following, compare manuscripts such as the *Lancelot du Lac*, Paris, Bibl. Nat., fr. 434 (Toesca, *op.cit.*, pp. 371ff); the *Taccuinum Sanitatis*, Vienna, Hofmuseum (Schlosser, bibl. 480, pp. 146ff with attribution to the School of Verona); the *Taccuinum Sanitatis*, Paris, Bibl. Nat., lat. *nouv. acq.* 1673 (Toesca, *op.cit.*, pp.

tiers and damsels, whether worldly or saintly, shown wearing the newest fashions. They pick fruits, stroll through gardens and warm themselves by the fireside. Their servants perform prosaic tasks, shopping and working in the kitchen. An angler crouched on a river bank, tries to hook a huge squid. The *Annunciation* and *Birth of the Virgin* are set in deep architectural spaces wherein the action vibrates with life. At times, though rarely, drapery has the richness and linear volume of the Angers tapestries.[21] The work of these Lombard *enlumineurs*, including the best known among them, Giovannino de' Grassi, without doubt contains a native note of its own, but always conditioned by the broader framework of fourteenth century realism.[22]

The international character of this new realism in Upper Italy becomes abundantly evident.[23] As early as 1373 Jean Arbois, working in the service of Philip of Burgundy, traveled to Lombardy. Forty years later his fame was still so well remembered south of the Alps that local historians mentioned him in the same breath with Michelino da Besozzo and Gentile da Fabriano, hailing him as a new Apelles. The account books of the *fabrica del Duomo* in Milan leave no doubt but that one out of every ten sculptors was either French, Flemish, Dutch, German or Austrian by birth and training.[24] The illuminator, Jacques Coene, a Flamand living in Paris, was one of these many *oltramontani*. He was called upon to make a drawing of the Milan Cathedral and his trips back and forth between Paris and Milan give a good idea of the network of communications woven across Europe.[25] In the 1380's the Duc de Berry commissioned the workshop of the Embriachi in Venice to make a large ivory retable for the convent in Poissy.[26] Johannes Alcherius, a painter of indeterminate nationality, between 1382 and 1411 went around Milan, Venice, Bologna, Genoa, and Paris collecting painting recipes from scholars, painters, and illuminators.[27] Whether by the hand of Giovan-

338ff and 354ff); the *Historia plantarum*, Rome, Bibl. Casanatense, 459 (Toesca, *op.cit.*, pp. 334ff; the *Uffiziuolo of Gian Galeazzo Visconti*, Modrone, Library of Duke Visconti (Toesca, *op.cit.*, pp. 312ff).

[21] E.g. the *Creator Mundi*, Paris, Bibl. Nat., lat. 757 (Toesca, bibl. 520, p. 291, fig. 222). The miniature seems to be by far among the best of the entire codex.

[22] Goldsmith work may well have played a leading part in the penetration into and the development of the realistic fashion within the North Italian milieu. But even more than the sculptors' workshops those of the goldsmiths in Venice, Udine, Milan, Brescia, and Padua want further exploration.

[23] All the following examples are well known. See in particular, Durrieu, bibl. 138, p. 369, and van Schendel, bibl. 472, pp. 46ff.

[24] Bibl. 335 *passim*; Baroni, bibl. 40, pp. 123ff.

[25] Panofsky, bibl. 380, p. 54 and note 1; p. 56, and note 3 with reference to the identification, as yet not quite certain of Coene as the Boucicaut Master.

[26] Paris, Louvre (Molinier, bibl. 341, pp. 217ff); see also Schlosser, bibl. 481 and Durrieu, bibl. 138, p. 369.

[27] Merrifield, bibl. 322, I, pp. 17ff. The various sources of Alcherius' information and his method of collecting it sharply illuminate the international character of his milieu. In 1382 he received certain recipes from Alberto Porzellas, who had a school in Milan. In 1398 he got others from Jacobus Cone (Jacques Coene) *flamingus pictor* in Paris; in 1409 he drew information from one Frater Dionysius in Genoa. In 1410 in Bologna he copied a manuscript of formulas written in French, lent him by one Theodericus from Flanders, who was working in Pavia and had received them in London. In Bologna, Alcherius collected other recipes from one Johannes da Modena. The same year Michelino da Besozzo taught him more recipes in Venice. In 1411, he was back in Paris. A manuscript, formerly in Strasbourg (Berger, bibl. 47, III, pp. 155ff) similarly contains

nino de' Grassi or someone in his workshop, the Bergamo model book, dating prior to 1393, contains the famous *Boar Hunt* which later, between 1413 and 1416, was memorably illustrated in the *Très Riches Heures* of the Duc de Berry. On another of these pages by the Limbourg brothers, in the scene of the *Meeting of the Magi*, at least one and possibly two figures are drawn from the emperors on horseback in a set of medals forged *all'antica* and sold to the Duc de Berry by Italian merchants between 1400 and 1402.[28] In the *Coronation of the Virgin*, still from the same manuscript, saints are placed on the lower frame, partly cut from sight and looking upwards and inwards, the spatial device employed by Jacopo da Campione in his *Salvator Mundi* relief for the Cathedral of Milan. Whatever they may mean, the terms *ouvraige de Lombardie*, *ouvraige romain*, and *ouvraige de Venise* (the first two apparently referring to illuminated books, the third to jewelry), are to be found listed from time to time in the inventories of the princely collections of France.[29] The links apparently run from France to Italy as well as from Italy to France. Altogether the international exchange is so much in evidence that North Italian art from the 1380's on can hardly be viewed except within this network of relations between the major courts and centers of Central Europe, both north and south of the Alps.[30]

It is less clear how Florence fitted into the international pattern at the time the competition for the Baptistery doors began. The Limbourg brothers, or at least one of them, drawn by a fascination for Italian art, appear to have twice visited Florence and Siena, once before, once after 1413. On one of these occasions they were struck by the antiquish decor of the Porta della Mandorla.[31] Brunelleschi's earliest sculptures on the altar of S. Jacopo in Pistoia, suggest that he felt a potent stimulus from the Masegne workshop: the standing church father, which he apparently designed for the silver altar of Pistoia, is surprisingly close in his abrupt movement, forcefulness of body, and ferocious mien to the apostles on the rod-screen of Saint Mark's (Figs. 10, 12).[32]

However, neither the North Italian centers, nor the monumental sculptures of the French, Austrian, and Bohemian courts appear to have scored a very serious impact on the young Ghiberti. True, he could hardly have helped being affected by trends which strove to explore reality through art, so powerfully in fashion were they by 1400. The bony face of the older servant in his competition relief and the worn-out saddle on the donkey are details which definitely speak the language of current realism.

recipes collected around 1400 from Colmar, Lübeck, and in the Lombard Manner (*nach lampenschen sitten*).

[28] Panofsky, bibl. 380, p. 63, p. 64 and notes 2 and 5; Schlosser, bibl. 473, pp. 75ff. Panofsky, *loc. cit.*, convincingly suggests that, in addition to the king derived from the "Constantine" medal, the king in the foreground of the Meeting of the Magi derives from a medal of the same set. As for the origin of the forgery, Schlosser suggests a Flemish-Burgundian goldsmith (bibl. 473, p. 83). But the horse of the Constantine is so close to the horses at S. Marco, that one is inclined to think of Venice as the locale of the forgery.

[29] Toesca, bibl. 520, pp. 407ff; van Schendel, bibl. 472, pp. 49f.

[30] F. Wormald, "The Wilton Diptych," *Journal of the Warburg and Courtauld Institutes,* XVII (1954), pp. 191ff, has pointed out the links between Upper Italy and England during these decades.

[31] Winkler, bibl. 556; Panofsky, bibl. 380, p. 64 and note 1.

[32] Sanpaolesi, bibl. 466, p. 226, fig. 2, and Krautheimer, bibl. 252, fig. 8.

But they are details submerged in a framework of melodious, decorative, and unrealistic, even antirealistic, character. What distinguishes Ghiberti's competition relief from the traditional art of his native Florence is mainly twofold: first, the feeling for tactile values shared only with the Hercules Master, secondly, the blending of realistic and decorative elements. It is the latter feature which more than anything recalls the style of the Parisian workshops of the goldsmiths and *enlumineurs* during the last third of the fourteenth century.

Indeed, Ghiberti knew more than one facet of French art. Manuscripts illuminated at the French courts during the seventies, and related tapestries, abound in types, stances, and draperies that seem to prefigure the art of young Ghiberti. Without doubt he knew either French or Flemish tapestries, as well as the French technical term *verdure*.[33] Unless he were well acquainted with the style from which such products issued, it would be impossible to explain the striking resemblances in vocabulary and design that often occur between his competition relief and the tapestries of the *Apocalypse* at Angers, designed by Jean Bondol and woven in Paris for Louis I of Anjou, 1377 and after.[34] Similarities rest in the rich drapery hangings, the elegant yet firm stances, the volume of the bodies encased in their garments and the bony firm faces. In the Angers series *Saint John Eating the Book* (Revelation 10:10) wears a cloak thrown over his shoulders, the ends fluttering, much like Abraham's in Ghiberti's competition relief. Like Ghiberti's young servant the angel in the Angers tapestry is tightly wrapped in a cloak richly overhung with long curved folds all joined together by short interlocking grooves. In the *Dragon Threatening the Woman* (Fig. 14) Saint John bears a close likeness to Ghiberti's draped figures; even the face with its strong beaked nose and high cheekbones bears an undeniable resemblance to Abraham's (Pl. 2b). This is not to suggest that Ghiberti actually saw the Angers tapestries. Possibly he knew manuscripts from Bondol's workshop. Almost certainly he was acquainted with model books in which were displayed motifs and types from the Parisian style of the seventies, the source of such tapestries.

These general stylistic similarities point the way towards one of the major sources of Ghiberti's early work. Indeed, Ghiberti's youthful style bears more resemblance to French art of the seventies than to Italian art of the turn of the century, whether Florentine, Venetian, or Lombard, and comes closer to the French fountainhead than these Italian schools ever did. What, after all, is the source of the foliage strips on his first Baptistery door, those dense rows of closely heaped, full ivy leaves interspersed with lively little animals, spiders, grasshoppers, bugs, frogs, snails, and a small human head or two (Pls. 69a, b)? Tradition records that all this tiny wild life was cast from nature; whether or not tradition is right, such use of flora and fauna was altogether new to Tuscan decoration, which during the fourteenth century almost never deviated from the customary diamond studs and rosettes on altar and door frames and jambs and the equally customary acanthus friezes.

[33] Ghiberti-Schlosser, bibl. 178, I, p. 28; II, p. 105.
[34] De Farcy, bibl. 154, pp. 13f; for illustrations, see Lejard, bibl. 272; Panofsky, bibl. 380, pp. 38ff and note 3, has pointed out the place of the tapestries within the work of Jean Bondol.

Close parallels to Ghiberti's foliage strips occur only in France, for instance on the great cathedrals—Amiens for one. Since the thirteenth century clusters of vine, oak, and ivy leaves had encircled pier and shaft capitals and filled string courses beneath triforia. The foliage need not be directly transcribed from nature, but it is always full of life. Throughout the next century leafwork continued as part of French architectural design, spreading to the minor arts, growing ever richer. Petrarch, about 1360, ridiculed the new fashion of decorating goldsmith work "with entire forests and their inhabitants, all kinds of trees, beasts, birds, human faces and whatever else the eye can see, the ear hear and the mind invent."[35] Goldsmith work of this kind has since largely disappeared, but Petrarch's remark is readily recalled when looking at a comparatively late French example, the *Trinity Morse* from the Widener Collection, now in the National Gallery, Washington, D.C. (Fig. 15): oak leaves enamelled a bluish green fill the groove along the rim; small bits of dark brown branches intertwine and in between six large pearls project.[36] The pearls occupy places which in Ghiberti's foliage strips are filled with tiny animals and, to be sure, the leafwork of the North Door of the Baptistery will bring to mind the Petrarch passage as readily as will the French *Trinity Morse*. As early as the 1320's in France, as shown in the work of Jean Pucelle, tiny animals had invaded the flora in the decorative margins of illuminated manuscripts.[37] An even livelier and more diversified fauna play among the marginal foliage of book illuminations during the seventies and eighties. Just as on Ghiberti's door, butterflies, birds, snails, and bugs intermingle with small angels and human busts, as witness the *Cité de Dieu* of 1376 and the *Beau Breviaire* of Charles V.[38]

In Italy only Lombard book illuminations show comparable decorative bordering. Pliny's *Naturalis Historiae*, illustrated in 1389 by Frate Pietro di Pavia and other anonymous masters, is by far the closest to French work. The narrow stem of leaves is accompanied by dragonflies, flies, and bugs, delicately drawn and correctly proportioned in relation to the leaves.[39] However, such frenchified margins of foliage are exceptional. True, the region of Lombardy responsible for this Pliny and the region of the Veneto became during the last decade of the Trecento centers of convincing quasi-naturalistic animal and floral design. Dozens of animal drawings in the model books of Giovannino de' Grassi and his workshop bear witness to this movement, as also do the Carrara herbal from Padua (prior to 1403) and the Rinio herbal (1419). But these North Italian nature studies bear a special note of distinction. They are,

[35] The passage occurs in *De Remediis*, chapter IV, *De Vasis Corinthiis*, where Petrarch thunders against the increasing luxury of his age, worse even than the luxury of late Roman times. The Romans, he said, complained about vessels, decorated with ivy, vines, and bunches of fruit (*corymbi*): ". . . novissime autem his diebus non hederas modo, vel corymbos, sed ipsas cum incolis suis sylvas, omne genus arborum ac ferarum, et volucrum et hominum vultus, et quaecumque vel oculus vidit, audivitque auris vel mens fixit, in auro expressa vel argento longe iam consuetudine non miratur, gemmis inhians de quibus paulo ante tractavimus" (Petrarch, bibl. 396, p. 41; quoted previously by Muentz-d'Essling, bibl. 354, p. 58, note 3).

[36] Krautheimer, bibl. 247, p. 33. [37] Panofsky, bibl. 380, p. 32.

[38] Paris, Bibl. Nat., fr. 22912-22913 and lat. 1052 respectively. Martin (bibl. 306, p. 48) suggests the name of Jean Bondol for both manuscripts. Panofsky (bibl. 380, p. 41) assigns lat. 1052 to a Paris workshop as yet unidentified.

[39] Milan, Ambrosiana, Cod. E 24 inf.; see Toesca, bibl. 520, fig. 250.

to borrow a phrase from Paecht, "repetitions of first recordings from life." Trait by trait they are transcribed from nature, but remain motionless, inanimate, simply naturalistic observations turned into atelier formulas. Preserving exactly the same stereotyped features, they transgress the scientific manuals and penetrate the border decorations of North Italian book illumination: in the Coccharelli Manuscript painted in Genoa in the late fourteenth century big inanimate insects stand against a background of thin foliage with stiff regulated lifeless leaves reminiscent of a lepidopterologist's or botanist's collection.[40]

Ghiberti's foliage (Pls. 69a, b) has little in common with this North Italian work. The combination of animated fauna and surrounding leaves made in lifelike proportion to each other is found, if anywhere, in France. But nowhere else, not even in France, is the integration of leaves and animals quite so accomplished, the design quite so condensed, the leaves so closely heaped, rolling over and overlapping each other and creeping along the groove under the molding, or so closely interspersed with tiny fauna hopping and creeping with such liveliness. If a French note is thus unmistakable in Ghiberti's early work, goldsmith work naturally would have had the strongest appeal. His own words, in fact, give a clue.

His history of Trecento art in the second book of the *Commentarii* is dominated by an account of the great painters of Florence, Rome, and Siena. The sculptors—Giovanni Pisano, Giotto, Andrea Pisano and Orcagna—are dismissed in a few words. Yet at the very end of the chapter, just before starting his autobiography, Ghiberti inserts the life story of a mysterious foreigner, Master Gusmin from Cologne.[41]

In Germany in the city of Cologne lived (*fù*) a master much experienced in the art of sculpture, he was of the highest genius, [his name was Gusmin]; he was employed (*stette col*) by the Duke of Anjou who had him make a great many works in gold; among other works he made a golden altar (*tavola d'oro*) and with all solicitude and care he executed this altar very excellently. He was perfect in his works, equal to the ancient Greek sculptors; he made the heads and all the nude parts marvellously well. There was no fault in him, save that his statues were somewhat squat. He was very outstanding and skilled and excellent in his art. I have seen many figures cast after his (*formate delle sue*). He had the most delicate air to his works, he was very skilled. He saw the work destroyed that he had made with so much

[40] Paecht, bibl. 376, has brought out concisely the importance and specific traits of North Italian studies of flora and fauna in the late fourteenth century. In his opinion, Northern Italy, and specifically Lombardy, plays a dominant role in the development of nature studies and calendar landscapes throughout Europe.

For Giovannino de' Grassi's model book (Bergamo, Museo Civico, Δ 1) see Toesca, bibl. 520, pp. 298ff, for the Carrara herbal (London, Brit. Museum, Egerton 2020) and the Rinio herbal (Venice, Marc. Lat. vi, cod. 59), Paecht, bibl. 376, pp. 30f. For the Coccharelli manuscript (London, Brit. Mus., add. 27695, 28814 and Egerton 3127, "attributed to the Genovese miniaturist of the family of Cybo, known as the Monk of Hyères," Brit. Mus., *Reproductions from Illuminated Manuscripts*, ser. iv, London, 1928, p. 13 and pl. xxxi) see also Paecht, bibl. 376, p. 21.

[41] Ghiberti-Schlosser, bibl. 178, i, pp. 43f; ii, pp. 164ff. Though missing in the only extant copy of the *Commentarii* (see below, p. 306, and Ghiberti-Schlosser, *loc.cit.*), the name Gusmin was presumably contained in Ghiberti's original manuscript and taken over from there, directly or by way of a more complete copy, by the Anonimo Magliabecchiano (bibl. 22, pp. 87f). Attempts at identifying the enigmatic goldsmith from Cologne have ranged from Claus Sluter to the Neapolitan stonemason Baboccio and to a Middle Rhenish alabaster worker, the Master of Rimini. My own solution of the riddle, as offered below, has been presented previously (bibl. 247) at greater length and with an abundance of footnotes, including a discussion of earlier hypotheses on Gusmin.

love and art on account of the public needs of the Duke; he saw his labor had been in vain and he fell upon his knees and raised up his eyes and hands to Heaven saying: O Lord, Thou who governest Heaven and Earth and hast created all things; my ignorance be not so great that I follow any but Thee, have mercy on me. Forthwith he undertook to give away whatever he owned for love of the Creator of all. He went up on a mountain where there was a great hermitage: he entered and did penance as long as he lived: he grew old (*fu nella età*), he died in the time of Pope Martin. Some young men who tried to gain knowledge of the art of sculpture told me how skilled he was in one art and another and how he painted where he was living; skilled he was and he died in the 438th Olympiad. He was a very great draughtsman and very gentle (*docile*). Young men who desired to learn went to see him and when they begged him he received them most humbly, gave them skilled advice and showed them a great many proportions and made them many examples; he was most perfect, with great humility did he die in his hermitage. Altogether he was most excellent and of a most saintly life.

On the basis of Ghiberti's charming tale, Gusmin's place in the history of fourteenth century art can be reconstructed in outline. Legendary as the story sounds, its core is pure historical fact. Gusmin was a goldsmith and his work was well known to those of the craft. Ghiberti himself had seen "many figures cast after his." He admired them with critical appraisal. Gusmin lived at the court of a Duke of Anjou and, among other works, wrought for him a large golden altar. After the collapse of the Duke's fortune, he retired to a monastery and apparently lived there a long time. Young men of Ghiberti's acquaintance visited him in his hermitage. He died, apparently an old man, during the pontificate of Pope Martin V between 1417 and 1420.[42] Also, judging from the outlines of Ghiberti's tale, he did not live in Italy, but in what was to Ghiberti a faraway country.

Given all we know about the three dukes of Anjou, Gusmin's patron can only have been Louis I, brother of Charles V of France, Jean de Berry and Philip of Burgundy. Born in 1339, Louis died in 1384 amid unsuccessful campaigns to conquer first the nebulous Kingdom of Adria and then the scarcely more concrete Kingdom of Naples. Both his son and grandson inherited his Neapolitan dream and spent their lives and the remainder of their fortune in struggling for it. But neither of them owned any collections to speak of,[43] while Louis I, like his brothers, was one of the biggest patrons of art and collectors of goldsmith work of his time. It was he who ordered the splendid tapestries of Angers. His inventories enumerate a thousand and one sundry objects collected through the years 1360 to 1380, untold riches, goldsmith work strewn with rubies, pearls and emeralds, Roman cameos, translucent enamels, table plate, tapestries, and jewelry. Listed among the goldsmith work is a large golden altar. The term *une très grande table d'autel d'or*, corresponds exactly to Ghiberti's phrase for Gusmin's late masterpiece. This altar, along with many other fabulous treasures of the duke, was either sold or sent to the mint in 1381 in order to bring money for his "public needs," the conquest of Naples.[44] To those who appreciated goldsmith work, who knew its makers and collectors, the duke's bankruptcy and the consequent

[42] The date 1417-1420 results from Ghiberti's calendar of Olympiads; see App. B.

[43] Krautheimer, bibl. 247, pp. 27f and notes 14-20.

[44] Moranvillé, bibl. 345, p. 2; and pp. vi f; see also Laborde, bibl. 259, II, 1853, pp. 1ff and Ledos, bibl. 269, pp. 168ff.

dispersal of his treasures must have seemed no less notorious than his excessive riches. To them Louis I would have been *the* Duke of Anjou.

Gusmin, then, must have been in the service of Louis I of Anjou between the years 1360 and 1380. He would have been born around 1340. His origin, Cologne, is in keeping with the practice of French courts of that period of frequently hiring artists from the lower Rhine.[45] After the bankruptcy of his duke and the loss of his great golden altar, he retired from the world and died long after, presumably at the age of eighty. The young men of Ghiberti's acquaintance, who visited him in his solitude, were in all likelihood Ghiberti's own age. All the details of the story fall neatly into place, including Ghiberti's habit of not discussing his contemporaries. The termination of Gusmin's activities in 1381 puts him outside the category of a contemporary and placed him among the artistic ancestors.

Gusmin's *œuvre*, golden altar and everything, is lost. French goldsmith work of the late Middle Ages was all but completely destroyed from the fourteenth through the eighteenth centuries. Of the few remaining pieces, not one can be identified as the work of Gusmin, nor, for that matter, of any other single master. However, the little that survives is enough to convey a precise idea of how French goldsmith work of the late fourteenth century looked and thus to suggest the tenor of Gusmin's personal style. There is the magnificent Scepter of Charles V in the Louvre (Fig. 17), wrought before 1379 for *le sacre des roys de France*. Out of a fleur-de-lis rises the seated figure of Charlemagne, made of solid gold, but gilded to boot and beautifully chased. The head is forceful, the cheekbones strong, the nose aquiline, the eye sockets deep. Cloak and garment are articulated by long heavy, yet melodiously fluid folds, their ridges slightly broken. Closely related in style to the Scepter is the gold drapery of the so-called *Constantine* in the Bibliothèque Nationale, a fourth century crystal head which Charles V had mounted to put into Sainte Chapelle (Fig. 18). Another product of these royal ateliers is the *Libretto*, a reliquary formerly in the Baptistery of Florence and now in the treasury of the Cathedral, given by Charles V as a gift to his brother Louis I of Anjou. These works, plus some decorative pieces like mountings, jewelry, perhaps some bookcovers and one known piece of table plate, the Royal Cup of France now in London, are the outstanding surviving relics from French goldsmith shops of the seventies and eighties.[46] Another group, dating slightly later, the majority from the

[45] Krautheimer, bibl. 247, p. 29, notes 31-33, with further bibliography.

[46] The Scepter of Charles V (Louvre, Gallerie d'Apollon) appears as no. 3449 in the inventory of the treasures of Charles V, drawn up in 1379 (Labarte, bibl. 257, pp. 353f). It was certainly not made for the *sacre* of Charles V in 1365. Darcel (bibl. 115, p. 570, D 943) gives a careful description. The staff, probably from a cantor's baton of 1394 from Saint Denis, was added in 1804; see also Krautheimer, bibl. 247, p. 30, note 35, with further bibliography.

For the Constantine, now in the Cabinet des Médailles of the Bibliothèque Nationale, see Babelon, bibl. 28, p. 128, no. 14; for the *Libretto* in Florence, see Poggi, bibl. 415. Outstanding among the mountings of jewelry of the royal ateliers are those of the large cameo with Jupiter and the Eagle offered by Charles V to the Cathedral of Chartres (Paris, Bibl. Nat., Cabinet des Médailles; Babelon, bibl. 28, p. 137) and of the Lothar crystal (British Museum; Dalton, bibl. 113, pp. 103ff). The bookcovers (Paris, Bibl. Nat., lat. 8851, 8892, 9455, 14497) are discussed by Bouchot, bibl. 65 *passim*, the *Royal Cup of France* by Dalton, bibl. 112. See also Krautheimer, bibl. 247, pp. 30f, notes 39-45, with reference to additional pieces of goldsmith work lost or of inferior quality.

reign of Charles VI (1380-1422), is given color and increased lavishness by the addition of shiny enamel on all or on part of the metal surfaces. A few of the best from this group are: a delicate reliquary altar in Amsterdam, sheltering an *imago pietatis*, with Mary and Saint John in the wings and a Coronation of the Virgin on top; a small half figure of Saint Catherine from a convent in Clermont-Ferrand, now in New York; a splendid *Virgin Annunciate* in the Louvre, her figure gilded, her hands and face enamelled; the magnificent Reliquary of the Holy Thorn in London, dated between 1391 and 1407 (though closer to the latter), according to the coat-of-arms of Louis I d'Orleans; the *Madonna of the Folding Chair* in Toledo, Spain; the Reliquary of the Holy Spirit in the Louvre, a *Calvary* in Gran, Hungary, and a number of smaller pieces; finally the *Golden Roessel* in Altoetting, dated 1404, and the *Trinity Morse* from the Widener collection in the National Gallery, Washington, D.C.[47] A number of these French pieces entered Italian collections early: a *pax* with an *imago pietatis* from Montalto which, in 1457, belonged to Cardinal Pietro Barbo, later Paul II; a similar piece in Arezzo, with the *imago pietatis* on the obverse side and Mary and John on the reverse; a sardonyx with another *Pietà*, now in the Argenteria of the Pitti Palace.[48]

What little is left of these small masterpieces is superb in quality. They represent the peak of late fourteenth century art. Their market was not the "common man," but the wealthiest, most sophisticated connoisseurs in Europe at the time. These valuables formed the bulk of their princely riches, of the treasures in their chapels, the plate in their households and their personal jewels. They were curios coveted by every collector and, last but not least, they represented large scale investments in stable values, easily sold, pawned or sent from place to place, light cargo of major import, going the routes of commercial traffic and helping to spread new concepts of design.

Insofar as these valuables from north of the Alps were widely sought and highly priced, Italian goldsmiths were on the lookout for them for purposes of trade or for use as models. If originals could not be procured, copies in less expensive material or plaster casts could always be obtained. Casts of Gusmin's work were what Ghiberti had seen, *figure formate delle sue*.

As a rule, Ghiberti shows little enthusiasm in the *Commentarii*. Quite to the contrary, he is somewhat critical and matter-of-fact. The only two "moderns" whose

[47] A catalogue with abundant bibliography of these gold-enamelled pieces is found in Th. Müller and E. Steingräber "Die französische Goldemailplastik um 1400," Münchner Jahrbuch für bildende Kunst, N.F., v (1954), pp. 29ff. The publication reached me through the kindness of Dr. Müller as my manuscript was going to press. For the period on which I have concentrated, prior to 1420, the authors have added beyond those enumerated above only a few objects and I don't know whether to rejoice over the relative completeness of my provisional list or to feel dejected that, indeed, only so few of these precious works of art have survived.

The Annunciation in the Louvre (*legs* Duseigneur 1946), to my knowledge has never been published.

[48] The Montalto *pax* is described in 1457 in the inventory of Paul II, then Cardinal of Vicenza. It came to Montalto as a gift of Sixtus V (Zippel, bibl. 562, pp. 252ff; Swarzenski, bibl. 514, p. 69; Serra, bibl. 490, ii, pp. 492ff). The Arezzo *pax* was donated to the Cathedral of Siena in 1464 by Pius II (Salmi, bibl. 461, pp. 17f). The Pitti Sardonyx was first published as Burgundian by Kris (bibl. 254, i, p. 14, no. 6) and discussed more recently by Swarzenski (bibl. 514, p. 70).

work truly fascinated him were Ambrogio Lorenzetti and Gusmin. Gusmin excited his admiration; he personified to him the superb quality of the work done by the great French goldsmiths of the recent past. Ghiberti knew, if anything, a good work of art when he saw it.

Considering how warm his appreciation of these precious products, it would be altogether strange if his own work showed no trace of their effect. Time and again his competition relief and the first quatrefoils of his North Door reflect the patterns of French goldsmith work from the last third of the fourteenth century. The head of Charlemagne on the Scepter of Charles V (Fig. 17), with its furrowed forehead, fine aquiline nose, and bushy brows, foreshadows the heads of Abraham and the older servant in the competition relief (Pls. 2a, b). Like the French goldsmith, Ghiberti has built the head up from its bone structure, the skin tightly drawn over the cheekbones, jaw, and forehead, each wrinkle marked. Yet, again like the French sculptor, Ghiberti has merged this detailed, precise modeling into a monumental pattern. The hands of both Charlemagne and Abraham keep a convincing grasp on what they hold, the Emperor's globe and the Patriarch's knife, while at the same time their structure is strangely summary. Like the hands of Charlemagne, those of Ghiberti's men in the competition relief have long thin fingers, the joints scarcely marked, the nails short and barely indicated, the backs smooth, without veins and tendons, very much in contrast to Brunelleschi's anatomical rendering. Abraham's mantle, its deep hanging folds slightly twisted and indented, likewise recalls the seated Emperor. The drapery of the *Constantine* in the Bibliothèque Nationale, its long interlocking grooves and curved folds drooping over the back and falling over the arms in cascades of fine cloth, anticipates the garments of Abraham and the servant seen from the back in Ghiberti's competition relief (Fig. 18).

The modeling of drapery and anatomy, the fusing of true-to-life details into graceful linear patterns, are mutually shared concepts of sculpture. Obviously Ghiberti did not know the Scepter of Charles V or the *Constantine*, but he was intimately aware of the *ambiente* whence they came as personified for him in the art of Master Gusmin. What impressed him about the royal goldsmiths of France was a particular approach that remained throughout his life a fundamental constituent of his own art. As expressed in his own words, the grounds for his admiration lay first in the precision and neatness of workmanship, the "perfection," second in the marvelous realization of heads and nude parts, their convincing appearance, and third in the "gentle air" of these works, their sweetness and unsentimental melodiousness. The combination of forceful credibility, melodious sweetness, precise workmanship and precious refinement, for which Ghiberti praises Gusmin, remained essential to his own *œuvre* from the *Sacrifice of Isaac* to the Gates of Paradise.

His express esteem for precise and subtle workmanship runs like a leitmotif through the *Commentarii*. He sets great store by it, whether remarking upon an antique gem, a choice product of Master Gusmin or one of his own pieces of goldsmith work. Putting the same emphasis on well-tooled minutiae as on his major works, the two bronze doors of the Baptistery, Ghiberti describes the tiny details of diligent lettering and mounting

of the Medici Cornelian (Dig. 152), the miters of Martin V and of Eugene IV (Digs. 64, 222), metalwork, precious stones and pearls with the affectionate devotion of a goldsmith to his materials and craft.

The appearance of Ghiberti's art shortly after 1400 was not, then, a throwback to Sienese painting of the early Trecento. Whatever is "Gothic" about it directly reflects the influence of surviving and revived early Trecento elements in French art of the last third of the fourteenth century.

Even so, Ghiberti's early style is easily distinguished from the French masterpieces of the seventies and eighties. His figures are more slender in proportion than the "somewhat squat" figures of Master Gusmin and his contemporaries. They move more freely within the space suggested by their own stances and gestures, as well as by shelter-ing rock cavities. Their tactile values are more strongly brought out, they bear the im-print of the art of antiquity. Their draperies stress decorative linear patterns more strongly than did the art of the seventies in France, their stances are more melodious. Their melodiousness, their decorative linearism, and their comparatively greater slenderness to some degree recall the characteristics of the beginning International Style which in the last two decades of the fourteenth century was shaping in France in the workshops of goldsmiths and enlumineurs. Some faint echoes of this new style would seem to have reached Ghiberti by 1400. Yet, it is more important to realize that to a young goldsmith in Florence about 1400 the style of master Gusmin, that is of the French goldsmith shops of the seventies and eighties, would still be a new and very exciting language and a decisive element in shaping his own style. At the same time, in the decade immediately preceding Ghiberti's competition relief the Hercules Master had implanted new concepts into Florentine sculpture based on a strong feel-ing for tactile values and the beauties of antique art. In this atmosphere Ghiberti grew up, presumably influenced by it at precisely the same time he made his acquain-tance with French goldsmith work of the seventies and eighties. The currents repre-sented by the Hercules Master, on the one hand, and French goldsmith work, on the other, were both new to Florence, both alien to older traditions developed during the Trecento and retained by Ghiberti as a determining factor in his competition relief.

THE BRONZES AT OR SAN MICHELE

CHAPTER VI

SAINT JOHN AND THE INTERNATIONAL STYLE

Wiтн the competition relief done when he was twenty or a little older, the stage was set for Ghiberti. The three bronze statues at Or San Michele mark the subsequent development of his art over the next twenty-five years. Although they by no means represent the whole picture, they stand as milestones in the unfolding of Ghiberti's figure style. At the same time they establish his position in European sculpture of the first two decades of the fifteenth century, his place in the nascent movement of a Florentine Renaissance, and finally his emergence as a highly individual exponent of a clearly marked current in early Renaissance sculpture. The three statues are the *Saint John the Baptist*, 1412-1416, the *Saint Matthew*, 1419-1422, and the *Saint Stephen*, 1425-1428 (Pls. 3-17).

The history of Or San Michele can be summed up in very few words.[1] In 1336, in order to replace the old market hall, the city council decided to build the *palatium Orti S. Michaelis*, a corn exchange building with an oratory of the Virgin on the ground floor, opening onto the street through arches on all four sides. In 1339 each of the guilds was assigned one of the thirteen niches in the ten supporting piers in which was to be placed a statue of its patron saint; later the number of niches was increased to fourteen. At this point, only the *Arte della Lana* fulfilled its obligation, setting up in its niche a stone statue of Saint Stephen.[2] Corresponding plans made in 1340 by the *Arte di Calimala* and *Arte della Seta* evidently fell through.[3] Real progress was made only sixty years later after the interior decoration was almost completed: Orcagna's tabernacle of the Virgin, 1352-1360; the tracery inserted in the open arches, 1366-1380, and the walling-up of these arches sometime after 1380; finally, between 1350 and 1409, the murals of the interior.[4] In 1399 the *Medici e Speziali* had a statue of the Virgin placed in a niche in the south side.[5] About the same time the *Arte della Seta* set up a marble figure of Saint John the Evangelist.[6] Between 1403 and 1406 the *Giudici e Notai* erected a statue of Saint Luke[7] and in roughly the same years the *Vaiai e Pellicciai* followed suit with a statue of Saint James Major, the former almost certainly, the latter probably by Niccolo Lamberti.[8] In 1406 the city council pressed the matter fur-

[1] Paatz, bibl. 375, IV, pp. 480f, with references to the older bibliography; Gaye, bibl. 173, I, pp. 46ff; Passerini, bibl. 391; Franceschini, bibl. 164; Davidsohn, bibl. 118, IV, pp. 150f.

[2] Paatz, bibl. 375, IV, pp. 504, and note 177.

[3] Passerini, bibl. 391, p. 20 (132); see, however, Paatz, bibl. 375, IV, p. 504 and note 178.

[4] Paatz, bibl. 375, IV, p. 500 and notes 155ff; pp. 483f and notes 33ff; pp. 495ff and notes 115ff; Passerini, bibl. 391, pp. 13ff (125ff).

[5] Paatz, bibl. 375, IV, p. 493, and notes 94f. Recent attributions agree that Niccolo di Piero Lamberti was its author.

[6] Now at the Ospedale degli Innocenti and attributed to Piero di Giovanni Tedesco by Schmarsow, bibl. 485, p. 51. Paatz (bibl. 375, IV, p. 553, note 178) sees the manner of Andrea Pisano in the statue. In my opinion there can be no doubt but that it is a late fourteenth century statue and probably by Jacopo di Piero Guidi.

[7] Now at the Bargello; Paatz, bibl. 375, IV, p. 504 and note 181, with reference to the documentary evidence. Replaced in 1601 by Giovanni da Bologna's statue.

[8] The various attributions of the figure of Saint James Major, including one to Ghiberti (Ven-

ther, setting a deadline of ten years for the guilds to meet their obligation.[9] Presumably as a result of this ultimatum, activity was accelerated: the *Arte di Pietra e Legname* commissioned the group of the *Quattro Coronati* (Fig. 19), the blacksmiths ordered the *Saint Eligius* and the cobblers the *Saint Philip*. None of these statues are dated, but all were clearly executed by Nanni di Banco, probably between 1410 and 1416.[10] The statue of Saint Peter, patron saint of the *Beccai*, the butchers, is also undated and may have been done in collaboration by Nanni di Banco and Donatello or by a master under their mutual influence.[11] In 1408 the *Linaiuoli e Rigattieri*, the linen weavers and rag dealers, entrusted the statue of Saint Mark to Niccolo Lamberti and in 1411 transferred the commission to Donatello (Fig. 20)[12] and apparently in 1417 the *Corrazzai*, the armorers, commissioned him to do the *Saint George*.[13]

All the statues ordered after 1400 were the commissions of relatively minor guilds. Thus it is astonishing that only those few commissioned at the beginning of the new spurt of activity were entrusted to conservative workshops like that of Niccolo Lamberti. About 1410 a radical change took place. In an amazing about-face, the guilds, including insignificant ones like the cobblers and armorers, began handing over their commissions to the two leading rebels among Florentine artists: Nanni and Donatello. The switch from Niccolo Lamberti to Donatello, made by the *Linaiuoli e Rigattieri* in 1410-1411 highlights the situation. Of the major guilds, the *Arte della Lana* and the *Arte della Seta* may be said to have acted with premature zeal in commissioning their statues in 1339 and about 1400 respectively. The other big guilds, notably the *Calimala* and the *Arte del Cambio* had so far been holding back.

Such was the atmosphere in which the consuls of the *Calimala* began to discuss plans for a statue of their patron saint, John the Baptist (Pls. 3, 4). Few of their deliberations are known, but the general course of events can be surmised from scattered excerpts in Strozzi's notes. Moreover, Strozzi's index to the *Libri Grandi* of the *Calimala* contains

turi, bibl. 534, VI, pp. 141f), have been summarized by Paatz, bibl. 375, IV, p. 493 and note 93. Paatz hesitantly thinks of Niccolo di Piero Lamberti or his son Piero about 1420. In my opinion the statue is close to Niccolo di Piero Lamberti's statue of Saint Luke and his Saint Mark from the façade of the Cathedral, now at the Museo dell'Opera del Duomo. Hence, it should date approximately 1405-1410. The relief on the socle of the niche likewise bespeaks an early date. Schlosser has suggested, not convincingly, that it was executed after a design of Ghiberti's; see Ghiberti-Schlosser, bibl. 178, II, p. 183, note 7.

[9] Passerini, bibl. 391, p. 19.

[10] The *œuvre* of Nanni di Banco, both in its chronological sequence and significance for the beginnings of the Renaissance remains to be explored; the best contribution so far remains Lanyi's brilliant study, bibl. 264. A recent monograph by Vaccarini, bibl. 528, has contributed little but confusion, due to the author's tendency to exalt Nanni's leading position over Donatello's; certainly the sequence he suggests for Nanni's work at Or San Michele—*Saint Philip*, 1409-1411; *Quattro Coronati*, 1412 (?); *Saint Eligius*, 1413-1414—appears to be reversed. No documentary evidence exists for any of these figures. But at least the sequence suggested by Paatz (bibl. 375, IV, pp. 492 and note 90; 494f and notes 110f): *Saint Eligius* 1410-1411, the *Quattro Coronati* 1410-1411 (?), the *Saint Philip* 1412-1414 (?), is correct. Regarding the dates I would strongly favor dating the *Quattro Coronati* around 1412, the *Saint Philip* around 1416.

[11] Paatz, bibl. 375, IV, p. 494 and note 118 with attribution to Donatello, based on Manetti, bibl. 293, p. 164.

[12] Paatz, bibl. 375, IV, p. 493 and note 92; documents in Gualandi, bibl. 196, IV, pp. 104ff.

[13] Paatz, bibl. 375, IV, p. 495 and note 113.

a large batch of references which concern the niche and statue, although they do not specify the state of progress. The first is an isolated entry for the year 1405 referring to the "Figura del Pilastro d'O[r] S. M[ichele]." Such indefinite references become more and more frequent from 1409 through 1412, numbering from seven to twelve annually, and in 1414 and presumably in 1415 reach a peak of several dozens per year (Digs. 16, 38; Doc. 80).[14] They are supplemented in Strozzi's excerpts by only a few items where the project of Or San Michele is described in some detail. An entry taken from the *Deliberazioni dei Consoli* for 1407 records the consuls' decision "to have the pilaster of the guild at the palace of Or S. Michele decorated" and to appoint an appropriate committee of three to look after the matter (Dig. 23; Doc. 63). The decoration of the niche in mosaic and stonework also got under way, for between 1414 and 1416 several payments are listed for this purpose (Digs. 32ff, 42, 46ff). An item from the account book of the *Calimala* for 1413 mentions, "the figure for the pilaster of Orto S. Michele (which) is being worked on" (Dig. 31; Doc. 54). Ghiberti, in the *Commentarii*, seems to say that the statue was set in place (*puososi*) in 1414,[15] but Strozzi's excerpts indicate that it was set up in 1416 (Dig. 48; Doc. 53) and the gilding, what little there was, not done before 1417 (Dig. 56; Doc. 56). A slightly later, but apparently reliable note quotes the cost of the *Saint John* as roughly 530 florins (Dig. 57; Doc. 129). A comparison between this amount and both the total cost, 1,100 florins, and the fee, 650 florins, paid to Ghiberti for the *Saint Matthew* suggests that the 530 florins for the *Saint John* was merely Ghiberti's remuneration, in excess of other expenses. Finally, Baldinucci quotes a crucial passage from Ghiberti's lost diaries, dated December 1, 1414: "In the following I shall record all the expenses I shall have for casting the figure of Saint John the Baptist. I undertook to cast it at my own expense; in case of failure I was to forfeit my expenses; in case of success . . . the consuls and *operai* . . . were to use toward me the same discretion that they would use toward another master whom they sent for to do the casting. On the above day I shall start taking note of all the expenses that will occur in the casting" (Dig. 36; Doc.163).

The decree issued by the city council in 1406 gave the major guilds the right to erect statues in bronze rather than in stone. The granting of this permission clearly opened new vistas for monumental sculpture in Florence. Possibly the bronze doors of the Baptistery, under way under the auspices of the *Calimala*, gave impetus to the use of a more costly and difficult medium. One is even tempted to wonder whether the decree of 1406 might not have been issued at the request of the *Calimala* who, taking pride in the door-in-process, may have been eager to try a hand at another bronze undertaking, a bronze figure for the sanctuary of the guilds, large, conspicuous, weatherproof, expensive, and somewhat ostentatious. Only an organization as wealthy as the *Calimala* or some other major guild could have afforded to spend ten times the cost of a stone statue on a bronze figure of equivalent size. In any event, Ghiberti's commission for the *Saint John* initiated a competitive drive among the other major guilds to likewise

[14] Regarding this index of Strozzi and the related problem of dating the lost *Libri Grandi* of the *Calimala*, see App. C 1, p. 364, and note 13.

[15] Ghiberti-Schlosser, bibl. 178, I, p. 46.

set up large bronze statues. A new field of activity and thereby of business was opened, especially for Ghiberti and his workshop. In 1419 the *Arte del Cambio* turned to him for a statue of Saint Matthew and in 1425 the *Arte della Lana* decided to replace the old stone statue of Saint Stephen with a new bronze figure cast by Ghiberti. Only the *Parte Guelfa* prior to 1423 awarded to Donatello a commission, that of the bronze statue of Saint Louis.[16]

The *Calimala* did not come easily to its decision to entrust the statue of its patron saint to Ghiberti. Not only was the initial decision of 1407 "to have the pilaster decorated" separated by an interval of nearly two years from the implementing discussions of 1409 through 1412, but it would seem from the great number of entries in the *Calimala* records for these years that debate on the matter was prolonged. Indeed, although the guild did not proclaim a competition, the quotation from Ghiberti's notebooks suggests that a competitive estimate was requested from at least one other master. As usual in the fifteenth century, the ultimate price paid for the work was left to the discretion of the guild. Ghiberti's journal also states that the casting began December 1, 1414. Insofar as both the *Saint Matthew* and the *Saint Stephen* were started two years before their casting commenced, it is reasonable to assume that a similar amount of time intervened between the casting and preliminary stages of the *Saint John*. Hence, the design itself would have been started late in 1412 or early in 1413, a dating which tallies with the references from the account books of the *Calimala* for 1413. Ghiberti's statement thirty years later to the effect that the statue was set up in 1414[17] may simply allude to the completion of the cast that year—a year *stile fiorentino*, of course, thus including the first three months of 1415. Also the abundance of references in the *Libri Grandi* 1414 and 1415 confirms the impression that the shop was more than usually active just then. The statue would have been chased in 1415 and 1416. At the same time, work continued on the niche, from 1414 to 1416. In any case, a date for the *Saint John* of between 1412 and 1413, rather than 1414 or later, is consistent with the style of the figure.

No statue as large as the *Saint John* had ever before been cast in Florence. Ghiberti himself had had no previous experience with modeling and casting on such a scale. One can understand the guild's wary tactics, as witnessed in Ghiberti's journal, of letting the risk of failure devolve on the sculptor's own shoulders. One must also admire Ghiberti for his self-reliance in taking the risk. Rising from its base to a height of 2.55 m, or 4⅓ *braccia*,[18] under the protective arch of a Gothic niche, the statue must

[16] The niche was commissioned in 1422 (Poggi, bibl. 417, p. 8, quoting the document). In 1423 a sum of 300 florins was set aside "to have the statue finished" (Fabriczy, bibl. 147, pp. 242ff and Poggi, bibl. 417, pp. 8 and 18, doc. 1). Judging from the analogy to the payment for Ghiberti's *Saint Stephen* (see below, p. 94), one would conclude that in May 1423 the *Saint Louis* was modeled but not yet cast. Carrying the analogy further, one suspects that Donatello had started modeling the *Saint Louis* one or two years before, in 1421 or 1422.

[17] Ghiberti-Schlosser, bibl. 178, I, p. 46.

[18] The sheltering niche, like the base of the statue, is the handiwork of a reliable stonemason, Albizzo di Piero (Dig. 42), who was frequently employed at Or San Michele (e.g. *ASF, Archivio dei Capitani di Or San Michele*, vol. 261, c.2v). The mosaic was apparently executed by the Dominican Fra Bernardo di Stefano (Digs. 46, 48), but what was his share and what that of the painters' firm, Giuliano di Arrigo and partners, in the work, including the mosaic frieze by the latter

have struck Ghiberti's contemporaries as an unparalleled achievement. The cast is hollow, the bronze quite thin, barely 5 mm thick.[19] Judging from the methods used for the *Saint Matthew*, the figure was evidently cast all in one piece[20] from a form modeled in wax and packed in clay. Despite the large scale of the figure, the chasing is markedly fine and detailed. Only in the back, below the cloak collar, was the rough cast permitted to remain, smoothed over by a few chisel strokes. Otherwise, every curl of the goatskin, beard and long hair is finely chased, including two long coils, one falling down the back, the other dangling over the left shoulder. Drapery, chest, throat, cheeks, and forehead are smooth and polished.[21] The cheekbones protrude sharply and the forehead is clearly modeled, receding deeply at the temples (Pls. 5, 10a). The brow overshadows the sunken sockets of the eyes and the lips are beautifully sensuous. The beard grows softly along the cheeks and a few locks of hair fall over the forehead. Hair and beard are modeled by the bold curving strokes of the spatula. The eyebrows are engraved in rows of elegantly waved grooves, the lids and pupils are marked by thin lines and the cornea is formed by a shallow circular scoop. Hands and feet are shaped in every detail, the veins and tendons of the bare arms standing out strongly beneath the skin, the knuckles and joints of each bony hand outlined clearly, the nails of toes and fingers sharply set off. Below the pointed collarbones and deep groove of the throat, the goatskin is tied in an involved bow. The feet are clad in double-knotted sandals (Pl. 13a). The hem of the cloak, engraved in a thin cufic ornament, bears isolated letters in small circles forming the signature OPUS LAUR[E]NTII.[22] Only the hem shows traces of gilt and this tallies with the frugal sum of five florins spent on gold (Dig. 56; Doc. 56).

The statue of the Baptist stands apart from the rest of Ghiberti's work through distinct features. True, like the competition relief it literally transcribes reality in the form of carefully observed details, such as bone structure, tendons and veins, the curls of the goatskin. But while the figure rests determinedly on the left leg, its solidity is counteracted visually by the curve of the shoulders, the sweeping folds of the cloak, the backward bend of the body, the slightly protruding abdomen and the forward thrust of the head and neck (Pls. 4, 9a). Rich folds of drapery tend to conceal the body. Two massive cascades, dangling from the hip, frame these melodiously swaying folds, the

(Dig. 47), remains undetermined. The pediment of the niche originally contained a mosaic half figure of a prophet or John the Evangelist. It was attributed to Ghiberti by the Anonimo Magliabecchiano (bibl. 22, p. 71), Vasari-Milanesi (bibl. 533, II, p. 232) and Baldinucci (bibl. 35, I, p. 351), who was the last to see it. No trace is left and the attribution cannot be checked; see also Paatz, bibl. 375, IV, p. 504 and note 101, and Haftmann, bibl. 203, p. 103.

[19] In their narrow niches, the three figures cannot be closely inspected and no investigation of them was made before they were put back in place in 1946. But at that time a number of photographs were taken by the Sopraintendenza ai Monumenti and I am greatly indebted to both Dr. Filippo Rossi and Cavaliere Bruno Bearzi for providing me with such excellent records.

[20] A few small parts, such as the second toe on the left foot, were apparently recast and fitted on.

[21] Corrosion is apparent in only a few spots, mostly on the right shoulder and the neck.

[22] Schlosser, in Ghiberti-Schlosser, bibl. 178, II, pp. 174f had given the inscription correctly. But both he (bibl. 477, p. 38, note 12) and Planiscig (bibl. 404, p. 96) rendered it erroneously as LAURENTIUS GHIBERTUS MCCCCXIV, and indeed even earlier the Anonimo Magliabecchiano had given it as LAURENTIUS GHIBERTUS—a reading not only out of keeping with Ghiberti's civil status prior to 1444 but simply not there.

right one joining the curving fall of drapery from the shoulder. The cloak's hem ripples with an ornamental design (Pls. 4, 11a). Long curls fall on the shoulders, the moustache and beard move in symmetrical double curves (Pl. 5). Fragments of a literal realism lie embedded in a decorative pattern far richer than anything ever dreamt of by Ghiberti when he made the competition relief or, for that matter, by the French goldsmiths of the fourteenth century. The entire figure of the *Saint John* is marked by the interplay of soft dreaminess and hard reality, the face recording a blend of languor and savagery.

The style of the *Saint John* is far removed from that of the competition relief. Its beginnings in Ghiberti's *œuvre* appear first in the *Assumption* window which he designed for the Cathedral in the winter of 1404-1405 (Fig. 7).[23] True, the overall design of this window harks back to Bartolo di Fredi's *Assumption* of 1388 in Montalcino (Fig. 8), and Ghiberti's Virgin, solidly and a trifle heavily planted amidst a host of angels, shows not yet the rich flow of draperies that envelops the *Saint John*. But the angels float about the Virgin, bending and swaying, their bodies hidden beneath soft draperies, surrounding her in garlandlike, curvilinear patterns. The same tendencies prevail in a large group of Ghiberti's quatrefoils for the North Door, as witness the *Temptation*, and the *Agony in the Garden* (Pls. 33, 43). External and internal evidence places the majority of these quatrefoils between 1407 and 1415.[24] Against the background of these works, the *Saint John* should be viewed.

At the time of the competition, Ghiberti's workshop was the outpost for a new movement which had introduced to his native city concepts springing from French art. It is natural that Ghiberti continued also in later years to look beyond the pale of Florence at developments north of the Apennines and the Alps. When he started work on the *Saint John*, the art of Master Gusmin, the art of the seventies and eighties, had grown obsolete. With the statue of the Baptist Ghiberti took up a new style which, during the whole first quarter of the fifteenth century, prevailed in all Western Europe, the International Style.[25]

Born of the art of the seventies and eighties, the International Style inherited from its elder both decorative lyrical traits and hard realism. But it would seem that by 1390, these components which had been blended in the courtly art of Master Gusmin and his contemporaries began to change in character. A lyrical narrative, expressed in

[23] Ghiberti-Schlosser, bibl. 178, I, p. 51. Ghiberti lays specific claim to the design of this window "on the façade of S. Maria del Fiore, in the round window in the center the Assumption of Our Lady." The documents (Dig. 13f) mention payments only to the glass painter Niccolo di Piero, including one "pro desingno quod fecit ochuli anterioris ecclesie s. Reparate." Still, this implies no inevitable contradiction: the glass painter would have to make a large cartoon from Ghiberti's preliminary and possibly small drawing. See also van Straelen, bibl. 508, pp. 53ff, in contrast to Poggi, bibl. 413, p. lxxxi. For Bartolo di Fredi, see Faison, bibl. 150.

[24] See below, pp. 123ff.

[25] In discussing the International Style, I refer time and again to Panofsky's masterly presentation, bibl. 380 *passim*. Like Mr. Panofsky, I am deeply convinced that the term is misleading. Certainly the art around and shortly after 1400 was no more international than the immediately preceding phase of realism. Perhaps one could say that the new style spread from the courts into an upper-class bourgeois and even into a popular lower-class milieu. But throughout, the term must be used with such mental reservations as the historian will apply to any stylistic terminology.

calligraphic patterns, is at the very center of the new style. Realistic traits are in no way lost. But more often than not they are turned into convincing by-play of a fairy tale narrative. Unreality and reality mingle in a texture of rich lines, colorful sophistication, and ornate luxury. High society and its Biblical and legendary counterparts are no longer portrayed in a true-to-life manner, but become, instead, idealized and sophisticated. On the other hand, stark descriptive realism continues to be the determining factor in portraiture and in the presentation of "nature, animals and the lower classes."[26]

From the very start the International Style contained seeds of rebellion against the literal realism that had formed a basic constituent of art in the preceding generation. It looked back with nostalgia to a time before the fall of man into realism. Thus, along with linearism the new art inherited from the seventies and eighties, a yearning after the Gothic past. The Limbourg brothers and Lorenzo Monaco revived the types and compositions of Simone Martini, Ambrogio Lorenzetti, and Taddeo Gaddi. At the same time, however, the new generation, having eaten of the fruit of realism, could not return to medieval concepts in complete earnestness. Like the art of the seventies and eighties, the International Style is no longer Gothic, but it is post-Gothic. It is not so much a last flowering or waning as a romantic revival of the High Middle Ages.

Stories presented from the Holy Scriptures change in character. The Adoration of the Magi turns into a fairy tale; the Virgin (we are thinking of the *Très Riches Heures du Duc de Berry*) is dressed in a sky-blue cloak. She presents the child ceremoniously. The oldest king has sunk down, the second lies prostrate in *proskynesis*, the third kneels somewhat stiffly in adoration. The realism of the preceding decades is here confined to the suite of the three kings, composed of decorative Orientals, a few colored men in their midst. Dressed in the rich garments of the East, wearing turbans and oriental casques, they have brought along not only Arab horses, but even hunting *cheetahs*. The flasks they carry and the rug on which the Virgin is seated are as genuinely Moslem in workmanship as the castles in the landscape are French. But these elements of reality are not used for their own sake; whether plucked from the fabulous reality of the Near East or from the surrounding presence of contemporary France, their aim is to add a rich and exotic note to the fairy tale, as well as lend it that air of credibility which fairy tales require.

Alongside these religious fairy tales, secular themes come to the fore. Wild men roam the forests in half idyllic savagery, as a typological counterpart to the elegant courtiers for whom they were depicted. Beggars and villains appear at their lowly everyday tasks, more often than not the butt of jokes.[27] Arthurian legends, together with chivalresque reinterpretations of the Trojan wars and other Greek and Roman legends, both in vogue since the mid-fourteenth century, become more than ever popular. It is tempting to view the International Style against the aftermath of the bloody defeat of the social revolutions that broke out during the decades between 1365 and 1385: the

[26] I am borrowing this formulation from Mr. Panofsky who, as I recall, coined it in a lecture at Vassar College in about 1950; see also his book, bibl. 380, pp. 70f.

[27] Warburg, bibl. 545, I, pp. 221ff; Schlosser, bibl. 474, pp. 304ff.

Jacquerie, the Wat Tyler riots, the revolt of the *Ciompi.* Very possibly the style reflects a desire for self-assertion on the part of the victorious forces. Royalty and nobility had been forced, during their struggles, to replace feudal ideals with the new economic philosophy advanced by a powerful ally, high finance. Just for this reason they retained, with nostalgic longing, the hollow shell of chivalresque customs. At the same time the upper bourgeoisie adopted these same empty fashions, purchasing castles and decorating them with Arthurian cycles in an attempt at self-ennoblement.[28]

This background and the characteristics of the new style are perhaps better known than its specific beginnings. It would seem to have originated at the courts of Paris and Prague during the last decades of the fourteenth century. The calligraphic and lyrical elements featured in the seventies began to spread outside the shops of goldsmiths and *enlumineurs* and beyond their original domain, the realm of supernatural figures. Perhaps as early as the eighties, and certainly by the nineties these decorative elements had invaded the entire realm of art. The new style came to the fore in book illustration, possibly as early as 1380. To cite a few scattered dated examples: the figure of the Virgin on the "first dedication page" of the Brussels *Hours;*[29] prior to 1391 the small gilded wooden figures and reliefs which Jacques de Barze carved for the Dijon Altar (Fig. 23);[30] between 1391 and 1399 Broederlam's paintings for the wings of the same altar, and prior to 1397 two female saints of Klosterneuburg in Austria.[31] By the turn of the century the movement had gathered full force. Sluter's prophets on the Well of Moses are somewhat old-fashioned in their descriptive realistic traits and monumental weightiness, for, as a rule, figures of the new style are nearly weightless, disappearing behind walls of ever richer drapery. They swing ever more elegantly in sophisticated subtle gestures. Folds of garments roll and curl in ever richer calligraphic curves. Compositions are flattened, and the boundaries between sculpture, painting, and metalwork grow ever less strict. Wooden figures are clad in gilded garments, the gold contrasted to the shiny flesh color of their faces. Goldsmith work is covered with bright enamel, and sculpture is presented in large pictorial ensembles.[32] The new style had enormous appeal, pleasing both sophisticated and popular taste and spreading far and wide. Works by the Boucicaut master and the Limbourg brothers, executed for the most expert connoisseurs of Europe, rest side by side with dozens of saints by the Sluter school, carved for small rural churches in the Burgundian countryside. The *Schoene Madonnen,* soft, lyrical, and lovely, their bodies hidden under rich drapery, are scattered about village and convent churches of Bohemia, Austria, France, and the Rhine-

[28] Huizinga, bibl. 223 *passim;* Panofsky, bibl. 380 *passim;* Krautheimer-Hess, bibl. 253, pp. 103f.

[29] Brussels, Bibl. Royale, ms. 11060/61; see Panofsky, bibl. 380, pp. 46f, for the interpretation of the miniature as a first dedication page of a date earlier than the rest of the manuscript.

[30] Kleinclausz, bibl. 244, pp. 256f. Closest to the tenets of the International Style are figures such as Saint John the Evangelist in his wide cloak, overhung by rich cascades or scenes such as the group of women in the Crucifixion and Mary and Joseph in the Adoration of the Magi.

[31] Garger, bibl. 171.

[32] Panofsky (bibl. 380, pp. 77ff) convincingly as always brings out the pre-eminence of the pictorial qualities in the sculpture of the International Style. See also Müller and Steingräber, as quoted above, p. 65, note 47.

land.[33] Time and again one is reminded of Ghiberti's *Saint John*, whether in looking at a charming figure like the Saint Paul at Baume-les-Messieurs (Fig. 22) or at the drapery of a French *Schoene Madonna* (Fig. 24).

How this style spread south to Italy is less well known. Italian studios appear to have had access to its formulas and principles shortly before 1400. The spread of the new fashion was facilitated through the increasing exchange of artists, model books, casts and *objets d'art* which traversed the Alps throughout the fourteenth century supported by the close ties between courts and high finance in France, Italy, and Bohemia. Ghiberti, by the time he designed his competition relief, had absorbed the rudiments of the new style through his knowledge of late fourteenth century goldsmith work from French ateliers. But all in all Tuscany remained for some years almost immune to such outside influences in the years that workshops north of the Apennines were assimilating the full-fledged International Style, beginning with Milanese book illustration, around the end of the century.[34] By 1400 the style had already made an appearance, in such a remote spot as the small country church of S. Maria de' Ghirli in Campione, in the *Last Judgment*, signed and dated by Franco and Filippolo de' Veris.[35] Besides Michelino,[36] the long-lived and as yet somewhat enigmatic champion of the International Style in Pavia, Milan, and for a time in Venice, Stefano da Verona was working first in Milan and then in Verona.[37] In North Italy sculptors and painters vied with each other from the first in adapting the style to their media. The *Annunciation* in the main window of the choir of the Milan Cathedral, dated as early as 1402, shows all the familiar characteristics of the mode: the richly cascaded drapery falling over the arm of the angel, the folds of the cloak curling on the ground. In Matteo Raverti's *Saint Babila* (1404), in Walter Monich's *Saint Stephen* (1406), in the Carelli tomb (1406), the International Style is manifested in full force.[38] As early as 1404, Pier Paolo Masegne's south window for the Palazzo Ducale established the vogue in Venice.[39]

In the first five years of the fifteenth century the new style also penetrated the painters' studios in Central Italy. As early as 1403 it appeared fully developed in the *œuvre* of the Sienese, Taddeo di Bartolo. His large altarpiece for S. Domenico at Perugia (Fig. 21) dated in that year, displays the well-known richness of drapery,

[33] The group of the *Schoene Madonnen* was traced first by Pinder, bibl. 400, certainly with overemphasis on the supposed origin of the type in what he called East German territory. To be sure, a great number of the apparently early examples are found in Bohemia (Krummau) and Austria. But the Western branch was of greater importance than Pinder assumed. A perfect example of an early date, probably about 1400, now in the Gallery of Vassar College, Poughkeepsie, N.Y., formerly in the collection of Felix M. Warburg (Fig. 24), is carved in soft Amiens limestone, leaving no doubt of its French origin.

[34] Modena, Bibl. Estense, α3, perhaps as early as 1390. Toesca, bibl. 520, pp. 368f; Beroldo manuscript, commissioned 1396, paid 1399 florins to Salomone di Grassi, Milan, Bibl. Trivulziana, ms. 2262 (Toesca, bibl. 520, pp. 307ff); Eulogy for Gian Galeazzo Visconti, 1403, Paris, Bibl. Nat., lat. 5888 (Toesca, bibl. 520, pp. 439ff).

[35] Toesca, bibl. 520, pp. 345ff, 434f; figs. 276-280, 348.

[36] Michelino's activity can be traced from 1388 to 1444; see Durrieu, bibl. 138, p. 372 and Toesca, bibl. 520, pp. 435f.

[37] Degenhart, in Thieme-Becker, bibl. 517, XXXI, p. 526, with the dates 1374-75 to 1438. Stefano's dated paintings are all from his late years.

[38] Baroni, bibl. 40, pp. 138, 143f; figs. 317f. [39] Gnudi, bibl. 184, p. 35, note 31.

although in a slightly hard manner, the folds hiding the body, swinging across and flanked on either side by heavy cascades. When he painted the frescoes at San Gimignano in 1395, Taddeo was obviously not yet acquainted with the new mode. Yet it marks one of his next major works, the *Baptism* of 1397 in the Collegiata church of Triora in Liguria. Thus he evidently picked up the new mode in this Genovese milieu, a dependency of France since 1395.[40] In any event, he carried it back to Central Italy where he became one of its chief exponents in Perugia, Montepulciano, and Pisa. His frescoes in the Palazzo Pubblico in Siena, dating between 1407 and 1412, bring the style to a climax in Tuscany.[41]

A few years after reaching Siena the International Style took root in Florence, exerting a powerful influence on Florentine artists between 1405 and 1415. Shortly after 1404 its main stronghold in painting became the workshop of Lorenzo Monaco. In fact, in the first decade of its penetration into Florence no other painter of significance seems to have adopted its vocabulary and principles. It spread among painters far and wide only after 1415 when the *Maestro del Bambino Vispo*, coming from Spain appears to have started what might be called the second wave of the International Style in Florence:[42] witness the Maestro's own work or the *œuvre* of Giovanni del Ponte or of Parri Spinelli or, for that matter, the first works of Masolino, e.g. the *Bremen Madonna* (1421). Gentile da Fabriano's arrival in Florence in 1423 and his two major works there, the *Epiphany* altarpiece for the Strozzi family and the Quaratesi altarpiece (1424?) only reinforced the movement, bringing it to a last flowering in Florence.

Given both the early influence of the International Style on Taddeo di Bartolo, and the persistent strength of the Gothic tradition in Siena, it has frequently been suggested that the style reached Florence by way of Siena, transmitted specifically by Lorenzo Monaco, Sienese that he was. Indeed, the mature work of Lorenzo Monaco bears all the earmarks of the movement: the soft ducts of drapery, harmonious stances and a fairy-tale quality of narrative. It was obvious to postulate that Monaco was an early leader of the new style in Florence and that he transmitted it to Ghiberti.[43] But this theory has been exploded in the last twenty years. In the first place, Monaco does not appear to have received his earliest impressions of the International Style in Siena. By the time the style made itself known there, he had gone, for apparently in 1388 he painted the Nobili altarpiece for S. Maria degli Angeli in Florence,[44] and in the nineties assisted Agnolo Gaddi with the Castellani frescoes in S. Croce.[45] Secondly, a brilliant analysis of his style[46] has demonstrated that only in his mature work after 1404, did he fall in with the delicate expressive designs of the new fashion, at first hesitantly in the Empoli altarpiece (1404), then with growing confidence in Berenson's *Madonna dell'Umiltà* (1405), in the *Annunciation* in the Accademia (*ca.*

[40] Muratori, bibl. 356, XXI, p. 215. [41] Van Marle, bibl. 301, II, pp. 545ff.

[42] Pudelko, bibl. 429, pp. 47ff.

[43] Sirén, bibl. 496, pp. 123, 134; *idem*, bibl. 498, pp. 38ff. [44] Gronau, bibl. 194.

[45] I owe this suggestion to many informative and stimulating conversations with Mr. Marvin Eisenberg in the spring of 1951 in Florence.

[46] Pudelko, bibl. 430 *passim*.

1408-1410), in the Louvre diptych (1408, see Fig. 27), and finally in the miniatures of the Diurnale in San Marco (1409). This period of tender linearism culminated in the two altarpieces of the *Coronation of the Virgin* of 1414 and after 1415, respectively, the first in the Uffizi and the second in the National Gallery in London. Eventually this phase yields to a slightly harsher and more linear treatment of rhythmical forms. Hence one cannot assume *a priori* that Lorenzo Monaco championed the International mode in Florence before Ghiberti. Either their works ran a parallel course in developing the vogue or, contrary to the old supposition, it was Ghiberti who transmitted to Monaco the vocabulary and principles.[47]

Even a cursory glance reveals innumerable resemblances between the work of the two Lorenzos. One need only compare Monaco's *Adoration of the Magi*, formerly in the Raczinsky collection (Fig. 28), with Ghiberti's rendering of the same subject on his first door (Pl. 28); or the figure of the Baptist in Monaco's Empoli altarpiece with the young king in Ghiberti's *Magi*; or the drapery of the *Madonna dell'Umiltà*[48] with that of Joseph in Ghiberti's *Nativity* (Pl. 27). One may compare as well the walking figure with his cloak outspread behind Mary in Monaco's *Flight into Egypt* in Altenburg with the bystander at the left edge of Ghiberti's *Lazarus* relief (Pl. 47a) or finally a Benedictine monk in one of the predella panels to Monaco's London *Coronation*[49] (Fig. 25) with the prostrate Magdalen in the *Lazarus* (Pl. 40). The motif of Saint John and the Virgin crouching under the cross in Ghiberti's *Crucifixion* (Pl. 52) is also frequent in Monaco's vocabulary; but, then, this particular motif had been well known to both Siena and Florence in the last half of the Trecento.[50] Nor is the iconography of Ghiberti's *Annunciation* necessarily dependent on Monaco's, as had been suggested.[51]

However, these comparisons are not always helpful. As far as chronology is concerned, that of Ghiberti's reliefs can be only approximately established. Lorenzo Monaco's dates, though clearer, are far from definitely settled. Moreover, the evidence fluctuates as to which used certain motifs and compositional types first. The Raczinsky *Epiphany*, for instance, which would seem to belong to Monaco's later phase, possibly about 1415, is certainly later than Ghiberti's quatrefoil of the *Magi* which corresponds compositionally to it. At other times Monaco seems to set the pace; witness that the *Flight into Egypt* in Altenburg seems to antedate Ghiberti's *Lazarus*.[52] Just as frequently they seem to hit on the same motif at the same time: for instance the Joseph in Ghiberti's *Nativity* is nearly contemporaneous with Monaco's *Madonna dell'Umiltà*. Whether Monaco purloined more from Ghiberti, or vice versa, it is evident that both drew on the same model books and that they established a mutual exchange of ideas and motifs, so that the two workshops were linked by a reciprocal,

[47] *Ibid.* [48] Berenson, bibl. 45, p. 32.

[49] For illustrations of Lorenzo Monaco's *œuvre* see Sirén, bibl. 496, Pudelko, bibl. 430, and Van Marle, bibl. 301; for the London *Coronation*, see Davies, bibl. 119.

[50] Shorr, bibl. 493, specifically p. 60, note 47.

[51] Sirén, bibl. 496, pp. 123ff.

[52] The Altenburg panel may possibly have belonged to the predella of the Annunciation Altar in the Accademia in Florence (Sirén, bibl. 496, pp. 56f) and would thus perhaps date 1408-1410. The Raczinsky *Epiphany* is assigned by Sirén (bibl. 496, p. 92) the date 1415-1417.

rather than one-sided, borrowing. The relationship is demonstrated in their respective compositions of the *Mount of Olives*. Monaco did two versions; one is in the Accademia and presumably prior to 1400,[53] the other is in the Louvre and dated 1408 (Figs. 26, 27). Ghiberti's falls between and resembles both; for while Monaco's second variant is manifestly dependent upon Ghiberti's, his first is not only earlier, but seems to form the basis from which Ghiberti evolved his solution, transposing it into the idiom of the International Style (Pl. 43).

Hence, both Ghiberti and Lorenzo Monaco were champions of the International Style in Florence. Of the two, however, Lorenzo Monaco turned to the new vogue without warning. The curling hems and sweeping folds appear suddenly in his work around 1404 and not until 1408 does he give evidence of a full-fledged vocabulary of overabundant draperies, or appear to grasp the principle of binding the entire surface of a panel in a calligraphic network of wavy lines.[54]

In Ghiberti's work, on the other hand, the new style had been ingrained from the outset. His competition relief of 1401 already forecasts what is to come. At the opening of the century he had absorbed the rudiments of calligraphic design through the influence of the French goldsmiths, and these early seeds grew organically in his work, following a step by step development from the competition relief to the garland of angels in the *Assumption* window of 1404-1405 (Fig. 7) and on to the first quatrefoils of the North Door, dated between 1404 and 1407. The style then continued through a second large group of reliefs, designed after 1407, and finally led to the *Saint John*.[55]

Thus it can be assumed that through Ghiberti Lorenzo Monaco became acquainted, about 1404, with the vocabulary and concepts of the fully developed International Style. These first contacts seem then to have been succeeded by a period of mutual exchange which lasted until roughly 1414. At this point and in the hands of both artists the style hardened and grew dry. Actually, Monaco preceded Ghiberti to this phase, as early as 1410 in the Montoliveto altarpiece. Ghiberti takes up these harsher forms around 1412-1413 with the *Saint John*, and a cursory glance at the *Baptism* of the North Door, dated as it is prior to 1409 (Pl. 32),[56] marks the route along which he had traveled. After the Or San Michele statue he did not continue along the same lines. The development that had started with the *Nativity* of the North Door terminates with the *Saint John*, the last and most grandiose product of Ghiberti's international phase.

In general outline Ghiberti's international phase parallels developments north of the Alps during the first fifteen years of the century. It has even been suggested that he became acquainted with transalpine art of the International Style during a stay in Upper Italy.[57] To be sure, his early travels had led him to Pesaro where he reached the fringe of the Venetian milieu. But by 1400 Venice had not yet been touched by

[53] Gronau (bibl. 194, p. 221) dates the early *Agony in the Garden* "not after 1395."

[54] Pudelko, bibl. 430, pp. 78f. [55] See below, pp. 123ff. [56] See below, p. 120.

[57] Pudelko, bibl. 429 *passim*; Valentiner (bibl. 529, pp.25ff) mentions in general terms the impact of the International Style on Ghiberti.

the new style. Thus no direct link can be proven to connect Ghiberti in these years with Northern sources. Still, one cannot help but suspect that while working on the quatrefoils of his first door he remained in contact, either through model books or through other media, with French art of the International Style. At least one isolated piece of goldsmith work suggests a path leading from north of the Alps to a Florentine *ambiente* very close to Ghiberti. This is the small bronze statuette of Saint Christopher, dated 1407, now in Boston (Fig. 29). It shows the hallmarks of the mature International Style; at the same time it partakes equally of Northern and Florentine characteristics, to such a degree that it has been attributed, understandably enough, once to Master Gusmin and another time to a goldsmith close to Nanni di Banco and Ghiberti.[58] The iconography of the statuette clearly has its origins north of the Alps, in either northern France or Flanders. Its design, on the other hand, is beyond a doubt Florentine. It recalls Nanni's angels on the archivolt of the Porta della Mandorla, but it is also surprisingly similar to some of Ghiberti's figures on his first door: the overabundant swinging folds of the drapery, the taut stretching of garments over thighs and buttocks, the snail hair and S-curls of the beard repeatedly recall quatrefoils like *Christ among the Doctors*, the *Baptism* or the *Temptation* (Pls. 30, 32, 33). To be sure the details of execution, superb though they are, do not warrant an attribution to Ghiberti himself. But in any event, the figure establishes a tie between Ghiberti's *ambiente* and the Northern tradition.

In Florence the International Style seems at first to have made a deeper impression on sculptors and goldsmiths than on painters. The angels on the archivolt of the Porta della Mandorla, carved between 1406 and 1409 by Antonio di Banco, his son Nanni, and Niccolo Lamberti, richly display the new vocabulary.[59] Nanni's *Isaiah*, designed in 1408 for one of the Cathedral buttresses, fuses the taut forms of the late Trecento with a head *all'antica* and the familiar soft draperies of the new vogue (Fig. 31). At least two of the four seated Evangelists designed for the façade of the Cathedral show an almost complete assimilation of formulas from the new trend, soft draperies, rich ornamental hangings of folds: the *Saint Mark* by Niccolo Lamberti, begun in 1409, and the *Saint Matthew* by Bernardo Ciuffagni, commissioned in 1410. Both were completed in 1415. Their companion pieces, Nanni's *Saint Luke* (1410-1414) and Donatello's *Saint John the Evangelist* (1410-1415),[60] while avoiding the vocabulary proper, reflect the fashion in the soft treatment of drapery. Donatello's early *œuvre* reveals an undeniable influence from the International Style, traces of it still lingering in his *Saint George*. If the small prophet at the left and above the

[58] Boston, Museum of Fine Arts (formerly Budapest, Collection E. Delmár). Swarzenski (bibl. 513) originally suggested a connection with the Master of Rimini whom he identified with Gusmin. In a brilliant analysis (bibl. 512) he has recently brought out both the Northern and the Florentine elements of the statuette, "connected with the young Ghiberti, the greatest representative of the international current in Florence and with Nanni di Banco, the first exponent of classical spirit in this trend" (*op.cit.*, p. 95).

[59] For the archivolt of the Porta della Mandorla, see Paatz (bibl. III, p. 367 and note 224) with reference to the varying attributions of its individual parts and Poggi (bibl. 413, docs. 360-369). For Nanni's *Isaiah* see Lanyi, bibl. 264.

[60] See below, p. 90, note 8.

Porta della Mandorla can be attributed to Donatello, he felt its full impact around 1408.[61] In goldsmith work the prophets engraved at the foot of the reliquary of San Jacopo in Pistoia (Fig. 46) and the Boston *Saint Christopher* (Fig. 29), both dated 1407, represent the International Style at its height in Florence. Since both these works are closely linked in style to Ghiberti's workshop, and since both Ciuffagni and Donatello were among Ghiberti's assistants before and shortly after 1407, it would seem that his workshop was the first and, roughly between 1407 and 1415, the leading stronghold in his city of the movement in sculpture. Thus Ghiberti appears a chief exponent, possibly the signal representative of the International Style in his native town, his statue of *Saint John* its outstanding example in sculpture.

Time and again since Vasari's day has the *Saint John* been viewed as a conservative work, a bypath in the history of fifteenth century art. But hindsight is apt to distort the situation of 1412. In its niche at Or San Michele the *Saint John* stands in the company of Nanni's *Quattro Coronati*, *Saint Philip* and *Saint Eligius*, and of Donatello's *Saint Mark* and *Saint George*. All of them originated in the second decade of the century, but by 1412 only the *Saint Mark*, the *Saint Eligius* and possibly the group of the *Quattro Coronati* had been started, and it is doubtful if any were near completion. In 1414 and 1416, when the *Saint John* was cast and finished, neither the *Saint Philip*, nor the *Saint George* was apparently begun. True, the *Saint Mark* and the *Quattro Coronati*, different though they are from each other, are pregnant with the spirit of a new and revolutionary art. But in 1412 and 1413 these first works of Nanni and Donatello for Or San Michele need not have struck contemporary Florentines as products of a common spirit, nor as holding greater promise for the future than the *Saint John*. No doubt they appeared more rebellious, more experimental, but not necessarily more advanced. Officials of a staid old guild like the *Calimala* may not have been inclined to favor the experiments of the young iconoclasts. While they surely wanted an up-to-date design, they probably did not want too daring a venture. The *Saint John* would have eminently satisfied such a de-

[61] The two prophets on either side of the tympanum above the Porta della Mandorla, both originally believed to be by Donatello, have in recent years gone through a series of attributions. Lanyi (bibl. 263, p. 23) assigned the prophet to the left, with rich hanging drapery to Nanni di Banco, the one to the right, because of its uncompromising organic build, to Donatello. Planiscig (bibl. 402 and 405, p. 52) pointed out that the faun's head of the prophet to the right recalls Nanni's work and hence reversed the attribution.

H. W. Janson, following W. R. Valentiner, "Donatello and Ghiberti," *Art Quarterly*, III (1940), pp. 182ff, believes the figure on the left to be an angel from an Annunciation which he attributes to neither Nanni nor Donatello. The one on the right he believes to be by Nanni, dependent upon Donatello's *David* of 1409. He thus links it to Nanni's later work on the tympanum of the Porta della Mandorla of 1417 and thereafter. The dependence on the David, is certainly convincing; however I am still reluctant to eliminate the figure to the left from the *œuvre* of Donatello. The head of the small statue is very similar to that of Donatello's *David*. The documents (Poggi, bibl. 413, docs. 262, 263) are not entirely conclusive. But they clearly state that Donatello was commissioned to supply more than one prophet (*prophetas*) for the Porta della Mandorla, *la porta che va ai Servi*, even though payment was made for only one. This would still leave the possibility that both statues were originally started by Donatello and that the one to the left was finished either by him or by an unknown collaborator at an early date, while the one to the right was finished by Nanni, possibly as Janson proposes, at a later date.

mand. It could not seem old-fashioned, for instead of representing a survival of Trecento elements, it boasted the still fresh international vogue. This style, though in many respects romantic, was decidedly post-Gothic, having been created scarcely twenty years before north of the Alps, and, thanks largely to Ghiberti, introduced but ten years earlier in Florence where by 1412 it represented the height of fashion. It put Florence on the map of communication with the great northern centers, and for more than a century the *Saint John* was to remain the last piece of Florentine monumental sculpture to emerge from an international atmosphere. In commissioning Ghiberti to do a statue of their patron saint, the gentlemen of the *Calimala* selected not only the best bronze founder in Italy, but also an artist who stood at the forefront of a movement sponsored by the most sophisticated connoisseurs of Europe, a movement widespread, new, yet far from breaking, rebelwise, with the past. No one could have foretold in 1412 that the future lay elsewhere.

Just because it invites comparison with its neighboring statues at Or San Michele, the *Saint John* may seem to be somewhat contradictory in itself. But the reason for this is not what is judged to be its conservatism. Rather, the conflict lies in its size. For the first time in his life Ghiberti was obliged to compete with monumental stone sculpture, and to compete in bronze. Of course, he was used to bronze, but so far he had handled it only on small scale, perfecting the refinements that are a part of the goldsmith craft. As he had been taught to use it, bronze did not lend itself to such powerful monumentality as stone. Furthermore, the mood and entire tradition of the International Style was essentially non-monumental. Although the style had gradually outgrown the scale of the goldsmiths' and illuminators' works, it had rarely achieved monumentality. Both its decorative and realistic detailing counteract the qualities of large scale design. Sluter's *Moses* is perhaps the only exception, but whether it can be called representative of the International Style is, to say the least, doubtful. Ghiberti, then, was faced with the dilemma of having to meet demands for the kind of statue not traditionally associated with either his craft or the style which he had introduced and cultivated in Florence. The result—large size combined with an over-all decorative design, literal realism in face and hands, insecure stance and lyrical mood—makes for a statue that strove for monumental grandeur, but was, from the beginning, fated not to achieve it. Still, despite this, the *Saint John* remains the only first-rate piece of sculpture to have been produced during the international phase in Florence. Writing at the court of Naples as late as 1455 in the atmosphere of a late International Style, Fazio was from his point of view justified in singling out the *Saint John* as Ghiberti's greatest work.[62]

[62] Fazio, bibl. 156, p. 50. See also Swarzenski, bibl. 512, as quoted in note 58 above and Planiscig, bibl. 406, pp. 47f.

CHAPTER VII

SAINT MATTHEW AND *SAINT STEPHEN*

ONLY six or seven years after designing the bronze figure of the *Saint John*, Ghiberti started on his second statue for Or San Michele, the *Saint Matthew* (Pls. 6, 7). However, since the *Saint John*, begun in 1412, a new race of statues had appeared in the niches of Or San Michele: Donatello's *Saint Mark* and *Saint George*, Nanni's *Quattro Coronati* and *Saint Philip*. A new classical movement had come to the fore, based on a concept of nature as cleansed and improved, on classical principles and a vocabulary *all'antica*, and on the mutual absorption of nature and antiquity. It is reasonable to assume that the bankers wanted the statue of their saint to be at least as modern in style and thus as much admired, as the statues of the rag dealers, cobblers and armorers.

No other work of Ghiberti's—or for that matter, no other work of Renaissance sculpture—is so well documented in the history of its commission, execution, and payment proceedings. Luckily the account book of the commissioning corporation, the *Libro del pilastro* of the *Arte del Cambio*, still survives.[1] From the outset the bankers' guild made clear its intention of outdoing the *Calimala* with its statue of the Baptist. The *Saint Matthew* was to be "as beautiful as possible" (Dig. 66). Bronze was the obvious material to choose for it and Ghiberti, master of the *Saint John*, the obvious artist to hire. In August 1419, a detailed contract was drawn up (Dig. 71). The figure was to be "at least of the size of the . . . Baptist . . . or larger . . . at the discretion of . . . Lorenzo." It was to be cast in "one piece or two, the head as one piece and all the rest as another piece." Its weight, including the base, was not to exceed 2,500 pounds, and it was "to be gilded, as a whole or in part, whichever seems best to the consuls and committee of four." All materials, bronze, charcoal, wax and the like, were to be provided by the guild, but assistants' pay seems to have been Ghiberti's responsibility. The contract followed upon events *post festum*, since the official decision to give Ghiberti the commission had been made a month before (Dig. 69). Indeed, Ghiberti had started work even earlier, a fortnight after the *Arte del Cambio* had secured the rights to its pilaster at Or San Michele from the bakers' guild (Dig. 67). The last months of 1419 and all of 1420 were spent on setting up the wax model of the figure (Digs. 73, 83); the date of 1420 inscribed on the statue (Dig. 82) suggests that the model was completed in that year or by March 1421 (Dig. 83). Work on the casting started apparently in May 1421 (Dig. 85); a first casting failed in July (Dig. 86), but the defective parts were recast by January 1422 (Dig. 87). Immediately after this Ghiberti appears to have started the cleaning and chasing. The rest of the same year was spent in decorating the niche following Ghiberti's specifications (Digs. 90, 91, 93), and, last but not least, on levying from members of the guild the cost of the enterprise, a total of roughly 1,100 florins (Digs. 88, 92, 95,

[1] *ASF, Arti, Cambio*, vol. 18. It has been published in its entirety and with admirable care by Doren, bibl. 133.

98).[2] In December 1422, Ghiberti was asked to recast the base of the statue, and his honorarium was set at 650 florins (Dig. 97). The bankers' guild succeeded in outdoing the *Calimala* in every respect, even to the extent of fixing the master's fee 120 florins higher.

No doubt, then, the record proves that Ghiberti was commissioned and did execute the *Saint Matthew*. Yet his authorship has often been regarded with suspicion. As early as the fifteenth and sixteenth centuries it was sometimes omitted from standard listings of Ghiberti's *œuvre*, and even on occasion outspokenly declared not his but Michelozzo's, a notion to which even Burckhardt still held. Such doubts must have arisen in Florence at an early date: why otherwise would Ghiberti in his memoirs stress that he executed the *Saint Matthew* with his own hand—an elucidation absent from the accounts of his other work and somewhat defensive in tone.[3] Indeed, it is quite true that Michelozzo was a member of Ghiberti's workshop when both the *Saint Matthew* (Digs. 85, 100) and the last parts of the North Door (Dig. 81) were in process. It is equally true that in the early twenties Michelozzo seems to have been not just an employee, but a partner, a *compagno* of Ghiberti's (Dig. 100), and this may explain why a major share of the *Saint Matthew* has so often been ascribed to him. But Michelozzo seems to have acted primarily in the role of an expert on casting and still more on chasing, a capacity warranted by his previous training as a die-cutter in the Florentine mint. It is significant that he joined Ghiberti shortly before or in 1421, just when the shop was at a crucial point in the organization of its technical work; the chasing of the North Door had reached a decisive phase and the casting of the *Saint Matthew* was about to begin, its chasing looming as the major task ahead. Conversely Michelozzo evidently left Ghiberti at an equally telling time, in the fall or winter of 1424 when both the North Door and the *Saint Matthew* were completed. In fact, at this point Donatello seems to have lured Michelozzo away to assist in the chasing of the *Saint Louis*, his first large bronze, which had apparently reached its final stages just then.[4] Many years later, in 1437, Michelozzo returned to Ghiberti's shop to assist in the finishing and chasing of the Gates of Paradise (Dig. 200). In all these various engagements he appears to have been employed as a technician of bronze work, not as a designer. Moreover, Michelozzo's early *Virtues* on the tomb of John XXIII (1425-1427), done independently after joining Donatello's shop, are qualitatively weak and exhibit none of the classical tenets or vocabulary *all'antica* which characterize the *Saint Matthew* and which emerge equally in his own work of the thirties.[5] On the other hand, the *Saint Matthew* in every respect fits into Ghiberti's development shortly before 1420.

[2] The total of 1,039 florins as calculated by Doren (bibl. 133, p. 51, note 1) falls short of the total actually spent.

[3] Ghiberti-Schlosser, bibl. 178, I, p. 47.

Fazio (bibl. 156, p. 50) omits the *Saint Matthew*. The Anonimo Magliabecchiano, while attributing the statue to Ghiberti, apparently on the basis of the *Commentarii*, yet remained in doubt, as witness his marginal note: "Dire, dove è detta statua, se nel pilastro d'Orto San Michele o dove?" (bibl. 22, p. 72 and note 1). Gelli (bibl. 175, p. 50), Billi (bibl. 52, p. 84) and Burckhardt (bibl. 82, p. 556) assigned the figure to Michelozzo.

[4] Poggi, bibl. 417 *passim*; see also above, p. 74, note 16.

[5] Discussion has centered for some time on the possible authorship of the figures of the Annunciation above the niche of the *Saint Matthew*. Formerly attributed to Piero di Niccolo Lamberti (Gamba, as quoted by Fabriczy, bibl. 146, p. 166, note 7, and by others, see Paatz, bibl. 375, IV,

In externals the *Saint Matthew* does not differ greatly from the *Saint John*. It is slightly larger, 4½ as compared to not quite 4⅓ *braccia*, roughly 2.70 and 2.50 m. respectively; the cast is hollow, the bronze wall thin. The documents assure us that the figure consists of several separately cast pieces, one for the head, another for the body, plus parts that had to be replaced in the recasting. But, as seen in its niche, no joints are visible.[6] The finishing is as accomplished as that of the *Saint John*. The ornamental hem of the cloak bears the inscription: OPUS UNIVERSITATIS CANSORUM FLORENTIAE ANNO MCCCCXX. Gold traces on the cloak suggest that the entire drapery, as foreseen in the contract (Dig. 71), was gilded at some time; but the accounts of the *Cambio*, complete though they otherwise are, are silent on this point.

Not only technical features link the *Saint Matthew* to the *Saint John*. The profile of the body is not dissimilar: it looks strangely hollow when seen from the side, the back descending in a monotonous vertical, the head inclined sharply forward (Pls. 9a, b). A literal rendering of reality perseveres in such details as veins and tendons of the hands, creases on knuckles, nails of fingers and toes, skin stretched between fingers, crows-feet in the corners of the eyes (Pls. 8, 12a). The contrast of textures is, if anything, more sharply marked than in the *Saint John*. Forehead and hair seem almost to respond differently to the touch and even the coarser locks of the head are set off against the finer eyebrows and softer curls of the beard (Pls. 8, 10a, b). The skin of the foot is flesh, the leather of the sandal, leather (Pl. 13a, b). In short, the *Saint Matthew* and the *St. John* have more points in common than is generally conceded.

Yet stylistically the *Saint Matthew* represents the antithesis to everything the International Style, as embodied in the *Saint John*, stood for. The deep niche with its pilasters and architrave, and the squarish base of the statue with its classical moldings, are in themselves proof of a new antimedieval taste (Fig. 92). The languid savagery of the *Saint John* (Pl. 4) has given way to a monumental grandeur. Not by chance is the *Saint Matthew* larger than any of the earlier figures at Or San Michele, including the *Saint John*: his very size underscores the desire of artist and commissioning corporation for greater monumentality. Not by chance is his size further stressed by the extraordinarily low base on which he stands.[7] The body of the Saint is solider

p. 492 and note 87), they have been assigned to Nanni di Bartolo il Rosso in more recent years, first by Venturi (bibl. 534, IV, p. 228) later by Planiscig (bibl. 407, pp. 59f, 87, and *passim*). See also Paatz, *loc.cit.* Brunetti (bibl. 74, pp. 271, note 11) has come out against this attribution, Valentiner (bibl. 529, p. 63) has attributed the group to Michelozzo and to the years around 1420, and Heydenreich and Middeldorf, as quoted by Paatz, *loc.cit.*, appear to have arrived at the same hypothesis. Janson (bibl. 232, pp. 26ff) has refuted this attribution on the grounds that the figures represent prophets, the head of the Virgin being in his opinion a modern faulty restoration. It would still seem to me that the figures are an *Annunciation*, both heads being original, even though such a group belongs over a statue of Saint Luke rather than over one of Saint Matthew. Likewise I would suggest that the figures reminiscent as they are of Michelozzo's later style were possibly added after he had rejoined Ghiberti's workshop in 1437.

[6] No observations on the technical features of any of the statues at Or San Michele are on record, and the technical details visible are of no significance: the index finger of the right hand appears to have been broken in casting and soldered back; some medium-sized holes all over the figure indicate that the thin bronze broke in some places. See also above, p. 75, note 19.

[7] The base of the *Saint Matthew* is only .14 m high as against the height of the base of *Saint John*, .18 m, and of the *Saint Stephen*, .21 m. When completed, it apparently proved to be too

than that of the *Saint John*, his shoulders squarer, hands and feet stronger; he stands erect, resting solidly on his left leg, the right is placed slightly forward and to the side; the left hand holding the book and the right raised in front of the chest carry out the balanced *contrapposto*. But the body is in no way heavy, nor the stance rigid; despite its decisiveness the movement is smooth. The head, like the body, combines monumentality and tectonic feeling with suavity (Pl. 8). The nose, rising above a broad beard, straight forceful mouth and wide mustache, supports the forehead like a pier carrying an architrave. The exaggerated boniness, the indented cheeks and temples of the *Saint John* (Pl. 5) have given way to smoother and fuller volumes. Forehead and temples are articulated by a few furrows, deeply engraved; the eyebrows, no longer thin wavy lines, grow forward in heavy tufts. The curls of the beard, short and tightly coiled, are more clearly set off from the outline of the cheeks, and locks of hair are more massive. Every detail stresses the sculptural quality of the design, and it is hardly by chance that in the eyes even the pupils protrude slightly. Classical tenets have replaced the concepts of the International Style. In principles and details the vocabulary of the figure belongs to the movement which was taking shape in the second and third decades of the fifteenth century and which eventually ripened into what we term the Renaissance.

Because of its pronounced character and strong bearing on future developments, we are apt in retrospect to view this movement in distorted perspective as widespread, uniform, and forward-looking. None of this is true. During the second decade of the fifteenth century the new art was carried by a desperately small group; it was confined to large-scale stone sculpture, to the local Florentine scene, and within Florence it existed side by side with the International Style. Far from having clear and unified aims, the nascent art of the Renaissance expressed itself in diverse ways. Its first experiments were youthful, rebellious, and somewhat rambunctious, with no conscious common denominator, except an anti-Gothic mood. To be sure, these beginnings gravitated towards the two poles, reality and antiquity, which had already shaped the work of the Hercules Master and of young Brunelleschi, and which eventually, would become the guiding stars of the new art. However, only after 1430 did these two factors gradually take on the dominance which we ascribe to them today, when speaking of the Renaissance. Rather than transcribe reality in the literal sense of copying its surface appearance, artists after 1420 inquired into the nature of things, the governing laws. Classical art became an instrument of this inquiry, and both its principles and vocabulary were absorbed as welcome tools. In the end the borderline between reality and antiquity was obliterated, the two becoming nearly equated. Yet none of this held true prior to 1420. Nature and antiquity were then but dimly realized as goals of expression and far from being identified with each other. Both lay open to fluctuating and indefinite forms of interpretation.

Just as the presentation of reality ranged from literal transcription of details to a

deep for the finished niche and thus had to be cut down in the back. The gap was filled crudely with concrete. The figure, incidentally, also turned out to be somewhat too large and when set up, its left shoulder damaged the second pilaster to the right within the niche.

search for fundamentals, so too did the image of antiquity oscillate between an eagerly absorbed, somewhat inarticulate use of vocabulary *all'antica* and consistent adaptation of the principles of antique art. Only two artists, both young stonecutters, led the early stages of the new movement. Donatello set out on this path, hesitantly, with the seated statue of John the Evangelist for the Cathedral (1410-1415), then more confidently with the *Saint Mark* for Or San Michele, 1411-1413 (Fig. 20), followed by the *Saint George* in or shortly after 1417, the *Baptist* for the Campanile, 1415-1418, and the *Marzocco*, 1418-1419 (Fig. 30).[8] During the same years Nanni di Banco developed along very different lines, moving from the figure of *Isaiah* (Fig. 31) to the statue of *Saint Eligius*, the *Quattro Coronati* (Fig. 19) and the *Saint Philip*, and thence to the relief of the Virgin on the Porta della Mandorla.[9] In no way did the aims and methods of the two artists coincide. Donatello thought in terms of what might be described as reality governed by classical principles (Fig. 20). He stressed powerful firmness of stance and facial expression, balance between weight and support and a sturdy organic clarity in the sharp segregation of the figure's constituent parts. All such elements are derived from Roman statuary. But whereas antique artists employed these elements with ease and as a natural basis for their design, Donatello abstracted and thus transformed them into classical tenets, albeit less alive. At the same time the vocabulary he used during these years calls to mind not so much Roman as the post-Gothic art of the ending Trecento. The fall of a piece of drapery, the facial types, the flow of a patriarchal beard or the armor of a knight are reminiscent of the powerful heads of Brunelleschi's prophets at Pistoia (Figs. 3, 4) or possibly of the knightly saints of Northern workshops.[10] In Donatello's hands this late Trecento vocabulary was changed into another language, fusing the fundamentals of reality with principles *all'antica*. The language sounds classical, but the words are neither Greek nor Roman. Nanni took the opposite path. He focused only secondarily, if at all, on either reality or classical tenets. Instead he continued the tradition of the Porta della Mandorla, and leaned heavily on the vocabulary of

[8] Any attempt to establish a new chronology of Donatello's *œuvre* would be presumptuous at this point when H. W. Janson's Donatello Corpus is about to be published by Princeton University Press. Thus, I think it best to cling to traditional dates, pointing out only a number of new suggestions which I owe to Mr. Janson's generosity.

The figure of Saint John the Evangelist, now in the Museo dell'Opera, while commissioned in 1408, has frequently been assigned to the years 1412-1415, when most of the payments are recorded (Poggi, bibl. 413, docs. 172, 199-220; Kauffmann, bibl. 237, pp. 16f; Paatz, bibl. 375, III, p. 385 and note 427). Janson, however, points out that the documentary evidence is fragmentary and that stylistic evidence suggests that the work started early, about 1410. The dates for the *Saint Mark* are ascertained through two documents, the transfer of the commission to Donatello and the final payment (Passerini, bibl. 391, pp. 49f; Paatz, bibl. 375, IV, p. 493 and note 92). For the *Saint George*, only one document, now apparently lost, furnishes an approximate date; it refers to the payment in 1417 for a marble block for the relief beneath the statue (Vasari-Milanesi, bibl. 533, II, p. 404; Paatz, bibl. 375, IV, p. 495 and note 113). The *Baptist* on the Campanile appears to date from 1415-1418 (Kauffmann, bibl. 237, p. 26); H. W. Janson has been good enough to confirm this early date as against Poggi's suggestion of the later date 1423-1426 (Poggi, bibl. 413, pp. lixf; see also Paatz, bibl. 375, III, p. 390 and note 458). The *Marzocco* dates beyond any doubt 1418-1419 (Cavallucci, bibl. 91, p. 140; Paatz, bibl. 375, III, p. 755 and note 547). For the entire development of Donatello during the years 1410-1420, see Kauffmann, bibl. 237 *passim*.

[9] See above, p. 72, note 10. [10] Kauffmann, bibl, 237, pp. 5f, and notes 7f.

Roman sculpture. The head of his *Isaiah* closely resembles a Roman faun with short upswept curls, truculent eyes, and sensuous lips (Fig. 31). His *Quattro Coronati* are Roman *togati* and their heads are drawn from busts of the second and third centuries (Fig. 19). More often than not, however, Nanni embedded these antique features in overall designs that are either late Trecento or International Style in character, as witness the swaying stances of his *Isaiah* and even of his *Eligius*.

Classical tenets, the vocabulary of antique art and reality had not become interchangeable by the second decade of the fifteenth century. Far from representing the taste of the period, the new movements had sprung up amidst a milieu fundamentally still medieval. Though the young champions of the new trend offered novelty, they did not necessarily hold more promise around 1415 than did Ghiberti who just then had firmly established the International Style in Florence.

Shortly before 1420 the movement began to take a new turn: reality and antiquity were no longer treated as separate approaches to problems of art nor could the principles and vocabulary of ancient art any longer be conceived as independent of each other. Nanni, in his figure of Saint Philip combined a vocabulary *all'antica* with a pose modeled after the classical tenets of Donatello's *Saint Mark*. Donatello, conversely, began to draw occasionally upon the vocabulary of ancient art as well as upon its principles. The gently floating princess in his Saint George relief, clearly stems from a running maiden on a Roman sarcophagus. The majestic *Marzocco* goes back to a Roman lion (Fig. 30) and the ferocious head of the *Jeremiah*, perhaps as late as the mid-twenties, appears to be derived from a third century portrait.[11] At the same time Donatello began to exchange classical principles for a freer and, one is inclined to say, more realistic interpretation, allowing features and movements an ever wider range of expressiveness. Between 1415 and 1420 the new movement both crystallized and expanded and during these critical years Ghiberti found his way into it.

The principles embodied in the *Saint Matthew*—the even distribution of weight, the drapery that underscores stance and movement and the tectonic build of the face—make the statue at first glance resemble Donatello's *Saint Mark* (Fig. 20) as much as they make it differ from Ghiberti's own previous figure of *Saint John* (Pl. 4). Like Donatello, Ghiberti portrays his Evangelist in classical *contrapposto* and a classical dignity and monumentality that call to mind the statues of Greek and Roman antiquity. Yet, the differences between the *Saint Matthew* and the *Saint Mark* are fundamental. For one, the *Saint Matthew* in stance and costume is drawn from Roman figures of poets and orators, both directly and by way of reflections in medieval art (App. A, 21). His vocabulary, in contrast to that of the *Saint Mark*, does not recall the waning Trecento. Likewise in design, the *Saint Matthew* is far more akin to antique orators than to Donatello's statue. Instead of playing down, as did Donatello, the lively, gentle ease of antique sculptures, Ghiberti transposed their classical stances and draperies into the soft melodious key of his own style. While Donatello thought in terms of masses, Ghiberti bound volumes within a linear framework. The uncompromising harshness of Donatello and his forceful approach were not for Ghiberti. In the *Saint Matthew*

[11] Francovich, bibl. 166, p. 148, figs. 9, 10.

movements are smooth. Contrasts are toned down. The stance is light and the head, while virile, is serene. Whereas Donatello in the *Saint Mark* viewed ancient art primarily in terms of classical principles, Ghiberti saw in it overtones and moods to be assimilated to his own language. What Ghiberti brought to bear on these critical and formative years of the Renaissance around 1420 was his own personal note of graceful melodiousness.

Within Ghiberti's *œuvre*, the *Saint Matthew* is not the only nor first work with classical overtones. Two or three years before the *Arte del Cambio* commissioned the large bronze, he had begun experimenting with classical compositions on his first door. Quatrefoils, such as the *Flagellation* or the *Way to Calvary* (Pls. 45, 50), are designed with a strong feeling for easy balance: solid figures revolve around a central axis; more often than not a figure stands firmly, yet lightly, weight and support are carefully balanced, the drapery, rather than hiding the body, becomes the expressive counterpart of pose and movement. The disciple John consoling Mary at the left edge of the *Way to Calvary* (Pl. 51b) anticipates the stance of the *Saint Matthew*: his right leg is forward, clearly revealed by his garment and accentuated on the inner side by a long fold; a shorter fold reaches to the knee, a very short one crosses high up on the thigh; the right arm rests in the sling of the mantle. The figure of Christ in the *Arrest* shows a similar classical stance (Pl. 44). In fact, this plaque, along with the *Lazarus*, the *Entry*, and the *Pilate* (Pls. 39, 41, 48) leads on to the late classical compositions of the North Door. Combined with the compositional tendencies of these reliefs are specific elements drawn from antique models: in the *Entry* a group of figures is derived from a wedding sarcophagus (App. A5); the *Pilate* is based on a Roman ceremonial scene (App. A6); in the *Arrest* and the *Way to Calvary* heads are rendered in flat relief and this intimation of distance finds its counterpart in Roman historical reliefs.[12] Evidence shows that all these quatrefoils were designed before 1419 when the *Saint Matthew* was started. In the same years the modeling of most of the prophets' heads was begun. Here again, the physiognomies are largely based on heads in Roman sarcophagi (App. A7ff). The *Saint Matthew*, then, culminates a development gradually begun in Ghiberti's *œuvre*, around 1416 or 1417, the very year or year after the *Saint John* was set up in its niche at Or San Michele. At the same time the *Saint Matthew* marks the turning point at which Ghiberti with a monumental figure fell in with the young *avant-garde* movement of the incipient Renaissance. Thus far both his tools and objectives had been very much of his own making. The melodious linearism and lyrical presentation of a figure or scene had formed the essence of his style. His interpretation of the newly imposed classical laws remains imbued with these personal traits. The literal transcription of reality, which still perseveres in the *Saint John,* became at this point subdued and subordinated to the new aim of creating a monumental design.

The *Saint Matthew* is unique to Ghiberti's *œuvre*. He had never before achieved the same fusion of elements, nor did he ever revert to it again. Sometime in the mid-twenties the principles of antique art which Ghiberti had striven to incorporate in

[12] See below, pp. 146f.

his work took on a new aspect in his eyes. Balance, *contrapposto* and monumentality lose predominance in his work. Indeed, the blend of tranquillity and strength of the *Saint Matthew* disappears for some decades from fifteenth century sculpture. While Ghiberti evolved further and further his own melodious, elegant, and very lively image of the Renaissance, Donatello, in contrast, developed his dramatic and violent style. Just at the point where it started to coalesce, the new movement parted into widely divergent streams. The *Saint Matthew* found no likeness in fifteenth century sculpture. Its perfect equilibrium, firmness and sweetness, monumentality and melodiousness, make it the most balanced work not only of Ghiberti's *œuvre*, but of the entire early Renaissance scene.

Roughly the same span of time, five to six years, which separates the *Saint Matthew* from the *Saint John*, intervenes between the *Saint Matthew* and the third and last bronze figure Ghiberti designed for Or San Michele, the *Saint Stephen*, patron saint of the *Arte della Lana* (Pl. 14). The history of this work is not documented in such great detail as that of the *Saint Matthew* but is clear in the general outlines. As early as 1340 the *Arte della Lana*, next to the *Calimala* the most powerful guild in Florence, had taken over one of the pilasters at Or San Michele and had placed in it, the first guild to do so, a marble statue of its patron saint. Eighty years later, the very speed with which the *Arte della Lana* had acted had become a handicap: the *Calimala* and the *Cambio*, both old competitors of the *Lana*, had set up modern bronze statues in their pilasters. The *Parte Guelfa*, prior to 1423, possibly in 1421, had commissioned its new tabernacle and the bronze statue of Saint Louis from Donatello. Without question the *Arte della Lana* had been quite surpassed. The consuls in a meeting on April 2, 1425 (Dig. 114; Doc. 107) admitted to themselves that "the tabernacles, particularly of the *Calimala* and the *Cambio*, were much superior to the niche of the *Lana*," in beauty and ornament. The situation cried for a remedy, the more so "in view of the splendor of this guild which always has striven to be the mistress and head of all other guilds." Hence the consuls decided to replace the old marble figure by a bronze statue and to beautify the niche (*ornetur tabernaculum*) "so that the said tabernacle will exceed in beauty and ornament or at least equal in ornament the more beautiful ones." The number of supporting arguments, recorded in the minutes of this meeting (Dig. 114; Doc. 107), makes one suspect the existence of some opposition to the proposal. After all the project meant replacing, for reasons of mere prestige, what must have been thought a good, if not handsome, statue. But the motion was carried and a committee of four was appointed to put the decision into effect (Dig. 114; Doc. 108). The cost was to be covered by income received from a partnership formed by the guild and one Michele Becchi to whom apparently had been farmed out the job of levying guild dues; these funds were to be supplemented by the revenue expected from the sale of the old marble figure. The contract which entrusted the commission to Ghiberti is lost, but it is referred to in the minutes of a later meeting (Digs. 116, 140; Doc. 111). Since the *Lana* explicitly intended to compete with, and possibly to surpass, the great bronze statues of the *Calimala* and the *Cambio*, it was natural that the commission for the new figure should go, pos-

sibly in the late spring or early summer of 1425, to the master who had designed the *Saint John* and the *Saint Matthew*. The supervisory committee was reappointed in May, 1427 (Dig. 136; Docs. 109f). For the casting new funds were assigned, "so that the previous labor and expenses should not be lost and the work remain incomplete." The treasurer of the guild was empowered to purchase bronze, 4,000 pounds, Venetian weight (Dig. 140; Doc. 111). The casting and chasing, as could be expected, took more than another year. Early in 1429 the statue was completed and placed in its niche, and the surplus bronze and iron placed on sale (Dig. 154; Doc. 113). The bronze, 1,661½ pounds, was bought three years later by the *Opera del Duomo* for the work then beginning on the Shrine of S. Zenobius (Dig. 169). As early as 1428 the old marble statue of Saint Stephen was disposed of to the *Opera* for the sum of 175 florins. The amount was unusually high for a second-hand marble statue, but then the *Arte della Lana* was in charge of both the *Opera del Duomo* and the pilaster at Or San Michele, so that the sale and purchase of the figure was merely a bookkeeping operation, the funds themselves actually staying within the family, as it were. The old statue, which Ghiberti may have believed to be by the hand of Andrea Pisano, was set up on the Cathedral.[13]

[13] Poggi, bibl. 413, docs. 294ff. Schlosser (Ghiberti-Schlosser, bibl. 178, II, pp. 162f) was the first to propose identifying the *Saint Stephen*, mentioned by Ghiberti as standing on the façade of the Cathedral and as a work of Andrea Pisano, with the figure transferred there in 1428 from Or San Michele. But his argument is not entirely convincing. The documents state merely that Ghiberti and the *capomaestro* of the Cathedral "can place the figure [from Or San Michele] on the façade [of the Cathedral] wherever they think best." On the other hand Ghiberti (*ibid.*, I, p. 43) says only that "a figure of *Saint Stephen* (by Andrea Pisano) stood on the façade of Santa Reparata on the side towards the Campanile," that is the southwest corner, but does not mention the provenance. Properly speaking then, it is nowhere stated *expressis verbis* that the *Saint Stephen* which Ghiberti saw at the southwest corner of the façade and attributed to Andrea Pisano was the one transferred there in 1428 from Or San Michele. The situation becomes further involved both through a lack of visual evidence regarding the aspect of the façade at the time Ghiberti wrote and through an overabundance of figures of *Saint Stephen* extant and apparently coming from this façade.

The only reliable reproduction of the façade is the well-known drawing of 1583 (Poggi, bibl. 413, p. xxiii, fig. 3). This drawing shows, in the fourth tier in the southwest corner next to the campanile, a statue supposedly representing Saint Stephen since he carries what is presumably a stone in his right hand. The statue appears to be the one seen by Poggi in the Venturi-Ginori gardens (Poggi, bibl. 413, fig. 53) which carries a stone in the right hand and another stone on top of the (possibly restored) head. The style leaves no doubt that, together with its counterpart (Poggi, bibl. 413, fig. 52), it was produced about 1300, possibly by the shop of Arnolfo di Cambio. Thus this *Saint Stephen* cannot be the one commissioned by the *Arte della Lana* for Or San Michele, nor can it be by Andrea Pisano. (The attribution to the late fourteenth century suggested by Poggi [bibl. 413, p. xlvii] is equally impossible.) Hence either Ghiberti saw this statue at the southwest corner where it still stood in 1588 and wrongly attributed it to Andrea Pisano, or else he saw at this place a *Saint Stephen* by Andrea Pisano (or resembling his style) for which at a later time, but prior to 1588, was substituted the early fourteenth century *Saint Stephen*, which appears on the drawing of 1588. Indeed, the counterpart of this *Saint Stephen* stood at the left edge of the façade in the second tier on a level with Arnolfo di Cambio's tympana. Hence the early *Saint Stephen* probably stood originally in the same tier. He may have been transferred to the fourth tier of the southwest corner sometime during the fifteenth or sixteenth centuries.

The *Saint Stephen* by Andrea Pisano, then, would appear to be lost. Valentiner (bibl. 529, pp. 17f and note 1) has recently proposed identifying him with the figure of a sainted deacon, now at the Museo dell'Opera di S. Maria del Fiore, formerly at Palazzo Medici-Riccardi (Poggi, bibl. 413, fig. 39; the Dionysos head it then carried has meanwhile been removed). Poggi (*op.cit.*,

When deliberations on the project began, it would seem that the wool guild also intended to remodel the niche wherein the new statue would stand. A large drawing in the Louvre (Pl. 15), first published by Kauffmann,[14] would seem to reflect this as the original plan, and the documents offer some confirmation. The minutes of the first meeting of the *Arte della Lana*, held in April 1425 (Dig. 114; Docs. 107f), emphatically mention both the figure and the prospective decoration of the tabernacle. Two years later, in 1427 and 1428, the construction of the niche is alluded to only perfunctorily in referring to the earlier discussions. In all likelihood the cost proved prohibitive; a thousand florins could not go far, even for the statue alone. In any event the old niche of 1340 remained unchanged, even though the new statue fitted it so badly that the wall paneling was damaged when the figure was put in place in 1429.

The wool guild, in deciding to erect a fashionable bronze statue at Or San Michele and to entrust the commission to Ghiberti, explicitly went on record as intending the work to equal, possibly to excel, the other bronze statues of the sanctuary, or at least those which Ghiberti himself had made for the *Calimala* and the *Cambio*. The impending completion of Donatello's *Saint Louis* for the *Parte Guelfa* undoubtedly stimulated the *Lana* further into demanding, in the spring meeting of 1425, the best possible results from the work. Despite these good intentions, the outcome was not quite what had been expected. While cast in the same hollow technique as the *Saint Matthew*, the *Saint Stephen* is much smaller in size, not even 4 *braccia*, 2.30 m, as opposed to 4½ *braccia*, 2.70 m.[15] Correspondingly, the amount of bronze used was smaller—for while the *Lana* had purchased a greater supply of bronze than had the

p. xxxix) had seen in this figure a *Saint Stephen* executed between 1391 and 1395 for the façade where it occupied, together with three other saints, the niches of the second tier. But the deacon is larger than the figures that stood in that tier, 2.10 m as against 1.85 m and indeed all four of the smaller figures are preserved, two in Palazzo Medici-Riccardi and two in the Louvre. Valentiner, then, is no doubt right in not accepting Poggi's hypothesis. He has likewise suggested that the deacon, now in the *Opera* is not only by Andrea Pisano, but identical with the *Saint Stephen* originally at Or San Michele, basing his argument largely on similarities between this figure and Ghiberti's bronze *Saint Stephen*. Indeed, in some details the figure in the *Opera* does recall Ghiberti's statue at Or San Michele and one might add that its absence from the drawing of 1588 suggests the possibility of its being the lost figure from the southwest corner which Ghiberti attributed to Andrea Pisano. However, its style suggests the end rather than the middle of the fourteenth century. Hence, instead of being identical with Andrea's *Saint Stephen* from the façade or with the *Saint Stephen* from Or San Michele, he would seem to be a third *Saint Stephen*, still to be identified and not necessarily from the façade of the Cathedral.

This leaves to be discussed as a fourth figure the *Saint Stephen* of Piero di Giovanni Tedesco, executed between 1391 and 1395 (Poggi, bibl. 413, p. xlvi, fig. 51, docs. 89-92, 98, 105) for the niche to the right of the main portal in the second tier. The statue, now in the Louvre, is small in size, 1.85 m; the bearded head did not belong to the original statue (Kauffmann, bibl. 238, pp. 158ff; Paatz, bibl. 375, III, p. 395, and note 499). Strangely enough, this *Saint Stephen* in a number of points recalls Ghiberti's *Saint Stephen* at Or San Michele and the preparatory drawing, see below, p. 98 (Pl. 15; Fig. 34).

[14] Kauffmann, bibl. 239.

[15] In the *Commentarii* (Ghiberti-Schlosser, bibl. 178, I, p. 48) Ghiberti gives the height of the *Saint Stephen* as 4½ *braccia*, adding roughly 40 cm. Was this perhaps the measurement stipulated by the guild and hence transferred by Ghiberti without much thought from his diaries to the *Commentarii*?

Cambio, 4,000 as compared to 3,000 pounds Venetian weight, it was in the end left with a surplus of 1,660 pounds. The economizing inclinations of the *Arte della Lana* are clearly evident in the figure of Saint Stephen. Very much in contrast to the superbly fine craftsmanship of the neighboring statues by Ghiberti, particularly the *Saint Matthew*, the chasing of the *Saint Stephen* is neglected, the only perfectly finished parts being his face and the *rinceaux* ornament of his deacon's collar (Pls. 14, 16). The cufic design along the hem of the cloak is poorly engraved, and one wonders whether its chasing was ever completed. The hair above the ears and in back is rendered by only a few crude strokes (Fig. 33), whereas in the *Saint Matthew* even the curls of the back of the head are at least outlined. The hands are summarily done, the nails scratched in, not set back as in the *Saint Matthew* (Pls. 12a, b). The left foot of the Saint, protruding from beneath his garments, is a mere clubfoot, the toes barely indicated. A few scanty traces of gilding have survived.

No doubt the limited amount which the *Arte della Lana* intended to spend on the statue was at the bottom of Ghiberti's negligence in chasing the figure, just as it was the reason for its relatively small size. Moreover the master was pressed for time. The contract of the *Porta del Paradiso* had been hanging over his head ever since he started work on the *Saint Stephen*. Yet, surely a certain indifference makes itself felt even in the design of the statue (Pl. 14). The lower portions of the figure are somewhat sloppy, both in drapery and physique. The hips are hidden, the stance not quite clear, the drapery somewhat schematic. Yet, as a whole, it is convincing in elegance and firmness. The body swings slightly upwards in a curve from the narrow base formed by the broadening of the garments at its feet. A series of deep folds fall in elliptical and catenary curves over chest and abdomen. The hands protrude lightly from the cavities of the sleeves. The left hand carries the book, the right holds with an almost precious gesture the stem of a palm, of which a small fragment is still preserved (Pls. 12b, 17). From the serpentine curves of drapery over the shoulders and framed by the deacon's collar, neck and head rise lightly. The pose is determined by an easy flow rather than by weight and counterweight of a *contrapposto*. The intelligible clarity of the *Saint Matthew* has given way to a richer, more sophisticated, and more ambiguous design. The few main curves of the drapery are complemented and supported by dozens of lines in a minor key. The folds recede from massive to ever shallower planes and this abundance of planes, graded into depth, is the outstanding hallmark of the *Saint Stephen*, and, indeed, of Ghiberti's style in the mid-twenties. Yet blended with these linear draperies are surprisingly strong volumes in the rendering of the body, manifest in the square-set shoulders and strong chest. The flow of drapery enfolds the figure, encircling the body, enhancing its volume and defining its place within the limited space of the niche. The head is firmly shaped, the cheeks and forehead smoothly and clearly modeled, sinking slightly towards the temples and eye sockets. The mouth opens lightly with finely shaped lips and firmly modeled chin. The short hair encircling the tonsure falls nimbly, almost silkily over the top of the forehead (Pl. 16). The head throughout is a blend of firmness and softness. At first glance its round smoothness is deceptive. But, while the

young deacon has none of the virile strength of the *Saint Matthew*, he reflects a surprising resilience.[16]

Throughout the centuries Ghiberti's *Saint Stephen* has by and large been given cool reception. Unlike the *Saint Matthew*, its authenticity has never been doubted. But, beginning with Vasari, art historians from Bocchi to Baldinucci[17] and local antiquarians have passed over it with a perfunctory sentence. This curtain of polite silence was pierced by Burckhardt. To him the *Saint Stephen* seemed "one of the purest and at the same time finest works of Christian sculpture [by which he means medieval], severe in treatment and lines, yet of an uninhibited beauty." Schmarsow, at the very end of the nineteenth century went even further, as was his wont, to express the sentiment that "the true Ghiberti comes to the fore in only one work, the Saint Stephen"; in this figure, he says, "the Renaissance achieved the best for which the idealism of the Middle Ages had striven." Planiscig likewise interprets the statue as belonging to and, indeed, "progressing within the Gothic orbit," though at the same time he considers it of relatively poor quality.[18]

The enthusiasms of Burckhardt and Schmarsow have the same basis as the indifference of the other critics, both earlier and later. The statue of Saint Stephen is ambiguous in quality, as well as style, offering in turn superbly beautiful and completely negligible parts. Nor is it easy to classify stylistically as either Gothic or Renaissance. Obviously it contrasts sharply with the *Saint Matthew*, and if the latter represents a paragon of classical interpretation in body, drapery and mood, the *Saint Stephen* does not. At least, it does not stand for quite the same kind of classical interpretation.

This ambiguity may be explained in part, by the history of the *Saint Stephen*. The original design for the figure, submitted by Ghiberti to the *Arte della Lana* in 1425 is presumably preserved in the large scale drawing in the Louvre (Pl. 15).[19]

[16] A halo which, prior to 1943 surmounted the skull, clearly was not original. It has been removed since the statue was restored to the niche after the war. The hole in the apex of the tonsure suggests that possibly the figure carried a halo originally (Fig. 33).

[17] Vasari-Milanesi, bibl. 533, II, p. 233; Bocchi-Cinelli, bibl. 56, p. 64; Baldinucci, bibl. 35, I, p. 363.

[18] Burckhardt, bibl. 82, p. 557; Schmarsow, bibl. 485, pp. 48f; Planiscig, bibl. 404, p. 71.

[19] Paris, Louvre, Cabinet d'Estampes, 1231 (old 23918). Tempera and bluish-gold on linen, 69 x 30 cm. Ground, black-blue, fluting and capitals with white-black highlights, niche greyish-brown. Marble paneling in the background of niche, triangular fillings of the spandrels and edges of the niche, purple. Ground of vault and pediment bluish-black, the former set with gold stars. Cornices of niche behind the head blue-black on the left side, brown-specked on the right; possibly the blue is omitted on that side. Figure of Saint and base brown with white highlights, shadows black, hems of garment gold, palm olive green. Hair and neckcloth possibly redrawn in black ink. On the socle the words: SCS STEFANUS MAR in Gothic gold lettering.

To the bottom of the mat on which the drawing is mounted is fastened a paper slip with seventeenth century handwriting, possibly Baldinucci's: "Di Lorenzo Ghiberti che fece le porte di S. Gio. ni: ed è il designo della statua di Bronzo fatta dall medesimo nella nicchia di Orsanmichele per l'arte della Lana circa all-Anno 1420." The reverse of the mat carries the words "Baldinucci, tome 1, p. 22."

Kauffmann, the first to identify the drawing, suggested that it was done in Ghiberti's workshop. In Berenson's opinion (bibl. 46, I, p. 327, note 1; II, p. 310, no. 2391B) the drawing is neither by Ghiberti nor for the *Saint Stephen*, but "has much more affinity with Nanni di Banco's Philip . . .

Carefully analyzed by Kauffmann, who claims it as a work of Ghiberti's shop, if not of Ghiberti himself, the drawing painstakingly shows a bronze figure of Saint Stephen standing in a niche, flanked by slender fluted pilasters and surmounted by a low triangular pediment. The drawing can hardly be by Ghiberti's hand. It is timidly done and one might be inclined to view it as a copy after the completed statue were this not impossible for three distinct reasons. In the first place, it resembles the statue at Or San Michele in general outlines, but departs from it in detail. The pose, the hands carrying book and palm, even the general flow of the cloak in the upper part of the body are akin to the statue; so are parts like the drapery piled on top of the book, the folds crossing the chest, the deep cavities in both sleeves. Yet the differences are equally clear. Some are minor, such as the fact that in the drawing the Saint wears his neckcloth loosely tucked into his tunic, instead of the broad embroidered collar. Others are major. The drapery in the lower part of the figure in the Louvre drawing, instead of gliding to the ground in elegant folds, is nearly evenly divided into two heavy pyramids. The head is broad and blocky, the forehead exceedingly high. It has none of the elegant firmness of the statue at Or San Michele. In the second place, the figure in the Louvre drawing recalls Gothic sculpture in many more ways than Ghiberti's bronze statue. Thirdly, the figure in the drawing stands on a hexagonal rather than on the octagonal base of the present *Saint Stephen* at Or San Michele.[20] Hence the drawing cannot be a copy of Ghiberti's finished statue. On the other hand, the close resemblances between the Louvre drawing and Ghiberti's *Saint Stephen* are not to be overlooked, and the fact that the drawing clearly represents a bronze figure is telling in itself.

Only one explanation remains. As Kauffmann suggests, the Louvre drawing was executed in Ghiberti's workshop. Its painstaking meticulousness, timid draftsmanship, and large size indicate that it was done by either a member of the workshop or an outsider, perhaps a painter, and possibly after a sketch by Ghiberti, and that it was meant as a prospectus drawing for the committee of the *Arte della Lana*. It must have been executed in 1425 when the guild's plans for Or San Michele were still at an early stage, since it shows the original project of a new niche containing the bronze figure. Also the figure itself is still a long way from its final form. In fact, Saint Stephen as represented in the Louvre drawing is replete with traits that recall statues of the Trecento much more than of the Quattrocento. The heavy pyramidal blocks of drapery that cover the legs are not like anything in Ghiberti's work or, for that matter, in Florentine sculpture of the fifteenth century. These pyramidal draperies are, however, reminiscent of Florentine work shortly before the middle of the fourteenth century. They appear as a hallmark of the late workshop of Giovanni Pisano in the

and may be a sketch for it by Rossello di Jacopo Franchi." Goldscheider (bibl. 186, p. 153, note 51), considers the attribution to Ghiberti "impossible." In my opinion the drawing may well have been executed by an assistant of Ghiberti or by a painter of his acquaintance such as Rossello Franchi, who happens to be his exact contemporary (1377-1456); but it represents Ghiberti's first project for the *Saint Stephen*. See also Lotz, bibl. 278.

[20] The hexagon in the drawing fits neatly into the niche; the octagon of the base as executed, does not fit and damaged the niche at two points.

thirties and forties; particularly close are the two figures of an *Annunciation* from the Berlinghieri Tomb in S. Croce (1332-1338) possibly by Giovanni Balduccio da Pisa.[21] Also the short broken folds gathered at the feet of the figure in the Louvre drawing are reminiscent of sculptures of the second quarter of the Trecento.

After 1350 such elements became quite rare, cropping up only occasionally in the stone sculptures carved for the façade of the Cathedral in the last third of the fourteenth century. Outstanding among these sculptures is Piero di Giovanni Tedesco's statue of Saint Stephen now in the Louvre (Fig. 34).[22] Strange as it may seem, this *Saint Stephen* recalls the figure in the Louvre drawing. Obviously it is unlikely that the craftsman of the Saint Stephen in the prospectus drawing would have derived his design from a relatively small and unimportant figure which had no immediate ties to Or San Michele. Thus one wonders whether the common features of the prospectus drawing and of Piero di Giovanni Tedesco's statue of Saint Stephen were not drawn from the same prototype, the old marble statue of the deacon which the *Lana* had set up at Or San Michele in 1340. Clearly this statue was a well-known piece of sculpture. Piero di Giovanni Tedesco could easily have used it as a model in the last decade of the fourteenth century. On the other hand, when in 1425, the consuls of the *Arte della Lana* asked Ghiberti to replace the old statue with a bronze figure, they may have insisted upon Ghiberti's producing a statue, more precious in material, but otherwise reminiscent of the venerable image of their patron saint. Thus without attempting to copy the old figure, the Louvre prospectus drawing of 1425 assimilated an array of Trecento traits. Only gradually, in evolving from this preliminary idea his final design, did Ghiberti supplant such Trecento elements with the present fluid elegance.

Fluidity, elegance, and sweetness in Ghiberti's *Saint Stephen* have been interpreted as signs of Gothic heritage. But none of these features are found in the severe Gothic of the Florentine Trecento; hence they do not denote a survival of elements from the old statue of Saint Stephen, owned by the *Lana*. If they are reminiscent of anything Gothic, it would be the art of Siena prior to the middle of the fourteenth century, and of painting rather than sculpture. Indeed, the head of Ghiberti's *Saint Stephen*, both tender and firm, is not unlike the saints of Lippo Memmi or Ambrogio Lorenzetti. Yet even these likenesses do not signify a return to Gothic design on Ghiberti's part. The slim proportions, the sweeping stance, the flowing drapery, the lyrical elegance of the *Saint Stephen* need not necessarily conjure up Gothic connotations, even if the term Gothic is applied in a limited sense to Sienese and French art of the fourteenth century.

Only in the *Saint Matthew* had Ghiberti approached the classical Renaissance concept of the younger generation in Florence, led by Donatello. But even there the organic clarity, dignity and monumentality of the new style were tinged with more fluid and elegant forms. In the *Saint Stephen* Ghiberti gave a new meaning to balance

[21] Paatz (bibl. 375, I, p. 558 and note 291) gives a summary of the various attributions (Venturi, bibl. 534, IV, pp. 662ff: Giovanni Balduccio da Pisa; Bodmer, bibl. 60, pp. 616ff: Orcagna; and others) and with some hesitation attributes the group to Giovanni Balduccio.

[22] See above, note 13.

by stressing not so much the contrast of weight and support as the easy fluidity of stance and elegance of design. He toned down the emphasis on massive solidity and defined instead the volume of the figure by the linear ducts of drapery and the gradations of planes. He redesigned the proportions of the human figure: the head becomes smaller in proportion to the body, the ratio 1:8 as compared to 1:7 used from the competition relief through the *Saint Matthew*. He no longer viewed dignity in terms of forcefulness, but of sweet firmness. Reality he imparted in terms of a convincing easy liveliness.

The *Saint Stephen* does not stand isolated in Ghiberti's work of the late twenties. It shares its basic characteristics with the angels from the Cassa dei SS. Proto, Nemesio e Giacinto and with the figures from the *Baptism* in Siena (Pls. 73, 76). To be sure, Ghiberti explored different facets of his new style. In the *Cassa* he focused on the problem of antiquity and its relation to nature and on the problem of shallow relief. In the *Baptism* he evolved for the first time a fully developed pictorial relief. In the *Saint Stephen* he explored from a new angle and not quite successfully the problem of large scale sculpture. But the common traits are obvious: they lie in the new, overslender proportion, in the fine faces, in the linearism of the draperies, in the multitude of planes from which the sculptures are built up. Whether drawn from antiquity or from contemporary sources, Ghiberti evolves formulas by which he explores the boundaries of his basic problem: to develop within the art of the Renaissance a solution of his own. With the Saint at Or San Michele and his companion pieces, the Siena *Baptism* and the Shrine of the Three Martyrs Ghiberti sets out on a stylistic quest which was fulfilled in the best panels and the figures on the frame of the Gates of Paradise, and altogether determined the course of his work over the last twenty-five years of his life.

In exploring various facets of the new style Ghiberti only participates in a general trend which marks the years around 1425. Ten or even five years earlier, the aims of the nascent Renaissance movement had been limited in scope and only dimly envisaged. Around 1425 these aims expanded and each artist of the new movement clarified them in his own way. Masaccio set out to translate the statuesque concepts developed by Donatello into painting. Donatello's own style became more and more dramatic and violent, almost brutal. Nanni, in his last work, the tympanum of the Porta della Mandorla, incorporated the vocabulary *all'antica* into a design of new melodiousness. The artists who in the second decade had ventured towards vague concepts, now set themselves clearly envisaged objectives. These objectives differed widely from artist to artist. But all were part and parcel of a new phase of the Renaissance. Thus the new style became infinitely richer and more complex as it became more coherent and better defined. Within this new phase Ghiberti like his contemporaries explored new formulas, both *all'antica* and *alla moderna* and tried new tools of presentation, both in statuary and relief sculpture. Thus, in his own way, he falls in with the general development of the Renaissance in Florence around 1425.

THE NORTH DOOR OF THE BAPTISTERY

CHAPTER VIII

DOCUMENTS AND PROGRESS OF WORK

THE jury and the committee in charge of the competition recommended in 1402 or early in 1403 that the new door be entrusted to Ghiberti. But a whole year passed before the contract was signed.[1]

It was a year of important decisions. On September 3, 1403, the consuls of the *Calimala* decided to place the new door in the main portal, the one that faces east towards the Cathedral (Dig. 7; Doc. 60). Also sometime during this year the program of the door was changed. The competition had been held for a prospective door with scenes from the Old Testament as is evident from the subject-matter of the contending reliefs. One of Strozzi's excerpts confirms this as the original plan by paraphrasing a document to the effect that the competition relief was to be gilded and shelved "in case an Old Testament [door] was to be made . . . ; [for] it was decided to place the New Testament on the above named door" (Dig. 6; Doc. 33). In the disorganized *Libro della seconda e terza porta* this document followed right after the second contract of 1407. Consequently, both the document and the change of program have been assigned to this late date. It has even been suggested that none of the reliefs was modeled before 1407.[2] However, it is perfectly clear that a highly trained staff of assistants was employed beginning at least by 1405 (Digs. 15, 17, 24; Docs. 62, 2, 28), and that by 1407 at least some of the reliefs were executed. It seems hardly reasonable to assume that a complete change in program took place after work had been in progress for three and a half years. More likely the document in question, together with the revision of program date back to a period before the door was started.

As executed, the program of the door is clear enough (Pl. 18; Diagram 1). At the bottom are the four seated church fathers and in the second row the evangelists. The narrative reliefs beginning with the third row start with the *Annunciation, Nativity, Adoration* and *Christ among the Doctors*. They are followed by the *Baptism*, the *Temptation*, the *Expulsion of the Money Changers* and *Christ in the Storm*. The fourth row represents the *Transfiguration*, the *Raising of Lazarus*, the *Entry*, and the *Last Supper*, the fifth, the *Agony in the Garden*, the *Arrest*, the *Flagellation, Pilate*. The top row terminates the Passion with the *Way to Calvary*, the *Crucifixion*, the *Resurrection* and the *Pentecost*. The reliefs are surrounded by frames with ivy leaves. At the cross sections of the frames small quatrefoils with prophet heads are inserted.

Just why the change was made from an Old Testament to a New Testament cycle is unclear. Perhaps the *Calimala*, despite its power and prestige, was temporarily unsure of its ability to finance two doors, and thus decided to set up first the one which

[1] Since the publication of my preliminary paper (Krautheimer, bibl. 249), Ghiberti's North Door has been studied extensively by Paatz (bibl. 375, II, pp. 98f and notes 138ff) and by Albrecht (bibl. 15). Miss Albrecht's thesis, written under the direction of Professor Paatz and made known to me through his kindness, contains a great many acute observations primarily concerning the iconography of the scenes.
[2] Albrecht, bibl. 15, pp. 7ff.

Way to Calvary, Pl. 50 Christ, Pl. 51a Mary and St. John, Pl. 51b	*Crucifixion,* Pl. 52	*Resurrection,* Pl. 53	*Pentecost,* Pl. 54
Agony in the Garden, Pl. 43	*Arrest,* Pl. 44	*Flagellation,* Pl. 45 Christ at the Column, Pl. 47b	*Pilate,* Pl. 48 Pilate and Servant, Pl. 49b
Transfiguration, Pl. 37 Apostles, Pl. 38	*Raising of Lazarus,* Pl. 39 Man at Left, Pl. 47a Mary Magdalene, Pl. 40	*Entry,* Pl. 41	*Last Supper,* Pl. 42
Baptism, Pl. 32 Angels, Pl. 49a	*Temptation,* Pl. 33 Wing of Satan, Pl. 55a	*Expulsion,* Pl. 34 Fallen Youth, Pl. 35	*Christ in the Storm,* Pl. 36
Annunciation, Pl. 25 Mary, Pl. 26b	*Nativity,* Pl. 27	*Adoration of the Magi,* Pl. 28 Holy Family, Pl. 29	*Christ among the Doctors,* Pl. 30 Right Side of Panel, Pl. 31
Saint John, Pl. 21a Eagle, Pl. 23	*Saint Matthew,* Pl. 21b Detail, Pl. 24 Wing of Angel, Pl. 55b	*Saint Luke,* Pl. 22a	*Saint Mark,* Pl. 22b
Saint Augustine, Pl. 19a	*Saint Jerome,* Pl. 19b	*Saint Gregory,* Pl. 20a	*Saint Ambrose,* Pl. 20b

DIAGRAM 1. Schema of the North Door (Pl. 18)

would illustrate the more important and appropriate theme for a baptistery: the life of Christ, which explicitly, not implicitly, represents salvation. Possibly, too, the decision to place the new door opposite the Cathedral came as a direct consequence of this change. Only the portal which faces the Cathedral, dedicated to the Virgin Mother, and which looks to the east, whence would appear His second coming, may have been deemed worthy of sheltering the door devoted to Christ. Andrea's door of the life of Saint John occupied the south portal (Fig. 35), facing the city. The north portal, the Porta della Croce, was of lesser importance than the other two because it faced the still suburban area of S. Lorenzo. It could wait, but when and if it, too, was to have a door, it was the appropriate place for an Old Testament cycle, the north being customarily the side *absque Christo*. Only after the third bronze gate was finished in 1452 was the New Testament banished to the north side and the Old Testament given the place of honor, all custom put aside "stante la sua bellezza."

Ghiberti has little to say about his first door. He signed it with three simple words: LAURENTII FLORENTINI OPUS. In the *Commentarii* he describes only the overall scheme, the twenty-eight panels, twenty with stories from the New Testament and at the bottom four of evangelists and four of church fathers, "with a great number of human heads around . . . ; this work is executed diligently, with frames and ivy leaves."[3] He mentions in addition the total cost, including the frame, as 22,000 florins, and the weight as 34,000 pounds. These scanty remarks are fortunately supplemented by the considerable number of documents preserved in Strozzi's notebooks.

On November 23, 1403, the contract was signed; but it was not made out in Ghiberti's name alone. The commission was formally given "to the goldsmiths Lorenzo di Bartolo and Bartolo di Michele his father" (Dig. 8; Doc. 26). Ghiberti was obviously not in the position to take upon himself the legal responsibility. Bartolo, a member of the *Arte della Seta* (Doc. 114) in good standing and the owner of the workshop, had to be the consignatory. Yet, in the form quoted by Strozzi, Ghiberti's name preceded that of his stepfather, and in fact the artistic responsibility was placed squarely on his shoulders. The contract even goes on to say, "Lorenzo must work with his own hand the figures, trees and similar things in the reliefs." After all, it was apparently for the perfection of such details as these that the jury had awarded him first prize in the competition. Thus, one of the conditions of the contract was that Ghiberti should direct the work, and in this capacity he was permitted "to employ for assistance his father Bartolo and other masters, good and true, according to his discretion." The partners, Bartolo di Michele and son, were asked "to put only their labor into the work; everything else would be taken care of" by the *Arte di Calimala*. Everything else covered a good deal: materials—bronze, charcoal, wax, sand and clay, the building of the casting furnace and the wages of assistants. Assistants, then, were not on the payroll of the firm, but they were employed by the *Calimala* on Ghiberti's recommendation; personnel was part of his professional, but not financial responsibility. The arrangement was exceptionally advantageous for the master. As a rule the commissioning guild supplied the materials and paid the master a lump sum

[3] Ghiberti-Schlosser, bibl. 178, I, p. 46.

for his own work and for the wages of the hired help. Extant contracts leave no doubt as to this being the usual procedure, not only with the stonecutters' and painters' guilds, but also with bronze founders.[4] Ghiberti evidently had a knack for making special arrangements beginning with his first work.

According to normal procedure in the fourteenth and fifteenth centuries, the final price of the work of Lorenzo and Bartolo was to be determined after its completion by the commissioning guild.[5] Meanwhile, the two masters were to be jointly granted an advance of up to 200 florins annually, an amount which later in Ghiberti's life seems to have been his standard fee for a year's work. A special committee was elected by the *Calimala* to supervise progress of work. The members were Matteo di Giovanni Villani, Niccolo di Luca di Feo, and Palla di Nofri Strozzi. All three were leading members of the guild. Moreover, Palla Strozzi, the wealthiest man in town, was one of the heads of the Young Optimates and a foremost promoter of humanist studies. It was stipulated that three reliefs should be completed each year. If the term completed is taken verbatim, this meant that by each year three more reliefs should be modeled, cast, and finished. Considering the additional work on the frame, the *Arte di Calimala* was evidently counting on no less than ten years' labor—three more years than it had taken Andrea Pisano to complete the first door of the Baptistery. Ten years meant an outlay of 2,000 florins for Ghiberti and his father alone. Apparently the *Calimala* was willing to be generous in every respect in order that the product should live up to expectations. Work was to start December 1, 1403, but instead two months were taken up with mapping out details after the contract was signed. On January 30, 1404, the *Officiali di Musaico* appear to have told Ghiberti to go ahead (Dig. 10; Doc. 65). Perhaps only in the last two months before activity began was it decided to give precedence to a New Testament program.

The lost *Calimala* records of the next three years—until June 1407—contained a number of items concerning the door. Strozzi indexes a few of the expense entries from the *Libri Grandi* for the years 1404 and 1405, and lists a considerable number of indefinite references for 1406 and 1407 (Doc. 80). The names of Ghiberti's helpers, and presumably their wages, were regularly recorded in the accounts, beginning at least with 1405, and once a roster of names was apparently given (Dig. 15; Doc. 62). Finally, the *Libro della seconda e terza porta* names the assistants who were employed in Ghiberti's workshop up to June 1, 1407. It also notes the sum total of wages paid to Ghiberti and his shop crew (Dig. 24; Doc. 28). The assistants of the firm numbered eleven, one of whom was possibly an apprentice boy. This number does not include Bartolo di Michele who had the status of a partner. The total pay of partners and assistants up to this time, June 1, 1407, amounted to approximately 950 florins with the *Arte* still owing them 200. If the two partners' stipend for this period came to 700 florins, the eleven assistants totaled between them 450 florins. Apparently the length of time these helpers stayed in the shop was determined by the degree of pres-

[4] Wackernagel, bibl. 543, pp. 351f; for proof of this situation, see the contracts for Donatello's *cantoria* (Poggi, bibl. 413, doc. 1287), and Luca della Robbia's Sacristy door of the Cathedral (Marquand, bibl. 302, pp. 196f).

[5] Doren, bibl. 133, pp. 14f.

sure of work. Assuming that the wage rate for this period was the same as after 1407, the average working time of each assistant in these three and a half years would have been not quite twelve months. Activity in the shop would thus appear to have been slow and irregular.

It did not take either Ghiberti or the *Calimala* long to realize that even such a generous deadline as ten years was not enough. A revised agreement was drawn up on June 1, 1407. "Since Lorenzo di Bartolo did not observe to complete three reliefs each year, as agreed above," it begins, "the following contract is made anew with Lorenzo di Bartolo alone, without mentioning the father" (Dig. 22; Doc. 27). The wording here is probably in part Strozzi's own. Certainly he inserted the phrase, "without mentioning the father." But the interpolation is justified, for the fact that Bartolo was not mentioned in the new contract is, indeed, an important point. Lorenzo, although matriculated as a goldsmith only two years later (Dig. 28; Doc. 115), was nevertheless considered qualified by the *Calimala* to sign legal documents as an independent master. In fact, beginning with 1407, the old man appeared on the payroll as an assistant, contrary to the situation under the first contract. The ambiguous position of stepfather and son is clarified. Ghiberti held the reins, and the firm, it would seem, was being reorganized.

One would like to know how far Ghiberti had advanced the reliefs by 1407. Undoubtedly, *some* plaques were finished. But the exact number remains indeterminate. Instead of the ten called for in the first contract, had he completed six or five or four? The question is left open, but probably the lower the number assumed, the more likely it is to be correct.

This, in fact, is suggested by subsequent paragraphs in the contract of 1407 which, unlike the opening sentence quoted from Strozzi's excerpt, appear to reproduce the original text. Conditions were made more stringent. Ghiberti had to agree "to work every working day, all day long, with his own hands like any journeyman." Every interruption was to be deducted and recorded "in a book kept for that very purpose." Apparently the guild, somewhat annoyed, did not propose to continue paying even the top artist a fixed annual advance without effecting a system of supervisory checks on the progress. Likewise he was forbidden "to accept any outside work without permission of the consuls" of the *Calimala*. As in the first contract, Ghiberti was made to promise to work with his own hand both "in wax and bronze," that is, to execute himself the wax models and to do the chasing of the cast, "particularly on those parts which require the greatest perfection like hair, nudes, and similar objects." Moreover, the *Arte di Calimala* established the wages of the assistants, although their selection was still left up to Ghiberti. A later decision of the guild also regulated the holidays of the shop crew (Dig. 27; Doc. 64). As in the first contract, the *Arte* promised to provide "material and tools" and to pay the wages of assistants.

Though perhaps wary, the *Arte di Calimala* had no intention of parting with Ghiberti's services. His pay was raised. As in the first agreement of 1403, the *Arte* was to advance him 200 florins *per annum*, but he no longer had to share this sum with Bartolo who, as an assistant, drew a separate salary. Indicative of the position to which

Ghiberti had risen is a clause that closely binds him to future plans of the *Calimala*. Once the door was completed, he was asked to "wait a year to see whether the guild would want to assign him to any other work." Thus Ghiberti gave the guild an option on his future production and in return the guild held out the prospect of another major commission, presumably the third and last door of the Baptistery.

On the basis of the second contract Ghiberti continued work after June 1, 1407. It is possible that the shop crew was enlarged at this date. The *Libro della seconda e terza porta*, according to Strozzi's excerpts, enumerated by name twenty-one assistants for the period after 1407, stating both their annual salaries and the wages they actually drew (Dig. 41; Doc. 31). But clearly this list does not necessarily reflect the personnel of the workshop as of June 1, 1407, or shortly thereafter. True, the enumeration began at this date, but it also appears to have extended over a number of years. Several names are mentioned twice, each time with a different salary, evidently drawn in successive periods. The wages of others were computed in three or four separate counts, probably for the same reason.

Together the first and second lists of assistants, before and after 1407, give a fair notion of the working habits of the shop and of the composition of its crew, but do not allow us to come to any far-reaching conclusions as to whether activity increased or diminished after the reorganization. The most one can say is that the permanent members of the workshop in the years after 1407 seem to have been employed more regularly and for longer spells than earlier. Of the eleven workers on the first list, seven stayed on after the second contract. Some of these were apparently old hands who formed the core of the workshop. This permanent staff remained small throughout, and most of its members are remembered as mere names: Bartolo di Michele who, after 1407, stayed on for a total working time of more than four years, first at a salary of 75 florins, then at a reduced wage of 50; Bandino di Stefano who worked for a time in the shop after 1407 at a top salary of 75 florins; Matteo di Donato who, after 1407, worked up to a leading position; lower on the scale was the goldsmith, Domenico di Giovanni, another old-timer who remained a fixture of the workshop, even though he seems to have opened shop for himself after 1409; Giovanni di Francesco, another old hand, but hardly more than a laborer. Giuliano di Ser Andrea, the most faithful helper, is dimly known through his presumed work on the Herod relief in Siena. He was working for Ghiberti as early as 1405 and stayed with him until about 1433 (Digs. 17, 24, 179; Docs. 2, 28, 83). For work on the North Door he drew after 1407 one of the top salaries of 75 florins *per annum* for a total working time of four or more years (Dig. 41; Doc. 31). Either Michele detto Scalcagno or Michele di Nicolai, both mentioned in the first list, may have been working thirty years later in Upper Italy.[6]

Occasionally amid this somewhat anonymous crew appears the name of a better known or even great artist of Florence. Maso di Cristofano, a member of the shop prior to 1407, is perhaps identifiable as Masolino.[7] Over a period of five to six years

[6] Fiocco (bibl. 159) has suggested identifying Michele da Firenze, the master of the terracotta reliefs in the Pellegrini chapel in S. Anastasia at Verona, as one of the two Micheles on Ghiberti's list of assistants.

[7] Milanesi has denied the identification of Ghiberti's Maso with Masolino (Vasari-Milanesi,

after 1407 he evidently worked up from a medium salary of 55 florins to a top one of 75. Bernardo di Piero Ciuffagni seems to have worked on the North Door, but mainly in the period before 1407; afterwards he is mentioned as the recipient of only a minor salary. An apprentice boy who entered the shop after 1407, Pagolo di Dono, better known as Paolo Uccello, eventually advanced to a salary of 25 florins per year; but his position suggests that he did little more than menial chores. Donatello is listed both before and after 1407. True, he worked for only six weeks after the second contract, and the duration of his activity in the earlier period is not known. But since after 1407 he drew a top salary of 75 florins annually, despite his young years, he ranked on a par with the leading old hands; hence in all likelihood he had been for some time in the employ of the workshop.

The second list of assistants, extensive though it is, does not seem to cover the entire period from 1407 to the termination of the door in 1424. In fact, there are good reasons to believe that it does not go beyond 1415. A number of those listed on it could not have been active in the shop after this date. Donatello's employment must fall into the period shortly after June 1407, since later he was far too busy with his own commissions to lend Ghiberti assistance. Similarly Uccello was in the shop probably only prior to 1415. He worked there as an apprentice from three to five years, then for more than another year with the salary of a young journeyman (Doc. 31). Apprentice boys in Florence were usually around ten to twelve years old when they started. Hence, Uccello, born in 1396 or 1397, must have joined Ghiberti's workshop sometime between 1407 and 1409. In October 1415, he matriculated as a painter in the *Arte de' Medici e Spetiali*. Since his wages in Ghiberti's employment never exceeded those of a low paid journeyman, he is unlikely to have continued in such a humble position after earning the right to set up shop as an independent master. Accordingly, he would probably have left Ghiberti around 1414 or 1415. But neither does the list show any sign of continuation after this point. Ghiberti is known to have employed another assistant in 1416, Papi di Bartolommeo (Doc. 138), but his name did not appear in the wage accounts of the *Libro della seconda e terza porta*. Michelozzo also worked on the North Door, probably between 1417 and 1424 (Dig. 81; Doc. 34), but neither is his name recorded among the assistants. Thus the list "after the second contract" certainly did not cover the years between 1416 and 1424, and probably it broke off as early as 1415.

As listed in the *Libro*, the accounts for materials also seem to have stopped after 1415, or at least in part. One item specifically, 5,564 pounds of bronze, was used up between 1404 and 1415 (Dig. 39; Doc. 29). The dates of accounts for other materials

bibl. 533, II, p. 264, note 1). He asserts that he was the goldsmith Maso di Cristoforo [*sic*] di Braccio who was matriculated in the *Arte della Seta* in 1409.

There is clearly no reason to assume that Vasari had any evidence for his statement that Masolino was Ghiberti's best assistant in chasing the door or that he was particularly able in "modeling and finishing the draperies and soft bulges of limbs and garments" (Vasari-Milanesi, bibl. 533, II, pp. 263f). At best Vasari's knowledge, if knowledge it was rather than pure invention, would have been derived from Ghiberti's great-grandson, Vittorio di Buonaccorso, but certainly Vasari confused matters by assigning Masolino's stay with Ghiberti to the period when the Gates of Paradise were under way (Vasari-Milanesi, bibl. 533, II, p. 243); see also Procacci, bibl. 426, pp. 378f, note 2.

are uncertain, such as for wood and charcoal, wax for the foundry and the torches for workers "to light themselves home at night." The amount of modeling wax which these accounts specify is 1,739 pounds (Dig. 108; Doc. 30). This corresponds to approximately half the amount used for the entire door—reliefs, skeleton frame, and back plaque—given the total weight of the door and the ratio of specific weights of bronze to wax, 8.91 to 0.96. Hence this account must be for an intermediary stage, possibly again 1415. A fourth item can be securely dated after 1415: a purchase of 831.1.11 florins worth of bronze at 6 to 6½ soldi per pound, thus resulting in a total amount of roughly 10,000 pounds (Dig. 108; Doc. 30).[8] This load is distinct from the 5,564 pounds given Ghiberti up to 1415, and thus must represent a later supply. Obviously these accounts for bronze are incomplete, since the two loads together do not equal even half the total of 34,000 pounds that went into the whole door. All told, the year 1415, like the year 1407, appears to have marked a turning point in the activities of the workshop.

The book entries offer no more than slight insight into the progress made between 1407 and 1415. The amounts of bronze and charcoal consumed in this period indicate that a good deal of casting was done. Indeed, there are signs of an extra spurt of activity shortly after 1407. For instance, a notary's entry of January 7, 1408, transmitted only by Baldinucci,[9] says that the *Signoria* granted permission to Ghiberti and his staff, each of whom is mentioned by name, to be on the street after the curfew (Dig. 25). One would like to interpret this as evidence of accelerated activity, understandable enough in the light of the second contract. Sums spent on torches for the workers (Dig. 108; Doc. 30) may also date from this period. Numerous entries in the *Libri Grandi* in the years 1405 to 1408, as indexed by Strozzi (Doc. 80), also point to increased activity, and the regulations made in 1409 regarding the holidays of the shop crew hint at pressure put upon Ghiberti by the *Calimala* to work faster (Dig. 27; Doc. 64).

Three items shed light on the final phase of work between 1415 and 1424. The first is an excerpt of Strozzi's which refers to Michelozzo as one of the collaborators of the *seconda porta*, and as drawing a salary of 75 florins a year (Dig. 81; Doc. 34). The

[8] Strozzi, mistakenly wrote l. 831, instead of fl. 831. But the item is composed of three figures and as always the first figure, 831, should refer to florins, the second, 1, to lire, the third, 11, to soldi. The normal cost of bronze per pound during the first half of the fifteenth century fluctuated from 6 to 7 soldi, or roughly 1 florin for fourteen pounds (see above, p. 46 note 6). Hence, the amount of 5,564 pounds cannot be equated with the sum of 831 florins as suggested by Lerner-Lehmkuhl, bibl. 273, p. 44.

[9] Baldinucci, bibl. 35, I, p. 372 ". . . s'è trovato in un libro di ser Nofri di ser Paolo Nemi, notajo de' Signori appo agli eredi del gia' Stefano Nemi, che in dì 7 di gennaio 1407 fu concessa licenza a Lorenzo Ghiberti maestro, ed a Bandino di Stefano, Bartolo di Michele, Antonio di Tommaso, Maso, Cristofano, Cola di Domenico di Gio. e Barnaba di Francesco, tutti lavoranti delle porte di S. Gio. di potere andare per Firenze per tutte l'ore della notte, ma però con lume acceso e patente."

The papers of Ser Nofri di ser Paolo Nemi are in the *ASF, Archivio notarile*, N 64. But the document referred to by Baldinucci is not among them, nor is it mentioned under that date in Nemi's journals. Also it is obvious that there are some inaccuracies in Baldinucci's reading. On the one hand he splits Maso di Cristofano into two men, on the other he contracts into one man Cola (di Liello?) and Domenico di Giovanni; see Doc. 31.

absence of Michelozzo's name from the second list of assistants, his high salary and the date of his birth, 1396, suggest that he assisted on the door around 1420 when he also collaborated with Ghiberti on the *Saint Matthew*. The second item is dated 1423 and concerns the decision of the consuls of the guild to have the door gilded "because higher consideration and value should be given to honor and fame than to expense" (Dig. 101; Doc. 92). Although the extra expense was not supported with an altogether light heart, for enough money had been spent, it was nevertheless taken on. The third matter relating to these years is the casting of the frame of the door. The only verifiable supply of bronze to seem adequate for the big back frame and skeleton is the 10,000 pounds presumably purchased after 1415. A document exists that supports this conclusion. It is a well-known source, but so far it has always been associated with the Gates of Paradise because it is found in the 1429 tax declaration of the *Calimala* (Dig. 157; Docs. 87f). Listed among the *Calimala's* deductible liabilities are the capital and interest of a loan contracted "in one operation . . . for bronze and other expenses . . . when the frame (*telaio*) of the door of S. Giovanni was cast." The total sum of this transaction was 1,800 florins: 1,000 florins, at an interest rate of six per cent, came from the estate left to the guild by Piero Broccardi who died in 1411; the remainder of 800 florins, at an interest rate of seven per cent, was borrowed from his widow, Mona Caterina, also deceased by 1429 and indeed, prior to June 1424.[10] The term *telaio* in the documentary parlance of that day referred either to the skeleton of the door or to the shape or pattern impressed on the door by such a skeleton. This document has been applied to the Gates of Paradise partly because it is followed in the 1429 *portata* by a statement that clearly refers to the expenses of the *terza porta di San Giovanni*. By this sequence, then, the loan contracted "when the *telaio* was cast" has been connected with the last door. This opinion wants revising. In the first place, the skeleton frame of the third door was cast, according to documents, between 1439 and 1447 (Digs. 209, 255; Docs. 25, 59, 41), not prior to 1429. Secondly, in the *portata*

[10] Brockhaus (bibl. 69, p. 39) was the first to publish the document in an excerpt which was reprinted by Frey (bibl. 532, p. 359, doc. 4). Partly through a misreading (*un deposito* instead of *in deposito*) Brockhaus misinterpreted the text, *loc.cit.*, p. 46. I am greatly indebted to Professor and Mrs. Raymond De Roover for their advice in interpreting the document.

Both the expressions *avere in deposito* and *torre denari* are key terms. The first means to have on deposit, the second means to take up a loan (cf. Tommaseo, bibl. 523, II, p. 96, "dare in deposito = depositare"; IV, 2, p. 1492, "torre a interesse = prendere danari a frutto"; see also Doren, bibl. 135, I, pp. 448f).

Regarding the date of this loan, the *catasto* of 1429 refers clearly to an event of the past, as witness the phrase "quando si gittò el telaio." Brockhaus (*loc.cit.*) interprets the passage as referring to a future event and is thus in error.

The date of the death of Piero Broccardi, 1411, results from the inscription on his tomb as reprinted by Richa (bibl. 443, V, p. 321). Originally in S. Michele di Croce di Via, the plaque was evidently transferred during the latter part of the eighteenth century to S. Bonifazio (marginal note of the period in my copy of Richa). See also, *BNF, Necrologio Cirri*, vol. IV, f. 14v, with the exact date, April 4, 1411.

The date of the death of Mona Caterina remains undetermined. The *portata* of the *Calimala* of 1429 reports her as defunct nor does her name appear in the *catasto* of 1427 or in the *Libro della Grescia*, the registry of the deceased, between June 30, 1424, and October 17, 1430. (*ASF, Libro della Grescia, Morti*, vol. 188, 1424-1430). The *Libro della Grescia* is missing from 1413 to June 1424. Hence, Mona Caterina must have died at some time during these years.

itself a distinction is made between the nomenclature of the two doors. The Gates of Paradise are referred to as the *terza porta di San Giovanni che è comminciata*, whereas the item concerning the *telaio* speaks of the *porta di San Giovanni* plain and simple, that is, the door past and done with. The precise date when the *telaio* was cast remains an open question. It fell sometime after Piero Broccardi died in 1411 and before the death of Mona Caterina between 1413 and 1424 and in all likelihood between 1415 and 1420.

Considerable energy must have been expended in the last years of work on the door. The total cost of the work, including the jambs, is given by Strozzi and Gori as 16,204 florins (Dig. 109; Doc. 121), nearly 6,000 florins less than the amount of 22,000 mentioned by Ghiberti in the *Commentarii*.[11] Out of this 16,000 florins about 2,400 was spent on the purchase of 34,000 pounds of bronze at 6 to 6½ soldi per pound. The cost of wood and wax amounted to roughly 400 florins (Dig. 108; Doc. 30), and Ghiberti's compensation for twenty years' work came to 4,000 florins at most and possibly far less in view of deductions made for time spent on other work. Finally, the wages of assistants up until 1415 totaled 2,200 florins. This leaves unaccounted for 7,000 florins which presumably made up the wages and other unspecified expenses for the years 1415 to 1424. The difference of 6,000 florins between Strozzi's memoranda and Ghiberti's statement may have been spent on the bronze jambs of the North Door, which were designed in 1423 (Dig. 102; Doc. 58) and probably not cast until after 1424.

However, a good deal of the work seems to have been done by 1415. Around that time Ghiberti took on a considerable number of outside commissions: the *Saint John* for Or San Michele in 1412-1413, the Siena Fount in 1417, the model for the dome of the Cathedral in 1418, and the *Saint Matthew* in 1419. Whether all these commissions required the express permission of the *Calimala*, as stipulated in the contract of 1407, is not clear. They could hardly have been accepted without the guild's tacit approval, at least. Since even the guild itself requested another work from Ghiberti, the *Saint John*, there would seem to have been no cause for protest against the outside commissions. The satisfaction thus reflected with the progress of the door as of 1415 must mean that by then a considerable number of reliefs were cast. Others undoubtedly followed, but the better part of the time between 1415 and 1424 was probably spent on the arduous and time-consuming task of the finishing. The gilding alone and the assembling of the door took fully a year, March, 1423 (Dig. 101; Doc. 92) to April, 1424. The nineteenth of that month, the door was set in place on the east gate of San Giovanni (Dig. 105; Docs. 32, 35).

[11] Ghiberti-Schlosser, bibl. 178, I, p. 46.

CHAPTER IX

THE QUATREFOILS AND HEADS

THE new bronze door for the Baptistery was envisioned from the outset as a counterpart to Andrea's door (Fig. 35). Seven rows of four slightly elongated panels form its pattern, divided by lattice work garnished with foliate ornament (Pl. 18). Each panel, .575 m wide, roughly one *braccio fiorentino*, and .65 m high, contains a quatrefoil. These quatrefoils, including their molded frames, measure .39 m by .39 m, or close to two-thirds of a *braccio* square. Structurally the wings of the door are composed of two principal elements. The first is a solid bronze slab, divided on the back into fourteen square panels, each of which contains a lion head in flat relief; two of these originally bit on rings which served as door handles (Pl. 68a, Fig. 54a, b). The second element is a strong skeleton frame that divides each wing into fourteen deep caissons. This frame on the front face of the door forms the dividing lattice work. In between its vertical and horizontal bars extend the square panels, cast in one piece with the lattice work. Openings were left in the center of every panel, surrounded by quatrefoil moldings which are also cast of the same piece as the panels. Into the openings the reliefs were inserted. Small corresponding quatrefoil moldings, placed at the intersections of the lattice frame, also surround openings into which were inserted prophets' heads. The same technique is employed on the back of the door; here round openings received the lions' heads. The reliefs, the heads of the prophets and lions were cast individually. Likewise, the foliate strips placed on top of the lattice frame were cast in separate pieces, each the length of the square panels and soldered onto the lattice frame.

A work as large and as rich as Ghiberti's first bronze door may constitute an artistic whole, but it cannot and does not present complete stylistic unity. This one door took up half of Ghiberti's life, from his twenty-third to his forty-fifth year. During this time, a quarter of a century, he changed from the style of the competition relief to that of the *Saint John*, and thence to that of the *Saint Matthew*. These changes encompass concepts of late fourteenth century French goldsmith work, of the International Style, and finally of the incipient Renaissance. They are equally perceptible, if not more so, in the reliefs of the North Door, in the compositions and the hundreds of figures of the quatrefoils, in the prophets' heads, foliage strips and, on the back of the door, in the lions' heads.

True, the pattern of the door, corresponding to Andrea Pisano's (Fig. 35), and its program were settled upon at the very start, presumably at the instruction of the *Arte di Calimala*. Within this given pattern, Ghiberti permitted himself a few minor changes (Pl. 18). Andrea's quatrefoils are taller than wide, so their four points touch the frame of the surrounding, slightly elongated panels. Ghiberti gave the horizontal and vertical axis of his quatrefoils the same length, so they float easily on the plain background of the panels. From the frame he omitted the dentil frieze that sets off the elongated panels of Andrea's door; for the rosettes and diamond studs of the lattice

113

grid, he substituted rich foliage strips. He marked the corners of the panels with human, rather than lions' heads. But the lions' heads were not lost; they only migrated to the back of Ghiberti's door.

The program of the door, like its pattern, was predetermined. Church fathers and evangelists occupy the two bottom rows, thereby offsetting Andrea's two bottom rows of virtues. Twenty scenes from the life of Christ counterbalance Andrea's twenty scenes from the life of Saint John. Even the sequence of scenes was preconditioned, both by necessity and tradition. As early as the late twelfth century Bonannus had filled the bottom panels of his bronze door at Pisa with figures of prophets, and the five upper rows with scenes from the life of Christ. The narrative sequence, from lower left to upper right, had been customary since the early Middle Ages, connoting the upward path of salvation. The reverse sequence had long been used for Old Testament cycles to connote man's fall from the pure state of creation to sin and toil.[1] Andrea's door, in telling the life of the precursor of Christ, follows a sequence comparable to Old Testament cycles, starting at the top left corner and ending in the bottom right. But instead of running from left to right across the width of both wings of the door, Andrea's narrative runs first down the left wing, then continues on the right. This arrangement was due to the position of the door. The scenes are read like opposite pages in an illuminated manuscript, indicating that Andrea counted on his door facing the town, and thus being kept open, as indeed it is to this very day. The other two doors, facing north and east, respectively, remain closed as a rule. Hence, both Ghiberti's New Testament scenes and his Gates of Paradise (Pl. 81), as well, incidentally, as Leonardo Bruni's projected scheme of 1424 for the latter, read in a continuous line across both wings.

Pattern and program of the North Door were thus preëstablished. But Ghiberti's style unfolded as work on the quatrefoils progressed. To establish the line of progress is nevertheless not easy. The technical features reveal little. In the quatrefoil reliefs the figures were modeled singly or in groups and set on a platform, and likewise the ground plaque with the setting was modeled separately. Finally the platform with the figures and the ground plaque were joined together and adjusted. Often figures are prepared for a rounder view in a manner that clearly shows they must have been done before the wax model was fastened onto the ground plaque and before the setting was inserted: in the *Flagellation*, the executioner to the left got caught with his right hand behind a column in a pose that would prevent him from striking, proof of his having been modeled before the architecture got in his way (Pl. 45). At times, a figure may have been replaced in the wax model by a later version. The casting, *à cire perdue*, resulted in the entire relief's forming a hollow sheet, except for the few figures which strongly protrude from the background and therefore were separately

[1] The Hildesheim door and the Alcuin Bible are outstanding early examples of this pattern. Notwithstanding digressions from the general rule for practical or decorative purposes (Bonannus' door at Monreale is an Old Testament series following an upward sequence while the door of Benevento Cathedral is a downward New Testament sequence), the custom continued through the fourteenth century: both Duccio's *Maestà* and Ugolino da Vieri's Reliquary of the SS. Corporale in Orvieto are examples in Trecento art.

cast. Since such figures are scattered all over the door, they give no clue regarding the date.[2] Figures that turned out failures were recast or repaired.[3] The analogous procedure on the Gates of Paradise, where documents are more plentiful, leaves but little doubt that the casting took much less time than the subsequent chasing.[4] But throughout, the chasing of earlier reliefs appears to have run side by side with the modeling and casting of the later ones. Finally, in 1423 the reliefs were gilded and inserted into the frame, not without some minor mutilations.[5]

[2] Figures cast separately are: the young king at the left edge of the *Adoration of the Magi*; the figure of Saint John in the *Baptism*; the fallen youth in the foreground of the *Expulsion from the Temple*; the figures of the two disciples to the right and left of the feet of Christ in the *Transfiguration* and possibly also the figure of Christ; the Christ in the *Crucifixion*; the figure of Lazarus in the *Raising*; the warrior at the left and perhaps the two figures at the right of the *Pilate*; finally the three principal figures of the *Flagellation*.

Small objects carried by the figures were likewise cast separately. Thus, Gabriel in the *Annunciation* seems to have carried a lily, the older shepherd in the *Nativity* a crook, Christ in the *Expulsion from the Temple* to have held a scourge, the executioners in the *Flagellation*, whips, the helmeted soldier to the left of Christ a halberd or lance.

[3] Vasari-Milanesi, bibl. 533, II, p. 228, mentions such recastings. Repairs, major and minor, appear in nearly all reliefs. A short list of the major ones should suffice.
Saint Gregory: hole in background, left of platform, plugged.
Saint John the Evangelist: hole in ground, left of lectern, plugged.
Nativity: hole in rock below Mary, plugged.
Christ Among the Doctors: pier left edge, mended, pier left of Christ cracked.
Transfiguration: small hole right of Moses, plugged.
Lazarus: background upper nose of quatrefoil repaired with large triangle.
Mount of Olives: background center, large rectangular hole, no repair; smaller holes higher up, plugged, one with nail; holes in rock, unrepaired.
Arrest: large irregular piece, upper right lobe, repaired.
Way to Calvary: two rectangular holes, right upper lobe, plugged.
Crucifixion: two rectangular holes, foot of cross, plugged.
The lower stem of Christ's cross in the *Way to Calvary* was soldered back at a wrong angle, apparently in 1947.

[4] Between April 1437 and July 1439 only three panels of the Gates of Paradise were completely or almost completely chased, with one or two others partially so (Dig. 208; Doc. 24). Within the following four years the number was increased to six (Dig. 241; Doc. 40) and the remaining four took another four years (Dig. 259; Docs. 20, 42). In other words, it took Ghiberti on the average of one year or slightly more, to do the chasing of each of the large plaques for the second door. Specifically, the agreement of 1448 stated that it would take "a good master three and a half months to finish one of the twenty-four strips" composing the frame, each being .85 m long and .08 m wide (Dig. 263; Docs. 22, 24).

[5] A list of such mutilations follows:

John the Evangelist: left lower lobe mutilated by eagle.

Saint Augustine: lectern damaged by frame.

Annunciation: right lower lobe mutilated to squeeze in platform.

Nativity: tree slightly mutilated by right upper lobe; both lower lobes damaged.

Adoration of the Magi: right lobe cut by pier.

Christ among the Doctors: tiny mutilations both edges.

Baptism: both right lobes.

Transfiguration: drapery of angel mutilated by right frame; both lower lobes damaged, upper right lobe by horns of Moses.

Raising of Lazarus: both lower lobes damaged to accommodate rocks, upper left lobe to accommodate figure.

Entry: both lower lobes to accommodate rocks.

Last Supper: right nose of frame to accommodate arm of Disciple.

Mount of Olives: tree to the left and right wing of angel mutilated; right lower lobe to accommodate foot of apostle, left nose of frame to accommodate rock.

Arrest: left lower lobe to accommodate rock.

Flagellation: right nose of frame to accommodate arm of executioner.

Pilate: left nose of frame to make room for

The documents support the general impression of a slow, often irregular pace of work. They suggest that a few of the reliefs were modeled and cast before 1407; that after 1407 work went on at greater speed until 1415; that during the same years a good deal of time was spent on the chasing until 1423 when the different parts of the door were ready to be gilded. But neither the documents nor the technical features indicate which reliefs were modeled prior to 1407 or between 1407 and 1415 or, for that matter, after that date. Nor is there any indication of the sequence in which the prophets' and lions' heads were designed, or when the frame was cast.[6]

However, enough external evidence exists to establish at least a fragmentary chronological sequence. The quatrefoils of the North Door made a deep impression on Ghiberti's contemporaries. Motifs purloined from them are reflected in the work of many a minor master, after the door was set in place in 1424.[7] But other masters

arm of young warrior.

Way to Calvary: both lower lobes to accommodate rock, left nose of frame for thigh of Saint John; right nose for bearded soldier.

Crucifixion: left angel, garment, and supporting clouds mutilated; right lower lobe to make room for figure of Saint John, upper nose of frame for horizontal bar of cross.

Resurrection: right upper lobe in order to accommodate tree.

Pentecost: right lower lobe and both upper lobes in order to accommodate the heads of Saint Peter and Saint Paul; architecture damaged by right hand nose of frame.

[6] A somewhat intricate problem is presented by the technique and the date of the skeleton frame. The sum total of the evidence at hand, both documentary and visual, would seem at first glance to be contradictory in itself. As far as Cavaliere Bruno Bearzi could observe in 1946-1947—and I am greatly indebted to him for all the information which has repeatedly enlightened my ignorance—the skeleton frame, the lattice work, and the back plates appear to have been cast in one piece. Documentary evidence, which indicates the purchase of large supplies of bronze after 1415 and discloses funds borrowed from the estate of Piero Broccardi and from his widow (see above, pp. 111f), points to a late date for the frame. However, the moldings of the lattice frame and connecting square panels clearly display Gothic profiles that suggest a relatively early date. The profiles of the back plates are, on the other hand, decidedly late and close to those of the Gates of Paradise. These contradictions can be resolved by one of two hypotheses: either the front frame was modeled at an early date and left to stand until it could be cast together with the later back plates, shortly before 1424; or else the frame was cast in two separate parts, the lattice front early and the back plates late, and then the two were soldered together. In view of Cavaliere Bearzi's observations, the first alternative is far more likely.

[7] Outstanding among late echoes of Ghiberti's first door after 1424 are a *paliotto* from Teramo, dated 1433-1444 and executed by Niccolo di Guardiagrele, and a series of six undated reliefs from Castel di Sangro, now at the Museo dell'Opera in Florence (Fig. 36). Carli (bibl. 86, pp. 147ff) has proved beyond doubt that the relief series cannot be attributed to the same master as the Teramo *paliotto*, i.e. Niccolo di Guardiagrele, while clearly demonstrating their links with Ghiberti's first door. Their main interest lies in the fact that they employ a number of scenes from the life of Christ which, while Ghibertian in character, are not included in the cycle on Ghiberti's door; they may therefore reflect scenes which Ghiberti had designed, but later discarded.

Echoes of Ghiberti's quatrefoils likewise occur in a series of crucifixes with reliefs from the hand of Niccolo di Guardiagrele, dated 1431 and later (Carli, bibl. 86, pp. 158ff). Other echoes appear in Giovanni Rosso il Fiorentino's Brenzoni tomb at S. Fermo in Verona (Brunetti, bibl. 74, pp. 263f, and 271, note 7, with reference to the earlier bibliography). They permeate the reliefs in the Pellegrini chapel of S. Anastasia in Verona, which between 1433 and 1438 were executed by Michele da Firenze, possibly Michele Scalcagna or Michele di Nicolai, both listed in Ghiberti's shop (Fiocco, bibl. 159). A silver crucifix, formerly in the Impruneta, reflects the Christ of Ghiberti's *Crucifixion* in a free variation, probably executed after 1425 (Krautheimer, bibl. 249, pp. 76f) (Fig. 44).

As late as 1464-1469, Luca della Robbia drew heavily, not only on the Gates of Paradise, but also on Ghiberti's first door for his bronze door of the North Sacristy of the Cathedral (Marquand,

drew on the reliefs when they were still in the workshop; obviously when such echoes are dated, a *terminus ante* or a *terminus ad* is established for those reliefs of Ghiberti's that had served as the models. Thus Giovanni Turini from Siena, in 1417, when designing the *Birth of Saint John* (Fig. 39) for the Baptismal Font of his native city, borrowed copiously from Ghiberti's reliefs. His Elizabeth was copied from Ghiberti's Virgin in the *Nativity* (Pl. 27), his woman visitor from Mary in *Christ among the Doctors* (Pl. 31), and from Christ in the *Lazarus* (Pl. 39); for the nurse he drew on the Virgin in the *Adoration of the Magi* (Pl. 29), for Zacharias on Ghiberti's *Saint Luke* (Pl. 22a), for the man in the background on Abraham in Ghiberti's competition relief and possibly on the head of an old man, bearded and hooded, in the crowd of the *Money Changers* (Pls. 2b, 34). For his *Preaching of Saint John*, designed probably in 1419 (Fig. 40), Turini based the figure of Christ on Ghiberti's *Christ in the Storm*, and the Saint John on the young king in the *Adoration of the Magi* (Pls. 36, 28). One of his listeners is taken from the same young king of the *Adoration*, another from the figure of Christ in the *Transfiguration* (Pl. 37).[8]

For some of these borrowings Turini may have drawn on model books in Ghiberti's shop or on the wax models of the figures. But in most cases he would appear to have used casts of Ghiberti's reliefs: no drawing could have communicated the sculptural qualities of the original so closely. In copying Ghiberti's *Saint Luke* (Pl. 22a) Turini transferred to his Zacharias even the embroidery on the sleeves and across the chest, either from a cast or from a rubbing. No doubt, then, the majority of the reliefs from which Turini drew his motifs in 1417 and 1419 respectively had all been finished and chased and were just waiting in Ghiberti's workshop for the door to be assembled.[9] Indeed these same quatrefoils, together with others by Ghiberti, were known to Julià lo Florentì who in July 1418, began a series of alabaster reliefs in Valencia. For his *Pentecost* relief (Fig. 37) Julià drew on the right-hand group in Ghiberti's scene of

bibl. 302, pp. 79ff, 183ff), especially from the figures of the church fathers and evangelists and from the prophets' heads. The Virgin on Luca's door represents a variant of the Herodias in Ghiberti's *Saint John before Herod* in Siena.

Marchini (bibl. 299, pp. 182ff) who correctly recognized the close links between the angels on the reliquary in Pistoia and Ghiberti's art (see below, p. 120, note 14), has suggested, less convincingly to my mind, a dependence on Ghiberti for Gualandi's cross at S. Sebastiano in Vignole of 1421 and his Reliquary of S. Eulalia, 1444.

[8] Bacci (bibl. 31, pp. 117ff) has published in full the documents regarding Giovanni Turini's reliefs. Turini's acquaintance with Ghiberti (Krautheimer, bibl. 249) certainly goes back to the latter's first visit to Siena in July 1416 (Dig. 44; Docs. 131, 134). In December Turini paid a visit to Florence for further talks regarding the Font (Dig. 45; Doc. 135). In April 1417 Giovanni and his father, Turino di Sano, were commissioned to execute the two reliefs of the *Birth of Saint John* (Fig. 39) and the *Sermon* (Fig. 40). One was begun in the summer of 1417 and cast sometime before or during the summer of 1418 (Bacci, bibl. 31, pp. 117f), the other was modeled and cast between July 1419 and April 1420 (Bacci, bibl. 31, pp. 119f). Before casting the second relief in July 1419, Turini again visited Florence (Bacci, *ibid.*). Since in the *Sermon* a motif is taken from Quercia's *Annunciation to Zacharias* on the Font, in my opinion modeled in 1419, the *Sermon* probably dates from 1419-1420 and the *Birth* from 1417-1418. Both reliefs were delivered only after the chasing and gilding in 1427.

[9] One of Ghiberti's reliefs was sent to Siena early in 1417 (Dig. 50; Doc. 132) as an example of the work intended for the Font. Presumably this was the competition relief; for the Siena contract put considerable stress on the proposed gilding of the reliefs and hence Ghiberti would have sent his only relief which, up to that time, had been gilded.

Pilate (Pl. 48) and on one of the seated rabbis in *Christ among the Doctors* (Pl. 31). For the *Resurrection* he used the floating angel in Ghiberti's relief of the *Evangelist Matthew* (Pl. 24). In his *Samson* relief (Fig. 38) Julià seems to have drawn on the design for *Saint John before Herod* of the Siena Font. Samson's stance and his outstretched leg with the leggings rolled up, recall the young warrior who restrains the Baptist (Pl. 72). Samson's head covered with tight curls, resembles the young man represented behind Saint John. Hence this relief too was begun probably in 1417 or in the spring of 1418.[10]

[10] Schmarsow (bibl. 484) was the first to discuss Julià's reliefs on the basis of the documents discovered by Sanchis y Sivera and to point out their general dependence on Ghiberti's style, but with only occasional reference to specific Ghiberti models. He overemphasizes the possible connection both to Lorenzo Monaco and to later painting, as well as the quality of the Valencia reliefs. They are rather pitiful things with a strange mixture of Spanish Late Gothic and Florentine elements, and can hardly be used to demonstrate a general development in the history of the style. These objections have been made already by Mayer (bibl. 312), who thought, however, of explaining the non-Florentine elements by distinguishing them as Northern and related to Sluter—or as Sienese.

The reliefs were started in July 1418. The first was delivered to its destination in December 1419, the last in May 1424.

To establish the identity of Julià lo Florentì is not easy. Schmarsow, and Mayer have attempted to identify him with Giuliano di Giovanni da Poggibonsi who, sometime between 1407 and 1415, was an apprentice (*fanciullo*) in Ghiberti's shop (Doc. 31). (The sobriquet *il facchino*, Schmarsow, *loc.cit.*, occurs nowhere in the documents). Because of his youth this apprentice, Giuliano di Giovanni da Poggibonsi, can hardly be the "intagliatore di figure" Giuliano di Giovanni who, in 1410-1412 was commissioned to do a statue for the Cathedral (Poggi, bibl. 413, docs. 191, 193, 201, 203). Rather the *fanciullo* of 1407-1415 is the same as the *orefice* Giuliano di Giovanni who in 1422-1423 worked on a marble figure for the Cathedral (Poggi, bibl. 413, docs. 259, 264ff), in which case he cannot have been Julià lo Florentì who, at that time, was in Spain.

In theory this leaves several possibilities. One is that Julià might well be identical with the *intagliatore di figure* Giuliano da Poggibonsi, mentioned in 1410-1412. He was never a member of Ghiberti's workshop, but like many an outsider, might have known the reliefs of the North Door in both an incomplete and complete state. On the other hand, Julià lo Florentì might have been any stonemason or goldsmith by the name of Giuliano from Florence, such, for instance, as Giuliano di Monaldo, another member of Ghiberti's shop between 1407 and 1415. Finally there is the hypothesis that he might even be Giuliano di Ser Andrea, Ghiberti's long-term assistant. Giuliano di Ser Andrea disappears from the documents between June 1416 (Doc. 131) and March 1425 (Doc. 155). The gap corresponds exactly to the time Julià spent in Valencia and the two Giulianos could thus easily be identical, the more so since motifs from the *Herod* relief appear in the Valencia plaques. But in that case, one would have to accept the disturbing discrepancy in quality between the crude technique of the alabaster plaques in Valencia and the far superior, though not first-rate, bronze relief at Siena. Likewise, one would have to accept the thesis that Giuliano di Ser Andrea, once in Valencia, slipped easily into Spanish Gothic mannerisms and shed them as easily upon his return to Florence. All of this militates to some degree against the hypothesis that Giuliano di Ser Andrea and Julià lo Florentì are the same.

The preponderance of non-Italian elements is so strongly felt in the Valencia plaques that one ponders the possibility of Julià lo Florentì's having been a Spaniard who had spent time in Florence. Be that as it may, the question cannot be solved by fusing into one person two Giuliano di Giovannis, the *fanciullo-orefice* and the *intagliatore di figure* (Thieme-Becker, bibl. 517, XIV, p. 210) and throwing in for good measure either Giuliano di Monaldo (Bertaux, bibl. 50, p. 925) or Giuliano *del Facchino* (Vasari-Milanesi, bibl. 533, II, pp. 256, 285) who in 1457-1458 was *sentiator* of the Florentine *Zecca*. The hybrid Giuliano di Giovanni has been credited for some time with one of the large and two small figures from the Campanile, now in the Museo dell'Opera. (For the history of this attribution see Paatz, bibl. 375, III, pp. 388, 390, and notes 448, 465.) While the figures are close to each other stylistically, their link to the documents of 1410-1412 and 1422-1423 respectively is as hazardous as the identification of the two masters mentioned therein.

Be that as it may, neither the Turini reliefs nor the Valencia plaques give major support in constructing a chronology of Ghiberti's reliefs except to indicate that by 1417 or 1419 the bulk of the quatrefoils must have been finished. It is of somewhat greater interest that prior to March 1420 two statuettes for a reliquary at Città di Castello were made, the *Saint Andrew*, based on the figure of the Virgin and the *Saint Francis* on Christ, in Ghiberti's *Way to Calvary*[11] (Figs. 41, 42; Pls. 51a, b). They are not copies, but apparently contemporaneous workshop adaptations of the originals, showing the drapery as it was before the quatrefoil had been fully assembled, thereby

[11] The two statuettes, .195 m and .205 m high respectively and thus the same in size as the figures in Ghiberti's relief, belong to a reliquary which originally sheltered a bone from the arm of Saint Andrew. They first occupied the angle between the tall center niche and the flanking tabernacles of the reliquary, but in all likelihood they are not by the hand of the goldsmith who executed the latter; possibly they were soldered onto the reliquary at the last moment.

Both figures and reliquary are at present in the Galleria Municipale of Città di Castello. Schmarsow (bibl. 485, pp. 68f) thought them to be juvenile works of Luca della Robbia; Venturi attributed them to Ghiberti (bibl. 534, VI, p. 172); Middeldorf (bibl. 331) suggested an origin close to Ghiberti, but rightly pointed out that the reliquary proper could not be by the same master. Hence, he concluded that the reliquary and figures did not belong together. Indeed, the history of the reliquary over the last 150 years is somewhat complex (Fanfani, bibl. 153, pp. 48f). The reliquary proper comes from the church of S. Francesco. In the revolutionary upheavals of 1798 it disappeared and was brought a few years later to the municipal gallery, while the statuettes of the two saints were deposited there only in 1878 by an unknown. On the other hand, the identity of the saints suggests that prior to 1798 they formed part of the reliquary which in the church dedicated to Saint Francis sheltered the relic of Saint Andrew. Indeed, the bases of the two figures are crudely cut out on the sides and fit neatly into two semicircular holes in the reliquary, cut into the angles between the center niche and the flanking tabernacles; also their base moldings continue the moldings of the reliquary. In all likelihood the figures were forcibly removed when the reliquary temporarily left the church in 1798 and were not returned with it.

In checking on the documents and in fitting the figures into the reliquary, I received every conceivable consideration from Dr. L. Giombini, the director of the Archive and Gallery. I am greatly indebted to him.

The documents on the reliquary are largely preserved. On December 14, 1414, the city council decided to order a reliquary "unum Tabernaculum argenteum cospicuum et doratum (?) quo honorifice teneantur . . . ossa brachij Beati Andree Apostoli . . . apud Ecclesiam Beati Francisci." (Città di Castello, Archivio Communale, Annali Communali, vol. 39 (H), c. 20). A supervisory committee was elected on January 2, 1415 (*ibid.*, c. 23, c. 23v) and on February 8 it decided to raise the funds needed for the reliquary (*ibid.*, c. 32). A first contribution was paid to the convent on February 25 (*ibid.*), to be followed by others upon request of the supervisory committee, the "Soprastanti Tabernaculi Bracchiorum Sancti Andrea" (*ibid.*, c. 58v). A new committee was elected on May 9, 1418 (*ibid.*, c. 214); the decision contains no reference to pressure being exerted to get the work completed, as suggested by Magherini-Graziani (bibl. 287, p. 307). Finally, on March 27, 1420, this committee was dissolved. Its account was approved to the considerable amount of 226 florins, "facta fuit Apodisca soprastantibus tabernaculis s. Andree de fl. CCXXVI auri . . ." (*ibid.*, vol. 40 [K], c. 203v), and the new reliquary was exhibited in the church (*ibid.*). As it happens, the irrelevant names of the four citizens serving on the committee are carefully noted, but the identity of the artist or artists from whom the reliquary was commissioned remains unknown.

The documents were summarized from the original volumes by A. Certini, *Origine delle Chiese e monasteri di Città di Castello*, V, 1, 1726 (ms. Città di Castello, Archivio Capitolare). On the basis of Certini's paraphrase they were quoted by Magherini-Graziani (bibl. 287, pp. 307ff).

The identification of the two Saints with their models in Ghiberti's *Way to Calvary* is not my own; it was made by one of my students at Vassar College, back in 1946 or so; but unfortunately, I cannot remember the name of this keen observer.

establishing the date for the modeling of Ghiberti's *Way to Calvary* as shortly before 1420 and possibly as early as 1418.

Earlier echoes of Ghiberti's quatrefoils are rather rare. Lorenzo Monaco's *Agony in the Garden* of 1408 (Fig. 27) appears to mirror Ghiberti's *Mount of Olives* (Pl. 43). Donatello, for the Crucifix in S. Croce (Fig. 43), may well have drawn on the Christ in Ghiberti's *Crucifixion* plaque (Pl. 52). But Donatello's figure is undated though hardly later than 1412; also he may have used Ghiberti's preliminary design rather than the completed relief.[12] Early in 1409 Ghiberti's *Baptism* (Pl. 32) left traces on another work of art in Florence, though not a work of high quality. Zanobi di Pagholo d'Agnolo Perini, who in May 1409 wrote with his own hand and had illustrated a rhymed *Vita di S. Giovanni Battista*, was a devout citizen of the *Quartiere di Santo Lorenzo* in Florence.[13] Both his doggerels and the pen and ink drawings are crude and belong more to the realm of folklore than art. In the *Baptism* (Fig. 45), Christ, his hands crossed above the loincloth, and the two kneeling angels at the left, find their counterparts in the Baptismal Font of 1371 of the Baptistery. The illustration of Saint John, while just as crude as the other illustrations in craftsmanship, in strange contrast to the rest, is imbued with the new fashion of the time, the International Style. In fact, the wide-stretched curve of the arm, the crescent swing of the body, underscored by the drapery falling from the shoulder to the right foot, the rich fall of the cloak in deep swinging and overlapping folds show clearly that the honest citizen Zanobi had repeated trait by trait the figure of Saint John in Ghiberti's *Baptism* on the North Door. By 1409 then Ghiberti had designed and at least modeled in wax the figure of his Saint John. Possibly also Ghiberti's head of Christ with the long soft curls falling over the shoulders left an imprint on Zanobi Perini's Christ. Hence the first months of 1409 are a *terminus ante* or *ad* for Ghiberti's quatrefoil of the *Baptism*.

Copies of Ghiberti's work are rare indeed from the first stages of his career. His designs in these initial years had not yet become, as they did later, the almost academic prototypes from which large numbers of sculptors drew compositions and motifs. But adaptations though not copies of Ghiberti's style did occur even in this early phase. The reliquary for San Jacopo in Pistoia is one such adaptation (Figs. 46-48). Executed in 1407 by a Florentine goldsmith and a superb piece of design and craftsmanship, it is certainly related to Ghiberti's earliest style.[14] The two slim angels on either side

[12] H. W. Janson, has kindly suggested this possibility.

[13] *BNF, Magl. II*, 2, 445 (old Cl. xxxviii. 100 = Strozz. 35), f. 23; see Mazzatinti, bibl. 313, ix (1899), p. 128.

[14] Pistoia, Cathedral, *Sagrestia de'belli arredi*, dated by an inscription and by a series of documents which also refer to its Florentine origin (Beani, bibl. 43, pp. 151ff); see also the preliminary catalogue of the *Mostra d'Arte Sacra Antica*, 1950, no. 71 and Marchini (and others), bibl. 299, esp. pp. 182f. Marchini claims that the two angels were added as a possible afterthought during the execution and are "close reflections of Ghiberti's art." He attributes them, together with a cross from Vignole, dated 1421 (*ibid.*, 184f), to the goldsmith "Gualandi" who in 1444 designed the reliquary of S. Eulalia (*ibid.*, 185f). The attribution of the reliquary of S. Jacopo, either entirely or in part, to "Gualandi" does not rest on firm ground. Certainly the reliquary has little in common with the cross of 1421, and nothing in common with the reliquary of 1444. Professor Marchini suggests that the name Gualandi, which Beani (bibl. 43, pp. 165ff) found in a seventeenth century (?) manuscript, should possibly read "Giuliano di" The Pistoia archives were lost in 1944.

of the towerlike center are Ghibertian in more than one aspect (Figs. 47, 48). The fine faces, the short straight noses, the tiny mouths and firm chins, the lightly chiseled hair, the short massed curls which follow the outline of the skull, the tuft of hair above the forehead—all recall the head of Isaac in the competition relief or of the angel in Ghiberti's *Annunciation* (Pls. 25, 26a). Likewise the beautiful wings of the Pistoia angels, while not quite up to Ghiberti's own standards, clearly reflect his early style prior to 1407.

Some external evidence exists, then, upon which to build a chronological framework for the reliefs of the North Door. But this evidence is fragmentary, whether furnished by the few documents or by reflections of Ghibertian motifs in the work of his work-shop or of minor masters. Far more substantial is the internal evidence proffered by his major dated works executed during the same years the North Door was in the making: the competition relief of 1401-1402, the *Saint John* of 1412-1415 and the *Saint Matthew* of 1419-1422. These works establish a stylistic framework and within it the reliefs can be arranged in groups, each marked by its own distinct style and each leading into a later phase. Together these groups record the development of Ghiberti's style from 1402 to the end of the second decade when the last of the reliefs were modeled.[15]

[15] Schmarsow (bibl. 488, pp. 5ff and *passim*) suggested that Ghiberti planned the whole door from the outset with an overall rhythmical pattern, in which movement and design of the in-dividual reliefs would complement each other. To explain what he considered disturbances in this overall design, Schmarsow further suggested that the original plan was marred by occasional misplacements of plaques "which could no longer be corrected after casting." The main thesis is somewhat abstruse, the reference to the technical difficulties absurd.

On the other hand, Schmarsow believed the reliefs to have been executed in different stages, placing the *Crucifixion* early and proposing that it might be from the hand of Bartolo di Michele, and placing the *Pentecost* "hardly prior to 1424." When, in 1937, I first attempted to establish a chronological sequence for the reliefs (Krautheimer, bibl. 249), I overlooked two earlier tentative proposals in this same direction: one by Lanyi (bibl. 265, p. 42, note 1) who assigned the reliefs of the church fathers and evangelists to a late phase of the door because of their supposed dependence on the Fonte Gaia; the other by Schlosser in 1934 (bibl. 476, p. 52), who dated the *Crucifixion* "among the earliest" reliefs, the *Expulsion*, the *Entry* and the *Flagellation* late. Need-less to say, I remain in disagreement.

The sequence which I proposed in 1937 has evidently been generally accepted, save for some corrections: Paatz (bibl. 375, II, p. 199 and note 144) would include in the early group, along with the reliefs of group A, the *Entry*, and shift most of group B 1 into group B 2 (to use my designations of 1937); Albrecht (bibl. 15, pp. 133ff) proposes to establish a first "Gothic International Style" group with three subdivisions (*Nativity, Annunciation, Crucifixion, Transfiguration; Christ among the Doctors, Last Supper*, the reliefs of the church fathers; *Adoration of the Magi, Baptism* and *Temptation*), a second group, again subdivided (the reliefs of the evangelists, *Christ in the Storm, Lazarus, Arrest, Resurrection; Entry, Mount of Olives, Way to Calvary*) and a last group (*Expulsion, Pilate, Flagellation, Pentecost* and the heads on the frame). By and large this amounts to a fusion into one of what I believed to be the two early groups (A and B1) and seems a some-what finicky subdivision of the late groups (B2 and C). Miss Albrecht's inclination to date even the earliest reliefs after 1407 is based on an erroneous date of June 5, 1407 (Doc. 33), assigned to one of Strozzi's excerpts. See above, p. 103.

In going over the problem anew, it seemed to me less important to reassign a relief or two to another group, as I do the *Resurrection*, or to redate the groups slightly, than to consider that I may have formerly underestimated the amount of time and labor required for the chasing and hence may have been wrong in assigning the modeling of any quatrefoils to a period after 1418 or 1419. Secondly, I have tried to rid myself of the notion of all too cut-and-dried divisions

An early group of reliefs, modeled presumably between 1404 and 1407, stands out clearly from the rest. The documents show that during these years only a relatively small amount of work was accomplished. Ghiberti was probably too occupied with organizing his shop and the work to have much time left for designing or casting. But the design of the foliage strips on the frame of the door certainly belongs to this period, linked as it is to the foliate margins of French manuscripts, although the actual execution of these strips in the hands of assistants, may have extended over years.

The *Nativity* (Pl. 27) seems a key piece to the style of this small early group. As in the competition relief (Pl. 1), Ghiberti filled the quatrefoil with rocks and figures that mount up to a high horizon. Forming a squarish contour, the composition protrudes into the lower left and upper right lobes of the quatrefoil. The scene, like the *Sacrifice of Isaac*, is diagonally divided in two, the two parts corresponding to separate events, the Birth of Christ in the lower left and the Annunciation to the Shepherds in the top right. As in the competition relief the two parts are linked together by glances and gestures. Also as in the *Abraham* panel, the two groups of figures are each sheltered by a rocky cave and thus each provided with a separate space; at the same time they are bound together by the curves of drapery and by movement. The child Jesus, focal point of interest, is enframed like Isaac by surrounding figures. The story is told with the same reticence, the same sense of subdued drama. Like Abraham glancing at Isaac, the Virgin gazes down on the Child, her hand refraining from touching him, her attitude quiet, and yet she embraces him with her eyes and with the sway of her body.

Neither should the differences between the competition relief and the *Nativity* be overlooked. In the first place, the *Nativity* does not quite come up to the perfection of the *Abraham* relief. The finishing is not as superb and the details not quite so sophisticated. But, then, is it not to be expected that the early show-piece of the young master would be the superior? Likewise in composition and in individual figure design the *Nativity*, despite all resemblances, begins to break away from the precision of the competition relief. The individual figures are merged into an over-all pattern reminiscent of the angels in the *Assumption* window of 1405 (Fig. 7); the draperies in the *Nativity* lead the eye temptingly from figure to figure in a pattern that undulates softly over the surface plane. The composition appears flatter and shallower than that of the competition relief. Space plays less part, surface design more. The close resemblance of Joseph, crouching on the ground, to Lorenzo Monaco's figure of the Madonna of 1405 bears out this dating for the *Nativity* plaque.

While one of the earliest, the *Nativity* is not the first of this group. The *Annunciation* (Pls. 25, 26b), its composition likewise split diagonally across, is closer to the competition relief in details like the simpler and tauter lines of the draperies. The fact that the style of this relief is already reflected in the reliquary in Pistoia of 1407 corroborates its early date. Yet any attempt to fit each of these reliefs into a rigid chronological system is doomed to failure. After all, Ghiberti must have worked on

into groups and subgroups. Only the main groups can be properly outlined and regarding these, I still hold to my proposals of 1937.

several at once, just as a writer writes and rewrites a chapter, dropping and picking it up again in turn. Assistants could have taken over a job where Ghiberti wanted to leave off, and later he may have returned to it again to do a difficult part. Hence individual reliefs and groups of reliefs are bound to overlap in time and obsolete motifs will appear within advanced compositions. Yet with all these reservations, two or possibly three more reliefs can be placed alongside the *Annunciation* and *Nativity* in the early phase prior to 1407; these are the *Adoration of the Magi*, the *Baptism* and, possibly somewhat later, the *Mount of Olives*.

In the *Adoration of the Magi* (Pls. 28, 29) Ghiberti again relied on the compositional device of opposing two groups of figures on either side of a diagonal. The groups are not equally important and, as in the *Sacrifice of Isaac* (Pl. 1), the less important of the two, the group of kings, is the first to attract the eye. There is a moment's hesitation before one realizes the accent lies with the Virgin and because of this hesitation the scene as a whole is viewed in dramatic contrast. At the same time and to an extent unknown in the *Abraham* relief, this panel abounds in Trecento reminiscences, in the overall design, in the beautiful movement of the old king lifting himself off the ground to kiss the child's toes and in the shelter under which the Virgin is seated, its front support omitted to let the eye travel inside to the Holy Family. The *Baptism* (Pl. 32), on the other hand, advances new features, although its array of lively, steeply crowded angels, chattering and somewhat indifferent to the main event, recalls the train of the Magi in the *Adoration* (Pl. 28). More specifically the angels' heads, closely crowded and turning in all directions, look like the angels on the left in the *Assumption* window of 1404-1405 (Fig. 7). Indeed, an early date for the *Baptism* (Pl. 32) is supported by the copy of the figure of the Baptist in Zanobi Perini's manuscript of 1409. But the composition in its quatrefoil is no longer subdivided diagonally into two triangles, nor are the figures and groups surrounded by their own "space caves." Instead, a new concept of relief comes to the fore, based not so much on subdued dramatic tension and individual movements within defined spatial areas as on a melodious design of figures spread across a single plane and swaying against a blank ground.

Thus both the chronological and historical position of these early reliefs is easily ascertained. They are still close to the competition relief, but at the same time the gradual softening of draperies, the increasing calligraphic linearism, the ever stronger emphasis on surface design, recall Ghiberti's first work in which elements of the International Style make an appearance, the garland of angels in the *Assumption* window of 1404-1405. A starting point for this early group of reliefs is established by the working contract of January 1404 (Dig. 10; Doc. 65). A terminus of June 1, 1407 (Dig. 22; Doc. 27) is suggested by the second agreement which intimates a break in the work leading to the reorganization of the shop and the beginning of a new phase. This does not mean, however, that the four reliefs we presume to belong to the earliest phase were all necessarily cast by 1407. The *Baptism* may very well have reached only the modeling stage by then.

The tenets and mannerisms of the International Style are forecast throughout this

first group of reliefs. Around 1407 they became the dominant factor of Ghiberti's entire work, remaining so for seven or eight years, determining the character of his style. The figure of the Baptist at Or San Michele represents Ghiberti's ultimate expression of this fashion. Among the reliefs of the North Door, the style appears fully developed first in the *Mount of Olives. Christ among the Doctors* and the *Temptation* carry it further and the *Transfiguration* and *Crucifixion* bring it to a climax. Finally it fades away in the figures of the church fathers and evangelists.

In composition the *Mount of Olives* (Pl. 43), diagonally divided by a rocky spur, with Christ in prayer in the upper left corner, and the disciples sleeping in a huddle in the right foreground still recalls the *Nativity* of the first group. So do the high horizon, the *horror vacui*, the judicious disposition of the few blank spaces, the steep, sharp-edged cliffs, the roundish heads. On the other hand, the economical organization of garments seen in the earlier reliefs gives way here to rich heavy draperies and to long, swinging, deep folds. The entire design resembles Lorenzo Monaco's *Mount of Olives* of 1408 (Fig. 27).

Calligraphic unity, held in the curving frames of the quatrefoils remains the basic principle of the entire second group of reliefs of the North Door. Ghiberti had become more and more absorbed in the tenets of the International Style. Movements and stances and draperies are designed to fit the format of the quatrefoil. In the plaque of *Christ among the Doctors* (Pl. 30) the figure of the young scholar at the left smoothly repeats the curve of the quatrefoil, while the line of his drapery continues into that of the brooding scholar just behind him; at the same time it flows easily into the curve of the garment of his neighbor, the crouching rabbi to the right, whose movement accompanies the swinging curves of both lower lobes; Mary takes up the curve from the rabbi, her mantle continuing it in a serpentine line from lower to upper right. The tiny figure of Christ sits enthroned in a niche of the Temple, enframed by round arches, their curves balancing the swinging draperies and movements of the figures below. In the *Temptation* (Pl. 33), as in this relief, the figures of Christ and Satan are fully in the round, deeply undercut. Bending away from each other, they stand against the blank vastness of the ground and complement the curves of the quatrefoil. The head of Satan with its forehead corniced by short ram's horns and its fine subtle nose, is of rare manly beauty, and his bat wings, deep and strong, are of rare perfection (Pl. 55a). None of the plaques of the first group is quite so high in quality of design and workmanship, and of the second group only *Christ among the Doctors* is comparable. Indeed, in these two panels, Ghiberti fused his youthful style of full-bodied figures with an ever growing feeling for the linear beauty of the overall design. It is as if these two reliefs were a happy new departure made upon Ghiberti's discovery of the full implications of the International Style.

As he went along, Ghiberti more and more stressed the melodious curvilinearism of the International Style, new to him and new to Florence. In the *Transfiguration* and even more so in the *Crucifixion* (Pls. 37, 38, 52) this style reaches a climax. In the *Crucifixion* Christ with his raised arms is fitted symmetrically in the two upper lobes; the angels with their robes trailing after them continue in their flight the curve

of the frame; Mary and John, with their draperies turned toward and joined to the stem of the cross as if growing from it, lead back to the figure of Christ. One cannot help feeling that he had almost overreached himself, that graceful melodiousness threatens to become the only aim. Convincing gestures and details, still manifest in *Christ among the Doctors*, have given way to a mellower, tenderer spirit; the scenery is confined to a bit of rock, the horizon is low and behind the figures stretches the blank ground. The folds of drapery have lost some of their fullness, they have been flattened or been replaced by sharp hairpin lines. No longer do the figures create insular spaces bound by obliquely projecting props, rocks or buildings in which to stand and move. No distance of depth intervenes in the *Transfiguration* between the disciples huddled in the foreground and the apparition of Christ and his companions in the far background, high up on the mountain. Setting, previously so important, is played down and with it any illusion of reality. Gestures are soft and languid, the grandiose drama of the Crucifixion is turned into a poetic fairy tale. In the *Last Supper* (Pl. 42), no doubt the work of assistants, the calligraphic design follows a dull, somewhat schematic formula and because of its poorer quality would seem a later design than the others in this group, done when Ghiberti himself had already turned to different solutions.

Like the figures in the *Crucifixion*, the seated evangelists and church fathers (Pls. 19-24) stand immobile against a blank ground and no space is provided for them to move in. Their garments are formalized, the folds a trifle harsh. There are exceptions among them to this growing formalism: the *Luke* (Pl. 22a) whose free pose and soft drapery recall the disputing rabbis in *Christ among the Doctors*; the powerful figure of the *Evangelist John* (Pl. 21a), set off against the spacious curve of his throne, anticipates later reliefs like the *Raising of Lazarus*; Matthew's angel (Pl. 24) floats gently over him like the angels hovering over Christ in the *Crucifixion*. But these eight plaques of church fathers and evangelists have one feature in common that dates them all together in the last stage of the second group. For the first time on the North Door shallow relief becomes an instrumental factor; the reading desks, the draperies behind figures, the thrones and symbols of the evangelists, such as the eagle of Saint John (Pl. 23), emerge in delicate lines from the blank background. This is a new feature, destined to play an ever growing part in Ghiberti's work from 1415 on through the twenties and thirties.

The entire second group of reliefs ranges in style from the fair solidity of body and the fullness and softness of drapery that characterize the *Baptism* to the somewhat formalized harshness of the *Crucifixion* and of the *Baptist* at Or San Michele (Pl. 4). Thus it must be dated between 1407 and roughly 1413, the year when that statue was in the process of designing. The parallel development in the *œuvre* of Lorenzo Monaco from around 1408 until 1412 bears out this dating.

The years between 1413 and 1416 mark a turning point in Ghiberti's work. He had reached the middle thirties and was established as the leading bronze sculptor of his native town or, one could say, of Italy, remembering that in those days the map of Italy in the eyes of a Florentine, extended from Orvieto or Siena to the

southern slopes of the Apennines. Roughly to 1413 work on the North Door had progressed smoothly; nearly two thirds of the plaques were modeled and probably cast. The workshop was well organized and the master had a large number of assistants to help him.

The *Calimala*, evidently pleased with what Ghiberti had done so far, in 1412-1413 commissioned him to make a monumental statue, the like of which had never before been seen in Florence. In the winter of 1414-15 the *Saint John* was cast and the laborious task of chasing it began. In 1416 the *Operaio* of the Cathedral of Siena opened negotiations for the Baptismal Font of the church. In these years it is unlikely that work on the reliefs of the North Door proceeded at more than a moderate pace. Indeed, the accounts for materials consumed up until 1415 reflect an interruption, possibly brief, in the activities of the shop. Ghiberti appears to have paused at some point during these years to reappraise his own work. His interest in the International Style was flagging and the later plaques of the second group on the North Door, like those of the church fathers and evangelists, turned out somewhat commonplace. It seems to have been largely left up to assistants to continue and finish reliefs, such as the *Last Supper* (Pl. 42), while Ghiberti himself groped for new directions.

Elements from the vocabulary of the International Style, however, lingered on for some time to come. In the *Raising of Lazarus* (Pls. 39, 40, 47a) both the Magdalen, sunk down on the ground, her garments flowing and her hair streaming down her shoulders, and the turbaned onlooker at the left are representative of the Style's mannerisms. Christ, on the right, resembles Elias in the *Transfiguration* (Pl. 37). But in contrast to these survivals of a now obsolete vocabulary, the compositional scheme is grandiose, at once sculptural and spatial. Flanking the scene on either side are Christ to the right and to the left the turbaned gentleman in his large cloak; the rock behind Lazarus and the onlookers behind Christ form a semicircular space in which the action develops. In the center, towards the middle ground, the main figures are gathered, Lazarus tightly wrapped in his shroud, Martha kneeling and looking up at Christ, and the Magdalen at his feet. The figures move to and fro freely, into and through the space—the man at the left turning inwards, Lazarus turning to the right, Martha to the right and inwards, and the Magdalen to the right and outwards. The movement helps focus the narrative clearly; the bulk of attention is drawn to Lazarus, buttressed as he is by the rock behind him and by the onlooker to the left; but the eye also travels across the space in front of him, seeking the cause of his resurrection, gently led by the women until it meets the figure of Christ standing at the right edge. He turns to the left holding, as it were, the movements of the other figures, all of whom have been turning towards him. The compositional concepts which split the *Nativity* into small space caves and isolated centers of attention have now disappeared, and so too has the spaceless design which governed the *Temptation*.

The *Expulsion*, the *Entry into Jerusalem*, and *Christ before Pilate* (Pls. 34, 41, 48) show a similar unity of space and narrative, formed by slowly moving sculptural figures. For the principal action, a spacious half circle is formed by a rock, a city gate, a tree, a dense crowd, a diagonally projecting building and a shell-topped niche, the

last two of which are supported in the background by a curved structure designed in flatter relief. In the *Expulsion* the movement of the figures is checked by a woman at the right edge, carrying a bundle on her head, and at the bottom edge by a youth who has fallen and been trampled on in the mad rush of the crowd; in the *Entry* a child, led by a bare-armed woman, halts the tide of action; in the *Pilate* it is a pair of bystanders, one turned inwards, the other outwards, who perform this office. The narrative in the *Expulsion* is related by strong action and in the *Pilate* by quiet reticence, Christ almost disappearing behind the back of Pilate and the bored young guard. Supporting crowds are spread along the foreplane and in depth. Movement and gesture link the figures together and convey a sense of convincing, if not measurable, space in which the main action takes place. Blank ground, so important to the reliefs of the second group, has given way to architectural props and scenery. In both the *Expulsion* and *Christ before Pilate* three structural props are used, placed in different planes and at different angles, diagonal, transverse, and curved. The shallow relief of the city gate in the *Entry* and of the curved constructions in the *Expulsion* and in the *Pilate* indicate distance. Figures and groups are occasionally copied from the antique like the bare-armed woman in the *Entry*, and the fallen youth in the *Expulsion* (App. A 4, 5).

Christ in the Storm and the *Resurrection* (Pls. 36, 53) share with the *Expulsion* and the *Entry* elements both of composition and relief structure. On the other hand, the drapery of the figures more often than not literally reproduces that of the earliest panels: for instance, the cloak of the warrior to the left in the *Resurrection* seems to revert back to that of the Virgin in the *Nativity*. Neither *Christ in the Storm*, nor the *Resurrection* belongs among the most progressive or, for that matter, the best reliefs of the North Door. The *Christ in the Storm*, in fact, appears to be entirely the work of an assistant and the *Resurrection* largely so.

The panels of this third group of reliefs depart further and further from the principles of the International Style. In their place grows a new artistic language and a new vocabulary.[16] The date of their origin, roughly 1414-1416, is determined by the statue of Saint John, on the one hand serving as a point of departure, and on the other by the impression they made between 1416 and 1419 on Turini and Juliá lo Florentì, who in their own work drew on motifs from the *Christ in the Storm*, the *Expulsion*, and *Christ before Pilate*. In fact, Turini evidently saw the *Lazarus* as early as 1416, since he exploited it for his own scene of the birth of the Baptist, a fact which corroborates the early date of this relief in relation to others of the third group.

From the *Entry* and *Christ before Pilate* the way leads almost imperceptibly into the last small group of reliefs: the *Arrest of Christ*, the *Way to Calvary*, the *Pentecost*, and the *Flagellation* (Pls. 44, 50, 54, 45). In these, his last works for the North Door, Ghiberti drew closer to what might be termed classical principles of design. The compositions all center about one figure; in the *Flagellation* it is Christ, and in the *Way to Calvary* it is the soldier seen from the back. These figures form an axis about which the others revolve like counterbalancing wings. The abundant draperies

[16] It is by and large this group which I formerly called group B2, Krautheimer, bibl. 249.

and swaying folds of earlier reliefs have not altogether disappeared, but Ghiberti no longer conceals the body under them as he did earlier in the *Mount of Olives* or the *Transfiguration.* He exploits the drapery to underscore the stance and the build of the body. Figures like the executioners in the *Flagellation* and the young warrior left of center in the *Pentecost,* are placed in the foreground to attract the eye, their garments tight in order to accent, rather than obscure, the easy movements. Crowds are clarified in space. A front row of figures, fully in the round, occupies the foreplane; behind it is placed a second rank whose heads and bodies appear in the intervals of the first. A backdrop is formed in the far distance by a building, a fence of spears, torches and halberds, set against a blank ground. A mere suggestion of scenery is enough, a city gate, a few columns supporting an architrave, three arches representing a façade.

The four reliefs of this group do not all reach the same peak of quality or style. The *Arrest* is the least advanced and the poorest (Pl. 44). In it Christ and Judas share the limelight with Petrus and Malchus, surrounded by a semicircle of onlookers who recall the crowd in the *Entry.* The stances and interrelationships of the figures are far from clear. Nor does the *Pentecost* relief represent Ghiberti's work either at its most mature or at its best (Pl. 54). The composition follows traditional lines, the grouping of the figures is both unclear and trite; the architectural setting continues a Trecento pattern. But the two remaining quatrefoils, the *Way to Calvary* and the *Flagellation* represent a high point among the reliefs of the North Door. The composition reaches classical perfection. A soldier occupies the center of the stage, his back turned on the beholder (Pl. 50). He rests firmly on his feet, one arm holding the sword, the other the long round shield. His head is turned to the right, to where Christ slowly moves on, carrying his cross and rudely nudged on by the soldier. A young officer at the right edge seems to look back towards him, and to lead him gently on. To the left of the rude soldier and held back by his shield, Mary moves blindly forward, supported by Saint John, an almost effeminate youth, his long curls held by a taenia (Pl. 51b). Saint John to the left and the young officer to the right, then, frame the composition both halting on their way and slightly swaying. The soldier in the middle, solidly planted on his legs, a strong axis, holds the design together. These framing and centering figures attract the eye first. Only from them it travels to Christ and Mary; but on these two is focused the entire emotional effect of the scene. Separated from each other, they stand isolated within the crowd which forms a mere background pattern, women behind Mary, soldiers behind Christ. Yet the enormous cross pulls the scene entirely together. The modeling of the soldier, Christ, Mary, and Saint John in the *Way to Calvary* and of the three main figures in the *Flagellation* (Pl. 45, 47b) are among the most perfect of Ghiberti's works. Indeed, the *Flagellation* is designed with the same delicate perfection as the *Way to Calvary.* The front and back figures are balanced on either side of the strong center axis; they are fully integrated in position, in movement and countermovement. Even such a small detail as the halberd originally held by the soldier at the left and the scourge of the executioner help to frame the twisting movement of Christ's body.

A drawing for the *Flagellation*, rightly attributed, it seems to me, to Ghiberti himself, throws light both on his working methods and his sources (Pl. 46).[17] It shows five studies for a *Scourging of Christ*: in a lower tier two sketches for an executioner approaching Christ from the right, in the upper tier three studies for an executioner approaching from the left. An architectural setting is hastily sketched in at the very top, consisting of a foreshortened ceiling, supported in back by a wall with three blind arches, on the left by the mere hint of a bracket and on the right by a column. The freedom of the pen stroke is supreme and every movement is of surprising inventiveness. Moreover, the three upper figures leave no doubt but that the draftsman, in a series of successive revisions, realized in the center figure a final solution which is identical, barring only the smallest changes, with the figure of the executioner standing left of Christ in Ghiberti's relief. Hence the drawing must have been done in preparation for this relief, in all likelihood by Ghiberti himself. At the same time the two figures in the bottom row of the drawing reveal one of the sources of Ghiberti's art at this time: Sienese workshop formulas of the second quarter of the Trecento, such as they appear, for instance, in the scene of the *Scourging* on the Reliquary of the SS. Corporale in Orvieto (Fig. 49).

Whatever his source, Ghiberti used it merely as a basis for building a solution of

[17] Vienna, Albertina, no. 24409. Pen and bistre, on greyish-brown paper, 20.6 x 16.6 cm. The sheet was published as a drawing by Ghiberti's hand by Stix (bibl. 506; bibl. 505, pl. 35; bibl. 504, p. 4) and later by Schlosser (bibl. 477, p. 100), an attribution doubted by many scholars: Panofsky (bibl. 381, p. 31, note 5) called it "workshop, *ca.* 1430," Lanyi (bibl. 265, p. 47) "a copy, second half of fifteenth century," Goldscheider (bibl. 186, p. 153, note 51) ". . . imitation, perhaps by Parri Spinelli." Popham (bibl. 423, p. 12), possibly inclined to slight understatement, limits himself to saying that "there seems a good case for the attribution of the sheet . . . to Ghiberti himself."

It seems to me that the attribution of the Albertina drawing to Ghiberti can be firmly supported. The draftsman both in the two bottom and three top studies searched for a solution to the figure by correcting and revising poses and movements. On the bottom row he first drew on the right an executioner, his right leg strongly thrust forward; in retracing the figure he moved the leg back slightly. In a second study he changed the stance, putting the weight on the right leg and moving the left one stiffly forward; here again he made corrections by lightly drawing over his first hasty outlines. Of the three figures on the top row, the man on the left is bent far forward, his arms outstretched and held low, the pose unsuitable for striking. The figure on the right is a revision of this pose, the bent leg being pulled back somewhat, the body made upright and both arms raised with the scourge. The executioner in the center rests his weight on his left leg; his right leg is slightly forward and to the side, his left hip is sharply thrust out; his left arm crosses his body and his right is raised to strike. The last was evidently the solution picked by the draftsman from the three studies: for after it was sketched in, he went over it, not lightly, but with heavy pen strokes, changing minor deviations and strengthening the outlines. The differences between this figure and the executioner on the left in Ghiberti's panel on the North Door are limited to the baring of the left arm, the longer fall of drapery in front, and the lowering of the head.

The figure of the executioner on the right in the bottom row of the Albertina sketch has nothing in common with Ghiberti's *Flagellation*. Seen from the back and stepping forward, one heel slightly lifted, this figure recalls the corresponding executioner in the *Scourging* in the Reliquary of the SS. Corporale in Orvieto. To a lesser extent the top row of sketches of the Albertina drawing recall the left-hand executioner of the Orvieto *Scourging* (Fig. 49). In the left-hand figure of the drawing the motifs of the arm swinging across the chest and the stance of the legs have been transformed, but in the center figure the motif of the raised arm has been revived. The projecting roof with its center supporting column also recalls the Orvieto plaque.

his own. He would arrive at this solution by a process of trial and error, sifting out elements as he progressed through the preparatory stages of drawing, and modeling in wax. In the quatrefoil on the North Door the setting has changed from the foreshortened ceiling of the Vienna drawing to a backdrop of two rows of columns. The motif of the right-hand executioner seen from the back, in the bottom row of the drawing has been discarded, while that of the swinging arms of the left-hand executioner, at first abandoned and then revived in the Vienna sheet, is brought out even more strongly in the actual relief. Indeed, the quatrefoil contains elements reminiscent of the Orvieto *Scourging* that are not present in the Vienna sketch. As in the scene from the Orvieto reliquary, a soldier with helmet and spear peeks out from behind a column. The process of revising a first sketch would seem, then, to have continued past the drawing stage into the following phase when a wax model was made from the design.[18]

A number of fixed points in Ghiberti's *œuvre* determine the date of the last group of reliefs designed for the North Door. The *Saint John before Herod* in Siena, designed presumably in 1417, makes use of elements not only from the *Pilate* relief, but also from the *Arrest* (Pls. 44, 48). Standing on the borderline between the two last groups, these two quatrefoils might then be dated 1416-1417. The *Way to Calvary* contains the figures of Christ and Mary who, disguised as *Saint Andrew* and *Saint Francis*, reappear in the Città di Castello reliquary in about 1419. Finally, the balanced compositions of these reliefs, the solid stances and free movements of the figures, the draperies suggesting organic movement and the build of the bodies, the elements *all'antica*, and the architectural settings, all such features point to the classical style which Ghiberti was to embody in the statue of Saint Matthew for Or San Michele, begun in 1419. Even details are in places astonishingly similar to the *Saint Matthew*: the drapery of the statue, drawn across the breast in rich, yet tight, folds, recalls the drapery of the two executioners in the *Flagellation*. The years of 1416 and 1419 would thus seem the early and late *termini* of the last reliefs of the North Door.[19]

[18] Vasari owned a number of drawings which he had received from Ghiberti's great-grandson Vittorio and which he believed to be by the master (Vasari-Milanesi, bibl. 533, II, p. 249). But aside from the Albertina sketch and the Saint Stephen drawing in the Louvre, which is certainly not autograph, none known at this point can be linked to his work. The catalogue of the Gabinetto delle Stampe of the Uffizi lists under Ghiberti's name two late copies, a pen and wash drawing of the *Baptism* on the North Door (*Uff. dis.* 18), *ca.* 1520, and a sheet with pen and ink sketches from the Creation of Eve in the *Genesis* from the Gates of Paradise (*Uff. dis.* 16), *ca.* 1550.

Berenson (bibl. 46, I, pp. 327, 329; II, p. 19, no. 1764) lists with great reticence a small number of fifteenth century drawings as possibly close to Ghiberti's circle.

[19] I am revising here my 1937 dating (bibl. 249). At that time I tended to assign the last group of reliefs to the years between 1418 and 1424. A more careful look at the technical data, supported as they are by the documents referring to the Gates of Paradise, the realization that the chasing took much longer than I had originally assumed, and the identification of the Città di Castello figures have led me to this revision.

The general grouping into which the reliefs fall is substantiated by an external detail. While the open air scenes take place on rocky terrains, those with architectural and semi-architectural settings are placed on narrow tectonic platforms which are cast in one piece with the plaques and are decorated by small underlying ornamental brackets. The plain trefoil and quatrefoil bracket designs, pointed and rounded, underlying the platforms of the seated church fathers and evangelists were traditional for single figures in fourteenth century Florence and thus present nothing new.

These same and the following years around 1420 are also the time when the great majority of the prophets' heads on the lattice frame were modeled, cast, and chased. Obviously any attempt to link these larger prophets to the tiny heads in the narrative reliefs must remain tentative. But by confrontation with the most perfect among these and with the heads of the large statues of *Saint John* and *Saint Matthew* an approximate chronology can possibly be worked out.

Few of the prophets appear to date prior to 1415. But a dreamy-eyed youth wearing a kerchief slung over his curls (Pl. 57c) and a prophetess, her forehead crossed by an ornamented band (Pl. 58f), recall such early figures as the young king from the *Adoration of the Magi* and the angels in the *Baptism*, with long triangular faces, sensitive mouths, narrow and very long eyes, the hair engraved with wavy grooves. Four or five heads resemble the *Saint John* from Or San Michele and related figures among the church fathers: the hollow-cheeked youth (Pl. 63b), a young prophetess (Pl. 66a), one of the faunlike heads (Pl. 66b), and two frowning bearded prophets (Pls. 60a, 64b). The strongly protruding cheekbones; the loose short curls of the hair, worked with a narrow spatula; the wavy engraved lines of a beard or of long locks; the deep-set eyes with the narrow rim of the cornea surrounding the deep hole of the pupils, all these features find their counterpart in the *Saint John*. Ghiberti's self portrait (Pl. 136a), the eyebrows engraved in short lines, belongs with these same heads, and his age, thirty-five or so, would seem to confirm a date of shortly before 1415.

By far the largest number of the prophets' heads, however, are closely related to the *Saint Matthew* from Or San Michele and to the latest reliefs on the North Door. Bearded or beardless, young or old, their features become more marked, the bone structure more richly modeled, the curls of hair and beard fuller and more sculptural as the strokes of the spatula grow deeper and broader. In the eyes the rim of the cornea widens, the hole of the pupil narrows. A youthful prophet wearing a wreath of oak leaves (Pl. 58d) recalls the young Pharisee with rich piled-up curls in the *Entry* relief. His companion (Pl. 65a) resembles the guard leading Christ in the *Pilate* scene. One of the female prophets (Pl. 65b), broadcheeked, her face firm and radiant, is akin to the disciple Saint John in the *Way to Calvary*. Beautiful and incredibly expressive, their foreheads creased, their eyebrows heavily tufted, their beards falling in massive corkscrew curls, the elderly bearded prophets within this late group (Pls. 56e, 57f, 59e) are amazingly close to the head of *Saint Matthew*. The treatment of hair and bone structure links other prophets to the group, such as the two boy prophets (Pls. 58e, 60f) and King David (Pl. 59c). True, not all the heads are of the highest

But in the narrative scenes the bracket designs of the platforms undergo certain changes which correspond to the stylistic development of the reliefs. The *cavetto* platform underneath the *Annunciation* is divided by five brackets into four sections decorated with tendrils and suggestive of Trecento work (Fig. 50). *Christ among the Doctors* and the *Expulsion* rest on platforms where the vine and ivy foliage is clearly separated from the dividing brackets (Fig. 51). The *Last Supper*, the *Pilate* and the *Flagellation* all share in common a platform on which the brackets are incorporated into a fuller foliage of oak leaves. Finally, in the *Pentecost*, a rich vine foliage nearly obscures the brackets. Insofar as their modifications complement the stylistic grouping of the reliefs, these details seem of some significance.

quality. Alongside the superbly fresh heads of the girl prophet (Pl. 65b) and the curly-haired, turbaned youth (Pl. 65a), some of the bearded prophets (Pls. 57a, 57b, 57e) and the helmeted heads (Pls. 58c, 60e) look more than a trifle dull, and it is certainly not by chance that in none of these poorer heads is the cornea set off by the deep groove that is a hallmark of Ghiberti's own hand. But even these weaker heads, assistants' work though they undoubtedly are, appear to strive towards the classical type that was established by the *Saint Matthew*.

Within the framework of this classical style it is only natural to find among the late heads in the North Door a large number derived from the art of Roman antiquity. Barbarian heads of all kinds, mustachioed, clean-shaven (Pl. 63a), turbaned (Pls. 56b, e, f; 59f; 60d; 61e) and long bearded (Pls. 60a, 64b) are drawn from Roman battle sarcophagi; others (Pls. 58a, 62a, b; 63b) from a Phaedra sarcophagus. Roman portrait busts, a Caesar (Pl. 67) and Socrates (Pl. 60c) are inserted among the prophets. The style of the *Saint Matthew* and with it the impact of Roman art overshadow the entire last phase of Ghiberti's first door. Indeed, it was during these final years that the lions' heads in the roundels of the back frame were modeled (Pl. 68a; Fig. 54)[20] and they too show the traits of the *Saint Matthew* in the strong modeling of the face, heavy eyebrows, deeply indented forehead and massive locks of the mane. The friendly poodle-lion of the seated *Saint Mark* from among the evangelists on the door (Pl. 22b) gives way to a regal leonine head akin to Donatello's *Marzocco* of 1419 (Fig. 30), though less blocky, less violent and savage, more serenely firm, thus translated into Ghiberti's personal language.

At times one wonders whether all the compositions, the many dozens of figures and all the ornament could possibly have been modeled and chased by Ghiberti himself. His contract bound him to model and finish with his own hands all the subtle details, such as heads, figures, trees, and similar things (Digs. 8, 27; Docs. 26, 27). In the majority of plaques and heads of the frame he seems to have followed this directive. Every smallest piece of drapery, every curl, eyelid, pupil, and eyebrow is modeled and finished with the superb mastery and the characteristics which mark the competition relief. The high points of his supreme skill are the Virgin in the *Adoration of the Magi* (Pl. 29), Jesus seated in *Christ among the Doctors* (Pl. 31), Satan in the *Temptation* (Pl. 33), the fallen youth in the *Expulsion* (Pl. 35), Magdalen and the man at the left edge of the *Lazarus* (Pls. 40, 47a), the Christ in the *Flagellation* (Pl. 47b) and the soldier next to him, Mary and John in the *Way to Calvary* (Pl. 51b) and the seated *Evangelist John* (Pl. 21a). The execution of less important background figures was naturally entrusted to assistants. Only rarely, however, did Ghiberti attempt to smuggle in entire compositions modeled not by himself. In the *Christ in the Storm*, the *Last Supper* and possibly the *Arrest*, Ghiberti may have been content to hand over a summary sketch or a model book to an assistant, such as Giuliano di Ser Andrea, who in Ghiberti's name later executed the panel of *Saint John before Herod* for the Siena Font with similarly inept crowds and similar facial types, the hair screwed

[20] The curious fact that only twenty-seven of the back panels contain such heads is probably due simply to the hurry in which the door was finished and assembled.

into the same kind of snail-like curls. Likewise a few heads on the frame are of inferior quality (Pls. 56c, f; 57a, b, d, e; 58f; 60e; 61b). Only in the foliage of the frame, modeling and chasing were largely left in the hands of the workshop. Indeed, the foliage strips fall into two distinct patterns: one, a broad strip delicately molded, rich, and varied, the leaves rolling and overlapping, the grapes heaped and full, the animals hopping and creeping through the clusters of leaves, appears to be Ghiberti's (Pl. 69a); the other, occurring much more frequently, a thin strip with single leaves following one after the other, with dull clusters of grapes and lifeless animals, is the workshop's (Pl. 69b).

The amount of work Ghiberti did with his own hand, both modeling and chasing, is gigantic; but it does not sufficiently explain why the contributions of assistants should have lost their identity so completely in the overall design. Evidently Ghiberti managed to carry his assistants along with the development of his own language and vocabulary. His really overwhelming achievement lies in having completely unified his workshop under the impact of his personality. As a result, the North Door presents itself as a completely unified work of art, executed almost down to the last detail in a style which is Ghiberti's own.

Yet all the factors involved in the design come to light only if the door is seen in its rejuvenated state since the cleaning in 1947-1948. The heads and foliage on the frame are set off in gold and in the reliefs the figures and the scenic and architectural settings are gilded against a ground of dark dull bronze.[21] The final decision to have the door gilded was taken only in 1423 and it was not taken with a light heart. But both the guild and Ghiberti had been toying with the idea, apparently from as early as 1403 when the competition relief was gilded, perhaps as a trial piece (Dig. 6; Doc. 33). Both Ghiberti and the guild must have been eager to push the project forward. Ghiberti throughout his life assumed, evidently as an axiom, that reliefs should be shining with gold and so apparently did the consuls of the *Calimala*: "the honor and fame of the guild count more than the expense and therefore the door shall be gilded" (Dig. 101; Doc. 92). Splendor, ornateness, richness were constituent qualities of perfection in the eyes of Ghiberti and his contemporaries. Andrea Pisano's door had been gilded and this in itself was reason enough not to do less for the new door. More important, a craving for splendor had seized all Europe ever since the courts of the mid-fourteenth century had hoarded their golden and jeweled treasures. It reached a climax in the International Style. The inventories of the collections both of the royal princes of France and of the merchant princes of Florence, from Charles V to Cosimo Medici, reflect the delight which artists and patrons experienced in designing, beholding, and fingering these small precious objects, wrought in glittering gold, or cov-

[21] Rossi (bibl. 452) and Poggi (bibl. 415, pp. 251ff) have described both Ghiberti's gilding process and Cavaliere Bearzi's method of cleaning. The figures and settings of the reliefs, as well as the heads and foliage pieces of the frame, were covered with a solution of gold and mercury that had been liquefied at a temperature of over 450 degrees centigrade. The mercury volatilized and the gold adhered to the surface, a process which, in the course of centuries, caused the bronze exposed between the gold particles to oxidize. As a result, the gilding was eventually covered entirely with a thick layer of oxidized bronze mixed with sand dust from the piazza. Only in 1947-1948 was it uncovered by the superb restoration of Cavaliere Bearzi.

ered with shining colorful enamel.[22] Ghiberti, goldsmith that he was, betrays time and again this fondness for costly and precious material, gold, rubies, sapphires, and pearls as big as filbert nuts.[23]

The gilding of the North Door, then, was intended to satisfy the craving of the time for conspicuous display. It was to feign a lavishness far beyond that of the real material of the door, bronze. It loudly proclaimed the wealth of the *Calimala* and left the beholder gaping with awe. Yet, it had other functions as well. It underlines the precision of workmanship, the fine profile of a tiny head, the tightly rolled curls, the pupil of an eye, the high polish of the surface. It was intended to support the volume of the figures and to clarify their movement and interaction, and it did.

Terms such as movement and interaction apply to the reliefs of the door in a slightly ambiguous way, and it is largely the gilding which reveals the ambiguity. The eye is focused on the gilded parts, the figures, the rocks from which they rise, a tree, a city gate. Space and action appear to be confined to this sphere of gilding. Ground and frame seem neutralized. Time and again, however, the figures and props, trespass beyond the frame, or backward against the dark ground. Space, then, and action become ambiguous through the constant clashes between the neutral ground and frame on one hand and the gilded sphere of figures and props on the other.

The contrast to Andrea Pisano's door is manifest. His gilded figures and props likewise stand out from the dark bronze ground of the quatrefoil. But they exist in a clearly defined space like figures placed in the tympanum of a Gothic cathedral; neither the imaginary front plane, as marked by the frame of the quatrefoil, nor the curtain of the ground are ever pierced by their actions. By the time Ghiberti designed and gilded his reliefs this principle had lost its validity. Painters and sculptors through almost a century had transformed the ground behind the figures into a backdrop with props and sceneries, and these backdrops and sceneries nibble at the ground, as it were, and destroy the clear boundaries of the stage on which the figures act. Thus, the figures lose their footing, they start weaving back and forth and regardless of the treatment of the ground—scenic, patterned, or uniformly dark—the insecure movement of the figures clashes both with the ground and with the front plane. The very ambiguity of the relationship between space, object and ground, thus becomes one of the constituent elements of the International Style, and the gilding, in the reliefs of the North Door underscores this ambiguity. In a strange way, despite the changing style of the quatrefoils and the prophets' heads, the gilding falsely but powerfully imparts the note of the International Style to the entire North Door.

[22] Besides the French inventories (bibl. 259, 269, 345), see those of Cosimo and Piero Medici (Muentz, bibl. 351).
[23] Ghiberti-Schlosser, bibl. 178, I, p. 48.

THE NEW STYLE

CHAPTER X

PICTORIAL RELIEF

HAD Ghiberti died at the age of forty-five, after finishing his first bronze door, he would be remembered as one of the great exponents of the International Style. His contribution to the art that dominated all Europe at the beginning of the fifteenth century parallels that of Lorenzo Monaco and the Limbourg brothers. Almost a child prodigy, he had shown in the competition relief an upsurge of genius miraculously early in life. From then on his development was consistent, without surprising leaps or radical turns. Not until quite late, as a man of forty, with his statue of Saint Matthew, did he gain a place among the artists of the nascent Renaissance in Florence, nearly ten years after the movement had first sprung up with Donatello's *Saint Mark* and Nanni's *Quattro Coronati*. Only then did he finally break with his youthful dependency on French art of the late fourteenth century and with the International Style.

Perhaps external factors contributed to this break. Ghiberti's stepfather, Bartoluccio, died apparently in 1422 (Doc. 120), thereby severing a last link, however loose, with the traditions of the Trecento. A partnership that Ghiberti had formed, possibly with Michelozzo, was liquidated in the winter of 1424-1425; Ghiberti refers to the event in terms of good riddance (Doc. 155), and though he refrains from giving the name of his partner, it is known that at just this time Michelozzo left his shop and joined Donatello. The differences between Donatello and Ghiberti grew sharper than ever once Donatello went in for bronze casting, thus entering into open competition with Ghiberti's workshop. Such factors may have assisted Ghiberti to loosen the old ties and to establish a more definite new position among his contemporaries.

Perhaps more than any other time of his life, the years roughly 1417 to 1430 were a period of exploration for Ghiberti. Beginning with the last reliefs of the North Door and the statue of Saint Matthew, he examined possibilities of classical composition and figure design. With the *Saint Stephen*, begun in 1425, he pushed ahead and opened a path for himself in the upgrowth of the Renaissance. His reliefs from these years seek a way to tell a story with many figures in the confines of a narrow frame, and to suggest space and depth by combining three-dimensional forms with flatter and flatter ones. As is characteristic of any experimental state of mind, Ghiberti, during these years, was more readily susceptible to outside influences than he had been since the early days of the competition relief. Donatello impressed him both adversely and positively. Painters of his day exerted an impact, certainly Gentile da Fabriano and possibly Masolino. The art of antiquity became a potent factor in the shaping of his work, and the study of nature took on a new meaning for him. All these impressions intermingled and fertilized each other, with the result that as his world grew richer with the accumulated wealth of experience, he was able to see his own way more clearly.

Within these expanding boundaries the main quest throughout was for a new

pictorial relief. Solutions offered in the first door, with its quatrefoil frames, could no longer satisfy Ghiberti when he saw all about him the emergence of new concepts of space, movement, and composition, in the reliefs of Donatello, in the paintings of Masolino and Masaccio. The frame of a quatrefoil is not conducive to working out compositions in easy juxtaposition to each other, nor can the heaping up and crowding of three-dimensional figures, gilded and placed as they are against a dark bronze drop, ever convincingly suggest a space deeper than the bodies themselves. Thus in the twenties Ghiberti concentrated on and succeeded in evolving a relief space that communicates depth by a succession of planes, gradating volumes from relief fully in the round to a paper-thin, almost two-dimensional *schiacciato* layer. At the same time the traditional quatrefoil frame was supplanted by a square panel which, together with the new shallow relief, forms but a logical part of the new solutions. Problems of grouping numerous figures and of linear and aerial perspective were forced upon Ghiberti. In brief, the representation in his art, of reality as determined by space, figures and scenery, reflects the beginnings of an entirely new outlook. A narrative develops which is richer in the presentation of the individual story, yet clearer and more pregnant with allusion. All these problems are closely interlocked, unfolding themselves during the twenties and thirties almost year by year in Ghiberti's *œuvre*.

The works that succeed one another in these years are numerous and well documented. In 1423 Ghiberti seems to have designed and cast the lions' heads on the back of his door (Pl. 68a; Fig. 54a, b). In the same year he was either just commissioned to execute or—the text does not clearly say—was embarked upon the execution of the bronze jambs and lintel of the same door (Pls. 69c, d; 70a, b; 71a) (Dig. 102; Doc. 58).[1] Apparently they were set up in 1426, for in that year the stone architrave above the east gate, where originally the first door was located, was moved, presumably to fit in the bronze jambs and lintel (Dig. 127; Doc. 10). The tomb plaque of Leonardo Dati (Pl. 75), general of the Dominican order, was started immediately after his death on March 16, 1425,[2] for regardless of whether the commission came from Dati himself, or jointly from the monastery of S. Maria Novella and the republic of Florence,[3] Ghiberti emphasizes in his memoirs that he made Dati's features *al naturale*, from a death mask. The tomb was modeled, cast, and chased between that year and the spring of 1427. By July 1427 the friars were in the red in Ghiberti's book with an insignificant debt of ten florins (Dig. 138; Doc. 81). The Shrine of SS. Protus, Hyacinth, and Nemesius dates from the same years (Pl. 76; Fig. 55). The relics of the three martyrs were deposited as early as 1422 in the convent of the Calmaldulensians in Florence, S. Maria degli Angeli. Cosimo and Lorenzo Medici, at the instigation of their friend and protégé, Ambrogio Traversari, had taken it upon themselves

[1] Paatz (bibl. 375, II, p. 199 and note 145) appears to have been the first to call attention to the reference in the document of 1423 to the jambs of Ghiberti's first door.

[2] The date of Leonardo Dati's death is at times given erroneously as 1423 or 1424 (Planiscig, bibl. 404, p. 56). For the correct date, see among others Leonardo's brother Gregorio, bibl. 116, p. 106.

[3] Mortier, bibl. 349, IV, pp. 85ff; Baldinucci, bibl. 35, I, p. 381, note 1.

to have a shrine made, and either early in 1424 or, more likely, in the summer of 1425, Traversari sent Cosimo Medici a reminder by way of Lorenzo.[4] In July 1427 the shrine was still in Ghiberti's workshop (Dig. 138; Doc. 81), but had probably reached the finishing stage, since 135 florins, two-thirds the estimated price, had already been paid. That it was completed in 1428 is suggested by a long dedicatory inscription which Vasari read on the marble base supporting the shrine that in his time stood in the old church of the convent, inside an arch between the monks' choir and the laymen's anteroom.[5] A few years later the fame of the small shrine, even though it is not one of Ghiberti's greatest works, had already spread as far as Naples and Venice: the front relief, two angel victories holding a wreath around the dedicatory inscription, was copied on the tomb of Gianni Carracciolo del Sole in S. Giovanni a Carbonara in Naples, 1432, and on the Porta della Carta at the Palazzo Ducale in Venice, 1438.[6]

The two reliefs for the Baptismal Font of Siena fell within the period between 1417 and 1427 (Pls. 72, 73, 74). During 1416 and 1417 Ghiberti was called three times to Siena. His first trip in July 1416 precedes by several months the designing of a model either in plaster or drawn on canvas of the whole Font by local workmen. The visit was apparently a big occasion. He went, accompanied by two assistants, possibly Giuliano di Ser Andrea and Bartolo di Michele, and they were wined and dined and treated

[4] The transfer of the relics, confirmed by Martin V on January 29, 1422, had apparently taken place on January 7, 1422, or perhaps 1421 (Mittarelli-Costadoni, bibl. 340, VI, col. 287f, 754f). Traversari considered the shrine his own achievement "quorum corpora in ecclesia nostro studio condita sunt . . ." (Traversari, *Hodopoeoricon*, in: Dini-Traversari, bibl. 127, app., p. 39), see also *AA.SS., Sept. III*, Antwerp, 1750, p. 755, with the erroneous date of 1428 for the transfer. His reminder to Cosimo, sent by way of Lorenzo, "admonens quid Cosmus frater de ornandis sacris reliquiis mihi spem dedisset hortansque . . . illum ad rem perficiendam excitaret" (Traversari, bibl. 526, II, col. 389; Lib. VIII, ep. 32) is dated by a reference in the letter to a journey by Cosimo to Rome. Unfortunately, at least two stays of Cosimo in Rome are documented during the decisive years, one lasting from January until at least September 1424 (Traversari, bibl. 526, II, col. 354ff; Lib. VIII, ep. 3. See also [Albizzi], bibl. 14, II, pp. 181 and 183), and another in the summer of 1425 (Albizzi), bibl. 14, II, p. 340); during a third stay in Rome, on a diplomatic mission, from November 1426 through the spring of 1427 ([Albizzi], bibl. 14, III, pp. 57, 157), work on the shrine must have been under way. The date 1430 assigned to the letter VIII, 32, by Luiso, bibl. 281, X, p. 76 is based on a confusion with the letter VIII, 33. See also Frater Dominicus Joannis, bibl. 132, pp. 103f and Paatz, bibl. 375, III, p. 119 and note 48.

[5] The shrine stood in the old church which remained in use after Brunelleschi's new building of 1434 had been abandoned as incomplete after 1437 (Paatz, bibl. 375, III, p. 107 and notes 2, 3). The placing of the shrine below an arch between the *chiesa de'monaci* and the *chiesetta di fuori* is described in a letter of 1591, first published by Gronau, bibl. 193, pp. 120f. The inscription, now lost, was read by Vasari (Vasari-Milanesi, bibl. 533, II, p. 234) and later by Richa (bibl. 443, VIII, pp. 158f). It ran, on the choir side: CLARISSIMI VIRI COSMAS ET LAURENTIUS FRATRES MEDICES NEGLECTAS DIU SANCTORUM RELIQUIAS MARTYRUM RELIGIOSO STUDIO AC FIDELISSIMA PIETATE SUIS SUMPTIBUS AENEIS LOCULIS CONDENDAS COLENDASQUE CURARUNT. On the nave side it read: HIC CONDITA SUNT CORPORA SANCTORUM CHRISTI MARTYRUM PROTI ET HYACINTII ET NEMESII ANNO DOM MCCCCXXVIII. This part, except for the date, is nearly identical with the inscription on the shrine: HIC CONDITA SUNT CORPORA SANCTORUM MARTYRUM PROTI ET HUACINTHI ET NEMESII. Paatz (*op.cit.*, p. 119, note 48) suggested that the shrine stood under the altar of the chapel left of the center room. Sold as scrap in 1799 and poorly repaired in the early nineteenth century, the shrine was restored in recent years by Cavaliere Bruno Bearzi; see bibl. 500, pp. 62ff.

[6] Regarding the copy of Ghiberti's angels at Naples, see Venturi, bibl. 534, VI, p. 212, with attribution to Andrea da Firenze, regarding the one at Venice, Planiscig, bibl. 407, p. 102.

with kudos (Dig. 44; Docs. 131, 134). Thus one suspects that Ghiberti was called in as chief consultant for the new Font, and it has even been suggested that he was responsible for the architectural design as well.[7] A second visit followed on January 1, 1417—to judge from the menu a Friday (Dig. 49; Doc. 136). On his third visit in May 1417, made after having sent a sample of his work in March (Dig. 50; Doc. 132), he was given the commission for two of the six bronze reliefs (Dig. 54; Doc. 130)—*Baptism of Christ*, and *John Brought before Herod* (Dig. 143; Doc. 141)—contracted for delivery within ten and twenty months, respectively, provided they had been approved by the *Operaio*, both before and after the gilding. Ghiberti was also promised an option on the six bronze statuettes for the niches of the Font. Two other reliefs went to Turino and his son Giovanni, and a last pair to Quercia, but one of these apparently prior to 1423, was entrusted to Donatello. By 1420 Ghiberti had drawn an advance payment totaling up to 215 florins (Dig. 80; Doc. 139) or approximately corresponding to the price set for one relief. One assumes that the *Operaio* and his counsellors, wary men as the future was to show, would not have permitted such an advance, unless at least one relief had been cast, although surely not finished by then. Yet, apparently little else was done on the reliefs for a long time, for early in 1425 the Sienese grew so annoyed with "the masters from Florence . . . who make the stories of the Baptismal Font . . . and have not made them," obviously Ghiberti and Donatello, that they threatened to cancel the contracts (Dig. 112; Doc. 142). Representatives of the *Operaio* paid Ghiberti a call of inspection (Dig. 113; Doc. 154), and in two subsequent letters Ghiberti maintains that the reliefs were "nearly finished," whatever that means to a Florentine craftsman under pressure. In an official letter to the *Operaio* he explains the delay by his flight to Venice from the epidemic in Florence in the winter of 1424-1425 (Dig. 113; Doc. 154), but in a letter to his friend Giovanni Turini, he blames it on difficulties with his former partners (Dig. 115; Doc. 155). The contradiction between the official and private versions raises some doubt as to the veracity of either story. At any rate, he politely refuses Turini's offer to help him with the chasing, saying that one relief was in his hands and the other in Giuliano di Ser Andrea's. So by the time of this correspondence both reliefs must have been cast, the first having been so presumably in 1420 and the second, if we accept Ghiberti's story about the winter flight to Venice, in the fall of 1424 at the latest. In June 1425, one relief, that presumably cast by 1420, was sufficiently chased for Ghiberti to send it belatedly to the still suspicious committee in Siena for inspection, in compliance with his contract (Digs. 118f; Doc. 156).[8] However, it was far

[7] Whether Ghiberti was responsible for the design of the whole font (Lotz, bibl. 279, pp. 5f), must remain a moot question. A contract for the execution of the stonework of the font had been given to a group of local craftsmen as early as May 1416 and thus preceded Ghiberti's first visit to Siena. The details mentioned in this contract included steps, cornices, niches, and incrustation and seem to correspond in general terms to those executed. But the final model (Bacci, bibl. 31, p. 102) between March and April 1417, followed upon Ghiberti's second visit (Dig. 49; Doc. 136) and the shipment of a sample relief to Siena (Dig. 50; Doc. 132). This model, either a drawing on canvas or a plaster model, was executed by the same craftsmen mentioned in the first contract. Ghiberti's influence on the design of this final model remains indefinite.

[8] Planiscig (bibl. 404, p. 39) assumed that the reliefs had not been started by March 1425 and

from finished. Two months later he urged its return for completion and reported that the other was ready, inquiring somewhat prematurely, one feels, about the gilding (Dig. 121; Doc. 157); for, only two years later, in March 1427, both reliefs were brought to Siena for final approval and returned shortly thereafter (Digs. 130f; Docs. 144f, 158). In April and May the last touches were added to the chasing (Dig. 133; Doc. 159); then they were gilded, the *Baptism* first (Digs. 134f; Docs. 143, 160). At this point difficulties arose over the price: Ghiberti demanded more than the amount presumably promised by the former *Operaio* in 1417 (Dig. 142; Doc. 162) and far more than the new *Operaio* was willing to pay. He therefore withheld the finished reliefs until a compromise had been reached (Dig. 143; Docs. 141, 148-150). Only upon payment did he release them from his shop on October 30, 1427. The emissary of the *Operaio* lost no time, shipping them off on the same day to Siena (Dig. 144). This was the sad end of Ghiberti's relations with the Siena *Opera* which had begun so auspiciously.

Similarly complex is the history of the Shrine of Saint Zenobius (Pls. 77-80). In 1428 a committee was appointed by the *Arte della Lana* composed of laymen, theologians, and artists, among whom were the "most famous masters, Brunelleschi and Ghiberti" (Dig. 149). This committee proposed that the relics of Saint Zenobius, patron of Florence, should be removed from their previous resting place in the Cathedral, below the nave, to the easternmost chapel and deposited under the altar[9] in a shrine of bronze or marble with the figure of the Saint represented *gisant* on top. But not until four years later, February 1432, was a competition announced for the design of the new shrine (Dig. 164). That a deadline of only five days was set for the contest suggests that the announcement was a mere formality. In fact, Brunelleschi and Ghiberti immediately turned in models of the sepulcher. As might be expected, the architectural part, the altar was assigned to Brunelleschi, while the shrine itself went to Ghiberti. The contract of March 18, 1432 (Dig. 166) describes it in great detail: it was to be a bronze shrine, weighing up to 5,000 pounds, 3 *braccia* long and 1½ high, the lid formed "like that of a strong-box," thus eliminating the *gisant* Saint, with the sides depicting stories from the Saint's life. (As executed, the side panels measure .40 m, roughly ⅔ *braccio* square, the main panel .41 m x 1.60 m, or ⅔ x 2⅔ *braccia*). Delivery was to be made in three and a half years. The *Opera* immediately purchased the bronze left over from the figure of Saint Stephen, an amount of 1,661½ pounds (Dig. 169). In April 1432, two assistants were hired to work on the Shrine and payments to Ghiberti appear in the account books of the *Opera* for July 1433, and June 1434 (Digs. 170, 180, 183). In October an additional 500 pounds of bronze was purchased "to give . . . to Lorenzo di Bartoluccio for cast-

that in June Ghiberti sent the *Baptism* to Siena "the way it had come out of the casting furnace," while the Herod plaque had not yet been started. The assumption apparently is based on Bacci's interpretation (bibl. 31) of Docs. 140 and 157; but the term *storia del Battesimo* throughout the documents means simply "a story for the Baptismal Font." Only once, in Doc. 160, where *la storia del Battesimo* is distinguished from *l'altra storia* may the reference possibly, though not probably, be to the story of the Baptism.

[9] Paatz, bibl. 375, III, pp. 403 and note 571.

ing two stories on the Shrine," clearly those on the short sides (Dig. 184). Ghiberti's payments apparently ran up to a total of roughly 700 florins. On the basis of his standard fee of 200 florins *per annum*, this amount leads one to assume that he worked from April 1432 until late in 1435. At this point work seems to have stopped or slowed down to a trickle. The reasons are easily surmised: in all likelihood, the *Calimala* had grown impatient with the slow progress of work on the new Baptistery Door, a more important commission, after all, than the Shrine. In any case, the deadline for the Shrine expired in October 1435. Thus, despite the arrival of an additional 12,000 pounds of bronze from Venice early in 1437 (Dig. 197), the *Opera* and the consuls, with a sweeping gesture, canceled Ghiberti's contract in April of that year, and appointed a new committee which was "to have the Shrine completed by whomever they [the members] should decide upon" (Dig. 199).

As so often in life, and particularly Latin life, the gesture did not prove really final. No serious attempts were made to find another bronze caster, and in March 1439, a committee of experts, among them Leonardo Bruni, submitted new plans for completing the Shrine "ordered from Lorenzo di Bartoluccio": the main relief was to occupy the back, and the front was to have an inscription (Dig. 202). The Shrine was officially reassigned to Ghiberti on April 18, and he undertook to complete it within ten months, that is, by January 1440. The main relief, which is now on the front, was to show the miracle of Saint Zenobius resurrecting a boy of the Strozzi family, a relief "for which he [Ghiberti] has had the bronze" and which was "to be delivered within three months"; the sides were to present "the other stories which have been started," presumably those cast in 1434; the epitaph, now on the rear, was to be composed by Leonardo Bruni (Digs. 203ff). The six flying angels carrying the inscription in an elm wreath are not, strangely enough, referred to in the document. Ghiberti, in any event, did buckle down to work: from July 1439 on he received payments at regular intervals (Digs. 210ff). In January 1442, it was decided to have the Shrine varnished, possibly because gilding was too expensive (Dig. 226). By August of that year the work had evidently been finished and Ghiberti received the last payments (Dig. 236).[10] The total cost, 1,300 florins, results from the documents of the *Opera* and is confirmed by two slightly later references, one in the *Zibaldone* of Buonaccorso Ghiberti (Dig. 236; Doc. 126), the other in an undated note of the fifteenth century, in which is also contained a summary of the amounts of bronze and other materials used for the Shrine (Doc. 129).

[10] In addition to the amounts paid directly to Ghiberti, the *Opera* disbursed 105 florins towards the purchase of his *podere* at Settimo (Ginori-Conti, bibl. 181, pp. 11f).

The inscription, in beautiful *antiqua* lettering runs as follows: CAPUT BEATI ZENOBI FLORENTINI EPISCOPI IN CUIUS HONOREM HEC ARCA INSIGNI ORNATU FABRICATA FUIT.

The documents regarding the shrine and the transfer of the relics were apparently known as early as 1475 to Lodovico Strozzi (*AA.SS., Maii VI*, Antwerp, 1688, pp. 62f) and to Ippolito delle Nane, *Vita di Zanobi*, Florence, 1639, quoted by Goldscheider (bibl. 186, pp. 146f).

Regarding the later history of the shrine, particularly its gilding late in the sixteenth century, see Richa, bibl. 443, VI, p. 167; Poggi, bibl. 413, pp. civ f, note; Paatz, bibl. 375, III, p. 379 and note 354. Paatz erroneously assumed that the shrine was gilded from the outset; see, however, Poggi, bibl. 413, doc. 957.

In short, the four reliefs of the Shrine of Saint Zenobius date from different periods. The plaques at the short ends, were modeled between 1432 and 1434 and cast before, or in, June of the latter (Pls. 77a, b). The large main relief, the resurrection of the Strozzi boy (Pl. 78a), must have been modeled before Ghiberti's contract was suspended in 1437. For, if the model had not been already prepared when the contract was renewed in 1439, not even Ghiberti with all his self-confidence could have promised, nor would the *Lana* have expected him to deliver this relief within three months, cast and even chased. The bronze (was that the bronze purchased in February 1437?) was handed over to him upon the renewal of his contract in 1439, and probably in the same year he cast the big relief. The plaque in the back, with its six angels holding the elm wreath surrounding the epitaph (Pl. 78b), was apparently not modeled before 1439 or 1440. The chasing of the two small reliefs may have begun in 1434 or 1435, but, like the others, was not completed until sometime between 1439 and 1442.

This thorough documentation provides a framework within which to view the development of Ghiberti's style after 1417. To summarize the chronology briefly, the earlier of the two reliefs of the Siena Font dates from 1417-1420; the lions' heads on the back of the North Door probably fall in the year 1423; the jambs and lintel were under way the same year and completed by 1426; the second Siena relief was apparently modeled by 1424, and the Dati tomb by 1425; the Shrine for S. Maria degli Angeli was executed between 1426 and 1428; it was followed in 1432-1434 by the two small reliefs for the Shrine of Saint Zenobius; finally the main panel of this Shrine was probably modeled in 1435, and the back relief in 1439-1440.

As an occasional technical device, shallow relief was long familiar to Ghiberti by 1417. He had employed it from the start, in the competition relief and on his first door for parts of an architectural setting, the rigging of a ship, a palm shrub, the wing of an angel, the leg of a servant, supposedly seen at a distance but really so close to the foreplane that a three-dimensional representation would have been impossible. This early use of shallow relief differs little from the application of it by most of Ghiberti's contemporaries, such as Nanni di Banco in his relief below the *Quattro Coronati* or Quercia in his *Expulsion* on the Fonte Gaia. Only in the very late reliefs of the North Door, approximately between 1416 and 1419 does Ghiberti go further. Distance is graded into a limited number of interrelated planes: the full round figures of the front plane in the *Flagellation* (Pl. 45) standing against the half raised colonnade of the middle ground and this in turn is set off against the shallow relief of a second row of columns. Figures or parts of figures are outlined in thin relief. Both in the *Arrest* and in the *Way to Calvary* (Pls. 44, 50), depth, although undefined, is suggested by halberds, spears, torches and fluttering cloaks in the distance and by heads far back in a crowd; in the *Arrest* two legs belonging to two different bystanders, one in the middle ground, the other further back, appear in shallow relief at the left edge. The attempt to indicate distance by means of such fragmentary instances of shallow relief also marks the panel of the *Baptist Brought before Herod* in Siena (Pl. 72). This is not surprising, if one assumes that the *Herod* plaque was the relief

designed and modeled between 1417 and 1420 (Dig. 80; Doc. 139). Indeed, its composition is a variation on the contemporary *Pilate* of the North Door (Pl. 48), even though the design of the *Herod* appears superficially stronger by virtue of the excited group at the right, the quiet rulers on the dais at the left, and the deepening of the hall in an approximate linear perspective. But into this design inferior elements are incorporated. Composition, action, and the handling of the foreground figures bear the mark of Ghiberti's style of 1417 or thereabouts. Manifestly, the *Herod* relief and the Siena *Baptism* (Pl. 73) date from different periods.[11]

The heads of the lions (Pl. 68a; Fig. 54a, b), inserted into the *tondi* on the back of the North Door presumably in 1423 are close to the *Saint Matthew*. But they offer new and very different problems.[12] One of the heads pushes forward, the muzzle jutting out in strong relief. The jaw and forehead recede until the mane, on either side, tapers off into flat relief, its outlines blurred against the background. Here, then, shallow relief loses the character of a mere technique for hinting at distance. Its function has become that of forming the recessive planes in a design where strong, three-dimensional volumes must necessarily decline in depth.

Flat relief has the same function in the floral design on the outer face of the posts and lintel of the North Door. Into these outer surfaces are inserted strips, ranging in

[11] The confusion regarding Ghiberti's development and his position in early Quattrocento art is nicely revealed by the divergence of opinion regarding the two Siena reliefs. Frey (bibl. 532, p. 275) considered the *Baptism* "for the greater part the work of an assistant, Turini, who rather spoiled Ghiberti's design." Goldscheider (bibl. 186, p. 146) likewise thought that "the surface of the figures [in the *Baptism*] shows similarities to Turini's . . . *John preaching*, whereas other parts, such as the cloud of angels, belong among Ghiberti's finest achievements." Regarding the *Herod* plaque Goldscheider found that "even assuming that Giuliano worked from a *modello* of Ghiberti's, the quality of the execution is in part astonishingly good . . . and some of the heads are extremely expressive." Schlosser, so far as I can see, never expressed an opinion on Ghiberti's or Giuliano's respective authorship; but he held that the *Baptism* was decidedly the earlier because supposedly less advanced in style than the *Herod* (bibl. 477, p. 101). Planiscig (bibl. 404, p. 39) gives the execution of the *Herod* relief almost entirely to Giuliano because of what he terms its antiquated style, granting at the same time that the sketch and first idea might be Ghiberti's. But this is loose reasoning: the style is antiquated only if both reliefs, the *Herod* and the *Baptism* were designed in 1425; but if the *Herod* was designed in 1417, it fits neatly into place among the late reliefs of the North Door.

The weaknesses of the *Herod* plaque are apparent. The architectural setting of the *Pilate* relief, composed of niche, straight basilica wall, and a curved background building, has been lumped together in an obvious misunderstanding of the separate components of the original. The poses of the warriors are at times awkward; the shallow relief of the leg of the young guard in the foreground makes no sense. Because of such "blemishes" and since Giuliano di Ser Andrea in 1425 and later (Docs. 155, 159) was working on one of the reliefs—indeed Ghiberti had apparently brought him along to Siena on his first visit (Doc. 131)—it is understandable that the *Herod* panel has been attributed to him. But in our opinion, the entire design and part of the modeling are Ghiberti's. Possibly Ghiberti left it to Giuliano to complete the model, particularly in the background. The chasing is apparently Giuliano's. It is excellent throughout, and only the over-abundance and pedantry of the engraved details suggest that it is not by Ghiberti himself. The contrast between the mature classical garland frieze and the otherwise pseudo-antique architecture supports the assumption of a sustained period of work, see also below, p. 264 and Fig. 95.

[12] Marangoni (bibl. 297) has established that Ghiberti used six different types of heads for the lions, for the twenty-seven panels (one remained empty; see above, p. 132, note 20). His further statements regarding the crudeness of technique, the classical subject matter and the "too ferocious expression" and his consequent attribution of the heads to an assistant of Ghiberti's are untenable.

length from .57 to 1.15 m; thus they form continuous panels, imbedded between the raised profile edges that are part of the posts and lintel proper. From these strips emerge bunches of flowers, fruits and twigs, tied by short ribbons: wild roses, lilies or crocuses, acorns, pine twigs and cones, daisies, olives, juniper, filberts and laurel twigs, violet leaves, forget-me-nots, peapods, figs, ferns, and carnation leaves (Pls. 69d; 70a, b; 71a). Occasionally a small bird picks at the berries, a squirrel nibbles on the pine cones, a tiny snake wriggles through the twigs. The volume of the relief of the outer posts changes twofold. First it decreases in volume from top to bottom, the lintel and upper parts of the posts being fuller and gradually receding in depth as they near the eyelevel. Second, in the individual bunches, the animals and fruits, flowers and foremost leaves project into full, three-dimensional form; then, the relief diminishes in volume by two, three, or four layers, until finally a paper-thin *schiacciato* leaf or a tiny flower seems lost in the background. The character of both relief and design is fundamentally different on the inner side (Pl. 69c) of the frame—the jambs and the soffit of the lintel. The framing profile edge, instead of being raised above the flat surface, slopes downward from the adjoining flat plane of the post to the sunken panel. Bunches of flowers, tiny roses and lilies are tied to a long pole, encircled by a spiraling ribbon and all this is wrought in very shallow relief: three-dimensional forms do not exist, the leaves and the flowers grow flatter and flatter until they seem to vanish into the ground; even those brought most to the fore are not raised more than a couple of millimeters. At the same time, the sequence of ribbon, flowers, and the supporting pole, suggests a space far deeper than any represented by the succession from full, to half-full, to shallow relief on the outer face of the posts and lintel. To some degree this difference may be due to the relative positions of the inner and outer jambs: if strongly projecting forms were employed on the inner sides, they would interfere with the prophets' heads that jut out from the border edge of the lattice frame of the door. However, more than this is implied in the *schiacciato* relief of the inner jambs. It presents interlocking forms and space in two dimensions. It is no longer just a tool for building up three-dimensional volumes, but a new and in-dependent means for creating pictorial relief or, as it might be called, sculpture in terms of painting.

Floral design as such was nothing new to Ghiberti who in his early years, after all, had designed the foliate strips for the lattice frame of the North Door (Pls. 69a, b). These strips in Gothic fashion are limited to one species of leaf, lushly heaped and immensely alive, and interspersed with many tiny animals. The flora on the jambs of 1423 do not transcribe reality; but they are more inventive. A dozen or more species of flowers and leaves have been selected and the greater diversification necessitates greater individualization. Yet this, in turn, is linked to greater stylization: the leaves develop, without rigidity, from a center axis, growing forwards and backwards into depth; the big oval-pointed leaves of forget-me-nots are surmounted by smaller heart-shaped leaves of violets, the summit is reached in the half sphere of a rose. Nature is stylized and made an object of art, in contrast to the late fourteenth century where it had been an object of literal rendition.

Love of nature and shallow relief both point to new sources which, in these years, combined to shape Ghiberti's mature and late style. His love for the flora of his native Tuscany is indeed apparent in his writings as well as in his sculpture. Throughout his autobiography he carefully identifies the divers species of plants which he had designed: the ivy on his first door; the "leaves of many kinds" on the frame; the olive wreath on the Shrine for Santa Maria degli Angeli (Pl. 76); the palm wreaths on the sides (Fig. 55); the ivy on the Medici Cornelian; the wreath of elm leaves on the Cassa di S. Zenobio (Pl. 80a); finally, "the foliage, the birds and other small animals" on the frame of the Gates of Paradise (Pls. 71b, 138).[13] However, the new floral design, as it presents itself on the jambs of the North Door rests not wholly on his love of nature. It is intimately related to painting. In fact, it is particularly close to a specific work in Florence of exactly the same date as Ghiberti's door jambs. In the framing buttresses of his great altarpiece, the *Epiphany*, Gentile da Fabriano inserted a series of panels painted with floral decoration (Fig. 53). The altar, painted in 1423, and ordered by Palla Strozzi for the sacristy and tomb chapel of his father, adjoining S. Trinità, must have greatly impressed Ghiberti. Indeed, he acted as an adviser for the furnishing and possibly for the design of its portal (Dig. 73a)[14] Gentile's choice of flowers—crocuses, morning glories, and chicory[15]—and their representation in bunches, which convey the illusion of different planes from the projecting flowers and leaves back to thinner and thinner leaves that finally seem lost in the background, are much too close to Ghiberti's flora for the likeness to be explained as mere chance. This resemblance is all the more cogent in that flora of this species and manner of their presentation do not appear elsewhere in Florentine sculpture or painting of the time. But to Gentile these were familiar features, appearing time and again in his work: for instance, in the Jarvis *Madonna* wild roses like Ghiberti's and pomegranates weave in and out of the supports of the throne. Such designs are only natural in Gentile's work, for in the milieu of Venice and the *terra ferma* where he had worked for fifteen or twenty years before coming to Florence, floral motifs, long present in medieval herbals, took on new naturalistic traits during the early years of the Quattrocento.[16] In the narrow flower panels of the Epiphany Altar, painted in the very years that Ghiberti worked on the jambs of his door, Gentile achieves in painting precisely the effect Ghiberti wanted to attain through the shallow relief on the jambs of his door.

Ghiberti's sympathetic observation of nature was, then, doubtless reinforced by fresh impressions from Gentile's *Epiphany* and it was further enhanced by the impact that Roman decorative sculpture had on him in these same years (Fig. 52).

Indeed, in Ghiberti's quest for a pictorial relief Roman art did play a very considerable part. Time and again, as during the critical years from 1417 to 1423, he employs the shallow relief to suggest depth and distance, he turns his eye to Roman prototypes. The Herod plaque in Siena, derived as it is from Roman historical reliefs

[13] Ghiberti-Schlosser, bibl. 178, I, pp. 46ff. [14] See below, p. 256.
[15] Kennedy, bibl. 241, figs. 26, 27, 25. Albrecht (bibl. 15, p. 22) has remarked upon the similarities of Ghiberti's and Gentile's floral designs of 1423.
[16] For the transformation in the Venetian milieu of illustrations of medieval herbals into pure studies of nature from direct observation, see Paecht, bibl. 376, and above, p. 62, note 40.

(App. A 22), draws from its sources not only the group of the prisoner brought before his judge, but also the heads in flat relief, which far in the background convey the illusion of a deep atmospheric space. Similarly, in the *Arrest* (Pl. 44) on the North Door, the lances, torches, and ensigns rising above the crowd, and the heads, slightly embossed and suggestive of depth and atmospheric space, are drawn from Roman historical relief. To be sure, fourteenth century painters had made use of similar devices to indicate distance. Trecento and contemporary painting, then, combine with Roman relief sculpture as potent stimuli for Ghiberti as he gradually evolves the first stages of a pictorial relief from the last plaques of the North Door to the floral design on its outer frame.

As an old man, in his autobiography, Ghiberti concisely stated the problems attacked in the mid-twenties. In describing the Shrine of the Three Martyrs (Pl. 76; Fig. 55) he lays stress on the two angels in the front, the olive garland they carry and the lettering of the inscription. He speaks with even greater precision of the Dati Tomb (Pl. 75). It was done, he says, "in very shallow relief"; he "portrayed (the Dominican general) from nature"; and he placed at his feet *uno pitaffio*, an epitaph.[17]

To speak of last things first, it was obviously important to Ghiberti that the inscription on the Dati Tomb was not of the traditional, funeral type, but, instead, an epitaph of antiquish lettering, if not wording. Indeed, he puts equal emphasis on the *lettere* on the Shrine of the Three Martyrs, apparently because of their antiquish character: he employs the term *lettere* only twice elsewhere in the autobiography, once in reference to the Medici Cornelian and another time in speaking of the Shrine of St. Zenobius, distinguishing the *lettere* in both cases as *antiche*. Thus the term probably connotes the same in reference to the Shrine of the Three Martyrs—indeed, it is of antique script, just as the angels carrying the wreath are of antique character. Antiquity then, by 1425, was one of the determining factors in Ghiberti's art.

The second factor Ghiberti stressed in his reminiscences is the *naturale*, though it is less clear what he intends to imply by this term. Possibly he only meant that he used a death mask for the Dati Tomb; a fact, evident in the lids, closed over the protruding eyeballs, the thin lips, the upper one deformed, perhaps by a stroke. Such use of a death mask would simply have continued a tradition well known all over medieval Europe.[18] However, medieval sculpture in its use of death masks clung to a literal rendition of reality. In the Dati Tomb, on the contrary, elements of literal realism are toned down. Despite the badly worn state of the plaque, the face reveals

[17] Ghiberti-Schlosser, bibl. 178, I, p. 47.
The plaque is at present in the transept of the church; originally it was in the monks' choir (Richa, bibl. 443, III, p. 77; Paatz, bibl. 375, III, p. 702 and note 178). Both the bronze relief and the inscription have been badly worn down. The inscription reads:

CELEBRIS. HIC.MEMORIA.COLITUR.CLARI.RELIGIOSI.FRIS.

LEONARDI.STATII.DE.FLORENTIA.SACRI.THEOLOGII.AC.

TOTIUS.ORDINIS.PREDICATORUM.MAGISTRI.GENERALIS.

[18] Schlosser, bibl. 475. Examples of portraits made from death masks exist everywhere in the late Middle Ages, from the tomb of Isabeau of France at Cosenza, 1283 (Schlosser, bibl. 475, p. 102) to that of Bishop Hohenlohe at Bamberg, 1330 (Pinder, bibl. 400, I, fig. 35) and of Enrico Scrovegni at Padua, 1305 (Venturi, bibl. 534, IV, fig. 178). See also Keller, bibl. 240 *passim*.

an unexpected subtlety of design (Pl. 75). The small head grows from the elegant serpentine folds of the hood, and its clean ovoid must have stood out even more distinctly when the rich embroidery of the underlying pillow was better preserved. All the individual traits of the death mask have been absorbed into smooth surfaces. Hence to "portray from nature" in Ghiberti's sense included the translation of nature into the elegant firm style he evolved during the twenties. Nature here is stylized and volume converted into gradually thinning planes of relief just as in the floral borders of the North Door and in the three olive wreaths on the front and sides of the Shrine of the Three Martyrs.

Indeed, the quest for a shallow relief was uppermost in Ghiberti's mind when he reminisced in his autobiography about the Dati Tomb. Of course throughout the Trecento in Florence, tombstones were frequently done in flat relief, and Ghiberti himself, later in the twenties was to furnish designs for two stone plaques of this type (Figs. 56, 57), one to mark the tomb of Lodovico degli Obizi (Dig. 145), the other that of Bartolomeo Valori (Dig. 146).[19] But the Dati Tomb approaches the problem of flat relief with much greater thoroughness and comprehension than either of these stone plaques or their Trecentesque ancestors. Raised and flat relief are used in one design to suggest three-dimensional volume. The raised parts—the head, the hands, the feet—jut out toward the beholder; then from these points the relief recedes in ever flattening planes. Finally, in the last plane, the thinnest folds of the habit and the tassels of the pillow are set off against the blank ground. Just this calculated diminution of volume is the function of raised and shallow relief in the angels on the Shrine of the Three Martyrs: from the strongly raised volumes of the heads and arms, turned as they are towards the beholder, the forms recede in successive layers, until the flattest planes lie paper-thin, yet clearly outlined against the ground.

At first glance, this relief style seems much like that of the lions' heads on the back of the North Door and the flower bunches on the posts of the frame. However, both in the Dati Tomb and in the Shrine of the Three Martyrs, the eye is led with far greater consistency from plane to plane and inveigled into actually "seeing" the volumes of the entire body. The blank ground into which the planes recede has itself taken on a different function. The consistent recession of the shallow relief is joined to an expanse of ground which is vast compared to the size of the bodies. More noticeably, as Ghiberti proceeds from the Dati Tomb to the Shrine of the Three Martyrs, the expanse invites the beholder to interpret it as space in which the figures float. Both this space and the position of the figures are undefined. But no longer, as in the reliefs of the North Door, is space a void left by real solids, no longer is it dependent on their existence; it turns into a quality perceptible to the eye. Ghiberti has reached a turning point. He is moving towards a concept of relief in which space

[19] Ghiberti was apparently responsible only for the preliminary drawings for the two plaques (Ghiberti-Schlosser, bibl. 178, I, p. 47; Brockhaus, bibl. 68).

The tomb of Lodovico degli Obizi, killed in action in the battle of Zagonara in July 1424, was carved by the stonemason Filippo di Cristofano upon the commission of Bartolomeo Valori, Obizi's executor. It was not yet fully paid for by 1427 (Dig. 146). Valori himself died September 2, 1427.

is to become autonomous, constructed independently, and qualified both as a surrounding atmosphere to the figures and as a continuity in width, height, and depth. The pictorial relief of the Gates of Paradise announces itself.

Ghiberti's first pictorial relief, the *Baptism* of the Siena Font (Pl. 73), designed probably in 1424, is a further step in this development. The groups of figures now are fully incorporated into a narrative relief and their composition becomes intelligible only through its integration with what appears to be a deep space. Instead of the rich numbers of the *Herod* (Pl. 72), a few figures hold the design together: John to the right and two angels to the left form its upright supports; they frame Christ standing in the center, his body in a slight curve. The arm of the Baptist, stiffly outstretched, ties the composition together like the lintel of an architrave, and is complemented by a succession of horizontal cloud banks. A host of angels, finally, rises from the main supports as an arch, culminating in the figure of God the Father who floats above three cherub heads (Pl. 73). Everything in this composition is supported through contrast: even the tree behind John shoots up with a slim vertical stem to the horizontal branches of the crown, rather than growing in knotty twists like the trees on the North Door. The head of Saint John recalls that of *Saint Matthew* at Or San Michele (Pl. 8), but his body is long and slim like those of the standing angels. The draperies are thin, often transparent, with straight sharp folds, supporting the slenderness of the figure. Proportions, stances, draperies and, finally, the round, suave, yet firm heads of the angels recall the *Saint Stephen* (Pl. 16) and forecast the panels and statuettes of the Gates of Paradise. The composition is laid out in contrasts that are simple, clear and yet subtle; the story is told with reticence.

Both the continuity of space, however, and the position of the figures remain slightly ambiguous. John, Christ, and the two standing angels occupy a front stage, much like the group in the *Herod* plaque or in the *Way to Calvary* (Pls. 72, 50). But this stage has little depth. It slopes rapidly upward and inward; a few inches from the base line it runs against the vertical drop of the back plane. Front stage and backdrop in the bottom zone are thus divorced from each other (Pl. 73). The scenic setting is limited to this front stage and contributes little to suggest space or unity. Ghiberti in the twenties thinks preeminently and almost exclusively in terms of human figures; he leaves it to the imagination to fill in a landscape from a creek, a rock, and a tree. In the upper zone of the panel, on the other hand, extends a deep and continuous space. The gold ground stretches wide all around the figures, occupying four-fifths of the entire panel. Modeled onto this gold ground, two rows of angels flying between clouds form a deep wedge (Pl. 74). Their relief gradually decreases until finally the farthest angels and clouds barely rise from the ground. The grading of volumes thus suggests a space which consistently melts into depth. At the apex, the figure of God shoots forward suggesting in reverse the depth the eye has traveled along the wedge of the angelic host. All through the succeeding planes the figures are outlined with perfect clarity, and thus intimate intelligible though not measurable distances. No detail is blurred, clouds somewhat resemble heavy pieces of flint, and where they float in front of an angel, both their silhouettes and those of the angels remain distinct. The

gold ground itself, while connoting space, has no quality of atmosphere; it remains a backdrop which is almost solid and thus conveys a sense of finitude. Fundamentally, then, Ghiberti has arrived at a concept of space which is ambiguous in more than one respect: it is continuous, but this continuity is based on the succession of clearly defined bodies and does not extend beyond; it is finite, but the vast expanse of gold ground intimates an indefinite space; it is by and large restricted to the heavenly zone and while intentionally it starts from the figures on the front stage, the break remains noticeable even behind the standing angels to the left. Still, the overall design of the panel conveys the impression of an all-pervading space. Indeed, the arch formed by the flying angels rests solidly on the main figures that occupy the foreground, yet vaults not only upwards, but backwards into depth. The tightly held, unified composition thus heals the break between front stage and back plaque and between lower and upper zone, and intimates the existence of a continuous and unified space far beyond its actual presence. The unity and intelligibility of the upper zone is seemingly transferred to the entire panel by means of the composition.

The Siena *Baptism* represents an early stage in the development of Ghiberti's pictorial relief, and it sets forth but one of many answers to one of the basic problems which concerned the heroic age, as it can be called, of the Early Renaissance. Painters, sculptors, and architects strove by various means towards the representation, in intelligible form, of reality, whether human bodies, actions, or space. Brunelleschi constructs a central, linear perspective and thereby defines a continuous, measurable space in an architectural setting, an architect's space based on an architect's construction but quickly carried into painting such as Masaccio's Trinity fresco and Masolino's S. Maria Maggiore altarpiece (Figs. 87, 88). By 1435, presumably under the impact of Alberti, a painter's theoretical space has evolved which is intelligible and measurable in terms not of architectures, but of human figures and their actions. Painters at the same time attack the problem of how to suggest a convincing yet incommensurable space in a landscape setting: the fading of color in the faraway distance combines with elements of a linear, often prescientific perspective and with clearly outlined corporeal figures in the foreground. Gentile da Fabriano represents this phase, just as do his contemporaries in Flanders from the Limbourg brothers to Jan van Eyck. Masaccio, meanwhile, in his latest works, the predella of the Pisa Altar and the *Tribute Money* designs voluminous figures placed in wide landscapes with hilly background, yet supported by architectural elements laid out in a scientific linear perspective. But at the same time that the painters had found such solutions, or even before, both Ghiberti and Donatello had developed their widely different versions of pictorial relief.

Indeed, Donatello's concept of relief, his technique, his representation of space and his ultimate aim are diametrically opposed to Ghiberti's. Donatello's concepts became evident first in his *Saint George and the Dragon* at Or San Michele (Fig. 61) (*circa* 1417)[20] and then in the *Assumption* from the Brancacci Tomb in Naples (1427).

[20] The traditional date for both the statue and relief is based merely on the date of 1417 when the block for the relief was purchased. See Kaufmann, bibl. 237, p. 56 and note 176.

They were most clearly stated later in the *Giving of the Keys* (Fig. 66).[21] The panel is flat throughout: thin layers of mountains and trees, hardly differentiated in thickness, reach the front plane where the figures rise, paper-thin. Their outlines are blurred with the equally hazy outlines of the faraway hills, trees, and sky. While in Ghiberti's *Baptism* space is based on the unified composition and succession of graded layers of volume, in the *Giving of the Keys* space is felt as an all-pervasive misty atmosphere. Fluttering strands of hair, wings and draperies seem to vanish in thin air, clouds are shadows without substance gliding nebulously in front of objects. No perceptible gradation of thickness in the relief distinguishes the closest points from the farthest. Yet, regardless of their lack of high relief, the figures and objects suggest enormous volume. Rapid foreshortenings prevail. Ghiberti's *Baptism*, although it occupies a relatively low position on the Font, is designed to be seen on a level with its exact center. But in the *Giving of the Keys* an eye level is assumed for the beholder which is far below the bottom edge of the relief. Donatello thus forces upon the spectator an impression of giant figures bearing down on him from the very base line of the relief, pushed forward by an onrush of relief space.

Marble offers problems different from those of bronze, and in the *Salome* panel for the Siena Font (Fig. 59) Donatello built up the bronze relief from the back plaque, much as Ghiberti had done in the earlier *Herod* relief.[22] The deep front stage is crowded with figures, and the architectural setting behind seems to present a sequence of spatial layers. Yet, also here differences from Ghiberti are manifest: the action is dramatic and powerful; the crowds are so intricately placed as to preclude a clear understanding of their stance and movements; volumes and space are interlocked in a complicated network; figures push forward, far beyond the frame, and others almost without transition, move into depth in flat relief. The successive layers of architectural backdrops, with heads inserted into them in very shallow relief, are unconnected; the eye is forced to jump from one element to another. The key points of perspective construction are hidden and the perspective in general is not mathematically consistent. Just as in the *Giving of the Keys*, the action, figures, and relief space are forced upon the beholder in a violent onrush, although the effect is attained here by slightly different means. Even within an architectural setting and when working in bronze, Donatello conceived of space as indefinite and undefinable. He made no attempt to make distances intelligible or to work out a relationship of volumes to the surrounding space. His human figures, buildings, and scenic settings remain wholly incommensurable. He avoided the uninterrupted succession of planes leading back to a

[21] London, Victoria and Albert Museum. Pope-Hennessy (bibl. 421) in a sparkling little pamphlet has given an excellent analysis of the *Giving of the Keys*, discussing its place within Donatello's *œuvre* and its relationship to Masaccio. He suggests that the relief might have been meant to serve as predella for the altar of the Brancacci chapel and proposes the date of 1427-1432, nearer the beginning than the end of that period. H. W. Janson informs me that he inclines towards a slightly later date, *ca.* 1433.

[22] The *Dance of Salome*, commissioned to Quercia in 1417, was in the hands of Donatello prior to 1423 (information kindly supplied by H. W. Janson; see also Bacci, bibl. 31, p. 124); the contract with Donatello, if ever there was one, seems to be lost. In 1425 the relief was apparently as little advanced as Ghiberti's *Baptism* (see above, p. 140, and Doc. 142). In 1427 the panel was delivered to the *Opera* at Siena.

finite depth. To Ghiberti, meanwhile, space became more and more an intelligible quantity, beginning with the heavenly zone in the *Baptism*. To Donatello it was more and more loaded with an emotional quality and its ultimate function became for him to enhance the dramatic implications of action.[23]

These attempts to realize through pictorial relief spatial and plastic values in terms of two dimensions should not be viewed as isolated phenomena. The relation of Ghiberti and Donatello to each other and to contemporary painting during the twenties is far from clear. But more than at any other time in their lives it was a period of intense competition between the two masters. In 1423, with the statue of Saint Louis, Donatello broke the monopoly hitherto held by Ghiberti on large-scale bronze figures. Not only is the *Saint Louis* roughly the same size as the *Saint John* or the *Saint Matthew*, and thus vies with them for stature at Or San Michele, but—to add insult to injury—this statue was completed with the help of Michelozzo who, a few months before, had been a partner of the firm of Ghiberti. Even before 1423 Donatello was given the commission for the *Salome* plaque of the Siena Font and thus by implication challenged Ghiberti in the field of relief casting. In 1427 he accepted the commission for the figures of Faith and Hope for the Font, two of the six figures on which Ghiberti had held an option. In 1426, shortly after Ghiberti had started the Dati Tomb, Donatello undertook a bronze tomb for Giovanni Pecci, bishop of Grosseto in Siena (Fig. 60). Ghiberti placed the effigy of Leonardo Dati in a lying position, decreasing its volume plane by plane from half-raised relief to an almost flat surface. Donatello represented the deceased ambiguously, half-standing in a niche, but still giving the illusion of half-lying on a pillow, and confronted the beholder with tricks of perspective, such as the position of the feet, the rounded depth of the niche, the base at the bottom and the scroll-shaped epitaph. The competition between Ghiberti and Donatello expressed itself as a contest in the technique of bronze casting and finishing as much as in design. Ghiberti's perfect mastery of the casting of large figures *à cire perdue* surpasses Donatello's *Saint Louis*, for instance, which is composed of eleven pieces. Ghiberti's stress on chasing a figure down to the last detail is very much in contrast to Donatello's practice of partial chasing, leaving large portions in the raw or almost so. Above all, however, the contest was one of basic concepts of sculpture.

Competition and opposition never preclude an interchange of ideas. Ghiberti's lion heads on his first door are inconceivable without Donatello's *Marzocco* of three years earlier (Pl. 68a; Fig. 30). Nor would the *contrapposto* of the *Saint Matthew* have been possible if the *Saint Mark* had not paved the way for it. But at the same time the *Saint Matthew* should be viewed as a conscious critique on Ghiberti's part of Donatello's interpretation of antique art. Its greater elegance, fluidity, and lyricism bespeak a firm denial of Donatello's principles. The two angels on the Shrine of the Three Martyrs may be another critique of Donatello, this time of his chubby *putti* on the

[23] Donatello's relief style has been analyzed frequently; but rarely has it been discussed with greater brilliance than by John White (bibl. 552), though perhaps with some slight overemphasis on the role of linear perspective in Donatello's *œuvre*.

base of the *Saint Louis*. On the other hand, Donatello likewise shows signs of a critical estimate of his competitor's accomplishments. One wonders whether his stormy angels in the Brancacci *Assumption* of 1427 might not be a rebuttal of Ghiberti's peacefully gliding angel victories. The Pecci Tomb certainly implies a sharp rebuke of Ghiberti's plaque for Leonardo Dati. So can the *Salome* relief be interpreted as a critique of Ghiberti's *Herod* panel. Indeed, the two reliefs have more than one feature in common: the architectural settings, the tense excited group at the right, the figures pushing up to and, in Donatello's case, past the frame. But the placing of figures in space and their interaction is so fundamentally different that if, indeed, Donatello had Ghiberti's panel in mind, his criticism could not have been more radical.

The Siena *Baptism* is replete with elements which, conversely, are as rare in Ghiberti's vocabulary as they are frequent in Donatello's. The angels in the background fly energetically towards the middle ground, sharply foreshortened. The foreshortening of their heads and bodies, their convulsive flight, fluttering garments and profiles find close parallels in Donatello's *Assumption*. The sharp outline of their profiles resembles heads in the background of Donatello's *Salome* relief. Considering the date of Ghiberti's Siena *Baptism*, presumably 1424, and that of Donatello's *Assumption*, scarcely prior to 1427, one hesitates to assign these features to Donatello's invention. However, neither are they in any way anticipated in Ghiberti's earlier work; moreover, in his later *œuvre* they appear rarely if at all. The wildly storming angels of the Siena *Baptism* (Pl. 74) give way in the Shrine of the Three Martyrs (Pl. 76) to the peacefully gliding spirits that accompany the Lord's appearances in the Gates of Paradise. On the other hand, lively, foreshortened angels are a permanent characteristic of Donatello's work, perfectly suited to his violent dramatic treatment of narrative and pictorial relief. One can only assume, therefore, that Donatello was experimenting with foreshortenings when Ghiberti designed the *Baptism* and that briefly these experiments penetrated into Ghiberti's style. Much more important, however, were Donatello's exploits in fully developed pictorial relief in the *Saint George* panel some years before Ghiberti worked on the Siena *Baptism*.

This interchange of ideas and vocabulary did not alter the basic approach of either Ghiberti or Donatello to pictorial relief. For Ghiberti five elements remain decisive: figures always form the basis of his design; settings, whether scenic or architectural, are relegated to the background; every object is drawn with the utmost clarity; volumes recede in a succession of distinct planes without interruption; space is finite, terminated by a gilded backdrop. The approach as a whole strives constantly for greater intelligibility and altogether could not be further from Donatello's concepts. It evolved consistently, taking no radical turns from its experimental beginnings to its ripest achievements in the thirties on the Gates of Paradise.

Until he died Ghiberti treated pictorial relief as one of the fundamental problems of his art. The formula first used in the Siena *Baptism* did not remain untouched, but was explored and finally perfected in the Gates of Paradise where space looks truly autonomous and continuous and is intended to be measurable. Only very late in his life, for example in the *David* panel, did Ghiberti challenge these basic prin-

ciples of a relief wholly intelligible in both composition and spatial qualities. But until this rupture, the development was a consistent elaboration of elements inherent in the Siena *Baptism*. The Shrine of Saint Zenobius (Pls. 77-80) of the thirties represents two definite phases of this development. Its two small side panels are markedly different in style and date from the large relief in front. Both the right one of the *Resurrection of the Servant* and the left one of the *Miracle of the Cart* (Pl. 77a, b) were apparently modeled and cast, though not chased, between April 1432 and June 1434. The large front relief of Saint Zenobius resurrecting a boy of the Strozzi family (Pl. 78a) was probably designed prior to 1437 and cast after 1439. Only the back panel of six angels holding an elm wreath around Leonardo Bruni's inscription (Pl. 78b) was entirely executed between 1439 and 1442.

In the side panels, just as in the *Baptism*, the front stage slopes up rapidly and is occupied by a few figures fully in the round. The figures and objects modeled on the vertical back plaque grow shallower and shallower, the decline marked in distinct planes. Opposed to the *Baptism* are the groups of figures which, instead of balancing each other, give more weight to one side of the relief than to the other. High cliffs form a landscape setting much in contrast to the empty gilded backdrop that hovers over the horizon of the *Baptism*. Action takes place on a diagonal, in zigzag movements going back into depth: in the *Miracle of the Cart* (Pl. 77a), from right to left, along the backs of the yoke of oxen and the cart, directed towards the women in the rear, crosswise, from left to right, from the first to the second driver, and from the kneeling girl to the man behind the cart and so on to the mountain chain, finally, in a rising diagonal axis, from the heads of the oxen, to the tree and up to the Saint, floating down from heaven. The eye travels similarly over the composition of the *Resurrection of the Servant* (Pl. 77b). Space is conquered here, then, by a complicated movement of intersecting diagonals which travel both along the horizontal planes and upwards, and thus explore the relief in all directions. Looking back on the simple design of the Siena *Baptism*, this overall conquest of space stands out as a decisive new step in the further development of Ghiberti's pictorial relief.

While the basic problem in the two side panels is that of conquering space by striking out in various diagonals, the main relief of the Shrine of Saint Zenobius aims at building up a large scale composition within an autonomous and fully intelligible space. The narrative in the small reliefs is treated as an anecdote. In the large panel the narrative—the boy first lying dead and then resurrected between his kneeling parents—is made the center of the monumental design (Pls. 78a; 79a, b; 80b). Large crowds gather on either side, their presence supporting the main event and lending it weight like the chorus of a Greek tragedy. A piazza appears in the background and farther back, to the left and right, extend the hills, a city and a grove. The setting fills the entire height of the panel, and no longer is the eye forced to follow a zigzag pattern into a depth that is difficult to comprehend. Here space is constructed by intelligible means and made for figures to move and act in. The break between front stage and backdrop has disappeared. The rocky front plane slopes up slowly and gradually from the base line to a point nearly two-thirds up the height of the panel. The eye

travels smoothly over the long rows of the assisting crowds. The consistent linear perspective of the architecture further underscores the impression of a continuous and pervasive clear space. The relief technique also supports this impression: all the figures, even those in the foreground, adhere to the plaque with almost the whole of their bodies; only the heads are slightly inclined forward, sometimes in the round. Farther back the crowds are flattened out in a closely crowded *rilievo schiacciato*.

Ghiberti's development of pictorial relief, from the Siena *Baptism* on, only becomes fully comprehensible when viewed in the light of the ten large panels of the Gates of Paradise. Indeed, the Zenobius reliefs teem with figures, motifs, and groupings that are best understood as variations on similar features in the larger work. Yet, under no circumstances should this imply that the Shrine of Saint Zenobius is merely a workshop product. Its style, from the side panels to the flying angels on the back, marks successive stages of the development of Ghiberti's pictorial relief during the thirties, and in so doing elucidates the chronology and style of the Gates of Paradise.

THE GATES OF PARADISE

CHAPTER XI

DOCUMENTS AND PROGRESS OF WORK

GHIBERTI's first door with its twenty narrative scenes from the New Testament was set in place in April 1424. The *Arte di Calimala* lost no time in pressing the decoration of its *Bel San Giovanni* further towards completion. Eight months later, on January 2, 1425, the guild drew up another contract which commissioned Ghiberti to execute "the third bronze door of S. Giovanni" (Dig. 110; Doc. 36). Judging from Strozzi's excerpts (the original contract is lost) the conditions established by this document differed in only a few points from those of the contract for the first door, as first signed in 1403 and then amended in 1407. The new contract added to Ghiberti's name the words "excellente maestro." If this epithet was really contained in the original contract from which Strozzi drew his excerpt, as probably it was, it reflects the importance of the man, the satisfaction of the guild and, we may be sure, of the citizenry as well, with Ghiberti's work on the first door. But working conditions and pay remained the same as in 1403; after the work was finished the consuls of the guild would set a fair price.[1] Meantime, Ghiberti would receive on account his standard fee of 200 florins per year. The new contract stipulated in the usual form, though possibly with a renewed burst of hope, that "until the door was completed, he was not to take on any other work, a condition he had little observed while working on the second door." One wonders whether the last part of the clause was actually in the original contract, or added by Strozzi by way of explanation for the restriction. No details are given in the excerpt regarding the extent of Ghiberti's responsibility for the modeling and chasing of figures, or the amount of time he was supposed to spend on the job, and no deadline is given for completing the reliefs or the door as a whole. Altogether one suspects Strozzi of having omitted a few of the document's pertinent parts.

The *Deliberazioni de' Consoli*, which are preserved for the first four months of 1425, fail to record any reference to the contract. But this is not astonishing in so far as the consuls must have come to a decision and would have taken action some weeks or days before the contract was signed in January 1425. Indeed, there had evidently been a lot of preliminary discussion about the door, and not entirely of a placid nature. In a letter dated June 21, 1424, addressed to Niccolo Niccoli, Ambrogio Traversari, later general of the Camaldolese order and prior of S. Maria degli Angeli, mentions in a passage that deserves to be quoted in full, that Leonardo Bruni was composing a program for the door: "I understand and approve your feelings concerning the narrative scenes (*storie*) which are to be sculptured for that third door," he writes to the grand old man of humanism, "but I fear those in charge of this work are somewhat rash. I hear they have consulted Leonardo [Bruni] of Arezzo and I

[1] The *etc.* which follows the end of the sentence in Strozzi's excerpt (Doc. 36) may stand for *Officiali del Musaico*.

	Eve, Pl. 122a			Adam, Pl. 123a	
Ezekiel (?), Pl. 124a	**Genesis, Pl. 82** Adam, Pl. 83a Eve, Pl. 83b Expulsion, Pl. 84 Lord with Angelic Host, Pl. 105a	*Jeremiah (?), Pl. 124b*	*Unidentified prophetess, Pl. 125a*	**Cain and Abel, Pl. 85** Slaying of Abel, Pl. 86a Cursing of Cain, Pl. 86b Cain Plowing, Pl. 87 First Parents, Pl. 88a	*Joab (?), Pl. 125b*
Elias (?), Pl. 126a	**Noah, Pl. 89** Animals Leaving the Ark, Pl. 88b Noah's Drunkenness, Pl. 90 Noah's Sacrifice, Pl. 92 Noah's Sons, Pl. 91b Noah Leaving the Ark, Pl. 104a	*Jonah, Pl. 126b*	*Hannah (?), Pl. 127a*	**Abraham, Pl. 93** Servants Waiting, Pl. 91a Trees, Pl. 106a	*Samson, Pl. 127b*
Unidentified prophet, Pl. 128a	**Isaac, Pl. 94** Rebecca Praying, Pl. 95 Esau and His Dogs, Pl. 96a Visiting Women, Pl. 97a Blessing of Jacob, Rebecca, Pl. 97b	*Rachel (?), Pl. 128b*	*Unidentified prophet, Pl. 128c*	**Joseph, Pl. 98** Distribution of Grain, Pl. 99 Architectural Detail, Pl. 100 Joseph Revealing Himself, Pl. 101a Two Girls, Pl. 101b Corn Hall, Pl. 120a	*Unidentified prophet, Pl. 128d*
Miriam, Pl. 129a	**Moses, Pl. 102** Daughters of Israel, Pl. 103 People at Mt. Sinai, Pl. 104b Moses Receiving the Law, Pl. 105b Trees, Pl. 106b	*Aaron, Pl. 129b*	*Joshua, Pl. 129c*	**Joshua, Pl. 107** Carrying of the Stones, Pls. 108a, b Joshua on Chariot, Pl. 109 Group, Pl. 110 Walls of Jericho, Pl. 111a	*Gideon (?), Pl. 129d*
Judith, Pl. 130a	**David, Pl. 112** Right Side of Panel, Pl. 113 Detail, Pl. 114a Entry into Jerusalem, Pl. 114b Palm Tree, Pl. 115 Jerusalem, Pl. 111b	*Nathan (?), Pl. 130b*	*Daniel (?), Pl. 130c*	**Solomon, Pl. 116** Falconer with Dog, Pl. 96b Solomon and Queen of Sheba, Pl. 117 Group upper right, Pl. 118 Group lower right, Pl. 119 Architectural Detail, Pl. 120b	*Bileam (?), Pl. 130d*
	Noah, Pl. 122b			Puarphara, Pl. 123b	

DIAGRAM 2. Schema of the Gates of Paradise (Pl. 81)

conjecture the rest from this glorious beginning."[2] That the choice of program entailed a good deal of argument is also conveyed in a reference made by the eighteenth century antiquarian, Francesco Antonio Gori, in a footnote accompanying Mehus' edition of the Traversari letter just quoted. Gori maintains that he learned "from the old diaries" of the *Calimala* that the guild had "entrusted the task of inventing and describing these narrative scenes to some famous scholars of the time, but as they did not satisfy the wishes of the guild, the latter commissioned Leonardo of Arezzo."[3] If one accepts Gori's statement that Bruni was called upon after other programs had been proposed and rejected, one would interpret Traversari's letter to mean that Niccolo Niccoli was probably among these scholars first consulted. Obviously both Traversari and Niccoli had definite ideas regarding the choice of subjects and these ideas were not necessarily the same as Bruni's. In fact, relations between Bruni on one hand and Traversari and Niccoli on the other reached a point of low amiability in the spring of 1424. Invectives were customary on both sides and tension continued until late in 1426.[4] Hence Traversari's phrase, the "glorious beginning," is best interpreted as an ironical barb.

Bruni's program is preserved (Dig. 106; Doc. 52). It is contained in a letter addressed to the "Spettabili huomini Niccolo da Uzzano e Compagni deputati etc." [*sic*], evidently a committee of the *Calimala* that was in charge of selecting a program for the new door. The letter was obviously composed in answer to an inquiry from the committee whose chairman was Niccolo da Uzzano, the old leader of the *Calimala*. Later Bruni's letter was incorporated into the *Libro della seconda e terza porta*, evidently at the very end of the convolute. Thus it was copied by Strozzi and included in his excerpts.

The letter proposes that the new door be composed of twenty-eight panels. For the moment, however, the letter is chiefly interesting as testimony of the early discussions on the door. For while it bears no date and has been frequently attributed to the year 1425,[5] it cannot possibly have been written that late. Traversari's letter of June 1424, only states that Bruni had been approached by the committee of the *Calimala*, and

[2] Traversari, bibl. 526, I, col. 371ff (Lib. VIII, ep. 9): "Quid de historiis tertiae illi portae insculpendis senties video proboque; sed vereor ne nimium praecipites sint hi quibus ea opera injuncta est. Audio illos Leonardum Arretinum consuluisse praeclaroque ex hoc initio cetera coniecto." Regarding the date of the letter, see Luiso, bibl. 281, fasc. 2, p. 4.

[3] Traversari (bibl. 526, I, col. 373 note): "Suspicor heic . . . de ea porta intellegere qua ornatur . . . Baptisterium S. Joannis. . . . Hanc jusserunt consules Artis Mercatorum Calimalae . . . Lorenzo Ghiberto: sed eas historias inveniendi describendique munus iniunxerunt aliquot viris doctis eaque tempestate celeberrimis qui quum voluntati eorum non fecissent satis id munus commiserunt Leonardo Arretino; quod mihi constat ex priscis manu conscriptis Diariis eiusdem Artis; quae omnia in Adversariis meae Historiae Florentini Baptisterii S. Joannis adnotavi. Gorius."

Gori's "Historia Florentinae Basilicae et Baptisterii S. Joannis" was never written (see also Lumachi, bibl. 282, p. ix f); but a great number of his notes (*adversaria*), including two drafts for a first chapter, have survived (*BMF, A 199* I). Neither among these collectanea, however, nor elsewhere among Gori's literary remains has any reference turned up to the program of the Gates of Paradise. Regarding the manuscript in the Marucelliana, see also Appendix C1.

[4] Poggio, bibl. 418, I, pp. 40ff; 108ff; 191ff; 197ff (Lib. I, ep. 9; Lib. II, ep. 11; Lib. III, ep. 4, 5, 7).

[5] Frey, bibl. 532, pp. 357f, doc. 3; Brockhaus, bibl. 69, p. 37; Baron, bibl. 38, p. 124, questioningly dates the letter in June 1424.

therefore provides merely a terminus *ante*. But Bruni's letter to Niccolo da Uzzano is in itself proof that it must have been written before 1425. In 1425 Niccolo da Uzzano could not have presided over a committee of the *Calimala*, since in that year and the following he was among the *Decem Balie*, a high city office, and was thus on constitutional grounds excluded from office in the guild. Finally, Bruni mentions that he "would like to be near whomever will have the door to design," indicating quite clearly that the commission had not yet been given to Ghiberti. Bruni's letter thus dates before January 1425, possibly in the summer or fall of the previous year, and his election to honorary membership in the *Calimala* on March 24, 1425,[6] was probably a tribute for services already rendered.

Regarding the progress of work on the door, from the signing of the contract until its completion in 1452, the documents give a somewhat incoherent picture. Strozzi's notes, extracted from various books of the *Calimala*, are far richer, it is true, at least for some periods, than were his excerpts concerning Ghiberti's first door.[7] Also these late extracts are supplemented by a few original documents. Nevertheless, large and significant gaps remain in the documentation.

What there is makes it clear that work on the door proceeded in three main phases: the first terminated in 1436 or better 1437, the second lasted until 1447, the third phase occupied the years between 1447 and 1452.

The state of affairs in Ghiberti's workshop was such, when he signed the contract of January 1425, that he could not have begun immediately to work on the new panels. He had his hands full with other work, and new orders were pouring in. The contract, like many other contemporary agreements, did stipulate, *expressis verbis*, that Ghiberti was not to take on any other commissions while working on the door; but this stipulation need not at that time have had more than formal significance. Certainly with a man of Ghiberti's calibre, an "excellent master," the *Calimala* was not going to press the point. In 1425 the shop was crowded with unfinished work: the bronze jambs and architrave of the first door had just been started, the nettoyage of the two plaques for the Siena Font took two years, until 1427, the Dati Tomb and shrine for S. Maria degli Angeli were in progress, and, finally, the figure of Saint Stephen for Or San Michele occupied Ghiberti from 1425 through the entire year of 1428. Not until after 1427 and possibly through part of 1428, had Ghiberti time to start in earnest on the complicated work of designing, modeling or casting any part of the Gates of Paradise. True, in his tax declaration of 1427 (Dig. 138; Doc. 81) he added to his name the words, *lavora le porte di sangiovanni*, but this need not mean more than that he was under contract for the work, not necessarily actively busy at it. It is of some relevance, in fact, that in this same tax declaration Ghiberti does not mention among his credits any compensation due him from the *Calimala*.

Indeed, the financial situation of the *Arte di Calimala* was anything but splendid

[6] *ASF, Arti, Calimala*, vol. 18, c. 7f; quoted by Brockhaus, bibl. 69, pp. 35f.

[7] The unspecified entries in Strozzi's index of the *Libri Grandi* (Doc. 80) with reference to the Gates of Paradise are far more scattered and confused than those for the North Door. They are thus of little value in reconstructing the progress of work on the East Door.

in the years around 1425. It is perhaps characteristic of the disregard of political events by the great guilds, that the contract for the Gates of Paradise was signed five months after the catastrophic defeat of the Florentine armies at Zagonara. But immediately afterwards, the political difficulties had their impact also on the guild. The republic of Florence between 1424 and 1428 spent over three and one half million florins on her war budget.[8] The *Catasto* instituted in 1427 refilled the government's till. But no doubt, it reduced both the ability and the willingness of the wealthy to contribute towards the guild's expenses. The peace concluded in April 1428 seemed to forecast better times and, perhaps as a result, the *Opera di San Giovanni* may have decided to go ahead with the embellishment of the Baptistery. But in the late summer of 1428, they ran short of funds "because of expenses beyond what they had budgeted." They applied for permission to increase their income, but were refused (Dig. 150; Doc. 93). The hypothesis that these expenses were caused by work on the door, though not necessarily on its reliefs, seems borne out by two items in the tax declaration of the *Calimala* for 1429 (Dig. 157; Doc. 87f). The guild listed among deductible obligations first a payment of 200 florins annually to "the master of the third door of San Giovanni," and secondly unspecified expenses "impossible to estimate [for] the third door which has been begun"—and here the notary originally added, then canceled "to be cast." By 1429 then, and in all likelihood by the fall of 1428, work on the door had been started. The *Calimala* had incurred heavy expenses, and Ghiberti was drawing his salary. The financial difficulties of the guild apparently continued for some years. At least this is intimated in Ghiberti's tax declarations of January 1431, and May 1433, by statements to the effect that he had "advanced to the *Arte di Calimala*" the considerable sums of 280 florins and 100 florins (Digs. 162, 179; Docs. 82, 83). Possibly he had let part of his annual advance of 200 florins remain on credit in order to help the guild out of an embarrassing situation.

The documents of 1428 and 1429 offer no evidence regarding the specific kind of work that was under way on the Gates of Paradise. They suggest, however, a certain amount of hesitancy and, in fact, indecision can be detected between the lines of the document of 1429. Why otherwise would the notary in the *portata* have corrected the original statement that the door was "being cast" (Doc. 87)? In itself the insertion of these two words, *a gittare* could be explained as simply a *lapsus calami*. But one begins to wonder whether perchance some parts of the door had not actually been cast, with the notary merely doubtful as to what parts they were. Indeed, indecision is suggested by the structural evidence of the door itself.

Apparently the door was neither cast nor designed in a single operation. The back plaque of the two wings and the front frame enclosing five panels on each wing, cannot, under any circumstances, be contemporaneous.[9] For the back plaques, instead

[8] Procacci, bibl. 428, pp. 12ff, with abundant references to contemporary sources.

[9] Brockhaus (bibl. 69, pp. 6ff) was the first to point out the discrepancy between front panels and back plaques and to suggest that the latter may reflect an earlier project, later abandoned. He envisaged this project as containing the prophets' figures now on the frame and such individual scenes as the Creation of Adam, Creation of Eve, Cain slaying Abel, and Abraham and the Angels, as filling the rectangular plaques still evident on the back frame. Paatz (bibl. 375, II, p. 247, note

of containing ten panels, each measuring .73 m square, as in the front, contain twenty-four panels, each measuring .50 m square, not counting the frame (Pl. 68b). The back of the door then, follows a pattern, which later was abandoned and is therefore an earlier design than the layout of the front. Mr. Bearzi has observed that, indeed, the front skeleton, which forms the core of the door and frames the ten reliefs, was soldered at a later stage onto the back plaque with its twenty-four panels. This observation is borne out by the documents. The ten panels of the final scheme had all been cast by 1436 or 1437 (Dig. 198; Doc. 23). But the armature of the skeleton of the front frame, the *telaio*, was built only in 1439 (Dig. 209), its casting not effected until 1445 (Digs. 254f). The idea of substituting ten panels for the twenty-four in the pattern of the back wings must have occurred almost immediately after these back wings had been cast in 1428 or 1429. More than fifteen years elapsed before the skeleton of the front frame was soldered onto them.

The visual evidence coincides with the documents: the present pattern of ten reliefs on the Gates of Paradise evolved gradually. There can be no doubt that the reliefs were cast only several years after 1425. Bruni's program of 1424-1425 had envisioned twenty-eight panels; the pattern of the back plaques, which were cast by 1429 and possibly a year earlier, was reduced to twenty-four; finally the present design of ten large panels was evolved. The first, Bruni's that is, and second projects need not have been conceived at very distant intervals. In no case, however, can the panels of the last design have been started prior to 1429.

Considering these circumstances, it is rather strange to find that within relatively few years after 1429, all ten panels had been cast. Still, there is no doubt about it. A document, excerpted by Strozzi from the *Libro del Proveditore* (Dig. 198; Doc. 23), bearing the date of April 4, 1436, states in no uncertain terms that the "ten stories and twenty-four pieces of frieze have been cast and their nettoyage should be begun by Ghiberti, one of his sons, and Michelozzo." Obviously this is an excerpt of prime importance; in conjunction with the *Calimala's* tax declaration of 1429, it suggests that within the space of not more than about seven years the ten large panels of the door had been designed in wax and cast in bronze. The period may have been a year longer, for it is possible that the *proveditore* in dating the entry had mistakenly written 1436 instead of 1437, since by April 4, according to the Florentine calendar, the new year was barely ten days old. A mistake of this sort would be understandable and the assumption that the notary made such an error is supported by other evidence: the page number of the entry in the original notebook of the *proveditore* (c. 87), as given by Strozzi, seems suspiciously high for a book which only began its notations in March 1435, and, conversely, seems too low for an interval of only sixteen pages

129) has contradicted Brockhaus' thesis of an earlier project being reflected in the twenty-four panels of the back plaques. To support his rebuttal, he maintains that the pattern of the back plaques has "no structural connection with the reliefs on the front (of the door) from which it is separated by the cast-on thick bronze slab, the structural element, properly speaking." This, as Cavaliere Bearzi's observations show, is only half correct (the "thick slab" being really a skeleton) and moreover it would seem to prove just the point that indeed the back plaques belong to an earlier project.

between it and two items dated in July 1439. Also the *Libro della seconda e terza porta* repeats almost literally the phrase about entrusting the nettoyage to Ghiberti, Vittorio, and Michelozzo, but dates it under the year 1437 (Dig. 200; Doc. 37). Even assuming, however, that the casting was completed only in April 1437, the reliefs would still have been designed, modeled and cast in the course of eight years. This is an incredibly short span of time, especially if one recalls that the document of 1436 or 1437 records that twenty-four pieces of frieze were also cast by that time, obviously part of the front frame. One is led to wonder whether Ghiberti himself could have designed all the plaques. The overall design of the panels obviously could be no other than Ghiberti's own invention. But certainly he did not model with his own hands all the many hundreds of figures, and assistants very likely contributed to the varied backgrounds of buildings, tents, trees, and mountains. However, no assistant's name transmitted by the documents for the period prior to 1436 or 1437 can be definitely linked to the reliefs. Ghiberti's sons, Tomaso and Vittorio, born in 1417 and 1418 respectively, although certainly in his workshop, were still too young to be of much use. Giuliano di Ser Andrea, once the foreman of the shop, disappears from the documents in 1433. Papero di Meo, a carpenter, could have been employed only in menial work, Simone di Nanni, a stonemason, possibly in the chasing (Docs. 83, 90, 99). Michelozzo had not yet found his way back into Ghiberti's service.

It is apparent that Ghiberti not only hurried the work of designing, modeling, and casting the panels of the Gates of Paradise, but also followed a procedure much in contrast to that apparently used for his first door. He seems to have cast all the panels at once. True, the document of April 4, 1436 or 1437, merely states that by that year all the reliefs had been cast and thus leaves it open as to whether the casting was done in small batches or all at once. However, the second alternative seems more likely, considering how condensed the time was for work on the reliefs prior to the casting. Furthermore, casting all the reliefs in the course of a few days would have simplified the procedure and thus have increased the efficiency of the workshop.

Also in contrast to Ghiberti's previous methods whereby the casting and finishing were spread out over almost twenty years, the nettoyage of the reliefs of the Gates of Paradise and the casting of the front frame with its skeleton were relegated to two different successive stages. Both of these major undertakings fell into the ten years between April 1437 and August 1447 (Dig. 259). Immediately after the panels had been cast, Ghiberti was commissioned to do the chasing and to hire for this task one of his sons, probably Vittorio, his former partner Michelozzo, who was taken back into the shop apparently in good grace, and three other assistants. In July 1439, the nettoyage was well advanced. A report on the progress of the work under that date states that by June of that year (*allora*) two plaques, *Cain and Abel* and *Isaac* were completed; the *Moses* was almost completed, the *Joseph* half finished; of the *Solomon* it reports that "the architecture and a piece at the bottom were finished and the figures on the right side were a quarter completed; of the two pieces of the frieze, only the foliage had been cleaned" (Dig. 208; Doc. 24).[10] The document also states that Ghiberti and his

[10] Paatz (bibl. 375, II, p. 247, note 129), following Patch (bibl. 392) and Brockhaus (bibl. 69,

staff were due their salaries for the chasing of these panels from January 1438 on. Thus possibly the nettoyage was not started in April 1437, but delayed some eight months. In any event during the eighteen months that preceded July 1439, the workshop was busy as a beehive with the chasing. The permission granted by the *Calimala* in 1437 to hire five assistants for the chasing makes it clear incidentally that the guild was responsible for the wages of these helpers. Apparently the arrangement proved unsatisfactory, for in the years that followed work slowed down, and when, in 1443, Ghiberti's contract was renewed (Dig. 241; Doc. 40), he had to accept a lump sum for finishing the work and out of it had to pay for both materials and his *garzoni*.

Beginning in July 1439, the pace seems to have slackened; the task of finally completing the Shrine of Saint Zenobius was long overdue. Hence the chasing of the reliefs for the door seems to have been continued with a considerably reduced staff which, however, included Michelozzo who in 1442 still "works on the doors" (Dig. 235); the other assistants are unknown except for one, the stonemason Matteo di Francesco, from Settignano (Dig. 240). Apparently by June 1443 this skeleton staff had completed the nettoyage of those reliefs which in 1439 had been half finished and had added one more, to make a total of six (Dig. 241; Doc. 40). For the completion of the remaining four panels a new agreement was drawn up, a deadline of eighteen months was set, and neither Ghiberti nor his sons were to take on outside work. The deadline, needless to say, was not kept, but by the summer of 1447, all the plaques were completed and paid for (Dig. 259; Docs. 20, 42).

Heavy work on the door was undertaken in the years when the delicate work of chasing had slowed down. The armature for the frame, or part of it, was built in 1439 (Dig. 209; Docs. 25, 59). The purchase of a large amount of bronze, presumably for the frame, was discussed in 1440 (Dig. 219; Doc. 38). In 1445 the frame was cast (Dig. 255; Doc. 41). But only in January 1448 was Ghiberti paid for the "last frame of the door" (Dig. 263; Doc. 44).

With a major part of the door completed, a third phase started. In January 1448, Ghiberti and his son Vittorio contracted to finish the door, proving that the legal responsibility from then on was shared by the father and the younger son (Tomaso apparently died in 1447 [last ref. Dig. 260]). The remainder of the work consisted of the nettoyage of the twenty-four pieces of frieze[11] that had been cast in 1437, of the modeling and casting of twenty-four heads in their *clipei*, the bronze architrave and its cornice, the threshold and one of the jambs; it further comprised the nettoyage

pp. 39f), somewhat hesitantly dated the document 1437. But Strozzi's excerpts leave no doubt regarding the correct date, 1439, as also given by Frey (bibl. 532, pp. 359f, doc. 7).

Planiscig (bibl. 404, p. 55) has suggested that the document of 1436 or 1437 referred to the small plaques of an earlier program, presumably that of Bruni, and that only between 1436 and 1439 were the present large reliefs modeled in wax. He bases this suggestion on the use of the terms "finite," "quasi finite," "a metà finite" in the document of July 1439. But aside from the improbability of a recast at that stage of work, the philological evidence of the document leaves no doubt: *finire* in fifteenth century parlance always means to chase and it must be so interpreted in Doc. 24.

[11] Strozzi's excerpt from the *Quaderno del Proveditore, M, 1445-1449* is to the effect that the friezes *si rigettano* and this has created the impression that a recast of these parts occurred in 1445. But the passage is corrupt: Gori's copy, *BMF, A 199, I*, corrects the word to *rigettino*. The correct reading is probably *rinettino*, as witness the document of January 24, 1448 (Docs. 22, 44).

of the other jamb, presumably cast during the fall of 1447, the modeling, casting and chasing of twelve pieces of ornament to be inserted into the jambs and architrave, and finally the chiseling of the shallow frieze along the inside of the jambs. The deadline for all this was set for 1450, and throughout 1448 and 1449 minor payments were made to assistants (Digs. 264ff; Docs. 90f, 95ff, 102) most of whom were stonemasons like Simone di Nanni da Fiesole, serving in Ghiberti's shop since 1427, and Matteo di Francesco da Settignano who had been there since 1442 (Dig. 267). Financial difficulties during 1448 (Dig. 269; Doc. 100) might explain why progress was slow. Hence early in 1451 the deadline was once more prolonged and the firm, Ghiberti and Son, was told to hire a larger staff (Dig. 275; Docs. 11, 44). Not until March 1452, was the door entirely completed and the gilding begun; it was finished in June of that year (Digs. 280, 282; Doc. 47, 13).[12] In July the consuls decided to set up the new gates not at the north portal for which they had been designed, but instead, "because of their beauty," at the east entrance, opposite the Cathedral. Evidently during the summer months this decision was put into effect: Ghiberti's first door gave way to the new miracle and migrated to the north portal, facing "towards the column [of S. Zenobio] and the houses of the *Opera*" (Dig. 283; Docs. 73, 48).

Clearly the net result of this documentation leaves a great many gaps. Yet the predominant facts stand out. Beyond any doubt the ten panels of the Gates, as we know them now, had been modeled and were cast by April 4, 1437 and five of them had been wholly or partly chased two years later, by July 1439. The documents buttress each other. For one, the statement regarding the casting of the panels in 1437 is supported by another one of the same year which concerns the employment of Michelozzo, Vittorio Ghiberti and others for the chasing. The suggestion which has been made that the ten panels cast in 1437 were part of an earlier program, later discarded, is untenable. Not only is it unlikely that an earlier set should have been cast in 1437 and afterwards discarded; not only is it unlikely that of this earlier set precisely ten

[12] Schlosser (bibl. 477, pp. 52f) misinterpreted the documentary evidence and thus arrived at a strangely distorted sequence of events. He started off with a document of 1437 stating that "four of the *upper* reliefs are completed"; but no such document exists. He then quoted the document of July 4, 1439, and the purchase of bronze in 1440. But he interpreted these documents as referring to "models and trial pieces" and maintained that as late as June 24, 1443, "four of the ten reliefs were still due, although in the same year Francesco di Papi was commissioned to set in place the skeleton for the frame (*telaio*)." Only in 1447, according to Schlosser, were the other reliefs completed. Schlosser's mistake lies in his confusion of the casting and finishing processes and in underestimation of the length of time required for finishing.

A similar misinterpretation of the documentary evidence underlies the sequence as suggested by Schottmüller, in Thieme-Becker, bibl. 517, p. 542. According to her thesis, three reliefs were completed in 1437, to be followed by an interruption of work, 1438-1442. In 1443 four reliefs would still have been missing, to be cast between 1443 and 1447. At the same time the new *telaio* would have been recast, since the first one had been laid out to hold twenty-four small reliefs.

Mr. Pope-Hennessy, whose new book *Italian Gothic Sculpture*, London, 1955, reached me after this manuscript had gone to press, seems to incline towards a position similar to that taken by Schlosser, Schottmüller and Planiscig when suggesting the possibility that "all of the present reliefs date from after 1437" (p. 43). I regret having to disagree with a scholar of Mr. Pope-Hennessy's standing, but both the documentary and the philological evidence seems to me incontrovertible.

panels should have been cast corresponding by chance exactly to the number of panels in the present program; the document of 1439 makes it abundantly clear that the five panels which by then had been chased wholly or in part are decidedly those now on the door. The term *finite* for chasing is clear and even the architectural setting of the *Solomon* panel is specifically mentioned in the document. In short, the present panels were cast in 1437. Since work on them could not have been begun prior to 1429 or 1430, the span of time during which the ten large panels were designed, modeled and cast was incredibly short. On the other hand, the total amount of time allowed for the nettoyage of the plaques and ornamental parts is comparatively large, over ten years for the former, four and a half for the latter—indeed, the contract of January 24, 1448 specifies expressly that it would take "a good master three and one half months" to chase one of the twenty-four compartments of the frame with their foliage orna-ment. At the same time the documents give further hints regarding the irregular course of the chasing and, at least in part, the sequence in which the reliefs were chased. However, much remains in the dark. The twenty-four figures in the niches of the frame are not listed among either the parts that had been cast by April 1437, or in the brief inventory of parts that were finished or half finished by June 1439, nor even in the long and explicit catalogue of details which by January 1448, had still to be completed; hence these figures must have been cast somewhere along the way. Far more relevant, there remains the question of the sequence in which the ten panels, from the *Genesis* to *Solomon* were designed and modeled. The answer must be based entirely upon internal evidence; yet to find an answer is an essential premise for ap-proaching such problems as the characteristics and development of Ghiberti's mature style, his approach to the art of antiquity, his concepts of space, perspective and archi-tecture, his development of pictorial relief, and finally, his presentation of narrative.

CHAPTER XII

THE PROGRAM

Iɴ the late spring of 1424, some months before Lorenzo Ghiberti received the commission, the *Calimala* asked Bruni and possibly other scholars to submit a program for the third door. Bruni's report on his project is preserved, one remembers, in a copy among Strozzi's excerpts. It is addressed to Niccolo da Uzzano, as chairman of one of the *Calimala* committees. Bruni begins by saying in his opening paragraph that in his opinion "the twenty scenes for the new door which, as you have deliberated, shall be from the Old Testament, should have two principal features: for one they should be resplendent; secondly they should be significant [in content]." With this end in view, he goes on to say, he has selected twenty events and eight prophets to be represented. "Whoever will have them to design" must be well informed as to their meaning, "so that he can arrange both the persons and events that occur. [Also] he should have the gift of gracefulness (*habbia del gentile*), so that he will know how to adorn them well." Bruni concludes by saying that if his program were carried out, he had no doubt but that the door would be beautiful. But he wants to be near the prospective artist, "he who will have them to design," so as to be able to advise him on the meaning of every detail in each scene (Doc. 52).[1]

Bruni's program (Diagram 3) is far from exciting. It is plainly patterned after the New Testament door just completed by Ghiberti after twenty years' work; beyond this, it relies on Andrea Pisano's door of the life of Saint John. Obviously Bruni thought in terms of an exact counterpart to the already tried scheme, even to the point, one assumes, of planning to insert the scenes and prophets into quatrefoil frames. His conception follows throughout the medieval Italian tradition for Old Testament cycles. The sequence runs from upper left to lower right, according to medieval custom. The narrative is not continuous, but stresses certain parts of the Biblical story while to other parts it assigns only a few scenes and not the most important ones at that. But this also coincides with the medieval tradition. The complete Old Testament cycle known to the Roman Christian tradition, such as that in S. Paolo f.l.m. in Rome, which represents the entire history of events from the creation of the world to the life of Moses, was by necessity very rare. As a rule, it was abbreviated, the narrative dwelling at length on a few select episodes. The choice varies. The Creation was always treated at length in a series of scenes ending with the Curse of Cain. This was followed either by an equally elaborate presentation of the stories of the patriarchs from Lamech to Jacob, or else by excerpts from these stories, in which case the later Biblical narrative was again treated extensively, the tales of Joseph and Moses spun out lengthily.[2] The latter scheme underlies Bruni's proposed plan for the third door. He stresses the Creation and the stories of Joseph and Moses and,

[1] While reading proof I received through the kindness of Mr. Ernst Gombrich his paper "Apollonio di Giovanni," *Journal of the Warburg and Courtauld Institutes*, xviii (1955), pp. 16ff, which centers in the second part on the Bruni passage.

[2] Loessel, bibl. 276 *passim*, especially chart, appendix xi.

How the Lord creates the heaven and the stars	The Lord makes man and woman	Adam and Eve flanking the tree, eat the apple	How they are driven from Paradise by the angel
Cain kills his brother Abel	Every kind of animal enters into Noah's Ark	Abraham is willing to sacrifice Isaac, according to the commandment of the Lord	Isaac gives his blessing to Jacob believing him to be Esau
The brethren of Joseph sell him out of envy	The dream of Pharaoh of the seven kine and seven ears of corn	Joseph recognizes his brethren who have come to Egypt for grain	Moses sees the Lord in the burning thorns
Moses speaks to the Pharaoh and performs miraculous signs	The Sea divided and the people of the Lord passing through	The laws given by the Lord to Moses on the burning mountain, the trumpet sounding	Aaron makes sacrifice on the altar, (dressed) in priestly habit with bells and pomegranates around his robes
The people of the Lord pass the river Jordan and enter the land of promise with the ark of the covenant	David kills Goliath in the presence of King Saul	David made king amid the cheers of the people	Solomon passes judgment on two women over the question of the child
Prophet Samuel	Prophet Nathan	Prophet Elias	Prophet Elisha
Prophet Isaiah	Jeremiah	Ezekiel	Daniel

DIAGRAM 3. Bruni, Program for the Gates of Paradise

like so many medieval cycles, plays down those of Noah, Abraham, Isaac and Jacob. Medieval also is the emphasis put on the miracle episodes in the Joseph and Moses narratives. In fact, Bruni's program is so steeped in medieval tradition, in its sequence, selection of events and emphasis, that one is led to wonder whether by chance he based it on an old program outlined for Ghiberti's first door in 1401 and then discarded.

Bruni's program was neither the only one nor the first to be submitted to the *Calimala*.[3] Whether Niccolo Niccoli had taken a hand in previous proposals remains conjectural. But opposition to Bruni's program was voiced immediately by Ambrogio Traversari, presumably in agreement with Niccolo Niccoli. Thus one wonders whether either of them was also connected with the rejection of Bruni's scheme and with the choice, finally, of the present one of ten large panels. Ghiberti would seem to have us believe from his autobiography that he himself took the initiative in evolving a new plan: "I was given a free hand," so he says, "to execute [the door] in whatever way I thought it would turn out most perfect and most ornate and richest."[4] Certainly the use of large panels appears to coincide with the taste of the master who in the Siena Font in 1417 had already turned from quatrefoils to square panels only a little smaller than the plaques of the Gates of Paradise. But if Ghiberti really drafted the final program, it is difficult to explain why, in describing the door in the *Commentarii*, he should be so indifferent to the narrative as to omit mention of some subjects, to introduce others by the wrong names and even to enumerate events that are simply not represented. More likely the *Calimala* followed the established custom of calling upon another scholar to submit a learned program different from Bruni's. Ghiberti would certainly have had the chance to agree with, even plead for, an arrangement in which he could develop the series of Biblical scenes in ten large, rather than twenty-eight or twenty small panels (Pl. 81; Diagrams 2 and 3).

Be that as it may, these ten large panels offer a far more comprehensive and coherent program than did Bruni's plan. Each of the ten chapters, so to speak, contains several events, so that the net number of scenes has risen from twenty to thirty-seven. Throughout they gain in clarity by including secondary parts of the Biblical story that lead up to the main event. The miracle scenes, so important to Bruni's arrangement of the Joseph and Moses narratives, have been dropped. Finally, the coronation of David has been supplanted by his entry into Jerusalem, taking place in the background of the scene of his victory over Goliath;[5] another substitution is the meeting of Solomon and the Queen of Sheba for the judgment of Solomon—a highly significant change indeed.

None of these innovations means a complete severance with the medieval method of narrating the Old Testament, nor, for that matter, with the medieval cycles. In fact, one subject in the new program, the Storing of Grain by Joseph, is prominently displayed among the Old Testament mosaics in the dome of the Baptistery. Nor were

[3] See above, p. 161, note 3. [4] Ghiberti-Schlosser, bibl. 178, I, p. 48.
[5] Paatz (bibl. 375, II, p. 194) misinterprets Ghiberti's description (Ghiberti-Schlosser, bibl. 178, I, p. 50) as referring to a victory of Saul over "those of Idio."

all traces of Bruni's program eradicated. The Giving of the Law is presented just as he proposed it, with the sound of trumpets (*buccina suonante*), corresponding to the description in Exodus 20:18. Also in accordance with Bruni's program are the prophets who support the Biblical narrative.

But in place of the eight prophets whom Bruni envisioned on the bottom rows, the number, like that of the narrative scenes, has multiplied to include twenty-four figurines distributed in niches over the frame in alternation with twenty-four heads. The majority of the statuettes are obviously prophets. But four reclining figures, a man and woman along the top and bottom frame respectively, are in all likelihood the first and second parents of mankind, and they, again, are medieval in character.[6] Eve, on the left side of the top frame, is easiest to identify (Pl. 122a). She is lying down, resting on one elbow; in her pose, the furry skin of goat or lamb over her shoulders, the leafy fig branch in her hand, and her thin garment, she repeats a type common to Siena since the days of the Lorenzetti. With the same attributes, and occasionally identified by an inscription, she had appeared in frescoes and panels lying at the feet of the Virgin (Fig. 86). From Siena the type seems to have spread to Umbria in the second half of the Trecento and to Florence in the first years of the fifteenth century in at least one example.[7] Ghiberti's representation on the upper frame is, therefore, a traditional, though not frequent, Eve type. In fact, a cast of just this figure is applied several times on the socles of the stucco Madonnas from Ghiberti's workshop, clearly used as a typological counterpart to the Virgin. Adam (Pl. 123a), opposite Eve on the top frame, is characterized by the hoe in his hand, and Noah (Pl. 122b), on the left side of the bottom frame, by the exposure of his genitals. The woman opposite Noah can only be his wife, Puarphara (Pl. 123b).[8]

Like these four reclining figures, the twenty statuettes in the niches alongside the panels are spoken of by Ghiberti in the *Commentarii* simply as decorative *figure*. Such vague terminology is but another sign of his fundamental disregard for the thematic

[6] Nicolaus de Lyra, bibl. 362, with reference to Genesis 4:1; 6:9; 8:18.

[7] Rowley, bibl. 453; Meiss, bibl. 317, p. 51, note 148; see also below, p. 223.

Van Marle (bibl. 301, VI, p. 6) has listed a number of fourteenth century examples: Lorenzetti School, fresco, San Galgano, Monte Siepi (see also Rowley, bibl. 453, pp. 107ff); School of Pietro Lorenzetti, fresco, Montefalcone, S. Agostino; Cola di Petrucciuoli, Magione Church, 1371 (Van Marle, bibl. 301, V, fig. 62); Paolo di Giovanni Fei, New York, Collection Robert Lehmann (Van Marle, bibl. 301, II, fig. 340). Further instances as listed in the Index of Christian Art, Princeton University, are found at Parma, Pinacoteca (*Riv. d'arte*, XIV, p. 347); Altenburg (Staatliches Museum, no. 49; attr. to Ambrogio Lorenzetti or Andrea Vanni, Berenson, bibl. 45, V, p. 586); Cleveland, Ohio, Art Museum, attributed to Siena or the Marche (Cleveland, bibl. 103; Van Marle, bibl. 301, V, p. 168); Rome, SS. Domenico e Sisto, Lippo Vanni, 1358 (G. di Nicola, bibl. 361). Millard Meiss has been good enough to provide me with some additional examples, among them a panel in the Louvre (no. 11621, attributed to the school of Ambrogio Lorenzetti; Misciatelli, bibl. 339, pp. 215ff) which in his opinion proves the spreading of the type to Florence.

The sheaf of ears on which Ghiberti's Eve rests, does not appear among the attributes of any of her Trecento ancestors and the skin over her shoulder is clearly that of a lamb. These attributes, then, may allude to the offerings made by her sons Cain and Abel to the Lord and, in fact, on the socle of a Madonna by Filarete (Louvre; Venturi, bibl. 534, VI, fig. 362) Cain and Abel as small boys bring these very offerings to Eve reclining in the same way as she does on Ghiberti's door.

[8] Petrus Comestor, *Historia Scholastica*, cap. XXXIII, add. 1 (*P.L.* CXCVIII, col. 1084; see also Brit. Mus., Egerton 1894, f. 2v, James, bibl. 230, pl. 26) gives the rare name of Noah's wife.

side of his work, for apparently these *figure* were intended to play a definite part in the program of the door. Ever since Vasari's day the male figurines have been referred to as prophets, the female ones as sibyls.[9] The latter assumption, however, is clearly wrong. Since the time of Giovanni Pisano, sibyls had appeared in groups of six, eight and most frequently ten, and of the statuettes on Ghiberti's door, only five are women. Secondly, the sibyls are generally enthroned and accompanied by putti, and are represented in this form during the twenties and thirties of the fifteenth century in both painting and literature within the circle of Florentine humanists at the Roman *curia*.[10] Thirdly, at least two of Ghiberti's female statuettes can be identified by their attributes as Miriam and Judith (Pls. 129a, 130a), prophetic women in the Bible, but not sibyls. Hence, the whole group of twenty probably represents Old Testament heroes, prophets, and prophetesses. Their armor, turbans, scrolls and inspired gestures affirm their Biblical nature. One wants to apply to them Saint Augustine's interpretative statement to the effect that in their lives, as well as in their sayings, should those living before Christ be looked upon as prophets.[11] In the Gates of Paradise, the relation of these figures to the stories they accompany is, on the whole, amazingly simple. At times they merely expand the narrative scene into the area of the frame. Miriam (Pl. 129a), banging her tambourine and singing her song of victory, and Aaron (Pl. 129b), dressed in priestly garb, continue the story on the *Moses* panel between them. Joshua (Pl. 129c), on the left side of the *Joshua* relief, commands the sun to stand still, thus carrying on the story of the conquest of the Promised Land. Others are presented as typological counterparts to the narrative scenes, forming in the limited sense of the *Speculum Humanae Salvationis* a parallel anagogical forecast of a New Testament event.[12] Judith (Pl. 130a), to the left of the *David* panel, carries the head of Holofernes and, like David's victory over Goliath, foretells the salvation of mankind and Christ's victory over death.[13] Jonah (Pl. 126b) grasping a miniature whale to the right of the Sacrifice in the *Noah* alludes to the Lord's reconciliation with mankind and thus again to salvation. Samson (Pl. 127b), accompanying the Sacrifice of Isaac in the *Abraham* on the left, prefigures Christ's death and man's redemption. Other figures appear to have allegorical significance and represent Christian states of grace or disgrace. Still others are prophets whose sayings were traditionally understood, as in the *Biblia Pauperum* to refer to the Old Testament events represented in the panels. Yet, except for the six mentioned, their names remain in doubt. The warrior opposite Joshua, to the right of the *Joshua* panel, gauntlet in hand (Pl. 129d), may be one of the three Hebrew *preux*: if he is one of the judges, it should be Gideon, otherwise he may be Juda Maccabi who in the pavement of the Cathedral of Siena flanks Joshua's victory over the Amonites. The mourning woman (Pl. 127a) to the left of the *Abraham* panel may be Samson's mother, wife of Manoah, or Hannah,

[9] Vasari-Milanesi, bibl. 533, II, pp. 238f. He specifically identifies two prophets, Joshua and Samson.
[10] Freund, bibl. 167.
[11] Saint Augustine, *De catechizandis rusticis*, cap. 19 (*P.L.* XL, cols. 309ff; 338ff).
[12] Lutz-Perdrizet, bibl. 284.
[13] Saint Augustine, *Enarratio in Psalmum 33* (*P.L.* XXXVI, col. 302).

mother of Samuel; both women offered up their late born sons to the Lord as did Sara whose son is shown in the panel alongside. Also, like Sara, Hannah is a prefiguration of religion and grace.[14] The savage warrior (Pl. 125b) standing next to the Slaying in the *Cain and Abel*, leaning on his round shield, scimitar at his side, may be Joab, King David's *bravo*, or else King Saul; either one would make a worthy counterpart to Cain, since both persecuted the just and were, like Cain, *inimici*, prefigurations of the Devil.[15] Also Saul counts as a prophet, being the outstanding illustration of the saying that the "gift of prophecy is also granted the evil ones."[16] The prophet (Pl. 130d) on the right of the *Solomon* panel could be Bileam who forecast the "Rising Star" (Numbers 24:7) and thus in the *Biblia Pauperum* accompanies the scene of the Queen of Sheba.

So far, then, ten prophets can be identified, six beyond doubt and four with great plausibility. That leaves the names of ten in doubt. Eight of them are male, and thus are likely to represent the eight prophets whom Bruni envisaged in his program: Samuel, Nathan, Elias, Elisha, Isaiah, Jeremiah, Ezekiel and Daniel. Out of this number at least two are directly concerned with the stories at hand: Nathan who rebuked King David and Daniel who was a wise judge like Solomon. Hence, the youth to the left of the *Solomon* may well be Daniel (Pl. 130c) and the prophet to the right of the *David*, Nathan (Pl. 130b). The other six, some of whom represent the foremost prophets of the Old Testament, cannot be distinguished with any certainty. Perhaps the prophet raising his arm in wrath to the left of the *Noah* is Elias (Pl. 126a) who walked forty days and nights (III Reg. 19:8), corresponding to the duration of the Flood. But he could also be Isaiah to whom the Lord repeated the promise of redemption given to Noah (Is. 54:9). Possibly it is Ezekiel (Pl. 124a) who flanks one side of the *Genesis*, since he alludes to the gates of Eden (Ez. 44:2), and Jeremiah (Pl. 124b) who stands on the opposite side of the relief because of his references to Creation (Jer. 10:12). The prophetess on the right of the *Isaac* could be Rachel, Jacob's wife (Pl. 128b), who, like Rebecca next to her, is a prototype of Ecclesia.[17] But these identifications are only hypothetical.

Whoever they may be, the prophets in the frame of the Gates of Paradise bear a relatively simple relationship to the stories within the panels. There are none of the complex interweavings of four and eight meanings behind each event, character and saying, that signal scholastic thinking and mark the Biblical commentaries[18] and fresco cycles of the High Middle Ages up through the fourteenth century. The very simplicity of the scheme of the Gates of Paradise suggests a new and different exegetic approach. In opposition to the scholastic approach of the Middle Ages, which ulti-

[14] Saint Ambrose, *De Abraham* (*P.L.* XIV, col. 456); Saint Augustine, *Enarratio in Psalmum 59* (*P.L.* XXXVI, col. 715); Hilarius, *Tractatus in Psalmum 119* (*P.L.* IX, col. 648); Saint Augustine *De Civitate Dei*, XVII, 42 (*P.L.* XLI, col. 528); Isidor of Seville, *Allegoriae* (*P.L.* LXXXIII, col. 112).

[15] Saint Augustine, *Enarratio in Psalmum 103* (*P.L.* XXXVII, col. 1345); *idem, Enarratio in Psalmum 59* (*P.L.* XXXVI, col. 715).

[16] Saint Augustine, *Enarratio in Psalmum 103* (*P.L.* XXXVII, col. 1345).

[17] Saint Ambrose, *De Virginitate, cap. 14* (*P.L.* XVI, col. 303); *idem, Epist.* LXX (*P.L.* XVI, col. 1290).

[18] Spicq, bibl. 501, pp. 19f, 340ff.

mately stems from Saint Augustine, this simplicity of symbolism is much closer to the writings of Saint Ambrose. Such a direct approach as the program of the Gates of Paradise brings to mind patristic, rather than scholastic writings.

Patristic, not medieval, ideas do, indeed, underlie the entire final plan of the Gates of Paradise. Bruni's program, in following the medieval tradition, had presented a series of single episodes without relating them to each other and without regard for the important subdivisions of the Biblical narrative. His presentation of Biblical history is uneven in emphasis. Four events he devotes to the Creation and only one each to the stories of Cain and Abel, Noah, Abraham, Isaac and Jacob; three *effetti*, to use Ghiberti's term, he then allots to the story of Joseph, four to that of Moses, one to Aaron and Joshua respectively, two to David, one to Solomon. Moreover, only the first of these groups, the Creation, occupies one entire register in Bruni's scheme; the others are disrupted, running, if need be, from one tier to the next. In contrast to Bruni's layout, the outstanding feature of the actual program is its clear subdivision of the narrative into chapters as it were, each allotted to a single panel: Creation; Cain and Abel; Noah; Abraham; Isaac and Jacob; Joseph; Moses, including both the Crossing of the Red Sea and the Giving of the Law; Joshua; David; finally, Solomon. Within each chapter several events render the gist of the story, but the chapters are all equal in length and are given equal emphasis. Thus, this final program is far superior to Bruni's. It is clear, balanced, comprehensive and intelligible at first glance. Instead of chronicling Biblical history, it attempts to interpret it along its major lines, to give a grandiose condensation of the Old Testament. The concept does not appear to have had any forerunners in the fourteenth century, either in exegetical literature, or in the figurative arts. Nor, indeed, does it find parallels in the first half of the fifteenth century. The fresco cycle of the Chiostro Verde still holds to the medieval tradition of abbreviating history by cutting it down after a lengthy portrayal of Genesis through the story of Jacob. The program of the Gates of Paradise stands apart in that it comprises all the Old Testament in ten chapters, as it were, each marked by a few pertinent events.

This method of summarizing Biblical history, however, was not altogether novel. Frescoes of the fourteenth century, largely Sienese, had presented narrative sequences in just this way, as continuous narratives, each panel comprising a number of successive *effetti*.[19] But the tradition had remained limited to events in Genesis, never extending to Exodus, Judges, and Kings. In short, the presentation in painting and sculpture of the complete Biblical narrative through selection and condensation was a new idea. It developed out of the renascence of old exegetical ideas that occurred as part of the fifteenth century revival of the early Christian fathers.

In the history of scriptural exegesis Saint Ambrose had been first and foremost in working out a comprehensive and intelligible outline of the whole Bible. His allegorical commentaries on the Old Testament show his method.[20] *Hexaëmeron* in six books and *De Paradiso* concern the Creation.[21] They are followed by *De Cain et Abel*

[19] Piero di Puccio, Genesis scenes, Pisa, Camposanto (Figs. 79f); Bartolo di Fredi, San Gimignano, Collegiata (Figs. 81ff); see Faison, bibl. 150 and below, pp. 222f.
[20] Altaner, bibl. 18, pp. 240ff. [21] *P.L.* XIV, cols. 133ff.

in two books, *De Noe et Arca* in one book, and *De Abraham* in two books. *De Isaac et anima* and *De bono mortis* treat the story of Isaac and Rebecca, and *De fuga saeculi* and *De Jacob et vita beata* that of Jacob. *De Joseph patriarcha* concludes the series. By and large, then, the division of Ambrose' treatise into chapters corresponds to the layout of the first six reliefs of the Gates of Paradise in which are represented the stories of the Creation, Cain and Abel, Noah, Abraham, Isaac and Jacob, and Joseph. The analogy is further supported by specific details in the panels. In the book about Noah and the Ark Ambrose discusses at length Genesis 6:18 in the pre-Vulgate version: *nidos facies in arca*, "thou shalt make birds' nests in the ark." The passage is lacking in the Vulgate; but the birds that flock about the summit of the ark in Ghiberti's panel would appear to allude to a link between his design and Saint Ambrose' writing. Also in Ghiberti's relief the sides of Noah's ark are composed of square panels, recalling the pre-Vulgate text of Genesis 6:14; the patriarch was to make the construction *ex lignis quadratis*, instead of *ex lignis levigatis*, as was the accepted version throughout the Middle Ages,[22] from "square" timber, instead of from "well planed." Again, it is Saint Ambrose who among the Latin exegetes comments at length upon the allegorical significance of these squares.[23] Noah's Shame, absent from Bruni's program and indeed rare in Italian Old Testament cycles,[24] is strongly emphasized by Saint Ambrose in *De Noe*, as it also is in Ghiberti's relief. Ghiberti's motif of the respectful sons approaching the drunken patriarch by walking backwards, drawing a sheet over their shoulders, *pallium imposuerunt humeris suis et incedentes retrorsum* (Genesis 9:23), is a motif thoroughly commented on by Ambrose and other church fathers, and one commonly illustrated in early Christian manuscripts and their Eastern derivatives, but very rarely in the West. Bruni's program, following the general rule of the Italian medieval tradition, limits the story of Isaac to one scene, the Blessing.[25] But in Ghiberti's panel it is richly spun out corresponding to its long exegetic treatment in Ambrose' *De Isaac et anima*. Time and again Ambrose stresses Rebecca as a prefiguration of the Church, and in Ghiberti's panel she appears four times, giving birth to the twins, praying to the Lord, advising Jacob, and assisting at the blessing, all told an unusually full account of Rebecca's doings. Granted that a number of these motifs occur individually in other patristic writings, such as Saint Augustine's *De Civitate Dei* (Book XVI *passim*), still the main characteristic of the scheme of the Gates of Paradise, that clear division and subdivision of the Biblical narrative, is more a distinction of Saint Ambrose than of any other church father.

In at least one point, however, the writings of a Greek, rather than of the Latin church fathers are reflected in the third door. Ghiberti has represented Noah's ark in the shape of a pyramid. No Latin commentary on the Bible and no Western illus-

[22] Walafrid Strabo, *Glossa ordinaria* (*P.L.* CXIII, col. 105).

[23] Saint Ambrose, *De Noe et arca*, cap. VI (*P.L.* XIV, cols. 387f).

[24] Loessel (bibl. 276, p. 37 and appendix XI, chart) points out the rarity of the subject. An outstanding exception is its appearance in Bartolo di Fredi's Old Testament cycle at San Gimignano; see also below, p. 223.

[25] Outstanding exceptions are the mosaic cycle at Monreale and the fresco series at S. Maria in Vescovio; see Loessel, bibl. 276, pp. 76ff.

tration had ever suggested this form.[26] Throughout the Middle Ages the West liked to visualize the ark as an oblong structure with three decks and covered, as a rule, by a pitched roof, the type codified in the twelfth century by Hugh of St. Victor.[27] Eastern manuscripts, beginning with the Vienna *Genesis*, occasionally represent it as a square box covered by a truncated or stepped pyramid, and variations of this form once in a while appeared in Western literature and art from the ninth through the fourteenth centuries.[28] But of all church fathers only Origen interpreted Genesis 7:15, as referring to a regular four-sided pyramid.[29] His second homily *In Genesim*, leaves no doubt but that this was the form he visualized, doing so at the price of some fancy figuring to make the text of Genesis fit his reconstruction. No medieval theologian took up the concept and no illustration depicted it before Ghiberti's.[30] Insofar as Ambrose emphasizes the square wooden slabs used for the construction of the ark, Origen's stress on the same point[31] may seem of less relevance to Ghiberti's panel. On the other hand, Ghiberti's giving the ark so extraordinary a shape would seem to point to the homily of Origen as a direct source for his unusual representation.

An even more far-fetched source has been suggested for a detail in the panel of the Queen of Sheba. In the background, on the left, a man wearing a strange curved conical hat releases a bird, and this little by-play has been related to an incident in the legend of the Queen's visit to Solomon, as told by an Aramaic source, the Targum II to the Book of Esther.[32] To our knowledge this Targum, written in the twelfth century, had never been translated into Greek, Latin, or Italian. If, therefore, it is a source for this scene on the Gates of Paradise, it is an exotic intruder and hard to explain.

All these factors, the close relationship to the writings of Saint Ambrose, the acquaintance with Origen and possibly with a Jewish source, are so many clues indicating the participation of a scholar in the formulation and possibly in the drafting of the program for Ghiberti's door. Probably he was a theologian; in any case, he was well versed in patristic literature. A renewed and lively interest in the works of

[26] Miss Rosalie Green, in charge of the Index of Christian Art, Princeton University, was good enough to support my search for arks, pyramidal, stepped, and otherwise, and I am greatly indebted to her for many a piece of helpful advice. Allen (bibl. 17) discusses at length the various types of Noah's Ark, in both Western and Eastern art and literature.

[27] *De Arca Noe Morali* (*P.L.* CLXXVI, cols. 617ff, in particular, col. 627); *De Arca Noe Mystica*, *ibid.*, cols. 682ff).

[28] Hrabanus Maurus, *Commentarius in Genesim*, Lib. II, cap. 6 (*P.L.* CVII, col. 514); Vienna Genesis, f. 3, 4 (Wickhoff, bibl. 553, pls. III, IV); Monreale, doors; Florentine *Speculum* of the fourteenth century (Jones and Berenson, bibl. 236, pl. IV).

[29] I am greatly indebted to Mr. Edgar Wind for calling my attention to this passage and for allowing me the perusal in manuscript form of his paper (bibl. 555) demonstrating both the Origenist character of Ghiberti's ark, and the revival of Origenism in Florence and Rome after 1460. See also, Allen, bibl. 17, p. 167.

[30] Miss Rosalie Green has called my attention to a twelfth century German Bible, Dresden, Secundogeniturbibliothek (R. Bruck, bibl. 71, p. 33, fig. 29), in which the Ark is represented as a lying triangle. But the markings on the three sides in conjunction with Hugh of St. Victor's writings (see above, note 27) suggest that the three sides of the triangle represent the depth, width, and height of the ark.

[31] *P.G.*, XII, cols. 161ff.

[32] Semrau, bibl. 489. I am indebted to Mr. Harry Wolfson, Harvard University, for kindly confirming that the Targum was not known in translations in the fifteenth century.

Saint Ambrose, the *pater mellifluus*, forms part of the patristic renaissance which, during the thirties and forties of the fifteenth century, mainly centered on the writings of Lorenzo Valla, especially his critique of the Vulgate.[33] However, the movement was considerably older than Valla's contributions to it. An attempt to edit the Old Testament on the basis of the Hebrew original can be traced back to the second decade of the century, namely to Niccolo Niccoli and Poggio. It was combatted by no other than Leonardo Bruni. For the perfectly good reason that his Hebrew was nonexistent, he objected to Poggio's heretical mistrust of Saint Jerome.[34] Ambrogio Traversari, close friend of Niccolo Niccoli, was, on the other hand, one of the leaders of the neo-patristic movement.[35] His interest in the writings of the church fathers was supreme. Admiringly he mentions a complete collection of the Latin *patres*: forty-nine volumes of Saint Augustine, seventeen of Saint Jerome, nine of Saint Ambrose, twenty of Saint Hilarius.[36] He fought in behalf of Bernardino of Siena who, imbued with the Holy Spirit, had turned against the representatives of late scholasticism, "those who with their inflated scholarship . . . attempt to lay a new foundation and to destroy the name of Jesus and [who] want to seem rather than be, in the letter and in the spirit, experienced in all wisdom."[37] He approved with enthusiasm the project of Leonardo Giustiniani to translate the Bible into Italian and thus make the Scriptures accessible to the uneducated as well.[38] At the same time Traversari was well acquainted with the Greek fathers, a rare accomplishment in an *ambiente* where knowledge of Greek was scarce indeed.[39] Their writings struck him as the most important, if not the only contribution which Greece had made to the world.[40] Very reluctantly he consented to translate one work by a pagan, Diogenes Laertius.[41] But he was indefatigable in translating the Greek patristic writings. His reading of them was very broad, and in his bibliography the works of Origen held a prominent place.

A revival of Origen's unorthodox theological views was to take place in Florence in the third quarter of the fifteenth century.[42] It was carried by Matteo Palmieri and Leonardo Dati who, by the way, bears no relation to the homonymous general of the Dominicans whose tomb Ghiberti had cast in the 1420's. Both Palmieri and the younger Dati studied Greek under Ambrogio Traversari, and throughout the thirties Traversari kept Dati under his wing.[43] More than likely both became acquainted

[33] Voigt, bibl. 541, I, p. 475; II, pp. 475ff.

[34] Poggio, bibl. 418, I, pp. 1ff (Lib. I, ep. 1); Bruni, bibl. 78, II, pp. 160ff (Lib. IX, ep. 12).

[35] The only monograph on Traversari is still Dini-Traversari, bibl. 127. A brief evaluation of his work is contained in Ricci, bibl. 442, pp. 578ff. Mr. Hans Baron was good enough to call my attention to a valuable little book by Corsano (bibl. 108, pp. 11ff) which sketches Traversari's position in the neo-patristic movement.

[36] Traversari, bibl. 526, II, col. 112 (Lib. II, ep. 41); see also II, cols. 109f (Lib. II, ep. 39).

[37] *ibid.*, II, cols. 313ff (Lib. VI, ep. 31).

[38] *ibid.*, II, col. 349 (Lib. VIII, ep. 1); see also Agostino Fortunio, bibl. 163, p. 330.

[39] For a bibliography of Traversari's Greek translations and writings see Ziegelbauer, bibl. 561, pp. 2ff; Fortunio, bibl. 163, pp. 321ff.

[40] Traversari, bibl. 526, II, col. 4 (Lib. I, ep. 1); see also below, p. 185.

[41] *ibid.*, II, cols. 305f, 329ff, 967ff (Lib. VI, ep. 23; Lib. VII, ep. 1; Lib. XXIII, ep. 10).

[42] Wind, bibl. 555.

[43] Traversari, bibl. 526, II, cols. 78, 629f (Lib. II, ep. 8; Lib. XIII, ep. 22); see also Voigt, bibl. 541, I, pp. 291f.

with the Alexandrian father through their old teacher. After all, one of Traversari's proudest achievements was his discovery in Rome in 1432 of forty-two homilies of Origen in Saint Jerome's translation, of which thirty-nine deal with the Gospel of Luke and three with the Psalms. They were "more precious to him than the riches of Croesus," and his pride in the lucky find was shared by his friend, Niccolo Niccoli.[44] A few weeks later he reported the find of twelve unidentified homilies on Isaiah and on stylistic grounds attributed them to Origen.[45] True, Origen had been previously known from Rufinus' Latin translation of his homilies on Genesis, and his second homily, on Noah, survives today in Rufinus' edition alone. But Traversari, through his discovery of unknown homilies in the very years that the Gates of Paradise were being designed, was probably led to study those that had already been brought to light. Very likely it was through him or through Niccoli that the image of the pyramidal ark reached Ghiberti. In addition to his other accomplishments, the learned Camaldolese had at least a limited knowledge of Hebrew.[46] He could have studied it, as a few others did, from one of the Jews who had been recently admitted to Florence, and thus he may have become acquainted, if only indirectly, with the second Targum to Esther.

The "Origenist" Noah's ark and the possible use of a Talmudic legend tend to connect Ambrogio Traversari with the program of the Gates of Paradise. One is reminded that Traversari, neopatristic theologian that he was, was wont to view Biblical history along the same broad exegetic lines that Saint Ambrose had followed. In Traversari's mind the Scriptures fell into large categorical sequences, each one climaxed by a few outstanding events, just as in Saint Ambrose' commentaries the Biblical narrative is traced from the Creation through Joseph. Indeed, it is as if Traversari, at times anyway, had in his thoughts continued the commentaries of his great namesake. Such thoughts emerge when in a letter to Niccolo Niccoli he admonishes his friend to keep Easter "that the destroyer of Egypt be kept from you and your doorposts signed with the Blood of the Lamb, that you may cross the Red Sea and the desert of this world with much labor, may enter the Land of Promise, defeat the hereditary Amorite [i.e. the Devil] and be deemed worthy to possess the heavenly Jerusalem."[47] Clearly Traversari had in mind the three Biblical books that follow Genesis: Exodus, from which he takes his allusions to the plagues of Egypt, the passing through the Red Sea and the wandering in the desert; Joshua, which he indicates by references to the entry into the Promised Land and the defeat of the Amorites at Gibean; and II Kings, where he alludes to the permanent conquest of Jerusalem by David. Within our context, it is of lesser importance, that all these events are viewed

[44] Traversari, bibl. 526, II, cols. 406ff (Lib. VIII, ep. 42); Traversari, *Hodoeoporicon*, in: Dini-Traversari, bibl. 127, appendix I, p. 29; Voigt, bibl. 541, I, p. 261; Sabbadini, bibl. 458, I, p. 93.

[45] Traversari, bibl. 526, II, cols. 410ff (Lib. VIII, ep. 44).

[46] Vespasiano di Bisticci, bibl. 54, p. 241; Cassuto, bibl. 89, pp. 274ff; Dini-Traversari, bibl. 127, appendix I, p. 6.

[47] "... ut arceatur ab te et a postibus tuis signatis Agni sanguine exterminator Egypti, transitoque Mari Rubro et deserto seculi multo labore peragrato, terram repromissionis introeas celestumque Jerosolimam fugato Amoreo hereditario iure possidere merearis." (Mercati, bibl. 321, pp. 46ff). Cardinal Mercati suggests for the letter a date shortly prior to Niccoli's death, February 3, 1437.

in Traversari's letter as prototypes of salvation. But it is significant that their very themes find their counterparts in the three panels of Ghiberti's door that follow the *Joseph*; the three panels, that is, that continue the narrative at the point where the six chapters of Saint Ambrose end: the *Moses* in which are included the events of both the Red Sea and Israel in the desert; the *Joshua* where the Chosen People cross the Jordan and conquer Jericho, while on the frame the victory over the Amorites is personified in the figure of Joshua ordering the sun to stand still; finally, the *David* where David is shown entering Jerusalem.

All these factors help to build the working hypothesis that the Gates of Paradise are linked in some way to the scholarly pursuits of Ambrogio Traversari. One additional factor, extraordinary and quite inexplicable otherwise, appears to support this thesis: Ghiberti's panel of the visit of the Queen of Sheba to Solomon. To close an Old Testament cycle with this scene was most unusual. No fresco cycle of the Middle Ages in Italy and elsewhere had ever shown the encounter in quite so prominent a place. Thus the question is well justified as to why, in the final program of the Gates of Paradise, this scene was substituted for the judgment of Solomon which Bruni had proposed (Pl. 116).

Indeed, the substitution is perhaps the most noteworthy change from Bruni's program. The representation of the visit of the wealthy and clever queen of Arabia to the pious king of Israel was nothing new in itself. Often it had been used in the Middle Ages to prefigure events in the story of Salvation or to allude symbolically to figures and facets of afterlife.[48] It had forecast the Adoration of the Magi and had signified the pagan world submitting to the glory of Christ. Or else the subject had symbolized the blessed who reside in heaven, or (the two are obviously correlated) the marriage of Christ and the Church—the Church being like the Queen who had "come to listen to his wisdom and to bring in offering the souls of the faithful." As the *sponsa Christi* the Queen of Sheba had also prefigured the Virgin, and her meeting with Solomon thus forecast both the Marriage and the Coronation of the Virgin. Given their respective roles in prefiguring the Adoration of the Magi, the figure of Solomon, that is Christ, is usually represented enthroned, the queen as either standing or kneeling before him; sometimes he stands, while she kneels. When they prefigure the Blessed in Heaven or the Marriage of Christ and the Church, they stand opposite each other, or are seated as *synthronoi*. In this case the scene no doubt connotes also the Coronation of the Virgin where she and Christ share the throne.[49]

Very likely the representation of the meeting of Solomon and the Queen of Sheba on the Gates of Paradise carries one or more of these traditional meanings. It could stand for the Blessed in Paradise or the Marriage of Christ and the Church. It could also allude to the Coronation of the Virgin. In fact, Ghiberti's composition, with its two protagonists in the center, flanked by hosts of attendants who are grouped in two registers, appears closely related to traditional scenes of the Marriage of the Virgin

[48] Chastel, bibl. 94; Lutz-Perdrizet, bibl. 284, pls. 81, 82; Laborde, bibl. 258, p. 164; Warner, bibl. 546, pl. 146 (London, Brit. Mus., Roy. 2B VII, f. 65v).

[49] Lutz-Perdrizet, bibl. 284, pls. 71, 72.

and of other marriages, secular and semisecular. It likewise recalls the Coronation of the Virgin in Florentine painting of the early fifteenth century: witness the altarpieces of Lorenzo Monaco (1415), Roselli Jacopo di Franchi (*ca.* 1420) and of Fra Angelico (prior to 1438). Yet, withal, in the scene on the Gates of Paradise, these anagogical and symbolical connotations appear to be interwoven with a definite allusion to a specific ecclesiastico-political ambition of the early fifteenth century: the reconciliation of the Greek and Latin churches. This hope was to culminate in the proclamation of their union in 1439 at the Council of Florence. Abortive though the union was, it remained nevertheless one of the more ambitious undertakings of the papacy in history. Its ultimate aims were submission of the Christian East to the West, reconquest of the East from the infidels and universal recognition of the pope's supremacy. Its immediate objectives were support of the tottering Byzantine Empire against the Turks, on the one hand, and on the other the restoration of papal prestige in the West, badly shaken as it was by the long schism and recalcitrance of the hierarchy against the pope. Furthermore, vast political and economic prospects seemed to open up before this ambition. The reconquest of Byzantine territories lost to the Turks would strengthen diplomatic and trade relations with the Near East. In the preparatory years political and intellectual leaders in Italy must have been aware of these material prospects, as well as of the spiritual consequences of the hoped for reconciliation.

Just what relation these hopes and aspirations and their partial fulfillment had to the Biblical tale of Solomon's encounter with the Queen of Sheba and to Ghiberti's rendition of the subject on his door is not, at first, manifest. But two features point the way. For one, Ghiberti's panel breaks away from traditional concepts of the scene. The queen and Solomon are no longer seated side by side as co-rulers like Mary and Christ. Nor does the queen, symbol of the heathens, kneel before the wise king of Israel. The entire scene has been changed and enlarged into a grandiose, solemn festival. The royal pair, each accompanied by a large suite, halts before a church intended as the Temple of Jerusalem, Solomon on the right and the queen on the left. They face each other, standing on the same level, a landing raised a few steps above the ground. They have not yet entered the Temple; behind them a few more steps ascend to the entrance of this sacred structure. Both protagonists are seemingly given equal footing. Yet, there are differences between them which, slight as they are, carry some weight. Solomon grips in his left hand the right hand of the queen, while she, with head inclined, rests her left over her heart in a gesture of submission. Another sign of submission is hinted at: the queen has removed her traveling hat, crowned and with a pointed visor, and has given it to a lady-in-waiting to hold. Likewise the suites of Solomon and the queen are counterpoised by subtle, but nonetheless noticeable differences in costume, type, and posture. The queen's following, at the left, is swarming with oriental types, bearded, turbaned, or wearing conical, curved, tall hats. In Solomon's suite the tall conical hats are absent and costumes are more like those of contemporary Florentines, complemented by mantles draped *all'antica*. The figures on Solomon's side stand dignified and quiet, one group at

the far right peacefully discussing a point. On the queen's side, in the left foreground, arguments are noisy, men throw their heads back and look upwards, as if expecting illumination from heaven (Pls. 116-119).

These are but hints, but they take on more significance when one looks from Ghiberti's panel to other representations of the subject in Italian fifteenth century art. Indeed, Ghiberti's panel appears to have been a fountainhead for a whole series of representations of the scene. As an outgrowth of his, the meeting of Solomon and the Queen of Sheba, where both are shown standing in front of the Temple, became standard decoration for Florentine and possibly, too, for Ferrarese hope chests and marriage salvers after the middle of the century.[50] These later echoes of Ghiberti's panel give a clue as to the meaning of the subject for Florentines in the fifteenth century. Not too surprisingly the suites of Solomon and the queen are frequently garbed in rich, oriental dress; throughout the fourteenth century exotic costumes and animals in the train of oriental potentates like the Magi and Saint Helena had denoted the luxury of the East. But another feature is more significant. In the great majority of these representations the queen wears a strange tall sugar-loaf hat with a high boatlike brim. This headgear could have been known in Italy through only one person, John VIII Palaeologos, the last Byzantine emperor, the one who in Florence signed the declaration of union with the Latin church. Occasionally on these *cassoni* and salvers the Queen of Sheba is represented wearing a small crown resembling that of the Greek patriarch. Solomon, opposite her, displays the three-crowned tiara of the papacy, placed on top of either a turban or the hat of a Jewish high priest. The pope and Greek emperor are thus cloaked under the guises of Solomon and the Queen of Sheba. In Ghiberti's relief, twenty odd years earlier than these *cassoni* panels, the symbols have not yet jelled.[51] The trains of Solomon and the queen somewhat intermingle, at least on the lower register: a youth carrying a monkey from the queen's side approaches the quiet disputants on the right. Solomon wears a plain oriental turban, and the Queen of Sheba's headgear, carried by a lady-in-waiting, is not the curved brimmed conical type of hat worn by John Palaeologos and so much admired by Europeans, the "white little hat, pointed in front, with a big ruby on top. . . ."[52] Instead, it is a crowned traveling hat with a low visorlike brim. However, plain as it is, it still points in the direction of Byzantium, for in late fourteenth and early fifteenth century painting in Florence, this is the typical headgear worn by that great traveler through the East, the Empress Helena, mother of Constantine and first queen of the East, and hence the ancestress of the imperial house of Byzantium. So, under the *figura* of the meeting of Solomon and the Queen of Sheba, the whole scene betokens the hoped for reunion of the Greek and Latin churches.

The council that was to consolidate the pact did not assemble until 1438. Only in

[50] Schubring, bibl. 488, pl. XLII; Chastel, bibl. 94 *passim.*

[51] Millard Meiss, in a discussion at the Renaissance Seminar, Columbia University, 1954, suggested the possible existence of some lost intermediary work between Ghiberti's panel and these poor workshop representations of the scene, perhaps a lost fresco which introduced into the Queen of Sheba story the details of costume that specifically allude to the Union Council.

[52] Bartolomeo del Corazza, bibl. 105, p. 297.

1439, two or three years after Ghiberti had cast his plaque of the Queen of Sheba, were meetings transferred to Florence. Only then did the Florentines see the emperor and his following, the clergy "in silken gowns, in Greek fashion, very rich . . . and far more serious and dignified than the Latin prelates." But the fame of the Greek visitors had preceded them, including the notion that ". . . the Greeks, in fifteen hundred years or more, have not changed their habits of dress."[53] In fact, the Byzantines, those descendants of the ancient Greeks and supposedly their living image, kindled the imagination of all Italians alike, humanists, churchmen, and men in the streets, during the twenties and thirties. Hope constantly grew that they would be reconciled to the Roman Church. Negotiations over the union opened as early as 1418 at the behest of Martin V, and the calling of a council in Constantinople was proposed in 1420.[54] In 1428 John Palaeologos, then coemperor of Byzantium, came to Europe to seek assistance against the Turks. In the last months of his life, the pope concluded an agreement with a Greek delegation in preparation for a council to be held in South Italy.[55] Martin's successor, Eugene IV, while still a cardinal manifested his interest in the Greek question by applying in 1426, to Ambrogio Traversari for a copy of his translation of Kalakas' treatise on the errors of the Greeks.[56] Immediately after his election to the papacy, early in 1431, he threw himself energetically into the task of achieving the union and, in fact, a Greek delegation presented itself in Rome during the course of that year.[57] The situation grew somewhat involved due to the tension between the pope and the Council of Basel.[58] But Eugene IV did not give up. After his flight from Rome to Florence in 1434, his efforts apparently received the support of the republic of Florence and the banking house of Medici. Lengthy diplomatic exchanges between the *curia*, Byzantium, Florence, Venice, the Council of Basel and the German emperor finally ended with a council scheduled to meet in Ferrara. Financed by the republic of Florence and convoyed by the Venetian navy, a large group of Easterners, including Greeks, Russians and Rumanians, arrived in Venice in March 1438. The guests, led by the Byzantine emperor and the patriarch of Constantinople, were magnificently received.[59] The council opened April 8, 1438, in a solemn session, the Latins seated on the right, the Greeks on the left,[60] very much like the suites of Solomon and the Queen of Sheba in Ghiberti's panel. In January 1439, the council was transferred from Ferrara on account of an epidemic, and at last the long cherished wish of the Florentines to shelter the council was satisfied. Sessions were first conducted in the papal apartment in the Dominican convent of S. Maria Novella,

[53] Vespasiano da Bisticci, bibl. 54, pp. 14f.
[54] See Hoffmann, bibl. 214, I, pp. 5f (docs. 3, 4, 5).
[55] *ibid.*, I, p. 20 (doc. 26).
[56] Bertalot, bibl. 49, p. 103; see also below, p. 184.
[57] Mansi, bibl. 296, XXIX, p. 564; Hoffmann, bibl. 214, I, pp. 2of, (doc. 29).
[58] Hoffmann, bibl. 214 *passim*.
[59] Traversari, bibl. 526, II, pp. 57ff, 96, 194f (Lib. I, ep. 30; Lib. II, ep. 25; Lib. III, ep. 65 and *passim*).
[60] Morçay, bibl. 344, pp. 61ff. At the disputation meetings the Pope was seated facing west, the Emperor, facing east, the Latin doctors were seated on the pope's right, facing south, the Greeks on his left, facing north.

then later in the Cathedral, where, on July 6, 1439, the union of the two churches was solemnly proclaimed both in Latin and Greek. The Greeks renounced their errors, and some of their dignitaries, among them Bessarion, were created cardinals of the Roman church. The authority of the pope was universally recognized by those assembled. In 1440 the Syrian Maronites and in 1441 a group of Abyssinians likewise presented themselves with special delegations.

Anyone trained in theological thought in the fifteenth century would have pictured this reconciliation between Eastern and Western churches under the *figura* of the Queen of Sheba's visit to Solomon. She "had heard the name of Solomon and the name of the Lord and had come, to tempt him with riddles . . . and she said: It was a true report that I heard in mine own land of thy acts and thy wisdom. Howbeit I believed not the words until I came and mine eyes had seen it" (III *Reg.* 10:1-7). She was "the Queen of the South, come from the utmost parts of the earth to hear the wisdom of Solomon . . . [who] shall rise in the Last Judgment" (Luke 11:31). In his address to the pope, delivered October 9, 1438, in Ferrara, Andrea Chrysobergi, archbishop of Colossos and bishop of Rhodes, broadly intimated the parallel between the Biblical tale and contemporary events: the emperor and the patriarch, he said, "having been incited to venerate you by the widespread fame of your holiness and your divine acts, wanted to see with their own eyes he whom they had already adored with the highest reverence. In you, they universally confess, are continued all the ornaments of the virtues . . . [therefore] on the judgment day will you offer [to the Lord] those many saved human souls."[61] A few years later the Abyssinian delegation stated the comparison more outspokenly: like the Queen of Sheba who had come to Jerusalem attracted by the fame of Solomon's wisdom, "So have we who are much smaller come to you who are more than Solomon . . . [you who are] Christ walking on earth among the sinners."[62] Thus in the minds of those involved in preparing and directing the council, Eugene IV represented both Solomon "who had enjoyed greater glory than any other man," and Christ, whose vicar on earth he was. At the same time, they viewed the Greeks, led by the Byzantine emperor, as the embassy prefigured in the visit of the Queen of Sheba, the great dignitary of the East. Like her the Greeks incarnated the Church, given in marriage to Christ, bringing a dowry of blessed souls and sitting in judgment over the wicked.

Outstanding among the men who organized the union of Eastern and Western churches was again Ambrogio Traversari. As the best Greek linguist in Italy, he translated, as early as 1419, Kalakas' treatise on the errors of the Greeks for Pope Martin V who wanted it as guidance for "returning the lost sheep to the fold."[63] From this point on Traversari's interest in the Greek question never flagged. He studied the early church synods and the letters of Gregory the Great countering the claims of Constantinople—"they might come in handy some day."[64] He eagerly awaited the visit

[61] Mansi, bibl. 296, XXXVIB, *Suppl.* (Paris 1901), cols. 1454f; Giustiniani, bibl. 182, pp. 89f.
[62] *ibid.*, pp. 375ff. [63] *P.G.*, CLII, cols. 11ff.
[64] Traversari, bibl. 526, II, col. 364 (Lib. VIII, ep. 6). The date is known from references to the absence of Niccolo Niccoli and Cosimo Medici (in Rome?) and to the impending visit of the Greek co-emperor which took place in 1425. *Ibid.*, II, col. 369 (Lib. VIII, ep. 8).

of John Palaeologos to Europe. He became a power in the drive to achieve the union of the two churches. Eugene IV who had approached Traversari on the Greek question when he was still a cardinal, after his ascent to the holy see, employed the scholar as a close collaborator. In matters both of domestic reform in the Latin church and of prospective union with the Eastern church, Traversari stood behind the papal chair, urging and paving the way, smoothing out the difficulties. He was far more than a technical advisor;[65] in modern parlance we would call him chief of the Byzantine division in the papal chancellery. Just one week after the election of Eugene IV, he addressed a long memorandum to him on the tasks of the new papacy. Foremost among these was the reconciliation of the schismatics. "It is unbearable," he says, "nearly all the places where the dignity of Christianity has flourished so gloriously . . . have fallen to the enemies of Christ. Africa, where Cyprian, and . . . Augustine have assembled so many councils, has fallen. All of Asia and no small part of Europe where all the universal synods from all the world used to gather has come into the hands of the heathens. All of Greece which brought forth so many harbingers of the Word, so many philosophers of Christ, suffers from the long weary schism and is pressed by the barbarians because of her unbelief. . . ."[66] To support his argument he sends the pope the letter addressed by Bernard of Clairvaux to Eugene III, the very letter in which Bernard had urged the reform of the clergy and a crusade against the Saracens. Traversari adds pointedly "the terrors of war should be transferred from our midst to the infidels."[67] Clearly all this represents a policy, well considered and long prepared on the part of Traversari. Also when he became general of his religious order, the Camaldolese, he never abandoned his two great aims, the reform of the clergy and the union with the Greeks. In the fall and winter of 1435-1436, the pope sent him on a diplomatic mission of prime importance. He went to Basel for the twofold purpose of pressing the pope's claim to supremacy over the recalcitrant council and to win over the leading prelates, if necessary by pecuniary sacrifice—"small things must never be a hurdle where great things are at stake."[68] From there he went to Vienna and Budapest to solicit the mediation of the Emperor Sigismund.[69] Both actions were directed at solidifying the Church in the West and were thus prerequisites for conducting the pending negotiations with Byzantium. Back in Italy, he recommended that the pope, then in Florence, subsidize a group of visiting Greeks with the end in view of encouraging the desired union.[70] In September 1436, he submitted another memorandum in which he reasserts the need for a true union council; he recommends to the pope's attention the names of the theologians who later became the prominent defenders of the Latin cause, John Torquemada and John of Monte Nigro; he suggests inviting the largest possible body of prelates to the council, and he urges the pope to receive the Greeks with all possible honors, to send a permanent

[65] Hoffmann (bibl. 216, pp. 154ff) suggests a primarily advisory role for Traversari.
[66] Traversari, bibl. 526, II, pp. 1ff (Lib. I, ep. 1).
[67] *ibid.*, II, col. 9 (Lib. I, ep. 2).
[68] *ibid.*, II, cols. 26ff (Lib. I, epp. 11, 12, 13, 14, 15); cols. 1043f (Lib. xxv, ep. 1).
[69] *ibid.*, II, cols. 34ff (Lib. I, epp. 16, 17, 19).
[70] *ibid.*, II, cols. 149ff (Lib. II, ep. 39).

envoy to Constantinople, to promote some of the Byzantine clergy to cardinals, to bring a hundred Greek boys to Italy and instruct them in the rites of the Roman church.[71] He maintained this line when finally the council convened at Ferrara.[72] With a delegation of high prelates he went to Venice to receive the emperor and the patriarch and again recommended to the pope generous treatment of the visitors, both in minor concessions and in subsidies.[73] He participated as an advisor in the sessions of the council in both Ferrara and Florence.[74] Finally, he was author of the decree that codified the union, read at the closing session in the Florence Cathedral, the decree that gives thanks to "Christo qui tantum boni sponsae tuae Catholicae Ecclesiae contulisti."[75] Thus, being both a theologian and diplomat, Traversari must have constantly held in his mind's eye the *figura* of the visit of the Queen of Sheba to Solomon, alias the marriage of Christ to his Church, as the emblem of his preparations for the union and, in its behalf, for the visit of the Greeks to the pope.

A last clue may or may not be helpful to clinching the argument. In the panel of the Queen of Sheba, at the far right below Solomon—that is, on the Latin side, if our hypothesis holds—a group of men are assembled in lively discussion (Pl. 119; Fig. 64). They are placed so as to attract immediate attention and one suspects them of being portraits. In their midst stands a figure, middle-aged, his cloak drawn over his head, like a monk's hood. The face is characteristic enough. It is broad, the eyes stand wide apart, the eyebrows arch and then sink in a marked S-curve. The nose is short and straight, the mouth smallish and pouting, the chin small and weak. Two very deep creases run from the nostrils down to the jaw, the neck is emaciated, its tendons strongly marked. In short, it very closely resembles the only known portrait of Traversari, a bust in profile on the first page of his Diogenes Laertius translation (Fig. 65), in a manuscript once owned by Piero Medici.[76] The broad bridge of the nose, the S-curve of the brows, the small petulant mouth, the skinny neck, all are there. The conclusion, then, is inevitable. Traversari's portrait on the *Solomon* panel,

[71] *ibid.*, II, cols. 50ff (Lib. I, ep. 26). [72] *ibid.*, II, cols. 53ff (Lib. I, epp. 27, 38, 29).

[73] *ibid.*, II, cols. 57ff (Lib. I, epp. 30, 31).

[74] *ibid.*, II, cols. 974ff (Lib. XXIV, epp. 3, 5); Hoffmann, bibl. 216, IV, pp. 157ff.

[75] Mansi, bibl. 297, XXXIB, cols. 1695ff; Hoffmann, bibl. 216, IV, pp. 410, 413ff.

[76] Florence, Bibl. Laurenziana, plut. 65.22 (Bandini, bibl. 37, col. 737; see also Ricci, bibl. 427, opp. p. 584). The colophon on the last page establishes the ownership of the codex but determines neither the date of the writing nor that of Ambrogio's portrait. The portrait seems to present Traversari as a relatively young man, about thirty-eight years of age. Thus it would seem to coincide with the date 1424, when Traversari, born in 1386, was occupied with the translation of Diogenes Laertius, and to suggest that the Codex Laur. 65.22 was either written around 1425 or else copied from a manuscript produced at that time. The head in the *Solomon* panel suggests an older man, heavier and possibly about fifty. Thus it would neatly fall around 1436.

Mr. Wolfgang Lotz calls my attention to a suggestion made orally by Mr. Battelli (*Mitteilungen des Kunsthistorischen Instituts in Florenz*, VI [1941], pp. 145f; see also Paatz, bibl. 375, III, p. 240 and note 190), regarding a possible other portrait of Ambrogio Traversari's. Battelli proposed to interpret as a portrait of Ambrogio's one of Baldovinetti's prophets, dressed in the habit of the Camaldolese order, in the Chapel of the Cardinal of Portugal in S. Miniato. Indeed this prophet, though worn and elderly, resembles both the portrait in the Diogenes Laertius manuscript of the Laurenziana and the head in the *Solomon* panel. Given the late date of the Baldovinetti paintings (1466-1473), roughly thirty years after Traversari's death in 1439, one would have to assume that the painter made use of an extant portrait.

manifestly suggests that the story alludes to the hoped for church union for which he had been working. It also suggests that he himself had a hand in inserting this very panel into the scheme and that he, in fact, participated in drawing up the entire program for the Gates of Paradise.

The Meeting of the Queen of Sheba with Solomon need not from the outset have formed part of the final program which replaced Bruni's earlier scheme. It may have been inserted at a relatively late date, perhaps as late as 1436, after other panels had already been executed. In any case, its appearance in the program, prefiguring the projected union council, coincides with Ambrogio Traversari's activities in preparing for this council, and establishes another parallel between his ideas and the program of the Gates of Paradise. The closing scene of the Queen of Sheba, a rare subject for a Biblical cycle and never before used to terminate one, best makes sense as the invention of a theologian deeply concerned with uniting East and West. This explanation tallies with other clues: the obvious dependency of the first six stories on the exegetic writings of Saint Ambrose; the parallelism of the Biblical narrative; the occasional impact on the door of Origen's homilies and possibly of a Talmudic legend; the mistrust which Traversari and Niccoli expressed for Bruni's program already in 1424 when it was being drawn up; finally, Traversari's portrait in the panel of Solomon and the Queen of Sheba. Personal, scholarly, theological, and political implications indicate that Traversari, possibly in collaboration with Niccolo Niccoli, took part in the program. Even without documentation one can build up a good case for this argument; for, indeed, such a hypothesis best explains the combination of scholarly, theological, and political ideas that would seem to underlie the program of the door.[77]

[77] Prof. Frederick Hartt has been good enough to acquaint me with a passage in the *Summa Theologica* of Saint Antonine (Lib. III, tit. 31, cap. 7) in which John the Baptist is likened to a lantern throwing light both on the New and Old Testament. To demonstrate his point, Antonine selects ten stories under the Old Covenant, all of which in one form or another prefigure Christ and his Passion: the Creation of Adam and Eve; the Slaying of Abel; Noah's Salvation and his Drunkenness; Abraham's Sacrifice; Jacob's Blessing and his Flight; Joseph's Suffering and Triumph and the Distribution of the Grain; Moses' Childhood and the Passage through the Red Sea; Joshua's Conquest of the Promised Land; Job's Sufferings; David Slaying Goliath. In their general outline then, though not in detail, and aside from the Passion of Job, the stories seem to correspond to the first nine panels of the Gates of Paradise. Thus the temptation is understandable to link the program of the door to Saint Antonine's *Summa*.

On the other hand, Saint Antonine completed the *Summa* in 1455, three years after Ghiberti's doors were set up. The starting date of the *Summa* is uncertain, but he began it "as he was entering the winter of his life." Considering the date of his birth, 1389, the late forties would seem to be a reasonable date. But even assuming, as has been done (R. Morçay, *Saint Antonin, archevêque de Florence*, Paris 1914, p. 414), that he started writing as early as 1439 and that the preparation of the work went back even further, the *Summa* would always lag behind the program of the Gates of Paradise which in its initial form must have been laid down around 1430 or slightly earlier.

It is possible that Saint Antonine, who had returned to Florence in 1433, was acquainted with the program of the doors. It is even likely that he saw the reliefs in Ghiberti's shop in the forties. Certainly, like any Florentine, he knew the Gates after they had been placed on the Baptistery in 1452. But the resemblance between the stories, as outlined in the *Summa*, and the program of Ghiberti's doors is by and large of a general nature. None of the elements which specifically characterize the doors is alluded to in the *Summa*: the pyramidal shape of the Ark; its square boards; its birds' nests. Few of Saint Antonine's stories contain more than one *effetto*; hence they are linked to the scholastic rather than to the patristic tradition of Biblical exegesis. Also a number

of Saint Antonine's subtitles differ from Ghiberti's stories: neither Jacob's Flight nor Moses' Childhood is represented on the doors; the Passage through the Red Sea is only marginally indicated; on the other hand, the Giving of the Law, so prominent on the door, is absent from Saint Antonine's list. Finally the key story of the Gates of Paradise, Solomon's Meeting with the Queen of Sheba, is missing from the *Summa*.

Saint Antonine, it would seem to me, worked with a selection of Old Testament stories which for a long time had been common property of Florentine theologians. He may have modified this selection under the impact of the program prepared for the Gates of Paradise (as I think by Traversari) or of the completed doors. But in doing so he missed the essential points of Traversari's program.

CHAPTER XIII

THE PANELS

ATHEOLOGICAL program with Biblical chapters of broad and general scope formed the basis for the ten-panel pattern of the Gates of Paradise. This pattern coincided with Ghiberti's own wishes. The man, who had evolved a new pictorial relief set within a square frame for the Baptismal Font in Siena could not have returned to the quatrefoil scheme of the North Door. In any event, it was left up to Ghiberti to create a design for this program that would be both "illustrious and significant" (Dig. 106; Doc. 52). He had to work out the details and undoubtedly had to convince the gentlemen of the *Calimala* of the feasibility and desirability of the shift from the old quatrefoil pattern. This was certainly no easy task. After all, the change meant a radical break with the pre-established harmony of the three Baptistery doors. It may well have filled Ghiberti with pride that the *Calimala* gave him a free hand "to execute [this door] in whatever way I thought it would turn out most perfect and most ornate and richest."[1]

The decision to incorporate the program into ten large panels presented Ghiberti with new problems. It allowed no panel space to be given over to individual figures, and if prophets and the four parents of mankind were necessary to the program, they had to be moved onto the frame. It required a new relationship between individual figures and the overall design of a panel; there was no longer the possibility of filling a relief with a comparatively small number of proportionately large figures as was still done in the reliefs for Siena. The wealth of events called for by the program forced Ghiberti to represent several *effetti* in one panel and to distribute his figures across the width and depth of each square. This predicament was greatest in dealing with the first six panels, the *Genesis* through the *Joseph*, because for them an ample pictorial tradition existed. Conversely, the scarcity of pictorial tradition for the Biblical narratives of the last panels, from Joshua through Kings, permitted Ghiberti more freedom of treatment, with the result that only one or two scenes are assigned to each plaque. Indeed towards the end of the series it became apparently Ghiberti's aim to subordinate all elements to one or two *effetti*; for even in the *Moses* panel, for which tradition provided manifold narrative scenes, he focused on only two events. But these events are presented in a large and copiously filled composition containing the greatest possible number of figures. Indeed, Ghiberti was inordinately and justifiably proud of the mastery with which he handled large crowds for the Gates of Paradise (Pl. 81). He designed the panels, so he says, "abundant with many figures, in some stories . . . a hundred . . . in some . . . less and in some more."[2] Pedants can easily calculate that only in a few plaques the crowds approach anywhere near a hundred figures. But the very exaggeration shows how importantly it loomed before Ghiberti when he wrote his autobiography that these large panels were combined with large crowds of proportionately small figures. At the

[1] Ghiberti-Schlosser, bibl. 178, I, p. 48. [2] *ibid.*, p. 49.

same time, the presentation of a multiplicity of events and figures brought up two other related problems. Both the size of the crowds and the number of *effetti* for every panel made it impossible to arrange all the figures, or even the majority of them, on the front stage of the relief. Hence, they could not all occupy the same pictorial plane. Nor could Ghiberti limit the necessary recession into depth to one zone, as in the *Baptism* of the Siena Font (Pl. 73). On the contrary, he had to develop a relief that would suggest a deep and wide space populated by more or less autonomous individual scenes distributed over successive planes, and he had to do this with an eye to credibility and balance in composition. This entailed playing up or toning down various parts of the story, integrating figures and groups with setting, and thus evolving a deep pictorial relief on a large and complex scale. The plaques are nearly 20 cm larger in both width and height than the Siena reliefs, close to twice their dimension. But figures are smaller than in the Siena reliefs, the foreground figures averaging somewhat more than 25 cm as opposed to 33-34 cm. In short all aspects of the Gates of Paradise are interlinked: the literary theological program, the large size of the panels, the smallness of the figures, the complexity of the compositions and their wide spatial recessions.

Technically the structure of the door is simple. Soldered onto the back plaques is the skeleton which forms the five *caissons* on each wing that hold the panels in place. This skeleton appears on the front of the door as a lattice frame with floral decor, statuettes, and inserted heads. The panels, 79.5 cm square, or one and a third *braccia*, including a narrow marginal inner frame .85 cm wide, are all cast in one solid piece. The bottom of each panel projects somewhat beyond the framing margin, while the top recedes below the frame, so that the relief slopes inwards and upwards. A front stage of a few centimeters, rocky or architectural, is formed; then the ground rises slowly and grows steeper, as a rule, till it reaches the shoulder level of the foreground figures; finally, it steepens further, gradually in the landscape panels, and in a steep vertical plane in panels with architectural settings. Foreground figures from those in the *Genesis* and *Abraham* panels to those in the *Solomon* gradually decrease in size, while, conversely, the degree of their projection from the back plane increases. But these changes are no measure whatever of the development of Ghiberti's technique.[3] Much in contrast to the North Door, all the figures were cast in a piece with the solid plaques against which they stand. Occasionally, when placed close to the edge of a panel, the figures project over onto the marginal framing. All visible parts are chased; those parts not intended to be seen were left in the rough with only outlines indicating a cheek, an eye, an ear or a hand.[4] Hence, the beholder is meant to view these reliefs from a

[3] The accompanying chart gives the average measurements (for what they are worth) in millimeters.

[4] I append a list of the major casting failures:

Genesis	Numerous small failures in background.
Noah	Numerous small failures in back plane; left edge near the eagle, large failure, *ca.* 20 mm long; another failure in middle ground below Noah's family, filled with plug, 15-20 mm long.
Isaac	Small casting failures all over; two big holes behind group of four women; head of second woman in this group cracked all around neck and soldered back; minor

PANEL	Projection at bottom	Recession at top	Slope ends as discernible from bottom	Figures Projecting from ground		Height of figures	
				foreground	middle ground	foreground	middle ground
Genesis	45 mm	35 mm		45 mm	15-25 mm	300-310 mm	
Cain & Abel	35	30	250	100		270	190
Noah	15	32	210	70		240-260	150
Abraham	30	35	190-200	85-100	10	290	190
Isaac	23	35	220	65-90	20	230-270	125
Joseph	10	35	210	85-90		230-245	110-120
Moses	24	34	200	35-50	25	230-250	150
Joshua	29	40	230	95-100	23	250-280	170
David	14	34		70	25	260	170
Solomon	30	33		110	35-65	210-220	210-220

given standpoint. The decorative parts of the frame were cast in strips inserted into the frame, each bearing a niche for the statuettes, two half-round frames for the *clipei* and two flower pieces.[5] The statuettes, cast separately, were soldered into the niches, and the heads were inserted into the *clipei*. Panels, statuettes, heads, and floral pieces were fire-gilded. The frame, including its architectural profiles and narrow margin around the panels proper, was left in dark dull bronze.

It is unclear when Ghiberti started work on the ten panels. He may well have begun rough sketches shortly after he received the commission in 1425. In the next years he may even have modeled a few figures and scenes in wax.[6] Indeed, the *Genesis* suggests

	casting failures left lower edge and architecture.
Joseph	Large casting failure, hole in left-hand background of building; cracks through third and fourth pilaster from the left.
Moses	Heavy crack down center of plaque.
Joshua	Tiny casting failures all over.
Queen of Sheba	Tiny casting failures all over; small hole right aisle of Temple, first bay; large failure, 30 mm long, upper edge of panel above right aisle of Temple.

The panels of *Cain and Abel, Abraham* and *David* appear to have only a few minor casting failures.

[5] The strips measure .90 m in length and .148 m in width.

[6] A terracotta relief, .298 by .375, now in the Art Museum of Princeton University, Princeton, N.J., shows the left half of the main group of the *Moses*, including the warrior seen from the back and the woman carrying her child, and a dozen background figures and heads, yet with considerable variants from the panel. These variants, for instance the different spatial relation of the figures, their treatment in the round and the inclusion of figures from the right half of the bronze panel, such as the little boy clinging to his mother's skirts, have led to the suggestion that the Princeton panel represents a preliminary sketch by Ghiberti himself (Marquand, bibl. 303). Certainly the terracotta is not a copy after the bronze plaque. But I incline to the belief that it is a free variant of later date: the stances are at times strangely awkward (the bearded man to the left of the warrior), the limbs out of proportion (the left foot of the woman carrying the child), the movements arbitrary (the little boy grasping her skirt), the composition completed by stop gaps (the girl and the elderly woman to the left). The broken folds in the drapery over the leg of the girl to the left and the sharpness of the faces would suggest a date in the second half of the century.

this possibility. However, between 1425 and 1428, or 1429, both the program and pattern of the door were altered twice, from twenty-eight to twenty-four and then to ten panels. Ghiberti could have evolved his definitive compositions only after the final program had been established. Yet all ten panels were cast by April 1437, a remarkably short amount of time in which to have accomplished so much. As a result, stylistic differences between the panels seem slight at first glance. On the other hand, any attempt to evolve a chronology for them depends largely on stylistic evidence. Few dated contemporary works by other artists show any influence from the Gates of Paradise, and where it can be detected, the relationship is complex beyond simple dependency. Dated comparative material from Ghiberti's own *œuvre* is limited to a small number of works which either preceded or were designed simultaneously with the panels. These are the Siena *Baptism* (Pl. 73), and the three panels of the Shrine of Saint Zenobius (Pls. 77-80).

Parallels between these works and the reliefs of Ghiberti's second door can certainly be drawn, but with vague conclusions. The front of the Zenobius Shrine, probably prior to 1437, recalls the *Solomon* (Pls. 78a, 116) in the recurrent groups and individual figures, in the clear centralized disposing of crowds, in the architectural settings that fill the upper halves of both reliefs, and in the atmospheric space which is made intelligible by a continuous grading of relief layers and a sagacious use of linear perspective. Resemblances merely prove an approximate contemporaneity. No more and no less can be proven by comparing the small panels of the Zenobius Shrine with the *Cain and Abel*, the *Noah* and the *Abraham* (Pls. 77a, b; 85; 89; 93). Similarities are clear: the few nearly in-the-round figures assembled on the front stage, the large stretches of blank ground, the rocks rising like giant props in the middle distance, and the opening of space by diagonals that lead in zigzag movements back into depth. If, then, the small Zenobius reliefs date between 1432 and 1434, the related panels on the door, or at least their wax models, should have been completed at roughly the same time. The *Genesis* (Pl. 82), with its slender figures, low horizon and sparing use of scenic props, still reflects the Siena *Baptism* (Pl. 73). These few works, then, set up a general chronological framework for the sequence in which Ghiberti modeled the ten reliefs of his second door. But on this basis alone the sequence would remain but dimly visible. Its ultimate clarification rests with the internal evidence furnished by the style of the reliefs.

The *Genesis* (Pls. 82-84, 105a) can be reasonably singled out as the first modeled of the ten. In many ways it stands apart from the rest. More than any of the others its narrative unfolds through the simultaneous appearance of several autonomous scenes within the plaque. Yet, obviously Ghiberti modulated the weight and importance of the scenes. Three are spread across the front stage in full or almost full relief and all are given nearly equal weight. Two more are relegated in flat relief to the background, despite their importance to the story of the Creation. For why, after all, should the Fall of Man be represented in a minor key when from the theologian's point of view it is a crucial event in the history of mankind, or why should the Creation of the Universe be a marginal scene (Pl. 105a), so easily overlooked that Ghiberti forgot to mention

it in describing his panels? The demands of the narrative have been subordinated to the interests of a superbly, if all too neatly, balanced composition. The Creation of Adam on one side and the Expulsion on the other form two flanking supports unified by the Creation of Eve in the center, and surmounted by the wide arch of angels.

Within this carefully balanced design the scenes are almost painstakingly differentiated. One sees how it was possible to suggest that originally they were modeled to go individually into smaller separate plaques, presumably those of the twenty-four panel scheme, and that they became only later united in the *Genesis* plaque.[7] But this hypothesis has its limits. True, each of the three main events fits into plaques the size of those on the back of the door. However, if at one time these scenes were to be contained in the small plaques of the twenty-four panel scheme, only the Creation of Adam (Pl. 83a) and possibly the Expulsion (Pl. 84) with their foreground figures fully in the round could have reached the wax-model stage. A half-raised relief scene like the Creation of Eve could have existed only as a composition in a drawing (Pl. 83b). Be that as it may, an early date for the design of not only the individual scenes, but of the entire *Genesis* is substantiated by its manifest kinship with Ghiberti's dated works of the twenties. It shares with the Siena *Baptism* long slim bodies, elegant swaying poses, somewhat sharp features, parallel folds of drapery and, above all, a centralized composition and a comparable presentation of space. The design, balanced by flanking groups and surmounted by the arch of the angelic host, isolates the Creation of Eve in the center in much the same way that Christ stands isolated in the Siena *Baptism*. Like that relief, the *Genesis* contains a narrow front stage set off against the large blank gilded background which opens into depth only in an upper sphere and in only one horizontal plane. The landscape setting is sparing, the horizon very low. The resemblances are so close that the overall design of the *Genesis* relief cannot have originated much later than 1429.

True, Ghiberti's style has evolved beyond the Siena *Baptism*. The composition has grown richer; the ground set with a row of trees extends further into depth. The heads have become smaller, the bodies in the scenes to the right are slimmer than ever, twisted in mannered poses, unprecedented and never repeated in his work. Eve, floating up towards the Lord, is of a languid beauty, unheard of before and rarely after, the Lord stands in quiet but monumental dignity. Throughout the narrative is presented with lyrical calm. The few elements have vanished which in the Siena relief recalled the art of Donatello: the flying locks of hair, the rushing movements, the heads foreshortened in sharp perspective, the heroic gestures.

In the *Genesis* Ghiberti appears somewhat hesitant about how to fuse into a whole a number of scenes which at the start he had apparently envisaged separately, both as narrative and as visual elements. This initial hesitation is overcome in a second group of reliefs, the *Abraham*, the *Noah*, the *Cain and Abel*. Despite minor differences they are related in composition and style, and they all have their resemblance to the small lateral reliefs of the Zenobius Shrine, 1432-1434 (Pls. 77a, b).

Ghiberti's fundamental problem in this second group was clearly that of achieving a pattern for each relief in which the different scenes are compositionally unified, yet

[7] Brockhaus (bibl. 69, p. 6) has tentatively proffered this suggestion.

successive in time and narrative. In both the *Abraham* (Pls. 93, 91, 106a) and the *Noah* (Pls. 89, 88b, 90, 91b, 92, 104a) the two front scenes are still conceived as more or less autonomous elements. Like the two figures of God the Father in the Creation scenes of the *Genesis* panel, in the *Noah* the patriarch in the Sacrifice scene is placed back to back with one of his sons from the Drunkenness scene. Yet for the sake of creating a unified design, the center of the front plane, unlike the *Genesis* panel, is no longer taken up by a dominant scene. Between the flanking groups on either side the panel opens into depth and in this depth other scenes are scattered over the middle and background, apparently loosely, yet so as to form an integrated overall pattern: Abraham and the angels on one side, the waiting servants on the other, strongly stand out from the panel, linked by trees and the rock and lead up to the apex of the Sacrifice. The eye travels into depth by intersecting diagonals, in zigzag movements which lead from the angels towards Sarah over the kneeling figure of Abraham, along the rocky spur towards the altar, over the back of the donkey towards the fountain, over the servants and towards the long row of trees. In the *Noah*, his drunkenness and the sacrifice arrest attention; in the far distance Noah and his family appear standing before the Ark, overshadowed by its towering pyramidal shape, yet forming as a group the keystone of the entire composition. The foreground scenes in these panels are by no means necessarily key elements of the narrative. In the *Cain and Abel* (Pls. 85-88a), Cain plowing the field on the left is balanced by Cain receiving the Lord's curse at the right, the former an incidental detail of the story, the latter a key point in the tale. Abel, watching his flock in the middle distance is a scene of as much relevance or irrelevance as that of Cain the ploughman, and is placed on the same plane with the scene of the slaying, the pivotal event of the narrative. Far back and almost swallowed up by the distance and by the shallow relief appear two other turning points in the story of mankind, Adam and Eve at labor and the Sacrifice of the two brethren. The method of narrative is not easily understood. Attention is again brought to bear first on principal visual elements like the stooping figure of Cain and his yoke of oxen at the left, his upright powerful figure at the right, on counterbalancing these two images and on the beautiful shape of the bodies. The eye is led back, starting from the standing figure of Cain. At the left a diagonal leads up to the quietly seated figure of Abel and then to the family group, both supported and framed by the accessories of the trees, the flock, the beehive-hut. At the right the eye climbs the vertical rock to the scenes of the slaying and of the sacrifice, both enlivened by the wind-blown draperies, and the agitated flames on the altars. The eye is forced to travel into depth, straight forward, diagonally and upward, and thus to perceive a space which expands in many directions. Space is suggested by intermittent movements, much as in the small end panels of the Zenobius Shrine. Yet, in the *Cain and Abel* relief, which is larger, the eye picks out in its wanderings the many individual scenes, and these *effetti* compose a narrative sequence only when on a second trip, as it were, the eye follows them along a new route, traveling now first on the left side of the panel from the far background to the front stage, then on the right from the scene of the sacrifice to the curse.

The divergence of narrative sequence and both visual and space composition is de-

cisive, but the demands of the composition prevail over the narrative. Bruni had insisted that the reliefs should be both "resplendent and significant." Ghiberti, in evolving a new pattern, played down the "significance" of the Biblical tale and concentrated on the "splendor" of the design.

The *Noah* and the *Cain and Abel*, even more than the *Abraham* are based on new values of space, movement, balance, light, shade, and grading of relief. The front stage is clearly marked and confined to a narrow strip; but it no longer ends abruptly against a blank gold ground, as in the *Genesis*. Instead, comparable to the small Zenobius reliefs, its stony ledge blends into a steep wall of rocks. More crags and hills rise further back and together they fill two-thirds and more of the height of the panel with a barren scenic setting. Hilly ranges overlap, they run diagonally at opposite angles and thus conquer a vast depth. A grove of trees, laid out in long rows, cuts across from one hill to the next, hinting at wide distances. Minor perspective tricks support these suggestions of depth, the fountain head, the canteen, the washing bowl in the *Abraham*. In the *Noah* similar perspective devices are displayed in the vintner's hut, and the Ark, divided as it is into large decreasing squares, each marked with carpenter's crosses and crescents; in the *Cain and Abel* they appear in the furrows of the field and in the two altars. On all three reliefs only a small strip of the gold ground remains, just enough to suggest the sky against which the farthest mountain chain is set off. To suggest a deep yet finite space, rather than infinite depth, continued to be Ghiberti's main objective. The progressive gradation of the relief serves to this end. In the *Genesis*, full-round, half-round and shallow relief were used with a certain amount of inconsistency. They often merge in the same scene and appear unrelated to the degree of relief employed for neighboring, yet presumably further distant *effetti*. Now, in the *Cain and Abel* and *Noah*, the gradation of relief has been consistently exploited throughout to suggest a coherent expanse into depth. Figures in the first plane of the foreground are full in the round. They are half in the round in the second plane, and in the middle ground they appear in raised *schiacciato*. In the background they are further graded, ranging from shallow to paper-thin layers. The clear unblurred silhouette of the mountain ranges suggests the thinning out of background forms in a subtle aerial perspective.

No doubt the three reliefs were not all modeled at the same time. In the *Abraham* the comparatively low horizon, the elongated proportions of figures and the straight design of draperies are still close to the *Genesis*. In the *Noah* new elements are more pronounced and new figures come to the fore, tall, but no longer slim, and clad in fluttering draperies *all'antica*. In the *Cain and Abel*, the break with older formulas is complete. The individual scenes are no longer equal in weight; the main actors no longer stand back to back. Groups on the front stage are more radically torn apart, their accoutrements used as unifying elements in a free design which embraces the entire panel. The foreplane figures are fuller and rounder than in the *Noah* and *Abraham*. Movements are more varied, draperies flutter and billow more freely, undercuttings are more strongly marked. The three panels form a stylistic sequence, but one which is far from rigid in its order. In all likelihood, Ghiberti worked on more than one relief at once.

This overlapping in the development continues in the *Isaac* and *Joseph*. The general layout of the *Isaac* undoubtedly is a direct outgrowth of the *Cain and Abel*. It shares with the earlier relief the design of the figures who are placed on the front stage in full relief and who are free moving, yet dignified, light stepping, and full of life. Whether they are clad in the fluttering billowing draperies of Roman art, in the cloaks of Biblical characters or in fifteenth century hunting costume, they are in this panel, comparably to the *Cain and Abel*, marked by a fusion of organic clarity and melodiousness more strongly than in the earlier or later reliefs. The *Isaac* (Pls. 94-97) also recalls the *Cain and Abel* in its purposeful scattering of scenes over the whole area. But in the *Isaac* these groups are drawn together with greater power. The group of four women at the very left, close to the edge of the front stage, leads the eye directly to where Isaac is sending Esau off on his wild goose chase. The opposing curves formed by the patriarch, the woman nearest him and his son, instead of conflicting, complement each other. The dogs of Esau, the hunter, carry the composition over to the scene of the Blessing near the right edge of the front stage. Formally intertwined with this garland of foreground groups are the scenes in the middle and background, Rebecca lying-in, the quarrel between the twins, Rebecca briefing her son and finally Esau hunting. As in the *Cain and Abel* the narrative sequence is torn apart; the four women at the left are actually visitors of Rebecca lying in her bed in the background (Pl. 97a); Esau hunting complements both the scene of Rebecca advising Jacob and that of the Blessing (Pl. 97b). But, in contrast to the *Cain and Abel*, the figures in the background are seen on the same eye level as the large ones in the foreground. At the same time the groups, both near and far, fall into two halves, one on either side of the panel, leading from the center into opposite directions. This complex and infinitely subtle composition is strengthened and indeed, made possible by the architectural setting which fills almost the entire height of the relief. A monumental hall with wide arches and tall pilasters underscores the successive events of the story, setting off the single scenes in separate spatial units and calling attention to the protagonists. The architectural setting thus fulfills a triple function: it supports and clarifies the composition and narrative, its arcades create a deep space in the center and on both sides of the relief, and, since it follows a linear perspective, it contributes to the sense of a continuous all-embracing space. It enables the spectator to measure distances, evaluate the relative size of figures and objects and clearly comprehend movements and relationships.

In the *Isaac* Ghiberti's art and workmanship reach a climax. Nowhere else in the reliefs is the composition as a whole so crystal clear, nowhere else are design and narrative, setting and figures, space and action so inextricably interwoven; nowhere else is the balancing of groups and individual figures, the interplay of protagonists and supporting actors so perfectly presented. In none other are the movements so rich, the stances so forceful and at the same time, light, nor the various planes, front, middle and rear so masterfully exploited. It would be hard to find more than a few works in early fifteenth century sculpture comparable in inventiveness of design, in sureness of modeling and in quality of execution with the four women at the left edge of the *Isaac* or with the corresponding group of the Blessing of Jacob in the opposite corner. The ful-

ness of bodies, the stances, both solid and free, standing, seated, kneeling, walking and bending, the play of light over the surface of the gilded bronze, are perfection. If any of the other reliefs is of a comparable quality, it is the *Cain and Abel*.

The *Joseph* and *Isaac* are manifestly of about the same time. In both, a monumental architectural setting of classical aspect, constructed in a consistent linear perspective, creates intelligible measurable distances and underscores the principal events of the story. Yet, in other essentials the *Joseph* (Pls. 98-101) differs from the *Isaac*. It contains five *effetti*: two in the foreground, the Distribution of Grain and the Discovery of the Cup, two in the middle ground, the Gathering of Grain and Joseph revealing himself, and one far back, Joseph sold to the Ishmaelites. But the composition does not depend on these small separate groups. Rather it is sustained by two large groups in the foreground, each of which is formed by a dozen or more figures. Though the two are far apart in content, they are designed as one throng of people, joined together by the complementary movements of the two "leaders," a woman from the Distribution of Grain who turns inwards, and one of the brothers from the Discovery of the Cup who turns outwards. Ghiberti's attention was centered on these crowds to the extent that the individual has lost importance. Stances and movements have turned mechanical, the *invenzione* less rich, the draperies less articulate and free. Action is both more generalized and more weighted with pathos. In place of the quiet dignity and forceful motions of the protagonists in the *Isaac* panel, a few extras are singled out by rhetorical gestures from an otherwise almost undifferentiated mass. All this is in part due, no doubt, to the lesser quality of the panel—compared to the *Isaac*. But it also means that the *Joseph* leads into a new group of reliefs, the *Moses, Joshua, David* and *Solomon*, that it, indeed, initiates Ghiberti's *ultima maniera*.

Beginning with the *Joshua* and more strongly in the following reliefs, Ghiberti strove to eliminate the cleavage between narrative and composition. He avoided distributing numerous *effetti* over one panel in the integrated, yet free design of the *Cain and Abel* and *Isaac*. Figures and groups are consolidated into what seems one event braced by a large crowd. Scenic settings spread across the entire panel are pulled together as one. The narrative is condensed. Even where it required successive scenes, Ghiberti underplayed some. In the *Moses* (Pl. 102) the passage through the Red Sea is merely hinted at by a body of water at the left and a crowd moving through a background ravine towards a chorus of dancing maidens. In the *Joshua* (Pl. 107) the Crossing of the Jordan, the Laying down of the Twelve Stones, and the Pitching of the Twelve Tents, different episodes though they are in the Biblical account, are fused into what seems like one large foreground scene. Finally, in the *Solomon* (Pl. 116), the principle is brought to its conclusion with the representation of only one scene. A unity of narrative and design, of time and space, such as the seventeenth century would have it, has been established.

Presenting the narrative as a single or seemingly single *effetto* was closely connected in Ghiberti's *ultima maniera* with the preponderant importance given to creating a composition out of large crowds. Ghiberti's pride in building up and organizing vast human masses was clearly enough expressed when, ten odd years after he had cast the

panels, he commented on them in his autobiography; in retrospect the uppermost problem in his mind seems to have been the organization of great throngs of people in a clear composition.[8] The type of organization of the *Joseph*, where the foreground plane is taken up by two *effetti* of equal weight was bound to turn out somewhat ambiguously with no less than three main axes, left, right, and center. In the *Moses* some of this inherent ambiguity still remains. But with the further concentration of the narrative into a single scene, the organization of crowds takes on new aspects. In the *Joshua* an avenue opens down the middle of the crowd, empty and leading nowhere. The same is repeated in the *David* (Pl. 112), clearing the ground around David's victory over the sprawling giant. In the *Solomon* the path between the onlookers in the foreground leads up to the royal pair standing on the landing of the steps. In the *Joshua* and *David*, the fore- and middle-ground groups are intermingled, and processions of people extend into the backgrounds. In the *Solomon* the crowds have been subdivided on either side into two groups, the upper and lower tiers, so that a rational composition has been worked out, focused on a single event, fully unified, and perfectly balanced.

Concomitantly with building up a composition by large human masses goes a consistent devaluation of the single human figure. This devaluation begins with the *Joseph* and *Moses*. In the *Joshua, Solomon*, and *David* the single figure has almost completely lost individuality and freedom of movement. Draperies and gestures are repeated with but little differentiation. The same stances and gestures turn up time and again to support the composition and thus impart a false impression of variety: a figure clad in short tunic or armor seen from the back and looking upwards to join the lower to the upper tiers of a crowd (Pl. 96b); three or four figures set up in a row to tie the front ranks of a crowd to those further back (Pl. 110). Rarely does an individual face or a characteristic movement stand out. By and large, repetitiousness, even monotony were not avoided and perhaps were even invited.

Correspondingly, depth is no longer made measurable. Foreground crowds are pierced by a wedge of space, yet the depth of this space cannot be estimated with any degree of approximation. Crowds in a front plane are never sufficiently large to give the impression of an incalculable multitude; hence they are extended into depth by groups in shallow relief in the middle or back planes, mounting up to half the total height of the surface. In the *Joshua* (Pl. 111a) Ghiberti supplemented the crowds of the lower half of the panel with the procession going around the walls of Jericho in the upper register. In the *David* he placed in the upper tier not only the scene of Saul's and David's Entry (Pl. 114b), but also a dense grove of trees, interrupted by only a rocky peak which seems nearer the foreplane. The entire story is thus arranged in bands, superimposed above each other in a vertical composition. No longer is the scenic setting limited to a few barren crags, some trees, or an isolated building. In their place are spread out an abundance of trees, rocks, the panorama of a city *all'antica* or, in the *Solomon*, an assemblage of tall structures. Yet none of this wealth leads to variety. Rocks, buildings, mountains no longer stand at opposing angles but parallel to the

[8] Ghiberti-Schlosser, bibl. 178, I, pp. 48ff.

front plane, monotonously spread out. Barely an inch is left to the open sky and where the earlier reliefs were laid out with the concept of a free and deep, if finite, space, in these last panels, the scene is shut off by the backdrops. Linear perspective is played down, and with it the presentation of a consistent and measurable space. The gradation of the reliefs is no longer designed to indicate a succession of distinct planes, nor is it aimed at suggesting an aerial perspective through the thin outline of far distant mountain ranges. All elements beyond the very front plane, almost regardless of their distance, and of their degree of relief form a dense wall beyond which the space of the panel does not expand. More strongly than any of the other plaques, the *David* stresses this tapestrylike interweaving of figures and setting with the consequent decrease in spatial and sculptural values.

This group of four panels from the *Moses* to that of the *Solomon* represents Ghiberti's last efforts at large scale compositions. All had been cast by April 1437, and the *Solomon* is closely linked to the large relief on the Zenobius Shrine, modeled in 1435 or 1436. Within this last phase, the *Moses* (Pl. 102) manifestly stands at the beginning, continuing the incipient concepts of composition and narrative that had been present in the *Joseph* (Pl. 98). These concepts are further developed in the *Joshua* (Pl. 107) and in the *Solomon* (Pl. 116). The *David* (Pl. 112) then may well be the last of the ten reliefs designed for the Gates of Paradise.

To some degree the chronological and stylistic sequence of the panels is veiled by the homogeneous effect achieved by the overall gilding of the panels. The decision to have the reliefs gilded was formally taken only a few months before the door was set up (Dig. 279; Doc. 46).

In fact, within the development of Ghiberti's relief design during the twenties and thirties overall gilding apparently played as essential a role in evolving the pictorial character as the subtle gradation of layers. It was Ghiberti who pressed the authorities to have the panels of the Siena Font gilded. Gilding and grading jointly impart to the panels of the Gates of Paradise, even more than to the Siena *Baptism*, a harmonious blend of unity and diversity.

Much in contrast to the effect of the gilding on the North Door the gilding of the Siena *Baptism* and the Gates of Paradise unifies figures, props, scenery, architecture, and background. But this unity renders the relief anything but uniform. In the panels of the Gates of Paradise particularly, with their infinite variety of grading, it brings forth roundness and shallowness. Figures in the round and in flatter relief cast shadows on the rocks and on the ground, but the overall gilding counteracts the density of the shades; the result is not the uncompromising contrast of gleaming lights and pitch dark shades that had prevailed in the reliefs of Ghiberti's first door. A diffusion of moderate highlights and transparent shadows predominates all over the panels. This diffusion would have come out even more strongly if the Gates of Paradise had occupied the place for which they were originally intended, the north portal of the Baptistery, where they would never be struck by sunlight. Yet, even in their present location at the east gate, the temperate distribution of light and shade all over the plaques coincides with the very essence of Ghiberti's taste. Whenever he speaks in the *Com-*

mentarii of sculptures he has seen and admired, he stresses the fine transitions and tempered contrasts that become apparent to the eye only in diffused light, or else not at all, except to the touch of a seeing hand.[9]

The gilding at the same time brings forth the liveliness of backgrounds. The cleaning in 1947-1950[10] showed that the grounds of the panels undulate slightly and the gilt, since it did not turn out evenly from the firing, enhances the impression of an uneven surface through its light and dark patches. Thus the ground forms no glittering smooth foil for the figures as did the gold ground of fourteenth and fifteenth century paintings. The light plays over them, reflected unevenly, and light and gilding combined bring the reliefs intensely to life.

The gilding of the panels is in a way Ghiberti's answer to Donatello's contemporaneous atmospheric reliefs. The gold grounds of the Gates of Paradise are more than mere backdrops. They were intended, if not to reflect the real atmosphere, at least to simulate it and to complement the gilded figures and landscapes above which they rise. The overall tonality conveys the impression of a unified atmosphere. It enhances the sense of an aerial perspective merging one relief plane into another from the very foreground to the farthest distance. Yet, no object in the reliefs is ever blurred: the overlapping crags and hillocks are clearly marked off against each other, the mountain ridges are neatly silhouetted against the horizon by the hair-thin sharp lines of light reflected on their gilded polished edges.

Yet Ghiberti's importance to Florentine art, ranging far beyond the realm of sculpture, rests solidly assured on the basis of his development of pictorial relief in rapid successive phases. His pictorial relief style is closely linked to Florentine painting from the twenties through the fifties. These ties involved a complex give and take.[11] Granted that the pictorial relief of the Siena *Baptism* is rooted in his youthful experiments with shallow relief, still around 1424 his imagination must have been fired by the attempts of his contemporaries to represent a realistic space in painting. The altarpiece for S. Maria Maggiore had just been completed and its main scene, the *Miracle of the Snow* (Fig. 88), set down a new principle of spatial composition.[12] Two strongly vertical figures occupy either end of the foreground picture stage. Between them a wedge-shaped crowd leads into depth, the recession built up in many layers and supported by a scant scenic and architectural setting. In the upper heavenly zone solid gilded and flint-edged

[9] *ibid.*, pp. 61ff.

[10] There have been dissenting voices with regard to the cleaning. Ghiberti's doors have been known to us for a century or more as having greyish-green surfaces and masses, unified in tone, without contrasts of color, opaque, and without any reflection of light. It has been alleged that through cleaning "the reliefs have lost their rich gradation of tones and [that] they no longer show the mellowing influence of time on which artists so often rely when they create their works" (Goldscheider, bibl. 186, p. 7). Such objections are understandable for one reason only: it is always hard to get used to the changed appearance of a familiar, if dirty, countenance.

[11] Being anything but an expert in the complex field of Florentine painting in the second quarter of the fifteenth century. I must prudently limit any comparisons to a few reasonably well-dated pieces and can only hope not to be too far off the track.

[12] Clark (bibl. 101, pp. 338ff), has suggested for the *Miracle of the Snow* the date 1425-1426, while Procacci (bibl. 428, pp. 51ff) considers a date early in 1424 or even before. Meiss (bibl. 316, pp. 25ff) likewise holds a date of *ca.* 1423 plausible.

clouds lead towards the figures of Christ and the Virgin. The two zones, earth and heaven, are visually unconnected. Every detail is clear, atmospheric effects are disregarded, and depth remains finite. As opposed to this painting, Ghiberti in his Siena *Baptism* (Pl. 73) discarded architectural setting, as well as distant hills, and he more emphatically marked the break between front stage and back plane. He also divorced the deep wedge of figures from vertical side supports by tilting it heavenwards. Yet, despite these differences, the spatial principle is the same. Five or six years later, around 1430, the Creation of Eve in the *Genesis* (Pl. 83b) still echoed these concepts of the twenties.

Indeed, neither the *Baptism*, nor the creation scenes in the *Genesis* are as bold as the *Miracle of the Snow* in respect to experimentation with space. Neither one exploits fragmentary elements of linear perspective to reinforce the impression of depth and to clarify its extent. Certainly these particular reliefs are still a long way from Masaccio's late style in the *Tribute Money*, painted in 1426 or 1427, where the gigantic figures of Christ and his disciples stand in the immediate foreground, Peter and the tax collector on the right, set off by architecture, and far back Peter by the river bank; scattered trees lead back towards the bare hills rising against the horizon. Masaccio's late composition was not taken up again in painting for many years to come. However, it did find response, though along divergent lines, in the pictorial reliefs of both Ghiberti and Donatello of shortly before and after 1430. In the *Giving of the Keys* (Fig. 66), Donatello played up the combination of gigantic foreground figures and a wide hilly backdrop with scattered trees leading into depth. At this point he is so close to Masaccio that one cannot help but suspect a tie.[13] Ghiberti, when he finished the *Genesis* panel and was proceeding with the *Noah* and the *Cain and Abel*, evolved a type of composition which, while different from Donatello's, is likewise akin to Masaccio's late work. The grouping of scenes at either end of the front stage may still recall works of the twenties, such as the *Tabitha* fresco. But in both reliefs the narrative is, on the one hand, spread over a wide landscape and on the other unified by a clear integrated composition in which background *effetti* support the action and design of foreground figures and groups. True, Ghiberti did not attempt monumental overtones: he replaced Masaccio's dramatic form of narrative with his own epic approach, and in this respect looked back to painting of a much earlier period.

With the architectural setting of the *Isaac* and its consistent linear perspective, Ghiberti arrived at the forefront of his contemporaries. The composition stands alongside Donatello's *Dance of Salome* in Lille and the *tondi* of the life of Saint John the Evangelist in the *Sagrestia Vecchia* in which he employed the same devices as did Ghiberti, though for very different ends. Ghiberti's *Isaac* and *Joseph* panels were indeed the first in Florence to have created a fully rational space out of architectural and scenic setting, linear perspective, and figures. In contrast, in Masaccio's *Trinity*, figures and rational setting fell apart. Uccello in his *Deluge* of about 1446 went far beyond Ghi-

[13] Pope-Hennessy (bibl. 422, p. 11) has brought out the analogies between the *Giving of the Keys* and Masaccio's *Tribute Money*.

berti's treatment of these problems in or shortly after 1435.[14] Even so, his fresco is only understandable within the context of Ghiberti's development of pictorial relief. Ghiberti anticipated concepts which spread among painters a decade or so later. This continued to hold true as he produced shortly after the *Isaac* and *Joseph* the large scale compositions of the *Solomon* and of the Zenobius Shrine. The large crowds focused on the leading actors and systematically disposed like a choir on a stage, may fleetingly recall the composition of the *Miracle of the Snow*. But now the crowds have increased, and the clarity of their formation forecasts a pattern which first comes to the fore in painting at the end of the thirties, and then only occasionally, such as in Fra Filippo Lippi's *Coronation* altarpiece.[15] This crowd formation becomes really predominant in the forties and fifties, and this holds equally true for the deep landscapes and closely knit architectural settings that Ghiberti had evolved for the *Solomon* and *Joshua* panels and the Zenobius Shrine. Time and again, the works of Ghiberti call to mind the paintings of Domenico Veneziano or of Alessio Baldovinetti from the forties and fifties.

It is curiously illogical that in the very last reliefs of the door, culminating with the *David*, Ghiberti seems to have reversed the very principles he had previously sought to attain. Though inferior in the execution of details and less satisfactory as compositions than the best panels, these last reliefs are nevertheless of major importance. In them is reflected a denial of perfect intelligibility that runs counter to concepts which had dominated Ghiberti's *œuvre* but a few years before. The closely interwoven textures, the decrease in spatial and sculptural volumes, the few foreground figures pushed out from the hedges of crowds, de-individualized as they are, the ornate costumes, at first glance seem to hark back to the days of the International Style.[16] But at the same time these elements forecast the art which was to dominate the fifties and sixties. One thinks of paintings such as Uccello's *Hunt* in Oxford[17] and Gozzoli's *Magi* in the Chapel of the Medici Palace (1452) and one recalls that Gozzoli for three years from 1444 to 1447 worked on the Gates of Paradise. In these paintings, just as in the *David*, are fused the ornate lavishness of the now defunct International Style, the tapestrylike flatness and, on the other hand, the solid figures, the precise movements, and the spirit *all'antica* of the Renaissance.

[14] I accept for the *Deluge* the conservative date 1446, as suggested also by Pudelko, in: Thieme-Becker bibl. 517, XXXIII, pp. 524ff; see also Paatz, bibl. 375, III, pp. 726f, 750 and 810ff, note 297.
[15] Oertel, bibl. 364, pp. 20f, pls. 43ff.
[16] See E. Gombrich, as quoted above, p. 169, note 1.
[17] Pope-Hennessy, bibl. 421, p. 154, pls. 97ff, suggests a date near 1460.

CHAPTER XIV

THE LATE WORKSHOP

THE impact of Ghiberti and his workshop is early felt in what might be called the commercial art of Florence. Work on the North Door had hardly been started when he furnished a cartoon for a stained glass window to occupy the then most important place in the Cathedral, the large oculus in the center of the façade (Dig. 13). Other cartoons followed during the next ten years (Dig. 29). They were accompanied by drawings and models which Ghiberti furnished for gold and silversmith work (Dig. 59; Docs. 118, 119) and it seems likely that during these same years, between 1405 and 1420, the workshop started out making molds for some of the terracotta reliefs and statues of the Virgin and Child that go under Ghiberti's name. This early activity is no more than normal. Its products, whether terracotta figures, goldsmith work, or stained glass windows reflect at a greater or lesser distance, the master's personal style; they remain appended, as it were, to his own development. But both the character and the significance of the workshop's activities changed during the last decades of his life. Starting in the twenties and continuing through the thirties and forties, the workshop furnishes designs for tomb plaques (Figs. 56, 57) and for more than two dozens of the stained glass windows in the chapels of the three apses and the dome of the Cathedral (Fig. 63) (Digs. 194f, 201, 215, 218, 221, 223, 227ff, 242ff).[1] Of the many Madonnas executed in inexpensive materials, terracotta, stucco, or *cartapesta* which have been attributed by the score to Ghiberti, certainly not all can be linked even loosely to his name. But of those which bear the imprint of his style, the molds were mostly executed in these late years by his workshop. All this activity may have led him to maintain in his autobiography that he had helped "many painters, sculptors and stonecarvers . . . in their work, made very many models in wax and clay" and many drawings for painters, in brief, that "few things of importance were made in our city which were not designed and devised by my hand."[2]

[1] Ghiberti's activity in designing stained-glass windows for the Cathedral has been discussed by van Straelen (bibl. 508, pp. 53ff). Throughout he attempts to distinguish between design and execution, and in the latter phase between parts supposedly painted by Ghiberti himself and others executed by glass painters. Occasionally (*op.cit.*, p. 57) he suggests even later repairs undertaken by Ghiberti himself. I cannot help feeling that at times the author goes too far in attributing to Ghiberti part of the actual execution of some of the windows in the *tribuna* and in the drum below the dome. None of the designs, from what I can see, contribute anything towards an understanding of Ghiberti's late style. But the problem wants further investigation. See also Marquand (bibl. 304) and Lane (bibl. 262).

[2] Ghiberti-Schlosser, bibl. 178, I, pp. 50f.

Ghiberti's part in the production of fifteenth century terracotta and stucco Madonnas in Tuscany and beyond, has never been clarified despite Fabriczy's comprehensive and still standard catalogue, bibl. 149. Quite on the contrary, the question has been confused to the point of utter hopelessness over the last sixty years by the clamor of collectors, dealers, museum directors, and traders in expertises, all eager to give names to what are, after all, anonymous works of art. To unravel the problem calls for a renewed study from the very outset. It requires differentiating between Florentine, Sienese, and other types; singling out within the Florentine group the types that are linked to Ghiberti more or less closely; establishing the degree of their relationship to Ghiberti and

The true importance of all this production, however, lies not so much in its quantity and spread both within and without the workshop as in the impact it appears to have exerted on his own work. Needless to say, few of these terracotta Madonnas, stained glass windows, and tomb plaques show Ghiberti's personal touch. But it is remarkable how even in the major works of these years the personal note appears to diminish in strength. In the small bronze shutter with the figure of God the Father for S. Maria Nuova (Fig. 62), the last work to issue from his shop (Dig. 274), in the statuettes in the niches and the heads in the *clipei* on the frame of the Gates of Paradise, even in a large number of figures in the panels of the Gates of Paradise one gets the impression that his style was swallowed up more and more by the depersonalized style of the workshop.

Without doubt Ghiberti himself was responsible for the design of all ten panels of the Gates of Paradise. The style of the reliefs, the principles of space and composition developed in such rapid succession, the consecutive phases grew out of each other so consistently, that no one else in the workshop, except the master—in fact no one else in Florence prior to 1437—could have brought the style to such maturity. No doubt, either, that the master himself had a decisive hand in modeling and chasing the main figures, particularly of the early panels: the superb figure of Cain being cursed (Pl. 86b), the groups of Isaac and Jacob, Isaac and Esau, the four women in the *Isaac* relief (Pls. 94, 96a, 97a) and the scenes of the Creation (Pls. 83a,b, 84). Yet, not even in these reliefs was Ghiberti responsible for all the figures and background settings; the group of the Sacrifice of Isaac (Pl. 93), the figure of God the Father in the upper right corner of the *Noah*, perhaps even Ham in the Drunkenness scene (Pl. 89) are the works of assistants. In the later panels, beginning with the *Joseph*, it becomes more and more questionable as to how much was done by the master himself. In the Distribution of the Grain (Pl. 99), the dominant group in the foreground, Joseph, the youth loading his camel, and the woman and child clearly manifest Ghiberti's mastery; so does the scene of the Recognition, at least in its outlines (Pl. 101a). On the other hand, the background scene of Joseph being sold to the Ishmaelites is such a poor composition that one hesitates to assume for it even the existence of a drawing from Ghiberti's hand. In the last group of reliefs, from the *Moses* to the *David*, the amount of assistants' work appears to increase. But even in these last reliefs a few figures or entire groups are by Ghiberti. At times they occupy the very foreground, such as the stone carriers in the *Joshua* (Pls. 108a, b) or the two main groups of disputants in the *Solomon* (Pl. 119), at other times the middle and background such as the dancing maidens in the *Moses* (Pl. 103) or the horses' heads of Joshua's quadriga (Pl. 109). But the majority of figures and groups in these reliefs are of inferior workmanship.

Assistant hands naturally become more evident in the chasing than in the modeling.

his shop, working out the changes these types undergo when transferred to a foreign milieu, such as Verona or even Arezzo; distinguishing original designs from *pasticcios*; finally assigning the pieces that turn out to be close to Ghiberti to the various phases of the master's development. All this requires, I feel, the writing of a new book. Thus I limit myself to listing the more recent bibliography: Bode, bibl. 58 and 59; Schottmüller, in Thieme-Becker, bibl. 517, XIII, pp. 541ff; Wulff, bibl. 559; Planiscig. bibl. 407, pp. 87f; Fiocco, bibl. 159; Goldscheider, bibl. 186, pp. 147ff; Valentiner, bibl. 529, *passim*.

Needless to say, the sequence in which the ten panels were chased in the years from 1437 to 1447 does not coincide with the order in which, during the first phase of work, they were modeled. The progress report of July 4, 1439 (Dig. 208; Doc. 24) lists, one recalls, the *Isaac* and the *Cain and Abel*, as completed, the *Moses* as nearly done, the *Joseph* as half finished and the *Solomon* as finished only in small parts. Apparently the nettoyage of the remaining five reliefs had not even started. By June, 1443 (Dig. 241; Doc. 40) a total of six reliefs had been completed and it seems safe to assume that this batch included the *Moses, Joseph* and *Solomon*. The remaining four reliefs were completed by August 1447 (Dig. 259; Docs. 20, 42).

The style and quality of chasing vary widely among the different panels. The *Cain and Abel* and the *Isaac* are superb (Pls. 87, 96a). Since they were done in the two years preceding July 1439, the very period when suspension of work on the Shrine of Saint Zenobius allowed Ghiberti a spell of freedom, probably he himself chased these firm yet soft bodies, the sculptural draperies, the beautifully fine faces, the full, short locks and precisely finished architectural settings. Chasing, after all, was an essential part of the goldsmith craft and Ghiberti remained a goldsmith throughout his life. Parts of the *Genesis* (Pls. 83b, 84) are finished with similar love, care and subtlety of feeling. This panel was chased in all likelihood between 1443 and 1447, when Ghiberti had completed the Shrine of Saint Zenobius and was free to return to work on the Gates of Paradise. In the other reliefs, the quality of the chasing is not so uniformly high and at times is outright poor. A detail, such as the animals in the *Noah* (Pl. 88b), can be superbly finished, with all the soft firmness of the main figures in the *Isaac*. Yet the family of the patriarch gathered in front of the Ark (Pl. 104a), while beautifully modeled, is carelessly chased. In the *Joseph* the group in which Joseph reveals himself (Pl. 101a) also combines beautiful modeling with a finishing which, to say the least, is indifferent; the scene of Joseph sold into captivity is not only weakly modeled and designed, but flabby and poor in the nettoyage. Comparable disparities mark the *Moses* and *Joshua*. In the *Solomon* (Pl. 116) the chasing of all the figures behind the immediate foreground is of surprising mediocrity. The finishing of the ornamental parts on the frame is likewise uneven: the bunches of leaves are at times carefully done in every detail, at other times their ribs are hardly sketched in and in still other places the chasing has been altogether omitted (Pls. 137a, b, c, d).

Throughout the Gates of Paradise, even within the presumably autograph panels, parts of the chasing were apparently entrusted to specialists. The trees with their starfish foliage and little feathery leaves appear to have been done by the same assistant throughout the panels. Another specialist may have been in charge of chasing all the angel wings. Some day, indeed, it may well be possible to differentiate the various assistants that participated in finishing the reliefs and even to identify some of them by name. In the *David* (Pl. 113) overemphasis on decorative details engraved with a burin is combined with an extreme hardness of chasing to form a highly characteristic pattern. This pattern is paralleled on the frame of the door in the three warrior prophets, Joab (Pl. 125b), Joshua (Pl. 129c) and Gideon (Pl. 129d). One is reminded of a painter and recalls that not only did Benozzo Gozzoli work on the door from 1444 to 1447,

while the last panels were being finished, but also that in his frescoes of 1452, for the Medici Chapel, he rendered with extraordinary love and minuteness the embroidery of garments and the silver mountings of saddles and harnesses. Another assistant stands out as a clear-cut, though nameless personality in the *Moses* and *Noah*. His dramatic way of chasing expressive strong faces, surrounded by a fuzzy halo of beard or hair manifests itself in the figures of Noah and his family leaving the Ark (Pl. 104a) and he appears to have chased in the *Moses*, the heads of the dancing maidens and of the young man next to them (Pl. 103), and the hosts of angels accompanying God the Father (Pls. 105a, b). His style recalls that of Donatello, and one wonders whether perchance after Donatello's departure for Padua in 1443 one of his helpers entered the rival shop of Ghiberti.

As in the panels of the Gates of Paradise, the overall design of the Zenobius Shrine appears to be Ghiberti's own. But of the figures in the main panel (Pls. 78a, 79a, b) only a few are superior in both modeling and chasing: the three *putti* near the left edge, the two women next to them, one with her veil billowing, the other seen from the back, and finally the turbaned man to the left of the main group. In the *Miracle of the Cart* (Pl. 77a) the figures throughout are inferior, both in modeling and finishing. But only a master's hand could have designed and modeled a figure as elegant and at the same time as forceful as that of the shocked servant standing at the left edge of the *Resurrection of the Servant* (Pl. 77b) his cloak flowing in a beautiful curve over his shoulder, his stance free and his head finely chased. All six angels on the back of the shrine are excellent in workmanship (Pls. 78b, 80a), but not all are superior in design, and clearly they are all variations on the theme of the flying angels in the Shrine of the Three Martyrs (Pl. 76).

The constant use and reuse of standard types becomes a hallmark of the workshop in Ghiberti's late years. Rarely, however, do these types appear as exact copies of anything. As a rule they are variations on an original motif, sometimes turning up shortly after the original, at other times reappearing after a lapse of many decades. The front panels of the Zenobius Shrine abound in such variations (Pl. 78a); a bearded man in the middle ground, bareheaded, his cloak taken up in his right hand, his head turned towards his right shoulder, is an adaptation of a figure in the *Joshua* panel (Pl. 107), the left front bearer of the ark. The bearded turbaned gentleman in the foreground repeats, with only slight changes, the pose and drapery of the young man who stands in the *Solomon* at the left of the group around "Ambrogio Traversari" (Pl. 116). The woman at the far left in the foreground finds her counterpart in the woman carrying the bundle in the *Joseph* (Pl. 99). The woman next to her, seen from the back, echoes, with some variations, Noah's daughter-in-law in the group of the sacrifice near the right edge of the *Noah* (Pl. 92). At times such variants take strange liberties with the original: the young man at the right edge of Noah's Sacrifice, himself a variation on an antique figure (App. A 35), reappears among the prophets on the frame (Fig. 126a), to the left of the *Noah*; the fall of the toga remains the same but he is transformed from a peaceful son of Noah to a wrathful prophet by the lifted arm and by the haggard face. The adaptation of the same motifs during nearly the same years is, however, less

surprising than their renascence after many years. God the Father, enthroned on the shutter of the tabernacle at S. Maria Nuova, Ghiberti's last work (Fig. 62), takes up *verbatim* the pose and drapery of the seated figure of Herodias in the panel of *Saint John before Herod* at Siena (Pl. 72). Apparently, after an interval of thirty-odd years, Ghiberti or his workshop would still reuse the same motif. A young man in the foreground of the Zenobius Shrine, looking towards the center and, wrapped in a wide cloak, resembles one of the prophets on the frame (Pl. 128c), but he is seen from the left rather than *en face*; although the execution is much harsher than that of the prophet, the ducts of drapery and rich cascades are the same. However, the small prophet has little in common with the majority of figures who people the panels of the Gates of Paradise or the niches of the frame. Together with the figures of Nathan (Pl. 130b) and Bileam (Pl. 130d) he represents a late derivative of the International Style formulas that had dominated Ghiberti's work shortly before and after 1410.

The constant reappearance of motifs in Ghiberti's repertory, at times long after he had discarded the stylistic concepts that had engendered them, makes sense only if one assumes that such motifs were preserved through model books belonging to the workshop. This indeed is the core of the problem. No such model books have survived, but they must have accumulated over the years, in time becoming filled with drawings of the workshop's products, with figures and studies from nature, copies from older model books and drawings made from the antique. Indeed, the dozens of antique motifs, figures, draperies and facial types that permeate the panels, prophets, and heads on the frame, must have been transmitted through model book drawings to which Ghiberti had constant recourse for use over and over again in various combinations: both the two women seen from the back in the Zenobius Shrine and the *Noah* (Pls. 79a, 92), go back to a Roman model, a figure on the frieze of the Nerva forum (App. A 34; Fig. 129); the woman with the children from this same shrine together with her counterpart in the Joseph story are apparently variations on a drawing of Medea from an antique sarcophagus (App. A 67; Fig. 136), and the wrathful prophet (Pl. 126a) on the frame of the door and his companion in the *Noah* mutually derive from the figure of a moira on a Roman wedding sarcophagus, different though they may seem from each other at first glance (App. A 35; Fig. 133).

In fact, these model books, almost more than his late works, account for the impact of Ghiberti's motifs on his contemporaries. The style of most of the panels of the Gates of Paradise influenced, one recalls, the art of the forties and fifties far more than art exactly contemporaneous with it. Motifs from these panels, on the other hand, were echoed in Florentine art much sooner, often at a date too early for the major parts of the door to have been cast. Yet these echoes *avant la lettre* are manifestly Ghibertian, their dependence on the master unquestionable. They fall into two categories: a figure or group may be taken over *verbatim* into the work of an inferior artist in much the same way that Giovanni Turini had taken over motifs from the North Door; or else premature echoes of the Gates of Paradise crop up in the work of first-rate contemporaries during the early or middle thirties or even the late twenties, though usually these variants are very free. Either category presupposes an acquaintance with Ghibertian

models before the Gates themselves had reached a finished state. Thus, early variants, in either case, could only have derived from drawings in the master's model books, leading one to presume that these books were accessible outside, as well as within, the workshop. Their existence and extensive use were presumably the basis for Ghiberti's remark in the autobiography that he had designed very many things for painters in his native city.

In fact, long before the doors were completed, Ghibertian motifs were scattered throughout the frescoes of the Chiostro Verde, from the *Creation of Adam* through the scenes of Abraham and Jacob.[3] God the Father in the *Creation of Animals* (Fig. 67), the first in the east wing series of the Chiostro Verde, reflects a Ghibertian figure. One of the angels in the *Abraham* (Pl. 93) has been suggested as a model, but the resemblance is perhaps not that specific.[4] Likewise the rock formations and tree types in this fresco, and the three following, the *Creation of Adam*, the *Expulsion* and the *Labors of Man* are generically, not specifically Ghibertian. But at least it is clear that the steep rocky peaks, diagonally leading into depth, the tall straight-stemmed trees with their conical crowns, the dense shady woods, are all reminiscent of the *Abraham* and the *Cain and Abel* (Pls. 85, 93, 106a, b; Fig. 70). Other resemblances are more specific. Adam in the Creation fresco of the Chiostro Verde (Fig. 70) is very close to Ghiberti's Adam in the corresponding scene on the Gates of Paradise (Pl. 83a) and the similarity has often been remarked upon.[5] The angel in the *Expulsion* (Fig. 68) corresponds almost literally to one of Ghiberti's designs: the posture, the quick movement, the right arm elegantly bent, the chiton of transparent material with its skirt billowing out behind the leg, the belt, high up below the breasts and the fall of the peplum, are all features which coincide with one of the dancing maidens in the *Moses* panel (Pl. 103). Equally, the figure of Hagar in one of the Abraham frescoes in the Chiostro Verde (Fig. 69) coincides trait by trait with the woman at the left edge of Ghiberti's Zenobius Shrine (Pl. 79a). Posture and drapery leave no doubt as to both the basic resemblance and the inferior quality of the Chiostro Verde version. In the fresco the posture turned stiff and rigid, and where Ghiberti made the drapery rich, falling in a straight cascade from the abdomen to the feet and billowing into a beautiful curve over shoulder and arm, the painter of the Abraham scene in the Chiostro Verde transformed the billow into a bag in which Hagar carries her few possessions. The three putti that toddle behind the woman in the Zenobius Shrine have given way to little Ishmael walking ahead of his mother. But this grouping of a mother preceded by her child also appears on the Gates of Paradise in the *Joseph* (Pl. 99). Indeed, Lot's wife in the adjoining bay of the Chi-

[3] Paatz (bibl. 375, III, pp. 719ff and notes 296ff) gives a concise description of the frescoes, the state of their preservation and their sequence on the walls of the cloister, adding an excellent survey of controversial opinions on their date and authorship, and a vast bibliography.

[4] Pudelko, bibl. 431, p. 238.

[5] See Paatz, bibl. 375, III, p. 810 and note 297, and Pudelko, bibl. 431, p. 238, note 16, for reference to the earlier bibliography. Pope-Hennessy (bibl. 421, pp. 5ff) compares the figure of the Lord in the *Creation of Animals* with Ghiberti's *Saint Matthew*, and God the Father and Adam in the *Creation of Eve* with the corresponding figures in the Gates of Paradise. He sees Adam in the *Fall of Man* of the Chiostro Verde as derived from the Eve in Ghiberti's *Temptation* and Eve in the same fresco from Ghiberti's *Expulsion from Paradise*. I am afraid that I remain unconvinced.

ostro Verde represents another variation on the figures of Hagar and on both the women in Ghiberti's Zenobius Shrine and *Joseph*.[6]

The poor quality of the *Abraham* scenes makes their attribution within our context a problem of secondary importance. But their date, possibly as early as 1430, is of relevance, and so is the date of the *Creation* scenes. They have been assigned more or less generally to Uccello and while the date is in doubt, it is in any event hardly later than 1431 and possibly as early as 1425.[7] The neighboring scenes of the *Expulsion* and the *Labors of Man*, while somewhat lower in quality, are still so close in style that the interval can be only short. In brief, the date of Ghibertian motifs in the Chiostro Verde precedes their appearance on the Gates of Paradise. Since Ghiberti would not have turned to the poorly designed Abraham scenes for inspiration, his figures, groups and motifs on the door were evidently known to the masters of the Chiostro Verde long before he incorporated them in finished form into the panels. In some cases the painters may have drawn on Ghiberti's early wax sketches, for instance, on that of the Creation scenes. But the great majority of Ghibertian motifs in the Chiostro Verde murals would seem to have derived from drawings that Ghiberti had assembled over the years, drawings of trees and rock formations, drapery and heads, and studies from the antique. Indeed, many of the motifs which the Chiostro Verde frescoes share with Ghiberti's panels

[6] Salmi (bibl. 460, pp. 176ff) and following him, Paatz (bibl. 375, III, p. 719 and note 299) suggest a master from the circle of Lorenzo di Niccolo, Pudelko (bibl. 432, pp. 76ff) the Master of the Bargello Tondo. Both scholars seem to accept a date of *ca.* 1430. Pope-Hennessy (bibl. 421, p. 141) credits Pudelko's attribution with "some plausibility," adding that the murals cannot "have been executed before the end of the first or the beginning of the second quarter of the fifteenth century" and thus probably preceded those on the east wall, including the Creation scenes.

[7] Paatz (bibl. 375, III, pp. 810 and note 297) has made a survey of prevailing opinions. Salmi (bibl. 463, pp. 14ff, 118) and Pudelko (bibl. 431, pp. 257ff) favor the attribution of the Creation scenes to Uccello. Salmi has suggested a date of about 1431, Pudelko 1430-1436. Both base these dates specifically on the dependance of the figure of Adam and others on Ghiberti's panels which Uccello could have known in the wax-model stage after his return from Venice. Pudelko (bibl. 432, pp. 71ff) attributes the *Expulsion* and the *Labors of Man* to Dello Delli, Salmi (bibl. 463, pp. 16f) to an inferior artist under Uccello's influence, possibly with an occasional helping hand from the master. But Pudelko's dating, 1446-1447, carries little conviction, and Salmi remains vague regarding the date of these frescoes. Pudelko (in his article in Thieme-Becker, bibl. 517, XXXIII [1939], p. 525) reaffirms the attribution of the Creation series to Uccello, but proposes to date them as early as 1425 and thus returns to a suggestion first made by Horne (bibl. 220, p. 229). Pope-Hennessy (bibl. 421, pp. 5ff and 141f) assigns the Creation scenes to Uccello, but dates them in the mid thirties, immediately before the Hawkwood fresco in the Cathedral. The neighboring bay he assigns to an Uccellesque artist, possibly Dello Delli (*ibid.*, pp. 158f). Millard Meiss, whom I have consulted on this question, holds that the Creation scenes are definitely by Uccello and possibly prior to 1431.

The problem obviously is linked to three factors: one, we are completely in the dark about Uccello's activity between 1415, the date of his matriculation in the painters' guild (see above, p. 109) and August 1425, the date of his departure for Venice; second, the marked difference in style between the Creation scenes and the Hawkwood fresco of 1436; third, the length of Uccello's stay in Venice. Granted that he left shortly after August 1425 (last will; Gaye, bibl. 173, I, p. 147); that in 1427 he had been away from Florence for over two years (*portata al catasto* reported in his absence "andassi con Dio piu di due anni fà ed è a Vinegia"); to reappear in a Florentine document in January 1431 (Poggi, "Paolo Uccello e l'orologio di Santa Maria del Fiore," *Miscellanea di Storia dell'arte in onore di Igino Supino*, Florence, 1933, pp. 323ff), need he have been absent the entire five and a half years from 1425 through 1431? Or is it not quite possible that he was back in Florence some time between 1427 and 1431 and painted in the Chiostro Verde? The question can only be solved through a new, thorough inspection and interpretation of the documents.

are taken from Roman sarcophagi: Hagar and Lot's wife in the *Abraham*, and the woman in the Zenobius Shrine and the *Joseph*; the angel in the *Expulsion* fresco, and the girl in the *Moses* panel (App. A 43, 67; 44). But certainly the master who designed the *Labors of Man* and the *Expulsion*, not to speak of the very minor masters of the *Abraham* stories, knew the antique models only second hand, apparently from Ghiberti's drawings.

This dependence on Ghiberti's model books is sharply illuminated by the three versions of Adam, respectively found in Uccello's fresco (Fig. 70) in the Chiostro Verde, in the *sinopia* underneath the fresco (Fig. 71)[8] and in Ghiberti's *Genesis* panel (Pl. 83a). Clearly the ultimate source for all three is a figure of Adonis (App. A 24, Fig. 122), possibly that on the sarcophagus in the Palazzo Rospigliosi from which Ghiberti also drew the dancing maiden for his *Moses* panel. The relative bearing of the Adonis prototype in these three versions will stand closer investigation.

Like Adonis, Adam in Uccello's two versions, the fresco and *sinopia*, sits almost upright, his leg in the foreground, stretched out stiffly where Adonis' leg was broken off at the knee, and like Adonis, he shows a gracefully opened hand. Uccello departs from the antique prototype on two major points: Adonis' supporting arm, though slightly bent at the elbow, descends vertically, while in both Uccello's versions of Adam the arm is stretched back and stiffened in a diagonal; last but not least, Uccello's Adam reverses the position of Adonis, from left to right. *Sinopia* and fresco are alike in all these points: however, an important difference exists between them. Adam in the *sinopia* is beardless like Adonis, whereas in the fresco he is bearded with hair parted in the middle like the Adam in Ghiberti's panel (and, incidentally, as also in the mural by Piero di Puccio in Pisa, Fig. 79). Ghiberti's Adam, on the other hand, is closer to the Adonis model in exactly those points where Uccello's differs: the bend of his arm, even the spreading of the fingers, are identical with the Adonis, and the position is not reversed. But Ghiberti's Adam leans farther back, his right leg slightly drawn up. Clearly the versions of both Uccello and Ghiberti are close to the antique model, but significantly they are not close in the same features. The beardless Adam of the *sinopia* would at first suggest that it was Uccello who furnished Ghiberti with a drawing of the Adonis or that both he and Ghiberti had known the original. But this is unlikely. In Uccello's work motifs from Roman antiquity disappear after the Creation scenes. Ghiberti's *œuvre*, on the other hand, is permeated with vocabulary and concepts *all'antica*. Thus a different solution suggests itself. It must have been Ghiberti who made a drawing from the Adonis which both he and Uccello used, each one introducing his own slight changes.[9]

Sketches from Ghiberti's workshop rather than wax models and the finished figures

[8] The *sinopie* of the Creation scenes, sketched in red, came to light when the frescoes were removed to the refectory in the west wing of the convent (Fig. 71).

[9] The figure of Adam, similar to those in Ghiberti's panel and Uccello's *sinopia* and fresco, appears again slightly changed among the reliefs of the center arch of St. Mark's in Venice, alongside a *Sacrifice of Isaac* which recalls both Ghiberti's competition relief and the corresponding scene on the Gates of Paradise. A note from Mr. U. Middeldorf confirms this observation. Regarding their attribution to Piero di Niccolo Lamberti or Niccolo Lamberti, see Fiocco, bibl. 160, p. 348 and Planiscig, bibl. 407, p. 54.

on the Gates of Paradise also explain the appearance of Ghibertian motifs in the early work of Luca della Robbia. The heads in the quatrefoils of Luca's bronze door for the Sacristy of the Cathedral are, in part anyway, literally copied from their counterparts on both of Ghiberti's doors; but the Sacristy door belongs, after all, to so late a period in Luca's life[10] that the appearance of Ghibertian motifs has little interest for the historian. Of far greater importance is Ghiberti's manifest impact on Luca's *Cantoria*, designed between the end of 1434 and December 1437.[11] When Luca worked on these reliefs he could have and apparently did know wax models and rough casts as well as sketches for Ghiberti's second door. Thus the naked dancing boy in Luca's choral panel, seen from the back, may well be based on the more or less completed version of Ghiberti's figure of Esau in the *Isaac* relief (Pl. 96a). Likewise, one of Luca's drummer boys, his right arm beating the drum, his shirt fluttering, a veil billowing over his shoulder, is close enough to the figure of Miriam on Ghiberti's door (Pl. 129a) to indicate a tie, despite the difference in sex and dress. The young girl at the far left among Luca's cithara players, in pose, drape of the cloak, the gesture of placing a hand on the shoulder of a neighbor, finds her counterpart in reverse among the four women in the *Isaac* relief (Pl. 97a). Yet, in every detail, in the folds of the drapery, in the bend of the body, Luca's girl is so very different from Ghiberti's that only a fleeting, overall resemblance remains. Throughout, Luca's figures appear like variants of prototypes from which Ghiberti too had drawn, and again, all the motifs that Luca's *Cantoria* has in common with the Gates of Paradise were apparently derived from sketches after the antique in Ghiberti's model books.

The use of model books, then, accounts for the widespread appearance of Ghibertian motifs at an early date. It explains as well their continuous reappearance in Ghiberti's own work and in that of his assistants. Also, to some degree, it explains the inconsistency of Ghiberti's figural style during the thirties and forties. Time and again one is struck by the visible contrast between the consistency of development in compositional, spatial, and narrative concepts and the equal lack of consistency in the design of figures for the panels and niches of the Gates of Paradise. To be sure, Ghiberti's figure style changes radically between the *Genesis* where draperies are soft and voluminous, and bodies overly slim, and the *Isaac* where figures, elegant and agile yet strong, stand in melodious poses. But this development did not continue into the late group of reliefs. Beginning with the *Joseph* a multitude of figures different in type and style stand side by side in the same panel: scattered about are faces both roundish soft and sharp-featured, draperies both thin and hard-creased and physiques tall and short, stiff and agile. Even the early panels show at times an intermingling of types: the two figures of God the Father in the *Genesis,* one in the Creation of Adam, the other in the Creation of Eve, differ vastly in facial types; drapery formulas and different stylistic concepts prevail in the twenty-four figures on the frame. Evidently all these different types stem from a wide variety of models. Trecento figures, Roman sarcophagi, life studies must all have been preserved as models in the model books of the workshop.

[10] Marquand, bibl. 302, pp. 195ff; Paatz, bibl. 375, III, pp. 532f and note 378.
[11] Poggi, bibl. 413, docs. 1240-1285; Marquand, bibl. 302, pp. 3ff; Paatz, bibl. 375, III, p. 603 and note 675.

Yet the inconsistency and variety within Ghiberti's late figural style rests on a deeper cause than either the use of model books or the fact that the largest share of work was assigned to assistants. No doubt the two factors are interlinked. Ghiberti was getting along in years. He had trained a dependable shop crew and he had only to put into their hands selected models from among the hundreds of drawings of types and motifs which he had collected over the years for eventual use. The reliance of the old, experienced master, both on his shop crew and on his "treasure chest" of conserved images, is nothing extraordinary. But, in Ghiberti's case, it coincides with an increasing indifference in his late years to the value of the individual figure or object. This indifference comes to the fore throughout the late panels where masses and crowds appear to have preoccupied him at the expense of single figures, stances, and draperies. This explains more than anything the reason for the fair amount of carelessness which strikes the beholder again and again when focusing on details, both in the late panels and on the frame. Ghiberti, it seems, relaxed his supervision and approved parts of the work which earlier he would surely have rejected, including the six prophets considerably smaller than the rest (Pls. 127a, b; 129b; 130a, b, d), and the almost unchased floral ornament.

The workshop was evidently developing into a large factory. Work on the panels and frame of the Gates of Paradise dragged on interminably. The shop crew was constantly changing, old hands leaving, and new hands, such as Gozzoli, being hired for a limited amount of time. It was inevitable that the quality of work should vary and, in spots, decline. More remarkable, however, than these divergencies in quality is the clarity with which the individual personalities of the assistants stand out, one from another, as well as from the master. Much in contrast to the North Door, Ghiberti no longer absorbed their individual contributions into his personal style to a degree that makes it impossible to differentiate, except by shades of perfection, their work from his own. In the Gates of Paradise, his personal dominance no longer seems to the same degree the common denominator. His loss of interest in the individual figure is at the root of his increasing reliance on old model books and assistants. Both this loss and the declining vigor of his late years coincide with a marked variety of style among the individual figures of the Gates of Paradise, which is as much the product of the workshop as of Ghiberti.

The depersonalization of the late style of Lorenzo's workshop in the years shortly before his death does not extend to the last major work executed by the shop, the frame around Andrea Pisano's doors at the Baptistery. To be sure, the contract was still made with Lorenzo late in 1452; but Vittorio signed it as a full-fledged partner (Dig. 288; Docs. 16, 50). Indeed it is doubtful whether much, if any, preliminary work on the frame was done by the time of Lorenzo's death. Payments for the frame at any rate get under way only in 1456 and continue until its completion, probably in 1463 (Digs. 296ff; Docs. 77, 51, 78, 68, 9, 69, 123). More important the style of the frame both in figures and floral decoration is novel in design, crisp in execution, and reveals a fresh approach, very different from the last parts designed and executed for the Gates of Paradise. To be sure Lorenzo's model books were further exploited: obviously the figures of Adam and Eve far down on the jambs of the frame draw on antiques used by

Lorenzo (Fig. 128) (App. A 27). But their style is new. Whether it is Vittorio's style alone or whether the collaboration of Antonio Pollaiuolo and possibly other members of the workshop played a significant part, the frame of the Andrea Pisano door initiates a new phase of sculptural design which was to determine to a large degree the development of Florentine sculpture in the second half of the fifteenth century. But thereby hangs another tale.

CHAPTER XV

GHIBERTI AND THE TRECENTO

THE ten panels of the Gates of Paradise represent the crowning achievement of Ghiberti's life. All his long experience went into designing them; yet they reveal the astonishing freshness of mind of a man who, at nearly sixty, evolved a new art permeated by and emulating that of antiquity, an art based on new principles of composition and working with new scientific tools, such as linear perspective. However, these same panels also reveal, rather unexpectedly, the impact of the Trecento on Ghiberti's late style.

It has often been remarked that a preponderant place is assigned in the *Commentarii* to painters of the fourteenth century and especially to those of Siena. Ambrogio Lorenzetti is given first place among them.[1] This particular outlook on the history of art was not just a quirk on Ghiberti's part. It should be viewed in the context of his life during the thirties and forties when, simultaneously, he completed the Gates of Paradise and began preparing the *Commentarii*. It seems that at this point the great painters of the preceding century loomed before him as giants.

In his early years this idea need not have occurred to him quite so consciously. In those far-away days the art of the Trecento as he encountered it in the goldsmiths' and painters' workshops of his native town and through Tuscany, meant fundamentally little to him. The outlook of the Trecento artists was so different from his own that any closer contact was precluded. At the same time, because he had grown up in the milieu of these artists, he did indiscriminately draw, as a matter of course, upon occasional motifs and formulas from their outmoded tradition. In so doing he cared little about whether these elements were more at home in Florence or Siena, and it did not occur to him to consider whether they were new or obsolete.

In the Competition relief and the *Nativity* rocky spurs project into the foreground and thus separate the plaques into two scenes each, a device frequent in the work of Agnolo Gaddi and his shop (Fig. 72).[2] From Taddeo Gaddi's quatrefoil, *Christ Among the Doctors* (Fig. 73), painted two generations earlier, Ghiberti bodily transferred the entire architectural setting to his *Pilate* (Pl. 48): an apse, a straight wall with tracery windows and, above and in back of it, another diagonal wall.[3] Mary presenting the Child to the adoring kings is seated under the usual spidery canopy sheltering her in

[1] Ghiberti's admiration for the painters of the Sienese Trecento has been pointed out frequently (Schlosser, bibl. 477 *passim*; Sinibaldi, bibl. 494). In two seminars given at Yale University in 1952 and at the Institute of Fine Arts, New York University in 1953, I have tried to establish more precisely his relationship to fourteenth century painting and many observations in this chapter I owe to the participants in these discussions, in the first place to Mr. Paul Etter, Yale University, Mr. Joseph Polzer, Miss Mary Ann Rukavina, and Mrs. Mary Lee Thompson, New York University.

[2] Agnolo Gaddi's frescoes, both in the main apse of S. Croce and in the Castellani chapel, abound with that motif; see Salvini, bibl. 464 *passim*. Mr. Marvin Eisenberg was good enough to point out to me the resemblance of the settings in Agnolo Gaddi's and in the early work of Ghiberti.

[3] The near identity of the two settings was observed by Mrs. Mary Lee Thompson, see above note 1.

any *Adoration of the Magi* of the waning Trecento, whether Florentine or Sienese. The *Assumption of the Virgin* which in these early years Ghiberti had designed for the main oculus of the façade of the Cathedral, was probably derived, one recalls, from Bartolo di Fredi's Montalcino Altarpiece (Figs. 7, 8). Off and on an individual figure reveals itself as part and parcel of the vocabulary customary in the painters' studios of the late Trecento, as for instance the cloaked and turbaned man who on the right edge of the *Pentecost* scene turns his back to the beholder (Pl. 54). Ghiberti, in those early years, seems to have leaned rather heavily on iconographical prototypes which, for generations, had been common to painters' workshops in Florence.[4] The ultimate source for scenes like the *Resurrection, Pentecost* and *Christ in the Storm* (Pls. 53, 54, 36) is Andrea da Firenze's cycle of 1360 in the Spanish Chapel; but such cycles later were widespread in Florence. However, more often than not, Ghiberti turned to formulas which had been obsolete in the workshops of his town since the middle of the Trecento. In the *Nativity* (Pl. 27) he spurned modern representations in which Mary either kneels and adores, or nurses Christ at her breast; instead, he favored an older type in which Mary is shown reclining, her head slightly bent so she can gaze down at the infant, a formula, originally Byzantine,[5] which had survived into, indeed through, the four-teenth century. But it was decidedly old-fashioned when around 1405 young Ghiberti took it up.[6] The *Baptism* abounds in Trecento features. The rocky prop, the gnarled tree behind the Baptist, and the Baptist's outstretched arm, recall Andrea Pisano's quatrefoil (Pl. 32; Fig. 35).

In a few of his early reliefs, Ghiberti seems to have drawn upon models of the early Trecento—indeed, the late Dugento. In *Christ Among the Doctors*, Christ is enthroned in the center; his parents enter from one side, while one of the rabbis turns to look at them. This compositional scheme is a formula transmitted from Giotto to some of his closest followers; but already Taddeo Gaddi (Fig. 73) had modified it by shifting the figure of Christ to one side, and only in this form did it survive through the second half of the Trecento. The *Annunciation* (Pl. 25) manifests more antiquated elements: in the presentation of Gabriel floating towards Mary, who awaits him beneath a diminutive canopy, Ghiberti reintroduced a compositional type that seems to have been outmoded in Florence for nearly a century.[7] Considering these circumstances, it is little wonder

[4] Albrecht (bibl. 15, pp. 26ff) has made an attempt to determine the iconographic family tree of Ghiberti's reliefs on the North Door. She sees as derived from a general Byzantine and Sienese Tre-cento tradition the *Transfiguration*, the *Baptism*, the *Flagellation*, the *Arrest* and the seated *Church Fathers* and *Evangelists*; from Giotto's Arena cycle directly the *Last Supper* and the *Expulsion*; from Giotto by way of his Florentine and Sienese followers, the *Adoration of the Magi, Christ in the Storm*, the *Entry, Lazarus, Christ among the Doctors* and the *Way to Calvary*; from Duccio, the *Pilate*, the *Mount of Olives* and the *Temptation*. Post-Giottesque Florentine types, according to Miss Albrecht are: *Pentecost* and *Resurrection*; Sienese Trecento types, the *Annunciation* and the *Crucifixion*. The *Nativity* with Mary gazing down on the Child, Miss Albrecht believes is derived from north of the Alps; see however below, note 5.

This segregation of groups is possibly too precise. In particular, it would seem that Miss Albrecht has overstressed the direct influence of Giotto while underrating the importance of the fusion in Florentine painting of the late Trecento of Giottesque and Sienese elements.

[5] Meiss, bibl. 317, pp. 39ff. [6] Cornell, bibl. 107 *passim.*

[7] Robb (bibl. 447, pp. 487f, note 35, with reference to a study by Millard Meiss, then in prepara-tion) discusses this *Annunciation* type in which the angel's flight is suggested by levitation of the

that the greatest Florentine cycle of the late thirteenth century, the mosaics in the Baptistery, is reflected in the iconography of the North Door. In the same sequence as that in which they appear on the bottom row of the North Door, bishop, hermit, pope, and bishop, the four church fathers are lined up one after the other at the feet of Christ in the mosaics of the Baptistery. They are even identified by name: the bishop on the left is Saint Augustine, the one on the right is Saint Ambrose.[8] This same cycle also contains a clue to the identity of the forty-eight heads on the lattice frame of the North Door. They are, no doubt, prophets, their placement at the corners of the panels corresponding to the points from which they gaze down in many a quatrefoil in Florentine Trecento murals of the life of Christ. After the fashion of Trecento prophets, Ghiberti's are frequently bearded and turbaned. Yet, the large number of them on the door, forty-eight, is unusual. It finds a near equivalent only in the series of forty-two prophets on the parapet of the gallery inside the Baptistery.[9] Furthermore, in both the thirteenth century cycle and on Ghiberti's door, forty-one of the prophets are male. Nor is it mere coincidence that in both cases David and Solomon are crowned, or that three of the helmeted heads on the door find counterparts in three warrior prophets in the mosaic, Joshua, Serubabel and Juda Maccabi. Also, the one lonely prophetess inside the Baptistery, Hannah, makes a conspicuous figure on the door. Younger prophetesses, for whom no prototype exists in the mosaic, compose the rest of Ghiberti's female heads. To assign names to these extra prophetesses is impossible, just as it is for the majority of Ghiberti's male prophets. Even so, there is little doubt but that the mosaic cycle in the Baptistery largely determined Ghiberti's first series of prophets.

One wonders at times if Ghiberti intentionally revived such obsolete motifs and formulas. The greater likelihood is that in those early years he acted out of sheer indifference to iconographical problems which were never to rank high in his thinking, even later. The selection of scenes from Christ's life and their sequence on the door is

walking figure. Meiss (bibl. 315, pp. 55ff) has localized the origin of the type in the workshop of Ambrogio Lorenzetti. See also Firestone, bibl 161.

[8] Planiscig (bibl. 404, figs. 4 and 7) should be correspondingly reversed.

[9] A series of prophets was almost a prerequisite for the scheme of any New Testament cycle, the more so, since this particular cycle was intended for the church of Saint John the Baptist. All the earlier prophets and their sayings lead up to the *Ecce Agnus Dei*, the last prophecy to precede Christ's Sacrifice and the last one to point to His mission: "Fuerunt prophetae ante Joannem et multi et magni et sancti, digni Deo, Dei pleni, Salvatoris praenuntiatores, veritatis attestatores. Verumtamen de nullo eorum dici potest quod dictum est de Joanne 'in natis mulierum nemo exsurrexit usque Joannem Baptista.'" (Saint Augustine, *Sermo 288, P.L.* xxxv, cols. 1302f, with reference to Matthew 11:11.) The Baptistery cycle comprises the sixteen canonic prophets; Enoch and Noah, the patriarchs; Moses; Joshua and Samuel; David and Solomon; Elias and Elisha; Baruch, Ezra, Nehemia, and Serubabel; Matthatia and Juda Maccabi; down to such relatively unknown figures and prophetic collectives as *Onia filius* and *Hic Filii Josedei* (?) (see also Gori's list, *BMF, A 199, I*, pp. 233ff). In addition, to these thirty-six, six more prophets adorned the parapets of the organ loft, until a few years ago. They are now preserved in the storeroom of the Museo dell'Opera di S. Maria del Fiore and appear to be eighteenth century reproductions of thirteenth century (?), five of them New Testament figures who recognize the Savior prior to His Baptism: Hezekiah, Simeon, Hannah, Joseph, Zachariah, finally John the Baptist; the entire cycle, then culminates, as indeed it should, in the figure of Saint John.

Regarding the impact of the Baptistery mosaics on Andrea Pisano's door, see Falk-Lanyi, bibl. 152.

commonplace. The program of the Gates of Paradise is interesting for the simple reason that its author was not Ghiberti, but a learned theologian. Ghiberti remained throughout his life innocent of iconographical subtleties. In his autobiography he referred to the prophet heads on the North Door as just "human heads."[10] Likewise, formulas for the great majority of his New Testament scenes were simply those at hand in Florentine workshops.

There emerges, nonetheless, one exception to this indifference. When the time came for Ghiberti to design the most dramatic episodes of the Passion, from the *Last Supper* through the *Way to Calvary*, he turned his back on conventional Florentine formulas and, instead, focused on Sienese models of the first half of the Trecento. In particular, the *Last Supper*, the *Flagellation* and the *Way to Calvary* (Pls. 42, 45, 50) recall both in details and composition Ugolino da Vieri's enamels on the reliquary of the SS. Corporale at Orvieto. These enamels, in turn reflect the influence of Pietro Lorenzetti and his school.[11] The stance of the left-hand executioner and of Christ in the *Flagellation* point to the corresponding scene on the enamel as prototype (Fig. 49).[12] In the *Way to Calvary* Christ carries an enormous cross, while a soldier seen from the back restrains Mary, John and the crowd behind them with his shield. Again the entire composition almost exactly mirrors the same scene on the Orvieto reliquary (Fig. 74). In the *Last Supper* the apostles are seated in two rows parallel to the front plane, a seating arrangement which corresponds to the representation on the enamel (Fig. 75). In particular the architectural setting of the *Last Supper*, a hall with large tracery windows and a strongly accentuated *cavetto* ceiling, was carried over with exactly the same features, though reshuffled, into Ghiberti's quatrefoil. None of this necessarily means that Ghiberti drew specifically upon the reliquary for his compositions. More likely he was impressed by a fresco cycle, probably one by Pietro Lorenzetti or his workshop, which had also served as a source for Ugolino's enamels. In fact, Ghiberti's *Entry* is even closer to Pietro Lorenzetti's fresco of the same subject in Assisi[13] than to the reliquary's

[10] Ghiberti-Schlosser, bibl. 178, I, p. 46. Vasari, who erroneously identified the female heads as sybils, was nevertheless fully aware that the male heads represented prophets (bibl. 533, II, p. 229).

[11] Venturi, bibl. 534, IV, pp. 937ff; Toesca, bibl. 522, pp. 899ff. Schmarsow (bibl. 483, I, pp. 179ff and II, pls. 124ff) with a full set of illustrations, has established the probable dependence of the enamels on designs by Ambrogio Lorenzetti.

Albrecht (bibl. 15, pp. 33ff) was the first to point out links between some of the quatrefoils on the North Door and the Orvieto reliquary. She lists the corresponding scenes as *Christ among the Doctors*, the *Arrest*, and *Pilate*. None of these comparisons is convincing. Strangely enough, she disregards the parallels that exist between Ghiberti's *Last Supper*, his *Flagellation*, and his *Way to Calvary* and the Orvieto enamels. In Miss Albrecht's opinion both the *Last Supper* and the *Way to Calvary* derive from Giotto, while the *Flagellation* simply follows a Sienese tradition. But the seating arrangement in two rows of the apostles in the *Last Supper* is not confined to Giotto's Arena fresco; the *Way to Calvary* as Ghiberti presents it, has little to do with Giotto, and the *Flagellation* is not so much related to an overall Sienese tradition as specifically to the Lorenzetti workshop.

Ghiberti's *Crucifixion*, contrary to prevailing opinion, does not necessarily draw directly upon a Sienese prototype. The representation with Mary and John alone, crouching under the Cross, had, it is true, apparently originated in Siena. But it also entered Florence in the days of Bernardo Daddi and became common during the later Trecento beside the more traditional formulas (Offner, bibl. 370, III, 4, p. 55; Shorr, bibl. 493, pp. 68f; see also Albrecht, bibl. 15, pp. 26ff).

[12] See also above, p. 129, note 17.

[13] De Wald, bibl. 126, pp. 151ff with attribution of the cycle to the school of Pietro Lorenzetti.

version of it: the disciples, densely ranged behind Christ, press forward from the upper left through a rocky gorge, and the people stream from the city gate to greet him in the foreground, instead of pressing forward from the upper right. Likewise, in the *Arrest* the dense crowd, the background filled with halberds, torches and ensigns, indicate a Sienese model: the type was first developed by Duccio, then taken over by the Lorenzetti workshop and thus handed down to Barna and his followers in the second half of the century. Ghiberti, then, appears to have turned to a specific Sienese cycle, possibly of Pietro Lorenzetti's design, for the late quatrefoils on his first door.

None of the quatrefoils in which these Sienese elements are fully absorbed dates prior to 1416. In that year Ghiberti paid his first official visit to Siena. He had then, if not before, a good opportunity to make a more than superficial acquaintance with the work of the great Sienese masters, notably of the Lorenzetti. At that time he rejected indiscriminate and random dependency on the Florentine workshop tradition and made, it appears, a conscious effort to select iconographical models from a cycle outside his native habitat. What is more, this cycle belonged to the early Trecento. Ghiberti was looking back, it would seem, into the distant past. Reasons for this change are not clear. Perhaps it was the dramatic representation of the Passion that attracted him, or possibly traces of the art of antiquity lingering in the Lorenzetti workshop. Or else it might have been the high quality of the Lorenzettis' work that won his approval. But all this is guess work; only the fact of such influence is discernible and indisputable.

Far more strongly, however, than in the last quatrefoils of the North Door, the Sienese note is sounded in the Gates of Paradise. It is revealed in the overall pattern, in the vast scenic settings and in the simultaneous presentation of successive narrative episodes in nearly every one of the panels. Indeed, the impact of the great Sienese masters of the early Trecento as much as that of the art of antiquity shapes Ghiberti's late style in the panels of that door.

The very pattern of the Gates is unusual: two vertical columns of broad rectangular panels cover the surface of each wing, flanked by pairs of figures set into niches on the frame. It departs from the traditional medieval pattern for bronze doors in Italy, as exemplified by the bronze doors of Bonanni in Pisa and Monreale, by Andrea Pisano's door and by Ghiberti's first. On the other hand, this pattern was common enough to altar retables in Siena. The back of Duccio's *Maestà* is covered with rows of broad narrative panels which, in the predella, are flanked by standing figures. Similarly, vertical rows of narrative panels cover the opening wings of the reliquary of the SS. Corporale, while tiny figures of prophets have been pushed onto the framing pier buttresses. The history of Sienese painting repeated this pattern time and again, forever introducing variations to it.

Sienese elements are unmistakable in the presentation of the narrative and in the scenic and architectural settings of the panels. Narrative and settings are closely interwoven: vast landscapes, terminated by rolling chains of hills in the far distance, dense groves of trees leading diagonally into depth, and judiciously disposed architectural settings, lend support to the action; small groups of figures are scattered through the landscapes of the early panels; larger crowds are distributed in the foregrounds of the

late panels; supporting scenes which lead the eye far into depth are spread throughout the hills and buildings. None of these elements is typical of Florentine art of the closing fourteenth and early fifteenth centuries. Florentine painters, from the early fourteenth century on, were apparently averse both to presenting in one panel a number of successive scenes and to composing a setting of either architecture or a wide and deep landscape. The tradition established by Giotto tended, on the contrary, towards what has been termed an "aggregate" pattern in which the successive events of a continuous narrative are assigned individual panels laid out in superimposed rows.[14] Also, Florentine artists were inclined to favor settings wherein figures, acting on a narrow front stage, are set off against a sparse background of barren crags, an occasional rocky spur projecting into the foreground. Except for the generation between 1340 and 1370, especially except for Andrea da Firenze and his followers, this type was prevalent in Florence during the first third of the fourteenth century, the generation of Giotto and his pupils, and during the last decades of the century, manifestly in the workshops of Giovanni da Milano, Niccolo Gerini, and Agnolo Gaddi. Throughout the Trecento the painters of Siena knew and applied formulas similar to those popular in Florence. But alongside the "aggregate" type of pattern, they cultivated an antithetical trend of presentation, beginning in the second quarter of the Trecento and continuing well into the second half of the century. The scenic settings tend to be deep and filled with a rich variety of hills, towns and fields, with trees scattered all over, singly or in groves; the architectural settings are complex and spacious. Lorenzetti's murals of *Good and Bad Government* are the outstanding examples and high point of this Sienese tradition (Fig. 76). On a "composite," as opposed to "aggregate," pattern, each fresco panel incorporates the greatest possible number of events, with the action distributed in many groups throughout the architectural settings and over deep and wide landscapes filled with rolling hills and broad valleys, the horizon rising high and leaving but the narrowest strip of sky. Among hills, valleys and buildings are scattered the various scenes of the story, thus forcing the beholder to let his eye wander from one to the next and in these wanderings to absorb the expanse of space.

Ghiberti's admiration for the painters of Siena of the mid-fourteenth century, and in particular for Ambrogio Lorenzetti, recurs time and again throughout the *Commentarii*. He dramatically describes one of Ambrogio's frescoes in which, through numerous scenes, was represented the story of Saint Louis of Toulouse and the Franciscan mission to Morocco. It covered one entire wall of the cloister (or possibly the chapter house) of S. Francesco in Siena and it showed ". . . how a youth (that is the Saint) decides to turn friar and take up the holy habit; how a group of brethren ask for leave to work among the heathen; how they leave and preach and are brought before the sultan; how they are whipped and how the executioners relieve one another, sweating, their hair matted; how the bystanders look on, and how the brethren are sentenced to hang, how they are decapitated and how, then, a tempest rises with lightning bolts, thunder claps and a hail storm; how the trees are bent to the ground and

[14] Isermeyer (bibl. 227) in what seems to me a good analysis, has stressed these differences in composition between Florentine and Sienese painting.

the High Justice is thrown from his horse and how, as a result, a large crowd is baptized."[15]

The fresco is lost, save for a few fragments, but Ghiberti's loving words convey a fair idea of what it looked like and of what qualities led him to describe it with such boundless wonder. Covering a long wall, the scenes apparently followed each other, scattered among architectural and scenic settings in a pattern similar to Ambrogio's murals in the Palazzo Pubblico. Like them, they were apparently not divided by ornamented borders. But in contrast to the frescoes of *Good and Bad Government*, the murals in San Francesco apparently did not present simultaneous events, but rather *effetti* arranged in the successive order of a continuous narrative. The iconographic content of the story was again of little interest to Ghiberti. Either he did not know or he did not bother to find out that the youth who turned friar was Saint Louis; nor did he care that the stories of Saint Louis and the missionaries were two entirely unrelated narratives. He was impressed by the dramatic force of the narrative, the convincing show of reality, its epic tightness, the liveliness and lifelikeness of the presentation and by the ability to create rich compositions. What is more, he apparently thought of himself as the one upon whom Ambrogio's mantle had fallen. It is only Ambrogio's paintings that he analyzed with the same loving attention to detail that he gave to descriptions of his own Gates of Paradise. Only in describing Ambrogio's frescoes and his own panels did he lay stress on the rich compositions, the large crowds of bystanders, the continuous development of the narrative. Only for Ambrogio's paintings did he employ expressions identical to those he used when speaking of the Gates of Paradise, such phrases as "istoria molto copiosa" and "fu nobilissimo compositore." Again, only Ambrogio and himself among the moderns did he call experts in the *teorica dell'arte*, directly referring to Ambrogio as such, and by implication, to himself. The exact meaning of the term is unknown. It vaguely defines the science underlying the art of both sculpture and painting, the science which is "the origin and foundation of both arts," that is of sculpture and painting. But whatever it meant, the term was of fundamental importance within Ghiberti's vague theory of art and thus it must be stressed that he employs it in the *Commentarii* only with reference to the ancients, to himself and to Ambrogio Lorenzetti.[16] No wonder then, that the panels of the Gates of Paradise, with their many successive *effetti* scattered over wide landscapes, generally call to mind murals which Ambrogio Lorenzetti and his contemporaries had created in Siena eighty years before.

The presentation in one panel of a number of successive scenes of a continuous narrative seems to have undergone a general revival in Florentine art during the decade 1425-1435. In the *Tribute Money* of 1426 or 1427, Masaccio placed his two main *effetti* in the foreground plane, Christ, the disciples and the gatekeeper on the left, Peter and the gatekeeper on the right—in other words, the opening and closing epi-

[15] Ghiberti-Schlosser, bibl. 178, I, pp. 40f; II, pp. 142f. See also Sinibaldi, bibl. 494, and regarding the remnants of the fresco, Van Marle, bibl. 301, II, pp. 385ff, figs. 254ff and Toesca, bibl. 522, p. 588.

[16] Ghiberti-Schlosser, bibl. 178, I, pp. 4, 5, 8, 31, 41, 45; II, p. 202.

sodes of his story. The intermediary scene, Peter taking the stater from the mouth of the fish, is relegated to the background as an auxiliary *effetto*, hard for the eye to discover. The arrangement is not dissimilar to certain panels of the Gates of Paradise, as witness the *Noah* (Pl. 89). Donatello, at about the same time, seems to have employed for his Salome relief a continuous narrative in which the background figures hint at the successive events that culminated in the dance taking place on the forestage.[17] All three, then, Masaccio, Donatello, and Ghiberti, within the course of five odd years, fell back on the method of presenting a continuous narrative which, a century earlier, had dominated the art of the Sienese masters. Thus there would seem no certainty that Ghiberti was the first to revert to Sienese models. Indeed, the chronological sequence of pertinent works, the *Salome, Tribute Money*, and Gates of Paradise respectively, weighs against this assumption. On the other hand, both in distribution of *effetti* and in treatment of landscape setting, Ghiberti's panels come closer to Sienese prototypes than do the compositions of Masaccio and Donatello. Ghiberti, by and large, was inclined to relegate key events to the background, while attracting the spectator's eye through byplay in the foreground, such as Cain's ploughing, the four women visiting Rebecca, or Abraham's servants. At the same time the scenic setting is composed not of a few barren far-away hills, with three or four isolated trees leading into depth, such as in the *Tribute Money*, but of conical crags or steep cliffs interspersed with dense groves of trees and terminated by rolling mountain ranges.

To be sure, Ghiberti's compositions and landscapes do not find their most immediate parallel in the few remaining fragments of Ambrogio Lorenzetti's frescoes. Needless to say, the majority of fresco cycles by the great Sienese masters of the early Trecento are lost, and only to a limited extent are they reflected in predella paintings by the same masters and their workshops. In fact, these cycles are equally reflected, though often weakly, in fresco cycles by minor masters from Sienese territory of the second half of the century, as witness Bartolo di Fredi's Old Testament series in San Gimignano.[18] Finally, they found reflection around and shortly after the middle of the century in what might be called the satellite centers of Sienese art: the workshop of Andrea da Firenze in Florence, most particularly the frescoes of the Spanish Chapel;[19] and Pisa where Sienese influence prevailed from the forties to the nineties, manifest in the large murals covering the walls of the Campo Santo, from Francesco Traini's monumental *Trionfo della Morte* and *Thebais*[20] to Pietro di Puccio's scenes of *Genesis*.

Indeed, the cycles of Pisa, the Spanish Chapel and San Gimignano are, in many respects, nearer to Ghiberti's panels on the Gates of Paradise than to what little survives of Ambrogio Lorenzetti's work. In the murals of *Good and Bad Government* the landscape forms a wide plain from a knoll occupying the front stage, to the rows of distant hills, one chain extending beyond the other. Thus, while in general appearance

[17] H. W. Janson, generous as always, has pointed out this parallel in one of our many conversations.

[18] Faison, bibl. 150.

[19] Meiss, bibl. 317 *passim*; Van Marle, bibl. 301, III, pp. 425ff, figs. 243ff.

[20] Meiss, bibl. 318.

this landscape resembles Ghiberti's scenic settings, in specific details it does not. On the contrary, Andrea da Firenze's murals in the Spanish Chapel, a culminating point of Sienese impact on Florentine painting, recall in more than one detail the late panels of the Gates of Paradise. Like Andrea's *Via Veritatis* (Fig. 77) and *Crucifixion*, Ghiberti's *Joshua* (Pl. 107) is built up in superimposed tiers to resemble a tapestry. A dense crowd moves across the front stage and is closed off by a steep rocky wall. A small crowd, surmounted by a few trees, marks a ledge in the middle ground which intimates further extension into depth. Finally, a terrace above the rocky wall creates a second register, a terminating scene, either the Crucifixion or the Blessed in Paradise, arranged in a long horizontal band, as are in Ghiberti's panel the people of Israel whom Joshua leads around the crumbling walls of Jericho. Further back in the *Via Veritatis* soft rolling hills, crowned by structures and trees, terminate the scenery, pushed high up against the horizon, recalling the similar layout of Ghiberti's *David* (Pl. 112). Traini's murals in Pisa, the *Trionfo della Morte* and the *Thebais* (Fig. 78), on the other hand, more closely recall the earlier panels of Ghiberti's door, *Cain and Abel, Noah, Abraham, Moses* (Pls. 85, 89, 93, 102). As in the *Cain and Abel*, the front stage is cut off by steep conical crags, and only in the distance are the shapes repeated by rounded mountain chains. Dense groves of trees fill the ravines between two crags and lead the eye from plane to plane. Ramplike paths lead upwards and backwards into the depth of the rocky landscape. The last mountains are clearly outlined against the high horizon. Such resemblances to the earlier panels frequently crop up in the murals of the Campo Santo. They are to be found also in the three *Genesis* frescoes which, between 1389 and 1392, were painted by Piero di Puccio from Orvieto, a disciple of Ugo di Prete Ilario from Siena (Figs. 79, 80).[21] Poor though these murals are, they still reflect, both in narrative and scenic setting, principles of the great Sienese tradition. At the same time, they come closer perhaps than the earlier and far superior work of Traini to elements which later contributed to the Gates of Paradise. In the fresco of the *Creation*, as in Ghiberti's panel of the same subject, the horizon is low and the story is arranged in two registers: Adam, who raises himself, resting his weight on one arm, his fingers splayed on the ground, is very like Ghiberti's Adam; the Lord, followed by the angelic host, approaches the tall Gate of Eden from high up. In the fresco depicting the story of Cain and Abel (it also includes the story of Lamech), tall conical crags fill the scene; groups of trees lead into depth; narrative episodes are scattered among the rocks and ravines, very much as in Ghiberti's corresponding panel. Also similar in Piero's *Noah* mural to Ghiberti's relief (Pl. 89), a drowned corpse sprawls in front of the Ark and the Lord who, extending his promise of reconciliation to the patriarch, is represented as a half figure protruding from the ground.

True, it is hard to imagine how Ghiberti could have found in the coarse daubs of Piero di Puccio inspiration for the superb figures peopling his Gates of Paradise. This question indeed constantly arises in connection with Ghiberti's relations to Trecento Siena. The Old Testament cycle which Bartolo di Fredi executed in the

[21] Van Marle, bibl. 301, v, p. 262, figs. 172f.

Collegiata in San Gimignano (Figs. 81-83) is, to say the least, of indifferent quality. Nonetheless, Ghiberti turned to these murals for a number of the motifs that appear in his panels: Abel, in the scene of the slaying, toppling over and trying to support himself on both arms; Cain receiving the Lord's curse, represented in Bartolo's mural as standing at the right edge, his staff in hand; Noah, lying drunk, his left arm resting on his thigh, his legs oddly twisted, the left flexed and raised, the right bent so as to enclose a diamond shape. In Bartolo's *Passage through the Red Sea* a woman carries a child in her left arm, his cheek pressed against hers; the same pair appear in Ghiberti's *Moses* (Pl. 102). Indeed, even the overall composition of Ghiberti's *Moses* follows to some extent the fresco in San Gimignano, in the steep shape of the mountain, the crowds assembled in the foreground, the conical roof tents on the right, surmounted by globes. By and large, however, the expansive scenic settings of the Gates of Paradise have nothing in common with the narrower landscapes of Bartolo di Fredi, spotted as they are with a few rocky props. What Ghiberti seems mainly to have drawn from Bartolo's San Gimignano frescoes are individual figures in strange poses.[22]

Needless to say, in Ghiberti's hands the awkward figures offered by Bartolo di Fredi took on new life. They have shed their Trecento garments, they stand and lie in elegant poses, monumental despite their smallness. Indeed, time and again one wonders whether Ghiberti really used the murals in San Gimignano or, for that matter, those of Piero di Puccio in the Campo Santo. To be sure, in the *Commentarii* he cited the Old Testament cycle in San Gimignano, but instead of to the second-rater, Bartolo di Fredi, he attributed it to Barna da Siena who had executed the superior New Testament scenes.[23] Ghiberti's confusion on this point may easily have resulted from a sexton's misinformation or from a faulty note in his own sketchbooks. Piero di Puccio's name, needless to say, is missing from the pages of the *Commentarii*. Nor is there mention of Andrea da Firenze's frescoes in the Spanish Chapel or of Traini's in Pisa. Obviously Ghiberti meant to limit his comments to the best works he could think of, and apparently not even Francesco Traini's or Andrea da Firenze's frescoes were, in his eyes, worthy of this top category. Who knows, we might feel the same if the paintings of Ambrogio Lorenzetti which Ghiberti knew were still in existence. Sienese works of the later Trecento are, after all, pervaded with motifs handed down from great masters of a half century before. It is therefore quite possible that through dim reflections in the murals of Piero di Puccio and Bartolo, Ghiberti sensed their grandiose prototypes, if indeed he did not know the prototypes themselves. Time and again, in fact, Ghiberti appears to have seized on motifs that demonstrably derive from the work of the Lorenzetti or their workshops. Eve (Pl. 122a) reclining easily on the frame of the Gates of Paradise, a goatskin draped over one shoulder, a fig leaf in one hand, goes back to a type first used by Pietro Lorenzetti which then persisted through the entire century, mostly in Siena and territories under Sienese influence (Fig. 86). The group of visiting women in the *Isaac* (Pl. 97a), and in particular the one carrying

[22] Faison, bibl. 150. A number of elements from Bartolo di Fredi's cycle embedded in the Gates of Paradise were observed and analyzed by Miss Mary Ann Rukavina, see above, note 1.

[23] Ghiberti-Schlosser, bibl. 178, I, p. 42; II, pp. 155f; Faison, bibl. 150, p. 288.

a basket on her head, is a Lorenzetti motif. Even the architectural setting of the *Isaac* (Pl. 94) is drawn from the vocabulary of the Lorenzetti workshop. Pietro Lorenzetti in the predella of his Carmine altarpiece (1328-1329) placed the dream of Sebach into a similar bodiless structure (Fig. 84). The interior is divided into two square bays, surmounted by a flat ceiling. Sebach lies on his bed at the left, in the background of the farthest bay; to the right, set back one bay from the façade, a wing projects at a right angle to the main body of the building.[24] The link that leads to Ghiberti's hall in the *Isaac* panel is evident: true, the half Romanesque, half Gothic vocabulary of Lorenzetti has given way to antique pilasters and entablatures; the upper story has disappeared, but the overall plan of the structure remains the same, including such details as the cloth hanging from horizontal poles and the place assigned to Rebecca lying in bed which is identical to that of Sebach. In the corresponding panel of *Saint Albert's Consigning the Order of the Carmelites to Saint Broccardo* the main scene on the front stage is supported by a number of subordinate scenes scattered over crags and hills in the background. Hence, the possibility must certainly be considered that Ghiberti found in lost frescoes of the Lorenzetti, large-scale scenic settings and the continuous narrative, earmarks of the same Sienese Trecento tradition which has come down to us only through derivatives, often of secondary quality.

As it is, we can only state once more that these derivatives contain motifs which reappear in the Gates of Paradise and that they frequently anticipate Ghiberti's use of scenic settings and his distribution of successive narrative episodes over a landscape and among architectural structures. Even in later years, however, he did not entirely exclude Florence. Not only did he draw upon Andrea da Firenze's scenic settings which, dependent as they are on Sienese models, naturally attracted him, he was just as apt to take over a motif from Maso di Banco's Sylvester legend in Santa Croce which he briefly mentions in the *Commentarii* (Fig. 85). The group of Joseph's Brethren in the Finding of the Cup (Pl. 98) is derived from a group of women in one of the murals of that cycle; the combination of two adjoining figures, one who tears a dress open at the chest, another who rests a hand against the cheek, is unmistakably akin in both the Sylvester mural and Ghiberti's relief.[25]

However strong the impact of Trecento painting was on the Gates of Paradise, it need hardly be said that Ghiberti made its elements completely his own once he incorporated them into his mature style. They became one with the finely graded gilded relief, the elegant yet powerful figures, the receding planes and intricate yet clear overall designs. They became as integrated a part of his own language as the elements he purloined from antiquity. Yet, only some of the reasons are clear for

[24] Van Marle, bibl. 301, II, p. 231; De Wald, bibl. 126, fig. 10; (Carli), bibl. 87, pl. LVIII. Mr. Paul Etter (see above, note 1) has pointed out the resemblance between the setting in Ghiberti's *Isaac* panel and that in the Carmine painting. The same structure with nearly the same features, appears in a *Flagellation* from Pietro Lorenzetti's workshop in Grenoble, which I know only from a photograph in Mr. Richard Offner's collection.

[25] Van Marle, bibl. 301, III, pp. 413ff; Offner, bibl. 368. Mr. Joseph Polzer (see above, p. 214, note 1) has observed the dependence of Ghiberti's on Maso's group. Regarding Ghiberti's reference to Maso's frescoes in S. Croce see Ghiberti-Schlosser, bibl. 178, I, p. 38; II, pp. 129f.

Ghiberti's predilection for the Sienese masters. For one, when confronted with the program of the Gates of Paradise, Ghiberti was required to compress into a limited number of panels an abundance of successive scenes from a continuous narrative. This was exactly the problem which Ambrogio Lorenzetti had tried to solve and which had permeated the art of Siena and her epicenters during the second half of the century. Hence, to accomplish this particular task, Ghiberti quite naturally turned to Sienese models. The Sienese masters had developed rich landscapes, with hills, cliffs and trees, the overlapping of which suggests depth. They worked out closely interlocking figures and scenery, integrating story with landscape. They evolved a discursive narrative method of profound liveliness, giving reality to the stories. They filled their murals with large crowds and the best handled these crowds with masterly skill. They placed their figures and groups into deep, spatially convincing architectural settings. All these were the elements Ghiberti stressed time and again in the *Commentarii* when discussing Ambrogio Lorenzetti and the other fourteenth century masters that were to his liking, and which he emphasized again when describing his own Gates of Paradise.

All this relates to the composition and settings of the panels. When Ghiberti drew individual motifs from the Sienese masters of the fourteenth century, he seems to have been attracted by still another element, different but of equal importance. Almost without exception the motifs he extracted from their work are ultimately of antique origin: Adam in Piero di Puccio's mural; Abel and Noah in the San Gimignano cycle; Eve reclining. The route by which these motifs had found their way into Sienese painting is tortuous. Frequently it may have led over Early Christian and Byzantine art and, indeed, the mural of the woman carrying her child in the *Red Sea* is simply the *Hodegetria* in type. In taking over these motifs, Ghiberti invariably recreated their antique flavor. Frequently he merged them with, and refashioned them into, the very prototypes of antiquity from which they had originally sprung: a tumbling barbarian, a reclining goddess. Poor as these derivatives were at times and remote from the antique model, their intricate poses and movements seem to have reminded him of the art of antiquity, which after the early twenties more and more dominated his thinking.

RENAISSANCE PROBLEMS

CHAPTER XVI
LINEAR PERSPECTIVE[1]

AMONG the panels of the second door, the *Isaac, Joseph* and *Solomon* are constructed according to what appears to be a correct linear perspective: within the receding space of architectural settings, figures and objects diminish progressively and proportionately in size and relief (Pls. 94, 98, 116). Looking back on his work after more than a decade, Ghiberti spoke with emphatic pride of this exploit and, indeed, his words seem to encompass not just these three but all the panels of the Gates of Paradise: "Cominciai detto lavorio in quadri i quali erano di grandezza d'uno braccio et terzo; le quali istorie molto copiose di figure erano istorie del testamento uecchio: nelle quali mi ingegnai con ogni misura osseruare in esse cercare imitare la natura quanto a me fosse possibile, et con tutti i lineamenti che in essa potessi produrre et con egregii componimenti et douitiosi con moltissime figure. Missi in alcuna istoria circa di figure cento; in quale istoria meno et in qual piu. . . . Furono istorie dieci tutti in casamenti colla ragione che l'ochio gli misura e ueri in modo tale, stando remoti da essi appariscono rileuati. Anno pochissimo rilievo et in su e piani si ueggono le figure che sono propinque apparire maggiori elle remote minori; come adimostra il uero. Et o seguito tutta questa opera con dette misure."[2]

Preceded by a short introduction and followed by the long enumeration of Biblical

[1] I am deeply indebted to Mr. Erwin Panofsky for the indulgent friendship and infinite patience with which he has been good enough to illuminate my ignorance of matters perspective, in many conversations and in long correspondence. I am particularly grateful to him for reading this chapter in an earlier version. His constructive criticism has helped me no end in clarifying controversial points and reformulating unclear passages.

There still remains an area of disagreement. Mr. Panofsky inclines to believe that the more progressive painters may have succeeded even before 1435, in fusing the Brunelleschi method of determining the sequence of the transversals with the traditional practice of evolving a correct convergence of the orthogonals and may thus have produced a picture space within which the entire composition, figures as well as the architectural setting, are defined by a three-dimensional system of coordinates. If this assumption—which leaves me unconvinced—were correct, the construction described in Alberti's *Della Pittura* would represent the first codification of existing practice rather than a new departure, and would not necessarily have influenced the linear perspective of Ghiberti's Gates of Paradise.

Obviously the question is closely linked to the view one takes of Alberti's place in the theory and practice of Florentine Quattrocento painting. At present the prevailing opinion appears to tend towards interpreting his position as that of an intellectual who formulated into theories, practices current among the leading Florentine artists of the twenties and thirties (Clark, bibl. 102). To be sure, in many passages of *Della Pittura* Alberti merely codifies what he saw practiced in Florence, both among the *avant-garde* and possibly even in conservative workshops. But it seems to me that he brought to Florence and developed there workshop tricks of his own devising, such as the *velo* and the peep shows he describes, practices of his own, such as his perspective construction, and most important his own views on art, both ancient and modern, unformed as they may have been to start with. Hence I tend to view his impact on the Florentine *avant-garde* as an element as decisive as their impact on him. Of course, I may be wrong but that is the way it looks to me.

[2] Ghiberti-Schlosser, bibl. 178, 1, pp. 48f. For an English translation, see above p. 14. In the interpretation of the texts of the Ghiberti and (Manetti) passages I am again greatly indebted to Mr. Erwin Panofsky for many a discussion. Mr. Erich Auerbach, Mr. Rudolf Wittkower, and Mr. Enrico de Negri have also been good enough to lend a helping hand.

events represented in the panels, the passage sums up what Ghiberti deemed most relevant in this his last work: the composition of the panels, the emulation of nature, the treatment of the relief; finally the convincing presentation of space and reality. These leading ideas are clear despite the involved syntax of the first sentence. But the interpretation of the text requires further explanation of the terminology. To be sure, Ghiberti's phrasing is far from precise. But it should be possible to determine the meaning of the key terms: *lineamenti; misura* and *misure; ragione; casamenti; piani.*

Lineamenti is a Renaissance Italianization of the classical *lineamenta.* The Latin word, while it occurred during the Middle Ages, seems to have done so only in a figurative sense, denoting lineage or ancestry. It was apparently first restored to its original meaning, or to one close to it, by fifteenth century writers in both Latin and in the new Italian form. Its significance in classical Latin was evidently "lines," or "an outline drawing"; occasionally it meant also the outline or the sketch of a speech. In the fifteenth century when Alberti used the term in *De Re Aedificatoria,*[3] he may possibly have intended something close to this original meaning, and indeed Bartoli's translation of 1550 renders the Latin word as *disegni,* a word denoting both drawings and designs, and possibly chosen because of its double meaning. Correspondingly, *lineamenti* in the Ghiberti passage has occasionally been interpreted to mean designs. But the term in classical times had both a more specific and a more general use: first as an architectural term, referring to a ground plan; second, figuratively speaking, to denote outlines, possibly in the form of, or accompanied by schematic drawings, graphs or diagrams, or even principles. In this latter sense—outlines or principles—the term was used by Pliny: Polykleitos' canon, he says, is a source from which artists attempt to draw the *lineamenta artis,* the outlines, the elementary principles, or perhaps even the basic laws of art.[4] Consequently, *lineamenta,* as used by Alberti in *De Re Aedificatoria,* should probably be rendered by "schematic outlines" instead of "drawings" or "designs" as translated by Bartoli. Ghiberti likewise, when discussing Polykleitos in the first book of his *Commentarii,* took the word *lineamenti* over from Pliny, using it in association with and as complementary to *regole,* rules, and again the best translation would seem to be principles, possibly as illustrated by drawings. When discussing the disintegration of ancient art and the ensuing loss of ". . . the statues and paintings . . . the volumes and memoirs (*commentarii*), and *lineamenti* and rules which gave instruction to this . . . art,"[5] Ghiberti leaves little doubt but that *lineamenti* are part of the theoretical knowledge of the ancients. He employs the term to complement the term rules, just as he mentions paintings as a counterpart to statues, and memoirs as a counterpart to volumes. Consequently in Ghiberti's discussion of the second door, *lineamenti* must again be understood as a counterpart of rules: that is, as principles, outlines or diagrams that illustrate the rules. Just what principles or outlines Ghiberti had in mind remains for the moment an open question; to translate his meaning as simply

[3] Alberti, bibl. 5 *passim*, particularly Book I. The *Accademia della Crusca* (bibl. 1, IX, 1, pp. 377f) renders the term as "disposizione di linee . . . conformazione di una cosa rappresentata da linee qualsiasi."

[4] Pliny, bibl. 408, IX, p. 366, Lib. XXXV, 145; see Ghiberti-Schlosser, bibl. 178, II, p. 200.

[5] Ghiberti-Schlosser, bibl. 178, I, pp. 15, 35.

"perspective" goes probably too far,[6] but certainly the *lineamenti* had some very close connection with his attempts at "imitating nature as far as possible."

The term *misure* has been discussed at some length by Schlosser. Its original meaning is, of course, measurements. It does not, however, always have this original meaning in the fifteenth century. The final passage of the first book of the *Commentarii* calls for both a more generic and a more specific interpretation within the framework of Ghiberti's art theory: "The ancient and excellent sculptors and painters . . . arrived at such excellence in art, they were so expert, that they wrote memoirs and infinite volumes of books which gave much light to those that came after them, they reduced art [to its essentials?] by that *misura* which nature offers."[7] Obviously in this passage *misura* is, like *lineamenti*, part of the legacy of ancient art theory; it is a fundamental element contained in nature and essential to any good work of art. Thus—and particularly when used in the plural—the term probably indicates a system of proportions. This is certainly the case when Ghiberti uses the term *misure* to translate Pliny's *symmetria*, or *misure dell' arte* as equivalent to Vitruvius' *commensus e membris* or when he employs it to discuss the proportions of the human body. *Proportioni* and *misure* are unmistakably complementary to each other when Ghiberti speaks of the "misure e proportioni che deve avere alcuna figure. . . ."[8] Again, *misure* may mean either proportion or scale when Ghiberti says that Giotto "brought forth natural art and gentleness with it without ever trespassing against the *misure*," or when he tells how Gusmin showed his young visitors "very many *misure* and made them many models. . . ."[9] In the final paragraph of the second book, the meaning is absolutely clear: whenever an artist had to design figures of over life-size, Ghiberti "gave him the rules *(regole)* to carry them out in perfect scale *(con perfetta misura)*."[10] In the passage concerning the Gates of Paradise he seems to use it in this same specific sense: he says he set out to observe nature *con ogni misura* or, as we would say, with full knowledge of scale and proportion. On the other hand, the concluding passage is perhaps quite general in meaning and can be interpreted as "I have pursued this entire work with these measures . . ." meaning that he employed all necessary measures or means for representing reality.

The term *ragione*, particularly in the combinations *alla ragione* or *colla ragione* has a more definite meaning. It always refers to a proportionate relationship. In the language of business it is used thus in the expression *a ragione (kagione) di sette per cento*, in a relationship of seven percent, or as we would say, at seven percent interest. In mathematics and perspective theory it refers to the proportional relationship of geometrical forms such as lines or triangles.[11] Hence within Ghiberti's text the term must equally refer to a proportionate relationship concerning either both stories and *casamenti* or only these latter.

The other two key terms, *casamenti* and *piani* belong to the language of daily life and to the vocabulary of the practice rather than the theory of art. *Casamenti* today

[6] Holt, bibl. 218, p. 90. [7] Ghiberti-Schlosser, bibl. 178, I, p. 31.
[8] *ibid.*, pp. 16, 55, 64, 228f; see also Schlosser's *Indiculus Ghibertianus*, *ibid.*, II, pp. 200f and the *Accademia dell Crusca*, bibl. 1, x, pp. 367ff with reference to sixteenth century usage.
[9] Ghiberti-Schlosser, bibl. 178, I, pp. 36, 43f. [10] *ibid.*, p. 51.
[11] Wittkower, bibl. 558, p. 277 and note 3, with reference to Alberti, bibl. 8, pp. 71ff.

means large buildings, such as tenements. In the fifteenth century Cennini used it to mean architectural settings.[12] For the Ghiberti passage one is at first somewhat hesitant to employ this translation: after all, the phrasing seems to imply both that the ten stories were within and that *all* were within *casamenti*. (The bothersome masculine *tutti* as joint to *storie* first seems to suggest either a copyist's misreading for an original *tutte*, or an anticipatory anacoluthic use of the masculine with reference to the following *casamenti*. But throughout the paragraph Ghiberti frequently switches the *genera*, e.g. in the phrase *dovitiosi*.) Since only three panels have architectural settings, it has been suggested that the term relates to the English "casement" and can be translated "frame." But though ingenious, this conjecture is not convincing. The meaning "frame" for the term *casamenti* has never existed in Italian writings, fifteenth century or otherwise, and buildings or architectural settings is not merely the familiar, but the only meaning given it. For instance, it is the only possible interpretation of the term in the report of 1439 on the progress of the Gates of Paradise: "in the relief of Solomon the *casamenti* and a piece at the bottom [are] completed, the figures on the right side almost one quarter completed" (Dig. 208; Doc. 24). The *casamenti* then, are *in* the relief; they constitute the upper zone which complements the "piece at the bottom" and they are mentioned independently of figures. Correspondingly, Ghiberti in describing the door meant that his stories were placed in architectural settings.[13]

Obviously not *all* the reliefs are placed in architectural settings, as the text would seem to suggest, and the difficulty increases when Ghiberti continues that in all the reliefs the figures on the *piani* (*in su e piani*) appear "those close larger, those farther away smaller as reality shows it." *Piani*, in this passage has been translated as relief planes.[14] This is possible and, indeed, Alberti in *Della Pittura* uses the term at least once with the similar meaning "picture plane."[15] But more frequently the word *piano* in fifteenth and sixteenth century parlance refers to horizontal levels: either generically to the planes of landscapes or to the "standing planes" of figures; or specifically to the horizontal levels of buildings, that is in simple language, their floors—just as the term to this day is used in combinations such as *pianterreno, piano nobile, primo piano* and so on. It is in this sense that *piano* was employed most frequently also in fifteenth century usage. Throughout *De Re Aedificatoria* Alberti uses *piano* thus for the floors of buildings, and Ghiberti in the passage on the Gates of Paradise would seem to have in

[12] Cennini, bibl. 93, 1, p. 55; Ghiberti-Schlosser, bibl. 178, 1, p. 42, "molto adorne di casamenti e di figure" with reference to two frescoes by Simone Martini; (Manetti), bibl. 294, p. 9, "casamenti, piani e montagne e paesi," to describe a rich setting. See also *Accademia della Crusca*, bibl. 1, 11, p. 622, and Ghiberti-Schlosser, bibl. 178, 11, p. 198, in the *Indiculus*.

[13] Mr. Panofsky has suggested cutting the Gordian knot by emending the words *tutti in casamenti* into *tutti con casamenti*. Indeed, a *con*, especially when written *cō* with a ligature above the line might easily have been misread as *in*. Based on this emendation the term *casamenti* could possibly be extended to include all architectural props in the panels, from the Gate of Eden to the hut in *Cain and Abel* and the tents in *Abraham* and *Moses*. However, both present day and fifteenth century usage as quoted in the preceding note would seem to imply a limitation of the term to more sizable architectural settings.

The translation frames for *casamenti* occurs in Holt, bibl. 218, p. 90.

[14] Holt, *ibid.* [15] Alberti, bibl. 8, p. 79.

mind this same meaning. Indeed, in his text he links *piani* so closely to *casamenti* that the terms become inseparable: "There were ten stories all in *casamenti* in the relation with which the eye measures them and real to such a degree that if one stands far from them they seem to stand out in high relief. [However] they have very low relief and on the *piani* one sees the figures which are near appear larger and those that are far off smaller as reality shows it."

In reading over the entire passage the impression grows that Ghiberti despite his somewhat loose phraseology conveyed his essential points with remarkable clarity. He strove, so he says, to imitate nature *con ogni misura*, we would probably say, to emulate nature with full knowledge of scale and proportion. This aim is achieved in three ways: by *lineamenti*, elementary principles and outlines of representatio; by beautiful compositions; finally, by an abundance of figures. As he goes on to explain these various ways, he elaborates first on the number of figures and thus by implication on the compositions. But then he fastens on a number of points, all related to the true-to-life representation of three-dimensional stories in relief; also it soon becomes clear that within this representation the *casamenti*, the architectural settings, fulfill a very important function. The stories are all placed in architectural settings, or if one prefers, they all have architectural settings. In any event these settings either are designed in a relationship, or they provide the relationship, by which the stories, that is figures and objects, become measurable to the eye (*colla ragione che l'occhio gli misura*). At the same time they (again either the settings or the stories) are so real that they seem to stand out in high relief, that is in three dimensions even though (a *ma* must be inserted between *rilevati* and the following [*h*]*anno*) they are done in very shallow relief. The architectural settings thus are intended to convey an impression of depth. Then, Ghiberti would seem to continue this thought: on the *piani* figures appear smaller or larger depending on their distance from the beholder. Taken by itself, the term *piani* need have little significance and might refer generally to the "standing planes" of the figures, whether in scenic or architectural settings. But within the specific context the expression is apparently intended to be given particular stress. It parallels the *casamenti* in the previous sentence and it is closely related to the principal subject of the phrase, the diminution of figures in depth. Indeed, this progressive diminution of the figures is apparently dependent on the *piani*. They ought then to consist of units which may serve as *moduli* for both the size of the figures and the depth of the relief. Within the three-dimensional space of the reliefs, *casamenti*, *piani* and figures in Ghiberti's text form a triad, jointly aimed at producing the impression of a true-to-life reality (*come adimostra il vero*).

Since only three reliefs on the Gates of Paradise are placed in architectural settings and only two of them have floors divided into measurable units, Ghiberti's all embracing statement must appear either as a lapse of memory or a piece of *braggadaccio*. Most likely, it is both and, in any event, it is revealing: for throughout the passage on the Gates of Paradise, he implies that his proud words refer not merely to the *Isaac*, *Joseph* and *Solomon*, but to all the ten panels of the door. *All* have architectural settings; *all* are filled by large crowds; *all* have shallow relief; in *all*, the figures stand on

floors and thus at measurable distances. In brief, he concentrated on emphasizing the presentation of a homogeneous, convincing, and measurable space and on large scale compositions to such a degree that the goal he had achieved in a few of the panels became in his eyes the underlying principle of the entire door.

The presentation of figures and crowds within a measurable space thus emerges as an essential, and indeed, the essential element in Ghiberti's attempt to reproduce nature, *cercare imitare la natura*, in the panels of the Gates of Paradise. To this end, the stories are placed in architectural settings, with *piani* designed to make the relief space measurable and convincing, and by regulating the progressive and proportionate decrease in the size of figures in depth, to create an impression of reality. Architectural settings and their floors are, in other words, essential tools for designing a convincing space within which figures could move. They create an illusion of depth and allow a correct relationship of figures to each other and to their distance from the spectator, "as reality shows." And when Ghiberti concludes the passage by stressing that he has pursued this entire work *con dette misure*, one begins to wonder whether these *misure* do not also include a correct perspective construction, one of the elementary principles, the *lineamenti* which would enable him to represent reality as he saw it.

Brunelleschi

A correct linear perspective construction, that is, a mathematically controllable one, had been worked out among Florentine artists ten or fifteen years before Ghiberti designed the panels of his second door. It is generally agreed that Filippo Brunelleschi was the key figure in its achievement. Why otherwise should Alberti have dedicated his *Treatise on Painting* in 1435 to him, an architect, unless that architect had made an essential contribution to painting—more specifically a contribution to the very problem of perspective with which the first book of Alberti's treatise is exclusively concerned? Indeed, in or about 1463 Filarete mentioned Brunelleschi specifically as the discoverer of perspective and around 1480 the master's first biographer set forth the invention of perspective as one of the major achievements of his hero's early years, before 1420. This assertion is confirmed by Manetti's *Uomini singholari*.[16] Vasari, in his first edition of 1550 promulgates the tradition as common knowledge.

According to the *Vita di Brunellesco*, the ancients, though possibly they knew the practice, did not know the theory of perspective, and for that reason Brunelleschi had to invent practice and theory anew. The biographer had seen with his own eyes two of Brunelleschi's experimental perspective paintings, both on wood. One represented the Piazza de'Signori with its surrounding buildings, among them the Palazzo Vecchio, whose north and west façades were clearly shown. The sky of the panels was sawed out, so that if the painting were placed at a clearly defined point some *braccia* towards Or San Michele and the spectator stood at another fixed point some *braccia* distant, the skyline of the painting would coincide exactly with that of the real buildings. The second panel was about half a *braccio* square and represented a view of the piazza in front of the Cathedral, drawn from a point "three *braccia* or so" inside the main portal. It

[16] Alberti, bibl. 8, pp. 47ff; Filarete, bibl. 158, pp. 609, 619, 621; (Manetti), bibl. 294, pp. 9ff; Manetti, bibl. 293, p. 163.

showed "that part of the piazza which the eye can see," including the Baptistery and part of the buildings bordering the square. The sky in this painting, rather than being cut out, was covered with burnished reflecting silver. Now, so the biographer goes on, "the painter must assume one single point from which his painting should be seen in relation to both the upper and lower limits and the lateral boundaries (si per altezza e bassezza e da' lati) of the picture, as well as the distance (come per discosto)." Thus, "to prevent the spectator from falling into error" by choosing a wrong point of view, Brunelleschi had drilled through the panel a hole "which fell in the painting in the direction of the temple of San Giovanni at the point where the eye struck, opposite a beholder looking out from inside the center door of Santa Maria del Fiore where he would have taken his position had he painted it" (che veniva a essere nel dipinto della parte del tempio di San Giovanni in quello luogo dove percoteva l'occhio al diritto da chi guardava da quello luogo dentro alla porta del mezzo di Santa Maria del Fiore dove si sarebbe posto se l'avesse ritratto). "This hole was small as a lentil on the painted side," while "on the back of the panel it opened out in pyramidal [i.e. conical] form to the size of a ducat or a little more like the crown of a woman's straw hat." Then with one hand the spectator should hold the back of the painting against his eye and look through the larger end of the hole at a flat mirror held in the other hand at arm's length. The painting would thus be reflected in the mirror; and this extension (dila-zione)[17] of the hand with the mirror would correspond to the approximate distance [from the Baptistery] in braccia piccoline. The reflection of the sky and the moving clouds in the silver-coated upper part of the painting would heighten the impression of reality.

The basic principles involved in Brunelleschi's perspective construction were for the first time elucidated by Panofsky many years ago.[18] The following is merely an attempt to trace Brunelleschi's perspective procedure step by step in the light of the specific topographical conditions within which he worked. He placed himself inside the Cathedral, three odd braccia behind the main portal. Thus he stood exactly 60 braccia from the Baptistery.[19] The floor level of the Cathedral rose about one braccio above the piazza, and given Brunelleschi's diminutive height, to which his biographer attests, his eye would have been 3 to 3½ braccia above the piazza. The portal of the church framed his field of vision both vertically and horizontally. At its upper boundary it would have been practically unlimited, the architrave being 13 braccia from the threshold; but at

[B's perspective procedure.]

[17] The *Accademia della Crusca* (bibl. 1, IV, p. 326) renders *dilatare* as "accrescere in distanza o distenzione," (increase in distance or extension).

[18] Panofsky, bibl. 385, particularly, pp. 258f, 283, and a lucid summary *in nuce* bibl. 379, pp. 91ff, particularly pp. 93-96; see also Bunim, bibl. 81, pp. 186ff, White, bibl. 552, Wittkower, bibl. 558, and recently Siebenhüner and others, in a discussion, reported in *Kunstchronik* 1954, pp. 129f.

[19] The following measurements were obtained in a survey of the site in 1951. The distance from the Gates of Paradise to the inner boundary of the threshold on the main gate of the Cathedral amounts to 32.80 m. By adding three and one third *braccia*, 2.04 m, one arrives at 34.84 m, just 20 cm short of 60 *braccia*. Within this total, 7.82 m correspond to the distance from Brunelleschi's position inside the Cathedral to the far edge of the platform in front of the church, an additional 1.74 m to the width of the stairs ascending to the platform. The level of the platform above the present level of the square, 0.75 m must be discounted. The original difference in level, according to the excellent survey of Sgrilli (bibl. 491, pls. I, II, IV) appears to have been only 0.60 m.

the bottom it would have been cut off by the platform in front of the door and by the four steps ascending from the square. The edge of this platform, 13½ *braccia* from his position, was bound to eliminate from Brunelleschi's field of vision roughly 20 *braccia* of the piazza, one third of the total distance to the Baptistery. The limitations of the horizontal angle of vision were even more severe; for given the width of the door, only 6½ *braccia*, he could see, beyond the looming mass of the Baptistery, only a small section on either side at the far ends of the piazza. At the point where his eye would hit the piazza first, beyond the edge of the platform and 20 *braccia* from where he stood, the section he could see was exactly 30 *braccia* wide.[20]

These data of the topographical situation were supplemented by Brunelleschi's use of a mirror, or rather of two mirrors: for since the picture was to be viewed in a mirror held by the outstretched hand it must have been a mirrorlike left to right reversal of the original. Therefore, it was either painted on a mirror (hence the silvercoated reflecting surface) or with the help of a mirror placed alongside the panel.

The use of a mirror in verifying the phenomena of linear perspective was common Quattrocento practice. Indeed, three-dimensional relationships in a mirror are automatically transferred onto a two-dimensional surface as they would be in a drawing by means of a perspective construction. Filarete probably codified an old tradition when stating that the mirror revealed perspective elements which could not be seen with the naked eye: the squares of a floor or the beams of a ceiling appear to converge in the distance, "and if you want to see this more clearly, take a mirror and look into it. And you will clearly see this to be so. But if the same were opposite your naked eye, they would seem but equidistant to you." He adds that in his opinion it was through the use of a mirror that "Pippo di Ser Brunellesco from Florence found the procedure to evolve this method (of perspective) which indeed was a subtle and beautiful thing, that he discovered by reasoning what you see in the mirror."[21] While this statement obviously need not be taken literally, it is at least possible that Brunelleschi originally designed the view of the Piazza del Duomo on the reflecting surface of burnished silver as a means of control for his perspective construction.

Still, the important mirror was not the one on which or with the aid of which Brunelleschi painted, but the one in which the painting was reflected; for it served to fix the exact point from which the painting was to be viewed. By drilling a hole through the panel and making the spectator peep through it at the reflection in the mirror, and by

[20] Mr. John White has been good enough to make accessible to me the manuscript of his dissertation, University of London, 1952. In discussing Brunelleschi's perspective, Mr. White points out that Brunelleschi's field of vision was further limited by the porch which then projected in front of the portal of the Cathedral as seen in the drawing of the façade of 1587 (Poggi, bibl. 413, p. xxiii). Therefore, Mr. White thinks of Brunelleschi's position as three *braccia* inside the porch and barely beyond the sill of the door, so as to allow him to see more of the piazza. But it seems significant indeed that Brunelleschi's biographer places such stress on the far corners of the piazza, the *Canto alla Paglia* and the *Canto de'Pecori*, being represented. Thus, one wonders whether the greater part of the sides of the piazza was not really cut off.

[21] Filarete, bibl. 158, pp. 608f. See also Alberti, bibl. 8, p. 135: "Objects taken from nature should be corrected with the mirror . . .; for objects well painted, I do not know how, have much gracefulness in a mirror, and it is wonderful how each defect of a painting shows distorted in the mirror." The Latin version (bibl. 10, p. 14) differs slightly in wording.

leaving the sky of the painting a reflecting surface which would register any difference between the skyline of the original objects and that of the painting, Brunelleschi forced him to occupy the exact point from which he himself had viewed the piazza and to look at exactly the point on the Baptistery façade at which he himself had looked as well as to hold the mirror at a specific distance from the painting. Thus Brunelleschi made two sets of points coincide: that from which he had seen the object and the point opposite on the façade of the Baptistery, and the "view point" of the spectator and the corresponding point of the Baptistery in the painting.

All this makes sense only on the assumption that Brunelleschi started out from the concept of a constant mathematical and proportional relation between the reality of the object and its representation. His biographer leaves no doubt in this respect, saying, it may be recalled, that the "extension" of the beholder's outstretched arm between panel and mirror corresponded to the distance from the Baptistery *a braccia piccoline*. Within his vocabulary this term always signifies a relation in scale,[22] and a definite relation in scale was indeed the keystone in Brunelleschi's perspective procedure.

It was easy to calculate such a relation for the Piazza del Duomo panel. The distance from the painting to its mirror reflection being one *braccio*, and that from the eye to the Baptistery, 60 *braccia*, the scale was 1:60, a normal ratio in any duodecimal system. Brunelleschi had evidently chosen his standpoint very carefully so as to arrive at this particular proportion. The line that marked what was for him the piazza's near boundary, was 30 *braccia* long, exactly half the distance from his eye to the Baptistery; thus it corresponded in scale to the width of the panel, which was one half *braccio*. In other words, Brunelleschi established in scale both distance and base line of his painting. Since the panel was square, the proportions of distance to width to height were 2:1:1.

If, then, Brunelleschi drew to scale *a braccia piccoline* both the distance from the Cathedral to the Baptistery, and the base line of his painting, he must have started out by making a ground plan of the entire square on a scale of 1:60, including in it his own position inside the Cathedral. Plans and elevations drawn to scale in the early fifteenth century were fundamental innovations of architectural tooling, and if Brunelleschi's biographer is correct, Brunelleschi was the first to introduce them in Florence. On this plan of the piazza he must have marked the horizontal visual angle as determined by the portal jambs through which he gazed. The location of all points on this horizontal plane, such as the corners of the Baptistery and piazza, were indicated in the ground plan by lines extending from his position. On the same scale as the plan, he would draw elevations: one of the Baptistery and the buildings behind, and two at right angles to this, each including his position, the Baptistery and the right and left sides of the piazza respectively. Since the Baptistery appeared the same from all three sides, the three elevations were practically interchangeable. By means of these elevations, the location of

[22] (Manetti), bibl. 294, with reference to the drawing for the Innocenti portico, p. 56 and to the model for S. Spirito. Mr. Wolfgang Lotz has been good enough to call my attention to a passage quoted by Oertel (bibl. 367, p. 261 with older bibliography), expressly stating that as early as 1390 the model of S. Petronio in Bologna was made to scale.

all points within the vertical angle of vision could be marked out again by lines connecting them with his eye point.

Within such a construction, achieved by means of a plan and elevations, it was desirable for purposes of location to indicate the greatest possible number of points, which would form a network over all the structures to be represented. Indeed, Brunelleschi's biographer states that to survey ancient buildings in Rome the master used parchment strips and transferred the measurement to paper ". . . marked by numbers and letters"; in brief, to graph paper with the coordinates marked both vertically and horizontally, a system "which Filipo by himself understood," that is, a method of his own invention. The Baptistery, with its geometric marble incrustation could easily be adapted to such a system of coordinates and hence would have made an ideal testing ground for Brunelleschi's method of perspective construction.[23]

After locating the greatest possible number of points on both plan and elevation, the next step was simple: Brunelleschi must have drawn a transverse line across the ground plan at the exact point where his eye first hit the piazza at the lower limit of his vertical angle of vision. The points of intersection on this transversal marked by lines drawn within the horizontal angle of vision from his position to the key points of the Baptistery and piazza were then transferred to the base line of the panel. In an analogous operation he dropped a perpendicular through the elevations at a point corresponding to the transversal on the ground plan. The intersections of this perpendicular with the vertical sight lines that Brunelleschi had drawn from his position to key points on the Baptistery and background buildings he then transferred to the right and left edges of the panel. Finally, beginning from these marked points along the base and sides, he could draw a network of vertical and horizontal lines on the panel, their intersections establishing the exact location of each point of the buildings. Whatever their angle to the picture plane, parallel, orthogonal, or oblique, all lines of the perspective picture of the object could easily be drawn by simply connecting on the panel the corresponding points of intersection. Combining the horizontal and vertical visual angles, through which in a number of independent drawings he had linked his "eye-point" to the largest possible number of points on the object, he coordinated them eventually into a final perspective design. The result was a perspective picture arrived at by what later theorists called the *costruzione legittima* (Diagram 4).[24] Alberti's *intersegazione* appears to be nothing but the physical reproduction of this linear network by a "veil" of strings, and, indeed, Vasari contended that Brunelleschi drew his perspective by way of ground plan, elevation, and *intersegazione*.

[23] (Manetti), bibl. 294, p. 21. Brunelleschi and Donatello, in surveying the heights of ancient buildings ". . . dove e' potevano congetturare l' altezza . . . ponevano in su striscie di pergamene che si lievano per riquadrare le carte con numero d'abaco e caratte[re], che Filipo intendeva per se medesimo" (The comma between *carte* and *con* can be omitted). Prager (bibl. 425, in particular, pp. 539f; see also Lowry, bibl. 280) has correctly suggested such scale drawings of plans and elevations as the basic element of Brunelleschi's perspective construction. He has also stressed the likelihood of Brunelleschi's having used graph paper as a tool for establishing the vertical and horizontal coordinates on both his scale and perspective drawings.

[24] Panofsky, bibl. 385, p. 283; bibl. 379, p. 93. Since Brunelleschi's picture of Piazza del Duomo showed three sides of the square, its construction must have required three rather than just one elevation.

However, to Brunelleschi the *eye point* in the picture was not necessarily what we know as a *vanishing point*. Its position on the picture plane was not arbitrarily assumed so as to serve as the starting point for the orthogonals. On the contrary, if we interpret Brunelleschi's biographer correctly, in his construction this point served only

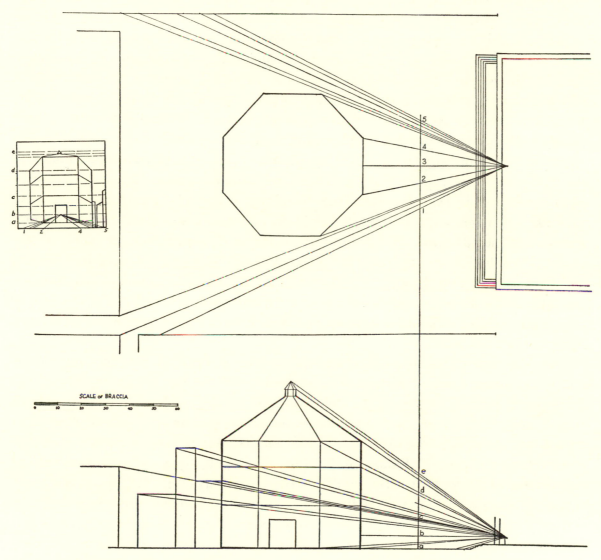

DIAGRAM 4. Brunelleschi, Perspective Construction, Piazza del Duomo

to fix the position of the spectator's eye in relation to both painting and reality and the distance from which the painting should be viewed. It was, therefore, a coordinator to begin with—a stable pole of reference for the position of artist, object, spectator, and representation. The orthogonals converged towards it, as a result of Brunelleschi's construction, but not because it was the vanishing point from the outset. Likewise, this point would seem not to have been located in the center of the panel. On the contrary, it must have been far down, roughly 8 cm from the picture base, corresponding exactly to the level at which Brunelleschi's horizontal sight line struck the façade of the Baptistery.

Brunelleschi, then, proceeded along lines strictly architectural in thought. His aim was architectural and practical: one suspects that he worked out his procedure as a means of representing building projects in perspective and to scale, and of surveying existing architecture, whether Roman ruins or architectural sites in Florence. His methods of architectural representation were those of a practicing architect; that is, he worked only with ground plans and elevations drawn to scale on a mathematical basis.

Brunelleschi's perspective method was fundamentally an architectural tool. True, it could be used for pictorial ends by drawing plan and elevation of one or more imaginary buildings. Indeed, a consensus of opinions towards the end of the century held that the practice of linear perspective in both painting and sculpture derived directly from Brunelleschi's construction.[25] But as first evolved by Brunelleschi, the method could hardly become a popular tool for painters. It was unwieldy, requiring a number of preliminary drawings followed by complicated transferral of coordinate points to the final panel. It was apt to result in rapid foreshortenings. Since Brunelleschi's principal preoccupation was drawing actual buildings to *scale*, he must have placed the spectator's vantage point at a man's height on the same scale as the building represented: also the narrowness of medieval streets forced close proximity of spectator and object. Thus, both a low viewpoint and a view at close distance made rapid foreshortenings inevitable and the drawing would reveal that he looked at buildings with his neck craned. Finally, since Brunelleschi's linear perspective was devoted to the representation of architecture, it contained no formula as to how to incorporate within it human figures drawn to scale.

To what degree Brunelleschi's procedure was ever accepted *in toto* by painters and sculptors remains a moot question. The two hall marks, the low eye point and the covering of the picture surface by the different-sized rectangles of the intersecting horizontals and verticals, are rarely found. For the latter, one might think of Pisanello's perspective drawing in the Louvre as a late example. But as early as the twenties, the architectural perspective of Masaccio's Trinity fresco (Fig. 87) may be the outstanding representative in Florence of a construction based precisely on Brunelleschi's method.[26] It is, in fact, the only Florentine painting of the twenties in which the "eye point" corresponds to the eye level of a *real* beholder—an essential element of Brunelleschi's perspective construction—in this case standing in the aisle opposite the fresco. But such orthodox use of the *costruzione legittima* was exceptional. To make the method applicable among practitioners it had to be reduced to handy formulas. First, the "eye point" of Brunelleschi's construction had to be transformed from a "coordinator" into what we call a vanishing point. This was easily done, since within the *costruzione legittima*, the "eye point" was necessarily recorded in the picture as a central point towards which all orthogonals would and must converge; obviously it was easy to reverse the procedure and to turn this focus into the vanishing point from which the orthogonals would radi-

[25] (Manetti), bibl. 294, p. 163.

[26] The Pisanello drawing is illustrated and discussed, though in terms of an Albertian perspective by Meder, bibl. 344, p. 608 and fig. 293. Regarding the perspective of the Trinity fresco, see Kern, bibl. 242; Wieleitner, bibl. 554; Panofsky, bibl. 385, p. 284 and *Kunstchronik*, N. F. XXVI (1914-1915), cols. 505ff; Mesnil, bibl. 324; Oertel, bibl. 356.

ate towards the edges of the picture. In accordance with established practice this vanishing point would be placed arbitrarily in the center of the panel, even though this meant abandoning Brunelleschi's insistence on the coincidental positions of painter and real beholder in whose place an ideal beholder was substituted. A string fixed by a nail at this central vanishing point would allow the painter to draw all orthogonal lines at their correct angles. In fact, from the early fourteenth century the practice in the Tuscan workshops had been to construct the orthogonals of such individual horizontal planes as ceilings or pavements with the aid of strings attached to hubs in or near the center of the panel.[27] Brunelleschi's "discovery" of a single "eye point" made it possible to apply this workshop practice to *all* the horizontal planes represented in one painting. A corresponding workshop trick could be substituted for Brunelleschi's construction of the side elevation: a quasi-distance point could be marked level with the vanishing point on a plane continuing the picture plane sideways, at a distance arbitrarily assumed. By fastening a nail at this point and by rotating a string towards the ends of the orthogonals on the picture base, the painter could mark off along the picture edge his vertical sight lines. Again then, a workshop trick would take the place of Brunelleschi's original construction, enabling the painter to determine the correct distances from the front plane of objects and lines parallel to that latter. Theoretically one would expect the painter to be able to apply this trick to the construction of *all* transversals in the *entire* painting. Finally, it should have been easy to draw all objects in a painting, both architectures and figures to scale. Abstractly speaking, one would assume that the problem of linear perspective was solved in the 1420's by simply reducing Brunelleschi's complicated construction to shortcut formulas.

Strange as it seems, however, the transfer was apparently not easily achieved. Throughout the twenties perspective constructions in Florentine painting as a rule remained fragmentary. While the placement of a vanishing point governing the orthogonals throughout the painting from the middle of the picture plane is generally accepted, as in the frescoes in the Branda Chapel at S. Clemente in Rome, the Tabitha fresco and the Madonna della Neve panel, minor deviations notwithstanding,[28] the transversals are treated with striking insecurity. Both in the Madonna della Neve panel and the Tabitha fresco indications regarding the correct or incorrect determination of their distances are avoided.[29] In the frescoes of S. Clemente, the distances of the transversals are correctly worked out from a "quasi-distance point," in the coffered ceilings

[27] Panofsky, bibl. 385, pp. 279f.

[28] Regarding the perspective constructions from the Madonna della Neve panel and the Tabitha fresco to the murals at S. Clemente, see Oertel, bibl. 365 and Longhi, bibl. 277, pp. 145ff, and above, footnote 1, with reference to Mr. Panofsky's differing interpretation. Regarding the two former studies, the reader may not agree with the attempts at interpreting variations in perspective construction either with Oertel, as successive steps in Masaccio's development or with Longhi, who views them as hallmarks distinguishing the *œuvres* of Masolino and Masaccio. In fact, I am not entirely convinced that the orthogonals in the paintings of the Masaccio-Masolino group always converge towards a single vanishing point throughout the painting: in the Tabitha fresco, for instance, the orthogonals of the foreground seem to converge towards one vanishing point marked by the hole in the plaster next to the young dandy (Oertel, bibl. 365, p. 33), those of the background streets towards another.

[29] Oertel, bibl. 365, pp. 18f against Mesnil, bibl. 324, p. 122 and fig. 6.

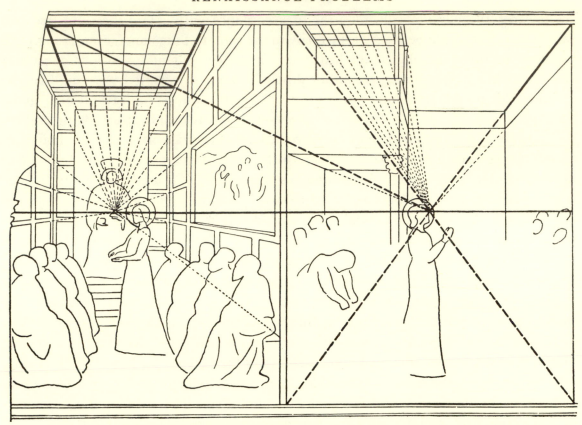

DIAGRAM 5. Masolino, Perspective Construction, *Disputation and Miracle
of St. Catherine* (after Oertel, bibl. 365)

of both the *Disputation of Saint Catherine* (Diagram 5) and the *Death of Saint Am-
brose*; but this construction remains limited to a single horizontal plane. It may be
worth while to analyze the situation with respect to the *Death of Saint Ambrose* (Fig.
89) in some detail. That the correct construction of the coffered ceiling is not trans-
ferred to the horizontal plane is indicated by the bed of the Saint. Its headboard and
footboard convey the impression of differing widths, indicating that they are drawn
from two different distance points.[30] The front post of the headboard appears to be
located in the very front plane of the mural, perpendicularly beneath the right-hand
corner of the first ceiling coffer. Thus it is far closer to the eye of the beholder than the
bed curtain above, which runs along the far end of the second row of ceiling coffers. In
fact, the front post could never stand where it is since the very front plane of the pic-
ture base is occupied by a *cassone*. The footboard, on the other hand, stands with its
front post perpendicularly under the rear corner of the second ceiling coffer, thus
correctly making room for the *cassone* and corresponding to the position of the bed
curtain. From this point, it extends the length of eight ceiling coffers into depth.[31]
In short, the painter, while employing a distance point for the plane of the ceiling, did
not retain this point immobile for the entire painting. Indeed, the correct distancing

[30] Oertel, bibl. 365, pp. 24f.
[31] Oertel, bibl. 365, p. 30, note 2, while suggesting a greater width for the footboard rather than
the headboard of Saint Ambrose's Death, points out these same "irregularities" in construction.

of transversals remained a crucial and apparently unsolved problem within the workshop procedures of the twenties and early thirties among Florentine painters. Alberti described and condemned an arithmetical formula—apparently in frequent use—which established these distances as diminishing progressively by one third.[32]

Just as the painters seem to have disregarded the principle of retaining an immobile distance point for the entire painting, they paid apparently no attention to the third basic law of Brunelleschi's construction, that of drawing to scale. In the *Disputation of Saint Catherine* in S. Clemente, the wall panels, though seemingly intended to be of equal length, correspond, the farthest to five, the adjoining one, if completed, to only four ceiling coffers.[33] In the Tabitha fresco likewise, the portico under which Tabitha lies is constructed on a scale different from the houses in the background: its height would correspond to only one half the height of the ground floor of the tall house in the center axis of the plaza. Only in the Trinity fresco does a constant scale appear to apply to the entire architectural setting.

But the Trinity fresco is an outstanding exception to contemporary Florentine perspective construction. The rule seems rather that Brunelleschi's method penetrated the pictorial arts piecemeal and by partially understood workshop shortcuts. Of his three basic principles, horizontal eye point, quasi-distance point and drawing to scale, only the first is accepted as governing the entire painting; the second is employed only for individual planes, the third never as governing all objects in the painting. In consequence, perspective construction among Florentine painters of the twenties remained fragmentary as a rule.

This fragmentary character becomes even more apparent in the failure of the painters of the twenties to incorporate within their architectural settings figures drawn to scale. In the *Madonna della Neve* (Fig. 88) the architectures are tiny as compared to the far larger figures. The clerics in the *Death of Saint Ambrose* are dwarfed by the enormous bed. Even in the Trinity fresco, the figures are not correct in proportion to the vertical planes to which they are assigned. The figure of God the Father stands on a ledge, presumably in the background of the chapel, yet looms so large that it appears almost as close to the front plane as the Crucified Christ in the middle ground, or John and Mary in the foreground. Contacts between figures and architecture are avoided whenever possible. The lack of mathematical relation between the two was of course inherited from Trecento painting. Neither had Brunelleschi been concerned with the problem of incorporating figures into his architectural perspectives. In this, his lack of interest in designing figures, lies another principal reason why his method could never become a really handy tool for painters.

The painter's problem was, after all, not the representation of a real architectural situation in perspective, but the construction of convincing space, architectural or otherwise, which would give the impression of reality and house figures in a convincing relation one to another. The creation of such a space had been a principal aim of Trecento painting at least since Ambrogio Lorenzetti had painted his *Presentation in the*

[32] Alberti, bibl. 8, p. 81; see also Wittkower, bibl. 558, p. 280 and note 1.
[33] Oertel, bibl. 365, p. 25., note 2.

Temple.[34] To this end, during the fourteenth century all kinds of perspective tools were developed to suggest degrees of depth: orthogonals converging toward a vanishing area or, in different horizontal planes, toward separate vanishing points, square-tiled floors, coffered ceilings, brackets, and canopied buildings. Obviously, however, these space representations, while partially convincing, were not measurable. Brunelleschi, on the other hand, started from the measurable construction of an architectural layout. His approach was both so revolutionary and so consistent that he could throw overboard the conventional Trecento symbols. Yet these symbols, "incorrect" though they were, were not useless. Once placed within a consistent spatial framework, they could form helpful links between figures and architecture; they could divide depth into measurable distances by marking off commensurable intervals along the width and height of the picture, and in such a pictorial space, figures could be arranged intelligibly in relation both to one another and to the space in which they stood.

How to blend traditional Trecento methods with Brunelleschi's perspective construction seems to have become a central problem of painting and sculpture in Florence and beyond, between 1420 and 1440. Donatello's *Salome* relief in Siena (Fig. 59) merges just such details of Brunelleschian perspective with Trecento patterns and spatial tricks. The orthogonals converge toward a vanishing area rather than toward a vanishing point. Within this area, the three divisions of the stage in depth point to separate subareas, and within these, in turn, the orthogonals above and below the horizon converge toward separate vanishing points; another, different vanishing point, high above the horizon, is suggested by the height of the two parapets and by the three levels of heads: they almost imply a cavalier's perspective from which the spectator looks down upon the entire scene. The transversals are laid out in a succession of distances which are progressively decreased by one sixth, one fourth, and so on, a method similar to that with which Alberti took issue. Tile floor, receding brackets, a successive series of arches, ceiling decorations, and orthogonal beams make for a convincing though not measurable space. Figures are unrelated to the architecture and they seem to lean out from the relief or back into it.

Brunelleschi, according to his biographer, never formulated a theory of linear perspective. Such a theory, both correct and easy to apply was first formulated by Leone Battista Alberti in 1435, in the first book of *Della Pittura*.[35] It has been suggested first that Alberti in this treatise merely codified practices common in the workshops of the

[34] Panofsky, bibl. 385, pp. 279f; Bunim, bibl. 81, pp. 139ff.

[35] The dates of *Della Pittura* in the Latin version of 1435 and the Italian version of 1436 are given in Janitschek's introduction to Alberti, bibl. 8, pp. iiiff. I am using for quotations, as a rule, the Italian version in Janitschek's edition. For the interpretation I am referring to Sir Kenneth Clark's brief and brilliant analysis (bibl. 102), Panofsky's comments regarding Alberti's linear perspective (bibl. 385, pp. 284f and bibl. 379, pp. 95f), and Ivins' study (bibl. 228). A new edition of Alberti's Italian text with English translation and extensive commentary is being prepared by Mr. John Spencer at Yale University.

The Latin version of *De Pictura* was last published appended to a Vitruvius edition in Amsterdam in 1649, bibl. 10. It was translated into Italian by Cosimo Bartoli in 1550 (bibl. 6) and this translation forms the basis of James Leoni's English version (bibl. 5). The variations from Alberti's own Italian text are significant enough to warrant renewed study.

Occasional recourse in chapter XXI to Alberti's Latin text will be pointed out.

Florentine *avant-garde*, and second that his perspective construction was but an abbreviation of Brunelleschi's. Mathematically speaking, indeed, Alberti's method simply consisted in reducing the number of operations required by Brunelleschi.[36] He was well acquainted with the older master's perspective method and must have sided with him against short-cut variations. Like Brunelleschi, he started from the fundamental assumption that a scientific and consistent linear perspective rested on Euclid's theorem of a proportionate mathematical relationship between the object and its pictorial presentation. Like Brunelleschi, he established for the artist a position fixed in height and distance from both object and painting, and thus identical for both painter and beholder. But what counted for his contemporaries was the practice, and with all due respect for Brunelleschi, young Alberti in his treatise left little doubt regarding the distinctiveness and the advantages of his own method. Indeed, his approach differs from Brunelleschi's on three counts: his procedure was methodically founded on theory: his method was simpler and better adjusted to a painters' needs; his aim was to present a measurable space for the action of figures, not to represent buildings as an architect. Indubitably, Alberti develops his approach with an eye to its potential usefulness for painters; but this does not mean that he evolved it from their workshop practices.[37]

Alberti in *Della Pittura* begins the explanation of his theoretical basis by his hypothesis of the "visual pyramid." This is assumed to be a cone formed by the "visual rays," its apex resting in the eye of the spectator and its base encircling the object. The central ray fixes the position of the observer and his distance from the object. On this basis, Alberti established the picture plane as a section through the visual pyramid, a transparent plane on which objects are represented in corresponding proportions.[38] As a first step the vanishing point is fixed on the plane at the base of the central ray and specifically defined as the meeting point of all orthogonals (Diagram 6). A horizontal drawn through the vanishing point marks the horizon. But, rather than establish arbitrarily the distances of the orthogonals, Alberti determines them by dividing the picture base into a number of equal sections corresponding in scale to one *braccio* each—that is, to one third the height of a human figure standing at that level. From the markings dividing these sections the orthogonals converge to the vanishing point.[39] In a subsidiary operation, Alberti transferred this scheme to a second auxiliary drawing. On it an auxiliary base was drawn corresponding to that of the first picture and like it divided into equal sections. Alberti then placed on the second drawing an auxiliary point, x, on the level of the horizon in the first picture. Point x was moved along an auxiliary horizon to some distance from the auxiliary base line and then connected with its divisions. Finally, at an arbitrary distance from point x, corresponding to the assumed distance of the spectator from the original picture, Alberti dropped a perpendic-

[36] Panofsky, bibl. 385, pp. 284f.

[37] Among fully developed perspective constructions with correctly diminishing transversals (such as the *Desco di Parto* from the Kaiser Friedrich Museum in Berlin and the *Healing of the Paralytic* in Philadelphia) and hence based either on Brunelleschi's unabbreviated procedure or more likely on Alberti's method, none can be assigned with any reliance a date prior to 1435. See, however, above note 1.

[38] Alberti, bibl. 8, pp. 71ff. [39] *Ibid.*, pp. 99ff.

ular, *j′*, down to the auxiliary base line. The lines connecting point *x* with the equidis-tant markings on the auxiliary base line intersected the perpendicular at diminishing intervals. When transferred to the vertical edge of the picture proper, these intervals establish the diminishing distances of the transverse lines parallel to the picture base, and together with the orthogonals these transversals seem to produce a series of squares receding into depth on the picture's horizontal plane. A diagonal drawn through any of these squares will continue as a diagonal through all the following squares and thus offer a means of control for the correctness of the construction. This diagonal is, how-ever, merely a control, and its connection with the "quasi-distance point" is not even intimated by Alberti.[40]

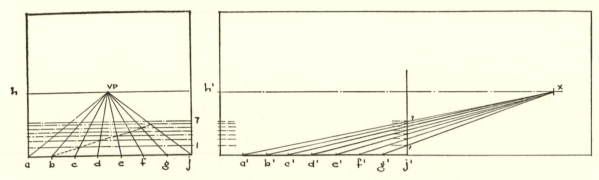

DIAGRAM 6. Alberti, Perspective Construction

So far then, Alberti would seem to be presenting in simplified form Brunelleschi's complicated procedure with the aim of substituting a consistent and correct construc-tion for the fragmentary workshop practices of the twenties. As in the latter, vanishing and distance points are arbitrarily assumed rather than corresponding to the real posi-tion of the beholder in relation to the object. Like the painters of the twenties, Alberti works with what appears to be a rectangular, and possibly a square picture panel. Theo-retically, he recognizes the vanishing point may be fixed anywhere within it; but it is advisable, he says, to place it on the panel's middle line and he leaves little doubt but that he would like to see it placed dead center. On the other hand, as did Brunelleschi, and much in contrast to the workshop tradition, Alberti time and again insists on the mathematical principle of vanishing and distance points and the retention of a common scale for all objects represented.

However, both in determining and applying this scale, Alberti would seem to go beyond Brunelleschi. The mathematical principles of perspective construction, while correct, are only seemingly his point of departure. His real aim is to incorporate human figures into a linear perspective; in fact, to make the perspective construction de-pendent on the scale of the human figure. To this end he starts from the perspective principle which determines the position of the vanishing point by the line of sight of the beholder—an ideal beholder to be sure. This ideal beholder Alberti represents by a figure standing on the picture base in the middle, its eye level in line with the van-ishing point. The real beholder is supposed to identify himself with this figure.

[40] *Ibid,* p. 83; Panofsky, bibl. 385, pp. 319ff, note 60 and bibl. 379, p. 96.

The figure at the picture base becomes the key element of Alberti's construction. He assumes it, one recalls, to be three *braccia* high. For this reason, he states, he has divided the picture base into sections, each one third the height of the figure. The orthogonals, originating from these dividing points towards the vanishing point, stand therefore at distances of one *braccio*. Also, since an auxiliary base line identically subdivided governed Alberti's construction of the transversals, they too denote distances equal to one *braccio*. As a result, Alberti specifically states,[41] the squares of the receding network each denote one *braccio* in length and in width. The figure on the picture base, that is the ideal beholder, thus becomes the *modulus* for the entire painting in depth, width, and height. Against this *modulus* all objects, their distances from each other and from the beholder can be easily measured. A coherent spatial unity is achieved, embracing all the objects in the panel as well as the real beholder.

In constructing a floor set out in squares, Alberti consciously continued a Trecento tradition. But he imparted a new function to the device, by assuming the squares to be uniform in size and to stand in a proportionate relation of one to three to the figures in the painting. Thus, the tile floor became a scale for arranging figures in diminishing proportion within a measurable picture space. Throughout, the desire for a measurable relation of measurable figures to measurable space underlies Alberti's thought and method. Therefore, he works with simple squares rather than with richer but less measurable shapes. The size of the squares along the width of the panel equals the size of the squares in depth, and since the size of the figures depends in an invariable proportion of three to one to the squares on which they stand, the height of any other object in the panel can be calculated by the size of these figures.

Hence, the use of a tile floor is fundamental to Alberti in carrying out his implicit premise, that of establishing a space measurable in relation to figures. At the same time, it is linked to his preoccupation with architectural settings as vehicles of perspective construction. In the architectural theory of the ancients, linear perspective and architectural settings, particularly stage settings, had been so closely linked that Vitruvius treated them as almost synonymous.[42] Among theoreticians of Renaissance stagecraft, Alberti was the first, it appears, to accept this synonymy.[43] Naturally, then, when he discusses the theory of linear perspective in his *Treatise on Painting* he sees it as linked to the designing of architectural settings, of *casamenti*, and specifically, of interiors. Though Alberti nowhere explicitly defines a particular kind of architectural setting, he implies throughout that he means an interior: at the very beginning of his perspective discussion, he proposes to make the horizontal surfaces the "pavements and ceilings of buildings," and the vertical planes "walls"; or else he exemplifies by referring to pavements, walls or the "faces of square piers set up in order in a portico"[44]—that is, as in a courtyard or plaza, either of which constitutes a quasi-interior. Throughout the discus-

[41] Alberti, bibl. 8, p. 83.
[42] Vitruvius, bibl. 540, II, p. 70 (Lib. VII, prooemium 11), see also Panofsky, bibl. 385, p. 302.
[43] Krautheimer, bibl. 251, p. 344.
[44] Alberti, bibl. 8, pp. 71, 107.

sion he never seems to depart from this premise of an architectural interior in contrast to Brunelleschi whose perspective experiments referred to exteriors.[45]

Like the tile floor trick, the use of an architectural setting for suggesting depth is an old Trecento tradition and again Alberti appears to have re-formed this tradition in accordance with his new concepts of a measurable picture space. As he describes them, these settings form simple rectangular boxlike spaces with one side open towards the picture plane. He mentions occasionally surfaces standing at other than right angles to the picture plane, but rapidly glides over the problem, just as he makes no suggestions regarding the connection of several spatial units in *one* perspective design. These self-imposed limitations of Alberti's contrast sharply with Brunelleschi's profound interest in representing complicated shapes such as the Baptistery, an octagon with arcades in foreshortening, a piazza with buildings of varying heights, or streets, that is, secondary spatial units opening onto the piazza. His principal interest was always the exact reproduction in perspective of an architectural survey. To Alberti, on the contrary, the aim of perspective was the creation of a single homogeneous space, measurable horizontally by squares of a floor or ceiling, vertically by the height of walls or pilasters, that is by *casamenti*, and always proportionate to the figures contained within.

Within the framework of these premises Alberti could not have tolerated "distortions" of any kind. He strongly disapproves of placing the vanishing point either above or below the assumed height of a figure standing on the picture base since this would result in sudden foreshortenings. While he never suggests actual changes in a correct perspective construction, he aims throughout at simple views and situations. In brief, linear perspective is to Alberti a means towards a pictorial end, not an end in itself. He is even willing to replace the entire procedure of perspective construction by a simple craftsman's tool: the "veil" which allows for a mechanical transfer of forms from its squares onto the corresponding squares of a panel.[46]

Only against this background does Ghiberti's approach to linear perspective become clear. In his first door, he employed only the fragmentary forms of perspective known from Trecento painting. Still in the relief of *Saint John before Herod* the squares of the three ceiling compartments and the pier capitals converge toward separate vanishing areas (Pl. 72). His approach when he starts on the Gates of Paradise is not fundamentally different. In the early group of reliefs depth is convincingly suggested by a scenery in which mountain ranges overlap each other, standing at a slight angle to the picture plane and to each other, by a copse of trees leading into depth and by a series of figures distributed through the picture space. Linear perspective, if used at all, is confined to occasional elements like the two altars of the *Cain and Abel* (Pl. 85), the gate of Eden at the right edge of the *Creation* (Pl. 84), the squarish wellhead, the water canteen, the altar, and the table in the *Abraham* (Pl. 93). As in the North Door these isolated attempts at foreshortening, are unrelated to the principle of a consistent linear

[45] The contrast between Brunelleschi's exterior and Alberti's interior perspectives was brought out by my friend, James S. Ackerman, in a seminar discussion, 1948-1949, at the Institute of Fine Arts, New York University.

[46] Alberti, bibl. 8, p. 101.

perspective. In the *Abraham* the wellhead behind the resting servants is drawn with widely diverging orthogonals; so is the altar in the scene of the Sacrifice, and in the table standing behind the three angels, the bordering lines run parallel. The polygonal water canteen in front of the servant's group functions as a *repoussoir* comparable to the flower vase in so many fourteenth century Annunciations; foreshortenings are employed as tricks to suggest depth, just as they had been used in hundreds of paintings a century before.

However, the *Isaac* and *Joseph* (Pls. 94, 98) stand in the strongest possible contrast to these early reliefs. They, with the *Solomon* (Pl. 116), are characterized by monumental architectural settings, and they alone are designed in terms of a homogeneous linear perspective. The deep hall in the *Isaac* and the round edifice and palace in the *Joseph* almost fill the panels, obviously with the aim of organizing both the narrative and the picture space in terms of a perspective system. The principal lines of this system coincide with the architectural setting: the surfaces and all the horizontals and verticals of walls and pilasters that parallel the picture surface recede in different planes; the squares of the flagstone pavement, the walls and cornices, all run into depth at right angles to the picture plane. They form a system of orthogonals which converge from above and below and from left and right with only minor divergencies toward one vanishing point (Diagram 7). In the *Isaac* this point is placed in the middle arch of the big hall, right in the center of the architectural setting and indeed in the center of the panel. The diagonals, harder to check, yet still unmistakably marked by corners and by the squares of ceilings and pavements, appear to converge toward what today is called two distance points, placed outside the panel, at a distance corresponding roughly to half its width. Thus by means of the architectural setting—the *casamenti*—an intelligible space has been designed, continuous in depth, width and height. This space is populated by figures which diminish proportionately as the eye follows them into depth. To this end the floors of the hall and the plaza in front have been divided into a number of squares. Figures and architectural elements are placed on these squares and on their intersections. A network of coordinates has been laid out to determine the exact place and consequently the exact size of each element within the space constructed. This network is in its entirety related to the human figure. Indeed, the base of the panel has been divided into nine equal parts marking off the nine squares along the front of the panel. Each of these nine parts—that is the width of each square—measures 8.6 cm, exactly one third of the average height, 26 cm, assigned to an adult person placed in the panel's immediate foreground. Since a life-sized human figure must be assumed to be about 1.75 m high, the length of the squares is intended to represent proportionately .583 m each, that is, exactly one *braccio*. Correspondingly, the heights of the figures in the middle and backgrounds are consistently three times the width of the squares on which they stand, except, that is, for those of Rebecca and Jacob, on the side stage to the right.

Without doubt, then, Ghiberti's *Isaac* in its clear linear perspective construction, in its consistent emphasis on a dominant architectural setting, and in its reference to the

human figure as a standard measure, represents not a stage within an evolution but a revolutionary change, almost a reversal, both in the new concept of a unified space and in the procedure of constructing this space according to linear perspective. Nor is there any doubt but that these new elements are closely linked to the theory, principles, and methods first formulated by Alberti. In the pages of *Della Pittura* are contained all the

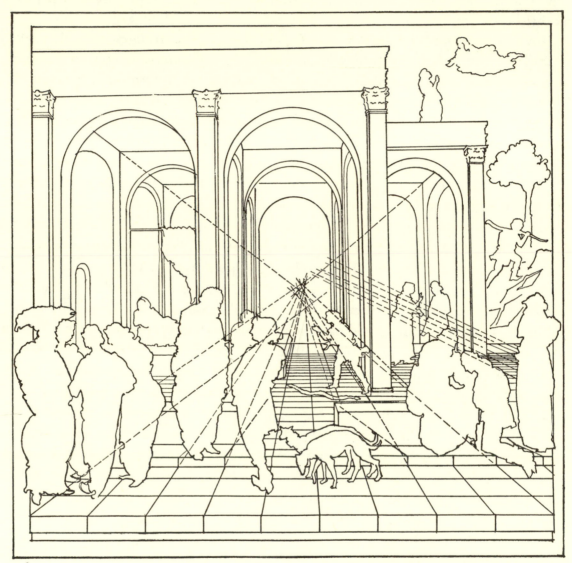

1435

DIAGRAM 7. Ghiberti, Perspective Construction, *Isaac*, Gates of Paradise

elements of construction used by Ghiberti in the *Isaac* panel: the position of the vanishing point in the center of the panel; the division of the picture base into a number of equal sections; the relation of these sections to the height of the figures in a proportion of one to three; the tile floor used as a network of coordinates for the exact placing of each object; the convergence of all diagonals toward a "quasi-distance point"; and lastly, the architectural setting as a proportionate frame for these figures, the principal agent both in creating an intelligible space for their actions, and in giving the entire scene a wholly measurable depth and height. As Ghiberti puts it in his own words:

". . . colla ragione che l'occhio gli misura e veri in modo tale stando remoti da essi appariscono rilevati."

It need hardly be stressed that the time at which the *Isaac* panel was designed—around 1435—coincides with the date when Alberti wrote his *Treatise on Painting*. Contemporary, then, with the publication of Alberti's little work, either in its completed form or in a preliminary state, in the *Isaac* and *Joseph* panels Ghiberti presented suddenly and without any preparatory transitions a consistent linear perspective constructed with the primary tools as well as the method Alberti had used and with the same ultimate aim in mind, the creation of a visual and measurable picture space related to the size and designed for the action of human figures.

The conclusion seems to be inevitable: Ghiberti in the *Isaac* and *Joseph* panels applied verbatim the perspective construction which Alberti had expounded in the *Treatise on Painting*. Indeed, the new method as prepared by its young champion in 1435 must have wrought a revolution in Florentine art. There it was, finally, a construction simpler and handier than Brunelleschi's which would permit the presentation of a wide picture space, theoretically unlimited, yet clearly defined and fully measurable, filled with settings and with figures, whose actions became clarified and understandable through the consistent use of the new tool. It was exactly what an entire generation, since 1415 or thereabouts, had been groping for. Ghiberti would naturally endeavor to appropriate and absorb the new method and to exploit it for designing the panels of his door, and we can imagine how he would consult young Alberti and listen to his explanations. One might even toy with the idea of Alberti's having sketched for him the basic perspective construction of the *Isaac* panel.

But this last hypothesis, tempting as it is, has to be discarded: for Ghiberti evidently never fully grasped Alberti's theory of space presentation. He did absorb the overall guiding principles and the fundamental elements: vanishing point, distance point, horizon, tile floor, and even the proportionate interrelation of figures and architecture. But in details often essential to Alberti's concept and procedure of perspective he turned deviationist. To give an example: in accordance with Alberti's suggestion, the vanishing point in the *Isaac* panel is right in the center of the relief; but it is placed at the eye level of the middle ground figure of Isaac standing on the front steps of the large hall—and thus high above that recommended in the *Treatise*, the eye level of the figures on the picture base. Also deviating from directions in the *Treatise*, and strange as it seems, the "quasi-distance point" is apparently not placed on the horizon line together with the vanishing point; it lies somewhat lower, on a level with the heads of the foreground figures. The horizon in other words, is shifted, and as a result of assuming this higher position for the vanishing point, the beholder would seem to be looking down on the scene from a considerable height; a construction which is all the stranger since the panel is placed on the door far above the eye level of the beholder. On the other hand, the lower horizon assumed for the "quasi-distance point" causes the distance between transversals to appear shorter than one would expect in view of the high vanishing point. Therefore, an essential of Alberti's theory, the intimate connection between distance and vanishing points, between the eye level of figures

251

standing on the picture base and the eye level of the beholder, and correspondingly the uniformity of the horizon, have been disregarded. In fact, the panel is not even altogether directed towards one vanishing point. Only in the fore-stage and center bay of the hall do the orthogonals nearly converge. Those in the right bay of the hall, where Rebecca is instructing Jacob, and in the plaza beyond, run toward a different vanishing point, slightly above the first and apparently to its left. This entire side-stage, then, is not quite incorporated into the overall perspective design, another inconsistency impossible within a wholly Albertian perspective.

The *Joseph* (Pl. 98) follows the same method of perspective construction. As in the *Isaac* the base line is divided into nine sections, each representing to scale one *braccio*. Again, the entire floor of the forestage and of the round structure behind, is divided into the squares of a flagstone pavement, with the distances of the transversals diminishing in a consistent geometrical progression. Again the orthogonals of this pavement, of the round structure, and of the palace to the left, all converge toward one vanishing point; and again this vanishing point is placed in the center of the round structure high above the eye level of the figures on the picture base. The "quasi-distance point" this time appears to be placed on the same horizon as the vanishing point. The size of figures diminishes progressively into depth, each corresponding in height to three times the width of the square on which he stands. But again there is a break in the consistency of the overall perspective. As in the *Isaac*, a side-stage is half detached by a separate perspective system: the dais in front of the palace to the left, where Joseph is recognized by his brethren, sends orthogonals toward a vanishing point of its own, far to the right and below the principal one.

To summarize, the designs of the *Isaac* and *Joseph*, with their large-scale, consistent architectural perspectives, introduced an unexpected change in Ghiberti's work sometime around 1435, presumably due to the impact of Alberti's theories. At the same time, Ghiberti tried occasionally to evade the inexorable logic of these theories. In fact, it seems as though their impact on him lasted but the shortest possible time: even on the Gates of Paradise it is limited to the two panels of *Isaac* and *Joseph*; the *Solomon*, though but little later than these two and like them staged in a large scale architectural setting, no longer follows Alberti's perspective construction.

True, the structures in the *Solomon* are by and large designed so that their orthogonals converge toward one vanishing point, and this point, though not in the panel's exact center, is placed on its vertical center line (Pl. 116). It lies just below the middle window sill in the apse of the temple. Thus it is not only quite some distance above the heads of Solomon and the Queen in the middle ground, but also high above the heads of the foreground crowd. This departure from the Albertian theory of perspective is by itself of far greater significance than the earlier deviations in the *Isaac* and *Joseph*. Yet this is not the only departure; others are both numerous and significant. In the first place, the entire perspective construction does not quite come off: the jambs of the balustrade in the middle ground, orthogonals though they are, converge toward a point considerably lower than the principal vanishing point. In the second place, very much in contrast to the *Isaac* and *Joseph*, the architectural set-

ting is but a backdrop, and the figures stand in front rather than inside it. Third, the space reserved for them in the foreground seems altogether too narrow, and certainly the amount of room on the platform between the parapet and the Temple façade is not sufficient for the large crowd of courtiers squeezed in behind Solomon and the Queen. Fourth, the figures do not diminish proportionately in size; Solomon and the Queen halfway back are of exactly the same height as the crowd in the immediate foreground, while figures quite close behind them diminish abruptly by one third, with hardly any transition. Finally, the ground on which the figures stand, instead of appearing as a pavement squared up into large flagstones, inclines in unmarked surfaces from the panel base to the first steps, and thence to the steps of the Temple. There is therefore no way to measure the space in this panel, or to relate the figures either to each other, or to the architecture, or to the ground on which they stand. Both sizes and distances are indeterminate. To be sure, a foreground, a middle ground and a background stage are neatly marked off, and connected by steps along the center axis. But these stages are visually separated by a high parapet and by the crowds which conceal the edges of the steps. Almost as in the very early reliefs of the door, Ghiberti uses overlapping forms to avoid the necessity of demonstrating spatial measurability and coherence. The three stages rise so rapidly behind one another that they almost seem superimposed, rather than receding, and the entire depth appears contracted into a tapestrylike surface.

It is unlikely that he consciously tried to disregard Alberti's perspective construction. More likely he simply set out to reduce it to what he considered practical essentials. From the basic elements he discarded the division of the floor into squares to which the height of figures and their distances could be related; he omitted the corresponding subdivisions of the picture base; he made it impossible for the onlooker to establish the distance points; and he allowed the horizon to assume a level which forces the beholder to view the relief from high above—as indeed an onlooker would anyway have to do when looking at this, the lowest of all the panels on the door. In brief, he eliminated the very elements which in Alberti's system had guaranteed both the complete homogeneity and measurability of the space represented, and the complete intelligibility of the figures and their actions. No doubt he did so only with the intention of simplifying what seemed to him an unnecessarily complicated procedure, without realizing the consequences of his omissions. His discussion in the *Commentarii* shows clearly enough that still, ten or fifteen years later, he thought of all ten reliefs of the door in terms of measurable depth. After all, his mind had never run along theoretical lines, and almost unaware he slipped out of Alberti's perspective system as suddenly as he had slipped into it.

CHAPTER XVII

GHIBERTI ARCHITETTO*

GHIBERTI terminated his autobiography with a claim for recognition as an architect: "Few things of importance were made in our city, which were not designed or devised by my hand. And especially in the building of the dome [of the Cathedral] Filippo and I were competitors for eighteen years at the same salary; thus we executed said dome. We shall write a treatise on architecture and deal with this matter."[1]

Had Ghiberti been able to carry out his intention we might know more about the position he held in the history of fifteenth century architecture in Florence. We might know the exact extent of his contribution to the field. And we might know to what degree he thought as a "builder of buildings," or whether, on the contrary, his concepts remained within the realm of architectural dreams, too vague to be harnessed within structural realities.

Ghiberti's part in preparing and supervising the construction of the dome of the Cathedral is hard to define. The report given in the *Vita di Brunellesco* is twisted, and the documents of the *Opera* of the Cathedral are open to interpretation. This much seems clear, that in the preparatory stage, three phases stand out.[2] In a first exploratory period, May 1417 through August 1418, preliminary models were designed, seemingly under Brunelleschi's supervision, both for the dome and for a centering. In a second period of implementation, Ghiberti and Brunelleschi, in the fall of 1419, competed with one another and with a large group of other contestants each designing a model and executing it in masonry (Digs. 6off). Apparently Ghiberti planned to vault the dome over a centering while Brunelleschi intended to do without one, and this, indeed, would have been a fundamental difference.[3] Possibly a second contest limited to Brunelleschi and Ghiberti, took place in the summer of 1419.[4] In the winter of 1419-1420, after receiving further direction from a committee of four, constituted by the *Opera*, Brunelleschi and Ghiberti appear to have worked jointly on a definitive model (Digs. 74, 75). Finally, in the spring of 1420, both were appointed supervisors of construction, together with the reliable master mason of the Cathedral, Battista d'Antonio, and two substitutes (Dig. 76), all three working at a salary of three florins

* For an abbreviated version of this chapter see bibl. 248.

[1] Ghiberti-Schlosser, bibl. 178, I, p. 51. The plural of the last sentence can be only an author's plural.

[2] Sanpaolesi (bibl. 468) has given careful study to these documents with regard to the preliminary stage of work, 1417-1420, and I gratefully refer to his analysis. But I fear that throughout he is inclined to overestimate the importance of Ghiberti's contribution to the building of the dome.

[3] There seems to be no basis in fact for Sanpaolesi's hypothesis (bibl. 468, p. 331) that Ghiberti's model also was planned without centering.

[4] A small group of documents referring to both Ghiberti (Digs. 70, 72) and Brunelleschi (Guasti, bibl. 198, docs. 29f) have been interpreted by Sanpaolesi (bibl. 468, p. 330) as hinting at such a second contest; but they may just as well refer to belated payments for the contest of 1418.

monthly. Except for two intermissions, one lasting from June 1425 through January or possibly March 1426 (Digs. 120, 123ff), the other through the first half of 1431 (Digs. 160, 163), Ghiberti was regularly appointed at more or less fixed intervals, together with his two colleagues and maintained this position through 1436 (Dig. 192). During this entire period, however, his name was specifically mentioned only three times: once in 1426 when he jointly signed with his colleagues and one of the substitutes a report to be followed in building the upper portions of the dome (Dig. 123); again in 1429, when he and Brunelleschi received the commission to have executed a model of the entire Cathedral (Dig. 156); finally in 1432 when he collaborated with Brunelleschi and Battista d'Antonio in designing a wooden model for the terminating key ring of the dome (Dig. 171), a model which was changed at Brunelleschi's insistence six months later. As a free lance he entered the competition for the lantern of the dome in 1436 but his project was rejected as were those of three other contestants in favor of Brunelleschi's winning design (Digs. 193, 196).

The documents, then, cast serious doubt on Ghiberti's assertions regarding his contribution to the building of the *cupolone*. To be sure, credence need not be given to the malicious presentation of the story in the *Vita di Brunellesco*, which abounds with broad hints at Ghiberti's incompetence, his ignorance, and helplessness in matters of construction, and his readiness to accept pay without rendering services.[5] But a small kernel of truth may be contained in these aspersions. In the preparatory stage, Ghiberti and Brunelleschi seem to have started out on an equal footing. Ghiberti lost the first contest, but strangely enough he was nevertheless conjoined with Brunelleschi in designing the final model and appointed supervisor at an equal salary. Within a short time, however, Brunelleschi appears to have risen above his colleague. As early as 1423 he is called *inventor et ghubernator maior cupolae* and thus seems to have held a special responsibility. In 1426, in extending the contracts of both Brunelleschi, and Ghiberti, the *Opera* retained Brunelleschi's full-time services, but Ghiberti's only part time. He could draw pay only for those days when he reported at least for one hour's work. Brunelleschi's salary was raised to 100 florins yearly, Ghiberti's remained the same, 36 florins (Dig. 124). Also from the very outset, Brunelleschi received special fees in addition to his regular salary: 100 florins for the design of the pulleys in July 1421, and an equal amount for the design of the masonry chain in the summer of 1423. All told, Brunelleschi was "to provide, arrange, compose or cause to have arranged and composed, all and everything necessary and desirable for building, continuing and completing the dome," while Ghiberti had only "to provide" towards this end (Dig. 129).[6] Also the suspension of Ghiberti's appointment in 1425 and 1431 causes one to wonder. True enough, both suspensions were undoubtedly linked with his having had both hands full with other tasks. Yet at the same time Brunelleschi's salary was seemingly never suspended, despite an otherwise crowded outside schedule.

[5] (Manetti), bibl. 294 *passim*; Sanpaolesi (bibl. 468) insists on Ghiberti's equality with Brunelleschi in designing and executing the dome. The very convincing objections to this thesis have been summed up by Pica, bibl. 397.

[6] Sanpaolesi, bibl. 468, and Guasti, bibl. 198 *passim* for the documentary evidence.

None of this answers satisfactorily the question of Ghiberti's part in preparing and supervising work on the *cupolone*. His collaboration with Brunelleschi in that task had apparently been the choice of the committee in charge. The natural antagonism between their personalities, between Brunelleschi's somewhat abrupt disposition and Ghiberti's conciliatory nature, was bound to give trouble. Indeed, their incompatibility was reflected at the very outset of their association in the contrast between the boldness of Brunelleschi's design for a vault without centering and the cautiousness of Ghiberti's competing plan. Just this contrast, however, would explain why conservative groups in the *Opera* and citizenry may have insisted on having the bold innovator associated with his less radical opponent, assisted by the old craftsman, Battista d'Antonio. In fact, Brunelleschi and his circle seem to have looked upon Ghiberti as the holder of a sinecure on the team of supervisors, and the author of the *Vita di Brunellesco* implies that Ghiberti availed himself of political pull to get in on the important and well-paid job. In any event, whether or not Ghiberti's was a political job, his position was apparently envisaged as that of a mediator. The real responsibility for the construction obviously rested from the outset with Brunelleschi and his importance grew as the work progressed. The confidence which at first only one group in the *Opera* placed in him, must have become general as the entire city grew proud of the great feat of the *cupolone*. Correspondingly, Ghiberti's influence as supervisor of the construction seems to have declined, presumably, the *Vita di Brunellesco* suggests, not without a little intriguing on the part of Brunelleschi and his clique. During the ten years between 1426 and 1436 Ghiberti's job on the team of supervisors may have been only that of a part-time consultant who was occasionally obliged to put in an appearance. All this helps to clarify Ghiberti's position in the administration of the *Opera*, but does not throw much light on his actual contribution to the design and the construction of the dome.

Documentary evidence is altogether scant regarding Ghiberti's activities as an architect. In May 1419, he designed a stairway for the papal apartment, then in preparation in the convent of S. Maria Novella (Dig. 65; Docs. 127f), but neither a trace nor a description are left of the *corpus delicti*.[7] Beginning January 1420, together with one Cola di Niccola (Spinelli), a goldsmith, Ghiberti supervised work on the choir stalls and other furnishings of the sacristy and Strozzi tomb chapel adjoining S. Trinità (Dig. 73a). He may also have had a hand in designing the portal to the chapel (Figs. 90, 93), but the documents are silent on this point.[8] In any event, at the time the contest for the *cupolone* was drawing to a close, Ghiberti seems to have nurtured his greatest ambitions in the field of architecture. He made a late bid, in competition with Brunelleschi and one Angelo d'Arezzo, for the choir of the Cathedral, submitting a project for it in 1435 (Dig. 191). Evidently in conformity with his competitors, Ghiberti designed an octagonal choir screen, with the altar in the very

[7] Poggi, bibl. 409. The documentary evidence is somewhat contradictory; for while Ghiberti's design was accepted over those of two competitors, one of the losers was urged a few weeks later to submit a new drawing, either to replace Ghiberti's or as a working drawing, and was commissioned to execute the staircase.

[8] See below, note 16.

center underneath the lantern of the dome;[9] but the jury rejected his project on the grounds that it did not provide sufficient space for the singers and officiating clergy. The criticism proves, if nothing else, how inconsequential were questions of practicability in Ghiberti's architectural thinking.[10]

As a practicing architect Ghiberti may have been a failure, but even so his importance to architecture might still be supreme. Within the entire history of architecture flights of imagination and concrete realities are inextricably interwoven; but they are not always merged in one and the same personality. Indeed, large, beautiful architectural designs of a progressiveness unparalleled in real architecture of the time and hardly ever paralleled in contemporary architectural settings dominate three of the reliefs on the Gates of Paradise, all cast by April 1437, the chasing completed or almost completed by 1439. They are the *Isaac*, the *Joseph* and the *Solomon*. The front panel of the Zenobius Shrine belongs in the same group.

The architectural setting in the *Isaac* (Pl. 94) consists of a hall two bays wide and at least two bays deep. Corresponding to the second bay in depth, a one-bay porch projects on the right. The building opens on all sides in round arches. Similar arches divide the interior into bays, covered by what looks rather like a flat ceiling. The piers from which the arches spring are slender, but it remains unclear whether they are square or cross-shaped. This casualness of the constructive features is strangely contrasted to the perfect logic and consistency of the façade design: pilasters with Corinthian capitals flank the arches of the main building, another one rises at the end of the projecting porch. Above them, the entablature is formed by an architrave consisting of three fasciae, a plain, lithe frieze, and a projecting cornice; above the porch this entablature serves as the parapet of a roof terrace. The pilasters are extraordinarily slender, their height corresponding to about fifteen diameters; capitals and entablature are drawn sharply as though with a razor. The whole design is elegant, clear, and precise.

In the *Joseph* (Pl. 98) a round building rises from a platform with two steps; an open courtyard in its center with a wheat pit in the middle, is encircled by an ambulatory. Radial arches divide the ambulatory into bays; but again their covering remains quite indefinite. Both outside and inside, the ambulatory opens in twenty tall arches, supported by weightless piers, with slim pilasters in front. The entablature is surmounted by a low upper story, which is divided into bays by small pilasters. Its windows are framed by aediculas with triangular gables, set off by sharply molded cornices. The same clarity and simplicity of design, the same emphasis on plain surfaces, the same slenderness and purity of the vocabulary mark the palace to the left, in front of which Joseph, seated on a lofty dais, receives his brethren (Pls. 100, 101a). Pilasters mark the corners and the receding angle of the street floor, and flank an open niche and a linteled doorway surmounted by an oculus. The same membering is re-

[9] Poggi, bibl. 413, p. cxx and doc. 1176. Brunelleschi's choir screen was executed only in wood (Vasari-Milanesi, bibl. 533, VI, pp. 175f).

[10] Vasari's fleeting reference to Ghiberti's having made a wooden model for Brunelleschi's S. Lorenzo (Vasari-Milanesi, bibl. 533, VII, pp. 97f; see also *ibid.*, II, p. 244) has no basis in fact, documentary or otherwise.

peated on the upper story, though with pairs of windows occupying each bay. The terminating cornice, neat, precise, and clear, links the palaces to the round building and to the triangular mountain in the background.

In the *Solomon* Ghiberti goes further (Pl. 116). The architectural setting for the first time creates an ideal plaza of the Renaissance. A platform is raised above the street level, accessible by a flight of steps and set off by parapets. Three buildings rise on it, set back a short distance. In the middle, elevated another few steps, stands the Temple, a basilical structure with ribbed groin vaults over the nave and the aisles and with a ribbed polygonal apse with pointed tracery windows behind a square crossing. In contrast to the Gothic vocabulary of this interior, the façade is organized in the same classical forms as the buildings in the *Isaac* and *Joseph*. The flanking palaces are equally classical in design and spirit: the ground floors open in arcaded or architraved porticoes, supported by inordinately tall piers; the upper floors, with their windows, are articulated either by plain low pilaster strips or by slender pilasters surmounted by an entablature. Comparable concepts, though less carefully executed, dominate the architectural setting on the main relief of the Zenobius Shrine (Pls. 78a, 80b). A long narrow plaza extends into depth, flanked at the far end by tall, shallow palaces rising in three or four stories. A small one-storied building, marked by tall, yet strong pilasters, stands farther in front, resembling a Roman tomb. The main vista is terminated by the façade of a church raised on three steps, its ground floor is articulated by four pilasters, flanking the narrow bays of the aisles and the wide center bay. On the upper floor, above the separating entablature, the low and broad center part is again terminated by pilaster strips, corresponding to those of the center bay below. An oculus appears to occupy its middle, a triangular gable tops it off. On either side it is flanked by the low triangles of the aisle roofs. It is the first church façade of the Renaissance.

The cities in the background of the Zenobius Shrine, the *Joshua* and the *David* (Pls. 79b; 111a, b) are all compressed within high crenellated walls with square towers. The individual structures are closely packed: churches and spires, the tilted, gabled roofs of low houses, the tall blocks of palaces, their many stories segregated by clear cornices and entablatures and occasionally organized by orders of pilasters. Among them rise a few buildings *all'antica*, an octagon, a Colosseumlike structure, a ruin.[11]

[11] Two types of city representations seem to coexist and intermingle from the beginning of the Trecento. On one hand stands the heaped, upturned bird's-eye view: ultimately derived from Early Christian and medieval representations of Jericho and Jerusalem, it is expanded and used to represent contemporaneous cities: Florence (Badajolo miniature, *ca.* 1330; Bigallo Fresco, 1352), Siena (Lorenzetti, *Good Government*, Palazzo Pubblico, Siena, *ca.* 1340), Pisa (San Ranieri frescoes, Camposanto, *ca.* 1370), or Rome. Frequently it presents an abstract in the form of a few outstanding monuments (Cimabue, Assisi, *ca.* 1300; Seal of Louis of Bavaria, 1328). On the other hand, a new type of city representation seems to develop in the Trecento, the distance view, in which housetops and monuments show above the encircling walls of the city (Taddeo Gaddi, *Martyrdom of St. Lawrence*, Or San Michele, Florence, 1360; Francesco da Volterra (?), Job frescoes, Pisa, Camposanto, *ca.* 1370; Andrea da Firenze, *Way to Calvary*, Florence, S. Maria Novella, Spanish Chapel; Silver Altar of Saint John, Florence, Museo dell'Opera, 1365ff). While the two types are not strictly segregated, both seem to continue throughout the fifteenth century

A strange discrepancy prevails in these architectural settings. The vocabulary and the design are consistent, and form evidently part and parcel of the newly developing concepts of a classical architecture. The architectural skeleton, conversely, is anything but classical. The buildings lack body, they are cardboard-thin. Their plans, their structural framework, and their individual parts stand in no clear relationship to another, either as a whole or in detail.

Strictly speaking, indeed, all these settings show a painter's outlook. They rest on the tradition of Tuscan Trecento workshops, both in Florence and Siena. This tradition of creating large architectural settings, composed of deep, but weightless structures, had found its boldest representative in Florence in the 1370's in the Sylvester frescoes in S. Croce. But it survived far into the first decades of the fifteenth century. From Lorenzo Monaco to Sassetta and to Bicci di Lorenzo, architectural settings are treated as weightless boxlike structures, with cardboard-thin walls.[12] A system of intersecting arches, springing without cornices from weak piers, divides the interior into squarish bays, covered by ill-defined ceilings. While the hall in Ghiberti's *Isaac* finds an exact counterpart in a lost fresco by Dello Delli, representing the *Blessing of Isaac*,[13] it harks back ultimately to the architectural settings of Pietro Lorenzetti and his workshop (Fig. 84).

However, Ghiberti's real importance to fifteenth century architecture is not determined by such trecentesque elements in his settings. It rests, on the contrary, entirely in the classical hue he imparts to these dream structures.

Whether they are temples, round or octagonal buildings, or palaces, all are well defined in every part (Pls. 80b, 94, 98, 100, 116, 120a, b). Pilasters are integrated with the entablature into fully developed orders. A smaller order on the top floor takes up and continues the larger order on the ground floor, intercolumniations on arches are repeated by a corresponding series above, at times in double rhythm (Pls. 100; 120a, b). Arcades on piers and entablatures resting on pilasters form arch-and-lintel combinations (Pl. 94). Bays are clearly marked off, windows or doors are set in the very center of the bays. The corners of buildings are stressed by strong double-faced piers. The capitals are of a simple sketchy Corinthian type, the entablatures have their three clearly distinct members (Pl. 95). Columns appear to be avoided throughout. Arches, except for the Temple of Solomon, are invariably round. They are carried by piers, either square or cross-shaped. In the Zenobius Shrine, a series of square piers carries the architrave of a portico (Pl. 80b). Windows are set either into plain rectangular

in representations of Rome (for instance, Masolino, Castiglione d'Olona, 1435; Virgil Master, Jarvis Collection, Yale University, New Haven, *ca.* 1460) and other cities (Bergomer woodcut, 1490; woodcut map of Florence, 1470-1480 [map with the chain]). Whether they represent Rome or an imaginary city, all these views are interspersed with antique monuments, such as the Colosseum or triumphal columns. Clearly Ghiberti's city views were rooted in this tradition.

[12] Lorenzo Monaco, *Adoration of the Magi*, Uffizi (Van Marle, bibl. 301, IX, plate opposite p. 152); Sassetta, *Thomas Aquinas before the Cross*, Vatican, Pinacoteca (*ibid.*, IX, fig. 149); *idem, Saint Francis, the Fire Test*, formerly Duveen, New York (*ibid.*, IX, fig. 222); Bicci di Lorenzo, Saint Nicolaus panels, New York, Metropolitan Museum (*ibid.*, IX, fig. 9).

[13] The fresco is known only through a line engraving in Rosini, bibl. 451, II, pl. 244. See also Paatz, bibl. 375, III, p. 720 and notes 300f; Pudelko, bibl. 432, pp. 71f; Salmi, bibl. 460, pp. 169ff.

frames or into aediculas with flanking pilasters and triangular gables (Pl. 120a); oculi when they occur are surrounded by beautifully strong, clearly shaped moldings (Pl. 100). Doors are flanked as a rule by pilasters and surmounted by precisely designed wide architraves with dentil friezes. Departures from this uniform vocabulary are rare and limited to the towers and spires of city views or to the Gothic rib vaults of the Temple of Solomon; but these inconsistencies are readily explained: the towers and spires by the late medieval tradition of city representations, the rib vaults by the fifteenth century custom of representing the Temple of the Old Covenant in antiquated forms, in Romanesque north of the Alps, in Gothic in Italy.[14]

Obviously these late architectural designs of Ghiberti's are intended to revive the architecture of antiquity. But within the full range of antique architectural vocabulary a choice has been made. The buildings consist of lithe smooth façades and their vocabulary excludes such well-known elements of ancient architecture as the column or decorated frieze. The entire membering is unencumbered by ornament. The contrast between the membering and the smooth wall surface, the clear interrelation of all parts, the rational composition and perfect consonance of façades, buildings, and entire palaces, the precision of the membering, their chaste coolness, their almost frigid purity result in a highly sophisticated, reticent and somewhat uncorporeal classicism. These structures are of a rare, subtle beauty. If Ghiberti himself, prior to 1437 designed them, then indeed, he holds an important place in the history of Renaissance architecture.

To determine the exact position of these settings in relation to the architectural currents of the early fifteenth century in Florence is nevertheless far from easy. Certainly they have nothing in common with Ghiberti's architectural designs of the first twenty years of the century and little with those of the twenties. The niche of *Saint John* at Or San Michele with its mixed-linear arch (*arc mixtiligne*) (Pl. 3), if, indeed it was conceived by Ghiberti, is of a fashionable early fifteenth century Late Gothic design, possibly of Venetian provenance, much like the nearly contemporary windows on the main apse of the Cathedral.[15] The majority of the architectural settings of the North Door are steeped in the tradition of the Florentine painters' workshops of the Trecento (Pls. 34, 42, 54). The architectural skeleton is garbed with the forms of what in

[14] Panofsky, bibl. 382.

[15] The documentary evidence proves incontestably that the niche for the *Saint John* was not executed by Ghiberti (Digs. 33, 42; Docs. 3, 55); but he may well have furnished the design.

Reymond (bibl. 437, p. 246) was the first to stress the use of the *arc mixtiligne* on the *Saint John* niche (1417) and on the portal of Or San Michele (1414-1416; *ASF, Archivio dei Capitani di Or S. Michele*, vol. 259, c. 5; vol. 260, c. 6v and *passim*; vol. 261, c. 2v). His hypothesis regarding the migration of the *arc mixtiligne* from Florence to Venice is untenable (see also Weise, bibl. 548). Marchini (bibl. 298, pp. 33f and p. 34, note 1) has stressed the resemblance of the niche of *Saint John* to the windows on the clerestory level of the Cathedral which likewise have this type of arch. The date, 1404-1406, and the presence of Ghiberti on an advisory committee for these windows is known through documents (Digs. 12, 19), but considering the broad membership of that committee, Ghiberti's presence on it has little bearing on the resemblance between window and niche. It may, though it need not be, of greater importance to point out with Marchini, *loc.cit.*, the origin of the *arc mixtiligne* in the Masegne workshop, its first appearance on the façade of the Cathedral of Mantua, 1396-1404, and Ghiberti's attested presence in 1400 in the Venetian *ambiente*, at Pesaro (though not at Rimini, as Marchini assumed).

Florence amounts to a Late Gothic vocabulary: paneled pilasters; semicircular niches; brackets, cornices, bases and moldings of run-of-the-mill Trecento design; bundles of thin polygonal shafts; windows, filled with Gothic tracery. Occasionally, these forms intermingle with elements of vaguely antiquish character: tripartite, paneled entablatures; archivolts set off by projecting bands; shell-vaulted half-domes. *Pilate* (Pl. 48) is seated on a dais with rich scroll decorations; behind him rises an apse with a shell vault, and four stilted arches; the oblong clerestory windows are separated by pilaster strips. Yet these elements rather than being genuinely antique, form part of a pseudo-antique vocabulary that had permeated the entire Trecento. To be sure, shortly before 1420, Ghiberti absorbed more and more elements of genuinely Roman character. In the *Flagellation* and the *Herod* (Pls. 45, 72; Fig. 95) he employs columns with fluted shafts. But the bases of these columns are polygonal and the capitals in the *Flagellation* run the gamut from Corinthian to composite, to nearly High Gothic, just as in the *Herod* panel they are best defined as vaguely Corinthian.

Occasionally such pseudo-antique Ghibertian forms appear also reflected in real architecture. The portal of the Strozzi chapel in S. Trinità erected between 1418 and 1423 (Fig. 93) is flanked by columns with fluted shafts of extreme slenderness rising from awkwardly tall bases much like the columns in the *Flagellation*. The capitals, vaguely Corinthian, are so high as to recall Gothic capitals, and surmounted by tall impost blocks, comparable to those in the *Herod* relief. The foliate garlands along jambs and archivolt are faintly antiquish, woven from stereotyped oak leaves (Figs. 90, 91) and tied by spiraling ribbons, like those encircling the infinitely more elegant and more precise floral decor on the inner jambs of Ghiberti's North Door (Pl. 69c). All this seems to indicate that Ghiberti's design, though somewhat misinterpreted (and poorly executed), had formed the basis of the portal at S. Trinità.[16] Indeed, while the frame of the North Door of the Baptistery is far superior in workmanship and design, it shows architectural forms of a comparable intermingling of Late Gothic, pseudo-

[16] The importance of the portal at S. Trinità was stressed by Reymond, bibl. 437 and 439. Marchini (bibl. 298, pp. 37ff) in an interesting study has attributed the portal and the original design for the entire sacristy to Ghiberti, basing his argument for the portal on comparisons with the *Saint John* niche (acanthus scroll) and with the architectural setting of the *Pentecost* relief, for the building itself on a confrontation of the triangular window gables with those of the *Saint Matthew* niche and of the Linaiuoli Altar. Mr. Marchini might have alluded as well to the resemblance of the floral decoration of the portal to that of the jambs on Ghiberti's North Door frame, in my opinion, the best evidence for establishing convincingly at least an impact of Ghiberti's style on the design of the S. Trinità door.

The documents prove only that Ghiberti had dealings with the Strozzi bank and that he acted as an advisor for the choir stalls of the chapel (Milanesi, bibl. 337, pp. 75ff; Poggi, bibl. 409, pp. 16f, 17, note 3; see also Digs. 73a, 78a). The double entry in the account books of the Strozzi bank of August 7, 1420, refers to a payment of 600 florins made to the *Capitani* of Or San Michele in favor of Ghiberti, who had purchased from them two farms (Poggi, bibl. 409, p. 17, note 13). But the amount is far in excess of any possible compensation for work executed for the Strozzi family. In all likelihood the payment represents a bank loan. Another document from the same archive refers to the commission in January 1420 of intaglio work for the choir stalls and other furnishings in the Strozzi chapel to Arduino del Baese. In the contract, Ghiberti is mentioned as one of two supervisors for the carpentry work and the carving, the other being Cola di Niccola Spinelli, who is also entrusted with the financial responsibilities. The amounts dealt with are all small (Poggi, bibl. 409, pp. 16f; Milanesi, bibl. 337, pp. 75ff).

antique and antique features: the cavettoes framing the floral panels are Late Gothic, the bronze architrave continues the eleventh century pseudoclassical profile of the Baptistery; added to it is at the bottom a cornice with a dentil frieze of extraordinarily large dentils.

It would seem that all these architectural elements, whether pseudo-antique or genuinely *all'antica*, Ghiberti employed without much consistency, intermingling them with Late Gothic forms. Even when genuinely antique, capitals, bases, shafts, and entablatures, are not woven into a system in which everything tallies and results in what the ancients, as well as those who in the fifteenth century consciously strove to revive the architecture of antiquity, called an "order." No relation has been evolved between membering and wall, between supporting and supported parts. No axial network has been developed to hold in place the entire design of the structure. And no general concept of the principles and properties of the architecture of the ancients underlies the architectural designs of Ghiberti's prior to and around 1420.

The niche of the *Saint Matthew* (Fig. 92) seems at first glance to suggest that by 1422 Ghiberti had found a new approach to architectural design. The documents leave no doubt but that the niche was executed according to his specifications: its fluted pilasters, Corinthian capitals, bases and entablature suggest not only the vocabulary of ancient architecture, but also its standard of conformity. Yet, this first impression is modified after the eye has turned to details. To be sure, the pointed arch of the niche may have been required by the pre-existing architecture. Yet equally medieval in character are the Trecentesque flat shell, the Late Gothic moldings, the panels of the flanking pilaster strips, impost blocks and spandrels, and the foliage creeping along the triangular gable. The vocabulary, then, is still anything but consistent; the overslender proportions of the architrave and of all its details contrast with the classical forms embedded into the design.

The increased importance and the greater purism of the classical forms in the *Saint Matthew* niche is due, no doubt, to the impact of Brunelleschi's first architectures, from the portico of the Spedale degli Innocenti and the Sagrestia Vecchia to the Palazzo di Parte Guelfa (Fig. 94) and the Pazzi Chapel. Much in contrast to his later *œuvre*, these early designs are marked by mathematical clarity, disciplined differentiation and conjunction of forms, and precise gracefulness. Brunelleschi thought of a building in terms of plan and elevation, constructing them in simple and plain *moduli*.[17] These same principles underlie his selection of a classical vocabulary and his self-imposed limitations in using this vocabulary. Columns, pilasters, entablatures, archivolts, oculi, and aediculated doors and windows have been chosen to convey

[17] Heydenreich (bibl. 211) has distinguished the two phases of Brunelleschi's work and has convincingly worked out the contrast. His remains a splendid analysis and the basic writing on Brunelleschi, though some modifications may be necessary: there is no evident need to limit Brunelleschi's trips to Rome to a single one in 1432-1433 and to assume that he became acquainted with genuine Roman architecture only at that late date; or to accept the contrast proposed by Heydenreich between the basic measurements of S. Lorenzo and S. Spirito. Argan (bibl. 23) and more recently Wittkower (bibl. 558) have attempted to interpret Brunelleschi's architecture in relation to his system of perspective proportions. Nyberg (bibl. 363) has given a lucid analysis of the canon of proportions used by Brunelleschi in the Sagrestia Vecchia and the Pazzi Chapel.

just this impression of graceful elegance and to translate into visual terms the standard proportions from which plan and elevation are evolved. Hence the linear qualities of the vocabulary counted more than anything else, and for this very reason Brunelleschi after his early Roman trips turned, rather than to the massive structures of Imperial Rome, to Early Christian basilicas or to Romanesque churches in and near Florence. Only another visit to Rome, 1432-1433, in the company of Donatello appears to have led him to revise his interpretation of Roman architecture and to develop fundamentally new architectural standards. S. Spirito (1434ff), S. Maria degli Angeli (1434ff) and the lantern of the dome of S. Maria del Fiore (1436ff) are designed with more rounded and massive forms, half-columns, strong architectural moldings and fuller capitals; chapels and niches hollow the solid of a wall, planes and lines are replaced by mass and spatial voids.

Brunelleschi's late powerful style exerted little influence on his contemporaries. On the other hand, his early designs furnished an entire generation with a new concept of architecture and with a new vocabulary. But neither were unquestioningly absorbed and variations rather than copies were the rule. The architecture of Masaccio's Trinity fresco (Fig. 87) is close to Brunelleschi's concepts of the mid-twenties, but it does not quite conform.[18] Fluted pilasters with Corinthian capitals and columns with Ionic ones are crowded together; the barrel vault is articulated by sculptural coffers. The result is an emphasis on massiveness, depth and contrasts of light and shade which departs from Brunelleschi's early principles. On the other hand Donatello as early as 1423, in the niche of the *Saint Louis* at Or San Michele (Fig. 96) adapted Brunelleschian forms to his own taste by enlarging their vocabulary and employing them to stress solid masses and extending space. He increased depth and massiveness by placing beside the flanking Corinthian pilasters of the niche colonettes with spiral flutings, crowning them with strong Ionic capitals and with a sturdy entablature, and filling the archivolt with a torus *à billettes*, the tympanum with a *caput triciput*, the corners of the base with masks. The design almost seems to forecast Brunelleschi's architectural concepts of ten years later. But while Brunelleschi constantly searched for classical standards and principles, Donatello increasingly employed a vocabulary culled from ancient prototypes, but placed it within the framework of a free and fundamentally anticlassical style. To be sure, the niche of the *Saint Louis* is still far from a complete break with Brunelleschi's early style. But such a break becomes more and more obvious in Donatello's later architectural concepts whether architectural decoration or relief settings. In the *Dance of Salome*, as early as the mid-twenties he inserted into an assemblage of crude piers and arches fragments of an antique vocabulary, such as fluted piers and pieces of entablature, none ever heard of in Brunelleschi's work (Fig. 59). In the *Cantoria* and the frame of the Cavalcanti Altar sun wheels, acanthus leaves, vases, shells, capitals with masks, bases with Ionic scrolls, egg-and-dart and bead-and-reel friezes intermingle in a design of fantastic, unbridled and unexpected contrasts.

[18] Whether or not Masaccio himself designed the architecture of the fresco, Vasari's version of Brunelleschi's authorship cannot be accepted without question. See also Paatz, bibl. 375, III, p. 753.

To be sure among the tondi of the Sagrestia Vecchia one shows an extremely simple hall, its barrel vault supported by arcades on simple square piers. But this simplicity, while also present in the *Miracle of the Ass* on the Padua Altar, in the settings of the other Paduan reliefs gives way again to the fantastic wealth of a fragmented antiquity. More and more, then, Donatello used the architectural forms of antiquity to evoke vague but grandiose images of a rich and colorful past, rather than to create rational standards as did Brunelleschi.[19]

Like Donatello in the twenties, Ghiberti in designing the niche of the *Saint Matthew*, and for a decade thereafter, thought in terms of a modified Brunelleschian vocabulary of the twenties: pilasters, fluted and with fillets and corinthian capitals with center flowers (Fig. 92). Like Donatello, he inserted into this vocabulary elements entirely foreign to Brunelleschi's idiom: capitals, set with almost Gothic leaves, upright, and rounded rather than the fan-shaped acanthus leaves which Brunelleschi used, or with an extra pair of broad smooth leaves, as opposed to the helices so clearly marked on Brunelleschi's capitals. Also, like Donatello, he was apparently not interested in the Brunelleschian standards of congruity, clarity and order. But whereas Donatello departed consciously from these basic standards, Ghiberti in the twenties seems to have been unaware of such principles. He concentrated primarily on building up a Brunelleschian or para-Brunelleschian vocabulary, but he continued to use it in fragmentary form. In the projected niche for the statue of *Saint Stephen* (Pl. 15) in 1425 (Dig. 114; Docs. 107, 108), he renounced the last vestiges of Late Gothic architecture, retaining only the rib vault and pointed arch, both remnants of the old niche. The flanking pilasters, fluted and with fillets, support a plain triangular gable framing an oculus; the moldings are *all'antica*, the capitals show leaves of genuine *acanthus spinosus* and double pairs of helices. The forms, then, are strictly classical. Yet the overall design lacks congruity and order. Alongside the overly slender supremely elegant pilasters stand stumpy half columns which rise inside the niche and a projecting entablature of extraordinary heaviness.

To be sure, Ghiberti's vocabulary steadily developed toward greater purity of classical forms and the way he has traveled becomes manifest in the Herod relief in Siena (Pl. 72; Fig. 95); the setting with its columns, fluted, but without fillets, and the capitals, with overly slender chalices and single helices are of the pseudoclassical hue that marks Ghiberti's work in 1416 and thereabouts; but to the entablature of this hall he added, presumably during the chasing between 1425 and 1427, a fully classical frieze of garlands, streamers, and *bucrania*. The architectural frame for Fra Angelico's Linaiuoli Altar of 1432, since it was executed by a run-of-the-mill stonemason, should probably be attributed to Ghiberti with some caution (Fig. 97). But the design is Ghiberti's (Dig. 174; Docs. 105, 106): the triangular pediment with the relief of God the Father, recalls somewhat the project for the niche of *Saint Stephen* (Pl. 15); the proportions are again overly slender, the long dentils of the entablature resemble

[19] Regarding the dates on Donatello's *œuvre* I am relying on information kindly supplied by H. W. Janson: Dance of Salome, *ca.* 1423-1427; Cantoria, 1434-1438; Cavalcanti Altar, *ca.* 1435; Sagrestia Tondi, 1435-1438.

those on the *Saint Matthew* niche. Equally unorthodox are the delicate acanthus *rinceaux* that cover pilasters and architrave, a late offshoot of Ghiberti's early ornament. The vocabulary is non-Gothic, but it does not rest on any particular principle of selection, nor does it seem based on any underlying principle of proportion, congruity, and order.

The architectural settings in the panels of the Gates of Paradise reveal an approach fundamentally different from these designs of the twenties and early thirties. Their homogeneous highly selective classicism is diametrically opposed to Ghiberti's previous fragmentary and incongruous use of a vocabulary *all'antica*. Not even the drawing for the niche of *Saint Stephen* prepares in any way for the grandeur and purism of the settings in the *Isaac* and *Joseph* of the mid-thirties (Pls. 94, 95, 98, 100, 120a). The new departure which they represent raises two questions. The first refers to Ghiberti's authorship or rather to the degree of his authorship, of the architectural designs of the Gates of Paradise. If he was the author, what impelled him to change so completely the vocabulary of his buildings, their function within the composition, and his general concept of architecture? The second question concerns the position of these new designs within the development of fifteenth century Florentine architecture. The two questions indeed interlock to such a degree that they must be answered in conjunction.

At least some of the constituent factors of Ghiberti's new architecture are obvious. He has now fully absorbed the new vocabulary and the outstanding principles of Brunelleschi's style of the twenties. The aediculated windows, both in the round structure of the *Joseph* panel (Pl. 120a) and in the Temple façade of the *Solomon* relief (Pls. 116, 117), recall those of the Spedale degli Innocenti. The upper stories in both these buildings are articulated by small pilasters, just as Brunelleschi had apparently planned it for the upper floor on the outer bays of the Spedale.[20] The palace in the *Joseph* relief shows the two pilasters flanking a bay with architraved door and elegantly molded oculus, which characterize also the outer two bays of the Hospital in Brunelleschi's original plan. The molding of the oculus likewise recalls Brunelleschi's oculi and tondi from the Sagrestia Vecchia through to the Pazzi Chapel.[21] Similar observations have been made before.[22] Of even greater importance is Ghiberti's apparent assimilation of Brunelleschian principles. He has absorbed the idea of an order in which pilasters, capitals, bases, moldings, and entablatures are in strict correspondence; he has embraced the idea of conformity of design, and he has

[20] (Manetti), bibl. 294, p. 57.

[21] In a yet unpublished thesis (*Brunelleschi's Capitals*, M.A. Thesis, Institute of Fine Arts, New York University, 1955), Mr. Howard Saalman assigns the Corinthian capitals throughout the panels of the Gates of Paradise to the hand of Michelozzo. Indeed these capitals closely resemble those in the Medici Chapel, adjoining S. Croce, which Michelozzo designed about 1445. At the same time the documents leave no doubt regarding the large part played by Michelozzo between 1437 and 1443 in chasing the panels of the Gates of Paradise. Since the capitals in these panels, in contrast to the general layout of the architectural settings would have been both designed and executed only during the chasing, their attribution to Michelozzo seems most convincing.

[22] Fasolo (bibl. 155, p. 199) speaks at least in passing of the Brunelleschian character of Ghiberti's settings in the *Isaac* and *Joseph* panels.

assimilated the well-exploited contrasts between the membering and the wide stretches of wall space which mark Brunelleschi's early *œuvre*.

None of the settings of the Gates of Paradise, however, are completely Brunelleschian. Nowhere does Ghiberti use the fluted pilaster, which is almost a trademark of Brunelleschi's *œuvre* and which he himself had employed consistently from the niche of *Saint Matthew* (Fig. 92) through to that of *Saint Stephen* (Pl. 15). On the other hand, the unfluted pilaster, that distinctive feature of Ghiberti's architectural grammar, occurs only twice in Brunelleschi's vocabulary, on the exterior of the Palazzo di Parte Guelfa (Fig. 94) and in the crossing of S. Spirito. Nowhere did Brunelleschi employ pilaster strips or pilasters terminated by cornices, such as appear in the Temple and palace of the *Solomon* panel (Pls. 116, 117). On the other hand, throughout the Gates of Paradise Ghiberti shuns both full and half-columns as an architectural feature, dear though they were to Brunelleschi's heart and even though he himself had employed them in the *Saint Stephen* niche. The aediculas on the windows of the Innocenti are simple frames surmounted by triangular gables; in Ghiberti's panels two well-developed pilasters rise from the window sill to support a complete entablature and, above this, the pediments; nor do these windows rise from the entablature from which springs the upper story, as they do at the Ospedale degli Innocenti; instead they stand by themselves in the middle of the bay (Pl. 120a, b). Not until he laid out the chapels along the aisles of S. Lorenzo, did Brunelleschi combine arcades, pilasters, and entablatures into an arch and lintel system as it appears in the architectural settings of the Gates of Paradise. Nowhere in Brunelleschi's structures are two or more stories linked by an integrated continuous system of upper and lower orders, here and there strengthened by doubling the rhythm of the upper bays.

No doubt the architectural settings of the Gates of Paradise could only have grown on a soil nurtured by Brunelleschi's designs of the twenties and Ghiberti's departures could possibly be explained as variations on Brunelleschian themes. Yet, Ghiberti's architectural schemes go in fundamentals beyond Brunelleschi's early style and at the same time differ basically from his late work. The abhorrence of even the slightest trace of ornament, particularly strange in a sculptor's design, is alien to Brunelleschi. Early and late, he had been anything but hostile to sculptural decoration. In the settings of Ghiberti this elegant, gay, and graceful abundance has been replaced by an extraordinarily sober purism. The vocabulary is more limited than Brunelleschi's and thus becomes perhaps more consistent, but also far more rigid. The architectural settings of the Gates of Paradise convey an impression of monumental grandeur and of a fully antique flavor that Brunelleschi never achieved: palaces with two upper imposed orders, Renaissance church façades, the round structure in the *Joseph* panel (Pl. 120a).[23] Finally, the architectural setting in each panel is conceived of as an all-

[23] The round building in the *Joseph* panel presents a neat puzzle. No doubt, it is intended to represent one of the corn houses, the *horrea* of Egypt (Genesis 41:35). Indeed, in the mosaics of the Baptistery towards the en ' the thirteenth century, these corn houses are shown as domed buildings.

However, Ghiberti's round structure, open to the sky in the center and surrounded by an ambulatory which opens into arcades both inward and outward, recalls not so much the domed

embracing unit. Palaces, churches, market halls, rectangular and circular structures, one-storied and two-storied façades, are all composed of the same basic elements and evolved from the same spirit.

Brunelleschi, throughout his life, had thought in terms of individual buildings, rising incongruously within medieval surroundings. The realities of Florentine life

corn houses of medieval Joseph stories as round buildings of Roman antiquity. Specifically, it recalls one such structure which, while no doubt a church building of the fifth century, was generally claimed, until about 1900, to be of Roman origin: S. Stefano Rotondo on the Celian Hill in Rome (Krautheimer, bibl. 250; Colini, bibl. 104, pp. 245ff). The aspect of the building at the time of its restoration in 1450-1454 under Nicolaus V is known both through descriptions and through documents referring to the repair work (Muentz, bibl. 350, pp. 141ff). Its state prior to 1450 is described by Biondo, bibl. 53, f. 11v: "ecclesia sancti stephani rotunda . . . quam tecto nunc carentem marmoreis columnis et crustatis varii coloris marmore parietibus musinoque [!] opere inter primas urbis ecclesias ornatissimam fuisse iudicamus. Eaque in Fauni aede prius fundata fuit. Simplicius primus papa aut extruxit aut quod magis credimus exornavit." The roof over the center room, then, had collapsed. The chapels and porticoes which originally projected from the ambulatory had disappeared as early as the twelfth century; the arches which from the ambulatory opened onto these chapels and porticoes had been walled up. But these arches are clearly visible on the outside and inside, and anybody in the fifteenth century would have seen that once they had been openings. In the interior a series of small pilasters articulated the incrustation above the colonnade, as witness a drawing by Cronaca of 1489 (Fig. 98) (Bartoli, bibl. 41, I, fig. 31). Any fifteenth century Roman traveler must have been tempted to envisage S. Stefano Rotondo in its original form as closely resembling the corn house in Ghiberti's Joseph panel.

The resemblance, indeed, may well be more than incidental. Flavio Biondo seems to have been the first to identify S. Stefano Rotondo with a temple of Faun, but he was apparently not too certain of his hypothesis. It appears to be based both on the round plan of the building and on a confusion of S. Stefano Rotondo with the round temple of Vesta on the Tiber, in the Middle Ages S. Stefano delle Carozze, and according to the *Mirabilia* a Temple of Faun (Urlichs, bibl. 527, p. 112). Only in the second half of the fifteenth century and in the sixteenth century was Biondo's opinion more widely held (Fulvio, bibl. 169, f. 52). However, it was never generally accepted. The name of the divinity to whom the building had been dedicated remained in doubt in Biondo's own time (Giovanni Ruccellai, in Horne, bibl. 221, p. 573: *tempio d'idoli tondo*) and even the original function of the structure as a temple seems occasionally to have been suspect: Alberti, in contrasting round secular basilicas with round temples, appears to refer (Bk. VII, 15) to no building but S. Stefano Rotondo (bibl. 11, f. 133): "Basilicas etiam rotundas facere aggressi sunt. In his medii conceptaculi altitudo tanta est quanta et totius basilicae latitudo. . . ." Leoni's insertion of the word *recently* into this passage (bibl. 5, II, f. 46v), is misleading. Alberti simply says that they—meaning the ancients—tried their hands at the building also of round basilicas, and the suggested proportions, 1:1, correspond to those of S. Stefano as of *ca.* 1450. Yet, Alberti's interpretation of the building as a basilica need not have been the only one. The Celian Hill was known also as the site of Nero's *Macellum Magnum* (*Curiosum Urbis*, Urlichs, bibl. 527, p. 2). To be sure, no exact location was suggested in the fifteenth century for this great market hall. Nardini, writing in 1660 (bibl. 359, pp. 257f, 270) was the first to hint at the possibility of identifying it with S. Stefano Rotondo, and his proposal was eagerly received in the nineteenth century.

However, it is well worth considering hypothetically whether as early as the fifteenth century one school of archeologists did by some chance see in S. Stefano Rotondo the former *Macellum Magnum*. A number of elements would form the basis for this belief. There was, for one, the location of the *Macellum Magnum* somewhere on the Celian Hill. (See for the following, Krautheimer, bibl. 250.) There was, further, the round plan, attributed to *macella* in general by Roman writers such as Varro. Indeed, throughout the second half of the Quattrocento market places *all'antica* were envisaged with a round building, a *macellum* occupying their center, witness the Urbino panel (Fig. 100), the Marcanova manuscript and Filarete's treatise. The specific identification of the *Macellum Magnum* with a round structure, open on all sides, such as S. Stefano Rotondo, would be seemingly confirmed by the *Macellum Magnum dupondia* of Nero's on which

had set limits to the fancies of the new style. Ghiberti's settings, on the contrary, are imaginary designs, free from the fetters of reality—a stage set, as it were. They represent a never-never architecture which derives its principles and vocabulary from a homogeneous, monumental and purist interpretation of antiquity. They are intended to revive the world of the ancients through architectural design; they represent the vision of a higher genus of architecture, and of a better world, lost, but not necessarily forever.[24] These architectural dreams find no parallels in the first third of the fifteenth century, neither in actual architecture nor in architectural theory. In representations of architecture in paintings and reliefs, only the barrel-vaulted hall in one of the tondi of the Sagrestia Vecchia is comparable in the sobriety of its design. Visions comparable in comprehensiveness to the settings of the Gates of Paradise, though not necessarily equally purist, come to the fore only after 1450, at Pienza and possibly in the rejected rebuilding of the Borgo under Nicolaus V;[25] in Donatello's Paduan reliefs; in the Baltimore and Urbino panels (Fig. 100);[26] in Filarete's Treatise,[27] and in Alberti's *De Re Aedificatoria Libri Decem*.[28]

the center pavilion of the market appears as a round two-story structure open on all sides. Indeed, the two interpretations of S. Stefano Rotondo either as a temple or as a *macellum* need not be mutually exclusive. The round buildings rising on the market places of fifteenth century paintings and treatises, were also envisaged apparently as having sacred connotations: they are surmounted by the figure of a divinity, such as Abundantia or even by a cross—a detail I had previously overlooked when discussing the Urbino panel.

In brief, there is a strong likelihood that Ghiberti's round structure in the *Joseph* panel was designed with an eye to S. Stefano Rotondo on the Celian Hill; plan and details speak for themselves and a corn house could easily borrow such features from a Roman *macellum* or a round secular basilica such as Alberti described.

[24] Clark (bibl. 100, pp. 18ff) has sketched the problem with great acuteness, stressing both the non-Brunelleschian character of Ghiberti's settings and their "influence on the building styles of the next generation."

[25] Dehio, bibl, 124; Magnuson, bibl. 288; MacDougall, bibl. 285.

[26] Kimball, bibl. 243; Krautheimer, bibl. 251; Sanpaolesi, bibl. 469. The authorship of Laurana has been frequently contested in favor of an attribution to Francesco di Giorgio or to Piero della Francesca (see among others Baldini, in Salmi, bibl. 462, pp. 128f), and I gladly leave the decision to experts in the field of Quattrocento painting. But it remains my belief that the panels date from the seventies rather than from the nineties; that their architectural traits reflect the impact of Alberti, as demonstrated by Fiske Kimball, rather than pointing to Giuliano da Sangallo (Sanpaolesi, bibl. 469); and that they were intended to interpret the Vitruvian concepts of the *scena tragica* and *comica* respectively, albeit in fifteenth century terms and thus crowning, for instance, the *macellum* of the Urbino panel with a cross.

[27] Von Oettingen's edition of the *Treatise* is fragmentary and obsolete, and a premature death has prevented Emil Kaufmann from completing a new edition. The illustrations of the Ambrosiana copy of the treatise have been reproduced by Lazzaroni and Muñoz, bibl. 268.

[28] The date of *De Re Aedificatoria* has forever been a bone of contention. Most recently, Magnuson (bibl. 288, p. 110 and note 93f) while admitting the possibility that "the two first books had been written [at] the beginning of the 1450's, even though perhaps not in their final shape" insists that "the rest of the treatise was not written until later on" and "that it was only finished in Alberti's later years." He thus sides with an opinion first expressed two generations ago by Hoffmann (bibl. 217, pp. 10ff) and Stegmann-Geymueller (bibl. 502, III, pp. 13f). This opinion was most clearly formulated by Theuer (in Alberti, bibl. 12, pp. xxxii f), who maintained that the work was perhaps in an initial stage in the early fifties and that from that time Alberti wrote and revised it through the rest of his life. On the other hand Wittkower (bibl. 557, p. 32) has pronounced himself in favor of an early date prior to 1450 for the writing of the entire treatise. Indeed, the argument in favor of an early date for the bulk of the treatise seems preferable

The architectural settings of the Gates of Paradise were designed fifteen or more years before Alberti set down on paper his architectural concepts, and they date roughly forty years before the Baltimore and Urbino panels were painted. Yet they call to mind the principles and particular vocabulary employed in Alberti's architectural treatise and in related paintings. Alberti, in *De Re Aedificatoria* bases his ideas on a clear and homogeneous image of architecture, and in his arguments he proceeds logi-

to me. The data are all well known, but it is worthwhile to assemble them in a summary. Palmieri's statement, under the year 1452, has often been quoted and misquoted: "Albertus . . . eruditissimos a se scriptos de architectura libros Pontifici ostendit" (bibl. 357, supplement I, col. 241). Hoffmann, *loc.cit.*, suspects the reliability of the passage terming Palmieri's chronicle a late composition, possibly dating after 1475; but even if it were, the specific phrase remains untainted. In any event, in view of the frequent misinterpretations (Magnuson, *loc.cit.*), it should be emphasized that the Palmieri passage does not limit the number of books completed by 1452 to two. The misunderstanding goes back to Fazio (bibl. 156, p. 13): "Scripsit et de architectura libros duos quos intercoenales inscripsit." Obviously Fazio, in 1455-1456, had seen neither *De Re Aedificatoria* nor the two books of the *Intercoenales*; or else, and this is more likely, the passage has been corrupted by a copyist through omission of a few words. (Theuer suggested, *loc.cit.*, that Alberti had included in the *Intercoenales*, some general ideas on architecture only to omit them later when incorporating them into *De Re Aedificatoria*. But this hypothesis is both complicated and unconvincing.) Coincident with Palmieri, Flavio Biondo hints at an early date for the completion of the bulk of *De Re Aedificatoria*. In his *Italia illustrata* (bibl. 53, f. 70; first draft, according to Voigt, bibl. 541, II, p. 508, *ca.* 1443, final revision 1450-1453), in a passage dealing with the salvaging of the Roman ships from Lake Nemi (see below), he refers to "Leo Baptista Albertus geometra nostri temporis egregius qui de re aedificatoria elegantissimos composuit libros." An early date is further confirmed by Albert's own references to *De Re Aedificatoria* in his *Ludi Mathematici*. In this treatise which he wrote for Meladusio d'Este, Alberti alludes both to the beginnings of *De Re Aedificatoria* and, in specific terms to the writing of Book X: "che ragione sia da trovare le vene dell'acqua, con che arte si deducono, qual sia l'ordine de' rivi, quale argumento moderi i fiumi e rompe loro impeti . . . vedrete quelli miei Libri d'Architettura quali io scrissi richiesto dallo illustrissimo vostro fratello e mio Signore Messer Lionello . . ." (Alberti, bibl. 9, IV, p. 424). The *Ludi Mathematici* were written while Meladusio (d. January 25, 1452) was still Abbot of Pomposa (Alberti, bibl. 9, IV, p. 434: "dal monastero vostro . . .") and possibly before Lionello's death October 1, 1450 (Michel, bibl. 329, p. 32; Mancini, bibl. 289, p. 281). Hence, Book X of *De Re Aedificatoria* was under way (*vedrete*), but the bulk of the work was finished (*scrissi*) in 1450 or 1451 though possibly in the form of a draft.

Moreover, Alberti in at least two passages throws light on the question when he prepared *De Re Aedificatoria*. As pointed out by Mancini (bibl. 289, p. 280) and others, he referred in Book V, chapter 12, to the fact that he was working on the treatise while the first Nemi ship was being salvaged: "ex navi Traiani per has dies dum quae scripsimus commentarer ex lacu nemorensi eruta." Thus, contrary to the misleading translations of Bartoli and Leoni, he states precisely that the ship was salvaged while he prepared (*commentarer*) his book. The excavations, sponsored by Cardinal Prospero Colonna and directed by Alberti himself (Flavio Biondo, *loc.cit.*) took place in 1447 (Mancini, bibl. 289, pp. 279f; Theuer, in Alberti, bibl. 9, *loc.cit.* gives no reason for his late date, 1450-1452). Hence, Alberti was working on the preparation of his treatise in 1447. Indeed, since Lionello d'Este was the one who urged Alberti to compile his work on architecture (Alberti, bibl. 9, IV, p. 404; see Mancini, bibl. 289, p. 352) the opening date of preparation would presumably be pushed back to the years of close personal contact between Alberti and Lionello, 1437-1444 (Mancini, bibl. 289, pp. 139, 171ff, 195). The omission of architecture among Alberti's interests in a passage in the dedicatory epistle of *De Equo animante*, "qui pingendo fingendoque nonnihil delector," addressed after November 1444 to Lionello d'Este (Alberti, bibl. 7, p. 239, note 4) would appear at first to establish that date as a *terminus ante* for the beginning of work on *De Re Aedificatoria*. But properly speaking, Alberti in this passage refers only to his never having *practiced* architecture, and he may well have occupied himself at the time with preparing a treatise on the theory of architecture.

The evidence then seems to suggest that Alberti presented to Nicolaus V in 1452 an apparently

cally from one point to the next. A discussion of the essential parts of buildings leads him on to materials and methods of construction; from there, basing himself on the Vitruvian triad of *firmitas, commoditas,* and *venustas,* firmness, commodiousness, and delight, he goes on to analyze the functions of buildings, public, and private; finally he examines the principles of design. Design rests on beauty and ornament; and while beauty is "a Harmony of all Parts, fitted together with such Proportion and Connection that nothing could be added, diminished or altered but for the worse . . . ," ornament is "auxiliary, concealing what is deformed and polishing what is handsome" (VI, 3). Consequently beauty is based on the three elements of number, finishing and collocation and "from the Connection of these three will rise Congruity which we may consider as the origin of all that is graceful and handsome" (IX, 5). Beauty in fine is "such a Consent and Agreement of the Parts of a Whole . . . as Congruity, that is to say the principle Law of Nature, requires" (IX, 5).[29] Thus Congruity which is constituted not only by harmony and symmetry but equally by musical proportions, has taken the place held in Brunelleschi's design by the simple mathematical relationship of parts. Ornament, while doubtless important, is no longer an essential element of beauty. Hence the demand for perfect homogeneity in Alberti's theory leads to a strict selection of elements and finds its natural complement in a highly exclusive purism.

The purist concepts in Alberti's theory are linked to a second factor. All design is aimed at imparting to a building the degree of dignity which corresponds to its "social rank." A temple requires not only a plan, but also construction and ornament different from a secular building such as a basilica. Architecture is thus directly related to the actions for which it is intended, and to the human beings who participate in these actions. These humans, according to Alberti's philosophy, are beings of a higher nature.

final version of the entire book; that the bulk of the work was finished, possibly as a draft, in 1450; and that he began preparing it before 1447, and possibly prior to 1444. However, neither the beginning nor the terminating date should be taken to be absolute. Grayson (bibl. 192 with reference to *Della Famiglia*) has elucidated Alberti's working method of revising in later years supposedly finished manuscripts and, as suggested by Theuer, *loc.cit.,* the evidence is strong that he followed this same procedure in *De Re Aedificatoria.* The references to the damaging of the Ponte S. Angelo (VIII, 6; X, 10) were thus inserted in or after 1450, into the almost finished manuscript, another passage alluding to the repairs of an aqueduct, presumably the Acqua Vergine, into the finished manuscript after 1453. Likewise, the reference to the marble incrustation of S. Francesco in Rimini, that is presumably to the center niche, can hardly date prior to 1454 (Alberti's letter to Matteo de Pasti and Matteo's letter to Sigismondo Malatesta, November 18 and December 17, 1454, respectively, Ricci, bibl. 441, pp. 557f); the *terminus post,* 1447 (Hoffmann, bibl. 217, p. 12) is too early. Alberti's allusion to his use of centering for the construction of coffered vaults (VIII, 11) indeed, seems to have no parallel in his work previous to the porch of S. Andrea in Mantua; thus this reference may be an interpolation made shortly before his death in 1472.

None of this disproves the termination by 1452 of a final version of the entire manuscript except for such later insertions. Even less does it give any clue regarding the date of Alberti's work on the drafts and collection of notes for a treatise on architecture. He did work on a draft around 1447 and he would seem to have begun it prior to 1444, encouraged by Lionello d'Este. Such encouragement, however, presupposes that Alberti for some time had pondered the subject, studying it and taking notes. All this would have required years, especially in view of his many other writings during the forties. After all, *De Re Aedificatoria* is not the kind of book one writes in a short time, and the further the date of the preparatory phase can be pushed back into the forties and thirties, the more plausible it becomes.

[29] Alberti, bibl. 5, II, f. 3, 84v (for English quotations, I am using Leoni's translation).

They once existed in antiquity, "in the days of those ancients of the past of the highest *virtus*." Men of their ilk might come again through the efforts of modern humanists. Ancient architecture had formed an appropriate setting for these monumental ancients and, if such men were to return, modern architecture should be built on comparable principles. For these higher human beings of the future Alberti designs his architecture. To his humanist thinking architecture is aimed at creating dignified backgrounds for dignified actions of dignified people.

Only architecture of the highest social order warrants the perfect, fully homogeneous design. Since this "perfect" design is at the basis of Alberti's thinking, he would seem to limit architecture to buildings for the Divinity, the State, and the "noblest citizens"; since architecture rests on a concept of interaction within the highest strata of society, it must be based on the interaction of buildings of the noblest types: temples, public edifices, and palaces.

Alberti's theories of architecture are based, of course, on actual antique buildings and on actual antique methods of construction; but the architectural works he conjures up for the reader's thought are ideal rather than real. Their postulative character first of all explains a certain amount of seeming contradiction: theoretically he is all in favor of stone vaulted temples, that is, churches, "because it gives them a greater dignity and makes them more durable" (VII, 11); but at the same time he knows flat roofs are lighter and more resilient (v, 6) and improve the acoustics (v, 9). Likewise, "columns that are to have arches over them ought by right be square" (VII, 15), that is, they ought to be piers, but this demand is limited to buildings of the highest order, temples (VII, 6). In brief, Alberti established optimum postulates but balanced them by minimum demands.

These postulates by their very nature are abstract, and both their abstractness and their optimum character explain the divergencies between Alberti's theories and at least the early examples, if not the majority, of his architectural designs. When first encountering the demands of building "in flesh and stone," he was apt to depart from his postulates in favor of concessions to the taste of his patrons and the local milieu, the more so, if this milieu was familiar to him. S. Francesco in Rimini is probably contemporary with the first version of parts of *De Re Aedificatoria*. But its richly ornamented façade, not to mention the interior, do not meet the purist demands of Albertian theory; they decidedly recall the Venetian *terra ferma*, the cultural milieu to which Rimini belonged,[30] and in which—a factor all too easily forgotten—Alberti had spent his boyhood and youth. It almost looks as if the Venetian idiom, repressed in his theories, came through in his design. But he is equally apt, when in Florence, to do as the Florentines do, as witness the striated façade of S. Maria Novella.[31] The same local flavor may underlie the deviations from his postulates which appear in Palazzo Ruccellai.

[30] I am accepting for the moment, though with some hesitancy, Wittkower's thesis (bibl. 557, p. 33) that Alberti was responsible not only for the exterior, but also for the interior design of S. Francesco. Ricci (bibl. 441, pp. 253ff) has been the first to stress the Venetian elements in the building.

[31] Wittkower (bibl. 557, pp. 36ff) in his beautiful analysis of Alberti's architecture, has brought out the "historicizing" elements in the façade of S. Maria Novella.

The palace is certainly the house of a "noble citizen," but in the courtyard the arches rest on columns in open contrast to Alberti's written postulate. Only in his last works, S. Sebastiano (Fig. 99) and S. Andrea in Mantua, did Alberti create designs in compliance with his theory of a fully developed wall architecture, coordinated in function and design, purist and monumental, as he had envisaged it in the pages of *De Re Aedificatoria*. To the layman these late buildings remained "quel viso fantastico di messer Battista."[32] But the fact is that in *De Re Aedificatoria* Alberti established this phantastic vision fifteen and twenty years before he carried it into stone.

Not even in his last buildings, however, are Alberti's visions completely translated into reality. To be sure, both S. Sebastiano and S. Andrea are temples, as Alberti would have it, not churches. But they are incomplete, a far cry from his all-embracing vision: it looks noble, he says "to have the house of the king near . . . the Theater, the Temple and some handsome houses" (v, 3); the Temple should be in the middle of the city "placed where it may appear with most Majesty and Reverence; in order thereunto it should have a spacious handsome Area in the front . . . surrounded on every side with great streets or rather with noble Squares . . . somewhat raised above the level of the Rest of the Town which gives the Fabrick a great Air of Dignity" (v, 6; vii, 3; vii, 6). Only in his writings could such dreams spring to life, not in reality, confined as it was by practical exigencies; otherwise his ideas could only take shape in paintings such as in the Baltimore and Urbino panels. They are not only sample cards, as it were, of an Albertian vocabulary, in the representation of round and octagonal "temples," a triumphal arch, a church façade, "columns of honor" and palaces of a calculated variety of design, but, more important, they present these elements in large scale urbanistic layouts, monumental, completely homogeneous in character and with a puristic sparseness of ornament.

Alberti's theories and their reflections in such paintings as the Urbino and Baltimore panels (Fig. 100) come to mind when one looks at the settings of the Gates of Paradise or of the Zenobius Shrine (Pl. 80b). Even details of the vocabulary hover strangely between a Brunelleschian and an Albertian language. Piers are placed beneath arches, paralleling Alberti's precept that "columns with arches above them ought by right to be square" (vii, 5). Contrary to Florentine custom Ghiberti's pilasters are unfluted. Again, it is Alberti who recommends that pilasters should not be fluted since they are slices of piers (vi, 12) and throughout his architectural designs unfluted pilasters predominate.[33] Corner piers mark the ends of Ghiberti's buildings and thereby correspond to Alberti's postulates; for to Alberti pilasters are meant to articulate the skeleton of a structure and thus must mark its corners (i, 10; ii, 6), instead of being slightly removed as Brunelleschi's are. Ghiberti's aediculae complete in the antique manner with pilasters, base, entablature, and pediment, again correspond to Alberti's rules (vi, 12). Con-

[32] Letter of Cardinal Federigo Gonzaga to his father Lodovico, March 16, 1473 (=1474) (Davari, bibl. 117, p. 94).

[33] The seeming exceptions are the fluted pilasters flanking the portal of S. Maria Novella, and those in the upper story of the façade of San Francesco. But the latter, at least, were not necessarily designed by Alberti: his orginal model, known from the medal of 1450, had half columns at this point.

versely Alberti's postulates come to mind when one looks at Ghiberti's palaces with homogeneous orders of pilasters integrated in each story, and porticoes on the ground floor (v, 3; ix, 3). These porticoes are formed either by square piers carrying entablatures or, in an arch-and-lintel system, by arcades on piers and by pilasters supporting an entablature above the apex of the arches; while neither form is specifically recommended by Alberti, both are represented in the Baltimore and Urbino panels. The Urbino panel likewise offers a parallel to one of the most striking features in Ghiberti's architectural settings, the church façade in the Zenobius relief (Pl. 80b). In the *Joseph* panel the round structure and the palace on the left, the Temple in the *Solomon* relief and the two flanking palaces, the church and the noblemen's houses in the Zenobius Shrine with the "spacious, handsome Area in front" form altogether so many homogeneous architectural units, just as do those postulated in *De Re Aedificatoria*.

The closeness of Ghiberti's late architectural settings to Alberti's theories on architecture, despite the time lag of roughly fifteen years or more, is a phenomenon so striking that it demands an explanation. The settings of the Gates of Paradise were all designed prior to 1437, the *Isaac* as the earliest, the *Solomon* as the latest. In 1434 Alberti had come to Florence. In 1435 he put forth in *Della Pittura* his thoughts on painting and relief sculpture, and the little book became an important factor, not only in spreading the gospel of linear perspective, but more generally, in reflecting and shaping the taste of *avant-garde* patrons and artists. Its impact was all the greater since its publication coincided with a crisis which at that point had developed in the art of the nascent Renaissance. Masaccio's early death had left his work in a fragmentary state and throughout the thirties painting drifted on without direction. In sculpture Donatello had turned from a classical to a new dramatic and violent style, while Ghiberti was searching for diametrically opposed solutions. In architecture Brunelleschi's early designs, barely fifteen years after their first appearance, were becoming obsolete, and he had started on a quest for a different architecture, radically new in its concepts of space and mass. In the last analysis all these attempts at discerning new principles in art were closely tied up with the search for new interpretations of antiquity. While Brunelleschi in the thirties viewed the architecture of antiquity as composed of powerfully contrasting voids and masses, Donatello, as a rule, saw it as based on a free, rich ornament. Ghiberti simultaneously, in the Gates of Paradise presented it in the guise of a classicistic and quiet purism. The interpretations were as manifold and as varied as the number and minds of the interpreters, and any new opinion on the meaning of ancient art was eagerly heard. No doubt, Alberti's word carried weight in these councils; and he had very definite opinions regarding the world of antiquity.

Time and again, in these years, Ghiberti's work strongly and strangely recalls Alberti's theories. The linear perspective, suddenly arrived at in the *Isaac* and *Joseph*, presumably in 1435, tallies with the perspective described in *Della Pittura*. His new interpretation of the sculpture of antiquity, linked as it is to his presentation of life through lithe, quickly moving figures, finds its counterpart in the pages of that same treatise.[34] Thus the question almost naturally arises as to whether perchance the

[34] I must anticipate here some of the results of chapters xix and xxi.

architectural settings of the Gates of Paradise and of the Zenobius Shrine were shaped under the impact of Albertian theories or whether, vice versa, Alberti formulated the theories of *De Re Aedificatoria* under the impression made on him by Ghiberti's designs.

At first glance, the arguments seem to weigh the scales in favor of the former hypothesis: the new style makes its appearance in Ghiberti's work suddenly, seemingly unheralded by anything in his earlier architectural designs, and at exactly the time when Alberti arrived in Florence. Yet, the counterarguments prove just as strong. In the first place, the new style dominated the settings of the Gates of Paradise some fifteen years before making its appearance in the pages of Alberti's book. Second, Ghiberti in all the varied aspects of his entire work during the twenties had been moving towards new interpretations of the art of antiquity. Hence, the alternative possibility need not be excluded that Ghiberti had arrived at his new architectural style independently of Alberti; that he was, in fact, *Albertianus sine Alberto.*

History rarely tallies with a simple answer, whether in the affirmative or in the negative. Alberti, when coming to Florence, certainly did not arrive with the theories of *De Re Aedificatoria* all ready in his pocket. To be sure, these theories, as laid down around 1450, are not the kind that are worked out in a short time. They give the impression of long thought and preparation. But it seems most unlikely that by the mid-thirties Alberti had envisaged more than their rudiments. Until 1435 he had not thought primarily in terms of architecture. He was a humanist, and he was intent on writing a treatise on the principles of the visual arts. As a humanist he had composed for himself an inner vision of antiquity. Since this vision was all-embracing it included architectural images as well. But what the precise character of these images was must remain in the realm of conjecture. One would assume that they rested on the monumental grandeur of the structures of antiquity and on the comprehensiveness of a design in which the core of a city, truly *all'antica*, was formed by buildings of the "noblest types." Indeed, it is such noble buildings which, as early as 1434, in the preface to *Della Famiglia*, Alberti lists as symbols of ancient grandeur: "our temples, our altars, our theaters, our palaces," so he says, "fell prey to the barbarians when they broke into the Roman Empire."[35] But the visual outlines of these buildings, their architectural idiom, need not have been more than dimly envisaged by Alberti at that time. Presumably their antique flavor was to be enhanced by a vocabulary *all'antica*. He had seen this vocabulary while admiring the ruins of Rome, but it would be rash to assume that a humanist walking through the vestiges of antiquity would immediately seize upon the details of the architecture. Indeed, Alberti's scattered remarks from the mid-thirties on architectural design are vague and few. He may or may not have thought of antiquity when illustrating a perspective problem by referring to a portico resting on piers. But he was equally impressed by the Gothic interior of the Cathedral of Florence and by the monumental size of Brunelleschi's dome.[36]

But as he moved into the Florentine milieu, the outlines of ancient architecture, and

[35] Alberti, bibl. 9, ii, p. 13. [36] Alberti, bibl. 8, p. 47; bibl. 9, i, p. 81.

thus of architecture of the future such as he envisaged it, were bound to grow more precise in shape. Brunelleschi's buildings—what little had been completed of them by 1434—the front of the Spedale, the Sagrestia Vecchia, the fragment of the Palazzo di Parte Guelfa, parts of the transept of San Lorenzo—with their stress on a vocabulary *all'antica* and on consistency, harmony, and proportion, must have struck young Alberti as an incarnation of his own shadowy images of antiquity. True, Brunelleschi's buildings could be improved upon. The vocabulary was unlike that of the Roman ruins through which Alberti had wandered, and less consistently executed. But presumably more disappointing to a humanist would be other defects. To Alberti, Brunelleschi's buildings must have seemed small. They lacked the size of the Tempio della Pace—Constantine's basilica that is—of the Pantheon, of the Colosseum. They were not temples, theaters or palaces of the noble, and therefore not representative of Alberti's idea of antique buildings as the noblest *genera* of architecture. Finally, they were isolated individual buildings, no more than fragments, as it were, of Alberti's vision of a city wherein every building and every detail contributed towards a monumental architectural whole symbolizing the world of the ancients.

A grandiose harmony of humanist architecture, composed of the noblest *genera* of buildings, was never attempted in the thirties. Such buildings could not have been built in medieval Florence, neither by Brunelleschi nor anyone else. They could only be represented in the visual arts, free from the fetters of hard reality. Thus it was almost natural that young Alberti, his mind filled with general visions of a harmony of noble buildings and preoccupied with problems of the visual arts would find a common ground more easily with the "painter" Ghiberti than with the architect Brunelleschi. Ghiberti was used to thinking in terms of architectural settings and they lent themselves readily to the representation of large scale monumental layouts of the kind Alberti envisaged. At the same time Ghiberti for ten odd years before Alberti's arrival in Florence, from the *Flagellation* relief to the niche of *Saint Stephen*, had been searching for a vocabulary *all'antica* and had striven to assimilate the principles of harmony and coordination that formed the basis of Brunelleschi's art. But much as he tried, his structures *all'antica* remained fragmentary and inconsistent. Then, shortly before 1430 he visited Rome, a second time, by the way, and there are good reasons to suspect that he made Alberti's acquaintance at that time. But whether they met in Rome or a few years later in Florence, Ghiberti must have been impressed by the visions of a monumental, consistent, fully integrated, and purist architecture which the brilliant young humanist spread out before him. He was ready to meet Alberti half-way. At the same time he was equipped to give visual reality to the humanist's vague dream of vast plazas surrounded by noble buildings of a purist design. Perhaps it will never be possible to trace the exact steps along which this process of mutual assimilation developed, a process which involved not only Alberti and Ghiberti, but equally Brunelleschi and Donatello. In fact is it by mere chance that the contacts between the artists of the Florentine *avant garde* and Alberti coincide precisely with the remarkable change in Brunelleschi's architectural concepts and with the lonely appearance of the strangely

"Albertian" hall among the tondi of the Sagrestia Vecchia? The question cannot be answered at this point. But that much can be suggested that the settings of the Gates of Paradise and the Zenobius Shrine with their temples, palaces and vast squares gave pictorial reality to the visionary architecture of which Alberti dreamed in these same years.

CHAPTER XVIII
GHIBERTI AND ANTIQUITY

OUR picture of ancient art has been shaped largely by two periods: the era of great discoveries in the soil of Rome, the sixteenth century, and the years from Winckelmann to the present day, during which the focus gradually shifted to Greece, to the Hellenistic East and back again to Rome as the center of the Roman Empire. This picture is based on a wealth of monuments, on architecture, vase and mural painting, sculpture in the round and in relief, sculptural ensembles, bronzes, coins, and jewelry. It is further based on a concept of successive stages in the development of ancient art. Altogether it has little in common with the image of the art of antiquity held by a Florentine of the early fifteenth century. To him Greece and the East were fabulous territories known only from the tall tales of a lonely explorer. Even within Italy his range of visual exploration was confined to Tuscany and Rome. Only rarely did it extend beyond the Apennines to include Venice and possibly Ravenna. These geographical restrictions were linked with historical and material limitations. A concept of evolution in ancient art would have occurred to no one, except perhaps Alberti.[1] The body of known Roman monuments to all practical intents excluded painting and the bulk of sculpture in the round, which still lay underground. Poggio maintained in 1430 that aside from the few bronzes on public exhibit at the Lateran palace—the *lupa*, the *spinario*, the *Camillus*, and the colossal head and hand of the bronze statue of Constans II—only six statues had survived in Rome commemorating great men: two river gods and the horse tamers on the Quirinal; the Marforio near Santa Martina at the foot of the Capitol; finally the Marcus Aurelius, then near the Lateran. True, Poggio narrowed the field to these few pieces since he was after all concerned with the changes of fortune; the inheritance of extant statuary was slightly greater than he claimed.[2] Nevertheless, the number was desperately small, even including a few new finds, such as the hermaphrodite which Ghiberti had witnessed being brought to light before Poggio drew up his list.[3] North of Rome the number of

[1] Alberti, bibl. 5, II, f. 3v, f. 5 (VI, 3).

[2] Poggio, bibl. 419, pp. 2of, quoted also by Urlichs, bibl. 527, p. 241. "Hoc videbitur levius fortasse, sed me maxime movet, quod his subjiciam, ex innumeris ferme Colossis, statuisque tum marmoreis, tum aeneis (nam argenteas atque aureas minime miror fuisse conflatas) viris illustribus ob virtutem positis, ut omittam varia signa voluptatis atque artis causa publice ad spectaculum collocata, marmoreas quinque tantum, quatuor in Constantini Thermis; duas stantes pone equos, Phidiae et Praxitelis opus, duas recubantes; quintam in foro Martis statuam quae hodie Martis fori nomen tenet; atque aeneam solum equestrem deauratum, quae est ad Basilicam Lateranensem Septimio Severo dicatam, tantum videmus superesse. . . ." The passage refers apparently only to statues still *in situ* which had been on public display in ancient Rome. Thus it excludes the Lateran collection as no longer *in situ* and all reliefs, as not being statues. Even so, however, Poggio's list omits, among others, the "Pasquino" and four statues, Constantine and his three sons, then on the Quirinal, all of which were certainly known to the fifteenth century; see Michaelis, bibl. 328.

[3] Ghiberti-Schlosser, bibl. 178, I, pp. 61f, and II, pp. 187ff; Lanciani, bibl. 261, I, p. 46. The type is known through a number of replicas in Rome (Villa Borghese), Munich (Glyptothek) and elsewhere, but according to Schlosser, the statue Ghiberti saw excavated appears to be lost.

known ancient statues would seem to have been equally small. On the other hand, relief sculpture was common all over Italy, and while the reliefs on the columns of Trajan and Marcus Aurelius in Rome exerted little influence before 1480, the triumphal arches with their historical reliefs had great impact. The churches of Rome, of Pisa and, to a lesser extent, of Florence housed aside from an occasional piece of decorative sculpture large numbers of mythological, historical, and ceremonial sarcophagi which had been reused during the Middle Ages for burial and for altars. As late as the early sixteenth century archeological draftsmen and writers in Rome were still basing their observations largely on these historical and sarcophagus reliefs. Of the latter alone the churches of Rome sheltered two or three dozen. Throughout the Middle Ages the Campo Santo, the Cathedral and other churches in Pisa had formed a large repository of ancient sculpture. Smaller groups of sarcophagi had survived elsewhere. From at least the thirteenth century four had stood in and near the Baptistery and one in San Pancrazio in Florence.[4] Another group, mostly Early Christian and Byzantine sculpture *all'antica* had been assembled in Saint Mark's at Venice; finally, all over the country individual sarcophagi and reliefs were to be found, such as the famous sarcophagus of Dionysos battling the Amazons, in Cortona and the putto relief in San Vitale in Ravenna.

This material was supplemented to some degree by coins, gems, medals, and small bronzes and these small objects may have played an important part in the early revival of antiquity in the Venetian milieu.[5] But it would seem that only after 1430 did they become more numerous in the humanist circles of Florence and Rome. Only around the middle of the century when Cosimo and Piero Medici and Cardinal Pietro Barbo, later pope Paul II (and incidentally a Venetian) formed their large collections, did they occupy the center of attention and gradually determine the image of ancient art.[6] Coins, gems, and bronzes were precious and thus a sound capital investment. They could be easily handled and carried from place to place. They were readily reproduced in lead casts or wax impressions. They represented on a small scale the material which would illustrate the writings of the ancients: gods, historical events and personalities, ceremonies, sacrifices, triumphal processions. They were, in a way, the photographs of the time, and the game of scholarship could be won by the owner of the greatest collection. But simply because they represented to the fifteenth century objects of scholarship, gems and coins gained real importance only after 1430 when scholarship and art entered into a new relationship. It was in these years that Ghiberti saw in Florence and admired two *intagli*, the cornelian with the *Flaying of Marsyas*, and the chalcedony with the *Rape of the Palladium*.[7]

However, the situation around 1400, unexplored though it is, appears to have been vastly different. Its intricacies become apparent in a small group of sculptures, Ghiberti's and Brunelleschi's competition reliefs, the decoration of the Porta della Man-

[4] For bibliography on the foregoing, see App. A, introduction and list.
[5] Traversari, bibl. 526, II, cols. 411f (Lib. VIII, ep. 45).
[6] Muentz, bibl. 351 and 352; Ministero della Pubblica Istruzione, bibl. 338, I, pp. 1ff.
[7] Ghiberti-Schlosser, bibl. 178, I, pp. 17, 64; II, pp. 177, 192.

dorla, and the Virgin Annunciate in the Museo dell'Opera. Ghiberti's figure of Isaac (Pls. 2b, 26a) is designed decidedly in an antique manner, but it remains extremely puzzling. There is no doubt but that the figure draws on an antique prototype, even though thus far no specific model can be indisputably established. The pose would seem to be derived from a kneeling figure as shown by the unbroken curve along the right of the chest and hip and the upward and forward thrust of the right shoulder, and the modeling of the figure in the round leads one to think of a statue or a torso. Indeed, in pose the Isaac is reminiscent of the kneeling son of Niobe (App. A 1; Fig. 102). But while the outlines correspond, the body of Isaac with its small rippling planes and its silky skin is far closer to Greek sculpture of the fourth century than to the harsh, flat nude of the Niobide. The combination in the Isaac of an antique pose and an antiquish treatment of the surface is unparalleled in Ghiberti's subsequent work. Yet the exact model for the Isaac remains unknown and its relation to the antique a riddle as taunting as the figure is beautiful.

The body of Isaac is not the only antiquish element in Ghiberti's competition relief. The head of Abraham (Pl. 2b) recalls Zeus, but the resemblance is vague. On the other hand, the two servants (Pl. 2a) are derived from a specific antique group, the figures of Pelops and his companion on a Roman sarcophagus (App. A 2; Fig. 103). The pose of Ghiberti's younger servant is unmistakable: one leg flexed, toes to the ground, his back turned to the beholder, the swing of his body, the half lost profile of his head—each detail tallies with the figure of Pelops, despite the cloak which replaces Pelops' short tunic. Indeed, the grouping of the two facing servants, as well as their placement at the left edge of the composition corresponds exactly to the Pelops sarcophagus.

This recurrence of antique motifs in the early relief falls into place when viewed within the contemporary atmosphere of Florence. During the last decade of the fourteenth century Coluccio Salutati, grand old man of the early humanist movement in Florence, had successfully set out to instill in a generation of civic and intellectual leaders and their sons the spirit of humanism. Scions of old families such as Niccolo Niccoli and the much younger and much wealthier Palla Strozzi provided both financial and intellectual backing. In 1396 Manuel Chrysoloras was called to Florence as professor of Greek, and in 1397 Giovanni Malpaghini of Ravenna was appointed professor of rhetoric. At their feet sat humanists from the Florentine nobility and their protégés: Niccolo Niccoli and Palla Strozzi, Roberto de'Rossi, Giacomo da Scarparia, and Leonardo Bruni. Humanist studies became the basic discipline for training the young—Marsuppini, Poggio, Traversari, Cosimo and Lorenzo di Medici, Ser Filippo di Ser Ugolino.[8] Against this literary, humanist background must be placed the all'antica fashion which sprang up in Florentine art in the last decade of the Trecento.

The reliefs on the jambs of the Porta della Mandorla throw light on the links between humanism and art in Florence during these years.[9] Putti chase one another over the volutes of the tendrils on the inner jambs, female half figures grow out of rinceaux, a nude helmeted warrior kneels at the top of the left jamb, on the lintel a Zeuslike fig-

[8] Vespasiano da Bisticci, bibl. 54, p. 272; Voigt, bibl. 541, 1, passim.
[9] See above, pp. 52f, and notes 8-10.

ure reclines next to one who may be Prometheus. On the diagonal jambs, double curved acanthus candelabra enclose other antique and pseudo-antique figures between hexagons containing half figures of angels; a half-naked Abundantia stands holding a cornucopia (Fig. 5); putti play bagpipes and violas; a youth resembling Apollo plays the violin. Outstanding among these figures, however, are two: one is unmistakably Hercules wearing the lion's skin (Fig. 6); another seen from the back, youthful, almost boyish, clasps two snakes, and is thus again presumably Hercules. These two figures of Hercules are supplemented by the representation of at least two of his outstanding deeds in the *rinceaux* of the left inner jamb: the wrestling match with Antaeus and the battle with the Nemean lion. The preponderance of incidents from the Hercules story on the jambs of a late fourteenth century portal in Florence calls to mind the fact that it is in these years that Coluccio Salutati completed his work on the Labors of Hercules, one of its four books being the first complete treatise (Petrarch's early attempt was abortive)[10] to be written on the antique hero in modern times. It cannot be a mere coincidence that both the Florentine humanists and the masters of the Porta della Mandorla developed a simultaneous interest in Hercules.

If the humanists influenced the choice of a program, it was the artists who turned for its execution to specific models from Roman art. While acanthus scrolls are part and parcel of the vocabulary of Trecento decoration, the combination of double curved acanthus candelabra with interspersed standing figures recalls nothing so closely as a set of Roman pilasters, then in Old St. Peter's in Rome (Fig. 101). The resemblances include not only the general layout—*rinceaux* enclosing standing figures—but also the strong, fleshy character of the acanthus. To be sure, the figures scattered among these *rinceaux* in Florence are, in part, manifestly pseudo-antique: no antique Apollo ever played the fiddle, no putto the bagpipe. But others echo specific Roman, and occasionally Greek, prototypes.[11] Abundantia is derived from a Roman coin, the kneeling warrior points to Greece. Hercules with the lion's skin, its head dangling over his shoulder, reproduces a rare type known only in two Roman bronze statuettes, and indeed not even they are identical. But the very rarity of the motif bespeaks its dependence on a genuine antique model,[12] and the handling of the surface reveals the master's deep con-

[10] See Mommsen, bibl. 342; Coluccio Salutati's *De laboribus Herculis* was begun between 1383 and 1391; see Ullman, bibl. 465, p. vii.

[11] The four pilasters of third century workmanship decorated, from the eighth to the seventeenth century the chapel of John VIII on the interior façade of the basilica. They are illustrated in Dionysius, bibl. 129, pls. I, III, LXXIII, and in Gusman, bibl. 200, II, pls. 93f. The occasional appearance of a Greek prototype on the Porta della Mandorla has been pointed out by Saxl, bibl. 471, p. 35.

[12] Hercules statues resembling the Hercules of the Porta della Mandorla in general pose are frequent in antiquity: the weight resting on the right foot, the right arm hanging and loosely holding the club, which in the model known to the Hercules Master was evidently broken off. Also the motif of the left hand wrapped in the lion's skin occurs in at least one Hercules type (see Lehmann, bibl. 271, p. 7). But the combined features of the hand wrapped in the lion's skin and of the lion's head resting on the shoulder of Hercules, are at this point unknown to me. To be sure, in an early fourth century bronze statuette from Alt-Szoeny, Hungary (Vienna, Kunsthistorisches Museum; Bulle, bibl. 80, pl. 57) the lion's head is worn on the left shoulder; but the left hand is not wrapped in the skin and the position of the right arm is different from the Hercules on the Porta della Mandorla. A similar small bronze, formerly in the Uffizi, at present in the Museo

cern for the tactile values of ancient sculpture. The Virgin Annunciate in the Museo dell'Opera also by the "Hercules Master," though medieval in stance and gesture carries upon fine shoulders the head of a young Greek athlete, the short hair bound by a *taenia*. While the antique fashion is most strongly and perfectly displayed in the work of the Hercules Master, it is equally dominant in that of his lesser collaborators. It even infected the production of a neighboring, though inferior workshop, that of the Porta de'Canonici.[13]

It is hardly possible to overrate the importance and exceptional position of the Porta della Mandorla and the related works. For the first time in many centuries a cycle of antique motifs has been carried over without a change in iconography—Hercules remains Hercules, Abundantia remains Abundantia. Only fifty years later was this principle broadly adopted. But at the turn of the century the retention of both the form *and* the content of an antique prototype was extremely rare.[14] Concomitantly, it is inconceivable that within the highly organized framework of Florentine art patronage such works could have been designed without the express approval, if not at the suggestion of the commissioning guild. Thus, one wonders if the committee in charge of the competition for the Baptistery door in 1401 may not likewise have insisted upon the use of motifs *all'antica* as one of the conditions for the contestants. For it cannot be by pure chance that both Ghiberti and Brunelleschi placed motifs drawn from antiquity at key points in their competition reliefs. The inclusion of such elements must have been an established condition, explicitly or by implication. Certainly the motifs *all'antica* would have recommended the work to the attention of the jury. The learned among the judges would have admired the humanist connotations of such elements. By implication they would also have admired the skill of an artist able to emulate the works of the ancients.

Brunelleschi's Isaac, kneeling on the altar (Fig. 1) is derived from a kneeling prisoner such as those on the Arch of Constantine; of the two servants, the one on the left is taken from a thorn picker, the one on the right, bent double, comes possibly from a figure on a Roman relief of the *Slaughtering of the Pig*. Yet, when set off against Brunelleschi's interpretation of antiquity, Ghiberti's approach becomes particularly clear. Brunelleschi, as a rule, sees the forms of antiquity through an overlay of medieval transpositions. While the pose of Isaac is nearly identical to that of the barbarian on the Arch of Constantine, it is also a type which appears similarly adapted to portrayals

Archeologico in Florence (*Reale Galleria di Firenze illustrata*, ser. IV, vol. III, pp. 36f, pl. 115; Reinach, bibl. 436, I, p. 474, no. 1964D), is possibly a sixteenth century imitation. (Information by the museum staff, kindly relayed through Mr. Myron Laskin Jr., Institute of Fine Arts, New York University.) On the other hand, the presence in fifteenth century Florence of such a Hercules statue seems to be confirmed by a drawing in the Francesco di Giorgio codex (Florence, Bibl. Nazionale, cod. Magl. II. 1. 141; see W. Lotz "Eine Deinokratesdarstellung des Francesco di Giorgio," *Mitteilungen des Kunsthistorischen Instituts in Florenz*, V [1940], pp. 428ff), representing a youth in the stance of the Hercules bronze in the Museo Archeologico and the figure from the Porta della Mandorla, wearing a lion's skin, draped this time over both shoulders, but with the lion's head resting on his right shoulder.

[13] Poggi, bibl. 413, docs. 143ff, 335ff.

[14] For the retention in medieval art of antique subject matter transformed or, vice versa, the retention of antique types with changed subject matter, see Panofsky-Saxl, bibl. 388.

of Isaac in Trecento painting. Likewise Brunelleschi's thorn picker recalls the original only through an overlay of medieval transformations.[15] He appears then to have been attracted by complicated poses derived originally from antique sculpture and passed on to him in medieval garb with but faint echoes of the original. These motifs he transferred into the pitiless and jerky language of fourteenth century realism, and tied somewhat loosely into the context of his narrative. But the unresolved discrepancies between the original Roman prototype, the medieval transformations and, above all, Brunelleschi's own realism, cause these motifs to stick out conspicuously in the composition. Obviously he had good and valid reasons for crowding the Abraham relief with these alien elements. Whether pseudo-antique or genuine in appearance, they were to him, in the words of the Trecento, "more lifelike" than the art of his own time and "better than nature." They were motifs seemingly observed from nature and they thus offered scientific, or pseudoscientific solutions to otherwise insoluble problems of reality and its dramatic presentation.

Ghiberti's approach to the art of antiquity is much closer to that of the Hercules Master than to Brunelleschi's. His treatment of the body of Isaac indicates that he, like the Hercules Master, was primarily drawn by the tactile values of antique modeling. The sensuous treatment of the nude, the small easy planes, the rippling muscles, the silky surface of the skin, stand out so distinctly from the rest of his work that one is led to suspect him in this instance of copying directly the modeling of a Lysippan or Scopasian torso. During the next twenty years he never again focused so directly on the tactile qualities of the human body. Only in the nudes of the Gates of Paradise did he return to a modeling similar to that of the Isaac. Indeed, it is only in the late years of his life that he stresses the touch of fingers, the "seeing hand," when discussing works

[15] Huebner, bibl. 224, p. 267, suggested as the direct prototype of Isaac, one of the kneeling barbarians on the bases of the columns on the Arch of Constantine. The pose is similar, but the prisoner is bearded and wears long pants, as do the majority of kneeling prisoners in Roman art. On the other hand, Isaac, naked and kneeling on the altar, hands fettered behind his back, appears frequently in Italian art from the earliest through the latest Trecento (S. Maria in Vescovio; S. Croce, Florence, sacristy, see above, p. 50, note 2).

Brunelleschi's thorn picker is not derived directly from the *spinario* in the Palazzo de' Conservatori, even though the bronze was known at the Lateran certainly from the thirteenth century as *ridiculus ille priapus* (Rushforth, bibl. 456, p. 49). The *spinario*, like the great majority of its Hellenistic and Roman replicas, picks the thorn from his sole while steadying his instep or ankle with the other hand (Salis, bibl. 459, pp. 124ff; 252ff). Brunelleschi's servant, on the contrary, grasps his foot with both hands and tries to squeeze out the thorn with his thumbs. Extremely rare in antiquity, the motif turns up alongside the conventional type in medieval art (Adhémar, bibl. 2, p. 191). Equally, cloak and leggings point to the use of a Byzantine or medieval, rather than an immediate antique prototype. Professor W. Heckscher, who is preparing an extensive study on the survival of the *spinario* type has referred briefly to the Byzantine forerunners of Brunelleschi's version (bibl. 208, p. 422). In a letter he has been good enough to elaborate on his thesis of the medieval character both in iconography and form, of the thornpicking servant. As this manuscript goes to press I receive from Mr. Heckscher the reprint of his article on the *spinario* from *Reallexikon zur deutschen Kunstgeschichte*, s.v. *Dornauszieher*.

The comparison between Brunelleschi's right-hand servant and the Roman *Slaughtering of the Pig* (Bartoli-Bellori, bibl. 42, pls. 44f) was suggested to me independently by two of my students, Mr. John Hoag, Yale University, and Mr. Joseph Polzer, Institute of Fine Arts, New York University.

of ancient art.[16] Also, like the Hercules Master, Ghiberti would seem at first glance to have transferred antique elements *tale quale* into his design of the competition relief: both in the servants' poses and in their position at the edge of the relief he seems to have clung almost verbatim to his model, the Pelops sarcophagus. However, this first impression is deceptive. Only the stance and movement of the antique figure remain unchanged, in the transferral to the new context. The types are changed and are fully assimilated into the drama of Abraham's sacrifice; Pelops' short classic tunic has been replaced by the long Biblical cloak of the servant. Ghiberti has imparted to the antique models the melodiousness and reticence which underlie his entire style and has thus created a sense of congruity absent from Brunelleschi's relief. The gliding movements of Isaac and the young servant, both antique in origin, are no smoother than those of Abraham and the angel, both of whom are fourteenth century types; the heads, whether *all'antica* or not, are modeled in the same small planes (Pls. 1; 2a, b; 26a). Instead of faithfully copying his antique prototypes, as did the Hercules Master, or instead of translating them into the harsh realism of Brunelleschi, Ghiberti merged only a few visual elements from these models with the personal qualities of his design. This design is in itself so fluid, works so decidedly with small planes and elegant easy stances, is so clearly based on the demands of a tempered realism, that it absorbs antique elements easily, to the extent at least that they too contain or suggest these very same qualities.

One cannot escape the impression that either Ghiberti's early interest in the art of antiquity was short-lived or else that in the competition relief he exploited it for the sake of catering to the antique fashion in Florence at the turn of the century. Certainly during the years that followed directly after the contest of 1401 the art of antiquity did not hold a central place in his thinking. The great majority of the quatrefoils on the North Door show no significant impact from ancient art. In one of the earliest reliefs, the *Nativity* (Pl. 27), a reflection of Roman sculpture glimmers faintly: the head, chest, and an arm of one of the shepherds appear to derive from a seated nude god on a sarcophagus in Florence (App. A 3; Fig. 104). But on the whole, motifs *all'antica* and concepts of ancient art are absent from the early reliefs of the North Door, and this is but to be expected; Ghiberti in these years was the foremost leader among Florentine artists of the currently popular International Style; within its framework there was little if any room, for the motifs and concepts of Greek and Roman art.

However, the art of antiquity was to resume a central place in Ghiberti's work after 1416. The late reliefs of the North Door, the majority of the heads on its frame, the *Herod* relief and the *Saint Matthew* at Or San Michele, abound with Roman elements. On the North Door, at the right edge of the *Entry* (Pl. 41), a woman leans forward, her arms bare, her hair held by a fillet; she matches trait by trait, even to her position at the right edge of the composition, the figure of a servant girl in the wedding scene of the Fieschi sarcophagus in San Lorenzo fuori le mura in Rome, a work well known to every visitor from the thirteenth century on (App. A 5; Fig. 106). The fallen youth in the *Expulsion* (Pl. 35) appears modeled after a hunter in a Hippolytus sarcophagus; his pose retains the classical outline, while his costume is modified ever so slightly to

[16] Ghiberti-Schlosser, bibl. 178, I, pp. 62ff.

suit the Biblical context (App. A 4; Fig. 105). Of the prophets' heads at the corners of the lattice frame of the North Door, four (Pls. 58a; 62a, b; 63b) are purloined from the Phaedra sarcophagus in Pisa (App. A 7-10; Figs. 109-112); others (Pls. 57e; 59f; 61c, d; 64a, b) are derived from or are variations on battle sarcophagi then in Rome (App. A 13-16; Figs. 113, 115, 116, 117) and Pisa (App. A 17; Fig. 114). Although no specific models can be pointed out for another half dozen (App. A 18, 19, 20; Pls. 56b, 57d, 59f, 60a, 61e, 63a), their beards and mustachios, wildly flying locks, Dacian nightcap turbans, savage faces, strained poses, and glances directed upwards and downwards point unquestionably to one or more sarcophagi on which were depicted barbarians locked in battle. Another of the prophets' heads (Pl. 67) clearly reflects a portrait bust of Caesar (App. A 11; Fig. 107). Occasionally entire compositions are drawn from antique reliefs. In the *Herod* relief (Pl. 72) the guards who thrust the Baptist before the king appear to be based on two of the Aurelian reliefs on the Arch of Constantine, the *Clementia* and *Justitia Imperatoris* (App. A 22; Figs. 119, 120), the rulers on the dais are possibly based on still another type of Roman ceremonial relief, the *Liberalitas Augusti* (App. A 6).

The wealth of antique motifs in the last phase of Ghiberti's work on the North Door is proof of his renewed interest in antique art. At the same time, his approach after 1416 differed considerably from that of his early years around 1400. His knowledge of ancient monuments and his scope were now broadened. Clearly, between 1416 and 1420 his acquaintance with ancient art was not based on random glances, but on a careful scrutiny of Roman sarcophagi and historical reliefs. He certainly had himself seen the heads in shallow relief in the background of the *Justitia Imperatoris* and of the Trajanic battle scene on the Arch of Constantine (Figs. 120, 131), and hence adopted them for his *Herod* plaque and the *Arrest* (Pls. 72, 44). No sketch by another artist could ever have transmitted to Ghiberti that faithfully the details and the spirit of the Roman originals. He himself must have sketched from the Phaedra sarcophagus and the Borghese battle sarcophagus with silverpoint or pen, noting down the heads, feature by feature. At times he followed the Roman models closely enough for one to wonder if by any chance in addition to making drawings he may not have carried home a few casts. Be that as it may, his work from about 1416 to the end of his life is evidence that over the years he must have built up a huge portfolio of drawings of antique works.

Ghiberti, then, prior to 1416 must have visited both Pisa and Rome. He must have known from first-hand observation the Phaedra sarcophagus in the Campo Santo, the Borghese sarcophagus, then in Saint Peter's, the wedding scene in San Lorenzo fuori le mura, and the historical reliefs on the Arch of Constantine. It was not to be his last visit to Rome, nor do we know that it was his first. But the sudden appearance of motifs in his work after 1416 taken from sculptures then on view in Rome would seem evidence of a Roman sojourn at approximately that date.

Whether or not this Roman sojourn provided him with a new understanding of Roman art, the motifs *all'antica* embedded in his work offer a clue to what the art of

antiquity meant to Ghiberti in those years. It was apparently of minor importance to him that striking differences of style and quality existed among his prototypes. Most of the sarcophagi known to him were poor workshop products, with a few exceptions such as the Phaedra sarcophagus. But he drew upon good and bad with equal enthusiasm. The quiet elegance of the second century Phaedra story and the excitement of a third century battle scene were both welcome to him. On the other hand, a catholic taste did not prevent Ghiberti from fixing his attention on very specific motifs and from underscoring those traits which most attracted him. His outlook is no longer dominated by the tactile values of a torso or the elegantly swinging stance of an antique figure. Instead, ancient art now became to him a rich source of expressive physiognomic types and complicated figure groupings: a woman bending forward from the rear to the frontal plane; a group centered around the figure of a captive; the clash between the agitated crowd and the commanding figure of their ruler; the parchmentlike features of an old woman, the fine face of a youth, the savage heads of barbarians craning their necks to look upward or downward. Ghiberti transfers these elements from the antique model with fewer changes in context and costume than he had made earlier, at the time of the competition relief, thus rendering the types easily identifiable. But stylistically he transposes them energetically into the highly sculptural, yet melodious idiom evolved in these years. He brought a new vehemence to a Roman ceremonial scene or the scene of a prisoner brought before the emperor. Figures are deeply undercut and isolated, both from their neighbors and from the ground. Light and shade clash in sharp contrasts. In the prophets' heads cheekbones and brows protrude strongly, eye sockets and cheeks are more deeply sunken than in the Roman originals. The hard bordering planes of a barbarian's face are replaced by powerful yet smooth modeling, his stringy hair and beard are turned into soft full locks. It almost seems as though Ghiberti sensed through these poor Roman workshop derivatives the true essence of the Hellenistic originals. But it might be better to say that in his style in the years after 1416 he seized upon and enhanced the congenial traits of Hellenistic art, still faintly mirrored in Roman battle reliefs and mythological sarcophagi, late descendants though they were. Comparably, Ghiberti saw in Roman decorative sculpture a far greater proximity to nature than they actually offered. To be sure, the floral designs on the jambs of the North Door must be viewed within the framework of Ghiberti's ever present love for the smallest details of natural forms (Pls. 69d; 70a, b; 71a). To be sure, the bunches of flowers on the inner jambs (Pl. 69c) are closely linked to Gentile's Strozzi altarpiece. But the bundles of leaves and fruits on the outer frame have no medieval antecedents and no contemporary counterpart. Garlands on Roman *cippi*, altars, and sarcophagi (Fig. 52) on the other hand, contain the very fruits which Ghiberti employed: olives, grapes, pomegranates, figs, filbert nuts and pine cones, with birds occasionally pecking at the fruits. As on Ghiberti's frames, the relief of these Roman garlands decreases in depth from near full round to the flattest possible layers. But granted the similarities, Ghiberti transformed the Roman workshop products through his use of a wider vocabulary, his dissolution of the Roman garlands into a

sophisticated design of particularized bunches of leaves and fruits, and last but not least, through the quality of his modeling.

One must not see ghosts of ancient art where they do not exist. A balanced composition or a piece of armor fashioned in the antique mode need not denote dependency on an antique prototype. Even classical poses in many an instance derive from crypto-antique Trecento models rather than from genuine antique prototypes. Ghiberti, when turning to Trecento art in the twenties and early thirties was apt to seize upon types evolved from latent antique formulas which reminded him of ancient art, either in costume or in their intricate, yet reticent poses. Whatever their appeal, in his hands these crypto-antique Trecento types come surprisingly close to the ancient models from which they were ultimately derived. The *contrapposto* of *Saint Matthew*, his right arm cradled in the sling of the toga (Pl. 7), reflects Greek and Roman orator figures; but these types had become part and parcel of Christian iconography during Early Christian, Byzantine and medieval times (App. A 21). To be sure, the medieval apostles, evangelists, and saints had gradually lost the classical distribution of weight and support that had marked their antique ancestors. No doubt Ghiberti evolved his Evangelist from this slightly tired medieval formula. But at the same time, he was inspired by figures of poets and orators standing in shell-topped niches, as he could find them in "Asiatic" sarcophagi or their Roman derivatives. But in revitalizing the crypto-antique formula, he gave it a flavor more lively, more monumental, and more classical than any of the medieval or late antique works which could have served as his model. No second or third century figure seems quite so solidly balanced nor so serenely firm as the *Saint Matthew*.

Whatever it was that Ghiberti saw in ancient art and however his perception was enhanced, the process was linked to his search for a new understanding of nature and the sculptural and pictorial means for its interpretation. In the course of this search and under the influence of Donatello's rediscovery of classical principles, Ghiberti, in his *Saint Matthew* gave back to the postclassical formulas of late antique and medieval prototypes a full classical *contrapposto* and a classical head. At the same time, he discovered the expressiveness of Roman portraits, as well as that of Hellenistic and barbarian physiognomies. He learned from Roman ceremonial compositions how to build up a group of people, unified, and thus suggestive of depth, and how to form a relief design through a multitude of planes. Flatly carved heads in the backgrounds of Roman historical reliefs signified to Ghiberti as they had to Roman sculptors, a device for hinting at depth and atmosphere. But very much in contrast to the Roman stonecarvers, Ghiberti turned this minor spatial device into the springboard for the development of an entirely new technique of pictorial relief. In the Shrine of the Three Martyrs (Pl. 76) he breathed new life into the medieval motif of flying angels by blending it with an antique formula, a pair of Roman victories (App. A 23; Figs. 58, 121); at the same time he exploited the Roman shallow relief technique to convey to the heads, bodies, and transparent garments a sense of depth and free movement through space. When, after 1416, Ghiberti started feeling his way along many different paths he turned time and again to ancient art for the solutions. But though ancient art held

many of the answers, it did not have a dominant role in his art during this period of exploration.

The situation changes in the thirties when Ghiberti entered his most mature phase. Then the art of antiquity did become a dominant force shaping his style. In the first place, during these years his mind was filled with ever more images of ancient art. The panels of the Gates of Paradise teem with motifs taken from an astounding variety of antique monuments. But, and herein lies the second point, as a rule it is hard to identify the specific sources of these motifs. Ghiberti so changed them that the borderline between copy and variant became ever more fluid. Third, this freedom in the handling of antique models is related to his evolution of a consistent image of what he apparently considered the style of ancient art. He identified this image with his own late style in which, as a consequence, elements drawn from ancient art and elements of his own free invention are indissolubly blended.

Both the range and the variety of ancient works reflected in Ghiberti's late *œuvre* are astounding. The monuments assembled at Pisa, the sarcophagi and reliefs he had known in earlier years such as the Trajanic battle scene on the Arch of Constantine, the Borghese battle sarcophagus, the Fieschi and Pelops sarcophagi, while still exerting some influence, were far outnumbered by an abundance of other monuments which had on his work an impact not previously felt. Among the latter monuments were three, possibly four bacchic sarcophagi; two Meleager sarcophagi; two Medea sarcophagi; one Adonis sarcophagus; a marine sarcophagus with Tritons and Nereids; and a sarcophagus showing scenes from the life of a Roman general. There were, besides, the Minerva frieze from the Forum of Nerva and probably the Iphigenia *cippus* in Florence. All of these can be individually identified from their reflections on the Gates of Paradise. All except the Iphigenia *cippus* were still in Rome in the sixteenth century. But the number of ancient monuments drawn upon by Ghiberti went far beyond the specific ones which we can name with certainty as known in the fifteenth and early sixteenth centuries. Ghiberti knew sarcophagi with an orator standing in a shell-topped niche; he knew at least two variants on the type of *Venus Pudica*;[17] he was familiar with an Endymion sarcophagus and with a Proserpina sarcophagus. Finally he seems to have known Roman bronzes such as a statuette of a standing Zeus or Poseidon. To be sure, the bulk of the monuments he knew and admired were apparently the sarcophagi scattered all over Rome, and one gets the impression that he knew a large variety of them. In fact, there is scarcely a group of Roman sarcophagi known to us today with which

[17] A *Venus Pudica* in Florence is described about 1390 by Benvenuto da Imola. Another one until 1357 in Siena was known to Ghiberti through a drawing by Ambrogio Lorenzetti; a third, found in Florence, he saw in Padua.

Schlosser correctly points out that these statues represent different types and, in fact, a precise distinction is possible. The statue seen by Benvenuto da Imola was of the Venus Medici type, but apparently without the dolphin. Giovanni Pisano, for his *Prudentia* on the Pisa pulpit may or may not have drawn on this specific figure. The Siena Venus—Ghiberti tells vividly of its wanton destruction in 1357—recalled the Medici Venus even more closely, including the dolphin against the leg. The Paduan statue, with drapery over the hips, must have been of one of the types related to the Venus of Milo. (Ghiberti-Schlosser, bibl. 178, I, pp. 62f; II, pp. 31 and 187ff, with quotation from Benvenuto da Imola's reference to the Florentine *Venus Pudica*.)

he was not familiar. His portfolios must have overflowed with drawings of these works, and one wonders whether such drawings reproduced only individual figures, as did the sketches of Pisanello, or groups of figures or even entire reliefs.

The wealth of monuments then in Rome, which first found reflection in the Gates of Paradise makes it seem likely that Ghiberti made or renewed an acquaintance with them shortly before starting work on the panels. Indeed, his autobiography hints at a stay in Rome sometime between 1425 and 1430 (App. B)—a second stay, it would seem. It is tempting to speculate on the possibility of his having looked at antique monuments together with Pisanello who, just in these years, appears to have made a number of drawings of Roman sarcophagi, among them one possibly used also by Ghiberti (App. A 53b; Fig. 144).[18] It is even more tempting to speculate on the great likelihood of Ghiberti's having first come under the spell of Leone Battista Alberti during this, his second Roman stay, and of his having been deeply impressed with the young humanist's interpretation of the ancient world.[19]

Indeed, neither the range, nor the variety of ancient monuments with which Ghiberti was acquainted after 1430 is as astounding as the newness of his approach. To be sure, the haphazard borrowings from antiquity which characterize the competition relief are no longer found on the North Door after 1416. Instead he had scattered all over the frame and throughout the quatrefoils a large number of elements *all'antica* drawn from a relatively small group of ancient monuments. These prophets' heads and figures *all'antica* remained easily recognizable as derivatives from specific Roman sarcophagi. They are transposed from the language of late antiquity into Ghiberti's idiom; but facial types, stance, headgear, hair-dressing, even costume are rarely altered, much in contrast to the competition relief where young Pelops was turned out in Biblical garb. They are not copies, but they stay very close to their prototypes. On the other hand, in describing the Gates of Paradise the term "copy" could hardly be applied to Ghiberti's approach to the antique and, indeed, his borrowings are often hard to identify. This is all the more surprising as style, costumes, and motifs are unmistakably antique in veneer. But just this overall flavor *all'antica* veils the specific dependence of a figure on a given Roman model. After all, throughout the Gates of Paradise, the dress of the figures, male and female, is not really that of antiquity. Rather it is of an antiquity of Ghiberti's own invention. The style, while undoubtedly intended to recall the art of antiquity, is Ghiberti's style of the thirties. Finally, the stances, gestures, and draperies of the figures are rendered with a freedom which loosens the tie to the original model, even if ever so slightly. The very fact that these changes in style, costume, and motif take place in an atmosphere saturated with an ideal image of antiquity, which is still not antiquity itself, throws light on the novelty of Ghiberti's approach.

The changes from the antique prototype may often seem at first glance minor: a mere shift in stance, a small change in the flow of drapery, a slightly different twist of the body. In the scene of Noah's Sacrifice one of the daughters-in-law of the patriarch,

[18] Degenhart, bibl. 122, pp. 24ff. [19] See below, pp. 328ff.

her back to the beholder (Pl. 92), has a close counterpart in a figure on the frieze of the Forum of Nerva in Rome, the *colonnacce*, a landmark to the artists of the Renaissance (App. A 34; Fig. 129). Perhaps, the girl did not slip into just this panel entirely by chance: the *colonnacce*, in the late Middle Ages bore the name *arca Noe*, a corrupted version of *arcus Nervae*. But the stance of the young woman in the *Noah* scene is elegant and fluid, very different from the stiff figure on the Nerva frieze; she steps lightly, poised in a delicate curve; her dress, long despite the wrap around the waist, flows downward to mark the swinging movement of her body and spreads around her feet. Noah's wife in the middle ground of the panel (Pl. 104a), is modeled after the bride on the Fieschi sarcophagus (App. A 33; Fig. 106), but again stance and drapery are infinitely more fluid than in the Roman work. Eve, gliding up towards the Lord (Pl. 83b), is of an elegance unheard of in the Roman nereids from which she is derived (App. A 25; Fig. 124). One of the daughters of Israel in the *Moses* scene (Pl. 103) is drawn from a Venus rushing towards Adonis (App. A 44; Fig. 122); but she glides smoothly along with the gait of a dancer, and her veil and dress billow in long even lines, rather than breaking into hard folds. Miriam dancing among the figures on the frame (Pl. 129a) is drawn from a maenad on a bacchic sarcophagus (App. A 57; Fig. 145), but her stance has lost the violent twist of the bacchic figures: she moves more gently, feet crossed, her dress flows in smoother folds. Correspondingly, in the *David* panel, Ghiberti translates the figure of a fighting barbarian, seen from the back on the battle sarcophagus Borghese (App. A 52; Fig. 113) (Pl. 114a), into a pose, less violent and twisted than that of the prototype, but also more energetic and taut. One of the men in the *Joshua* panel, weighed down by the heavy stone on his back (Pl. 108b), steps with greater springiness than his antique counterpart (App. A 50; Fig. 141), his longer tunic emphasizing his forward movement. His companion, to the left (Pl. 108a), departs even further from the antique model (App. A 49; Fig. 141). He turns forward instead of sideways, lifting the stone to his waist, his garment is freely designed in the antique manner. Indeed, nobody would guess from the way the two stone carriers in Ghiberti's panel appear in a fresh context as unrelated figures that in the antique original they formed part of a tightly knit group, carrying the dying Meleager.

These changes, minor though they may seem at first, lead imperceptibly from free copies to freer and freer variants on the antique models. Throughout the Gates of Paradise the borderline between copy and variant fluctuates. Ghiberti took over the *moira* from a sarcophagus, then in St. Peter's (App. A 35; Figs. 132, 133) and transformed her into one of Noah's sons in the scene of the Sacrifice (Pl. 92). The position of the bare arms, the cascade of folds falling from the right shoulder, the chiton caught at the left shoulder by a fibula are alike in both figures. But stance, drapery and, needless to say, even sex are changed. The *moira* turns right, the young man left; the mantle curves widely in a compact fold across the small of her back and is tightly drawn over her thigh, while his hangs loosely down his back, is gathered into a beautifully curved fold under the elbow and continues to fall in loose curves, twice repeated but widely spaced over his thigh and leg. Ghiberti played on the theme of the *moira*; he modified it, added

to it, and invented the stance and drapery over the legs which on the sarcophagus were hidden by the kneeling nurse. However, Ghiberti's invention of these features is so much in keeping with his interpretation of the specific antique models, that there is no discernible break; the Roman prototype is absorbed completely into Ghiberti's own design. This free play on a Roman theme is repeated in two other figures on the Gates of Paradise, both of which are linked to the same *moira*. For the woman standing to the right of the group of visitors in the *Isaac* panel (Pl. 97a) Ghiberti would seem to have drawn on a number of those characteristics of the *moira* which he had discarded when rendering the son of Noah: the bend of the head, the coiffure *à chignon*, the drapery across the hip (App. A 40; Figs. 132, 133). The elderly prophet on the frame, his arm raised in wrath (Pl. 126a) (App. A 55) represents a third variant in disguise of the same model. Again, the relationship is complex. The prophet's chiton, fastened at one shoulder, the cloak falling in a long cascade over the other, the drapery folds thrice repeated over the right hip, thigh, and leg, are features which most resemble the young man in Noah's Sacrifice, Ghiberti's first version of the *moira* theme. On the other hand, like the woman in the *Isaac* panel, the old prophet has traits in common with the *moira* which are not shared by Noah's son: the belt of the chiton, the characteristic twist in the uppermost fold of the cloak and, last but not least, the view of the right rather than the left profile.

All three figures illustrate the imaginativeness and almost dangerous virtuosity with which Ghiberti in the Gates of Paradise played on antique themes. From one antique motif he would develop two, three, or possibly more variants, each reminiscent of the original in one or two of its features, but never in all of them and never in exactly the same way. Here and there he moved even further away from the Roman originals. As in the twenties, he sometimes still seized upon a crypto-antique motif as a point of departure and revitalized it by creating a figure closer to the antique original. Or else he would evolve new types by fusing motifs from different antique figures; or again, in another complex interplay, he would create a variant of a variant, with the Roman original only dimly recognizable through the overlays. No doubt the thoughtful standing Rebecca in the *Isaac* (Pl. 97b) is a variant on some antique type of mourning woman, perhaps on the Iphigenia *cippus* in Florence (App. A 41; Fig. 134). Abel, in the scene of the Slaying (Pl. 86a), shares decisive elements of pose with both a fallen Dacian in the Trajanic relief on the Arch of Constantine and a Trecento figure replete with crypto-antique traits (App. A 28; Figs. 81, 131). But as a rule Ghiberti proceeded along more complex lines. He liked to incorporate into his panels similar antique figures from different sources, to provide subtle variations of mood and gesture. In the *Moses* panel a terrified bystander (Pl. 104b), in the *Joseph* panel one of the brethren (Pl. 98), the former hiding his face in his hands, the latter, in his cloak, are derived from mourners who appear on two different sarcophagi in scenes of Meleager's death train (App. A 42, 46; Figs. 138, 141). Similarly, in composing the reclining figures of Eve and of Noah's wife on the frame (App. A 59, 61; Figs. 104, 142), Ghiberti drew on two antique versions of Gaia (Pls. 122a, 123b). For the figure of Eve in the Expulsion he fused three prototypes and thereby created a variant of rare beauty and intricacy (Pl. 84). The ges-

ture of the arms is taken from a *Venus Pudica,* the stance derives from a whirling maenad on a famous bacchic sarcophagus then in S. Maria Maggiore, and the crossed feet, probably from another dancing figure on the same bacchic sarcophagus (App. A 27; Figs. 125, 126). The freedom with which antique elements are combined in new variants is made strikingly clear if one looks at the bacchantic Eve on Vittorio Ghiberti's frame of the Andrea Pisano door (Fig. 128). She is a more literal translation of the same maenad which went into the Eve of the Expulsion and it must have been in his father's sketchbooks that Vittorio found a drawing of the prototype. This interlocking of variants and copies exemplified by the permutations of the maenad and *moira* themes, is far from rare in the late phase of Ghiberti's work. While at times he creates two variants of one antique model, as a general rule he prefers to design the second variant from the first one, the two being related to one another often by a single expressive stance or gesture. The terror-struck Adam in the Expulsion finds a counterpart in the terrified warrior of the *Moses* (Pls. 84, 102). But while Adam is directly drawn from a satyr on the sarcophagus from S. Maria Maggiore (Fig. 127), the warrior recalls the Adam only in the thrust of the legs (App. A 26, 45). A young woman on the left side of the *Joshua* (Pl. 107) is related in stance to the dancing maiden in the *Moses* (Pl. 103), but she has been stripped of the antique garment and fluid movement, and thus of the most striking attributes of the original antique model (App. A 48; Fig. 123). A woman accompanied by children (Pl. 79a) in the Zenobius relief, is basically a variant on a Medea from a lost Roman sarcophagus known from a drawing in the Coburg sketchbook (App. A 67; Fig. 136). But Ghiberti added to this model not only traits taken from a second Medea sarcophagus, then in San Cosma e Damiano in Rome (Fig. 146), but also the billowing veil worn by maenads or by Selene approaching Endymion —the veil that adorns both a woman visitor in the *Isaac* (Pl. 97a) and the enchanting prophetess on the frame (App. A 38, 54; Pl. 125a; Figs. 135, 140). At the same time Ghiberti took from the lost Medea sarcophagus certain features which he had rejected for the woman in the Zenobius Shrine, using them instead for a woman in the *Joseph* (App. A 43; Pl. 99).

Given this complicated process of adaptation one wonders frequently whether one is confronted with a variant of an antique prototype or with a free invention of Ghiberti's in the antique manner. It would seem that the borderline between variants and *invenzioni all'antica* remained as fluid as that between copies and variants. The beautiful prophetess on the frame, to the left of *Cain and Abel* (Pl. 125a), is reminiscent equally of a Selene on an Endymion sarcophagus and of a maenad on a bacchic sarcophagus. Yet she is identical to neither, is so much the creation of Ghiberti that all possible prototypes would seem practically lost in a design *sui generis.* Of the group of female visitors in the *Isaac* (Pl. 97a), only one or two can be linked to specific antique models; yet the three in the foreground as a group breathe the spirit of antiquity so fully that they can only be described as *invenzioni all'antica* (App. A 37). One of the prophetesses (Pl. 128b) sways lightly, much like one of the bacchic dancers on the S. Maria Maggiore sarcophagus (Figs. 125, 126). In Ghiberti's version her pagan nudeness has been clothed, abdomen and breasts covered by thin, transparent stuffs, her legs

wrapped in a heavy cloak. Judith, further down on the frame (Pl. 130a) similarly leans back alluringly, a veil arched over her head, but her heavy dress is that of a Roman matron. The details throughout recall the vocabulary of ancient art. But they form combinations that occur nowhere in antiquity. Likewise Cain, standing in the countenance of the Lord (Pl. 86b), recalls in every detail a shepherd on some antique sarcophagus, even though his pose and position in the panel correspond exactly to Taddeo di Bartolo's Cain in San Gimignano (Fig. 81). No specific prototype from antiquity can be established for him, and yet Ghiberti's Cain evokes the spirit of antiquity with unheard-of strength. Like the four women in the *Isaac*, like the prophetesses on the frame, like the procession under the walls of Jericho, the figure of Cain is proof of the extent to which Ghiberti, in these late years had become imbued, not only with the vocabulary of ancient art, but with an image of antiquity. This image permeates his entire art and within it he creates his variants and permutations on antique themes, as well as his own free inventions *all'antica*. No doubt some, or perhaps many, of the figures and groups which now appear to be inventions in the antique manner may in the course of time prove to be copies of, or variations on, antique themes that have as yet not been identified. But what characterizes Ghiberti's late art in its relation to antiquity is the almost complete absence of literal copying of ancient works as opposed to an ease of variations on them and concomitantly the fluidity of the borderlines between copy, variation, and free invention.

Ghiberti's mature approach was in its very foundations novel. He had evolved for himself not only an all-pervading, but a consistent and homogeneous image of antiquity. This meant, in the first place, that he made selective use of the dozens of Roman sculptural works with which he was acquainted. Entirely, or almost entirely, he discarded the historical reliefs so important to him fifteen years earlier as objects of interest. He was no longer fascinated by the traces of shallow relief in Roman sculpture, by the expressive physiognomies or by the figures pressing forward at the foot of an imperial throne. He rarely had eyes for the quietly standing figure which had so much attracted him in his design of the *Saint Matthew*. Where he still drew upon such calm poses, as he did when he transformed the woman on the Minerva frieze into Noah's daughter-in-law and the Iphigenia into Rebecca, he endowed the figures with fluid movement. Needless to say, the monuments that intrigued him did not do so by reason of iconography. Throughout his life he remained impervious to aspects of hermeneutics. What attracted him in the works of ancient art was the style, or better still, the stylistic interpretations he could put upon them, and beyond style, it was the human emotions they conveyed: gestures of terror, the lassitude of a mourning woman, the sprightliness of a youth, the playfulness of a dancing maiden.

Regardless of whether they present bacchic scenes or nereids, stories of Endymion, Meleager, Medea, or Paris, all of Ghiberti's models had one thing in common: they are peopled by elegant, long, slim figures, nude or clad in thin transparent garments. Goddesses step from chariots and suddenly reveal themselves to their lovers; maenads and satyrs dance and jump, agile and lively; a scene is filled with figures staggering under heavy loads and overwhelmed by sorrow. Draperies flutter, veils billow, as if blown

by a high wind. Indeed, these were the figures which fascinated Ghiberti on sarcophagi: dancers, nude youths and running girls, goddesses with windblown garments, men carrying loads, figures writhing in sorrow or exuberant with bacchantic joy.

Quick movements, agile, elastic bodies, slim proportions, strong passionate gestures, fluttering and billowing draperies then were at the basis of Ghiberti's image of antiquity when he designed the Gates of Paradise. No doubt this image was closely linked to the pictorial aspects of sculpture which, in his late years, grew ever stronger in Ghiberti's work. Relief sculpture in his eyes, just as in Alberti's, approximated painting, and the Roman sarcophagi on which he concentrated, with their many lively figures, narrative presentation and deep undercutting, must have suggested to him paintings in three dimensions. For this very reason his image of antiquity was selective, based by and large on sarcophagi owning these pictorial qualities.

Within this group, however, the range of monuments and motifs drawn upon is astonishingly wide. To Ghiberti, in these years, the art of antiquity signified a style with specific features, not a grab bag from which to pull indiscriminately an interesting head here, an intriguing movement or an excited group there. Selective, homogeneous and consistent as it is, Ghiberti's image of antiquity was total, complete and expandable. It thus allowed for free variations on antique themes and inventions *all'antica*, while, conversely, it precluded mere copies.

Ghiberti's discovery of a new image of antiquity after the mid-twenties coincided with his creation of a new concept of beauty which reached its peak in his late years. Beauty and antiquity mutually determined each other. For in Ghiberti's eyes beauty was synonymous with his image of ancient art, and in evolving this image, he re-created ancient models according to his own taste. His figures stand and move with greater elegance and fluidity, they are livelier and more exciting, and their bodies are more elastic than any on a Roman sarcophagus. Their proportions are slimmer: no figure known to Ghiberti from a sarcophagus was ever as manneristically elongated as the Eve in the Expulsion from Paradise. The surfaces of nudes ripple in smaller planes, as witness the body of Adam in the creation scene (Pl. 83a) as compared to that of his prototype Adonis (App. A 24; Fig. 122). Fluttering drapery and its textural contrast to the nude body likewise attracted Ghiberti: the body of the falling Abel breaks through a scant and ragged tunic; a veil billows playfully over a woman's head, while her model, Medea, walks bareheaded. Gestures are reinterpreted in terms of more passionate emotions. A satyr pulling a faun's tail is turned into a terrorized Adam or an equally terrorized warrior. A *moira* becomes a wrathful prophet, livelier and more monumental than either the Roman model or its more immediate derivative, Noah's peaceful son.

Clearly this image of antiquity reflected for Ghiberti the image of his own art. The aim of his art, as he saw it late in life, was to extract from nature an idealized image of reality, and it was to this concept that the art of antiquity was linked. Antiquity, in Ghiberti's view, was not nature itself; but it contained the principles and rules governing nature, its *lineamenti*. Its importance for Ghiberti lay in its being a cleansed and improved edition of nature.

CHAPTER XIX

HUMANISTS AND ARTISTS

THE visual image of antiquity, such as we hold at present, goes back to Winckelmann and Jefferson, to the Adam brothers and David, and beyond them to Bellori and Poussin, to the Carracci, Raphael, and Vasari. Through the continuous interplay of creative art and creative scholarship, a picture of antiquity has been formed, multiform but consistent. By and large this interplay came to an end around the middle of the nineteenth century. But the mutual impregnation of art and scholarship, extending over four centuries, has remained potent to this day. Indeed, it has led us to forget that when antiquity was rediscovered in the fourteenth and fifteenth centuries in Italy, such cross-fertilization did not necessarily exist. Throughout the fourteenth century, and far into the fifteenth, there stood on one side the literary set, the learned—poets, philosophers, historians, antiquarians—and on the other, in a separate camp, those whom contemporaries called the experts and connoisseurs. Though these latter may have been erudite, they were not so of necessity. While undoubtedly some were to be found among the humanists, the majority, it would seem, were either collectors or practitioners of art.

Petrarch's concept of antiquity established the approach of the learned.[1] Needless to say, his outlook was permeated with medieval thought: Rome and antiquity were synonymous; Rome and her monuments symbolized all that was worth remembering of antiquity, and memorable to Petrarch was that only which had living significance for the present. History to him, as to the entire Middle Ages, was part of politics, and the past, therefore, represented a political reality. Consequently, like many a medieval visitor in Rome, he expected to find the city a tangible symbol of the entire past in which Christian and pagan elements were inextricably interwoven.[2] But once arrived in Rome, the Christian memories, though essential to his philosophy, did not greatly affect his image of the city. It was the pre-Christian past (rather this than the pagan) that prevailed in his mind. From his reading of Virgil, Horace, and Ovid, he had conjured up a preordained idea of Rome and her past; hence in his wanderings around the city, he saw the dream image, not the reality.[3] Instead of monuments, he saw sites, meaningful to him only insofar as they were scenes of historic or pseudohistoric events: the "palace" of Evander, the youth of Romulus and Remus, the rape of the Sabines, the trysts of Numa and Egeria, the triumph of Pompey, the rule of Trajan. Sometimes these sites were marked by monuments: the *Lupa*, the Grotto of Egeria, the Column of Trajan. But to Petrarch it mattered little whether or not a site was commemorated by a monument, or merely haunted by memories. For his approach was entirely literary, almost emphatically nonvisual. Monuments and sites alike stimulated his imagination, evoked a picture of Rome as a blend of political, historical, archeological and poetical factors, be it the Rome of the legendary heroes or, as in his late years, of the

[1] Muentz-Essling, bibl. 354, p. 32, note 2, and pp. 37, 38, note 1; De Rossi, bibl. 125.
[2] Petrarch, bibl. 395, I, p. 95 (Ep. fam. II, 9). [3] Petrarch, bibl. 395, II, pp. 56ff (Ep. fam. VI, 2).

early emperors.[4] He visualized antiquity not only without much stress on the magic-legendary elements that had prevailed in the *Mirabilia* and still in Dante,[5] but with nearly exclusive emphasis—it need hardly be said of the days of Cola di Rienzo—on its political and moral character. Delving into antiquity was not a pastime for Petrarch; it was a serious and essential occupation. Rome was to become again the *caput mundi*; she was to be revived, and this rebirth would succeed through a revival of her ancient virtues. They had made possible her great deeds of the past, and by implication they promised a comparable future. Hence her monuments were mementos not so much of the past, and certainly not of the past alone, as of an exemplary and timeless way of life, of *virtus*, manliness with all its historical and pragmatic connotations. At the same time these monuments held out a promise of future greatness and were, besides, re-minders of the passing of all earthly grandeur—a concept medieval in origin. Within this same intellectual framework, a collection of antiques was meant to incite the owner "to follow the ways of the ancients," which leads one to assume that such was the aim underlying Petrarch's own sporadic attempts to collect Roman coins and the like.[6]

Thus in the circle of Petrarch and his learned humanist followers, the determining factors in their image of antiquity were moral and political by implication, literary by character, and always comprised more a mood than a clear concept. Monuments, whether inscriptions or figurative, were, as their name implies, mementos: Cola di Rienzo, brooding all day over marble fragments scattered through Rome, read "li antichi pataffii; tutte scritture antiche volgarizzava, queste fiure di marmo justamente interpretava."[7] Rarely does this approach find clearer expression than in a letter writ-ten from Rome by Giovanni Dondi, Petrarch's learned medical friend from Padua.[8] As he saw them in 1375, Roman monuments and their inscriptions were mementos of Roman virtue and of great men: "the statues . . . of bronze or marble preserved to this day and the many scattered fragments of broken sculptures, the grandiose triumphal arches and the columns that show sculptured into them the histories of great deeds and many other similar ones erected publicly in honor of great men, because they estab-lished peace and saved the country from threatening danger or enlarged the empire by subjugating the barbarians; as I remember reading about, not without some remark-able excitement, wishing you also might see them [the monuments] some day, similarly strolling and stopping a little somewhere and perhaps saying to yourself: These are indeed the testimonies (*argumenta*) of great men."[9] The inscription on the Arch of Septimius Severus had moral and political meaning for Dondi, just as the writings of the ancients seemed to him testimony of their superiority in "justice, fortitude, tem-perance and prudence."[10] It would seem the realm of Roman *virtù* was in all innocence being invaded by the quadrivium of medieval virtues.

[4] Mommsen, bibl. 343; Bailey, bibl. 33. [5] De Rossi, bibl. 125.
[6] Petrarch, bibl. 395, III, pp. 289, 315, 337 (Ep. fam. XVIII, 8; XIX, 3; XIX, 12). See also Muentz-Essling, bibl. 354, p. 37, notes 2ff.
[7] De Rossi, bibl. 125.
[8] Morelli, bibl. 346, II, pp. 285ff, with excerpts from Dondi's letters (Venice, *Marc. lat.*, Cl. XIV, 223, ff.47-68v).
[9] Letter to Fra Guglielmo da Cremona, *op.cit.*, fol. 56ff; Morelli, bibl. 346, pp. 303f.
[10] Letter to Paganino da Sala; Morelli, bibl. 346, p. 302.

This nonvisual, evocative approach to antiquity among the learned has dominated nearly all humanist thought down to recent times. To this day the literary outlook survives among historians, philologists, and educated sightseers. Of all Coluccio Salutati's letters, none shows any concern over a work of art except for an occasional reference to subject matter. This is only natural, since literary men will follow literary lines, and humanism has reached us largely through its literature. The prevalence of the literary point of view has thus obliterated the fact that once a different, indeed, a diametrically opposed approach to antiquity existed among men who did not live by their pens, men who were artists for the most part. Their attitude is to be gleaned from occasional remarks, and has been made crystal clear in a passage from the same letter by Giovanni Dondi. The excerpt has been quoted several times,[11] but is worth repeating: the learned doctor deplores the small number preserved of "works by those geniuses of old," and tells how eagerly these relics were hunted and highly paid for "by those who have a feeling for the matter" (*ab iis qui in ea re sentiunt*); he remarks on how these remnants demonstrate the greater natural talent and the superior skill of the ancients as compared to those of today: "I am referring to the ancient buildings and statues and reliefs and other similar things. If our modern artists look at them carefully they are stunned (*obstupescunt*). I myself used to know a marble sculptor—a craftsman in this field, famous among those whom Italy then had, particularly in working figures. More than once I heard him discuss (*movere*) the statues and sculptures he had seen in Rome with such admiration and veneration that in his discourse he seemed to be all beyond himself, so full of wonder was the subject. It was said that once he came along with five friends [to a site] where some such images were to be seen; he looked and was so arrested by the wonder of the craftsmanship (*artificii*) that he forgot his company and stood there until his friends had gone on half a mile or more. He talked a great deal about the excellence (*bonitas*) of these figures and praised their makers and acclaimed their genius beyond all measure. He used to conclude—I quote his own words—that if such sculptures had only the spark of life, they would be better than nature; as if he wanted to say that by the genius of such great artists nature had not just been imitated but indeed excelled."

Dondi's story is illuminating from more than one point of view. We have no idea which sculptor he had in mind. It seems he had not known him in Rome and whether he knew him in Padua or elsewhere remains an open question. Whether or not the sculptor was Dondi's contemporary is not clear; but his statement that he was "the most famous artist among those whom Italy *then* had," gives the impression that he had died by 1375 when the letter was written. He may have been older than Dondi and active in the first half of the century. Whatever his name, age and origin, however, to Dondi the scholar, he was obviously an expert, and one who loved art. Nor was he unique, for he belonged to a wider circle of men with "a feeling for the matter" among whom were some willing to pay good money for works of ancient art—collectors who did not seek such objects solely for their literary value. In contrast to them, Dondi, despite all his

[11] Letter to Fra Guglielmo da Cremona, *op.cit.*, ff.56-59. It is quoted in Muentz-Essling, bibl. 354, p. 45, note 3 and translated into German, in Schlosser, bibl. 477, pp. 148f.

learning, did not feel altogether at home with ancient art. He was purblind to the very qualities which others looked for. But he by no means felt inferior to these art lovers. He simply regarded them as artists and collectors who admired beyond comprehension achievements of antiquity to which his own criteria did not apply. Dondi felt himself at home when the hermeneutics of an ancient relief or statue were in question, especially when they were linked to an inscription. But obviously the sculptor and the collectors to whom he alludes did not look upon these works as illustrative of historic events, or as evocative of political dreams or of an elegiac mood. Their attitude was more direct and naïve. Just because they had not read their Virgil and Livy, or not in the way the humanists read them, they were free to discover other aspects of Roman art. Clearly it was the visual aspect that attracted them: for Dondi's sculptor staked his judgment on criteria of craftsmanship (*artificium*), excellence (*bonitas*) and lifelikeness—"if they had but the spark of life, they would be better than nature."

That artists and collectors should adopt a visual approach to antiquity was nothing new to the fourteenth century. New was the incomprehension with which the learned looked upon those queer ducks who admired fragments of the ancient world for reasons other than their literary overtones. But even this incomprehension was not quite new. As far back as the twelfth century, Henry of Winchester had exposed himself to the ridicule of serious scholars by scouring Rome for ancient statues,[12] "his beard unkempt." The collecting of antiques, along with other art objects, sporadically continued all through the Middle Ages. The purchase list of a collector from Treviso, Oliviero Forzetta, is well known. It was compiled in 1335, and among other works of art, antique as well as contemporary, there is mentioned for possible acquisition the Roman relief with Four Putti, which was then in S. Vitale in Ravenna and later in S. Maria de'Miracoli in Venice.[13] Aesthetic enjoyment, pride in owning the wondrous and precious, and admiration for ancient as well as modern art, were likewise inherent in the collecting activities of Charles V of France and his royal brothers. Mentioned in their inventories, among hundreds of medieval *objets d'art*, are a few antique cameos and other gems. Such collecting reflects a naïve and natural approach to the art of antiquity, one that was apparently widespread in the High Middle Ages. Against this background must be viewed the classical renascence movements which pervaded France, Germany, and Italy in the eleventh, twelfth, and thirteenth centuries:[14] the schools of Provence and Campania; Villard de Honnecourt; the Peter and Paul Master and the Visitation Master of Rheims; the Master of the Bamberg Visitation; Capuan and other South Italian workshops; Niccolo Pisano. These schools and masters readily transposed antique models into their own language. The art of antiquity was not alien to them or to their patrons. They saw no chasm between their own products and those of the faraway past. Their approach to antiquity was naïvely visual. Occasionally a scholar would look at the art of antiquity with the same naïve pleasure: for instance, early in the thirteenth century Magister Gregorius, a British jurist, visiting in Rome,

[12] John of Salisbury, bibl. 233, pp. 6off.
[13] Schlosser, bibl. 473, p. 104, note 1 and, the more complete version, Muentz, bibl. 352, pp. 47f.
[14] Panofsky, bibl. 387.

felt constrained to return three times, each time walking two miles, to see a statue of Venus on the Quirinal, "executed with such marvelous and inexplicable skill that it bore its nudity like one blushing, the forms suffused with reddish color . . . on account of its wonderful beauty and some magical power. . . ."[15] Ristoro, an Italian scholar at the end of the thirteenth century praised fragments of Aretine vases for their figures "so excellent and natural [that] . . . sculptors, draftsmen, and other connoisseurs (*cognoscenti*) go almost crazy with pleasure, [and] . . . preserve them like sacred relics and are stunned to see that human nature could rise so high in craftsmanship."[16] One hundred years later this terminology was used almost verbatim by Dondi as he quoted the unknown sculptor.

During the course of the fourteenth century, this naïve, simple appreciation came to an end with the recognition of a fundamental difference between the late medieval present and the ancient past.[17] In the courtly *ambiente* of France and in North Italy this recognition led to picturing literary works of antiquity in contemporary settings, to transposing Greek and Roman history and legends into an atmosphere of chivalresque romance. Certainly it was not by chance that the illustrated manuscripts from the circle of Petrarch conformed to the general tendency which, from the middle of the fourteenth century, especially north of the Alps, was to present antique themes with chivalric overtones. Personages and themes from antiquity were transcribed into contemporary costume, with just a detail *all'antica* added, a laurel wreath or the like. Simone Martini's illustrations for Petrarch's Virgil strikingly illuminate the approach: much like the French *grand-seigneurs* of his time, Petrarch, Italy's most learned antiquarian and most sensitive poet, approached his beloved world of antiquity as an experience of exclusively political and moral meaning; his visual image of it was fettered to traditional medieval forms,[18] and both he and his circle disregarded the visual aspects of ancient art. Naïve delight felt by artists and collectors was considered suspect, perhaps slightly ridiculous. Scholars and artists parted ways. The artists, in Tuscany at any rate, continued on their way undisturbed. At least, during the first half of the fourteenth century they absorbed and admired antique forms, at times assimilating the vocabulary into their own work. Andrea Pisano's reliefs of the *artes* on the Campanile include Hercules as the representative of war, an antiquish ploughman as the symbol of agriculture and an antiquish horseman as the personification of horsemanship. Ambrogio Lorenzetti's *Pax* from the Palazzo Pubblico and the reclining *Eve*, from the Lorenzetti workshop (Fig. 86), both *all'antica*, are proof of the impact of antique vocabulary on the art of Siena. Dondi's sculptor may well have been the contemporary of Pisano and Lorenzetti.

After the middle of the fourteenth century, however, antiquity no longer found an echo in either Florence or Siena. Circumstances did not favor the use of a vocabulary *all'antica* in public art. In the general mood of penitence and asceticism that followed

[15] Rushforth, bibl. 456, pp. 49f.
[16] Ristoro d'Arezzo, bibl. 445, ɪɪ, pp. 201ff, quoted in German translation also by Schlosser, bibl. 477, pp. 143f.
[17] Adhémar, bibl. 2, pp. 270ff; Panofsky-Saxl, bibl. 388, pp. 255ff; Panofsky, bibl. 387.
[18] Muentz-Essling, bibl. 354, p. 37; Chiovenda, bibl. 97, pp. 13f.

the Black Death,[19] a Hercules or a Venus, even disguised as Eve, as a Christian Virtue, or as one of the *artes,* was none too acceptable. The destruction by the Sienese in 1357 of the statue of Venus for which Ambrogio Lorenzetti had still recorded his appreciation in a drawing, reflects the change of atmosphere. In any event, the demand for an art permeated with antique elements was small, almost nonexistent, among those who were in a position to commission extensive and expensive works. If some individual artists continued to admire ancient art, their admiration remained entirely passive, finding no expression in their works.

But in the last years of the Trecento a new and positive approach to the art of antiquity began to appear, both in northern Italy and in Florence. In Padua, from about 1390 on, the medals of the house of Carrara reproduced Roman imperial coins.[20] As might be expected in this milieu which, more than any other, lay beneath the spell of Petrarch and his work, antiquity was viewed in an evocative and erudite humanist spirit. In Florence the jambs of the Porta della Mandorla and, a few years later, both Brunelleschi's and Ghiberti's reliefs for the competition of 1401, reflect a fresh vogue for the antique. In fact, under the leadership of Petrarch's disciple, Coluccio Salutati, Florence, shortly before the turn of the century, was fast becoming the center of humanist endeavor south of the Apennines. It is doubtful, to say the least, if all the leaders and scholars of the new generation, from Niccolo Niccoli to Palla Strozzi, appreciated or were indeed interested in the visual interpretation of antiquity manifested in the work of the Hercules Master and young Ghiberti. What scholars would obviously welcome was antique subject matter, a Hercules or an Abundantia, for its power to evoke the antique world and all it meant to a learned humanist. This renewed interest in antiquity was bound to reactivate among artists the fascination which ancient sculpture had held for their predecessors of the first half of the fourteenth century. Its life-like quality, "better than nature," its relaxed movements and tactile values, while perhaps not attracting the run-of-the-mill sculptors, would and did attract the best, such as the Hercules Master from the workshop of the Porta della Mandorla and young Ghiberti.

Yet, the fresh visual attraction which antique art had for this generation was not limited to the artists' workshops. It would appear that by the end of the century, at least some humanists no longer felt the sense of superiority towards the visual aspects of art, either antique or reborn, that Giovanni Dondi had felt. They must have enjoyed the antique motifs hidden under the medieval overlay of Brunelleschi's design, and they could not have missed the tactile values of Ghiberti's Isaac, even though the underlying antique prototype was disguised as a Biblical figure. The interest of learned humanists in subject matter, and that of artists spellbound by the aesthetic qualities of antique art, while not coincident, were slowly approaching one another. One wonders if it were not by more than mere chance that Palla di Nofri Strozzi, the eager and financially powerful champion of humanism, was assigned to the three-man committee appointed by the *Calimala* to supervise work on Ghiberti's first door (Doc. 26).

The gradual rapprochement between artists and humanists continued during the

[19] Meiss, bibl. 317 *passim.* [20] Schlosser, bibl. 473, pp 86ff.

next decades, reaching a peak of coincidence in the twenties and thirties. A number of contemporary phenomena concurred to make it apparent: the increasing desire on the part of humanists to build up collections of antiques; the new spirit in which these collections were assembled; the new approach of artists to the world of antiquity and to both its artistic and scholarly interpretation; and—a revolutionary phenomenon—the exchange of ideas between artists and humanists on ancient and modern art. Art became permeated with the concepts and vocabulary of humanism; it became a part of humanist endeavor. Concomitantly, the humanists turned art into a problem of their own.

Throughout the fourteenth century, if not earlier, the *grand-seigneurs*, from Oliviero Forzetta to Jean, Duc de Berry, had included in their collections antique gems, coins, bronzes, and occasional marble sculptures.[21] The collections of the Medici in the first half of the fifteenth century were hardly different in character. A few antique pieces were mixed in with hundreds of other precious objects. Lorenzo Medici the Elder upon his death in 1440 left "precious clothes and plate, statues (*signa*), paintings, wrought vessels, pearls and books"—a collection, in other words, in which antiques played a minor part, if any.[22] Neither was Cosimo's collection focused on antiques, despite the general assumption to the contrary. When Ciriaco d'Ancona visited it in 1433, he saw only precious table plate and no antiques whatsoever.[23] Timoteo Maffei, writing before 1450, vaguely mentions, together with "egregious paintings," some marble statues as being in Cosimo's collection.[24] The cornelian representing the Flaying of Marsyas, which Ghiberti mounted around 1430,[25] may well have been a unique item at the time. The large Medici collection of antiques, gems, coins, and medals seems to have been accumulated by Cosimo's son, Piero, in the fifties and sixties of the fifteenth century. His first inventory, dated 1456, lists nineteen cameos and hundreds of ancient coins. By 1464, when a second inventory was drawn up, the number of cameos had increased to twenty-nine.[26] He may have inherited the added ten from Cosimo's

[21] A history of collecting in the fifteenth century remains to be written, despite the splendid work Muentz (bibl. 351 and 352) and Schlosser (bibl. 473 and 479) have done. The material is scattered through inventories of collections and through letters of humanists as they were published two hundred years ago by the indefatigable Mehus. But despite his efforts and his meticulous precision, the epistolarium of Traversari, bibl. 526, is probably still incomplete (Bertalot, bibl. 49; Mercati, bibl. 321). Poggio's letters have been edited only in part in the (extremely rare) edition of Tonelli (bibl. 418). Niccolo Niccoli's epistolarium seems to be lost. Among inventories the catalogue of the collection of antiques of Pietro Barbo, that is Pope Paul II, has been published *in extenso* (bibl. 338), those of the Medici collections incompletely (Muentz, bibl. 351). Hence, any attempt to give an even partially complete survey of Florentine collections and collectors in the first half of the Quattrocento is impossible. Nor can any interpretation of the spirit in which these collections were built up be more than at best tentative.

[22] Antonio Pavino, as quoted by Mehus, in Traversari, bibl. 526, I, pp. xviiif.

[23] Ciriaco d'Ancona, as quoted by Muentz, bibl. 351, pp. 3f.

[24] Timoteo Maffei, bibl. 286, p. 155 limits himself to general terms: ". . . videritque . . . marmoreas statuas picturasque egregias. . . ." Mr. Ernst Gombrich has been good enough to inform me that the account of the Medici collection of antiques as given by Alberto Avogadrio from Vercelli (bibl. 27, pp. 147f) must be discounted since Avogadrio probably wrote from hearsay.

[25] Ghiberti-Schlosser, bibl. 178, I, p. 47. [26] Muentz, bibl. 351, pp. 11ff, 38f.

collection developed over the last twenty-five years of the old gentleman's life. Cosimo, in turn, may have acquired them in 1437 from the estate of Niccolo Niccoli.

Indeed, prior to 1450, the scholars, rather than the *grand-seigneurs*, appear to have concentrated on collecting antiques. What is more important, they did so in a new spirit. Niccolo Niccoli was foremost among them. True, as scion of an old family and a gentleman through and through,[27] he had a good deal of the *grand-seigneur* about him, and like them, he collected medieval paintings as well.[28] But by and large his emphasis was on antiques. Friends and agents combed Italy and the Near East seeking Greek and Roman relics to send him.[29] He himself purchased whatever he could, sometimes paying up to the limits of his financial ability,[30] at other times making his buys dirt cheap. His best *trouvaille* was the chalcedony with the Rape of the Palladium which he bought right off the neck of a child playing in the street.[31] In his house he assembled innumerable coins dating "from the oldest times," statues (*signa*), portraits of the ancients (*veterum imagines*), "many ancient bronze figures, many marble heads," statues, ancient vessels and crystal cups, inscriptions and reliefs (*sculture*).[32] No doubt Niccolo's image of antiquity, like Petrarch's, was largely determined by his profound knowledge of Greek and Latin literature. His collection of antiques, much as he rejoiced in it, was mainly for the purpose of illustrating and evoking past history. He was even occasionally chided for using his numismatic collection as reliable philological material.[33] Still, his approach did differ from that of previous generations. For one thing, Niccolo's collection was enormous in comparison to the few paltry coins and potsherds which Petrarch had owned; second he lived amid his antique objects as everyday surroundings; he regarded them not only as objects of study, but used the drinking cups, table plate and so forth, as implements of his household. They were a part of his normal existence, the tools of his single purpose in life, to relive antiquity and thus to revive it. And while his approach was decidedly that of a learned man, he liked these works of art beautiful as well—and this was the third new phenomenon. This attitude is reflected clearly in his correspondence. Traversari, in his letters to Niccolo, cannot limit himself to philological and historical statements. He feels impelled to include aesthetic evaluations: Ciriaco d'Ancona, he says, owns "a portrait in onyx of Scipio the Younger, of supreme elegance; never had I seen a more beautiful one."[34] Small wonder that Niccolo was considered an expert on art by his contemporaries and as one who had revived not only the ancient writers but "painting, sculpture and lettering[35] and other noble arts," including book illumination.[36] He advised not only

[27] Bisticci, bibl. 54, p. 470.
[28] Poggio's funeral oration for Niccoli as quoted in excerpts by Mehus, in Traversari, bibl. 526, I, p. li.
[29] Traversari, bibl. 526, II, cols. 393f, 417 (Lib. VIII, epp. 35, 48).
[30] Gianozzo Manetti, as quoted by Mehus, in Traversari, bibl. 526, I, p. li.
[31] Bisticci, bibl. 54, pp. 476f.
[32] Poggio, as quoted by Mehus, in Traversari, bibl. 526, *loc.cit.*; Bisticci, bibl. 54, pp. 476, 480; Traversari, bibl. 526, II, cols. 393f (Lib. VIII, ep. 35).
[33] Letter of Guarino Veronese to Biagio Guasconi, dated 1413 (bibl. 197, I, pp. 33ff, esp. p. 38).
[34] Traversari, bibl. 526, II, cols. 411f (Lib. VIII, ep. 45).
[35] This is the meaning of the term *veterum helementorum forma*, as witness Alberti's corresponding usage in *Della Pittura*, bibl. 8, p. 149.
[36] Fazio, bibl. 156, p. 11.

scholars but artists as well "knowing much about painting, sculpture, and architecture and giving them great support in their profession: Pippo di Ser Brunellesco, Donatello, Luca della Robbia, Lorenzo di Bartoluccio—and with all of them he was on the most friendly terms."[37]

What remains unclear is Niccolo's exact relation to these artists. We know of his personality and behavior. We picture him as "dressed always in rose-colored stuffs . . . trailing on the ground" and as having meticulous table manners.[38] He was no doubt very agreeable. But he was perhaps a bit awe-inspiring. Consequently, one would suspect that his attitude toward artists was slightly patronizing. Great scholar and gentleman that he was, he must have been only too happy to give advice from his enormous store of knowledge to artists who sought it; but he would have had to be the one to give, and they the ones to receive.

Nevertheless, Niccolo approached ancient art and contemporary artists with a new spirit. Although artists belonged to a different social category from his own, he did not look down on them as did Aurispa when speaking of "that sculptor," Ghiberti,[39] or as did Leonardo Bruni. Bruni, in the preamble to his program for the Gates of Paradise, has no doubts whatever that not only should it be he, the scholar, who advises the artist, he who chooses the events worthy of memory; but also he who through his personal supervision will make sure that they will also "please the eye by the variety of their design" (Doc. 52). The scholar should not only lay down the program, he should also decide about the propriety and beauty of design. To Bruni the artist was fundamentally the *vilis mechanicus*, a mere practitioner, and, accordingly, he attempted to appropriate for himself nearly all the functions which the commissioning bodies of Florence usually ascribed to three advisory committees, composed of scholars, artists, and "men with common sense."[40] Remarks reflecting a similar attitude occur in at least one of Bruni's letters: artists, he says, neither need to be possessed of theoretical knowledge (*scientia*), nor steeped in the natural sciences (*materiae rerum cognitio*).[41] It is doubtful if he ever collected antiques. The "little stone with a Narcissus" which he mentions in a letter to Niccolo Niccoli was intended for the latter's collection, and one wonders if it is by chance that the phrase, "you who are so keen on that kind of thing," should sound a bit critical of Niccolo's collecting mania.[42] In short, one suspects Bruni of being as purblind as had been Giovanni Dondi two generations earlier.

Poggio Bracciolino went much further than Niccolo Niccoli in his approach to artists and their works a few years later.[43] Niccolo's junior by twenty years, and—a point of

[37] Bisticci, bibl. 54, pp. 478f. [38] *ibid.*, p. 480.
[39] See below, p. 312. [40] Poggi, bibl. 413, doc. 905.
[41] Bruni, bibl. 78, ii, pp. 134ff, esp. p. 143 (Lib. ix, ep. 2).
[42] "Pollicitus fuit mihi Romanus quidam civis lapillum cum Narcisso in aqua sese vidente, quem averat Ostiae dum foderetur inventum. Hunc ego laeto animo exspectabam ut tibi qui harum rerum studiosus es gratificarer. Statueram enim illum ad te mettere quam primum essem assecutus. Verum mihi iste qui promiserat . . . fidem fregit . . ." (H. Baron, bibl. 38, pp. 105ff, with the date March 1407). The letter is missing from Mehus' edition of Bruni's letters (bibl. 78); but he quotes the above passage with slight variations in his introduction to Traversari, bibl. 526, i, p. liii.
[43] The passages referring to Poggio's collecting activities have been compiled from his letters by Mehus (Traversari, bibl. 526, i, pp. lii ff) and by Walser, bibl. 544, pp. 147ff.

some relevance—not a gentleman by birth, Poggio was a *literateur*. When in 1429, in the company of Antonio Loschi, he looked at the ruins of Rome from the foot of the *rupe Tarpeia*, he was deeply imbued with the nostalgic, literary, moralizing mood of Petrarch and his circle. Poggio's interpretation of Rome, like theirs, was fundamentally literary: the importance of antique remnants lay in their inscriptions; the admonitory flavor of these inscriptions he stressed time and again; and his prevailing mood was one of sorrow over the decay of the ancient buildings listed in his treatise on the changes of fortune, *De Varietate Fortunae*: "few . . . are left and they are half destroyed and decayed." Still, Poggio represented also a new kind of humanist. His list of Roman ruins was not only a good deal longer than Petrarch's, it also excluded all Christian sites; most important, it was based on visual impressions, on observations of monuments, not on mere sites. His motives for collecting were different from Niccolo Niccoli's, and his choice of objects new. He focused exclusively on works of ancient art—probably he could not afford medieval *objets d'art*; he copied inscriptions and epitaphs but did not collect them. What he owned, however, he loved. Overtones of pride, often clad in bantering self-persiflage, permeate his letters to Niccolo whenever he mentions his treasures: "I have gone a bit crazy and do you want to know how. I have had my bedroom furnished with marble heads; one is elegant and intact, the others have had their noses broken off, but still they will delight a good artist. . . ."[44] "I have picked up (*expiscatus sum*) the marble bust of a woman, the breast well preserved—anyway, I like it. . . ."[45] "[Francesco di Pistoia] . . . has written me from Chios that he holds for me three marble heads of Juno, Minerva, and Bacchus, by Polycletus and Praxiteles. As for the names of the sculptors I would not be sure: you know those little Greeks talk a lot and may have made up those names to raise the ante. I hope I am wrong. . . . The head of Minerva wears a marble wreath; that of Bacchus has two little horns. When they arrive I shall place them in my little study (*gymnasiolum*). Minerva will not be out of place. I shall put her among my books. Bacchus will fit even better. Also for Juno we shall find a place. She was once married to a philanderer; now she will be a concubine. I have here also [he writes from Rome] something I shall send home. Donatello has seen it and praised it greatly."[46] To more distant acquaintances he wrote more seriously about what he saw in ancient works of art and why he wanted to own them: "I am moved by the genius of the artist when I see how the very forces of nature are represented in marble. . . . Many suffer from other diseases; but mine is that I admire too much perhaps and more than a learned man should, those marbles carved by great artists. True, nature herself must be greater than those who work like her; but I am forced to admire the art of him who, in mute matter, expresses [her] as living so that often nothing but the spirit seems to be lacking."[47] Or else he says, "I am greatly delighted by sculptures and bronzes (*caelaturis*) made in memory of the excellent men of old. I am forced to admire their genius and art since they render a mute and lifeless thing as if it breathed and spoke; often indeed they represent even the emotions of the

[44] Poggio, bibl. 418, I, pp. 213ff (Lib. III, ep. 15). [45] *ibid.* p. 284 (Lib. III, ep. 37).

[46] Poggio, bibl. 418, I, pp. 322ff (Lib. IV, ep. 12).

[47] Poggio, bibl. 418, I, pp. 330ff (Lib. IV, ep. 15). In the last sentence I have emended the word "*ipsum*" to "*ipsam*."

soul so that a thing which can feel neither pain nor joy looks to you as if it laughed or mourned."[48]

All this points to one simple fact: Poggio loved ancient art. He did so with a bad conscience. He tried to rationalize his feelings to himself and his correspondents in the traditional terms of an aesthetic inherited from the Trecento. He felt a learned man should not dote on these playthings quite so much, and he poked fun at his passion for a pastime which was perhaps not altogether shared by Niccolo; he jested about the broken noses of his marble heads, about the way he was going to distribute the gods over his study so they would fit in nicely; he possibly did not know the head of a faun from one of Bacchus; nor did he care—at least he pretended not to—who made the sculptures in his collection, whether Polycletus or Praxiteles; but then he retorts: "anyway, I like them"; "still they will delight a good artist"; or he insists that Donatello has seen it and says it's good. Doubtless Poggio was on the defensive against Niccoli and possibly others. He thought himself just as good a scholar as they, but he sought in ancient art not only its subject matter but its beauty.[49] To justify his stand he appeals to his own taste and to the judgment of contemporary artists, among them Donatello. Scholar though he was, he combined for the first time scholarly knowledge, not only with a highly developed taste, as did also Niccolo Niccoli, but also with a genuine love of ancient art and a deep respect for the artists of his time. The time had ended when Giovanni Dondi could only shake his learned head in amazement over the enthusiasm of an unlearned sculptor. Poggio called on Donatello to hear his judgment on the quality of a work of ancient art.

Humanist scholars and artists in the twenties and thirties groped for a new mutual understanding. An exchange of ideas began to take place. The group of artists and scholars involved was small—among the scholars, certainly Poggio and to some degree Niccolo Niccoli; among the artists, as witness Vespasiano da Bisticci, Brunelleschi, Donatello, Ghiberti, Luca della Robbia. It was obviously not by chance that in 1436 Alberti named these same four artists together with the late Masaccio as the leaders of the new style.[50] In the eyes of their learned contemporaries they represented a new type of artist who had grown beyond the stature of the traditional craftsman. They knew and cared about art by inclination and training. For years they had been enthusiastic about the art of antiquity, vaguely and emotionally, with intuitive understanding, but without what the humanists would have considered precise knowledge. They had attempted along scientific lines to solve problems of space representation, proportion, balance, and a credible rendering of reality. They had begun to build a vocabulary *all'antica* in architecture, sculpture and, to a lesser degree, in painting. Now the scholars would guide them toward an ever greater number of antique monuments and explain precisely matters large and small: the subject matter of these monuments, their meaning, the costume of antiquity, the new antique lettering, *veterum helementorum*

[48] Poggio, bibl. 418, I, pp. 374ff (Lib. IV, ep. 21).

[49] I fail to see how Gutkind (bibl. 201), an understanding scholar, could characterize Poggio's attitude as "the learned sentimentality of a recording antiquarian."

[50] Bisticci, bibl. 54, p. 476; Alberti, bibl. 8, p. 47.

forma, the scientific basis of perspective, the importance of collecting and thus living in daily contact with works of ancient art. Thus enlightened by humanist scholars, the artists would be able to help create the new world for which every humanist longed. They would be the artists of humanism.

Ghiberti holds a key position in this area of rapprochement between humanists and artists. Yet it is important to realize that only during the last twenty years of his life did he join the circle of the select. Only in the Gates of Paradise did he evolve a homogeneous and consistent style *all'antica*. Only in the late thirties and forties did he apparently develop into a collector of antiques on a large scale. When in 1434 Ciriaco d'Ancona visited his house, it contained but a few old and new bronze and marble statues *(simulachra)*; at the time of Ghiberti's death in 1455, on the other hand, the collection was valued at the sizeable sum of 1,500 florins.[51] Only in the thirties did he turn to the problems of scientific perspective, and only late in life did he try his hand at the eminently humanist task of writing. The *Commentarii*, indeed are but one, though perhaps the most signal product, of Ghiberti's humanist endeavors.

[51] Ciriaco d'Ancona, as quoted by Muentz bibl. 351, p. 3. Baldinucci (bibl. 35, I, p. 355) still saw among the papers of Cristofano Berardi the original list of antiques Ghiberti owned at the time of his death.

In years of masterful research Schlosser (bibl. 479) has attempted to reconstruct the collection. Albertini (bibl. 13, p. 12) in 1510 was shown "excellent pieces by the hand of Polyclitus in the house of the Ghibertis and a carved marble vase which Lorenzo caused to be brought from Greece"; Vasari, in 1550, listed a bronze leg, life-size, male and female heads, some *torsi*, finally the *letto di Policleto*, apparently a bronze relief with an erotic scene (or possibly a funeral meal; Sirén, bibl. 498, pp. 109f). These pieces were sold by Ghiberti's grandson to Monsignor Giovanni Gaddi. From Gaddi's collection Schlosser has traced the *letto di Policleto* further to Prague, a satyr torso to the Uffizi. An eighteenth century commentator of Vasari mentions two *torsi* of Venus, one of the Medici type, a genius, a Narcissus and a Mercury. Yet, the fact that with increasing distance in time these reports become ever more specific, deprives them of much of their value. After all, a good number of the objects may have been acquired by his son, Vittorio, or by his grandson after Ghiberti's death. Others may have disappeared.

CHAPTER XX
GHIBERTI THE WRITER

IN THE *Commentarii* Ghiberti attempts no less than to establish his own position within the history and theory of the figurative arts.[1] The First Book is devoted to the art of ancient times, the Second to that of "modern times," together leading from the end of antiquity to Ghiberti's own life work; the Third Book was to discuss those auxiliary sciences which in Ghiberti's eyes were a necessary prerequisite for the training of a sculptor: optics, anatomy, the proportions of the human body. Possibly he also planned to deal at some length with the other disciplines listed at the end of the preface to the First Book—geometry, *teorica del disegno* (whatever the term meant to him), grammar, philosophy, medicine, astrology, history and arithmetic.

The work has survived in only one manuscript (Florence, Biblioteca Nazionale, II, I, 333, formerly Magl. Cl. XVII.33), and this, apparently is a very imperfect copy. The handwriting, evidently of the mid-fifteenth century is beautiful; but clearly the text is carelessly copied and more often than not, words and even entire lines have been dropped.[2] The First and the Second Book, in the extant copy, seem to be comparatively the best preserved. All the same, the Second Book at least appears to have been known to the Anonimo Magliabecchiano about 1520 in a better copy, with fewer gaps and misreadings than are contained in the one that has survived. The Third Book, in the extant copy, is clearly fragmentary. On its first folios the text is accompanied by a few diagrammatic illustrations. In the last forty folios of the manuscript space was prepared for illustrations, but the drawings were never executed. A lacuna, nearly two pages long, separates this section from the illustrated portions of the manuscript. Finally, the text breaks off at the end, in the middle of a sentence. Schlosser suggested

[1] Schlosser both in his *Prologomena* (bibl. 478) and in the edition of the *Commentarii* (bibl. 178) has brought out this basic character of Ghiberti's treatise. It is only natural that Schlosser tended to view Ghiberti as more of a humanist than he was and to interpret as great writing even weaker parts of the *Commentarii*. But this shortcoming, if shortcoming it is, weighs little as against the immense knowledge and the masterly analytical sense that underlie every line of his introduction and commentary. His edition remains unsurpassed.

In a splendid analysis of the *Commentarii*, Olschki (bibl. 371, pp. 88ff) has brought out the very split between Ghiberti's ambitions and his limitations as a theoretical writer. Perhaps he occasionally went somewhat far in castigating Ghiberti's "dilettantism." But even so, Olschki's chapter seems to me so far to give the best estimate in existence of Ghiberti's position in fifteenth century scientific literature.

The recent edition by Morisani (bibl. 179) reprints Ghiberti's text, as edited by Schlosser, unchanged, except for modernizing Ghiberti's spelling. But the introduction fails. To be sure, Morisani is right in stressing the dichotomous character of the *Commentarii* and the fact that Ghiberti's humanist leanings never tallied with his experience as a craftsman. But he forgets that a good artist should be seen even if he wants very much to be heard, and as a result he projects the dichotomous figure of the writer into the work of the artist Ghiberti, and thus arrives at what seems to me a distorted picture.

The older, mostly fragmentary editions of the *Commentarii* and the use of the manuscript in the sixteenth century have been discussed by Schlosser (bibl. 178, II, p. 8) and Morisani (bibl. 179, pp. xix f).

[2] Ghiberti-Schlosser, bibl. 178, II, pp. 7ff.

that Ghiberti died over the writing; but the more prosaic assumption is equally possible, that the copyist lost his way through a sheaf of notes he did not know how to handle.

Indeed, a minute analysis of the Third Book made nearly thirty years after the publication of Schlosser's edition has shown that what Schlosser termed the "Third Book" is by and large a hodgepodge of reading notes gathered from ancient and medieval writers.[3] Insofar as they regard the proportions of the human figure, they are excerpted from Vitruvius; where they refer to anatomy, from Averroës; where they concern optics, from Alhazen, Avicenna, Witelo, John Peckham, and Roger Bacon. Ghiberti seems to have arranged these notes in an orderly fashion for only the first section of the Third Book. This section also contains the beautiful insert of his own composition in which, based on his observations of works of ancient art, he demonstrates the effect of light on sculpture.[4] Further on, the excerpts from various authors follow one another in utter confusion: several times a passage from one writer breaks off in the middle of a page and continues some folios later. Thus it is legitimate to ask whether Ghiberti or the copyist was responsible for this tangle; whether these excerpts were made by Ghiberti himself or were compiled for him by some learned collaborator; and when exactly this last part, or for that matter the whole treatise, was prepared and composed.

Only this last question can be answered. The autobiographical portions at the end of the Second Book were completed in the winter of 1447-1448, as witness the comparison between the documents and Ghiberti's listing in the *Commentarii* of both the completed and the uncompleted portions of the Gates of Paradise.[5] At the same time, the First and Second Books give the impression of being a consecutive piece of writing. The beginning of the Second Book, for example, continues the concluding thought of the first: while the First Book terminates with an emphatic reference to the theoretical writings of the ancients, the Second Book starts with a passage deploring their loss.[6] Hence, the assumption seems to be justified that the two books were written more or less at one time in the years shortly before and in 1447. To be sure, it remains an open question how much time Ghiberti spent on the writing of these two books; but it is reasonable to allow for two or three years. After finishing the Second Book, he intended obviously to continue right away with the Third, as witness the concluding sentence of the Second

[3] ten Doesschate, bibl. 131. Since this excellent doctoral dissertation is perhaps not easily obtainable, it may be useful to sum up at least the author's list of sources and of the respective passages in Ghiberti's Third Commentary.
Vitruvius = Ghiberti-Schlosser, bibl. 178, I, pp. 55, 227-233.
Alhazen = *ibid.*, pp. 59-61, 84-86, 122f, 127-132, 136-169, 205.
Avicenna = *ibid.*, p. 221.
Averroës = *ibid.*, pp. 22-226.
Witelo = *ibid.*, pp. 56f.
John Peckham = *ibid.*, pp. 111-121, 123-126, 133-135.
Roger Bacon = *ibid.*, pp. 67-83, 87-98, 107-111, 169-186, 217-220.
From the same sources Ghiberti took also the names of authors he had never read.
Schlosser (bibl. 178, II, pp. 26ff) had given up in despair a first attempt at establishing the sources of the Third Book. Castiglioni (bibl. 90) prior to ten Doesschate had found in Alhazen the source for Ghiberti's optics.
[4] Ghiberti-Schlosser, bibl. 178, I, pp. 55-65. [5] *ibid.*, p. 50, and below, Doc. 44 and Dig. 263.
[6] Ghiberti-Schlosser, bibl. 178, I, pp. 31, 35.

Book: "The Second Commentary is finished, now we shall go on to the Third."[7] But since the beginning of that book never went beyond the stage of a first draft and the rest remained reading excerpts, it is likely that these parts were only put together, to the extent that they were, between 1448 and the time of Ghiberti's death in the winter of 1455.[8]

On the other hand, Ghiberti apparently started collecting notes for his work from the First through the Third Book, long before he began to write. As early as 1430 he tried to borrow from Aurispa the manuscript of a rare strategic writer, Athenaios and, later, used a passage from it as the opening paragraph of his First Commentary.[9] When he started excerpting the other sources, from Pliny to Averroës, Peckham, and Roger Bacon, remains a moot question, but the likelihood is that this preparatory stage may well have covered fifteen or twenty years.

Schlosser's masterly edition makes it unnecessary to recount at length the content of the *Commentarii* or to analyze it in detail. It is clear that the entire book was planned as an interlocking unit. The First Book on ancient art, establishes the image of a past which to Ghiberti was, at the time of writing, the unexcelled prototype in whose image he wanted to shape his own work. In the Second Book he attempts to clarify his position within the art of the immediate past from which he had sprung. At the same time both these historical books are interspersed with remarks on the theory of art and thus Ghiberti is led to lay down in the Third Book his views on art theory.

It is equally true, that the three books are of very different value. To be sure it is not quite fair to pass judgment on the Third Book, since its bulk has come down to us in wholly fragmentary condition and since its beginning, in the drafting stage, proceeds methodically and clearly from problem to problem, illustrated by examples from Ghiberti's experience. But one is justified in doubting that Ghiberti would have managed to fuse these notes for his Third Book into a truly independent and conclusive whole.

The First Book, dealing with the art of Greece and Rome, is in a somewhat different category. To be sure it resembles the Third in that it is largely compiled from reading notes, excerpted, for the greater part, from Vitruvius and Pliny. Also like the Third Book, these excerpts swarm with misreadings and occasional misunderstandings. Yet, in this First Book, Ghiberti adapts his sources to his own concept of the history and theory of art. Whereas Pliny had cut up the entire history of art according to the materials employed—marble, clay, bronze and colors—Ghiberti gathered all of Pliny's references to the origins of art into a chapter near the beginning of his First Book. Moreover, he oriented his text to meet the needs of a sculptor and included long passages which reflect his own interests: he interpolated, at the end of the preface, a list of theoretical sciences which he deemed necessary for the education of a sculptor— very different from Vitruvius' comparable enumeration. He interpreted the contest

[7] *ibid*, p. 51.

[8] Schlosser (bibl. 178, II, pp. 9f) arrived at a date 1445-1455 for the writing of the *Commentarii*; Morisani, bibl. 179, p. vii, gives the date shortly after 1447.

[9] See below, note 21.

between Apelles and Protogenes as a contest in *prospettiva*, here probably perspective; and finally he stresses continuously the theoretical writings of the ancients.

But it is in the Second Book that Ghiberti really excels. This section of the *Commentarii* ranks among the great writings on art of all times. In it Ghiberti attempts to give a history of his artistic ancestors, as it were, to prepare the reader for his concluding account of his own work. He starts out by lamenting the loss of the works of art and theoretical wisdom of the ancients under Constantine. At that time all statues and paintings of antiquity were destroyed. "After art had [thus] come to an end, the churches stood whitewashed for 600 years." The statement concerning this interval of 600 years makes one wonder whether perchance he interpreted Carolingian mosaics in Rome, well dated as they are by their inscriptions, as marking the end of the first period of what apparently struck him as the Dark Ages. This first period, he says, was followed by a second which lasted another two hundred and fifty years, or so, and was dominated by the *maniera greca*, the Byzantine style. Finally, Ghiberti says, art was resurrected in Tuscany by Giotto. He discusses the work of Giotto and afterwards that of his pupils, Stefano, Taddeo Gaddi, Maso, and Bonamico-Buffalmacco. At this point he inserts a discussion of the work of Cavallini in Rome, after which he returns to speaking of Florence where the works of Orcagna and his brothers impressed him as important for the second half of the Trecento. He concludes that "there were in our city many other painters who might be listed among the outstanding, but to me it does not seem that I should place them among these." The discussion of Florentine painters is followed by that of the painters in Siena. This part opens with the long, beautiful and enthusiastic analysis of the works of Ambrogio Lorenzetti, a "most perfect master, a man of great genius . . . a most noble designer . . . much experienced in the theory of this art (*teorica di detta arte*)." Simone Martini he ranks as decidedly inferior. With Barna da Siena and Duccio the chapter closes, the latter being described as "most noble, [though] he followed the Byzantine style." Tuscan sculptors are treated briefly: Giovanni Pisano, Andrea Pisano and, in a preceding paragraph, Orcagna. But the place of honor in this long section leading up to Ghiberti's autobiography is given to the goldsmith Gusmin.

This Second Book is a masterpiece of presentation. Throughout the style is lively, the formulations concise and clear, the observations on works of art sound, the judgments on artists independent and uncluttered by side issues, anecdotes and *campanilismo*. Very much in contrast to earlier attempts at writing history of art, such as Villani's biographies of artists in his *Uomini singholari*,[10] Ghiberti limits himself to discussing the *œuvre* of his artistic ancestors; their personal lives did not interest him. Also he does not accept judgments handed down from earlier generations: Cimabue and Duccio are not the ancestors of Trecento painting, but are representative of Romanesque-Byzantine art, of the *maniera greca*, and thus are opposed to Trecento principles. Local prejudices play no part in his thinking: Giotto, Florentine though he is, is treated with respect, but somewhat coolly. The Roman Cavallini is awarded

[10] Ghiberti-Schlosser, bibl. 178, II, pp. 9f; Morisani (bibl. 179, p. xiii) contends that Ghiberti did not know Villani's book but that both employed a terminology current among artists and connoisseurs.

praise, and even more, the Sienese masters. Among them he ranks highest not Simone Martini, who "the Sienese painters hold was the best," but Ambrogio Lorenzetti, who "it seems to me was more skilled (*dotto*) than anybody else." This clarity and independence of judgment prevails whenever Ghiberti has seen a work of art with his own intelligent and observing eyes. As a rule his descriptions are centered on rendering the narrative of a painting or fresco cycle, and this he does vivaciously, forcefully and often with dramatic warmth; where he alludes to qualities of design, he proceeds with a delicate feeling for the specific characteristics of the individual artist. His value judgments are excellent and unerring, but he never attempts to see as an integral whole either the *œuvre* of an individual artist or the art of an entire period. Assuredly this Second Book places Ghiberti among the great historians of art.

However, there is yet another side to the *Commentarii*. Viewed as a whole, the work reveals not only Ghiberti's sensitivity as an artist and his independence as a historian, but his ambition, slightly out of proportion to his training and his capabilities, to be taken for a humanist and a scholar. The very title, *Commentarii* previously employed by Bruni is in accordance with humanist custom.[11] The terminology whenever referring to art theory, is based on the humanist revival of antique nomenclature such as Alberti had employed: *lineamenti, misura, teorica dell'arte* or *teorica del disegno* all belong to this category. Ghiberti's complete reliance on Pliny in the First Book of the *Commentarii*, his excerpts from Vitruvius and even from the practically unknown Athenaios are obvious, now that Schlosser has pointed them out.[12] Likewise, his calendar of olympiads, which has led to so much confusion, is a typically humanist mystification.[13]

The decisive proof of the humanist approach of the *Commentarii*, however, lies in the overall plan, the historical scheme, and tenor of the work. For an artist of the fifteenth century to write a history and theory of his own art meant striking out in an entirely new direction. Also, in accordance with humanist concepts, Ghiberti presents the historical development in two widely separate sections, the First and Second Books of the *Commentarii*, thereby sharply differentiating between antiquity and modern times. The two eras are divided by a gulf, the Dark Ages. This concept of a dichotomy in history had originated with Petrarch.[14] Boccaccio had applied it to the history of art in a famous passage in which he contrasted what we call the art of the Middle Ages with the birth of a new art in the painting of Giotto.[15] Indeed, like Boccaccio Ghiberti claims that with Giotto art revived and modern times started. But Ghiberti views the two-partite evolution of history with new clarity, comparable, then, in the mid-fifteenth century, only to Alberti's contemporary presentation in the preface of *Della Famiglia*.[16] This historical scheme then, is humanist. It is likewise in a humanist spirit that Ghiberti constantly emphasizes the importance of a theory of art.

[11] Ghiberti-Schlosser, bibl. 178, II, pp. 10f. Bruni, who employs the term time and again in his writings (Baron, bibl. 38, pp. 167, 176f), in one of his letters (bibl. 78, I, pp. 134f; Lib. IV, ep. 20) explains its meaning as a presentation "more condensed and less explicit" than a full-dress history.
[12] Ghiberti-Schlosser, bibl. 178, II *passim*, particularly, pp. 63ff.
[13] See below, App. B.
[14] Mommsen, bibl. 343; Bailey, bibl. 33.
[15] Decamerone, VI, 5.
[16] Alberti, bibl. 9, II, *proemio*.

Ghiberti may have been stimulated by Alberti's writings, but his real foundation, based probably on Vitruvius, was a deep conviction that in antiquity the practice and theory of art were closely interwoven. Time and again he refers to the lost "... *vilumi et commentarii et lineamenti et regole*, the volumes, the commentaries, the outlines and rules of the ancients."[17] Artists at that time, he says in a somewhat cryptic sentence, were "so expert that they composed *commentarii* and infinite volumes of books which spread the greatest light to those who came after them and explained [?] (*ridussero*) art by the proportion (*misura*) which nature offers."[18] Apparently he labored under the impression that the great artists of antiquity had put their knowledge and theoretical concepts of art into writing and had frequently recorded their work: he specifically credits Phidias with having left "in his *commentarii* a record of the many ... buildings he designed."[19]

With this picture in mind, Ghiberti sat down to his desk to do just the same. He gives us a record of his *œuvre* within a historical context and he liberally intersperses the account with offhand remarks about his theories of art. By constant repetition he makes sure the reader understands the importance of optics, of drawing, of the *teorica dell'arte*, of proportions, anatomy, of outlines and principles, *lineamenti*. Highly characteristic is his interpretation of the contest between Apelles and Protogenes. It is his personal opinion, proffered "*con riverentia di ciascuno lettore*," that the competition could not have consisted, as Pliny tells it, of merely drawing finer and finer lines, but that it must have been a contest in perspective problems.[20] In the Third Book he apparently planned to add a survey of the *artes liberales* which he considered basic to a sculptor's background. Not by a single word does he propose to deal with the technical problems of sculpture or with a sculptor's training in the mechanics of his trade. He writes as a humanist artist and hence with professed disregard of the craftsman's approach. What he concentrates on is ultimately the humanist education of an artist.

Ghiberti, then, aimed at composing a truly humanist treatise. It would deal with the history and theory of art along the lines of Pliny, of Vitruvius and, last but not least, of Leone Battista Alberti, who, by the time Ghiberti wrote the *Commentarii*, had long ago published both his *Treatise on Painting* and his little pamphlet on sculpture, *De statua*, and was already in the midst of working on the *Ten Books on Architecture*. We know that Ghiberti was in touch with Niccoli and his circle of humanists; only in their libraries could he have found and perused the writings of the ancients, and only they could have helped him when his linguistic, philological, and archeological training failed. Together with Donatello and Luca della Robbia, he stood on the fringes of the humanist group and was received into their houses. He knew Traversari well enough to use him as a middleman in applying to participate in the private interlibrary loan service which played so significant a role in the intellectual life of the early fifteenth century. Through Traversari Ghiberti approached Aurispa for the loan of the Athenaios manuscript on military engines.

[17] Ghiberti-Schlosser, bibl. 178, I, p. 35; II, p. 11.
[18] *ibid.*, I, p. 31. [19] *ibid.*, p. 7. [20] *ibid.*, pp. 24f.

Aurispa, it is evident, was not too sympathetically inclined: in the first place he was an avid bookworm and loathed parting with any of his books; second he loathed even more giving something for nothing; but despite these peculiarities Ghiberti seems to have squeezed out of him at least the translation of the Athenaios preface, to use it as the introduction for his *Commentarii*.[21]

Aurispa's letters to Traversari regarding this book loan illuminate Ghiberti's position in relation to the humanist circle. He apparently could not write Aurispa directly. He had to approach him through a learned friend, a man of standing in the humanist community. To Aurispa Ghiberti was "that sculptor Laurentius," a nobody, and even if at one point, he adds to Ghiberti's name the adjective "outstanding," he does so only once and presumably in response to a phrase used by Traversari. Ghiberti plainly was not recognized as an equal by the humanists.

In his narrow way Aurispa was, of course, right. Ghiberti was no scholar. He was not equipped like a learned humanist to deal either with the writings of the ancients or with theoretical problems. Naturally he did not know Greek; even among scholars that was the rarest of achievements. But also his Latin was apt to give out when he ran into one of the more complicated passages in Vitruvius.[22] His lack of interest in, and understanding of, subject matter in ancient art seems at first glance equally revealing: the *Flaying of Marsyas* on the Medici Cornelian he calls a representation of the Ages of Man;[23] but then Poggio himself could not tell a Bacchus from a faun. It is of greater significance that Ghiberti treats the writings and theories of antiquity

[21] *ibid.*, pp. 3f. Schlosser (*ibid.*, II, pp. 11f, 63f) had identified the provenance of the passage from Athenaios. Ernst Gombrich was good enough to draw my attention to two pertinent passages in Aurispa's letters heretofore unknown in the Ghiberti literature and certainly unknown to me (Sabbadini, bibl. 457, pp. 66ff, 68ff). Both are addressed to Ambrogio Traversari, date from 1430, and refer to a request of Ghiberti's to borrow through Traversari's intermediation Aurispa's copy of Athenaios' Ὀργάνικα. Sabbadini (bibl. 457, p. xvii) suggests that Aurispa met Ghiberti halfway by sending him instead the manuscript of a Latin translation of the introductory paragraph. Here are the passages: "Volumen illud Ὀργανικῶν Laurentio isti sculptori eximio mittam; sed pro eo velim illud Virgilium antiquum quem iamdiu desidero; velimque praeterea Oratorem et Brutum: consentanea ea res mihi videtur. Quae conditio si sibi fortassis placet, aut mittam volumen illud aut si fortuna daret, ego mecum afferrem . . ." (*op.cit.*, p. 67; January 2, 1430). ". . . Caeterum cupiditas quaedam mira quae me in habendis codicibus tenet, facit ut non solum quas istic habebam apud me sint, imo alios quosdam insuper habuerim. Τὰ Ὀργάνικα ἐκεῖνα παρὰ μοι sunt. Itaque si sculptor iste eum istum Virgilium antiquum qui in monasterio vestro est, et Antonianas Ciceronis (i.e. the Philippicas) perfectas ut nuper inventae sunt mihi restituere poteret, dedam Τὰ Ὀργάνικα. . . . Si Philippicae non pulcherrimae modo plenae et emendate essent etiam placerent . . ." (*op.cit.*, p. 69; March 15, 1430). The letters are clear enough regarding both Ghiberti's request and Aurispa's reluctance to comply. They are equally clear regarding his own request to receive in exchange "an old Virgil" and several Cicero manuscripts. But it remains unclear who owned these books. Aurispa says in so many words that he wants Ghiberti to let him have them and this would seem to suggest that Ghiberti had built up a library of ancient authors. On the other hand, Aurispa explains to Traversari that the Virgil is "in your monastery," that is in S. Maria degli Angeli. Does he, then, mean to imply that through the loan to Ghiberti he can induce Traversari to reciprocate from his monastery's resources? Or had Traversari borrowed the volume from Ghiberti? Ghiberti may have known the Athenaios manuscript as early as 1427. At that time Traversari had it on loan in Florence, and Aurispa asked for its return (*op.cit.*, p. 51).

[22] Ghiberti-Schlosser, bibl. 178 *passim*, particularly II, p. 12.

[23] Ghiberti-Schlosser, bibl. 178, I, p. 47.

not so much with the cool analysis of a scholar as with the awe of the romantic neophyte before "the lost secret" of the past. Moreover, Ghiberti apparently neither mastered the terminology, nor possessed the clarity of abstract thought, which enabled Alberti to compose his works on the theory of art.[24] Ghiberti's terminology is shifting: *prospettiva* means both optics and perspective, and *lineamenti* is an equally ambiguous term. He had not found sure footing in the new-fangled, concise idiom of art criticism which Alberti, that somewhat glib young theoretician, was the first to coin. Ghiberti's constant interspersion of his historical account with offhand theoretical remarks are a far cry from the crystal clear cogency with which Alberti in *Della Pittura* pursues his argument point by point, until he arrives at a logical conclusion. Nor do the *Commentarii* possess the limpid precision with which *De Re Aedificatoria* is subdivided by subject, according to the sacred Vitruvian triad of firmness, commodity, and delight. Neither by nature nor training was Ghiberti fundamentally equipped for the learned abstract and analytical approach of humanist theory.

Ghiberti was a humanist and scholar by ambition only. In fact it is downright refreshing to see how time and again his unscholarly nature breaks through. He tries employing the stiff humanist terminology only in the theoretical portions of his text. In the descriptive and historical sections he uses his tongue as God made it. His language is the vernacular used around Florentine workshops, limited and by 1450 slightly obsolete. It is often clumsy, but in its simplicity very charming. His key words in these portions of the manuscript are not ambiguous italianized Latin, but simple and concise Italian terms: *industria, disciplina, diligentia*. He characterizes the Gates of Paradise as "most perfect and most ornate and richest"—principal criteria in prehumanist art criticism. Works of art, whether his own panels on the Baptistery gates or Ambrogio Lorenzetti's frescoes in Siena, he describes primarily in terms of their narrative and frequently he is carried away into a dramatic elaboration far beyond the events actually rendered. When describing stylistic qualities of such works, particularly his own achievements of giving the illusion of credible reality, he is apt to start out with somewhat stilted humanist terms. But then he abandons them, almost in despair at their inadequacy, and chooses simple words of his own. He does not say the panels of his second door are done in perspective; he simply relates that they "have very little relief and on the *piani* one sees the figures, which are near, appear larger and those that are far off, smaller, as reality shows it." Indeed, it is from these descriptive portions of his book that one realizes what art meant to him. The art of the Trecento, his own art, and the art of antiquity, they all come to life for him when he deals with objects, moreover objects which he intimately knows. Nothing could be more sensitive than the descriptions of ancient works of art which he had seen with his own eyes. The hermaphrodite, found in Rome during one of his visits, he described as lying "on a little sheet, arms on the ground, hands crossed, one over the other, and he keeps off one of his legs with the big toe of his foot. . . . He had no head, nothing else was missing. There were many refinements in it, but the eye did not discover them

[24] See also Olschki, bibl. 371, pp. 92ff. See also above, pp. 230ff.

unless the touch of the hand found them." Or else he describes the chalcedony with the *Rape of the Palladium*: "This sculpture could not be seen better than by turning the hollow part towards a strong light, then one saw [it] perfectly. . . . Many details which are invisible in delicate sculptures . . . when one pulls them into strongly lit places or into strong light or places them against the light of the sun [then] the features will come forth which are hidden by the weak light or in dark places."[25] In such passages as these, when writing as a sensitive lover of art, Ghiberti's warmth and forcefulness as a writer come forth.

Humanist writing and scholarship were but the unhappy loves and aspirations in his life.

[25] Ghiberti-Schlosser, bibl. 178, I, pp. 62, 64.

CHAPTER XXI

GHIBERTI AND ALBERTI

I N 1434 Pope Eugen IV was forced to flee from Rome to Florence at some risk to
his life. In his suite came a young man, Leone Battista Alberti, just turned thirty.
Born in Genoa of an old Florentine family, Alberti had spent his boyhood in
Venice and Padua, and throughout life he maintained close ties with the small
dynasts of the Venetian *terra ferma*, from Ferrara to Rimini and Mantua. Again within
the cultural milieu of Venice, he had received his degree in Canon Law at the Univer-
sity of Bologna, certainly prior to 1428.[1] During his years at the university and shortly
thereafter, half a dozen publications—none too weighty—had called the young *litera-
teur* to the attention of humanist circles; poetry, imitations of Latin and Greek com-
edies, a pamphlet on the inconvenience of cramming, some essays, a treatise on love.
In 1432 he was in Rome where he apparently worked on a map, the *Descriptio urbis
Romae*, made experiments in perspective, and wrote the first three books of *Della Fa-
miglia*.[2] All these works were literary, mathematical, or philosophical in content. But it
was in Florence that he wrote the work by which he is perhaps best known—the *Treat-
ise on Painting*, first published in 1435 in Latin and a year later in Italian.[3]

It is a slender volume, fifty-odd pages at most. In the first book Alberti presents the
basic elements of two-dimensional geometry which a painter must know for his art; he
goes on to discuss principles of linear perspective and their implementation. In the
second book he examines elements of representation, composition, movement, emo-
tions, light, and color. In the third he deals with the task of and the education for a
humanist painter, an education to be based on both the knowledge of antiquity and
the study of nature.

The treatise must have been a deep shock to humanists and artists alike. Manuals of
painting had been written before. But this was not a manual in the sense of Cennini's
which is filled with recipes for preparing colors and with craftsmen tricks and while
Alberti stressed that he was writing as a painter for painters, his continued reference to
"us painters" is more than a bit of pretense. Nor was the treatise a collection of anec-
dotes from the history of art drawn from Pliny's *Historia naturalis*. It was infinitely
more—and about this more, Alberti was not unduly modest: "not like Pliny do we tell
stories, but we build a new art of painting." Indeed, the *Treatise* was neither more nor
less than an attempt to establish a theory of the pictorial arts, meaning painting and
relief sculpture. This at the time was an unheard-of undertaking. Since heretofore only
the liberal arts, the scholarly disciplines of antiquity and the Middle Ages, were sup-
ported by underlying theory, Alberti's treatise on the pictorial arts implied that they

[1] The best biography of Alberti is still Mancini's, bibl. 289. I am using the second edition of
1911. P.-H. Michel (bibl. 329) gives a thorough, though not always clear, presentation of Alberti's
philosophy. Alberti's writings, aside from those in the field of art and architecture, are collected,
the Italian ones by Bonucci (Alberti, bibl. 9), the Latin ones by Mancini (Alberti, bibl. 7).

[2] Mancini, bibl. 291, p. 194. [3] See above, p. 244, note 35.

too could claim a place among these disciplines. Poetry had held a theoretical rank since the days of Aristotle and Horace, oratory since Cicero and Quintilian. Hence, it would appear more than fortuitous that the treatise *Della Pittura* was modeled in part after Quintilian's *Institutiones*, in part after Aristotle's *Poetics* and in part after Horace's *Ars Poetica*: "Ut pictura poesis" had inevitably to invite such an equation.[4] Still, the claim to so exalted a position for the visual arts was in the 1430's just short of subversive. Alberti dedicated the second edition of the little work to Brunelleschi, in Italian *notabene*, so that the grand old man could read it. Alongside Brunelleschi, Alberti named in his preface the other champions of the new art in Florence. Thus a young scholar of parts dealt with a subject that until that time had been considered worthy only of the attention of *viles mechanici*. He associated publicly with art and artists, proclaiming by implication that scholars need not be ashamed to take a serious interest in that upstart discipline, the pictorial arts. He opined explicitly that scholars could advise artists on subject matter (that was nothing extraordinary) and—implicitly —that they should actually look at works of art. Conversely, artists were to seek scholarly advice, not just on subject matter, but on perspective, composition, representation of nature, and last, but not least, on the art of antiquity, the model according to Alberti, which modern art had ever to emulate if it were to produce works of equal *virtù* and grandeur. Obviously then, as Alberti saw it, this association of artists and scholars, did not invite unconditional fraternization. Alberti made a fine distinction between mere craftsmen, and artists of intellectual ambitions: the latter could be admitted at least to the fringes of humanist society, even though the smell of paint would always cling to them.

Never in his life was Alberti simply an artist among artists. Certainly this was not his role when writing the *Treatise on Painting*. His background was that of a humanist *literateur* and it was among humanists and their patrons that he felt at home. The Latin edition of the *Treatise on Painting* which preceded the version in *volgare* was apparently dedicated to Giovanni Francesco Gonzaga of Mantua. The *Descriptio urbis Romae*, written in or about 1433, was not by any means intended as a guide to the great architectural monuments of the city. It is a list of landmarks intended to index an archeological map of Rome which Alberti, upon the instigation of humanist friends, *amici literati*, was drawing by means of a surveyor's transit of his own invention.[5] Nothing suggests that Alberti, in compiling this list, saw in these landmarks more than the mementos that every humanist antiquarian saw, from Petrarch on. Likewise and in the same spirit in which they appear in Poggio's *De Varietate Fortunae*, the listing of altars, temples, theaters, and palaces in the preface of *Della Famiglia*, written in Rome

[4] Gilbert (bibl. 180) has brought out the character of *Della Pittura* as an isagogic treatise and has discussed its connection with Quintilian and Horace and its significance in treating art as a philosophical discipline.

The idea of raising the visual arts to the level of the *artes liberales* may well have been in the air, as witness Cennini's introductory remarks; see Panofsky, bibl. 383, p. 2. The date of Cennini's treatise, 1400 or 1436, remains in some doubt.

[5] Alberti, bibl. 7, pp. 36ff.

prior to 1434, designates these structures as witnesses merely to the grandeur of ancient Rome.[6]

Alberti's background, then, was literary. But woven into the traditional features of humanist thinking were additional elements. Painting, drawing and modeling had apparently been essential factors in his upbringing.[7] As a young man he had already made it a habit in his travels to look at buildings;[8] whether they were ancient or modern remains a question, for certainly the Venetian elements embedded in the design of S. Francesco in Rimini, hint at the deep impression made on him by his boyhood surroundings. But this interest in architecture does not make Alberti into a professional artist, nor does it seem to have been paramount. On the contrary, the practice of the visual arts had been for him in his youth, as he reminisced in his autobiography, merely a relaxing pastime: "when it happened that he was tired out from books, then music, painting and sports restored him."[9] He considered himself a *dilettante* who enjoyed his ability and employed it either for pleasure or as a tool for his scientific interests: the paintings he produced in his Roman years, vast landscapes, ships in a storm and the like, were merely objects for perspective demonstrations.[10]

Yet the man who wrote the *Treatise on Painting* in 1435 had grown into more than a *dilettante*. For him the visual arts were a deep concern. The common assumption has been that this fresh outlook of Alberti's resulted from the new Florentine atmosphere in which he moved, with its lively interest in art and artists. But numerous and good reasons lead one to suspect that even before he came to Florence in 1434, art had become a determining factor in his intellectual make-up. In Rome, he says in *Della Pittura*, he was struck by a relief of Meleager wherein the body of the hero was "dead down to the very fingernails." No one could formulate such a sentence unless he were deeply impressed by the visual qualities of sculpture. The question then is how this humanist *literateur* was awakened to a sensitiveness which turned him into an art lover. The answer is conterminous with the extent of his experiences and contacts in the years between his university studies and his appearance in Florence in 1434.

Almost no facts are known regarding these years. Alberti appears to have taken his degree in Bologna in 1426 or 1427.[11] In 1431, possibly into the spring of the following year, he seems to have accompanied Cardinal Albergati to the Netherlands,[12] and it is

[6] Alberti, bibl. 9, II, p. 13. The date of *Della Famiglia* results from Alberti's autobiography (Alberti, bibl. 9, I, p. xciv) where he states that he wrote it before his thirtieth year.

[7] Alberti, bibl. 9, I, p. xc.

[8] Quoted after Alberti's *De commodis litterarum atque incommodis*, by Voigt, bibl. 541, II, 374.

[9] Alberti, bibl. 9, I, p. xc. [10] *ibid.*, pp. cii f and bibl. 8, p. 67.

[11] Mancini (bibl. 289, p. 70) has suggested the date of 1428. Bonucci (Alberti, bibl. 9, I, p. cxxiv), dates the preface of the *Philodoxis* from ten years after Alberti's graduation; since the preface seems to be contemporaneous with the dedication of the play to Lionello d'Este in 1437 (Alberti, bibl. 9, I, p. cxx; Poggio, bibl. 418, II, p. 129 [Lib. VI, ep. 23]), 1427 appears to be a preferable date for the termination of Alberti's studies.

[12] The assumption of Alberti's journey to the Netherlands in 1431-1432 rests on a triple argument: on a number of allusions contained in *De Re Aedificatoria* to things seen in these regions (Alberti, bibl. 5, I, f. 30v, 33, 100; II, f. 12v, 17v [Bk. II, 9 and 11; V, 17; VI, 8 and 11]); on his continued documented presence in Italy from the fall of 1432 on; and on the diplomatic mission to the Low Countries and France undertaken by Cardinal Niccolo Albergati beginning February 1431.

tempting to speculate on the possibility of a meeting between Alberti and Jan van Eyck. In October 1432, he was in Rome where he remained as an *abbreviator* in the papal chancellery until 1434. The question thus is reduced to Alberti's whereabouts and activities between 1427 and 1431. A visit to Florence late in 1428, shortly after the ban on his family had been lifted, is possible, but not at all certain,[13] and in any event, could only have been brief. But a number of indications lead to the conclusion that Alberti went to Rome in 1427 or 1428, shortly after taking his degree. It was the natural course for an impecunious bright young man who had studied Canon Law and was looking for employment. Bologna was rife with civil strife, and the University was closed from 1428 to 1431.[14] Alberti himself drops the hint that the *Philodoxis*, written when he was hardly twenty, that is, before or in 1424, was taken as a genuine antique comedy "some years later when he was employed in the papal chancellery, *occupatus scriptis Pontificiis*." Hence, he would seem to have received this employment earlier than is generally assumed.[15] His appointment to the priorate of S. Martino in Gangalanda, connected as it was with his employment at the papal court, likewise seems to date before 1431.[16] Finally, the preface to the Italian version of *Della Pittura* also indicates Alberti's presence in Rome by at least 1428.

The preface, with its apostrophy to Brunelleschi and the other artists of the Florentine circle, is indeed the principal clue to Alberti's whereabouts from 1427 to 1434 and to the extent of his acquaintance with Florentine art and artists during these years. "After I had returned," he says, "from the long exile in which we Albertis have grown old, here to our . . . homeland, I recognized in many, but foremost in you, Filippo, and in that very good friend of ours, Donato the sculptor, and in those others, Nencio and Luca and Masaccio, a genius for all praiseworthy endeavors not inferior to that which had been ancient and famous in these arts." Later he repeats the same thought, referring to the virtues of Brunelleschi and Donatello and "those others who because of their habits are dearest to me."[17]

One's first impression is that Alberti knew the entire group personally, and that he wrote the preface under the influence of fresh impressions received upon his arrival in Florence, presumably in 1434. Yet, the tenor of his address to Brunelleschi and of his

The suggestion (Mancini, bibl. 289, p. 87) that Albergati took along the young humanist as secretary is appealing, but since Albergati's mission lasted three years (*AA.SS., Maii*, II, pp. 472ff) and Alberti was in Rome by the fall of 1432 and possibly earlier, he would have been with the Cardinal only part of the time, presumably into the winter of 1431-1432, since in Holland he saw ice skating (Alberti, bibl. 5, II, f. 12v).

[13] Mancini, bibl. 289, p. 67, and after him Michel, bibl. 329, pp. 6of; see also Palmieri, bibl. 377, p. 139.

[14] Mancini, bibl. 289, p. 61. [15] Alberti, bibl. 9, I, p. cxxiv.

[16] The papal bull by which Alberti, in October 1432 was appointed *abbreviator* (Mancini, bibl. 291, pp. 190ff) refers to the benefice of S. Martino in Gangalanda as having been granted him *olim*, a long time ago; to the threat of a disbarment which had arisen regarding this grant because of illegitimate birth; to a recent petition by him (*nuper facta*) and the granting of a papal dispensation; finally to a general permission to exchange the priorate of S. Martino against any other benefice. All this sounds as if he had been nominated to the priorate quite some time before and, since he was absent from Rome from early 1431 to the spring of 1432, possibly as early as 1430.

[17] Alberti, bibl. 8, pp. 47, 49; and Janitschek's remarks, *ibid.*, p. 258.

reference to Donatello suggests an intimacy of some years' standing and hence earlier than 1434. It is of course perfectly possible that he had already visited there briefly late in 1428, had met some of the artists and seen the first accomplishments of the new movement: the façade of the Innocenti; the *Saint Mark* and the *Saint George*; the Trinity fresco and the Brancacci chapel; the *Saint Matthew* and the Shrine for S. Maria degli Angeli. But he could not have seen at that time any major work by Luca della Robbia: the *Cantoria* for the Cathedral had just been begun when Alberti came to Florence in 1434 and it was far from completion in 1436, when he wrote the preface of the *Treatise on Painting*. But a visit of Alberti's to Florence in 1428 is entirely conjectural and in any event, his intimacy with the *avant-garde*, in particular with Brunelleschi and Donatello, presupposes years of close acquaintance and this acquaintance would seem to have developed prior to 1434 in Rome. Indeed, both Donatello and Brunelleschi came to Rome, while Alberti lived there at the *curia*, the former apparently either for an extended stay lasting from 1431 or 1432 to 1433 or for several visits during this period,[18] the latter in all likelihood in 1432 and 1433.[19] Alberti may well have befriended them there. Masaccio, in fact, he could only have known in Rome: from all that is known, it would appear that Masaccio left for Rome prior to October 1428, the earliest possible date for Alberti's visit to Florence, if, indeed, he made one, and that he died in Rome prior to November 1429.[20] In short, the preface of *Della Pittura* suggests that Alberti

[18] Kauffmann (bibl. 337, pp. 226f, note 300) appears to consider as certain only one stay, from 1431 or 1432 to 1433.

[19] Fabriczy, bibl. 148, pp. 43f; Heydenreich, bibl. 211, p. 8.

[20] Mesnil (bibl. 323) was the first to point out that the reasons usually given for placing Masaccio's death in the year 1428 are not really cogent. Nevertheless, Masaccio's recent biographers seem to agree on the date 1428 (Pittaluga, bibl. 501, pp. 156f; Clark, bibl. 101; Procacci, bibl. 428) or even late 1427 (Lavagnino, bibl. 267) and it is with great hesitation that I venture to suggest reconsidering the question.

The known data are the following. On July 27, 1427, Masaccio in person deposited his *portata al catasto* in Florence. On the *campione* of this *portata* the assessment of his house is changed under the date of November 18, 1429, and Masaccio's name is canceled, with a marginal note "dicesi è morto a Roma. . . ." (The term *dicesi* is accepted parlance for a report made to the authorities.) In 1472, Masaccio's younger brother told Antonio Manetti (Manetti, bibl. 293, p. 165) that Tomaso was born December 21, 1401, and died at the age of twenty-seven. The date of his death would thus appear to fall between December 1428 and November 1429, and the chances are that it was reported to the authorities shortly after it had occurred. The time of his departure for Rome depends largely on what works in Florence, if any, should be placed after the Pisa diptych and which, if any belong to this last period in Rome and on this question there is considerable disagreement. See bibliography quoted above.

Janitschek's attempt to identify the Masaccio mentioned by Alberti with the bronze caster Maso di Bartolomeo (Alberti, bibl. 8, pp. 257ff) has been recently revived by Oertel (bibl. 366). It remains wholly unconvincing. The tenor of Alberti's preface precludes the inclusion of a second-rate artist: Masaccio within the context and mentioned alongside Brunelleschi, Donatello, Ghiberti and Luca della Robbia, can be only *the* Masaccio. Janitschek's argument was based both on the correct impression of a personal acquaintance between Alberti and all the artists he mentions, including Masaccio, and on the mistaken assumptions first that this could have occurred only in Florence late in 1428, and second that by then the painter, Masaccio, was dead. The argument falls, once the acquaintanceship is placed in Rome, where Alberti could have met Masaccio at any time in 1428 or even through the greater part of 1429. Oertel's argument to the effect that Masaccio would be the only painter mentioned by Alberti among a group of sculptors has no validity: in 1436 no painter's *œuvre* in Florence would have been considered worthy of mention to Alberti, save for Masaccio's and possibly Uccello's.

stayed in Rome, except for the trip to the Netherlands, from about 1428 to 1434, and that there he met at least some of the Florentine artists who had started on the path of a new art.

At the same time, Alberti in his preface does not refer to just one meeting with these leaders of the Florentine *avant-garde*. He appears to telescope a number of his encounters with artists and a number of the impressions he had received between 1428 and the date of the preface, 1436. He refers to artists he had met during this time, making no note of whether he had met them recently or eight years earlier, or of whether in 1436 they were living or dead. Likewise he telescopes the places where these encounters took place. Some Florentine artists, such as Masaccio, he had known in 1428-1429 in Rome; Luca probably first gained his attention in Florence after 1434; his acquaintance with Donatello and Brunelleschi while possibly dating back to 1428 would have developed into close friendship in Rome to continue later during Alberti's Florentine years. In brief, the passage merely sums up the impressions made upon him by artists and their works during the decisive years before the writing of the *Treatise*.

One is too easily inclined to underrate the ease with which Florentines in the first third of the fifteenth century commuted between their native city and Rome. In fact, it is amazing how frequent travel between the two cities appears to have been. Between 1424 and 1427 Cosimo Medici visited Rome at least three times, on private and diplomatic business; the last time he stayed for several months.[21] His brother Lorenzo went at least twice, once in 1424 or 1425, and again in 1428-1429.[22] Brunelleschi between 1403 and 1418, appears to have gone back and forth several times,[23] and was back in Rome in 1432-1433. Donatello was in Rome for one long or for several short stays between 1431 and 1433 and nothing precludes his having made one or more earlier visits prior to 1418, as suggested by Brunelleschi's biographer.[24] Ghiberti seems to have gone to Rome once prior to 1416 and again "in the 440th olympiad," covering the years from 1425 to 1430. Both Masolino and Masaccio may have been twice in Rome, once possibly in 1423-1424 when they painted the S. Maria Maggiore altar for Martin V, and again in 1428-1429, when working for Cardinal Branda at S. Clemente.[25] Even a slow and very particular gentleman like Niccolo Niccoli allowed himself to be lured to Rome at least once, in 1424.[26] Donatello's visits in the early thirties were possibly in the hope that like Gentile da Fabriano, Pisanello, Masolino, and Masaccio, he might find work at the papal court. At the same time, he may have wanted to study the ancient monuments of Rome. This was certainly what brought Brunelleschi time and again to the Eternal City, and Ghiberti likewise seems to have considered his Roman journeys as primarily study trips. For humanist visitors in the twenties and early thirties the main attractions of Rome consisted in her monuments, libraries and intellectual col-

[21] See above, p. 139, note 4.

[22] *ibid.*, and Poggio, bibl. 418, I, p. 271ff (Lib. III, epp. 31, 32, 33).

[23] Fabriczy, bibl. 148, pp. 43f. [24] (Manetti), bibl. 294, p. 20.

[25] The assumption of an early stay of Masolino's and Masaccio's in Rome, 1423-1424, rests on the date of the S. Maria Maggiore altar, see above, p. 200, note 12. Their second stay is ascertained by Masaccio's *portata al catasto* (see above, note 20) and by the date of the frescoes in S. Clemente, 1428-1431, see Procacci, bibl. 428, pp. 51ff.

[26] Poggio, bibl. 418, I, pp. 85ff, 97ff, 136ff (Lib. II, epp. 1, 7, 17).

ony. Bruni, to be sure, had returned to Florence by 1415. But Poggio spent almost fifty years at the *curia*, and from 1403 to 1453 was the very center of the humanist circle in Rome. Around him were assembled Bartolomeo Aragazzi, Antonio Loschi, Cenci de' Rustici and their patrons, the Cardinals Prospero Colonna, Giordano Orsini, Niccolo Albergati, Gaspare Molini.[27]

Young Alberti belonged to this group; and while the circle was possibly the largest in Italy, it was still desperately small. Every newcomer, likely to be interested in the treasures of antiquity, whether patron, humanist or artist, was eagerly welcomed and shown the sights by the more or less permanent members of the humanist colony. A series of letters from Poggio to Niccoli in expectation of the latter's first visit to Rome in 1424 gives an idea of the eagerness with which the "old settlers" in Rome looked forward to the opportunity of showing newcomers around. "How splendid" he writes, "if you were here! Think of the many talks! of the bull sessions about so many subjects. . . . I see myself already with you . . . Cosimo [Medici] is here with us as a good precursor. You shall have a good room, either by yourself or with a girl to rub your feet when you are tired. Cosimo will lend you horses. . . ."[28] "Together we shall seek out all the remnants of antiquity. . . ."[29] Traversari recounts what an experienced guide Poggio was ". . . reliquias civitatis probe callens nos comitatur."[30] It is unlikely that Alberti was less eager than the rest. It was thus, as a humanist established in Rome and acquainted with her monuments, that he would have taken up with Brunelleschi, Donatello, and possibly Masaccio. It is more than likely that during these Roman years he also met Ghiberti—or met him again. A visit of Ghiberti to Rome in the 440th olympiad, at some time between 1425 and 1430 is certain (App. B), and perhaps the date can be further pinned down. No document attests his presence in Florence between February 1 and July 21, 1429, and again he is not mentioned there from September 22, 1429 to January 2, 1430 (Digs. 154-159). A similar lack of documents reaching from March 15, 1430, to January 20, 1431—indeed at the semi-annual election of the supervisors of the dome of the Cathedral in December 1430 only Brunelleschi is reappointed —might coincide with a sojourn of Ghiberti in Venice (Digs. 160, 161). Hence it is likely that either in the early summer or the fall of 1429 Ghiberti was in Rome. In that case he and Alberti could not help meeting. In fact, there are good reasons to assume that they were in close contact; but discussion of these reasons will have to wait.

Alberti's Roman years were decisive for shaping his approach to art and artists. Unlike his fellow humanists, except for Poggio, he began to view the monuments of ancient art not only as *munimenta*, reminders of a grandeur passed away. He viewed them equally as witnesses of an art greater than that of the immediate past and hence exemplary for the art of his own time and of the future. This implies that he took upon himself the concern of the Florentine artists to "build a new art of painting,"[31] an art

[27] Voigt, bibl. 541, II, pp. 7ff. [28] Poggio, bibl. 418, I, pp. 85ff (Lib. II, ep. 1).
[29] *ibid.*, I, pp. 97ff (Lib. II, ep. 7).
[30] Traversari, bibl. 526, II, cols. 406ff (Lib. VIII, ep. 42).
[31] Alberti, bibl. 8, p. 93.

which would emulate that of the ancients. This is a widely different approach from that of his former years. If, around 1430 he sought the company of the Florentine *avant-garde*, he was no longer acting as a *dilettante*. In his youth, so he says, he had asked advice of everybody, so as to perfect himself and to please best, "of blacksmiths, of architects, of shipowners, even of cobblers, whether by any chance they had in their craft anything rare and hidden and particular, as it were."[32] Now his approach had apparently changed fundamentally. The visual arts had become a major concern of his. Both the *Treatise on Painting* and the little pamphlet *De Statua*[33] presuppose a good deal of preparatory thinking, as indeed was Alberti's customary practice.[34] This preparatory period must coincide with his Roman years. Between 1430 and 1434 he must have evolved a vocabulary adapted to the visual arts and a new sensitivity to their peculiar qualities. He must have learned to look with new eyes at works of art, both ancient and modern, and one would like to think that he developed this new outlook in association with the Florentine artists visiting Rome.

Alberti's contacts with art and artists during these Roman years remain necessarily hypothetical. But one thing is certain: when he appeared in 1434 in Florence, his main concern was to help and guide in the creation of the nascent art of the Renaissance. In the *Treatise on Painting* he gives the impression of having thought over the problems for quite some time. His approach departs fundamentally from that of Bruni or, for that matter, of Niccolo Niccoli. It differs even from Poggio's fondness for art and his respect for artists.[35] Poggio's is the naïve love of a collector for his objects, Alberti's the sophisticated and penetrating self-identification of a scholar with his subject. For one, he was aware of the problems of the craft: he had tried his hand at painting, albeit as a *dilettante* and to experimental ends, and thus knew what he was talking about. Secondly, his understanding of art was highly articulate; and thirdly, it was based on a genuine concern with principles of art more than with works of art: the nature of art, how it is produced, and what makes an artist. He was convinced that art is closely tied to a knowledge of other subjects: of humanities, that is of antiquity, of nature, including optics, physiognomics, cinetics and psychology, and of mathematics, that is geometry and perspective.[36] Fourth, his concern for art was founded on a strong conviction that contemporary art, as he wished it to develop, should emulate ancient Roman art as he interpreted it. Lastly, his interest rested on a profound respect for the artists among whom he moved. Alberti's respect for these artists differed widely from Poggio's esteem for Donatello's judgment. To Poggio Donatello represented an expert on questions alien to the scholar's mind, but which required advice if one went in for collecting. To Alberti the artists of his Florentine circle were practitioners in a field for which he strove to establish a theory. They met him on a common ground, for though they differed among themselves, all worked within a framework of what were to Alberti principles of an art of humanism. By implication he viewed them as humanists, hu-

[32] Alberti, bibl. 9, I, pp. xc and c.

[33] The date of *De Statua* is uncertain; but the instrument Alberti describes in it is fundamentally identical with the surveyor's transit employed in the *Descriptio Urbis Romae* of 1432-1433.

[34] Grayson, bibl. 192. [35] See above, pp. 302ff. [36] Michel, bibl. 329, p. 373

manists not in learning, but in action. He asked for criticism, in the first place from Brunelleschi: "no writer ever was so skilled that educated friends were not most useful to him."[37] This concept of working toward common goals with the Florentine artists, though by different means, underlies the entire preface of *Della Pittura*: the modern artists of Florence, so Alberti's argument runs, are by natural gift (*ingegnio*) not inferior to the ancients; indeed they are superior, for what they have achieved, they have accomplished without models from which to learn and without mentors (*preceptori*) to guide them. The further implication is obvious: Alberti is the mentor they lack. He will instruct them in the mathematical basis of their art, in various facets of their craft, in the education of the artist. He will also direct them towards the right models offered by the art of antiquity.[38]

Alberti's relation to Brunelleschi shows the intricacies of his position. The dedication to Brunelleschi of the Italian version of *Della Pittura* is, needless to say, a testimonial of the admiration he bore the old man. But he did not praise him *expressis verbis* as the founding father of a new architecture *all'antica*. He praised the inventiveness with which he had carried to successful completion the dome of the Cathedral: "a structure so great, rising above the skies, large enough to shelter all the people of Tuscany in its shadow, built without the help of any centering or of much woodwork, of a craftsmanship . . . perhaps by the ancients neither known nor understood."[39] To Alberti, Brunelleschi is in the first place the inventor who "perseveres to find . . . from day to day [new] things. . . ." Yet, the context makes it clear that in the eyes of Alberti such engineering feats were made possible only through a combination of moral qualities. In achieving *virtù*, he says, our own efforts (*nostra industria et diligentia*) are no less essential than gifts bestowed by nature and circumstance (*per beneficio della natura e de'tempi*). Indeed, they are more important: the ancients were endowed with only the latter, while modern artists, most of all Brunelleschi, had both. The tenor and context of the first book of *Della Pittura* indicate another feat by which Brunelleschi won Alberti's admiration. He was renowned after all as the first to work out a consistent linear perspective, an accomplishment that could hardly have failed to impress Alberti. The dedication of his book proves how deep the impression was; at the same time, however, the young humanist handed back to the old practitioner an improved system of perspective construction, simplified and solidly grounded in principles of plane geometry.[40]

Also in regard to other artists of the Florentine *avant-garde*, Alberti's approach seems generally to have been one of admiration and approval. In going over the pages of his slim volume, one is reminded time and again of the art of Masaccio, of Donatello, of Ghiberti, possibly of Luca della Robbia. One recalls that in the *Isaac* and *Joseph* panels Ghiberti employed a system of linear perspective which followed almost trait for trait the prescription given in the first book of *Della Pittura*. One remembers that the architectural settings in these panels seem to anticipate the purist features of classi-

[37] Alberti, bibl. 8, p. 49. [38] *ibid.*, pp. 47ff.
[39] For this and the following passages, see Alberti, bibl. 8, pp. 47ff.
[40] See above, pp. 244ff.

cal architecture as it issues forth from Alberti's later work, *De Re Aedificatoria*.[41] But these are details. The essence of Alberti's *Treatise on Painting* is contained in his discussion of outline, composition, and color in the second book.[42] His essay on composition stands out in both length and importance. It contains Alberti's basic theories of movement, beauty, and dignity, touchstones in his appraisal of Florentine artists of his circle.

It is almost superfluous to point out that Alberti in the *Treatise on Painting* does not deal exclusively with painting. The boundaries between painting and relief sculpture fluctuate, for both are to him pictorial arts.[43] Phidias he calls specifically a painter,[44] and the bulk of what he has to say refers to pictorial reliefs as well as to panel or fresco painting.

The second book of the treatise, then, contains the basic tenets of Alberti's theory. The ultimate source of art, according to him, is life. The aim of art is the convincing presentation of life. Life manifests itself in agitated movement and, conversely, the absence of movement is death, "the dead must seem dead down to their fingernails," and this is where he quotes the example of the relief with the homecoming of Meleager. On the other hand, of the living, all the tiniest parts must be alive. A body is living when through itself it has movement: "hence when the painter wants to express life in his figure, let him show all its parts in motion."[45] Movements by their differences express moods: "who is saddened holds himself low and tired . . . , happy people have free movements . . . with . . . agreeable turns of the body";[46] "and when the soul is moved by strong feelings the movements of the limbs should be equally strong."[47] Movements of different kinds characterize the sexes and the ages of man: "movements and poses of virgins should be airy and full of simplicity . . . , of boys light and joyful," of men firm, of old men slow.[48] Inanimate objects as well participate in movement and thus are brought to life. "Hair, branches, the folds of drapery must sometimes turn upwards, sometimes outwards, sometimes inwards, and sometimes be interwoven like ropes." The folds must spread as branches from a tree trunk, "in them thou shalt follow all the movements so that no part of the drapery remains without motion. . . ."[49] To justify such movement, he recommends that one of the winds in the painting be personified "so that the bodies, on the side where they are hit by the wind, will show below the draperies a good deal of nude, while on the other side the draperies lifted high by the soft breeze will fly in the air. . . ."[50] Yet, throughout, movements and motions must be dignified and full of grace. Gracefulness, indeed, is beauty itself—"that gracefulness in the bodies which is called beauty. . . ."[51] "In painting it is proper that movements be suave and graceful," he says, after an attack on figures that throw themselves about like fencers and clowns.[52] The painter "in every motion shall preserve elegance (*venusta*)

[41] See above, pp. 269ff. [42] Alberti, bibl. 8, pp. 99, 141.

[43] *ibid.*, p. 95: "from the same natural gifts are born painting and sculpture." See also the remark of Sir Kenneth Clark (bibl. 100, p. 18) regarding "those low reliefs which the men of 1430 made more pictorial than their paintings. . . ."

[44] Alberti, bibl. 8, p. 147. [45] *ibid.*, pp. 113ff. [46] *ibid.*, p. 121.

[47] *ibid.*, p. 129. [48] *ibid.*, pp. 127f. [49] *ibid.*, pp. 129f.

[50] *ibid.*, p. 131. [51] *ibid.*, p. 109. [52] *ibid.*, p. 127.

and gracefulness. Most graceful and . . . full of life are those movements that move upward into the air."[53]

Thus the triple equation of life and art, life and movement, movement and art, forms the core of Alberti's theory of pictorial representation. But, as his definitions and prerequisites grow more specific, they sometimes seem to bear contradictory features. Though movement must be graceful and light, it must also have dignity. Or else, in discussing pictorial composition Alberti, at one moment suggests that a story should be rich and varied, containing an "intermingling of old men and young ones, boys, women, girls, children, chickens, kittens, birds, horses, sheep, buildings, and scenery," and in the next cautions that copiousness must also be "moderate and grave, dignified and decorous." He specifically condemns "those painters who leave nothing empty and thus create a riot, not a composition." Hence, in an apparent reversal of his argument he recommends to those "who seek first dignity for their story . . . the beauty of a design with a . . . certain sufficient (that is obviously limited) number of figures."[54] In the Latin edition one year earlier he had explicitly recommended a composition consisting of "no more than nine or ten figures . . . , as I see it from the example of the tragic and comic playwrights who present their tales with as few actors as possible."[55] He may have changed his mind on this score. More likely, however, what seems a contradiction is a key, to both the character of Alberti's postulates and his relation with Florentine artists.

Alberti's postulates regarding movement, drapery and composition inevitably call to mind specific works of art. More than fifty years ago, Aby Warburg set out to establish a link between the *Treatise on Painting* and Botticelli's *Primavera*.[56] His thesis rested on a double premise: he maintained that Poliziano had absorbed from such Latin poets as Ovid the stress on agitated movement; and that at the same time, and possibly under the stimulus of Alberti, artists of the second half of the century, beginning perhaps with Agostino di Duccio, started looking for this kind of agitated life in Roman sarcophagi and Neo-attic reliefs. In the seventies, in the work of Botticelli, the literary and visual currents fuse. Thus by a stroke of genius, Warburg initiated a fundamentally new approach to the establishment of the impact of literary sources on the visual arts. But at the time he could only sketch the problem. Along with Poliziano, Marsilio Ficino appears to have played an important part in the seventies in transmitting formulas for movements from antique poetry; and these formulas were culled not only from Ovid, but particularly from Apuleius.[57] However, the interpretation of life and art as movement had certainly found its way into the pictorial arts of Florence long before the middle of the century. In the twenties and thirties Donatello and Ghiberti had put the idea into visual form, while Alberti in his theory had formulated it as a

[53] *ibid.*, p. 115. [54] *ibid.*, pp. 117ff.

[55] Alberti (bibl. 10, p. 20); see also Janitschek (Alberti, bibl. 8, p. xx). This is one of the passages that suggest the possible usefulness of a careful collation of the Italian and Latin versions of *Della Pittura*.

[56] Warburg, bibl. 545, 1, pp. 5ff, in particular, pp. 10ff and the notes of the editors, pp. 308ff; see also Michel, bibl. 329, pp. 419, 438f.

[57] Gombrich, bibl. 189, pp. 7ff.

prerequisite of art. But neither the artists of his circle nor Alberti himself viewed movement as an abstract phenomenon. The concrete realization of movement as gentle or violent was what mattered, and thus it can only be understood within a context of other specified elements, such as dignity, copiousness and decorousness in composition, and a framework of measurable and intelligible space.

Misunderstandings are next to inevitable when works of art are linked to literary descriptions or to aesthetic postulates. Thus the reader of the *Treatise on Painting* is torn between two reactions. In a first reading one is almost overwhelmed by the temptation to identify Alberti's set of postulates with the *œuvre* of a well-known artist from his circle, or even with a particular work of art. When Alberti suggests that a composition be built of nine or ten figures and thus achieve dignity, Masaccio's *Tribute Money* comes almost automatically to mind. When he speaks of a composition marked by copiousness and a rich variety of elements, from old men to kittens and birds, Gentile's *Epiphany* or Ghiberti's *Solomon* relief are evoked with equal force. Yet, upon second reading the conviction grows ever stronger that such simple pinpointing of a postulate in a specific work of art is bound to be fallacious. Literary terms have by definition a precision of their own. Gracefulness, dignity or movement, as literary terms mean something very specific, while to the artist who designs a painting or relief they may mean something considerably different. The writer's meaning is to a large degree determined by the literary tradition underlying his verbal sense or by the style he sets out to create. Literary style may thus force upon the writer formulas very much in contrast to the work of art he has either in mind or else before his eye. This dichotomy between word and work may take one of several forms. A writer may stand within the literary tradition of an art terminology echoing a far livelier and more grandiose artistic situation than the buildings or paintings he sets out to describe; almost any Western *ekphrasis* of Early Christian times exemplifies this type of dichotomy. Or the literary terminology may be underdeveloped and unfit to keep pace with the work of art it refers to, as frequently happened throughout the Middle Ages. Or, again, the writer, about to create a new literary language and terminology, will adapt it to a conceptual and visual image far in advance of the reality of works surrounding him; as a result his descriptions become postulates. Yet these postulates go so far beyond the real situation that they achieve a generality that is applicable to any work of art as long as it shares at least some features with the postulate. Hence, the impression upon second reading of *Della Pittura* may well be that of criteria and terms so general as to fit almost any painting or relief of the incipient Renaissance. Yet again this impression would be fallacious.

Alberti did not think along lines of a simple equation between his postulates and a specific work of art. Nor is his terminology vague, though his terms, being literary, reveal their meaning only when found in combinations which delimit and thus clarify the postulate. His demand for richness of composition, on one hand, and for sparing reticence, on the other, are not contradictory criteria: they represent poles, the one dictated by Alberti's taste for variety, the other by his insistence on dignity. Between these poles extends a scale of possibilities, and along this scale Alberti expected the

artist to find a place appropriate to the character of his subject. But no matter what solution was chosen, the composition should be well arranged. Comparably, movement, as prescribed by Alberti, takes on concrete meaning when it is further defined by such qualifying terms as dignity and gracefulness. Movement, dignity, and grace mark, as it were, the corners of a triangle and within this area, the artist is asked to find his own solution. Alberti's postulates, then, do not refer to specific works of art. But they do establish boundaries beyond which the artist should not trespass. No doubt these boundaries were laid down with an eye to groups of artists and of works of art, both ancient and modern, that had received Alberti's approval. This does not mean that he gave his approval unconditionally, but rather that he confined it to the aesthetic limits he had set up, these limits being at the same time the grounds for his criticism.

If the premise is accepted that Alberti's principles grew out of his endorsement of certain criteria based on contemporary art, his relation to the painters and sculptors of his Florentine circle can perhaps be established. Certainly the simplicity of Masaccio's sparing compositions and the noble dignity of his figures were bound to appeal to him; yet at the same time they lacked the qualities of movement and of gracefulness. Again, Alberti would have found such dignity in the compositions and grandeur of some of Donatello's reliefs, such as the *Giving of the Keys*. In any event, one would expect Alberti to have appreciated highly the art of the man whom he called "our very dear friend Donato." But this esteem for Donatello's art does not by any means imply unqualified approval of his entire *œuvre*, and perhaps just the intimate character of their relationship allowed for a good deal of frank criticism. In discussing perspective construction Alberti refers to an erroneous shortcut which corresponds nearly to the method employed by Donatello in the Siena relief.[58] In the second book he objects at the same time to movements "too bold . . . [so that] in one figure one sees at the same time the chest and the small of the back; a thing impossible and improbable";[59] or again, he complains about those "who make their figures look like fencers and clowns, *schermidori et istrioni*, without any pictorial dignity [and] . . . think they deserve praise because they have heard that those figures are lively which throw about every single limb." True, he says, "a runner must agitate his hands as well as his feet; but I want a philosopher in discussion to show far more restraint than fencing ability (*l'arte di schermire*)."[60] Filarete, twenty years later interpreted these remarks as a specific dig at Donatello. He warned explicitly against "making apostles look like *schermidori* as did Donatello in S. Lorenzo . . . in the sacristy, in the bronze doors."[61] Given his frequent misgivings about Donatello, his may well be an *ex post facto* interpretation. Indeed, if the sacristy doors really date as late as 1440, Alberti could not have had them in mind in 1435, when writing his barb against philosophers looking like clowns and fencers. But possibly the date of Donatello's sacristy doors should be pushed back to the thirties, and then Alberti might have known them, at least in a wax model. Any-

[58] Alberti, bibl. 8, p. 81; see also above, p. 244. [59] *ibid.*, p. 127.

[60] *ibid.*, pp. 127, 113; the term philosopher was generally applied throughout the Renaissance to apostles, evangelists, and church fathers, see e.g. Traversari, bibl. 526, II, col. 4 (Lib. I, ep. 1).

[61] Filarete, bibl. 158, p. 123.

way, his criticism applies to many a work by Donatello where figures show their chests and backs at one and the same time as for instance in the Siena Dance of Salome. In brief, Alberti's admiration for Donatello cannot have been entirely unmixed. His insistence on graceful, suave movements was bound to clash with Donatello's vehemence and dramatic sense. Where he grew violent, Donatello placed himself outside the boundaries of dignity and gracefulness, and thus incurred the criticism of his "very good friend" Leone Battista.

The panels of the Gates of Paradise, in their great majority seem to fall convincingly within the aesthetic boundaries set by Alberti in his *Treatise on Painting*. The compositions move from sparing reticence to rich and lively variety; nothing could be more dignified and impressive than the few figures that quietly enact the scenes of the *Isaac*, nothing more vivacious and varied than the crowds in the *Moses*. In the *Isaac* and *Joseph* the figures move through the planes of a relief that is measurable: depth, width and height were determined within the frame of Alberti's precepts, by the construction of a consistent linear perspective and by architectural settings. The figures move gracefully, elegantly, and melodiously. Young girls walk lightly and sway in delicate postures, boys run briskly and step gayly; men stand in quiet dignity: the four women in the *Isaac* panel, the young Jacob and Esau, the patriarch Isaac, offer so many examples. A soft breeze in the Creation of Adam presses the garments of the angels hovering behind the Lord against one side of their bodies and lifts them high on the other. These billowing draperies appear all through the panels, in the group of Noah's family leaving the Ark, in the four women in the *Isaac*, in the dancing maiden far back in the *Moses*, among the prophetesses on the frame (Pls. 125a, 129a, 130a). The folds of a garment spread out like branches from a tree trunk and no part of the drapery remains motionless. Movements are expressions of emotions: in the discovery of the goblet, Joseph's brethren manifest surprise, sorrow, rage, not so much in their facial expressions as by their gestures and poses. Adam in the Expulsion, the warrior below Mount Sinai in the *Moses* are frozen in poses of terror. Yet, throughout, these movements are not merely agitated. They are suave, graceful, gentle, and thus present life, the very source of art, corresponding to Alberti's postulates.

Such coincidences between Alberti's theories and Ghiberti's panels abound. Yet the more closely their relationship is scrutinized, the more complex the question grows. Alberti, one recalls, had come to Florence in the spring or early summer of 1434 to stay for ten odd years. The *Treatise on Painting* was published in 1435 and 1436 respectively; the panels of the Gates of Paradise were begun in or shortly before 1430, and all of them had been cast by the spring of 1437. On first consideration, then, it would seem valid to conclude that Alberti in his treatise merely codified what he saw executed in Ghiberti's panels and in the work of the other artists of the same Florentine circle.[62] But this conclusion would be rash and lopsided. In the first place, Alberti certainly started pondering, formulating and discussing his

[62] Clark (bibl. 102) seems to lean, at least by implication, somewhat towards viewing Alberti as a codifier of practices for some time in use among Florentine artists. Explicitly he limits Alberti's impact on his contemporaries to Uccello and Piero della Francesca.

theories long before putting them to paper.[63] Secondly, the reliefs which seem closest to Alberti's postulates, the *Isaac*, for instance, were probably executed at exactly the time Alberti wrote his treatise. Could then a reverse dependence, of Ghiberti's panels on Alberti's theories, be assumed?

We have been moving into the realm of hypotheses and might as well go further. The relationship between Ghiberti and Alberti, it would seem, involves an intricate give and take, with the positions of giver and receiver shifting as points of contact change. Only Alberti could have acquainted Ghiberti with the new procedure of constructing pictorial space by means of a consistent scientific linear perspective, designed for the actions of figures. No doubt either but that Ghiberti became acquainted with this new perspective formula at approximately the time of Alberti's arrival in Florence. But if, indeed, Alberti passed on to Ghiberti his solution for linear perspective, it must be recalled that the area of contact here is of a technical nature. The situation in this case, need not therefore be symptomatic of the overall relationship between the young humanist and the old master. If the architectural settings in these same panels foretell the purist classicism of Alberti's later theories, the give and take is more clearly manifest.

The most essential area of contact, in any event, is that of the interpretation of composition, narrative, design of draperies, movement of bodies—in brief, the concept of animated movement as the source of both life and art. Here, the correspondence between Ghiberti's panels and Alberti's postulates becomes more evident, and their mutual give and take most intricate. Ghiberti, since the late twenties, had gradually evolved a world filled with slender and agile figures, nude or clad in billowing transparent draperies, moving quickly yet gently and with dignity through the picture space: the angels on the shrine for S. Maria degli Angeli between 1425 and 1428, the Eve and the angelic host in the *Genesis* panel in the early thirties. In the *Noah* these figures are gathered into intelligible groups; in the *Isaac*, around 1435, they are incorporated into a space, made measurable by architectural settings. It is a world similar to that evoked by Alberti in 1435 on which he based his fundamental postulates of art as life and hence, as movement, animated, yet dignified and gentle. Again, the concept of a measurable pictorial relief, so essential to Ghiberti from the mid-thirties on, appears to form the very core of Alberti's *Treatise on Painting*. Obviously, by the time he formulated these tenets, Alberti was well acquainted with Ghiberti's work: possibly with the Siena reliefs, certainly with the shrine at S. Maria degli Angeli and finally with the panels of the Gates of Paradise, insofar as they had been modeled in wax. Yet it is equally clear that Alberti did not formulate his postulates on the basis of Ghiberti's designs. The new type of pictorial relief, which he saw perfected in the hands of Ghiberti and Donatello, may well have impressed him, as had the new type of painting he had come to know in the murals of Masaccio. But the link is not entirely direct between his postulate of gentle animated movement and those figures of Ghiberti embodying the same concept.

What seems to tie them together is, in the first place, a nearly identical interpreta-

[63] Grayson, bibl. 192 *passim*.

tion of ancient art, and a shared belief in antiquity as the key to representing life and movement. Ghiberti, one recalls, had been evolving a new style since the twenties. His new concept of art appears to have been shaped by new contacts with Roman monuments and by a new interpretation of Roman art presumably during a visit to Rome in 1429. His knowledge of antiquity broadened, and, within this wider range, he focused on new categories of monuments. His understanding of the antique grew deeper and more articulate and gained consistency. He selected prototypes, created variations on antique themes and at times invented freely in the antique manner. As one might expect, his approach throughout is based on visual experience.

Alberti's image of the antique, surprisingly close though it is to Ghiberti's, is based to a large extent on his readings of Greek and Roman authors. Their formulations were fundamental in conditioning him to a visual image of the art of antiquity. Such sources were Seneca's description of the Three Graces as "holding hands, smiling and draped in loose, transparent garments";[64] and possibly the fast-moving figures in the *Imagines* of Philostratus. Yet these literary *concetti* in Alberti's mind took on definite visual forms, and this they could do only because the art of antiquity had become for him an essential visual experience. At first reading, the pages of *Della Pittura* do not seem to bear out the importance of monuments in the shaping of Alberti's image of antiquity. Following a humanist tradition, he cites by name or by implication dozens of ancient works of art which he knew through the ancient authors; but he mentions only one work of ancient art he had actually seen, the Meleager relief. In the same way in *De Re Aedificatoria* he quotes extensively from ancient descriptions of buildings, but refers lightly, in passing, to monuments he actually knew. But despite his tacitness he knew these buildings practically stone for stone; humanist writing in Alberti is permeated by a new visual force. He had looked intently at the Meleager and he had seen that a total lack of movement intimates death and therefore, movement, life. He fails to mention other sarcophagi; but they must have taught him that transparent and billowing draperies, wind-blown veils, moving twigs, graceful movements reflect life, and that gracefulness and movement are determinant qualities in ancient art. But he knew also, and again both from his reading and from visual experience, that ancient art is marked by other, equally determinant qualities: dignity, propriety, monumentality. As a result, his picture of antiquity encompasses a concept that corresponds to Ghiberti's, but is less one-sided. At the same time, man of the pen that he was, Alberti was able to put into words his visual experience.

Ghiberti's and Alberti's concepts of ancient art are, all told, so close in the thirties that it is hard to assume a completely independent development for each. One would much rather think of an exchange of ideas at an early point, that is before Alberti definitely formulated his postulates in the *Treatise on Painting* and before Ghiberti fully evolved his style *all'antica* in the Gates of Paradise. Such an assumption rests, of course, on the hypothesis of an encounter in Rome, presumably in 1429. At that time Ghiberti would have been ready to open the eyes of the *literateur* Alberti to the

[64] Alberti, bibl. 8, pp. 145f, and Janitschek's notes *passim*; see also, Warburg, bibl. 545, p. 27 and Salis, bibl. 459, pp. 155ff, 259.

visual qualities of Roman reliefs. He would have been equally ready to absorb the gist of the theories Alberti was beginning to formulate. In an interchange of ideas they would have recreated between them an image of antiquity and thus, at the same time, a new art, which might be termed an art of humanism. This art of humanism had so many features in common for Alberti and Ghiberti that five or six years later in the panels of the Gates of Paradise and in the pages of *Della Pittura*, the common basis is plain.

If this interpretation is valid, the years between 1429 and 1435 were crucial for the relationship between Alberti and the Florentine artists. They certainly were crucial for Ghiberti's life and his art. Indeed, as one tries to reconstruct in broad outlines Ghiberti's development, two periods emerge which clearly mark fundamental changes in his thinking, the first around his fortieth, the second after his fiftieth year. Shortly before 1420, the brilliant young goldsmith, the "Gothic" craftsman and protagonist of the International Style had suddenly come abreast of the *avant-garde* of his native city. Under the impact of antique sculpture and of Donatello's early work he had achieved in the *Saint Matthew* a monumental contribution to the nascent Renaissance, only to turn rapidly toward a more lyrical interpretation of the new style and toward an exploration of the pictorial qualities of shallow relief. At that time he is an attractive, no doubt a significant, but not a decisive figure in the new movement. But the situation changed radically after 1430, when with the panels of the Gates of Paradise, Ghiberti emerges as a key figure, an artist of humanism, destined to shape decisively the art of the Quattrocento. In the *Isaac, Joseph*, and *Solomon* panels he creates a new style, both gentle and monumental: a style carried by lively figures, saturated with the image of antiquity; by compositions built from a multitude of figures and arranged in carefully balanced yet loosely knit groups; by the construction of an intelligible space, based on a mathematically correct linear perspective; by architectural settings of a purist antiquish design, more advanced than anything built at the time.

To be sure, throughout the twenties the new style of the Gates of Paradise seems to cast its shadow ahead. In the Siena *Baptism*, in the Shrine of the Martyrs, figures have turned to slimmer proportions, movements have become livelier, the relief has taken on pictorial qualities, the vocabulary has absorbed elements *all'antica*. But these features are rather casually presented. The new elements are scattered rather than linked one to another by a common denominator, and their appearance leaves one unprepared for the magnitude of the change which marks Ghiberti's work beginning with the side panels of the Zenobius Shrine and the mature panels of the Gates of Paradise beginning with the *Noah*. The scattered features are now absorbed into a unity of style in which all parts are interdependent. They are employed not casually but with the awareness of forming part and parcel of the whole pattern.

This change in Ghiberti's orientation approaches a conversion. It is essentially unforeshadowed in his previous work. It can be explained only by an assumption that powerful new impressions exerted their impact on the artist at this particular juncture and led him within a new framework to reinterpret what had been a loose vo-

cabulary without a common bond. These new impressions are hard to define precisely. But some facts are clear. First, the change starts roughly in 1430. Second, it can be stated without hesitation that none of the works of contemporaries, whether painters or sculptors could have led Ghiberti towards his late style. No painting and no relief in Florence prior to 1430, or for that matter prior to 1435, neither Masaccio's monumental murals, nor Donatello's heroic and dramatic compositions could have imparted to him the inspiration for the panels of the Gates of Paradise. Hence, the impressions which so completely reshaped Ghiberti's art shortly after 1430 must have other roots. Two such sources, closely interlinked, come to mind immediately: the art of ancient Rome, and the new postulates as laid down in *Della Pittura*. In the question of the impact of ancient art on his work at this time, the ground is comparatively safe. Ghiberti had known Roman sculpture before, but by 1430 his repertoire of such works had been enlarged, his taste had become selective; he focused on sarcophagi peopled by figures with quick movements, lively gestures and billowing, flying draperies. "Antique pathos formulas"—to use Warburg's terminology—attracted him and permeated his vocabulary and style to such a degree as to enable him to create figures *all'antica*, hardly distinguishable from the original. These figures are embedded in clear compositions; actions are intelligible, narrative rich yet reticent. Measurable space is produced by linear perspective construction and supported by visionary architectural settings. In brief, Ghiberti evolves an art, new, revolutionary within his development and coincidental to a surprising degree with the concepts of the nascent art criticism of Quattrocento humanism.

The links between Ghiberti and humanist contemporaries, and Ghiberti's humanist approach to art pose problems of some difficulty. But this much is certain. After 1430 he not only aimed at creating an art to rival that of antiquity, but began to cast himself in the role of a humanist of sorts. He wanted to emulate the authors of old in the *Commentarii*; he worked out a system of olympiads *all'antica*; and, in preparation for his literary efforts he sought to acquaint himself with ancient literature, seeking in January 1430 to negotiate the loan of Aurispa's Athenaios manuscript.

The date, early 1430, is important. It coincides almost exactly with the emergence of his new style. Also it follows immediately upon what we believe to be the date of Ghiberti's second visit to Rome, "in the 440th olympiad." There can be no doubt that by 1430 he had been exposed to humanist thought. Certainly he was then acquainted with the humanists of Florence, with Bruni, Niccoli, Traversari. But apparently at that time the Florentine humanists did not hold artists and their endeavors in high esteem. In Roman humanist circles, on the other hand, as represented by Poggio and presumably by Alberti, a different spirit prevailed. In fact Alberti looms large in any attempt to trace the forces which may have led Ghiberti into his varied yet closely related humanist endeavors, from his reinterpretation of ancient art to his identification of life, art, and movement, from his construction of a linear perspective to his visions of a never-never architecture *all'antica* and his literary humanist ambitions. The beginnings of all these endeavors of Ghiberti's fall within the time of his Roman sojourn when he presumably became acquainted with Alberti's

nascent theories on art, ancient and modern, and began to see himself as a humanist artist of the type Alberti was to postulate in the third book of *Della Pittura*.

To be sure, all this must remain a working hypothesis. In 1429 Alberti had not yet formulated in writing any of his theories on art. His thoughts, *avant la lettre* can at best be guessed at, and conversations with him are impossible to trace. Thus it is only natural that an exchange of ideas between Ghiberti, the artist with humanist ambitions, and Alberti, the humanist with artistic aspirations can perhaps be supposed, but not definitely established.

Still, the conjunction of Alberti's theories and Ghiberti's late art is based on more than supposition: Florentine artists of a younger generation seem to have viewed Ghiberti's work and Alberti's theories as complementing each other. Needless to say, they looked to Ghiberti's panels as a constant source of inspiration. It is not very significant that time and again younger artists appear to have purloined motifs and entire figures from the vocabulary of the old master. To be sure, an angel in one of Gozzoli's murals in Palazzo Medici resembles Ghiberti's beautiful prophetess (Pl. 125a; App. A 54). Piero Pollaiuolo's Hercules from the Hydra panel, until 1944 in the Uffizi, recalls the Adam from Ghiberti's Expulsion (Pl. 87; App. A 26), Botticelli's lying Venus in London, the Puarphera on the frame of the Gates of Paradise (Pl. 123b; App. A 61). But these resemblances might well be accounted for by their derivation from the same antique prototypes Ghiberti had exploited, and the question is only whether the masters of the later Quattrocento drew directly on these or on Lorenzo's portfolios still extant in Vittorio Ghiberti's workshop. Only occasionally is a composition drawn beyond doubt directly from Ghiberti. In Botticelli's *Sacrifice of the Leper* in the Sistine Chapel, a woman carrying a fagot on her head, is preceded by a child carrying fruits in his lifted skirt, his head turned towards the woman, and this particular combination, while foreign to Roman art, finds its exact prototype in the *Joseph* (Pl. 99; App. A 43).

But Ghiberti's late style represented more to the masters of the latter Quattrocento than a source from which to draw motifs, figures, or groups. Its impact reaches the very core of their art. Ghiberti's highly individual interpretation of the Renaissance, the lyrical mood of his narrative, his gentle facial types, the graceful movements of his figures, their elegant linear draperies are carried on in the fifties in the art of Agostino di Duccio and Desiderio da Settignano, to be taken up again, by Botticelli. The slender proportions of the human body as they prevail throughout the second half of the fifteenth century, with the total height of the figure averaging between eight and nine heads, are first seen in the figures of the Gates of Paradise. Again these panels, rather than Donatello's reliefs, first embody the elegance and agility which later marks the paintings of Botticelli, of Filippino, of the Polloaiuolo's, the reliefs of Agostino di Duccio and Desiderio, the sculptures of Verrocchio. From the Gates of Paradise stem the billowing flowing garments, the windblown tresses and curls which in the second half of the century are common features of painters and sculptors in Florence, from Gozzoli to Agostino di Duccio and Verrocchio.

No doubt, as suggested many years ago, Alberti's postulates as formulated in

Della Pittura were decisive in shaping the "pathos style" of the second and third Quattrocento generations. But it would seem that alongside Alberti, the writer, stands Ghiberti, the sculptor, as a key figure in the formation of that style. This at least is what some circles near the end of the century appear to have sensed. They saw in his work, if nothing else, an illustration of what they accepted as Alberti's ideas. When Botticelli designed the Three Graces in the *Primavera*, he took his clue from the description of that group "holding hands, smiling and draped in loose, transparent garments," as Alberti had taken it from Seneca. But Botticelli visualized this group in the image of the three main figures in Ghiberti's Visiting Women in the *Isaac* (Pl. 97a), one lightly approaching from the left, one standing quietly to the right, the third seen from the back, lifting her heel in a swaying stance. Botticelli apparently saw in the Ghiberti group a visual translation of Alberti's literary *concetto*, or at least something very akin to it. Perhaps one can go further and suggest that the rich but clear compositions, distributed through a measurable space and supported by architectural settings *all'antica*, the lively figures and their windblown garments, the decorous, but eloquent movements and figures which Alberti postulated in *Della Pittura* and which Ghiberti executed in the Gates of Paradise, jointly become a fountainhead of art for the second half of the Quattrocento; that in brief to that later generation Ghiberti and Alberti represented, the one the literary, the other the visual expression of a common ideal.

APPENDIX A

HANDLIST OF ANTIQUES

THIS appendix attempts to establish a handlist of motifs and types from works of ancient art upon which Ghiberti drew. In drafting this list we have imposed on ourselves several limitations:

(1). We have tried to focus the list on such works of antiquity which, either certainly or with great probability, were known in the fifteenth century and were accessible to Ghiberti. These include a few sculptures in the round such as those then assembled in and near the Lateran or otherwise scattered in Rome.[1] They include obviously sculptures still *in situ* on Roman monuments, triumphal arches and the like. But again these are comparatively few, and among them we have come to exclude the Columns of Trajan and of Marcus Aurelius. They provide no prototypes for Ghiberti's work that do not occur better on sarcophagi and, indeed, it is unlikely that the majority of their reliefs could be seen in Ghiberti's time.[2] Most important among works of ancient art known to the fifteenth century seem to have been the sarcophagi then extant in or near the churches of Rome, Pisa, Florence, and elsewhere and re-used, either as altars or tombs, during the Middle Ages or in the fifteenth century. Isa Ragusa (bibl. 434) has assembled a most valuable, though somewhat incomplete, list of such sarcophagi. To this same general group belong the few ancient sarcophagi and other reliefs walled up or otherwise inserted for decorative purposes in medieval churches or known to have been brought to such churches prior to Ghiberti's time.

Few of these sarcophagi remain *in situ* and,

indeed, many have been destroyed. But this lacuna is bridged to a large degree by drawings made from such monuments in the course of the fifteenth and sixteenth centuries. We have thus made extensive use of these drawings. The best known among fifteenth century drawings after Roman sculptures are those by Pisanello scattered through European libraries and print rooms (Degenhart, bibl. 122 and 120), a group of anonymous drawings in the Ambrosiana (Vincenzi, bibl. 539; Degenhart, bibl. 120), a number of drawings attributed to Michele di Giovanni di Bartolo (Louvre, Cabinet des Estampes; Degenhart, bibl. 120), finally the sketchbooks of Francesco di Giorgio scattered through various collections and still insufficiently published (Weller, bibl. 549) and the Codex Escurialensis (Egger, bibl. 139). Among the numerous sixteenth century drawings of Roman sculptures our most important source is the sketchbook in the collection of Prince Wolfegg (Castle Wolfegg, Wuerttemberg), dated prior to 1516 and possibly as early as 1503, described and analyzed by Robert (bibl. 449). As stressed by Robert, the unique value of this sketchbook for our knowledge of antique sculpture known to the Renaissance lies in its almost exclusive limitation to sarcophagi still sheltered in Roman churches in the early sixteenth century, as is apparent from the draftsman's notes regarding their location. Since transfers of such works to churches are rare after 1450 it is reasonable to assume that they had stood there for centuries.[3]

The Codex Coburgensis (Coburg, Bavaria, Castle, Library; Matz, bibl. 310) of *ca.* 1550

[1] Michaelis, bibl. 328.

[2] The earliest drawings from the columns known to us date from the end of the fifteenth or the beginning of the sixteenth century. Extensive sketches could be made only at that time when an apparatus was constructed by which the artist could be hauled up to see the upper reliefs (Strong, bibl. 510; Paribeni, bibl. 390).

Meyer-Weinschel's almost exclusive use of the Column of Trajan for Ghiberti's prototypes (bibl. 327) is thus even methodologically untenable.

[3] We are greatly indebted for generous advice and assistance given during the preparation of this list to Mrs. Phyllis Pray Bober, who is in charge of the *Census of Antique Works of Art known to the Renaissance*, sponsored by the Institute of Fine Arts of New York University and the Warburg Institute, London. As part of this project, Mrs. Bober is preparing an edition of the Aspertini sketchbook in London, British Museum, 1898-11-23. The early date of the Wolfegg sketchbook

was likewise suggested by Mrs. Bober. Mrs. Bober's information will be referred to as "Mrs. Bober-Census." We are likewise indebted to Mr. Cornelius Vermeule, Bryn Mawr College, who has prepared a catalogue, as yet unpublished, of the Dal Pozzo drawings at Windsor, Royal Library, and has generously made available both his catalogue and his photographs. The numbers of his catalogue correspond to the new Windsor numbers, and will be referred to as "Vermeule-Catalogue." We are most grateful also to the Warburg Institute for kindly providing us with photographs of the Wolfegg and Coburg sketchbooks, to the German Archeological Institute in Rome for their help in procuring photographs of Roman sarcophagi in Italy, and to Mr. Bernard Ashmole of the British Museum and Mrs. V. Verhoogen of the Musées Royaux in Brussels for providing us with photographs of the sarcophagus of the Ince Blundell Hall and the Brussels sarcophagus respectively.

and the Codex Pighianus (Berlin, Staatsbibliothek, at present Tübingen, Universitaetsbibliothek; Jahn, bibl. 229) of approximately the same period, are of lesser importance from our point of view. The far richer material which they reproduce no longer necessarily reflects reliefs preserved *in situ* or in churches and hence long known, but evidently largely the new Roman collections of the period, including both material transferred into them from churches, and the numerous finds made during the first half of the sixteenth century. Moreover these two sketchbooks contain no captions giving the location of the antiques, and the identification of the monuments has been laboriously sorted out by Matz and Jahn.

We have by and large refrained from using drawings or illustrations made after 1550. Exceptions are Dal Pozzo's Windsor collection of drawings and Gori's engravings (bibl. 191) after sarcophagi in Florence. Among the sarcophagi in the Camposanto in Pisa, even though they are known from Martini's engravings (bibl. 307) as a rule only those dated by medieval inscriptions, or otherwise known in the fifteenth century, have been used.

On the other hand it seemed safe to assume that Ghiberti was acquainted with works of ancient art which are reflected in the work of his contemporaries such as Donatello. Conversely reflections of such works in the second half of the fifteenth century have been excluded by and large from this list.

Since our objective was to build up a list of monuments known to Ghiberti we have concentrated primarily on the provenance of the objects and on the time when they are first recorded. We have referred to additional recordings of these objects only when they help to establish restorations relative to our problem. We have intentionally excluded the question of dating the antique sculptures.

(2). We have attempted equally to limit ourselves to specific motifs or types which Ghiberti borrowed from ancient art, and we hope thus to have avoided loose comparisons. Within this framework the comparison of details becomes of primary importance. To give one example for many: the figure of a servant girl accompanying the bride in a wedding scene is frequent on Roman sarcophagi; but the details of the dress held together on her shoulder and her hand lifting her skirt are rare and occur in only one example definitely known to the fifteenth century (see below, item 5).

(3). This attempt to be specific encounters several major obstacles.

For one, Ghiberti rarely, and never in his later years, copied verbatim an antique motif. Hence at times it is difficult to recognize the antique prototype in Ghiberti's variant. To some degree this difficulty is offset by Ghiberti's habit of distributing the elements of the prototype over different variants. The evidence, thus, is upheld by mutual buttressing.

Second, antique monuments, particularly of the class of sarcophagi, are apt, as is well known, to be stereotype. Hence exactly the same or nearly the same sequence of scenes, composition, and style may occur on several sarcophagi. Likewise, figures and motifs are often stereotype and used for different iconographic types; the same figure may appear as a muse, a *moira*, or a victory. Hence, if the motif occurs on several monuments known to have existed in the fifteenth century, the specific model used by Ghiberti can be identified only under particularly fortunate conditions. This is the case, for instance, if Ghiberti draws on a number of figures or heads from the same ancient monument, so that again the mutual buttressing of elements leads to a specific source.

Third, a number of antique monuments have demonstrably disappeared since the fifteenth century without having left any trace in fifteenth and sixteenth century drawings; an equally great number must be presumed to have been lost. For this reason we have departed in some rare instances from our guiding principle of referring primarily to monuments known to have existed in the fifteenth century: when a type or motif in Ghiberti's work very clearly reflects a work of ancient art known to us but unrecorded in the fifteenth century or proved to have been found only later, we had to assume either a missing record or the existence of an identical prototype now lost. As a result, what seem to be Ghiberti's very free variants on antique models may also well be derived from a much closer prototype either unrecorded or, indeed, unknown.

Whenever, on any grounds, reasonable doubts preclude the identification of a clearly antique motif with a specific prototype, we have thought it best to list it as "unidentified," hoping for future clarification.

The handlist, then, is decidedly of a preliminary nature. No doubt, it can and will be enlarged as time goes on. Nor is there any doubt that the number of antiques known to Ghiberti far exceeded those from which he drew individual motifs. Despite these shortcomings, the value of the list in its present state seems to us twofold, in that it presents both a preliminary contribution towards a

census of antique works of art known to the early Renaissance, and a clue to Ghiberti's selective principles in approaching antiquity and to his image of ancient art.

COMPETITION RELIEF

1. *Isaac* (Pls. 2b, 26a). Derived from an antique statue, probably a torso. Exact prototype unidentified. Possibly close to the kneeling son of Niobe, Rome, Capitoline Museum (Jones, bibl. 234, pp. 121f, pl. 12) (Fig. 102).

Isaac kneels, his right shoulder drawn upward and thrust forward, his right hip protruding, his left shoulder sloping down. A nearly continuous curve runs from his right armpit to the knee, with only a slight nick at the waist; at his left side a sharp indentation at the waist breaks the line. The body is adolescent, the yet undeveloped muscles built up from small planes.

In general terms the figure recalls Lysippan or Skopasian sculptures and one is inclined to think of a prisoner with his arms tied behind his back. But none of those known to us combines the uninterrupted curve of the body on one side and the double thrust of the shoulder with the fourth century features of the adolescent body.

The outline with the continuous curve on one side and the broken one on the other corresponds in reverse to the figure of the kneeling son of Niobe in the Capitoline collection. The figure is badly restored. Originally it was a torso, with head, right hand, right leg, and left arm missing (information kindly confirmed by Dr. Pietrangeli). Both the outline of the upper part and the pose of the left thigh call Ghiberti's *Isaac* to mind. The style of the Niobid, however, lacks the sculptural treatment in small planes found in Isaac's body.

The provenance of the Niobid is far from certain. It entered the Capitoline collection under Pope Clement XII before 1750 (Jones, *loc.cit.*), though not from the Albani collection, as was the case with many other items (see inventory as published in Jones, bibl. 234, pp. 384ff, information kindly confirmed by Dr. Pietrangeli). Nothing seems to be known of its earlier history.

Of the two other Niobid statues of the same type in the Uffizi in Florence, one (Duetschke, bibl. 136, III, no. 268) was in the Valle-Rustici collection about 1550 (Aldrovrandi, bibl. 16, p. 56; Mandowsky, bibl. 292, p. 262, note 16); the other one (Duetschke, bibl. 136, III, no. 269) was found together with the rest of the group in 1583. But neither of the two Floren-

tine statues shows the strong curve of the right side that marks the Capitoline Niobid.

With the evidence available, the relationship of the Capitoline Niobid to Ghiberti's *Isaac* is possible, but it remains hypothetical at best.

Schlosser had suggested as Ghiberti's model for the *Isaac* a satyr torso, in the Uffizi. Since this torso was in the possession of the Gaddi family since the mid-sixteenth century, Schlosser surmised that it had been acquired by Monsignor Giovanni Gaddi, who in 1550 had bought some antiques from the collection of Ghiberti's great-grandson and that hence it had belonged to Lorenzo Ghiberti and, indeed, to his stepfather. But this theory cannot be proved and certainly the torso is different from the *Isaac* in outline as well as in the massive treatment of the muscles (Schlosser, bibl. 477, pp. 141ff). Another suggestion (Gruenwald, bibl. 195, pp. 155ff) referring the *Isaac* to the Ilioneus in Munich need not be discussed. Recently Van Essen (bibl. 141) has compared the *Isaac* with a figure from an Etruscan ashurn.

2. *Group of two servants* (Pl. 2a). Derived from a Pelops sarcophagus of the type now in Brussels (Fig. 103), (Robert, bibl. 448, III, 3, no. 329).

Of the two servants, one is seen from the back, clad in a tunic and short mantle, standing on his left foot, the right one raised, as if walking. Only a small part of his face is shown in profile; the other servant, visible from the shoulder up, is seen in three-quarter view.

The group corresponds to that at the left edge of the Brussels sarcophagus, representing Pelops entering Oenomaos' palace (see also below, item 47). Pelops, seen from the back in a walking stance identical with that of Ghiberti's servant, differs from that latter only in his antique costume. The youthful companion looks out from Oenomaos' palace, much as Ghiberti's second servant from the cave.

The history of the Brussels sarcophagus is unknown prior to 1840. Either it or an identical piece, now lost, must have been known to Ghiberti.

NORTH DOOR

NATIVITY

3. *Shepherd, left hand* (Pl. 27). Derived from the seated Phoebus, Phaeton sarcophagus, Florence, Museo dell' Opera di S. Maria del Fiore (Fig. 104), (Ragusa, bibl. 434, p. 62, no. 176).

The shepherd leans back slightly, his torso nude, his right upper arm and shoulder cov-

ered by the cloak, his right hand pointing in an awkward gesture towards the angel; his head turned away to the right contrasts sharply with the pose of the arm and leg. The upper part of his body, thus is apparently an insert. It recalls closely the half-reclining figure of Phoebus in the upper left corner of the Phaeton sarcophagus. The god's left arm has been switched to the right, including the covering cloak. Otherwise, the pose, including even the drapery curving along to the right side, is extremely close. The god's head is too badly damaged for comparison.

The Phaeton sarcophagus was re-used in the cathedral, its relief turned to the wall, for the burial of Piero Farnese (d.1367). The first projects for erecting his tomb date from 1395 (Paatz, bibl. 375, III, pp. 371f, and note 260), although the date of final execution is unknown. Ghiberti as a young man could still have seen the Phaeton relief.

EXPULSION

4. *Fallen youth* (Pl. 35). Possibly derived from a fallen hunter from a sarcophagus with the Wounding of Hippolytus. (The correct identification of the subject was kindly suggested by Prof. B. Ashmole.) Closest among the extant examples is the sarcophagus at Ince Blundell Hall (Fig. 105), early history not known. (Robert, bibl. 448, III, 2, 154; Ashmole, bibl. 26, no. 246, pl. 49.)

The fallen hunter lies half upright, naked, supporting himself on the ground with his right arm strongly bent. The front leg (restored from above the knee down) was slightly flexed, the other not visible, the left arm raised, grasping the chlamys to head off the boar.

Ghiberti's fallen youth is reversed in pose and his left leg more strongly flexed. His raised right arm, in the position of the fingers still indicating the grasp on the chlamys, and his nude body barely covered by the little mantle, strikingly recall the antique prototype.

ENTRY

5. *Woman, right edge* (Pl. 41). Slave girl from right edge of Marriage Ceremony, most likely from so-called Fieschi sarcophagus, S. Lorenzo f.l.m. in Rome (Fig. 106), re-used for the burial of Cardinal Guglielmo di Lavagna in 1256 (Matz-Duhn, bibl. 311, II, no. 3090; Ragusa, bibl. 434, pp. 160ff, no. 80).

The pose of the girl, bent forward and sideward, the bare arm, the hand lifting the skirt, the chiton, belted high below the breasts, the hair held by a fillet, are nearly identical with

the girl on the S. Lorenzo sarcophagus. In all other examples of Roman marriage scenes traceable to at least the sixteenth century, e.g. Mantua, Palazzo Ducale, no. 186 (Duetschke, bibl. 136, IV, no. 643); Florence, Uffizi (*ibid.*, III, no. 62); Florence, Rinuccini Collection, now lost (Gori, bibl. 191, III, pl. XXIV, and Duetschke, bibl. 136, II, no. 316), the dress of the girl slips from her shoulder, a piece of drapery crosses her arm and her hand touches the arm of the bride, instead of lifting her own dress.

PILATE

6. *Group around throne* (Pl. 48). Variation on the *congiarium* or *liberalitas augusti*.

The composition, showing Pilate enthroned obliquely, the page pouring water, the Pharisees in front, Christ and his guard in the rear at the foot of the low dais, recall the traditional representation of Roman ceremonial scenes of the emperor's largesse: enthroned, the emperor is occasionally accompanied by an assistant or a goddess standing on or at the foot of the dais, and a group of citizens in front. At times an architectural setting fills the background as in Ghiberti's panel. The Roman type appears frequently on coins (e.g., Mattingly, bibl. 309, I, p. 138, pl. 42, 2) and occasionally on reliefs, such as the Sacchetti relief (Strong, bibl. 509, II, p. 144, fig. 475; Hamberg, bibl. 205, pp. 32ff).

FRAME

7. *Elderly prophetess* (Pl. 62a). Head of nurse, Phaedra sarcophagus, Pisa, Camposanto (Fig. 109), (Lasinio, bibl. 266, pl. LXXIII; Duetschke, bibl. 136, I, no. 24; Papini, bibl. 389, no. 113; Robert, bibl. 448, III, 2, no. 164; Ragusa, bibl. 434, pp. 97f, no. 39).

Re-used for the burial of Beatrix of Tuscany in 1076 (inscription) it was frequently used as a model from the time of Niccolo Pisano.

The deeply lined face, the profile view, the kerchief of Ghiberti's prophetess and of the nurse are identical. While the type is frequent on Roman sarcophagi, the exact resemblance, the fame of the Phaedra sarcophagus and Ghiberti's frequent use of it permit direct identification.

See items 8, 9, 10.

8. *Youthful prophet* (Pl. 63b). Head of standing Hippolytus, Phaedra sarcophagus, Pisa, Camposanto (Fig. 110).

The narrow bony head with the straight nose, protruding cheekbones, deepset eyes, and

short, curly, disarranged hair of this prophet corresponds closely to that of Hippolytus.

See items 7, 9, 10.

9. *Prophetess* (Pl. 58a). Head of slave girl above and behind Phaedra, Phaedra sarcophagus, Pisa, Camposanto (Fig. 111).

The young face, seen in three-quarter view, looking upward, the hair parted in the middle, soft waves encircling a fillet, the slightly parted, open mouth and soft chin correspond to the girl behind Phaedra.

See items 7, 8, 10.

10. *Prophet with flying hair* (Pl. 62b). Probably derived from the companion of Hippolytus on horseback, Phaedra sarcophagus, Pisa, Camposanto (Fig. 112).

The type with broad face and bold features in general terms recalls presumed portraits of Alexander the Great and their frequent derivatives.

The companion of Hippolytus on the Phaedra sarcophagus belongs to such reflections. Given the frequent use Ghiberti made of this sarcophagus, the identification of this prophet with the companion's head is likely, even though the damaged state of the latter makes it impossible to be definite.

See items 7, 8, 9.

11. *Prophet* (Pl. 67). Caesar portrait, specific prototype not identified.

The long face, furrowed forehead, strong brows, straight nose, creases in the corner of the mouth and cheeks of Ghiberti's prophet, as well as the garment, point to a bust or full-sized figure of Caesar (Boehringer, bibl. 61, *passim*; Curtius, bibl. 111, *passim*) in military dress with *paludamentum* and *fibula*. In particular, the features are close to the Camposanto type, so called after a portrait in Pisa (Curtius, bibl. 111, pp. 202ff; Vessberg, bibl. 537, pp. 138ff), with long face and carefully arranged, full hair. Among the busts of this type again, Ghiberti's prophet is closest to two, one in Florence, Palazzo Pitti (Fig. 107), (Curtius, bibl. 110, fig. 4; Arndt-Amelung, bibl. 24, nos. 234f), the other in the Vatican, Museo Chiaramonti (Curtius, bibl. 111, p. 218, pls. 49ff; Amelung, bibl. 20, I, p. 376, no. 107). The Pitti portrait is severely restored (nose, lips, chin); the military bust is probably second half of the fifteenth century (the latter information kindly supplied by Mr. M. Weinberger). That it was known in the later fifteenth century is proved, however, by a free variation on the head, possibly from the Rossellino workshop (New York, Metropolitan Museum of Art), (Fig. 108). Indeed it has been suggested, though not quite convincingly, that around

1420 it served as model for the so-called Poggio in the Cathedral of Florence (Francovich, bibl. 166, p. 149, figs. 11, 12). The Chiaramonti bust is equally close in type, but in civilian dress. Nothing seems to be known about its early history. Both heads, however, show the hair swept to the right, rather than to the left as in Ghiberti's prophet.

Ghiberti may have drawn either on the Pitti head or on a lost Caesar bust of similar type.

12. *Prophet* (Pl. 60c). Socrates head, specific prototype unidentified.

Among the three groups of Socrates portraits as distinguished by Bernoulli (bibl. 48), the Ghiberti head is closest to the second type with "ugly expressive features," such as the head in the Vatican, Sala delle Muse, no. 514 (Amelung, bibl. 20, pl. XXII, right).

13. *Bearded and mustachioed prophet* (Pl. 61c). Barbarian, probably from battle sarcophagus, Rome, Villa Borghese (Fig. 113).

The head, seen in profile, is turned upwards. The beaked nose and narrow eyes, the mouth almost disappearing between mustache and beard, the beard tilted slightly upwards, the curly hair, covering the ears, are drawn from the first barbarian at the left in the upper tier of the Borghese sarcophagus (Fig. 115). A similar head appears on the left small side, in the figure of a prisoner of the large battle sarcophagus in Pisa.

The battle sarcophagus, now in Villa Borghese, was in the atrium of St. Peter's around 1500 (Wolfegg, f. 30v, 31; Robert, bibl. 449); the large Pisa battle sarcophagus, now in the Camposanto, was formerly in the abbey of S. Zeno in Pisa, where it had probably stood since the Middle Ages (Lasinio, bibl. 266, pls. CXII, CXIII; Duetschke, bibl. 136, I, no. 60; Papini, bibl. 389, no. 111).

See also, items 14ff.

A relatively large group of prophets' heads on the North Door recall barbarian types frequently found on Roman battle sarcophagi. Among battle sarcophagi known in the fifteenth century, the outstanding examples seem to have been the Borghese and the Pisa sarcophagi. The front of the Pisa sarcophagus is half destroyed and hence identifiable only in the over-all composition and a few heads, among them one of a bearded barbarian. But it is reflected quite closely in Bertoldo di Giovanni's bronze relief in the Bargello (Fig. 114; Bode, bibl. 57, pp. 53ff). With all due precaution it can be stated that some of the heads in that plaque recall strongly some of Ghiberti's prophets. But only one of Ghiberti's prophets (Pl. 59f), finds its counterpart on the Pisa sar-

cophagus alone. One other prophet (Pl. 61c) occurs both in the Pisa relief (the prisoner on the left small side) and in the Borghese example (Fig. 115). Two more (Pl. 64a, b), are found only on the Borghese sarcophagus (Figs. 116, 117). Hence, despite Ghiberti's preference in his earlier years for the Pisa collection, it seems that it was the Borghese sarcophagus, rather than the one in Pisa on which he primarily drew. It is higher in quality, and in the one prototype common to both sarcophagi the Borghese sarcophagus head is closer in detail to Ghiberti's prophet.

Given the stereotype character of the entire group, the possibility should still be considered that Ghiberti knew battle sarcophagi, now lost, which combined both the Pisa and the Borghese types with others. The appearance of several unidentifiable barbarian heads among Ghiberti's prophets suggests that the Pisa and Borghese sarcophagi were not the only ones known to him.

14. *Bearded prophet* (Pl. 64b). Barbarian, probably from battle sarcophagus, Rome, Villa Borghese (Fig. 116).

The head in profile is turned up sharply, similar to that of the naked barbarian right of center in the bottom tier of the Borghese sarcophagus. Also the details are very much alike: deep-set, narrow eyes, beaked nose, lightly waved, stringy strands of hair and long, pointed, and curved beard.

See also items 13 and 15ff.

15. *Prophet with mustache and short goatee* (Pl. 64a). Barbarian from battle sarcophagus, probably the one in Rome, Villa Borghese (Fig. 117).

The Ghiberti head, looking upward, with a goatee and mustachios, is derived in all likelihood in reverse from the second barbarian to the left in the upper tier of the Borghese sarcophagus. The badly damaged mouth and chin of the barbarian preclude a comparison of these parts; but it is evident that he shares with the Ghiberti prophet the similar tilt of the head, the deep-set eyes, the heavy brows, the strong cheekbones and, despite a different handling, the lightly waved, short hair.

See also items 13f, 16f.

16. *Bearded and mustachioed prophet* (Pl. 57e). Barbarian from a battle sarcophagus, possibly a variation in reverse on the prophet, item 13, and thus likewise related to the Borghese sarcophagus.

See items 13ff.

17. *Bearded and turbaned prophet* (Pl. 59f). Barbarian from a battle sarcophagus, perhaps

the one in Pisa, Camposanto, formerly S. Zeno, copied by Bertoldo (Fig. 114).

Ghiberti's prophet is seen in profile, his face sharply molded, his beard long, the curls escaping from under the turban. Thus he recalls closely the barbarian in Bertoldo's variant on the destroyed barbarian left of the rider in the center of the Pisa sarcophagus.

See item 13.

18. *Bearded and turbaned prophet* (Pl. 61e). Barbarian from a battle sarcophagus; specific prototype unidentified.

See item 13.

19. *'Hellenistic' prophet* (Pl. 63a). Barbarian from a battle sarcophagus; specific prototype unidentified.

See item 13.

20. *Bearded and mustachioed prophet* (Pl. 60a). Barbarian from a battle sarcophagus; specific prototype unidentified.

See item 13.

SAINT MATTHEW

21. (Pl. 7). Developed from a Trecento type under the impact of orator or related figures from Roman sarcophagi. Exact prototype unidentified.

The saint stands in his shell-topped niche in a pose reminiscent of the antique orator type, his left hand holding the book, his right arm cradled in the sling of his cloak, his left leg firmly planted on the ground in a classical *contrapposto*.

The antique orator type had survived in the disguise of apostles and other saints through Early Christian and Byzantine into Italian Dugento and Trecento art. The classical features of the *Saint Matthew*, however, the shell motif of the niche, the clear *contrapposto* and the firm modeling beneath the drapery point to a revitalization of the old type under the renewed impact of antique models. No large scale antique figures of orators were known to the fifteenth century. But on Roman sarcophagi both pagan and Early Christian, the type is used to represent rhetors, actors, poets, apostles and muses.

The combination of this type with a shell niche, the conch hinged at the bottom, narrows down the choice to sarcophagi of the so-called "Asiatic" type or their Western derivatives, Early Christian (Morey, bibl. 347, type I) or medieval. Several such sarcophagi must have been known to Ghiberti; but among these, none offers a satisfactory prototype for the *Saint Matthew*. The sarcophagus of the Camposanto (Duetschke, bibl. 136, 1, no. 61;

Lasinio, bibl. 266, pls. CXLIII, CXLIV), which on its left flank shows a muse in a pose relatively similar cannot be traced beyond 1833. Sirén (bibl. 484, pp. 117f) has suggested as possible models statues of the type of the Sophocles figure in the Lateran and an Aesculapius statue in the Villa Ludovisi. The Sophocles was found only in the nineteenth century; the Aesculapius has but the most superficial resemblance to the *Saint Matthew*.

HEROD PLAQUE (SIENA FONT)

22. (Pl. 72). The two main groups of the relief, Herod and Herodias enthroned on a high dais and the guards pushing the Baptist forward, are placed against an architectural background. The two figures seated on the dais present a variant on the *Pilate* (see item 6) and on a *congiarium* scene with two enthroned figures. The group of the Baptist and the guards is evolved from two reliefs on the Arch of Constantine, both belonging originally to an Arch of Marcus Aurelius (Hamberg, bibl. 205, pp. 89ff; Wegner, bibl. 547):

a) wounded barbarian chieftain, submitting to emperor enthroned (*clementia imperatoris*; Hamberg, bibl. 205, pl. 14), (Fig. 119).

b) barbarian prisoner brought before emperor, standing in judgment (*justitia imperatoris*; Hamberg, bibl. 205, pl. 15), (Fig. 120).

The position of the Baptist surrounded by guards recalls the prototype of the *clementia*. The steeper design of the group, however, is closer to the second scene and equally, the young warrior next to the dais who lunges forward towards the Baptist, stems from a corresponding figure in the *justitia* relief.

SHRINE OF THE THREE MARTYRS

23. *Flying angels* (Pl. 76). Derived from medieval prototypes transformed by direct reference to Roman sarcophagi with flying victories.

The antique type of flying victories had survived through the Middle Ages, transformed into flying angels supporting inscriptions (Ambrogio Lorenzetti, Good Government, Siena, Palazzo Publico) or other objects. Among the latter, the tomb of Raneri Zen, Venice, SS. Giovanni e Paolo, 1283 (Fig. 58) shows the angels not only in a position similar to Ghiberti's but also with comparable hair and with round faces turned towards the beholder.

Ghiberti revitalizes the type by direct reference to Roman sarcophagi with flying victories, supporting *clipei* with the effigy of the deceased or tablets with inscriptions. At least two such sarcophagi were certainly known to him:

a) Cortona, Cathedral, lid of sarcophagus with Dionysos fighting the Amazons, certainly known in the early fifteenth century (Vasari-Milanesi, bibl. 533, II, pp. 339f; Ragusa, bibl. 434, pp. 48f, no. 7), (Fig. 121).

b) Pisa, Camposanto, sarcophagus from cemetery of S. Pietro in Vinculi, front (Lasinio, bibl. 266, pl. XXIX; Duetschke, bibl. 136, I, no. 152; Papini, bibl. 389, no. 108; Ragusa, bibl. 434, p. 142, no. 68), reused in the fourteenth century, as witness the coat of arms in the *clipeus*.

Three more, also at Pisa, were possibly known to Ghiberti, although two of them are first illustrated by Martini.

c) Sarcophagus of T. Aelius, probably part of the old collection (Martini, bibl. 307, pls. 34, 131; Lasinio, bibl. 266, pl. XXXVII; Duetschke, bibl. 136, I, no. 141; Papini, bibl. 389, no. 111).

d) Sarcophagus front, with Gaia and Oceanus probably part of the old collection (Lasinio, bibl. 266, pl. CXXXVII; Martini, bibl. 307, pl. 34.16; Duetschke, bibl. 136, I, no. 44; Papini, bibl. 389, no. 109).

e) Lid of an Endymion sarcophagus of different size, used 1467 for reburial; inscription and coat of arms (Lasinio, bibl. 266, pl. LXIII; Duetschke, bibl. 136, I, no. 115; Papini, bibl. 389, no. 76; Ragusa, bibl. 434, pp. 145f, no. 71).

Beyond the Trecento prototypes, the angels on Ghiberti's shrine recall the slender proportions, and the ribbonlike folds of the garments on the Roman sarcophagi. The position of the arms and the wings both turned backward, and the bared arms and shoulder specifically recall the Cortona sarcophagus lid.

GATES OF PARADISE
GENESIS

24. *Adam, Creation* (Pl. 83a). Evolved from a Trecento type and revitalized by the impact of an antique, possibly the Adonis sarcophagus, Rome, Palazzo Rospigliosi (Fig. 122).

The posture of Adam, half seated and leaning backward, his right leg slightly raised, is reminiscent in reverse of the Adam in Piero di Puccio's Creation fresco in the Camposanto in Pisa (Fig. 79).

At the same time, the right arm of Ghiberti's Adam, slightly bent, supporting the body, the hand spread out with thumb apart, the left arm stretched forward, closely recalls the wounded Adonis from the sarcophagus, Rome, Palazzo Rospigliosi, formerly Palazzo Cevoli

(now called Sacchetti), traceable to about 1615 and possibly further. Drawing Windsor, Dal Pozzo Collection, no. 8046 (Vermeule-Catalogue; Robert, bibl. 448, III, 1, nos. 15, 15′).

In both Uccello's *sinopia* and his fresco of the *Creation* of the Chiostro Verde (Figs. 70, 71), Adam, though in reverse, is even closer to the Adonis from the Rospigliosi sarcophagus. Comparable are the more upright position of the body and the outstretched leg in the foreground (the leg of the antique figure is bent so sharply it could easily be mistaken for an outstretched leg, broken at the knee) and—in the *sinopia*—the youthful face and the outstretched arm showing the palm of the hand. All this suggests the existence of a drawing from the Adonis sarcophagus to which Uccello adhered more closely than Ghiberti (see p. 210).

25. *Eve, Creation* (Pl. 83b). The figure of Eve is derived in reverse from the floating Nereid at the right edge of the marine sarcophagus, Vatican, *Giardino della Pigna* (Amelung, bibl. 20, I, p. 828, pl. 92, no. 34; Robert-Rumpf, bibl. 455, V, no. 116), (Fig. 124).

The sarcophagus can be traced at least to the early sixteenth century, when it was at S. Maria in Aracoeli (Wolfegg, f. 29v, 30; Coburgensis, f. 120, Matz, bibl. 310, no. 176).

The angle at which Eve floats from Adam's rib is slightly steeper than that of the Nereid. But pose and proportion of the body, including the shape of the breasts and the taut line from breast to shoulder, the closely parallel legs, the one in front covering the other at the same angle, and even the disappearance of the ankles and feet behind the body of Adam and behind the waves, respectively, are so close as to preclude mere coincidence.

26. *Adam, Expulsion* (Pl. 84). Adam is standing terrorized behind Eve, his left leg forward and sharply bent, his right leg stretched far back, his left arm reaching backward in an unmotivated gesture, his head turned backward and upward.

The curious position of Adam's arm is explained by that of the young satyr pulling the tail of his victim on the Bacchic sarcophagus from S. Maria Maggiore (London, British Museum; Smith, bibl. 499, III, pp. 301ff), (Fig. 127). The resemblance extends not only to the sharp thrust of the legs, but even to details such as their muscles and bone structure. The sarcophagus (Figs. 125-127), in S. Maria Maggiore in Rome in the fifteenth century, was one of the antiques best known to the Renaissance and frequently drawn. Earliest instances are: Anonymous, Milan, Ambrosiana, F. 237,

1407r and v (Vincenzi, bibl. 539, p. 6; Degenhart, bibl. 120, fig. 4); Polidoro da Caravaggio, Munich, Graphische Sammlung, no. 2536 (Degenhart, bibl. 120, fig. 14); Wolfegg, f. 31v, 32, 32v, 50, front; f. 47v, 48, flanks (Robert, bibl. 449, pp. 201ff; Degenhart, bibl. 120, fig. 5). See also next item.

27. *Eve, Expulsion* (Pl. 84). The posture of Eve, her very slender body slightly bent backward, her head tilted to the side and slightly upward toward the Angel, her left hand covering her genitals, her right arm bent and lifted in a gesture of terror, her feet in a kind of *entrechat*, her right foot touching the ground with the toes only, draws on several antique prototypes. In the gesture of her hand covering her genitals she recalls the type of *Venus Pudica* used frequently, from at least the thirteenth century on, for the figure of Eve in the Expulsion (Niccolo Pisano, Perugia, Fountain; Masaccio, Brancacci Chapel, see Mesnil, bibl. 325). Ghiberti may have revitalized this type by direct reference to one of the Venus statues of the Medici type known to him (see above, p. 287) and note 17.

However, he fused this gesture into an overall design drawn from a dancing maenad beating the tambourin on the S. Maria Maggiore sarcophagus, see above item 26 (Fig. 125). Eve's right leg (missing from the knee down in the model but presumably identical in position), the strong, hipshot stance and the outline of chest, abdomen, and thigh correspond in reverse; the slant of the shoulders, the slimness of the body, the tiny breasts, correspond directly to the prototype. Indeed, this maenad is reflected even more immediately in Vittorio Ghiberti's figure of Eve on the frame of the Andrea Pisano door (Fig. 128), in original position, veil and all. Also, in that later variant, Eve adopts *one* of the gestures of the *Venus Pudica*, the hand at the breast, which had been altered in Lorenzo's design.

Both Lorenzo's and Vittorio's Eves thus are variants of one maenad of which a drawing must have existed in the workshop, but both add different gestures of the *Venus Pudica*.

The dancing step of the Eve in the Expulsion at first glance recalls the *entrechat* of a restored satyr right of center on the same S. Maria Maggiore sarcophagus. But this figure already at the time of Polidoro da Caravaggio was missing except for part of one foot (Degenhart, bibl. 120), and this indicates a different pose. Thus the stance of Ghiberti's figure is either a free invention or derived from an unknown prototype.

For curiosity's sake it should be mentioned

that in the Wolfegg drawing of the sarcophagus, f. 32v (Figs. 125, 126), a male dancer to the left of the dressed maenad has been transformed into a female bacchante, covering the *pudenda* with her right hand in the gesture of a *Venus Pudica* and with her feet crossed, much like Ghiberti's Eve. This is one of several instances where Ghiberti's and the draughtsman's variants on the antique strangely coincide.

CAIN AND ABEL

28. *Abel slain* (Pl. 86a). Possibly a Trecento type, revitalized by direct reference to an antique prototype.

Abel, toppling forward, and Cain, swinging the club with both hands from behind, are presented in postures not infrequent in medieval art, e.g. Bartolo di Fredi, Old Testament scenes, S. Gimignano, Collegiata (Fig. 81; observation by Miss Mary Ann Rukavina, Institute of Fine Arts, New York University). Ghiberti's Abel, however, supporting himself on one arm with his back curved, his knee pushed forward, the toe of his other foot bent, is drawn in reverse from the collapsing Dacian in the foreground of one of the Trajanic battle reliefs inside the Arch of Constantine (Fig. 131). The barbarian in that relief is damaged, but the break on the right side of the head suggests that originally, like Abel, he may have protected his head with his free hand. Cf. already the drawing by Antonio Federighi, Munich, Graphische Sammlung, no. 36909 (Degenhart, bibl. 123, p. 136, fig. 49), where the right arm is broken, and Piero della Francesca's Battle of Constantine (Warburg, bibl. 545, I, pp. 253ff).

29. *Abel watching his flock* (Pl. 85). Variant on antique shepherd from a sarcophagus, possibly of the Endymion group, or variant on the servant in the Abraham relief, see below item 36.

30. *Cain ploughing* (Pl. 87). Derived from a ploughing peasant on a Roman relief.

While the motif existed all through the Middle Ages among the Labors of the Months, it was presented with new emphasis on an antique prototype in Andrea Pisano's relief of Agriculture, Florence, Campanile (Paatz, bibl. 375, III, p. 191; the comparison with Etruscan terracotta groups is untenable). Ghiberti's design, however, is derived directly from a Roman model, such as the ploughman among the reliefs with rustic scenes, lost, drawing Dal Pozzo, Windsor, no. 8053 (Vermeule-Catalogue), (Fig. 130), or the small figures of a ploughman with oxen frequent on Season sar-

cophagi below the medallion of the deceased; the best example known was formerly in the Giustiniani collection (Galleria Giustiniani, bibl. 183, II, pl. 100; Hanfmann, bibl. 206, II, chapter III, note 82).

NOAH

31. *Noah's shame* (Pl. 90). Noah, his body slightly raised on the right elbow, his right leg flexed forward, his left one raised and sharply bent, his left arm resting on his left thigh, is close to Bartolo di Fredi's Noah in the Old Testament cycle, S. Gimignano, Collegiata (Fig. 82; observation Miss Mary Ann Rukavina, Fine Arts Institute, New York University). Similarities include the position of the prostrate body and the pose of the legs, which are not crossed but form a kind of rhomboid pattern.

However, the languid pose of Ghiberti's Noah, his nakedness, his head and its position, reminiscent of the antique, turned towards the beholder and resting on his right shoulder, and finally the drinking bowl, recall the drunken Silenus on Bacchic sarcophagi, who is either carried on a skin, e.g. Ny-Carlsberg (Poulsen, bibl. 424, no. 777a), and Villa Medici (Cagiano de Azevado, bibl. 83; drawing Wolfegg, f. 48, then in the Della Valle collection, Mrs. Bober-Census); or drawn on a chariot, e.g. Naples, Museo Nazionale (Pietrogrande, bibl. 399, fig. 10, similar to the drawings Coburgensis, f. 112, Matz, bibl. 310, no. 128, and Dosio Berolinensis, f. 13v, Hülsen, bibl. 225, pl. XIX).

Still, the differences remain considerable: in all antique examples the body is obese, the legs are crossed, the face utterly different. No exact prototype can be determined.

32. *Animals leaving Ark: elephant* (Pl. 89). The diamond pattern of the elephant is a device frequently used to indicate a net covering the elephant on Roman sarcophagi. We are indebted to Prof. Karl Lehmann for this suggestion.

Obviously no precise prototype can be established, but one might think of the large sarcophagus with the Indian triumph of Bacchus, now Rome, Palazzo Rospigliosi, in the early sixteenth century at S. Lorenzo f.l.m. (Wolfegg, f. 36v, f. 37); see below, item 39.

33. *Noah's wife in front of the Ark* (Pl. 104a). Noah's wife, second from the right, is undoubtedly drawn from the bride in a marriage scene, possibly the one on the Fieschi sarcophagus (see above, item 5). Aside from her right arm, outstretched rather than descending to grasp the hand of the groom, and the backward movement of her head, her

stance is identical: seen in three-quarter view, her right foot forward, left leg slightly bent, she clasps an end of the cloak with her left hand.

34. *Noah's Sacrifice: woman seen from back* (Pl. 92). Derived from a figure, Rome, Forum of Nerva (*le colonacce*), Minerva frieze (Fig. 129).

Ghiberti's figure, slightly turned to the left, is shown advancing toward the scene, her right heel raised slightly, her right leg showing plainly through the garments, her left leg hidden by vertical folds, her cloak, gathered in a roll around the waist, her dress pulled from the shoulders toward the waist in triangular folds. The general pose as well as the fall of the drapery appear almost identically in the female figure seen from the back on the Minerva frieze (Blankenhagen, bibl. 55, no. 41), despite the stiff, angular stance of the Roman figure, the different pose of her left arm, the coarser treatment of her draperies, and the poorer quality of workmanship.

The frieze was famous all through the Middle Ages, occasionally known as *Arca Noe* (Urlichs, bibl. 527, p. 140 and *passim*).

35. *Noah's Sacrifice: Noah's son, right edge* (Pl. 92). Derived from a sarcophagus illustrating the private life of a Roman official, Los Angeles County Museum (Feinblatt, bibl. 157, figs. 1, 9, 11), in the early sixteenth century in the atrium of St. Peter's (Wolfegg, f. 25v, 26, 27v, 28).

Ghiberti's figure is a variant in reverse on the *moira* (Figs. 132, 133), assisting at the birth of a baby, on the right short side of the sarcophagus. (For the iconographical interpretation of the *moira* see Brendel, bibl. 67, p. 1ff.)

Ghiberti's figure raises his hands in prayer, his left arm is bare, the tunic fastened on the shoulder. The mantle is draped around his left hip and leg in deep folds and falls forward over the right shoulder in a cascade. He shares with the *moira* the general pose, the movement of the arms and the fall of the mantle over the shoulder. The *moira*, however, hidden, as she stands behind the kneeling nurse in the foreground on the sarcophagus, shows little of the abundant drapery which envelop both hip and leg of Noah's son.

Curiously enough, the drawing in the Wolfegg sketchbook represents the *moira* with drapery not unlike that of Noah's son (Fig. 133) and thus shows again an interpretation very close to Ghiberti's. Also it shows her as a flute player, mistaking the compass for a *tibia* and thus with both arms half-raised almost

identical to the praying gesture of Ghiberti's figure.

ABRAHAM

36. *Servant, seated, right edge* (Pl. 91a). The servant is seated low on a rock, his legs crossed, his hands holding a crook (now missing), dressed in a short sleeveless tunic, and mantle which follows his back in a long fold.

He is derived from an antique shepherd on a sarcophagus, probably of the Endymion group.

A variation of this figure is Abel, watching his flock, see above, item 29.

ISAAC

37. *Group of visiting women* (Pl. 97a). The four women are shown, one walking in from the left, one seen from the back, one standing relaxed to the right with her left hand resting on the shoulder of the one in the middle; the fourth woman, in the background between left and center figures, is so inobtrusive as to be easily overlooked. The grouping of the three others vaguely recalls the Three Graces in Siena and similar groups. Indeed, the Siena Graces, while first recorded visually around 1480 (Antonio Federighi, Munich, Graphische Sammlung, no. 36909; Degenhart, bibl. 123, fig. 48; Salis, bibl. 459, pp. 154ff, pp. 259ff) and then owned by Cardinal Francesco Piccolomini, came from the collection of Cardinal Francesco Colonna (Egger, bibl. 139, I, pp. 106f) and may have been known as early as 1425. However, the similarity between Ghiberti's women visitors and the Three Graces, based mainly on the center figure seen from the back, is probably accidental. On the other hand, there can be no doubt, that Botticelli based his three dancing Graces in the *Primavera* both on the literary image of the Three Graces "dancing, holding hands and clad in transparent drapery" as transmitted by Alberti and Seneca (Warburg, bibl. 545, I, pp. 29f and note 3; Gombrich, bibl. 189, pp. 30ff) and on the visual image of Ghiberti's group of women in the *Isaac* (see, however, Salis, *op. cit.*). Hence, to Botticelli, Ghiberti's group recalled the antique type as described by Alberti and Seneca.

38. *Visitors' group: woman carrying basket* (Pl. 97a). A woman carrying a basket on her head is traditional in Trecento painting among the visitors to Anna or Elizabeth lying in. The type, however, has been transposed by Ghiberti into a more or less free variation on an antique theme, for example, a figure of Selene on an Endymion sarcophagus, such as:

a) Rome, Palazzo Giustiniani (Robert, bibl. 448, III, 1, no. 78; Rizzo, bibl. 446, pls. VII-VIII, 3); drawing by Dosio, Berolinensis, f. 12 (Hülsen, bibl. 225, pl. XVI), (Fig. 135).

b) lost (?) sarcophagus, in the mid-sixteenth century at Palazzo Colonna (Robert, bibl. 448, III, 1, no. 86). Drawings: Oxford sketchbook, attributed to Jacopo Ripanda (information, Mrs. Bober-Census); Dosio, Berolinensis, f. 9 (Hülsen, bibl. 225, pl. XII).

Details comparable to the Selene are seen in the profile view, the double-belted chiton, the lively, sharp drapery folds of the overhanging peplum, the pose of the right arm, the veil, clutched in the right hand, crossing the forearm and billowing out in back. The step, the movement of the skirt, the left hand and the veil crossing the legs are different. Ghiberti's variant must be viewed together with another variant of his, a prophetess, based on Selene and a maenad (Pl. 125a; see below, item 54).

39. *Visitors' group: woman seen from back* (Pl. 97a). The woman steps briskly forward on her left leg, her right heel is raised. Her body turns to the left in a lithe movement, her face is seen in one-quarter view only, the hair taken up in a bun. Only her left arm is visible. She wears what appears to be a fifteenth century dress, long and unbelted, which glides in serpentine folds over the back and ends in zigzag drapery over her left leg. The figure seems to be a free variant on a yet unidentified antique prototype, possibly the priestess (?) seen from the back who recurs time and again on sarcophagi with the Indian Triumph of Bacchus. Among examples known to the fifteenth century, the figure at the right edge of the Rospigliosi sarcophagus (Fig. 137; see above, item 32), despite differences in drapery, may be compared to Ghiberti's visiting woman in the lithe curve of her stance, one hip protruding, her step, with one heel slightly raised, and her upper left arm pressed close to her body.

40. *Visitors' group: woman to the right* (Pl. 97a). The figure, in profile, bends her head slightly forward, the sleeveless dress held by a round *fibula* on her shoulder. A small veil frames the back and hangs over her left elbow. Her cloak has slipped off the hip and envelops her legs, while another part falls forward in a long cascade over her right shoulder.

Pose and dress are generally reminiscent of muses and related female allegories, but Ghiberti's figure appears rather to be a variation in reverse on the *moira* from the Los Angeles sarcophagus (Figs. 132, 133; see items 35 and 55). Both share the profile pose, including the slight slant of the leg below the curving folds

of the cloak, the bare arms, and the general type of head and arrangement of hair. The small veil and the elaboration of the lower part of the drapery are Ghiberti's own additions.

41. *Blessing of Jacob: Rebecca* (Pl. 97b). The mourning pose, while frequent throughout the Middle Ages (Shorr, bibl. 493) is permeated in Ghiberti's design by genuinely antique features reminiscent of female mourners of antiquity, *Pudicitia* and others: the stance, the belted peplum, the pose of the arms, the left one crossing below the breast, the hand bent down, the right raised to support the cheek, the head covered, the left leg strongly protruding through the garment, the right leg hidden behind vertical folds.

Among possible prototypes known to the Renaissance only a few compare, such as:

a) sister of Meleager, though with uncovered head, from a relief with the Death of Meleager, Villa Albani, Coffeehouse, formerly Palazzo della Valle (Coburgensis, f. 99, Matz, bibl. 310, no. 224; Robert, bibl. 448, III, 2, no. 278).

b) Iphigenia from a *cippus* showing her sacrifice, now in the Uffizi (Fig. 134), originally at Giardino di Castello and thus probably an old Medici possession (Duetschke, bibl. 136, III, no. 165). Similar are the stance, the covered head, the pose of the right arm, the bent left hand, and the stance of both legs and the drapery. The differences are minor: Iphigenia's peplum runs horizontally, instead of sloping; her left arm is held likewise horizontally and partly covered by the gown which slides from the shoulders.

JOSEPH

42. *Discovery of the Cup: mourning brother* (Pl. 98). Free variant on mourner from a Gathering-in of Meleager (Fig. 138), now lost, but evidently known in the early fifteenth century (Coburgensis, f. 70, Matz, bibl. 310, no. 227; Robert, bibl. 448, III, 2, no. 286).

The pose of the man, his head hidden in the folds of the cloak raised up to his face, and the fall of the cloak in large cascades, is a free variant on the figure of a mourner following the body of Meleager. Donatello seems to have used this sarcophagus and the one in Wilton House in his tabernacle at St. Peter's. (For the latter suggestion, see Robert, bibl. 448, III, 2, no. 275.)

43. *Woman with bundle and small boy* (Pl. 99). Variant on two figures from a Medea sarcophagus. The woman in a sleeveless, double-belted chiton gathers her skirt with her right hand. Her head is turned slightly downward

and to the side. A veil crosses her breast and right arm. A small boy, walking ahead of her, toward the right, his head turned back, his short tunic lifted, carries provisions. The position of the two figures recalls a Medea sarcophagus, now lost (fragment, Turin, Museum; Duetschke, bibl. 136, IV, no. 12; Robert, bibl. 448, II, nos. 190, 190'), but known from the Coburgensis, f. 32 (Matz, bibl. 310, no. 214) (Fig. 136).

a) Medea approaching the wedding ceremony of Jason and Cresilla, running and lifting her skirt, followed by her two children, is similar to Ghiberti's woman in the turn of the head and the stance, her skirt gathered in a bundle of lively folds. Another variant on the Medea appears in the Zenobius Shrine, see item 67.

Gruenwald (bibl. 195, pp. 150ff) had suggested as a prototype for Ghiberti a Hora, balancing a pail on her head with her raised left arm. Her right arm lifts her skirt, as she appears on a *cippus* at Este, Museo Nazionale Atestino, prior to 1653 at Padua (Ursatus, bibl. 374, p. 261; Callegari, bibl. 84, p. 65).

b) "Camillus," carrying sacrificial fruits, preceding Medea, but belonging to the wedding scene of the same sarcophagus. Ghiberti has fused this motif with that of one of Medea's children bringing presents to her, from another class of Medea sarcophagi, of which several were known to the Renaissance, among them the sarcophagus drawn in Coburgensis, f. 42 (Fig. 146), now Rome, Museo delle Terme; see item 66. Similar to the child in the *Joseph* is the forward movement of Medea's son, the position of his arms and the uncovering of legs and abdomen.

MOSES

44. *Passage through the Red Sea: dancing maiden* (Pl. 103). Derived from the figure of Venus, Adonis sarcophagus, Rome, Palazzo Rospigliosi (Fig. 122); see item 24.

The maiden is clad in a double-belted chiton; behind her back a veil billows, which she grasps with both hands. The running pose, the skirt flaring over the leg and the billowing veil recall the figure on the Rospigliosi sarcophagus. The outstretched pose of the left arm is different in the antique relief.

45. *Terrified warrior, right foreground* (Pl. 102). The pose, especially the wide step of the legs, is a variation on Adam in the Expulsion who, in turn, is derived from the Bacchic sarcophagus from S. Maria Maggiore, see item 26.

46. *Man, hiding face, right foreground* (Pl. 104b). Derived from the figure of a mourner

walking behind Meleager's body, Meleager sarcophagus (Fig. 141), Rome, Villa Doria Panfili (Robert, bibl. 448, III, 2, no. 283), traceable at least to the first half of the sixteenth century. Excellent work, badly restored. The earliest drawing preserved, by an anonymous artist, first half of the sixteenth century, is a composite of several sarcophagi, incorporated into Dal Pozzo, British Museum, I, f. 81 (Robert, bibl. 448, III, 2, no. 278''); among later drawings one, attributed to Salvatore Rosa, Uffizi, no. 895 (Robert, bibl. 448, III, 2, no. 283') is the most important.

Despite minor differences the gesture of Ghiberti's figure corresponds exactly to that of the mourner covering his face with his right hand, while clutching his cloak with his left. The gesture appears also on other Meleager sarcophagi but none is as close to Ghiberti's variant as is the Panfili example. Further proof for Ghiberti's use of this specific sarcophagus lies in his having drawn on it for two other figures, see items 49 and 50.

JOSHUA

47. *Horses of Quadriga* (Pl. 109). Derived from Quadriga, Pelops sarcophagus, Brussels, Museum (Fig. 103), (Robert, bibl. 448, III, 3, no. 329) or an exact replica; see also item 2.

The horses are all of similar type—wild, with windblown manes, slender muzzles, open mouths, without bridles, and only held by belts across their chests. They are seen, the first in three-quarter view, the second almost *en face*, the third in profile, the fourth fully frontal.

Although quadriga horses on Roman sarcophagi are frequent, this complicated composition occurs only in the Fall of Oenomaus to the right on the Brussels sarcophagus. There are only slight differences in the pose of the first two horses.

48. *Girl, second from left, foreground* (Pl. 107). The girl, in a double-belted chiton, her right hand holding the drapery of her cloak, her left hand raised in wonder, is possibly a variation on the dancing maiden from the *Moses*, see item 44.

49. *Man, carrying rock in his hands* (Pl. 108a). Variant on servant, Meleager sarcophagus, Rome, Villa Doria Panfili; see items 46 and 50 (Fig. 141).

The bearded man in Ghiberti's relief stands with both feet firmly planted on the ground, his knees slightly flexed; he carries a rock with both hands. His pose, the position of his hands and even his footgear correspond to the figure of the man who, in the Panfili sarcophagus,

carries the shoulders of Meleager. His head, helmeted on the sarcophagus, is modern, as witness the unrestored drawing, Uffizi, no. 895.

The identification of this figure was made by Mr. Joseph Polzer in a seminar report in 1952, at the Institute of Fine Arts, New York University.

50. *Man carrying rock on shoulders* (Pl. 108b). Copied from servant, Meleager sarcophagus, Rome, Villa Doria Panfili (Fig. 141), see items 46 and 49.

The man in a short tunic bends forward carrying the rock on his head and shoulders, with his arms bent backward and upward. His right leg placed securely on the ground, is flexed at the knee; the left leg set back, with the foot seen *en face*, touches the ground with the toes only. The pose is copied from the servant on the Panfili sarcophagus, carrying the feet of Meleager (the legs are restored except for the left foot, seen *en face*, but their position can be ascertained through the drawing, Uffizi, no. 895). The servant's right arm and shoulder are naked; the line of the edge of the tunic baring his shoulder is recognizable in a big drapery fold across the back of Ghiberti's figure.

51. *Youth in female dress, seen from back* (Pl. 108b). The very contrast between the female double-belted peplum and the young man's head suggests an antique prototype for garment and stance of the figure. The pose, the right foot lifted and the windblown drapery have led to a comparison (Meyer-Weinschel, bibl. 327, p. 25) with bronze statuettes of victories such as those at Cassel (Bieber, bibl. 51, no. 153). While a statue of this type in 1457 was in the collection of Cardinal Pietro Barbo (Ministero della Pubblica Istruzione, bibl. 338, I, p. 5; Mrs. Bober-Census), Ghiberti's figure recalls more closely a dancing maenad from a Bacchic sarcophagus, such as the one, now at Arbury Hall, Newdgate Collection, England, which was known as early as the sixteenth century (Coburgensis, f. 52, Matz, bibl. 310, no. 146; Dal Pozzo, Windsor, no. 8012, Vermeule-Catalogue), (Fig. 139).

DAVID

52. *Warrior seen from back, center* (Pl. 114a). Barbarian battle sarcophagus, probably the one Rome, Villa Borghese (Fig. 113), formerly at St. Peter's, see items 13, 14, 15, 64.

Pose and garment of Ghiberti's warrior are nearly identical with those of a barbarian, fourth from the left, on the Borghese sarcophagus: the legs far apart, the right arm close to the body, the muscles of the calves sharply

marked, the pants hanging in loose folds, the short tunic with sleeves fastened with a belt. The head of the barbarian in the Borghese sarcophagus is missing; in the drawing Wolfegg f. 30v (see item 13) he is bareheaded, while Ghiberti's warrior wears a turban.

The half destroyed battle sarcophagus at the Camposanto in Pisa (see above, item 13), would appear to have contained a corresponding figure. Bertoldo's bronze copy shows him nude, but in a similar pose and the original still shows traces of the feet and of the shield.

FRAME

53. *Samson* (Pl. 127b). Variation on two antique prototypes.

The left leg of the Samson is pushed forward, the knee bent, the right hip thrust outward, the body lithe and muscular; the right arm coming downward, holds the ass's jawbone, the left arm is raised and embraces the column. Hair and beard are formed by tight curls, the face is small. A large veil, falling over the left shoulder and enveloping the right leg, frames the figure. The Samson recalls:

a) bronze statuettes of Zeus holding the scepter in the raised left hand and thunderbolt in the right, such as Paris, Bibl. Nat., Cabinet des Medailles, no. 14 (Babelon-Blanchet, bibl. 29, p. 8), New York, Metropolitan Museum, (Poseidon[?]), (Richter, bibl. 444, no. 20), Cassel, (Bieber, bibl. 51, no. 129), Munich, private collection (Fig. 143). Such a statuette is described in 1457 in the collection of Cardinal Barbo (Mrs. Bober-Census), Ministero della Pubblica Istruzione, bibl. 338, I, p. 4);

b) in contrast Samson leans against the column, hip thrust out sharply; also the veil is no attribute of Zeus. These departures recall the drunken Dionysos on the Bacchic sarcophagus in the Vatican (Fig. 144), (Amelung, bibl. 20, II, no. 102, pl. 24), a monument drawn by Pisanello and his circle after the 1420's (Degenhart, bibl. 122, pp. 24ff, fig. 30; *idem*, bibl. 121, pp. 7ff, figs. 15, 16).

A Samson remarkably close to Ghiberti's was drawn by Jacopo Bellini (V. Golubev, *Die Skizzenbücher des Jacopo Bellini*, Brussels, 1908-12, II, pl. LXXXVII).

54. *Prophetess* (Pl. 125a). Ghiberti's figure is a variation on two antique types.

In her main features the prophetess recalls a) the figure of a maenad from a Bacchic sarcophagus, now lost (?), formerly Rome, Palazzo Gentili (photograph German Archeological Institute, Rome, no. 36. 631; drawing Dal

Pozzo, Windsor, no. 8649, Vermeule-Catalogue), (Fig. 140).

The two figures share the frontal pose, the flaring peplum of the belted chiton, the forward position of the right leg in a dancing movement, and the fluttering drapery alongside the leg. The right leg of the maenad is naked and the lines of her skirt baring her leg can still be discerned in the drapery of Ghiberti's prophetess.

Combined with this prototype are elements from b) Selene, alighting from her chariot on an Endymion sarcophagus such as the one from the Giustiniani Collection, or the lost one, known through sixteenth century drawings, see above, item 38.

Comparable are the position of the bare arms and the movement of the veil. Held by the right hand and crossing the forearm in both Selene examples as well as in Ghiberti's prophetess and in the Visiting Woman (above, item 38) the veil in the two Ghiberti figures is drawn across the thighs, while Selene held it high over her head with her left hand. In the prophetess, this raised left arm and hand, devoid of the original meaning have been transformed into an admonishing gesture.

55. *Male prophet with raised arm* (Pl. 126a). Variation on both the *moira* from the Los Angeles sarcophagus, and the son of Noah, derived from her; see above, items 35 and 40 (Figs. 132, 133).

The prophet is clad in the sleeveless chiton of the *moira* and in her massive cloak which envelops his right hip in deep folds and falls down over his left shoulder in a cascade.

56. *Prophetess (Hannah?)*, (Pl. 127a). Mourning woman, exact prototype unidentified. Ghiberti's prophetess is similar to a figure drawn by Heemskerk as a statue, but probably part of a relief (Hülsen-Egger, bibl. 226, II, f. 65, pl. 92, p. 40).

The covered shoulders and the fall of the drapery from the right arm are comparable, the drapery to the left different.

57. *Miriam* (Pl. 129a). Derived from a maenad with tambourin on a Bacchic sarcophagus. There are countless tambourin-playing maenads on Bacchic sarcophagi; the exact pose of the Miriam, however, is less frequent. It occurs among examples known to the sixteenth century, on the Blenheim sarcophagus (Coburgensis, f. 119; Matz, bibl. 310, no. 142), and, even more similar on a lost Bacchic sarcophagus (Coburgensis, f. 195; Matz, bibl. 310, no. 140), some remnants of which are preserved in Rome, Villa Aldobrandini (Matz-Duhn, bibl. 311, II, no. 2265), (Fig. 145). The Miriam

shares with the maenad the three-quarter view of the body, combined with the frontal view of the face; the forward step of the legs, combined with the backward movement from the waist up; the movement of both arms, one arm crossing the breast; the position of both hands, holding the tambourin; the pose of both legs, the right one strongly emphasized in volume; the stance of the dancing feet; the windblown folds of the peplum and the skirt, ending in hornlike triangles; finally, the veil, crossing the right arm, billowing behind the head with the fluttering end trailing behind. The differences are all minor and mainly concern the pose of the feet. Ghiberti's figure crosses her feet in the dancing *entrechat* (cf. his Eve, see above, item 27). A third similar maenad appeared on a (lost) Bacchic sarcophagus (Coburgensis, f. 53, Matz, bibl. 310, no. 144), but there the lower parts of the body are hidden by a little satyr.

58. *Adam* (Pl. 123a). Variation on a river god or Oceanus of a type frequent also on sarcophagi, e.g. Paris sarcophagus, Rome, Villa Medici (Robert, bibl. 448, II, no. 11; Cagiano de Azevado, bibl. 83, p. 54, fig. 43), a sarcophagus frequently drawn upon in the Renaissance.

Ghiberti's *Adam*, half seated, leans with his left arm on a bundle of leaves, tied by a band in the form of a vessel. He is naked from the abdomen up, the muscles of his chest and abdomen are strongly marked. Under the mantle, his right leg is crossed over his left one. His right elbow rests on his hip, his hand, slightly raised above the thigh, holds a hoe. The god in the Paris sarcophagus is seated in almost the same pose and even details, such as the left hand falling over the opening of the amphora, are close. But gods of this type are so frequent that the one on the Medici sarcophagus can serve only as a typical example.

59. *Eve* (Pl. 122a). Derived from a Sienese Trecento prototype revitalized by direct reversion to a reclining figure of Gaia, of the type known from the Phaeton sarcophagus, Florence; see above, item 3.

Eve is supporting herself on her right elbow, her right leg stretched out in front, her left knee sharply raised; her left hand rests on her raised knee, holding a fig branch. She is fully dressed and a goat's skin covers her shoulders.

Gaia is not too frequently represented on Roman sarcophagi in exactly this position. Usually she has her legs crossed. She appears, however, in a pose similar to Ghiberti's Eve on the Phaeton sarcophagus from Florence Cathedral. Ghiberti probably had seen this

sarcophagus in his youth and he may have made drawings. But the resemblances are not close enough for specific identification and Ghiberti may have drawn as well on another similar Gaia, from an unidentified sarcophagus.

60. *Noah* (Pl. 122b). Free variant on an unidentified antique prototype.

The reclining pose and the crossed, draped legs recall a river god such as the Marforio, now Rome, Capitoline Museum (Jones, bibl. 234, p. 21, no. 1, pl. I), formerly near S. Martina e Luca. Yet the fat body, the bald head, the short upturned nose and the stringy beard recall equally a Silenus, reclining in a similar pose; see above, item 31.

61. *Noah's wife (Puarphera),* (Pl. 123b). Derived from a figure of Gaia of the type known from a partly lost Proserpina sarcophagus (Wolfegg, f. 36v, 37; Fig. 142), remnants Paris, Louvre (Robert, bibl. 448, III, 3, no. 359). In the early fifteenth century the sarcophagus was at SS. Cosma e Damiano in Rome and used even earlier as a fountain (Robert, *loc.cit.*).

Noah's wife is leaning on her left arm, her right hand lying loosely across her body, her right leg crossing her left one and shown *en face*, in a mannered pose, her head in profile, looking down. This is exactly the pose of Gaia on the Proserpina sarcophagus, except for the nakedness of Gaia's bust and the more natural position of her crossed legs.

Botticelli in his Venus and Mars panel (London, National Gallery) while undoubtedly influenced by a relief in the Vatican (Tietze-Conrat, bibl. 519, fig. 173; Gombrich, bibl. 189, p. 47), again reverts to Ghiberti in the mannered pose of the frontally depicted left forward leg, a feature not contained in his antique model.

62. *Head* (Pl. 133a). The classical features and the long locks crowned with an elaborate wreath of vine leaves and flowers, seem to be derived from a Dionysos. Exact prototype unidentified.

63. *Head* (Pl. 132b). The sinister-looking, sharply molded head with its shock of bushy hair is probably derived from the head of a satyr. Exact prototype unidentified.

64. *Head* (Pl. 131e). Derived from a barbarian female prisoner, possibly the one on the Borghese sarcophagus (Fig. 118), see items 13ff, 52.

The head with unruly hair, one long curl dangling over the right shoulder, a shorter one over the left shoulder, is derived from a female prisoner on a battle sarcophagus. The three

strands of upswept hair above the center of the forehead occur among extant battle sarcophagi only on the Borghese sarcophagus, and only in the prisoner to the right.

65. *Head* (Pl. 131d). Derived from a barbarian prisoner, probably from a battle sarcophagus. Exact prototype unidentified.

ZENOBIUS SHRINE, MAIN PANEL

66. *Two children following woman, left edge of panel* (Pl. 79a). The two boys, the first in three-quarter view, his right arm stretched forward, the second in frontal position, his head turned toward his companion, his arm also stretched forward, are variations on one of the two children of Medea bringing presents to her. Thus they appear, with a minimum of clothing, on several Medea sarcophagi. The closest one, formerly Stamperia Reale, now at the Museo delle Terme (Fig. 146), (Robert, bibl. 448, no. 199, 199′) was in the mid-sixteenth century at SS. Cosma e Damiano (Coburgensis, f. 42; Matz, bibl. 310, no. 216) and already drawn in all likelihood in the fifteenth century (Milan, Ambrosiana, F237, 1707v, attributed to the circle of Pisanello; Degenhart, bibl. 120).

The same sarcophagus was used before by Ghiberti, see item 43b.

67. *Woman with child clutching her skirt* (Pl. 79a). Variant on Medea sarcophagus, see item 43a (Fig. 136).

The woman is seen in three-quarter view, her head turned back and downward. She wears a dress with an apronlike unbelted overhang; her right leg is marked underneath the garment, her left one hidden. With her right hand, she lifts the apron in an unmotivated gesture. A veil billows behind her shoulder and crosses the right arm. A child, scantily dressed in a short skirt and turning his head back toward the two other children (see item 66), clutches her skirt. The intricacies of Ghiberti's variations on antique themes are obvious in this group. In her pose, the movement of her right arm and head, the apron slightly lifted, the woman recalls the figure of Medea approaching Jason and Cresilla on the Medea sarcophagus (Coburgensis, f. 32). The child clinging to her skirt also may be compared with this model.

On the other hand, the fall of the heavy draperies gathered in Medea's hand, which Ghiberti copies in the drapery of the woman with the bundle in the Joseph panel (see above, item 43a), he has interpreted very differently in the Zenobius Shrine. The strongly marked right

leg and the billowing veil likewise depart from Medea; they may be derived from any number of other antique models which Ghiberti is known to have used.

68. *Woman seen from back* (Pl. 78a). The woman is a variant on the woman seen from the back in the Noah panel; see above, item 34 (Fig. 129).

APPENDIX B

GHIBERTI'S CALENDAR OF OLYMPIADS

THIS appendix is intended for hardy souls only. Acquaintance with its contents is not required for an understanding of the book although the results, as minor elements, have been carried over into the interpretation of Ghiberti's life and of his outlook on history.

One of the headaches in interpreting Ghiberti's *Commentarii*,[1] is caused by what seems at first but a queer fad of his; that is, his substitution of a chronology of olympiads for the years of the Christian era. The obvious source for his olympiadic calendar was, as pointed out by Schlosser, Pliny's *Natural History*. Together with other information on Greek and Roman art Ghiberti literally incorporated into the first book of his *Commentarii* Pliny's dates given in years of a genuine Greek calendar of olympiads, starting in 776 B.C. and covering four years each. Yet, the difficulty starts when Ghiberti applies, in the Second and Third Commentary a calendar of olympiads which apparently does not follow a four year cycle and moreover asserts that his starting point is the foundation of Rome, a date placed by all writers of the Renaissance and by most ancient historians in 753 B.C.[2] Scattered through the history of art from Constantine to his own time Ghiberti indicates five events which he connects with this chronology of olympiads of his own.

1. The period of the *maniera greca*, the italobyzantine style, coincides with olympiad 382. "Finita che fu l'arte (under Constantine) stettero e templi bianchi circa d'anni 600. Cominciorono i Greci debilissimamente l'arte della pictura et con molto roçeza produssero in essa ... Dalla edificatione di Roma furono olimpie 382." (After the art [of antiquity] had come to an end, the churches stood whitewashed for about 600 years. [Then] the Greeks began very weakly the art of painting and with great crudeness produced in it. ... This was 382 olympiads from the building of Rome.)[3]

2. Bonamico-Buffalmacco works until olympiad 408. "Fece moltissimi lavorij a moltissimi signori per insino alla olimpia 408 (418?), fiorì (in?) Etruria molto egregiamente. ..."

(He executed a great many works for very many gentlemen; he flourished outstandingly in Etruria until the 408th [418th?] olympiad.)[4]

3. Andrea Pisano's activity coincides with olympiad 410. "Fu grandissimo statuario fu nella olimpia 410 (420?)." (He was a very great sculptor; he lived in the 410th [420th?] olympiad.)[5]

4. Gusmin, the Cologne sculptor, died in olympiad 438, at the time of Pope Martin, who occupied the papal see from 1417 to 1431. ". . . finì al tempo di papa Martino. . . . era docto et finì nella olimpia 438." (He died at the time of Pope Martin. . . . Skilled he was and he died in the 438th olympiad.)[6]

5. In olympiad 440 Ghiberti visited Rome and saw the statue of a hermaphrodite being excavated. ". . . vidi in Roma nella olimpia quattrocento quaranta una statua d'uno Ermafrodito di grandeza d'una fanciulla . . . fu trovata in una chiavica . . . sopra a sancto Celso, in detto lato si fermò uno scultore fece trarre fuori detta statua et condussela a sancta Cecilia in Trastevere oue (el) scultore lauroraua una sepultura d'uno cardinale. . . ." (I saw in Rome in the 440th olympiad a statue of a hermaphrodite of the size of a girl. It was found in a sewer . . . above S. Celso. A sculptor stopped in this locality, he had the statue drawn forth and brought it to S. Cecilia in Trastevere where the sculptor worked on the tomb of a cardinal and he had marble removed from it to make it easier to carry it into our territory [Florence].)[7]

Whatever they are, Ghiberti's olympiads cannot correspond to the genuine four-year cycle of the Greek calendar. Even if we put faith in his assurance that he calculated from the foundation of Rome in 753 B.C. rather than from 776 B.C., a calculation of olympiads of four years' length would result in such nonsensical dates as, for example, 1756-1760 *ab urbe condita* equal to 1003-1007 for Ghiberti's visit to Rome (4 x 439 − 753).

Several solutions have been suggested to solve the puzzle. Hermanin[8] proposed that possibly Ghiberti made two mistakes in his

[1] Ghiberti-Schlosser, bibl. 178, II, pp. 108f.

[2] *ibid.*, I, p. 35. [3] *ibid.*

[4] *ibid.*, I, p. 38f. Schlosser has suggested correcting the date 408 to 418 and inserting *in* between *fiorì* and *Etruria*; see also, below, pp. 354, 357.

[5] *ibid.*, I, p. 43; and II, p. 164 with the substitution of

420 for 410; see also, below, p. 354.

[6] *ibid.*, I, p. 44.

[7] *ibid.*, I, pp. 61f. Schlosser had originally read *scultura* for *sepultura*, but restored the correct reading in bibl. 477, p. 159.

[8] Hermanin, bibl. 209, pp. 8of.

calculations: first, that contrary to his assertation, Ghiberti started his calendar not with 753 B.C., but in the Greek fashion with 776 B.C.; and second, that in his computation he was constantly off one hundred years. Olympiad 440 should really read olympiad 540, thus resulting, if we follow Hermanin, in a date of 1407-1411 for Ghiberti's stay in Rome. Incidentally, Hermanin in proposing this specific date for Ghiberti's visit to Rome evidently used 753 as a starting point, not 776 B.C. as he had promised; had he stuck to 776 B.C. he would have arrived at the impossible date of 1384-1388. The period 1407-1411 seems at first plausible enough for Ghiberti's trip to Rome; yet if extended to the other events mentioned within Ghiberti's chronology of olympiads, Hermanin's calculation leads to absurdities. Gusmin, for example, would have died between 1399 and 1403, if the year 753 was taken as a starting point, or even between 1376 and 1380 assuming the earlier beginning, that is, forty-one to fourteen years before Martin V ascended to the pontificate in 1417. For this and other reasons, Schlosser suggested a different solution: he proposed to calculate Ghiberti's olympiads *ab urbe condita* (753 B.C.), thus accepting Ghiberti's assertion, but to figure them at five rather than four years each.[9]

The results Schlosser obtained on this basis are, to be sure, more convincing than any previous attempts at explanation. Still, questionable points remain.

Ol. 382 = 1157. According to Schlosser this date marks for Ghiberti the beginning of the *maniera greca*. Yet, nowhere does Ghiberti suggest that his olympiad 382 coincides with the beginning of that period. On the contrary, he twice states clearly that the Byzantines "produced their crude paintings at that time."

Ol. 408 = 1287. Ghiberti makes it clear that he identifies this date with the end of Bonamico-Buffalmacco's activity. Since, however, Vasari states that Buffalmacco was born either in 1262 or in 1272 and died in 1340, Schlosser proposed to correct the olympiad figure into 418, thus arriving at a date of 1337-1341. This emendation synchronizes Schlosser's calculation of olympiads with Vasari's account, even though no textual evidence supports the correction.[10]

Ol. 420 = 1347. The passage concerning Andrea Pisano's activity reads olympiad 410 in the only extant manuscript of the *Commentarii*. Since the date 1297 resulting from Schlosser's calculation is meaningless, he suggested the

emendation 420, corresponding to 1347, and interpreted it to refer to Andrea's death. Olympiad 420 is, indeed, the reading preserved in the manuscript of the Anonimo Magliabecchiano, whose history of Trecento art is based on Ghiberti's Second Commentary.[11] Schlosser's revision thus appears to be justified. This can, however, hardly be said of his interpretation, for while it is possible, though by no means certain, that the master died in 1348, Ghiberti states clearly that Andrea *lived* in olympiad 420—"fu nella olimpia 420."

Ol. 438 = 1437. Within Schlosser's calculation of olympiads the Cologne sculptor Gusmin would have died in 1437. However, this equation contradicts Ghiberti's explanatory statement that the Cologne master died during the pontificate of Martin V, 1417-1431.[12]

Ol. 440 = 1447. Within Schlosser's scheme this is the time when Ghiberti visited Rome. No other record exists of this voyage. It may have occurred, as Schlosser assumes, after the main work on the Gates of Paradise had been completed in 1447, but any other time in Ghiberti's career would be equally likely.[13]

No doubt, then, Schlosser's calculation of Ghiberti's olympiads at five years each leads to halfway possible solutions; indeed it seems to be the only sensible point of departure for establishing at least a preliminary frame of reference within which to fit both Ghiberti's calendar of olympiads and the corresponding events as recounted by him. However, ingenious though they are, Schlosser's proposals still leave a number of problems unsolved.

Any attempt to solve the puzzle should start from the fact that Ghiberti gives at least one, possibly two, unequivocal clues to his equation of olympiads and years of the Christian era. Olympiad 438 falls within the pontificate of Martin V, that is, some time between 1417 and 1431. If then we assume with Schlosser the length of an olympiad to have been five years, olympiad 438 may have begun in 1412 so as to include at least one year of Martin's pontificate, but not earlier; or it may have begun at the latest in 1431 and ended in 1436, but not later. These dates need but one slight qualification: for of course Ghiberti calculated *stile fiorentino*; that is, in his calendar the year ran from March 25 to March 24. Martin V was elected November 1417, and died February 20, 1431, that is 1430 *stile fiorentino*. The beginning of olympiad 438 then must fall at some time between March 25, 1413, and March 25,

9 Ghiberti-Schlosser, bibl. 178, II, pp. 108ff.

10 Vasari-Milanesi, bibl. 533, I, p. 167, and Vasari-Ricci, bibl. 531, I, p. 519, respectively; Ghiberti-Schlosser, bibl. 178, II, pp. 110, 130f.

11 Ghiberti-Schlosser, bibl. 178, II, pp. 110, 164.

12 *ibid.*, I, p. 44; II, pp. 110, 165.

13 *ibid.*, II, p. 110; on p. 187, Schlosser gives the date as 1445.

1430, its end between March 24, 1418, and March 24, 1435.

The second clue is not quite so definite, but it is good enough. Ghiberti suggests that Andrea lived in olympiad 420. It seems not far-fetched to equate this date with that of Andrea's bronze door. The date inscribed on it is 1330, but the documents which Carlo Strozzi excerpted in the seventeenth century from the books of the *Calimala* stress emphatically that Andrea started work in 1329, *stile fiorentino*,[14] and it would not be surprising if Ghiberti was aware of that earlier date. Hence olympiad 420 in his calendar would cover five years somewhere within the period from March 25, 1325 or 1326, to March 24, 1335 or 1336, respectively.

Taking as a basis these two equations, the starting point of Ghiberti's calendar of olympiads can be approximately established. But one point is easily overlooked: by multiplying the figure of the olympiad by five, one arrives at its last year; in order to get its first year, the olympiad figure before multiplication must be reduced by one. Hence, from the first equation, the concordance of the beginning of olympiad 438 with a date between March 25, 1413, and March 25, 1430, and of its end between March 24, 1418, and March 24, 1435, the starting point of Ghiberti's calendar should lie between March 25, 772 B.C. (5 x 437 = 2185 − 1413) and March 24, 755 B.C. (5 x 438 = 2190 − 1435); the second equation, the coincidence of olympiad 420 with a five year period in which either the year 1329 or the year 1330 or both are contained would cut the margin further down to between 770 or 769 B.C. and 766 or 765 B.C. respectively.

The point of departure of Ghiberti's calendar would thus lie somewhere between 772 and 755 B.C. However, this calculation presupposes a correct figuring of olympiads on Ghiberti's part, including the realization that in multiplying the olympiad figure with five he had first to subtract one in order to find its first year. Yet, he possibly made the very natural mistake of assuming that the figure of the olympiad times five marked the *first* year of the respective period; Schlosser and Hermanin fell into the trap, and so did this writer in his first draft. If, then Ghiberti made the same mistake, the margin for the starting date of his calendar would shift five years. On the basis of the dates for Gusmin and Andrea Pisano, the starting date of Ghiberti's olympiads would

thus fall between 777 and 760, and possibly between the narrower limits 775 or 774 and 770 or 769.

Despite his assurances to the contrary then, Ghiberti's calendar did not begin "dalla edificatione di Roma," 753 B.C., and Hermanin's thesis is justified at least on this point.

If then, the foundation of Rome must be eliminated as a point of departure, only one earlier date appears to make sense as a starting point for Ghiberti's calculations: the date at which the Greek calendar of olympiads started, 776 B.C. Of the margins 777-760 and 775/74-770/69 B.C., as they resulted from the two equations for Andrea's and Gusmin's activity the second seems to be at variance with this assumption. Yet, whoever told Ghiberti of a calendar of olympiads had good reasons to assume that the actual starting date of the Greek calendar was not 776, but either 774 or, in all likelihood, 775 B.C.

Indeed, it was certainly not Ghiberti who went into the maze of figuring and came up with the answer 775 B.C. One of his humanist acquaintances must have told him that the Greek calendar started that year and, in the light of their sources, they were almost bound to be led to this assumption. Their primary source for calculating a calendar of olympiads would of course have been Pliny's *Natural History* where Ghiberti himself had first encountered the olympiad. Based on Pliny, it would have been easy, one would suppose, to translate a calendar of olympiads into years of the Christian era or into years from the foundation of Rome: for in discussing the razing of Corinth in 146 B.C. Pliny gave the equation of olympiads and years *ab Urbe condita*, (ol. 158,3=608 *a.U.c.*), starting correctly in 776 and 753 B.C. respectively and adding that he did so in order to enable the reader to make other computations on this basis.[15] Yet, in other passages (XXXIV, *19*,49; XXXV, *34*,55) Pliny's equations are loose, with divergencies up to ten years; also, through the very nature of his work, he presents scattered dates rather than a continuous chronological scheme. Whatever the reasons, Ghiberti, when reading Pliny, evidently felt unable to work out a continuous scheme beyond antiquity; consequently, he may have turned to a learned friend for advice. The best tool for building up a calendar of olympiads for the Christian era, would have been St. Jerome's continuation of Eusebius' Chronicle.[16] Well known throughout the Mid-

[14] Falk, bibl. 151, pp. 40ff.
[15] Pliny, bibl. 408, IX, p. 131 (XXXIV, *3*, 7).
[16] *Eusebii Pamphilii Canon Chronicus interprete S. Hieronymo*, P.L., bibl. 354, XXVII, col. 259ff.

An error of calculation slipped in during the third century tabulations leading in A.D. 382 to a divergency of four years; but within our problem this is irrelevant.

dle Ages, it gives in synoptic columns the main dates of ancient history until A.D. 382: first in Biblical computations and in years of an imaginary Assyrian calendar, later in years from the foundation of Rome, then in olympiads; finally in years from the birth of Christ and in years of the Roman emperors. The calendar of olympiads in these tables starts correctly in 776 B.C. and the olympiads are four years each. Nothing would have been simpler than to use this comparative table. But Ghiberti's humanist adviser preferred to use pagan not Christian models for his new chronology *all'antica*.

Among the ancient authors who, aside from Pliny, were known to early fifteenth century humanists, at least two used a chronology of olympiads and a continuous chronology to boot: Diodorus Siculus and Polybius. A complete manuscript of Diodorus' *World History* was first brought from Greece to Italy under Eugene IV (1431-1447) and at least in part translated by Poggio Bracciolini between 1450 and 1455.[17] Polybius' *Roman History* had survived in manuscripts throughout the Middle Ages in both European and Byzantine libraries.[18] In the second quarter of the fifteenth century it became one of the principal sources for the revived knowledge of the Roman past. Leonardo Bruni, as early as 1421, used it extensively for his *Commentarii de Bello Punico* which indeed was little more than a rewriting of Polybius' first two books.[19] Between 1452 and 1454 Niccolo Perrotti translated the first five books of Polybius and dedicated them to Nicolaus V. No doubt, at least Bruni's version was known even to Ghiberti, when he worked on his *Commentarii* and one may safely assume that his humanist acquaintances knew also the as yet untranslated portions of both Polybius' and Diodorus Siculus' works. They may possibly have known even a manuscript of Dionysius of Halicarnassus' *Roman Antiquities*, even though the work was first translated under Paul II (1464-1471).[20]

The chronology of any of these ancient historians would lend itself to an interpretation by which a calendar of olympiads would have to or might start in 775 B.C. To be sure, Polybius in his first six books appears—like a good Greek—to have used a calendar beginning in 776 B.C.; but from book VII on, he changed to a calculation of olympiads of his own inven-

tion: "he starts his years with the beginning of winter, middle or end of November, the first year of the olympiads being counted from the winter after, rather than before the festival; olympiad 1,1 starts consequently November (11) 776."[21] To a Florentine of the fifteenth century, used to the *stile fiorentino*, this meant that the last eight months of this year from March through November would coincide with the year 775 B.C. The same result would have been arrived at, if perchance either Dionysius of Halicarnassus or Diodorus Siculus had been used: Dionysius indeed must appear to any reader to have calculated his olympiads starting in 775 B.C.; the outbreak of the first Punic War, for example, in 264 B.C. is placed by him in olympiad 128,3;[22] similarly Diodorus dates the beginning of the Gallic war, 59 B.C., ol. 180; again this leads to 775 B.C. as the starting point of his calendar; for (180 − 1 =) 179 x 4 equals 716 and this added to 59, results in 775. Based on these ancient sources Ghiberti's learned friend, whoever he was, had little reason to doubt that the first year of the first olympiad coincided with 775 B.C.

Polybius may equally be the source of Ghiberti's strange assumption of olympiads of five years' length. Each book of his *Roman History*, aside from the two introductory ones, corresponds to one, or to part of one, olympiad. Yet, occasionally in the earlier books events are included preliminary to those falling into the respective olympiad. Book III, for instance, terminating with the outbreak of the second Punic War and thus known to every educated man in the Renaissance, deals with the early part of olympiad 140, equaling 220-216 B.C.; but it also recounts at some length the events that in 221 led up to the war. A reader might thus have concluded that Polybius' olympiads were five, not four years long. Ghiberti's adviser evidently jumped to this conclusion, induced perhaps, as Schlosser suggested, by a vague identification of olympiads and *lustra*, in the back of his mind.[23] On the other hand, try as I may, I cannot find any satisfactory explanation for Ghiberti's manifestly incorrect statement that his calendar of olympiads started *ab Urbe condita*, a premise forgotten in the writing. Another good chance of course, is that the phrase "della edificatione di Roma furono olimpie 382" was interpolated by the copyist of the manuscript.

[17] Diodorus Siculus, bibl. 128, p. xxiii; Voigt, bibl. 541, II, p. 185. Portions of Diodorus were already known to Salutati, bibl. 465, pp. 569ff.

[18] Voigt, bibl. 541, II, pp. 134f; see also Mercati, bibl. 320, pp. 22, 36.

[19] Leonardo Bruni, bibl. 79.

[20] Dionysius of Halicarnassus, bibl. 130, p. xli.

[21] Müller, bibl. 355, I, pp. 603ff; Steigemann, bibl. 503; Susemihl, bibl. 511.

[22] (127 x 4 =) 508 + 264 + 3 = 775. Cary's explanation, bibl. 130, pp. xxxf.

[23] Ghiberti-Schlosser, bibl. 178, II, p. 110.

We return again to our attempt to transpose Ghiberti's calendar of olympiads into years of the Christian era, starting with 775 B.C. and figuring in olympiads of five years each. On this basis the following interpretation of the events referred to by Ghiberti suggests itself.

Ol. 382 = March 1135-March 1140. To Ghiberti these years marked the period of Byzantine painting. The question is what he had in mind when focusing on these particular years. The first thought goes, of course, to Florence, but no painting or mosaic of such early date appears to be known there or to have been known in the fifteenth century. Yet, Ghiberti may well have thought of Rome rather than of Florence when discussing the *maniera greca*. Indeed, his text favors such an interpretation: for the first chapter of the Second Commentary, the chapter which concludes with the date ol. 382 appears to deal with the situation in Rome. It begins with Constantine and Sylvester; it continues with the statement that afterwards the churches remained whitewashed for 600 years; in the concluding sentences finally it refers to Byzantine painting. The second chapter quite intentionally, it would seem, starts with the contrasting statement: "In Tuscany began the new art of painting."[24] Byzantine painting, to Ghiberti, may well have been identified with some work in Rome.

Granting this, it is anybody's guess which works in Rome represented to Ghiberti the painting of the Byzantine era. Yet, Rome possesses a group of Romanesque-Byzantine mosaics which Ghiberti certainly knew and which exactly fit the years 1135-1140: the mosaics of the façade and the apse of S. Maria in Trastevere. They are dated by inscriptions into the pontificate of Innocent II (1130-1140) and Ghiberti must have been intimately acquainted with them. When discussing the work of Pietro Cavallino he devotes considerable praise to this master's mosaics in S. Maria in Trastevere where they cover the apse wall right below the twelfth century mosaics of Innocent II in the half dome. Nothing would have been more natural for Ghiberti than to contrast in his mind Cavallini's *maniera moderna* with the *maniera greca* of the older work. Thus, the latter and its date could easily become the outstanding monument of Byzantine painting within Ghiberti's concept of the history of medieval art.

Ol. 408 = 1265-1270. To Ghiberti this date seems to signify the end of Buffalmacco's activity. Buffalmacco, may or may not be identified with the Master of S. Cecilia.[25] Yet in either case, Ghiberti's statement must contain an error: for the years 1265-1270 correspond roughly to Buffalmacco's birth date, 1262 or 1272. Various explanations offer themselves: it may be that Ghiberti's original manuscript contained the statement that Buffalmacco's activity *began* in the 408th olympiad. The omission of one single letter would cause such a reversal of the original meaning, the change from "per insino *dalla*" to "per insino *alla* olimpia 408." Tempting as this emendation seems, its strength is diminished through the position of the passage containing the date, towards the end of Ghiberti's passage on Buffalmacco. Another possibility is that the figure 408 originally read 418 as proposed by Schlosser. This version, if justified, would result in the date 1315-1320, and indeed this is the very period when Buffalmacco's frescoes in the Badia di Settimo (1315-1319) and at Porta a Faenza (1314-1315) were dated through inscriptions.[26] No doubt, these inscriptions marked Buffalmacco's activity in the mind of Ghiberti, even though they do not refer to the end of the painter's activity.

Ol. 420 = 1325-1330, the date Ghiberti gives for Andrea Pisano. Only this date tallies with the beginning of work on the bronze door, 1329 or 1330; with the olympiad figure 420 as given by the Anonimo Magliabecchiano; finally with Ghiberti's statement that the master lived at this date.

Ol. 438 = 1415-1420: the goldsmith, old master Gusmin died at the time of Pope Martin V. Since Martin was elected November 11, 1417, Gusmin must have died between that date and March 24, 1420. This date corresponds neatly to the account of Gusmin's life as given by Ghiberti: his activity in the services of Louis I of Anjou (1339-1382); the melting-up of his great golden altar for the "public needs" of the duke in 1381 and his retirement to monastic life; finally his death as an old man "at the time of Pope Martin."

Ol. 440 = 1425-1430. According to our calculation this is the date of a visit of Ghiberti to Rome, when he saw, among other things, the antique hermaphrodite being excavated and brought to the studio of a sculptor who at the time was working on the tomb of a Cardinal at S. Cecilia.[27] Schlosser placed the visit in

24 *ibid.*, I, p. 35.
25 See the latest bibliography, in Offner, bibl. 370, III, 1, pp. 39ff and Thieme-Becker, bibl. 517, XXXVII,

p. 63.
26 Vasari-Milanesi, bibl. 533, I, p. 503ff.
27 Ghiberti's reference to the sculptor working at the

1447, but admittedly without grounds, save for the fact that the Gates of Paradise were cast and almost completed and that therefore Ghiberti finally had time on his hands. Yet, in 1447 Ghiberti was nearly seventy years of age, somewhat old for the not unfatiguing trip to Rome. Also Ghiberti probably was in Rome more than once, and a trip between 1425 and 1430 seems very likely. Certainly, he had just as much time for a visit of some months to Rome in the spring or fall of 1429 when the *Saint Stephen* was placed at Or San Michele and before he started in earnest work on the panels of the Gates of Paradise. The vocabulary *all'antica* as it appears in these panels manifestly testifies to a new contact with Roman monuments shortly before 1430.[28] Thus, his visit would coincide with the general spread of archeological pilgrimages to Rome among Florentine humanists, both *literati* and artists, before and around 1430.

With the interpretation of Ghiberti's olympiad calendar herewith proposed, beginning in 775 and using a spread of five years for each olympiad, the art historical events he refers to fall neatly into place—with only a minor divergency in the Buffalmacco dates in the way. Such minor errors mean little in the application of a system of periodization at once so complicated and so unusual for a fifteenth century artist. Yet, needless to say, Ghiberti in building up a chronology of olympiads, does not simply pursue a queer whim. He is deadly serious; for him as for his fellow humanists such a calendar *all'antica* was a true manifestation of their belief in a classical antiquity come again to life.

tomb of a cardinal at S. Cecilia at the time of this visit to Rome is of little help. The passage cannot refer to the tomb of Adam of Eaton, Bishop of Hertford and Cardinal of S. Cecilia; he died in 1397 and his monument in S. Cecilia for stylistic reasons can hardly be later than the first decade of the fifteenth century. The next tomb there of a cardinal may well have been that planned for Antoine de Challante, who died in 1418 in Lausanne, or for Ludovico Alamandi, Archbishop of Arles, who succeeded him in 1426 (see also Ghiberti-Schlosser, bibl. 178, II, p. 187). In any event, no cardinal's tomb is likely to have been under construction in the decade between 1440 and 1450; for Ludovico Alamandi was deprived of his title in 1440 and reinstated only in 1449, shortly before his death in 1450. (See Eubel, bibl. 142 *passim*.)

[28] See above, pp. 287ff, and Appendix A.

APPENDIX C: SOURCES

LIST OF ABBREVIATIONS

Archives and Libraries:

AOF	Archivio dell'Opera di S. Maria del Fiore, Florence
ASF	Archivio di Stato, Florence
AUF	Archivio Uffizi, Florence
BNF	Biblioteca Nazionale, Florence
BMF	Biblioteca Marucelliana, Florence
ODS	Opera del Duomo, Siena
ODF	Opera del Duomo, Florence
Magl.	Fondo Magliabecchiano, Biblioteca Nazionale, Florence
BLF	Biblioteca Laurenziana, Florence

Documents:

Libro Grande Calimala X	Libro Grande dell'Arte de'Mercatanti, segnato X
Delib. Cons. Calimala	Deliberazioni de'Consoli dell'Arte de'Mercatanti comminciato [date] all' [date]
Delib. Cons. Lana	Deliberazioni de'Consoli dell'Arte della Lana
Libro seconda e terza porta	Libro della seconda e terza porta
Strozz. LI, 1, LI, 2, LI, 3	Spoglie (Carte) Strozziane, serie seconda, LI, 1, LI, 2, LI, 3
Delib. Off. Musaico	Deliberazioni degli Offiziali del Musaico
Delib.	Deliberazioni degli Operai di S. Maria del Fiore
Uscità Calimala	Uscità dell'Arte de'Mercatanti
Stanz.	Stanziamenti degli Operai di S. Maria del Fiore
Libro deb. cred.	Libro (giallo) dei debitori e creditori
Libro doc. art.	Libro di documenti artistici
Ricordi Proveditore	Quaderno di ricordi segnato [letter], comminciato [date] e finisce l'anno [date], del proveditore dell'Arte de'Mercatanti (or di Ser Francesco Guardi, etc.)
Bast. Ser Niccolo di Ser Diedi	Bastardello di Ser Niccolo di Ser Diedi
Beni di Compagnie e Arti	Beni di Compagnie e Arti di Firenze e de'Sei di Arezzo e Cortona

THE data of Ghiberti's life and work are supported by an uncommonly rich collection of sources. First among them, both in importance and extent, ranks his autobiography as contained in the *Commentarii*.[1] The only other autobiographical source is an account book, holograph at that, concerning the purchase and maintenance of the possession he had acquired at Settimo in 1442; known to Baldinucci and then lost, it was rediscovered some twenty years ago and has since been made available *in extenso* by the owner of the manuscript, Principe Ginori-Conti (Dig. 224).[2] A small batch of letters in the Archives of the *Opera* at Siena, written in the years 1425-1427 by Ghiberti and addressed to the *Operaio* of the Cathedral of Siena and to the bronze founder Giovanni Turini, concern the two bronze reliefs for the Baptismal Font and have been published by Milanesi, Lusini, and Bacci (Docs. 154-162).[3] This correspondence was at one time collected in a *Libro di documenti artistici* which has since been dissolved into its original components. Equally personal in character, though public documents, are Ghiberti's tax declarations, his *portate al catasto*, supplemented by the *campioni*, the notary's copies with the indication of the sums Ghiberti was required to pay (Docs. 81-86a). Running from 1427 to 1451, and filed under the district in which he lived, the *Quartiere San Giovanni, Gonfalone Chiavi*, they are preserved in the Florentine State Archives, and had been published previously in part by Gaye and, with occasional misreadings, by Rufus G. Mather.[4] They give, as do all such documents, Ghiberti's personal circumstances: his age and that of his wife and his sons; his possessions, both in bank accounts and real estate; his commitments and, occasionally among his credits what was still owing him for works of art completed, but not yet paid for in full. The minutes of the meeting of the Council of the Two Hundred at which the circumstances surrounding his birth and upbringing were discussed are, of course, also highly personal. The document contained in the *Riformazioni del Grande Consiglio* for 1444 has been published with minor omissions and mistakes by Gaye (Doc. 120); more recently Aruch has published another closely related document from the Laurenziana.[5] Ghi-

berti's registration in the goldsmiths' guild and those of his son Tomaso, and old Bartolo di Michele are contained in the *Matricola* of the *Arte della Seta*, his registration in the stonemasons' guild and in the painters' confraternity, in the *Matricola* of the *Arte di Pietra e Legname* and in the *Libro della Compagnia di San Luca* respectively (Docs. 114-117, 104, 103). One minor item to be added concerns the lease of his workshop opposite S. Maria Nuova on May 12, 1445, which is in the *Archivio di Stato* filed among the papers of the notary Ser Matteo di Domenico Zafferini (Dig. 253).

Two brief notes may reflect a tradition, written or oral, which originally emanated from Ghiberti himself. They concern the cost and weight of the *Saint John* and *Saint Matthew* and of the bronze shrine of Saint Zenobius and are contained, one in an anonymous sheet of the later fifteenth century in a volume of *miscellanea* in the Archives of the Uffizi Gallery in Florence (vol. 60, formerly *Misc.* 1, no. 4; Doc. 129), the other (Doc. 126) in the Biblioteca Nazionale in Florence (*Banco Rari* 228, formerly *Fondo Magliabecchiano Cl. XVII*, II, 27), in a *zibaldone* written by Ghiberti's grandson Buonaccorso di Vettorio and largely filled with notes for an architectural treatise. Both passages have been published.[6]

Important for the chronology of Ghiberti's *œuvre* are principally the documents of the guilds for which he executed his major works. All the great guilds naturally kept a variety of books in which their business was recorded. Major decisions, such as the commissioning of an expensive work of art, were discussed by the consuls, the governing body of the guild, and put into writing as a rule in Latin in the *Deliberazioni de'Consoli*, one volume of which may run over a number of years, sometimes as many as thirty. Minor decisions taken by the consuls, such as clearance for the treasurer of the guild to make payments or the like, would as a rule appear in the small *Deliberazioni e partiti de'Consoli*, or simply *partiti*; they contain the actual minutes of their meetings, and notes, as recorded either in Latin or Italian by the notary—we might say the syndic of the guild—often in an almost illegible shorthand. The *Calimala*, moreover, had the more im-

1 See above, Chapters I and XX, pp. 3ff and 306ff.
2 Baldinucci, bibl. 35, I, pp. 373ff; Krautheimer, bibl. 249, pp. 79ff; Ginori-Conti, bibl. 181, pp. 290ff.
3 Milanesi, bibl. 356, II, pp. 119ff, doc. 85, I-IX; Lusini, bibl. 283 *passim*; Bacci, bibl. 31 *passim*.

4 Gaye, bibl. 175, I, pp. 103ff; Mather, bibl. 308, pp. 56ff.
5 Gaye, bibl. 175, I, pp. 148ff; Aruch, bibl. 25.
6 Fabriczy, bibl. 147, pp. 251f; Corwegh, bibl. 109.

portant of their minutes transcribed into a clean copy in a series of *Libri Grandi*, as a rule one volume per year. Payments of the guilds would appear in their expense books, the *Uscità dell'Arte* written in Italian, and incidentally in the tax declarations of the guilds when Florence had a corporation tax (which was the case only in 1429). To supervise the commissioning and the execution of a specific work of art, the guild would appoint a special committee, as did the *Arte del Cambio* for the statue of Saint Matthew at Or S. Michele. Sometimes a standing committee was put in charge of the maintenance, completion, or decoration of a building entrusted to the care of the guild: for the *Arte della Lana* the *Operai di S. Maria del Fiore* supervised work on the Cathedral; for the *Arte di Calimala* the *Offiziali del Musaico* were in charge of the Baptistery. Like the guild itself, these committees would have their important decisions, such as the conclusion of contracts and the commissioning of specific sections of work, recorded, usually in Italian, by their notary in a separate book of *Deliberazioni*; payments would appear in their expense books, *Stanziamenti* or *Uscità*. Also the syndic of the guild, the *proveditore*, would as a rule keep a journal of his business, a *Quaderno di ricordi* or *Ricordanze*. Moreover the important provisions regarding a major work of art might be collected in a separate volume.

The most complete set extant of such documents is represented by the papers of the *Arte della Lana* and of the *Operai di S. Maria del Fiore* which are preserved, the first in the *Archivio di Stato* in Florence, the latter in the *Archivio dell'Opera di S. Maria del Fiore: Deliberazioni de'Consoli, Deliberazioni* of the *Operai, Stanziamenti* and *Ricordanze*. The documents concerning the building of the Cathedral and of the dome have been meticulously published by Cesare Guasti (bibls. 198, 199). Giovanni Poggi (bibl. 413) has edited with equal care the documents that refer to the decoration of the Cathedral, among them Ghiberti's Zenobius Shrine, his cartoons for stained glass windows, and his unsuccessful participation in the contest for a new choir enclosure. Among the papers of the *Arte del Cambio* in the *Archivio di Stato* a separate volume records all business regarding the statue of Saint Matthew; this *Libro del Pilastro* has been painstakingly edited by Alfred Doren (bibl. 133). The *Deliberazioni* of the *Consoli* of the *Arte della Lana* contain the major de-

cisions referring to the planning and casting of the *Saint Stephen* (Docs. 107, 108, 109, 110, 111, 112, 113); they were published by Passerini (bibl. 391), though with minor errors and in some cases in mere summaries. The Archives of the *Opera del Duomo* in Siena preserve a set of documents referring to the Baptismal Font in Siena in the *Libri Gialli de'-Debitori e Creditori*, the *Pergamena* and the journals (*Memoriali*) of the *Camerlengo*. These documents were published first by Milanesi (bibl. 336) and Borghesi-Banchi (bibl. 63) and again with some additional material by Lusini (bibl. 283); a final highly important supplement has been edited by Peléo Bacci (bibl. 31). Others are published *in extenso* here for the first time. Some documents of minor importance are scattered through the *Libro delli atti e emanati dai Capitani di Or S. Michele* and the *Deliberazioni de'Consoli* of the *Arte dei Rigattieri, Linaiuoli e Sarti*, vol. 20, *Deb. e Cred. 1418-1451*, both in the *Archivio di Stato*, and the latter's *Quadernuccio di cassa 1449-1452*, at the Archive of S. Maria Nuova. They concern in this sequence: a drawing for two candlesticks to be executed by the goldsmith Guariento Guarienti (Doc. 118f);[7] the frame for Fra Angelico's Linaiuoli Altar (Docs. 105f);[8] finally the shutter for the tabernacle at S. Egidio (Dig. 274).[9]

Perhaps the largest and most comprehensive set of such records was kept by the *Arte di Calimala*. The *Deliberazioni de'Consoli* and their *Deliberazioni e partiti* were supplemented by a complete set of *Libri Grandi*, each signed with a capital letter and with the date of its year; a set of running expense books, both of the guild and of the Committee in charge of the Baptistery, *Uscità dell'Arte* and *Uscità di S. Giovanni*; a set of *Quaderni di ricordi*, kept by the *Proveditore dell'Arte*; and attached to the *Deliberazioni de'Consoli*, the *Deliberazioni degli Offiziali del Musaico*. Loose documents were either from the outset or later collected in a number of convolutes, *Filze di più sorte scritture*; by the late seventeenth century at least four of these were preserved, partly in disorder, so that documents of slightly earlier or later date had slipped in. Altogether these various record books must have contained all the important documents referring to the three main works commissioned to Ghiberti by the *Arte di Calimala*: the *Saint John* at Or S. Michele and the two bronze doors for the Baptistery. The material referring to these doors was moreover collected in a separate vol-

[7] Referred to by Vasari-Milanesi, bibl. 533, II, p. 259.
[8] Gualandi, bibl. 196, p. 109.

[9] Poggi, bibl. 411, pp. 105ff.

ume, the *Libro della seconda e terza porta*. However, other volumes referring to the work on the doors may have existed outside the offices of the *Calimala*, in the *Opera di S. Giovanni*, where the *Offiziali del Musaico* did business. Only three volumes of *Deliberazioni de'Consoli* survive in the *Archivio di Stato*: January 1, 1425 (*st. c.*), through May 13, 1426; January 1, 1444, through April 22; and January 5, 1448, through April 29, 1449 (*Arti, Calimala*, vols. 18, 19, 20). The latter two contain a small amount of material concerning Ghiberti's work on his second door and these passages have been published by Heinrich Brockhaus (bibl. 69); one of the documents, which refers to Gozzoli's collaboration on the Gates of Paradise, was edited with minor omissions by Milanesi (bibl. 337). A miscellaneous *Filza* (*Arti, Calimala*, vol. 17 bis) collected from various books of the fifteenth and sixteenth centuries contains a few folios from the *Deliberazioni e partiti de'Consoli* for the years 1423, 1427, 1428, and 1449-1450, including some records referring to work on the doors. They are here published for the first time. An important stray entry in the *Denunzia dei beni* of the *Arte di Calimala* for 1429 has so far been published only in a somewhat misleading excerpt (Docs. 87f).[10]

The great majority of the rich collection of documents of the *Calimala* was apparently lost when the offices of the guild burned down in the eighteenth century; but a great many excerpts had been taken from them in the latter part of the seventeenth century by a Florentine antiquarian, the Senator Carlo Strozzi. As *proveditore* of the *Calimala*, he was in the best position to explore and draw from their archives at leisure and it is not unreasonable to suspect that occasionally he carried a few volumes of original documents home. Possibly the few papers of the *Calimala* which survived the fire were saved just because of such irregular behavior on the part of the Senator; if this suspicion is justified, it is only to be hoped that he carried home many more volumes and that these will turn up in good time. Strozzi's papers, in any case, are preserved in their great majority: excerpts from the documents of the *Calimala* and from other sources, vast numbers of original documents of miscellaneous provenance, and essays and studies of his own, fill several hundred volumes. The essays are largely distributed between the *Biblioteca Nazionale* and the *Laurenziana*. The greater

part of the original documents and of the excerpts are in the *Archivio di Stato*, but a good number have also gone to the *Biblioteca Nazionale* and some to the *Marucelliana*. They are a mine of information, largely unexplored and not even all catalogued. Two volumes in the *Archivio di Stato* contain an extensive index to Strozzi's collection of excerpts: the *Repertorio Generale delle Cose Ecclesiastiche* and *Cose Laiche* respectively. From them it appears that the many volumes of excerpts preserved represent but a fragment of what Strozzi had gathered.

The excerpts from the papers of the *Calimala*, as far as they refer to the works of art commissioned by the guild from Ghiberti, are contained together with many other items in two volumes among the *Carte Strozziane* of the *Archivio di Stato: Serie Seconda, LI, 1* and *2*. A third volume, *LI, 3*, contains only one relevant leaf, f. 153-153v, and thus, in the search for Ghiberti documents, has been frequently overlooked. Yet this one leaf is of no mean importance, for on it Strozzi had begun an index of passages from the *Libri Grandi* referring to Ghiberti's two doors for the Baptistery and to his *Saint John* for Or S. Michele.[11] The original title of the volumes is *Spoglio primo (secondo, terzo) delle scritture dell'Arte di Calimala altrimenti detta de'Mercatanti e suoi annessi fatto da me Carlo Strozzi . . . ,* their title on the cover *Fatti e Memorie dell'Arte de'Mercatanti*, and they have been quoted alternately as *Spogli Strozziani* or as *Fatti e Memorie*; we think it best to quote them simply as *ASF, Strozz. LI, 1, 2* and *3* respectively. An excerpt of part of the contents of *Strozz. LI, 1* made either by Strozzi himself or by an amanuensis is preserved among the Strozzi papers of the *Biblioteca Nazionale* (*Fondo Magliabecchiano Cl. IX, 127*). In the first half of the eighteenth century Francesco Antonio Gori copied from *Strozz. LI, 1* and *2* the passages referring to the Baptistery and among them those concerning Ghiberti's doors, and inserted them among the notes he assembled for a planned history of that building (*Marucelliana, Manoscritti, A 199 I*); these *Goriana* help to clarify some illegible passages in Strozzi and are used here for the first time. They also contain, ff. 32ff, some valuable passages copied from a lost manuscript of Strozzi's, *Descrizione dell' insigne Tempio di S. Giovanni del Senatore Strozzi*.

The general assumption so far has been that

10 See above, pp. 111f.

11 Brockhaus (bibl. 69, p. 36, note 1), knew and referred to this index, but apparently misinterpreted its

content as concerning largely the *Gates of Paradise*; see above, p. 73.

the *Strozziana* in their entirety are but summaries of the original documents collected somewhat haphazardly and transcribed by Strozzi freely and with extensive explanatory insertions of his own. True, the value of the notes is not equal throughout: large parts of *Strozz. LI, 2* are but repeats, other parts free summaries of one or more entries in *Strozz. LI, 1*. On the other hand, the majority of the entries in *Strozz. LI, 1*, and some in *LI, 2* contain surprisingly large portions which are obviously culled verbatim from original documents, as witness the passages in which Strozzi breaks off with or interrupts a phrase by an *etc*. Occasionally he copied literally an entire document, such as Leonardo Bruni's letter (Doc. 52). At other times his notes appear to be faithful copies from the marginal notes in the original document in which the notary of the guild had summed up for easy reference the contents of a lengthy document. This correspondence becomes manifest from a comparison between Strozzi's formulations and these notaries' marginalia in the few cases where both the *Strozziana* and the original documents are preserved (Docs. 72, 91). Other such notary's marginalia, now lost, would appear to be recognizable among Strozzi's notes by their terse style such as "Porta di S. Giovanni terza si da a armare" (Docs. 25, 59). Occasionally Strozzi summed up the content of an important document in a phrase which, however, contains all relevant data, as witness the correspondence of his entry regarding Gozzoli's collaboration on the Gates of Paradise and the text of the original document in the *Deliberazioni de' Consoli* (Docs. 71, 94). Only in the passages culled from the *Libro della seconda e terza porta* did Strozzi apparently reword and make insertions in the original documents.

The exact nature of this *Libro della seconda e terza porta* is not quite clear. From Strozzi's notes it would appear that, in contrast to the other record books of the *Calimala*, it lacked pagination, a strange deficiency in a regular account book or journal of the fifteenth century. Likewise its chronology was apparently disordered: an entry probably from 1403 and referring to the gilding of the competition relief (Doc. 33) would follow a list of assistants' wages dated after 1407 (Doc. 31). The text is frequently interspersed with explanatory remarks or summaries: the contract for Ghiberti's second door contains a phrase to the effect that "in working on his first door he had little observed his obligation not to take on any other work"; or else, an annotation in the

agreement of 1407 refers back to the contract of 1403 "as it had been agreed above"; another states that this new agreement was made with Lorenzo di Bartolo "alone, without naming the father" (Doc. 27). In the list of assistants employed on the North Door (Doc. 31) the helpers are enumerated with their varying annual salaries and the amounts of wages received totaling ". . . fl. 113.6.2, item fl. 87.1.4, item fl. 131.7.8"; or (Doc. 30) weight and cost are computed into figures such as fl. 57.l. 1344 d.4 without transforming them into the corresponding total of roughly 390 florins. The entire book then bears the mark of a compilation and indeed it has been suggested that it was compiled long after the doors had been completed.[12] This obviously cannot be so, for why would Strozzi, faithful historian that he was, excerpt or copy a compilation of his own under a misleading title? The impression is rather that the original had been gathered while work on the doors was going on, possibly as a loose convolute, in which the *Offiziali del Musaico* had collected for easy reference in copies the important documents regarding Ghiberti's two doors (and incidentally also the bronze frame for Andrea Pisano's door). Such a convolute would naturally lack pagination and even if originally arranged in chronological order, this sequence might well have been disturbed. In fact, other *filze* used by Strozzi showed apparently the same lack of pagination and the same chronological disorder. If the *Libro* then, was such a convolute it need not have been complete and in not more than rough chronological order by the time it fell into Strozzi's hands. But it would have contained, as did the *Libro del Pilastro* of the *Arte del Cambio*, in addition to the contracts and the like, the detailed running accounts of expenses, including workers' annual salaries and actual pay received. On the basis of this convolute then, Strozzi would seem to have made excerpts of the relevant passages of the contracts and to have compiled his lists of workers and of their salaries; going back and forth and occasionally repeating an assistant's name or else computing his wages in several, rather than in one single item; taking up at a later point a forgotten entry, summing up accounts on amounts of material purchased, or sums spent up to a certain point; finally inserting, when necessary, an explanatory annotation.

Strozzi went systematically, it would seem, through the books of the guild selecting items he deemed important. Obviously, he did not

[12] Frey, bibl. 532, pp. 353f, note.

exploit all the books of the *Calimala* for his ends and certainly he was unable to complete his task. Some of the original record books may well have been missing, others may have been incomplete. One gathers this impression from Strozzi's own notes: in *Strozz. LI, 1,* excerpts from a series of *Libri Grandi* follow each other year by year from 1402 to 1406 and sporadically from then until 1416 or 1417; in the following years, until 1461 and later, one volume seems to have covered occasionally more than one year.[13] These excerpts are followed by notes from three *ricordi* covering the period 1435-1463, from the *Libro della seconda e terza porta,* from a few expense books dating 1415-1417 and from a *Filza di varie scritture.* At the end of the volume finally appear excerpts from the *Deliberazioni de' Consoli* and the *Deliberazioni degli Offiziali del Musaico,* the former apparently extant at Strozzi's time, for the years 1401-1414 in one continuous volume, for the years 1439-1459 though with gaps in a number of volumes covering from one to four years, the latter only for the period 1401-1414 as an appendix to the *Deliberazioni de'Consoli.* This sketchy list is supplemented by the fragmentary index of relevant items in the *Libri Grandi* inserted into *Strozz. LI, 3:* from this it would appear that the series of these records ran unbroken or nearly unbroken from 1402 through 1421 and perhaps through 1440, but that the following years were covered at Strozzi's time

only by scattered volumes. On the other hand this same index makes it quite patent that Strozzi never was able to finish his compilation as planned: none of the passages noted down in the index obviously for future use appear anywhere among the items he actually did enter in *Strozz. LI, 1* or 2.

The excerpts as far as Strozzi collected them give the impression of being highly trustworthy. He never fails to give carefully the exact quotation of his sources: title of the series; year or signature of volume or both; name of notary; page of item. Occasionally he may have made a mistake in nomenclature, by entering an expense book of the guild as an *Uscità di S. Giovanni* (Docs. 55, 56), but this is of little importance. Exact dates for individual items he gives only occasionally.

Not only was Strozzi unable to finish his task, but his notes appear to be preserved only in part. One volume marked XX and according to the *Repertorii Generali* crammed with entries on Florentine artists has disappeared from the *Fondo Magliabecchiano.* Other lost items are reflected in Gori's notes in the *Marucelliana* (Ms. A199 1). His copy of the *Descrizione dell' insigne Tempio di San Giovanni* contains, along with summaries of the material exploited in *Strozz. LI, 1,* a number of new items: three computations, regarding the cost of the two doors and of the bronze frame of the Pisano door, added up in Strozzi's characteristic manner and obviously based on lost

[13] The original sequence of the *Libri Grandi* does not come out clearly in Strozzi's excerpts. Apparently they were marked each by a capital letter and presumably the date of the year, for example C 1402. A fragmentary list in one of Strozzi's volumes (*BNF Magl. IX,* 127, c.185ff) is of considerable help. However, in his excerpt in *ASF, Strozz. LI, 3* (see our Doc. 80), Strozzi frequently gives only the signature by capital letter, e.g. L, but omits the corresponding date; second, he occasionally makes mistakes such as dating volume C, once 1402, another time 1403; third, the alphabetization has been confused by the insertion of letters accompanied by a cross, e.g. Q+, following P for 1414 and preceding Q for 1416. This indication Q+ may, then, refer to a supplement for the volume marked Q, in this case 1416, or to the volume for the preceding year, 1415, or even the succeeding year, 1417. Finally, one volume seems occasionally to have covered more than one year and at times a volume seems to have been missing by Strozzi's time.

With these reservations in mind, the following list can be tentatively established:

C = 1402 (dated by *Strozz. LI, 1,* f. 2; *Strozz. LI, 3,* f. 153 is probably erroneous)

D = 1403 (dated by *Magl. IX,* 127, c.185)

E = 1404 (dated by *Magl. IX,* 127, c.185)

F = 1405 (dated by *Magl. IX,* 127, c.186 and *Strozz. LI, 1,* f. 3)

G = 1406 (dated by *Magl. IX,* 127, c.187 and *Strozz. LI, 1,* f. 3, 3v)

I (mentioned by *Strozz. LI, 3,* f. 153, but not dated)

K = 1409 (dated by *Magl. IX,* 127, c.187)

L = 1410 (?) (mentioned by *Strozz. LI, 3,* f. 153, but not dated)

M = 1412 (?) (dated by *Magl. IX,* 127, c.187, but perhaps mistaken for 1411)

N (mentioned by *Strozz. LI, 3,* f. 153, but undated)

O (mentioned by *Strozz. LI, 3,* f. 153, but undated)

P = 1414 (dated by *Magl. IX,* 127, c.187, and *Strozz. LI, 1,* f. 5)

Q+ = 1415 (?) (mentioned by *Strozz. LI, 3,* f. 153, but undated)

Q = 1416 (dated by *Magl. IX,* 127, c.188 and *Strozz. LI, 1,* f. 5v)

T = 1421 (*sic*) (dated by *Strozz. LI, 3,* f. 153)

I = 1429 (dated by *Magl. IX,* 127, c.188 and *Strozz. LI, 1,* f. 6)

K (mentioned by *Strozz. LI, 3,* f. 153, but undated)

L = 1433 (dated by *Magl. IX,* 127, c.188, mentioned *Strozz. LI, 3,* f. 153)

M = 1436 (dated by *Magl. IX,* 127, c.189, mentioned *Strozz. LI, 3,* f. 153)

N (mentioned by *Strozz. LI, 3,* f. 153, but undated)

O (mentioned by *Strozz. LI, 3,* f. 153, but undated)

P (mentioned by *Strozz. LI, 3,* f. 153, but undated)

Q (mentioned by *Strozz. LI, 3,* f. 153, but undated)

B = 1455 (dated by *Strozz. LI, 1,* f. 9v)

F = 1461 (dated by *Strozz. LI, 1,* f. 10f)

notes of his; and, in a list of the assistants who had worked on the Gates of Paradise, a number of names which do not appear in Strozzi's extant notes.

The value of Strozzi's notes was recognized early and in consequence the references pertaining to works of art commissioned by the *Calimala* have been published several times: the excerpts from the *Libro della seconda e terza porta* by Patch and Gregori (bibl. 392) as early as 1773 and, in a reprint of this publication, by Muentz in 1890; the excerpts from that and from other books of the *Calimala*, as far as they concern the Gates of Paradise, together with the original documents regarding that door, by Brockhaus (bibl. 69); finally most of Strozzi's notes which concern the works of art commissioned by the guild including both doors of the Baptistery and the *Saint John* at Or S. Michele by Frey (bibl. 532) in his monumental, if abortive Vasari edition. None of these editions has been critical; none has attempted to use, along with Strozzi's excerpts in the *Archivio di Stato*, corroborative and supplementary material offered by the original documents or by the copies and summaries in the *Biblioteca Nazionale* and the *Marucelliana*; no attempt has been made to evaluate the various portions of Strozzi's notes or sources, nor have his excerpts in their entirety been fully exploited.

Frey's edition though the most complete so far, suffers from a number of shortcomings. It is incomplete and overlooks a considerable number of items; it is uncritical and thus repeats at times items from different sources used by Strozzi, without indicating that they refer to the same event. Likewise, to cite but one more example, the entries referring to the jambs of Andrea Pisano's door are not recognized as such and are intermingled with those concerning the frame of the Gates of Paradise. In addition Frey's dating of Strozzi's entries, often concerning years and almost without exception concerning month and day, is unreliable. Obviously a date which in Strozzi's excerpts appears two, three, or even ten lines higher up on the margin must not under any circumstances be referred to all of the following entries. Contrary, then, to Frey's procedure, the undated entries should be inserted between the preceding and the following marginal

dates, thus establishing a loose, but not a fatally wrong chronology. On the other hand, Strozzi's careful indication of the page on which an entry appears in the original document gives at times a lead regarding its chronological relationship to the nearest dated items, and even where no date closely precedes or follows, the page indication alone may place an entry early or late in the period covered by the original volume.

With all this it must be remembered that almost all the original documents are at this moment, it seems, irretrievably lost. As late as the eighteenth century a number of record books may still have survived even outside the archives of the *Calimala*: Richa[14] alluded to expense books extant at his time in the *Opera di S. Giovanni*, but it must be admitted that his account sounds much like an excerpt from Strozzi's notes, including possibly his *Descrizione*; Gori mentioned an important note referring to the preparation of a program for the Gates of Paradise which he maintained to have culled from the "Diaries of the Calimala."[15] Certainly Baldinucci in the latter part of the seventeenth century knew a great number of original papers, both public and private, regarding Ghiberti: a journal in which Ghiberti had entered his works, "beginning May 1, 1403" (Doc. 163); his household books (*libri domestici*), then in the possession of the Altoviti family; his last will, dated November 1455, drawn up by the notary Ser Santi di Domenico Naldi (Dig. 293); an estimate of his collection of antiques "valued at more than 1500 florins," a note at Baldinucci's time in the possession of Cristofano Berardi in Florence, who owned also Ghiberti's account book concerning his possession at Settimo; a journal of the notary of the Signoria, Ser Nofri di Ser Paolo Nenni, then in the possession of his family and containing an important entry referring to Ghiberti's assistants in 1407 (Dig. 25); finally a document referring to a law suit over Ghiberti's inheritance from Cione made out by Ser Pietro di Ser Michele Guidoni.[16] As late as the mid-nineteenth century Milanesi appears to have known some of these and some more documents which have meantime disappeared, not the least among them the record of Ghiberti's death and burial at S. Croce (Dig. 294).[17]

[14] Richa, bibl. 443, v, p. xxi.

[15] See above, p. 161 and note 3.

[16] Baldinucci, bibl. 35, I, pp. 350ff. None of the notaries' documents mentioned by Baldinucci appear to be extant among their papers in the *Archivio di Stato*.

[17] Vasari-Milanesi, bibl. 533, II, pp. 248f, note. Milanesi refers to the *Libri dei Morti* as his source for the

record of Ghiberti's death and burial; but the series of the *Libri della Grescia* (*Libri dei Morti*) extant in the *Archivio di Stato* has at present a gap between 1449 and 1457, as I am informed by Miss Eve Borsook, who, with the help of Signora Giulia Camerani of the *Archivio di Stato*, was good enough to make another check.

ASF, STROZZ., LI, 1

DOC. 1, 1402, NORTH DOOR, Dig. 4

f. 2. *Libro Grande dell'Arte de Mercatanti segnato C, dell'anno 1402*: Nencio di Bartoluccio orafo debbe fare la Porta del Metallo, c. 255.[2]

LI, 2, f. 123v.

DOC. 2, 1405, NORTH DOOR, Dig. 17

f. 3. *Libro Grande dell'Arte de Mercatanti segnato F, 1405*: Giuliano di Ser Andrea discepolo di Lorenzo di Bartoluccio, c. 171[3]

DOC. 3, 1414, SAINT JOHN, Digs. 33, 37

f. 5. *Libro Grande segnato P, 1414*: Giuliano di Arrigo detto Pesello e compagni Dipintori[(a)] segli paga fl. 20 per parte di pagamento del lavorio fanno nel Tabernacolo dell' Arte di Orto S. Michele, c. 236
dipinge detto (?), c. 417
pittori (?) di S. Gio., c. 423[4]

BNF, Magl., Cl. IX, 127, f. 187: breaks off at: [(a)]Dipintori

DOC. 4, 1414, SAINT JOHN, Dig. 34

f. 5. *ibidem*: Frate Bernardo di Stefano dell' Ordine de Predicatori segli paga fl. 12 per opera del lauro del vetro a tolto a lauorare per lo Tabernacolo di O.S.M., c. 236.[5]

DOC. 5, 1414, SAINT JOHN, Dig. 35

f. 5. *ibidem*: Libbre 1884 di Mosaico si compra degli Operai del Duomo di Pisa per fl. 65[6] (pagination illegible).

DOC. 6, 1416, SAINT JOHN, Dig. 46

f. 5v. *Libro Grande segnato Q, 1416*: Frate Bernardo di Stefano . . . lavora i vetri nel tabernacolo di Orto s. Michele[7] (no pagination).

DOC. 7, 1416, SAINT JOHN, Dig. 47

f. 5v. *ibidem*: Giuliano d'Arrigo detto Pesello e Compagni Dipintori nel Corso degli Ademari lavora il fregio del vetro del Tabernacolo d'Orto Santo Michele da beccatelli in giù[8] (no pagination).

DOC. 8, 1429, EAST DOOR, Dig. 158

f. 6v. *Libro Grande segnato I, 1429*: Colonne di S. Gio si levano dinanzi alla porta di S. Gio e pongonsi a lato alla faccia di detta Chiesa 1429, c. 176.[9]

LI, 2, f. 111; *BNF, Magl., Cl. IX, 127,* f. 188, with minor variations.

DOC. 9, 1462 [possibly 1463], EAST DOOR, Dig. 300

f. 10v. *Libro Grande segnato F, 1461*:[(a)] Vettorio di Bartoluccio dee hauere per gli stipiti soglia e altro della terza Porta [sic] di S. Gio. fl. 1060, lire 6124,[(b)] s. 15, c. 219 & 241.[10]

[1] Appendix C2 contains a transcript of 163 documents. They fall into three categories: unpublished documents; documents published heretofore only in excerpts; documents published heretofore with significant errors in transcription or dating. Documents outside these categories, such as those gathered by Doren, bibl. 133, Guasti, bibl. 198, 199, Poggi, bibl. 395, 397, 399 and Ginori-Conti, bibl. 181 are not included in this appendix.

The Digest, Appendix C3 contains a list of all references to Ghiberti's life and works in chronological order, a day by day account, as it were, irrespective of whether the relevant document is published in Appendix C2 or elsewhere.

In Appendix C2 the documents are listed according to archives and, within the archives, according to their classification.

Repetitions of documents contained in other manuscripts are indicated in Appendix C2 immediately following the main source. Variants from the text are referred to by notes a, b, c. Archives and *fondi* from which these repetitions are taken, are indicated only if they differ from those of the main source. (The manuscript *BMF, Collezione Gori, A 199* I, is quoted simply as Gori.) In the Digest Appendix C3, such repetitions or variants are referred to only if providing additional information.

Relevant bibliography and discussion of the docu-

ments contained in Appendix C2 will be found in the footnotes. In the Digest, Appendix C3, bibliographical references have been limited to data based on documents either not contained in Appendix C2 or else of questionable chronology.

A list of abbreviations of archives, *fondi*, and volumes precedes Appendix C1.

[2] Frey, bibl. 532, p. 353, doc. 2.

[3] Frey, bibl. 532, p. 354, doc. 6.

[4] Frey (bibl. 532, p. 381, doc. 20) adds, perhaps from another source "per la statua di S. Giovanni, a. 1413."

[5] Frey, bibl. 532, p. 381, as first part of his doc. 21.

[6] Frey, bibl. 532, p. 381, as second part of his doc. 21.

[7] Not in Frey, bibl. 532.

[8] Frey (bibl. 532, p. 381, doc. 24) adds a second part, based on Berti's nineteenth century transcript: "si mette su la figura di S. Giov. Batt. nel detto tabernacolo."

[9] Frey, bibl. 532, p. 342, doc. 78.

[10] Frey (bibl. 532, p. 364, doc. 44), with the date 1461. Since, however, Doc. 9 must be later than Doc. 68, its date is probably 1463.

Our dating of such Strozzi documents with the terms "after" and "before" a given date is cumbersome, but inevitable in order to avoid misdatings. By referring to the nearest preceding and following dates in the margin of Strozzi's manuscripts these terms establish chronological limits. Where in our transcript such approxi-

Gori, 140v and 153, where correct date is to be found: (a)*Libro Grande G, 1462*; (b)6129.

DOC. 10, 1426, after Apr. 26; just before Dec. 29, BAPTISTERY, Dig. 127

f. 37ff. *Filza di più sorte scritture dell' Arte de Mercatanti dall'anno 1414 al 1433*, f. 38v: drawing of lintel | br. 3¼ | br. 2⅓ | br. ¼ |
Per il frontespicio della Porta di S. Gio scrive Forasasso (?) da Carrara per minore spesa volendo pigliare di tre pezzi come sopra(a)11

Gori, 153v, with date 1424 or 1425: cio fu intorno al 1424 o 25; (a)come di contro

DOC. 11, 1451, Jan. 5 [or 16], EAST DOOR, Dig. 275

f. 43. *Quaderno di Riccordi segnato O comminciato 1450 e finito 1453*: Lorenzo di Bartoluccio e Vettorio suo figliolo si obbligano di dare finita interamente la terza porta di S. Gio fra venti mesi con certe condizioni nel qual tempo(a) devono tenere a lavorare quattro maestri buoni e tre non cosi perfetti, e un ragazzo, c. 132.12

(a)Only first part until *tempo* legible in *LI, 1*, dated Jan. 5; repetition of first part in *LI, 2, 113*, dated Jan. 16.
Reconstruction of whole entry after Gori, 153, dated Jan. 16, 1451.

DOC. 12, 1452, after Apr. 18 and before Aug. 22 [probably June 16], EAST DOOR, Dig. 281

f. 44v. *ibidem*: Lorenzo di Bartoluccio è dichiarato avere bene indorato la 3a porta di S. Gio, c. 147.13

Gori, 153 and 142 with date June 16, 1451; summary of this and following entry in *LI, 2, 113* with date June 16, 1451.

DOC. 13, 1452, after Apr. 18, before Aug.

22 [probably after June 16], EAST DOOR, Dig. 282

f. 44v. *ibidem*: Lorenzo di Bartoluccio e Vettorio suo figliolo è dichiarato che interamente habbino finite la terza porta di S. Gio, c. 149.14

LI, 2, 113 for summary of this and previous entry; also *LI, 2, 114v*, with date June 16, 1451.

DOC. 14, 1452, after Aug. 22 [probably Dec. 12-18], SOUTH DOOR, Dig. 285

f. 45. *ibidem*: Alla Porta del Battesimo di S. Gio si faccia li stipiti da lato e soglia e cornice e cardinale in modo che la risponda all' altre due che sono fatte, c. 154.15

LI, 2, 113; Gori, 153

DOC. 15, 1452, after Aug. 22 [after Dec. 12-18; before Feb. 12, 1453], EAST DOOR, Dig. 287

f. 45. *ibidem*: A Lorenzo di Bartoluccio se gli da una casa e bottega appresso S. Maria Nuova dove s' è lavorato la Porta di S. Gio per fl. 218.3.4 che restava havere per la fattura di detta porta, c. 155.16

DOC. 16, 1452, after Aug. 22 [probably Feb. 12, 1453], SOUTH DOOR, Dig. 288

f. 45. *ibidem*: A Lorenzo detto s' alluoga a fare gli stipiti e altro della porta del Battesimo, c. 155.17

LI, 2, 113v, with date 1452; Gori, 153v.

DOC. 17, 1453, after May 9, EAST DOOR, Dig. 290

f. 45. *ibidem*: Fregio di Marmo si fa intorno alla Porta dinanzi di S. Gio, c. 158.18

LI, 2, 113v; Gori, 141v, dated 1453; *ibid.*, 153v.

DOC. 18, 1445, after Jan. 7; shortly before June 1, EAST DOOR, Dig. 252

mate dates are followed by more precise indications, placed in brackets, these dates are based either on a dated document referring to the same event or on conclusions obtained from other relative material.

11 Brockhaus, bibl. 69, p. 39; Frey, bibl. 532, p. 357, doc. 1 with erroneous date April 22, 1423. The revised date results from the pagination of the original *filza*. As excerpted by Strozzi, c.38 contains entries dating from Nov. 23, 1423 to April 26, 1426; c.38v begins with Doc. 10 followed by an entry dated Dec. 29, 1426.

12 Frey, bibl. 532, doc. 28 and Brockhaus, bibl. 69, p. 45, both give only the first part. The entry is nearly identical with the last part of our Doc. 44.

13 Unpublished. The approximate date results from the nearest entries preceding and following; the specific date results from doc. 47, the first part of which refers to the same event.

14 Frey, bibl. 532, p. 361, doc. 21 with date of April 13, 1452. The date is probably slightly later than doc.

11 and precedes doc. 75 of July 13, 1452.

15 Frey, bibl. 532, p. 363, doc. 37, with date of August 22. Frey mistakenly brings all the documents relating to the frame around the Andrea Pisano door, i.e., the south portal, under the heading "third door," i.e., *Porta del Paradiso*. See our Doc. 74.

16 Frey, bibl. 532, p. 363, doc. 36, with date of August 22, 1452. The pagination of the *Quaderno O*, excerpted by Strozzi, contradicts Frey's dating: c. 153 (Doc. 14)= after August 22; c. 158 (Doc. 17)= after May 9, 1453. Ghiberti evidently received the house after the decision had been taken to decorate the Andrea Pisano door, i.e., Dec. 12-18 (Doc. 74) and before it is commissioned to him and Vittorio on Feb. 12, 1453.

17 Frey, bibl. 532, p. 363, doc. 38 with date August 22, 1452. The approximate date results from the nearest entry preceding it; for the correct date see Doc. 50.

18 Unpublished. The date results from the nearest entries preceding and following.

f. 48. *Quaderno di Riccordi segnato M cominciato 1° Gennaio 1444 e finisce l'anno 1449 del Proveditore dell' Arte de Mercatanti*: Fiorini 2000 di Monte dell'Opera di S. Giouanni si vendono[a] per pagare l'Ottone che si fa venire di Bruggia, c. 136[19]

Gori, 162v: [a]vendino

DOC. **19**, 1445, after June 1; shortly before Oct. 7, EAST DOOR, Dig. 254

f. 48v. *ibidem*: Ottone lb. 14623 si fa venire da Bruggia e sono posto in Firenze fl. 1135, c. 138[20]

DOC. **20**, 1447, Aug. 7, EAST DOOR, Dig. 259

f. 49v. *ibidem*: 7 agosto Lorenzo di Bartoluccio M.° delle Porte di S. Gio è dichiarato havere finito le dieci storie e se gli paga il resto di fl. 1200 prezzo convenuto con lui della fattura di esse, c. 148[21]

LI, 2, 113v; Gori, 141v, 153v.

DOC. **21**, 1447, after Aug. 7; before Apr. 22, 1448, CANDELABRA, Dig. 260

f. 49v. *ibidem*: Candellieri due di rame coperti d'argento si fanno a S. Gio. per Maso di Lorenzo di Bartoluccio, c. 151.[22]

LI, 2, 114, dated 1447

DOC. **22**, 1447, after Aug. 7; before Apr. 22, 1448 [probably Jan. 24], EAST DOOR, Dig. 263

f. 49v. *ibidem*: Piu[a] pregi fatti con Lorenzo di Bartoluccio e Vettorio suo figlio per i fregi, teste 24[b] che hanno a stare nei compassi, cornici[c] . . . soglia etc. della terza porta di S. Gio[d], c. 152[23]

LI, 2, 114: [a]Pregi fatti; [b]24 teste; [c]supplements: stipiti, cardinale; [d]adds: 1447; Gori, 153v.

DOC. **23**, 1436 [1437?], Apr. 4, EAST DOOR, Dig. 198

f. 61f. *Quaderno di Ricordi segnato K cominciato 1° marzo 1434 (=1435) e finisce l'anno 1440, del Proveditore dell'Arte de Mercatanti*:

Historie dieci e pezzi 24 di fregi delle porte di S. Gio gettati si comincino a nettare[a] per Lorenzo di Bartoluccio e un suo figliolo e Michelozzo di Bartolomeo, c. 87[24]

Gori, 153v; *LI, 2*, 114: [a]rinettare

DOC. **24**, 1439, July 4, EAST DOOR, Dig. 208

f. 63v. *ibidem*: 4 Luglio concordia con Lorenzo di Bartoluccio per le Porte di S. Gio al quale si paghi per lavoro fatto su dette Porte egli, il figlio ed altri da dì 1° Genn.° 1437[a] a tutto Giugno passato fl. 180 rogatu Ser Francesco. Le Storie erano all'hora in questo termine.
Una Storia di Caino e Abel finita a fatto
Una Storia di Moise perla Legge, manca poco d'essere finita
Una Storia di Giacob et Esau, finita
Una Storia di Giuseppe del Grano per metà finita
Una Storia di Salomone erano fatti i Casamenti e un pezzo da piè le figure da lato ritto quasi per ¼
Due delle spiagie [?] fattone solo il fogliame, c. 103.[25]

Gori, 153v f: [a]1438

DOC. **25**, 1439, after July 17, before Oct. 3 [probably July 18], EAST DOOR, Dig. 209

f. 64. *ibidem*: Porta di S. Gio terza si da a armare, c. 103[26]

Gori, 154, with date July 17

DOC. **26**, 1403, Nov. 23, NORTH DOOR, Dig. 8

f. 79ff. *Libro della seconda e terza porta di Bronzo della Chiesa di S. Gio. Battista di Firenze*: Si da a fare la seconda Porta di S. Gio a Lorenzo di Bartolo, e a Bartolo di Michele suo padre Orafi, con che Lor.zo debba lavorare in sui[a] Compassi di sua mano le figure, alberi e simili cose de compassi con che possa torre in suo aiuto Bartolo suo padre e altri sufficienti maestri che gli parra.
Deve ogn' anno dar compiuti tre Compassi et il tempo cominci il p.° [b] di Dicembre. Non devono mettere se non la loro fatica, a tutte

[19] Frey, bibl. 532, p. 360, doc. 15, as Jan. 3. The date results from the nearest entries preceding and following.

[20] Frey, bibl. 532, p. 360, doc. 16, with date of Jan. 3. The revised date results from the nearest entries preceding and following.

[21] Frey, bibl. 532, p. 360, as last part of his doc. 17. See our Doc. 42.

[22] Frey, bibl. 532, p. 370, doc. 43, with date of August 7, 1447. The correct approximate date results from the nearest entries preceding and following.

[23] Frey, bibl. 532, p. 361, as second part of his doc. 18 with date of August 7, 1447. The event referred to is evidently identical with the new agreement of Jan.

[24] 1448 (see our Doc. 44). The excerpt Doc. 79 precedes the above by one page in the original quaderno. The preceding paragraph in Frey, starting "e piu prezzi fatti," and identical in content with our Doc. 22, could not be identified in any of the different variants of the entry.

[24] Frey, bibl. 532, p. 359, doc. 5; for the probable date 1437, see p. 164.

[25] Frey, bibl. 532, pp. 359f, doc. 7, with slight variations; Brockhaus, bibl. 69, pp. 39f, with erroneous date 1437.

[26] Frey, bibl. 532, p. 360, as first part of his doc. 8. See our Doc. 59 which refers to the same event and is dated July 18.

l'altre cose deve pensare l'Arte. Devino havere per fattura di d.a Porta quello sara giudicato da Consoli e Off.li di Mosaico et a buon conto se gli possa dare sino in fl. 200 l'anno.

Furono eletti a sollecitare la d.a Opera Matteo di Gio. Villani, Palla di Nofri delli Strozzi e Nicolo di Luca di Feo.[27]

Gori, 154v: [a]su; [b]dì; *LI*, 2, 114, summary; *BNF, Magl. IX, 127*, f. 197

DOC. 27, 1407, June 1, NORTH DOOR, Dig. 22

f. 79f. *ibidem*: Non osservando Lorenzo di Bartolo di dare compiuto ogn'anno i tre Compassi come di sopra era convenuto si fa di nuovo l'infra scritta convenzione con Lorenzo di Bartolo solo senza nominare il padre [la quale, cancelled]. Seguiti il d.o Lorenzo il lavorio cominciato della d.a porta [la quale canceled] e finche non sara finito non possa pigliare a fare altro lavoro senza Licenza de Consoli e finito che sia deva aspettare un altro (?) anno per vedere se dall' Arte gli verra (?) esser dato a fare altro lavoro.

f. 79v. Deva havere per suo Magisterio fl. 200 l'anno.

Deva ogni giorno che si lavora lavorare di suo mano tutto il dì come fa chi sta a provisione e scioperandosi lo sciopero gli debbe essere messo a conto e scritto in su un libro fatto a posto.

Deva il d.o Lorenzo lavorare di sua mano in su Cera e Ottone e massimamente in su quelle parti che sono di piu perfezione come Capelli, ignudi, e simili.

Deva trovar lui i lavoranti; ma il salario gli deva essere stabilito da Consoli.

Non deva mettere se non la sua fatica e Magisterio, e ogni materia e instrumenti gli deve essere dato dall'Arte.[28]

Gori, 154v f

DOC. 28, 1404-7, NORTH DOOR, Dig. 24

f. 79v. *ibidem*: Hebbe Lorenzo di Bartolo in tutto il tempo della prima conuenzione fra lui e suoi lauoranti fl. 882, l. 260, d. 66 a oro, e resto havere fl. 200.

Suoi lavoranti nel tempo della prima convenzione furono.

Bandino di Stefano

Giuliano di Ser Andrea
Donato di Niccolo di Betto Bardi
Jacopo d'Antonio da Bologna
Domenico di Gio
Maso di Christofano
Michele di Nicolai
Bernardo di Piero
Michele detto (?) [a]Scalcagna
Giovanni di Francesco
Antonio di Tommaso, nipote di Bandino[29]

Gori, 155: [a]dello

DOC. 29, 1403 (=1404)-1415, NORTH DOOR, Dig. 39

f. 79v. *ibidem*: Hebbe il d.o Lorenzo per il lavorio della d.a Porta dell'anno 1403 al 1415 lb. 5564 d. 11 d'ottone.[30]

Gori, 155v

DOC. 30, 1403 (=1404)-1424 (?), NORTH DOOR, Dig. 108

f. 79v. Costo l'ottone per la d.a porta detto ottone di Ritaglio[a] l. 831 [b] l. 11 parte a s. sei la lb. e parte a s. sei e mezzo. Costo il carbone e le legne fl. 57, l. 1344, d. 4. Si consumò nella d.a Opera lb. 1739 d.[oncie] 8 di cera e lb. 69 d.[oncie] 4 se ne dette ai lavoranti in falcole per tornare la sera a casa.[31]

Gori, 155f.

DOC. 31, after 1407 [presumably before 1415], NORTH DOOR, Dig. 41

f. 80f. *ibidem*: Lavoranti alla d.a Porta dopo la seconda convenzione furono con il d.o Lorenzo.

Bandino di Stefano a fl. 75 l'anno. Ebbe in tutto fl. 87.l.12. d. o (?).

Giuliano di Ser Andrea a fl. 75 l'anno. Hebbe in tutto fl. 179.13.10, item fl. 120 incirca.

Donato di Niccolo di Betto Bardi a fl. 75 l'anno. Hebbe in tutto fl. 8.4.0.

Maso di Christofano in prima a fl. 55 e di poi a fl. 75 l'anno. Hebbe in tutto fl. 113.6.2 item fl. 87.1.4 e fl. 131.7.8.

Domenico di Gio a fl. 38 l'anno, hebbe in tutto fl. 38.

Bernardo di Piero a fl. 26 l'anno. Hebbe in tutto fl. 6.5.4.

[27] Frey, bibl. 532, pp. 353f, doc. 4.

[28] Frey, bibl. 532, pp. 354ff, doc. 7. Our Docs. 27-32 have been presented by Frey as one single document, all under the date June 5, 1407.

[29] Frey, bibl. 532, pp. 354ff, doc. 7 with erroneous figures and date of June 5, 1407. Clearly this entry refers to the entire period of the first contract.

[30] The document manifestly refers to the entire period 1404-1415, contrary to Frey, (bibl. 532, pp. 354ff,

doc. 7) who brings it under June 5, 1407.

[31] It is unclear whether these three items or any one of them refer to the period of 1404-1424 or, like the preceding one, to the period 1404-1415, or possibly to the period 1415-1424. Frey, bibl. 532, pp. 354ff, doc. 7, gives the document under June 5, 1407, and with misreadings: [a]dorato; [b]*881*.

While the reading l(=lire)831 is clear in both Strozzi and Gori, it may yet be a *lapsus calami* for fl.

Nanni di Franc.o a fl. 24 l'anno. Hebbe in tutto fl. 11.

Franc.o di Gio. detto Bruscaccio a fl. 25 l'anno. Hebbe in tutto fl. 3.18.2.

Cola di Liello di Pietro da Roma. Hebbe in tutto fl. 13.19.2 a fl. 48 l'anno.

Franc.o di Marchetto di Verona a fl. 4 il mese. Hebbe in tutto l.13 d. 4 d'oro.

Giuliano di Gio. da Poggibonsi per fanciullo fl. 6 l'anno. Hebbe in tutto fl. 6.

Maestro (?) Antonio di Domenico (?) di Cicilia a fl. 5 il mese. Hebbe in tutto fl. 3.13.6.

Bartolo di Michele a fl. 75 l'anno. Hebbe in tutto fl. 197.1.7.

Bernardo di Piero Ciuffagni a fl. 45 l'anno. Hebbe in tutto fl. 14.13.—.

Domenico di Gio. a fl. 48 l'anno. Hebbe in tutto fl. 147.16.6, item fl. 67.1.1.

Zanobi di Piero a fl. 16 l'anno. Hebbe in tutto fl. 66.15.11.

Niccolo di Lor.o a fl. 25 l'anno. Hebbe in tutto 21 [sic].

Jacopo di Bartolomeo fanciullo a fl. 6 l'anno e di poi a fl. 9. Hebbe in tutto fl. 20.10. [b]

Giuliano di Monaldo a fl. 18 l'anno. Hebbe in tutto fl. 16.14.3.

Pagolo di Dono garzone di bottega a fl. 5 l'anno e di poi a fl. 7. Hebbe in tutto fl. 20.10.—.

Matteo di Donato a fl. 60 l'anno hebbe in tutto fl. 190 incirca e dipoi a fl. 75 l'anno, hebbe fl. 190 incirca.

Bartolo di Niccolo a fl. 75 l'anno. Hebbe in tutto fl. 64.13.11.

Bartolo di Michele a fl. 50 l'anno. Hebbe in tutto fl. 48.18.9.

Niccolo di Baldovino a fl. 8 l'anno. Hebbe in tutto fl. 7.12.5.

Pagolo di Dono a fl. 25 l'anno. Hebbe in tutto fl. 31.1.7.[32]

Gori, 154v with several minor variants, the only important ones being that [a]Maso di Cristofano's last two wages are added to Donatello's and that [b]Jacopo di Bartolomeo is credited with fior. 16 total wages.

DOC. 32, 1424, April 19, NORTH DOOR, Dig. 105

f. 8ov. *ibidem*: La detta Porta fu compiuta del Mese d'Aprile 1424 a dì 19 del d.o Mese si puose e rizzò alle Porti [sic] di S. Gio[33]

Gori, 156

DOC. 33, no date [possibly 1402-3], COMPETITION RELIEF, Dig. 6

f. 8ov. *ibidem*: Dorassi il Compasso della Storia d'Abramo del testam.o vecchio per fare prova di diversi Maestri e pigliare che meglio facesse. Deliberossi poi di(?) mettere nella Porta sopradetta il Testamento Nuovo e si riserbo la detta Storia per metterla nell' altra Porta se Testamento Vecchio vi si facesse. Vi si messe d'oro in dorare d.a Storia fl. 12.3.—.[34]

Gori, 156; *LI*, 2, 141

DOC. 34, no date [*ca.* 1420], NORTH DOOR, Dig. 81

f. 8ov. *ibidem*: Michelozzo di Bartolomeo lavorò piu tempo alla d.a seconda Porta a fl. 75 l'anno.[35]

Gori, 156

DOC. 35 [April 19, 1424], NORTH DOOR, Dig. 105

f. 8ov. *ibidem*: La d.a seconda Porta fu messo alla Porta di S. Gio.[a] risguarda verso S. Maria del fiore.[36]

Gori, 156: [a]che

DOC. 36, 1424 (=1425), Jan. 2, EAST DOOR, Dig. 110

f. 81. *ibidem*: Si da a fare la terza Porta di Bronzo della Chiesa di S. Gio a Lorenzo di Bartolo di Michele, excellente maestro con che finche non sarà finita, non possa pigliare a fare altro lavoro; il che nel fare la seconda porta haveva poco osservato, e per sua fatica e opera deve havere quello sara giudicato da consoli etc. [sic]. Se gli paghi a buon conto a ragione di fl. 200 l'anno. Michelozzo di Bartolomeo che lavora in su d.a Porta se gli paghi fl. 100 l'anno.[37]

LI, 2, 141; Gori, 142, 156

[32] Frey, bibl. 532, pp. 354ff, doc. 7, with date June 5, 1407. However, this list clearly is a summary which may refer either to the period 1407-1424, or more likely to part of it such as 1407-1415.

[33] Frey, bibl. 532, pp. 354ff, doc. 7.

[34] Frey, bibl. 532, pp. 356f, doc. 7, with date June 5, 1407 (?). The passage refers to both the gilding of the competition relief and the subsequent change of program. Frey dated it, questioningly, June 5, 1407. Yet, by that time work on the New Testament panels was well advanced. The change of program must have been made before work got under way, and thus probably

in 1403. In fact, the tenor of the phrase which refers to the gilding has been interpreted to mean that the gilding was part of the competition (Rossi, bibl. 452, pp. 334ff).

[35] Frey, bibl. 532, p. 357, doc. 9, as of June 5, 1407 (?). Since Michelozzo was not born until 1399 the date is erroneous.

[36] Frey, bibl. 532, p. 357, doc. 10. The date of April 19, 1424, derives from our Doc. 32.

[37] Frey, bibl. 532, p. 357, doc. 2, without the Michelozzo passage which he quotes under p. 359, doc. 6, and dates 1437.

DOC. 37, 1437, EAST DOOR, Dig. 200

f. 81. *ibidem*: Lorenzo di Bartolo possa tenere al lavoro della d.a Porta Michelozzo sudetto, Vettorio, figliolo di d.o Lorenzo, e altri tre.[38]
Gori, 156

DOC. 38, 1440, EAST DOOR, Dig. 219

f. 81. *ibidem*: Si delibera di comprare in Fiandra per fare d.a Porta lb. 17000 d'ottone fine.[39]
Gori, 156

DOC. 39, after 1440; before June 24, 1443 [possibly 1442],[a] EAST DOOR, Dig. 240

f. 81. *ibidem*: Matteo di Fran.o d'Andrea da Settignano lavorante della d.a Porta se gli paghi l. 14 il mese.[40]
Gori, 156v with date[a] 1442

DOC. 40, 1443, June 24,[a] EAST DOOR, Dig. 241

f. 81. *ibidem*: Restando a farsi ancora di dieci storie che andavano nella terza porta quattro, si conviene con Lorenzo di Bartolo, che egli per compiemento di dette dieci storie per suo magisterio e fatica, garzoni con legne e carboni habbia fl. 1200 o più e meno all'arbitrio degli officiali, con obligo di finire ogni sei mesi la terza parte, che ne egli ne suoi figliuoli possino torre a fare altro lavoro in d.o tempo, ma deva continuamente tenere a lavorare in d.a porta Tommaso e Vettorio, suoi figliuoli etc. [sic].[41]
Gori, 156v, with date[a] 1442

DOC. 41, after June 24, 1443; before Aug. 7, 1447 [possibly 1445], EAST DOOR, Dig. 255

f. 81. *ibidem*: Francesco di Papi se gli da a fare il telaio della d.a porta.[42]
Gori, 156v

DOC. 42, 1447, Aug. 7, EAST DOOR, Dig. 259

f. 81. *ibidem*: Si delibera di pagare fl. 1200 a Lorenzo di Bartolo per havere finite le storie delle porte, conforme a che era tenuto.[43]
Gori, 156v

DOC. 43 [before Jan. 24, 1448], EAST DOOR, Dig. 262

f. 81. *ibidem*: Si paghi al d.o Lorenzo di Bartolo per fattura delle spranghe fl. 125.[44]
Gori, 156v

DOC. 44, 1448, Jan. 24, amended 1451 [Jan. 5 or 16], EAST DOOR, Digs. 263, 275

f. 81, 81v. *ibidem*: Si da a fare a L.o di Bartolo il restante della terza Porta cioè 24 spiaggie gettate gl'una di nettatura solamente, per insino si possa dorare, fl. 25, perche siamo chiari, si penera (?)[a] a nettare l'una per un buono maestro mesi tre e mezzo o poco meno; e per provisione del tempo vi mettera Lorenzo, mettiamo fl. 3 dell'una. In tutto si fece l'una fl. 28; montano in tutto fl. 672.

Ventiquattro teste, che s'hanno a fare di cera e le forme a gettare e nettare secondo nostra informazione facevamo, si habbia Lorenzo per il tutto sino si possa dorare, fl. 300 a spese dell' Arte di Carboni e Cera.

A Gettare e fare di Cera la Cornice sopra il cardinale, facemmo n'habbia d.o Lorenzo per insino sara cavata dalla forma e del fuoco, a spese dell'Arte fl. 60.

A Gettare e fare di Cera e forme del Cardinale e della soglia e d'uno stipide e d'un altro che n'ha gettato e fatto la forma fra tutto fl. 320.

A fare le forme di Cera e gettare circa di 12 pezzi di spiaggie, che sara l'una braccie cioè 2⅛ o circa per mettere negli stipidi e cardinali d'intorno[b] alla porta di fuori, dove saranno i fogliami e animali e debbono essere piu belli di quelli che sono nella Porta fatta, fl. 30 l'una; in tutto fl. 360.

A scarpellare un fregio di poco rilievo dentro alli stipiti e Cardinali d'intorno alla porta che sara braccie 25½ o circa fl. 140.

Per il getto fatto da Lorenzo dell'ultimo telaio della porta e condottolo fino a questo dì, fl. 100.

Tutte le sopradette cose si danno a fare a Lorenzo di Bartoluccio e a Vettorio suo figliuolo, le quali [dovevano canceled] l'anno 1450 non havendo[c] finite, di nuovo se gli alluogano per haverle finite in venti mesi da cominciare il dì primo febbraio 1450 (= 1451).[45]
Gori, 156v; 139

[38] Frey, bibl. 532, p. 359, doc. 6.

[39] Frey, bibl. 532, p. 360, as first part of his doc. 11.

[40] Frey, bibl. 532, p. 360, as second part of his doc. 11, with erroneous date of 1440. The approximate date results from the nearest entries preceding and following. The date 1442 is given by Gori.

[41] Frey, bibl. 532, p. 360, doc. 12.

[42] Frey, bibl. 532, p. 360, doc. 13, with erroneous date June 24, 1443. The approximate date results from the nearest entries preceding and following, the probable date 1445 from Doc. 19.

[43] Frey, bibl. 532, pp. 360f, first part of doc. 17. See our Doc. 20.

[44] Frey, bibl. 532, p. 361, doc. 19, with date of Jan. 28. The date results from the silence of Doc. 44 regarding these cross bars.

[45] Frey, bibl. 532, pp. 361f, doc. 20, misread: [a]*ponera*; [b]*d'un terzo*; [c]*parte havendo*. The last part of the document is identical with the dated Document 11 and covers a new agreement. Frey assumed, erroneously, that the agreement of 1448 became active only at that late date.

DOC. **45**, 1452 [Mar. 19], EAST DOOR, Dig. 278

f. 81v. *ibidem*: Bilichi della 3 a porta si danno a fare a Tinaccio fabbro, figliuolo di Piero.[46]

Gori, 139 as March 19, 1451 (=1452)

DOC. **46**, 1452, Apr. 2, EAST DOOR, Dig. 279

f. 81v. *ibidem*: Essendo finito la terza porta di S. Gio., si da a indorare a Lorenzo di Bartoluccio e a Vettorio suo figliuolo per fl. 100 di lor magisterio e fatica a tutt'altre spese dell'Arte per doverla haver' finita il dì 20 di Giugno prossimo.[47]

Gori, 142 with date 1451; 139 with date 1452, April 2.

DOC. **47**, 1452, June 16, EAST DOOR, Dig. 280

f. 81v, 82. *ibidem*: Il di 16 di Giugno fù dichiarato essere la d.a Porta finito del tutto indorare. Si paga fl. 884 d'oro e l. 99, s. 3, d. 8 per oro comprato per dorare la d.a Porta.[48]

Gori, 139

DOC. **48** [July 13, 1452], EAST DOOR, Dig. 283

f. 82. *ibidem*: Porta terza di bronzo essendo del tutto finita, si ponga alla porta di S. Gio, che risguarda verso Santa Maria del Fiore.[49]

Gori, 139

DOC. **49** [after Dec. 12-18, 1452; before Feb. 12, 1453], EAST DOOR, Dig. 287

f. 82. *ibidem*: Bottega si da a Lorenzo di Bartoluccio e Vettorio, suo figliuolo, posta parte nel popolo di Santa Maria in Campo e parte nel popolo di San Michele Visdomini per fl. 270, che restavano creditori per la fattura della porta di S. Gio. terza, nella qual bottega havevano lavorato la d.a terza porta.[50]

Gori, 139

DOC. **50**, 1453, Feb. 12, SOUTH DOOR, Dig. 288

f. 82. *ibidem*: Stipiti, cardinale, soglia e grado della porta del Battesimo di S. Gio. si danno a fare a Lorenzo di Bartoluccio e Vettorio suo figliuolo.[51]

Gori, 139 with date Feb. 12, 1453 (=1454)

DOC. **51**, 1457, Feb. 11, SOUTH DOOR, Dig. 297

f. 82. *ibidem*: A Vettorio di Lorenzo di Bartoluccio si paga a conto del magisterio de sopra detti stipiti e altro fl. 100. Item fl. 50.[52]

Gori, 139v

DOC. **52**, 1424 [June ?], EAST DOOR, Dig. 106

f. 82, 82v. *ibidem*: A tergo: Spettabili huomini Niccolo da Uzzano e Compagni, deputati etc. [sic] Intus vero [sic]:

Spectabiles etc. [sic]. Io considero che le 20 historie della nuova porta le quali avete deliberato che siano del vecchio testamento, vogliono avere due cose principalmente: l'una che siano illustri, l'altra che siano significanti. Illustri chiamo quelle che possono ben pascere l'occhio con varietà di disegno, significanti chiamo quelle che abbino importanza degna di memoria. Presupponendo queste due cose, ho eletto secondo il giudicio mio 20 historie le quali vi mando notate in una carta. Bisognerà che colui, che l'ha a disegnare, sia bene instrutto di ciascuna historia, si che possa ben mettere e le persone e gl'atti occorrenti, e che habbia del gentile, si che le sappia bene ornare. Oltra all'historie 20 ho notato otto profeti come vedrete nella carta. Hora (?) dubito punto (?) che quest'opera, come io ve l'ho disegnata riuscira excellentissima. Ma bene vorrei essere presso a chi l'harà a disegnare per fargli prendere ogni significato, che la storia importa. Raccomandomi a Voi Vostro Lionardo d'Arezzo. [See scheme on p. 373.]

Gori, 140f, with the explanatory notes: "Copia di lettera rinchiuso drento a detto Libro della seconda e terza porta di S. Gio.," and in the margin: "Bellissima Memoria finora non saputa."

DOC. **53**, 1416, SAINT JOHN, Dig. 48

f. 91. *Uscita d'Arte de Mercatanti 1416*: Tabernacolo si fa a Orto S. M[ichele], c. 7 e si paga a Frate Bernardo di Stefano, frate di S. M[aria] Novella per parte del Lavorio del

[46] Frey, bibl. 532, p. 363, doc. 29.

[47] Frey, bibl. 532, p. 363, doc. 30.

[48] Frey, bibl. 532, p. 363, as first part of his doc. 32. See Doc. 12.

[49] Frey, bibl. 532, p. 363, as second part of his doc. 32, with date of June 16. This entry is essentially identical with the dated one of July 13, 1452, Doc. 73.

[50] Frey, bibl. 532, p. 363, doc. 34, with date of June 16, 1452. Regarding the date, see Docs. 15, 75.

[51] Frey, bibl. 532, p. 364, doc. 40, with date of June 16. The date 1453 (=1454), as it appears on f. 82 and in the copy in Gori, 139, must be revised into 1452 (=1453). Doc. 16, which refers to the same event, was extracted from c. 155 of *Quaderno O*. Since c. 158 of the same quaderno is dated after May 9, 1453 (see Doc. 17), the above entry must be earlier.

[52] Frey, bibl. 532, p. 364, doc. 42.

Scheme from Doc. 52

Come Dio crea il cielo e le stelle	Dio fa l'huomo e la femina	Adam et Eva intorno al albore mangiano il pome	Come sono cacciati del Paradiso dall'Angelo
Cain uccide Abel suo fratello	Ogni forma d'animale entra nell'Arca di Noe	Abraham vuole immolare Isaac per command.o di Dio	Isaac da la benedizione a Jacob credendo che sia Esau
E fratelli di Josef il [?] vendono per invidia	Il sogno di Faraone di 7 vacche e 7 spighe	Josef riconosce i fratelli venuti per lo grano in Egitto	Moise vede Dio nelle spine ardenti
Moise parla a Faraone e fa segni miracolosi	Il mare diviso et il popolo di Dio passante	Le leggi date da Dio a Moise nel monte ardente buccina sonante	Aron immolante sopra l'altare in abito sacerdotale con campanelle e melagrane intorno a vestimenti
Il popolo di Dio passa il fiume Giordano et entra in terra della promissione con l'arca federis.	Davit uccide Golia in presenza del re Saul	Davit fatto re con letizia del popolo	Salamone giudica intra le due femine la questione del fanciullo
Samuel Profeta	Natan Profeta	Helia Profeta	Heliseo Profeta
Isaia Profeta	Jeremia	Ezechiel	Daniel[53]

vetro fà a d.o Tabernacolo. c. 7. Si mette su la figura del S. Gio.[(a)] c. 7[54]

LI, 2, 115v: [(a)]Batt. nel d.o tabernacolo

DOC. 54, 1413, SAINT JOHN, Dig. 31

f. 93. *Uscita dell'Arte, 1413*: Figura[(a)] si fa per il Pilastro di O. S. M. c. 5[55]

Gori, 173: [(a)]di bronzo

DOC. 55, 1415, SAINT JOHN, Dig. 42

f. 101. *Uscita di S. Gio., 1415*: A Albizzo di Piero Maestro per parte della sua provisione del Tabernacolo fa a Orto S. Michele fl. 7, c. 12[56]

DOC. 56, 1417, Nov. 28, SAINT JOHN, Dig. 56

f. 101. *Uscita di S. Gio., 1417*: Alla figura di S. Gio. a dì 28 di Novembre fl. 5 d'oro pagammo per d.a poliza [?] a Lorenzo di Bartoluccio proprio dette per oro e altro lavorio a

comprato per la d.a figura, c. 20[57]

LI, 2, 115: summary

DOC. 57 [after 1455], PROPERTY, Dig. 295

f. 115ff. *Filza 2 a dell'Arte de Mercatanti di Partiti e Deliberazioni de Consoli dall' 1425 al 1438* [sic]: Consoli possono dare licenza a Vettorio di Lorenzo di Bartoluccio di poter transmutare un podere presso a Careggi il quale Lor.o compro dall'Opera di S. Gio. a vita sua della moglie e di Tommaso e Vettorio suoi figlioli i quali Lor.o e Tom.so di puoi erano morti purche (?) trovano da venderlo bene e possino ancora d.i consoli venderlo libero per doppo [sic] la morte di d.o Vettorio con alcune condizioni, c. 14[58]

DOC. 58, 1423, NORTH DOOR, Dig. 102

f. 118v. *ibidem*: Porte di S. Gio, Cardinale e stipiti si fanno conforme al disegno di Lo-[ren]zo di Bartoluccio, c. 281[59]

[53] Frey, bibl. 532, pp. 357ff, doc. 3, with date of 1425; Brockhaus, bibl. 69, p. 37. For date, see Dig. 106.

[54] Frey, bibl. 532, pp. 380f, doc. 16, quoted from LI, 2, 115v, but with erroneous date of 1412. Repeated, Frey, p. 381, doc. 25, last part only, with correct date of 1416.

[55] Frey, bibl. 532, p. 381, doc. 17.

[56] Frey, bibl. 532, p. 381, doc. 23.

[57] Frey, bibl. 532, p. 381, doc. 26, without month and day.

[58] Unpublished. The document must date from after Ghiberti's death in 1455.

[59] Unpublished.

DOC. 59, 1439, July 18, EAST DOOR, Dig. 209

f. 123. *Filza 4a dell'Arte de Mercatanti di Petizioni e altre scritture dal 1434 al 1461*: Tinaccio di Piero e Piero di Francesco segli da a fare l'armatura del getto del telaio della terza porta di bronzo di S. Gio, c. 255[60]

DOC. 60, 1403, Sept. 3, NORTH DOOR, Dig. 7

f. 183ff. *Deliberazioni de Consoli dall' 1401 al 1414*: Porta di Metallo si delibera che si faccia per la Porta dinanzi della Chiesa di S. Gio. che risguarda S. M[aria] del fiore, c. 35[61]

DOC. 61, before Jan. 12, 1404 [probably Nov. 23, 1403],[(a)] NORTH DOOR, Dig. 8

f. 184. *ibidem*: Porta di Bronzo: Si da a fare a Lorenzo di Bartoluccio Orefice, c. 38[62]

 Gori, 33: [(a)]l'anno 1404

DOC. 62, 1405, after Aug. 31; before Feb. 11, 1406, NORTH DOOR, Dig. 15

f. 184v. *ibidem*: Lorenzo di Bartoluccio fa la Porta di Metallo e sono nominati i suoi lavoranti, c. 65[63]

DOC. 63, 1407, on or before June 3, SAINT JOHN, Dig. 23

f. 185. *ibidem*: Pilastro dell'Arte nel Palazzo d'O.S.M. si orni e per questo s'eleggi[e] [?] tre Offi.li, c. 77[64]

DOC. 64, 1408, after Dec. 24; before May 2, 1409, NORTH DOOR, Digs. 26, 27

f. 185v. *ibidem*: Porta di Metallo S. Gio. lavoranti, c. 95 hore che i lavoranti devino havere di vacanza, c. 109[65]

DOC. 65, 1403 (=1404), Jan. 30, NORTH DOOR, Dig. 10

f. 185v. *Delib. degli Offiziali di Musaico*: Porta di Bronzo si da a fare a Lorenzo di Bartolo Orefice, c. 113[66]

DOC. 66 [1404-1415?], NORTH DOOR, Dig. 40

Lavoranti, c. 114, 115, 116, 117, 118, 119, 120, 121, 122, 123[67]

DOC. 67, 1454, after Apr. 23; before Apr. 29, 1456, EAST DOOR, Dig. 292

f. 191. *Libro di Provisioni del 1420 al 1470*: Non si possa spendere danari per l'opera di S. Gio. se prima non sara deliberato per i consoli officiali di mosaico e Proveditori delle porte di S. Gio. fuorche per i salari ordinari, c. 28[68]

DOC. 68, 1462, after July 5; before March 13, 1463 (=1464), SOUTH DOOR, Dig. 299

f. 192v. *ibidem*: Porte di S. Gio[(a)] erano fornite[(b)] e solo restava fare il pregio con Vettorio di Lorenzo di Bartoluccio che l'haveva fornite, e particolarmente si doveva restare d'accordo degli stipiti, cardinale, cornice, scaglione e soglia che ultimamente haveva fatto per dette porte, c. 48[69]

 LI, 2, 119v and Gori, 143: [(a)]l'anno 1462; [(b)]finite; Gori, 143 ends after finite

DOC. 69, 1463 (=1464), before March 13, DOORS, Dig. 301

f. 192v. *ibidem*: Proveditori delle Porte di S. Gio. havendo finito l'officio loro per essere finite le porte, i quali dovevano intervenire negli stanziamenti da farsi delle spese di detta chiesa, però si delibera, che per l'avvenire si stanzino solamente per [illegible] de consoli e offiziali di mosaico, c. 48[70]

DOC. 70, 1440, after Dec. 7; before Jan. 4, 1441, EAST DOOR, Dig. 217

f. 199ff. *Deliberazioni 1439 e 1440*: Porte di S. Gio si fabbricano, c. 47[71]

[60] Frey, bibl. 532, p. 360, doc. 9; Brockhaus, bibl. 69, p. 40.

[61] Frey, bibl. 532, p. 353, doc. 3.

[62] Unpublished. The pagination points to a date prior to Jan. 12, 1404; for the exact date, Nov. 23, 1403, see Doc. 26.

[63] Unpublished. The date results from the nearest dated entries preceding and following.

[64] Unpublished. The date results from the nearest dated entries preceding and following.

[65] Unpublished. The date results from the nearest dated entries preceding and following.

[66] Frey, bibl. 532, p. 354, doc. 5.

[67] Unpublished. An approximate date can be established from the following entries: on c. 113, dated Jan. 30, 1404; on c. 118, dated May 28, 1406; on c. 120, dated Jan. 30, 1409.

[68] Unpublished. The date results from the nearest dated entries preceding and following.

[69] Frey, bibl. 532, p. 364, doc. 45, with date of July 5, 1462 and reference to *Porte del Paradiso*. The correct date results from the nearest dated entries preceding and following.

[70] Frey, bibl. 532, p. 364, doc. 46, with date of July 5, 1462. The correct date results from the nearest dated entries preceding and following. Docs. 68 and 69 must be close in date as evident from the pagination of the *Libro di Provisioni*, excerpted by Strozzi.

[71] Frey, bibl. 532, p. 360, doc. 10, with the erroneous date of Dec. 7, 1439. The correct date results from the nearest entries preceding and following.

DOC. 71, 1444, after Jan. 3; before Feb. 24 [Jan. 24], EAST DOOR, Dig. 246

f. 203. *Deliberazioni de Consoli 1443 e 1444*: S. Gio. Porta di Bronzo Vettorio di Lor[en]zo di Bartolo M.stro delle d.e Porte in nome di suo padre conduce per tre anni a lavorare a d.a Porta Benozzo di Leso (?) Pittore po.lo di S. Friano, c. 8[72]

Gori, 141v

DOC. 72, 1449, Sept. 22, EAST DOOR, Dig. 273

f. 206. *Deliberazioni de Consoli dall'anno 1447 al 1451*: Porta di S. Gio di bronzo scarpellatori elezione, c. 73[73]

DOC. 73, 1452, July 13, EAST AND NORTH DOORS, Dig. 283

f. 209ff. *Deliberazioni de Consoli dall'anno 1452 al 1454*: Pratica circa il rizzare e porre la porta di bronzo nuovamente fatta nella chiesa di S. Gio. Si delibera stante la sua bellezza, che si metta alla porta di mezzo, che risguarda S. Maria del Fiore e che[(a)] quella che era in d.o luogo si ponga alla porta verso la colonna e case dell'Opera, c. 17[74]

LI, 2, 119v: [(a)]la porta che era prima in d.o luogo si ponga . . . ; Gori, 143, identical.

DOC. 74, 1452, Dec. 12-18, SOUTH DOOR, Dig. 285

f. 209v. *ibidem*: S. Gio. Stipiti, cardinale e soglia si faccia fare alla porta di d.a chiesa, che e vicino al Battesimo nel modo e forma che stanno le altre porte di d.a chiesa, c. 33[75]

LI, 2, 119v; Gori, 143, with date 1452

DOC. 75, 1453, Apr. 9-26, EAST DOOR, Dig. 289

f. 210. *ibidem*: Casa si consegna per fl. 250 a M.o Lorenzo di Bartoluccio Maestro d'Intaglio [?] e Vettorio suo figliuolo che ultimamente havevano fatto la Porta del Bronzo per fl. 250

che era per il resto di quando havevano havere per d.a manifattura, c. 53[76]

DOC. 76, 1453, May 14-26, EAST DOOR, Dig. 291

f. 210. *ibidem*: Scaglione di bronzo si mettono dalla porta di mezzo verso l'Opa., c. 58[77]

DOC. 77, 1456, April 3 and following months, EAST DOOR, Dig. 296

f. 213f. *Deliberazioni e altro de Consoli dall'anno 1455 al 1459*: Vettorio di Lorenzo di Bartoluccio se gli paga danari per fare gli stipiti scaglione e soglia della porta di S. Gio., c. 17, 19, 32, 42, 79[78]

DOC. 78, 1458, after Nov. 21; through April 1459, SOUTH DOOR, Dig. 298

f. 217v. *ibidem*: Bronzo si faccia venire per le porte e stipiti di S. Gio., c. 192, 215, 221, 228[79]

ASF, STROZZ., LI, 2

DOC. 79, 1447, after Aug. 7; before Apr. 22, 1448 [probably before Jan. 24], EAST DOOR, Dig. 261

f. 114. *Quaderno di Riccordi segnato M dal 1444 al 1449*:[(a)] Fregi della terza Porta di S. Gio. si rigettano[(b)] per Lorenzo di Bartoluccio, c. 151[80]

Gori, 153v: [(a)]gives the source; [(b)]rigettino

ASF, STROZZ., LI, 3

DOC. 80, Digs. 5, 9, 11, 16, 38

f. 153. Nencio di Bartoluccio f. 30 lib. C 1403[81] 270; Libr. D 178 fl. 100.
Spese per la Porta del Metallo che si fa lib. D 183 fl. 3 l. 87 s. 13; lib.o E 173, 174, 226; lib.o F 150, 157, 281; G 126, 131, 156, 158, 159, 166, 176; J 91, 93, 94, 97, 98, 130, 139.
Figura del Pilastro d'O.S.M. F 97; K 96, 27,

[72] Frey, bibl. 532, p. 360, doc. 14, as Jan. 3, 1444. The approximate date results from the nearest entries, preceding and following, the exact date from the original document (Doc. 99).

[73] Brockhaus, bibl. 69, p. 45; Frey, bibl. 532, p. 362, doc. 27, with the date of Sept. 12. The date 1449 is confirmed by the original document, Doc. 95; c. 73 in Strozzi's excerpt corresponds to c. 73v in the original document.

[74] Frey, bibl. 532, p. 363, doc. 35, with date of June 16; Brockhaus, bibl. 69, p. 45. See Doc. 48 for the same event.

[75] Frey, bibl. 532, pp. 363f, doc. 39. Frey fails to realize that this document refers to the Andrea Pisano door and not to Ghiberti's second door. The date results from the nearest entries preceding and following. See also Doc. 14.

[76] Unpublished. The date results from the nearest entries preceding and following. See the earlier Docs. 49 and 15.

[77] Unpublished. The date results from the nearest entries preceding and following.

[78] Frey, bibl. 532, p. 365, doc. 41.

[79] Frey, bibl. 532, p. 364, doc. 43, with date of November 21, 1458. The correct date results from the last dated entry preceding, November 21, 1458, and the entries on c. 215 and c. 228, dated February and April 28, 1459, respectively.

[80] Frey, bibl. 532, p. 361, as first part of his doc. 18. The approximate correct date results from the pagination in the original *Ricordo M*: c. 148=Aug. 7, 1447 (cf. Doc. 20); c. 152=Jan. 24, 1448 (cf. Docs. 22 and 44).

[81] Error of Strozzi's. The *Libro Grande C* corresponds to the year 1402.

104, 123, 126, 131, 138; L 88, 90, 102[?] . . . ,
103, 107, 110, 121, 134; M 23, 88, 89, 91, 92, 98,
102, 107, 120, 130; N 68, 78, 80, 81, 82, 92, 97,
100, 102, 104, 120; P 6.z[?],8.y, 79, 80, 81, 82,
100, 103, 112.y, 113.z, 181, 182, 183, 184, 185,
187, 188, 199, 200, 201, 202, 203, 204, 207, 229,
235, 236, 374, 375, 376, 377, 380[?], 381, 391,
392, 393, 394, 395, 396, 397, 398, 399, 400, 407,
409; O 8, 87, 89, 90, 98, 99; Q+ 5, 172, 173, 174,
176, 177, 178, 190, 191, 197, 231, 232, 247, 248,
252, 256, 262, 264, 266, 272, 274, 275, 276, 279,
280, 367, 272 [sic], 376, 378, 380, 382, 383, 386,
402; T 173, 176, 177, 180, 186, 187, 190, 191,
207, 272, 275, 276, 279, 281, 363; T 1421. 187,
188, 189, 193, 196, 202, 207, 209, 210, 212, 213,
217, 222, 223, 225, 233, 234, 240, 243, 245, 246,
247, 249, 258[?], 300, 304, 306, 308, 322, 323,
325, 326, 330, 338, 352, 355, 356, 357, 358; G
256, 258, 259, 266, 268, 271, 272, 297, 298, 301,
307, 316, 319, 323, 330, 332, 333, 335, 341, 352.
Terza Porta 337, 338, 365, 373, 166, 169, 182,
198; K 177, 178, 179, 188; L 263, 264, 265.
Seconda Porta J 165, 166, 167 [canceled], 171,
190; L 271.
Terza M 286, 287, 288; N 310, 311, 312, 313;
O 164; P 184, 185, 186; Q[?] 162, 163[?], 164.[82]

ASF, CATASTO

DOC. 81, 1427, July 9, TAX DECLARATION,
Dig. 138

*ASF, Quartiere di San Giovanni, Gonfalone
Chiavi, Portate al Catasto, 1427, vol. 58, c. 199,
199v*

+XPUS MCCCCXXVII a di VIIII di luglo
Dinanzi a voi signori ufficiali del chatasto del
comune di firenze sustanze inchariche per
me
Lorenzo di bartolo orafo lavora le porte di
sco. giovanni ghonfalone delle chiavi [h]o di
prestanzon fl. II s. XVI d. X le sustanze sono
queste cioe
una chasa posta nel popolo di sco. anbruogio
di firenze nella via borgho allegri confinata
da primo via da secondo zanobi di jachopo
de rosso da terzo tomaso di bartolone granaiu-
olo detto bolliera (?) e piu altri confini a
detta chasa con piu maseritie a uso di me e
della mia famiglia. . . . fl.
uno pezzo di terra posto nel popolo di sco.
donato in fronzano da primo via da secondo
labadia di valonbrosa da terzo Nanni di nich-
olo e piu altri confini cioe lavoratia ulivata e
vignata
Lavorala Nanni di nicholo dame di fitto
l'anno soma una dolio [d'olio] . . . fl.
truovomi in bottega II istorie dottone per

una fonte di battesimo le quali o fatto per a
Siena le quali due storie sarano per amici
comuni a stimare penso averne pellomeno
quatro cento o circa de quali o auti fl. 290
restero avere fl. cientodieci fl. 110
truovomi ancora in bottegha una chasetta
dottone fatta per chossmo demedici stima di
fl. CC° circha della quale o avuti gia piu
tempo per ispese sono ite in essa fl. CXXXV
Resto avere ancora fl. LXV . . . fl. 65
In sul monte del chomune di firenze mi truovo
iscritti in me fl. 714½ di monte dotto [d'otto][(a)]
percento de quali ve [v'e] posto la conditione di
fl. 100 per fl.L gli resto a dare cioe al bancho
d'isau e compagni fl.
Resto avere da frati di sca maria novella fl. 10
della sepoltura ch'io feci pel gienerale . . . fl. 10
da giuliano di piero Maestro di murare detto
scanbella fl. 5
+XPUS a di VIIII di luglio 1427
Incharichi a me Lorenzo di bartolo orafo
Lorenzo sopradetto detta [d'età] danni [d'an-
ni] XLVI o circha
La marsilia mia donna detta danni XXVI o
circha
tomaso mio figliulo deta danni X o circha
vetorio mio figlouolo deta danni VIIII o circha
[H]o debito con piu persone come apresso
diro
Antonio di piero del vaglente e compagni
orafi fl. 13
Nichola di messer veri de medici fl. 10
Domenicho di tano coltriciaio fl. 9
Nicholo charducci e compagni ritaglatori fl. 7
Papi d'andrea legnaiuolo fl. 16
Mariano da ghanbassi Maestro di murare fl. 7
Papero di meo dassettignano ⎫ sono miei
Simone di nanni da fiesole ⎬ garzoni in
Cipriano di bartolo da pistoia ⎭ bottega fl. 48
Antonio chiamato el mastro sarto fl. 15
Domenicho di lippo coltriciaio fl. 2
Allessandro d'Alessandri e compagni fl. 4
Duccio adimari e compagni Ritaglatori fl. 8
Antonio di giovanni cartocaio fl. 3
Isau d'agnolo e compagni fl. 50
L'opera di sca crocie fl. 6
Lorenzo da brucianese fornaciaio e
 compagni fl. 3
Meo lastraiuolo a sco pulinare fl. 5
Pippo . . . chalzolaio a le porte (?) fl. 8
(in different handwriting:)
Chiavi a di X di luglio
Lorenzo di bartoluccio orafo . . . l. 3 s 10 d 10
. . . questo a libro (?) c. 423
(in the first hand:)
scritta di lorenzo di bartolo orafo[83]

[82] Unpublished. For the date of the *Libri Grandi*, see
above, p. 364, note 13.

[83] Autograph. Mather, bibl. 308, pp. 56f, misread
detto for (a)*d'otto*.

DOC. **81**a, *ibidem, Campione, 1427, vol. 80,* c.423v

Repeats the same items, adding the tax assessment for items not specified in the *Portata* and deducts 200 fiorini per dependent (*bocca*), thus arriving at the tax due:

. . . chonposto per gli uficiali in fl 1 s VIII[84]

DOC. **82**, 1431, Jan. 26, TAX DECLARATION, Dig. 162

ibidem, Portate al Catasto, 1430, vol. 386, c. 192, 192v

+XPUS MCCCCXXX a di XXVI di giennaio
Dinanzi a voi signori uficiali del chatasto del comune di firenze sustantie e incharichi per me Lorenzo di bartolo orafo lavora la porta di sco giovanni quartier di sco giovanni ghonfalone delle chiavi le sustanze son queste.
O di catasto fl 1. s. VIII [inserted]
Una Casa posta nel popolo di sco anbruogio di firenze in via borgho allegri confini da primo via da secondo zanobi di jacopo di rosso vaiaio da terzo tomaso di bartolone da rovezzano e piu altri confini a detta casa con piu altre maseritie a uso di me e della mia famiglia
uno pezzo di terra posto nel popolo sco donato in fronzano da primo via da secondo labadia di valleonbrosa da terzo nanni di nicholo di fio e piu altri confini la detta terra lavora arotto (?) nani di nicholo e damene di fitto una soma dollio detta terra vignata ulivata e lavoratia
45 pechore tielle [tienele] neri di piero dello popolo di sco bartolo a pomino a mezo pero e mezo danno
In sul monte del chomune di firenze mi truovo iscritti in me fl. MCCCVII[(a)] dotto percento e quali ve posto una conditione dico in alesandro di giuliano torrig[i]an[i] di fl. CC laquale conditione e per 80 fl. mi presto el detto alesandro e quali denari e . . (?) pel banco d'agnolo d'isau martellini
O avere dal arte di chalimala franciessca fl. dugiento ottanta e quali denari o avanzati colla detta arte come aparisce peloro libri
O avere da giuliano di piero del banbaccio fl. cinque maestro di murare[(b)]
+XPUS MCCCCXXX a di gienaio a di XXVI
Incharichi di lorenzo di bartolo orafo
Lorenzo sopradetto detta d'anni 49 o circa
La marsilia mia donna detta d'anni 30 o circa
Tomaso mio figluolo deta d'anni 13
Vetorio mio figluolo deta d'anni 12
o debito con piu persone
Allexandro di giuliano torrigiani fl. ottanta fl. 80

Filippo di nicholo da fiesole fl. settantacinque	fl. 75
Nichola di messer veri fl. dodici	fl. 12
L'erede d'Agnolo d'Isau Martellin fl. otto	fl. 8
Antonio sarto chiamata el mastro fl. sedici	fl. 16
Al fondaco di spinello adimari fl. tre	fl. 3
A pippo chalzolaio fl. quatro	fl. 4
A Jacopo . . . legnaiuolo da sco tomaso fl. tre	fl.(c) 3[85]

repeated:
ibidem, Portate al Catasto, 1430, cod. 388, c. 170, 170v
Evidently a revised second *Portata*, with the following additions: in ending the list of *sustanze:* (b)avere le paghe di detti fl. MCCCVII di prestanze; in ending the list of *incarichi:*

(c)a l'opera (?) di sca croce per uno luogho di sepultura	fl. 15
a frate francesco frate di detta chiesa per le spese e muratura di detta sepultura	fl. 6
avere (?) la detta opera per uno . . . (?) ibi dalloro	fl. 5 d 2
A francesco di pagholo orafo e compagni	fl. 2 d 2
Andrea di ser laudo e compagni	fl. 1 s 2[86]

DOC. **82**a, *ibidem, Campione, 1430, cod. 409,* c. 191v, 192

DOC. **83**, TAX DECLARATION, 1433, May 29, Dig. 179

ibidem, Portate al Catasto, 1433, cod. 481, c. 149, 149v

+XPUS MCCCCXXXIII a di XXVIIII di maggio
Inanzi a voi ufiziali del chatasto del comune di firenze sustantie e incharichi per me lorenzo di bartolo orafo lavoro la porta di sco giovanni ghonfalone delle chiavi o di chatasto s. sedici
le sustantie mie sono queste
una chasa posta nel popolo di sco anbruogio di firenze in via Borgho allegri Confini da primo via da secondo zanobi de rosso vaiaio da terzo tomaso di bartolone da rovezzano e piu altri confini a detta chasa co[n]masseritie a uso di me e della mia famiglia
uno podere a vita di me e della mia donna e dei miei figluoli posto nel popolo di sco piero a chareggi confini da primo via da secondo ugolino ruccellai da terzo chola di nicholo d'arezzo e molti piu altri confini. Eb[b]i el detto podere dall arte di chalimala avea la detta arte di fitto del detto podere fl. 34 tenealo a fitto bartolo del manzuolo e rimase

[84] Unpublished.
[85] Autograph. Mather, bibl. 308, p. 57, with MCCVII

instead of (a)MCCCVII.
[86] Unpublished.

in sudetto podere el quale e [è]con terra lavor-
atia vignito [vigniato] e ulivato con piu altri
frutti in su detto podere e chon chasa da
lavoratore e non da oste

uno pezzo di terra a sco donato in fronzano
laquale mi chosto fl. XIIII confini da primo
via da secondo labadia a vallenbrosa da terzo
nanni di fio tiella a mezo da me el detto nanni
ane [hane] in mia parte istaia due di grano
b[arili] tre di vino

[H]o circa di venti pecore le quali tiene a
mezo neri di piero da matamorelli (?) del
popolo di sco bartolo a pomino

In sul monte del comune di firenze mi truovo
iscritti fl. 984 dotto percento o in sudetto monte
le page sostenute di fl. M e quali i vende (?)
antonio di nicho Barbadori d'otto percento .
o in sudetto monte pagati a riavere i miei
chatasti da marzo nel 1432 insino a detto di di
sopra

[H]o avere dall'arte di chalimala circha di fl.
cento[(a)] e quali o avanzati colla detta arte
da giuliano di piero del bambaccio fl. cinque
XPUS MCCCCXXXIII a di XXVIIII di mag-
gio

Incharichi di Lorenzo di bartolo orafo gho-
falone delle chiavi. Io lorenzo sopradetto
deta danni XXXX [canceled] LII o circa la
marsilia mia donna deta danni XXXIII o
circa tommaso mio figluolo deta danni sedici
vettorio mio figluolo deta danni quindici
[H]o debito con piu persone

a filippo di nicholo da fiesole a dare circa
di fl. XXXVIII fl. 38
antonio chiamato el mastro sarto circa di
fl. XVI fl. 16
a giuliano di ser andrea ista a sco. sebbio
circa di fl. X fl. 10
alla ghabella del sale per nanni di bartolo
di latino del popolo della pieve di piti-
ano fl. XX e quali promisi a nicholo
carduci proveditore della detta ghabella
 fl. 20
al fondaco di nicholaio degli allesandri fl.
XVIII o circa fl. 18
a simone di nanni da fiesole lavora mecho
fl. XVI fl. 16
a papero di meo da settignano lavora
meco fl. X fl. 10
a papi d'andrea legniaiuolo a sco. tomaso
fl. II fl. 2
a chola di nicolo d'arezo fl. tre fl. 3
a guarente orafo per una promessa per
mano di nanni da fiesole circa di fl. III fl. 3
antonio del maestro gherardo circa di fl.
II½ fl. 2½[87]

ibidem, cod. 479, C. 143, 143V
copy of previous document with some minor
mistakes.[88]

DOC. 84, 1442, Aug. 30, TAX DECLARATION,
Dig. 237

ibidem, Campione, 1442, cod. 627, c. 214, 214V
In nomine domini MCCCCXXXXII a di 30
dagosto Quartiere scto giovani Gonfalone
chiavi

Dinanzi da voi s[ignori] dieci huficiali della
conservazioni e augumentazione della nuova
gravezza del comune di firenze per me si ra-
porta [in margin in different hand: Lorenzo
di Bartolo detto Bartoluccio maestro delle
porte]

Lorenzo di bartolo Maestro delle porte di scto
giovani dj firenze Le mie sustantie e beni in-
frascripttj cio e

Una chasa e suoi edifizj posta in firenze nel
popolo dj scto ambruogio Luogo detto via
borgallegri con una casetta allato alla sopra-
detta Laquale conperai da mona pagola donna
che fu dj tomaso di bartolone da rovezano le
quali io habito da primo via da secondo zanobi
de rosso vajaio da terzo sengnia di ser Lucha e
da quarto le chase di scto ambruogio e via
. . . fl.

[in margin in different hand . . . (?) una chassa
donna pagola di tomaso del bartolone (G°)
chiavi c. 196]

Uno pezzo di terra lavoratja e un pocho di
vignja la quale comperai da nani di nicholo e
una mezza chasa per non divisa da[l]lavoratore
posta nel popolo dj scto donato in fronzano
e da primo e secondo vja da terzo labadja di
valenbrosa Lavora la. detta terra e vignja e
abita la detta chasa il sopradetto nanj di nich-
olo costommj fiorini trentacinque rende in
parte

grano staia due
vino barili sei
oljo uno mezo barile

Uno podere posto nel popolo dj scto piero a
chareggj e chasa da lavoratoj e da primo e
secondo e terzo vja e da quarto cola d'arezzo[e]
el veschovo di fiesole Lavoralo michelino di
matteo mjo lavoratore rende in parte lenfra-
scritte chose

Grano staja venti
Vino congnja (?) tre
Oljo barili quatro
fichi sechi staia due
Mandorle staio uno

Conperai detta possessione dall'arte de mer-
chatanti a vjta di me e della mia familglia

[87] Autograph, unpublished.
[88] Mather, bibl. 308, p. 57 transcribed this copy in-
stead of the autograph original, erroneously inserting
at [(a)] fl. 1000 instead of *cento.*

dipoi torna a detta arte ebesi per prezzo di fiorini trecentosesanta

Tre prezzetti [sic] di terra lavoratia con alchuno uljvo da primo e secondo e terzo via e quarto cosimo de medici posti in detto populo e luogo detto monte piano lavorale il sopradetto lavoratore e rende

Grano staia sei

Oljo orge mezo

costomj fiorinj sessanta

Uno podere chon chasa da singnjore [e] da[l]lavoratore posto nel popolo della pieve a septimo dj stajora cinquanta confinato da primo e secondo e terzo e quarto vja E un pezzo di terra dj stajora quatordjcj chon chasa da[l]lavoratore posto in detto luogo e in detto popolo da primo e secondo via terzo e quarto l'arte de merchatantj Lavoralo papj dj gustino rendemi i sopradettj terrenj in parte

Grano staja trenta

biada e fave staja otto

Vino barili cinque

Uova serque quatro

Conperaj dettj terrenj dalle rede dj sandro biliotti costomj fiorinj trecento cinquanta

Ritrovami nel secondo chatasto avere in sul monte fl. MCCCVII de qualj nessuno mj ritruovo oggj avere ne dj nessuna fatta [nessun affatto?] de qualj danarj no [n'ho] comperato

Le sopradette chose e parte pagate mje gravezze

Boche e eta

Lorenzo deta dannj sesantadue

La dona sua deta dannj quarantaquatro

Maso deta dannj ventjsej ⟩ suoj

Vettorjo deta dannj ventjcinque ⟩ filgluiolj

Rjtruomj [sic] avere dj graveza uno fl. s. 9 d. 11

Io vettorjo filgluiolo del sopradetto Lorenzo meto qui da pie Cento sessanta fiorjnj di monte i qualj danarj dichono in me Ma non sono mj ipso (?) sono di mona lisa donna che fu di betto de rugieri G[onfalone] L[eone] d'oro e chosi si contera pella sua scritta[89]

DOC. 85, 1447 [after Feb. 28, before Mar. 25], TAX DECLARATION, Dig. 258

ibidem, Portate al Catasto, 1446, cod. 682, c. 825, 825v

1446

Q.S.G.G. chiavi

Djnanzi da voj singnjorj ufizjalj elettj a porre la nuova gravezza del **popolo di firenze raporto** per me si fa

Lorenzo di cione di ser bonachorso ghibertj altrimentj chiamato Lorenzo di bartoluccjo maestro d'intagljo

Nella diecina ebbj fl. 1

Nel dispiacente ebbj fl. 1 s. 3 d. 2

Nel primo chatasto ebbj fl. 1 s. 8

Una chasa per mjo abitare posta nel popolo di scto anbruogj° di firenze luogo detto vja borgallegrj che da primo vja e secondo zanobi di hiachopi del rosso vajajo a terzo foio (?) pantolini a quarto sengnja di ser Lucha di ser sengnja cholla detta chasa era una chasetta della quale per istretezza di chasa ho fatto d'ongnj chosa una la quale si compero da mona pagola donna fu di tommaso di bartolone da rovezzano fl. 115 charta fatta per mano di ser Luigj di ser michele guidi nell'anno 1438

Un podere posto nel popolo di scto piero a chareggj che da primo vja e secondo da terzo chosimo di giovannj de medicj da quarto chardjnale dalbulletta da quinto meastro ugoljno medicho da pisa e piu altri confini. El quale podere mj fu asengnjato dall arte de merchatantj dall anno 1431 e del mese dagosto el quale [h]o a vita dime [e] della mia famjlglja di poj torna a detta arte chostomi fl. 370 sichome apare charta fatta per mano di ser franciescho guardi notajo fiorentino ollo (ho lo) afittato nel presente anno a donato di njcholo natj (?) chon alquante masseritje Rendemi di fitto l'anno dal sopradetto

L'anno fl. 38

Un pezzo di terra lavoratja posta nel popolo di scto donato in fronzano che da primo vja e secondo la badia di valenbrosa La quale terra fu achatastata per me Lorenzo rendevamj in detto chatasto soma 1 [una] d'oljo di fitto chostomi fl. dieci Rendemi ogi

Oljo barile mezo

Grano st[aia?] 2

Un pezo di terra vingnjata posta in detto popolo di scto donato in fronzano che da primo vja e secondo betto di calcagnio (?) a terzo il piu detto Lorenzo chonparossi dall anno 1442 dal mese d'aprile fu comperato per vettorjo mio filgljuolo carta fatta per ser luigi di ser michele guidi chonperossi da nanni di nicholo Lavorala e detto nanni di nicholo sopradetta terra e vingnia chosto fl. 35 Rende l'anno in parte

Vino barili 6

Un podere posto nel popolo della pieve di scto guljano a settjmo chon chasa per nostro abitare e chasa da lavoratore Conperalo dall anno 1441 a di 2 di gennajo da biliotto di sandro biljotti insieme chon una chasetta dove si fa la vendemja chosto fl. 360 sichome appare charta di ser Jachopo salvestrj Rende in parte lanno

[89] Not autograph; published by Mather, bibl. 308, p. 58 as a *Portata* with misprinted date 1432. In the margin throughout illegible assessment notes by different hand. *Portata* not traceable.

Grano staja	st 36
Biada e fave	st 6
Noci staio	st 1
Vino barilj sei	b. 6
Caponi pajo uno	
polastri pajo uno	
Uova serque quatro	

Un pezo di terra vingnjata posta in detto popolo dalla pieve che da primo e secondo vja a terzo Maestro gabrielle giudeo a quarto bartolomeo t[r]onciavegli (?) La quale conperaj d'agustino di franchiescho del popolo della badja di settjmo chosto fl. 70 charta fatta per mano di ser Luigj di ser michele guidi sotto di tre di dicembre 1444 Rende in parte a me

Vino barili trenta	b. 30

Un pezzo di terra vingnjata posta nel popolo di scto cerbazzo a pelago che da primo vja a secondo la badia di valonbrosa a terzo fiume di vicsano (?) a quarto l'erede di piero fabro la quale Riconperaj dell anno 1446 a di 15 d'agosto d'antonio di piero chasella chostomi fl. 50. Carta fatta per ser romolo di ser guido e piu le chasolari con detta vingnja posto nel popolo di scto chimanti (?) a pelago e dentro nel chasteluccio che da primo via a secondo muro chastellano a terzo altri Rendemi detta vingnja nel presente anno barilj cinque di vino Lavorala bartolo di domenjcho da pelago Rende

Vino barili cinque	b. 5
Creditj di monte	

fiorini cinqueciento trenta di monte comune e qualj dicono in me Lorenzo e vettorjo mio filgljuolo abiamoglj vendutj per soperire a nostri bisognj vendevonsj sotto di 27 prossimo passato

Una chasa e botega posta al chanto alla palglia che da primo e secondo via a terzo matteo cosmi palgljaiuolo e quarto antonio di ser giovannj bonaiutj La quale chasa e botega e chonsengnjata per dota dela Madalena filgljuola di antonio di ser giovanni predetto E donna di vettorjo mio filgljuolo l'entrata della quale debbe essere di detto vettorjo marito di detta madalena tiella[tienela]a pigione piero di francescho marja spetiale danne di pigione l'anno

fiorini cinquanta	fl. 50

Carta fatta per mano di ser antonio pugi notajo fiorentino sotto di ventotto di febrajo.[90]

DOC. 86, 1451, Aug. 14, TAX DECLARATION, Dig. 276

ibidem, Portate al Catasto, 1451, cod. 718, c. 297, 297v

Dinanzi da voj singnjorj ufizialj aporre la nuo[va] graveza Raportasi per me Lorenzo di cione di ser bonacorso ghiberti altrimenti chiamato Lorenzo di bartoluccjo

Ebbj di graveza nella diecina fl. 2 s. 10 d. 9	
fu sgravato	s. 10 d. 4

Una chasa per mjo habitare posta nel popolo di scto anbruogjo luogo detto vja borgo allegrj con una chasetta laquale chonperaj da mona pagola donna che fu di tomaso di bartolone da rovezano charta fatta per mano di ser luigi di ser michele guidi che da primo vja secondo zanobi di jachopo vaiaio da terzo sengnia quarto vja pantoljno tutta a mjo uso.

Un podere posto nel popolo di scto piero a chareggj a mja vita da primo secondo vja terzo chardinale dalbulletta quarto antonjo del rosso chaljzajo ollo [ho lo] afittato one [hone] di fitto fl. trentotto

Una chasetta da lavoratore chon aja e pergola intorno e orto chon vingnja allato alla chasa jnsieme chon un pocho di terra vavevo [v'havevo] insino (?) nel primo chatasto insieme con un pezo di terra salvaticha postj nel popolo di scto donato in fronzano luoogho detto labonafalda da primo via secondo andrea di baldo terzo rede (?) di cantino farsattaio laquale chasa vingnja e terra conperaj da nanni di nicholo di detto popolo empta da goro di bruno da baroncelli sichome apare charta per mano di ser luigi e di ser domenicho di ser santi tiella [tienela] afitto detto nicholo di nanni damene di fitto lire sedici chosto-[rono] detti beni fl. quarantacinque

Un podere chon chasa per mjo abitare e da lavoratore posto nel popolo di scto guljano a settimo chon terra lavoratia e parte vignjata Insieme con una chasetta dove si fa la vendemja con altra chasa di staiora 68 o circha in tutto, da primo l'arte de merchatanti secondo terzo quarto via luogo detto pantanaccjo Rende in parte

Grano staia	36
vino b (arili)	6
Fave staia	6
Caponi paio uno	
Uova serque	4

Conperaj detto podere da biljotto di sandro di biliotto sichome appare charta per mano di ser iachopo salvestrj.

Un pezo di terra vingnjata posta in detto popolo e[l]luogo detto in pantano che da primo secondo vja terzo maestro gabriello gudeo e quarto nicholo tronciavelli (?) conperata da quintino di cecho charta fatta per mano di ser luigj di ser michele guidi Lavora detto podere e vignja guljano gustini con con-

[90] Not autograph; Mather, bibl. 308, pp. 58f. *Campione* not extant.

ditione che dalla detta vignja mi debba dare barili dodicj di vino e talgliare e riporre a ongni sua spesa ognj anno staioro uno di detta vingnja

Un pezo di terra vingnjata posta nel popolo di scto cerbazzjo a pelago la quale conperaj d'antonjo di piero chasella insieme con un chasolare posto nel chastello vecc[h]io di pelago

Rende barilj sej di vino

Una chasa posta al chanto alla palglia che da primo secondo vja terzo antonjo di ser giovanni quarto matteo chasini (?) fummj consengnjata [consegnata] in dota di vettorjo mjo figljuolo e pella [per la] madalena sua donna filgljuola d'antonio di ser giovannj bonaiutj e suocero di detto vettorjo tiella [tienela] a pigione batista e jachopo filgljuolj furono di piero spetiale danone di pigione fl. cinquanta.[91]

DOC. 86a

ibidem, Campione, cod. 719, c. 515, 515v
repeats the above, including the assessments

DOC. 87, 1429, TAX DECLARATION CALIMALA, Dig. 157

ASF, Portate al catasto, 1429, cod. 291, Beni di Compagnie e Arti di Firenze e de Sei di Arezzo e Cortona, portata, Arte di Chalimala, c. 5ff

(c. 5
. . . Beni e possessioni donati alla detta arte per Piero di Francesco Broccardi
c. 6
Incharichi [h]anno i detti beni . . .)
c. 6v
Seghuono incharichi sopra e beni di Piero di Francesco detto
Lopera di San giouanni di firenze a in diposito dalla detta kagione fl. MDCCC de quali fl. DCCC sono della donna fu del detto Piero e costano lanno a kagione di fl. 7 per c[ent]o perche cosi ne da larte allej. E fl. M costano fl. 6 per c[ent]o. Et detti denari si tolsono quando si gitto el telaio della porta di san giouanni per ottone e altre spese bisognorono torre a un tratto montano l'anno fl. ciento sedicj d[oro] fl. 1800
c. 24
(Entrata dell'opera di san giouanni battista di firenze . . .
a la detta opera di spese)
a di spese dinteressi di fl. 1800 chella detta opera a in diposito dalla commessione di piero di francescho brocchardi de quali fl. 800 sono

della donna del detto piero e costano fl. 7 perc[ent]o che chosi ne da larte allej e fl. M costano fl. 6 perc[ent]o. J detti denari dicono si tolsono per conperare ottone per lo getto del telaio della porta di san giouanni e per altre cose bisongnorono fl. 116
c. 24v
. . . seguono incharichi dellopera di san Giouanni detto. . . .
Et piu dicono [h]anno di spesa per la terza porta che e comminciata [a gittare cancelled] e che non si puo immaginare il costo costa solo il maestro lanno fl. 200 . . .[92]

DOC. 88, 1429, TAX DECLARATION CALIMALA, Dig. 157

ibidem, cod. 293, Danari uno per lira della Mercanzia e Arti e Compagnie della Citta di Firenze e Beni patrimoniali dei religiosi, Campione, c. 4ff

(c. 4
beni e possessioni lasciati alla detta arte per piero di francesco brocchardi. . . .
c. 5
debitori appartenenti a detto lascito . . .)
Lopera di san giouanni a in diposito della detta kagione fl. 1800. . . .
c. 5v
Incharichi appartenenti a detto lascito di piero brocchardi. . . .
E piu anno dincharicho le prestanze ovvero chatastj di Mona chaterina donna fu di piero detto perche era creditore di detta kagione di fl. 800. Ella [E la] detta mona chaterina e morta e detti denari restano all arte e sono messi alle sustanze di detta kagione in somma di fl. 1800 a in diposito lopera di san giouanni e stimano tocchi appaghare l'anno fl. 20 che sono a kagione di fl. 7 perc[ent]o fl. 285, s. 14, d. 3. . . .
c. 10v
Incharichi alla detta hopera. . . .
Et piu [h]a debito la detta arte colla [e]redita di piero brocchardi fl. 1800 e chon piu persone fl. 260 come appare al detto libro c. 24 in tutto fl. 2060
Et piu dichono anno di spesa nella 1/3 porta di san giouanni che chomminciata e non possono albitrare per momento (?) dache solo il maestro chosta o mmo (?) fl. 200 fl. (sic)[93]

ASF, ARTI

DOC. 89, 1449, [Sept. 22], EAST DOOR, Dig. 272
ASF, Arti, Calimala, vol. 17 bis, Petizioni e

[91] Perhaps autograph; Mather, bibl. 308, p. 39.
[92] Unpublished. Summaries Brockhaus, bibl. 69, p. 39 and Frey, bibl. 532, p. 359, doc. 4.

[93] Unpublished. Summaries Brockhaus, bibl. 69, p. 39: Frey, bibl. 532, p. 359, doc. 4.

Deliberazioni, 1422-1518,[94] f. LXXIIIv (part f)

MCCCCXLVIIII . . . (in margin: Datur Cera Laurentio) Item suprascripti consules absente et presentibus dicto Angelo Uzzano Bartholomeo de Alexandriis et Leonardo de Acciaulis duobus ex tribus offitialibus musayci sci Johannis prouiderunt et stantiauerunt Quod possit et debeat dari et ordinetur Laurentio bartoluccij magistro januae quae fit pro Eccl. s. Johannis patroni (?) pro parte eius quod debet habere pro sua mercede laborerij dicte januae librarum mille et usque in libras mille cere de cera operae s. Johanis que cera computetur ei flor. auri novem et quarta parte alterius flor. pro quolibet centenario.

DOC. 90, 1449, Sept. 22, EAST DOOR, Dig. 273

ibidem, f. LXXIIIv (part f)

(in margin: M. simonis)

Item suprascripti uffitiales musayci deliberaverunt et stantiaverunt simoni Johannis scarpellatori super telario dicte januae ll [lire] quinquaginta Eidem debite pro Residuo sui salarij mercedis et provisionis III mensium (?) per totam diem XVIIII mensis Julij preteriti proximi.[95]

DOC. 91, 1449 [Sept. 22], EAST DOOR, Dig. 273

ibidem, f. LXXIIIv

(in margin: Electio dicti simonis)

Item reconduxerunt in dictum laborerium dictum simonem ad usum talem mercedis (?) pro tempore quo offitialibus dicte januae placuerit

Item locauerunt Simoni Johannis de fesolis Matteo Francisci de settignano Domenico Antonii Salviati	omnibus simul cooperandibus (?) laborerij scarpelli restantis de dicta janua pro pretio in totum flor. trigintaquinque ad [illegible] pro floreno

Item Quod dentur dicto Simoni fl. sexaginta auri qui denari componentur ad eius computum pro pretio declarando per Johannem protomagistrum.[96]

DOC. 92, 1423, March 30, NORTH DOOR, Dig. 101

ibidem, no pagination (part h)

Adi XXX di marzo 1423. . . . Die XXX martij. . . .

Super facto dorandi januam. Quod erat magis considerandum et extimandum honor et fama quam expensa et ideo (?) ipsa doretur.

DOC. 93, 1428, Sept. 1, EAST DOOR, Dig. 150

ibidem, no pagination (part i)

Adi primo di settembre MCCCCXXVIII. . . . Lopera e chiesa di san Giouanni e in disordine per le sopra spese che vi si fanno piu chel convenuto. E percio (?) se tenuto pratica di crescer l'entrata. Et formossene prouisione in palagio e non si ottenne

DOC. 94, 1444, Jan. 24, EAST DOOR, Dig. 246

Calimala, vol. 19, Deliberazioni de Consoli, gen. 4, 1444-aprile 22, 1444, c. 8f

(in margin: pro Laurentio Bartoli)

. . . vigesimo quarto mensis januarii presentibus testibus . . (?) Lionardo de Altovitis et Benedetto Bernardi de Auricellis . . .

Constituti in dicta curia in presentia mei francisci notarii et scribe dicte artis et testium suprascriptorum. Vectorius filius Laurentij bartoli magistri januarum sancti Johannis vice et nomine ditti Laurentii sui patris et Benozius Lesis pictor populi Sancti Fridiani de Florentia et inter se ad invicem fuerunt et remanserunt in hanc concordiam et convenerunt de infrascripta locatione et conduttione, vz. Quod dittus Vectorius suo nomine conduxit dittum benozium et dittus benozius locavit se ad laborandum et se personaliter exercendum cum omni sua industria et magisterio in labo-

[94] The volume, unpublished, consists of a number of fragments without continuous pagination in the following sequence:

 a) two folios, March 26, 1517, marked f. 125, 126

 b) one folio, August 26, 1508, marked f. 161

 c) six folios, 1501-1508, marked f. 162-167

 d) three folios, 1501, marked f. 173-175

 e) four folios, 1501, marked f. 196-199

 f) sixteen folios, May 1, 1449-January 14, 1449, marked f. LXV-LXXX, remnants of a volume *Deliberazioni de Consoli*.

 g) two folios, unknown year, April 10-30, possibly 1423 or 1426, since Niccolo da Uzzano is consul. Probably also from a volume *Deliberazioni de Consoli*.

 h) two folios, 1423, March 30-April 20

 i) two folios, 1428, before September 1-September 22

 j) two folios, 1423, before March 30-April 20

 k) four half folios with *petizioni*, XVI century

 l) four folios, December 29, 1428, fragment of a no-

tary's diary.

 m) one folio *petizioni*

 n) two folios, February 14, 1427-March 1, fragment of a notary's diary (containing notice referring to Cosimo de' Medici acting as executor for the will of Andrea de Scholaribus, bishop of Varadin, Hungary).

 o) one folio *petizioni*

 p) one folio, September 10, 1428 to November 12, from a notary's diary.

 q) four folios, unknown year, December 10 through October 22.

 r) two folios, *petizioni*, unknown year

 s) ten folios, matriculae, 1517

[95] The date results from the identity of Doc. 90 to Doc. 72. See following note.

[96] The date of month and day results from the identity of the item referred to in the above and in Strozzi's excerpt in Doc. 72.

rerio hostiorum ianue Sancti Johannis que fiunt per dictum Laurentium bartoli diebus et horis debitis et usitatis in similibus laboreriis per tempus et terminum trium annorum initiandorum die primo mensis martii proxime futuri. Et in ditto tempore fideliter et absque aliqua fraude se exercere prout eidem impositum fuerit per dittum laurentium. Et ex alia parte dittus Vittorius promisit et convenit ditto benozio ipsum benozium in ditto laborerio durante ditto tempore retinere et eidem dare solvere et pagare pro suo salario provisione et mercede pro primo anno dictorum trium annorum flor. sexaginta auri et pro secundo anno dittorum trium annorum, flor. settuaginta auri et pro tertio et ultimo anno dittorum trium annorum flor. ottuaginta auri. . . .[97]

DOC. 95, 1448, April 6, EAST DOOR, Dig. 264
Calimala, vol. 20, Deliberazioni de Consoli . . . 1447, die V jan. al 1451,[98] c. 12
Die VI aprilis. Suprascripti consules omnes simul congregati ut supra servatis servandis providerunt et deliberaverunt Quod retentis et detractis primo de pecunia operae S. Johannis pecuniis depositis pro expensis ordinariis possit solvi de residuo. . . . [sic] laboranti cum Laurentio Bartoluccii in laborerio tertiae januae S. Johannis cum consensu tamen dicti Laurentii usque in florenos triginta auri.[99]

DOC. 96, 1448, April 22, EAST DOOR, Dig. 265
ibidem, c. 14v
Die XXII aprilis. Item modo et forma praedictis deliberaverunt et stantiaverunt Quod depositarius S. Johannis solvat et solvere possit et debeat Laurentio Bartoluccii magistro januae S. Johannis florenos quindecim auri pro eo dandos Bernardo Bartolomei laboranti cum dicto Laurentio in laborerio dictae januae pro parte ejus quod debetur dicto Laurentio pro dicto laborerio.[100]

DOC. 97, 1448, May 18, EAST DOOR, Dig. 266
ibidem, c. 16v
Die XVIII maij. Suprascripti consules omnes simul in loco eorum solitae residentiae congregati pro eorum officium exercendo servatis servandis providerunt deliberaverunt et stanti-

averunt Quod depositarius operae S. Johannis Baptistae de quantacunque pecunia dictae operae ad ejus manus perventae et perveniendae det et solvat et dare et solvere teneatur et debeat solvere et dare Laurentio Bartoli magistro hostiorum januae S. Johannis praedicti florenos quindecim auri eidem debitos pro suo magisterio dictorum hostiorum.[101]

DOC. 98, 1448, July 12, EAST DOOR, Dig. 267
ibidem, c. 27v
Die XII julii. Item simili modo et forma deliberaverunt et stantiaverunt Quod depositarius operae S. Johannis de Florentia solvat et dare et solvere teneatur et debeat Matteo Francisci scarpellatori residuum ejus quod restat habere usque in praesens pro suo labore in laborerio telarii tertiae januae S. Johannis usque in quantitatem librarum octuaginta et non ultra si plus restaret habere et si plus restat habere sint librae LXXX pro parte.[102]

DOC. 99, 1448, July 24, EAST DOOR, Dig. 268
ibidem, c. 27v
Die XXIV julii Consules praefati absente tamen dicto Doffo eorum collega deliberaverunt et stantiaverunt Quod depositarius praedictus det et solvat Simoni Johannis de Fesolis scarpellatori in laborerio telarii supradicti pro parte ejus quod restaret habere pro suo labore scarpellandi dictum telarium libras triginta florenorum parvorum Dominico Antonii scarpellatori supradicti laborerii pro parte ut supra libras triginta.[103]

DOC. 100, 1448, Nov. 15, EAST DOOR, Dig. 269
ibidem, c. 37vff [In margin: pro faciendis expensis et (?) laborerii . . . necessitas]
MCCCCXLVIII Die XV mensis novembris. Suprascripti consules absente tamen dicto Johanne de Canigianis informati qualiter propter expensas extraordinarias quae cotidie non congnitae occurrunt operae S. Johannis Baptistae et maxime praesentibus temporibus eo quod opportet in partibus providere de reficiendo de novo tendam qua hoperitur platea S. Johannis quae est inter ecclesiam S. Johannis et domum operae in quibus opportuerit expendere prout creditur florenos quadringentos et ultra ac item opportet providere de

[97] Milanesi, bibl. 337, p. 90, doc. 107 with misreadings and omissions, mostly insignificant despite the almost illegible handwriting. See also Doc. 71.

[98] The volume ends April 29, 1449.

[99] Brockhaus, bibl. 69, p. 39; Frey, bibl. 532, p. 362, doc. 21.

[100] Brockhaus, bibl. 69, p. 39; Frey, bibl. 532, p. 362,

doc. 22.

[101] Brockhaus, bibl. 69, p. 39; Frey, bibl. 532, p. 362, doc. 23.

[102] Brockhaus, bibl. 69, p. 39; Frey, bibl. 532, p. 362, doc. 24.

[103] Brockhaus, bibl. 69, pp. 39f; Frey, bibl. 532, p. 362, doc. 25.

reparando copertam templi S. Johannis versus domum operae cuius expensa non potest immaginari et quod introytus operae non suppetit dictis expensis nisi unum ex duobus fiat videlicet quod aut cantores removeantur aut laborerium januae quae ad praesens fit pro ecclesia S. Johannis suprasedeat pro aliquo tempore. Et advertentes quantae importantiae praedicta sint visum fuit eis consulere homines mercatores artis et propterea requiri fecerunt plures mercatores dictae artis. Ex quibus mercattoribus et se cum dictis consulibus congregaverunt infrascripti videlicet:

> Dnus Guiglelminus de Tanaglis
> Dnus Geronimus de Machiavellis
> Adoardus Lodovici de Acciaiuolis
> Oddus Vierii de Altovitis
> Ugolinus Niccolai de Martellis
> Niccolaus Johannis dni Amerigi de Cavalcantibus
> Bartholomaeus Contis de Peruzis
> Tommasius Niccolai de Ciampoleschis
> Bartolus Bartoli de Tedaldis
> Laurentius dni Andreae de Montebuonis
> Franciscus Guidetti de Guidettis
> Bernardus Francisci Girozii de Bardis
> Johannes Filippi de Corbizis
> Franciscus Filippi de Nerlis
> Franciscus Altobianchi de Albertis
> Tommasius Fancisci de Davizis
> Johannes Francisci de Riccis
> Zenobius Sandri Johannis de Biliottis et
> Johannes Niccolai Folchi

Quibus omnibus simul cum dictis consulibus in domo dictae artis congregatis praefati consules exposuerunt et narraverunt omnia et singula suprascripta et eos consulerunt de praedictis et super praedictis. Qui mercatores retenta inter eos lunga pratica super praedictis et demum conclusum fuit inter eos refferre dictis consulibus. Et sic retulerunt et pro eis suprascriptus dnus Guglelminus Tanagle Quod eis videbatur quod dicti consules eligant et eligere et deputare debeant quattuor aut usque in sex mercatores et artifices dictae artis quos voluerint et eis visum fuerit qui videant et examinent exitum et expensas ac introytus et redditus operae S. Johannis et examinent si dictus introitus et redditus suppetat dictis expensis. Et si repertum fuerit sufficere provideatur suprascriptis defectibus. Sin autem non sufficeret recurratur ad dominos priores et procuretur si possibile est habere adliquod adjutorium a comuni Florentiae ac vadant ad

officiales montis et procurent quod dicti officiales dent dictae operae pagamentum pro supplendo necessitatibus dictae operae. Et si opportuerit dicti sic eligendi et deputandi possint ponere hominibus artis aliquam taxam. Et quod nullo modo removeantur cantores neque desistatur laborerio januae quia redundaret unum alterum in non modicam verecundiam artis et hominibus dictae artis. Qui consules incontinenti servatis servandis providerunt eligerunt et deputaverunt ad omnia suprascripta relata per suprascriptos mercatores egregios et nobiles viros

> Dnum Guglelmino de Tanaglis
> Dnum Geronimum de Machiavellis
> Adovardum Lodovici de Acciaiuolis
> Daniellum Loygii de Canigianis
> Angelum Nerii de Vettoriis.

Qui sic electi habito primo inter eos colloquio et tractato super commissis die XX dicti mensis novembris retulerunt dictis consulibus Quod ipsi prout melius potuerunt examinaverunt expensas tam ordinarias quam extrahordinarias operae S. Johannis ac introytus et exitus. Et quod eis nullo modo videbatur quod expensae dictae operae essent inhutiles sed utiles et necessarias. Et quod deminuendo ipsas expensas cederetur in dedecus dictae artis ac dictae operae et consulum praedictorum. Et quod nullo modo videbatur eis posse dictas expensas defalcari. Et quod opportebat dictis consulibus si volebant reparare ruinae ecclesie S. Johannis et necessitatibus operae unum ex duobus facere aut removere camptores aut desistere in laborerio januarum pro aliquo tempore. [104]

DOC. **101**, 1449, April 28, EAST DOOR, Dig. 270
ibidem, c. 63v
Die XXVIII mensis aprilis. Praescripti consules absente tamen dicto Ghirigoro eorum collega in suprascripto loco pro eorum officium exercendo providerunt declaraverunt et stantiaverunt Quod possit solvi Laurentio Bartoluccii floreni viginti quinque auri pro parte laborerii hostiorum januae S. Johannis quae fiunt per eum.[105]

DOC. **102**, 1449, April 29, EAST DOOR, Dig. 271
ibidem, c. 64v
Die XXVIII mensis aprilis. Item modo et forma praedictis deliberaverunt et stantiave-

[104] Brockhaus, bibl. 69, p. 42, with erroneous indication of c. 37, 38; Frey, bibl. 532, p. 343, doc. 65, excerpts only.

[105] Brockhaus, bibl. 69, p. 44; Frey, bibl. 532, p. 362, as first part of his doc. 26.

runt scarpellatoribus laborantibus super telario
januae S. Johannis unam pagam unius mensis
pro quolibet eorum.[106]

DOC. 103, 1423, MATRICULATION, Dig. 103

ASF, Arti, Accademia del Disegno, vol. 1, Matricola della Compagnia de' Pittori di San Luca. c. 11v

Lorenzo di bartolo orafo populi s.o Anbruogo
MCCCCXXIII.[107]

DOC. 104, 1426, Dec. 20, MATRICULATION, Dig. 126

ASF, Arti, Maestri di Pietra e Legname, vol. II, Matricole dell'Arte, 1388-1518, c. 32v
Anno millesimo CCCCXXVI . . . Laurentius
Bartoluccij michaelis scultor pp. s.ambrosij de
florentia die 20 decembris 1426[108]

DOC. 105, 1432, Oct. 29, LINAIUOLI ALTAR, Dig. 174

ASF, Arti, Rigattieri, Linaiuoli, e Sarti, vol. 20, Campione dei debitori e creditori, 1418-1511, c. 98v (in margin: Tabernacolo del Arte cioe legname)
MCCCCXXXII a di XXIX dottobre. Ricordo
chome detto di E sopradetti Operaj avendo
alloghato a Jacopo vo [vocato] papero di
piero legnaiuolo a fare e legname del tabernacolo grande di detta arte dove oggi e dipinta
la figura di nostra donna. Avendo fattone fare
di tutto uno modello per mano di Lorenzo di
bartoluccio e paghatolij di sua faticha fl. III
di oro e paghato per ferramenti e maschietti
di detto tabernacolo l. XVII, s. IIII pagharono
a detto papero per parte di detto tabernacolo
l. XXX. Et dipoi a di VI. daprile. 1433. gli
promisono dare di detto tabernacolo di sua
manifattura. quello fussi giudicato et cosi
rimasono dacordo. Et a di II di luglio 1433 gli
paghorono l. III per resto di detto tabernacolo
Chome di tutto appare desto(?) fornito al libro
de partiti di detta arte s[egnat]o. D 169, 198,
213 - - - - fl. — l.82 —.[109]

DOC. 106, 1433, Aug. 11, LINAIUOLI ALTAR, Dig. 174

ibidem: c. 98v. (in margin: Tabernacolo di marmo del arte)
MCCCCXXXIII. adi. XI dagosto.
Ricordo chome detto di . E sopradetti Operaj
alogorono a Jacopo di bartolo da settignano

et Simone di Nanni da fiesole a fare e intagliare di marmo el tabernacolo dove debbe stare
nostra donna Indorato etc (?) dalteza di br.
6 1/6 et largheza di br. 3 1/3 con cornice e
fogliamj. Et dio padre di mezo rilievo di sopra
nel frontone con due serafini e con altrj ornamentj chome apare per uno disegno fatto di
mano di Lorenzo di bartoluccio a ogni sua
[above line: loro] spesa per loro ferramenti e
[pid . . . ?] per pregio di fl. LXX doro. Et
dettero mallavadori chome di tutto appare a
libro de partiti di detta arte s[egnat]o. D 218,
223 . . . fl. 70.[110]

DOC. 107, 1425, April 2, SAINT STEPHEN, Dig. 114

ASF, Arti, Lana, vol. 49, Deliberazioni dei Consoli, 1408, October 27-1427, August 25, c. 109v
(in margin: Quod figura sci stefani fiat de bronzo et ornetur tabernaculum)
Die II mensis aprilis. Supradicti Consules in
palatio dicte artis pro ipsorum offitio exercendo in sufficienti numero more solito collegialiter congregati absente tamen Ugolino
Francisci de Oricellariis advertentes et considerantes cum diligentia ad legem firmatam
per Capitaneos societatis beatae Virginis
Mariae Sancti Michaelis in Orto disponentem
in effectu quod pro ornamento Oratorii quelibet Ars civitatis Florentie ex viginti una artibus in loco eis et cuilibet earum assignato per
Capitaneos dicte Societatis certo termino ut
in dicta lege latius continetur deberet fecisse
seu construi et fabricari fecisse eorum tabernacula bene et diligenter ornata maxime pro
honore civitatis et ornamento Oratorii prelibati. Et considerantes prefati domini Consules quod omnes artes eorum tabernaculis
dederunt integraliter complementum. et maxime considerantes tabernacula fabricata per
artem Calismale Cambii et aliarum artium
que in pulcritudine et ornamento tantum excedunt tabernaculum artis Lanae quod verisimiliter posset comuniter dici quod predicta
cederent in non modicum honorem artis Lane
attenta maxime magnificentia dicte artis que
omnium aliarum artium semper voluit esse
domina et magistra. Et volentes prefati domini
consules pro magnificentia et evidente honore
dicte artis in hoc providere de remedio salutari[;] ideo servatis primo et ante omnia solepnitatibus servari debitis et requisitis secundum
formam statutorum et ordinamentorum dicte

[106] Brockhaus, bibl. 69, p. 44, with erroneous date of April 28; Frey, bibl. 532, p. 362, as last part of his doc. 26.
[107] Referred to by Baldinucci, *Notizie dei professori,* ed. D. Manni, Florence 1767ff, III, p. 1, note 1; published by Mather, bibl. 308, p. 60; the words *Ambruogo*

and the date 1423 appear to be added later.
[108] Vasari-Milanesi, bibl. 533, II, p. 260; and Mather, bibl. 308, p. 60.
[109] Gualandi, bibl. 196, p. 109, summary.
[110] Gualandi, bibl. 196, p. 109, summary.

artis vigore eorum offitii auctoritatis et balie eis concesse per quecumque ordinamenta dicte artis omnique modo via et jure quibus magis et melius potuerunt providerunt ordinaverunt et solemniter deliberaverunt quod presentes domini Consules et eorum in offitio succesores et due partes eorum aliis absentibus etc. hinc ad per totum mensem augusti proxime futuri auctoritate presentis provisionis teneantur et debeant pilastrum seu tabernaculum et figuram seu imaginem beati Stefani protomartiris ac protectoris et defensoris inclite artis Lane et ad eius honorem et reverentiam Dei de novo reficere et construi et fabricari facere illis modis et formis prout eis et duabus partibus eorum videbitur fore honorabilius magnificentie dicte artis[;] dummodo dictum pilastrum vel in pulcritudine et ornamento excedat vel saltem possit in ornamento pulcrioribus adequari[.] In qua constructione figure et tabernaculi possint prefati domini Consules et due partes eorum, aliis absentibus etc, expendere in constructione prefata usque in quantitatem florenorum mille auri. Et possint prefati Domini Consules durante dicto tempore dictam figuram et tabernaculum locare illi seu illis personis et pro eo pretio seu pretiis et cum illis pactis et modis et pro eo tempore et termino quibus eis videbitur fore utilius pro dicta arte[;] providentes insuper quod de redditibus infrascriptis camerarius presens et omnes alii in futurum possint teneantur et debeant solvere pro executione et perfectione omnium predictorum usque in quantitatem florenorum mille auri de redditibus infrascriptis[,] videlicet precedente nicchilominus semper stantiamento dominorum Consulum pro tempore existentium[:] hoc addito presenti provvisioni quod pro executione et efficacia constructionis tabernaculi prelibati omne lucrum factum seu fiendum cum Micchaele Becchi durante societate quam habet cum dicta arte ratione inter eum et artem revisa et calculata intelligatur esse et sit ex nunc dicte constructioni integraliter assignatum. Item pro executione constructionis prefate assignaverunt omnes et singulas quantitates per eum dicte arti debitas a kalendis mensis januarii proxime preteriti MCCCCXXIIII° retro generaliter ex quibuscumque membris minoribus dicte artis et similiter ex tassis lanificum comuniter non exactis. Et similiter omnem quantitatem retrahendam ex figura marmorea beati Stefani et tabernaculo prefato dicte constructioni penitus adsignaverunt et deputa-

verunt. Que quantitates sic adsignate et deputate non possint in aliam causam converti quoquo modo nisi solum et dumtaxat in constructione figure et tabernaculi prelibati. Possint insuper prefati Domini Consules et due partes eorum aliis absentibus etc pro maiori efficacia et effectu omnium predictorum provisiones et ordinamenta facere providere ordinare et deliberare semel et pluries et toties et quoties eis et duabus partibus eorum videbitur et placebit solum dumtaxat pro executione fabrice figure et tabernaculi prelibati. Et facta et gesta provisa et deliberata et ordinata per eos et duas partes ipsorum valeant et teneant et executioni mandentur ac si facta provisa et ordinata forent per totam universitatem prefatam. Cum hac modificatione tantum quod per predicta vel predictorum aliquod prefati domini Consules pro constructione figure et tabernaculi prelibati ullo modo directe vei indirecte tacite vel expresse vel aliquo alio quovis quesito colore non possint lanificibus dicte artis aliquam impositam facere vel indicere nec aliquam quantitatem pecunie pro constructione prefata mutuo vel ad interesse acquirere.[111]

DOC. 108, 1425, April 2, SAINT STEPHEN, Dig. 114

ibidem, c. 110 (in margin: quod eligantur quattuor operarii pro constructione figure s. stefani et tabernaculi eiusdem)
Item secundo modo et forma predictis providerunt ordinaverunt et deliberaverunt ut supra[:] Quod presentes domini Consules et Consules in offitio proxime successores et due partes eorum aliis absentibus etc possint teneantur et debeant per totum presentem mensem auctoritate presentis provisionis eligere et deputare ex artificibus dicte artis unum videlicet pro quolibet conventu videlicet quatuor prudentes et expertos cives et artifices dicte artis pro tempore duorum annorum proxime futurorum in operarios figure et tabernaculi prelibati prout eis videbitur fore utilius pro dicta arte. Et possint et teneantur dicti operarii sollicitare et providere quod dicta constructio dicte figure et tabernaculi bene et sollicite ac perfecte fiat et perficiatur ad honorem artis predicte. Cum hac tamen modificatione et declaratione, quod nullam provisionem vel deliberationem aut stantiamentum facere possint nisi una cum consulibus artis predicte pro tempore in offitio presidentibus.[112]

111 Passerini, bibl. 391, pp. 44f, with erroneous indication of volume as 48.

112 Passerini, bibl. 391, pp. 45f.

DOC. **109**, 1427, May 14, SAINT STEPHEN, Dig. 136

ibidem, c. 127v (in margin: quod eligi debeant operarii ymaginis S. Stephani)

Die XIIIIa maij.

Suprascripti domini Consules in sufficienti numero congregati ut supra considerantes quod electio operariorum seu officialium figure seu tabernaculi Sancti Stefani jam spiravit et volentes de successoribus providere ne ipsum opus remaneat imperfectum sed bene et honorifice perficiatur servatis servandis secundum formam ordinamentorum dicte artis providerunt ordinaverunt et deliberaverunt quod ipsi presentes domini Consules et due partes eorum possint teneantur et debeant eligere nominare et deputare ex artificibus dicte artis quatuor pro quolibet conventu viros prudentes et expertos et ipsos omnes scruptinare et ponere ad partitum inter se ipsos et consiliarios dicte artis ex quibus omnibus sic scruptinandis illi quatuor[,] videlicet unus pro conventu[,] qui obtinuerent partitum ad fabas nigras et albas per duas partes vel ultra[,] dummodo habeant plures fabas nigras omnibus aliis de suo conventu[,] intelligantur esse et sint electi et deputati in operarios et offitiales et offitiales figure et tabernaculi prelibati pro tempore et termino unius anni proxime future a die electionis de eis ut predicitur[,] fiende cum offitio auctoritate et potestate sollicitandi curandi et providendi quod constructio dicte figure et tabernaculi bene sollicite et perfecte fiat et perficiatur ad honorem ipsius artis. Cum hac tamen modificatione[:] quod nullam provisionem deliberationem aut stantiamentum facere possint per se ipsos sed una simul cum Consulibus dicte artis pro tempore in offitio presidentibus[;] et quod dicti offitiales[,] ut supra eligendi[,] pro aliquali remuneratione eorum laboris habeant a dicta arte in fine eorum offitii et anni predicti unum ensenium prout habent consiliarii dicte artis.

DOC. **110**, 1427, May 15, SAINT STEPHEN, Dig. 136

ibidem, c. 128v (in margin: pro electione operariorum figure s. stefanj Electio operariorum predictorum)

Die XVa mensis maij predicti.

Prefati domini Consules in sufficienti numero adunati ut supra. Visa auctoritate eis supra proxime concessa per consilium artis predicte circa modum et formam electionis fiende de offitio operariorum figure seu ymaginis Sancti Stefani que fit de octone pro arte predicta[;]

et volentes predicta exequi cum cedere videatur ad honorem et magnificentiam artis eiusdem premisso et celebrato inter eos solempni et secreto scruptinio et obtento partito ad fabas nigras et albas secundum ordinamenta dicte artis elegerunt promoverunt et nominaverunt infrascriptos quatuor cives praticos et expertos dicte artis pro quolibet conventu scruptinandos[,] et qui scruptinari et poni debeant ad partitum inter seipsos dominos Consules ac Consiliarios dicte artis quorum unus pro quolibet conventu remanere et eligi debeat in operarium dicte figure secundum formam supra traditam[;] quorum nomina sunt ista[,] videlicet[:] Gherardus domini Filippi de Corsinis[;] Sander Joannis de Biliottis[;] Tommasus Bartholomei de Corbinellis[;] Joannes Jacobi Bini pro conventu Ultrarni[;] Pierus Cardinalis de Oricellariis[;] Dominicus Jacobi Mazzinghi[;] Franciscus domini Raynaldi de Janfigliazis[;] Taddeus Bartholommei Lorini, pro conventu Sancti Pancratii[;] Antonius Tommasi Ghuccii[;] Stefanus Salvi Filippi[;] Alexander Ugonis de Alexandris et Lapus Joannis Niccolini pro conventu Sancti Petri Scheradii[;] Bindus Gherardi Piaciti[;] Joannes Laurentii de Stufa[;] Andreas ser Landi Fortini et Simon Francisci ser Gini pro conventu Sancti Martini[;] quibus omnibus suprascriptis civibus, positis ad partitum inter ipsos dominos Consules et consiliarios dictae artis in sufficientibus numeris more solitis adunatis in palatio dicte artis dicta die XV maij predicti quomodolibet[,] videlicet eorum singulariter et de per se in suo conventu[,] electi et deputati fuerunt infrascripti quatuor tanquam plures fabas nigras habentes ultra duas partes redditas pro sic[,] videlicet Joannes Jacobi Bini pro conventu Ultrarni[,] Alexander Ugonis de Alexandris pro conventu Sancti Petri Scheradii[,] Pierus Cardinalis ex Oricellaris pro conventu Sancti Pancratii et Bindus Gherardi Piaciti pro conventu Sancti Martini pro tempore et cum offitio auctoritate enseniis et aliis in reformatione suprascripta de predictis disponente latius annotatis.[113]

DOC. **111**, 1427, Aug. 5, SAINT STEPHEN, Dig. 140

ibidem: c. 130v (in margin: quod expense figure S. Stefani fieri possint de qualibet pecunia)

Dicta die V augusti.

Item advertentes domini Consules supradicti ad quandam reformationem editam de mense aprilis MCCCCXXV° disponente inter alia in effectu[,] quod de quibusdam redditibus et

[113] Docs. 109 and 110, Passerini, bibl. 391, p. 58, with minor omissions and errors.

introitibus dicte artis in reformatione predicta particulariter annotatis[,] fieret et fieri et construi deberet figura seu ymago S. Stefani Protomartiris enea seu de bronzo modo et forma quibus et prout in eadem reformatione inseritur[;] in qua quidem expendi posset usque in quantitatem florenorum mille auri prout et per dictam reformationem enarratur[;] et attenta locatione facta de dicta figura Laurentio Bartolucci magistro et constructori figure eiusdem[;] consideratoque quod huiusmodi figura per eumdem Laurentium conducta est de terra et cera[,] taliter quod necessarium est ipsam proici et fieri de ottone[,] alias quod actum est destrueretur et sumptus propterea facti perderentur[;] et visa emptione facta per dictam artem et per habentes baliam et auctoritatem ab ea vigore reformationis prefate de libris quatormilibus ottonis ad pondus Venetorum quod dicitur fore necessarium ad proiciendum et perficiendum figuram huiusmodi[.] Et considerato quod ex redditibus prelibatis et ut supra assignatis non est exacta nec exigi posset tanta pecunia que sufficeret ad solutionem et satisfationem pretii ottonis memorati et aliarum expensarum que opportune erunt ad perfectionem operis prelibati nolentesque quod opus predictum remaneat imperfectum[;] ideoque pro honore ipsius artis premisso et obtento partito inter eos ad fabas nigras et albas secundum ordinamenta artis eiusdem et servatis servandis secundum ordinamenta predicta providerunt ordinaverunt deliberaverunt et stantiaverunt[,] quod quicumque camerarius generalis tam presens quam quicumque successor de quacumque pecunia dicte artis ad eius manus perventa et pervenienda ex quibuscumque introitibus et ex quibuscumque causis det et solvat et dare et solvere teneatur et debeat[,] libere et absque eius preiudicio vel gravamine[,] dicto Laurentio et seu aliis quibuscumque personis[,] uni vel pluribus[,] usque in dictam quantitatem florenorum mille uni[,] computato in summa predicta toto eo quod solutum esset et ad exitum reperiretur[,] eo modo et forma tempore et termino ac conditionibus quibus et prout deliberatum et seu stantiatum fuit semel et pluries per Consules dicte artis et operarios dicte figure tam presentes quam qui pro tempore fuerint et duas partes ipsorum pro executione et perfectione omnium premissorum.[114]

DOC. **112**, 1428, June 30, SAINT STEPHEN, Dig. 148

[114] Passerini, bibl. 391, pp. 47f, with minor omissions and errors. Passerini erroneously indicates the *carta*

ASF, Arti, Lana, vol. 50, Deliberazioni dei Consoli, 1427, Dec. 1–1432, Oct. 1, c. 23, 23v (in margin: Auctoritas stantiandi concessa pro complendo[?] figure s. stefani)
Die ultimo mensis junij dicti anni MCCCCXXVIII ind. VI
Item Intellecto

Quoniam de mense aprilis anno dni MCCCCvigesimo quinto fuerit per tunc dominos consules dicte artis una cum consilio artis eiusdem dispositum et provisum in effectu. Quod [above line: dicti?] domini consules dicte artis eorumque successores tenerentur construi facere figuram et tabernaculum sancti stefani protomartiris gloriosi. Et in dictam causam expendere possent usque in quantitatem et summam florenorum Mille auri de artis redditibus dicte artis in provisione presentis (?). Et statim per aliam provisionem dispositum fuit in effectu Quod per consules eligerentur quattuor offitiales super perfectionem operis supradicti. Et dummodo nichil stantiare vel expendere possent nisi una cum consulibus dicte artis quorum electorum auctoritas duraret duobus annis tunc proxime venturis. Et quod postea de mense maij anno MCCCCXXVII finita auctoritas ipsorum quattuor electorum vigore alterius provisionis in consilio dicte artis firmate alii quattuor electi deputati fuere quorum nomina ista sunt vz

Johannes Jacobi bini	per tempus unius anni finiti die XV mensis maij proximi preteriti cum eadem seu simili auctoritate ipsis primo electis concessa et data. Et quod etiam (?) tempus ipsorum electorum expiravit.
Alexander Ugonis de Alexandris	
Pierus Cardinalis de Oricellariis et	
Bindus Gherardi Piansi (?)	

Et quod ad huc restant fieri stantiamenta et pagamenta pro complemento solutionis tam dicte figure quam eius tabernaculi . . . tam (?) usque in integram quantitatem ipsorum florenorum Mille quam maiorem et quod si aliter (?) provideretur aliquid stantiamentum seu solutio per predictos fieri non possit. Et videntes omnia predicta pro honore dicte artis prout convenit providere. Domini consules dicte artis habita propter huius. . . . (?) deliberacione solempni et demum Int. . . .(?) In . . arum(?) in palatio dicte artis more solito in loco eorum audientie in sufficiente numero congregati et premisso et facto solepni et peracto scruptinio ad fabas nigras et albas et obtento partito secundum formam ordinamentorum artis predicte. Providerunt deliberaverunt et ordina-

as 530v.

verunt quod illa eadem seu similis auctoritas balia atque potestas hactenus ut supra fertur data concessa et attributa ipsi Johanni Jacobi bini et sociis predictis una cum dominis consulibus dicte artis et que finem habuit die XV mensis maij proximi preteriti in stantiando deliberando et solvi facendo tam Laurentio bartolucii aurifici magistro dicti laborerii quam alteri (?) . . (?) que pro predictis habere et capere debenti usque in dictam summam florenorum Mille auri. Et nunc intelligatur eis et sit de novo data concessa et attributa ipsis Johanni jacobi bini et sociis una cum dominis consulibus dicte artis et duabus partibus eorundem usque ad preteritum mensem agusti proximi futuri in stantiando et solvi faciendo de quibuscumque redditibus et introytibus dicte artis tam dicto Laurentio pro eius magisterio et labore quam alteri (?) . . . (?) que pro predictis capere et habere debenti et tam usque in dictam summam florenorum Mille auri quam maiorem prout et sunt et quod . . . (?) ipsis dominis consulibus et dictis Johanni jacobi bini et sociis et duabus partibus eorum predictorum . . . (?) pluries videbitur et placebit. Et quod omnia et singula fienda et deliberanda per predictos dominos consules et dictos quattuor vel duas partes eorum infra dictum mensem agusti rem predictam exequi debeant et executam mandarunt qualibus oppositione et contradicta cessante.[115]

DOC. 113, 1429, Feb. 1, SAINT STEPHEN, Dig. 154

ASF, Arti, Lana, vol. 50, Deliberazioni de Consoli, 1427, Dec. 1–1432, Oct. 1, c. 42, 42v (in margin: Consules possunt vendere res superfluas figure s. stefani)
Die primo mensis februarij dicti anni.
Supra dicti domini consules ut supra more solito in loco eorum audientie in sufficiente numero congregati. Audito qualiter pro constructione figure sci stefani protomartiris gloriosi ipsius artis patroni empte fuerunt certe quantitates et summe ottonis et ferramentorum atque aere Et quod ipsa completa et perfecta superfuerunt ex predictis vz. libre mille octaginta ottonis et libre dugenta ferramentorum et certa quantitas aere. Que res vendi vel alienari non possunt alio non proviso. Et audito atque cognito quod ad presens ars non indiget dictis rebus sed indiget pecuniis quia non integre suffici possit constructioni dicte figure. Et volentes pro utilitate dicte artis providere promisso et facto. Inter eos solepni et peracto scruptinio ad fabas nigras et albas et obtento partito secundum formam ordinamentorum artis predicte providerunt ordinaverunt et deliberaverunt. Quod presentes domini consules dicte artis et due partes eorum aliis etiam absentibus et in requisitis vel presentibus et contradicentibus possint vendere et alienare tradere et concedere dictas res et bona supra expressa. Qui et quibus et pro pretio et pretiis dicte arti solvendo vel solvendis de quo et quibus et prout et sicut ipsis dominis consulibus aut duabus partibus eorum (videbitur [cancelled]) aut cui vel quibus comiserit placuerit et videbitur atque utilius potuerit pro ipsa arte. Et pretium et pretia inde recipienda et solvenda solvi et dari facere camerario dicte artis pro ipsa arte recipienti. Et quod que facta fuerunt per ipsos consules aut duas partes eorum aut per quem vel quos cui vel quibus commisserint . . . (?) valeant et teneant et possint et debeant immutabile (?) observari qualibus contra dicta cessanti.[116]

DOC. 114, 1376, July 30, MATRICULATION OF BARTOLO DI MICHELE

ASF, Arti, Seta, vol. 7, Matricula, 1328–1433, c. 30. Bartolus Michelis aurifex populi s. pauli de florentia quia juravit pro magisterio secundum formam statutorum dicte artis die XXII mensis febr[uarii] a.d. MCCCLXXV existentibus consulibus dicte artis orlandino lapi, bardo corsi, niccolao d'andrea, niccolao bartolj cinj, sandro cambinj et francescho bonacursi alderottj et quia solvit secundum formam sue taxationis dicte artis lb quinque ad flor. ideo matriculatus et descriptus fuit in presenti matricula per me dionisium di ser joh(?) notarium dicte artis die XXX julij a.d. MCCCLXXV tempore consulatus chiarissimi pagnj pergolettj franceschj Bianchi bonsi pauli bartolini pagni luche et pieri gherardi bonsi consulum dicte artis.[117]

DOC. 115, 1409, Aug. 3, FIRST MATRICULATION OF GHIBERTI, Dig. 28

ibidem: c. 115v, Laurentius filius Bartoli olim michelis aurifex populi s. pauli de florentia quia iuravit pro magisterio secundum formam statuti et ordinamentorum dicte artis die III° mensis augusti Anni dm. MCCCCnoni indictionis secunde existentibus consulibus dicte artis Mariano niccolai simonis et eius collegijs et quia habet beneficium ex patre dicti Bartoli

[115] Passerini, bibl. 391, p. 48, gives a brief paraphrase with the erroneous date 1418 and erroneous number of volume, 48.
[116] Passerini, bibl. 391, pp. 48f, gives a brief paraphrase with the same errors as in the previous one.
[117] Unpublished. Summary in Vasari-Milanesi, bibl. 533, II, p. 259.

eius patris in hac matricula pro magisterio matricolatj ideo matriculatus fuit in presenti matricula per me Lodovicum bertini notarium dicte artis dicta die III° augusti tempore consulatus consulum predictorum.

DOC. 115a, 1444, Apr. 30, CANCELLATION, Dig. 250

The words from Laurentius to s. pauli have been cancelled. (in margin: die 30 aprilis 1444 habetur pro non matriculatus quia non habet dictum beneficium ideo cassatur (?)Ubertus notarius.)[118]

DOC. 116, 1446, June 14, REMATRICULATION, Dig. 257

ASF, Arti, Seta, vol. 8, Matricola, 1433–74, c. 133. Laurentius olim Cionis quondam ser bonachursi abatini de ghibertis vocatus Lorenzo di bartoluccio popoli s. ambrosii de florentia Intalliator et aurifex aurarius Quia juravit pro magisterio secundum formam statutorum dicte artis die XIII maij anno dnj millesimo CCCCXL [sexto cancelled] quarto Ind settima vz. millesimo quattuorcentesimo quadragesimo quarto indict settima Existentibus consulibus dicte artis franciscio francisci della luna eiusque collegijs. Et quia solvit dicte arti pretium (?) introitus ad artem camerario artis florinos viginti auri Ideo matriculatus et descriptus fuit in presenti matricola per me Ubertum quondam Martini Bretj(?) de populo Donato in poggis civem (?) et notarium florentinum et nunc scribam dicte artis die XIIII junij anno dnj millesimo CCCCXLsexto ind nona tempore consulatus Caroli de boncianis eiusque collegiorum (?) consulum dicte artis[119]

DOC. 117, 1435, May 28, MATRICULATION OF TOMASO GHIBERTI, Dig. 250

ibidem: c. 214. Thomasus filius Laurentii quondam bartoli michelis alias di Lorenzo di bartoluccio aurifex populi s. anbrosii de florentia Quia . . . (?) consulum juravit pro magisterio secundum formam statutorum dicte artis die xxviii maji anno dnj MCCCC XXXV ind XIIJ Existentibus consulibus dicte artis Parente Johannis pieri parentis eiusque collegis[.] Et quia habet beneficium ex patre dicti eius patris in matricula et per . . . (?) presenti matricula dicte artis pro magisterio matriculati. Ideo matriculatus et prescriptus fuit in presenti matricula per me ubertum martini breti (?) civem et notarium florentinum nunc scribam

dicte artis die . . . (?) et tempore consulatus consulum predictorum.

DOC. 117a, 1444, Apr. 30, CANCELLATION, Dig. 250

The words from Thomasus to Lorenzo have been cancelled. [in margin: 1444 die 30 aprilis cassatur quia fuit matriculatus vigore beneficii patris et pater fuit declaratus non habere beneficium et non habetur matriculatus et . . . (?) juravit Ego Ubertus Martini].[120]

ASF, ARCH. OR S. MICHELE

DOC. 118, 1418, July 30, CANDELABRA, Dig. 59

Vol. 25, Libro delli Atti e Emanati dai Capitani di Or S. Michele, March 3, 1416–July 10, 1417 [recte: May 31, 1419], c. 42

Quod fiant duo candelabra argentea aurata pro altare oratorij et quod in eis possit expendi summa fl. CL vel circa et hoc commiserunt Suino Soderini et Tomasio Corsi quod [above line: Guariento quondam Guarienti aurifici. (?)] fieri facerent prout melius eis videbitur et stantiaverunt dictis fl. CL a denariis corporationis.

DOC. 119, 1418, Aug. 6, CANDELABRA, Dig. 59

ibidem, c. 44v. Die VI mensis augusti . . .
(in margin: locatio candelabrorum pro altarj)
Pateat omnibus Quod

Suinus pieri eucheri Soderini } duo ex numero
Tomasius Lapi Corsi } dictorum

Capitanorum vigore commissionis eis factae die XXX Julii proximi praeteriti elapsi de qua commissione plura habita . . . (?) deligati informati et colloquio de re ipsa . . . (?) movende . . . (?) et officii XV die martii praeter . . . (?) premissa (?) quod per [illegible] (?) locaverunt Guarento olim Johanis guarenti aurifici de florentia ad faciendum et fabricandum unum par candelabrorum argenteorum [above line: usque in libras 14 ulterioris] mensure unius brachij et unius quarti vel circa secundum formam eorundem designationis facte per laurentium bartolucij in quodam folio [above line: magno] de papiro cum additione [above line: . . . (?)] de ipso facto per dictum laurentium in quodam petio papirj pro pedistallo dicti designi et promiserunt [above line: . . . (?)] eidem Guarento dare et solvere florenos quattuordecim auri et quartos tres alterius

[118] Unpublished. Summary in Vasari-Milanesi, bibl. 533, II, p. 259.
[119] Unpublished. Referred to by Gaye, bibl. 173, I,

p. 150, note.*
[120] Unpublished.

floreni pro qualibet libra dictorum candel-
abrorum. Et supra (?) dictus Guarentus prom-
isit et convenit dictis Suino et Tomaso [above
line: et m.a.] jure et . . . dicte artis(?) complere
dicta candelabra bene et diligenter facere et
fabricare bono et fino argento et cum smaltis
in omnibus et per omnia prout et sicut in
dicto disegnio continetur ad usum discreti-
onem et arbitrium bonj virj sine fraude et
malitia [illegible?]. Et ipsa candelabra perficere
et dare completa hinc ad per totum mensem
novembrem proximum futurum suo argento
et magisterio et omnibus suis sumptibus et
expensis excepto auro pro auratura desuper
fienda. Quae omnia infrascripta promiserunt
[several words illegible] observari sub pena
duplij fl. pro quibus omnibus sese obligaverunt
et renuntiaverunt et cum . . . (?)[121]

ASF, CONSIGLI MAGGIORI

DOC. 120, 1444, April 29, DECLARATION OF
LEGITIMACY, Dig. 249
Provisioni, Registri, vol. 134, c. 286ff

(In margin: Laurentii Bartoluccii absolutio
et habilitas)
Sexto. Provisionem infrascriptam super istam
petitionem et omnibus et singulis in . . . (?)
deliberatam et factam per ipsos dominos
priores et vexilliferum gonfalonierorum so-
cietatum populi et duodecim bonos viros civi-
tatis florentie secundum formam ordinamen-
torum dicte civitatis . . . (?) quod dicte petiti-
onis tenor talis est viz:
Exponitur cum debita reverentia vobis mag-
nificis et potentibus dominis dominis prioribus
artium et vexillifero iustitiae populi et comu-
nis florentini pro parte Laurentii Cionis ser
Bonacursi vocati Lorenzo di Bartoluccio civis
vestri quod sub die sextodecimo aprilis 1444
conservatores legum et ordinum dicti comunis
visa quadam notificatione et seu tamburatione
eorum officio facta die 17 mensis martii prox-
ime preteriti cuius quidem tamburationis et
seu notificationis tenor est talis[:] Lorenzo di
Bartolo fa le porte di san giovanni di nuovo
tracto al uficio de dodici e inabile a tale ufizio
perche non e nato di legittimo matrimonio[;]
perche detto Lorenzo fu figliuolo di Bartolo e
Mona Fiore, la quale fu sua femmina ovvero
fante e fu figliuola d'un lavoratore di Val di
Sieve, e maritolla a Pelago a uno chiamato
Cione Paltami[,] uomo della persona molto
disutile e quasi smemorato il quale non pi-
acque alla detta Fiore[:] fuggissi da lui e ven-
nesene a Firenze capito nelle mani di Bartolo
predetto dell anno 1374 o circa e in quattro

o cinque anni ne ebbe due figliuoli[,] una
prima femmina[,] poi questo Lorenzo dell'-
anno circa il 1378[;] e quello allevo e inseg-
nolli l'arte sua dell Orafo[;] dipoi circa l anno
1406 mori il detto Cione el detto Bartolo tro-
vato da certi amici[,] i quali mostrarongli che
male era a vivere in adulterio la sposo come
di questo e pubblica voce e fama e come per
li strumenti di matrimonio. E s[e] egli dicesse
esser figliuolo di Cione e non di Bartolo tro-
verete che Cione mai ebbe figliuoli della Fiore
e che Lorenzo prese e uso i beni di Bartolo e
quelli ha venduti e usati come figliuolo e legit-
timo erede[:] e perche s[i] e sentito inabile mai
ha accettato l'ufizio del Consolato dell'Arte al
quale piu volte e stato tratto. Ma sempre per
piccola cosa e stato allo specchio a lasciatosi
stracciare[:] et pero non consenta la signoria
che per lui sappruovi meno diligentia doversi
usare in volere gli ufici principali della terra
che uno piccolo consolato. E se di tutto vuole
la signoria vostra buona informatione pigliate
da suoi artefici[,] cioe orafi come intagliatori[,]
e saperete la verita. Sievi raccomandato lonore
del comune e delle persone vostre. Ricordan-
dovi che tutte le dette cose io prima senti da
bartolo suo padre col quale piu tempo usai.
Et visa quadam alia notificatione dicta die
facta coram dominis officialibus cuius notifi-
cationis tenor est talis: Notificasi a voi signori
ufitiali e conservatori delle leggi che lorenzo
di bartolo che lavora le porte di san giovanni
che di nuovo de dodici non puo essere e
perche non e legittimo e fu figliuolo di barto-
luccio orafo e duna sua femina chiamata
monna fiore la quale fu di val di sieve nato
duno povero lavoratore maritolla a pelago a
uno tristanzuolo il quale in pochi dì ella
ricrebbe fuggisi dalui e capito a Firenze alle
mani di detto Bartoluccio el quale lungo
tempo se la tenne per amica e nei primi tempi
che con lui stette che fu circa al 1375 nebbe
piu figliuoli femina e maschio lultimo fu questo
lorenzo il quale detto bartolo allevo ensegnolli
larte sua. Dipoi sendo morto detto cione detto
bartolo s'anello alla detta mona fiore del anno
1404 or in quel torno e cosi troverete quando
noverete il detto cione non ebbe mai figliuoli
della detta fiore come certificatum est (?) per
paesani e suoi parenti verete informati. Di
Bartolo come suo figluolo uso e suoi beni e
muro in su una casa avea nella via nuova di
S. pagolo e dopo la morte di Bartolo la vende
come suoi beni patrimoniali e altre ragioni
non aveva ne titolo col quale la potesse ven-
dere[;] di tutte queste cose ne troverete nella
via della scala e nella via nuova assai che sene

[121] Docs. 118 and 119 unpublished. Referred to by
Vasari-Milanesi, bibl. 533, II, p. 259 with erroneous date
1417.

ricordano e che daloro passati che tutto vidono udirono. Il consolato del arte de maestri ove piu volte e stato tracto mai non a accettato etc. etc.[;] e se volessi pur dire essere figluolo di cione che troverete il contrario cade in un altro inconveniente peroche di cione lui ne sua gente mai furono prestantiati in firenze. Lorenzo in suo nome a auto graveza dal 1420 in qua[;] siche ne per luno padre ne per laltro e non puo accettare l'ufficio. Fategli ragione, ricordandovi cheglie molte volte incorso nella pena pero che negli anni passati e stato piu volte del consiglio del popolo e del comune come alle tracte saresti avisati—

Et visis attestationibus plurium et plurium testium examinatorum ex commissione et pro parte dictorum officialium et visa citatione facta de dicto Laurentio notificato ad se excusandum a dictis notificationibus et qualibet earum et visa comparitione dicti Laurentii facta occasione dictarum notificationum et dicte notificationis dicentis in effectum, quod dominus Laurentius fuit et est natus et conceptus de legitimo matrimonio et quod ipse fuit filius legitimus et naturalis Cionis S. Bonacursii de pelago et domine fioris uxoris legitime dicti Cionis et quod constante matrimonio inter predictos Cionem et dominam fiorem natus fuit videlicet de anno 1378[;] et quod non fuit filius nec legitimus nec naturalis dicti bartoli sive bartolucci sed fuit educatus et nutritus et etiam instructus in arte aurificis a dicto bartoluccio tanquam filius a pueritia sua et quod propterea a multis fuit putatus et vocatus filius bartoluccii[;] et etiam quia post mortem domini Cionis sui patris legitimi et naturalis dicta domina fiore eius mater accepit in virum et maritum dictum bartoluccium[;] et quod ipse Laurentius de anno 1413 pro recuperatione bonorum que fuerunt dicti Cionis sui patris fecit quoddam compromissum in dominum Masum de albizis[,] videlicet ipse tamquam filius dicti Cionis vocatus nencio bartoluccii ex una parte et quidam consanguinei dicti Cionis ex alia[;] ex quo secutum fuit quod ipse acquisivit quoddam petium terre quod fuit dicti Cionis et quod ipse ab anno 1413 citra solvit onera et factiones comunis flor[entie] partim sub isto nomine videlicet bartolo di michele orafo el figliuolo et partim sub nomine proprio Laurentii Bartoluccii aurificis[,] videlicet ab anno 1422 citra. Et quod ipse sub dicta descriptione que dicit bartolo de michele orafo el figliuolo tanquam filius putativus dicti bartoli comprehenditur et maxime quia dictus bartolus nullum alium filium legitimum nec naturalem habuit praeterquam dictum Laurentium eius filium pu-

tativum[:] Et demum quod notificationes fuerunt facte per calunpniam et quod contenta in eis non fuerunt et non sunt vera et petens se a dictis notificationibus et qualibet earum absolvi et liberari. Et viso quodam publico instrumento producto per dictum laurentium publice scripto manu domini ser laurentii ser Jannini notarii florentini de anno millesimo trecentesimo septuagesimo et mense aprilis per quod patet qualiter dictus cione et dicta donna per verba de presenti ad invicem et inter se matrimonium legitimum contraxerunt. Et viso etiam alio instrumento per dictum laurentium producto publice scripto manu dicti ser laurentii per quod patet qualiter de anno millesimo trecentesimo septuagesimo et mense septembris dicti anni dominus Cione confessus fuit habuisse in dotem dicte domine fioris libras 85 f. p.[;] et viso instrumento dicti compromissi de quo supra fit mentio scripto et rogato per s. Pierum s. Micaelis Guidonis sub die 5 aprilis anni 1413 in quo instrumento dominus Laurentius promittit ut filius Cionis s. Bonacursi de pelago vocatus Nencio de bartoluccio[;] et visis etiam dictis et actestationibus plurimorum testium pro parte dicte Laurentii productis et ipsis actestationibus diligenter examinatis[;] et visa dicta descriptione facta de dicto bartolo micaelis aurificis de anno millesimo quadragesimo tertio decimo e qua constat in camera actorum (?) communis florentiae in libro distributionum prestantiarum quartiere sce marie novelle incameratarum de dicto anno 1413 ad c. 30. Et viso quod etiam secundum assertionem dicti laurentii non solvit sub suo nomine proprio neque etiam apellativo vc[viz] tanquam filius cionis cuius se asserit fuisse filium onera comunis flor[entie] nisi ab anno 1422 citra et sic non solvit onera comunis flor[entie] debito et requisito tempore secundum formam statutorum et ordinum et reformationum comunis flor[entie;] et viso quod dominus Laurentius ut est notorium electus ad officium duodecim bonorum virorum comunis flor[entie] de anno proxime preterito 1443 et mense decembri dicti anni dictum officium acceptavit et exercuit contra formam dictorum statutorum ordinamentorum et reformationum civitatis florentiae. Et audito pluries et pluries dicto laurentio et quicquid coram dictis conservatoribus dicere et allegare voluit. Et auditis etiam et pluribus et pluribus aliquibus pro dicto laurentio loquentibus et in eius favore. Et visa citatione facta de dicto laurentio et in eius persona ex parte et permissione dictorum offitialium per famulum dicti offitii ad infrascriptam declarationem et damnationem et

sententiam audiendum. Et visis consideratis [omnibus quae?] examinanda fuerunt dei nomine invocato pro tribunale sedentes in loco in sententia descripto prestito primo dictis conservatoribus et omnibus coram iuramento per notarium coram offitio secundum formam ordinamentorum civitatis flor[entie] considerantes dictum laurentium se excusare et defendere a dictis notificationibus,—quatenus continent dictum Laurentium non fuisse natum de legitimo matrimonio affirmando se non fuisse filium nec legitimum nec naturalem dicti bartoli sed fuisse filium legitimum et naturalem Cionis ser bonacursi de pelago[;] misso et obtento partito—declaraverunt[:] descriptionem predictam factam de anno 1413 in distributione prestanzonum sub isto nomine videlicet bartolo di michele orafo el figliuolo, nullo modo prodesse vel suffragari posse dicto Laurentio et dictum Laurentium sub dicta descriptione nullo modo potuisse vel posse comprehendi cum asserat se non fuisse filium nec legitimum nec naturalem dicti Bartoli et dictum Laurentium non solvisse debito tempore onera et factiones comunis flor[entie], et exercuisse dictum officium duodecim bonorum virorum comunis flor[entie] contra formam statutorum ordinamentorum et reformationum dicte communis et acceptasse et exercuisse dictum officium duodecim Bonorum virorum comunis florentie contra formam statutorum ordinamentorum et reformationum comunis florentie et propterea incidisse in penam libr. 500 f. p. et dictum Laurentium vocatum nencio di bartoluccio intagliatorem in lib. 500 f. p. dandis et solvendis generali camerario comunis flor[entie] pro ipso comuni recipiendis infra unum mensem tunc proxime futurum sub pena quarti pluris si infra dictum terminum non solveret condemnaverunt[;] ab aliis autem antedictis notificationibus—dictum Laurentium absolverunt et liberaverunt. Et quod ipse Laurentius ideo dictum offitium duodecim bonorum virorum acceptavit quia credidit reputari debere ab omnibus ac si nominatim descriptus esset una cum dicto bartolo eius patre putativo in distributione prestanzonis ordinata ut supra de anno 1413 rationibus et occasionibus[;]—sed nuper intellexit a peritissimis viris quemadmodum dicti conservatores secundum scripturas de hac re penes eorum officium existentes nec non predicta et allegata coram eis non potuerunt facere de stricto iure quominus declararent et condemnarent et absolverunt prout in prefata sententia expressum est[;] et sic et nunc idem Laurentius confitetur et recognoscit per ipsos conservatores sibi ius administratum fuisse. Et quod post dictam

latam sententiam idem Laurentius invenit quod dictus Cione ser bonacursi de pelago olim eius pater legitimus et naturalis fuerat et est descriptus in soldis quinque in distributione septinarum civium civitatis flor[entie] impositarum in anno 1375 in vexillo leonis rubei ad c. 21. ut constat—sub die 17 mensis aprilis[;] et sic si scivisset ad tempus et produxisset coram dominis conservatoribus fidem prefate descriptionis dicti Cionis credit ipsos eum absolvisse ab omnibus contentis in notificationibus et intamburationibus supradictis[;] posito etiam, quod officium habuisset et exercuisset sub nomine ut supra[;] et quod ipse Laurentius ad hoc[,] ut presens eius petitio proponi possit ante nos et nostra collegia solvit baptiste de Guicciardinis capserio camere die 18 aprilis presentis pro soldo uno pro libra solvi debito—in totum flor. sex libr. 3, prout constat de ipsa solutione[;]—et quod ipse cuperet a dicta condennatione liberari excepta tertia parte ut infra quam exceptare iustum putat pro assignamento salarii dictorum conservatorum et eorum ministrorum et aliarum expensarum occurrentium—ut magis ostendatur iustitia facta per eos in casu predicto; et etiam cuperet infrascripta firmari et confidens gratiam invenire decrevit vestram dominationem adire et ab eadem cum consensu nobilium virorum Ianozi bernardi de manettis et bernardi domini baldi della tosa, de nris. ven. collegiis auditorum suorum ad hoc legitime assumptorum postulare quod inferius est descriptum. Quare vobis dominis supradictis pro parte predicta devotissime supplicatur,— quatenus vobis placeat—oportune providere— quod etiam absque aliqua fide aut probatione de supra narratis—ipse Laurentius ex nunc intelligatur esse et sit a dicta condemnatione libr. 500 et quarti pluris et ab omni descriptione et registratione inde secutis vel propterea factis absolutus et plenissime liberatus[;] et possit et debeat de ipsa condennatione—licite et inpune cancellari absque aliqua solutione propterea fienda vel alia substantialitate servanda visa solum reformatione, quae super his facta fuerit[:] etc. etc. hoc salvo, quod predicta absolutio et liberatio non intelligatur neque locum habeat pro lib. 50 dicte condennationis quas solvere teneatur ipse Laurentius.
Item salvis predictis et in suo robore permanentibus, quod dicta sententia, declaratio, condennatio et absolutio et omnia singula— intelligantur esse et sint vigore reformationis quae super his facta fuerit plene et integre approbata et confirmata etc. etc.
Cum hoc tamen addito intellecto ac expresse apposito et inserto quia ipse Laurentius magis

cognoscitur sub nomine Laurentii bartoli sive bartolucci, eius patris putativi sub quo obtinuit officia quam sub nomine Laurentii Cionis ser bonacursi eius patris legitimi et naturalis[;] quod ipse Laurentius de cetero quaecunque officia comunis vel pro comuni florentie et alia quelibi ad que ipsum extrahi vel deputari contigerit sub nomine Laurentii bartoli aut bartolucci magistri intagli vel sub alio nomine vel denominatione artis vel exercitii vel sine aliqua denominatione possit acceptare curare et exercere licite et impune ac si dictus bartolus sive bartoluccius vere fuisset eius pater legitimus et naturalis etc etc

Super qua quidem petitione, et omnibus et singulis in ea contentis, dicti domini priores et vexillifer habita super predictis—invicem et una cum officiis gonfaloneriorum societatum populi et duodecim bonorum virorum comunis flor[entie] deliberatione solenni et secreto scrutinio ad fabas nigras et albas providerunt die 28 mensis aprilis 1444[:] quod dicta petitio et omnia et singula in ea contenta procedant firmentur fiant et firma et stabilita esse intelligantur non obstantibus predictis legibus etc etc

Qua provisione lecta et recitata, dictus dominus propositus proposuit, et petiit sibi per omnia bonum et utile consilium impartiri—CLVIIII ex ipsis consiliariis dedisse fabas nigras pro sic et sic secundum formam dicte provisionis obtentum firmatum et reformatum fuit non obstantibus reliquis XXXII ex ipsis consiliariis repertis dedisse fabas albas in contrarium pro non[122]

BMF, A 199 I

DOC. 121, 1404-1424, NORTH DOOR, Dig. 109
Collezione Gori, after C. Strozzi, Descrizione dell' . . . S. Giouanni, f. 33v Costo il magistero l'ottone, et ogn' altra cosa fl. 12040 e lire 16656.1.2 che fanno la somma di fl. 16204 s. 1 d.2 valutando il fl. 4 come valeva allora[123]

DOC. 122, 1424-1452, EAST DOOR, Dig. 286
ibidem: f. 33v. (Description of Ghiberti's second door) . . . egli vi potesse tenere a lauorare Vettorio suo figliuolo e Michelozzo di Bartolommeo, e altri tre che non furono sempre

gl'istessi, ma alcuna volta si mutarono. Matteo di Franc.o di Andrea da Settignano. Simone di Nanni da Fiesole. Domenico d'Antonio Salviati di d.o luogo. Franc.o di Papi Buoni. Franc.o di Nanni Buioni, Cristofano di Franc.o, Giov. di Giuliano, e altri furono in questo numero. . . .
Fu la spesa fra Magisterio e altro fl. 12290 l. 9219.4.1 che fanno la somma di fl. 14594.3. 4.1.[124]

DOC. 123, 1452-1466 (?), SOUTH DOOR, Dig. 302
ibidem: f. 34. Stipiti, cardinale, soglia, architrave . . . della porta principale e di quella dell'Opera furono lavorati per li stessi maestri che lavororno le Porte; et il costo è computato nella valuta di esse; ma quelli della Porta del Battesimo furon fabricati per Lorenzo di Bartolo, e Vettorio suo figliuolo, ma la maggior parte da q.o[questo? quello?]. L'anno 1466 (sic) furono finiti e costarono in tutto fl. 810 lire 10166.d.1 che fanno la somma di fl. 3351. 2.9.4. . . .[125]

DOC. 124, [1452, after July 13], EAST DOOR, Dig. 284
ibidem: f. 142 (source unnamed)
Piero Donati Orafo pulisce, e forbisce, e rizza la Porta di S. Gio., c. 14[126]

BNF, MAGL.

DOC. 125, 1414, SAINT JOHN, Dig. 32
BNF, Magl., Cl. IX, 127, f. 187 from *Libro Grande dell'Arte segnato P, 1414*
Al tabernacolo della detta Arte posto a O.S.M. si lavora, c. 236[127]

DOC. 126, 1442, Aug. 30, CASSA DI S. ZENOBIO, Dig. 236
BNF, Banco Rari, 228 (formerly *Magl., Cl. XVII, 2*), *Zibaldone di Buonaccorso Ghiberti*, c. 27.
. . . la fijura del santo mateo ebene lorenzo fl. 650 doro per suo salaro . . . di tutte i spesse di lorenzo
la sepoltura o vero chasa di bronzo di santo zanobi costo o vero fu giudichatto che lorenzo maestro dessa dovesi avere fl. 1324 . . . fl. 1324[128]

122 Published by Gaye, bibl. 173, I, pp. 148ff with call number, Filza 136 and a number of omissions and misreadings.
123 Unpublished.
124 Unpublished.
125 Unpublished. The terminating date, 1466, is probably a *lapsus calami*, the correct date being 1462-1464. See Doc. 68.
126 Unpublished. The date results from the corre-

sponding Doc. 73.
127 The pagination given for the original ms., c. 236, is identical with that indicated for Docs. 3, 4 and 5 in *Strozz*. LI, 1. In *BNF*, Magl. Cl. IX, 127, Doc. 125 follows immediately upon an entry repeating Doc. 3. Frey, bibl. 532, p. 381, doc. 22, again referring to Berti (see above, p. 366, note 8), thought that Doc. 125 was identical with his doc. 20, our Doc. 4.
128 Unpublished.

AOF

DOC. 127, 1419, May 20, DESIGN FOR PAPAL APARTMENT, Dig. 65

AOF, Delib., LXXVI, c. 29. Quod scalae habitationis papae in sancta maria novella fiant in una . . . (?) in qua non potest vz. ubi nunc est cappella quondam nicolaj et quod scala in apartamento . . . (?) ex latere ex quo non . . . (?) ita quod vadat per . . . (?) et fiant secundum designum quod datur per laurentium bartoluccij aurificem et removeatur murus quod nunc est in dicta . . . (?) ex latere orti et fiat alius murus loco dicti muri descendendi in dicto orto prout expeditur.[129]

DOC. 128, 1419, Aug. 2, BUILDING OF PAPAL APARTMENT, Dig. 65

AOF, Delib., LXXVII, c. 7. Pippus Johannis populi sancti laurentii magister qui ad praesens laborat in ecclesia sci. trinitatis de florentia pro domino palla de Strozzis debeat et teneatur sub pena librarum centum fl. ire ad hedificandum et designandum scalas habituri papae in sca. maria novella, Saint Matthew . . .[130]

AUF

DOC. 129, 1413-1422, SAINT JOHN, Digs. 57, 97

Florence, Uffizi, Arch., Misc., vol. I, 4.
El scto Macteo che fecie fare larte del cambio costo assue (sic) fl. 650 doro fu dimano di Lorenzo di bartoluccio
La fighura di scto. Giovani battista posta nel pilastro dorto scto michele fecela lorenzo di Bartoluccio per larte de merchatanti sino di genaio 1419 (sic) costo fl. 294, l. 931, s. 17, d. 3.
1432-1442, CASSA DI SAN ZENOBIO, Dig. 236
La sepoltura del bronzo di Scto Zanobi o vero Casone entravi dreto [dentro] libre 3277 dottone, libre 350 di cera, libre 122 di rame e ferro, libre . . . (sic) di carbonj fl. 4, l. 94. Costò tutto fl. 1314 doro fecela lorenzo di Bartoluccio.[131]

ODS

DOC. 130, 1417, May 21, SIENA FONT, Dig. 54

ODS, Pergamena, no. 1437: In nomine Domini amen. Anno ab ipsius Domini salutifera incarnatione MCCCCXVII Inditione decima—die vero vigesima prima mensis Maii.—Appareat omnibus et singulis—quod—dominus Caterinus Corsini miles et operarius Ecclesie cathedralis sancte Marie de Senis; dominus Petrus Thome canonicus dicte Ecclesie; Turinus Mathei mercator et Jacobus Jacobi lanifex; tres ex consiliariis dicti operarii, absente Nicolaccio Terocci eorum quarto collega,—locaverunt et concesserunt magistro Laurentio Bartholi, aurifici de Florentia presenti et conducenti, ad faciendum duas de sex historiis, et tabulis historiarum que fient et fieri debent in fonte Baptismi sancti Johannis de Senis, videlicet de attone fino, eo modo et forma et cum illis figuris, de quibus declaratum fuerit eidem magistro Laurentio per dictos operarium et consiliarios, et sub istis modis, conventionibus et capitulis, videlicet:
Imprimis, quod dictus magister Laurentius teneatur et debeat dictas duas tabulas et historias facere de bono attone, et cum figuris bonis et pulcris, tamquam bonus magister, pro illo pretio et salario, de quo vel declaratum fuerit per dictos dominum operarium et consiliarios supranominatos; in quos presentes et acceptantes dictus magister Laurentius plene et libere remissionem et commissionem fecit et promisit eorum declarationi stare tacitum et contentum, absque aliqua contraditione.
Item, quod dictus magister Laurentius teneatur et debeat perfecisse et complevisse unam de dictis tabulis et historiis infra decem menses proxime venturos, omni perfectione ipsius, et figurarum: quam sic factam et completam, ostendere debeat dictis operario et consiliariis suis, antequam ipsam tabulam deauret; et postea ipsam deauratam, idest prius sine auro et postea cum auro, ut possint ipsam videre et examinare si placeat eis, et si habeat omnem perfectionem suam, et super ipsam habere illam informationem, de qua eis placuerit. Et sic visis et examinatis omnibus, habeant, et teneantur declarare precium et salarium debitum eidem magistro Laurentio, tam pro ipsa prima tabula, quam pro alia: et secundum quod per eos fuerit declaratum, poni debeat ad executionem. Et quod ipse magister Laurentius, teneatur quando deaurabit eas, ipsas deaurare ad nuotum, et non cum panellis.
Item, quod dictus magister Laurentius teneatur et debeat, postquam dicta prima tabula fuerit facta et visa et pretium declaratum ut supra, infra decem menses tunc proxime secuturos, facere aliam tabulam seu historiam cum figuris et forma sibi per predictos datis et traditis, de bono attone et bonis figuris ad similitudinem prime, et melius, si fieri potest, ut bene stet sicut prima, et melius.

[129] Unpublished. Referred to by Vasari-Milanesi, bibl. 533, II, p. 260.

[130] Poggi, bibl. 409, p. 7.
[131] Fabriczy, bibl. 147.

Item, quod dictus dominus Caterinus et consiliarii prefati non possint nec debeant, antequam fiat et videatur dicta prima tabula et historia, et declaretur pretium ut supra, locare alicui sex figuras, que fieri debent in dicto fonte Baptismi.

Item, quod dictus dominus Caterinus teneatur et debeat de presenti eidem magistro Laurentio, prestare centum flor: auri; ut possit sibi providere de rebus opportunis et in fine operis ipsum integraliter accordare de debito suo absque aliqua contraditione vel lite: et interim etiam facere sibi illas prestantias de quibus fuerint in concordia.

Item, quod predicta omnia et singula intelligantur et sint ad bonam et puram fidem et intellectum[,] omni fraude seu cavillatione, vel mala interpetratione remotis.

Que omnia et singula etc.

Actum Senis in Opera seu in domo opere sancte Marie de Senis, coram Johanne Turini aurifice de Senis, Juliano Honofrii de Florentia, Doccio Jacobi[,] et Antonello Gori de Sen: testibus.

Ego Castellanus Utinelli Castellani de Sen: notarius scripsi et publicavi.[132]

DOC. **131**, 1416 [between June 28 and July 17], SIENA FONT, Dig. 44

ODS, Memoriale di Domenico di Mariano speciale (1416-1417), c. 5v. MCCCCXVI Maestro Lorenzo di Bartolo, Giugliano e Bartolomeo maestri d'intaglio da Firenze die' dare per le spese fatte di sotto— li quali maestri mandaro per loro misser Caterino e suoi chonseglieri per edifichare el Battesimo in S. Giovanni- prima, contanti le demo per detto di misser Caterino Hoparaio e per detto de conseglieri, le demo lire dodici per le spese della loro venuta, e per pigione, polastri e per malvagia, pane, aranci e altri cose, per far lor onore, come ci asegnio' Doccio, lire tre soldi diciotto e piu ci asegnio' de soldi 36 al'abergatore del Gallo, per spese d'uno loro ronzino tenne, e le dette cose e spese faciemo di consentimento di misser Chaterino e de' suoi conseglieri. In tutto fior. O, lib. XVII, sol. XIIII, den. VI. Messi a nostra Uscita fo. 53.[133]

DOC. **132**, 1417 [prior to Mar. 3], SIENA FONT, Dig. 50

ibidem, c. 16v. MCCCCXVI. Le spese della casa.

E die dare soldi otto pagamo al camarlengho delle some per cabella d'una storia d'atone fecie venire misser Caterino e consiglieri da Firenze per lo fatto del Battesimo.

E die dare per la vettura d'essa storia a Michele vetturale di qui a Firenze soldi XVJ.[134]

DOC. **133**, 1417, Mar. 11, SIENA FONT, Dig. 51

ibidem, c. 16v. MCCCCXVI. Le spese della Casa.

E a di XI di marzo lire sei soldi tredici per presto di ronzino e per spese feci quando andai a Firenze per lo fatto del Batesimo. . . .[135]

DOC. **134**, 1416 [between July 11 and 17], SIENA FONT, Dig. 44

ODS, Entr. Usc. di Domenico di Mariano, (1416), c. 52v. A maestro Lorenzo di Bartolo intagliatore da Firenze lire diecisette soldi quatordici den. sei per più spese se li fece quando miss. Caterino e chonseglieri el feciero venire da Firenze per edificare el Battesimo apare al nostro memoriale a fo. 5. [136]

DOC. **135**, 1416, Dec. 18, SIENA FONT, Dig. 45

ODS, Libro di Spese di Doccio di Jacopo fattore (1416). c. 10. MCCCCXVI Ancho spesi a di' XVIII dicembre quando Giovanni di Turino orafo ando a Fiorenza a maestro Lorenzo per lo fatto del Batesimo, lire IIII.[137]

DOC. **136**, 1417, Jan. 1, SIENA FONT, Dig. 49

ibidem, c. 10v. MCCCCXVI Ancho spesi a dì primo di genaio per biada e per pescio per fare onore a maestro Lorenzo da Fiorenza che venne per lo fatto del Batesimo lire II.[138]

DOC. **137**, 1417, May 20, SIENA FONT, Dig. 53

ibidem, c. 15v. MCCCCXVII Ancho spesi a di (sic) maggio per fare onore a maestro Lorenzo da Fiorenza quando venne a Siena a tollare le fighure de l'atone del Batesimo, per biada e strame e uno mezzo chapretto e per uova e chacio e due oncie di pepe e per pesegli e per uno pescio arrostito e bacegli e pesegli lire IIJ, soldi V.[139]

DOC. **138**, 1417, July 9, SIENA FONT, Dig. 55

ODS, Memoriale d'Antonio di Cristofano (1417), c. 6v. Maestro Lorenzo di Bartalo da

[132] Milanesi, bibl. 336, II, pp. 89ff, doc. 61; Lusini, bibl. 283, pp. 96ff, doc. 3; Bacci, bibl. 31, pp. 109f.

[133] Bacci, bibl. 31, p. 96; Milanesi, bibl. 336, II, p. 91, note, as c. 6v; Lusini, bibl. 283, p. 40, note 3.

[134] Bacci, bibl. 31, p. 101.

[135] *ibid.,* p. 107.

[136] Bacci, bibl. 31, p. 98; Milanesi, bibl. 336, II, p. 91, note; Lusini, bibl. 283, p. 40, note 3.

[137] Bacci, bibl. 31, p. 99.

[138] *ibid.,* pp. 99f.

[139] *ibid.,* p. 109.

Firenze die' dare a di 9 di luglio lire dugiento chontanti i quagli denari pagho per noi Ghucio di Ghalgano Bichi e chonpagni banchieri chome apare a Liro rosso a fo. 98 e a mia entrata a fo. 3, e i detti denari porto Papi di Bartalomeio suo garzone e i detti denari si pagaro per detto di misser Chaterino Hoparaio e i detti denari sono per parte di paghamento de le storie del Batesimo le quagli s'e alogate da misser Chaterino. Messi a Libro rosso a fo. 137 e a nostra uscita a fo. 57.
Entr. Usc. (1417), c. 57[140]

DOC. 139, 1420, Nov. 13, SIENA FONT, Dig. 80

ODS, Debitori e Creditori (1420-1444), Libro giallo, vol. 393, c. 3v. Maestro Lorenzo di Bartalo da Firenze die dare lire treciento e qua danari ane auti da Antonio di Cristofano e Ghabriello di Giannino Gucci chamarlenghi stati a la detta hopera come apare a liro Rosso in due partite che debi dare[;] e sbatuti la e messi qui a fo. 137.
E a di XIII di novembre fl. centoquaranta d'oro i quali ebbe per noi da Luca di Piero Rinucci in Firenze per some . . . (?) a fo. 52 cigliemo allibre l. 564 s. 13 d. 4.
Et die dare insino a di'detto . . . (?) l. otto s. nove, d. sei e quali si spesero per vetura d uno chavallo e altre spese quando io Pietro di Nofrio speciale kamarlengho vo andai a solecidare le dette storie e sono . . . iscritte a fo. 29.
E die dare l. quatro s. due d. sei i quali pagamo per lui a ser Castellino d' Utinelli notaio per chagione che fu rogato dell'alogazione del Batesimo tolsi a fare dal Uopera per la sua parte come appare inscritto da me Pietro di Nofrio kamerlengo a fo. 29 in soma di l. otto, s. cinque a Ser Castelino detto.[141]

DOC. 140, 1425, June 28, SIENA FONT, Dig. 119

ibidem, c. 3v. E debe dare a di 28 di giugnio 1425 soldi quarantacinque paghamo contanti per lui a Michele vetturale da San Donato, per detto di misser Bartalomeio nostro Operaio, furo per vettura d'una storia del Batesimo di santo Giovanni mando a vedere all' Operaio[;] paghali io Pietro di Marcho camarlingo e sonno a mia uscitta a f. 61.[142]

DOC. 141, 1427, Oct. 30, SIENA FONT, Dig. 143

ibidem, c. 240. Maestro Lorenzo di Bartalo da Firenze orafo e sculptore die' avere a dì 30 d'ottobre lire mille seciento ottanta so[no] per due historie d'attone dorate ci a fatto e consegnate el di detto in Firenze a me Berto d'Antonio camarlengo dell'Uopera per lo sacratissimo Batesmo si die fare in san Giovanni[;] l'una contiene[:] QUANDO SAN GIOVANNI BATEZO JESU CHRISTO NEL GIORDANO l'altra[:] QUANDO E RE HERODE COMANDA E FA METTARE SAN GIOVANNI predetto DA LA FAMEGLIA SUA IN PREGIONE. E questo per fiorini dugento dieci l'una[,] a lire 4 fiorino[,] che so[no] frammendue recati a lire in tutto lire 1680.
Del qual prezo di lire 1680 per amendune historie fumo d'accordo in Firenze el detto m.° Lorenzo da l'una parte e io Berto a vice e nome dell' Uopera dall'altra. E questo per commissione pienamente fattami da misser Bartolomeo di Giovanni Cechi Operaio nostro e Giovanni di Francino Patrici[,] Nanni di Piero di Guido e ser Bindotto di Giovanni notajo[,] al presente conseglieri del detto miss. l'Operaio e sopra el detto Batesmo. Et cosi el sopradetto miss. l'Operaio e suoi conseglieri[,] absente misser Giorgio Talomei lor quarto compagno[,] anno avuto rato e confermato nella mia tornata. E qui o acceso el detto m.° Lorenzo creditore di lor buon consentimento e volonta.[143]

DOC. 142, 1425 [between March 1 and 10], SIENA FONT, Dig. 112

ODS, Memoriale di mess. Bartolomeo operaio (1423-1427), c. 7 (in margin: Firenze)
A di . . . di marzo si delibero—harta per mano di ser Franciescho del Barbuto—che i denari che ano avutti i maestri da Firenze he fano le store del Batesimo si riabino hocio sia hosa so pasatti tutti i termini che le dovesono fare e no l' ano fatte.[144]

DOC. 143, 1427, April 17, SIENA FONT, Dig. 134

ODS, Entrata—Uscità di Antonio di Jacomo (1426-1427), c. 83v. A M[aestr]o Lorenzo di . . . da Fiorenza orafo (?) adi 17 d'aprile l[ire] dugiento e quegli deve per noi giovanni di giovanni pieri e compagni banchieri esso [e sono?] a lui al monito (?) di messer Antonio

[140] *ibid.*, pp. 110f.

[141] Milanesi, bibl. 336, p. 91, note, with large omissions and minor misreadings; Lusini, bibl. 283, p. 40, note 4, after Milanesi.

[142] Doc. 140 continues Doc. 139 in different handwriting. Bacci, bibl. 31, p. 161; Milanesi, bibl. 336, II,

pp. 91f, note; Lusini, bibl. 283, p. 41, note 4.

[143] Bacci, bibl. 31, p. 183f; Milanesi, bibl. 336, p. 92, note. See Docs. 148, 149, 150.

[144] Bacci, bibl. 31, p. 158. For the precise date see Doc. 154.

camerlengo nostro (?) deve dare. E detti denari si mandano[a] Antonio di Jacomo Pieri e compagni banchieri di Fiorenza per che gli desse al detto m[aestr]o Lorenzo perche el detto m[aestr]o Lorenzo dorasse due storie d'attone fatte per lo batessimo di san giovanni nostro. E detti denari si mandano per giovanni pieri per Michele di . . . veturale da san Donato per detto di messer Bartolomeo (cancelled) operaio e di Nanni di Francino e compagni per (?) el batesimo dan . . . (?) esso che maestro Lorenzo debe dare a di' sopradetto.[145]

DOC. 144, 1427, April 23 [Feb. 27-March 7], SIENA FONT, Dig. 130

ibidem, c. 84v. A'ntonio di Jacomo di Dota adi 23 d'aprile l[ire] vinti e questo per una andata fecie a fiorenza per comandamento e volonta di mis[ser] Bartalomeio Oparaio e di Checco Rosso[,] Nanni di Piero di Ghuido e ser Bindotto mandato per li detti a m.° Lorenzo di (.) per le tav[o]le e storie fatte per lo batesimo[;] ando a di 27 di feraio e torno a di 3 di marzo con due cavaglj stato dì cinque, per soldi quaranta di per ciashuno, cavalo e huomo; fatto questo salario per lo detto miss. Bartelomeio, Nanni di Francino, Nanni di Piero di Ghuido e ser Bindotto.[146]

DOC. 145, 1427, March 1-7, SIENA FONT, Dig. 130

ibidem, c. 85. Alle spese fatte in fiorenza per Antonio di Jacomo mandato di mis[ser] Ser Bartolomeio e Checho Rosso[,] Nanni di Piero di Giudo e Ser Bindetto lire quatro soldi due denari 6 per due casse di legno chostono lire 10 d. 2[;] per lire 3 daghuti per esse casse felle in fiorenza maestro ghino di pietro m[aestr]o di legniame a dì primo di marzo per mettarvi dentro le dette storie che venno da fiorenza le quali fa m[aestr]o Lorenzo di[. . .] Ese che le dette spese debino dare al l[ibr]o giallo a fo. Alle dette spese fatte in questo dì detto di sopra s[oldi] tre d[enari] 6 per fune per magliare (?) le dette casse di muovere dentro le dette storie d'atone
Alla detta spesa a dì 3 di marzo s[oldi] quattro a Nani di Cichanello portatore per recare le dette storie dalla cabella a l'Uopera. . . .
Alla dette spese fatte l[ire] dodici e questo per vetura di recare e portare le dette tavole e sono da Fiorenza a Siena e portare da Siena a Fiorenza: a Michele veturale da San Donato pesano l[ibre] 600 onc. (?) 20 che monta lire 12 porto insino a di' 7 di marzo a Fiorenza . . .[147]

DOC. 146, 1427, July 14, SIENA FONT, Dig. 139.

ODS, Entrata-Uscita di Berto d'Antonio (1427-1428), c. 63. A ser Jacomo di Nuccino notajo a di 14 di luglio l[ire] quatro le quagli so[no] per una carta ricogliemo da lui del contratto dell'alogagione di due historie d'attone per lo Batismo si die' fare in San Giovanni fatto a maestro Lorenzo di Bartalo orafo da Firenze del quale fu rogato ser Castellano d'Utinello. El detto ser Jacomo a le sue imbreviature.[148]

DOC. 147, 1427, Sept. 26, SIENA FONT, Dig. 141

ibidem, c. 63. A m.° Lorenzo di Bartalo da Firenze fa due storie nostre del Batesmo a di 26 di septembre l[ire] cento otto s[oldi] otto den. otto gli facemo dare a Firenze per fiorini vinticinque di camera[,] gli dè Esau Martellini per lettera di Giovanni Pini e Mariano banchieri per dorare le dette storie.[149]

DOC. 148, 1427, Oct. 30, SIENA FONT, Dig. 143

ibidem, c. 64. A Maestro Lorenzo di Bartalo da Firenze orafo e sculptore a dì 30 di ottobre l[ire] cento novantaquatro. So[no] per parte del prezzo delle due historie ci a fatte per lo batesimo di Siena de quali denari contanti in sua mano in fiorini d'oro 44 che montano . . . (?) per s[oldi] 8 d[enari] 2 l'uno l[ire] 194 in Fiorenza quando vi fui mandato da Misser Bartolomeo e conseglieri suoi per le dette due historie . . .
c. 64v
A maestro Lorenzo di Bartalo soprascripto a dì 30 di ottobre l[ire] trecento otto s[oldi] quindici d[enari] sei e quagli so[no] per resto di l[ire] mille secento ottanta doveva avere per le due historie dell'attone ci fece per lo batesimo si diè fare in san giovanni. E per noi glil de[diede] in Fiorenza Luca di Piero Rinieri banchiere da Fiorenza . . .[150]

DOC. 149, 1427, Oct. 30, SIENA FONT, Dig. 143

ibidem, c. 64v. Ala cabella dele porti di Fiorenza a dì 30 detto l[ire] quarantacinque so[no]

145 Unpublished. Bacci, bibl. 31, p. 170, excerpt only.
146 Unpublished. Summary, Bacci, bibl. 31, pp. 164f.
147 Unpublished. Summary, Bacci, bibl. 31, pp. 165ff.
148 Bacci, bibl. 31, p. 181, as c. 63v.
149 Bacci, bibl. 31, pp. 181f. Quoted by Milanesi, bibl. 336, II, p. 92, note and by Lusini, bibl. 283, pp. 41f, note 5 as *Libro Giallo de Deb. e Cred.*, c. 239v and as immediately preceding our Document 141. Repeated checks have failed to turn up this document.
150 Unpublished. Summary, Bacci, bibl. 31, p. 186.

per cabella dele sopradette due historie dell'-
atone per lo batesimo pagamo in Fiorenza
quando le feci venire per commissione di Mis-
[ser] Bartolomeo operaio nostro e suoi con-
seglieri. Et per me le pago Antonio di Jacomo
Pieri da Fiorenza.[151]

DOC. 150, 1427, Nov. 2, SIENA FONT, Dig. 143
ibidem, c. 64v. A Berto d'Antonio camarlengo
nostro a dì 2 di novembre l[ire] trentadue
so[no] per la sua andata e salaro quando ando
a Fiorenza con due cavagli a s[oldi] quaranta
per cavallo come è usanza per dì otto in tutto
cioe partì di Siena a dì 25 d'ottobre sabato e
torno l'altro sabato dì primo di novembre el
dì dognisanti. E questo per commissione di
Mis[ser] bartolomeo operaio nostro e di Gio-
vanni di Francino Parucci (?) e di Ser Bindotto
di Giovanni notaio e Nanni di Piero consig-
lieri del detto operaio e sopra el detto bates-
imo. Perche non si potevano avere le dette
historie dal detto maestro Lorenzo essendovisi
scripto piu e piu volte . . .[152]

DOC. 151, 1427, Nov. 15, SIENA FONT, Dig.
144
ibidem, c. 64v. A Antonio di Domenico fameg-
lio de nostri M[agnifici] S[ignori] col rotelino
a dì 15 di novembre s[oldi] cinquantacinque.
so[no] per suo salaro quando fu mandato da
l'oparaio e conseglieri predetti a me quando
ero a Fiorenza con lettere che dovessi a ogni
modo veder di conduciare le dette historie a
Siena commetendomi pienamente el far patto
col detto M[aestr]o Lorenzo.[153]

DOC. 152, 1427, Nov. 15, SIENA FONT, Dig.
144
ibidem, c. 64v. A Antoniello e uno compagno
portatori a dì detto s[oldi] quatro perche
recaro le dette due historie da la cabella nostra
di Siena a l'Uopara.[154]

DOC. 153, 1427, Nov. 15, SIENA FONT, Dig.
144
ibidem, c. 64v. A Michele da San Donato vet-
turale a dì 15 detto l[ire] sei s[oldi] 8 per vet-
tura dele dette due historie dell'attone da
Firenze a Siena e alcuno aguto e funella disse
messe di suo perche bisogno . . . erarle (?)[155]

DOC. 154, 1425, March 10, SIENA FONT, Dig.
113
ODS, Libro di Documenti Artistici, no. 52
Adi X di Marzo 1424: Honorevole magiore etc.
E suto a me Agnolo di Jacomo vostro fattore
el quale m'arecho una lettera[:] ami informato
Agnolo di vostra intentione intorno al fatto
delle storie, le quali esso a vedute[:] son presso
che finite[;] le quali sarebono chosta compiute
se non fosse stata la moria[;] pero ch'io mi
parti[:] andai a Vinegia e ancora tutti miei
lavoranti si partirono. E questa e suta la cagi-
one dello indugio d'esse. Per tutto el mese di
Giugno aremo finito el vostro lavorio. Altro
non c'e a dire. Christo ci conservi in pacie.
Per lo vostro Lorenzo di Bartolo orafo in
Firenze.
Egregio chavaliere messer Bartolomeo di Gio-
vanni honorevole operaio nella Chiesa chatte-
drale di Siena.[156]

DOC. 155, 1425, April 16, SIENA FONT, Dig.
115
ibidem (unnumbered at present; formerly no.
54)
Jhesus—Honorevole amicho etc. Ebi tua let-
tera a di XIIII d'Aprile la quale vidi come di
charo e fedele amicho oltre accio di tuo star
bene[:] la qual chosa . . . grolia. Anchora del
tuo buono animo in verso di me, el quale ai
auto sempre[:] cioe, se bisogno fosse tu m'aiu-
tassi nettare una di queste storie[;] di[ci] che
lo faresti volentieri[:] la qual cosa so che non
nasce se non per buono amore, del quale Idio
ti benifichi per me. Sappi caro amicho le storie
sono presso a finite[:] l'una a ne' le mani
Giuliano di ser Andrea, l'altra o io[:] e al
tempo ch' i' o promesso a messer Bartolomeo
saranno finite[:] et sarebono state finite e gia
gran tempo se non la 'ngratitudine di quelli
che pel pasato sono stati miei conpagni da'
quali non o ricevuto solo una ingiuria ma
molte. Colla gratia di Dio io sono fuori delle
loro mani[:] el quale io lodo senpre Dio, con-
siderato in quanta liberta a me pare esser
rimaso.
Al tutto sanza compagnia dilibero stare e vo-
lere essere el maestro della bottega mia e pot-
tere ricettare ongni mio amico con buona e
lieta cera. Ringratioti della tua buona e per-
fetta volonta in verso di me. Prieghoti charis-
simamente mi raccomandi a messer Bartolo-
meo.
Ancho ti priegho charissimamente se modo

151 Unpublished. Summary, Bacci, bibl. 31, p. 186.
152 Unpublished. Summary, Bacci, bibl. 31, p. 185.
See also Doc. 41.
153 Unpublished. Summary, Bacci, bibl. 31, pp. 185f.

154 Unpublished. Summary, Bacci, bibl. 31, pp. 185f.
155 Unpublished. Summary, Bacci, bibl. 31, pp. 185f.
156 Milanesi, bibl. 336, II, pp. 119f, doc. 85, I; Lusini,
bibl. 283, p. 99, doc. 5; Bacci, bibl. 31, p. 58.

veruno ti puoi adoperare ch' io riabi le charte delli ucielli ch' io prestai a Ghoro.[a] So che non ti sara faticha pregare Domenicho[b] che intagla di legname, che me le rimandi pero ch' io sento quelli et ogni altra chosa che era nelle mani del detto Ghoro è rimaso nelle mani di maestro Domenicho. E anchora mi saluta lui da mia parte et maestro Francesco di Valdambrina[;] e se per me si puo fare qua alcuna chosa, son senpre a picieri [sic] tuoi. Altro non ci e a dire. Christo ti conservi in pace. Fatta a di XVI d'Aprile 1425.
Per lo tuo Lorenzo di Bartolo, orafo in Firenze amicho tuo caro.

Prudente et honorevole huomo
Giovanni Turini orafo in Siena data.[157]

DOC. 156, 1425, June 26, SIENA FONT, Dig. 118

ibidem, no. 54. Honorevole maggior mio etc. E suto a me per vostra parte Giovanni di Turino ami [ha mi] detto come v'e suto scritto come in su el vostro lavorio non si lavora. Di questo non vo' che ne faccia relatione se non Giovanni. Sapiate, quella storia venne chosta è quasi finita[;] l'altra vi mando chome mi mandate a chiedere per Giovanni. E subito sara fatta perche io vi lavoro su. Quanto piu tosto potete me la rimandate E mandatemi a dire se volete si dorino chosta o qui; perche a me sarebe molto piu chomodo a doralle qui per le chose che a simile matera bisogna ci sono in punto spetialmente a queste e così grandi. Non dimeno mi contento di quello chon voi. Altro non c'è a dire. Christo vi conservi in pace. Fatta adi XXVI di giugno 1425.

Per lo vostro Lorenzo di Bartolo orafo in Firenze
Egregio kavaliere messer Bartolomeo operaio del Duomo di Siena.[158]

DOC. 157, 1425, Aug. 2, SIENA FONT, Dig. 121

ibidem (present no. 55; formerly no. 56)
Honorevole magior mio etc. La chagione di questa si è[:] come voi sapete e fu qua per vostra parte Giovanni Turini e chiesemi come voi vi contentavi ch' io mandassi chosta la storia del Battesimo[:] prieghovi che me la rimandiate accioch' io le possa dar fine pero ch' io o finita ogimai l'altra e ancora sono solecitato dalla ghabella[;] pero ch' io promisi a' maestri della ghabella di rimeterlla qui in

tre settimane. E pasato el termine ch' io promisi loro[;] se non viene tosto, saro stretto a paghare la gabella. Penso come sara finita questa mandarvela[:] e rispondetemi al fatto del dorarle, se vi contentate si dorino costa o volete si dorino qua. Di questo ne seghuiro el volere vostro. Altro non c'e a dire. Christo vi conservi in pace. Fatta adi II d'Aghosto 1425.

Per lo vostro Lorenzo di Bartolo orafo in Firenze.
Magnifico ed egregio kavaliere mesere Bartolomeo venerabile operaio del Duomo di Siena.[159]

DOC. 158, 1427 [after March 17], SIENA FONT, Dig. 131

ibidem: (unnumbered at present; formerly no. 53)
Honorevole magiore. Adi 17 di Marzo o ricevute le storie, m' avete mandate per Michele da Santo Donato[;] et chon esse una vostra lettera dove domandate è bene si levi la ghabella e l'obrigho fatto per voi da Lucha di Piero Rinieri.
Io sono stato alla ghabella, et vegio che per fretta non v' esendo gli uficiagli si presono dal proveditore, che tornando e non tornando si dovesse paghar la ghabella ma meno tornando che no[:] chome de' sapere il vostro camarlingho. Della quale 'npromessa o patto mi sono diliberato d'essere all'uficio e preghargli che la cancellino. Et penso per ongni rispetto la leveranno via. Et se non valesse alla prima, tornarvi tante volte che lo faccino[:] et pero penso che si raunino oggi. Sara la risposta come potro presto.

Aparechiato senpre avostri piacieri.
Lorenzo di Bartolo orafo in Firenze.
Nobili viro messer Bartolomeo di Giovanni oparaio dell'Opera di Siena.[160]

DOC. 159, 1427 [April 11-20], SIENA FONT, Dig. 133

ibidem (at present no. 64; formerly no. 56)
E suto qua Antonio di Jachomo vostro chamarlingo el quale a veduto come l' una delle storie et (sic) conpiuta[:] l'altra sara finita a Pasqua come per Giuliano vi fu promesso. Bisognaci l'oro per dorarle[:] che in su amendue le storie andra d'oro circha di fior. ottanta o piu. Mandate siamo serviti di fior. cento. Sono senpre aparechiato a vostri piacieri. Christo vi conservi in pace.

157 Milanesi, bibl. 336, II, pp. 119f, doc. 85, II; Lusini, bibl. 283, pp. 99f, doc. 6; Bacci, bibl. 31, pp. 159f. Milanesi, *loc. cit.*: (a) di Neroccio; (b) di Niccolo.
158 Milanesi, bibl. 336, II. p. 121, doc. 85, III; not in Lusini; Bacci, bibl. 31, p. 160.

159 Milanesi, bibl. 336, II, pp. 121f, doc. 85, IV; Lusini, bibl. 283, pp. 100f, doc. 7.
160 Milanesi, bibl. 336, II, p. 122, doc. 85, V, dated March 1425-1426 (?); Lusini, bibl. 283, pp. 101f, doc. 9, dated March 1426.

Per lo vostro Lorenzo di Bartolo orafo in Firenze.

El magnifico et prudente khavaliere messer Bartolomeo operaio del Duomo di Siena.[161]

DOC. 160, 1427, May 12, SIENA FONT, Dig. 135

ibidem (unnumbered at present; formerly no. 57)

Karissimo magiore mio. Le vostre storie son finite e in questa mattina a di XII di Magio cominciamo a dorare la storia del Battesimo[:] l'altra e finita non manca se none el dorarlla. Mandateci l'oro. Potremo mandarle amendue insieme. Non dimeno seghuiremo la vostra volonta di quello che volete si faccia. Altro altro [sic] non c'e a dire. Christo vi conservi in pace.

Per lo vostro Lorenzo di Bartolo orafo in Firenze

El egregio kavaliere messere Bartolomeo operaio del Duomo di Siena.[162]

DOC. 161, 1427, May 31, SIENA FONT, Dig. 137

ibidem, no. 58.

Ricevetti vostra lettera a di ventotto di magio nella quale mi scrivete avere ricevute due mie lettere el tenor d'esse[:] come le vostre istorie sono finite e n'e dorata una. Mandavi a chiedere l'oro per dorarlle amendue[;] mandasti per una. Essa e dorata[:] mandate altrettanto d'oro e doreremo l'altra pero che da me io non o el modo[:] sello avessi la dorerei. O achattato da Antonio di Jachopo Pieri nostro banchiere per mie niscista [sic] e fare finire il vostro lavorio a lato a dugiento fior. e convimi [sic] el resto ch'io resto avere da voi darllo allui. Pertanto mandate qua el vostro chamarlingo in modo ch'io possa dorare la vostra istoria e contentare el detto Antonio che m'a servito. Chi vera (verra) in un dì ne potra mandare le vostre storie pero che in un dì sara dorata. Altro [non] ci è a dire. Christo vi conservi in pace. Fatta a di XXXI di Maggio 1427.

Per lo vostro Lorenzo di Bartolo orafo in Firenze

Etgregio (sic) kavaliere messer Bartolomeo Giovanni honorevole operaio in Siena.[163]

DOC. 162, 1427, October, SIENA FONT, Dig. 142

ibidem (unnumbered at present; formerly no. 59)

Honorevole magior mio etc. La chagione di questa si è[:] per vostra lettera e stato fatto chomessione [a] Antonio di Jacopo Pieri nostro banchiere mi siano dati fior. 25 per dorare l'altra storia. E dorata e son finite. Mandate per esse a ogni vostro piacere. Si veramente fate contento della cantita [sic] ch'io resto avere Antonio di Jacopo Pieri nostro banchiere. E per chagione non si perdano troppe parole ponete mente in su el Memoriale di messer Chaterino segnato +[:] e lungo el detto quaderno. Ancora domandate e' detto [sic] operai che in quello tenpo erano, e ragionamenti avemo. In la verita fu questa che messer Chaterino mi volle dare dell' una delle dette storie fior. 220[;] a questo non fui mai contento[;] volevo d' esse fior. 240. Esso mi promisse ch'io le faciessi e che mi contenterebe. Ancor tolsi a far colle dette storie figure quatro[:] d'esse non si fece merchato[:] se vi contentate io le faccia, farolle volentieri in brieve tenpo. Altro non ci e a dire. Christo vi conservi in pacie.

Per lo vostro Lorenzo di Bartolo orafo in Firenze

Etgregio (sic) kavaliere messere Bartolomeo honorevole operaio del Duomo di Siena.[164]

DOC. 163, 1414, Dec. 1, SAINT JOHN, Dig. 36

Lost document, in 1681 in the possession of Cristofano Berardi, lawyer of the Collegio de' Nobili.

Giornale di Lorenzo di Cione di ser Buonaccorso di Firenze orafo nel quale iscrivero ogni mia faccenda di giorno in giorno e così in su esso faro ricordo d'ogni mia cosa cominciando a di primo di maggio 1403. Segnato A

A dì primo di dicembre 1414.

Qui appresso farò ricordo di ciò che io spenderò in gettare la figura di S. Gio. Battista. Tolsi a gettarla alle mie spese; se essa non venisse bene io mi dovessi perder le spese: io la gettassi, e venisse bene, mi rimasi nell'arte di calimala, che i consoli e gli operai, che in quel tempo fussono, usassono inverso di me quella discrezione, che essi usassono in' d'un altro maestro, per cui essi mandavano, che la gettassono. A di' d. comincerò a far ricordo di tutte le spese si faranno nel getto.[165]

[161] Milanesi, bibl. 336, II, p. 123, doc. 85, VI dates the letter 1426; Lusini, bibl. 283, p. 101, doc. 8, 1425; Bacci, bibl. 31, p. 167, note, with correct date.

[162] Milanesi, bibl. 336, II, p. 123, doc. 85, VII; Lusini, bibl. 283, p. 102, doc. 10.

[163] Milanesi, bibl. 336, pp. 123f, doc. 85, VIII; Lusini,

bibl. 283, p. 102, doc. 11.

[164] Milanesi, bibl. 336, pp. 124f, doc. 85, IX, with date 1427 (?); Lusini, bibl. 283, p. 104, doc. 13; Bacci, bibl. 31, p. 182.

[165] Quoted after Baldinucci, bibl. 35, I, pp. 254f.

1. 1378-1381. Docs. 81-86. Date of Ghiberti's birth (Tax declarations 1427-1442)

2. 1400-1401. Ghiberti at Pesaro (Ghiberti-Schlosser, bibl. 178, I, p. 45)

3. 1401-1402. Ghiberti participates in the competition for a bronze door to be set up at the Baptistery in Florence (Ghiberti-Schlosser, bibl. 178, I, p. 46)

4. 1402. Doc. 1. The consuls of the *Calimala* decide to entrust the bronze door of the Baptistery to Ghiberti, "Nencio di Bartoluccio Orafo."
ASF, Strozz. LI, 1, f. 2 from: *Libro Grande Calimala C, 1402*, c. 255 (Frey, bibl. 532, p. 353, doc. 2, with date 1403)

5. 1402. Doc. 80. Payment by the *Arte di Calimala* of 30 florins to Ghiberti, "Nencio di Bartoluccio," possibly for work on the competition relief.
ASF, Strozz. LI, 3, f. 153 (index) from: *Libro Grande Calimala C, 1402*, c. 270

6. no date, possibly 1402-1403. Doc. 33. Ghiberti's competition relief is gilded. Later it is decided to represent on the new door the New Testament and to save this relief for the other door "if there the Old Testament should be represented."
ASF, Strozz. LI, 1, f. 80v from: *Libro seconda e terza porta* (Frey, bibl. 532, pp. 356f, doc. 8, erroneously, June 5, 1407; for the correct date see above, p. 103)

7. 1403, Sept. 3. Doc. 60. The consuls of the *Calimala* decide to place the new bronze door at the main portal of the Baptistery facing the Cathedral.
ASF, Strozz. LI, 1, f. 184 from: *Delib. Cons. Calimala, 1401-1414*, c. 35

8. 1403, Nov. 23. Docs. 26, 61. Contract of the *Calimala* with "Lorenzo di Bartolo and Bartolo di Michele, his father, . . . for the second door of S. Giovanni"; they are to invest only their labor, all the rest is the business of the guild; they must finish three reliefs each year, beginning December 1; and they are granted up to 200 florins annually on account. A committee of the guild is elected to supervise the work.

ASF, Strozz. LI, 1, f. 79 from: *Libro seconda e terza porta*; cp. *ibid.*, f. 184 from: *Delib. Cons. Calimala, 1401-1414*, c. 38

9. 1403 (after Nov. 23). Doc. 80. Payment of 100 florins from the *Calimala* to Ghiberti.
ASF, Strozz. LI, 3, f. 153 (index) from: *Libro Grande Calimala D, 1403*, c. 128

10. 1404, Jan. 30. Doc. 65. The *Officiali del Musaico* of the *Calimala* make (final) arrangements with Ghiberti for work on the door.
ASF, Strozz. LI, 1, f. 185v from: *Delib. Off. Musaico*, c. 113

11. early 1404. Doc. 80. The *Calimala* pays small expenses for work on the bronze door, amounting to roughly 25 florins.
ASF, Strozz. LI, 3, f. 153 (index) from: *Libro Grande Calimala D, 1403*, c. 183

12. 1404, Nov. 10. Ghiberti acts as member of a committee of consultants to give an opinion on buttressing and windows for main apse of the Cathedral.
AOF, Delib. XLIX, c. 26 (Guasti, bibl. 199, doc. 425)

13. 1404, prior to Dec. Ghiberti designs window of the *Assumption of the Virgin* for the center oculus on the façade of the Cathedral (Ghiberti-Schlosser, bibl. 178, I, p. 51)

14. 1404, Dec. 10-1405, June 30. Working (?) design and execution of this window by Niccolo Pieri, without Ghiberti's name being mentioned.
AOF, Delib. XLIX, c. 31, 35v, 36; *L*, c. 19ff (Poggi, bibl. 413, docs. 516-521; Paatz, bibl. 375, III, p. 497, note 244)

15. 1405, after Aug. 31; before Feb. 11, 1406. Doc. 62. Ghiberti works on the bronze door for the Baptistery. His assistants are listed.
ASF, Strozz. LI, 1, f. 184v from: *Delib. Cons. Calimala, 1401-1414*, c. 65

16. 1405. Doc. 80. Deliberations of the *Calimala* regarding their pilaster at Or San Michele.
ASF, Strozz. LI, 3, f. 153 (index) from: *Libro Grande Calimala F, 1405*, c. 97

17. 1405. Doc. 2. Giuliano di Ser Andrea is mentioned as assistant (*discepolo*) to Ghiberti, evidently on the door of the Baptistery.

ASF, Strozz. LI, 1, f. 3 from: *Libro Grande Calimala F, 1405,* c. 171

18. 1406, Jan. 12. Small payment from *Opera del Duomo.*

AOF, scaffale LXXXVI, Quinterno di Cassa a di primo di Gennaio 1405, f. 3 (lost, quoted after Rumohr, bibl. 454, p. 444)

19. 1406, Feb. 16. Ghiberti and others are discharged as consultants of the *Opera del Duomo.*

AOF, Delib. LI, c. 6v (Guasti, bibl. 199, doc. 434)

20. 1406. Death of Cione di ser Buonaccorso (see Doc. 120)

21. 1407, Mar. 14. Ghiberti has to refund 3 florins received for advice and salary as consultant for a window in the main apse of the Cathedral.

AOF, Delib. LIII, c. 5 (Guasti, bibl. 199, doc. 438)

22. 1407, June 1. Doc. 27. A new contract is signed for work on the door of the Baptistery with "Lorenzo di Bartoluccio alone . . . ," made necessary because he failed to observe the stipulations of the first contract. Precise regulations of working conditions: he is not allowed to take on any other work without the permission of the consuls of the *Calimala,* and after completion of the door he has to wait one year in case the guild wants to entrust any other work to him. He is to be paid 200 florins annually for his labor. "He must work with his own hand every working day like any journeyman and in case of idleness this is to be noted down in a ledger kept for that purpose. He has to work in wax and bronze, in particular those parts which require greatest perfection, such as hair, nudes, and the like." He is to hire the workmen, but their salary is fixed by the consuls. All materials and tools are to be furnished by the *Calimala.* (For list of collaborators see Dig. 41 and Doc. 31)

ASF, Strozz. LI, 1, f. 79, 79v from: *Libro seconda e terza porta* (Frey, bibl. 532, pp. 354ff, doc. 71 with date June 5)

23. 1407, on or before June 3. Doc. 63. Decision of the consuls of the *Calimala* to decorate their pilaster at Or San Michele and to appoint a committee *ad hoc.*

ASF, Strozz. LI, 1, f. 185 from: *Delib. Cons. Calimala, 1401-1414* c. 77

24. 1404-1407. Doc. 28. Strozzi's summary referring to wages paid to Ghiberti and his collaborators for work on the door "throughout the time of the first contract" amounting to 882 florins, 260 lire, 66 denari, totaling over 950 florins; his credit is still 200 florins. His assistants during this period are listed, numbering eleven, among them Giuliano di Ser Andrea and Donatello.

ASF, Strozz. LI, 1, f. 79f from: *Libro seconda e terza porta* (Frey, bibl. 532, pp. 354ff, doc. 7 with erroneous date June 5, 1407)

25. 1408, Jan. 7. Ghiberti and six assistants are permitted to be on the street at night (Baldinucci, bibl. 36, 1, p. 372, from: *Libro di Ser Nofri di Ser Paolo Nemi;* lost)

26. 1408, after Dec. 24; before May 2, 1409. Doc. 64. Reference to a list of workmen employed on the door of the Baptistery.

ASF, Strozz. LI, 1, f. 185v from: *Delib. Cons. Calimala, 1401-1414,* c. 95

27. 1408, after Dec. 24; before May 2, 1409. Doc. 64. Free hours of workmen regulated.

ASF, Strozz. LI, 1, f. 185v from: *Delib. Cons. Calimala, 1401-1414,* c. 109

28. 1409, Aug. 3. Doc. 115. Ghiberti matriculated in the goldsmiths' guild.

ASF, Arti, Seta, vol. 7, matricola, 1328-1433, c. 115v

29. 1412 (?). Ghiberti designs two oculi for the façade of the aisles of the Cathedral (Ghiberti-Schlosser, bibl. 178, 1, p. 51); execution by Nicolo di Piero, 1412-1415, without Ghiberti's name appearing in the documents.

AOF, Delib. LXIV, c. 37; *LXV,* c. 13; *LXVI,* c. 12v, 13v, 17v; *LXVII,* c. 3, 5; *Stanz. QQ,* c. 66, 84v, 91, 93v, 96 (Poggi, bibl. 413, docs. 522-531)

30. 1413, April 5. Ghiberti reaches an agreement concerning the contested inheritance of Cione di Ser Buonaccorso (Baldinucci, bibl. 35, 1, p. 360, and note 1 from: lost document of notary ser Pietro di ser Michele Guiducci).

31. 1413. Doc. 54. Work is under way on a figure for the pilaster of the *Calimala* at Or San Michele.

ASF, Strozz. LI, 1, f. 93 from: *Uscità Calimala, 1413,* c. 5

32. 1414, Aug. 7. Doc. 125. Work is under way on the niche of *Saint John* at Or San Michele.

BNF, Magl. Cl. IX, 127, f. 187 from unmentioned document, probably *Libro Grande Calimala P, 1414,* c. 236

33. 1414. Doc. 3. Payments to Giuliano di Arrigo Pesello and partners for work on tabernacle of *Saint John* at Or San Michele.

ASF, Strozz. LI, 1, f. 5 from: *Libro Grande Calimala P, 1414*, c. 236

34. 1414. Doc. 4. Payments to Frate Bernardo di Stefano for mosaic he is to execute for niche at Or San Michele.
ASF, Strozz. LI, 1, f. 5 from: *Libro Grande Calimala P, 1414*, c. 236

35. 1414. Doc. 5. Material for mosaic of niche at Or San Michele bought from *Operai* of the cathedral of Pisa.
ASF, Strozz. LI, 1, f. 5 from: *Libro Grande Calimala P, 1414*, c. 236

36. 1414, Dec. 1. Doc. 163. Ghiberti begins casting the *Saint John* for Or San Michele. (Baldinucci, bibl. 35, I, p. 354, from a lost *Giornale di Lorenzo di Cione di Ser Buonaccorso orafo . . . cominciando a dì primo di Maggio 1403, segnato A*)

37. 1414. Doc. 3. Reference to painting (*sic*) done for the niche of *Saint John* at Or San Michele.
ASF, Strozz. LI, 1, f. 5 from: *Libro Grande Calimala P, 1414*, c. 417, 423

38. 1414-1415. Doc. 80. Numerous entries referring to the statue or niche of *Saint John* at Or San Michele.
ASF, Strozz. LI, 3, c. 153 (index) from: *Libro Grande Calimala P, 1414; Q+, 1415, passim*

39. 1404-1415. Doc. 29. Account for 5564 pounds of bronze purchased for the work on Ghiberti's first door of the Baptistery.
ASF, Strozz. LI, 1, f. 79v from: *Libro seconda e terza porta* (Frey, bibl. 532, pp. 354ff, doc. 7, with erroneous date June 5, 1407)

40. no date, 1404-1415 (?). Doc. 66. Reference to Ghiberti's workmen on the door of the Baptistery.
ASF, Strozz. LI, 1, f. 185v from: *Delib. Off. Musaico*, c. 114-123

41. after 1407, presumably before 1415. Doc. 31. Wage accounts for Ghiberti's assistants on his first door after 1407 and presumably before 1415, among them Giuliano di Ser Andrea, Bartolo di Michele, Donatello, Ciuffagni and Uccello.
ASF, Strozz. LI, 1, f. 80 from: *Libro seconda e terza porta* (Frey, bibl. 532, pp. 354ff, doc. 7, with erroneous date June 5, 1407)

42. 1415. Doc. 55. Albizzo di Piero is paid for work on the tabernacle for *Saint John* at Or San Michele.
ASF, Strozz. LI, 1, f. 101 from: *Uscità S. Giovanni, 1415*, c. 12

43. 1416, May. The stone work of the Baptismal Font in Siena, including steps, niches, etc., is commissioned from three stone masons, among them Giacomo di Corso detto Papi di Firenze.
ODS, (Libro doc. art., 37) (Milanesi, bibl. 336, II, pp. 74ff, doc. 48; Lusini, bibl. 283, pp. 93ff, doc. 1; Bacci, bibl. 31, pp. 92ff)

44. 1416, June 28-July 17. Docs. 131, 134. Expense account for visit to Siena, made by Ghiberti, Giuliano (di Ser Andrea[?]) and Bartolomeo (di Michele[?]) for consultation regarding the "building of the Baptismal Font."
ODS, Memoriale di Domenico Mariano, 1416, c. 5v and *ibid., Entr. Usc. di Domenico di Mariano 1416*, c. 52v

45. 1416, Dec. 18. Doc. 135. Giovanni Turini is sent by the *Opera del Duomo* in Siena to Florence to see Ghiberti regarding the Baptismal Font.
ODS, Libro di Spese di Doccio di Jacopo fattore, 1416, c. 10

46. 1416. Doc. 6. Frate Bernardo di Stefano works on the mosaic for the niche of *Saint John* at Or San Michele.
ASF, Strozz. LI, 1, f. 5v from: *Libro Grande Calimala Q, 1416, n.c.*

47. 1416. Doc. 47. Giuliano di Arrigo Pesello works on the mosaic frieze in the niche of *Saint John* at Or San Michele.
ASF, Strozz. LI, 1, f. 5v from: *Libro Grande Calimala Q, 1416, n.c.*

48. 1416. Doc. 53. Work on the niche of *Saint John* at Or San Michele under way; Bernardo di Stefano is paid for mosaic work. *Saint John* is set up (see, however, Dig. 56).
ASF, Strozz. LI, 1, f. 91 from: *Uscità Calimala, 1416*, c. 7; *LI, 2*, c. 115v (Frey, bibl. 532, pp. 380f, doc. 16, quoted from *LI, 2*, but with erroneous date 1412; also *ibidem*, doc. 25, last part only, with correct date 1416)

49. 1417, Jan. 1. Doc. 136. Expenses paid for a second trip of Ghiberti's to Siena regarding the Baptismal Font.
ODS, Libro di Spese di Doccio di Jacopo fattore, 1416, c. 10v

50. 1417, prior to Mar. 3. Doc. 132. Shipment of a bronze relief of Ghiberti's to Siena and back to Florence as sample for work on the Baptismal Font.
ODS, Memoriale di Domenico di Mariano, 1416-1417, c. 16v

51. 1417, Mar. 11. Doc. 133. Domenico di Mariano discusses the Siena Font in Florence.
ODS, Memoriale di Domenico di Mariano, c. 16v

52. 1417, Apr. 16. Quercia and the Turini firm, father and son, are commissioned to execute, from drawings furnished them, two reliefs each for the Baptismal Font in Siena.
ODS, (Libro doc. art., 39) (Milanesi, bibl. 336, II, pp. 86f, doc. 58; Lusini, bibl. 283, pp. 95f, doc. 2; Bacci, bibl. 31, p. 108)

53. 1417, May 20. Doc. 137. Expenses are paid for Ghiberti "who had come to Siena to take on *(tolare)* the bronze *figures* [sic] of the Font."
ODS, Libro di Spese di Doccio di Jacopo fattore, 1416, c. 15v

54. 1417, May 21. Doc. 130. Contract commissioning Ghiberti to execute for the Baptismal Font in Siena two of the six bronze reliefs "with the figures and in the form" handed to him, to be delivered within ten and twenty months respectively. He has to present the reliefs for inspection before and after gilding (fire gilding). He has to furnish the bronze and the price is to be established upon delivery (see Dig. 42). He is conceded an option to execute six figures for the font after delivering the first relief. He is granted an advance of 100 florins.
ODS, Pergamena, no. 1437

55. 1417, July 9. Doc. 138. Ghiberti receives 200 lire as an advance for work on the Siena Font.
ODS, Memoriale di Antonio di Cristofano, 1417, c. 6v

56. 1417, Nov. 28. Doc. 56. Payment of 5 florins to Ghiberti for gilding the *Saint John* at Or San Michele.
ASF, Strozz. LI, I, f. 101 from: *Uscità S. Giovanni 1417,* c. 20 (Frey, bibl. 532, p. 381, doc. 261 without month and day)

57. 1413-1417. Doc. 129. Cost (Ghiberti's fee?) for the *Saint John* at Or San Michele given as 530 florins.
Florence, Uffizi, Archivio, Misc. vol. 1, no. 4

58. about 1417. Docs. 81-84. Tommaso Ghiberti born.
Tax declarations 1427-1442

59. 1418, July 30 and Aug. 6. Docs. 118, 119. Guariente di Giovanni Guariento is commissioned to execute two silver candlesticks for Or San Michele after Ghiberti's design.
ASF, Or San Michele, vol. 25, Libro delli Atti . . . (dei) Capitani di Or San Michele,
March 3, 1416-May 31, 1419, c. 44v (referred to by Milanesi-Vasari, bibl. 533, II, p. 259 with erroneous date)

60. 1418, Aug. 19. A competition is opened for submitting models for the dome of the Cathedral.
AOF, Delib. LXXV, c. 9v (Guasti, bibl. 198, doc. 11)

61. 1418, Sept. 23. Ghiberti has four workmen assigned to help him in making a model for the dome of the Cathedral.
AOF, Delib. LXXV, c. 20 (Guasti, bibl. 198, doc. 29)

62. 1418, Dec. 13. The models for the dome of the Cathedral are submitted.
AOF, Delib. LXXV, c. 31; also *Stanz. RR,* c. 36 (Guasti, bibl. 198, docs. 14, 15)

63. about 1418. Docs. 81-84. Vittorio Ghiberti is born. Tax declarations of 1427-1442 (the birthdate is given erroneously as 1415 by Schlosser, bibl. 178, II, p. 54)

64. 1419, Feb. 26-1420, Sept. 8. Pope Martin V stays in Florence; Ghiberti designs a miter and morse for him (Ghiberti-Schlosser, bibl. 178, I, p. 47; Bartolomeo del Corazza, bibl. 105, pp. 256ff, 271f)

65. 1419, May 20. Docs. 127, 128. Ghiberti's design of a staircase for the papal apartment in the convent of S. Maria Novella is accepted by the *Opera di S. Maria del Fiore.*
ODF, Delib. LXXVI, c. 29
Other drawings by Giuliano d'Arrigo Pesello (*ASF, Strozz. Repertorio . . . laiche XX, 49*) and Pippo di Giovanni, who builds the staircase beginning Aug. 2, 1419 (*ODF, Delib. LXXVII,* c. 7, 8v, 11, 11v; Poggi, bibl. 409)

66. 1419, June 19. The consuls of the *Arte del Cambio* decide to set up on the pilaster at Or San Michele, assigned to them, a bronze statue of Saint Matthew and elect a committee of four *Operai,* among them Cosimo de' Medici, to implement the decision.
ASF, Arti, Cambio, vol. 18, Libro del Pilastro, c. 4ff (Doren, bibl. 133, pp. 20ff); cf. also *BNF, Magl. II, IV, 378 (=Cl. XXV, 259), p. 436*

67. 1419, June 22. The *Signoria* formally confirms the cession by the bakers' guild of their pilaster at Or San Michele to the *Arte del Cambio.*
ASF, Arti, Cambio, vol. 18, Libro del Pilastro, c. 5v ff (Doren, bibl. 133, pp. 23ff)

68. 1419, July 8-July 28. Ghiberti on August 26 receives several small payments for prepara-

tory work done from July 8 through July 28 for the form of the *Saint Matthew*, including the digging and facing of the foundry ditch, the erection of scaffolding and armature, and the purchasing of clay.

ASF, Arti, Cambio, vol. 18, Libro del Pilastro, c. 11ff (Doren, bibl. 133, pp. 30f)

69. 1419, July 21. The Consuls of the *Arte del Cambio* and the *Operai* decide to commission the *Saint Matthew* and the niche from Ghiberti.

ASF, Arti, Cambio, vol. 18, Libro del Pilastro, c. 7f (Doren, bibl. 133, pp. 25f)

70. 1419, Aug. 11. Ghiberti receives a payment from the *Opera del Duomo* for materials and help employed in preparing models of the dome of the Cathedral, one of them "in small bricks."

AOF, Delib. LXXVII, c. 47v and *Stanz. RR*, c. 54v (Guasti, bibl. 198, doc. 30; similarly [Manetti], bibl. 294, under August 15, 1419)

71. 1419, Aug. 26. Contract of the *Arte del Cambio* with Ghiberti for the *Saint Matthew* at Or San Michele. It is agreed upon that the statue is to be at least as large in size as the *Saint John*, to consist of one or two pieces (body and head) and to weigh not more than 2,000 pounds, to be gilded wholly or in part. The statue is to be completed in three years beginning July 21 by Ghiberti himself, with the assistance of masters good and true. His pay and that of his assistants is left to the good graces of the committee and not to be based on the annual advance received for the *Saint John* or any other work. The guild is to defray expenses for materials and to make advances at their discretion.

ASF, Arti, Cambio, vol. 18, Libro del Pilastro, c. 7v ff, 11f (Doren, bibl. 133, pp. 26ff, 30f)

72. 1419, Oct. 3. Payment of 300 lire to Ghiberti and assistants, among them a carpenter Bartolomeo, for work on models for the dome of the Cathedral.

(Manetti), bibl, 294, p. 44 from: *Libro [di uscità] di Migliore di Tommaso*; the amount of 300 florins is certainly erroneous.

73. 1419, Aug. 26-1420, Dec. 5. Ghiberti on Jan. 29, 1421 (see below, Dig. 83) receives payment for purchases of 362 pounds of wax, clay, copper, and charcoal, made between Aug. 26, 1419, and Dec. 5, 1420, for the *Saint Matthew*.

ASF, Arti, Cambio, vol. 18, Libro del Pilastro, c. 13f (Doren, bibl. 133, pp. 32ff; see also Gaye, bibl. 174, I, p. 108, note **)

73a. 1420, Jan. 4. Ghiberti and Cola di Niccola Spinelli are among the supervisors for the execution of the woodwork in the Strozzi Chapel in S. Trinità.

ASF, Carte Strozzi-Uguccioni (Milanesi, bibl. 357, pp. 75ff; Poggi, bibl. 395, pp. 16f)

74. 1420, Mar. 27-Apr. 3. Final competition (?) opened for the dome of the Cathedral between Ghiberti and Brunelleschi only (?).

AOF, Delib. LXXVIII, c. 29v, 31 (Guasti, bibl. 198, docs. 44, 45)

75. 1420, Mar. 8-Apr. 22. Minor payments to Ghiberti and assistants for the (new?) model for the dome of the Cathedral.

AOF, Stanz. RR, c. 79v (Guasti, bibl. 198, doc. 50)

76. 1420, Apr. 16. Brunelleschi, Ghiberti, and Battista d'Antonio are appointed supervisors for the construction of the dome of the Cathedral at 3 florins each monthly, with Giuliano d'Arrigo Pesello and Giovanni di Gherardo da Prato as substitutes.

AOF, Delib. LXXVIII, c. 34f (Guasti, bibl. 198, doc. 71); cp. also *ASF, Arti, Lana, Partite 148*, c. 61 (Doren, "Zum Bau der Florentiner Domkuppel," *Repertorium fuer Kunstwissenschaft*, XXI [1898], pp. 249ff; XXII [1899], pp. 220f)

77. 1420, April 24. Brunelleschi and Ghiberti are paid 10 florins each for working on a model for the dome and for advice given from Nov. 20, 1419.

AOF, Delib. LXXVIII, c. 66 and *Stanz. RR*, c. 77 (Guasti, bibl. 198, docs. 48, 49)

78. 1420, May 7. The *Arte del Cambio* authorizes the payment to Giovanni di Bicci de' Medici of 296 florins for 3000 pounds of bronze bought in Venice.

ASF, Arti, Cambio, vol. 18, Libro del Pilastro, c. 12 (Doren, bibl. 133, pp. 31f)

78a. 1420, Aug. 7. Ghiberti receives 600 florins (as a loan?) from the banking house of Palla di Nofri Strozzi to pay for the purchase of two farms from the *Capitani* of Or San Michele.

ASF, Carte Strozzi-Uguccioni, vol. 285 (*Libro d'Entr. e uscità dal 1420 al 1423*), c. 10v and 110v

79. 1420, Oct. 29. Salaries paid to both Ghiberti and Brunelleschi for four months and ten days work as supervisors of dome.

AOF, Stanz. RR, c. 90v, 91v (Guasti, bibl. 198, docs. 72, 73). See below Dig. 120.

80. 1420, Nov. 13. Doc. 139. Ghiberti has thus far received on account for work on the Siena Font 140 florins and 300 lire; the treasurer of the *Opera* in Siena goes to Florence to urge completion of the reliefs.

ODS, Libro deb. cred., 1420-1444, vol. 393, c. 3v

81. no date (*ca.* 1420). Doc. 34. Michelozzo assists Ghiberti for some time on his first door for the Baptistery at 75 florins a year.

ASF, Strozz. LI, 1, f. 80v from *Libro seconda e terza porta* (Frey, bibl. 532, p. 357, doc. 9, with erroneous date June 5, 1407 [?])

82. 1420. Dated inscription on the *Saint Matthew* at Or San Michele.

83. 1421, Jan. 29. Payment to Ghiberti for working expenses including cost of wax and clay (see also Dig. 73), plus an advance of 80 florins for work on the *Saint Matthew*.

ASF, Arti, Cambio, vol. 18, Libro del Pilastro, c. 15v ff (Doren, bibl. 133, pp. 35ff)

84. 1421, May 9. The *Arte del Cambio* authorizes the payment of 40 florins to Ghiberti as reimbursement for advances made in connection with building the casting furnace during the month of May for the *Saint Matthew*.

ASF, Arti, Cambio, vol. 18, Libro del Pilastro, c. 14 (Doren, bibl. 133, p. 34)

85. 1421, May 10-Aug. 23. Ghiberti, on Jan. 29, 1422, is reimbursed for numerous minor expenses paid between May 10 and Aug. 23, 1421, in connection with the armature, form, and casting of the *Saint Matthew*, among them payments to Michelozzo, Jacopo di Piero (Papero?) and "Pagolo" (Uccello?), an assistant of Michelozzo.

ASF, Arti, Cambio, vol. 18, Libro del Pilastro, c. 15v ff (Doren, bibl. 133, pp. 35ff)

86. 1421, July 16. The cast of the *Saint Matthew* has failed in part, and the *Arte del Cambio* decides, upon Ghiberti's suggestion, to have certain parts recast and to compensate Ghiberti for lost time by an advance of 30 florins.

ASF, Arti, Cambio, vol. 18, Libro del Pilastro, c. 14v (Doren, bibl. 133, pp. 34)

87. 1422, Jan. 30. The *Operai* accept the report of Cosimo Medici to the effect that the cast of the *Saint Matthew* is completed, and allot 200 florins for the cleaning, chasing, and setting up of the statue and the decoration of the niche. They propose to the consuls raising an additional 200 florins through a loan levied on the members of the guild, to be repaid in part by diverting income from a charity fund (see Doren, bibl. 133, pp. 39f, note 5).

ASF, Arti, Cambio, vol. 18, Libro del Pilastro, c. 17v ff (Doren, bibl. 133, pp. 38ff)

88. 1422, Feb. 13-Apr. 22. Listing of levies on members of the *Arte del Cambio* to raise 200 florins towards cost of the *Saint Matthew*.

ASF, Arti, Cambio, vol. 18, Libro del Pilastro, c. 19ff, 23f, 25f (see also Digs. 92, 95) (Doren, bibl. 133, pp. 41ff, 43f, 45)

89. 1422, Feb. 28-Apr. 22. Ghiberti is reimbursed for advances totaling 40 florins paid for the *Saint Matthew*.

ASF, Arti, Cambio, vol. 18, Libro del Pilastro, c. 24, 24v, 25, 26 (Doren, bibl. 133, pp. 44ff)

90. 1422, Apr. 22. The stonemasons Jacopo di Corso and Giovanni di Niccolo are paid 35 florins as reimbursement for work on the niche "where the statue of Saint Matthew is to be placed."

ASF, Arti, Cambio, vol. 18, Libro del Pilastro, c. 26 (Doren, bibl. 133, pp. 45f)

91. 1422, May 2. Contract with the stonemasons Jacopo di Corso and Giovanni di Niccolo to execute by August, after Ghiberti's design and specifications, the niche for the *Saint Matthew* at a price of 75 florins plus a block of marble.

ASF, Arti, Cambio, vol. 18, Libro del Pilastro, c. 27v ff (Doren, bibl. 133, pp. 46f)

92. 1422, May 9-13. Additional listings of levies for the *Saint Matthew* (see also Dig. 87)

ASF, Arti, Cambio, vol. 18, Libro del Pilastro, c. 26v f, 29v f, 30v f (Doren, bibl. 133, pp. 46, 48f)

93. 1422, May. The contract with the stonemasons (Dig. 91) is approved by the Consuls of the *Arte del Cambio*.

ASF, Arti, Cambio, vol. 18, Libro del Pilastro, c. 28v (Doren, bibl. 133, pp. 47f)

94. 1422, May 13. Advances of 15 florins to Ghiberti for work on the *Saint Matthew* and reimbursement of 17 florins for 200 pounds of tin purchased in July, 1421.

ASF, Arti, Cambio, vol. 18, Libro del Pilastro, c. 31 (Doren, bibl. 133, p. 49)

95. 1422, July 17. Additional listings of levy on members of the guild for the *Saint Matthew* as in Digs. 87 and 92.

ASF, Arti, Cambio, vol. 18, Libro del Pilastro, c. 31ff (Doren, bibl. 133, pp. 49f)

96. 1422, July 17. Discussion of a payment (though not effected) for the *Saint Matthew*.
ASF, Arti, Cambio, vol. 18, Libro del Pilastro, c. 33 (incomplete) (Doren, bibl. 133, p. 50)

97. 1422, Dec. 17. The consuls of the *Arte del Cambio* establish as Ghiberti's honorarium for the statue of Saint Matthew 650 florins, of which 338 have been advanced to him personally, on condition that he remake the base of the statue and fasten the figure to it.
ASF, Arti, Cambio, vol. 18, Libro del Pilastro, c. 33v f (Doren, bibl. 133, pp. 50f). See also Doc. 129.

98. 1422, Dec. 17-1423, Mar. 8. New levy is decided on and carried through by *Arte del Cambio* to pay debts for the *Saint Matthew*.
ASF, Arti, Cambio, vol. 18, Libro del Pilastro, c. 33v, 34, 34v, 35, 35v, 36ff, 37ff (Doren, bibl. 133, pp. 50f, 53ff)

99. 1423, Mar. 6. Final accounting for the *Saint Matthew*.
ASF, Arti, Cambio, vol. 18, Libro del Pilastro, c. 35 (Doren, bibl. 133, pp. 53f)

100. 1419-1422. Michelozzo, in his tax declaration of 1427, lists a claim of 13 florins against the *Arte del Cambio* for the *Saint Matthew* "when I was a partner" of Ghiberti.
ASF, Catasto, 1427, Quartiere S. Giovanni Gonf. Drago, vol. 54, c. 210 (Gaye, bibl. 173, I, p. 117)

101. 1423, Mar. 30. Doc. 92. The consuls of the *Calimala* decide to have Ghiberti's first door of the Baptistery gilded.
ASF, Arti, Calimala, vol. 17 bis, Petizioni e Deliberazioni 1422-1518, no pagination

102. 1423. Doc. 58. Architrave and jambs for Ghiberti's first door are executed according to his design.
ASF, Strozz. LI, 1, f. 118v from: *Filza seconda, Partiti e Deliberazioni dei Consoli 1425-1438*

103. 1423. Doc. 103. Ghiberti is matriculated with the *Compagnia dei Pittori*.
ASF, Arti, Accademia del Disegno, vol. I, Matricola della Compagnia de'Pittori di S. Luca, c. 11v

104. 1424, Apr. 4. Ghiberti designs two stained glass windows, *Expulsion of Joachim* and *Death of the Virgin*, to be executed for the first bay of the nave of the Cathedral by Fra Bernardino.
AOF, Delib. LXXXV, c. 12v (Poggi, bibl. 413, doc. 549)

105. 1424, Apr. 19. Docs. 32, 35. Ghiberti's first door is finished and set up at the east portal of the Baptistery opposite the Cathedral.
ASF, Strozz. LI, 1, f. 80v, from: *Libro seconda e terza porta* (two entries)

106. 1424, (June ?). Doc. 52. Leonardo Bruni submits to Niccolo da Uzzano a program for the third door of the Baptistery suggesting twenty Old Testament scenes and eight prophets.
ASF, Strozz. LI, 1, f. 82f with copy of Bruni's letter, from: *Libro seconda e terza porta* (Brockhaus, bibl. 69, p. 37; Frey, bibl. 532, pp. 357ff, doc. 3, erroneously dated 1425); for the correct date see letter of Ambrogio Traversari to Niccolo Niccoli, June 21, 1424, bibl. 526, II, cols. 371ff)

107. 1424, possibly May to Oct. Doc. 154. Ghiberti goes to Venice to escape epidemic in Florence (see Dig. 113)

108. 1404-1424 (?). Doc. 30. Expenses for the materials of Ghiberti's first Baptistery door are listed as 831 florins, 11 lire for bronze (evidently incomplete), 57 florins, 1344 lire, 4 denari for coal and wood; 1738 pounds of wax had been used and an additional 69 pounds given to the workmen for personal use.
ASF, Strozz. LI, 1, f. 79v from: *Libro seconda e terza porta* (Frey, bibl. 532, pp. 354ff, doc. 7, with date June 5, 1407)

109. 1404-1424. Doc. 121. Cost of labor, bronze and all other expenses for Ghiberti's first door given as 16,204 florins, 1 lire, 2 soldi.
BMF, Coll. Gori, A, 199 I, f. 33v after: *C. Strozzi, Descrizione dell' . . . S. Giovanni*

110. 1425, Jan. 2. Doc. 36. Contract of the *Calimala* with Ghiberti giving him commission for the third door of the Baptistery. He is to receive on account 200 florins a year. Michelozzo is to be paid 100 florins.
ASF, Strozz. LI, 1, f. 81 from: *Libro seconda e terza porta*

111. 1425, Jan. 12-29. Controversy between Ghiberti and Fra Bernardino regarding the design of the two windows for the dome [sic] of the Cathedral.
AOF, Delib. LXXXVII, c. 1v, 3v (Poggi, bibl. 413, docs. 551, 552, with correct reference to windows of nave)

112. 1425, prior to Mar. 10. Doc. 142. The *Operaio* and counselors of Siena cathedral decide to ask for reimbursement of advances made to the Florentine masters who had been commissioned to make the reliefs for the Bap-

tismal Font and who have not kept a single deadline.

ODS, Memoriale di Messer Bartolomeo operaio, 1423-1427, c. 7

113. 1425, Mar. 10. Doc. 154. Ghiberti confirms receipt of a letter from the *Operaio* in Siena. The two reliefs for Siena, delayed by his escape to Venice (see Dig. 107) are in the process of completion. Letter of Ghiberti to the *Operaio* in Siena.

ODS (Libro doc. art., 52)

114. 1425, April 2. Docs. 107, 108. Decision of the *Arte della Lana* to replace the marble *Saint Stephen* in their niche at Or S. Michele by a new bronze figure and tabernacle, and appointment of a supervisory committee.

ASF, Arti, Lana, vol. 49, Delib. Cons. 1408-1427, c. 109v, 110

115. 1425, Apr. 16. Doc. 155. Ghiberti thanks Giovanni Turini for his offer to help in chasing one of the reliefs for the font and maintains that the two reliefs are almost finished; one is in the hands of Giuliano di Ser Andrea, the other in his own. The delay was caused by arguments with his partners from whom he has separated. Letter of Ghiberti to Giovanni Turini.

ODS (Libro doc. art.; at present unnumbered, formerly 54)

116. 1425, April. Specific instructions of the *Arte della Lana* regarding the new *Saint Stephen* for Or S. Michele. (Document lost, but referred to in Doc. 111, Dig. 140.)

117. 1425, Spring or Summer. The *Arte della Lana* commissions the *Saint Stephen* from Ghiberti. (Document lost, but referred to in Doc. 111, Dig. 140.)

118. 1425, June 26. Doc. 156. Ghiberti mentions a prior visit of Giovanni Turini, on behalf of the *Operaio* of the Cathedral of Siena, to expedite the completion of the reliefs for the Baptismal Font; he announces shipment of one relief which is "almost finished" to Siena for inspection and promises to send the other which "will be done in no time." He asks whether the plaques should be gilded in Florence or in Siena. Letter of Ghiberti to the *Operaio*.

ODS (Libro doc. art., 54)

119. 1425, June 28. Doc. 140. Payment is made for shipment of one relief to Siena.

ODS, Libro deb. cred., vol. 393 (1420-1444), c. 3v

120. 1425, June 28. Ghiberti's salary as supervisor of the dome of the Cathedral is suspended, beginning July 1, despite his re-election.

AOF, Delib. LXXXVII, c. 25v (Guasti, bibl. 198, doc. 74). Payments had continued from October 1420 to this date (Guasti, bibl. 198, doc. 73, note).

121. 1425, Aug. 2. Doc. 157. Ghiberti asks the *Operaio* of the Cathedral of Siena to return his relief for completion; the other relief is finished and he promises to send it for inspection. Letter of Ghiberti to the *Operaio*.

ODS (Libro doc. art., 55, formerly 56)

122. 1425, Oct. 12. Payment to Ghiberti for five bronze winches for the construction of the main apse of the Cathedral.

AOF, Stanz. SS, c. 108 (Guasti, bibl. 198, doc. 141)

123. 1426, Jan. 24. Ghiberti, Brunelleschi, and Battista d'Antonio submit a joint report on the procedure proposed for building the dome.

AOF, Delib. 1425-1436, c. 170v, 171 (Guasti, bibl. 198, doc. 75; see also Baldinucci-Moreni, bibl. 36, pp. 220ff)

124. 1426, Feb. 4. The Committee of the *Opera* and the Consuls of the *Arte della Lana* accept the preceding report; Brunelleschi's salary for full-time work on the dome is fixed at 100 florins annually, Ghiberti's for part-time work remains at 3 florins monthly.

AOF, Delib. 1425-1436, c. 170v, 171 (Guasti, bibl. 198, doc. 75; Baldinucci-Moreni, bibl. 36, pp. 220ff)

125. 1426, Mar. 11-12. Decision to have Brunelleschi and Battista d'Antonio continue work on the dome; Ghiberti is not mentioned.

AOF, Delib. 1425-1436, c. 23; also AOF, Stanz. Termini e Malleverie, c. 32v (Guasti, bibl. 198, doc. 76)

126. 1426, Dec. 20. Doc. 104. Ghiberti is matriculated in the *Arte di Pietra e Legname*.

ASF, Arti, Maestri di Pietra e Legname, vol. II, Matricole dell'Arte, 1388-1518, c. 32v

127. 1426, after Apr. 26, immediately before Dec. 29. Doc. 10. The lintel of the East portal of the Baptistery is to be made of three pieces of marble.

ASF, Strozz. LI, 1, c. 38v (accompanied by drawing) from: Filza di più sorte scritture dell' Arte de Mercatanti 1414-1433 (Frey, bibl. 532, p. 357, doc. 1, with erroneous date of April 22, 1423)

128. 1425-1427. Tomb of Leonardo Dati in S. Maria Novella (d. March 16, 1425; Ghiberti-Schlosser, bibl. 178, II, p. 55, with erroneous date 1423), completed before July 9, 1427, when a final payment of 10 florins is still due.

Libro segreto di Gregorio Dati, ed. C. Gargiolli, Bologna, 1869 (*Scelta di Curiosità letterarie, 102*) p. 106. See also Ghiberti's tax declaration, Dig. 138.

129. 1427, Jan. 28. Brunelleschi and Ghiberti are re-elected supervisors for the dome for the year beginning March 1, 1427, Brunelleschi at 100 florins annually, full-time, Ghiberti at 3 florins monthly, part-time.

AOF, Delib. 1425-1436, c. 171v (Guasti, bibl. 198, doc. 77)

130. 1427, Feb. 27-Mar. 7. Docs. 144, 145. The *Camerlingo* of the Sienese *Opera* is reimbursed for a trip made to Florence, from February 27 to March 3, to see Ghiberti about the Siena reliefs. Ghiberti has the plaques boxed and sent to Siena. They arrive March 3 and are returned March 7. Their weight is given as 600 odd *libre*. Small accounts in connection with this transaction.

ODS, Entr. Usc. di Antonio di Jacomo, 1426-1427, c. 84v, 85

131. 1427, after Mar. 17. Doc. 158. Ghiberti acknowledges the receipt on March 17 of both reliefs which have been returned from Siena for completion. Letter of Ghiberti to the *Operaio del Duomo*.

ODS (Libro doc. art., at present unnumbered, formerly 53) (Milanesi, bibl. 536, II, p. 122, doc. 85, v, dated March 1425-1426 [?]; Lusini, bibl. 283, pp. 101f, doc. 9, dated March, 1426)

132. 1427, Apr. 7-11. The *Camerlingo* of the *Opera* of Siena calls on Donatello; as evident from Dig. 133, he also sees Ghiberti. He urges the two artists to complete the stories for the Baptismal Font.

ODS, Entr. Usc. di Antonio di Jacomo, 1426-1427, c. 84v (Bacci, bibl. 31, p. 16)

133. 1427, Apr. 11-20. Doc. 159. One of the Siena reliefs is finished. Ghiberti promises to have the other finished by Easter. The sum of 80 florins is wanted for gilding. Letter of Ghiberti to the *Operaio* with reference to his visit (see preceding digest).

ODS (Libro doc. art., 64, formerly 56). Milanesi (bibl. 336, II, p. 123, doc. 85, vi) dates the letter 1426; Lusini (bibl. 283, p. 101, doc. 8) 1425

134. 1427, Apr. 17. Doc. 143. Ghiberti receives 200 lire on account for the gilding of the Siena reliefs.

ODS, Entr. Usc. di Antonio di Jacomo, 1426-1427, c. 83v

135. 1427, May 12. Doc. 160. The Siena reliefs are completed; Ghiberti starts gilding one and asks for gold for the other. Letter of Ghiberti to the *Operaio*.

ODS (Libro doc. art., at present unnumbered, formerly 57)

136. 1427, May 14-15. Docs. 109, 110. A new committee is appointed by the *Arte della Lana* to supervise work on the *Saint Stephen* for Or San Michele.

ASF, Arti, Lana, vol. 49, Delib. Cons. 1408-1427, c. 127v, 128v

137. 1427, May 31. Doc. 161. Ghiberti renews his request for material to gild the second Siena relief. The gilding will take one day. He asks the *Operaio* to reimburse his banker for an advance of 200 florins which he has drawn against the rest of his fee. Letter of Ghiberti to the *Operaio*.

ODS (Libro doc. art., 58)

138. 1427, July 9. Docs. 81, 81a. Ghiberti's tax declaration (*denuncia de'beni*). In addition to a house in Florence for his own use and a piece of land at S. Donato di Fronzano and an account of 714 florins in the Monte, Ghiberti declares the following credits: for two bronze reliefs for the Baptismal Font in Siena a final payment of 110 florins on an estimated total of 400 florins; for the bronze shrine for Cosimo de' Medici (Cassa dei SS. Proto, Giacinto, e Nemesio) a final payment of 65 florins on an estimated total of 200 florins (these two works are still in the workshop); for the tomb of Leonardo Dati a final payment of 10 florins from the Frati di S. Maria Novella. Among his creditors appear Papero di Meo da Settignano, Simone di Nanni da Fiesole, and Cipriano di Bartolo da Pistoia, "my helpers (*garzoni*)" in the workshop, with a total of 48 florins.

ASF, Catasto, 1427, Quart. S. Giov., Gonf. Chiavi, portata, vol. 58, c. 199, 199v; *campione, vol. 80*, c. 423v

139. 1427, July 14. Doc. 146. The *Camarlingo* of the Cathedral of Siena pays a notary for a copy of the original contract with Ghiberti.

ODS, Entr. Usc. di Berto d'Antonio, 1427-1428, c. 63

140. 1427, Aug. 5. Doc. 111. The model (form?) of the *Saint Stephen* for Or S. Michele

is completed; the treasurer of the guild is empowered, with reference to earlier decisions, to purchase 4000 pounds of bronze.

ASF, Arti, Lana, vol. 49, Delib. Cons. 1408-1427, c. 130v

141. 1427, Sept. 26. Doc. 147. Ghiberti is credited with 25 florins for materials to gild the Siena reliefs.

ODS, Entr. Usc. di Berto d'Antonio, 1427-1428, c. 63

142. 1427, October. Doc. 162. Ghiberti has gilded the second relief for Siena. Both are ready for shipment if the *Operaio* will reimburse Ghiberti for the amount drawn against the rest of his claims. He refers to his original demand of 240 florins per relief and the *Operaio's* promise of 220. Ghiberti also reminds the present *Operaio* that the commission of four statues had been promised him. Letter of Ghiberti to the *Operaio*.

ODS (Libro doc. art., at present unnumbered, formerly 59) (Milanesi, bibl. 336, II, pp. 124f, doc. 85, IX, with date 1427 [?])

143. 1427, Oct. 25-Nov. 1. Docs. 141, 148, 149, 150. The *Camarlingo* of the Cathedral of Siena is sent to Florence since Ghiberti is withholding the reliefs for the Baptismal Font. A settlement is reached regarding the fee for the two reliefs, fixing it at 1,680 lire or 210 florins per relief. Adjustments are paid and Ghiberti hands over the reliefs.

ODS, Libro deb. cred., c. 240; Entr. Usc. di Berto d'Antonio, 1427-1428, c. 64, 64v

144. 1427, Nov. 15. Docs. 151, 153. Small payments are made for carrying Ghiberti's two reliefs from Florence to Siena and from the customhouse in Siena to the *Opera*.

ODS, Entr. Usc. di Berto d'Antonio, 1427-1428, c. 64v

145. 1427. The tomb of Lodovico degli Obizi (d. 1424) in S. Croce, designed by Ghiberti (Ghiberti-Schlosser, bibl. 178, I, p. 47) and executed by Filippo di Cristofano, has not yet been paid for in full. Money is still due the latter.

ASF, Catasto, 1427, Quart. S. Maria Novella, Gonf. Lione Rosso, portata, vol. 43, c. 722; see also campione, vol. 76, c. 292 (Brockhaus, bibl. 68, col. 222)

146. After 1427. Bartolomeo Valori's tomb (d. 1427) in S. Croce is executed by the stonemason Filippo di Cristofano after Ghiberti's design.

ibid. (Ghiberti-Schlosser, bibl. 178, I, p. 47;

Brockhaus, bibl. 68, col. 222, quoting Filippo's tax declaration)

147. 1428, May 21. Brunelleschi and Ghiberti are re-elected at previous salaries as supervisors for the dome of the Cathedral.

AOF, Delib. 1425-1436, c. 173 (Guasti, bibl. 198, doc. 78)

148. 1428, June 30. Doc. 112. The *Saint Stephen* is in the process of completion. The supervisory committee of the *Arte della Lana* is continued in office and empowered to make payments not exceeding 1,000 florins.

ASF, Arti, Lana, vol. 50, Delib. Cons. 1427-1432, c. 23 (summary in Passerini, bibl. 391, p. 48, with erroneous date 1418)

149. 1428, July 15. The consuls of the *Arte della Lana* refer to a preliminary discussion held by a committee with a group of experts, among them, as outstanding, Brunelleschi and Ghiberti, and to an ensuing discussion to choose a chapel for S. Zenobius and to place in it a shrine of marble or bronze with the figure of the Saint.

ODF, Delib. 1425-1436, c. 173v, 174 (Poggi, bibl. 413, doc. 898)

150. 1428, Sept. 1. Doc. 93. The *Opera* of S. Giovanni attempts to raise funds to cover its great expenses but is refused by the City Council.

ASF, Arti, Calimala, 17 bis, Petizioni e Deliberazioni, 1422-1518, no pagination

151. 1428. The Shrine of Saints Protus, Hyacinth, and Nemesius, donated by Cosimo and Lorenzo de' Medici, is set up at S. Maria degli Angeli. The inscription on the base carrying the shrine is lost, but reported by Vasari (Vasari-Milanesi, bibl. 533, II, p. 234; see also Dig. 138).

152. 1428 (?). Ghiberti mounts a cornelian with the Flaying of Marsyas (Ghiberti-Schlosser, bibl. 178, I, p. 47; Anonimo Magliabecchiano, bibl. 22, pp. 275f).

153. 1429, Jan. 7. Brunelleschi and Battista d'Antonio are empowered to build the masonry chain of the dome of the Cathedral after the design of Brunelleschi, Ghiberti, and Battista d'Antonio.

AOF, Delib. 1425-1436, c. 98v (Guasti, bibl. 198, doc. 193)

154. 1429, Feb. 1. Doc. 113. The *Saint Stephen* is completed, and the supervising committee is empowered to sell the remaining bronze.

ASF, Arti, Lana, vol. 50, Delib. Cons. 1427-1432, c. 42f

155. 1429, July 21. Brunelleschi and Ghiberti are re-elected for one year at the usual salaries as supervisors of the Cathedral.
AOF, Delib. 1425-1436, c. 175 (Guasti, bibl. 198, doc. 79)

156. 1429, Sept. 22. Brunelleschi and Ghiberti are ordered to commission a model of the entire Cathedral, including apses and façade.
AOF, Delib. 1425-1436, c. 112v (Guasti, bibl. 198, doc. 61)

157. 1429. Docs. 87, 88. The *Arte di Calimala* in its tax declaration, mentions two points of interest concerning Ghiberti's work for the Baptistery: a loan of 1,800 florins plus interest was contracted "when the frame (*telaio*) of the door of S. Giovanni was cast, for bronze and other expenses"; running expenses "for the third door which has been begun . . . and the cost of which cannot be estimated; the master alone is paid 200 florins per year."
ASF, Catasto, 1429, Beni di Compagnie e Arti, portata, vol. 291, c. 5, 6, 6v, 24, 24v, and *campione vol. 293*, c. 4, 5, 5v, 10v

158. 1429. Doc. 8. The two (porphyry) columns at the Baptistery are moved further to either side of the east gate.
ASF, Strozz. LI, 1, f. 6v from: *Libro Grande I, 1429*, c. 176

159. 1430, Jan. 2, Mar. 15. Two letters of Aurispa to Traversari refer to Ghiberti's wish to borrow an Athenaios ms. from the former (Sabbadini, bibl. 457, pp. 67, 69).

160. 1430, Dec. 14. Only Brunelleschi is re-elected as supervisor of the dome.
AOF, Delib. 1425-1436, c. 176v (Guasti, bibl. 198, doc. 80)

161. 1430. Trip to Venice (?)
(G. Fiocco, bibl. 160, based, according to a friendly note of Mr. Fiocco's, on communication made to him orally by the late O. Paoletti).

162. 1431, Jan. 26. Doc. 82. Ghiberti's tax declaration (*denuncia de' beni*). Aside from the real estate owned in 1427 and an account in the Monte of as much as 1,300 florins, he enumerates a credit of 280 florins with the *Arte di Calimala* "which I have advanced them." In the *campione* he also mentions a debt to the *Opera di S. Croce* for a tomb he has bought.
ASF, Catasto 1431, Quart. S. Giov., Gonf.

Chiavi, portata, vol. 386, c. 192, 192v; revised copy, *vol. 388*, c. 170, 170v (with greater detail); *campione, vol. 409*, c. 191v, 192

163. 1431, June 23. Brunelleschi and Ghiberti are re-elected on customary conditions as supervisors of the dome.
AOF, Delib. 1425-1436, c. 177 (Guasti, bibl. 198, doc. 83)

164. 1432, Feb. 22. The *Operai* of the Cathedral of Florence open a competition for designing a sepulcher for the relics of Saint Zenobius.
AOF, Delib. 1425-1436, c. 155 (Poggi, bibl. 413, doc. 903)

165. 1432, Mar. 3. The *Operai* of the Cathedral discuss a report regarding the sepulcher to be designed for the chapel of Saint Zenobius in the Cathedral, submitted by a committee of "outstanding citizens . . . masters of painting and sculpture . . . and theologians." On this basis they decide to commission the shrine to the sculptor (!) Ghiberti and the altar to Brunelleschi and to arrange for the purchase from the *Arte della Lana* of bronze left over from casting the figure of Saint Stephen at Or San Michele.
AOF, Delib. 1425-1436, c. 155 (Poggi, bibl. 413, doc. 905)

166. 1432, Mar. 4-23. Contract of the *Operai* of the Cathedral with Ghiberti concerning the Shrine of Saint Zenobius, giving details, salary, and working conditions: it is to be of bronze, 3 *braccia* long and 1½ high, with stories from the life of the Saint, and of a maximum weight of 5,000 pounds. The *Operai* furnish the materials and pay the wages for the workshop; Ghiberti himself is to receive 15 florins monthly, regardless of the time spent. Delivery is exacted by April 1435, and in case of failure the *Operai* may reassign the commission within six weeks.
AOF, Allogazioni 1438-1475, insert (Poggi, bibl. 413, doc. 906)

167. 1432, Mar. 18. Brunelleschi and Ghiberti are paid for models of the sepulcher of Saint Zenobius.
AOF, Stanz. CC, c. 28v (Poggi, bibl. 413, doc. 907)

168. 1432, Mar. 23. Guarantors, named by Ghiberti for the Zenobius Shrine, are accepted by the *Operai*.
AOF, Delib. 1425-1436, c. 156v (Poggi, bibl. 413, doc. 908)

169. 1432, Mar. 23. 1,661½ pounds of bronze for the Shrine of Saint Zenobius are bought from the *Arte della Lana* for 100 florins.

AOF, Stanz. CC, c. 29v, 46v, and *Delib. 1425-1436,* c. 156 (Poggi, bibl. 413, docs. 908, 911)

170. 1432, Apr. 9. Two assistants (*discepoli*) are hired for Ghiberti, to work on the Shrine of Saint Zenobius on a day-to-day basis at approximately 75 florins a year.

AOF, Delib. 1425-1436, c. 164 (Poggi, bibl. 413, doc. 910)

171. 1432, June 27-Aug. 12. Brunelleschi, Ghiberti, and Battista d'Antonio are to make a wooden model for the key ring of the dome of the Cathedral.

AOF, Delib. 1425-1436, c. 163, 167; also *Ricordi Proveditore 1432-1433,* c. 4 (Guasti, bibl. 198, docs. 247, 248)

172. 1432, Aug. 20. Refund of 40 florins authorized on an advance of 80 florins made by former provisor for sepulcher of Saint Zenobius.

AOF, Delib. 1425-1436, c. 168 (Poggi, bibl. 413, doc. 912)

173. 1432, Aug. 22. Brunelleschi and Ghiberti are re-elected as supervisors for building the dome.

AOF, Delib. 1425-1436, c. 178 (Guasti, bibl. 198, doc. 84, with correction of note on p. 188)

174. 1432, prior to Oct. 29. Docs. 105, 106. Ghiberti designs the model for an altar of the *Arte dei Linaiuoli.* Payments are made on Oct. 29, 1432, and on Aug. 11, 1433, to the woodcarvers Jacopo (Papero) di Piero and the stonemasons Jacopo di Bartolo da Settignano and Simone di Nanni da Fiesole for the execution of the wooden and marble frames after Ghiberti's design.

ASF, Arti, Rigattieri, Linauoli e Sarti, vol. 20, campione dei debitori e creditori 1418-1511, c. 98

175. 1432, Oct. 30. Brunelleschi (alone) makes a new model for the key ring of the lantern.

AOF, Delib. 1425-1436, c. 189v; also *Ricordi Proveditore, 1432-1433,* c. 13 (Guasti, bibl. 198, doc. 250)

176. 1432, Dec. 9. Further refunds authorized for advance made to Ghiberti and Brunelleschi for the sepulcher of Saint Zenobius.

AOF, Delib. 1425-1436, c. 192 (Poggi, bibl. 413, doc. 913)

177. 1433, Jan. 30. Regular payment to Ghiberti as supervisor of the dome of the Cathedral.

AOF, Ricordi Proveditore, 1432-1433, no page (Guasti, bibl. 198, doc. 84, note and p. 188)

178. 1433, May 27. Ghiberti is named as arbitrator in Donatello's contract for the Prato pulpit.

(Baldanzi, bibl. 34, pp. 78, 274ff)

179. 1433, May 29. Doc. 83. Ghiberti's tax declaration (*denuncia de'beni*). The real estate has increased through the lease for life of a farm at Careggi from the *Calimala,* against payment of 370 florins. His account in the Monte has correspondingly decreased but he enumerates a credit of 100 florins advanced to the *Arte di Calimala.* Among his creditors appear Giuliano di Ser Andrea (last time mentioned), Filippo di Nicholo da Fiesole, *iscarpellatore,* Simone di Nanni da Fiesole "who works with me," and Papero di Meo da Settignano.

ASF, Catasto 1433, Quart. S. Giov., Gonf. Chiavi, portata, vol. 481, c. 149, 149v; second copy *vol. 479,* c. 143, 143v (Mather, bibl. 308, pp. 57f with misreadings)

180. 1433, July 10. Payment of 25 florins to Ghiberti for work on the Shrine of Saint Zenobius.

AOF, Stanz. CC, c. 58v (Poggi, bibl. 413, doc. 916)

181. 1433, Dec. 30-1434, Apr. 14. Discussion whether Ghiberti's cartoon of a *Coronation of the Virgin* for a stained-glass oculus for the dome of the Cathedral should be commissioned for execution.

Of two designs, submitted by Ghiberti and Donatello respectively, for this oculus, that of Donatello is chosen for execution.

AOF, Delib. 1425-1436, c. 208v, 214v (Poggi, bibl. 413, docs. 717, 719)

182. 1434, Apr. 10. Two windows in the chapel of Saint Zenobius are to be designed by Ghiberti and executed by Bernardo di Francesco.

AOF, Delib. 1425-1436, c. 215 (Poggi, bibl. 413, doc. 605)

183. 1434, June 9. Ghiberti is paid 100 florins for work on the Shrine of Saint Zenobius.

AOF, Stanz. CC, c. 75v (Poggi, bibl. 413, doc. 917)

184. 1434, Oct. 22. For casting two reliefs for the Shrine of Saint Zenobius 500 pounds of bronze are bought, to be given to Ghiberti.

AOF, Stanz. CC, c. 81v (Poggi, bibl. 413, doc. 918)

185. 1434, Dec. 31. Ghiberti is paid 12 lire for a design for the choir screen of the Cathedral.
AOF, Stanz. CC, c. 85v (Poggi, bibl. 413, doc. 1173)

186. 1435, Jan. 24. The *Opera* of the Cathedral closes Ghiberti's (and Luca della Robbia's) accounts.
Delib. 1425-1436, c. 226 (Poggi, bibl. 413, doc. 1260)

187. 1435, Mar. 19. Ghiberti receives 15 florins for his rejected design for the oculus of the dome (see Dig. 181).
AOF, Stanz. CC, c. 91v (Poggi, bibl. 413, doc. 723)

188. 1435, May 6. A new committee is elected for supervising the Shrine of Saint Zenobius.
AOF, Delib. 1425-1436, c. 233 (Poggi, bibl. 413, doc. 919); see also Dig. 186

189. 1435, Sept. 30. The *Operai* of the Cathedral direct the *Offiziali* of the Sacristy to have a bronze shrine made for the body of Saint Zenobius.
AOF, Delib. 1425-1436, c. 241v (Poggi, bibl. 413, doc. 920); see Dig. 188

190. 1435, Nov. 15. Both Brunelleschi and Ghiberti are commissioned to design the arrangement of new altars in the chapels of the three apses of the Cathedral.
AOF, Delib. 1425-1436, c. 243 (Poggi, bibl. 413, doc. 1065)

191. 1435, Nov. 26. The *Operai* discuss the project for the new choir of the Cathedral as submitted by Ghiberti, Brunelleschi, and Agnolo d'Arezzo. The commission goes to Brunelleschi.
AOF, Delib. 1425-1436, c. 244, 244v (Poggi, bibl. 413, doc. 1176)

192. 1436, June 30. Last payment to Ghiberti for supervising work on the dome of the Cathedral.
AOF, Stanz. CC, c. 130v (Guasti, bibl. 198, correction of note to doc. 84, p. 188)

193. 1436, Aug. 14. Ghiberti has a model made for a lantern for the dome designed in competition with Brunelleschi and others.
AOF, Delib. 1436-1442, c. 2v (Guasti, bibl. 198, doc. 269)

194. 1436, Aug. 14. Ghiberti is pressed to furnish the design for a stained-glass window with a scene from the Life of the Virgin for the eastern apse of the Cathedral, to be executed by Bernardo di Francesco.
AOF, Delib. 1436-1442, c. 2v (Poggi, bibl. 413, doc. 614)

195. 1436, Oct. 32 (*sic*). Final payment is made to Ghiberti for designs of four windows for the chapel and apse of Saint Zenobius.
AOF, Stanz. CC, c. 137v (Poggi, bibl. 413, doc. 615)

196. 1436, Dec. 31. Ghiberti's model for the lantern of the dome and those of four others are rejected in favor of Brunelleschi's.
AOF, Delib. 1436-1442, c. 10v (Guasti, bibl. 198, doc. 273)

197. 1437, Feb. 14. The *Operai* of the Cathedral pay 196 florins for bronze purchased for the Shrine of Saint Zenobius.
AOF, Stanz. DD, c. 4 (Poggi, bibl. 413, doc. 922)

198. 1437[?], Apr. 4. Doc. 23. Ten stories for Ghiberti's second bronze door for the Baptistery and 24 pieces of frieze have been cast and the nettoyage is to be started by Ghiberti, one of his sons, and Michelozzo.
ASF, Strozz. LI, 1, f. 62 from: *Ricordi Proveditore, K, 1435-1440,* c. 87 with presumably erroneous date 1436

199. 1437, April 9-18. The consuls of the *Arte della Lana* and the *Operai* of the Cathedral declare Ghiberti in default for not having finished the Shrine of Saint Zenobius by April 1435. His contract is canceled and a new supervisory committee is appointed (see Dig. 188).
Ghiberti's account regarding the Shrine of Saint Zenobius is ordered closed (see Dig. 186).
AOF, Delib. 1436-1442, c. 15v, 17 (Poggi, bibl. 413, docs. 924, 925)

200. 1437. Doc. 37. Ghiberti may employ for work on his second door of the Baptistery his son Vittorio, Michelozzo, and three others, at 100 florins a year.
ASF, Strozz. LI, 1, f. 81 from: *Libro seconda e terza porta*

201. 1438, May 24. Ghiberti is paid for a drawing of four figures for a stained-glass window for the apse of Saint Zenobius.
AOF, Stanz. DD, c. 34 (Poggi, bibl. 413, doc. 622)

202. 1439, Mar. 8. A committee, among them Leonardo Bruni, reports to the *Arte della Lana* on the projected arrangement of the sepulcher, altar, and Shrine of Saint Zenobius, and suggests, among other things, that the bronze

shrine designed by Ghiberti should be placed below the altar with the main story facing the rear and an inscription facing to the front.

AOF, Delib. 1436-1442, c. 60v, 61 (Poggi, bibl. 413, doc. 927)

203. 1439, Mar. 18. The Shrine of Saint Zenobius is returned to Ghiberti for completion.

AOF, Delib. 1436-1442, c. 64v (Poggi, bibl. 413, doc. 928)

204. 1439, Mar. 26. Ghiberti is commissioned to complete the Shrine of Saint Zenobius by January 1440.

AOF, Delib. 1436-1442, c. 66 (Poggi, bibl. 413, doc. 929)

He receives an advance of 50 florins.

AOF, Stanz. DD, c. 51v (Poggi, bibl. 413, doc. 929)

205. 1439, Apr. 3. The *Operai* confirm the recommissioning of the Shrine of Saint Zenobius.

AOF, Delib. 1436-1442, c. 69 (Poggi, bibl. 413, doc. 930)

206. 1439, Apr. 18. Ghiberti receives a new contract from the *Operai* of the Cathedral for the Shrine of Saint Zenobius. It is to have three reliefs, including the Resurrection miracle in front (*sic*), the two other miracles already begun, and in the rear an inscription by Leonardi Bruni. The deadline for the completion is set for January 1440.

AOF, Allog., c. 5 (Poggi, bibl. 413, doc. 931)

207. 1439, Apr. 18. Ghiberti has received on account for his labor on the Shrine of Saint Zenobius over 700 florins; the main story of the shrine for which he has received the bronze, must be delivered within three months.

AOF, Stanz. EE, c. 73 (Poggi, bibl. 413, doc. 931)

208. 1439, July 4. Doc. 24. A new agreement is made with Ghiberti regarding further work on his second door for the Baptistery. He is to be paid 180 florins for work done by him, his son and other helpers during the period between January 1438 and June 1439. The state of work is as follows:

Cain and Abel	"really finished"
Moses	little missing
Jacob and Esau	finished
Joseph	half finished
Solomon	thus far completed: the architectural settings, a part at the bottom and the figures to the right, about one quarter.

For two of the compartments (*spiagie*) only the foliage is ready.

ASF, Strozz. LI, 1, f. 63v from: *Ricordi Proveditore K, 1435-1440*, c. 103 (Brockhaus, bibl. 69, pp. 39f with erroneous date)

209. 1439, July 18. Docs. 59, 25. Tinaccio di Piero and Piero di Francesco are commissioned to prepare the armature for the casting of the frame of Ghiberti's second door.

ASF, Strozz. LI, 1, f. 123 from: *Filza 4a di Petizioni e altre scritture Calimala, 1434-1461*, c. 255

Similar entry: the armature of Ghiberti's second door is commissioned.

ASF, Strozz. LI, 1, f. 64 from: *Ricordi Proveditore K, 1435-1440*, c. 103

210. 1439, July 31. Ghiberti receives 40 florins as a partial payment for work on the Shrine of Saint Zenobius.

AOF, Stanz. DD, c. 66v (Poggi, bibl. 413, doc. 940)

211. 1439, Nov. 23. Ghiberti receives 25 florins for work on the Shrine of Saint Zenobius.

AOF, Stanz. DD, c. 69 (Poggi, bibl. 413, doc. 943)

212. 1439, Dec. 18. Ghiberti receives 50 florins for work on the Shrine of Saint Zenobius.

AOF, Stanz. DD, c. 69v (Poggi, bibl. 413, doc. 944)

213. 1440, Feb. 22. Ghiberti receives 100 florins for work on the Shrine of Saint Zenobius.

AOF, Stanz. DD, c. 75 (Poggi, bibl. 413, doc. 947)

214. 1440, Mar. 8. Bruni's inscription for the Shrine of Saint Zenobius is accepted and the *Operai* decide to have it placed in a garland on the back of the shrine.

AOF, Delib. 1436-1442, c. 101v (Poggi, bibl. 413, doc. 948)

215. 1440, Nov. 8. Ghiberti receives a small payment for a drawing for a stained-glass window.

AOF, Stanz. DD, c. 87v (Poggi, bibl. 413, doc. 647)

216. 1440, Dec. 5. Ghiberti receives 50 florins for work on the Shrine of Saint Zenobius.

AOF, Stanz. DD, c. 90 (Poggi, bibl. 413, doc. 953)

217. 1440, after Dec. 7; before Jan. 4, 1441. Doc. 70. The doors of S. Giovanni (probably the armature of the frame) are in the process of being made.

ASF, Strozz. LI, 1, f. 200 from: *Delib. Cons.*

Calimala, 1439-1440, c. 47 (Brockhaus, bibl. 69, p. 40; Frey, bibl. 532, p. 360, doc. 10, with the erroneous date of Dec. 7, 1439)

218. 1440, Dec. 29. Ghiberti is paid for drawings for four stained-glass windows.
AOF, Stanz. DD, c. 91v, 92 (Poggi, bibl. 413, doc. 648)

219. 1440. Doc. 38. Deliberations to buy 17,000 pounds of fine bronze in Flanders for Ghiberti's second Baptistery door.
ASF, Strozz. LI, 1, f. 81 from: *Libro seconda e terza porta*

220. 1441, Jan. 27. Ghiberti receives 100 florins for work on the Shrine of Saint Zenobius.
AOF, Stanz. DD, c. 95 (Poggi, bibl. 413, doc. 956)

221. 1441, Sept. 26. Ghiberti receives a small payment for a drawing for a window in Saint Peter's chapel in the Cathedral.
AOF, Stanz. EE, c. 2v (Poggi, bibl. 413, doc. 655)

222. undated, perhaps late in 1441. Ghiberti works a miter for Pope Eugene IV during his second sojourn in Florence, Jan. 22, 1439-Mar. 7, 1443. (Ghiberti-Schlosser, bibl. 178, I, p. 228; Muentz, bibl. 350, p. 62, quotes a document of Dec. 7, 1441, according to which pearls were paid for in Florence for a miter for the Pope).

223. 1442, Jan. 5. Ghiberti receives small payments for drawings for stained-glass windows in and above the chapel of Saint Matthew in the Cathedral.
AOF, Bast. ser Niccolo di ser Diedi, III, c. 1v ff (Poggi, bibl. 413, doc. 658)

224. 1442, Jan. 5. Ghiberti purchases an estate at Settimo.
Ghiberti, Libro di Ricordanze A, Florence, Coll. Ginori-Conti. (Ginori-Conti, bibl. 181)

225. 1442, Jan. 20. Ghiberti, as a member of a commission of experts, gives his opinion on the display of stained-glass windows for the drum of the dome of the Cathedral and on decorating the sacristy.
AOF, Bast. ser Niccolo di ser Diedi, III, c. 3f (Guasti, bibl. 198, doc. 202)

226. 1442, Jan. 22. It is decided (by the *Operai*) to have the Shrine of Saint Zenobius varnished.
AOF, Bast. ser Niccolo di ser Diedi, III, c. 3v (Poggi, bibl. 413, doc. 957)

227. 1442, Feb. 10. Ghiberti receives a small payment for the drawing of a window for the chapel of Saint Thomas in the Cathedral.

AOF, Bast. ser Niccolo di ser Diedi, III, c. 7 (Poggi, bibl. 413, doc. 660)

228. 1442, Feb. 28. Ghiberti receives a small payment for the drawing of a window for the chapel of Saint Bartholomew in the Cathedral.
AOF, Bast. ser Niccolo di ser Diedi, III, c. 9 (Poggi, bibl. 413, doc. 663)

229. 1442, Mar. 5. Ghiberti receives small payments for drawings of windows for the chapels of Saint Andrew and Saint Stephen in the Cathedral.
AOF, Bast. ser Niccolo di ser Diedi, III, c. 10v (Poggi, bibl. 413, doc. 664)

230. 1442, May 12. Ghiberti receives small payments for the drawings for two windows for the chapels of Saint John the Evangelist and Saint Anthony Abbot in the Cathedral.
AOF, Bast. ser Niccolo di ser Diedi, III, c. 19v (Poggi, bibl. 413, doc. 667; Paatz, bibl. 375, III, p. 521, note 314)

231. 1442, June 14. Ghiberti receives a small payment for the drawing of a window for the chapel of Saint John the Evangelist in the Cathedral.
AOF, Bast. ser Niccolo di ser Diedi, III, c. 26v (Poggi, bibl. 413, doc. 671)

232. 1442, July 6. Ghiberti receives a small payment for the drawing of a window for the chapel of Saints James and Philip in the Cathedral.
AOF, Bast. ser Niccolo di ser Diedi, III, c. 31 (Poggi, bibl. 413, doc. 674)

233. 1442, July 31. Ghiberti receives a small payment for drawing for the chapel of Saint Barnabas in the Cathedral.
AOF, Bast. ser Niccolo di ser Diedi, III, c. 34 (Poggi, bibl. 413, doc. 677)

234. 1442, Aug. 14. Ghiberti receives a payment of 100 florins for work on the Shrine of Saint Zenobius.
AOF, Bast. ser Niccolo di ser Diedi, III, c. 34v (Poggi, bibl. 413, doc. 961)

235. 1442, Aug. 28. Michelozzo is employed in chasing Ghiberti's second door for the Baptistery.
ASF, Catasto, 1442, Quart. S. Giov., Gonf. Drago, portata, vol. 625, c. 79f (Fabriczy, bibl. 145)

236. 1442, Aug. 30. Ghiberti receives a payment of 27 florins and a final payment of 200 florins for work on the Shrine of Saint Zenobius.
AOF, Bast. ser Niccolo di ser Diedi, III, c. 40v (Poggi, bibl. 413, doc. 962)

The total cost amounted to 1,324 florins (Doc. 126), or 1,314 florins (Doc. 129).

BNF, Banco rari 228, formerly Magl. Cl. XVII, 2, c. 27 (Zibaldone di Buonaccorso Ghiberti); Florence, Uffizi, Arch. Misc. vol. I, no. 4

237. 1442, Aug. 20. Doc. 84. Tax declaration (*denuncia de'beni*) by Ghiberti, *"Maestro delle Porte di S. Giovanni."* He has sold his account in the Monte and owns only real estate; in addition to the older holdings (Digs. 138, 179) and the estate at Settimo, he has added to his land in S. Donato di Fronzano, acquired three lots at Montepiano, these latter only for a short time, and in 1438 a small house adjoining his residence in Florence.

ASF, Catasto, 1442, Quart. S. Giov., Gonf. Chiavi, portata, vol. 627, c. 214, 214v (Mather, bibl. 308, p. 48, with erroneous date 1432 and an erroneous volume number)

238. 1442, Nov. 24. Ghiberti receives a small payment for a drawing for a window in an unnamed chapel in the Cathedral.

AOF, Bast. ser Niccolo di ser Diedi, III, c. 56v (Poggi, bibl. 413, doc. 685)

239. 1442, Dec. 10. Ghiberti receives a small final payment for the drawing of a window in the chapel of Saint James Major in the Cathedral.

AOF, Bast. ser Niccolo di ser Diedi, III, c. 64 (Poggi, bibl. 413, doc. 686)

240. After 1440, before June 24, 1443; possibly 1442. Doc. 39. A monthly salary of 14 lire is granted to Matteo di Francesco d'Andrea da Settignano who works on Ghiberti's door at the Baptistery.

ASF, Strozz. LI, 1, f. 81 from: Libro seconda e terza porta; BMF, coll. Gori, A 199 1, c. 156v (whence date of 1442) (Frey, bibl. 532, p. 360, doc. 11, last part with erroneous date of 1440)

241. 1443, June 24. Doc. 40. New agreement regarding Ghiberti's second door for the Baptistery. Of the ten stories, four remain to be completed. Ghiberti is to receive for his work —wages, and charcoal and wood—1,200 florins at the discretion of the *Offiziali del Musaico* with the obligation of finishing the remaining reliefs within 18 months, assisted by his sons Vittorio and Tommaso and perhaps others.

ASF, Strozz. LI, 1, f. 81 from: Libro seconda e terza porta

242. 1443, July 13. Ghiberti receives 35 lire as a partial payment for the drawing of an *Ascension* for one of the oculi of the drum of the Cathedral's dome.

AOF, Stanz. G, c. 16 (Poggi, bibl. 413, doc. 751; see also doc. 758). An earlier date has been suggested (Paatz, bibl. 375, III, p. 514, note 289).

243. 1443, Sept. 11. Ghiberti receives 65 lire as a final payment for two drawings, one for this window and one for another oculus showing *Christ in the Garden.*

AOF, Stanz. G, c. 21v (Poggi, bibl. 413, doc. 752; see also doc. 749) (Paatz, bibl. 375, III, p. 513, note 288, suggests the possibility of an earlier date.)

244. 1443, Dec. 7. Ghiberti receives 50 lire for the drawing of an oculus with the *Presentation in the Temple* for the drum of the dome.

AOF, Stanz. G, c. 27v (Poggi, bibl. 413, doc. 756; see also doc. 772); (Paatz, bibl. 375, III, p. 513, note 287)

245. 1443, December. Ghiberti is elected to the Office of the Twelve (see Dig. 249)

246. 1444, Jan. 24. Docs. 94, 71. Agreement between Vittorio Ghiberti, in the name of his father Lorenzo "Master of the doors of S. Giovanni" and Benozzo Gozzoli who is to work exclusively on the doors at an annual salary rising from 60 to 80 florins.

ASF, Arti, Calimala, vol. 19, Delib. Cons. 1444, c. 8f; ASF, Strozz. LI, 1, f. 203 (Milanesi, bibl. 337, p. 90; see also Frey, bibl. 532, p. 360, doc. 14, with the date of Jan. 3)

247. 1444, Mar. 17. Doc. 120. Ghiberti is denounced as being of illegitimate birth and hence unable to hold office as one of the Twelve (see Dig. 245)

ASF, Consigli Maggiori, Provisioni, Registri, vol. 134, c. 286ff (Gaye, bibl. 173, I, 148ff with erroneous indication Filza 136 and numerous omissions; Gualandi, bibl. 196, pp. 17ff); also BLF, Cod. $\frac{252}{296}$ Cartella 2a (Aruch, bibl. 25, pp. 117ff)

248. 1444, Apr. 16. The *Consiglio Maggiore* recognizes Ghiberti's legitimate birth; he is fined 500 lire for tax irregularities.
BLF, Cod. $\frac{252}{296}$ Cartella 2a (Aruch, bibl. 25, loc.cit.).

249. 1444, Apr. 29. Doc. 120. Ghiberti's appeal to the *Signoria* against the imposition of the fine is granted and his right to hold office is recognized.

ASF, Consigli Maggiori, Provizioni, Registri,

vol. 134, c. 286ff (Gaye, bibl. 73, I, pp. 148ff; Gualandi, bibl. 196, pp. 17ff)

250. 1444, Apr. 30. Doc. 115a. Ghiberti's matriculation in the *Arte della Seta* is cancelled because of registering falsely as the son of a guild member.

ASF, Arti, Seta, vol. 7, Matricola 1328-1433, c. 115V

Also Tommaso Ghiberti's matriculation in the *Arte della Seta* is cancelled at that time. Tommaso had been matriculated in 1435. Docs. 117, 117a.

ASF, Arti, Seta, vol. 8, Matricola 1433-1474, c. 214

251. 1444, May 19. Ghiberti, Brunelleschi, and others are called on to advise on alterations of the fence of the Capella della Cintola in the Cathedral of Prato.

(Baldanzi, bibl. 34, pp. 258ff)

252. 1445, after Jan. 7 and shortly before June 1. Doc. 18. The *Operai di S. Giovanni* decide to sell 2,000 florins from the Monte to pay for bronze, expected from Bruges, evidently for Ghiberti's second door.

ASF, Strozz. LI, 1, f. 48 from: *Ricordi Proveditore M, 1444 (1445)-1449*, c. 136 (Brockhaus, bibl. 69, p. 40; Frey, bibl. 532, p. 360, doc. 15, with date of Jan. 3)

253. 1445, May 12. Ghiberti's workshop where the doors are being cast is mentioned as situated near S. Maria Nuova.

ASF, Archivio Notarile S 914, c. 61v f (unpublished, referred to by Baldinucci, bibl. 35, I, p. 371)

254. 1445, after June 1 and shortly before Oct. 7. Doc. 19. 14,623 pounds of bronze are shipped from Bruges and the price of 1,135 florins is deposited in Florence.

ASF, Strozz. LI, 1, f. 48v from: *Ricordi Proveditore M 1444 (1445)-1449*, c. 138 (Frey, bibl. 532, p. 360, doc. 16 with date of Jan. 3)

255. After June 24, 1443; before Aug. 7, 1447 (possibly 1445, see Dig. 254). Doc. 41. Francesco di Papi is commissioned to make the frame of Ghiberti's second door.

ASF, Strozz. LI, 1, f. 81 from: *Libro seconda e terza porta* (Frey, bibl. 532, p. 360, doc. 13, with erroneous date of June 26, 1443)

256. 1446, before May. Ghiberti had accepted together with Bonaiuto di Giovanni the commission for a fresco on the façade of the Bigallo, but it was executed by others.

ASF, Bigallo, vol. DCCLVI, Deb. e cred., 1442-1446, c. 7, 10 (Poggi, bibl. 412, p. 189ff)

257. 1446, June 14. Doc. 116. Ghiberti is rematriculated in the *Arte della Seta*.

ASF, Arti, Seta, vol. 8, Matricola, 1433-1474, c. 133

258. 1447 (after Feb. 28; before March 25). Doc. 85. Ghiberti's tax declaration (*denuncia de'beni*). In addition to his former land holdings, Ghiberti has acquired on Dec 3, 1444, more land at Settimo, on Aug. 15, 1444, a terrain with house in S. Cervazzo di Pelago, and a house with a druggist's shop in Florence as security for the dowry of his daughter-in-law. Vittorio and he have sold an amount of 530 fiorini in the Monte.

ASF, Catasto, 1446, Quart. S. Giov., Gonf. Chiavi, portata, vol. 682, c. 825f

259. 1447, Aug. 7. Docs. 20, 42. The *Arte di Calimala* declares that Ghiberti has finished the ten reliefs of his second door and is to receive the final payment of the agreed amount of 1,200 florins.

ASF, Strozz. LI, 1, f. 49v from: *Ricordi Proveditore M 1444 (1445)-1449*, c. 148 and *LI, 1*, f. 81 from: *Libro seconda e terza porta*

260. 1447, after Aug. 7; before April 22, 1448 (probably 1447). Doc. 21. Tommaso Ghiberti makes two bronze candlesticks, silver plated, for the Baptistery.

ASF, Strozz. LI, 1, f. 49v from: *Ricordi Proveditore M 1444 (1445)-1449*, c. 151 and *ASF, Strozz. LI, 2*, f. 114 from same source with date 1447 (Frey, bibl. 532, p. 370, doc. 43 with date of Aug. 7, 1447)

261. 1447, after Aug. 7; probably before Jan. 24, 1448. Doc. 79. The friezes of Ghiberti's second door are to be recast.

ASF, Strozz. LI, 2, f. 114 from: *Ricordi Proveditore M 1444 (1445)-1448*, c. 151 (Frey, bibl. 532, p. 361, doc. 18, first part, with date of Aug. 7, 1447)

262. 1448, before Jan. 24. Doc. 43. Ghiberti is to receive 125 florins for making the crossbars for his second door.

ASF, Strozz. LI, 1, c. 81 from: *Libro seconda e terza porta* (Frey, bibl. 532, p. 361, doc. 19, with date of Jan. 28)

263. 1448, Jan. 24. Docs. 22, 44. A new agreement is arrived at with Lorenzo and Vittorio Ghiberti regarding the completion of Ghiberti's second door: 24 compartments (*spiaggie*) which have been cast are to be finished and made ready for gilding, each within three and one half months, by a good assistant under Ghiberti's supervision at a cost of 28 florins each. Twenty-four heads are to be modeled,

cast, and finished at a cost of 300 florins; the cornice above the lintel, the threshold, and one of the jambs are to be modeled and cast and one jamb is to be chased at a total cost of 320 florins; 12 compartments (*spiaggie*) each 2⅛ *braccia* long, for the jambs and the architrave are to be modeled and cast with foliage and animals "more beautiful than those on his first door" at a cost of 360 florins. The frieze on the inside of the jambs and the architrave, to be 25½ *braccia* long, is to be chiseled at a cost of 140 florins.

Ghiberti receives 100 florins for having cast the "last (skeleton) frame" of the door.

ASF, Strozz. LI, 1, f. 81, 81v from: *Libro seconda e terza porta* (Frey, bibl. 532, p. 361, doc. 20 under date Jan. 28. Frey assumed erroneously that the agreement of 1448 became active only in 1451, see Dig. 275)

See also in abbreviated form *ASF, Strozz. LI, 1,* f. 49v from: *Ricordi Proveditore M 1444 (1445)-1449,* c. 152, supplemented from *ASF, Strozz. LI, 2, 114* (Frey, bibl. 532, p. 361, doc. 18, with date of Aug. 7, 1447)

264. 1448, Apr. 6. Doc. 95. Payment of up to 30 florins to an unnamed assistant for work on Ghiberti's second door.

ASF, Arti, Calimala, vol. 20, Delib. Cons. 1447 (1448)-1451, c. 12

265. 1448, Apr. 22. Doc. 96. Ghiberti receives 15 florins on behalf of Bernardo di Bartolomeo (Cennini) for work on the door.

ASF, Arti, Calimala, vol. 20, Delib. Cons. 1447 (1448)-1451, c. 14v

266. 1448, May 18. Doc. 97. Ghiberti receives 15 florins for his own work on the bronze door.

ASF, Arti, Calimala, vol. 20, Delib. Cons. 1447 (1448)-1451, c. 16v

267. 1448, July 12. Doc. 98. The stonemason Matteo di Francesco (d'Andrea) da Settignano receives 80 lire as final payment for work on the frame of the Baptistery door.

ASF, Arti, Calimala, vol. 20, Delib. Cons. 1447 (1448)-1451, c. 27v

268. 1448, July 24. Doc. 99. The stonemasons, Simone di Giovanni da Fiesole and Domenico d'Antonio (Salviati) receive final payments of 30 lire each for work on the frame of Ghiberti's second door.

ASF, Arti, Calimala, vol. 20, Delib. Cons. 1447 (1448)-1451, c. 27v

269. 1448, Nov. 15. Doc. 100. The consuls of the *Calimala* discuss the financial difficulties of the *Opera di S. Giovanni:* either work has to be temporarily suspended on Ghiberti's sec-

ond door or the singers have to be discharged. A special committee is elected to seek means to continue work on the door.

ASF, Arti, Calimala, vol. 20, Delib. Cons. 1447 (1448)-1451, c. 37v, 38, 38v

270. 1449, Apr. 28. Doc. 101. Ghiberti receives 25 florins for work on the door.

ASF, Arti, Calimala, vol. 20, Delib. Cons. 1447 (1448)-1451, c. 63v

271. 1449, Apr. 29. Doc. 102. Payment to stonemasons for one month's work on the frame of Ghiberti's second door.

ASF, Arti, Calimala, vol. 20, Delib. Cons. 1447 (1448)-1451, c. 64v (Brockhaus, bibl. 69, p. 42, with erroneous date and page)

272. 1449, Sept. 22. Doc. 89. Ghiberti receives 1000 pounds of wax for work on his second door.

ASF, Arti, Calimala, vol. 17 bis, Petizioni e Deliberazioni, 1422-1518, c. LXXIIIv

273. 1449, Sept. 22. Docs. 90, 91. The stonemasons Matteo di Francesco da Settignano, Simone di Giovanni da Fiesole, and Domenico di Antonio Salviati are rehired by the *Offiziali del Musaico* for the remaining work of chiseling the frame of Ghiberti's second door. Simone receives as payment for work done on the frame 50 lire, and 60 florins (?) credit for future work.

ASF, Arti, Calimala, vol. 17 bis, Petizioni e Deliberazioni 1422-1518, c. LXXIIIv; see also *ASF, Strozz. LI, 1,* f. 206 from: *Delib. Cons. Calimala 1447 (1448)-1451,* c. 73 (Frey, bibl. 532, p. 362, doc. 27, with the date of Sept. 12)

274. 1450, July 30, Sept. 18, Oct. 30, Nov. 27. Payments totaling 14 florins to the firm of Ghiberti and Son for their work on the tabernacle door at S. Egidio.

Arch. S. Maria Nuova, Florence, Quadernuccio di cassa, 1449-1452, c. 30, 36 (Poggi, bibl. 411, pp. 105ff)

275. 1451, Jan. 5 or 16. Docs. 44, last part, and 11. Renewal of the agreement of Jan. 24, 1448 (Dig. 263) with the added obligation that Lorenzo Ghiberti and Vittorio finish within 20 months, starting Feb. 1, 1451, the remainder of the work on the door of the Baptistery, assisted by seven helpers.

ASF, Strozz. LI, 1, f. 81v from: *Libro seconda e terza porta* (Docs. 44 and 11) and *ASF, Strozz. LI, 1,* f. 43 (partly illegible) completed after *BMF, Coll. Gori, A 199 I,* f. 153 from: *Ricordi Proveditore O, 1450-1453,* c. 132

276. 1451, Aug. 14. Doc. 86. Ghiberti's last tax declaration (*denuncia de'beni*). No changes as against 1446.

ASF, Catasto 1451, Quart. S. Giov., Gonf. Chiavi, portata, vol. 718, c. 297; campione vol. 719, c. 515f

277. 1451, Aug. 12. The goldsmith Bernardo di Bartolomeo Cennini works as assistant on the doors of the Baptistery.

ASF, Catasto, 1451, Quart. S. Giov., Gonf. Lion D'Oro, portata, vol. 711, c. 94 (?)

The entry on c. 94, quoted by F. Fantozzi, *Memorie biografiche . . . di Bernardo Cennini*, Florence, 1839, p. 8, has been removed from the volume.

278. 1452, Mar. 19. Doc. 45. The door weights for Ghiberti's second door are commissioned to the locksmith Tinaccio di Piero.

ASF, Strozz. LI, 1, f. 81v from: *Libro seconda e terza porta*. The exact date in: *BMF, Coll. Gori, A 199 I*, f. 139

279. 1452, Apr. 2. Doc. 46. Ghiberti's second door is finished and Lorenzo and Vittorio are commissioned to have it gilded against an advance of 100 florins, on condition that it be finished by June 20.

ASF, Strozz. LI, 1, f. 81v from: *Libro seconda e terza porta*. The exact date in: *BMF, Coll. Gori, A 199 I*, f. 139

280. 1452, June 16. Doc. 47. Ghiberti's second door is declared completely gilded and 884 florins, 99 lire, 8 soldi, 3 denari are paid for gold.

ASF, Strozz. LI, 1, f. 81v, 82 from: *Libro seconda e terza porta*

281. 1452, after Apr. 18, before Aug. 22 (probably June 16). Doc. 12. The *Arte di Calimala* acknowledges that Ghiberti has gilded his second door well.

ASF, Strozz. LI, 1, f. 44v from: *Ricordi Proveditore O, 1450-1453, c. 147*

282. 1452, after Apr. 18, before Aug. 22 (probably after June 16). Doc. 13. Lorenzo and Vittorio Ghiberti are declared to have entirely finished the third door of S. Giovanni.

ASF, Strozz. LI, 1, f. 44v from: *Ricordi Proveditore O, 1450-1453, c. 149* (Frey, bibl. 532, p. 363, doc. 31, with date of April 13); see also *ASF, LI, 2*, f. 113 with summary of this and previous entry.

283. 1452, July 13. Docs. 73, 48. The consuls of the *Calimala* decide to have Ghiberti's second door set up on the east portal facing the Cathedral, "because of its beauty," and to remove his first door to the north portal.

ASF, Strozz. LI, 1, f. 209 from: *Delib. Cons. Calimala, 1451-1454*, c. 17; see also *ASF, Strozz. LI, 1*, f. 82 from: *Libro seconda e terza porta* (Frey, bibl. 532, p. 363, doc. 33, with date of June 16, 1452)

284. 1452, after July 13. Doc. 124. Ghiberti's door is polished and set up by the goldsmith Piero di Donato.

BMF, Coll. Gori, A 199 I, f. 142, from unnamed source, c. 14

285. 1452, Dec. 12-18. Docs. 74, 14. The consuls of the *Calimala* decide to have jambs, threshold, cornice, and architrave made for the frame of Andrea Pisano's door to correspond to the two other doors of the Baptistery.

ASF, Strozz. LI, 1, f. 209v from: *Delib. Cons. Calimala, 1451-1454*, c. 33 (Frey, bibl. 532, p. 363f, doc. 39, erroneously under Ghiberti's second door.) Also *LI, 1*, f. 45 from: *Ricordi Proveditore O, 1450-1453*, c. 154

286. 1425-1452. Doc. 122. Description of Ghiberti's second door; total cost fl.14,594, l. 3, s. 4; list of assistants, among them three not appearing in other documents, Francesco di Nanni Buoni, Cristofano di Francesco, and Giovanni di Giuliano.

BMF, Coll. Gori, A 199 I, f. 33v from: *C. Strozzi, Descrizione dell' . . . S. Giovanni*

287. 1452-1453, after Dec. 12-18; before Feb. 12. Docs. 15, 49. Ghiberti is to be given the house and workshop where the doors had been made, in lieu of his final payment to the amount of 218.3.4 florins.

ASF, Strozz. LI, 1, f. 45 from: *Ricordi Proveditore O, 1450-1453*, c. 155 (Frey, bibl. 532, p. 363, doc. 36, with erroneous date of Aug. 22, 1452); see also *Strozz. LI, 1*, f. 82 from: *Libro seconda e terza porta* where the final credit is given as fl. 270 (Frey, bibl. 532, p. 363, doc. 34, with erroneous date of June 16, 1452)

288. 1453, Feb. 12. Docs. 16, 50. Ghiberti and Vittorio receive the commission for the jambs, architrave, threshold and step for Andrea Pisano's door.

ASF, Strozz. LI, 1, f. 45 from: *Ricordi Proveditore O, 1450-1453*, c. 155; repeated with wrong date Feb. 12, 1454, *LI, 1*, f. 82 from: *Libro seconda e terza porta* (Frey, bibl. 532, p. 364, doc. 40, with erroneous date of June 16, 1452)

289. 1453, Apr. 9-26. Doc. 75. Ghiberti and his son Vittorio are presented with the house

where the doors had been cast in lieu of the final payment due of 250 (!) florins.

ASF, Strozz. LI, 1, f. 210 from: *Delib. Cons. Calimala, 1451-1454,* c. 53

290. 1453, after May 9. Doc. 17. A marble frieze is placed around the east gate of the Baptistery.

ASF, Strozz. LI, 1, f. 45 from: *Ricordi Proveditore O, 1450-1453,* c. 158

291. 1453, May 14-26. Doc. 76. The bronze step is transferred from the east gate to the north gate of the Baptistery.

ASF, Strozz. LI, 1, f. 210 from: *Delib. Cons. Calimala, 1452-1454,* c. 58

292. 1454, after Apr. 23; before Apr. 29, 1456. Doc. 67. The consuls of the *Calimala,* the *Officiali del Musaico* and the *Proveditore delle Porte* block all funds for work on S. Giovanni except for ordinary salaries.

ASF, Strozz. LI, 1, f. 191 from: *Libro di Provisioni 1420-1470,* c. 28

293. 1455, Nov. 26 (?). Ghiberti makes his will with the notary Ser Santi di Domenico Naldi.

(Document lost, after Baldinucci, bibl. 35, p. 351, note 1)

294. 1455, Dec. 1. Ghiberti's death and burial at S. Croce.

(Document lost, after Vasari-Milanesi, bibl. 533, II, p. 249)

295. no date, after 1455. Doc. 57. Vittorio Ghiberti receives permission from the *Calimala* to exchange the estate near Careggi leased to his father.

ASF, Strozz. LI, 1, f. 115v from: *Filza dell'Arte de Mercatanti di Partiti e Deliberazioni de Consoli dall 1425 al 1438* [*sic*]

296. 1456, Apr. 3 and following months. Doc. 77. Vittorio Ghiberti receives various payments for the jambs, threshold, and step of Andrea Pisano's door.

ASF, Strozz. LI, 1, f. 213v from: *Delib. Cons. Calimala, 1455-1459,* c. 16, 17, 19, 32, 42

297. 1457, Feb. 11. Doc. 51. Partial payments, totaling 150 florins, to Vittorio for work on the frame of Andrea's door.

ASF, Strozz. LI, 1, f. 82 from: *Libro seconda e terza porta*

298. 1458, after Nov. 21, through Apr. 1459. Doc. 78. The consuls of the *Calimala* decide to purchase bronze for the jambs of Andrea's door.

ASF, Strozz. LI, 1, c. 217v from: *Delib. Cons. Calimala, 1455-1459,* c. 192, 215, 221, 228 (Frey, bibl. 532, p. 364, doc. 43, with date of Nov. 21, 1458)

299. 1462, after July 5, before Mar. 13, 1464. Doc. 68. The frame of Andrea Pisano's door is acknowledged to have been finished; payment is to be determined with Vittorio for the jambs, architrave, threshold, and so on.

ASF, Strozz. LI, 1, f. 192v from: *Libro Provisioni, 1420-1470,* c. 48 (Frey, bibl. 532, p. 364, doc. 45, with misreadings, date of July 5, 1462, and reference to the *Porta del Paradiso*)

300. 1462 (?)=1463 (?). Doc. 9. Vittorio Ghiberti is to receive a total of 2,591 florins, 15 soldi for the jambs, threshold and other work on the third [*sic*] door of the Baptistery.

ASF, Strozz. LI, 1, f. 10v from: *Libro Grande Calimala F, 1461,* c. 219, 241; correct volume G and year 1462 in: *BMF, Coll. Gori, A 199 I,* f. 153. (Frey, bibl. 532, p. 364, doc. 44, with date of 1461. The entry must follow that of Dig. 299)

301. 1464, before Mar. 13. Doc. 69. The *Proveditori delle Porte* have completed their task and it is decided to dissolve this special committee.

ASF, Strozz. LI, 1, f. 192v from: *Libro Provisioni, 1420-1470,* c. 48 (Frey, bibl. 532, p. 364, doc. 46, with date of July 5, 1462)

302. 1452-1464. Doc. 123. The cost of the frame of Andrea Pisano's doors amounted to 3,351 florins.

BMF, Coll. Gori, A 199 I, f. 34f from: *Carlo Strozzi. Descrizione dell . . . S. Giovanni*

119a. 1425, after June 13.

Lorenzo has been paid by the Opera in Siena lire eight hundred seventy nine, soldi ten, denari four.

ODS Libro Giallo, fol. 76ᵛ. (Transcript of this and other payments for the Siena reliefs, received from Mr. John T. Paoletti. Only this is added since the other documents refer to data already known from other documents or referring to only minor payments.)

179a. 1433, July 6.

Lorenzo is required by the Arte della Lana to provide before August the bronze figure of St. Stephen at Or San Michele with gilded embroidery ("cum brustis aureis").

ASF, Arti Lana, Partiti, Atti, etc., *vol. 168* (May 2-August 31), c. 37 (Krautheimer-Hess, bibl. *31, p. 318, App. B.)

255a. 1445, Sept. 4-Dec. 15.

Payments to Lorenzo Ghiberti, transmitted through various members of the workshop for the casting of parts of the second door, including repairs of furnaces and payments for bronze from Flanders. Tommaso di Lorenzo is frequently mentioned.

Archivio dello Spedale degli Innocenti, Estranei, n. 242, Quaderno di cassa . . . d'Andrea Cambini e compagni, c. 231ᵛ, 236ᵛ, 257ᵛ (Mendes Atanasio, bibl. *2, pp. 97ff., Docs. I, II, III.)

255b. 1445, Dec. 15.

Tommaso Ghiberti and his partner, Matteo di Giovanni, receive final installment on a total payment of fl. 169 for their work on the silver tabernacle of the *dossale* for S. Giovanni.

Archivio dello Spedale degli Innocenti, Estranei, n. 242, Quaderno di cassa . . . d'Andrea Cambini e compagni, c. 257ᵛ (Mendes Atanasio, bibl. *2, p. 102, Docs. III, 7.)

292a. 1455, Jan. 17, Feb. 3, and July 9.

Tommaso Ghiberti is still alive and mentioned in a minor real estate transaction. *Archivio dello Spedale degli Innocenti, Estranei, n. 788. Libro personale di Ricordi di . . . Leonardo Salutati, Vescovo di Fiesole*, c. 36 (Mendes Atanasio, bibl. *2, p. 94 and note 6.)

293a. 1455, Nov. 26.

Lorenzo di Ghiberti names his young granddaughters Fioretta, Andreula, and Angelica, daughters of Vittorio, as heirs. Incomplete entry.

ASF, Archivio notarile, Appendice, vol. 75, Registri dei Testamenti, S. Croce, VI, c. 5 (Krautheimer-Hess, bibl. *31, pp. 314, 317, App. A)

303. 1496, Oct. 5 and 29 (1455, November 26).

Lorenzo Ghiberti's will, excerpted in two arbitrations, mentions as part of his estate, alongside with the house and workshop at S. Maria Nuova, its contents, among them bronze, tools for bronzework, blacksmith work, books, writings, marble and bronze sculptures (*intaglio*), drawings and account books; except these latter, all were left to his grandson Buonaccorso.

ASF, Archivio notarile, A 613, c. 52ff, arbitration of Oct. 5, c. 54ᵛ; *ibid., A 614*, cc. 96ff, second arbitration, Oct. 29, c. 98 (Krautheimer-Hess, bibl. *31, pp. 320, 321, App. D)

According to another source, precious stones, cut and uncut, tools for sculpture, painting, goldsmith work, casting and engineering, belonged to the contents of Lorenzo's shop.

Archivio dello Spedale degli Innocenti, series CXLIV, Estranei, vol. 546, Libro di Ricordanze di Buonaccorso di Vittorio Ghiberti, 1496-1511, c. 7', 8, 8' (Krautheimer-Hess, bibl. *31, p. 319, App. C)

304. 1496, Oct. 30.

Buonaccorso redeems from the pawnbroker a ring belonging to his grandfather Lorenzo, with a cameo, showing a child standing on a running horse, for lire eight, soldi eighteen, denari eight.

Archivio dello Spedale degli Innocenti, series CXLIV, Estranei, vol. 546, Libro di Ricordanze di Buonaccorso di Vittorio Ghiberti, 1496-1511, c. 8ᵛ (Krautheimer-Hess, bibl. *31, p. 319, App. C)

BIBLIOGRAPHY

BIBLIOGRAPHY

1. Accademia della Crusca, *Vocabulario della lingua italiana*, 5th ed., Florence, 1863ff.

2. J. Adhémar, *Influences antiques dans l'art du moyen âge français*, London, 1937.

3. J. B. L. G. Seroux d'Agincourt, *Histoire de l'art par les monumens depuis sa décadence*, Paris, 1823ff.

4. A. M. E. Agnoletti, *Statuto dell'Arte della Lana (R. Deputazione di storia patria per la Toscana, Fonti e studi sulle corporazioni artigiane del medio evo, Fonti I)*, Florence, 1940.

5. L. B. Alberti, *The Architecture of Leon Battista Alberti in Ten Books, Of Painting in Three Books, and Of Statuary in One Book*, transl. J. Leoni, London, 1726.

6. L. B. Alberti, *Della Architettura, della pittura e della statua*, tr. Cosimo Bartoli (1st ed. 1550), Bologna, 1782.

7. L. B. Alberti, *Leonis Baptistae Alberti Opera inedita . . .*, ed. G. Mancini, Florence, 1890.

8. L. B. Alberti, *Leone Battista Alberti's Kleinere Kunsttheoretische Schriften (Della Pittura libri tre; De statua; I cinque ordini Architettonici)*, ed. H. Janitschek (*Quellenschriften für Kunstgeschichte*, ed. R. Eitelberger von Edelberg, XI), Vienna, 1877.

9. L. B. Alberti, *Opere volgari*, ed. A. Bonucci, Florence, 1843ff.

10. L. B. Alberti, *De Pictura*, in: M. Vitruvius Pollio, *De architectura*, Amsterdam, 1649, pp. 165ff.

11. L. B. Alberti, *De Re Aedificatoria*, Florence, 1485.

12. L. B. Alberti, *Zehn Bücher über die Baukunst*, ed. M. Theuer, Vienna, 1912.

13. F. Albertini, *Memoriale di molte statue et picture sono nella inclyta cipta di Florentia*, Florence, 1510; facsimile ed. H. Horne, London, 1909.

14. (R. degli Albizzi), *Commissioni di Rinaldo degli Albizzi. . . . (Documenti di Storia Italiana, I-III)*, Florence, 1867ff.

15. B. Albrecht, *Die erste Tür Lorenzo Ghibertis am Florentiner Baptisterium*, Diss. Heidelberg, 1950 (typescript).

16. U. Aldrovrandi, *(Le statue antiche di Roma)*, reprinted in: S. Reinach, *L'album de Pierre Jacques*, Paris, 1902, pp. 23ff.

17. D. C. Allen, *The Legend of Noah (Illinois Studies in Language and Literature*, XXXIII, 1949, 3-4), Urbana, Illinois.

18. B. Altaner, *Patrologie*, Freiburg/Br., 1938.

19. W. Amelung, *Führer durch die Antiken in Florenz*, Munich, 1897.

20. W. Amelung, *Die Skulpturen des Vatikanischen Museums, s. l.*, 1903ff.

21. (Amsterdam) *Rijksmuseum Amsterdam, Bourgondische Pracht*, Amsterdam (1951).

22. (Anonimo Magliabecchiano), *Il Codice Magliabecchiano, cl. XVII, 17*, ed. K. Frey, Berlin, 1892.

23. G. C. Argan, "The Architecture of Brunelleschi and the Origins of Perspective Theory in the Fifteenth Century," *Journal of the Warburg and Courtauld Institutes*, IX (1946), pp. 96ff.

24. P. Arndt, W. Amelung and others, *Photographische Einzelaufnahmen*, Munich, 1893ff.

25. A. Aruch, "Il ricorso di Lorenzo Ghiberti contra la prima sentenza della Signoria Fiorentina (17 April 1444)," *Rivista d'Arte*, X (1917-18), pp. 117ff.

26. B. Ashmole, *A Catalogue of the Ancient Marbles at Ince Blundell Hall*, Oxford, 1926.

27. A. Avogadrio (Albertus Advogadrius), *De Religione et magnificentia Cosimi Medices Florentini (ca. 1455)* in: G. Lami, *Deliciae eruditorum*, XII, Florence, 1742, pp. 117ff.

28. E. B(abelon), *Le Cabinet des Medailles et Antiques de la Bibliothèque Nationale, Notice historique et guide des visiteurs, I, Les antiques et les objets d'art*, Paris, 1924.

29. E. Babelon and J. A. Blanchet, *Catalogue des Bronzes Antiques de la Bibliothèque Nationale*, Paris, 1895.

30. P. Bacci, *Francesco di Valdambrino*, Siena, 1936.

31. P. Bacci, *Jacopo della Quercia*, Siena, 1929.

32. P. Bacci, *Gli orafi fiorentini e il 2° riordinamento dell'altare di S. Jacopo . . .*, (Pistoia, 1905).

33. C. C. Bailey, "Petrarch, Charles IV and the Renovatio Imperii," *Speculum*, XVII (1942), pp. 323ff.

34. (F. Baldanzi), *Della chiesa cattedrale di Prato*, Prato, 1846.

35. F. Baldinucci, *Notizie dei Professori del Disegno . . .*, Florence, 1845ff (first published 1681).

36. F. Baldinucci, *Vita di Filippo Brunellesco*, ed. D. Moreni, Florence, 1812.

37. A. M. Bandini, *Catalogus Codicum Latinorum Bibliothecae Mediceae-Laurentianae*, II, Florence, 1775.

38. H. Baron, *Leonardo Bruni Aretino (Quel-*

len zur Geistesgeschichte des Mittelalters und der Renaissance, I), Leipzig, 1928.

39. H. Baron, "A Struggle for Liberty in the Renaissance . . . ," *American Historical Review*, LVIII (1953), pp. 265ff.

40. C. Baroni, *Scultura gotica lombarda*, Milan, 1944.

41. A. Bartoli, *I Monumenti antichi di Roma nei disegni degli Uffizi di Firenze*, Rome, 1914ff.

42. P. S. Bartoli and G. P. Bellori, *Admiranda Romanarum Antiquitatum . . . Vestigia*, Rome, 1693.

43. G. Beani, *L'Altare di Sant' Jacopo Apostolo nella Città di Pistoia*, Pistoia, 1899.

44. G. B. Befani, *Memorie storiche . . . di San Giovanni Battista . . .* , Florence, 1884.

45. B. Berenson, *Italian Pictures of the Renaissance*, Oxford, 1932.

46. B. Berenson, *The Drawings of the Florentine Painters*, Chicago, 1938.

47. E. Berger, *Quellen und Technik der Fresko- Oel- und Temperamalerei des Mittelalters*, Munich, 1912.

48. J. J. Bernoulli, *Griechische Ikonographie*, Munich, 1901.

49. L. Bertalot, "Zwölf Briefe des Ambrogio Traversari," *Römische Quartalschrift*, XXIX (1915), pp. *91ff.

50. E. Bertaux, "La Renaissance en Espagne et en Portugal," in: A. Michel, *Histoire de l'art*, Paris, 1905ff, IV, pp. 817ff.

51. M. Bieber, *Die antiken Skulpturen und Bronzen des . . . Museum Fridericianum in Cassel*, Marburg, 1915.

52. (A. Billi), *Il libro di Antonio Billi*, ed. K. Frey, Berlin, 1892.

53. F. Biondo, *Blondi Flavii Foriulensis De Roma Instaurata libri tres . . . de Italia Illustrata opus . . .* , Venice, 1510.

54. Vespasiano da Bisticci, *Vite di uomini illustri . . .* , ed. A. Mai and A. Bartoli, Florence, 1859.

55. P. H. von Blanckenhagen, *"Flavische Architektur und ihre Dekoration, untersucht am Nervaforum*, Berlin, 1940.

56. F. Bocchi, *Le Bellezze della città di Fiorenza* (first ed. Florence, 1591), ed. M. G. Cinelli, Florence, 1677.

57. W. Bode, *Bertoldo und Lorenzo di Medici*, Freiburg/Br., 1925.

58. W. Bode, "Lorenzo Ghiberti als führender Meister unter den Florentiner Tonbildnern," *Jahrbuch der Preussischen Kunstsammlungen*, XXXV (1914), pp. 71ff.

59. W. Bode, "Ghiberti's Versuche seine Tonbildwerke zu glasieren," *Jahrbuch der Preussischen Kunstsammlungen*, XLII (1921), pp. 51ff.

60. H. Bodmer, "Una scuola di scultura fiorentina nel Trecento," *Dedalo*, X (1929-30), pp. 616ff.

61. E. Boehringer, *Der Caesar von Arcireale*, Stuttgart, 1933.

62. D. Boninsegni, *Storie della Città di Firenze dal . . . 1410 al 1460*, Florence, 1737.

63. J. Borghesi and L. Banchi, *Nuovi documenti per la storia dell'arte senese*, Siena, 1898.

64. G. G. Bottari and St. Ticozzi, *Raccolta di lettere sulla Pittura, Scultura ed Architettura*, Milan, 1822ff.

65. H. Bouchot, *Les réliures d'art à la Bibliothéque Nationale*, Paris, 1888.

66. J. Breck and M. R. Rogers, *The Metropolitan Museum of Art, The Pierpont Morgan Wing*, New York, 1929.

67. O. Brendel, "Symbolik der Kugel," *Archaeologisches Institut des Deutschen Reiches, Roemische Mitteilungen*, LI (1936), pp. 1ff.

68. (H. Brockhaus), Summary of a lecture, *Kunstchronik*, N. F., XVII (1905-06), col. 22. See also *Jahresbericht des Kunsthistorischen Instituts in Florenz*, 1905-06, p. 8.

69. H. Brockhaus, *Forschungen über Florentiner Kunstwerke*, Leipzig, 1902.

70. Ch. de Brosses, *Le président de Brosses en Italie*, Paris, 1858.

71. R. Bruck, *Die Malereien in den Handschriften des Königreichs Sachsen*, Dresden, 1906.

72. G. Brunetti, "Giovanni d'Ambrogio," *Rivista d'arte*, XIV (1932), pp. 1ff.

73. G. Brunetti, "Un opera sconosciuta di Nanni di Banco . . . ," *Rivista d'arte*, XII (1930), pp. 229ff.

74. G. Brunetti, "Ricerche su Nanni di Bartolo 'Il Rosso,'" *Bolletino d'arte*, XXVIII (1934-35), pp. 258ff.

75. G. Brunetti, "Jacopo della Quercia a Firenze," *Belle arti* (1951), pp. 3ff.

76. G. Brunetti, "Jacopo della Quercia and the Porta della Mandorla," *Art Quarterly*, XV (1952), pp. 119ff.

77. Leonardo Bruni, *Commentarii rerum suo tempore gestarum*, in: Muratori, bibl. 345, XIX, 1731, pp. 913ff.

78. Leonardo Bruni, *Epistolarum Libri VIII*, ed. L. Mehus, Florence, 1741.

79. Leonardo Bruni, *La prima guerra punica*, ed. A. Ceruti (*Scelta di curiosità letterarie* 165), Bologna, 1878.

80. H. Bulle, *Der Schoene Mensch im Altertum*, Munich, 1912.

81. M. Schild Bunim, *Space in Mediaeval Painting and the Forerunners of Perspective*, New York, 1940.

82. J. C. Burckhardt, *Der Cicerone . . .* (Basel,

1855), *Neudruck der Urausgabe*, Leipzig, 1930.

83. M. Cagiano de Azevado, *Le Antichità di Villa Medici*, Rome, 1951.

84. A. Callegari, *Il Museo Nazionale Atestino in Este (Itinerari dei musei e monumenti d'Italia, 59)*, Rome, 1937.

85. Giovanni Cambi Importuni, *Istorie di Giovanni Cambi*, ed. Ildefonso di San Luigi (*Delizie degli Eruditi Toscani*, XX-XXIII) Florence, 1785ff.

86. E. Carli, "Niccolo di Guardiagrele e il Ghiberti," *L'Arte*, XLII (1939), pp. 144, 222.

87. (E. Carli), *Capolavori d'arte senese*, Florence, 1946.

88. G. Carocci, "Le porte del Battistero di Firenze e l'ornamento imitato della natura," *Arte italiana decorativa e industriale*, V (1896), pp. 69ff.

89. U. Cassuto, *Gli ebrei a Firenze nell' età del rinascimento (Pubblicazioni del R. Istituto di Studi Superiori di Filosofia e Filologia, 40)*, 1918.

90. A. Castiglioni, "Il trattato dell'ottica di Lorenzo Ghiberti," *Rivista di Storia Critica delle Scienze Mediche e Naturali*, XII (1921), pp. 51ff.

91. C. J. Cavallucci, *S. Maria del Fiore . . .* , Florence, 1887.

92. Benvenuto Cellini, *I Trattati dell'oreficeria e della scultura*, ed. C. Milanesi, Florence, 1857.

93. Cennino d'Andrea Cennini, *Il libro dell' arte*, ed. D. V. Thompson, New Haven, 1932f.

94. A. Chastel, "La Rencontre de Salomon et de la Reine de Saba dans l'iconographie médiévale," *Gazette des Beaux-Arts*, XXXV (1949), pp. 99ff.

95. A. Chiapelli, "Della vita di Filippo Brunelleschi attribuita a Antonio Manetti," *Archivio storico italiano*, ser. 5, XVII (1896), pp. 241ff.

96. A. Chiapelli, "Due sculture ignote di Filippo Brunelleschi," *Rivista d'Italia*, II (1899), pp. 454ff.

97. L. Chiovenda, *Die Zeichnungen Petrarcas*, Diss. Frankfurt/Main, 1929. Reprint from *Archivum Romanicum* XVI (1933), pp. 1ff.

98. S. Ciampi, *Notizie inedite della Sagrestia Pistoiese*, Florence, 1810.

99. L. Cicognara, *Storia della scultura*, Prato, 1823.

100. (Sir) Kenneth M. Clark, "Architectural Backgrounds in XVth Century Italian Painting," *The Arts*, 1946-1947, I, pp. 13ff; II, pp. 33ff.

101. (Sir) Kenneth M. Clark, "An Early Quattrocento Triptych from Santa Maria Maggiore in Rome," *Burlington Magazine*, 93 (1951), pp. 338ff.

102. (Sir) Kenneth M. Clark, "Leon Battista Alberti on Painting," *British Academy Proceedings*, XXX (1944), pp. 283ff.

103. (Cleveland), *The Collection Holden*, Cleveland, 1917.

104. A. M. Colini, *Storia e topografia del Celio nell' antichità (Accademia Romana di Archeologia, Memorie, VII)*, Rome, 1944.

105. Bartolomeo del Corazza, "Diario fiorentino . . . (1405-1438)," ed. G. O. Corazzini, *Archivio storico italiano*, ser. 5, XIV (1894), pp. 233ff.

106. H. Cornell, *Biblia Pauperum*, Stockholm, 1925.

107. H. Cornell, *The Iconography of the Nativity of Christ*, Uppsala, 1924.

108. A. Corsano, *Il pensiero religioso italiano*, Bari, 1937.

109. R. Corwegh, "Der Verfasser des Kleinen Codex Ghiberti's," *Mitteilungen des Kunsthistorischen Instituts Florenz*, I (1910), pp. 156ff.

110. "L. Curtius, Der Geist der roemischen Kunst," *Die Antike*, V (1929), pp. 187ff.

111. L. Curtius, "Ikonographische Beitraege zum Portrait der Römischen Republik . . . ," *Archaeologisches Institut des Deutschen Reiches, Roemische Mitteilungen*, XLVII (1932), pp. 202ff.

112. O. M. Dalton, *The Royal Cup in the British Museum*, London, 1924.

113. (O. M. Dalton), *British Museum, A Guide to the Medieval Antiquities*, London, 1924.

114. Dante Alighieri, *Le Opere*, ed. E. Moore and P. Toynbee, Oxford, 1924.

115. A. Darcel, *Musée National du Louvre, Notice des émaux et de l'orfèvrerie*, Paris, 1891, *Supplément* (E. Molinier).

116. G. Dati, *Il libro segreto di Gregorio Dati*, ed. C. Gargiolli (*Scelta di curiosità letterarie*, 102), Bologna, 1869.

117. St. Davari, "Ancora della chiesa di S. Sebastiano in Mantova . . . ," *Rassegna d'arte*, I (1901), pp. 95ff.

118. R. Davidsohn, *Forschungen zur Geschichte von Florenz*, Berlin, 1896ff.

119. M. Davies, "Lorenzo Monaco's 'Coronation of the Virgin' in London," *Critica d'arte*, VIII (1949), pp. 202ff.

120. B. Degenhart, "Michele di Giovanni di Bartolo: Disegni dall'antico e il camino 'della Iole,'" *Bolletino d'arte*, XXXV (1950), pp. 208ff.

121. B. Degenhart, "Le quattro tavole della leggenda di S. Benedetto," *Arte veneta*, III (1949), pp. 6ff.

122. B. Degenhart, *Pisanello* (Turin, 1945).

123. B. Degenhart, "Unbekannte Zeichnungen Francesco di Giorgio's," *Zeitschrift für Kunstgeschichte*, VIII (1939), pp. 117ff.

124. G. Dehio, "Das Bauprojekt Nikolaus' V und L. B. Alberti," (1886), *Kunsthistorische Aufsätze*, Munich and Berlin, 1914, pp. 163ff.

125. G. B. De Rossi, "Sull' archeologia nel secolo decimo quarto," *Bulletino di corrispondenza archeologica*, 1871, pp. 3ff.

126. E. DeWald, "Pietro Lorenzetti," *Art Studies*, VII (1929), pp. 131ff.

127. A. Dini-Traversari, *Ambrogio Traversari e i suoi tempi* (Florence, 1912).

128. Diodorus Siculus, *Diodorus of Sicily*, ed. C. H. Oldfather (*Loeb Classical Library*), London, 1933ff.

129. F. L. Dionigi (P. L. Dionysius), *Sacrarum Vaticanae Basilicae . . . Monumenta*, Rome, 1773.

130. Dionysius of Halicarnassus, *The Roman Antiquities of Dionysius of Halicarnassus*, ed. E. Cary (*Loeb Classical Library*), Cambridge, Mass. and London, 1937ff.

131. G. ten Doesschate, *De deerde commentaar van Lorenzo Ghiberti*, Diss. Utrecht, 1940.

132. Frater Dominicus Joannis, O. P., *Theotocon*, in: G. Lami, *Deliciae eruditorum*, XII, Florence, 1742, pp. 49ff.

133. A. Doren, *Das Aktenbuch für Ghiberti's Matthäusstatue an Or S. Michele zu Florenz (Kunsthistorisches Institut in Florenz, Italienische Forschungen I)*, Berlin, 1906, pp. 1ff.

134. A. Doren, *Italienische Wirtschaftsgeschichte*, I, Jena, 1934 (all published).

135. A. Doren, *Studien aus der Florentiner Wirtschaftsgeschichte*: I, *Die Florentiner Wollentuchindustrie*, Stuttgart, 1901; II, *Das Florentiner Zunftwesen*, Stuttgart and Berlin, 1908.

136. H. Duetschke, *Antike Bildwerke in Oberitalien*, Leipzig, 1874ff.

137. P. Durrieu, "Jacques Coene, peintre de Bruges . . . ," *Les Arts anciens de Flandre*, II (1905), pp. 5ff.

138. P. Durrieu, "Michele di Besozzo et les relations entre l'art italienne et l'art française," *Mémoires de l'Académie des Inscriptions et Belles-Lettres*, XXXVIII, 2 (1911), pp. 365ff.

139. H. Egger (C. Hülsen, A. Michaelis), *Codex Escurialensis. . . . (Oesterreichisches Archäologisches Institut . . . Sonderschriften*, IV), Vienna, 1905-1906.

140. R. Ernst and E. von Garger, *Die früh- und hochgotische Plastik des Stefansdom*, Munich, 1927.

141. C. C. Van Essen, "Elementi etruschi nel rinascimento toscano," *Studi etruschi*, XIII (1939), pp. 497ff.

142. C. Eubel, *Hierarchia Catholica Medii Aevi*, Regensburg, 1913.

143. Pamphilus Eusebius, *Eusebii Pamphilii Canon Chronicus interprete S. Hieronymo*, in: Migne, *bibl.* 333, cols. 259ff.

144. J. Evans, "The Duke of Orleans' Reliquary of the Holy Thorn," *Burlington Magazine*, LXXVIII (1941), pp. 196ff.

145. C. von Fabriczy, "Michelozzo di Bartolomeo," *Jahrbuch der Preussischen Kunstsammlungen*, XXV (1904), *Beiheft*, pp. 34ff.

146. C. von Fabriczy, "Neues Zum Leben und Werke des Niccolo d'Arezzo, III," *Repertorium für Kunstwissenschaft*, XXV (1902), pp. 157ff.

147. C. von Fabriczy, "Donatello's Hl. Ludwig . . . ," *Jahrbuch der Preussischen Kunstsammlungen*, XXI (1900), pp. 242ff.

148. C. von Fabriczy, *Filippo Brunelleschi*, Stuttgart, 1892.

149. C. von Fabriczy, "Kritisches Verzeichnis der toskanischen Holz-und Tonstatuen . . . ," *Jahrbuch der Preussischen Kunstsammlungen*, XXX, *Beiheft*, 1909, pp. 1ff.

150. S. L. Faison, Jr., "Barna and Bartolo di Fredi," *Art Bulletin*, XIV (1932), pp. 285ff.

151. I. Falk, *Studien zu Andrea Pisano*, Diss. Zürich, Hamburg, 1940.

152. I. Falk and J. Lanyi, "The Genesis of Andrea Pisano's Bronze Doors," *Art Bulletin*, XXV (1943), pp. 132ff.

153. A. Fanfani, *Città di Castello, guida storico–artistica*, Città di Castello, 1927.

154. L. de Farcy, *Histoire et description des tapisseries de la Cathédrale d'Angers*, Angers, n. d. (*ca.* 1880).

155. V. Fasolo, "Riflessi Brunelleschiani nelle architetture dei pittori," *Atti del Iº Congresso di Storia dell'Architettura*, 1936, pp. 197ff.

156. Bartolommeo Fazio (Bartolomeus Fazius), *De Viris Illustribus*, ed. L. Mehus, Florence, 1745.

157. E. Feinblatt, "Un sarcofago Romano inedito nel Museo di Los Angeles," *Bolletino d'arte*, XXXVIII (1952), pp. 193ff.

158. Antonio Averlino Filarete, *Tractat über die Baukunst . . . ,* ed. W. von Oettingen (*Quellenschriften für Kunstgeschichte, N. F.*, III), Vienna, 1896.

159. G. Fiocco, "Michele da Firenze," *Dedalo*, XII (1932), pp. 542ff.

160. G. Fiocco, "I Lamberti a Venezia," *Dedalo*, VIII (1927-28), pp. 287ff, 343ff, 432ff.

161. G. Firestone, "The Iconography of the Annunciation in Florentine Painting of the

Third Quarter of the XVth Century," M.A. thesis, Institute of Fine Arts, New York University, 1939 (typescript).

162. V. Follini, *Lezione . . . letta all' adunanza dell'Accademia della Crusca . . . 13 Gennaio 1824*, Florence, 1824.

163. Agostino Fortunio, *Historiarum Camaldolensium Libri Tres*, Florence, 1575.

164. P. Franceschini, *L'oratorio di S. Michele in Orto in Firenze*, Florence, 1892.

165. M. Frankenburger, "Zur Geschichte des Ingolstädter und Landshuter Herzogs-Schatzes," *Repertorium für Kunstwissenschaft*, XLIV (1923), pp. 24ff.

166. G. de Francovich, "Appunti su Donatello e Jacopo della Quercia," *Bolletino d'arte*, IX (1929-30), pp. 145ff.

167. L. Freund, "Studien zur Bildgeschichte der Sibyllen," Diss. Hamburg, 1936.

168. B. Friedmann, "Ghiberti's Verhaeltnis zur Gothik und Renaissance," Diss. Bern, Vienna, 1913.

169. Andrea Fulvio, *L'Antichità di Roma*, Rome, 1588.

170. E. von Garger, *Die Reliefs an den Fürstentoren des Stefansdom*, Vienna, 1926.

171. E. von Garger, "Zwei gotische Statuen in Klosterneuburg," *Kunst und Kunsthandwerk*, XXIV (1921), pp. 106ff.

172. Pomponius Gauricus, *De sculptura seu statuaria libellus . . .*, Antwerp, 1528.

173. G. Gaye, *Carteggio inedito d'artisti . . . Documenti di Storia Italiana*, Florence, 1839.

174. G. Gaye, "Die Bronzetueren des Lorenzo Ghiberti," in: A. Reumont's *Italien*, II, 1840, p. 273.

175. G. B. Gelli, *Vite d'artisti*, ed. G. Mancini, *Archivio Storico Italiano*, ser. IV, XVII (1896), pp. 32ff.

176. M. L. Gengaro, "Precisazioni su Ghiberti architetto," *L'Arte*, XLI (1938), pp. 280ff.

177. Lorenzo Ghiberti, *I Commentarii*, R. Università di Firenze, Facoltà di Magistero, Gruppo rionale fascista, Corso di storia dell'arte, Anno 1939-40, Florence, 1940.

178. Lorenzo Ghiberti, *Lorenzo Ghiberti's Denkwuerdigkeiten (I Commentarii)*, 2 vols., ed. J. von Schlosser, Berlin, 1912.

179. Lorenzo Ghiberti, *I Commentarii*, ed. O. Morisani, Naples, 1947.

180. C. Gilbert, "Alberti and Pino," *Marsyas*, III (1946), pp. 87ff.

181. P. Ginori-Conti, "Un libro di ricordi . . . di Lorenzo e Vittorio Ghiberti," *Rivista d'Arte*, XX (1938), pp. 290ff.

182. O. Giustiniani (Horatius Justinianus), *Acta Sacra Oecumenici Concilii Florentini*, Rome, 1638.

183. (V. Giustiniani), *Galleria Giustiniani del Marchese Vincenzo Giustiniani*, Rome, 1631.

184. C. Gnudi, "Jacobello e Pietro Paolo di Venezia," *Critica d'arte*, II (1937), pp. 26ff.

185. C. Gnudi, "Nuovi appunti sui fratelli dalle Masegne," *Proporzioni*, III (1950), pp. 48ff.

186. L. Goldscheider, *Lorenzo Ghiberti*, London, 1949.

187. R. Goldwater and M. Treves, *Artists on Art*, New York, 1945.

188. H. Gollob, *Lorenzo Ghiberti's kuenstlerischer Werdegang*, Strasbourg, 1929.

189. E. Gombrich, "Botticelli's Mythologies," *Journal of the Warburg and Courtauld Institutes*, VIII (1945), pp. 7ff.

190. G. Gonelli, *Elogio di Lorenzo Ghiberti*, Florence, 1822.

191. A. F. Gori, *Inscriptionum Antiquarum Graecarum et Romanarum Pars tertia*, Florence, 1743.

192. C. Grayson, "Notes on the texts of some vernacular works of Leone Battista Alberti," *Rinascimento*, III (1952), pp. 211ff.

193. G. Gronau, "Notizie inedite su due bronzi del Museo Nazionale di Firenze," *Rivista d'arte*, V (1907), pp. 118ff.

194. H. Gronau, "The earliest works of Lorenzo Monaco," *Burlington Magazine*, XCII (1950), pp. 183ff, 217ff.

195. A. Gruenwald, "Ueber einige Werke Michelangelo's," *Jahrbuch der Kunsthistorischen Sammlungen des Allerhoechsten Kaiserhauses*, XXVII (1907-09), pp. 125ff.

196. M. A. Gualandi, *Memorie originali italiane risguardanti le belle arti*, ser. IV, Bologna, 1843.

197. Guarino Veronese, *Epistolario di Guarino Veronese*, ed. R. Sabbadini, I-III (*Miscellanea di Storia Veneta*, ed. R. Deputazione Veneta di Storia Patria, ser. 3, VIII, XI, XIV), Venice, 1915ff.

198. C. Guasti, *La cupola di S. Maria del Fiore*, Florence, 1857.

199. C. Guasti, *Santa Maria del Fiore*, Florence, 1887.

200. P. Gusman, *L'art décoratif de Rome*, Paris (1908ff).

201. C. S. Gutkind, "Poggio Bracciolini's geistige Entwicklung," *Deutsche Vierteljahrsschrift für Geistesgeschichte*, X (1932), pp. 548ff.

202. W. Haftmann, "Italienische Goldschmiedearbeiten," *Pantheon*, XXIII (1939), pp. 29ff, 54ff.

203. W. Haftmann, "Ein Mosaik der Ghirlandajo-Werkstatt aus dem Besitz des Lorenzo Magnifico," *Mitteilungen des Kunst-*

historischen Instituts in Florenz, VI (1940), pp. 98ff.

204. A. Hagen, *Lorenzo Ghiberti, Cronaca del Secolo XV* (first published 1831), Italian translation, Florence, 1845.

205. P. G. Hamberg, *Studies in Roman Imperial Art*, Copenhagen, 1945.

206. G. M. A. Hanfmann, *The Season Sarcophagus in Dumbarton Oaks*, Cambridge, Mass., 1951 (1952).

207. J. Havard, *Histoire de l'Orfèvrerie française*, Paris, 1896.

208. W. S. Heckscher, review of Salis, bibl. 459, *American Journal of Archaeology*, LII (1948), pp. 421ff.

209. F. Hermanin, "Gli affreschi di Pietro Cavallino a Santa Cecilia in Trastevere," *Le Gallerie italiana*, V (1902), pp. 6ff.

210. H. J. Hermann, *Die italienischen Handschriften des Ducento und Trecento der Wiener Nationalbibliothek (Beschreibendes Verzeichnis der . . . Handschriften in Oesterreich*, VIII, 5), Leipzig, 1930.

211. L. H. Heydenreich, "Spaetwerke Brunelleschi's," *Jahrbuch der Preussischen Kunstsammlungen*, LII (1931), pp. 1ff.

212. (Sir) George F. Hill, "Some Drawings from the Antique attributed to Pisanello," *Papers of the British School at Rome*, III (1906), pp. 297ff.

213. A. M. Hind, *Early Italian Engraving*, New York and London, 1938.

214. G. Hoffmann, S.J., *Epistolae Pontificiae ad Concilium Florentinum spectantes*, Rome, 1940.

215. G. Hoffmann, S.J., "Die Konzilsarbeit im Ferrara," *Orientalia Christiana Periodica*, III (1937), pp. 110ff, 403ff.

216. G. Hoffmann, S.J., "Die Konzilsarbeit in Florenz," *Orientalia Christiana Periodica*, IV (1938), pp. 157ff, 372ff.

217. P. Hoffmann, *Studien zu Leone Baptista Alberti's . . . De Re Aedificatoria*, Diss. Leipzig, Frankenberg, i. S., 1883.

218. E. G. Holt, *Literary Sources of Art History*, Princeton, 1947.

219. W. Horn, "Das Florentiner Baptisterium," *Mitteilungen des Kunsthistorischen Instituts in Florenz*, V (1938), pp. 100ff.

220. H. Horne, "Andrea dal Castagno," *Burlington Magazine*, VII (1905), pp. 66ff, 222ff.

221. H. Horne, "An Account of Rome in 1450," *Revue Archéologique*, ser. 4, X (1907), pp. 82ff.

222. G. Huard, "Saint Louis et la reine Marguerite," *Gazette des Beaux-Arts*, LXXIV (1932), pp. 375ff.

223. G. Huizinga, *The Waning of the Middle Ages*, London, 1924.

224. P. G. Huebner, "Studien ueber die Benutzung der Antike in der Renaissance," *Monatshefte für Kunstwissenschaft*, II (1909), pp. 267ff.

225. C. Hülsen, *Das Skizzenbuch des Giovanantonio Dosio*, Berlin, 1933.

226. C. Hülsen und H. Egger, *Die römischen Skizzenbücher von Martin van Heemskerk*, Berlin, 1916.

227. C.-A. Isermeyer, *Rahmengliederung und Bildfolge in der Florentiner Malerei des 14. Jahrhunderts*, Diss. Goettingen, Würzburg, 1937.

228. W. M. Ivins, *On the Rationalization of Sight . . .* , New York, 1938.

229. O. Jahn, "Über die Zeichnungen antiker Monumente im Codex Pighianus," *Berichte der Sächsischen Gesellschaft der Wissenschaften*, XX (1868), pp. 161ff.

230. M. R. James, *Illustrations of the Book of Genesis . . . facs. of the Ms. Brit. Mus. Egerton 1894 (Roxburghe Club*, 177), Oxford, 1921.

231. S. Jansen, "Iconography of the Meeting of Solomon and the Queen of Sheba," M.A. thesis, Institute of Fine Arts, New York University, 1934 (typescript).

232. H. W. Janson, "The Sculptured Works of Michelozzo di Bartolommeo," Ph.D. thesis, Harvard University, Cambridge, Mass., 1941 (typescript).

233. John of Salisbury, *Joannis Sarisberiensis Historiae quae supersunt*, ed. R. L. Poole, Oxford, 1927.

234. H. S. Jones, *A catalogue of the ancient sculptures in the municipal collections of Rome*: I, *The sculptures of the Museo Capitolino*, Oxford, 1912; II, *The sculptures of the Palazzo dei Conservatori*, Oxford, 1926.

235. H. S. Jones, "Notes on Roman Historical Sculptures," *Papers of the British School at Rome*, III (1905), pp. 213ff.

236. R. Jones and B. Berenson, *Speculum Humanae Salvationis*, Oxford, 1926.

237. H. Kauffmann, *Donatello, eine Einfuehrung in sein Bilden und Denken*, Berlin, 1935.

238. H. Kauffmann, "Florentiner Domplastik," *Jahrbuch der Preussischen Kunstsammlungen*, XLVII (1926), pp. 141ff, 216ff.

239. H. Kauffmann, "Eine Ghibertizeichnung im Louvre," *Jahrbuch der Preussischen Kunstsammlungen*, L (1929), pp. 1ff.

240. H. Keller, "Die Entstehung des Bildnisses am Ende des Hochmittelalters," *Römisches Jahrbuch für Kunstgeschichte*, III (1939), pp. 227ff.

241. R. W. Kennedy, *The Renaissance Painter's Garden*, New York, 1948.

242. G. J. Kern, "Das Dreifaltigkeitsfresko von S. Maria Novella," *Jahrbuch der Preussischen Kunstsammlungen*, XXXIV (1913), pp. 36ff.

243. F. Kimball, "Luciano Laurana and the High Renaissance," *Art Bulletin*, X (1927-28), pp. 125ff.

244. A. Kleinclausz, "Les peintres des Ducs de Bourgogne," *Revue de l'art ancien et modern*, XX (1906), pp. 161ff, 253ff.

245. H. Kohlhausen, *Gotisches Kunstgewerbe*, in: H. T. Bossert, *Geschichte des Kunstgewerbes*, V, Berlin, 1932, pp. 367ff.

246. R. Krautheimer, "Ghiberti," in: *Les sculpteurs célèbres*, ed. P. Francastel, Paris, 1954, pp. 212ff.

247. R. Krautheimer, "Ghiberti and Master Gusmin," *Art Bulletin*, XXIX (1947), pp. 25ff.

248. R. Krautheimer, "Ghiberti architetto," *Allen Memorial Art Museum, Oberlin College, Bulletin*, XII (1955), pp. 48ff.

249. R. Krautheimer, "Ghibertiana," *Burlington Magazine*, LXXI (1937), pp. 68ff.

250. R. Krautheimer, "Santo Stefano Rotondo a Roma e la Chiesa del Santo Sepolcro . . . ," *Rivista di archeologia cristiana*, XII (1935), pp. 51ff.

251. R. Krautheimer, "The Tragic and Comic Scene of the Renaissance: The Baltimore and Urbino Panels," *Gazette des Beaux-Arts*, XXXIII (1948), pp. 327ff.

252. R. Krautheimer, "Zur Venezianischen Trecentoplastik," *Marburger Jahrbuch für Kunstwissenschaft*, V (1929), pp. 94ff.

253. T. Krautheimer-Hess, review of R. S. Loomis, *Arthurian Legends in Medieval Art*, in: *Art Bulletin*, XXIV (1942), pp. 102ff.

254. E. Kris, *Meister und Meisterwerke der Steinschneidekunst in der italienischen Renaissance*, Vienna, 1929.

255. P. Kristeller, "Un ricordo della gara per le porte del Battistero di Firenze . . . ," *Bolletino d'arte*, IV (1910), pp. 297ff.

256. J. Labarte, *Histoire des arts industriels au moyen age et à l'epoque de la Renaissance*, Paris, 1864ff.

257. J. Labarte, *Inventaire de Charles V. Collection de documents inédits sur l'histoire de France*, ser. 6, XVI, Paris, 1879.

258. A. de Laborde, *Etude sur la Bible Moralisée illustrée*, Paris, 1911ff.

259. M. de Laborde, *Notice des Emaux . . . du Louvre*, II, Paris, 1853.

260. H. Ladendorf, *Antikenstudium und Antikenkopie (Abhandlung der sächsischen Akademie der Wissenschaften in Leipzig, Bd. 46 Heft 2)*, Berlin, 1953.

261. R. Lanciani, *Storia degli scavi di Roma*, Rome, 1902ff.

262. A. Lane, "Florentine painted glass and the practice of design," *Burlington Magazine*, XCI (1949), pp. 43ff.

263. J. Lanyi, "Problemi di critica Donatelliana," *Critica d'arte*, IV (1939), pp. 9ff.

264. J. Lanyi, "Il Profeta Isaia di Nanni di Banco," *Rivista d'arte*, XVIII (1936), pp. 137ff.

265. J. Lanyi, "Quercia Studien," *Jahrbuch für Kunstwissenschaft*, II (1930), pp. 25ff.

266. P. Lasinio, *Raccolta di sarcofagi . . . nel Campo santo di Pisa*, Pisa, 1814.

267. E. Lavagnino, "Masaccio: Dicesi è morto a Roma," *Emporium*, XLIX (1943), pp. 97ff.

268. M. Lazzaroni and A. Muñoz, *Filarete scultore e architetto del Secolo XV*, Rome, 1908.

269. G. Ledos, "Fragment de l'inventaire des joyaux de Louis I, duc d'Anjou," *Bibliothèque de l'Ecole des Chartes*, L (1889), pp. 168ff.

270. K. Lehmann, "The *Imagines* of the Elder Philostratus," *Art Bulletin*, XXIII (1941), pp. 16ff.

271. P. W. Lehmann, *Statues on Coins*, New York, 1946.

272. A. Lejard, *Les tapisseries de l'Apocalypse de la Cathédrale d'Angers*, Paris, 1942.

273. H. Lerner-Lehmkuhl, *Zur Struktur und Geschichte des Florentiner Kunstmarktes im 15. Jahrhundert (Lebensräume der Kunst, 3)* Diss. Münster, Wattenscheid, 1936.

274. A. Levi, "Rilievi di sarcofagi nel Palazzo Ducale di Mantova," *Dedalo*, VII (1926), pp. 205ff.

275. A. Liebreich, *Claus Sluter*, Brussels, 1936.

276. S. Loessel, "Santa Maria in Vescovio," M.A. Thesis, Institute of Fine Arts, New York University, 1942 (typescript).

277. R. Longhi, "Fatti di Masolino e di Masaccio," *Critica d'arte*, V (1940), pp. 145ff.

278. W. Lotz, Review of Planiscig, bibl. 403, in: *Rinascità*, IV (1941), pp. 289ff.

279. W. Lotz, *Der Taufbrunnen des Baptisteriums zu Siena (Der Kunstbrief)*, Berlin, 1948.

280. B. Lowry, "Letter to the Editor," *Art Bulletin*, XXXV (1953), pp. 175ff.

281. F. P. Luiso, "Ricerche cronologiche per un riordinamento dell'epistolario di A. Traversari," *Rivista delle biblioteche e degli archivi*, VIII (1897), pp. 35ff, 148ff; IX (1898), pp. 74ff; X (1899), pp. 73ff, 105ff.

282. A. Lumachi, *Memorie storiche dell'antichissima Basilica di San Giovanni Battista in Firenze*, Florence, 1782.

283. V. Lusini, *Il San Giovanni di Siena . . .*, Florence, 1901.

284. J. Lutz and P. Perdrizet, *Speculum humanae Salvationis*, Leipzig, 1907ff.

285. E. B. MacDougall, "Nicolas V's Plan for Rebuilding St. Peter's, the Vatican Palace and the Borgo," M.A. Thesis, Institute of Fine Arts, New York University, 1955 (typescript).

286. Timoteo Maffei, *In magnificentiae Cosmi Medicei detractores*, in: Lami, *Deliciae Eruditorum*, XII (1742), pp. 150ff.

287. L. Magherini-Graziani, *L'arte a Città di Castello*, Città di Castello, 1890.

288. T. Magnuson, "The Project of Nicholas V for Rebuilding the Borgo Leonino in Rome," *Art Bulletin*, XXXVI (1954), pp. 89ff.

289. G. Mancini, *Vita di Leon Battista Alberti*, 2nd ed., Florence, 1911.

290. G. Mancini, "Il bel S. Giovanni e le feste patronali . . . descritte nel 1475 . . . da Piero Cennini," *Rivista d'arte*, VI (1909), pp. 195ff.

291. G. Mancini, "Nuovi documenti e notizie sulla vita . . . di Leon Battista Alberti," *Archivio storico italiano*, ser. 4, XIX (1887), pp. 190ff.

292. E. Mandowsky, "Some notes on the early history of the Medicean Niobides," *Gazette des Beaux-Arts*, XLI (1953), pp. 251ff, 288ff.

293. Antonio Manetti, *Uomini singholari*, in: *Operette istoriche*, ed. G. Milanesi, Florence, 1887.

294. (Antonio Manetti), *Vita di Filippo Brunelleschi*, ed. E. Toesca, Rome, 1927.

295. Gianozzo Manetti, *De dignitate et excellentia hominis Libri IIII*, Basel, 1532.

296. G. Mansi, *Sacrorum Conciliorum nova et amplissima collectio*, ed. P. Labbaeus, G. Cossartius, N. Coleti, Florence, 1739ff.

297. M. Marangoni, "Rilievi poco noti nella seconda Porta del S. Giovanni in Firenze," *Rassegna d'arte*, XI (1911), pp. 31f.

298. G. Marchini, "Aggiunte a Michelozzo," *Rinascità*, VII (1944), pp. 24ff.

299. G. Marchini (and others), "Note brevi su inediti toscani," *Bolletino d'arte*, XXXVII (1952), pp. 173ff.

300. V. Mariani, *Michelangelo e la facciata di San Pietro*, Rome, 1943.

301. R. Van Marle, *The Development of the Italian Schools of Painting*, The Hague, 1923ff.

302. A. Marquand, *Luca della Robbia (Princeton Monographs in Art and Archaeology, III)*, Princeton, 1914.

303. A. Marquand, "A Terracotta Sketch by L. Ghiberti," *American Journal of Archaeology*, IX (1894), pp. 207ff.

304. A. Marquand, "Two Windows in the Cathedral of Florence," *American Journal of Archaeology*, N. S., IV (1900), pp. 197ff.

305. J. J. Marquet de Vasselot, *Musée du Louvre, Catalogue sommaire de l'orfèvrerie . . .*, (Paris, 1914).

306. H. M. R. Martin, *La miniature française du XIII⁰ au XV⁰ siècle*, Paris, 1923.

307. G. Martini (J. Martinius), *Theatrum Basilicae Pisanae*, 2nd ed. *Appendix*, Rome, 1728.

308. R. G. Mather, "Documents Mostly New Relating to Florentine Painters and Sculptors of the Fifteenth Century," *Art Bulletin* XXX (1948), pp. 20ff.

309. H. Mattingly, *Coins of the Roman Empire in the British Museum*, London, 1923ff.

310. F. Matz, *Über eine dem Herzog von Coburg-Gotha gehörige Sammlung alter Handzeichnungen nach Antiken*," *Monatsberichte der Berliner Akademie der Wissenschaften, Phil.-Hist. Klasse*, 1871, pp. 445ff.

311. F. Matz and F. von Duhn, *Antike Bildwerke in Rom*, Leipzig, 1881ff.

312. A. L. Mayer, "Giuliano Fiorentino," *Bolletino d'arte*, ser. II, vol. II (1922-23), pp. 337ff.

313. G. Mazzatinti, *Inventari dei manoscritti delle biblioteche d'Italia*, IX (*Firenze*), Forli, 1899.

314. J. Meder, *Die Handzeichnung*, Vienna, 1923.

315. M. Meiss, "Italian Style in Catalonia and a Fourteenth Century Italian Workshop," *Journal of the Walters Art Gallery* IV (1941), pp. 45ff.

316. M. Meiss, "London's New Masaccio," *Art News*, LI (1952), pp. 24ff.

317. M. Meiss, *Painting in Florence and Siena after the Black Death*, Princeton, 1951.

318. M. Meiss, "The Problem of Francesco Traini," *Art Bulletin*, XV (1933), pp. 97ff.

319. A. Melani, "I fascioni dell' imposte di Andrea da Pontedera," *Arte e Storia*, XVIII (1899), p. 128.

320. A. Mercati, *Per la cronologia della vita e degli studi di Niccolo Perotti (Studi e Testi*, 44), Rome, 1925.

321. Giovanni Cardinal Mercati, *Ultimi contributi alla Storia degli Umanisti (Studi e Testi*, 90), Città del Vaticano, 1939.

322. Mrs. Merrifield. *Original Treatises . . . on the Arts of Painting*, London, 1849.

323. J. Mesnil, "La data della morte di Masaccio," *Rivista d'arte*, VIII (1912), pp. 31ff.

324. J. Mesnil, "Die Kunstlehre der Fruehrenaissance im Werke Masaccio's" *Vorträge der Bibliothek Warburg*, 1925-26 (1928), pp. 122ff.

325. J. Mesnil, "Masaccio and the Antique," *Burlington Magazine*, XLVIII (1926), pp. 91ff.

326. A. G. Meyer, "Lorenzo Ghiberti," *Museum*, V (1900), pp. 17ff.

327. A. Meyer-Weinschel, *Renaissance und Antike (Tuebinger Forschungen zur Archäologie und Kunstgeschichte*, 12), Reutlingen, 1933.

328. A. Michaelis, "Monte Cavallo," *Roemische Mitteilungen*, XIII (1898), 248ff.

329. P. H. Michel, *La Pensée de L. B. Alberti*, Paris, 1930.

330. U. Middeldorf, Review of H. Kauffmann, bibl. 237, in: *Art Bulletin*, XVIII (1936), pp. 570ff.

331. U. Middeldorf, "Zur Goldschmiedekunst der toskanischen Fruehrenaissance," *Pantheon*, XVI (1935), pp. 279ff.

332. L. Migliori, *Firenze . . . illustrata*, Florence, 1684.

333. J. P. Migne, *Patrologiae Cursus Completus Series Graeca*, Paris, 1854ff, quoted as *P.G.*

334. J. P. Migne, *Patrologiae Cursus Completus Series Latina*, Paris, 1844ff, quoted as *P.L.*

335. Milan Cathedral, *Annali della fabbrica del Duomo di Milano*, Milan, 1877ff.

336. G. Milanesi, *Documenti per la storia dell'arte senese*, Siena, 1854ff.

337. G. Milanesi, *Nuovi documenti per la storia dell'arte toscana*, Florence, 1901.

338. Ministero della Pubblica Istruzione, *Documenti Inediti per servire alla storia dei musei d'Italia*, Rome, 1878ff.

339. P. Misciatelli, "Un' Eva Lorenzettiana nel Museo del Louvre," *Diana*, V (1930), pp. 215ff.

340. I. B. Mittarelli and A. Costadoni, *Annales Camaldulenses*, VI, Venice, 1761.

341. E. Molinier, *Musée National du Louvre, Catalogue des ivoires*, Paris, 1896.

342. T. Mommsen, "Petrarch and the Story of the Choice of Hercules," *Journal of the Warburg and Courtauld Institutes*, XVI (1953), pp. 178ff.

343. T. Mommsen, "Petrarch's Conception of the Dark Ages," *Speculum*, XVII (1942), pp. 226ff.

344. R. Morçay, *Chroniques de Saint-Antonin, Fragments . . . du titre XXII (1378-1459)*, Paris, 1913.

345. H. Moranvillé, *Inventaire de l'orfèvrerie et des joyaux de Louis I, duc d'Anjou*, Paris, 1906.

346. J. Morelli, "De Joanne Dondio," *Operette*, II, 1820, pp. 285ff.

347. C. R. Morey, *The Sarcophagus of Claudia Antonia Sabina and the Asiatic Sarcophagi (American Society for the Excavation of Sardis, Publications*, V, 1), Princeton, 1924.

348. O. Morisani, *Studi su Donatello*, Venice, 1952.

349. D. A. Mortier, *Histoire des maîtres généraux . . . des frères prêcheurs*, Paris, 1903ff.

350. E. Muentz, "Les Arts à la Cour des Papes," I, *Bibliothèques des Ecoles Françaises d'Athènes et de Rome*, IV (1878).

351. E. Muentz, *Les Collections des Médicis au XV Siècle . . .*, Paris, 1888.

352. E. Muentz, "Essai sur l'Histoire des collections italiennes d'antiquitées . . . ," *Revue archéologique*, LXIX (1879), pp. 45ff, 84ff.

353. E. Muentz, *Les précurseurs de la Renaissance*, Paris and London, 1882.

354. E. Muentz et Prince d'Essling, *Petrarque*, Paris, 1902.

355. I. von Müller, *Handbuch der Altertumswissenschaft*, I (1886).

356. L. A. Muratori, *Annali d'Italia*, Florence, 1827.

357. L. A. Muratori, *Rerum Italicarum Scriptores*, Milan, 1723ff; *Supplement*, ed. G. M. Tartini, Florence, 1748ff.

358. *idem*, new series, ed. G. Carducci and others, Città di Castello, 1900ff.

359. F. Nardini, *Roma antica* (1st ed., 1660), Rome, 1771.

360. Ugo Nebbia, *La Scultura nel Duomo di Milano*, Milan, 1908.

361. G. di Nicola, "Alcuni dipinti di Lippo Vanni," *Rassegna d'arte senese*, VI (1910), pp. 39ff.

362. Nicolaus de Lyra, *Postilla in universa Biblia*, Rome, 1471-72.

363. Dorothea F. Nyberg, "A Study of Proportions in Brunelleschi's Architecture," M.A. Thesis, Institute of Fine Arts, New York University, 1953 (typescript).

364. R. Oertel, *Filippo Lippi*, Vienna (1942).

365. R. Oertel, "Masaccio's Frühwerke," *Marburger Jahrbuch für Kunstwissenschaft*, VII (1933), pp. 1ff.

366. R. Oertel, review of K. Steinbart, *Masaccio*, in *Zeitschrift fur Kunstgeschichte*, XIV (1951), pp. 167ff.

367. R. Oertel, "Wandmalerei und Zeichnung in Italien," *Mitteilungen des Kunsthistorischen Instituts in Florenz*, V (1937-40), pp. 217ff.

368. R. Offner, "Four Panels, a Fresco and a Problem," *Burlington Magazine*, LIV (1929), pp. 224ff.

369. R. Offner, "Niccolo di Pietro Gerini, A List of Works by Niccolo di Pietro Gerini," *Art in America*, IX (1921), p. 238.

370. R. Offner, *A Critical and Historical*

Corpus of Florentine Painting, New York, 1930ff.

371. L. Olschki, *Geschichte der neusprachlichen wissenschaftlichen Literatur*, I, *Die Literatur der Technik und der angewandten Wissenschaften vom Mittelalter bis zur Renaissance*, Heidelberg, 1919.

372. H. A. Omont, *Miniatures des plus anciens manuscrits grecs de la Bibliothèque Nationale du VIᵉ au XIVᵉ siècle*, Paris, 1929.

373. H. A. Omont, *Les Miniatures du Psautier de Saint Louis*, Leyden, 1902.

374. S. Orsati (Ursatus), *Monumenta Patavina*, Padua, 1653.

375. W. and E. Paatz, *Die Kirchen von Florenz, ein kunstgeschichtliches Handbuch*, Frankfurt/Main, 1940ff.

376. O. Paecht, "Early Italian Nature Studies and the Early Calendar Landscapes," *Journal of the Warburg and Courtauld Institutes*, XIII (1950), pp. 13ff.

377. M. Palmieri, *Matthei Palmerii Liber de Temporibus (AA 1-1448) . . . Appendice: Matthei Palmerii Annales*, ed. A. Scaramilla in: Muratori, bibl. 358, XXVI, 1.

378. M. Palmieri, *Matthaei Palmerii opus de Temporibus suis*, in: Muratori, bibl. 357, *Supplement*, I, cols. 235ff.

379. E. Panofsky, *The Codex Huygens and Leonardo da Vinci's Art Theory*, (*Studies of the Warburg Institute*, 13), London, 1940.

380. E. Panofsky, *Early Netherlandish Painting*, Cambridge, Mass., 1953.

381. E. Panofsky, "Das erste Blatt aus dem Libro Giorgio Vasari's," *Staedeljahrbuch*, VI (1930), pp. 25ff.

382. E. Panofsky, "The Friedsam Annunciation," *Art Bulletin*, XVII (1935), pp. 433ff.

383. E. Panofsky, *Galileo as a Critic of the Arts*, The Hague, 1954.

384. E. Panofsky, "Imago Pietatis," *Festschrift für Max I. Friedlaender*, Leipzig, 1927, pp. 261ff.

385. E. Panofsky, "Die Perspektive als symbolische Form," *Vorträge der Bibliothek Warburg*, 1924-25, Leipzig and Berlin, 1927, pp. 258ff.

386. E. Panofsky, "Das perspektivische Verfahren Leone Battista Alberti's," *Kunstchronik*, XXVI (1914-15), p. 508.

387. E. Panofsky, "Renaissance and Renascences," *Kenyon Review*, VI (1944), pp. 201ff.

388. E. Panofsky and F. Saxl, *Classical Mythology in Mediaeval Art* (*Metropolitan Museum Studies*, IV, 2), New York, 1933.

389. (R. Papini), *Il Camposanto* (*Catalogo delle cose d'arte e di antichità d'Italia, Pisa*, II), Rome, 1932.

390. R. Paribeni, "La colonna Traiana in un codice del Rinascimento," *Rivista del R. Istituto d'Archeologia e Storia dell'Arte*, I, (1929), pp. 9ff.

391. L. Passerini, *Curiosità storico-artistiche Fiorentine, I, La Loggia di Or S. Michele*, Florence, 1866.

392. T. Patch (A. Cocchi) and F. Gregori, *La porta principale del Battistero di S. Giovanni*, Florence, 1773 (reprinted in: E. Muentz, *Les Archives des arts*, I, Paris, 1890, pp. 15ff).

393. C. Perkins, *Ghiberti et son école*, Paris, 1886.

394. C. Perkins, "Lorenzo Ghiberti," *Gazette des Beaux-Arts*, XXV (1868), pp. 457ff.

395. Francesco Petrarca, *Le familiari*, ed. V. Rossi, Florence, 1933ff.

396. Francesco Petrarca, *Opera omnia*, Basel, 1584.

397. A. Pica, "La cupola di S. Maria del Fiore e la collaborazione Brunellesco-Ghiberti," *Emporium*, XCVII (1943), pp. 70ff.

398. P. Pieri, *Intorno alla Storia dell'Arte della Seta in Firenze*, Bologna, 1927.

399. A. L. Pietrogrande, "Descrizione del sarcofago decorato ed esame della scena bacchica," *Notizie Scavi*, XII (1934), pp. 230ff.

400. W. Pinder, *Die deutsche Plastik vom ausgehenden Mittelalter bis zum Ende der Renaissance*, I (*Handbuch der Kunstwissenschaft*), Wildpark-Potsdam (1924ff).

401. M. Pittaluga, *Masaccio*, Florence, 1935.

402. L. Planiscig, "I profeti sulla porta della Mandorla," *Rivista d'arte*, XXIV (1942), pp. 125ff.

403. L. Planiscig, *Lorenzo Ghiberti*, Vienna (1940).

404. L. Planiscig, *Lorenzo Ghiberti*, Florence, 1949.

405. L. Planiscig, *Nanni di Banco*, Florence, 1946.

406. L. Planiscig, "Geschichte der Venezianischen Skulptur im XIV Jahrhundert," *Jahrbuch der Kunsthistorischen Sammlungen des Allerhoechsten Kaiserhauses*, XXXIII (1916), pp. 31ff.

407. L. Planiscig, "Die Bildhauer Venedigs in der ersten Hälfte des Quattrocento," *Jahrbuch der Kunsthistorischen Sammlungen in Wien*, N. F. IV (1930), pp. 47ff.

408. Pliny (Caius Plinius Secundus), *Natural History*, ed. H. Rackham (*Loeb Classical Library*), Cambridge, Mass. and London, 1938ff.

409. G. Poggi, *La Capella e la tomba di Onofrio Strozzi*, Florence, 1902.

410. (G. Poggi), *Catalogo del Museo dell'Opera del Duomo*, Florence, 1904.

411. G. Poggi, "Il Ciborio di Bernardo Ros-

sellino nella chiesa di S. Egidio," *Miscellanea d'arte*, I (1903), pp. 105ff.

412. G. Poggi, "La Compagnia del Bigallo," *Rivista d'arte*, II (1904), pp. 189ff.

413. G. Poggi, *Il Duomo di Firenze (Kunsthistorisches Institut in Florenz, Italienische Forschungen*, II), Berlin, 1909.

414. G. Poggi, *La Porta del Paradiso di Lorenzo Ghiberti*, Florence, 1949.

415. G. Poggi, "Il reliquario 'del libretto' nel battistero fiorentino," *Rivista d'arte*, IX (1916-18), pp. 238ff.

416. G. Poggi, "La ripulitura delle porte del Battistero Fiorentino," *Bolletino d'arte*, XXXIII (1948), pp. 244ff.

417. G. Poggi, L. Planiscig, B. Bearzi, *Donatello, San Ludovico*, New York (1949).

418. Poggio-Bracciolini, *Epistolae*, ed. T. de Tonellis, Florence, 1831ff.

419. Poggio-Bracciolini, *Poggii Bracciolini . . . Historiae De Varietate Fortunae Libri IV*, ed. D. Georgius, Paris, 1723.

420. Polybius, *The histories . . .*, ed. W. R. Paton (*Loeb Classical Library*), London and New York, 1922ff.

421. J. Pope-Hennessy, *The Complete Work of Paolo Ucello*, London and New York, 1950.

422. J. Pope-Hennessy, *Donatello's Relief of the Ascension*, London, 1949.

423. (A. E. Popham), *Old Master Drawings from the Albertina* (London), 1948.

424. F. Poulsen, *Catalogue of Ancient Sculpture in the Ny Carlsberg Glyptothek*, Copenhagen, 1951.

425. F. D. Prager, "Brunelleschi's Inventions and the Renewal of Roman Masonry Work," *Osiris*, IX (1950), pp. 457ff.

426. U. Procacci, "Gherardo Starnina," *Rivista d'arte*, XV (1933), pp. 151ff; XVII (1935), pp. 333ff.

427. U. Procacci, "Niccolo di Piero Lamberti . . . e Niccolo di Luca Spinelli," *Il Vasari*, I (1927-28), pp. 300ff.

428. U. Procacci, "Sulla cronologia delle opere di Masaccio e di Masolino tra il 1425 e il 1428," *Rivista d'arte*, XXVIII (1953), pp. 3ff.

429. G. Pudelko, "The maestro del Bambino Vispo," *Art in America*, XXVI (1938), pp. 47ff.

430. G. Pudelko, "The Stylistic Development of Lorenzo Monaco," *Burlington Magazine*, LXXIII (1938), pp. 237ff; LXXIV (1939), pp. 76ff.

431. G. Pudelko, "The early works of Paolo Ucello," *Art Bulletin*, XVI (1934), pp. 231ff.

432. G. Pudelko, "The Minor Masters of the Chiostro Verde," *Art Bulletin*, XVII (1935), pp. 71ff.

433. C. L. Ragghianti, "Apologo storico su vecchio e nuovo," *Il Mondo Europeo*, July 15, 1947 [mystification].

434. I. Ragusa, "The re-use . . . of Roman Sarcophagi during the Middle Ages and the Early Renaissance," M.A. Thesis, Institute of Fine Arts, New York University, 1951 (typescript).

435. S. Reinach, *Répertoire de Reliefs Grecs et Romains*, Paris, 1909ff.

436. S. Reinach, *Répertoire de la Statuaire Grecque et Romaine*, Paris, 1897ff.

437. M. Reymond, "L'arc mixtiligne florentin," *Rivista d'arte*, II (1904), pp. 245ff.

438. M. Reymond, "Lorenzo Ghiberti," *Gazette des Beaux-Arts*, 3rd ser., XVI (1896), pp. 125ff.

439. M. Reymond, "La porte de la Chapelle Strozzi," *Rivista d'arte*, I (1903), pp. 4ff.

440. M. Reymond, *La sculpture florentine*, Florence, 1897ff.

441. C. Ricci, *Il Tempio Malatestiano*, Milan and Rome, 1925.

442. P. G. Ricci, "Ambrogio Traversari," *Rinascità*, II (1939), pp. 578ff.

443. G. Richa, *Notizie istoriche delle chiese fiorentine*, Florence, 1754ff.

444. G. M. Richter, *The Metropolitan Museum of Art, Greek, Etruscan and Roman Bronzes*, New York, 1915.

445. Ristoro d'Arezzo, *Mappa Mundi*, in: V. Nannucci, *Manuale della Letteratura . . . Italiana*, Florence, 1857.

446. G. E. Rizzo, "Sculture antiche del Palazzo Giustiniani," *Bulletino della Commissione Archeologica Communale*, 1904-05.

447. D. M. Robb, "The Iconography of the Annunciation in the Fourteenth and Fifteenth Centuries," *Art Bulletin*, XVIII (1936), pp. 480ff.

448. C. Robert, *Die antiken Sarkophagreliefs*, II, III, 1-3, Berlin, 1890ff (see also Rumpf, bibl. 455).

449. C. Robert, "Über ein dem Michelangelo zugeschriebenes Skizzenbuch auf Schloss Wolfegg," *Archäologisches Institut des Deutschen Reiches, Roemische Mitteilungen*, XVI (1901), pp. 209ff.

450. A. Rosenberg, "Lorenzo Ghiberti," in: R. Dohme, *Kunst und Kuenstler*, Abt. II, 1 (1877), pp. 35ff.

451. G. Rosini, *Storia della pittura italiana*, Pisa, 1848ff.

452. F. Rossi, "The Baptistery Doors in Florence," *Burlington Magazine*, LXXXIX (1947), pp. 334ff.

453. G. Rowley, "The Gothic Frescoes at Monte Siepi," *Art Studies*, VII (1929), pp. 107ff.

454. K. F. von Rumohr, *Italienische Forsch-ungen*, Berlin, 1827.

455. A. Rumpf, *Die antiken Sarkophagreliefs*, v, Berlin, 1935 (see also Robert, bibl. 448).

456. G. McN. Rushforth, "Magister Gregorius De Mirabilibus Urbis Romae . . . ," *Journal of Roman Studies*, IX (1919), pp. 14ff.

457. R. Sabbadini, *Carteggio di Giovanni Aurispa (Fonti per la storia d'Italia pub-blicate dall' Istituto Storico Italiano*, LXX), Rome, 1931.

458. R. Sabbadini, *Le scoperte dei codici latini e greci*, Florence, 1914.

459. A. von Salis, *Antike und Renaissance*, Erlenbach-Zurich, 1947.

460. M. Salmi, "Aggiunte al Tre e al Quattro-cento fiorentino, II," *Rivista d'arte*, XVI (1934), pp. 168ff.

461. (M. Salmi), *Mostra d'arte sacra . . . Arez-zo*, Arezzo, 1950.

462. M. Salmi (and others), *Mostra di quattro maestri del primo Rinascimento*, Florence, 1954.

463. M. Salmi, *Paolo Uccello, Andrea del Cas-tagno, Domenico Veneziano*, Paris (1939).

464. Roberto Salvini, *L'arte di Agnolo Gaddi*, Florence, 1936.

465. Coluccio Salutati, *De laboribus Herculis*, ed. B. L. Ullman, Zurich, 1951.

466. P. Sanpaolesi, "Aggiunte al Brunelles-chi," *Bolletino d'arte*, XXXVIII (1953), pp. 225ff.

467. P. Sanpaolesi, *Brunellesco e Donatello nella Sacristia Vecchia . . .* , Pisa (1950).

468. P. Sanpaolesi, "Il concorso del 1418-20 per la cupola di S. Maria del Fiore," *Rivista d'arte*, XV (1936), pp. 301ff.

469. P. Sanpaolesi, "Le prospettive architet-toniche di Urbino, di Filadelfia e di Ber-lino," *Bolletino d'arte*, XXXIV (1949), pp. 322ff.

470. F. Sartini, *Statuti dell'arte dei rigattieri e linaiuoli di Firenze (R. Deputazione di Storia patria per la Toscana. Fonti e studi sulle corporazioni artigiane del medio evo, Fonti*, II), Florence, 1940.

471. F. Saxl, "The Classical Inscription in Renaissance Art and Politics," *Journal of the Warburg and Courtauld Institutes*, IV (1940-41), pp. 19ff.

472. A. Van Schendel, *Le dessin en Lombardie*, Brussels (1938).

473. J. von Schlosser, "Die aeltesten Medaillen und die Antike," *Jahrbuch der Kunsthistori-schen Sammlungen des Allerhoechsten Kai-serhauses*, XVIII (1897), pp. 64ff.

474. J. von Schlosser, " 'Armeleutekunst' in alter Zeit," *Praeludien* (Vienna, 1927), pp. 304ff.

475. J. von Schlosser, "Geschichte der Portrait-bildnerei in Wachs," *Jahrbuch der Kunst-historischen Sammlungen des Allerhoech-sten Kaiserhauses*, XXIX (1911), pp. 255ff.

476. J. von Schlosser, "Kuenstlerprobleme der Fruehrenaissance," 3. Heft. v. Stueck, "Lor-enzo Ghiberti," *Akademie der Wissenschaf-ten in Wien, Philosophisch-historische Klasse*, CCXV, 4 (1934), pp. 3ff.

477. J. von Schlosser, *Leben und Meinungen des Florentinischen Bildners Lorenzo Ghi-berti*, Basel, 1941.

478. J. von Schlosser, "Lorenzo Ghiberti's Denkwuerdigkeiten, Prolegomena zu einer kuenftigen Ausgabe," *Kunstgeschichtliches Jahrbuch der K. K. Zentralkommission*, IV (1910), pp. 105ff.

479. J. von Schlosser, "Ueber einige Antiken Ghiberti's," *Jahrbuch der Kunsthistorischen Sammlungen des Allerhoechsten Kaiser-hauses*, XXIV (1903), pp. 25ff.

480. J. von Schlosser, "Ein Veroneser Bilder-buch der höfischen Kunst des XIV. Jahr-hunderts," *Jahrbuch der Kunsthistorischen Sammlungen des Allerhoechsten Kaiser-hauses*, XVI (1895), pp. 144ff.

481. J. von Schlosser, "Die Werkstatt der Em-briachi," *Jahrbuch der Kunsthistorischen Sammlungen des Allerhoechsten Kaiser-hauses*, XX (1899), pp. 200ff.

482. A. Schmarsow, "Ghiberti's Kompositions-gesetze an der Nordtuer des Florentiner Baptisteriums," *Kgl. Saechsische Gesellschaft der Wissenschaften, Abhandlungen der Philosophisch-Historischen Klasse*, XVIII, 4, Leipzig, 1899, pp. 1ff.

483. A. Schmarsow, *Italienische Kunst im Zeitalter Dantes*, Augsburg, 1928.

484. A. Schmarsow, "Juliano Florentino, ein Mitarbeiter Ghiberti's in Valencia," *Säch-sische Akademie der Wissenschaften, Ab-handlungen der Philosophisch-Historischen Klasse*, XXIX, 3 (1911), pp. 1ff.

485. A. Schmarsow, "Die Statuen an Or San Michele," *Festschrift zu Ehren des Kunst-historischen Instituts in Florenz*, Leipzig, 1897.

486. A. Schmarsow, "Vier Statuetten in der Domopera zu Florenz," *Jahrbuch der Preus-sischen Kunstsammlungen*, VIII (1887), pp. 137ff.

487. F. Schottmueller, *s. v.* Ghiberti, Lorenzo, in: Thieme-Becker, bibl. 517, XIII, pp. 541ff.

488. P. Schubring, *Cassoni*, Leipzig, 1915.

489. M. Semrau, "Notiz zu Ghiberti," *Reper-torium für Kunstwissenschaft*, L (1929), pp. 151ff.

490. L. Serra, *L'Arte nelle Marche*, Pesaro, 1929.

491. B. S. Sgrilli, *Descrizione e studj della . . . fabrica di S. Maria del Fiore . . .*, Florence, 1733.

492. F. R. Shapley and C. K. Kennedy, "Brunelleschi in Competition with Ghiberti," *Art Bulletin*, v (1922-23), pp. 31ff.

493. D. C. Shorr, "The Mourning Virgin and St. John," *Art Bulletin*, xxii (1940), pp. 61ff.

494. G. Sinibaldi, "Come Lorenzo Ghiberti sentisse Giotto e Ambrogio Lorenzetti," *L'Arte*, xxxi (1928), pp. 8of.

495. O. Sirén, "Ghiberti's förste Bronzeporte," *Tilskueren*, xxv (1908), pp. 834ff.

496. O. Sirén, *Don Lorenzo Monaco*, Strasbourg, 1905.

497. O. Sirén, "Due Madonne della bottega del Ghiberti," *Rivista d'arte*, v (1907), pp. 48ff.

498. O. Sirén, *Studier i Florentinsk Renässansskulptur . . .*, Stockholm, 1909.

499. A. H. Smith, *A Catalogue of Sculpture in the Department of Greek and Roman Antiquities in the British Museum*, iii, London, 1904.

500. (Sopraintendenza alle Gallerie . . . di Firenze, Arezzo e Pistoja), *Mostra di opere d'arte trasportate a Firenze . . . e di opere d'arte ristaurate . . .*, Florence, 1947.

501. C. Spicq, *Esquisse d'une histoire de l'exégèse latine au moyen-âge (Bibliothèque Thomiste, xxvi)*, Paris, 1944.

502. C. von Stegmann and H. von Geymueller, *Die Architektur der Renaissance in Toscana*, Munich, 1885ff.

503. H. Steigemann, *De Polybii olympiadum ratione et oeconomia*, Breslau, 1885.

504. A. Stix and L. Froehlich-Bum, *Beschreibender Katalog der Handzeichnungen in der . . . Albertina, iii, Die Zeichnungen der Toskanischen, Umbrischen und Römischen Schulen*, Vienna, 1932.

505. A. Stix, *Handzeichnungen aus der Albertina, N. F. ii. Italienische Meister des XV bis XVI Jahrhunderts*, v, Vienna, 1928.

506. A. Stix, "Eine Zeichnung von Lorenzo Ghiberti," *Kunstchronik und Kunstmarkt*, N. F. xxxv (1925-26), pp. 139ff.

507. L. Stornaiolo, *Le miniature della Topografia Cristiana di Cosma Indicopleuste*, Milan, 1918.

508. K. van Straelen, *Studien zur Florentiner Glasmalerei des Trecento und Quattrocento (Lebensräume der Kunst, v)*, Diss. Münster, Wattenscheid, 1938.

509. E. Strong, *Art in Ancient Rome*, New York, 1928.

510. E. Strong, "Six Drawings from the column of Trajan with the date 1467 and a note on the date of Giacomo Ripanda," *Papers of the British School at Rome*, vi (1913), pp. 174ff.

511. F. Susemihl, *Geschichte der griechischen Literatur der Alexanderzeit*, Leipzig, 1892.

512. G. Swarzenski, "A bronze statuette of St. Christopher," *Bulletin of the Museum of Fine Arts* (Boston), xlix (1951), pp. 84ff.

513. G. Swarzenski, "Der Kölner Meister bei Ghiberti," *Vorträge der Bibliothek Warburg*, 1926-27, Leipzig, 1930, pp. 22ff.

514. G. Swarzenski, "Insinuationes Divinae Pietatis," *Festschrift Adolph Goldschmidt*, Leipzig, 1923, pp. 65ff.

515. K. M. Swoboda, *Peter Parler*, Vienna, 1943.

516. H. Taine, *Voyage en Italie*, 17th ed., Paris, n.d.

517. U. Thieme and F. Becker, *Allgemeines Lexikon der bildenden Künstler . . .*, Leipzig, 1907ff; quoted as *Thieme-Becker*.

518. H. Tietze ed., *Österreichische Kunsttopographie*, xxiii; *Geschichte und Beschreibung des St. Stephansdomes in Wien*, Vienna, 1931.

519. E. Tietze-Conrat, "Botticelli and the Antique," *Burlington Magazine*, xlvii (1925), pp. 124ff.

520. P. Toesca, *La pittura e la miniatura lombarda*, Milan, 1912.

521. P. Toesca, "Michelino di Besozzo e Giovannino de' Grassi," *L'Arte*, viii (1905), pp. 321ff.

522. P. Toesca, *Il Trecento*, Turin (1951).

523. N. Tommaseo, *Dizionario della lingua italiana*, Turin, 1861ff.

524. A. Della Torre, *Storia dell'Accademia Platonica di Firenze (Pubblicazione del R. Istituto di Studi Superiori . . . in Firenze, Sezione di Filosofia e Filologia, 28)*, Florence, 1902.

525. G. B. Toschi, "Le Porte del Paradiso," *Nuova Antologia di science, lettere ed arti*, ser. 2, xv (1879), pp. 449ff.

526. Ambrogio Traversari (Ambrosius Traversarius), *Latinae Epistolae . . .*, ed. P. Cannetus and L. Mehus, Florence, 1759.

527. C. L. Urlichs, *Codex Urbis Romae topographicus*, Würzburg, 1871.

528. P. Vaccarini, *Nanni di Banco* (Florence, 1950).

529. W. R. Valentiner, *Studies of Italian Renaissance Sculpture*, London, 1950.

530. B. Varchi, *Storia Fiorentina*, Cologne, 1721.

531. Giorgio Vasari, *Le Vite de' piu eccellenti architetti, pittori et scultori Italiani*, Florence, 1550, reprint, ed. C. Ricci, Milan and Rome, 1927.

532. Giorgio Vasari, *Le vite de' piu eccellenti pittori, scultori e architettori*, ed. K. Frey, I, 1, Munich, 1911; quoted as *Frey*.

533. Giorgio Vasari, *Le vite de' piu eccellenti pittori, scultori ed architettori* (*Le opere di G. Vasari*: I-VII, *Le Vite*; VIII, *I ragionamenti e lettere*), Florence, 1878ff; quoted as *Vasari-Milanesi*.

534. A. Venturi, *Storia dell'arte italiana*, Milan, 1901ff.

535. L. Venturi, "Lorenzo Ghiberti," *L'Arte*, XXVI (1923), pp. 233ff.

536. U. Verini, *De illustratione urbis Florentiae libri tres*, Florence, 1636.

537. O. Vessberg, *Studien zur Kunstgeschichte der roemischen Republik* (*Acta Instituti Romani Regni Sveciae*, VIII), Lund and Leipzig, 1941.

538. G. Villani, *Istorie fiorentine . . .* (*Classici italiani*, X-XVII), Milan, 1802ff.

539. C. Vincenzi, "Di tre foglie di disegni quattrocenteschi dall'antico," *Rassegna d'arte*, X (1910), pp. 6ff.

540. M. Vitruvius Pollio, *Vitruvius on Architecture*, ed. F. Granger (*Loeb Classical Library*), London and New York, 1934ff.

541. G. Voigt, *Die Wiederbelebung des Classischen Alterthums*, 3rd ed., Berlin, 1893.

542. J. J. Volkmann, *Historisch-Kritische Nachrichten von Italien* (first published 1770), Leipzig, 1777.

543. M. Wackernagel, *Der Lebensraum des Künstlers in der Florentinischen Renaissance*, Leipzig, 1938.

544. E. Walser, *Poggius Florentinus, Leben und Werke.* (*Beiträge zur Kulturgeschichte des Mittelalters und der Renaissance*, 14), Leipzig and Berlin, 1914.

545. A. Warburg, *Gesammelte Schriften*, Leipzig and Berlin, 1932.

546. (Sir) George Warner, *Queen Mary's Psalter*, London, 1912.

547. K. Wegner, "Bemerkungen zu den Ehrendenkmälern des Marcus Aurelius," *Deutsches Archaeologisches Institut, Archaeologischer Anzeiger*, LIII (1938), cols. 155ff.

548. G. Weise, "Gli archi mistilinei di provenienza islamica nell'architettura gotica italiana . . . ," *Rivista d'arte*, XXIII (1941), pp. 1ff.

549. A. S. Weller, *Francesco di Giorgio*, Chicago (1943).

550. (P. Wescher), *Beschreibendes Verzeichnis der Miniaturen . . . des Kupferstichkabinetts der staatlichen Museen Berlin . . .* , Leipzig, 1931.

551. A. Wesselski, *Angelo Poliziano's Tagebuch*, Jena, 1929.

552. J. White, "Developments in Renaissance Perspective," *Journal of the Warburg and Courtauld Institutes*, XII (1949), pp. 58ff; XIV (1951), pp. 42ff.

553. (W. von Hartel and) F. Wickhoff, *Die Wiener Genesis*, Vienna, 1895.

554. H. Wieleitner, "Zur Erfindung der verschiedenen Distanzkonstruktionen," *Repertorium für Kunstwissenschaft*, XLII (1920), pp. 249ff.

555. E. Wind, "The Revival of Origen," *Studies in Art and Literature for Belle Da Costa Greene*, Princeton, 1954, pp. 412ff.

556. F. Winkler, "Paul de Limbourg in Florence," *Burlington Magazine*, LVI (1930), pp. 95f.

557. R. Wittkower, *Architectural Principles in the Age of Humanism*, London, 1949.

558. R. Wittkower, "Brunelleschi and 'Proportion in Perspective,'" *Journal of the Warburg and Courtauld Institutes*, XVI (1953), pp. 275ff.

559. O. Wulff, "Ghiberti's Entwicklung im Madonnenrelief," *Amtliche Berichte der Berliner Museen* (*Beiblatt zum Jahrbuch der Preussischen Kunstsammlungen*), XLIII (1922), pp. 91ff.

560. O. Wulff, "Giovanni d'Antonio di Banco," *Jahrbuch der Preussischen Kunstsammlungen*, XXXIV (1913), pp. 99ff.

561. M. Ziegelbauer, *Centifolium Camaldulense*, Venice, 1750.

562. G. Zippel, "Paolo II e l'arte," *L'Arte*, XIII (1910), pp. 241ff.

563. G. Zocchi, *Scelta di XXIV vedute . . . di Firenze*, Florence, 1754.

ADDITIONAL BIBLIOGRAPHY

1. Anonymous Reviewer, *Times Literary Supplement*, XXVI (April 26, 1957), p. 254.
2. M. C. Mendes Atanasio, "Documenti inediti riguardanti la Porta del Paradiso e Tommaso di Lorenzo Ghiberti," *Commentari* (1963), pp. 92ff.
3. K. Bloom, "Lorenzo Ghiberti's Space in Relief: Method and Theory," *Art Bulletin*, LI (1969), pp. 164-169.
4. M. Boskovits, "Quello ch'e dipintor oggi dicono prospettiva, Contribution to 15th Century art theory," *Acta Hist. Artium*, VIII (1962), pp. 241-260 and IX (1963), pp. 139-162.
5. G. Brunetti, *Ghiberti*, Florence, 1966.
6. A. Carandini, *Vibia Sabina, la funzione politica, l'iconografia dell'Augusta e il problema del classicismo adrianeo*, Florence, 1969.
7. M. Ciardi-Dupré, "Sulla collaborazione di Benozzo Gozzoli a la porta del Paradiso," *Antichità Viva*, VI (1967), pp. 6off.
8. A. Chastel, "L' 'Etruscan Revival' du XVe siècle," Revue Archéologique, series 3, I (1959), pp. 165-180.
9. A. Chastel, "Mésure et demésure dans la sculpture florentine au XVe siècle," *Critique* (1958), pp. 960-975.
10. K. Clark, review, *Burlington Magazine*, C (1958), pp. 175-178.
11. M. Dalai, "La questione della prospettiva," *L'Arte*, Rassegna, n.s. 1 (1968), pp. 96-105.
12. E. De'Negri, "Un libro sul Ghiberti," *Critica d'Arte*, XXX (1958), pp. 489-496.
13. B. Degenhart and A. Schmitt, "Gentile da Fabriano in Rom und die Anfänge des Antikenstudiums. Antikennachzeichnung," *Münchner Jahrbuch für Bildende Kunst*, II (1960), pp. 59-151.
14. B. Degenhart and A. Schmitt, *Corpus der italienischen Handzeichnungen*, Berlin, 1968.
15. G. Fiocco, "Le porte d'oro del Ghiberti," *Rinascimento*, VII (1956), pp. 3-11.
16. C. Gilbert, "The Archbishop and the Painters of Florence, 1450," *Art Bulletin*, XLI (1959), pp. 75-87.
17. C. Gilbert, "When Did a Man in the Renaissance Grow Old?" *Studies in the Renaissance*, XIV (1967), pp. 7-32.
18. D. Gioseffi, "Complementi di prospettiva," *Critica d'Arte*, XXIII-XXIV (1957), pp. 468-488; XXV-XXVI (1958), pp. 102-149.
19. D. Gioseffi, *Perspectiva artificialis. Per la Storia della Prospettiva, spigolature e apunti*, Trieste, 1957.
20. E. Gombrich, "The Renaissance Concept of Artistic Progress and its Consequences," *Actes du XVIIe Congrès International d'Histoire de l'Art, Amsterdam, 23-31 juillet 1952*, The Hague, 1955, pp. 291-307.
21. E. Gombrich, review, *Apollo* (July, 1957), pp. 306-307.
22. E. Gombrich, *Norm and Form, Studies in the Art of the Renaissance*, London, 1966.
23. C. Grayson, "L. B. Alberti's 'costruzione legittima'," *Italian Studies*, XIX (1964), pp. 14-27.
24. F. Hartt, "The Earliest Works of Andrea del Castagno," *Art Bulletin*, XLI (1959), pp. 159-181 and 225-236.
25. H. W. Janson, *Donatello*, Princeton, 1957.
26. H. W. Janson, review, *Renaissance News*, X (1957), pp. 103-105.
27. H. W. Janson, "Donatello and the Antique," *Donatello e il suo tempo*, Florence, 1968, pp. 77-96.
28. J. Jantzen, "Kleinplastische Bronzeportraits des 15. bis 16. Jahrhunderts und ihre Formen," *Zeitschrift des Deutschen Vereins für Kunstwissenschaft*, XVII (1963), pp. 111-112.
29. R. Krautheimer, "Terracotta Madonnas," *Parnassus*, VIII, 7 (1936), pp. 5-8, and *Collected Essays*, New York (1969), pp. 315ff.
30. R. Krautheimer, "Die Anfänge der Kunstgeschichtsschreibung in Italien," *Repertorium für Kunstwissenschaft*, L, pt. 2 (1929), pp. 49-63, and as "The Beginnings of Art Historical Writing in Italy," *Collected Essays*, New York, 1969, pp. 257ff.
31. T. Krautheimer-Hess, "More Ghibertiana," *Art Bulletin*, XLVI (1964), pp. 307-321.
32. O. Kurz, review, *Gazette des Beaux-Arts* (1958), p. 364.
33. S. Lang, " 'De Lineamentis'—L. B. Alberti's use of a technical term," *Warburg and Courtauld Journal*, XXVII (1965), pp. 331-335.
34. E. Loeffler, "A Famous Antique: A Roman Sarcophagus at the Los Angeles Museum," *Art Bulletin*, XXXIX (1957), pp. 1ff.
35. W. Lotz, review, *Saturday Review* (March 16, 1957), pp. 13-14.
36. B. Lowry, review, *College Art Journal*, XVIII (1959), pp. 184-187.

37. G. Marchini, *Italian Stained Glass Windows*, New York, 1957.

38. G. Marchini, "Ghiberti Ante Litteram," *Bollettino d'Arte*, 50, III-IV (1965), pp. 181-193.

39. F. Matz, *Die Dionysischen Sarkophage*, II, Berlin, 1968.

40. U. Middeldorf, "L'Angelico e la Scultura," *Rinascimento*, VI (1955), pp. 179-194.

41. U. Middeldorf, "Su alcuni bronzetti all'antica del Quattrocento," *Il mondo antico nel Rinascimento (Atti del V convegno internazionale di studi sul rinascimento, Firenze, 2-6 settembre, 1956)* Florence, 1958, pp. 167-177.

42. Geza von Österreich, *Die Rundfenster des Lorenzo Ghiberti*, Ph.D. thesis, Fribourg, 1965.

43. E. Panofsky, *Renaissance and Renascences in Western Art*, Stockholm, 1960, pp. 118-145.

44. A. Parronchi, "La Croce dei Pisani," *Studi su la dolce Prospettiva*, Milan, 1964, pp. 156-181.

45. A. Parronchi, "Le misure dell'occhio secondo il Ghiberti," *Paragone*, 123 (1961), pp. 18-48.

46. J. Pope-Hennessy, *Catalogue of Italian Sculpture in the Victoria and Albert Museum*, London, 1964, vol. 1, 8th-15th centuries.

47. J. Pope-Hennessy, *An Introduction to Italian Sculpture*, 3 parts, London, 1955-1962.

48. L. Portier, review, *Revue des études italiennes*, nn. 2-3 (1959), pp. 222-224.

49. C. Ragghianti, review, *Sele Arte*, 40 (1959), pp. 38-56.

50. C. Ragghianti, "Aenigmata Pistoriensia," *Critica d'Arte*, V (1954), pp. 423-438.

51. M. Salmi, "Lorenzo Ghiberti e Mariotto di Nardo," *Rivista d'Arte* (1955), pp. 147-152.

52. M. Salmi, "Lorenzo Ghiberti e la pittura," *Scritti di storia dell'arte in onore di Lionello Venturi*, Roma, 1956, pp. 223-237.

53. G. Scaglia, "Drawings of Brunelleschi's Mechanical Inventions for the Construction of the Cupola," *Marsyas*, X (1960-1961), pp. 45-63.

54. G. Scaglia, *Studies in the 'Zibaldone' of Buonaccorso Ghiberti*, thesis, unpubl., New York University, Institute of Fine Arts, 1960.

55. G. Scaglia, "Drawings of Machines for Architecture from the Early Quattrocento in Italy," *Journal of the Society of Architectural Historians*, XXV (1966), pp. 90-114.

56. C. Seymour, "The Younger Masters of the First Campaign of the Porta della Mandorla," *Art Bulletin*, XLI (1959), pp. 1-17.

57. C. Seymour, *Sculpture in Italy, 1400-1500*, Harmondsworth and Baltimore, 1966.

58. C. Seymour, "Some Aspects of Donatello's Methods of Figure and Space Constructions. Relationships with Alberti's 'De Statua' and 'Della Pittura'," *Donatello e il suo tempo*, Florence, 1968, pp. 195-206.

59. W. Smith, "Definitions of Statua," *Art Bulletin*, L (1968), pp. 263-267.

60. J. Spencer, "Volterra, 1466," *Art Bulletin*, XLVIII (1966), pp. 95-96.

61. E. Steingräber, "A Madonna Relief by Michele da Firenze," *The Connoisseur* (1957-1958), pp. 166ff.

62. E. Steingräber, "The Pistoia Silver Altar, a Re-examination," *The Connoisseur* (1955-1956), pp. 152ff.

63. E. Steingräber, review, *Zeitschrift für Kunstgeschichte*, XXI (1958), pp. 271-274.

64. F. Taylor, review, *New York Herald Tribune Literary Magazine*, April 21, 1957, p. 3.

65. M. Trachtenberg, "An Antique Model for Donatello's Marble David," *Art Bulletin*, L (1968), pp. 268-269.

66. L. Vayer, "*L'imago pietatis* di Lorenzo Ghiberti," *Acta Hist. Artium*, VIII (1962), pp. 45-53.

67. C. Vermeule, *European Art and the Classical Past*, Cambridge, 1964.

68. J. White, *The Birth and Rebirth of Pictorial Space*, 2nd ed., Boston, 1967.

69. M. Wundram, "Albizzo di Pietro, Studien zur Bauplastik von Or San Michele in Florenz," *Das Werk des Künstlers, Festschrift H. Schrade*, 1960, pp. 161-176.

70. M. Wundram, *Die Künstlerische Entwicklung im Reliefstil Lorenzo Ghibertis*, Ph.D. thesis, Göttingen, 1952.

71. M. Wundram, "Der Meister der Verkündigung in der Domopera zu Florenz," *Festgabe für H. R. Rosemann*, Munich, 1960, pp. 109-121.

72. M. Wundram, "Niccolo di Pietro Lamberti und die Florentiner Plastik um 1400," *Jahrbuch der Berliner Museen* (1962), pp. 78-115.

73. M. Wundram, *Die Paradiestür*, Stuttgart, 1962.

ADDITIONAL BIBLIOGRAPHY SINCE 1970

1. *L. Ghiberti e la sua arte nella Firenze del '3-'400*, ed. M. Rosito, Florence, 1979.
2. *Lorenzo Ghiberti: materia e ragionamenti*, Florence, 1978. (Henceforth quoted as *Catalogo*.)
3. *Lorenzo Ghiberti nel suo tempo. Atti del Convegno Internazionale di studi . . . , 1978*, Florence, 1980. (Henceforth quoted as *Atti*.)
4. V. Androssov, "Relief from the Workshop of Ghiberti," *Soobščeni ja Gosudarstvennogo Ermitaža*, XXXVIII (1974), p. 4ff.
5. Anonymous, "Triple-headed Sceptre. Workshop of Lorenzo Ghiberti," *Burlington Magazine*, CXV (1973), p. 849.
6. M. Baxandall, *Giotto and the Orators*, Oxford-Warburg Studies, Oxford, 1971, p. 78ff.
7. B. Bearzi, "La tecnica usata dal Ghiberti per le porte del Battistero," *Atti*, p. 219ff.
8. C. Bec, "Il mito di Firenze da Dante al Ghiberti," *Atti*, p. 3ff.
9. L. Becherucci, "Una statuetta del Bargello," *Antichità viva*, XV (1976), n. 2, p. 9ff.
10. J. Beck, "Ghiberti giovane e Donatello giovanissimo," *Atti*, p. 111ff.
11. J. Beck, "Uccello's Apprenticeship with Ghiberti," *Burlington Magazine*, CXXII (1980), p. 837.
12. L. Bellosi, "A proposito del disegno dell'Albertina (dal Ghiberti a Masolino)," *Atti*, p. 135ff.
13. M. Bencivenni, "Lorenzo Ghiberti nel suo tempo," *Storia dell'architettura*, ser. 2, III (1978), p. 73ff.
14. F. Borsi. " 'e specialmente nella edificazione nella tribuna fumm concorrenti Filippo e io anni diciotto a un medesimo salario . . . ,' " *Atti*, p. 541ff.
15. M. Boskovits, "Il Maestro del Bambino Vispo," *Paragone*, XVI (1975), n. 307, p. 3ff.
16. A. Bove, S. Briccoli Bati, S. Di Pasquale, B. Leggeri, "Questioni marginali concernenti il rapporto Ghiberti Brunelleschi nella costruzione della cupola di Santa Maria del Fiore," *Atti*, p. 553ff.
17. G. Brunetti, "Ghiberti orafo," *Atti*, p. 223ff.
18. M. G. Ciardi Dupré Dal Poggetto, "Proposte per Vittore Ghiberti," *Atti*, p. 245ff.
19. K. Clark, *The Florence Baptistery Doors*, London, 1980.
20. A. Conti, "Un libro di disegni della bottega del Ghiberti," *Atti*, p. 147ff.
21. I. Danilova, "Sull'interpretazione dell'architettura nei basso-rilievi del Ghiberti e di Donatello," *Atti*, p. 503ff.
22. D. D. Davisson, "The Iconology of the Santa Trinita Sacristy," *Art Bulletin*, LVIII (1975), p. 315ff.
23. G. Degl'Innocenti, "Problematica per l'applicazione della metodologia di restituzione prospettica a tre formelle della Porta del Paradiso di Lorenzo Ghiberti; proposte e verifiche," *Atti*, p. 561ff.
24. *Disegni antichi degli Uffizi. I tempi del Ghiberti*, Florence, 1978.
25. G. Ercoli, "Il Trecento senese nei *Commentarii* di Lorenzo Ghiberti," *Atti*, p. 317ff.
26. S. Euler-Künsemüller, *Bildgestalt und Erzählung . . . Lorenzo Ghiberti*, Frankft-Bern-Cirenster, 1980.
27. G. Federici Vescovini, "Contribuito per la storia della fortuna di Alhazen in Italia: il volgorizzamento del Ms. Vat. 4595 e il 'Commentario terzo' del Ghiberti," *Rinascimento*, Serie II, V, 1965, p. 17ff.
28. G. Federici Vescovini, "Il problema delle fonti ottiche medievali del *Commentario Terzo* di Lorenzo Ghiberti," *Atti*, p. 349ff.
29. C. Fengler Knapp, *Lorenzo Ghiberti's Second Commentary*, Ph.D. dissertation, University of Wisconsin, 1974.
30. J. R. Gaborit, "Ghiberti et Luca della Robbia, à propos de deux reliefs conservés au Louvre," *Atti*, p. 187ff.
31. J. Gage, "Ghiberti's Third Commentary and its Background," *Apollo*, XCV (1972), p. 364ff.
32. D. Gioseffi, "Il *Terzo Commentario* e il pensiero prospettico del Ghiberti," *Atti*, p. 389ff.
33. E. H. Gombrich, "Topos and Topicality in Renaissance Art" (The Society for Renaissance Studies, Annual Lecture), London, 1975.
34. M. Gosebruch, "Ghiberti und der Begriff von 'copia e varietà' aus Albertis Maltraktat," *Atti*, p. 269ff.
35. F. Hartt, "Lucerna ardens et lucens. Il significato della Porta del Paradiso," *Atti*, p. 27ff.
36. J. L. Hurd, "The character and purpose of Ghiberti's treatise on sculpture," *Atti*, p. 293ff.
37. J. L. Hurd, *Lorenzo Ghiberti's Treatise on Sculpture: The Second Commentary*, Ph.D. dissertation, Bryn Mawr, 1970.
38. R.B.S. Jones, "Documenti e precisioni

per Lorenzo Ghiberti, Palla Strozzi e la Sagrestia di Santa Trinita," *Atti*, p. 507ff.

39. H. M. Kaplow, "Sculptors' Partnerships in Michelozzo's Florence," *Studies in the Renaissance*, XXI (1974) p. 145ff.

40. A. M. Kosegarten, "The origins of artistic competitions in Italy," *Atti*, p. 167ff.

41. G. Kreytenberg, "La prima opera del Ghiberti e la scultura fiorentina del Trecento," *Atti*, p. 59ff.

42. M. Lisner, "Die Skulpturen am Laufgang des Florentiner Domes," *Mitteilungen des Kunsthistorischen Instituts Florenz*, XXI (1977), p. 111ff.

43. C. A. Luchinat, "Momenti della fortuna critica di Lorenzo Ghiberti," *Atti*, p. 523ff.

44. C. Maltese, "Ghiberti teorico: i problemi ottico prospettici," *Atti*, p. 407ff.

45. A. Mantovani, "Brunelleschi e Ghiberti . . . ," *Critica d'Arte*, n.s. 20 (1973), p. 18ff.

46. A. Mantovani, "Brunelleschi e Ghiberti in margine all'iconografia del Sacrificio," *Critica d'Arte*, n.s. XX (1974), p. 22ff.

47. G. Marchini, "L'altare d'argento di S. Jacopo e l'oreficeria gotica a Pistoia," *Atti del II convegno internazionale di Studi, Pistoia, 1966*, Roma, 1972, p. 146ff.

48. G. Marchini, "Ancora primizie sul Ghiberti," *Atti*, p. 89ff.

49. G. Marchini, *Ghiberti architetto*, Florence, 1978.

50. G. Marchini, "Le vetrate," *Atti del I convegno sulle arti minori in Toscana, Arezzo 1971*, Florence, 1973, p. 65ff.

51. E. A. Maser, "Giotto, Masaccio, Ghiberti and Thomas Patch," *Festschrift Klaus Laukheit . . . 1973*, p. 192ff.

52. U. Middeldorf, "Additions to Lorenzo Ghiberti's Work," *Burlington Magazine*, CXIII (1971), p. 72ff.

53. U. Mielke, "Zum Programm der Paradiesestur," *Zeitschrift für Kunstwissenschaft*, XXXIV (1971), p. 115ff.

54. G. Morolli, "L'architettura dai *Commentarii*," *Atti*, p. 589ff.

55. P. Morselli, "The Proportions of Ghiberti's 'Saint Stephen,'" *Art Bulletin*, LX (1978) p. 235ff.

56. P. Murray, "Ghiberti e il suo secondo *Commentario*," *Atti*, p. 283ff.

57. R. Pacciani, "Lorenzo Ghiberti, o il Rinascimento senza avanguardie," *Atti*, p. 621ff.

58. J. T. Paoletti, " 'Nella mia giovanile età mi partì . . . da Firenze,' " *Atti*, p. 99ff.

59. A. Parronchi, "La croce d'argento dell'altare di San Giovanni," *Atti*, p. 195ff.

60. J. Pope-Hennessy, "The Sixth Centenary of Ghiberti," in *idem*, *The Study and Criticism of Italian Sculpture* (ed. The Metropolitan Museum of Art, New York), Princeton, New Jersey, 1980, p. 39ff.

61. F. Quinterio, "Filippo di Giovanni: quattro cantieri col Ghiberti," *Atti*, p. 643ff.

62. C. L. Ragghianti, "Prospettiva 1401," *Scritti in onore di Roberto Pane*, Napoli, 1972, p. 187ff.

63. S. Ray, " '. . . l'arte naturale e la gentilezza con essa, non uscendo dalle misure': costruzione e concezione dello spazio in Ghiberti," *Atti*, p. 483ff.

64. P. Rose, "Bears, Baldness and the Double Spirit: The Identity of Donatello's *Zuccone*," *Art Bulletin*, LXIII (1981), p. 31ff.

65. H. Saalman, "L'architettura e Ghiberti," *Atti*, p. 437ff.

66. J. R. Sale, "Palla Strozzi and Lorenzo Ghiberti: new documents," *Mitteilungen des Kunsthistorischen Instituts Florenz*, XXII (1978), p. 355.

67. P. Sanpaolesi, "Il Ghiberti nella Sagrestia di S. Trinita," *Atti*, p. 441ff.

68. G. Scaglia, "Drawings of Brunelleschi's mechanical inventions," *Marsyas*, X (1961), p. 45ff.

69. G. Scaglia, "A Miscellany of Bronze Works and Texts in the *Zibaldone* of Buonaccorso Ghiberti," *Proceedings of the American Philosophical Society*, CXX (1976), p. 485ff.

70. G. Scaglia, "La 'Torre del Marzocco' a Livorno in un disegno di Buonaccorso Ghiberti," *Atti*, p. 463ff.

71. G. Scaglia, "A Translation of Vitruvius and Copies of Late Antique Drawings in Buonaccorso Ghiberti's *Zibaldone*," *Transactions of the American Philosophical Society*, 60, I (1979), p. 1ff.

72. U. Schlegel, "Dalla cerchia del Ghiberti," *Antichità viva*, XVIII (1979), p. 21ff.

73. F. Sricchia Santoro, "Sul soggiorno spagnolo di Gherardo Starina e sul identità del 'Maestro del Bambino Vispo,' " *Prospettiva*, 1976, n. 6, p. 11ff.

74. E. Steingräber, "Studien zur florentiner Goldschmiedekunst," *Mitteilungen des Kunsthistorischen Instituts Florenz*, VII (1955), p. 87ff.

75. L. Vagnetti "Ghiberti prospettico," *Atti*, p. 421ff.

76. H. Van Veen, "L. B. Alberti and a passage from Ghiberti's *Commentaries*," *Atti*, p. 343ff.
77. J. Van Waadenoijen, "Ghiberti and the origin of his international style," *Atti*, p. 81ff.
78. J. Van Waadenoijen, "A Proposal for Starnina: Exit the Maestro del Bambino Vispo?," *Burlington Magazine*, CXVI (1974), p. 82ff.
79. M. Wundram, "Lorenzo Ghiberti," *Neue Zürcher Zeitung*, no. 239 (October 14-15, 1978), p. 65f.
80. D.F. Zervas, "Ghiberti's St. Matthew ensemble at Orsanmichele: symbolism in proportion," *Art Bulletin* LVIII (1976), p. 36ff.
81. D. F. Zervas, *System of design and proportion used by Ghiberti, Donatello and Michelozzo in their large-scale Sculpture-architectural ensembles*, Ph.D. dissertation, Johns Hopkins, 1973.

INDEX

Adam, John and Robert, 294

Adam of Eaton, Bishop of Hertford, 358n

Adonis sarcophagus, *see* Roman sculpture, sarcophagi

Agincourt, Seroux d', 22

Alamandi, Ludovico, Archbishop of Arles, 358n

Albani Collection (former), *see* Rome, Capitoline Collections, *Kneeling Son of Niobe*

Albergati, Cardinal Niccolo, 317-18, 321

Alberti, Leone Battista, 28, 150, 236, 240n, 246, 248, 267n, 268n, 269-71, 274, 276-77, 288, 293, 304, 310, 315-34, 346; linear perspective of, 244n, 245-47, 248n, 252-53, 273; appointed to Priorate of S. Martino in Gangalanda, 318

 Architecture: Florence, S. Maria Novella, 272n; Mantua, S. Andrea, 272; Mantua, S. Sebastiano, 272; Rimini, S. Francesco, 270n, 271, 272n, 317

 Writings: *De commodis litterarum atque incommodis*, 317n; *De Equo animante*, 269n; *Della Famiglia*, 270n, 274, 310, 315-16, 317n; *Della Pittura*, 229, 232, 234, 244-45, 247, 250-51, 273, 301n, 311, 313, 315-17, 319-20, 322-26, 328-29, 331-34; *De Re Aedificatoria*, 230, 232, 268-71, 273-74, 311, 313, 317n, 324, 330; *Descriptio urbis Romae*, 315-16, 322n; *De Statua*, 311, 322; *Intercoenales*, 269n; *Ludi mathematici*, 269n; *Philodoxis*, 317n, 318; *see also* antiquity, architecture; antiquity, art of; terminology

Albertini, Francesco, 18

Albizzi family, 33

Albizzo di Piero, 74n

Alcherius, Johannes, 58

Alcuin Bible, *see* Paris, Bibliothèque Nationale

Alexander the Great, portrait type, 341

Alhazen, 307

all'antica, see antiquity, art of

Altenburg, Staatliches Museum, *Reclining Eve, see* Lorenzetti, Ambrogio, and Iconography; *Flight into Egypt, see* Monaco, Lorenzo

Altoetting, *Golden Roessel*, 65

Altoviti family, 365

Ambrose, Saint, 175, 177-80, 187, 216; *De Abraham*, 174n, 176; *De bono mortis*, 176; *De Cain et Abel*, 175-76; *De fuga saeculi*, 176; *De Isaac et anima*, 176; *De Jacob et vita beata*, 176; *De Joseph Patriarcha*, 176; *De Noe et Arca*, 176; *De Paradiso*, 175; *De Virginitate*, 174n; *Hexaemeron*, 175

Amiens Cathedral, foliage decoration of nave, 61

Amsterdam, formerly Gutmann Collection, *imago pietatis* reliquary, 65

Andrea da Firenze, 139n, 219; Pisa, Camposanto, frescoes, 221; Florence, S. Maria Novella, Spanish Chapel, frescoes, *Via Veritatis, Crucifixion, Way to Calvary*, 215, 221-22, 224, 258n

Angelico, Fra, 181; Florence, Museo San Marco, Linaiuoli Altar (frame design by Ghiberti), 6, 261n, 264, 361

Angelo d'Arezzo, 256

Angers, Tapestries of the Apocalypse, 56, 60, 63; *Saint John Eating the Book*, 60; *Dragon Threatening the Woman*, 60

Anonimo Magliabecchiano, 19-20, 39, 62n, 75n, 87n, 306, 354, 357

antiquity, architecture, influence of: on Alberti, 269-75; on Brunelleschi, 262-63, 273; on Donatello, 263-64; on Ghiberti, 258-60, 262, 264-65, 273, 330, 334. *See also* Roman architecture

antiquity, art of, 25n, 279, 287, 293, 316; early revival in Venice, 278; impression made on Ghiberti, 278, 301, 314; known to the Renaissance, 337-57; Renaissance, image of, 90; Renaissance tool, 89. *See also* Roman art; Roman sculpture; Trecento, influence on Ghiberti; *influence*: on Alberti, 272-74, 315, 322, 324, 330; on Nanni di Banco, 83, 86, 90, 91, 100; on Brunelleschi, 45, 53, 273, 281-83; on city representations, 198, 267n; on Donatello, 90, 91, 273; on Florentine artists, 208, 273, 279, 304-5, 323;

on Vittorio Ghiberti, 212; on Hercules master, 52-53, 281-83; on Lorenzetti workshop, 218; on medals of Duc de Berry, 59; on Middle Ages, 297-98; on Pisanello, 288, 337, 349, 351; on Porta della Mandorla, 279, 280, 281; on Trecento 225, 286, 290, 292, 342, 343; on Lorenzo Ghiberti, 28, 49, 137, 260, 275, 277-93, 337-52; competition relief, 53, 281, 283-84; East Door, 210, 218, 225; architectural settings, 258, 262, 265, 273, 330, 334; figures and draperies, 181, 195, 332; North Door, 92, 127, 283-84; *Saint Matthew*, 87-89, 92; Roman trips, influence of, 288, 330, 332

Antonine, Saint, *Summa Theologica*, 187n, 188n

Antonio di Tommaso, 110n

Apelles, 309

Apuleius, 325

Aragazzi, Bartolomeo, 321

Arbois, Jean, 58

Arbury Hall, Newdgate College, Bacchic sarcophagus, *see* Roman sculpture, sarcophagi

Aretine vases, 298

Arezzo, Museum, *Pax* with *imago pietatis*, 65

Aristotle, *Poetics*, 316

Arnolfo di Cambio, 94n

art nouveau, 26-27

Arte di Calimala, etc., *see* Guilds

Arthurian cycles, 77-78

Assisi, S. Francesco, *see* Lorenzetti, Pietro

Athenaios, Τὰ Ὀργανικὰ, 308, 310-12, 332

Athens, Duke of, 33

Augustine, Saint, 173, 175, 178, 185, 216; *De catechizandis rusticis*, 173n; *De Civitate Dei*, 174n, 176; *Enarratio in Psalmos*, 173, 174n

Aurispa, 308, 311-12, 332

Averroës, 307-8

Avicenna, 307

Baboccio (Antonio da Priverno), 62n

Bacchic sarcophagi, *see* Roman sculpture, sarcophagi

Bacon, Roger, 307-8

Badia di Settimo, frescoes, *see* Bonamico (Buffalmacco)

Baerze, Jacques de, *see* Dijon, Museum, Altar

Baese, Arduino del, 261n

Baldinucci, Filippo, 11, 21, 27, 73, 75n, 97, 110, 360, 365

Baldovinetti, Alessandro, Florence, S. Miniato, Chapel of the Cardinal of Portugal, frescoes, 186n

Balduccio da Pisa, Giovanni, Florence, S. Croce, Berlinghieri Tomb, *Annunciation*, 99

Baltimore, Walters Art Gallery, Architectural panel, Luciano di Laurana (attributed), 268-69, 272-73

Bamberg Cathedral, Tomb of Bishop Hohenlohe, 147n; *Visitation*, 297

Banco, Antonio di, Florence Cathedral, Porta della Mandorla, archivolt, 83

Banco, Nanni di, 17n, 52n, 53n, 83, 84n; Florence Cathedral, Porta della Mandorla, Tympanum, 90, 100; *Isaiah*, 83, 90-91; Museo dell'Opera, *Saint Luke*, 71-72, 83; Or San Michele, *Quattro Coronati*, 72, 84, 86, 90-91, 137, 143, *Saint Eligius*, 72, 84, 90-91, *Saint Peter* (with Donatello?), 72, *Saint Philip*, 72, 84, 86, 90-91, 97n; *see also* antiquity, art of

Bandinelli, Baccio, 19

Bandino di Stefano, 108, 110n

Barbarian heads, *see* Roman sculpture, sarcophagi

Barbo, Cardinal Pietro, *see* Paul II, Pope

Barna da Siena, 56, 218, 223, 309

Barnaba di Francesco, 110n

Bartoli, Cosimo, 20, 244n

Bartolo di Fredi, 55; Montalcino, Museo Civico, Altarpiece, *Assumption*, 55, 76, 215; San Gimignano, Collegiata, Old Testament cycle, 175, 176n, 221-23, 225, 345

Bartolo di Michele, foster father of Lorenzo Ghiberti, 3-5, 36, 41, 51, 105, 106, 108, 110n, 121n, 137, 139, 360

Bartolomeo di Luca, father-in-law of Lorenzo Ghiberti, 4

Bartoluccio, *see* Bartolo di Michele

Battista d'Antonio, 254-56

Battle sarcophagi, *see* Roman sculpture, sarcophagi

Baume-les-Messieurs, *Saint Paul*, 79

Beardsley, Aubrey, 26

Bearzi, Cavaliere Bruno, 46n, 75n, 116n, 133n, 139n, 164

Beatrix of Tuscany, tomb of, *see* Pisa, Camposanto, Phaedra sarcophagus and Roman sculpture, sarcophagi

Beau Bréviaire of Charles V, Paris, Bibliothèque Nationale, 61

Becchi, Michele, 93

"bel San Giovanni," *see* Florence, Baptistery

Bellano, Bartolomeo, 18

Bellini, Jacopo, Sketchbook, drawing of Samson, 349

Bellori, Giovanni Pietro, 294

Benevento Cathedral, bronze doors, New Testament cycle, 114n

Benvenuto da Imola, 287n

Berardi, Cristofano, 365

Berenson Collection, *see* Monaco, Lorenzo

Bergamo, Museo Civico, model book, *Boar Hunt*, 59. See also Giovannino de'Grassi

Berlin, Kaiser Friedrich Museum, *Desco di Parto* (perspective construction), 245n

——, Kupferstichkabinett, *see* Dosio, Giovanni Antonio

——, Staatsbibliothek, Hamilton Bible, 39; Codex Pighianus, 338

Bernard of Clairvaux, 185

Bernardino of Siena, 178

Bernardo di Stefano, Fra, 74n, 79n

Beroldo Manuscript, *see* Milan, Biblioteca Visconti

Berry, Jean Duc de, 58, 63, 300

Bertoldo di Giovanni, Florence, Bargello, bronze relief after Roman battle sarcophagus, 341, 349

Besozzo, Michelino da, 58, 79

Bessarion, Cardinal, 184

Biblia Pauperum, 39n, 173-74

Bicci di Lorenzo, 259; New York, Metropolitan Museum of Art, Saint Nicolaus panels, 259n

Bisticci, Vespasiano de', 183, 304

Black Death, *see* Pestilence of 1348

Blenheim Castle, Bacchic sarcophagus, *see* Roman sculpture, sarcophagi

Boccaccio, Giovanni, 310

Bocchi, Francesco, 18, 21, 97

Bode, Wilhelm, 26-27

Bologna, Giovanni da, 71n

Bologna, Museo Civico, Legnano Tomb, 57; S. Maria de' Servi, Manfredi Tomb, 57

Bologna, University of, 315, 317-18

Bonamico (Buffalmacco), 309, 353-54, 357-58; Badia di Settimo, frescoes (lost), 357; Porta a Faenza, frescoes (lost), 357

Bonannus, Monreale Cathedral, bronze door, Old Testament cycle, 114n, 177n, 218; Pisa, Cathedral, bronze door, *Life of Christ*, 114, 218

Bondol, Jean (Hennequin de Bruges), 55-56, 60

Boninsegni, Domenico, 16

Boston, Museum of Fine Arts, *Saint Christopher*, bronze, 83-84

Botticelli, Alessandro, Florence, Uffizi, *Primavera*, 325, 334, 346; London, National Gallery, *Venus and Mars*, 333, 351; Rome, Sistine Chapel, *Sacrifice of the Leper*, 333

Boucicaut Master (Jacques Coene?), 58n, 78

Bracciolino, Poggio, *see* Poggio Bracciolino, Giovanni

Branda da Castiglione, Cardinal, 320

Broccardi, Mona Caterina (widow of Piero Broccardi, 111, 112, 116n

Broccardi, Piero, 111, 112, 116n

Brockhaus, Heinrich, 26

Broederlam, Melchior, *see* Dijon, Museum, Altar

De Brosses, President Charles, 21

Brunelleschi, Filippo, 5, 7-9, 12, 17, 19, 23, 25, 35-36, 38-42, 50-51, 66, 89, 139n, 234, 256, 263, 267, 272-73, 302, 304, 316, 318-21, 323; and Alberti, perspective method, 229n, 234-48, 251

Works: Florence Cathedral, dome, 15, 254-56, 263, 274, 323; design for choir, 256, 257n; Sepulcher of Saint Zenobius, design of architecture, 141; Hospital of the Innocents, 262, 265-66, 275, 319; Palazzo di Parte Guelfe, 262, 266, 275; Pazzi Chapel, 262, 265; Bargello, competition panel, *Sacrifice of Isaac*, 42-49, 50-53, 66, 278, 281-83, 299; S. Lorenzo, 257n, 262n, 266, 275; Sagrestia Vecchia, 262, 264-65, 268, 275-76; S. Maria degli Angeli, 33, 263; S. Spirito, 35n, 262n, 263, 266, 275; Pistoia, Silver Altar of San Jacopo, Prophets, 59, 90; perspective paintings, 234-48. See also antiquity, architecture; Early Christian basilicas; Manetti, Antonio di Tuccio; *Vita di Brunellesco*

Bruni, Leonardo, 37, 154, 161, 164, 169, 171-72, 174-76, 178,

180, 187, 279, 302n, 310, 321, 332, 363; *Commentarii de Bello Punico*, 356; program for East Door, Florence Baptistery, 114, 159-72, 174-76, 180, 217, 225, 302

Brussels, Bibliothèque Royale, *Brussels Hours*, 78; Musées Royaux, Pelops sarcophagus, *see* Roman sculpture, sarcophagi

Burckhardt, Jacob, 25, 27, 97; *Der Cicerone*, 24

Byzantine style, Ghiberti's discussion of, 309, 357

Cambi, Giovanni, *Istorie*, 16
Campania, School of, 297
Campione, Jacopo da, Milan Cathedral, *Salvator Mundi in His Glory*, 57, 59
Campione, S. Maria de'Ghirli, *Last Judgment*, Franco and Filippolo de'Veris, 79
Capuan workshop, 297
Caravaggio, Polidoro da, Munich, Graphische Sammlung, Drawing after Bacchic sarcophagus, 344, *see* Roman sculpture, sarcophagi, London
Carelli Tomb, *see* Milan, S. Eustorgio
Carracci, the, 294
Carrara herbal, *see* London, British Museum
Carocci, Giovanni, 26
Cassel, Museum, *see* Roman sculpture, Victory statuette, Zeus statuette
Castel del Sangro, reliefs, *see* Florence, Cathedral, Museo dell'Opera
Catasto (Portate al Catasto), 3, 7, 8, 111, 112, 162, 163, 360. *See also* Ghiberti, *Catasto* and Guilds, *Arte di Calimala*
Castiglione d'Olona, frescoes, Masolino, 259n
Cavallini, Pietro, 309; Rome, S. Maria in Trastevere, apse mosaics, 357
Cellini, Benvenuto, 20
Cennini, Bernardo, 232
Cennini, Cennino, 315, 316n
Cennini, Piero, 17
Challante, Antoine de, 358n
Charlemagne, *see* Paris, Louvre, Scepter of Charles V
Charles IV, German Emperor, *see* Vienna, Rathausmuseum, statue of
Charles V, King of France, 63, 133, 297. *See also* Paris, Louvre, statues from the Quinze-Vingt

Charles VI, King of France, 65
chivalric romances, 298
Chrysobergi, Andrea, Archbishop of Colossos, Bishop of Rhodes, 184
Chrysoloras, Manuel, 279
Cicero, manuscripts of, 312n
Cicognara, Luigi, 23-24
Cimabue, 309
Ciompi revolt, 78
Cione Paltami di Ser Buonaccorso Ghiberti, father of Lorenzo, *see* Ghiberti, Cione Paltami
Ciriaco d'Ancona, 300-1, 305
Cité de Dieu, Paris, Bibliothèque Nationale, 61
Città di Castello, Galleria Municipale, reliquary of Saint Andrew, 119, 130n. *See also* Ghiberti, Lorenzo, *Works* (attributed to), statuettes of Saint Andrew and Saint Francis
Ciuffagni, Bernardo di Piero, 84, 109; *Saint Matthew*, 83
classical art, *see* antiquity, art of; Roman art
classical principles in Ghiberti competition relief design, 53; in *Saint Matthew*, 87-89, 92; North Door, 92, 127-28; in Florentine Renaissance, 86, 90-91; in Donatello, 90, 91, 273, 286
classicism, 18th century, 25; 19th century, 22-25
Clement XII, Pope, 339
Clementia Imperatoris, *see* Roman sculpture, reliefs, Arch of Constantine, Aurelian reliefs
Cleveland Museum, *Reclining Eve*, attributed to Siena or Marche, 172n
Coburg, Bavaria, Castle, Codex Coburgensis, 291, 337; drawing of Bacchic sarcophagus, 345; drawing for *Gathering-in of Meleager*, 347; drawing after a Medea sarcophagus, 348; drawings after Bacchic sarcophagi, 350
Coccharelli Manuscript, *see* London, British Museum
Cocchi, Antonio, 22
Cocchi, Raimondo, 22
Codex Berolinensis, *see* Dosio, Giovanni Antonio
Codex Coburgensis, *see* Coburg, Bavaria, Castle
Codex Escurialensis, *see* Escorial
Codex Pighianus, *see* Berlin, Staatsbibliothek
Coene, Jacques (Boucicaut Master?), 58n, 78

Cola di Domenico di Giovanni, 110n
Cola di Nicola, *see* Spinelli
Colle, Simone da, 12, 40
Colonna, Cardinal Francesco, 346
Colonna, Cardinal Prospero 269n, 321
Cone, Jacobus, *see* Coene, Jacques
Constans II, colossal head and hand of, *see* Roman sculpture
Constantine, Emperor, 182, 309, 353, 357; Arch of, *see* Roman sculpture, reliefs
Constantine with three sons, *see* Roman sculpture
"Constantine," *see* Paris, Bibliothèque Nationale
Constantine medal for Jean Duc de Berry, 59. *See also* antiquity, art of, influence on medals of Duc de Berry
Copenhagen, Ny-Carlsberg Glyptothek, Bacchic sarcophagus, *see* Roman sculpture, sarcophagi
Cortona, Cathedral, *see* Roman sculpture, sarcophagi, *Dionysos Battling the Amazons*, lid
Cosenza, Cathedral, Tomb of Isabeau of France, 147n
Council of Basel, 183, 185
Council of Florence, 181-88
Cristiani, Giovanni di Bartolomeo, 51n
cupolone, *see* Florence Cathedral, dome
Cyprian, Saint, 185

Daddi, Bernardo, 217n
Dante Alighieri, 28, 31, 295
Dark Ages, 309
Dati, Leonardo the Younger, 178
Dati, Leonardo, General of Dominicans, 138n. *See also* Ghiberti, Lorenzo, *Works*, Florence, S. Maria Novella, Dati Tomb
David, Jacques Louis, 294
Delli, Dello, 209n; *Blessing of Isaac*, *see* Florence, S. Maria Novella, Chiostro Verde
Desiderio da Settignano, 17, 333
Dijon, Museum, Altar, Jacques de Baerze and Melchior Broederlam, 78; Chartreuse de Champmol, Virgin and donors, Claus Sluter, 55; *Well of Moses*, 78, 85
Diodorus Siculus, *World History*, 356
Dionysius of Genoa, Frater, 58n
Dionysius of Halicarnassus, *Roman Antiquities*, 356

Domenico di Giovanni, 108
Dominicus Johannis, Frater, 16
Donatello, 7, 17-20, 23-24, 27, 36, 40n, 72n, 84n, 93, 100, 109, 138, 140, 152n, 193, 200, 206, 238n, 262-63, 273, 275, 302-4, 311, 318-23, 325, 329, 331-32, 338. *See also* classical elements; antiquity, architecture; antiquity, art
　Works: Florence, Bargello, *David*, 84n; *Marzocco*, 90-91, 132, 152; *Saint George* (*see* Or San Michele); Cathedral, *Cantoria*, 106n, 263, 264n; Museo dell'Opera, *Jeremiah*, 90; *John the Baptist*, 90 (both from Campanile), *Saint John the Evangelist*, 83, 90; Porta della Mandorla, 84; S. Croce, Cavalcanti Altar, 263, 264n; *Christ on the Cross*, 120; S. Croce, Museum, *Saint Louis* (from Or San Michele), 5, 74, 87, 93, 95, 152-53; S. Lorenzo, Sagrestia Vecchia, bronze doors, 327; Tondi of *Life of Saint John the Evangelist*, 201; Or San Michele, *Saint George*, 72, 83-84, 86, 90 (*see also* Florence, Bargello), relief, 150, 153, 319; *Saint Louis* (*see* S. Croce, Museum) architecture of niche, 263; *Saint Mark*, 72, 84, 90-92, 137, 152, 319; *Saint Peter* (in collaboration with Nanni di Banco?), 72; alleged competition relief, *Sacrifice of Isaac*, 43n; Lille, Musée Wicar, *Dance of Salome*, 201; London, Victoria and Albert Museum, *Giving of the Keys*, 150, 327; Naples, S. Angelo a Nilo, Brancacci Tomb, *Assumption*, 150, 153; Padua, Santo, High Altar, *Miracle of the Ass*, 25, 264, 268; Rome, St. Peter's, Sacristy, *Tabernacle*, 347; Siena, Cathedral, Baptismal Font, *Salome*, 151-53, 221, 244, 263, 264n, 327-28, Pecci Tomb, 152-53
Dondi, Giovanni, 295-99, 302, 304
Doni, Anton Francesco, 20
Doren, Alfred, 26
Dosio, Giovanni Antonio, Codex Berolinensis, Berlin, Kupferstichkabinett, drawing of Bacchic sarcophagus, 345
Dresden, Secundogeniturbibliothek, *Bible*, 177n
Duccio, 54, 215n, 218, 309; Siena, *Maestà*, 114n, 218
Duccio, Agostino di, 325, 333

Early Christian basilicas, influence on Brunelleschi, 263
Early Christian and Byzantine art, influence on Ghiberti, 286, 325; sarcophagi and pyxides, *Sacrifice of Isaac*, 38n
Egeria, Grotto of, *see* Rome
Embriachi workshop, 58
Empoli altarpiece, *see* Lorenzo Monaco
Endymion sarcophagus, *see* Roman sculpture, sarcophagi
Escorial, Codex Escurialensis, 337
Este, Lionello d', 269n, 270n
Este, Meladusio d', 269n
Este, Museo Nazionale Atestino, *cippus, see* Roman sculpture, reliefs
Euclid, 245
Eugene IV, Pope, 5, 13, 67, 183-85, 315, 356
Evander, *see* Rome, Palace of
Eyck, Jan van, 17, 150, 318

Fabriano, Gentile da, 17, 58, 137, 146n, 147, 150, 320; Florence, Uffizi, Epiphany altar (Strozzi altar) from S. Trinità, 146, 285, 326; Quaratesi altarpiece, 80; New Haven, Conn., Yale University Art Gallery, *Jarvis Madonna*, 146
Farnese, Piero, 340
Fazio, Bartolommeo, 16, 85, 269n
Federighi, Antonio, Munich, Graphische Sammlung, drawing of barbarian from Arch of Constantine, 345; drawing of Three Graces, 346
Feo, Niccolo di Luca di, 106
Ficino, Marsilio, 325
Filarete (Antonio Averlino), 234, 236; Paris, Louvre, *Madonna*, 172n; *Treatise*, 267n, 268
Filippo di Ser Ugolino, Ser, 279
Finiguerra, Maso, 17
Fiore, Mona, mother of Ghiberti, 3
Florence, Guilds, *see* Guilds; Taxes, *see* Catasto
———, Accademia, *Annunciation*, Lorenzo Monaco, 80, 81n; Nobili altarpiece, Lorenzo Monaco, 80; *Mount of Olives*, Lorenzo Monaco, 82, 120, 124
———, Baptistery, history, 31, 33; Baptismal Font, 120
———, Baptistery, East Door (*Porta del Paradiso*), and North Door, *see* Ghiberti, Lorenzo
———, Baptistery, South Door, *Life of Saint John the Baptist*,

Andrea Pisano (frame by Vittorio Ghiberti and workshop), 9, 17, 24, 25n, 31n, 32-34, 38, 105, 113, 133-34, 169, 212-13, 215, 216n, 218, 363, 365; *Eve*, Vittorio Ghiberti, 291, 344. See *also* antiquity, art of; Roman sculpture, *Venus Pudica*, Roman sculpture, Bacchic sarcophagus, London
———, Baptistery, Mosaics of the Dome, *Storing of Grain by Joseph*, 171; Tomb of John XXIII, *Virtues*, Michelozzo, 87. See *also* Museo dell'Opera, Silver Altar of Saint John the Baptist
———, Bargello, Battle relief, Bertoldo di Giovanni, 341, 349; Competition relief, *Sacrifice of Isaac*, Brunelleschi, 42-49, 50-53, 66, 278, 281-83, 299; *David*, Donatello, 84n; *Saint George* (from Or San Michele), Donatello, 72, 83-84, 86, 90; *Marzocco*, Donatello, 90, 91, 132, 152; Competition relief, *Sacrifice of Isaac*, Ghiberti, 12, 31-54, 60, 61-67, 71, 76, 82, 113, 117n, 122-23, 132, 137, 143, 214, 278-79, 283, 299, 339, 363; Shrine of SS. Protus, Hyacinth and Nemesius, 5, 10, 12, 13, 100, 138-39, 143, 146-48, 152-53, 206, 286, 319, 329, 331, 343; *Saint Luke*, Niccolo di Piero Lamberti (from Or San Michele), 71, 72n
———, Biblioteca Laurenziana, Biadajolo miniature, 258n; Diogenes Laertius manuscript, 186n; *see also* Traversari
———, Biblioteca Nazionale, Codex, Francesco di Giorgio, 281n; *Vita di San Giovanni Battista*, Zanobi di Pagholo d'Agnolo Perini, 122, 123
———, Bigallo, fresco, 258n
———, Campanile, *Jeremiah*, Donatello, *see* Museo dell'Opera; *Saint John the Baptist*, Donatello, *see* Museo dell'Opera; *Artes, Agriculture*, Andrea Pisano, 298, 345
———, Cathedral (S. Maria del Fiore, S. Reparata), 33, 94n, 274; "*Poggio*," 341; *Cantoria*, Donatello, Luca della Robbia, 106n, 211, 263-64, 319; *Saint Stephen* from façade, Arnolfo di Cambio workshop (attributed), *see* Gardens Venturi-Ginori; *Isaiah*, Nanni di Banco, 83, 90, 91; choir, design by

Brunelleschi, 256, 257n; dome, 4-6, 15, 36, design by Brunelleschi, 15, 254-56, 263, 274, 323; Sepulcher of Saint Zenobius, design for architecture, Brunelleschi, 141; choir, design by Ghiberti, 6, 256; model for lantern, Ghiberti, 6; model for dome, Ghiberti, 112; Zenobius Shrine, Ghiberti, 5-6, 8, 12-14, 17, 22-23, 36, 94, 141-43, 146-47, 154-55, 166, 192-95, 200-2, 205-10, 257-59, 272, 276, 291, 331, 348, 351, 352, 360-61, Angels, 142-43, 154; Miracle of the Cart, 154, 206, Resurrection of the Servant, 154, 206, Resurrection of a Boy of the Strozzi family, 142, 154, 205-10, 351-52; stained glass window cartoons by Ghiberti, 4, 6, 203, 361, Assumption of the Virgin 15, 54, 76, 82, 122-23, 215, Ascent of Christ, Mount of Olives, Presentation in the Temple, 15; Saint Stephen from façade, Piero di Giovanni Tedesco, see Paris, Louvre; Saint Stephen from Or San Michele, Andrea Pisano (attributed to), 94; North Sacristy Door, Luca della Robbia, 7n, 106n, 116n, 117n, 211; Porta della Mandorla, 52, 53, 59, 83-84, 278-81, 299; Tympanum of the Porta della Mandorla Virgin, Nanni di Banco, 90, 100; prophets, Donatello, 84; Hercules with the Lion Skin, Hercules Master, 52-53, 60, 67, 89, 280n, 282-83, 299

————, Cathedral, Museo dell'Opera di S. Maria del Fiore, Saint Luke, Nanni di Banco, 71-72, 83; Saint Matthew, Ciuffagni, 83; Jeremiah, Donatello, 90; Saint John the Evangelist, Donatello, 83, 90; Annunciation from Porta della Mandorla, Hercules Master, 53, 279, 281; Saint Mark, Niccolo Lamberti, 83, Sainted Deacon, attributed to Andrea Pisano, 94n, 95n; Phaeton sarcophagus, 339-40, see Roman sculpture, sarcophagi; Prophets, copies after mosaics, 216; Silver Altar of Saint John the Baptist, 50, 258n, 279; six reliefs from Castel di Sangro, 116n

————, Cathedral Treasury, Libretto, reliquary, 64

————, Column of S. Zenobius, 167

————, Gardens, Venturi-Ginori, Saint Stephen from Cathedral façade, Arnolfo di Cambio workshop (attributed to), 94n

————, Hospital of S. Gallo, 33

————, Hospital of the Innocents, Brunelleschi, 262, 265-66, 275, 319, Galleria, Saint John the Evangelist, Jacopo di Piero Guidi (attributed to), 71

————, Medici Chapel, see Palazzo Medici

————, Museo Archeologico, bronze Hercules, 280n, 281n

————, Museo S. Marco, Linaiuoli Altar, Fra Angelico (frame design by Ghiberti), 6, 261n, 264, 361

————, Or San Michele, 73, history, 71; Quattro Coronati, Nanni di Banco, 72, 84, 86, 90-91, 137, 143; Saint Eligius, Nanni di Banco, 72, 84, 90-91; Saint Peter, Nanni di Banco (attributed, with Donatello?), 72; Saint Philip, Nanni di Banco, 72, 84, 86, 90-91, 97n; Saint George, Donatello (copy after, see Florence, Bargello), relief, 150, 153, 319; Saint Louis, Donatello (see S. Croce, Museum), architecture of niche, 263; Saint Mark, Donatello, 72, 84, 90-92, 137, 152, 319; Martyrdom of Saint Lawrence, Taddeo Gaddi, 258n; Ghiberti, three statues, 7, 11, 17-18, Saint John the Baptist, inscription, 3, commission, 4, mentioned, 13, 21, 24, 71-86, 88-90, 92-94, 112, 121, 124-27, 131, 152, 244-47, 260-61, 360, 362, 365, architecture of niche, 260; Saint Matthew, commissioned, 5, mentioned, 13, 19, 26, 71, 73-75, 86-97, 99-100, 111-13, 121, 131-32, 137, 144, 149, 152, 208, 283, 286, 292, 319, 331, 342-43, 360-61; architecture of niche, 261n, 262, 264-66; Saint Stephen, commission, 5, mentioned, 13, 71, 74, 86, 88n, 93-100, 137, 141, 358, 361, projected architecture of niche, 264-66, 275, preparatory drawing, 95n, 97-99, see Paris, Louvre; Saint John the Evangelist, Jacopo di Piero Guidi, attributed to, 71n, see Florence, Hospital of the Innocents, Galleria; Saint James Major, Nicolo di Piero Lamberti, 71; Saint Luke, Nicolo di Piero Lamberti, see Bargello; Saint Mark, commissioned to Nicolo di Piero Lamberti, 72; Annunciation, above niche of Saint Matthew, attributed to Michelozzo, 87n, 88n; Tabernacle of the Virgin, Orcagna, 72

————, Palazzo Medici, Chapel, murals, Journey of the Magi, Benozzo Gozzoli, 202, 205-6, 333; two deacons, 95n

————, Palazzo di Parte Guelfa, Brunelleschi, 262, 266, 275

————, Palazzo Pitti, Argenteria, Pietà (sardonyx), 65; Pope Leo X, Raphael, 39n; Caesar portrait, 341, see Roman sculpture

————, Palazzo Ruccellai, 271n

————, Pazzi Chapel, Brunelleschi, 262, 265

————, Porta della Mandorla, see Cathedral

————, S. Croce, 33; Convent, 33; Medici Chapel columns, Michelozzo, 265n; Berlinghieri Tomb, Annunciation, Giovanni Balduccio da Pisa, 99; Cavalcanti Altar, Donatello, 263, 264n; Christ on the Cross, Donatello, 120; Apse frescoes, Agnolo Gaddi, 214n; Castellani Chapel, frescoes, Agnolo Gaddi, 80, 214n; Sacristy, Crucifixion and Sacrifice of Isaac, Taddeo Gaddi or Niccolo di Piero Gerini, 50n, 282n; Tombs of Bartolomeo Valori and Lodovico degli Obizi, Ghiberti workshop, 6, 13, 203-4; Ghiberti Tomb, 9; Sylvester legend frescoes, Maso di Banco, 224, 259; Museum, Saint Louis (from Or San Michele), Donatello, 5, 74, 87, 93, 95, 152-53

————, S. Egidio, Shutter with God the Father, Ghiberti, see S. Maria Nuova

————, S. Lorenzo, architecture, Brunelleschi, 257n, 262n, 266, 275; Sagrestia Vecchia, architecture, Brunelleschi, 201, 262, 264-66, 268, 275-76; bronze door, Donatello, 327; tondi of the Life of Saint John the Evangelist, Donatello, 201

————, S. Maria degli Angeli, architecture, Brunelleschi, 33, 263; Shrine of SS. Protus, Hyacinth and Nemesius, Ghiberti, see Ghiberti, Bargello; Nobili altarpiece, Lorenzo Monaco, see Florence, Accademia

————, S. Maria del Carmine, Brancacci Chapel, frescoes, Masaccio, Expulsion, 344; Giv-

ing of the Keys, 201; *Tabitha fresco*, 201, 241-42; *Tribute Money*, 150, 201, 220-21, 326

———, S. Maria Novella, façade, 271; pilasters flanking portal, Alberti (?), 272n; papal apartment, 183, design for staircase by Ghiberti, 256; Chapel of Niccolo Acciaiuolo, murals, 33; Spanish Chapel, fresco cycle of New Testament, Andrea di Firenze, 215, *Way to Calvary*, 257n, *Crucifixion, Via Veritatis*, 221-22, 224; Tomb of Leonardo Dati, Ghiberti, 5, 12-13, 138, 143, 147-48, 152-53; *Trinity* fresco, Masaccio, 150, 240, 263, 319; Chiostro Verde, frescoes, *Abraham* scenes, 208-10; Dello Delli, *Blessing of Isaac*, lost, 259; Paolo Uccello and workshop, 178, 208-10, 344; *Creation of Adam*, 208, *sinopia* of *Adam*, 210, 344; *Creation of Eve*, 208n, 209n; *Creation of Animals*, 208, 219n; *Fall of Man*, 208n, *Expulsion*, 208, 209n, 210; *Labors of Man*, 208, 209n

———, S. Maria Nuova, bronze shutter with *God the Father* for tabernacle, Ghiberti, 9, 204, 207, 361. *See also* S. Egidio

———, S. Miniato, 33; Chapel of the Cardinal of Portugal, frescoes, Baldovinetti, 186n

———, S. Reparata, *see* Cathedral

———, S. Spirito, Brunelleschi, 33n, 262n, 263, 266, 275

———, S. Trinità, Strozzi Tomb Chapel, choir stalls and furnishings, 256, 261n; portal, 261; Epiphany Altar, Gentile da Fabriano, *see* Uffizi

———, Uffizi, Iphigenia *cippus*, 287-88, 290, 347; Niobid statues, 339; *Sacrifice of Isaac*, engraving, 43n; Satyr torso, 339; *Primavera*, Botticelli, 325, 334, 346; Epiphany Altar (Strozzi altar), Gentile da Fabriano, 146, 285, 326; *Coronation of the Virgin*, Fra Filippo Lippi, 202; *Presentation in the Temple*, Ambrogio Lorenzetti, 243-44; *Adoration of the Magi*, Lorenzo Monaco, 259n; *Coronation of the Virgin*, Lorenzo Monaco, 81; (formerly Uffizi), *Hercules and the Hydra*, Piero Pollaiuolo, 333; drawing after Meleager sarcophagus, Villa Doria Pamphili, 348

Forzetta, Oliviero di, 297, 300

Francesco di Giorgio (Martini), 268n, 281n, 337

Francesco di Papi, 167n

Francesco di Valdambrino, *see* Valdambrino, Francesco di

Franchi, Rosello di Jacopo, 98n, 181

French 14th century art, 54-67, 76, 122. *See also* International Style; realism

Gaddi, Agnolo, 219; Florence, S. Croce, Castellani Chapel frescoes and apse frescoes, 80, 214n

Gaddi, Monsignor Giovanni, 305n, 339

Gaddi family, 339

Gaddi, Taddeo, 50n, 77, 215, 309; Florence, Accademia, *Christ among the Doctors*, 214, 215; S. Croce, *Crucifixion* (attributed to), 50n; Or San Michele, *Martyrdom of Saint Lawrence*, 258n

Gates of Paradise, origin of phrase, 18; *see* Florence, Baptistery, East Door

Gauricus, Pomponius, 18

Gelli, Giambattista, 10, 20

Gentile da Fabriano, *see* Fabriano, Gentile da

Gerini, Niccolo di Piero, 219; S. Croce, *Crucifixion* (attributed to), 50n

GHIBERTI, LORENZO di Cione di Ser Buonaccorso (Lorenzo Ghiberti, Lorenzo di Bartolo di Michele, Lorenzo di Bartoluccio, Nencio di Bartoluccio), account book, 360; collection of antiques, 28, 305; death, 365; diaries or journals, 10-11; drawings, 95n, 97-99, 129-30; from the antique, 207, 284; knowledge of Greek and Latin, 312; legitimacy, 3-4; letters, 360; model books, 207-12, 288, 291, 333; *Portate al Catasto* (tax declarations), 3, 7-8, 111, 162, 163, 360; real estate holdings, 7-9, 11, 142n, 261n, 360; tomb, 9; trips to Pesaro, 4, 31, 51, 82, Pisa, 284, Rome, 6, 275, 284, 288, 321, 330, 332, 353-54, 357-58, Siena, 4, 117n, 140, Venice, 5, 140; use of antique, 28, 49, 137, 207, 277-93, 337-52; workshop, 203-13

Commentarii: 6, 10-11, 17, 20, 26, 34-36, 40-42, 51, 53, 62, 65-66, 73, 87n, 95n, 105, 112, 171-72, 199-200, 214, 219-20, 223-25, 230-32, 253, 305-13, 332,

353-54, 356, 360; attitude toward antiquity, 309, 313, 357; toward humanism, 310-13; perspective, 309; Sienese painting, 219-20, 309; Trecento, 219-20, 313; Autobiography, 12-15, 171, 203, 254, 360; *see also* terminology

WORKS

Designs for goldsmith work, 4, 203; molds for terracotta Madonnas, reliefs, and statues, 7, 26-27, 203-4; Medici Cornelian, *Flaying of Marsyas*, mounting, 5, 11, 13, 67, 146-47, 278, 300, 312; sketches in wax and clay, 7; papal miters and morses, 5, 13, 67

Città di Castello, Galleria Municipale, *Saint Andrew* and *Saint Francis*, attributed to Ghiberti workshop, 119-20, 130

Florence, Baptistery, East Door, 5, 6, 8-12, 16-22, 24-25, 27, 42, 66, 87, 96, 100, 109n, 111-12, 114-16, 149, 153, 155, 159-214, 218, 220-22, 225, 233, 272, 274, 282, 286-88, 293, 305, 307, 313, 328-32, 334, 343-45, 354, 358, 361-63, 365; program, 159-70, 217, 225, 301; iconography, 14-15, 172-74, 176-88, 217, 292; inscription, 4. *See also* Antiquity, art of, influence on Ghiberti

Frame: 146, 166, 204, 212, 349-51, 365; architrave, 166; figures of frame, 168, 204-5, 207, 211, 223, 289-92, 333; heads, 166; self portrait, 9-10; frieze, 11, 165-66, 168; jambs, 11, 146, 166; iconography, *Parents of Mankind*, 172, Prophets and Old Testament heroes, 172-74

Panels: Abraham, 163n, 173, 175-76, 190-91, 193, 195, 208-10, 222, 232n, 248-49, 346-47; architectural settings, 257-59, 265-66, 269, 272-73, 275-76; *Cain and Abel*, 163n, 165, 174-76, 191-97, 201, 204-5, 208, 222-23, 232n, 248, 290-93, 345; *David*, 153, 173, 175, 180, 191, 197-99, 202, 204, 222, 258, 289, 349; *Genesis*, 23, 130n, 163n, 168, 174-76, 189-95, 201, 204-5, 208-11, 222, 248, 289-91, 293, 328-29, 332, 343-45; *Isaac*, 165, 174-76, 190-91, 196-97, 201-2, 204-5, 210-11, 223-24, 229, 233, 249-52, 257-59, 265, 273, 290-92, 323, 328-29, 331, 334; *Joseph*,

165, 175-76, 180, 189, 191, 196-99, 201-2, 204-6, 208-11, 224, 229, 233, 249, 251-52, 257-58, 265-68, 273, 290-91, 323, 328, 331-32, 347-48; *Joshua*, 173, 175, 180, 191, 197-99, 202, 204-6, 222, 258, 289, 291-92, 348-49; *Moses*, 165, 171, 173, 175, 180, 189, 191, 197-99, 204-6, 208, 210, 222-23, 225, 232n, 289-91, 328, 348; *Noah*, 173-76, 190n, 191-95, 201, 204-7, 222-23, 288-90, 292-93, 328-29, 331, 345-46; *Solomon*, 165, 168, 174-75, 177, 180, 190-92, 197-99, 202, 204-6, 229, 232-33, 249, 252-53, 257-58, 265-66, 273, 326, 331

————, North Door, 3, 5, 9-10, 12-13, 16-18, 23-24, 26, 60-61, 66, 73, 87, 103-12, 127, 137, 142, 199, 203, 207, 212, 260, 265, 288, 299, 339-42, 361-63; commission, 105-6; competition for, 4, 11; competition relief, *Sacrifice of Isaac, see* Bargello; iconography, 38-39, 216; inscription, 3; program, 103, 105, 114; realism in, 60

Frame: 60-62, 103-6, 113, 122, 132-33; prophets' heads, 103, 121n, 132-33, 145, 216-17, 284, 340-342; self portrait, 9-10

Jambs: floral decoration, 138, 143-45, 147-48, 285

Panels: Adoration of the Magi, 81, 103, 115n, 117, 121n, 123, 131-32, 214-15; *Annunciation*, 81, 103, 115n, 121-23, 131n, 215; *Arrest*, 92, 103, 115n, 121n, 127-28, 132, 143, 147, 215n, 217n, 218, 284; *Baptism of Christ*, 82-83, 103, 115n, 120-21, 123, 125, 130n, 131, 215; *Christ among the Doctors*, 83, 103, 115n, 117-18, 121n, 124-25, 131n, 132, 215; *Christ before Pilate*, 92, 103, 115n, 121n, 126-27, 131, 144, 214, 215n, 217n, 261, 340; *Christ in the Storm*, 103, 117, 121n, 127, 132, 215; *Church Fathers*, 103, 121n, 125, 215n; *Crucifixion*, 81, 103, 115n, 116n, 120, 121n, 124-25, 215n, 217n; *Entry into Jerusalem*, 92, 103, 115n, 121n, 126-28, 131, 215n, 217, 283, 340; *Evangelists*, 103, 115n, 117-18, 121n, 125, 132, 215n; *Expulsion of the Money Changers*, 103, 115n, 121n, 126-27, 131n, 215n, 283, 340; *Flagellation*, 92, 103, 114, 115n, 121n, 127-32, 143, 215n, 217, 261, 275;

Last Supper, 103, 115n, 121n, 125-26, 131n, 132, 215n, 217; *Mount of Olives*, 76, 82, 103, 115n, 120, 121n, 123-24, 128, 215n; *Nativity*, 81-82, 103, 115n, 117, 121n, 122-23, 126-27, 214-15, 283, 339-40; *Pentecost*, 103, 116n, 121n, 127-28, 131n, 215; *Raising of Lazarus*, 23, 81, 92, 103, 115n, 117, 121n, 125-27, 132, 215n; *Resurrection*, 103, 116n, 121n, 127, 215; *Temptation*, 76, 83, 103, 121n, 124, 126, 215n; *Transfiguration*, 103, 115n, 117, 121n, 124-26, 128, 132, 215n; *Way to Calvary*, 92, 103, 115n, 116n, 119, 121n, 127-28, 131-32, 143, 149, 215n, 217

————, South Door, Frame, Vittorio Ghiberti and workshop, 9, 17, 24, 212-13, 291, 344, 363, 365

Florence, Bargello, Competition relief, *Sacrifice of Isaac*, 12, 31-54, 60, 66-67, 71, 76, 82, 113, 117n, 122-23, 132, 137, 143, 214, 278-79, 283, 299, 339, 363; Shrine of SS. Protus, Hyacinth and Nemesius, 5, 10, 12-13, 100, 138-39, 143, 146-48, 152-53, 206, 286, 319, 329, 331, 343

————, Cathedral, design for choir, 6, 256; dome, 15, Ghiberti appointed supervisor, 5-6, 255, model for, 112, model for lantern, 6; cartoons for stained glass windows, 4, 6, 203, 361, *Ascension of Christ* window, 15, *Assumption of the Virgin*, 15, 54, 76, 82, 122-23, 215, *Mount of Olives*, 15, *Presentation in the Temple*, 15; Zenobius Shrine, 5-6, 8, 12-14, 17, 22-23, 36, 94, 141-43, 146-47, 154-55, 166, 192-95, 200-2, 205-10, 257-59, 272-74, 276, 291, 331, 348, 351-52, 360-61, Angels, 142-43, 154, *Miracle of the Cart*, 154, 206, *Resurrection of the Servant*, 142, 154, 206, *Resurrection of a boy of the Strozzi Family*, 142, 154, 205-10, 351-52

————, Museo S. Marco, design for frame of Linaiuoli Altar, 6, 261n, 264, 361

————, Or San Michele, three statues, 7, 11, 17-18; *Saint John the Baptist*, inscription, 3; commission, 4; mentioned, 13, 21, 24, 71-86, 88-90, 92-94, 112, 121, 124-27, 131, 152, 244-47,

260-61, 360, 362, 365, architecture of niche, 261; *Saint Matthew*, commission, 5, 13, 19, 26, 71, 73-75, 86-97, 99-100, 111-13, 121, 131-32, 137, 144, 149, 152, 208, 283, 286, 292, 319, 331, 342-43, 360-61; architecture of niche, 261n, 262, 264-66; *Saint Stephen*, presentation drawing, Paris, Louvre, 95n, 97-99, 130n; *Saint Stephen*, statue, commission, 5; mentioned 13, 71, 74, 86, 88n, 93-100, 137, 141, 358, 361; architecture of niche (projected), 264-66, 275

————, S. Croce, Tombs of Bartolomeo Valori and Lodovico degli Obizi, 6, 13, 203-4.

————, S. Egidio, *see* S. Maria Nuova

————, S. Maria degli Angeli, Shrine of SS. Protus, Hyacinth and Nemesius, *see* Ghiberti, Bargello

————, S. Maria Novella, Dati Tomb, 5, 12-13, 138, 143, 147-48, 152-53; papal apartment, design for stairway, 5, 256

————, S. Maria Nuova, *God the Father*, on small bronze shutter, 9, 204, 207

————, S. Trinità, Strozzi Tomb Chapel, choir stalls and furnishings, influence on, 256, 261n; portal, 261

Paris, Louvre, Cabinet des Estampes, Presentation Drawing for *Saint Stephen* at Or San Michele, 95n, 97-99, 130n

Princeton University, Museum, *Moses*, terracotta relief attributed to Ghiberti follower, 191n

Siena Cathedral, Baptistery of S. Giovanni, Baptismal Font reliefs, 4-5, 112, 139-41, 149, 199, 329; *Baptism of Christ*, 13, 100, 144, 150-55, 190, 192-93, 200-1, 331; *John the Baptist before Herod*, 13, 108, 117n, 118, 130n, 132, 143-44, 146-47, 151, 153, 207, 248, 261, 264, 283-84, 343, 360

Vienna, Albertina, Drawing for *Flagellation*, Baptistery, North Door, 129-30

See also antiquity, architecture, influence of; antiquity, art, influence of; Early Christian and Byzantine art; terminology; Trecento, influence of

Ghiberti, Buonaccorso di Vittorio,

grandson of Lorenzo, 305; *Zibaldone*, 142, 360

Ghiberti, Cione Paltami di Ser Buonaccorso, father of Lorenzo Ghiberti, 3-4, 36, 365

Ghiberti, Mona Marsilia, wife of Lorenzo Ghiberti, 4, 9

Ghiberti, Tomaso, son of Lorenzo Ghiberti, 5, 6-8, 166, 360

Ghiberti, Vittorio, son of Lorenzo Ghiberti, 5, 6-9, 17-18, 165-67, 305n, 333; tax declaration, 17n; Florence Baptistery, South Door, frame, 212-13, *Eve*, 291, 344

Ghiberti, Vittorio di Buonaccorso, great-grandson of Lorenzo Ghiberti, 130n

Ginori-Conti, Piero, *see* Ghiberti, account book

Giotto, 10, 16, 21, 24, 62, 215, 218, 231, 309-10; Padua, Arena Chapel, 215n, 217n, 258n

Giovanni d'Ambrogio, 52n, 53

Giovanni da Milano, 219

Giovanni di Francesco, 108

Giuliano del Facchino, 118n

Giuliano di Giovanni, 118n

Giuliano di Monaldo, 118n

Giuliano di Ser Andrea, 108, 118n, 132, 139-40, 144n, 165

Giustiniani, Leonardo, 178

Goethe, Johann Wolfgang, 22

Gonzaga, Cardinal Federigo, 272n

Gonzaga, Giovanni Francesco, 316

Gonzaga, Lodovico, 272n

Gori, Francesco Antonio, 161, 362; *Historia Florentinae Basilicae et Baptisterii S. Johannis*, 161n; engravings after sarcophagi, 338; notes, 364-65

Governatori, *see* guilds, etc., *Arte della Lana*, *Operai di S. Maria del Fiore*

Gozzoli, Benozzo, 6, 212, 362-63; Florence, Palazzo Medici, Chapel, murals, *Journey of the Magi*, 202, 205-6, 333

Gran, Cathedral, *Calvary*, 65

Grassi, Giovanni de', 58-59, 61, 62n

Grassi, Salomone di, 79n

Greek authors, 330

Greek art, 280; 4th century sculpture and competition relief, 279. *See also* Hellenistic art

Greek orator figures and *Saint Matthew*, 286, 342

Greek revivalists, 19th century, 23

Gregory the Great, letters, 184

Grenoble, Museum, *Flagellation*,

Pietro Lorenzetti workshop, 224n

Gualandi, Pistoia, Reliquary of Saint Eulalia, 117n, 120n; Vignole, S. Sebastiano, Cross, 117n, 120n

Guardiagrele, Niccolo di, Teramo, Cathedral, *Paliotto*, 116n

Guarienti, Guariento, 361

Guasconi, Biagio, 301n

Guglielmo da Cremona, Fra, 295n, 296n

Guidi, Jacopo di Piero, 52n, 53n; Florence, Hospital of the Innocents, Galleria, *Saint John the Evangelist* from Or San Michele (attributed to), 71n

Guidoni, Ser Pietro di Ser Michele, 365

Guilds (committees, confraternities):

 Armourers' Guild (*Arte dei Corrazzai*), 72, 86

 Arte del Cambio (Bankers' Guild), 5, 32, 72, 74, 86-88, 93, 95-96, 361; *Libro del pilastro*, 86, 361

 Arte di Calimala (Merchants' Guild), 4-5, 7-8, 31-34, 36, 38, 41, 43, 46, 71-73, 84-87, 93, 95, 103, 105-7, 111-13, 126, 133-34, 142, 159, 161, 163-64, 166, 169, 171, 189, 299, 355, 364-65; *Deliberazioni e partiti de' consoli*, 159, 360-62; *Libri Grandi*, 72, 73n, 74, 103, 110, 111n, 361, 364; *Libri (Quaderni) del Proveditore*, 164, 166n, 360; *Libro della seconda e terza porta*, 22, 106, 108-9, 161, 165, 362-63; *Offiziali del Musaico* (*Governatori di S. Giovanni*, Regents, Committee of the Regents), 12, 35, 37-41, 106, 361-62; *Opera di S. Giovanni*, 163, 167; *Uscita dell'Arte*, 361; *Portata al catasto* (tax declaration), 111-12

 Arte dei Giudici e Notai (Lawyers' Guild), 71

 Arte della Lana (Wool Guild), 5, 13, 32-33, 36, 71-72, 74, 93-99, 141, 361; *Deliberazioni dei Consoli*, 361; *Operai di S. Maria del Fiore*, 6, 7n, 13, 35-37, 41, 73, 94, 140-41, 254-56, 361

 Arte dei Linaiuoli e Rigattieri (Linen Weavers' and Rag Dealers' Guild), 72, 86; *Deliberazioni de' Consoli*, 361

 Arte dei Medici e Spetiali (Druggists', Doctors' and Paint-

ers' Guilds), 41, 71, 109

 Arte dei Mercatanti di Calimala, see *Arte di Calimala*

 Arte Mercatoria, see *Arte di Calimala*

 Arte di Pietra e Legname (Carpenters' and Stone Masons' Guild), 72, 360; Ghiberti joins, 6

 Arte della Seta (Silk Weavers', Levant Dealers' and Goldsmiths' Guild), 7, 32, 41, 61n, 71-72, 105, 109n, 360; *Statuti*, 7n

 Arte di Por S. Maria, see *Arte della Seta*

 Arte dei Vaiai e Pelliciai (Tanners' and Furriers' Guild), 71

 Bakers' Guild, 86

 Blacksmiths' Guild, 72

 Butchers' Guild (*Arte dei Beccai*), 72

 Capitani di Or San Michele, 261n, 361

 Cobblers' Guild (*Arte dei Calzolai*), 72, 86

 Compagnia dei Pittori (Confraternity of Painters; *Compagnia di S. Luca*), 361; Ghiberti joins, 6

 Lawyers' Guild, see *Arte dei Giudici e Notai*

 Linen Weavers' and Rag Dealers' Guild, see *Arte dei Linaiuoli e Rigattieri*

 Opera di San Giovanni, see *Arte di Calimala*

 Operai di S. Maria del Fiore, (*Opera del Duomo*), see *Arte della Lana*

 Operaio of Siena Cathedral, 9, 140-41, 360, *Libro di documenti artistici*, 360; *Libri gialli*, 360

 Parte Guelfa, 5, 74, 93, 95

 Tanners' and Furriers' Guild, see *Arte dei Vaiai e Pelliciai*

Gusmin, *see* Master Gusmin

Hamilton Bible, *Sacrifice of Isaac*, *see* Berlin, Staatsbibliothek

Heemskerk, Marten van, drawing, 350

Helena, Empress, 182

Hellenistic art, 285, 286. *See also* Greek art, Roman art

Hennequin de Bruges, *see* Bondol, Jean

Henry of Winchester, 297

Hercules Master, 52-53, 60, 67, 89, 280n, 281, 282-83, 299;

Florence Museo dell'Opera, *Virgin Annunciate*, 279, 281; Porta della Mandorla, *Hercules with the Lion Skin*, 52-53, 60, 67, 89, 280n, 282-83, 299

Hermanin, Federigo, 353-55

hermaphrodite, found in Rome, *see* Roman sculpture, examples mentioned

Hilarius, Saint, 174n, 178; *Tractatus in Psalmos*, 119

Hildesheim, St. Michael, door, Old Testament cycle, 114n

Honnecourt, Villard de, 297

Horace, 294, 316; *Ars Poetica*, 316

Hrabanus Maurus, *Commentarius in Genesim*, 177n

Hugh of St. Victor, 177; *De Arca Noe Morali* and *De Arca Noe Mystica*, 177n

humanism, 17, 332; Florentine in the Renaissance, 52n, 278-80, 294-305, 312, 320-21, 331, 358; Roman in the Quattrocento, 332; of Alberti, 275; aspirations of Ghiberti, 28, 310-14; attitude towards art, 294-305

iconography; Florence, Baptistery, East Door, 14-15, 172-73, 176-88, 217, 292; *Noah* panel, 176-79, 187n; *Parents of Mankind*, 172; Prophets and Old Testament heroes, 172-74; Rebecca as prefiguration of the Church, 173; *Solomon* panel, 180-87, 188n, Queen of Sheba as prefiguration of Marriage and the Coronation of the Virgin, 180; alluding to Union of Churches, 181-84, 187; *Reclining Eve*, 172; *Sacrifice of Isaac* (Competition relief) as prefiguration of Crucifixion, 38-39; North Door, 216-17

Impruneta, near Florence, Silver Crucifix from, 116n

Ince Blundell Hall, *Wounding of Hippolytus*, sarcophagus, 337n, 340

Innocent II, Pope, 357

International Style, 17, 56, 67, 76-85, 88-89, 91, 113, 120, 121n, 123-24, 126-27, 137, 202, 207, 283; *see also* French 14th century art; Siena, Trecento art

Isidor of Seville, *Allegoriae*, 174n

Jacopo di Piero Guidi (attributed to), *see* Florence, Hospital of the Innocents

Jacquerie, 78

Japan, art of, 26

Jefferson, Thomas, 294

Jerome, Saint, continuation of Eusebius' *Chronicle*, 355; translation of Origen's *Homilies*, 179; *Vulgate*, 178

Johannes da Modena, 58n

John of Monte Nigro, 185

John VIII Palaeologos, Byzantine Emperor, 182-85

Julià lo Florentì, 118n, 127; Valencia, Alabaster reliefs, *Pentecost, Resurrection, Samson*, 118

Justitia Imperatoris, *see* Roman sculpture, Arch of Constantine, Aurelian reliefs

Kalakas, *Treatise on the Errors of the Greeks*, 183-84

Klosterneuburg, two female saints, 78

Laertius, Diogenes, *De Vita et Moribus Philosophorum*, 178, 186

Lamberti, Niccolo di Piero, 12, 36, 43n, 52n, 53n, 71n, 81n, 83, 88n, 210n; Florence, Bargello, *Saint Luke*, from Or San Michele, 71, 72n; Museo dell'Opera, *Saint Mark*, from Cathedral, 83; Or San Michele, *Saint Mark*, commissioned to, 72; *Saint James Major*, 71; *Annunciation*, above Ghiberti's *Saint Matthew*, formerly attributed to, 87n

Lamberti, Piero di Niccolo, 72n

Laurana, Luciano di, Baltimore and Urbino panels, attributed to, 268n, 269, 272-73

Lavagna, Cardinal Guglielmo di, 340

Leonardo da Vinci, 18

Liberalitas Augusti, 284

Lille, Musée Wicar, *Dance of Salome*, Donatello, 201; Witter Collection, Franco-Flemish Bible, 39n

Limbourg Brothers, 77-78, 137, 150; *Très Riches Heures du Duc de Berry*, *Adoration of the Magi*, 59n, 77, *Coronation of the Virgin*, 59

Lippi, Filippino, 333

Lippi, Fra Filippo, Coronation altarpiece, *see* Florence, Uffizi

Livy, *Decades*, 297

London, British Museum: Aspertini Sketchbook, 337n; Bacchic sarcophagus, from Rome, S. Maria Maggiore, 344, 348; Carrara herbal, from Padua, 62n;

Coccharelli Manuscript, 62; Lothar Crystal, 64n; Reliquary of the Holy Thorn, 65; Royal Cup of France, 64

——, National Gallery: *Coronation of the Virgin*, Lorenzo Monaco, 81; *Venus and Mars*, Alessandro Botticelli, 333, 351

——, Victoria and Albert Museum: *Giving of the Keys*, Donatello, 150, 327

Lorenzetti, Ambrogio, 54, 66, 77, 99, 214, 216n, 217n, 223, 287n, 309-10; Altenburg, Staatliches Museum, *Reclining Eve* (attributed to), 172n; Florence, Uffizi, *Presentation in the Temple*, 243-44; Paris, Louvre, *Reclining Eve* (School of), 172n; Siena, S. Francesco, lost murals, 219-20; Siena, Palazzo Pubblico, *Good and Bad Government*, 219-21, 258n, 313, 343, *Pax*, 298

Lorenzetti, Pietro, 217-18, 223, 259; Assisi, S. Francesco, *Entry into Jerusalem*, 217; Grenoble, *Flagellation* (Workshop), 224n; Montefalcone, S. Agostino, fresco (School), 172n; Siena, Accademia, Carmine altarpiece, predella, *Saint Albert Consigning the Order of the Carmelites to Saint Broccardo*, 224; *Dream of Sebach*, 224

Lorenzetti, the, 172, 224; workshop, 218; Monte Siepi, San Galgano, fresco (School), 172n

Lorenzo di Bartolo di Michele, *see* Ghiberti, Lorenzo

Lorenzo di Bartoluccio, *see* Ghiberti, Lorenzo

Lorenzo di Cione, *see* Ghiberti, Lorenzo

Lorenzo di Niccolo, 209n

Los Angeles County Museum, Sarcophagus with Life of Roman official, 207, 287, 289, 290, 346-47, 350

Loschi, Antonio, 303, 321

Louis I, Duc d' Anjou, 60, 62-64, 357

Louis I, Duc d'Orleans, 65

Lupa, 277, 294, *see* Roman sculpture, Rome

Lysippos, 282, 339

Maestro del Bambino Vispo, 80

Maffei, Timoteo, 300

Magione, Church, *Reclining Eve*, fresco by Cola di Petrucciuoli, 172n

INDEX

Magister Gregorius, 297

Maitre aux Boqueteaux, 55

Malatesta, Sigismondo, 270n, 271

Malpaghini, Giovanni, 279

Mancini, Girolamo, 315n

Manetti, Antonio di Tuccio, 35, 319n; *Uomini singholari*, 35, 234; *Vita di Brunellesco* (attributed to), 17n, 19-20, 27, 35-36, 40-43, 45, 234, 254, 256

Manetti, Gianozzo, 20

Mantua Cathedral, façade, 260n

Mantua, S. Andrea, Alberti, 272; S. Sebastiano, Alberti, 272

Marcanova Manuscript, 267n

Marine Sarcophagi, *see* Roman sculpture, sarcophagi

Marsuppini, Carlo, 279

Martin V, Pope, 5, 13, 63, 67, 139n, 183, 320, 354

Martini, Giuseppe, Pisa, Camposanto, engravings of Roman sarcophagi, 338

Martini, Simone, 54, 56, 77, 232n, 309-10; illustrations for Petrarch's *Virgil*, 298

Masaccio, 100, 138, 273, 304, 318, 320-21, 323, 327, 329, 332; death, 319; Berlin, Kaiser Friedrich Museum, Altar predella from Pisa, 150, 151n; Florence, S. Maria del Carmine, Brancacci Chapel, *Tabitha* fresco, 201, 241-42 (*see also* Masolino); *Tribute Money*, 150, 201, 220-21, 326; *Expulsion*, 344; S. Maria Novella, *Trinity* fresco, 150, 240, 242, 263, 319; Rome, S. Clemente, Branda Chapel, frescoes, 320 (*see also* Masolino); S. Maria Maggiore Altar, 320

Masegne brothers, 56; workshop, 260n; Bologna, S. Maria de'-Servi, Manfredi Tomb (circle), 57

Masegne, Jacobello, 56n, 57; Bologna, Museo Civico, Legnano Tomb, 57; Venice, Museo Correr, *Doge*, 57; S. Mark's, *Apostles*, 57, 59

Masegne, Pier Paolo, 56n; Venice, Palazzo Ducale, South Window, 79

Maso di Banco, 309; Florence, S. Croce, frescoes of *Sylvester* legend, 224, 259

Maso di Bartolomeo, 7n, 110n, 319n

Maso di Cristofano, 108, 109n, 110n. *See also* Masolino

Masolino, 108, 109n, 137-38, 241n, 320; *Bremen Madonna*, 80; Castiglione d'Olona, 259n;

Florence, S. Maria del Carmine, Brancacci Chapel, 319; Naples, *Miracle of the Snow*, from S. Maria Maggiore altarpiece, 150, 200, 202, 241, 243, 320; Rome, S. Clemente, Branda Chapel, frescoes, 241-42, 320, *Disputation of Saint Catherine*, 242-43, *Death of Saint Ambrose*, 242. *See also* Masaccio

Master of the Annunciation, *see* Hercules Master

Master of the Bamberg Visitation, 297

Master of the Bargello Tondo, 209n

Master Gusmin, 62-67, 76, 83, 231, 309, 353-57

Master of Rimini, 62n, 83n

Master of Saint Cecilia, *see* Bonamico (Buffalmacco)

Matteo di Donato, 108

Matteo di Francesco da Settignano, 166, 167

Medea Sarcophagus, *see* Roman sculpture, sarcophagi

Medici family, 39, 183, 300, 347

Medici, Cosimo, 5, 133, 134n, 138-39, 184n, 278-79, 300-1, 320-21

Medici, Lorenzo the Elder, 5, 138, 139n, 279, 300, 320

Medici, Piero, 134n, 186, 278, 300

Mehus, Giovanni, 300n, 301n, 302n

Meleager relief, Rome, *see* Roman sculpture, sarcophagi

Meleager sarcophagus, *see* Roman sculpture, sarcophagi

Memmi, Lippo, 99

Menabuoi, Giusto da, Padua, frescoes, *Sacrifice of Isaac*, 38n

Mengs, Anton Raphael, 22

Meyer, Alfred Gotthold, 26

Michelangelo, 18, 21

Michele da Firenze, Verona, S. Anastasia, Pellegrini Chapel, terracotta reliefs, 108, 116n

Michele di Giovanni di Bartolo (attributed to), drawings, Paris, Louvre, Cabinet des Estampes, 337

Michele di Nicolai, *see* Michele da Firenze

Michelozzo di Bartolommeo, 7n, 17, 19, 87, 109-11, 152, 164-67; Montepulciano, Aragazzi Tomb, 88n; Florence Baptistery, Tomb of John XXIII, *Virtues*, 87; Florence, Or San Michele, *Saint Matthew* (col-

laborator of Ghiberti), 6, 87, *Annunciation*, *see* Florence, Or S. Michele; S. Croce, Medici Chapel, capitals, 265n

Migliori, Leopoldo, 18

Milan, Biblioteca Ambrosiana, drawing after Bacchic sarcophagus, 344

——, Biblioteca Visconti, Beroldo Manuscript, 79n

——, Cathedral, Annunciation Window, 79; *Salvator Mundi in His Glory*, Jacopo da Campione, 57, 59; foreign sculptors, 58. *See also* Coene, Jacques; Monich, Walter; Raverti, Matteo

——, fabrica del Duomo, 58

——, S. Eustorgio, Carelli Tomb, 79

Mirabilia Urbis Romae, 295

Modrone, Library of Duke Visconti, *Uffiziuolo of Gian Galeazzo Visconti*, manuscript, 58n

Molini, Cardinal Gaspare, 321

Monaco, Lorenzo, 77, 80, 118n, 125, 137, 181, 259; Altenburg, *Flight into Egypt*, 81; Empoli Collegiata altarpiece, 80-81; Florence, Accademia, *Annunciation*, 80-81n, *Mount of Olives*, 82, 120, 124, Nobili altarpiece from S. Maria degli Angeli, 80; Bargello, *Diurnale* from S. Marco, 81; Uffizi, *Adoration of the Magi*, 259n, *Coronation of the Virgin*, 81; London, National Gallery, *Coronation of the Virgin*, 81; Montoliveto altarpiece, 82; Paris, Louvre, Diptych, *Mount of Olives*, 81, 82; Raczinsky Collection (formerly), *Adoration of the Magi*, 81; Settignano, Berenson Collection, *Madonna dell' Umiltà* (1405), 80-81, 122

Monich, Walter, Milan Cathedral, *Saint Stephen*, 79

Monreale Cathedral, bronze door, Old Testament cycle, Bonannus, 114n, 177n, 218; Mosaic cycle, Old Testament, 176n

Montalcino, Museo Civico, *Assumption*, Bartolo di Fredi, 54, 76, 215

Montalto *Pax*, 65n

Montefalcone, S. Agostino, *Reclining Eve*, fresco, Pietro Lorenzetti School, 172n

Montepulciano, Aragazzi Tomb, *see* Michelozzo

Monte Siepi, S. Galgano, *Reclin-*

ing Eve, fresco, Lorenzetti School, 172n

Montoliveto altarpiece, *see* Lorenzo Monaco

Munich, Glyptothek, hermaphrodite, 277n; *Ilioneus*, 339

——, Graphische Sammlung, drawing of Trajan relief from Arch of Constantine, 345; and drawing of Three Graces, Antonio Federighi, 346; drawing after a Bacchic sarcophagus, Polidoro da Caravaggio, 344

——, Private collection, Zeus statuette, 349

——, Staatsbibliothek, *Psalter of Queen Isabeau*, 39n

Naldi, Ser Santi di Domenico, 365

Nane, Ippolito delle, *Vita di San Zanobi*, 142n

Nanni di Bartolo il Rosso (Giovanni Rosso il Fiorentino), 88n; Verona, S. Fermo, Brenzoni Tomb, 116n

Naples, Museo Nazionale, Bacchic sarcophagus, 345; *Miracle of the Snow*, S. Maria Maggiore altarpiece, *see* Masolino

——, S. Giovanni a Carbonara, Tomb of Gianni Carracciolo del Sole, 139

——, S. Angelo a Nilo, Brancacci Tomb, *Assumption*, Donatello, 150, 153

Nazarenes, 23-24

Nemi, Nofri di Ser Paolo, 110n, 365

Nencio di Bartoluccio, *see* Ghiberti, Lorenzo

Neo-Attic reliefs, influence on Agostino di Duccio, 325. *See also* Roman sculpture

Nero, *see* Rome, *Macellum Magnum*

New Haven, Yale University Art Gallery, Jarvis Collection, *Solomon and the Queen of Sheba*, Virgil Master, 259n; *Madonna*, Gentile da Fabriano, 146

New York (formerly Duveen), *Saint Francis, the Fire Test*, Sassetta, 259n

——, Metropolitan Museum of Art, Saint Nicolaus panels, Bicci di Lorenzo, 259n; Caesar portrait, 341; Saint Catherine (from Clermont-Ferrand), 65; Zeus statuette, 349

——, Robert Lehmann Collec-

tion, *Reclining Eve*, Paolo di Giovanni Fei, 172n

Niccoli, Niccolo, 159, 161, 171, 178-79, 184n, 187, 279, 300n, 301-4, 311, 320, 322

Niccolo d'Arezzo, *see* Spinelli, Niccolo di Luca

Nicolaus V, Pope, 267n, 268, 269n, 356

Niobe group, *see* Roman sculpture

Niobe, Kneeling son of, *see* Roman sculpture

Numa, 294

Officiali del Musaico, see guilds, committees, confraternities, *Arte di Calimala*

Olympiads, Ghiberti's calendar, 353-58

Orcagna, Andrea, 51, 62, 99n, 309; Florence, Or San Michele, *Tabernacle of the Virgin*, 71

Orcagna brothers, 309

Origen, 177n, 178; *Homilies*, 179, 187; second homily *In Genesim*, 177

Orsini, Giordano, Cardinal, 321

Orvieto Cathedral, Reliquary of the SS Corporale, enamels, Ugolino da Vieri, 114n, 129-30, 217-18

Ovid, 294, 325

Oxford, Bodleian Library, French Psalter, 14th century, 39n

——, Ashmolean Museum, *Hunt*, Uccello, 202; Sketchbook, drawing of Endymion sarcophagus, attributed to Jacopo Ripanda, 347

Padua, Arena Chapel, Tomb of Enrico Scrovegni, Giovanni Pisano School, 147n (*see also* Giotto); Baptistery, *Sacrifice of Isaac*, fresco, Giusto Di Menabuoi, 38n; Carrara herbal, *see* London, British Museum; S. Antonio (Il Santo), tomb *gisants*, 56; High Altar, *Miracle of the Ass*, Donatello, 25, 264, 268

Paganino da Sala, 268n

Pagolo di Dono, *see* Uccello, Paolo

Palmieri, Matteo, 178; *De temporibus suis*, 16

Paolo di Giovanni Fei, New York, Robert Lehmann Collection, *Reclining Eve*, 172n

Papero di Meo, 165

Paris, Bibliothèque Nationale, Cabinet des Medailles, "Con-

stantine," from Sainte Chapelle, 64, 66; *Jupiter and the Eagle*, 64n; *Zeus*, 349

Department of Manuscripts: Alcuin Bible, 114, *Beau Breviaire* of Charles V, 81; *Bible of Jean de Sy*, 38n; *Cité de Dieu*, 64; *Creator Mundi*, 58n; *Eulogy for Gian Galeazzo Visconti*, 79n; *Homilies of Gregory of Nazianz*, 38n; *Lancelot du Lac*, 57n; *Psalter of Saint Louis, Sacrifice of Isaac*, 38n; *Taccuinum Sanitatis*, 57n

——, Louvre, *Annunciation*, 65n; *Charles V and Jeanne de Bourbon*, from the Quinze-Vingts, 55; *Parament de Narbonne*, 55; Reliquary of the Holy Spirit, 65; Scepter of Charles V, 56, 64n, 66; Silver *Madonna* of Jeanne d'Evreux from St. Denis, 54; *Virgin Annunciate*, 65; *Madonna*, Filarete, 172n; *Reclining Eve*, attributed to Ambrogio Lorenzetti School, 172n; Diptych, *Mount of Olives*, Lorenzo Monaco, 81, 82; *Saint Stephen*, from Florence Cathedral, façade, Piero di Giovanni Tedesco, 95n, 99; Remnants of a Proserpina sarcophagus, 351

Cabinet des Estampes, preparatory drawing for Ghiberti's *Saint Stephen*, 97-99, 130n; drawings (attributed to) Michele di Giovanni di Bartolo, 337; perspective drawing, Pisanello, 240

——, Notre Dame, *Vierge Blanche*, 54

Parlers, the, 55

Parma, Pinacoteca, *Reclining Eve*, 172n

Pasti, Matteo de, 270n

Patch, Thomas, *see* Cocchi, Antonio

Paul II, Pope, 65, 300n, 349, 356

Pavino, Antonio, 300n

Peckham, John, 307-8

Pelops sarcophagus, *see* Roman sculpture, sarcophagi

Perini, Zanobi di Pagholo d'Agnolo, *Vita di S. Giovanni Battista*, 120, 123

Perkins, Charles, 24

Perrotti, Niccolo, 356

perspective, aerial, 138; linear, 138, 199, 229-53, 323, 331; Ghiberti's scientific, 305, 329. *See also* Alberti, Brunelleschi, Ghiberti, Masaccio, Masolino

Perugia, Fountain, *Expulsion*, Niccolo Pisano, 344; Museum, San Domenico altarpiece, Taddeo di Bartolo, 79

Pesello, Giuliano di Arrigo, 74n, 75n

Pestilence of 1348, 33, 299; of 1400, 34; of 1424-1425, 140

Peter and Paul Master, Rheims, 297

Petrarch, 28, 61, 295, 298-99, 301, 303, 310, 316; concept of antiquity, 294; *Labors of Hercules*, 280; *De Remediis, De Vasis Corinthiis*, 61n; *Virgil*, 298

Petrucciuoli, Cola di, *see* Magione Church fresco

Phaedra sarcophagus, *see* Roman sculpture, sarcophagi

Phidias, 16, 311, 324

Philip, Duke of Burgundy, 58, 63

Piccolomini, Cardinal Francesco, 346

pictorial relief, 25, 137-55, 168, 201-2, 286

Piero della Francesca, 268n, 328n

Piero di Giovanni Tedesco, 51n, 52n, 53n; Florence, Or San Michele, *Saint John the Evangelist* (formerly attributed to), 71n; Paris, Louvre, *Saint Stephen*, 95n, 99

Pietro di Pavia, Frate, 61

Pippo di Benincasa, 51n. *See also* Brunelleschi, Filippo

Pirgotile, 13

Pisa, Cathedral, bronze doors, Bonannus, 114, 218; pulpit, *Prudentia*, Giovanni Pisano, 287n

————, Camposanto, San Ranieri frescoes, 258n; Genesis scenes, Piero di Puccio, 175n, 210, 221-23, 225, 343; *Trionfo della Morte* and *Thebais*, Francesco Traini, 221-23, 225; Job frescoes, Francesco da Volterra, 258n; Roman monuments, 287; Caesar portrait type, 341; decorative sculpture, 278; sarcophagi collection, 278, 342-43; sarcophagus of T. Aelius with victories, 343; Battle sarcophagus, 341-43; Endymion sarcophagus, lid with victories, 343; Gaia and Oceanus sarcophagus with victories, 343; Muse sarcophagus, 342-43; Phaedra sarcophagus, 132, 284-85, 340-41, 350; sarcophagus with victories, from S. Pietro in Vinculi, 343. *See also* Berlin,

Kaiser Friedrich Museum, Masaccio, altar predella

Pisanello, 17, 320, 337, 349, 351-52; Paris, Louvre, perspective drawing, 240

Pisano, Andrea, 31-32, 62, 71n, 106, 309, 353-55, 357; Florence Baptistery, South Door, *Life of Saint John* (frame by Vittorio Ghiberti and workshop), 9, 17, 24, 25n, 31n, 32-34, 38, 105, 113, 133-34, 169, 216n, 218, *Baptism*, 215; Florence Campanile, *Artes* reliefs, 298, 346, *Agriculture*, 298, 345; Florence, Cathedral, *Saint Stephen* from Or San Michele (attributed to), 94; Museo dell'Opera, *Sainted Deacon* (attributed to), 94n, 95n

Pisano, Giovanni, 54n, 56, 62, 98, 173, 309; Pisa, Cathedral, pulpit, *Prudentia*, 287n

Pisano, Niccolo, 297, 340; Perugia Fountain, *Expulsion*, 344

Pistoia Cathedral, Silver Altar of San Jacopo, 51n, 59, 84, Brunelleschi, 50; Prophets, Brunelleschi, 59, 90; Reliquary of Santa Eulalia, Gualandi, 117n, 120n; Reliquary of San Jacopo, 120-21

Pistoia, Francesco di, 303

Pius II, Pope, 65n

Pliny, 230-31, 308, 310-11; *Naturalis Historia*, 61, 315, 353, 355-56

Poggibonsi, Giuliano di Giovanni da, *see* Julià lo Florentì

Poggio, Bracciolino Giovanni, 178, 279, 300n, 332, 356; approach to art, 302-4, 312, 322; *De Varietate Fortunae*, 277, 303, 316

Policreto, 13

Poliziano, Angelo, 325

Pollaiuolo, Antonio, 17, 19, 213

Pollaiuolo, Piero, 17; *Hercules and the Hydra*, ex-Uffizi collection, 333

Polybius, *Roman History*, 356

Polycletus (Polykleitos, Policreto), 13, 303-4, 305n; canon, 230

Pompey, 294

Ponte, Giovanni del, 80

Ponte S. Angelo, *see* Rome

Porta a Faenza, lost frescoes, Bonamico (Buffalmacco), 357

Porta (Porte) del Paradiso, *see* Florence Baptistery, East Door

Portate al Catasto, see *Catasto*

Porzellas, Alberto, 58n

Poussin, Nicolas, 294

Pozzo, Dal, Collection, *see* Windsor Royal Library

Prague Cathedral, Imperial portrait busts, 55

Praxiteles, 303-4

Pre-Raphaelites, 23, 25; Rome, Casino Massimi, murals, 24

Princeton University, Museum, terracotta relief, *Moses*, attributed to Ghiberti, 191n

Proserpina sarcophagus, *see* Roman sculpture, sarcophagi

Protogenes, 309

Provence, School of, 297

Puccio, Piero di, Pisa Camposanto, Genesis scenes, 175n, 210, 221-23, 225, 343

Pucelle, Jean, 54, 56, 61

Quercia, Jacopo della, 12, 25, 40, 53n, 140, 151n; competition panel for North Door, 43n; Siena, Fonte Gaia, 121n, 143, *Expulsion*, 143; Cathedral, Baptismal Font, *Annunciation to Zacharias*, 117n

Quintilian, *Institutiones*, 316

Raczinsky Collection (formerly), *Adoration of the Magi*, see Lorenzo Monaco

Rape of the Palladium, *see* Roman sculpture, reliefs

Raphael, 23-24, 294; Florence, Pitti Palace, *Portrait of Pope Leo X*, 39n; Vatican, *School of Athens*, 25

Ravenna, Roman putto relief from S. Vitale, *see* Venice, Museo Archeologico

Raverti, Matteo, *Saint Babila*, *see* Milan, Cathedral

realism, 14th century, 54n, 55, 58-59, 100; 14th century Florentine, 90-91; 14th century French, 56, 76-77, 85; 19th century rediscovery, 24, 27; in Brunelleschi, 49; in Ghiberti, competition panel, 45, *Saint John*, 76, *Saint Matthew*, 88-89

Renaissance style, 21, 92-93, 100, 137; in Ghiberti, 89 and *passim*

Reymond, Marcel, 26

Rheims Cathedral, Peter and Paul Master, Visitation Master, 297

Richa, Giovanni, 21, 365

Rienzo, Cola di, 295

Rimini, S. Francesco, Alberti, 270n, 271, 272n, 317

Rinio herbal, Venice, Biblioteca Marciana, 61, 62n

Ripanda, Jacopo (attributed to), Oxford sketchbook, Endymion sarcophagus drawing, 347

Ristoro d'Arezzo, 28, 298

Robbia, Luca della, 7, 17, 19, 119n, 302, 304, 311, 318, 320, 323; Florence Cathedral, North Sacristy door, 106n, 116n, 117n, 211; *Cantoria*, 211, 319

Robert, Carl, 337

Roman architecture, influence on Brunelleschi, 263, 273; on Alberti, 272-73, 275; on Donatello, 273; on Ghiberti, 258, 262, 265, 273, 330, 334; on Masaccio, 273

Roman architecture: Basilica of Constantine (*Tempio della Pace*), 275; Colosseum, 275; *Macellum Magnum* of Nero, 267n; Pantheon, 31, 275; S. Stefano Rotondo, 267n, 268n

Roman art, 132, 146, 196, 330, 332-33; *see also* antiquity; Greek art; Hellenistic art

Roman relief sculpture, 331; shallow relief technique, 286

Roman sculpture: known to the Quattrocento, 90-91, 277-78, 287; in Ghiberti's collection, 28, 305; influence on Ghiberti, 6, 21, 28, 49, 132, 137, 277-93, 337-52; motifs in Ghiberti, 210; ceremonial compositions, 286, 289; medals, gems, coins, 278, 299; decorative sculpture, 146, 285-86; monuments known to Ghiberti, 132, 277-93, 330, 337-52. *See also* Roman sculpture; reliefs; sarcophagi

Roman sculpture (including copies after Greek originals): Rome, Villa Ludovisi, *Aesculapius*, 343; Caesar portrait, 132; Florence, Pitti, Caesar Portrait, 341; Pisa, Camposanto, Caesar Portrait, 341; Rome, Vatican, Caesar Portrait, 341; Rome, Capitoline Collections, *Camillus* from Lateran, 277; Rome, Capitoline Collections, Colossal head and hand of Constans II from Lateran, 277; Paris, Bibliothèque Nationale, Cabinet des Medailles, "Constantine," 64, 66; Rome formerly Quirinal, Constantine with Three Sons, 277n; Florence, Museo Archeologico, *Hercules*, statuette, 280n, 281n; Vienna, Kunsthistorisches Museum, *Hercules*, statuette, 280n;

hermaphrodite excavated with Ghiberti as witness, 277, 313; Munich, Glyptothek, hermaphrodite, 277n; Rome, Villa Borghese, hermaphrodite, 277n; Venice, *Horses of San Marco*, 59n; Rome, Quirinal, *Horse tamers*, 277; Munich, Glyptothek, *Ilioneus*, 339; Rome, Capitoline Collections, *Lupa from Lateran*, 277, 294; Rome, Capitoline, *Marcus Aurelius* from Lateran, 277, 278; Rome, Capitoline Collections, *Marforio* formerly near S. Martina, 277, 351; Niobid group, 279; Florence, Uffizi, Niobid group, 339; Rome, Capitoline Collections, *Kneeling Son of Niobe*, 279, 339; Rome, *Pasquino*, 277n; Rome, Capitol, formerly Quirinal, River Gods, 277; Florence, Uffizi, Satyr torso, 339; Rome, Vatican, Portrait of Socrates, 132, 341; Socrates Head, 132, 341; Rome, Lateran, *Sophocles*, 343; *Thorn Picker*, 281; Rome, Capitoline Collections, *Thorn Picker* (*Spinario*), formerly Lateran, 277, 281, 282n; *Venus Medici*, type, 287n; *Venus Pudica*, type, 287, 291, 344; formerly Padua, *Venus*, 287n; Paris, Louvre, *Venus de Milo*, 287n; formerly Rome, Quirinal, *Venus*, 298; formerly Siena, *Venus*, 287n; Cassel, Museum, *Victory*, statuette, 349; *Zeus*, statuette type, 349; Cassel, Museum, *Zeus*, statuette, 349; Munich, private collection, *Zeus*, statuette, 349; New York, Metropolitan Museum of Art, *Zeus*, statuette, 349

Roman sculpture, reliefs: Arch of Constantine, 281, 282n, 343; Aurelian reliefs from (destroyed) Arch of Marcus Aurelius, 284, 343; Trajanic reliefs, 284, 287, 290; battle reliefs, 285; ceremonial reliefs, 286, 289; Este, Museo Atestino, *Cippus*, 348; Rome, Column of Marcus Aurelius, 278, 337; Column of Trajan, 278, 294, 337; decorative reliefs, 285; Rome, St. Peter's formerly chapel of John VII, decorative reliefs, 280; historical reliefs, 146, 147, 284; Florence, Uffizi, Iphigenia *cippus*, 287, 288, 290, 337; Paris, Bibliothèque Nationale, Cabinet des Medailles, *Jupiter and*

the Eagle, cameo, 64n; formerly Florence, Medici Collection, *Flaying of Marsyas*, 278; Rome, Forum of Nerva, Minerva frieze, 207, 287, 289, 292, 346; Venice, Museo Archeologico, from S. Maria dei Miracoli, formerly S. Vitale in Ravenna, relief with four putti, 297; formerly Florence, Collection Niccolo Niccoli, *Rape of the Palladium*, 278, 301, 314; *Slaughtering of the Pig*, 281, 282n; Rome, Palazzo Sacchetti, ceremonial relief, 340

————, sarcophagi: Asiatic type, 342; Bacchic sarcophagi, 292; Barbarian heads, *see* Battle sarcophagi, Pisa, Rome; Battle sarcophagi, 132, 284-85; Ceremonial sarcophagi, 278, 291, 293, 332; Historical sarcophagi, 278; Mythological sarcophagi, 278, 285; Phaedra sarcophagus, 132; Rome, Palazzo Rospigliosi, Adonis sarcophagus, 270, 287, 293, 343, 348; Arbury Hall, Newdgate College, Bacchic sarcophagus, 349; Blenheim castle, Bacchic sarcophagus, 350; Copenhagen, Ny-Carlsberg Glyptothek, Bacchic sarcophagus, 345; London, British Museum, Bacchic sarcophagus formerly S. Maria Maggiore, 291, 344, 348; Naples, Museo Nazionale, Bacchic sarcophagus, 345; formerly Rome, Palazzo Gentili, Bacchic sarcophagus, lost (?), 349; Rome, Palazzo Rospigliosi, Bacchic sarcophagus (*Indian Triumph*), 345, 347; Rome, Vatican, Bacchic sarcophagus, 349; Rome, Villa Aldobrandini, fragments, Bacchic sarcophagus, 289, 350; Rome, Villa Medici, Bacchic sarcophagus, 345; Pisa, Camposanto, Battle sarcophagus, 284, 341-43, 349; Rome, Villa Borghese, Battle sarcophagus from St. Peter's, 284, 287, 289, 341-42, 349; Cortona, *Dionysos battling the Amazons*, 278, lid with victories, 286, 343; Pisa, Camposanto, Endymion sarcophagus, lid with victories, 343; Rome, Palazzo Colonna (formerly), lost Endymion sarcophagus, 347; Rome, Palazzo Giustiniani, Endymion sarcophagus, 287, 291, 292, 346-47, 350; Rome, S. Lorenzo f.l.m., Fieschi sarcophagus, 283-

84, 289, 340, 345; Pisa, Campo-santo, Gaia and Oceanus sar-cophagus, with victories, 343; Ince Blundell Hall, *Wounding of Hippolytus*, sarcophagus, 283, 337n, 340; Los Angeles, County Museum, sarcophagus with scenes from Life of Roman General, formerly Rome, St. Peter's, 207, 287, 289, 290, 346-47, 350; Mantua, Palazzo Du-cale, sarcophagus with Life of Roman Official, Marriage scene, 340; Florence, Uffizi, sarcophagus with Life of Ro-man Official, Marriage scene, 340; Florence, formerly Rinuc-cini Collection, sarcophagus with Life of Roman Official, Marriage scene, 340; *see also,* Rome, S. Lorenzo f.l.m., Fieschi sarcophagus; Rome, Vatican, Marine sarcophagus, 287, 289, 344; Medea sarcophagi, 207, 287; Rome, Museo delle Terme, Medea sarcophagus from SS. Cosma e Damiano, 291, 348, 351-52; Turin, Mu-seum, Medea sarcophagus, frag-ments, 207, 291, 348; Meleager sarcophagus (relief?) known to Alberti, 324, 330; Rome, Villa Albani, Coffee House, *Death of Meleager,* 347; Villa Doria Panfili, Meleager sarcophagus, 287, 289-90, 292, 348-49; lost Meleager sarcophagus, 287, 290, 347; Muse sarcophagus, 342-43; sarcophagus with orator in shell-topped niche, 286, 287, 342; Rome, Villa Medici, Paris sarcophagus, 350; Brussels, Musées Royaux, Pelops sar-cophagus, 279, 283, 287-88, 337n, 339, 348; Pisa, Campo-santo, Phaedra sarcophagus, 132, 284-85, 340-41, 350; Flor-ence, Museo dell'Opera, Phae-ton sarcophagus, 283, 290, 339-40; lost Ploughman relief, probably from sarcophagus, 345; Rome, Palazzo Giustini-ani, Ploughman on season sar-cophagus, 345; Paris, Louvre, Proserpina sarcophagus, frag-ments, 287, 290, 351; Pisa, Camposanto, sarcophagus with victories from cemetery of S. Pietro in Vinculi, 343; Pisa, Camposanto, sarcophagus of T. Aelius, with victories, 343

Roman authors, 330

Romanesque churches, influence on Brunelleschi, 263

romantics, 19th century, 23n, 24, 26

Rome, Biblioteca Casanatense, *Historia plantarum,* 58n

———, Monuments and Sites: Acqua Vergine, 270n

———, Arch of Constantine, 281, 282n, 343; Aurelian reliefs from Arch of Marcus Aurelius, 284, 343; Trajanic reliefs, 284, 287, 290, 345

———, Arch of Marcus Aurelius, reliefs from, *see* Arch of Con-stantine

———, Arch of Septimius Seve-rus, 295

———, Basilica of Constantine (*Tempio della Pace*), 275

———, Capitol, *Marcus Aurelius,* 277; *River Gods,* formerly Quirinal, 277; Capitoline Col-lections, *Camillus,* 277; Colossal Head and Hand of Constans II, 277; *Lupa,* 277, 294; *Mar-forio,* 351; *Kneeling Son of Niobe,* 339; *Thorn Picker,* 277, 281, 282n

———, Colosseum, 275

———, Column of Marcus Aure-lius, 278, 337

———, Column of Trajan, 278, 294, 337

———, Forum of Nerva, Minerva Frieze, 207, 287, 289, 292, 346

———, Grotto of Egeria, 294

———, Lateran, S. Giovanni in Fonte, 31

———, Formerly Lateran, *Ca-millus,* 277; Colossal Head and Hand of Constans II, 277; *Lupa,* 277, 294; *Marcus Aure-lius,* 277; *Thorn Picker,* 277, 281, 282n

———, Lateran Museum, *Soph-ocles,* 343

———, *Macellum Magnum* of Nero, 267n

———, Museo delle Terme, *Medea* sarcophagus, 291, 348, 351-52

———, Palace of Evander, 294

———, Palazzo Colonna (for-merly), lost Endymion sarcoph-agus, 347

———, Palazzo de' Conservatori, *see* Capitoline Collections

———, Palazzo Gentili (former-ly), lost Bacchic sarcophagus, 349

———, Palazzo Giustiniani, En-dymion sarcophagus, 287, 291-92, 346-47, 350; Ploughman from Season sarcophagus, 345

———, Palazzo Rospigliosi, Adonis sarcophagus, 270, 287, 293, 343, 348; Bacchic sarcoph-agus (*Indian Triumph*), 345, 347

———, Palazzo Sacchetti, cere-monial relief, 340

———, Pantheon, 31, 275

———, Ponte S. Angelo, 270n

———, Quirinal, *Horse Tamers,* 277

———, Formerly Quirinal, Con-stantine with Three Sons, 277n; two river gods, 277; *Venus,* 298

———, S. Clemente, Branda Chapel, frescoes, Masolino and Masaccio, 320; Masolino, 241-42, *Disputation of Saint Cath-erine,* 242, *Death of Saint Am-brose,* 242

———, Formerly S. Cosma e Damiano, Medea sarcophagus, *see* Roman sculpture, sarcoph-agi; Rome, Museo delle Terme

———, S. Lorenzo f.l.m., Fieschi sarcophagus, 283-84, 289, 340, 345

———, S. Maria Maggiore, altar, *see* Masaccio and Masolino

———, Formerly S. Maria Mag-giore, Bacchic sarcophagus, *see* Roman sculpture, sarcophagi; London, British Museum

———, S. Maria in Trastevere, 12th century mosaics of the fa-çade and apse, 357; apse mo-saics, Pietro Cavallini, 357

———, Formerly near S. Mar-tina, *Marforio,* 277

———, S. Paolo f.l.m., Old Testa-ment cycle, 169

———, St. Peter's Sacristy, Taber-nacle, Donatello, 347; Roman pilasters, formerly Chapel of John VII, 280

———, Formerly Old St. Peter's, Battle sarcophagus, *see* Roman sculpture, sarcophagi; Rome, Villa Borghese; sarcophagus with Life of Roman General, *see* Roman sculpture, sarcoph-agi; Los Angeles, County Mu-seum

———, S. Stefano Rotondo, 267n, 268n

———, Vatican, Bacchic sarcoph-agus, 349; Marine sarcophagus, 287, 289, 344; Caesar Portrait, 341; Socrates Portrait, 132, 341; Pinacoteca, *Thomas Aquinas before the Cross,* Sassetta, 259n; Sistine Chapel, *Sacrifice of the Leper,* Botticelli, 333; Stanze,

School of Athens, Raphael, 25; Vatican Library, *Cosmas Indicopleustes*, *Sacrifice of Isaac*, 38n

———, Villa Albani, Coffee House, *Death of Meleager*, 347

———, Villa Aldobrandini, fragments of a Bacchic sarcophagus, 289, 350

———, Villa Borghese, Battle sarcophagus, 284, 287, 289, 341-42, 349; hermaphrodite, 277n

———, Villa Doria Panfili, Meleager sarcophagus, 287, 289-90, 292, 348-49

———, Villa Ludovisi, *Aesculapius*, 343

———, Villa Medici, Bacchic sarcophagus, 345; Paris sarcophagus, 350

Romulus and Remus, 294

Rosa, Salvatore, Florence, Uffizi, drawing after Meleager sarcophagus, 348

Rossellino, Antonio and Bernardo, 17, 19; workshop, Caesar Portrait, New York, Metropolitan Museum of Art, 341

Rossi, Roberto de', 279

Rosso, Giovanni, il Fiorentino, *see* Nanni di Bartolo il Rosso

Rudolph II of Hapsburg, 28

Rudolph IV of Austria and his wife, *see* Vienna, St. Stephen

Rufinus, 179

Rumohr, Carl von, 23-24

Rustici, Cenci de', 321

Sacchetti relief, *see* Rome, Palazzo Sacchetti

Salutati, Coluccio, 279, 296, 299; *De Laboribus Herculis*, 280

Samson, *see* Bellini, Jacopo

San Gimignano, Collegiata, Bartolo di Fredi, Old Testament cycle, 175, 176n, 221-23, 225, 292, 345; Taddeo di Bartolo, frescoes, 80

Sangallo, Giuliano da 268n

S. Maria in Vescovio, Old Testament cycle, 176n; *Sacrifice of Isaac*, 282n

Sassetta, 259; *Saint Francis, the Fire Test* (formerly Duveen, New York), 259n; Rome, Vatican, Pinacoteca, *Thomas Aquinas before the Cross*, 259n

Scalcagna, Michele, *see* Michele da Firenze

Scarparia, Giacomo da, 279

Scepter of Charles V, *see* Paris, Louvre

Schlosser, Julius von, 10, 23, 25-28, 231, 339, 353-55; *Antiken*,

27-28; *Commentarii*, 27-28, 306, 307n, 308, 310; *Prologomena*, 27-28, 306n

Schoene Madonnen, 78-79

Schmarsow, August, 26

Seal of Louis of Bavaria, 258n

Seneca, 330, 334, 346

Sesto family, 6n

Siena, Accademia, Carmine altarpiece, predella, *Saint Albert Consigning the Order of the Carmelites to Saint Broccardo* and *Dream of Sebach*, Pietro Lorenzetti, 224

———, Cathedral (including Baptistery of S. Giovanni and Museo dell'Opera), *Baptismal Font*, 138-41, reliefs commissioned, 138-41; *Salome*, Donatello, 151-53, 221, 244, 263, 264n, 327-28; Ghiberti reliefs, 4-5, 9, 112, 126, 139-41, 149, 199, 329, 360; *Baptism*, 13, 100, 144, 150-55, 190, 192-93, 200-1, 331; *Saint John before Herod*, 13, 108, 117n, 118, 130n, 132, 143-44, 146-47, 151, 153, 207, 248, 261, 264, 343; *Annunciation to Zacharias*, Jacopo della Quercia, 117n; *Birth of John the Baptist*, Giovanni Turini, 117, 119; *Saint John the Baptist Preaching*, Giovanni Turini, 117-19, 144n; *Juda Maccabi* in pavement, 173; *Maestà*, Duccio, 114n, 218; Tomb of Giovanni Pecci, Donatello, 152-53; *Three Graces*, 346

———, Fonte Gaia, *see* Palazzo Pubblico

———, Palazzo Pubblico, *Good and Bad Government*, Ambrogio Lorenzetti, 219-21, 258n, 313, 343; *Pax*, Ambrogio Lorenzetti, 298; Fonte Gaia, Jacopo della Quercia, 121n, 143; frescoes, Taddeo di Bartolo, 80

———, S. Francesco, lost murals by Ambrogio Lorenzetti, 219-20

———, Trecento art and influence on Ghiberti, 53-54, 214-15, 217, 218-25, 309

Sigismund, Emperor, 185

Simone di Nanni da Fiesole, 165n, 167

Sirén, Osvald, 26

Sixtus V, Pope, 65n

Skopas, 282, 339

Sluter, Claus, 62n, 118n; Chartreuse de Champmol, 55; *Well of Moses*, 78, 85

Socrates Portrait, 132, 341, *see* Roman sculpture

Spano, Pippo, 33

Speculum Humanae Salvationis, 39n, 173

Spinelli, Cola di Nicola, 256, 261n

Spinelli, Niccolo di Luca, 12, 36, 40, 43n

Spinelli, Parri, 80, 129n

Starnina, Gherardo, 21

Stefano, 309

Stefano da Verona (da Zevio), 79

Strasbourg Cathedral, pretended influence of sculpture on Ghiberti, 26

Strozzi, bank, 261n; family, 33, 261n

Strozzi, Carlo, excerpts from documents of Arte di Calimala, 34, 39, 73, 121n, 169, 355, 362-65; Index of Libri Grandi, 106; excerpts from *Libri (Quaderni) del Proveditore*, 164, 166n; from *Libro della Seconda e terza porta*, 22 and *passim*; *Repertorio Generale delle Cose Ecclesiastiche*, 362; *Cose Laiche*, 363

Strozzi, Lodovico, 142n

Strozzi, Palla di Nofri, 105-8, 146, 279, 299

Sulla, 16

Sylvester, Pope, 357

Taddeo di Bartolo, Perugia, Museum, San Domenico altarpiece, 79; San Gimignano, Collegiata, frescoes, 80; Siena, Palazzo Pubblico, frescoes, 80; Triora, Collegiata, *Baptism*, 80

Taine, Hippolyte, 25

Talmudic legend from *Targum II* to the *Book of Esther*, 177, 179, 187

Teramo, Cathedral, *Paliotto*, Niccolo di Guardiagrele, 116n

Terminology: Albertian, 310, 313; *lineamenta*, 230; *piano*, 232; Ghibertian, *casamenti*, 230-33, 247-49; *commentarii*, 230, 310-11; *diligentia*, 313; *disciplina*, 11, 313; *industria*, 313; *lineamenti*, 230-31, 233-34, 293, 310, 311, 313; *misura*, 230-31, 233-34, 310-11; *piani*, 230-34, 310, 313; *prospettiva*, 313; *ragione*, 233; *regole*, 230, 311; *symmetria*, 231; *teorica dell'arte*, 309-11; Plinian, *lineamenta*, 230; *symmetria*, 231; Vitruvian, *commensus e membris*, 231; *firmitas, commoditas, venustas*, 270

Theodericus of Flanders, 58n

Toledo, Spain, Cathedral, *Madonna of the Folding Chair*, 65

Tomaso da Modena, 55

Torquemada, Juan (John), 185

Torriti, Jacopo, Assisi, S. Francesco, fresco, *Sacrifice of Isaac*, 38n

Toschi, Giovanni Battista, 25

Traini, Francesco, Pisa, Camposanto, *Trionfo della Morte, Thebais*, 221-23, 225

Trajan, 294

Traversari, Ambrogio, 279, 300n, 332; approach to art, 301; admiration of Bernardino of Siena, 178; Greek studies and knowledge of Greek Church-fathers, 178; interest in Saint Ambrose, 179, 187; in Origen, 178-79, 187; intermediary between Ghiberti and Aurispa, 311-12; knowledge of Hebrew, 179; neopatristic movement, 178-79; papal adviser on Byzantine affairs and Union of Churches, 183-87; portrait, 186-87, 200; program of Gates of Paradise, 171-80, 183-88; critique of Bruni's, 159, 161, 171; shrine of SS. Protus, Hyacinth and Nemesius, 138-39; translation of Diogenes Laertius, 178, 186

Trecento, influence of art on Ghiberti, 51, 90, 114n, 128, 147-48, 172, 214-25, 258n, 282, 309, 313; crypto-antique elements in, 292; influence on Ghiberti, 225, 286, 290, 342-43; features in Ghiberti's work, 28, 32, 61, 211; North Door, 259-61, *Saint John*, 85, *Saint Stephen*, 98-99; approach to art of antiquity, 298-99; symbols and traditions in perspective, 243-44, 247-48

Triora, Collegiata, *Baptism, see* Taddeo di Bartolo

Turin Museum, Medea sarcophagus, *see* Roman sculpture, sarcophagi

Turini, Giovanni, 9, 127, 140, 207, 360; Siena, Baptismal Font, *Birth of John the Baptist*, 117, 119, *Saint John the Baptist Preaching*, 117-19

Turino di Sano, 117n

Uccello, Paolo, 28, 109, 209-10, 319n, 328n; (and workshop) Florence, S. Maria Novella, Chiostro Verde frescoes, 175,

208-10, 344, *Creation of Adam*, 208, *Sinopia*, 210, 344, *Creation of Eve*, 208n, 209n, *Creation of Animals*, 208, 209n, *Fall of Man*, 208n, *Expulsion*, 208, 209n, 210, *Labors of Man*, 208, 209n, *Deluge*, 201-2; Oxford, Ashmolean Museum, *Hunt*, 202

Ugo di Prete Ilario, 222

Ugolino da Vieri, Orvieto, Cathedral, Reliquary of the SS. Corporale, 114n, 129-30, 217-18

Urbino, Palazzo Ducale, Architectural panel, Laurana, Luciano (attributed to), 267n, 268, 272-73

Uzzano family, 33

Uzzano, Niccolo da, 161, 169

Valdambrino, Francesco da, competition panel, 40, 43n

Valencia, Cathedral, alabaster reliefs, *Pentecost*, 117-19, *Resurrection* and *Samson*, 118, Julià lo Florentì

Valla, Lorenzo, 178

Valle-Rustici Collection, 339

Vanni, Andrea, 172n

Varchi, Benedetto, 18

Varro, 267n

Vasari, Giorgio, 10, 18, 20-22, 24, 27-28, 35-36, 43, 50, 51n, 84, 97, 109n, 130n, 139, 173, 217n, 234, 238, 257n, 263n, 294, 305n, 354

Vatican, *see* Rome, Vatican

Venice, Biblioteca Marciana, Rinio herbal, 61, 62n; Museo Correr, *Doge*, Jacobello Masegne, 57; Palazzo Ducale, Porta della Carta, 139; south window, Pier Paolo Masegne, 79

———, SS. Giovanni e Paolo, Tomb of Raneri Zen, 343

———, S. Marco, Collection of Early Christian and Byzantine sculptures *all'antica*, 278; Horses, 59n; center arch reliefs, *Sacrifice of Isaac* and *Adam*, 210n; rod screen with Apostles, Jacobello Masegne, 57, 59

———, Museo Archeologico, Roman relief with four putti, from S. Maria de' Miracoli, formerly S. Vitale in Ravenna, 297

Venturi, Lionello, 24-25, 27

Verini, Ugolino, 16

Veris, Franco and Filippolo de', Campione, S. Maria de' Ghirli, *Last Judgment*, 79

Verona, S. Anastasia, Pellegrini Chapel, terracotta reliefs, Michele da Firenze, 108n, 116n; S. Fermo, Brenzoni Tomb, Nanni di Bartolo il Rosso, 116n

Veronese, Guarino, 301n

Verrocchio, Andrea, 17-18, 333

Vienna, Albertina, *Flagellation*, drawing, Ghiberti, 129-30

———, formerly Hofmuseum, *Taccuinum sanitatis*, 57

———, Kunsthistorisches Museum, *Hercules*, statuette, *see* Roman sculpture

———, Nationalbibliothek, *Vienna Genesis*, 177; *Codex 1191*, 39n

———, Rathaus Museum, statues of Charles IV and Princes of the Austrian House from St. Stephen, 55

———, St. Stephen, statues of Rudolph IV and his wife; story of St. Paul, 55

Vignole, San Sebastiano, *Cross*, Gualandi, 117n, 120n

Villani, Filippo, 28; *Uomini singholari*, 309

Villani, Giovanni, 31

Virgil, 294, 297, 312n

Virgil Master, New Haven, Yale University Art Gallery, Jarvis Collection, *Solomon and the Queen of Sheba*, 259n

Visconti, Gian Galeazzo, 34-35, 57-58

Visitation Master, *see* Bamberg

Visitation Master, *see* Rheims

Vitruvius, 231, 244n, 247, 268n, 270, 307-8, 310-13

Volkmann, Johann J., 21-22

Volterra, Francesco da, Pisa Camposanto, Job frescoes, 258n

Warburg, Aby, 325, 332

Washington, National Gallery, Widener Collection, *Trinity Morse*, 61, 65

Wat Tyler riots, 78

Weyden, Roger van der, 17

Windsor Royal Library, Dal Pozzo Collection, drawings, 337n, 338, 344-45, 348-49

Winckelmann, Johann Joachim, 277, 294

Witelo, 307

Wolfegg Castle, *Wolfegg Sketchbook*, 337, 344-46, 349, 351

Zafferini, Ser Matteo di Domenico, 360

Zagonara, Battle of, 163

Zeuxis, 16

ADDENDA

p. 19, line 18: H. W. Janson who has read the book in page proof calls my attention to the fact that the Anonimo Magliabecchiano is dated by Schlosser and Kallab 1537 to 1542 as against Frey's date of 1505.

p. 72: H. W. Janson is of the opinion that Niccolo Lamberti was commissioned only to procure a block for the Saint Mark, but not to execute the statue.

p. 90, note 8: H. W. Janson tells me that he has come to accept as irrefutable Lanyi's thesis ("Le statue quattrocentesche dei Profeti nel Campanile e nell'antica facciata di Santa Maria del Fiore," *Rivista d'Arte*, XVII [1935], pp. 121ff; 245ff), that the *Saint John* is identical with a statue documented for Rosso in 1419 to 1420.

p. 147, note 17: The Dati Tomb in 1956 was transferred from its place in the transept into the Ruccellai Chapel, off the right transept arm.

p. 152: While I still cannot help feeling that Ghiberti's bronze technique surpasses Donatello's I should add in fairness the opinion of a great bronze founder, Bruno Bearzi ("Considerazioni di tecnica sul S. Ludovico e la Giuditta di Donatello," *Bollettino d'Arte*, XXXVI [1951], pp. 119ff), who explains Donatello's procedure of piecemeal casting as caused by the impossibility of firegilding a large-scale statue, cast in one piece.

p. 253: H. W. Janson very kindly has called my attention to the suggestion made by Kauffmann, bibl. 237, pp. 64ff, to the effect that Donatello in designing the perspective of the Lille *Salome* presumably in 1434 made use of the procedure expounded by Alberti. If the date is correct, it would only confirm my thesis that Alberti's impact was felt by the Florentine artists even before *Della Pittura* was completed. Needless to say I cannot agree with Kauffmann's view when he presents the perspective procedure of Alberti's as only "codifying thoughts discussed and practiced in the circles of artists gathering around Brunelleschi."

CORRIGENDA

p. 22 omit erroneous statement that Thomas Patch was a pseudonym for Antonio Cocchi (see Kurz, bibl. *32). I was apparently misled by the inclusion of Cocchi's name in parentheses in the title of the Italian edition of 1773.

pp. 64, 66 the bust of "Constantine," crystal with gilded silver trimmings, was not ca. 1370 but ca. 1300. Correction orally supplied by Willibald Sauerländer.

p. 166 line 5 and 4 from bottom. Cancel: "Tomaso apparently died in 1447" (see Dig. 292a).

p. 200 n. 12, line 2. instead of "early in 1424 or even before," read "the year 1428" (see Hartt, bibl. *24, p. 163, note 16)

p. 305 n. 51, line 9, read "great-grandson" instead of "grandson"

p. 312 n. 21, line 7, read "by sending him instead of the manuscript, a Latin translation" instead of "the manuscript of a Latin translation"

p. 345 no. 31, cancel "Ny Carlsberg (Poulsen, bibl. 424, no. 777a), and"; forgery, see Matz, bibl. *39, II, p. 212

p. 348 no. 43b, line 10, instead of "Rome, Museo delle Terme," read "Ancona, Museo Civico"

p. 351 no. 66, line 11, instead of "Museo delle Terme," read "Ancona, Museo Civico"; line 12, after "bibl. 448," add "II"

p. 421 Dig. 293: cancel question mark (see bibl. *31, p. 317 App. A)

ILLUSTRATIONS

WORKS OF GHIBERTI, PLATES 1-137

COLLATERAL MATERIAL, FIGURES 1-146

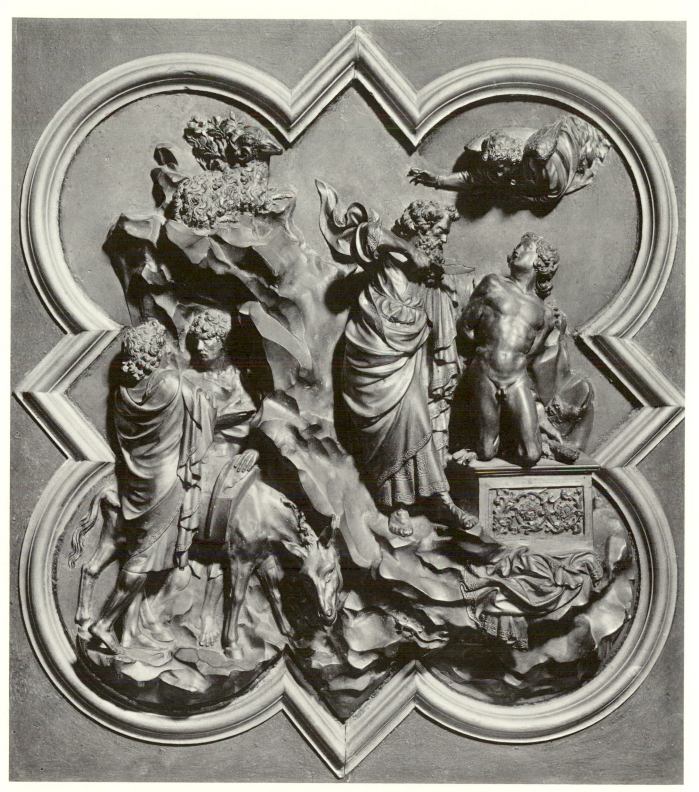

PLATE 1. Competition Relief. Florence, Bargello

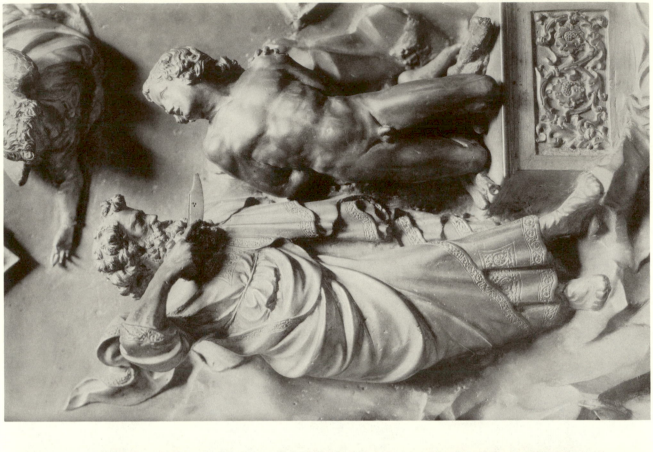

PLATE 2b. Competition Relief, Abraham and Isaac. Florence, Bargello

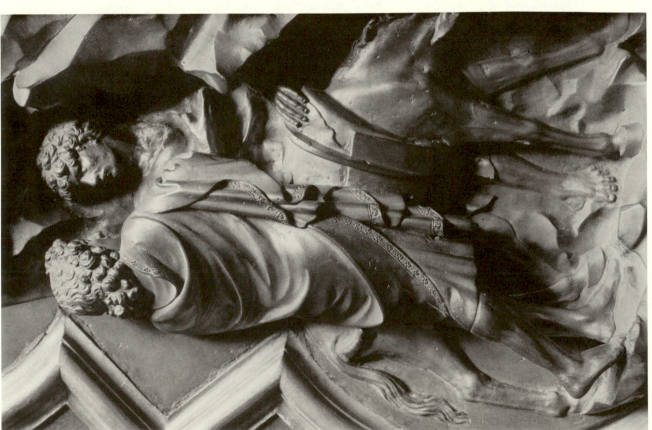

PLATE 2a. Competition Relief, Servants. Florence, Bargello

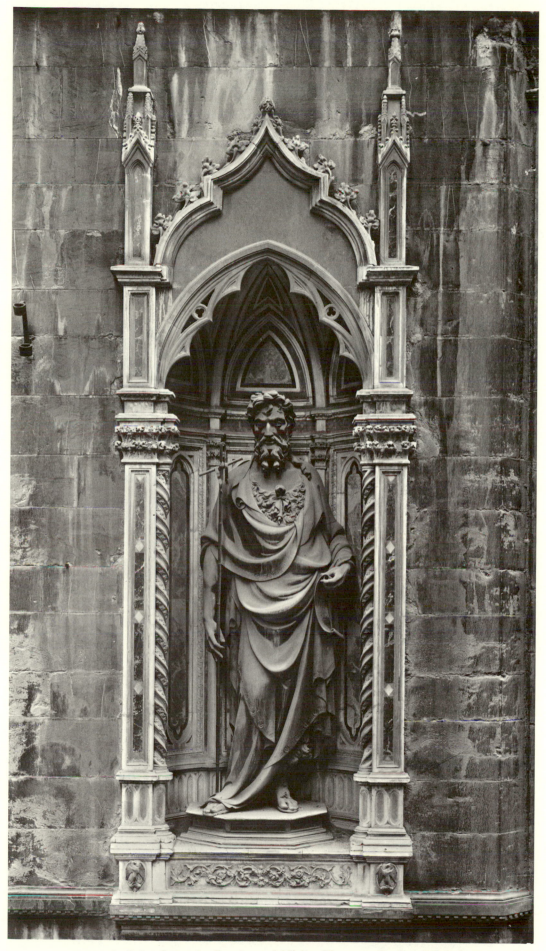

PLATE 3. *Saint John the Baptist* and Niche. Florence, Or San Michele

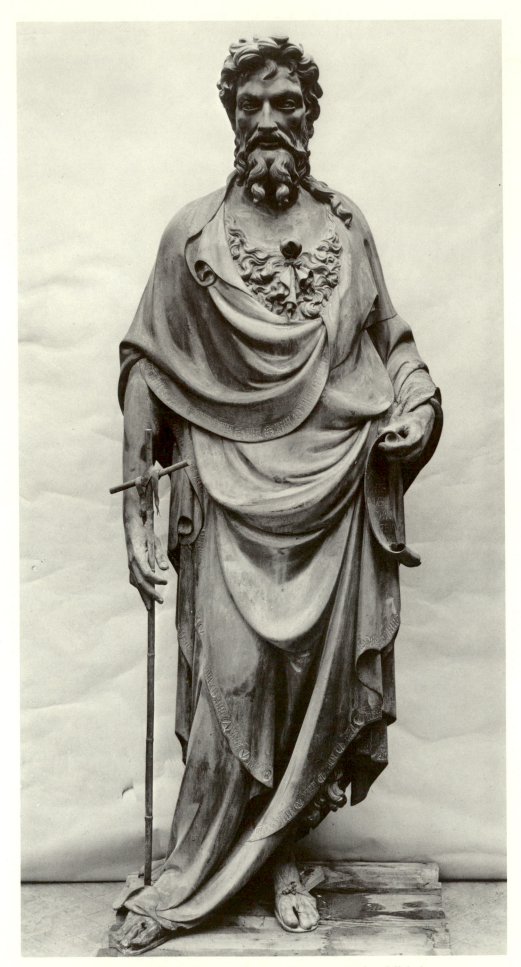

PLATE 4. *Saint John the Baptist*. Florence, Or San Michele

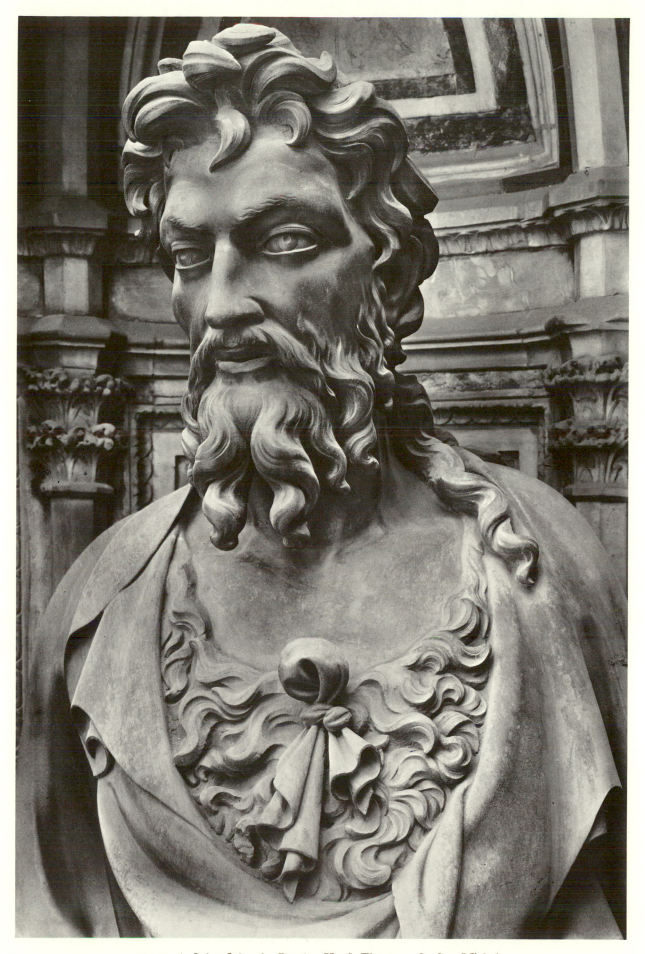

PLATE 5. *Saint John the Baptist*, Head. Florence, Or San Michele

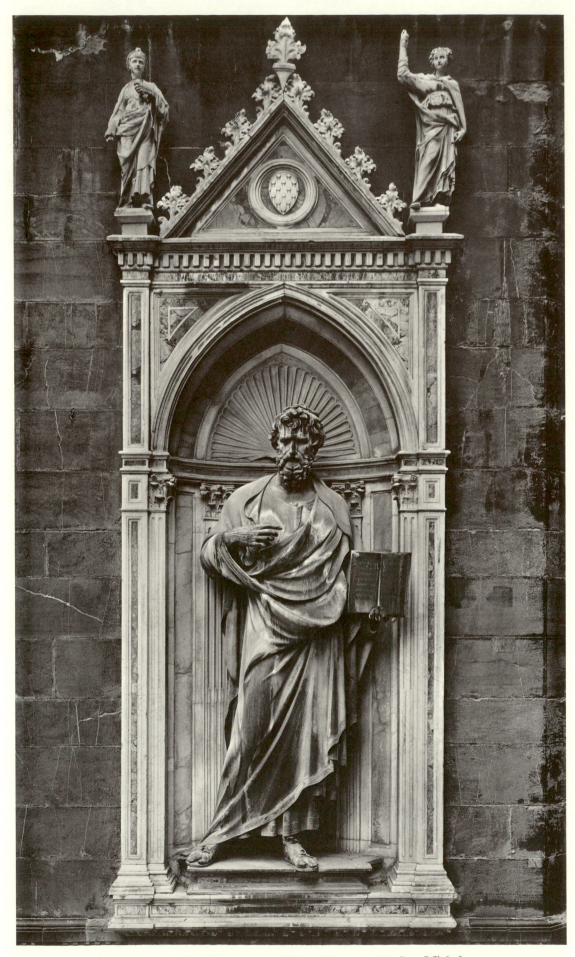

PLATE 6. *Saint Matthew* and Niche. Florence, Or San Michele

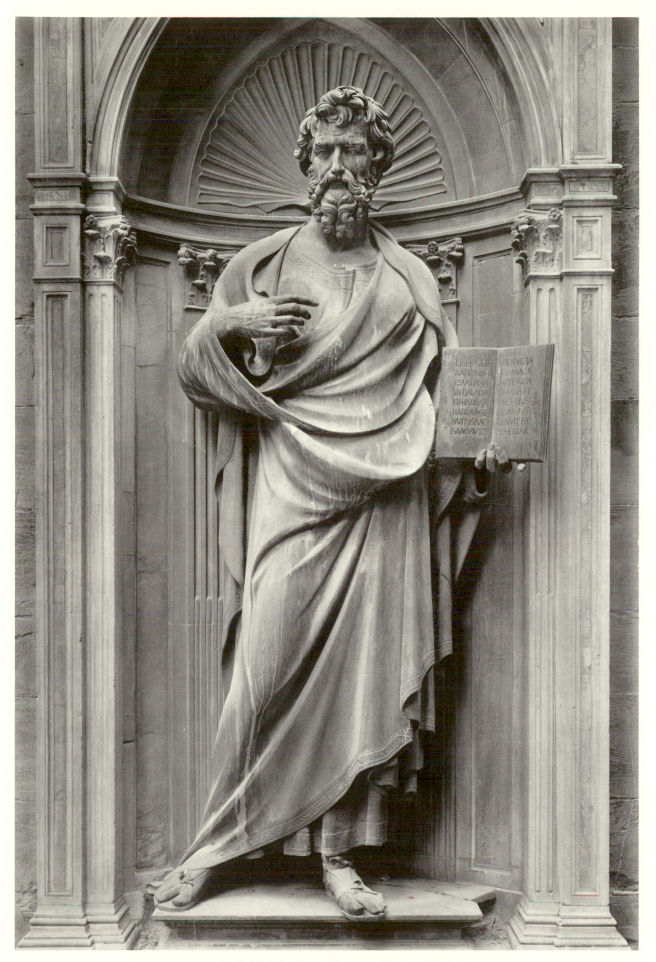

PLATE 7. *Saint Matthew.* Florence, Or San Michele

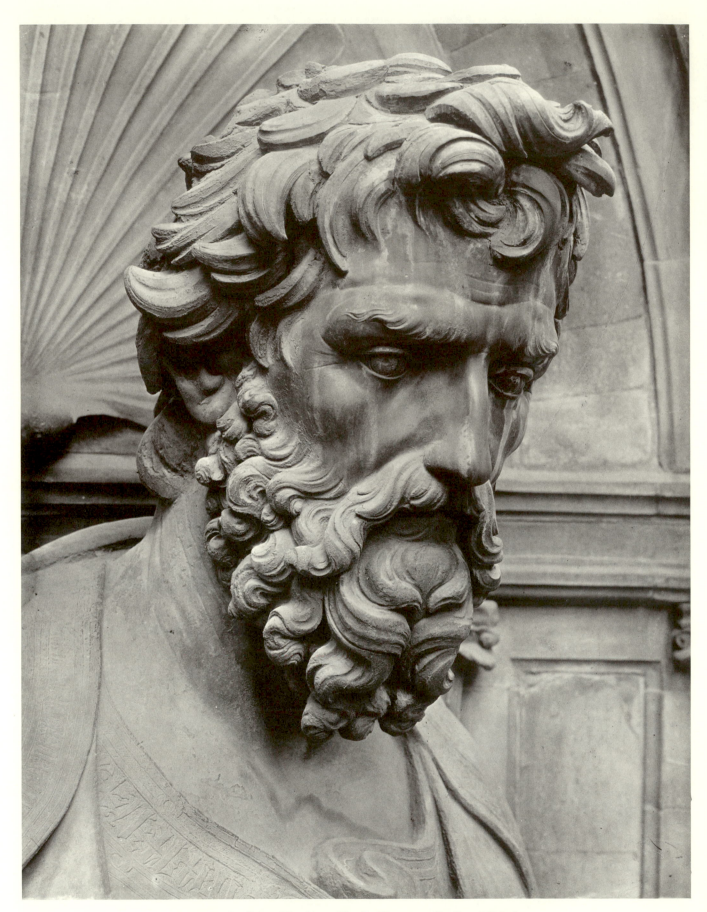

PLATE 8. *Saint Matthew*, Head. Florence, Or San Michele

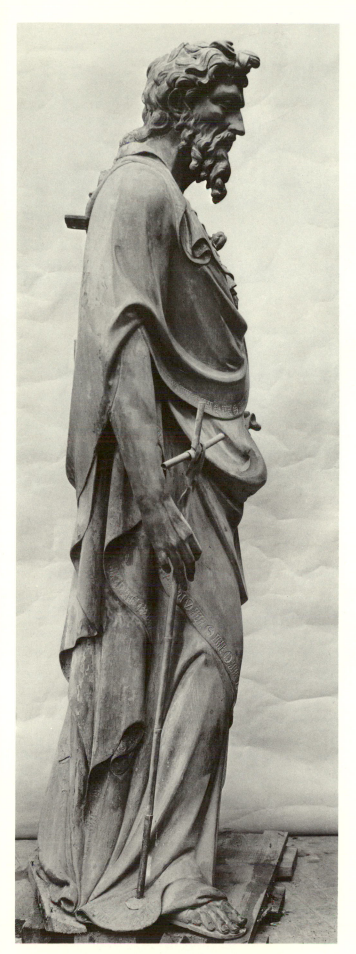

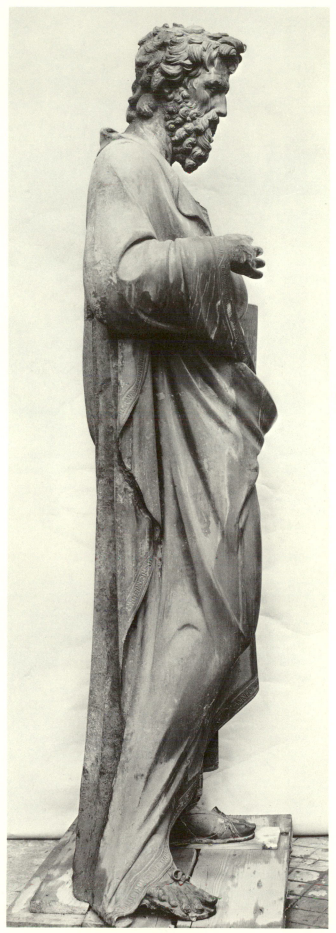

PLATE 9a. *Saint John the Baptist*, Profile.
Florence, Or San Michele

PLATE 9b. *Saint Matthew*, Profile.
Florence, Or San Michele

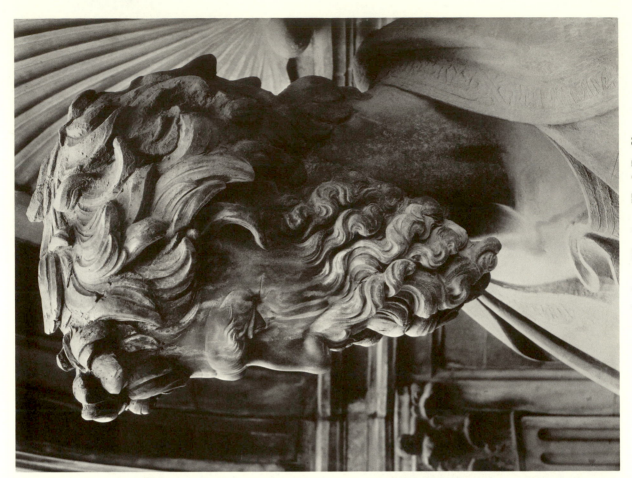

PLATE 10b. *Saint Matthew*, Head, Profile. Florence, Or San Michele

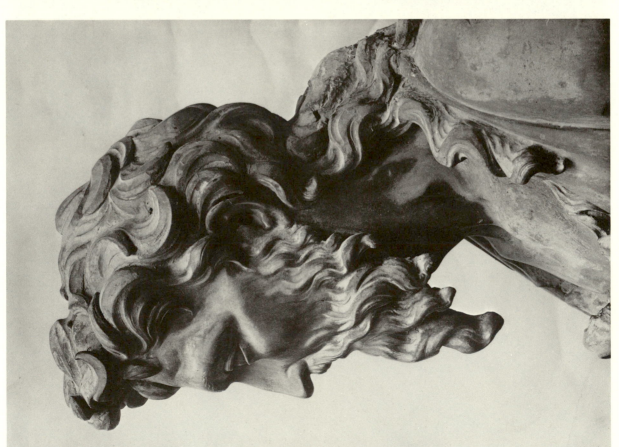

PLATE 10a. *Saint John the Baptist*, Head, Profile. Florence, Or San Michele

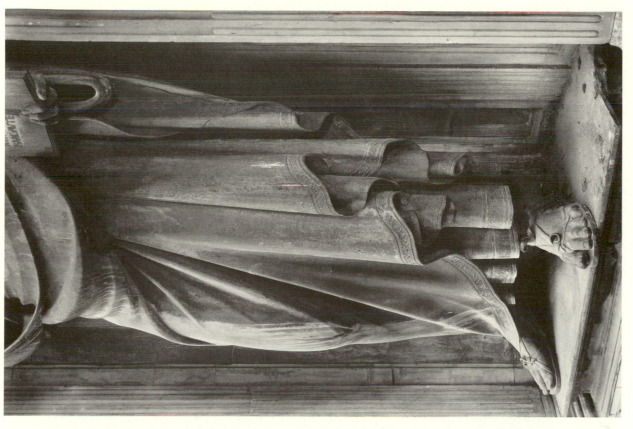

PLATE 11b. *Saint Matthew*, Drapery.
Florence, Or San Michele

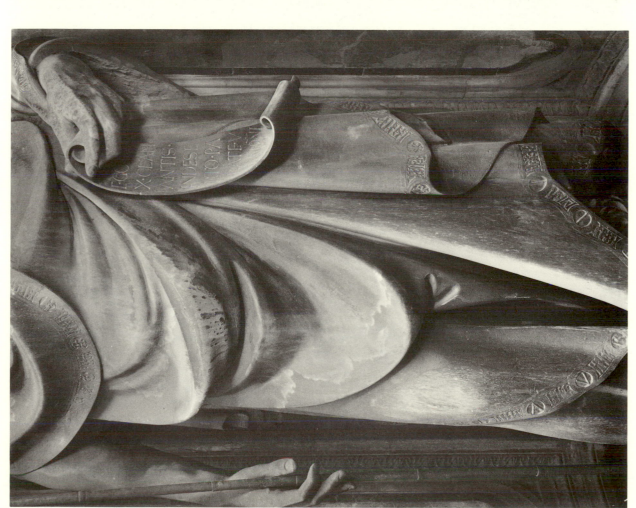

PLATE 11a. *Saint John the Baptist*, Drapery.
Florence, Or San Michele

PLATE 12a. *Saint Matthew*, Hand. Florence, Or San Michele

PLATE 12b. *Saint Stephen*, Hand. Florence, Or San Michele

PLATE 13b. *Saint Matthew*, Foot. Florence, Or San Michele

PLATE 13a. *Saint John the Baptist*, Foot. Florence, Or San Michele

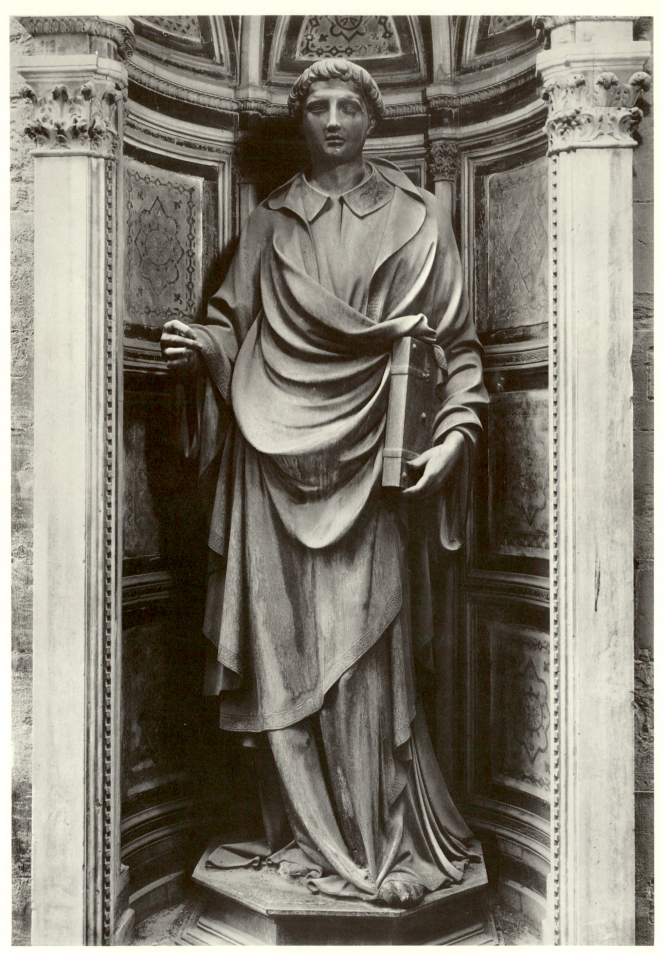

PLATE 14. *Saint Stephen*. Florence, Or San Michele

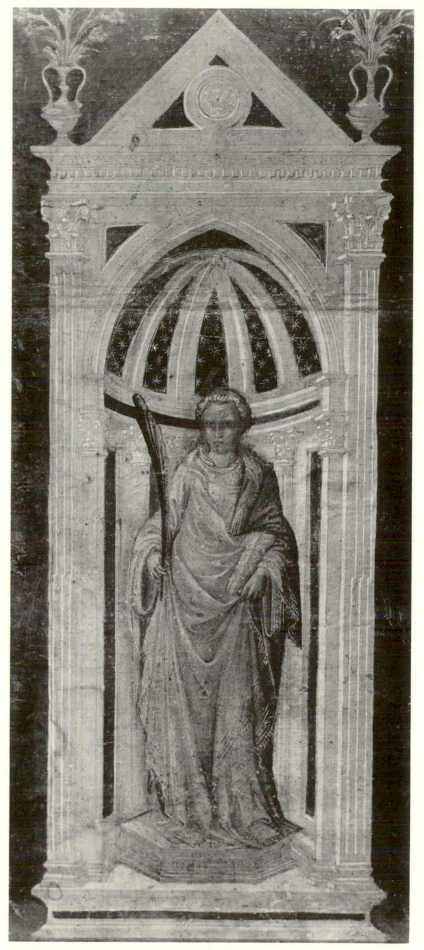

PLATE 15. Ghiberti Workshop: *Saint Stephen*, Presentation Drawing.
Paris, Louvre, Cabinet des Estampes

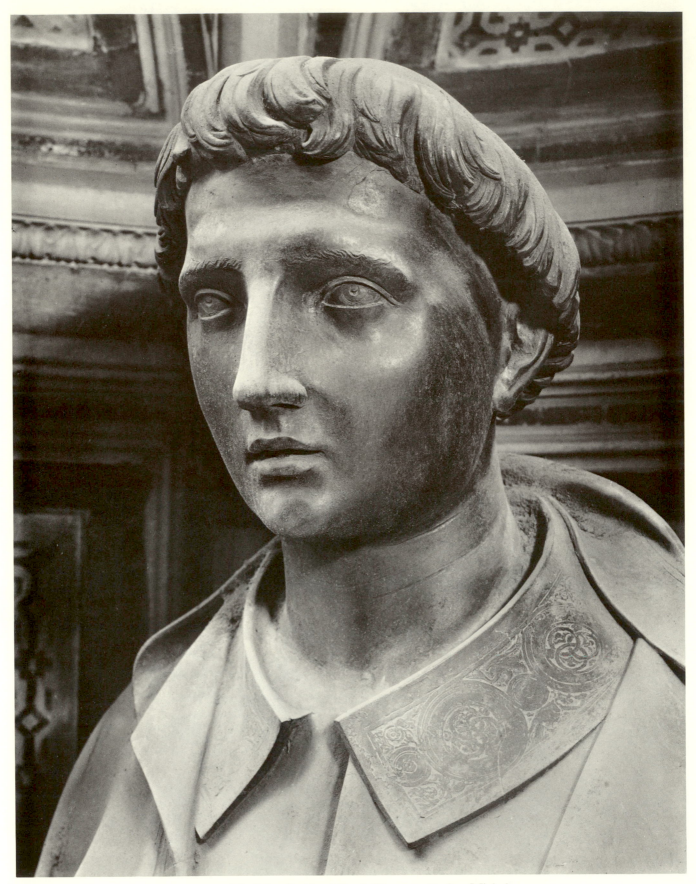

PLATE 16. *Saint Stephen*, Head. Florence, Or San Michele

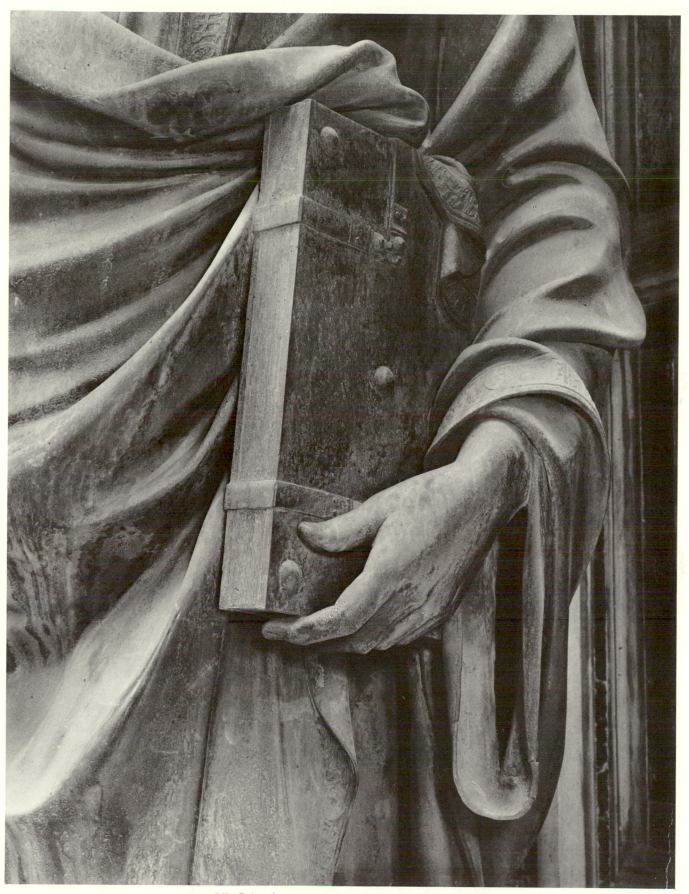

PLATE 17. *Saint Stephen*, Detail. Florence, Or San Michele

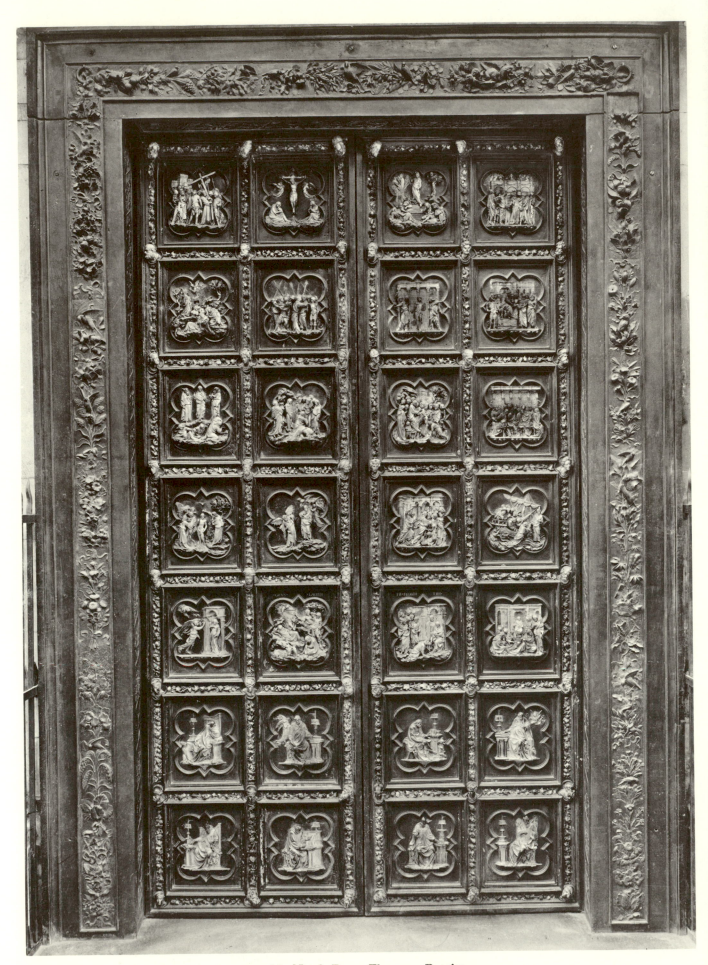

PLATE 18. North Door. Florence, Baptistery

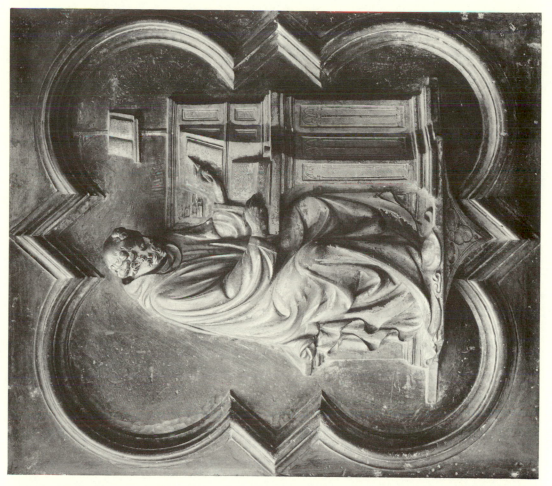

PLATE 19b. *Saint Jerome.* North Door

PLATE 19a. *Saint Augustine.* North Door

PLATE 20b. *Saint Ambrose.* North Door

PLATE 20a. *Saint Gregory.* North Door

PLATE 21b. *Saint Matthew.* North Door

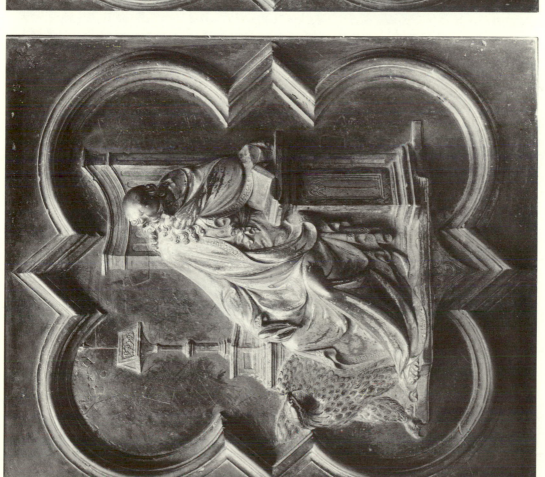

PLATE 21a. *Saint John the Evangelist.* North Door

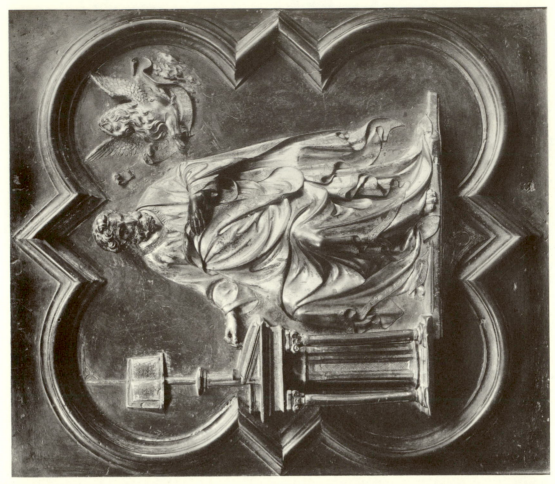

PLATE 22b. *Saint Mark*. North Door

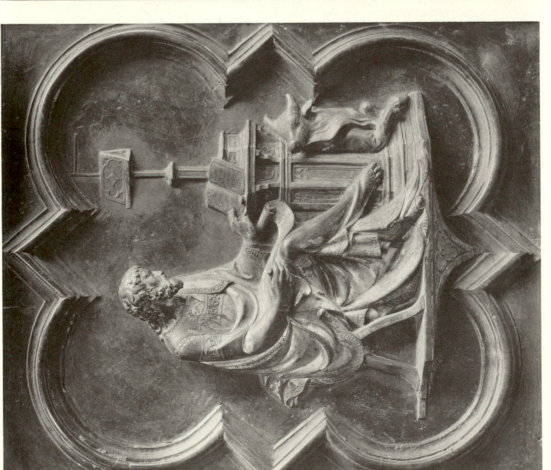

PLATE 22a. *Saint Luke*. North Door

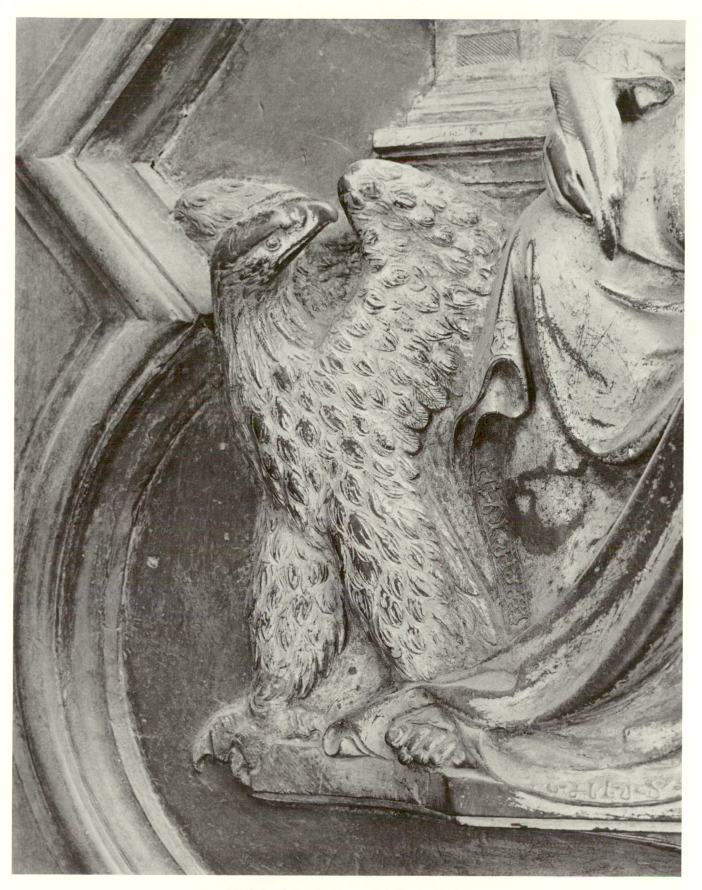

PLATE 23. *Saint John the Evangelist*, Eagle. North Door

PLATE 24. *Saint Matthew*, Detail. North Door

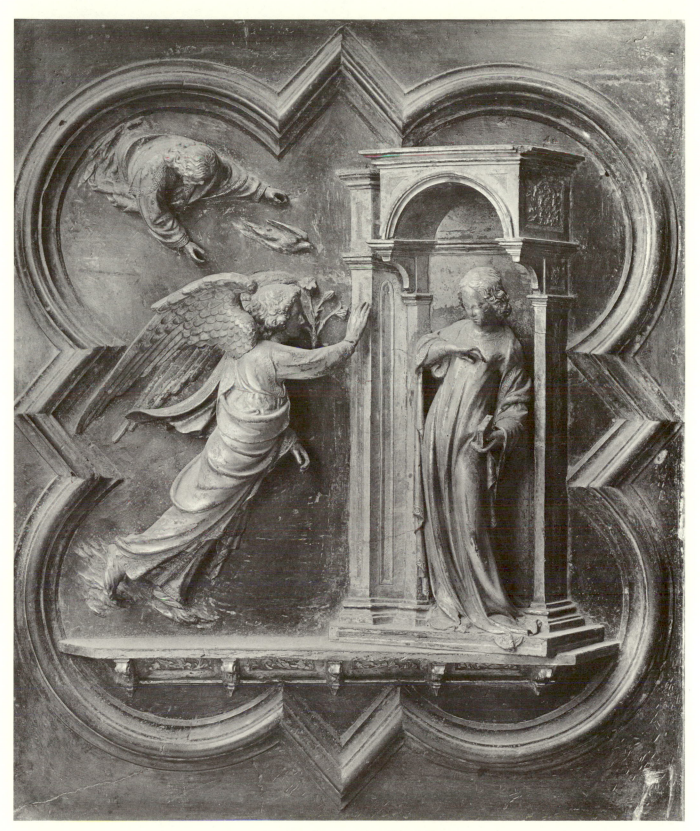

PLATE 25. *Annunciation*. North Door

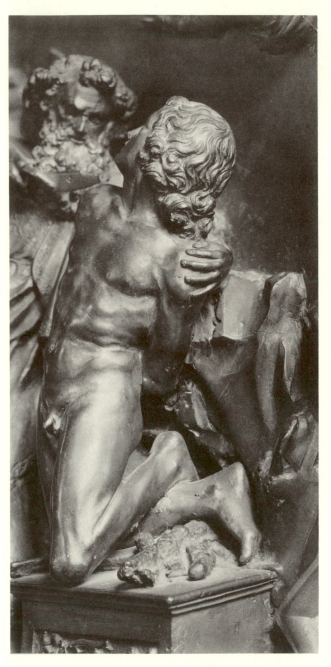

PLATE 26a. Competition Relief, Isaac.
Florence, Bargello

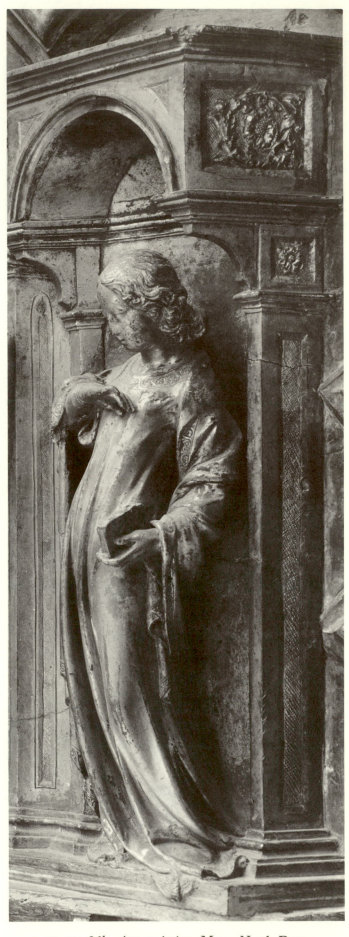

PLATE 26b. *Annunciation*, Mary. North Door

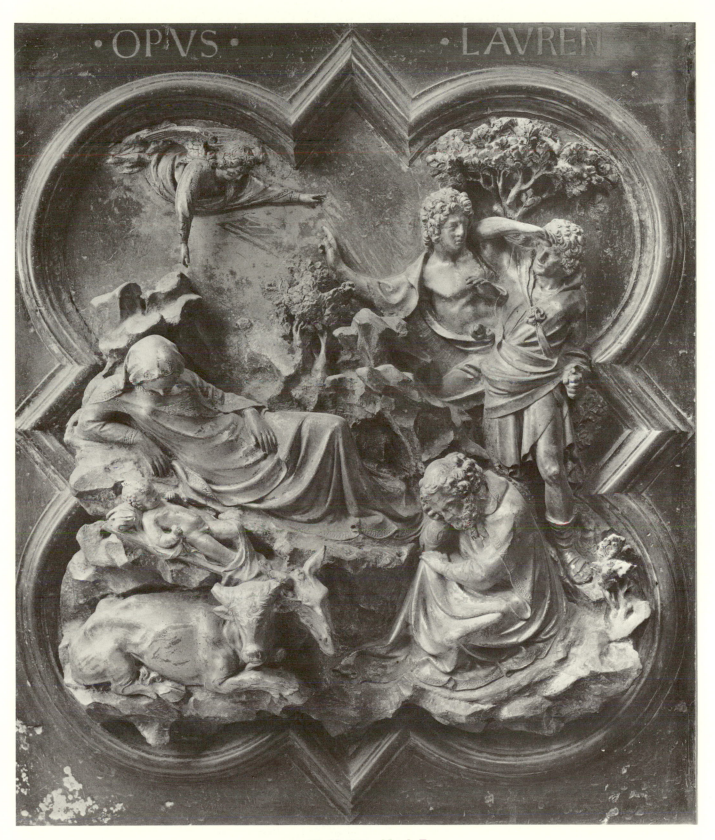

PLATE 27. *Nativity*. North Door

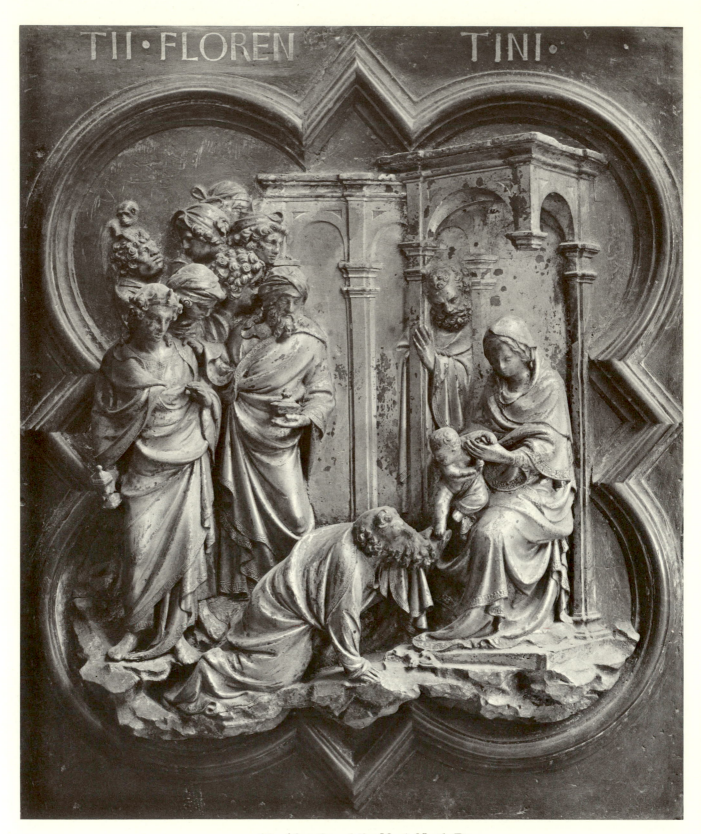

PLATE 28. *Adoration of the Magi.* North Door

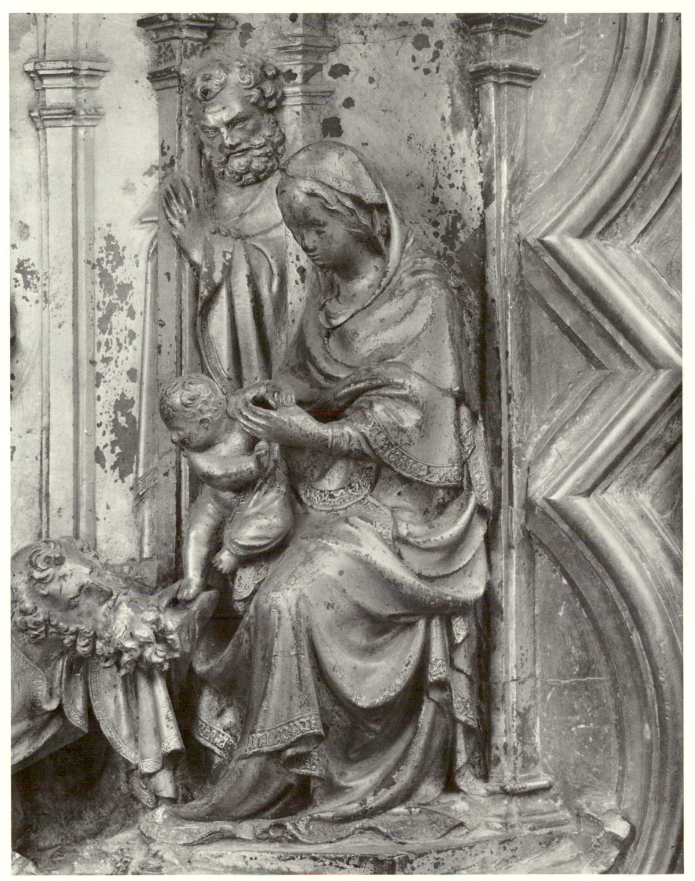

PLATE 29. *Adoration of the Magi*, Holy Family. North Door

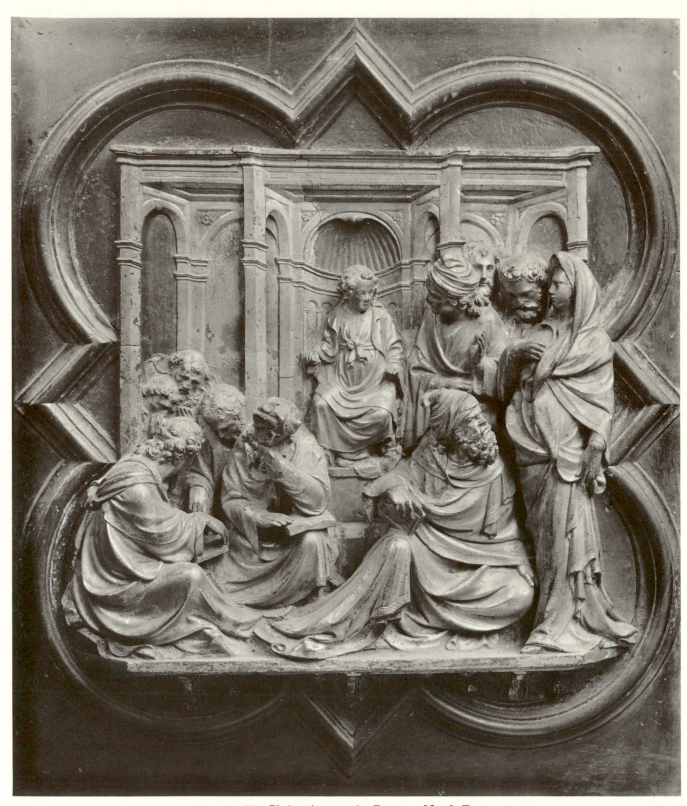

PLATE 30. *Christ Among the Doctors*. North Door

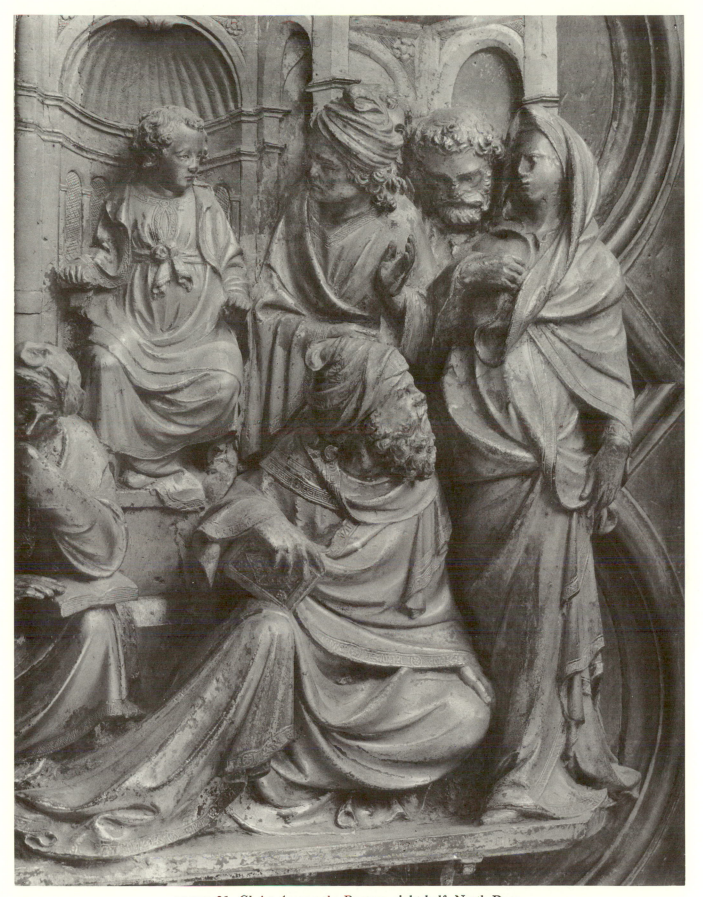

PLATE 31. *Christ Among the Doctors*, right half. North Door

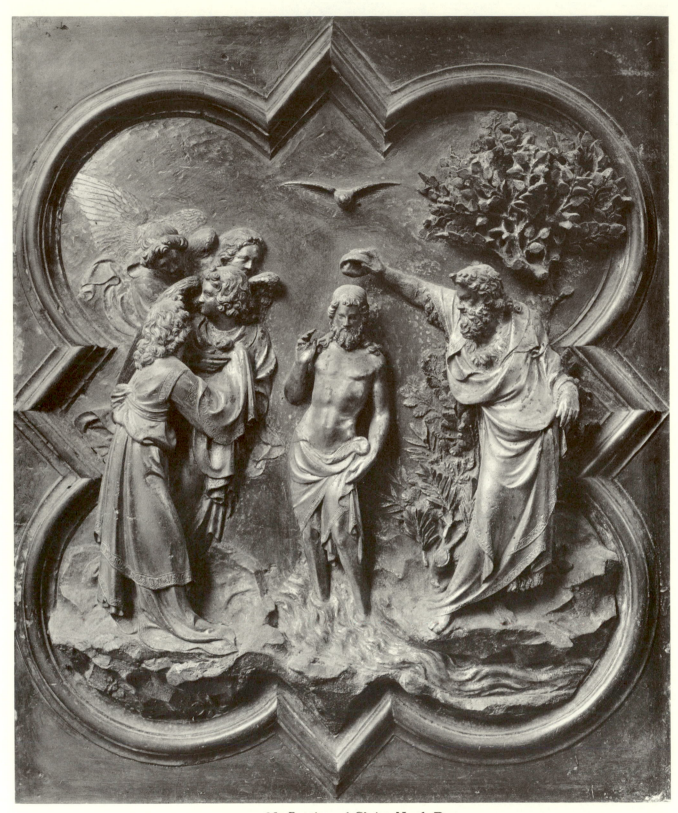

PLATE 32. *Baptism of Christ*. North Door

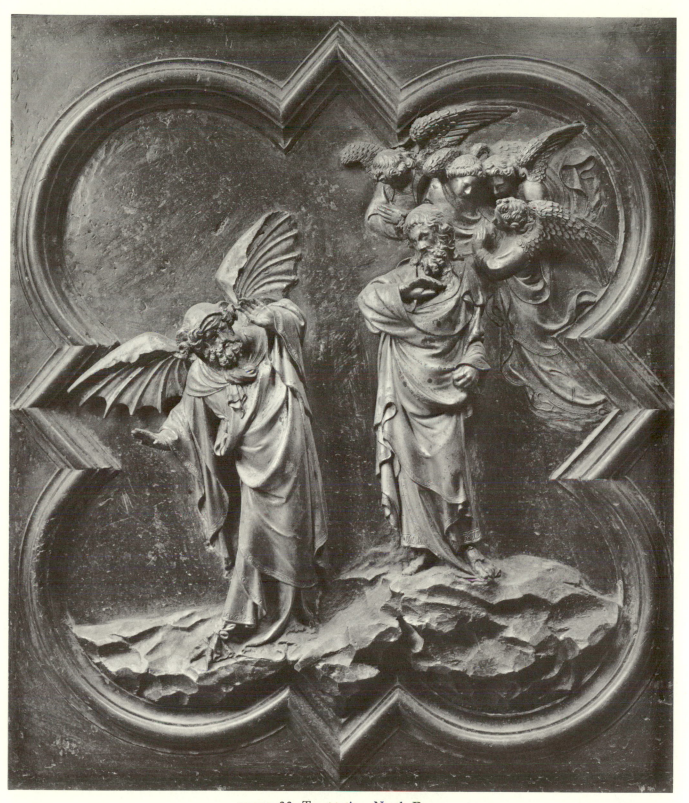

PLATE 33. *Temptation*. North Door

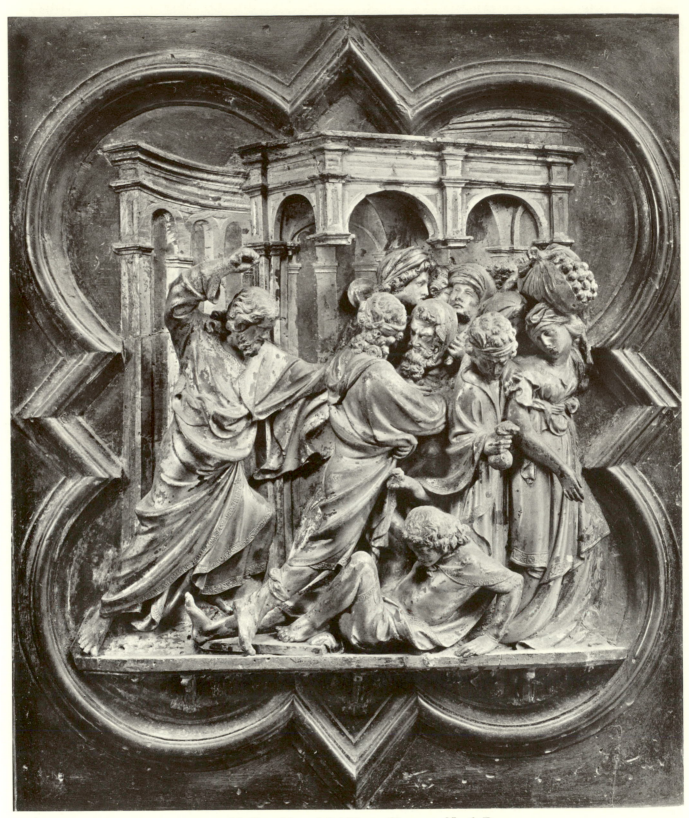

PLATE 34. *Expulsion of the Money Changers*. North Door

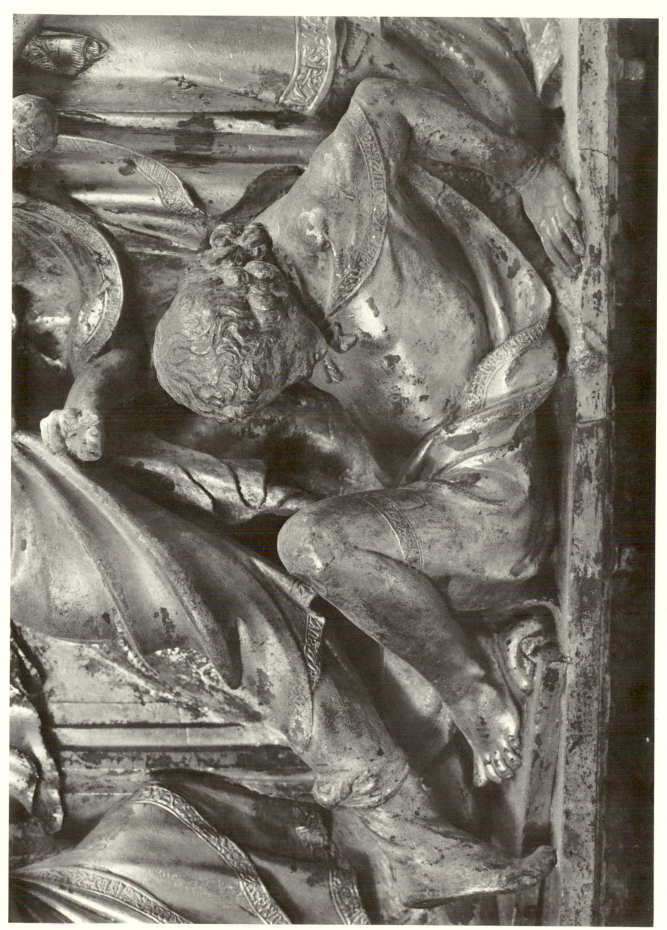

PLATE 35. *Expulsion of the Money Changers, Fallen Youth. North Door*

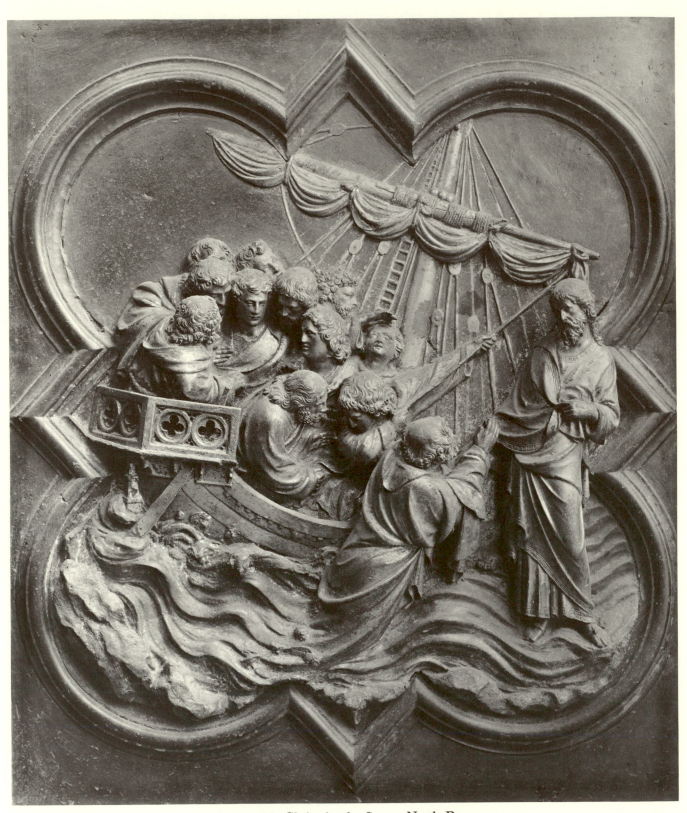

PLATE 36. *Christ in the Storm*. North Door

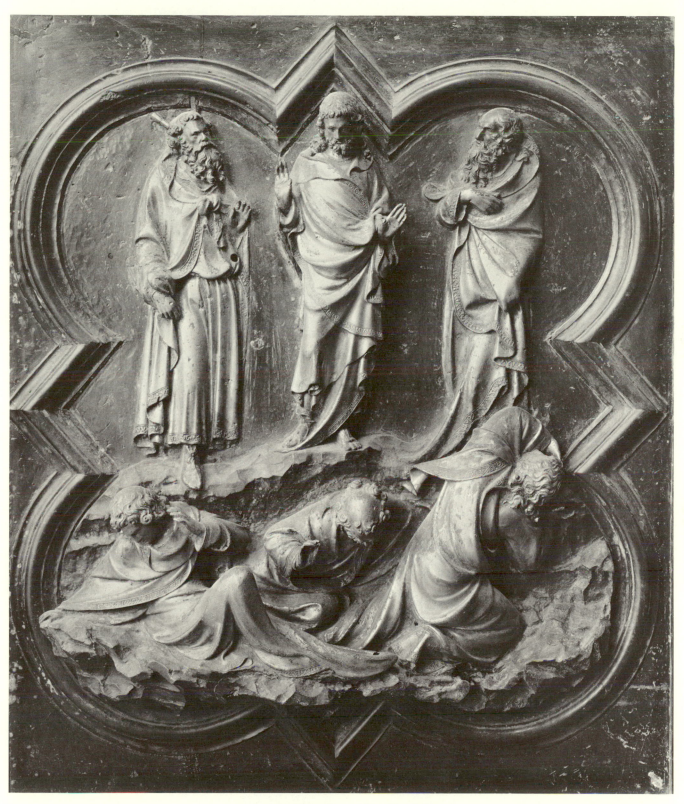

PLATE 37. *Transfiguration.* North Door

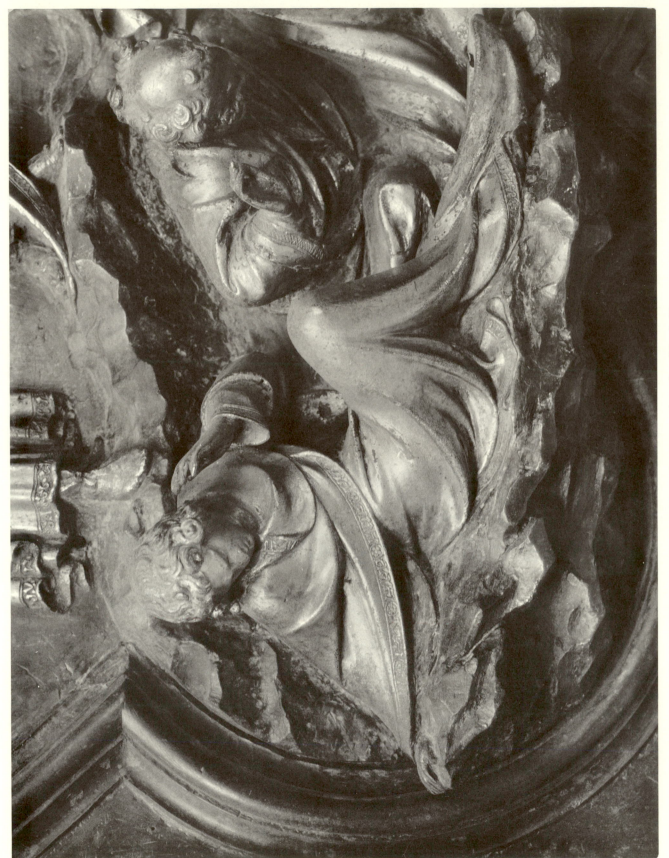

PLATE 38. *Transfiguration, Apostles. North Door*

PLATE 39. *Raising of Lazarus, Mary Magdalene. North Door*

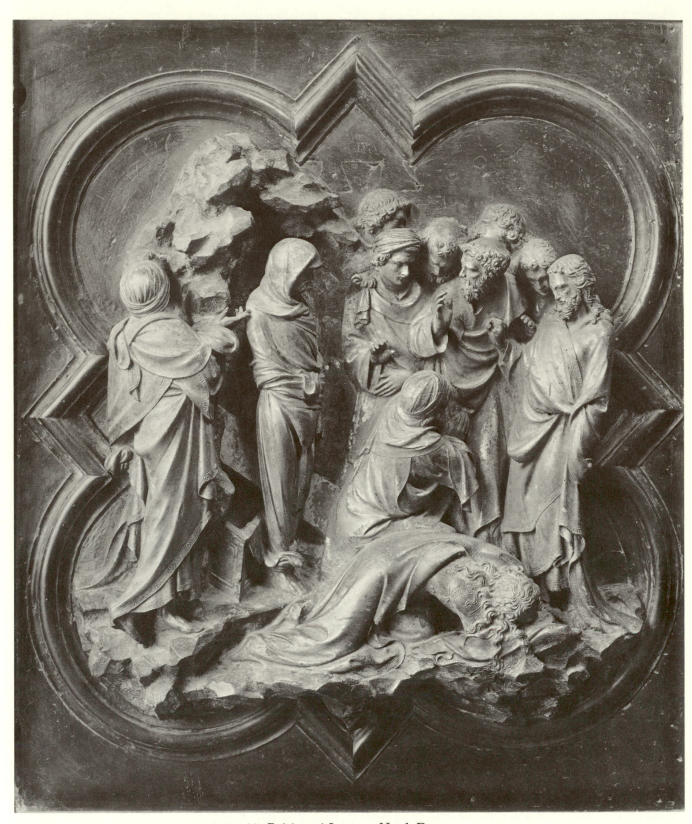

PLATE 40. *Raising of Lazarus*. North Door

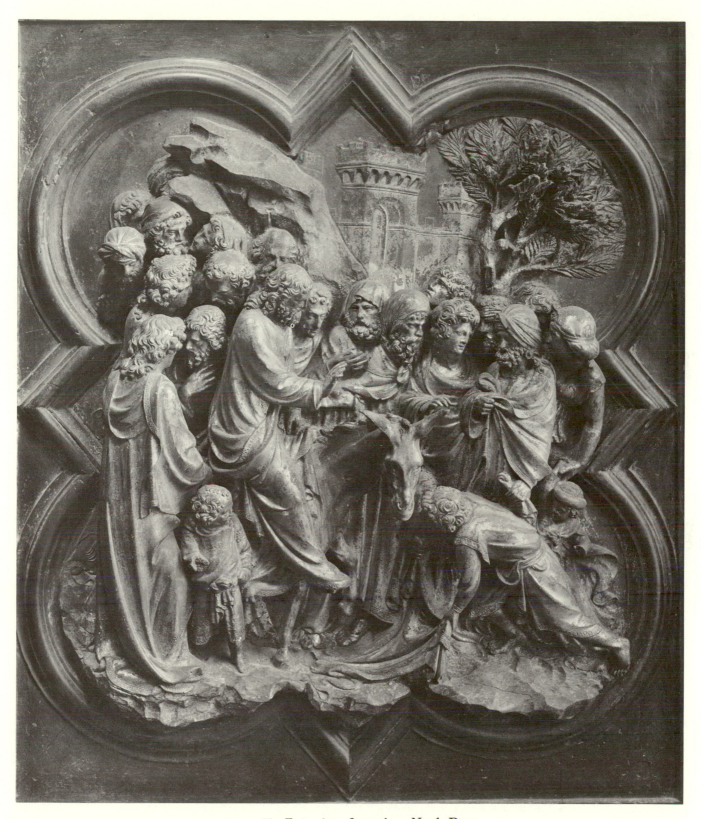

PLATE 41. *Entry into Jerusalem.* North Door

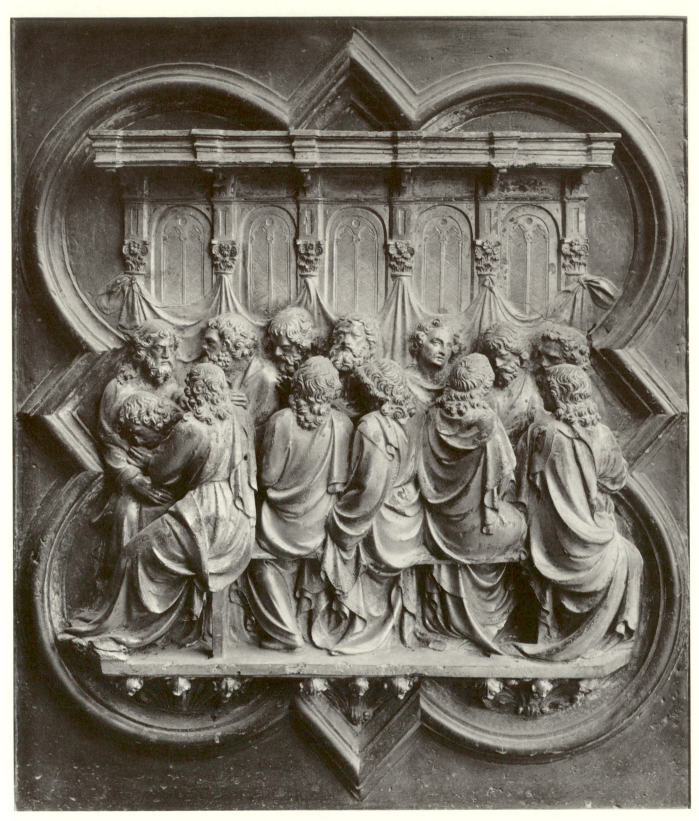

PLATE 42. *Last Supper*. North Door

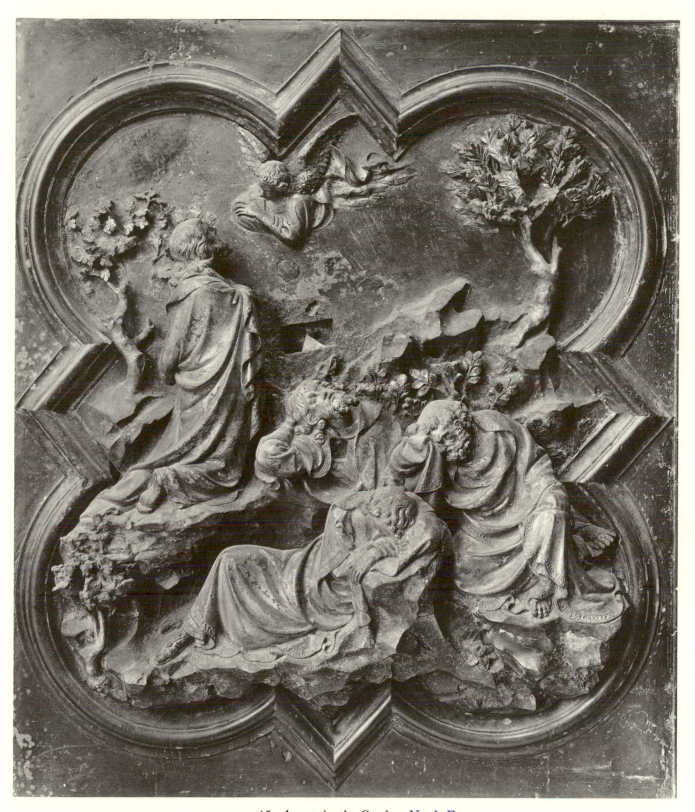

PLATE 43. *Agony in the Garden*. North Door

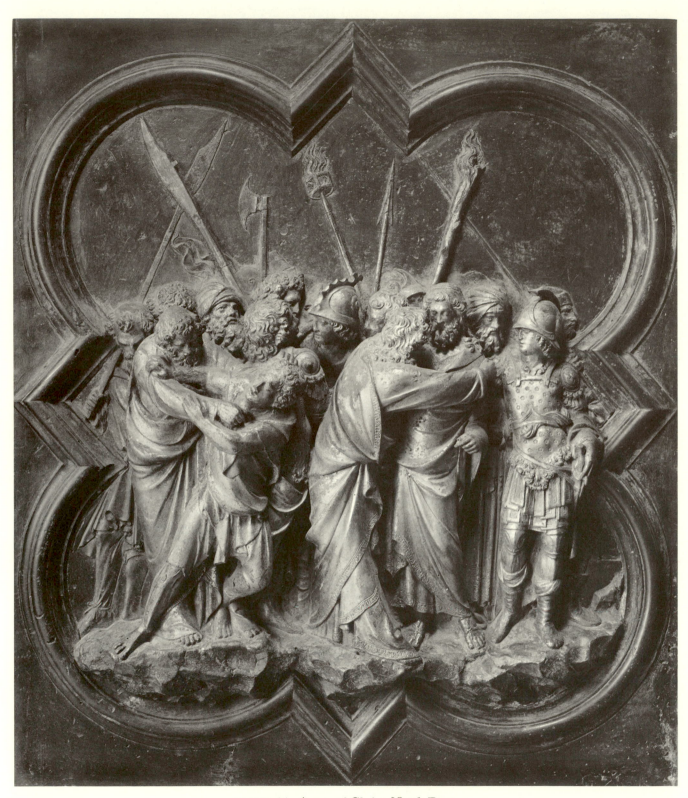

PLATE 44. *Arrest of Christ.* North Door

PLATE 45a. *Raising of Lazarus*, Man at Left. North Door

PLATE 45b. *Flagellation*, Christ at the Column. North Door

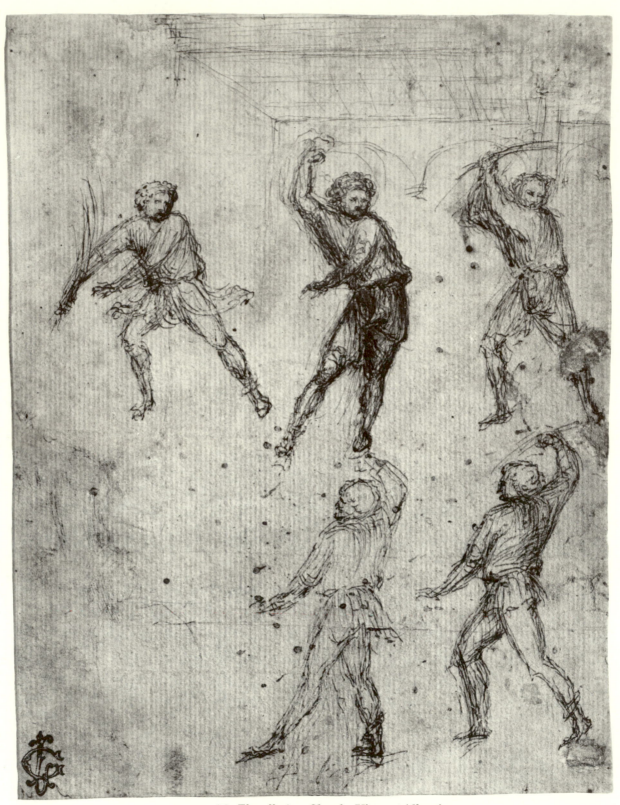

PLATE 46. *Flagellation*, Sketch. Vienna, Albertina

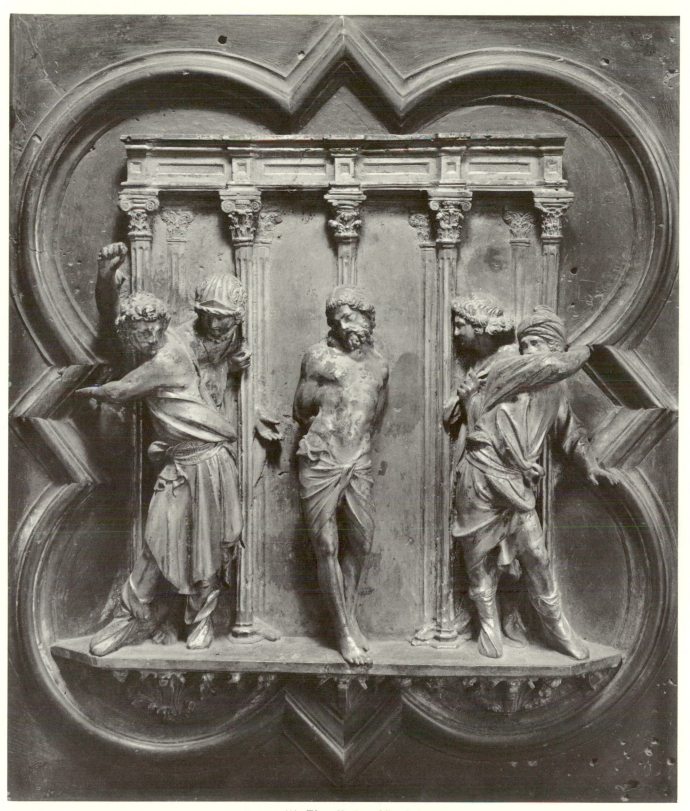

PLATE 47. *Flagellation*. North Door

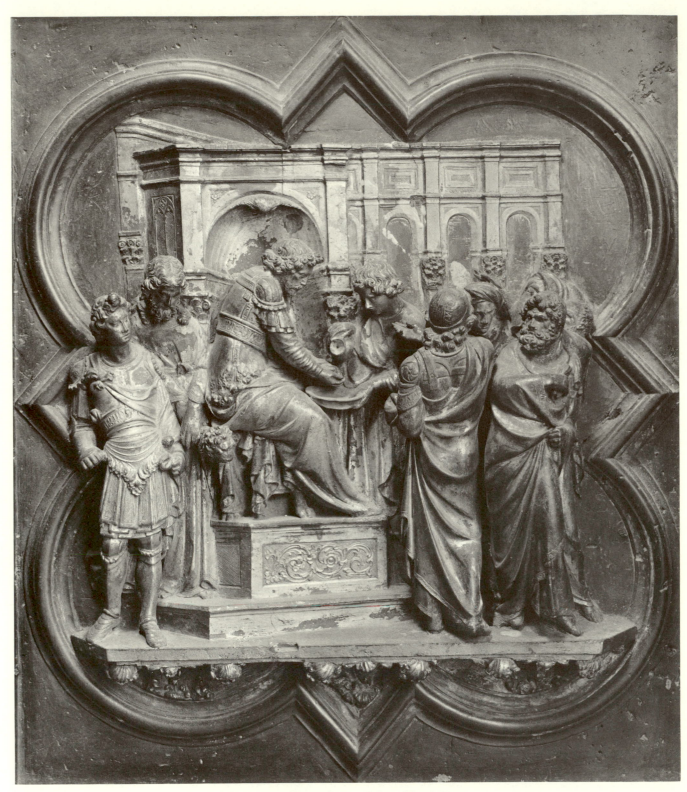

PLATE 48. *Christ before Pilate.* North Door

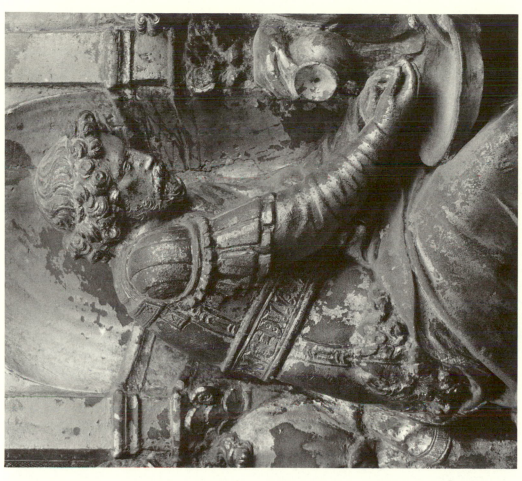

PLATE 49b. *Christ before Pilate*, Pilate. North Door

PLATE 49a. *Baptism of Christ*, Angels. North Door

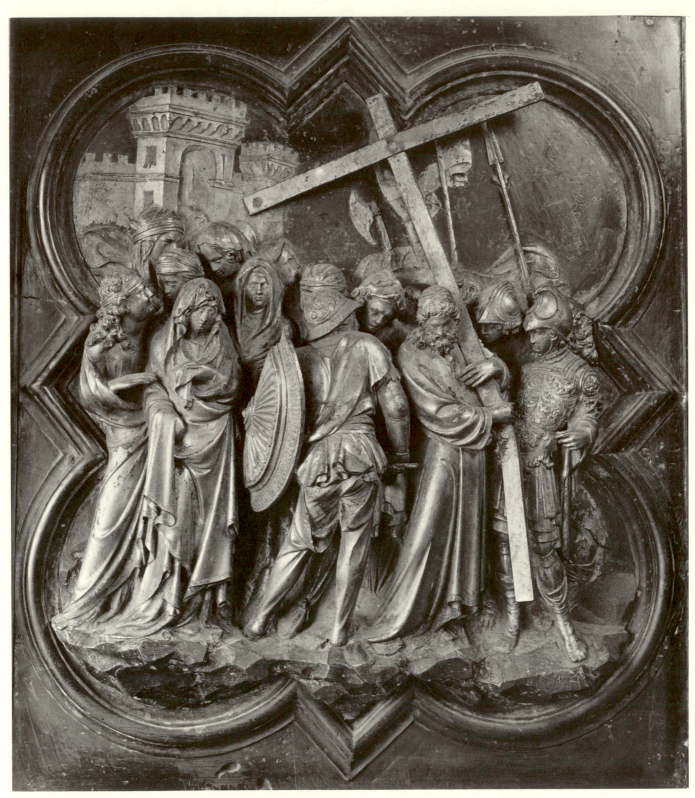

PLATE 50. *Way to Calvary.* North Door

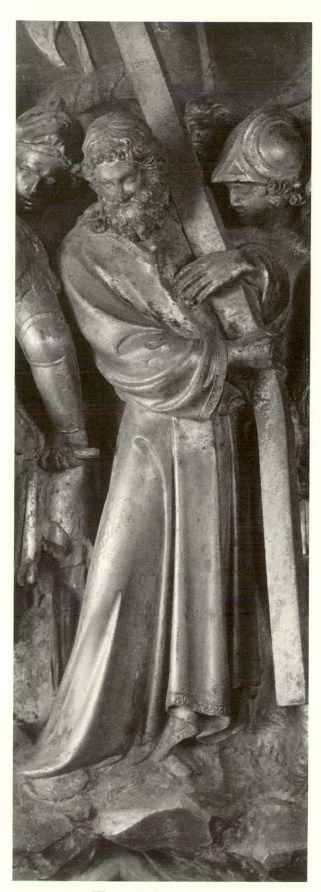

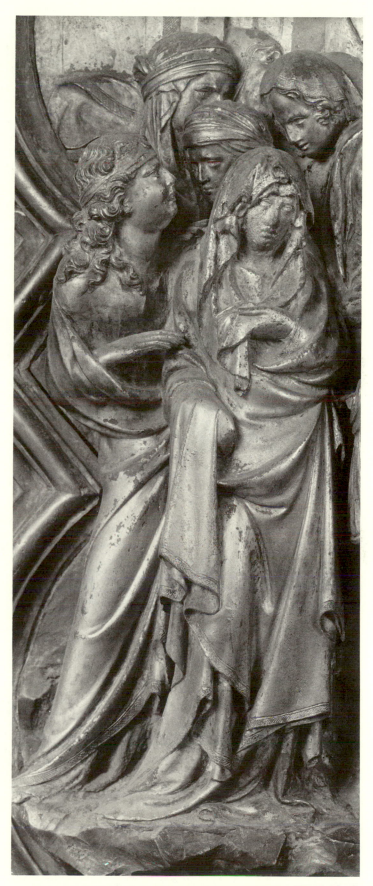

PLATE 51a. *Way to Calvary*, Christ. North Door

PLATE 51b. *Way to Calvary*, Mary and Saint John. North Door

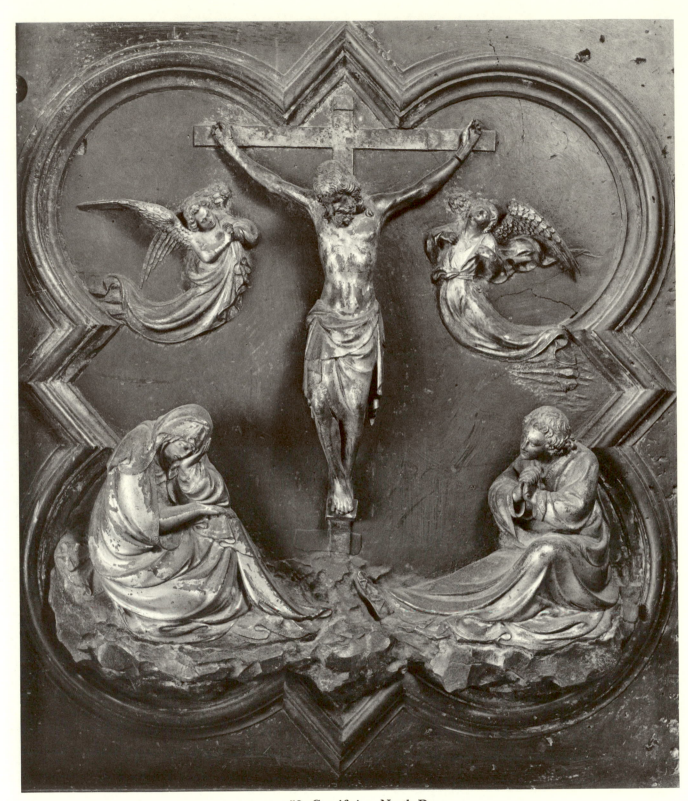

PLATE 52. *Crucifixion.* North Door

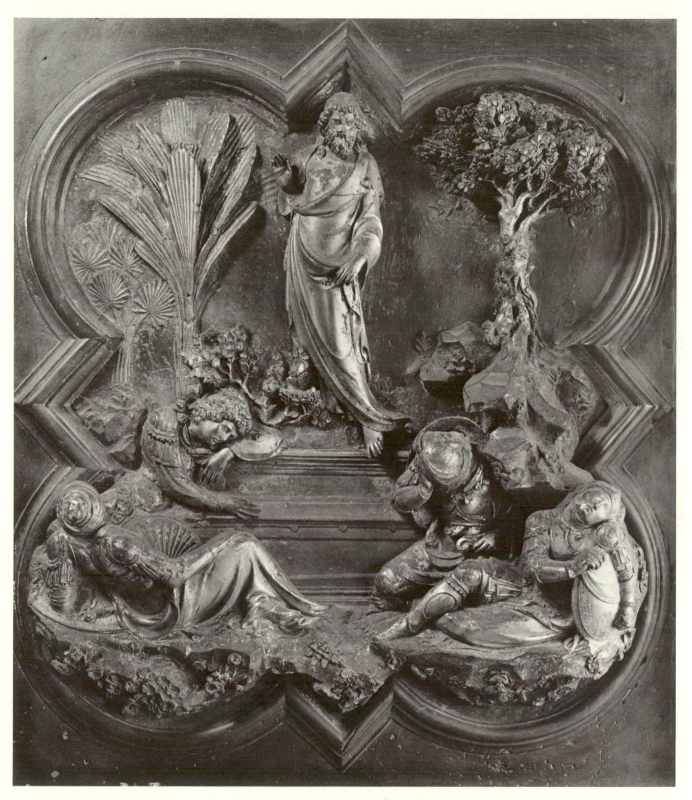

PLATE 53. *Resurrection.* North Door

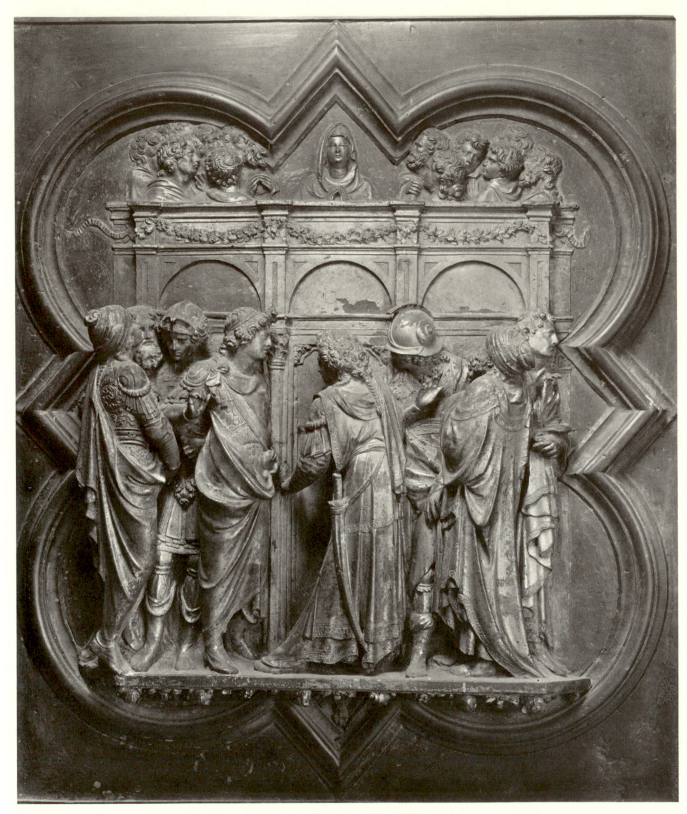

PLATE 54. *Pentecost.* North Door

PLATE 55a. *Temptation*, Wing of Satan. North Door

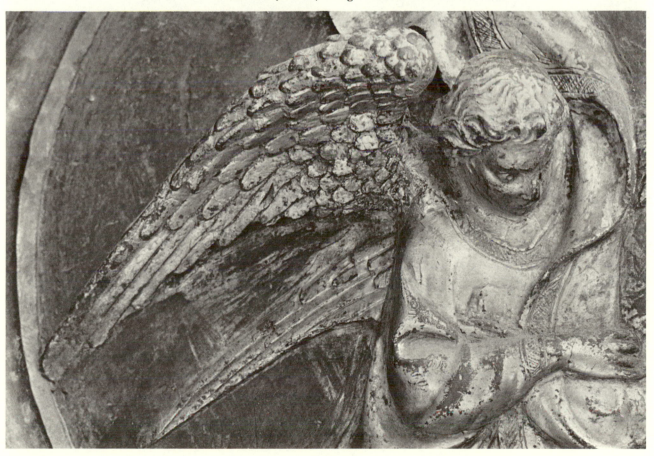

PLATE 55b. *Saint Matthew*, Wing of Angel. North Door

c

f

b

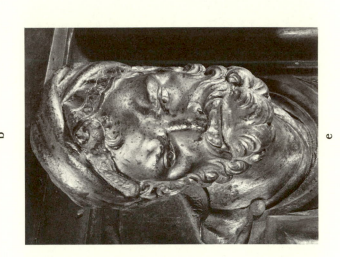

e

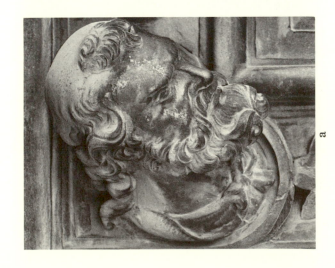

a

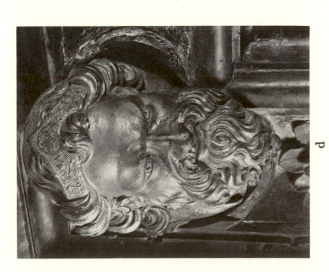

d

PLATE 56. *Prophets.* North Door

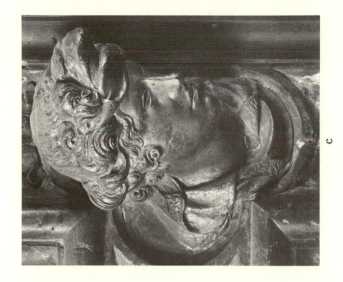

c

f

b

e

a

d

PLATE 57. *Prophets.* North Door

c

f

b

e

a

d

PLATE 58. *Prophets.* North Door

a

b

c

d

e

f

PLATE 59. *Prophets.* North Door

a

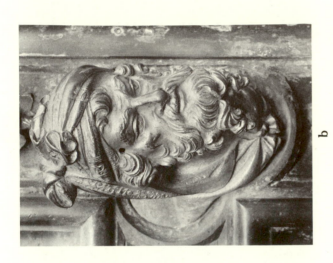

b

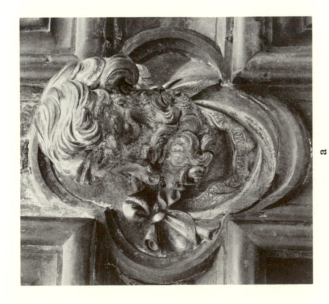

c

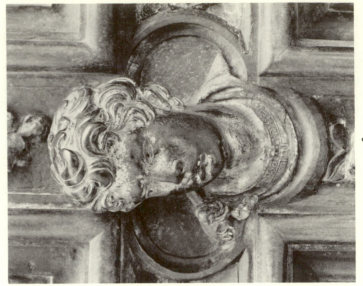

d

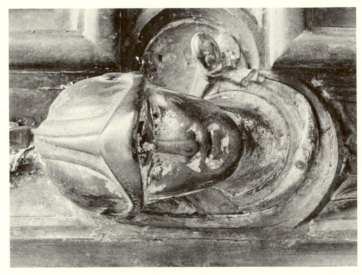

e

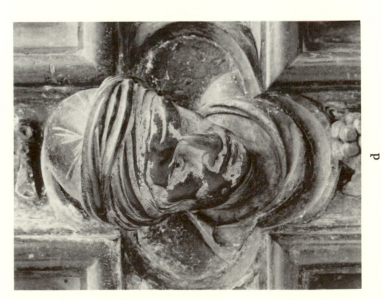

f

PLATE 62. Bosses in North Door

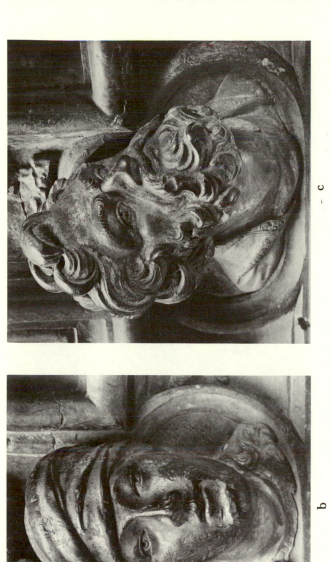

a

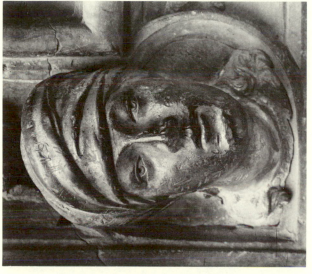

b

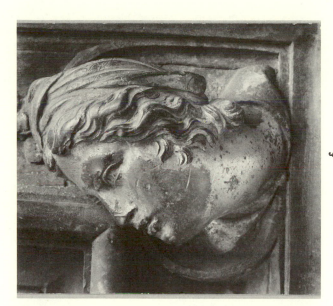

c

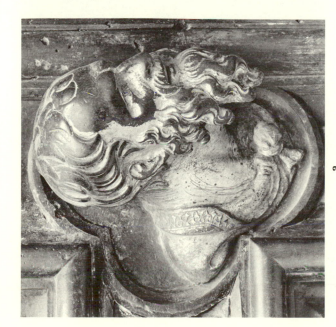

d

e

f

PLATE 61. *Prophets*. North Door

PLATE 62b. *Youthful Prophet. North Door*

PLATE 62a. *Elderly Prophetess. North Door*

PLATE 63b. *Youthful Prophet.* North Door

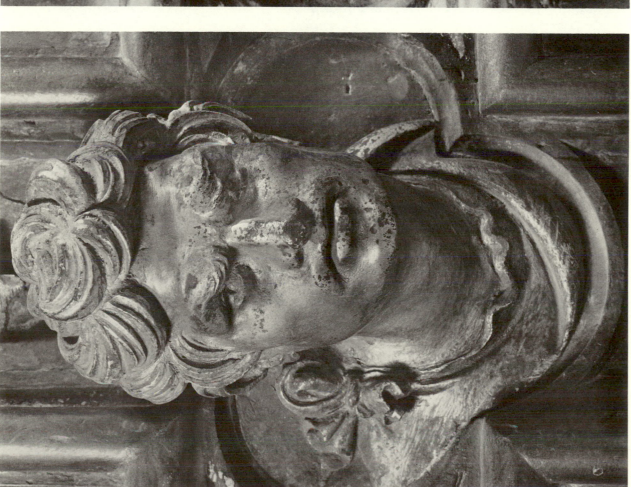

PLATE 63a. *Prophet.* North Door

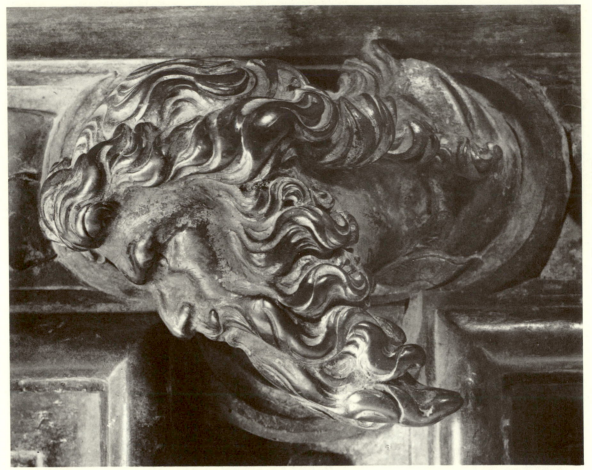

PLATE 64b. *Prophet.* North Door

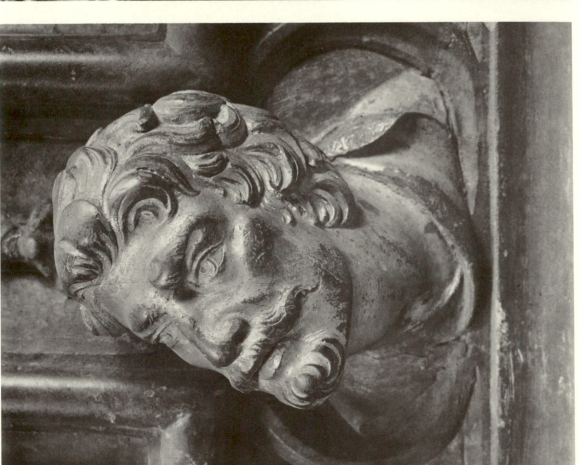

PLATE 64a. *Prophet.* North Door

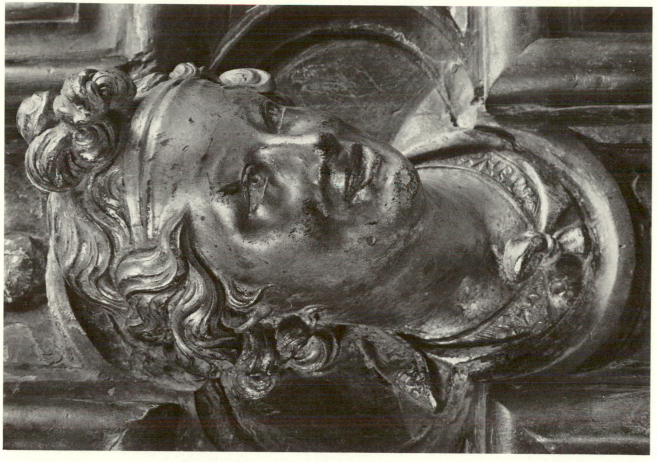

PLATE 65b. *Youthful Prophetess. North Door*

PLATE 65a. *Youthful Prophet. North Door*

PLATE 66b. *Prophet.* North Door

PLATE 66a. *Youthful Prophetess.* North Door

PLATE 67. *Prophet*. North Door

PLATE 68b. *Tondo, back frame. Gates of Paradise*

PLATE 68a. *Lion's Head,* back frame. North Door

PLATE 69d. Floral Decoration, outer jambs.

PLATE 69c. Floral Decoration, inner jambs.

North Door

PLATE 69b. Foliage, lattice frame.

PLATE 69a. Foliage, lattice frame.

PLATE 70b. Floral Decoration, outer jambs. North Door

PLATE 70a. Floral Decoration, outer jambs. North Door

PLATE 71a. Architrave, Detail. North Door

PLATE 71b. Architrave, Detail. Gates of Paradise

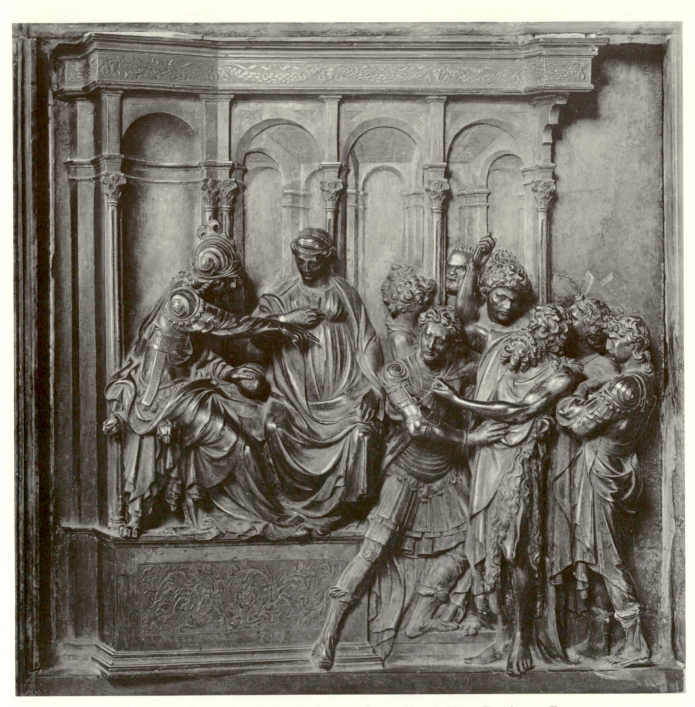

PLATE 72. *Saint John the Baptist brought before Herod.* Siena, Baptistery, Font

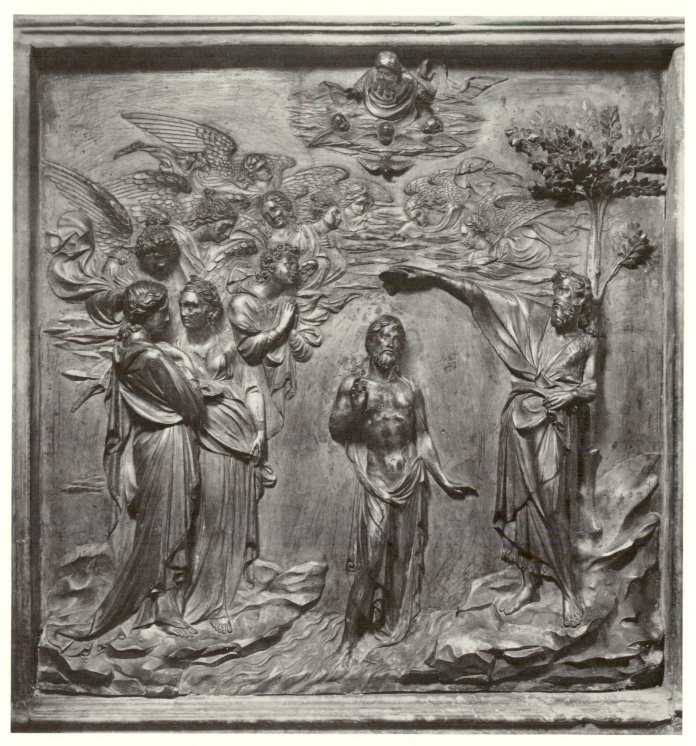

PLATE 73. *Baptism of Christ.* Siena, Baptistery, Font

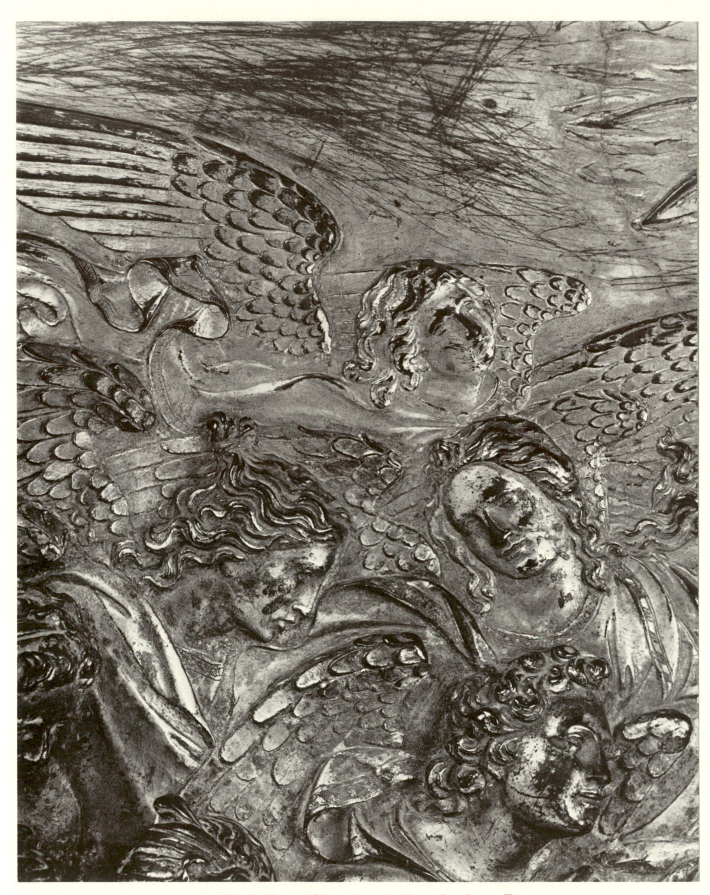

PLATE 74. *Baptism of Christ*, Angels. Siena, Baptistery, Font

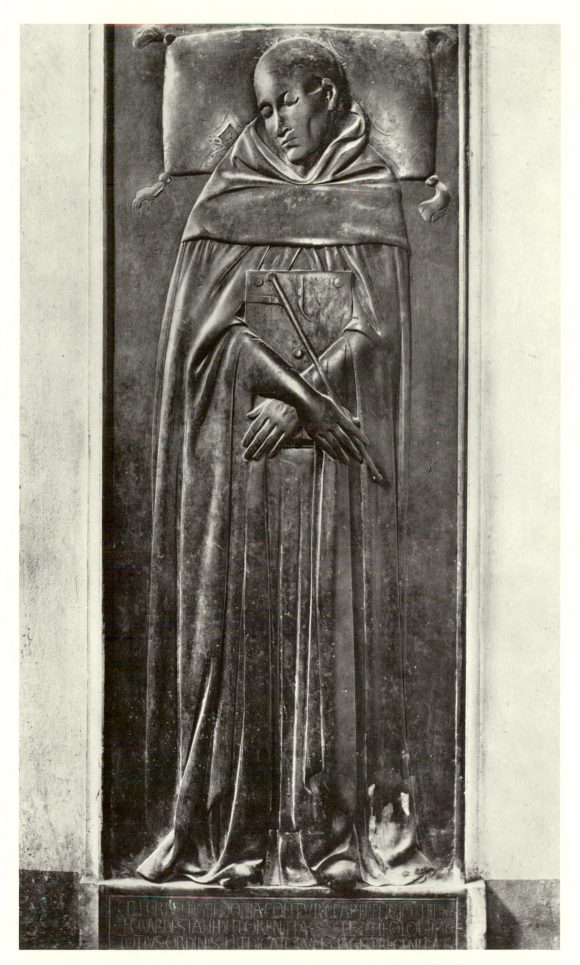

PLATE 75. *Tomb of Leonardo Dati.* Florence, S. Maria Novella

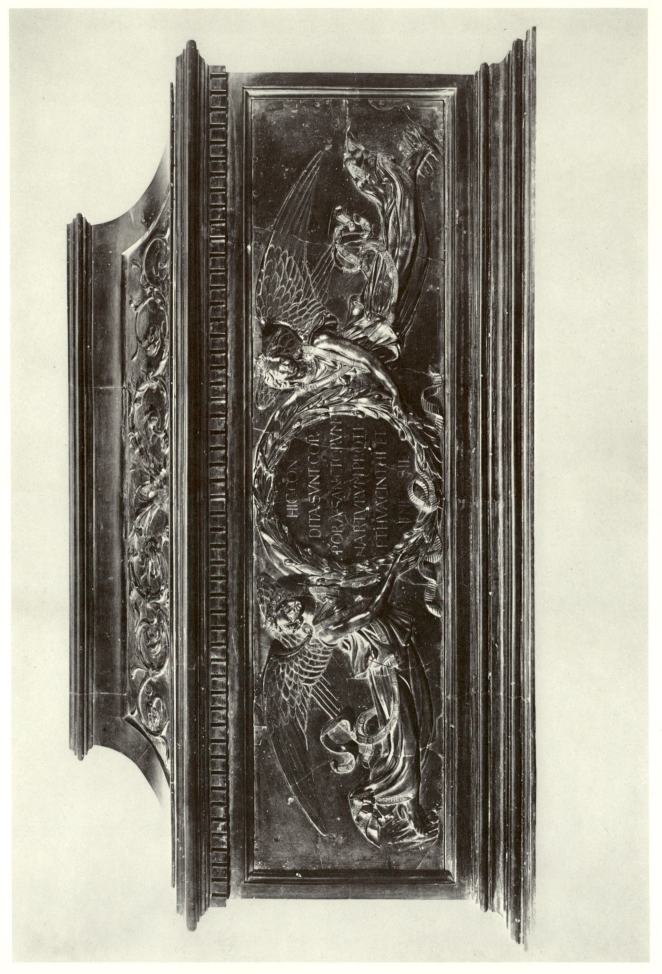

PLATE 76. Cassa dei SS. Proto, Giacinto e Nemesio, from S. Maria degli Angeli, front. Florence, Bargello

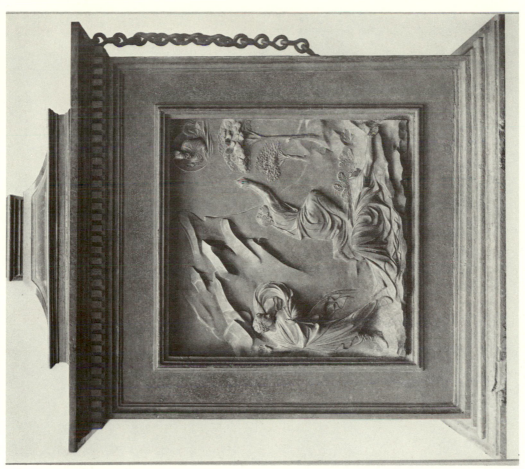

PLATE 77b. Cassa di S. Zenobio, *Miracle of the Servant.* Florence, Cathedral

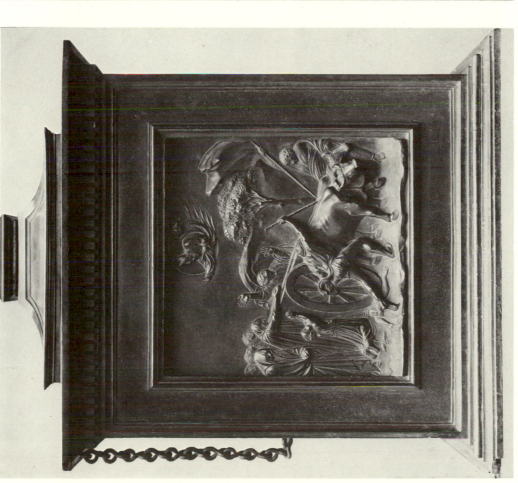

PLATE 77a. Cassa di S. Zenobio, *Miracle of the Oxcart.* Florence, Cathedral

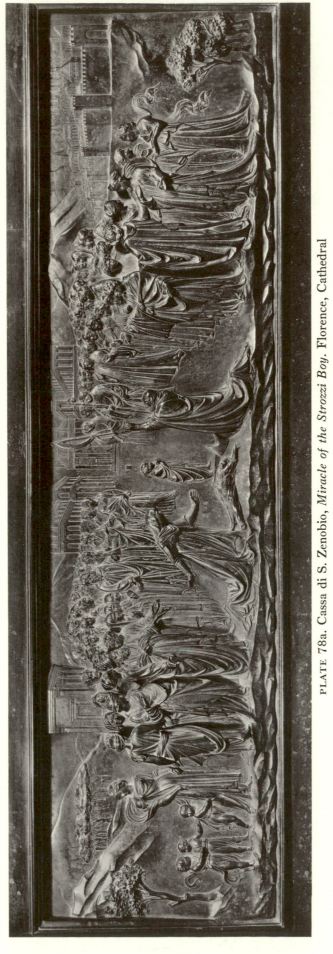

PLATE 78a. Cassa di S. Zenobio, *Miracle of the Strozzi Boy*. Florence, Cathedral

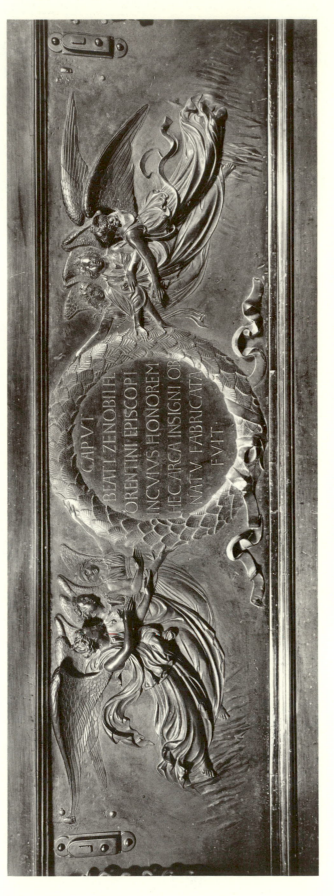

CAPVT
BEATI ZENOBII FL
ORENTINI EPISCOPI
INCVIVS HONOREM
HEC ARCA INSIGNI OR
NATV FABRICATA
FVIT

PLATE 78b. Cassa di S. Zenobio, *Angels with Garland*. Florence, Cathedral

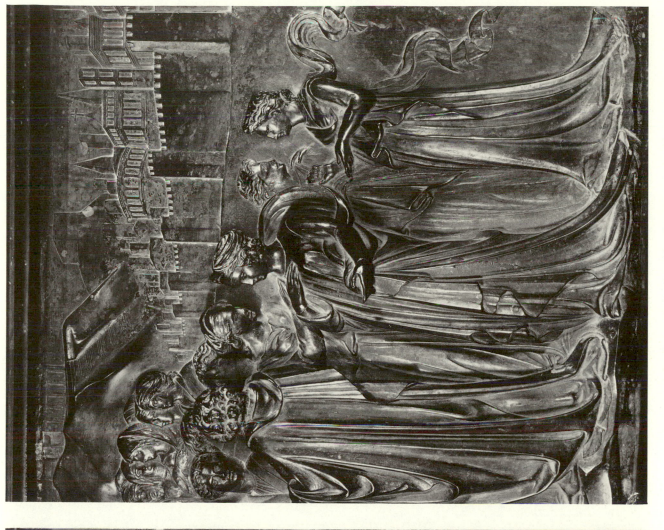

PLATE 79b. Cassa di S. Zenobio, *Miracle of the Strozzi Boy,*
Group at Right. Florence, Cathedral

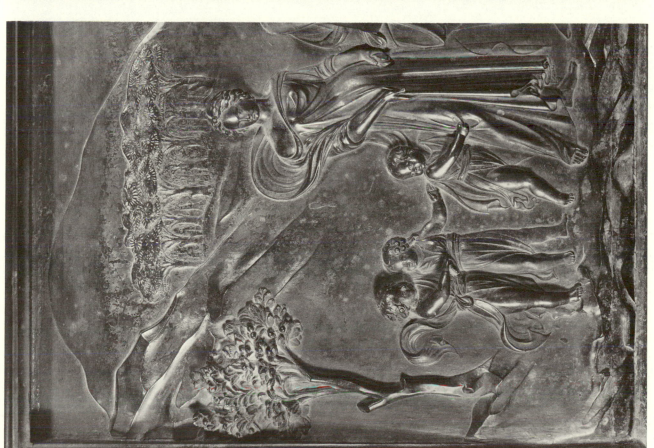

PLATE 79a. Cassa di S. Zenobio, *Miracle of the Strozzi Boy,*
Woman with Children. Florence, Cathedral

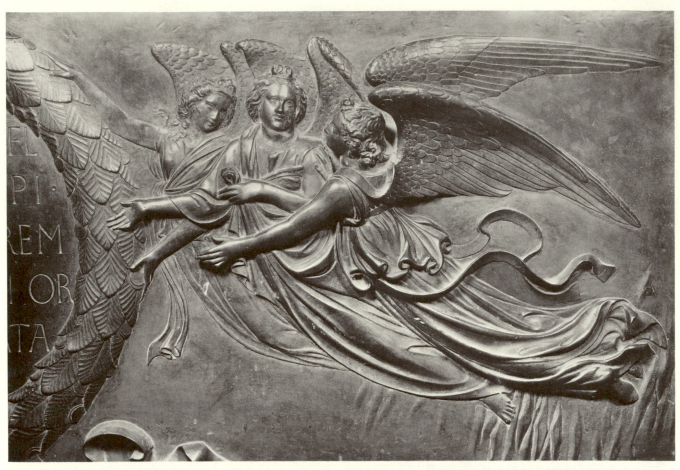

PLATE 80a. Cassa di S. Zenobio, *Angels with Garland*, Detail. Florence, Cathedral

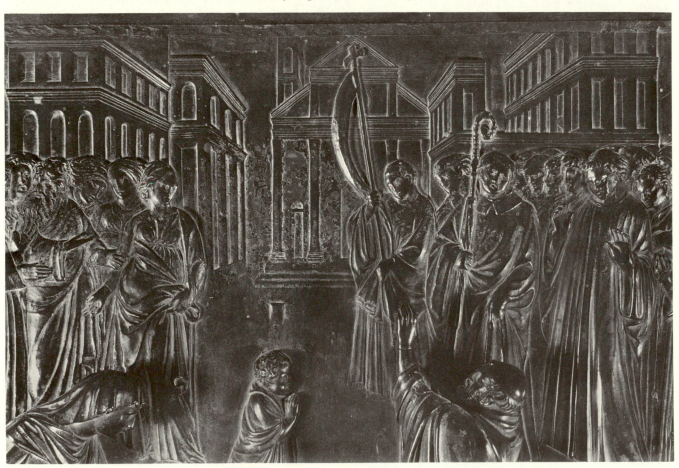

PLATE 80b. Cassa di S. Zenobio, *Miracle of the Strozzi Boy*, Detail. Florence, Cathedral

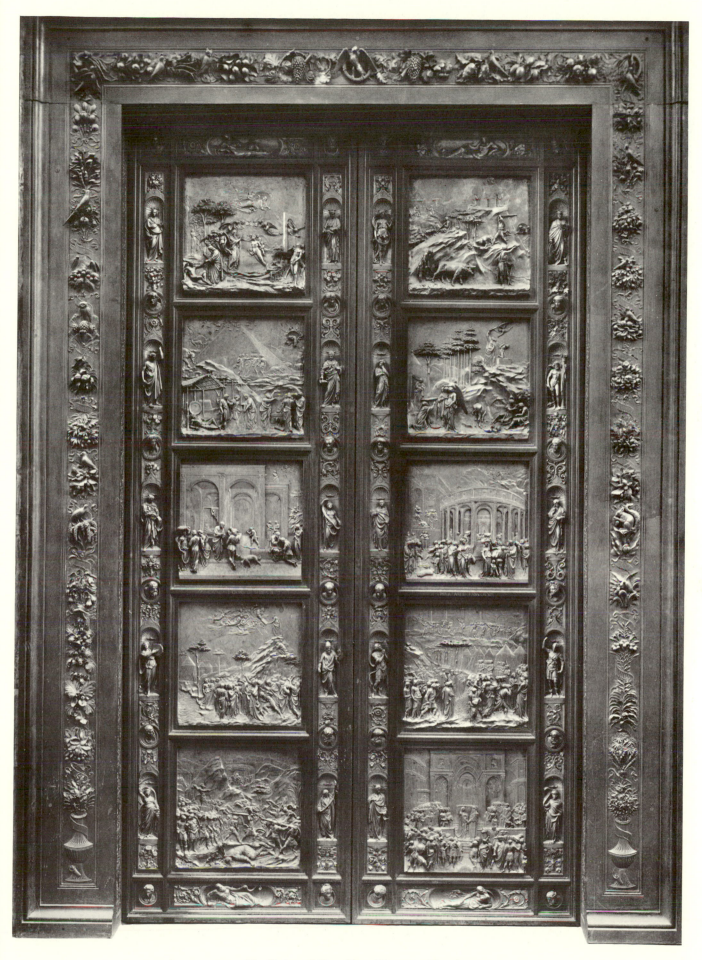

PLATE 81. Gates of Paradise. Florence, Baptistery

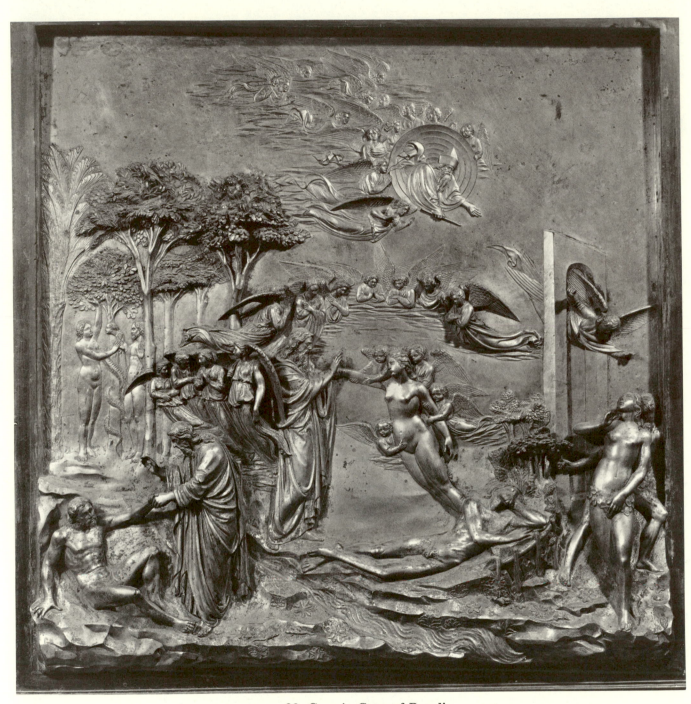

PLATE 82. *Genesis*. Gates of Paradise

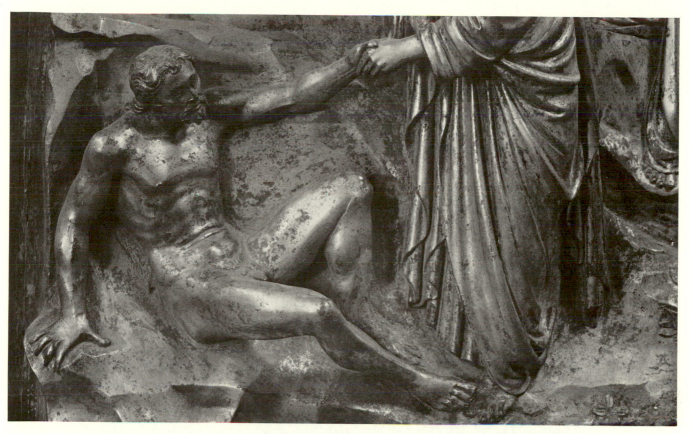

PLATE 83a. *Genesis*, Adam. Gates of Paradise

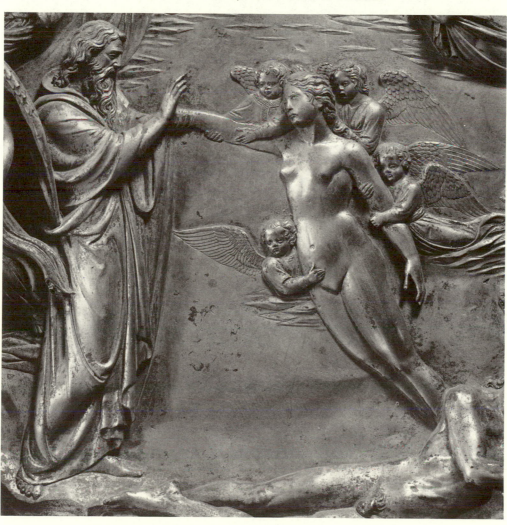

PLATE 83b. *Genesis*, Creation of Eve. Gates of Paradise

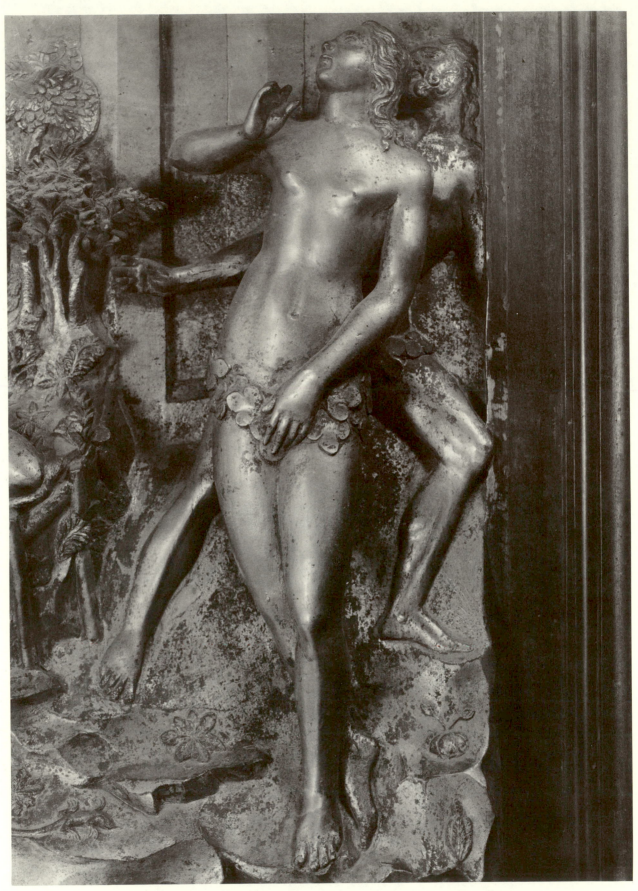

PLATE 84. *Genesis*, Expulsion from Paradise. Gates of Paradise

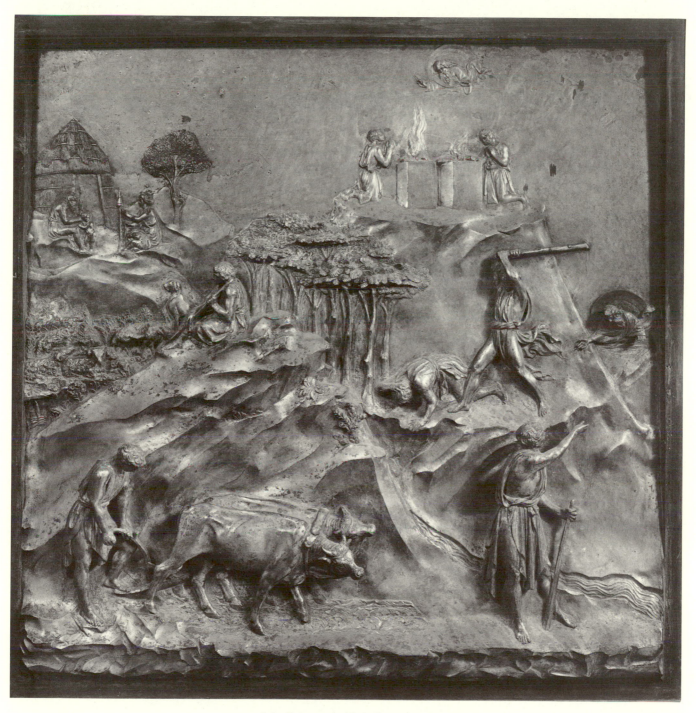

PLATE 85. *Cain and Abel*. Gates of Paradise

PLATE 86b. *Cain and Abel*, Cursing of Cain. Gates of Paradise

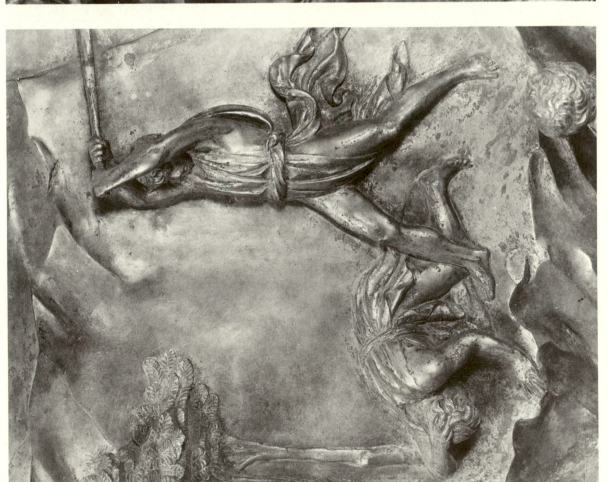

PLATE 86a. *Cain and Abel*, Slaying of Abel. Gates of Paradise

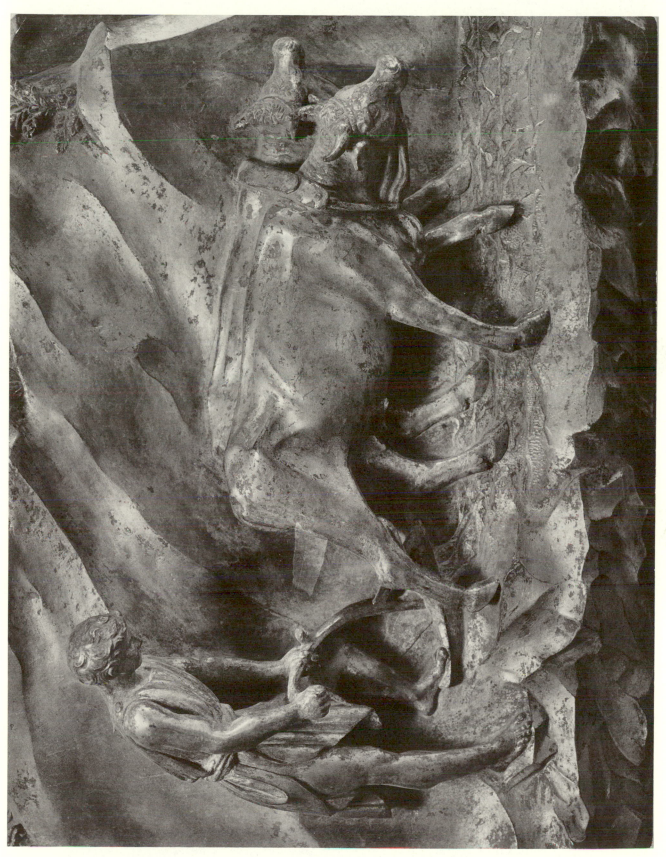

PLATE 87. *Cain and Abel*, Cain Plowing. Gates of Paradise

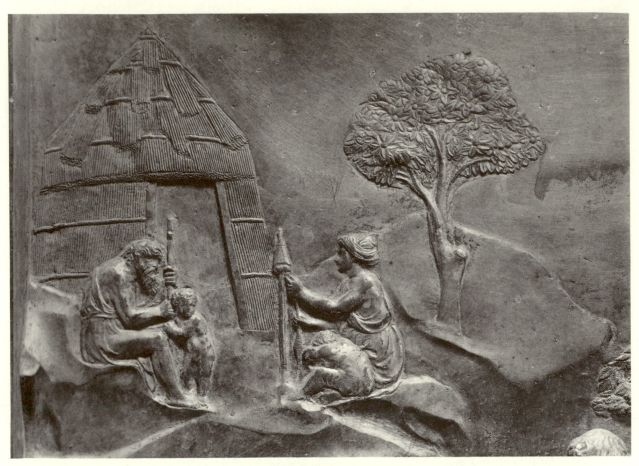

PLATE 88a. *Cain and Abel*, First parents of Mankind. Gates of Paradise

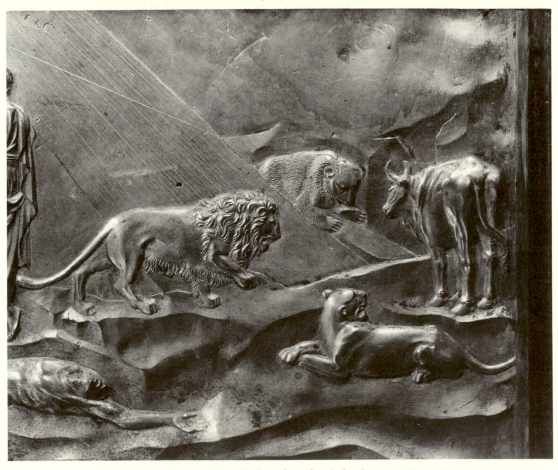

PLATE 88b. *Noah*, Animals Leaving the Ark. Gates of Paradise

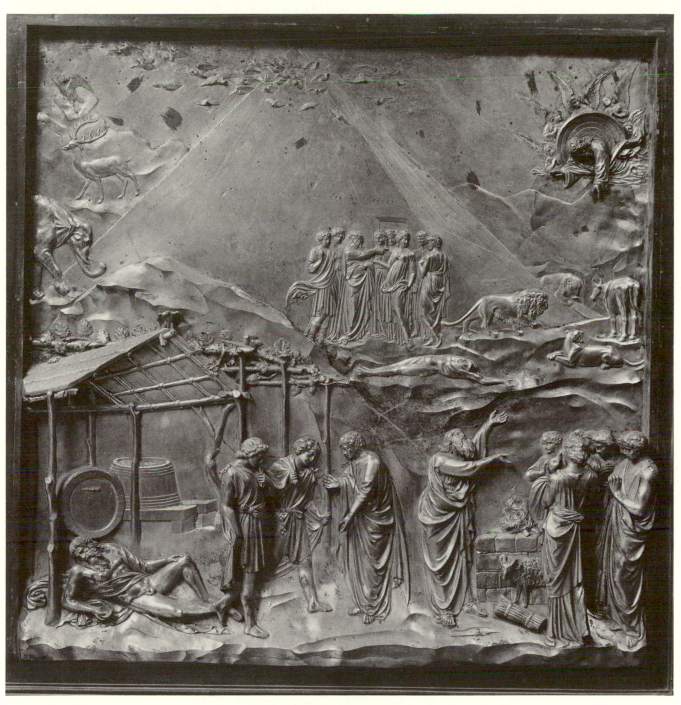

PLATE 89. *Noah*. Gates of Paradise

PLATE 90. *Noah*, Noah's Drunkenness. Gates of Paradise

PLATE 91b. *Noah*, Noah's Sons. Gates of Paradise

PLATE 91a. *Abraham*, Servants Waiting. Gates of Paradise

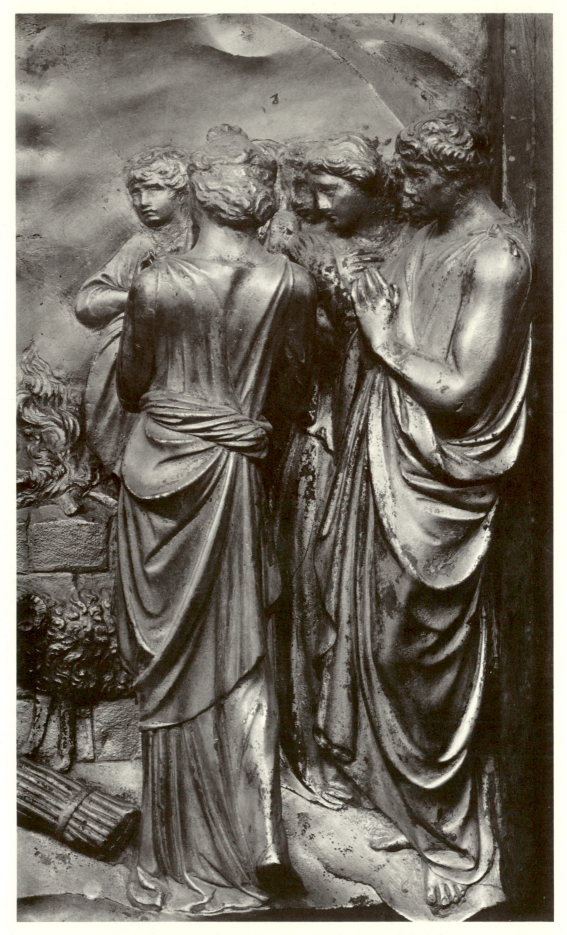

PLATE 92. *Noah*, Noah's Sacrifice, Detail. Gates of Paradise

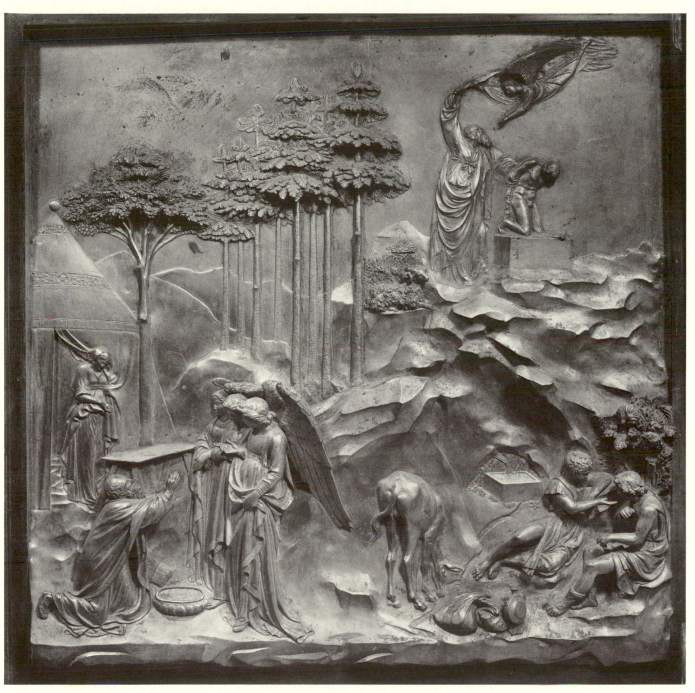

PLATE 93. *Abraham.* Gates of Paradise

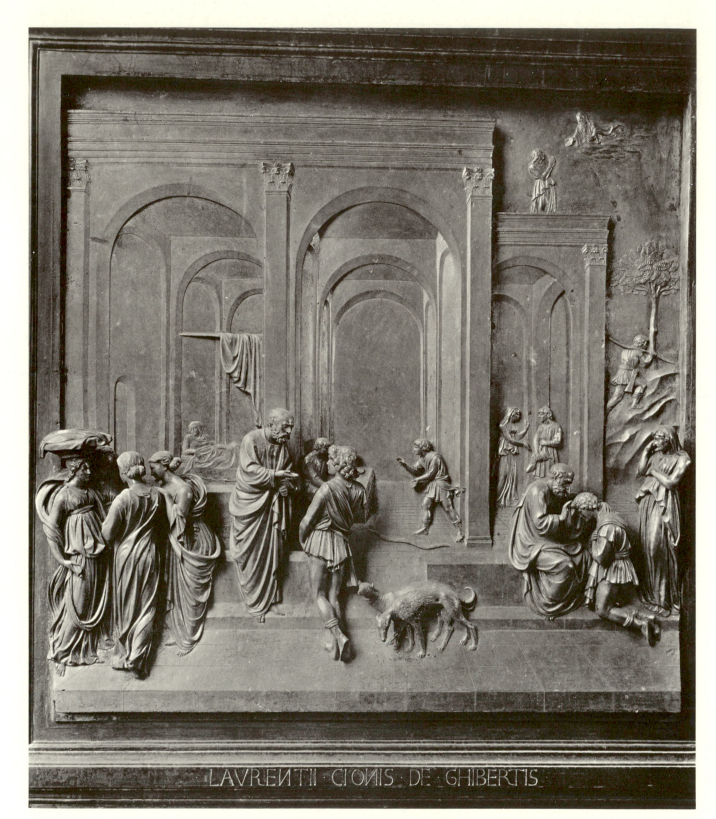

PLATE 94. *Isaac*. Gates of Paradise

PLATE 95. *Isaac*, Rebecca Praying. Gates of Paradise

PLATE 96b. *Solomon*, Falconier with Dog. Gates of Paradise

PLATE 96a. *Isaac*, Esau and His Dogs. Gates of Paradise

PLATE 97b. *Isaac*, Blessing of Jacob, Rebecca. Gates of Paradise

PLATE 97a. *Isaac*, Visiting Women. Gates of Paradise

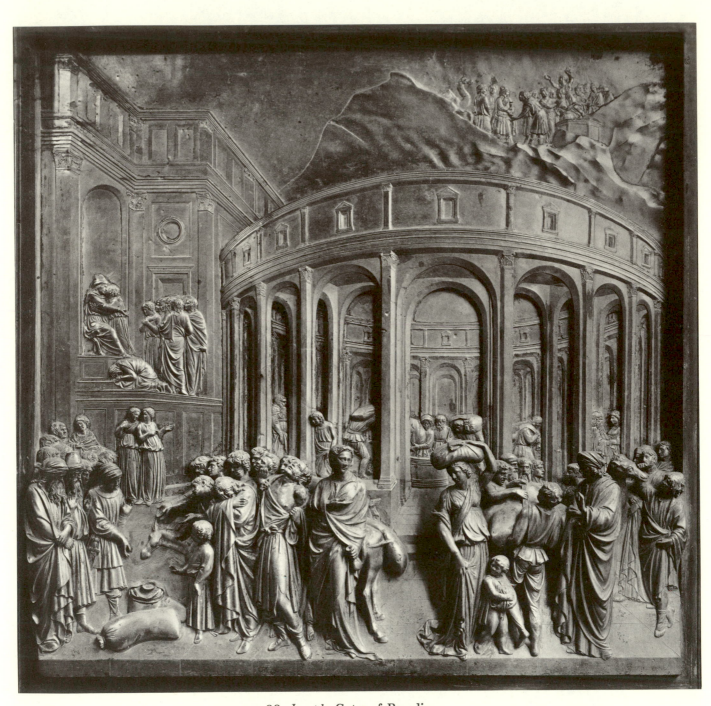

PLATE 98. *Joseph*. Gates of Paradise

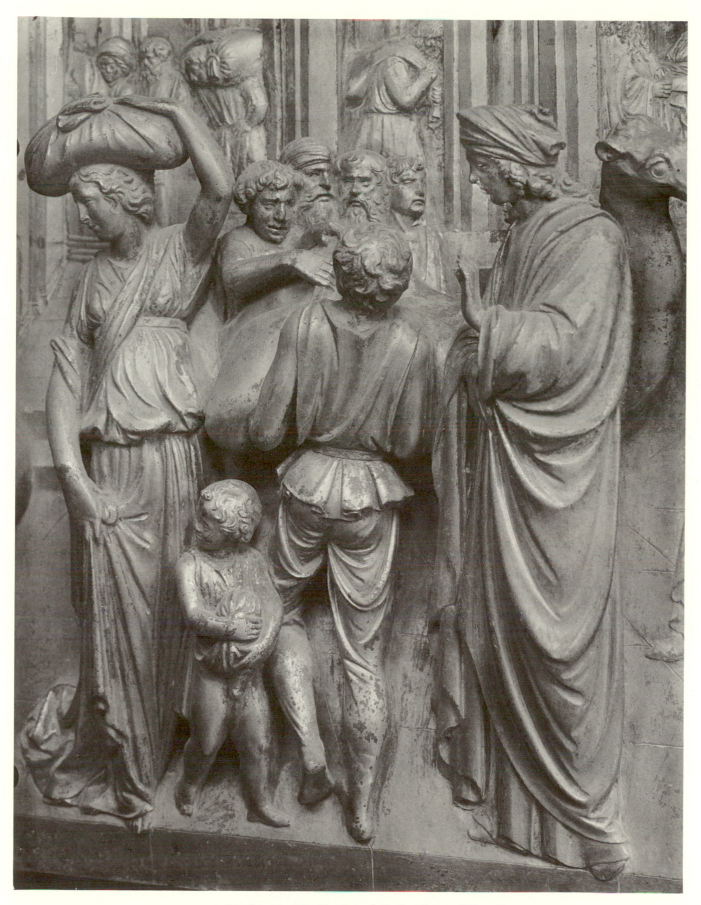

PLATE 99. *Joseph*, Distribution of Grain. Gates of Paradise

PLATE 100. *Joseph*, Architectural Detail. Gates of Paradise

PLATE 101b. *Joseph*, Two Girls. Gates of Paradise

PLATE 101a. *Joseph*, Joseph Revealing Himself. Gates of Paradise

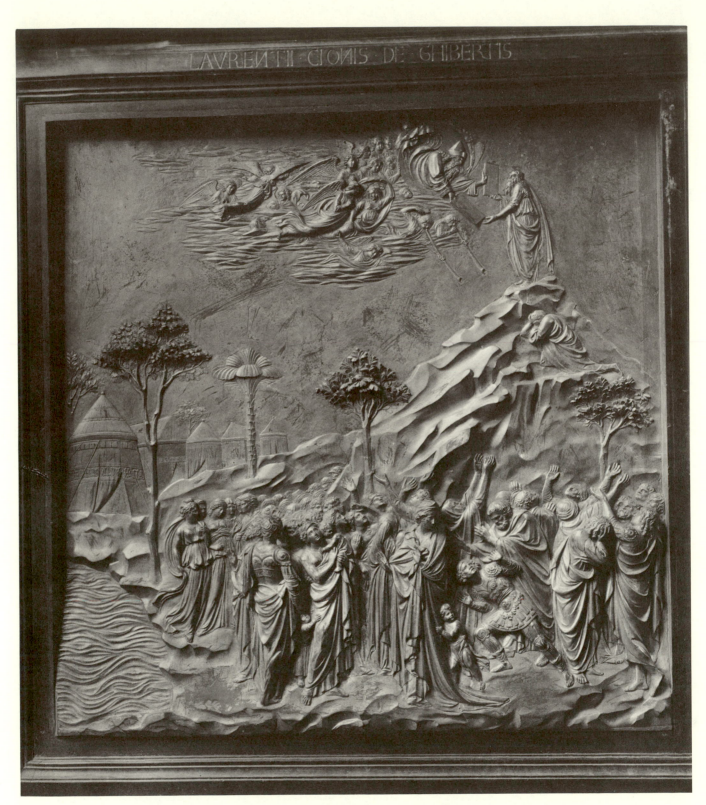

PLATE 102. *Moses*. Gates of Paradise

PLATE 103. *Moses*, Daughters of Israel. Gates of Paradise

PLATE 104a. *Noah*, Noah and His Family Leaving the Ark. Gates of Paradise

PLATE 104b. *Moses*, The People at Mount Sinai. Gates of Paradise

PLATE 105a. *Genesis*, The Lord with the Angelic Host. Gates of Paradise

PLATE 105b. *Moses*, Moses Receives the Law. Gates of Paradise

PLATE 106b. *Moses*, Trees. Gates of Paradise

PLATE 106a. *Abraham*, Trees. Gates of Paradise

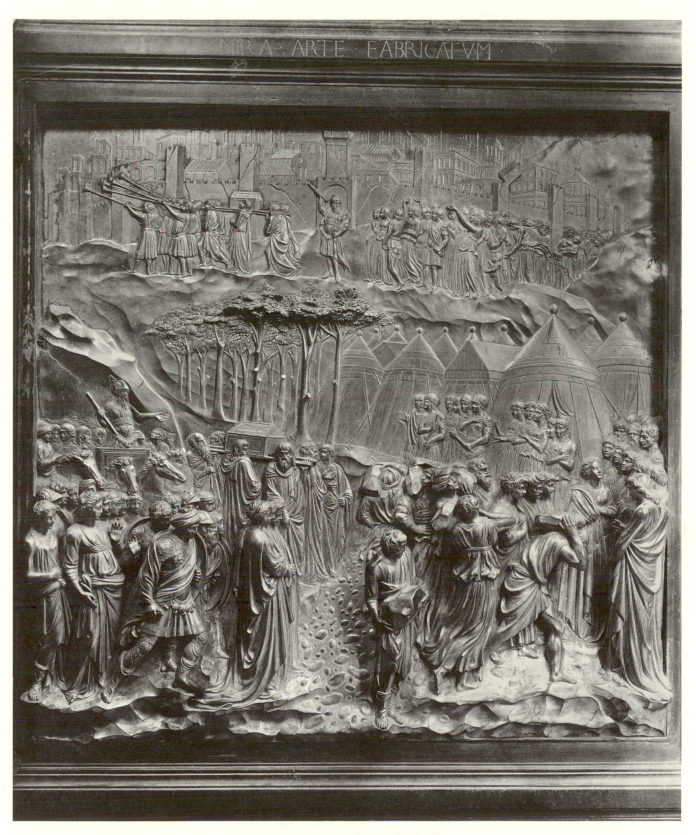

PLATE 107. *Joshua*. Gates of Paradise

PLATE 108a,b. *Joshua*, The Carrying of the Stones. Gates of Paradise

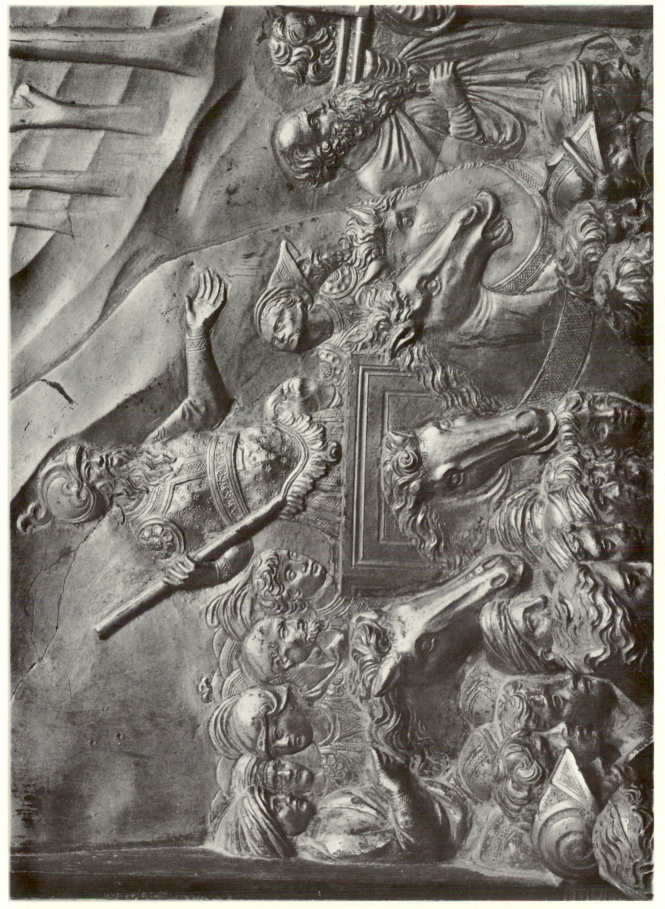

PLATE 109. *Joshua*, Joshua on Chariot. Gates of Paradise

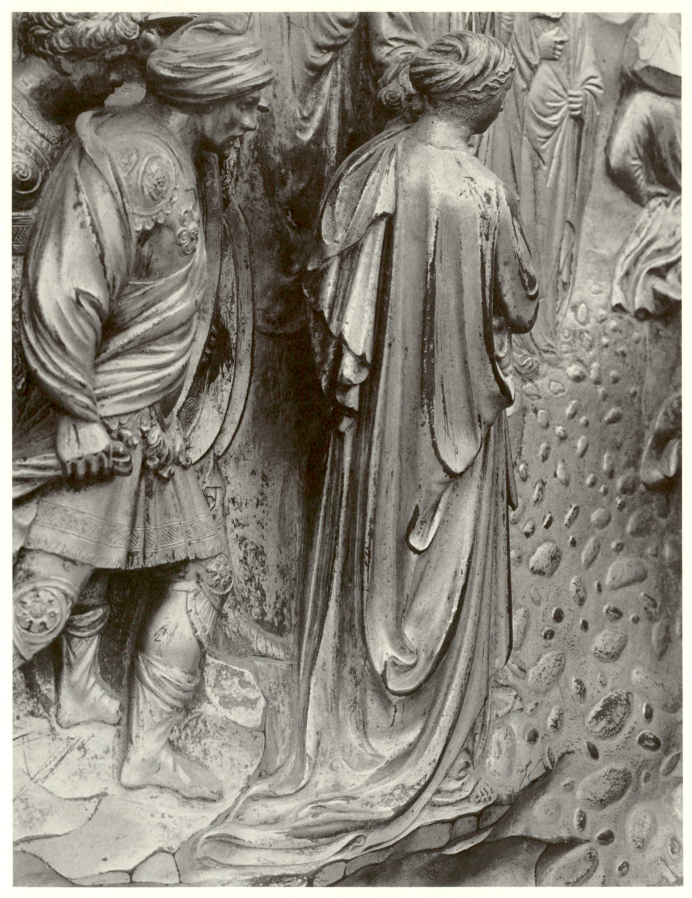

PLATE 110. *Joshua*, Group. Gates of Paradise

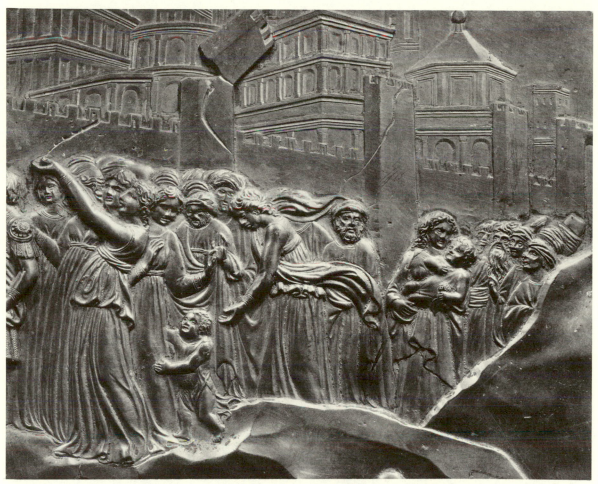

PLATE 111a. *Joshua*, The Walls of Jericho. Gates of Paradise

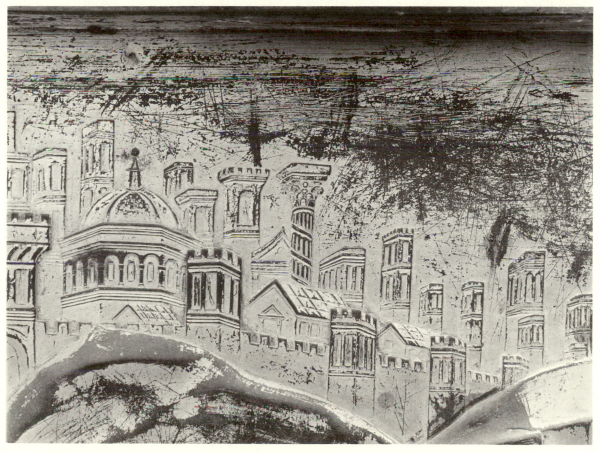

PLATE 111b. *David*, Jerusalem. Gates of Paradise

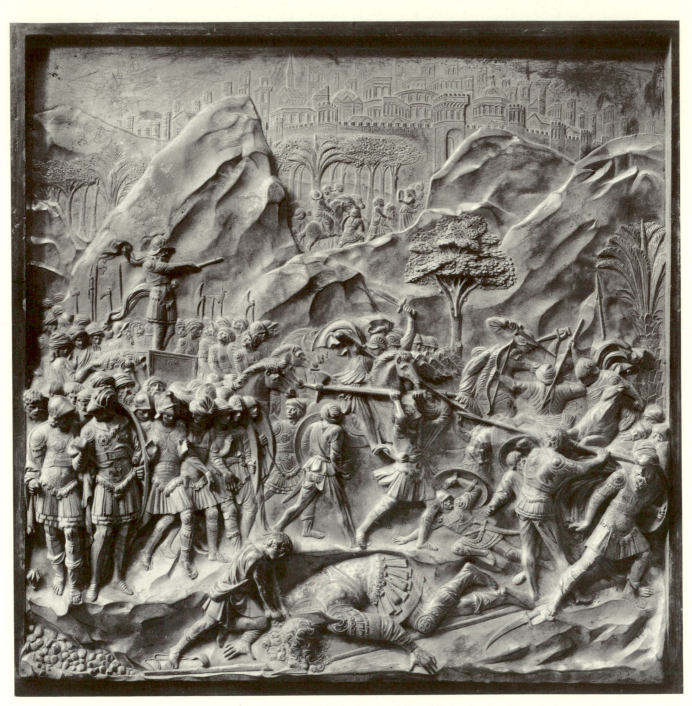

PLATE 112. *David*. Gates of Paradise

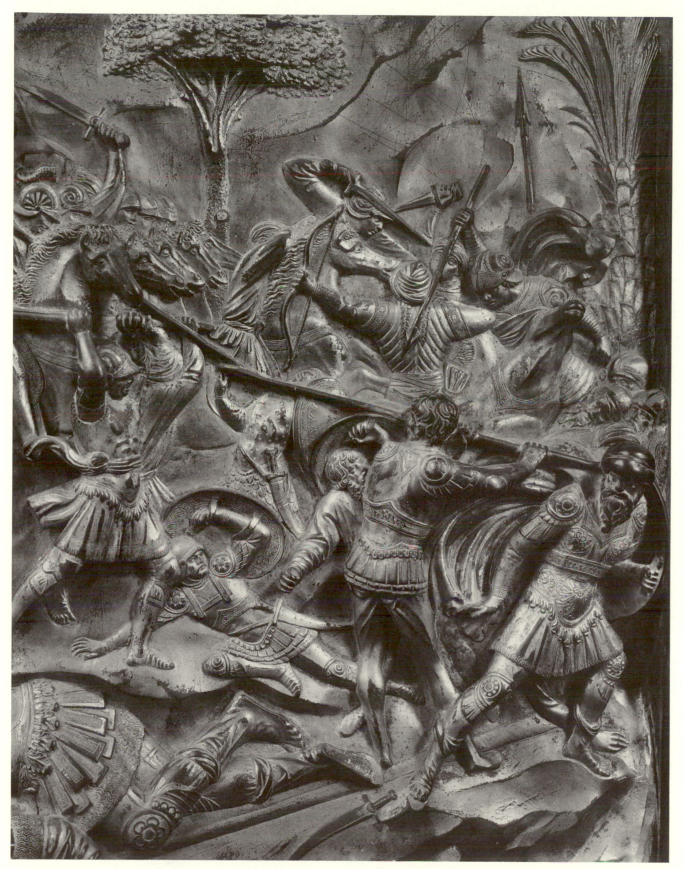

PLATE 113. *David*, right side. Gates of Paradise

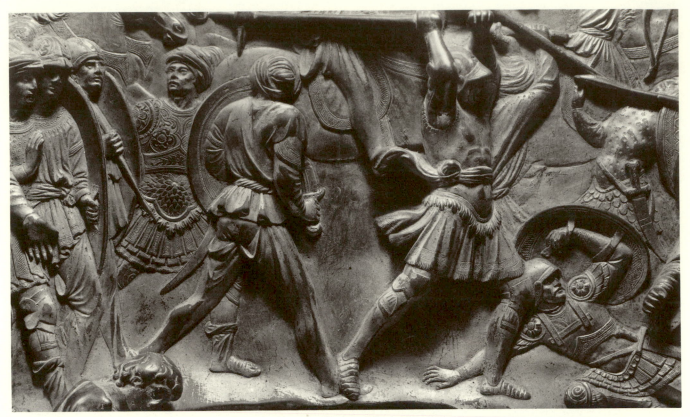

PLATE 114a. *David*, Detail. Gates of Paradise

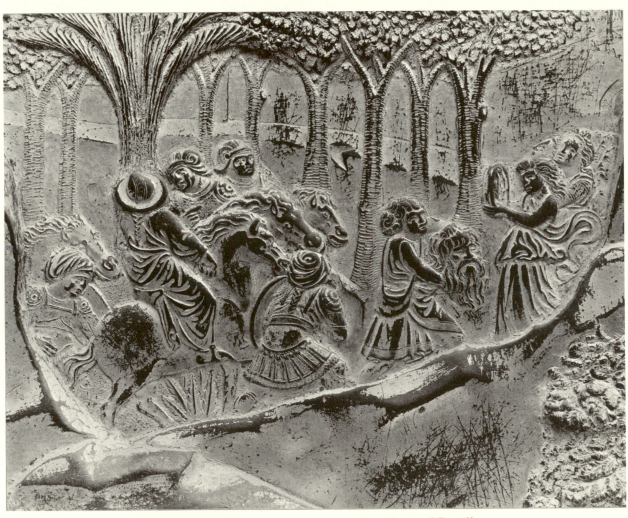

PLATE 114b. *David*, Entry into Jerusalem. Gates of Paradise

PLATE 115. *David*, Palm Tree. Gates of Paradise

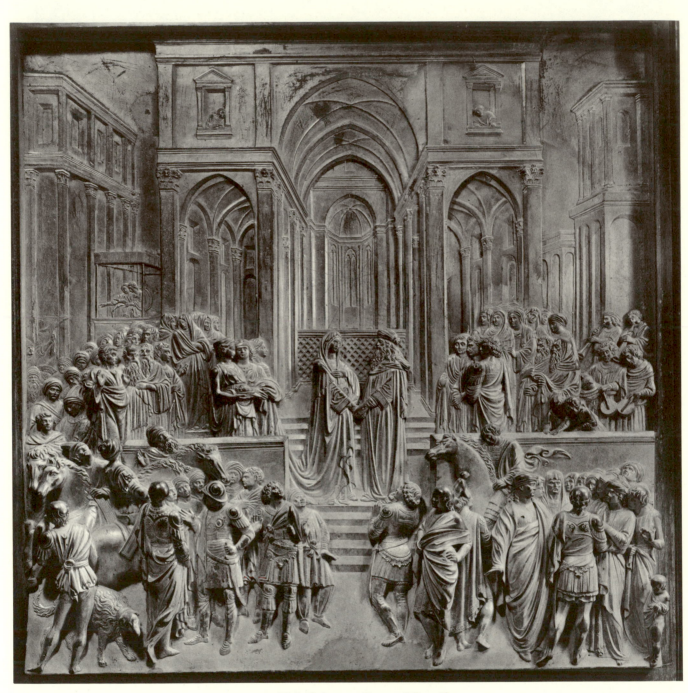

PLATE 116. *Solomon*. Gates of Paradise

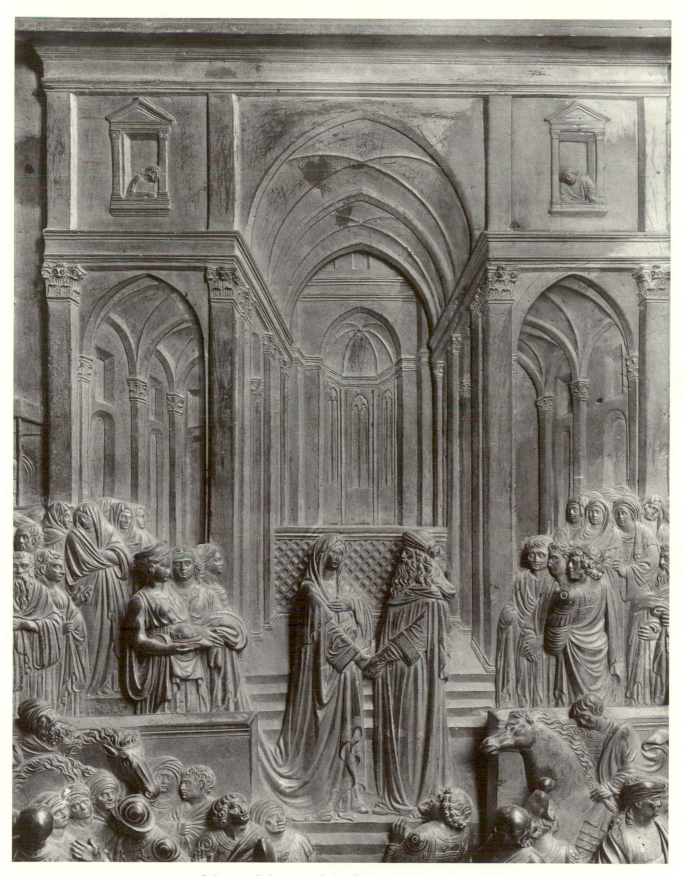

PLATE 117. *Solomon*, Solomon and the Queen of Sheba. Gates of Paradise

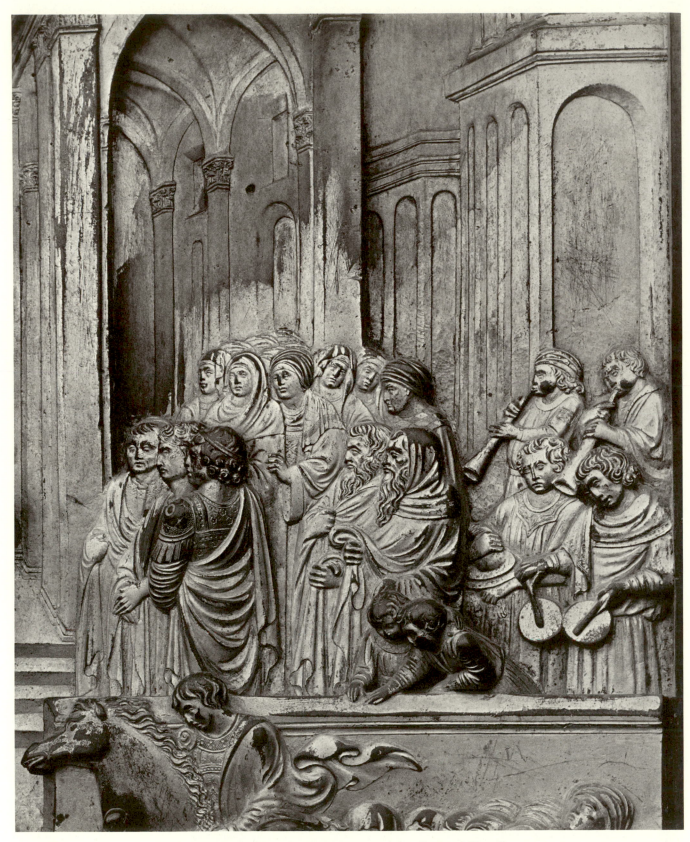

PLATE 118. *Solomon*, Group upper right. Gates of Paradise

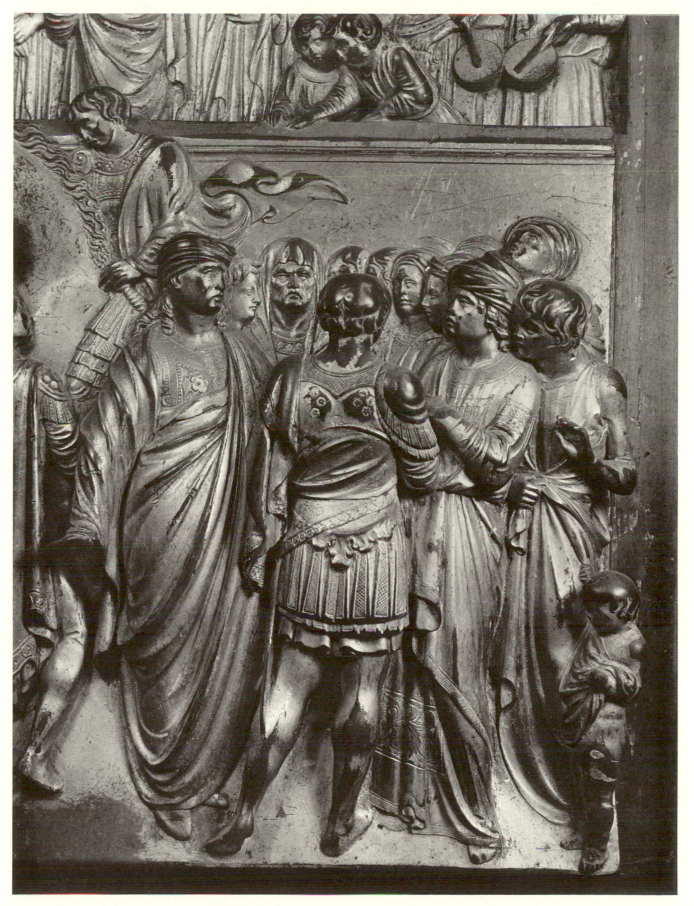

PLATE 119. *Solomon*, Group lower right. Gates of Paradise

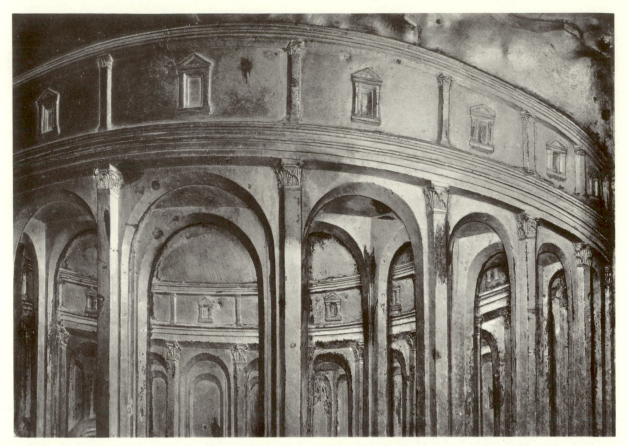

PLATE 120a. *Joseph*, Corn Hall. Gates of Paradise

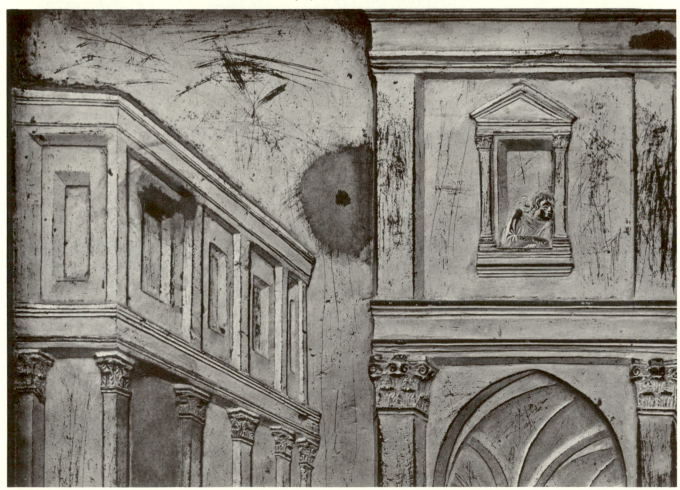

PLATE 120b. *Solomon*, Architectural Detail. Gates of Paradise

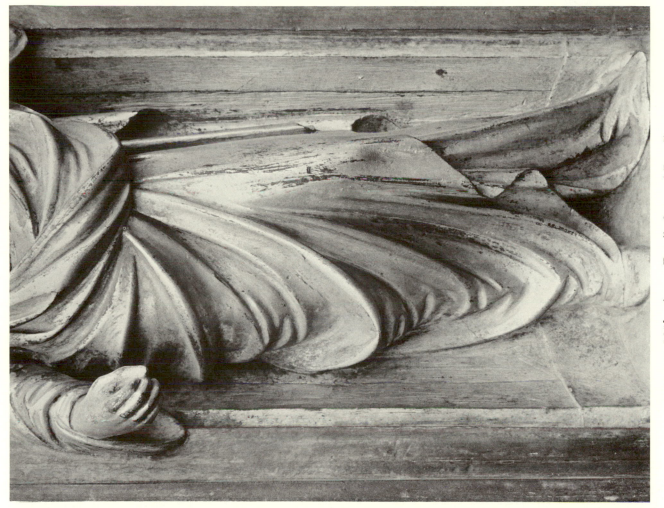

PLATE 121b. *Aaron*, Detail. Gates of Paradise

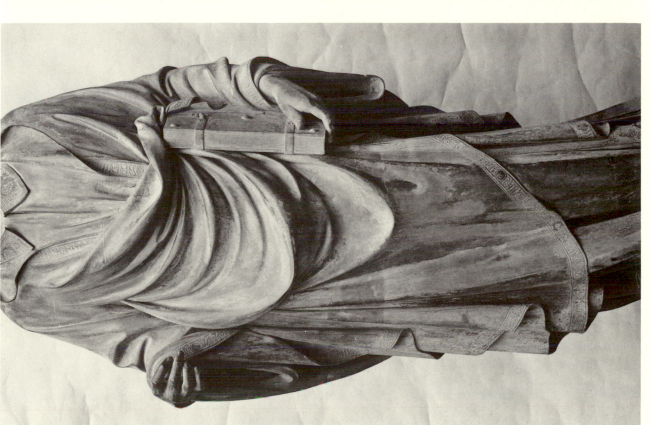

PLATE 121a. *Saint Stephen*, Detail. Florence, Or San Michele

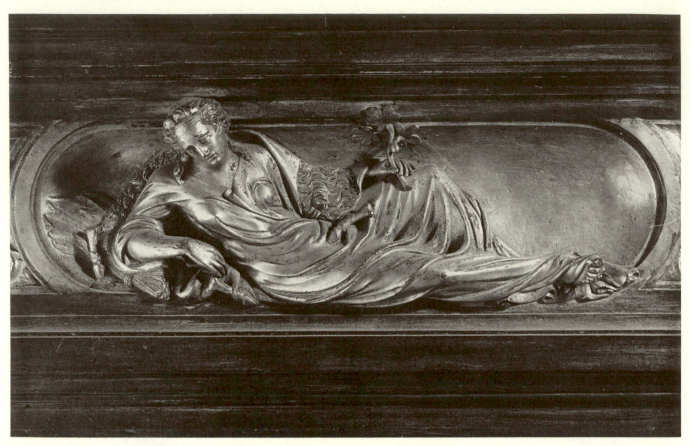

PLATE 122a. *Eve*. Gates of Paradise

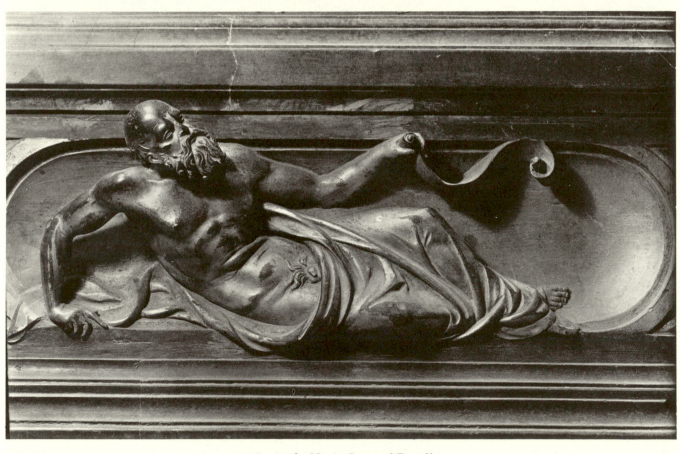

PLATE 122b. *Noah*. Gates of Paradise

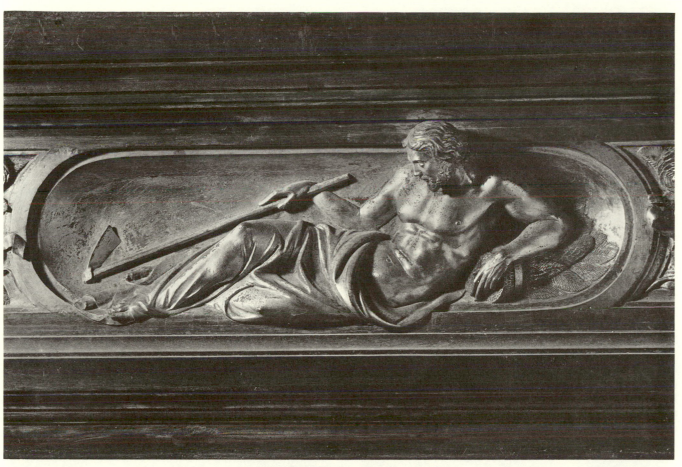

PLATE 123a. *Adam*. Gates of Paradise

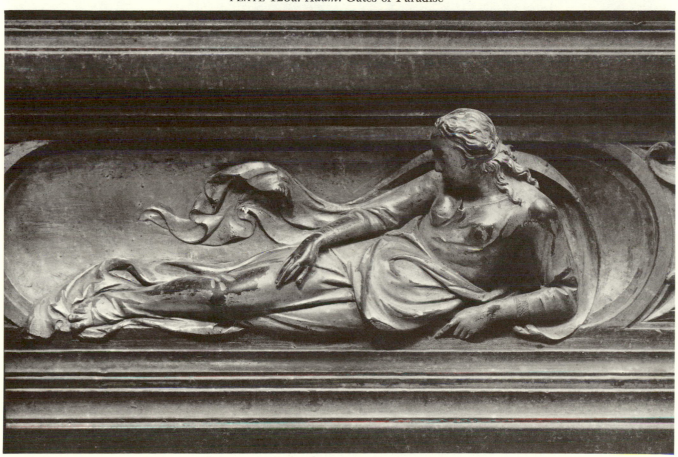

PLATE 123b. *Puarphera*. Gates of Paradise

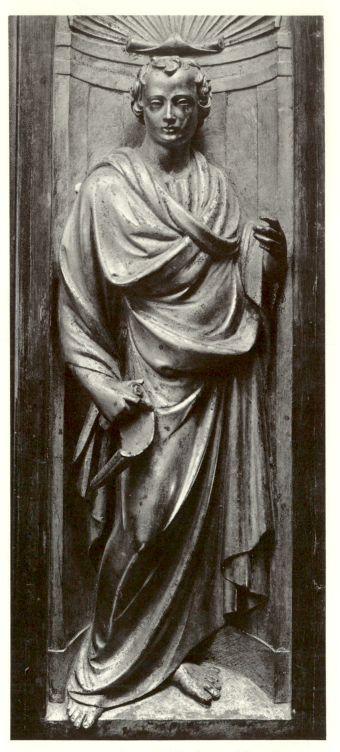 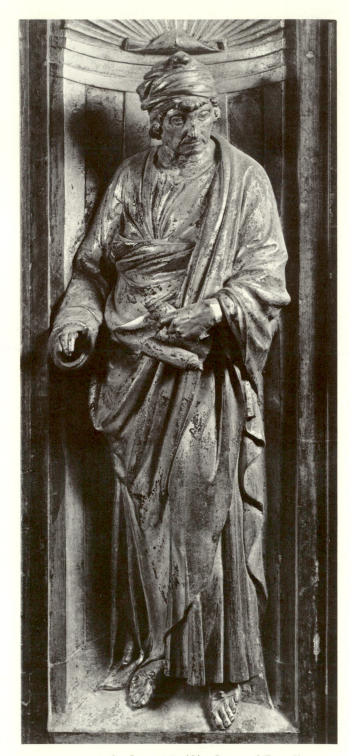

PLATE 124a. *Ezechiel* (?). Gates of Paradise PLATE 124b. *Jeremiah* (?). Gates of Paradise

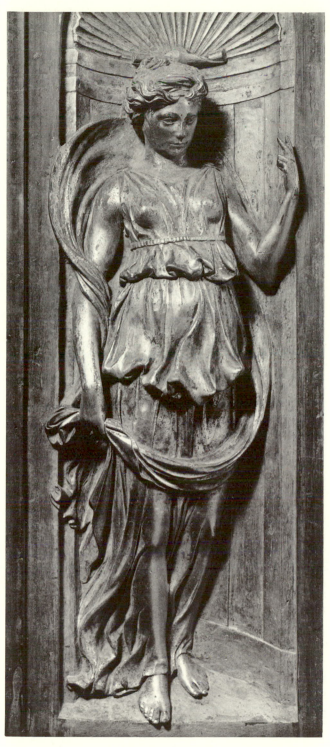

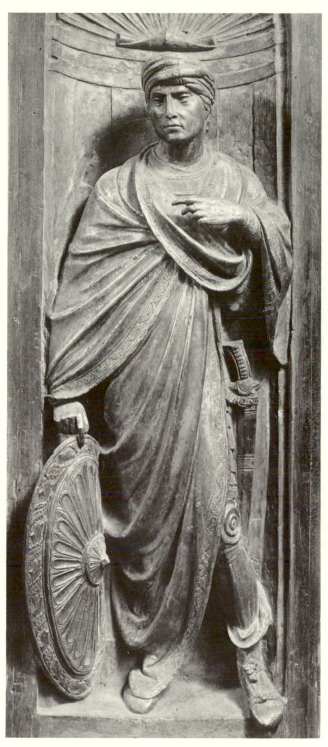

PLATE 125a. *Prophetess*. Gates of Paradise

PLATE 125b. *Joab* (?). Gates of Paradise

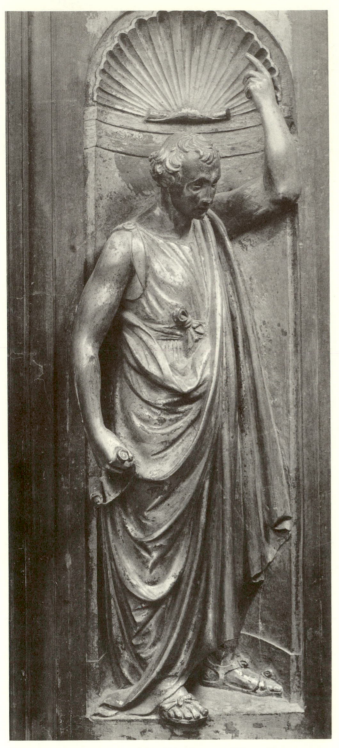 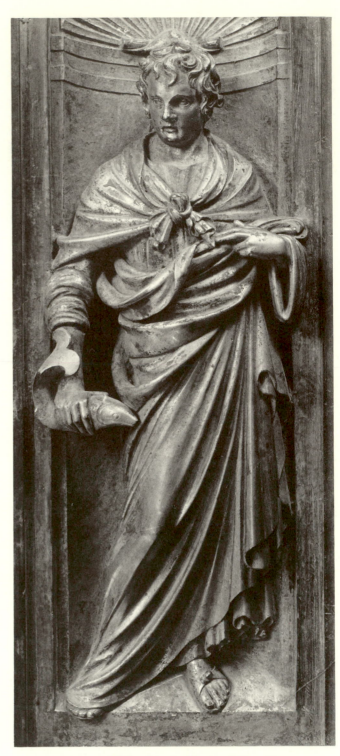

PLATE 126a. *Elia* (?). Gates of Paradise PLATE 126b. *Jonah*. Gates of Paradise

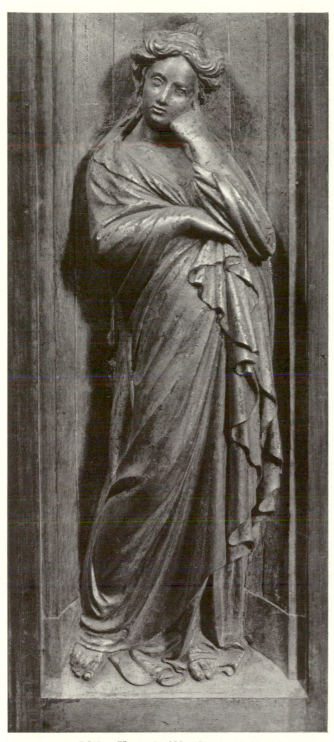

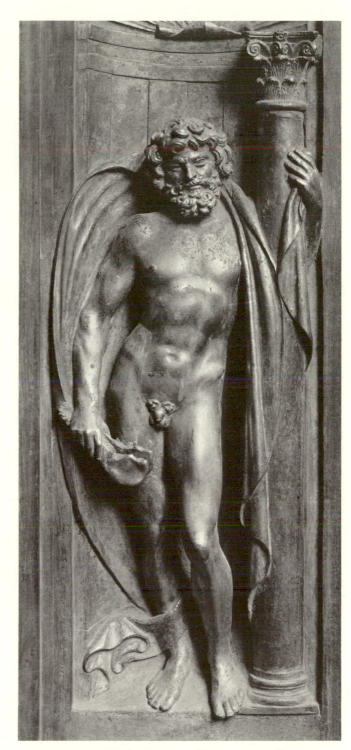

PLATE 127a. *Hannah* (?). Gates of Paradise PLATE 127b. *Samson*. Gates of Paradise

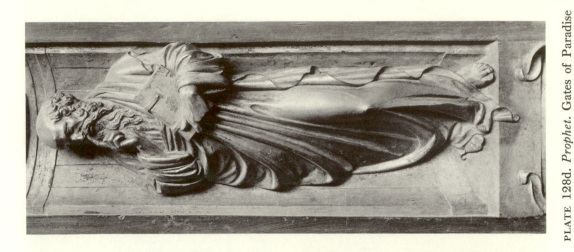

PLATE 128d. *Prophet.* Gates of Paradise

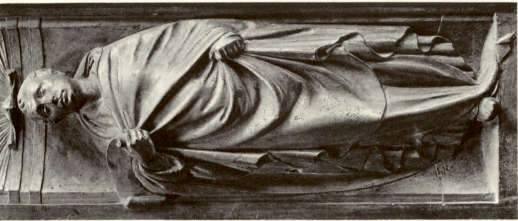

PLATE 128c. *Prophet.*
Gates of Paradise

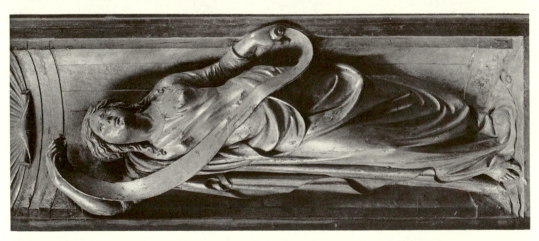

PLATE 128b. *Prophetess.*
Gates of Paradise

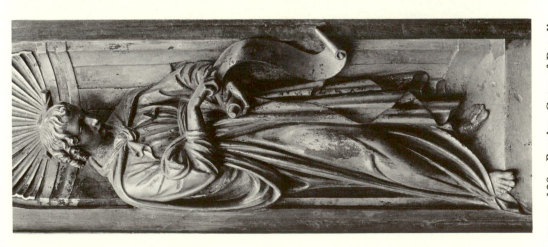

PLATE 128a. *Prophet.* Gates of Paradise

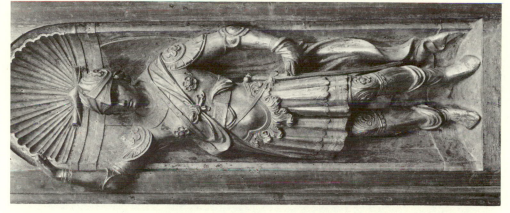

PLATE 129d. *Gideon* (?).
Gates of Paradise

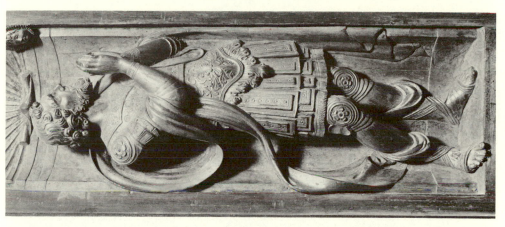

PLATE 129c. *Joshua.*
Gates of Paradise

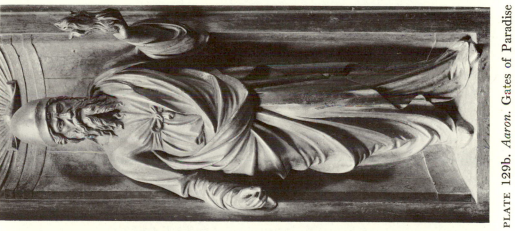

PLATE 129b. *Aaron.* Gates of Paradise

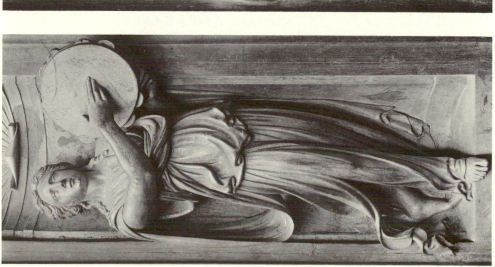

PLATE 129a. *Miriam.* Gates of Paradise

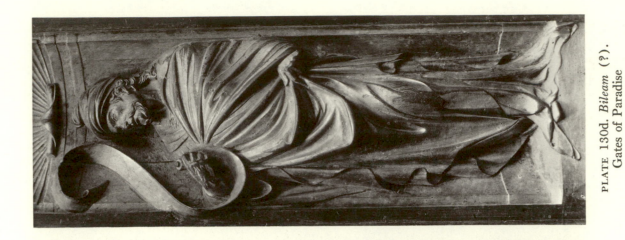

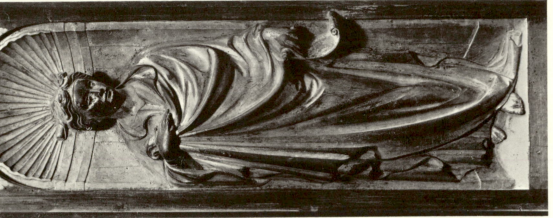

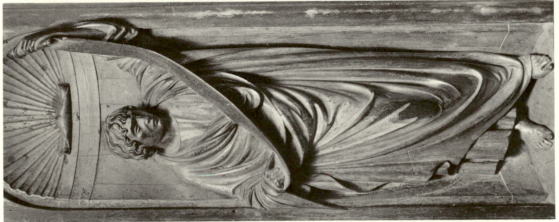

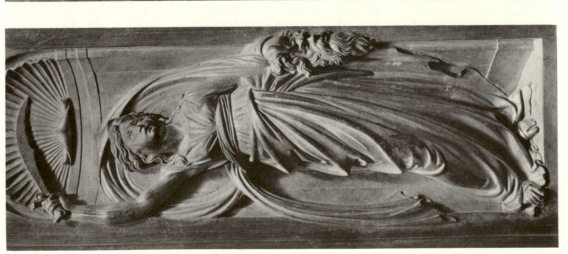

PLATE 130d. *Bileam* (?).
Gates of Paradise

PLATE 130c. *Daniel* (?).
Gates of Paradise

PLATE 130b. *Nathan* (?).
Gates of Paradise

PLATE 130a. *Judith*. Gates of Paradise

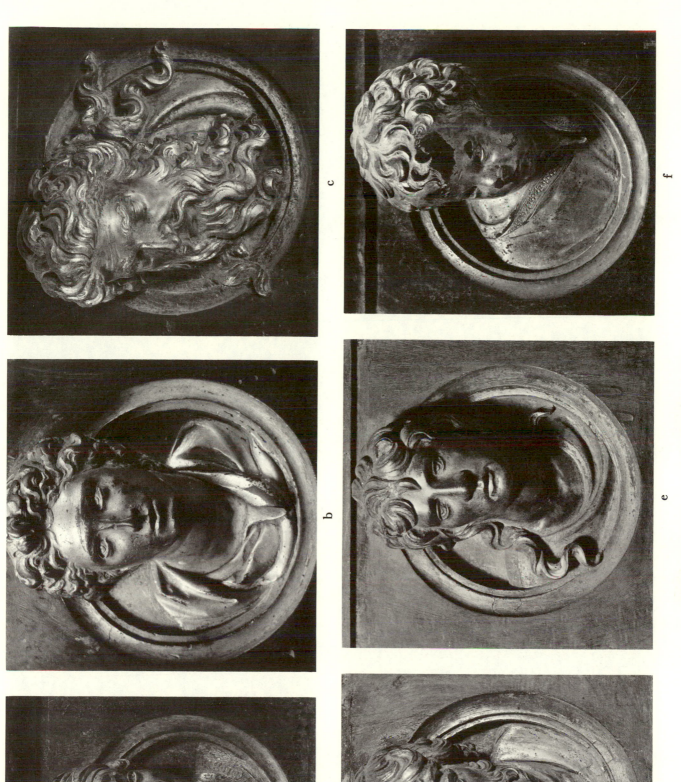

PLATE 131. *Prophets' Heads. Gates of Paradise*

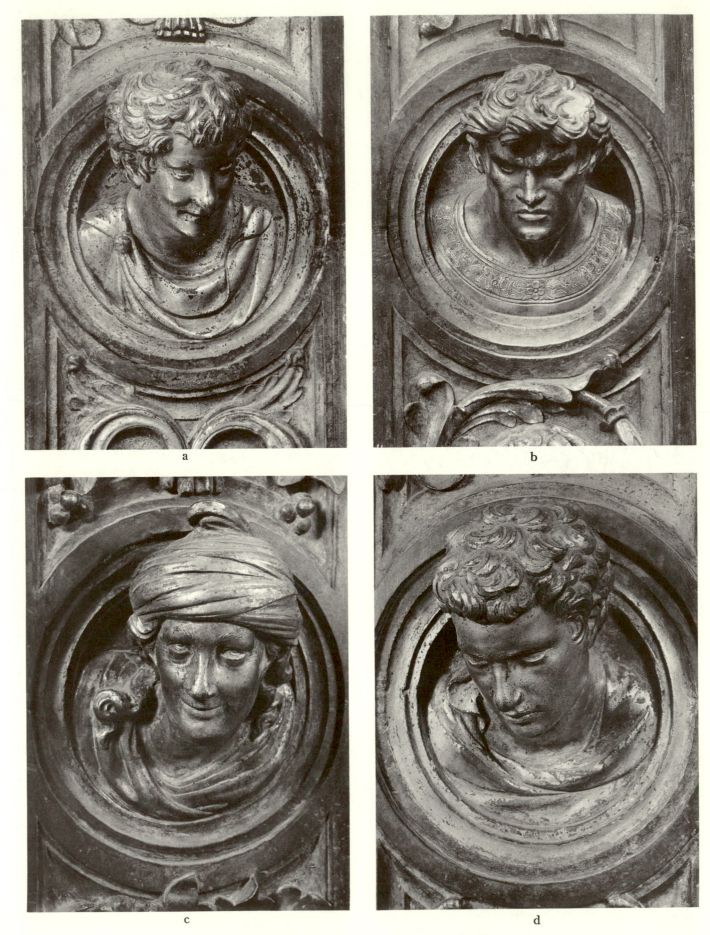

a

b

c

d

PLATE 132. *Prophets' Heads*. Gates of Paradise

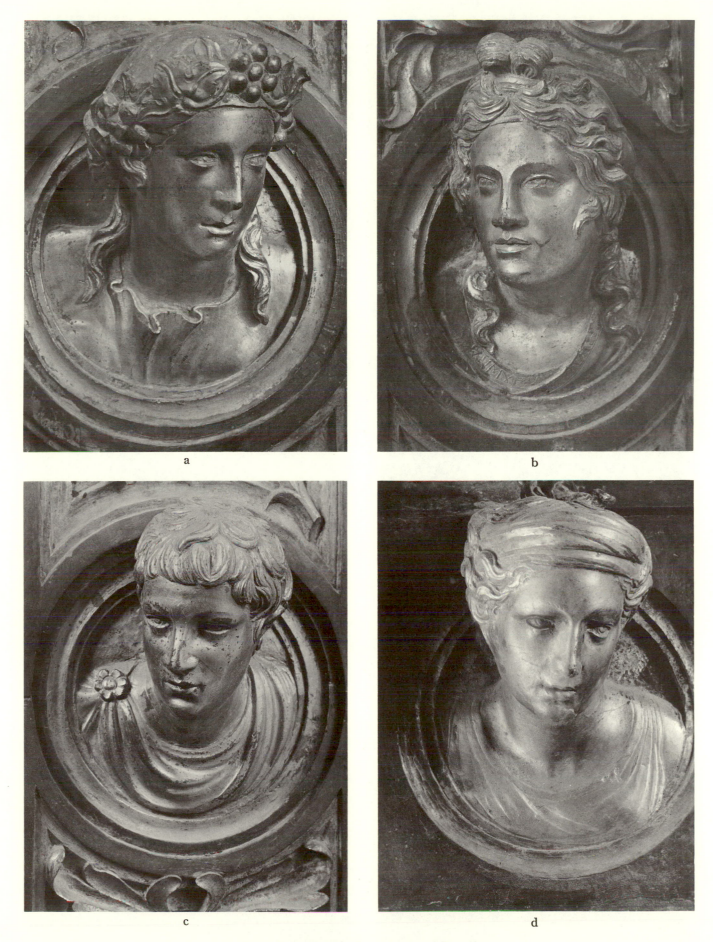

PLATE 133. *Prophets' Heads.* Gates of Paradise

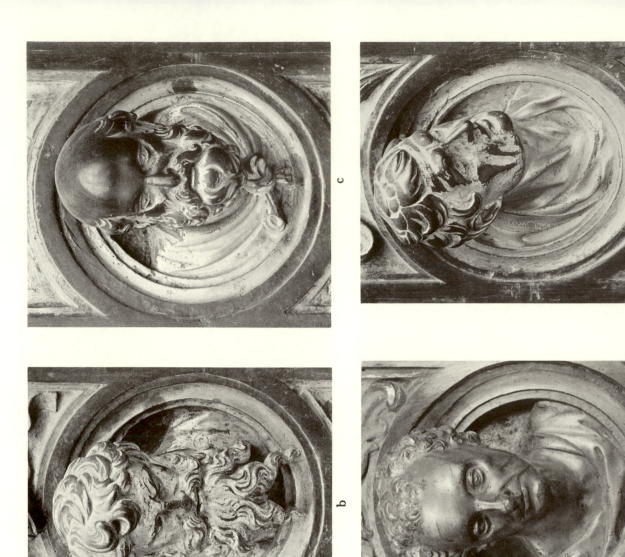

c

f

a

b

e

d

PLATE 134. *Prophets' Heads. Gates of Paradise*

PLATE 135b. Portrait of *Vittorio Ghiberti*. Gates of Paradise

PLATE 135a. *Lorenzo Ghiberti*, Self Portrait, Profile. Gates of Paradise

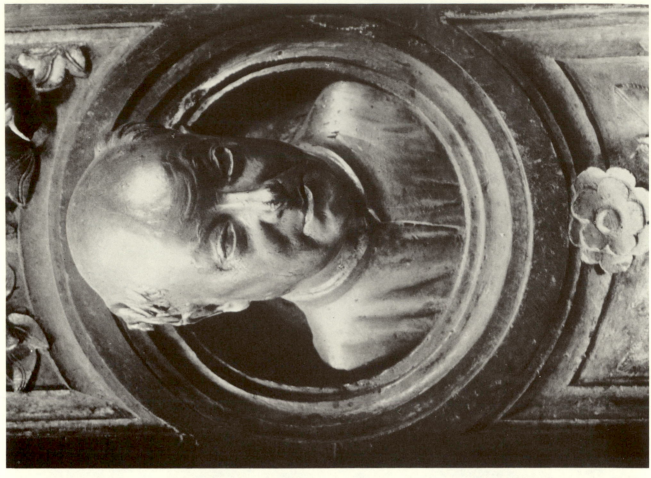

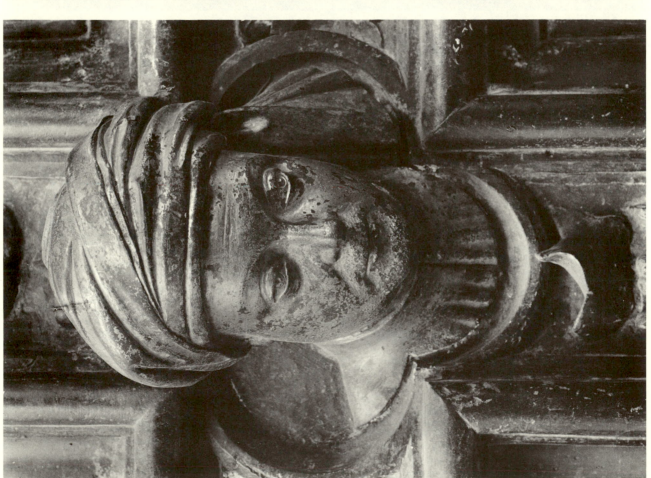

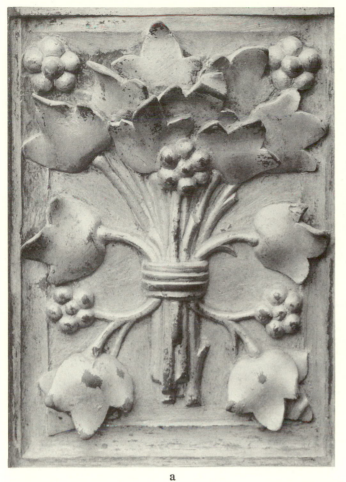

a

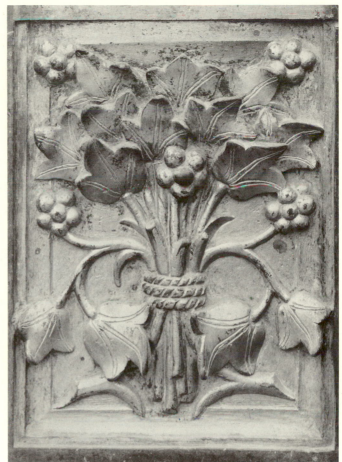

b

c

d

PLATE 137. Floral Decoration, lattice frame.
Gates of Paradise

PLATE 138a. Floral Decoration, outer jambs. Gates of Paradise

PLATE 138b. Floral Decoration, inner jambs. Gates of Paradise

PLATE 138c. Decoration, outer jambs. Gates of Paradise

PLATE 138d. Decoration, outer jambs. Gates of Paradise

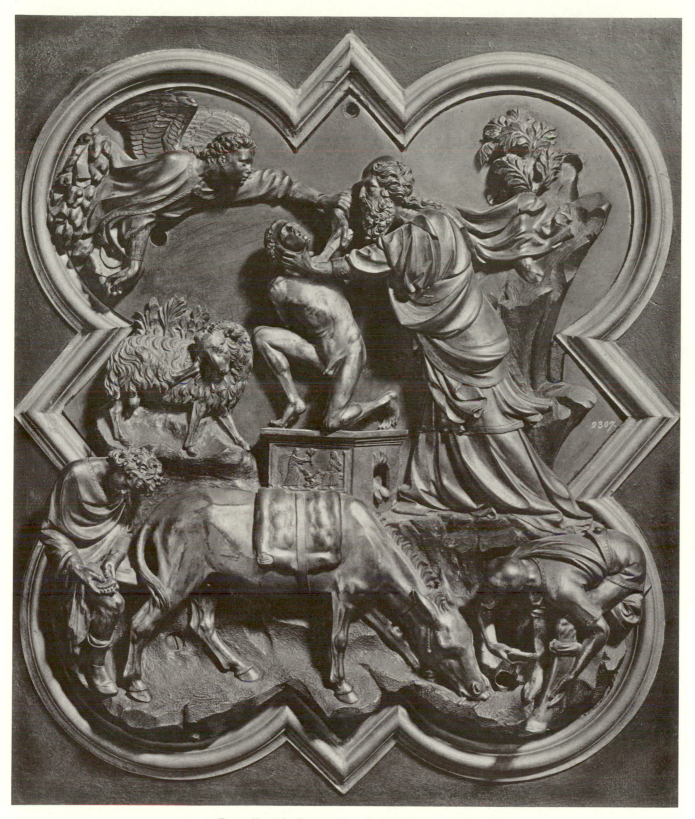

FIG. 1. Brunelleschi, Competition Relief. Florence, Bargello

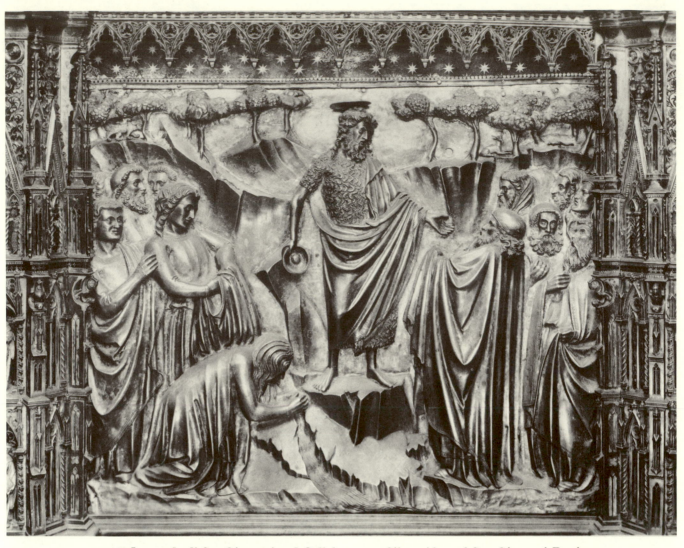

FIG. 2. Leonardo di Ser Giovanni and Collaborators, Silver Altar of San Giovanni Battista, *Saint John Baptizing the People*. Florence, Museo dell'Opera

FIGS. 3-4. Brunelleschi, Silver Altar of San Jacopo, Prophets. Pistoia, S. Jacopo

FIG. 5. Porta della Mandorla, *Abundantia*.
Florence, Cathedral

FIG. 6. Porta della Mandorla, *Hercules*.
Florence, Cathedral

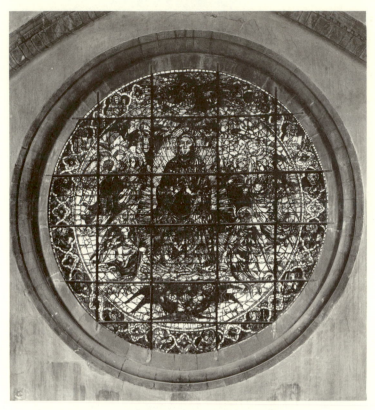

FIG. 7. Ghiberti, *Assumption*, Window.
Florence, Cathedral

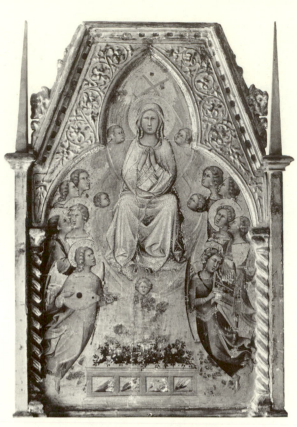

FIG. 8. Bartolo di Fredi, *Assumption*, from
Montalcino. Siena, Pinacoteca

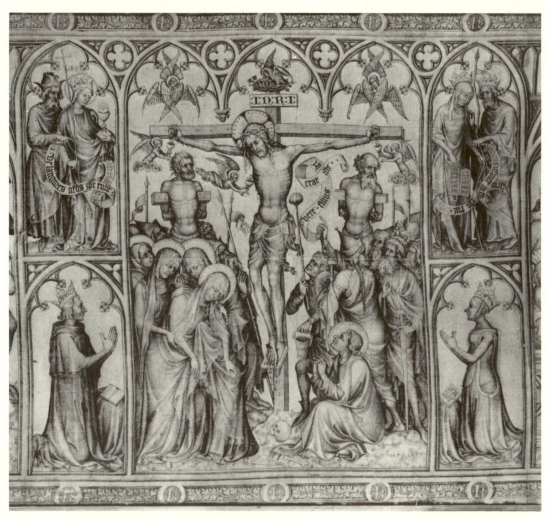

FIG. 9. *Parament de Narbonne*, Detail. Paris, Louvre

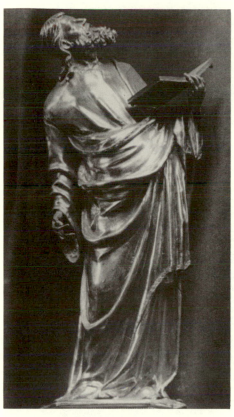

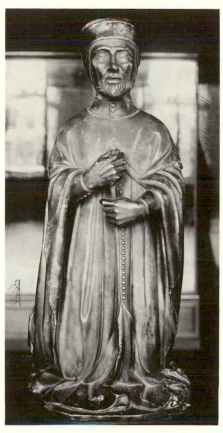

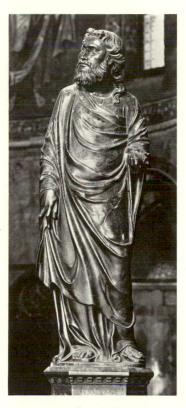

FIG. 10. Brunelleschi (?), Silver Altar of San Jacopo, *Church Father*. Pistoia, S. Jacopo

FIG. 11. Jacobello dalle Masegne, *Doge*. Venice, Museo Correr

FIG. 12. Jacobello dalle Masegne, *Apostle*. Venice, S. Marco

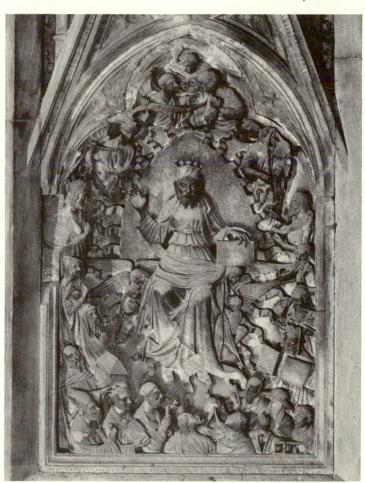

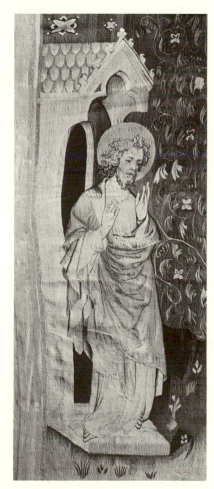

FIG. 13. Jacopo di Campione, *Salvator Mundi in His Glory*. Milan, Cathedral, North Sacristy Door

FIG. 14. *The Woman and the Dragon*, Saint John. Angers, Cathedral

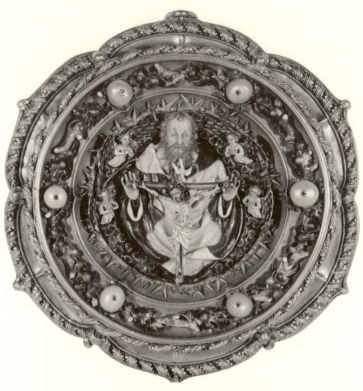

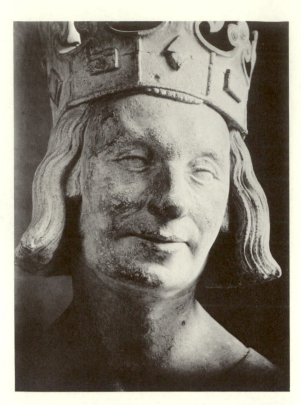

FIG. 15. Trinity Morse. Washington, National Gallery of Art, Widener Collection

FIG. 16. *Charles V*, from the Quinze-Vingts, Head. Paris, Louvre

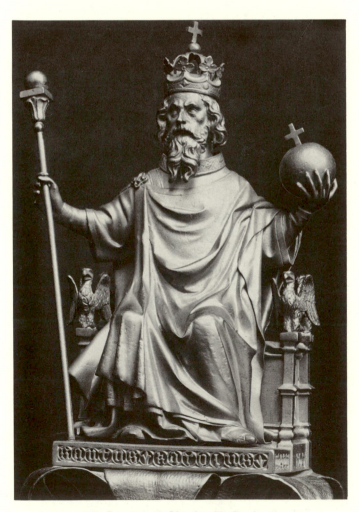

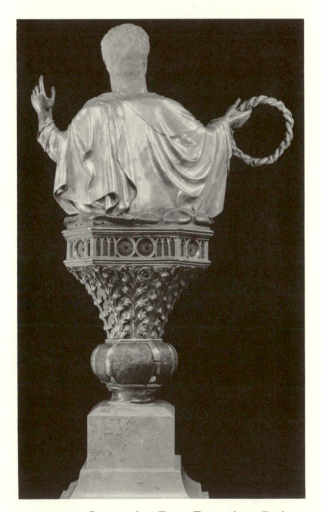

FIG. 17. Scepter of Charles V. Paris, Louvre, Gallerie d'Apollon

FIG. 18. Constantine Bust, Rear view. Paris, Bibliothèque Nationale, Cabinet des Medailles

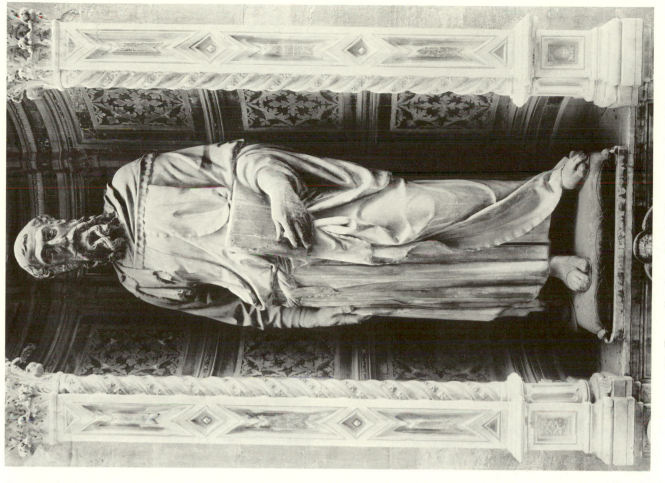

FIG. 20. Donatello, *Saint Mark*. Florence, Or San Michele

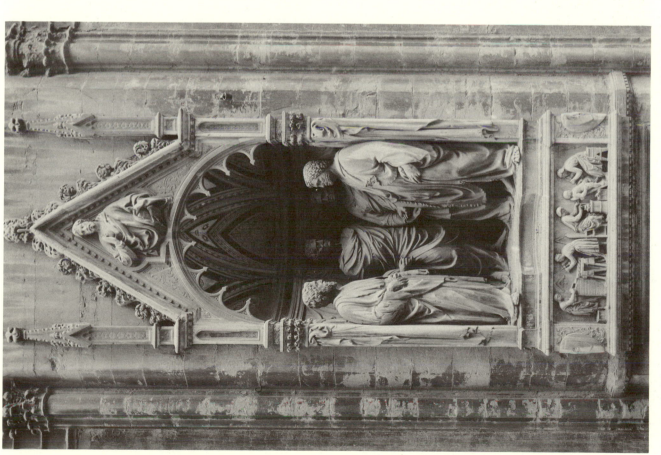

FIG. 19. Nanni di Banco, *Quattro Coronati*. Florence, Or San Michele

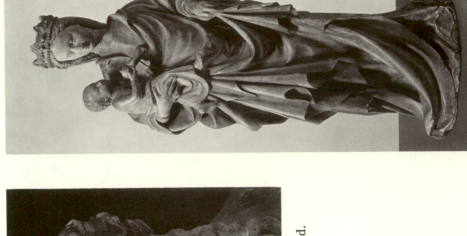

FIG. 24. *Madonna.* Poughkeepsie, Vassar College, Art Gallery

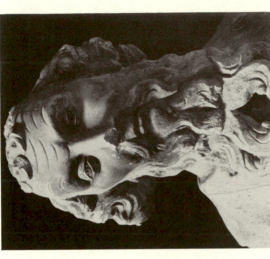

FIG. 22. *Saint Paul,* Head. Baume-les-Messieurs, Abbey Church

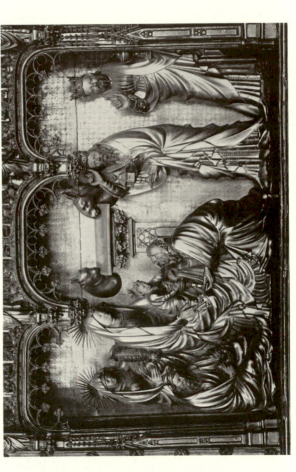

FIG. 23. Jacques de Baerze, Broederlam Altar, *Adoration of the Magi.* Dijon, Museum

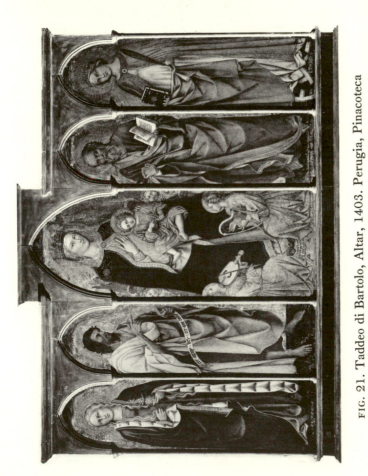

FIG. 21. Taddeo di Bartolo, Altar, 1403. Perugia, Pinacoteca

FIG. 27. Lorenzo Monaco,
Agony in the Garden.
Paris, Louvre

FIG. 26. Lorenzo Monaco, *Agony in the Garden.*
Florence, Accademia

FIG. 25. Lorenzo Monaco, Coronation Altar, Predella Panel,
Story of Saint Benedict. London, National Gallery

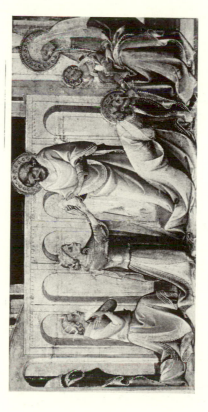

FIG. 28. Lorenzo Monaco, *Adoration of the Magi*, Predella Panel.
Formerly Poznán, Raczinsky Collection

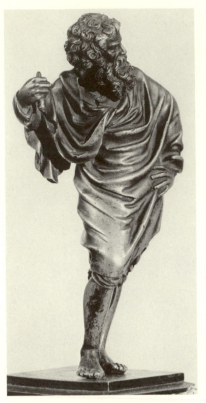

FIG. 29. *Saint Christopher*,
1407. Boston,
Museum of Fine Arts

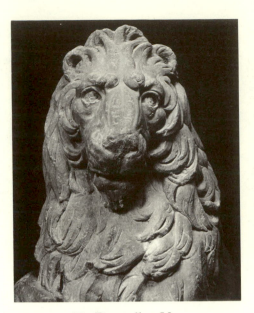

FIG. 30. Donatello, *Marzocco*.
Florence, Bargello

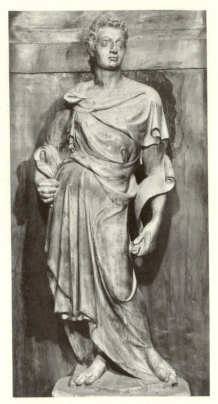

FIG. 31. Nanni di Banco
Isaiah.
Florence, Cathedral

FIG. 32. Ghiberti, *Saint John
the Baptist*, Head, Rear View.
Florence, Or San Michele

FIG. 33. Ghiberti, *Saint Stephen*,
Head, Rear View.
Florence, Or San Michele

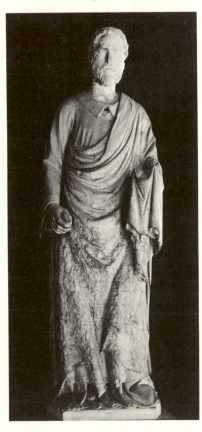

FIG. 34. *Saint Stephen*, formerly façade Florence Cathedral.
Paris, Louvre

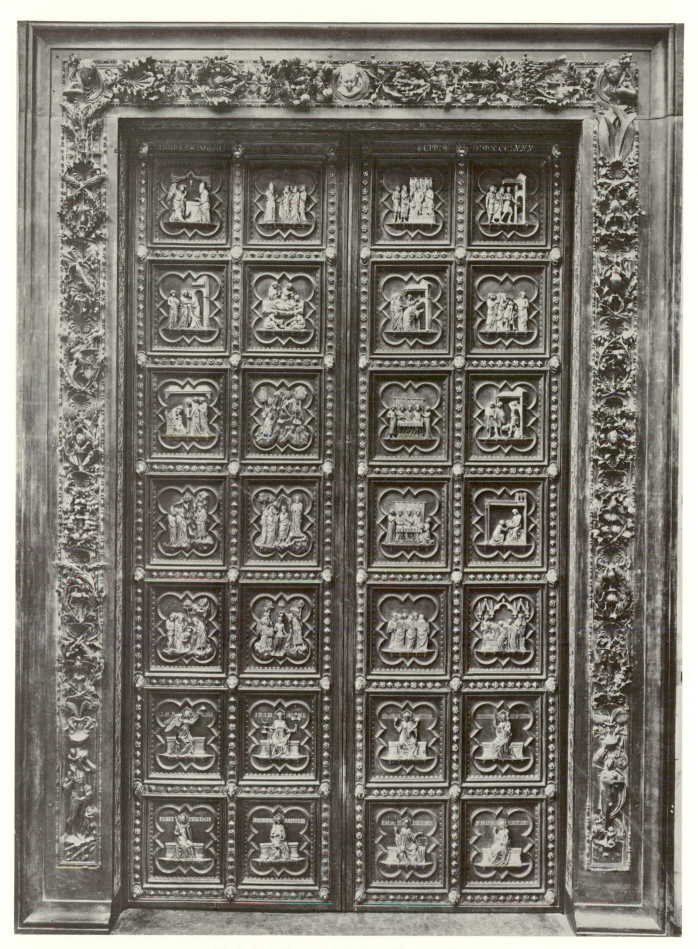

FIG. 35. Andrea Pisano, South Door. Florence, Baptistery

FIG. 36. *Adoration of the Magi* and *Presentation in the Temple*
from Castel del Sangro. Florence, Museo dell'Opera

FIG. 37. Julià lo Florentì, *Pentecost.*
Valencia, Cathedral

FIG. 38. Julià lo Florentì, *Samson.*
Valencia, Cathedral

FIG. 40. Giovanni Turini, *Preaching of Saint John.*
Siena, Baptistery, Font

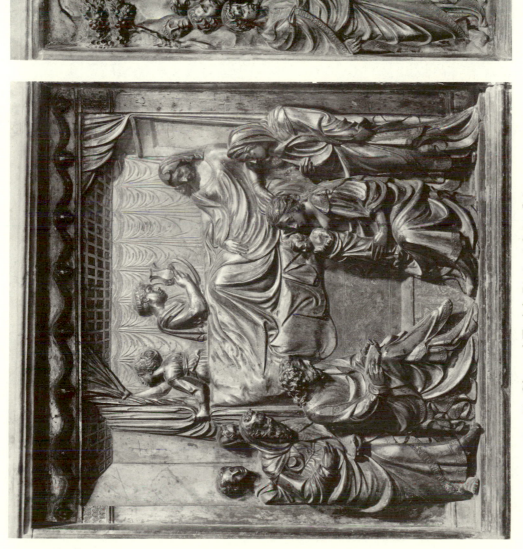

FIG. 39. Giovanni Turini, *Birth of Saint John.*
Siena, Baptistery, Font

FIG. 41. Reliquary of Sant'Andrea.
Città di Castello, Pinacoteca

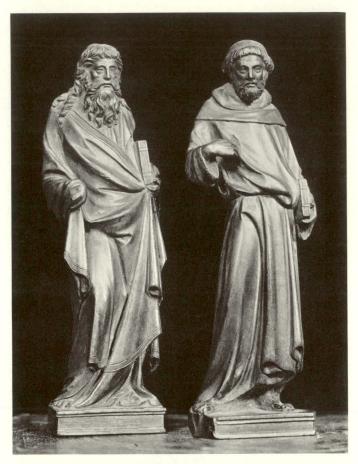

FIG. 42. Ghiberti Workshop, Reliquary of Sant'Andrea,
Saint Andrew and *Saint Francis*.
Città di Castello, Pinacoteca

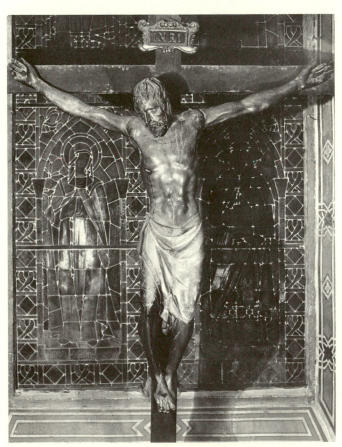

FIG. 43. Donatello, *Christ on the Cross*.
Florence, S. Croce

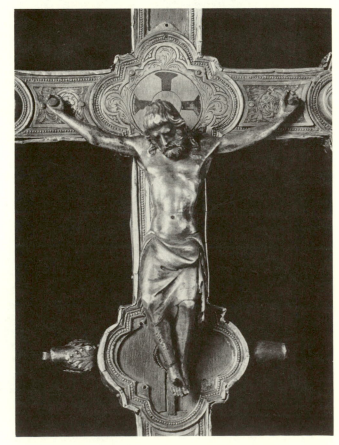

FIG. 44. Ghiberti Workshop, Crucifix.
Impruneta near Florence

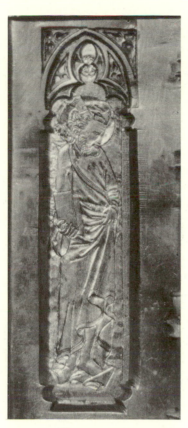

FIG. 45. *Baptism of Christ.* Florence, Biblioteca Nazionale, ii, 445 (Zanobi di Pagholo d'Angnolo di Pierini, *Vita di San Giovanni Battista*)

FIG. 46. Florentine Goldsmith, Reliquary of San Jacopo, *Prophet.* Pistoia, S. Jacopo

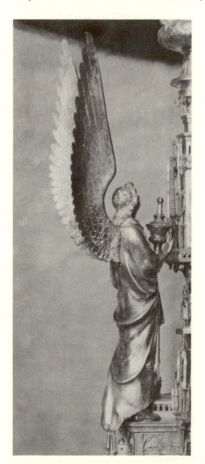

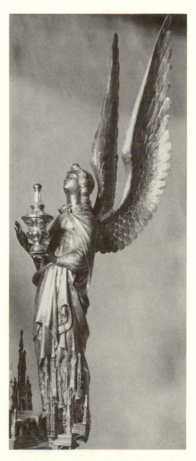

FIGS. 47-48. Florentine Goldsmith, Reliquary of San Jacopo, Angels. Pistoia, S. Jacopo

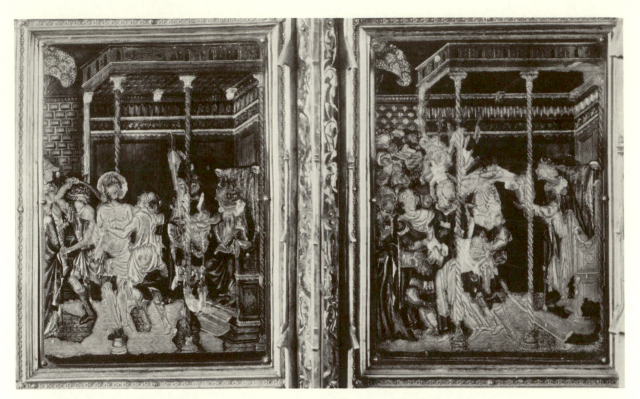

FIG. 49. Ugolino da Vieri, Reliquary of the SS. Corporale, *Flagellation*.
Orvieto, Cathedral

FIG. 50. Ghiberti, Bracket below *Annunciation*.
Florence, Baptistery, North Door

FIG. 51. Ghiberti, Bracket below *Christ among the Doctors*.
Florence, Baptistery, North Door

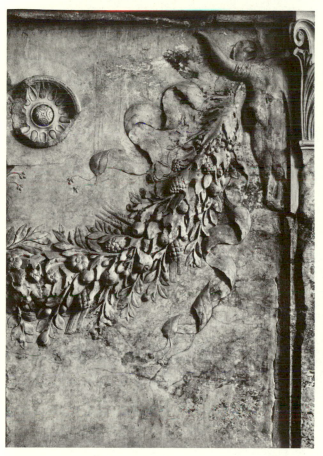

FIG. 52. Roman Garland, Ara Pacis, Detail. Rome

FIG. 53. Gentile da Fabriano, Epiphany Altar, Flowers.
Florence, Uffizi

FIG. 54a,b. Ghiberti, Lions' Heads. Florence, Baptistery,
North Door, Back frame

FIG. 55. Ghiberti, Cassa dei SS. Proto, Giacinto, e Nemesio,
from S. Maria degli Angeli, Flank.
Florence, Bargello

FIG. 56. Tomb of Bartolommeo Valori (from cartoon by Ghiberti). Florence, S. Croce

FIG. 57. Filippo di Cristofano, Tomb of Lodovico degli Obizi (from cartoon by Ghiberti). Florence, S. Croce

FIG. 58. Tomb of Ranieri Zen. Venice, SS. Giovanni e Paolo

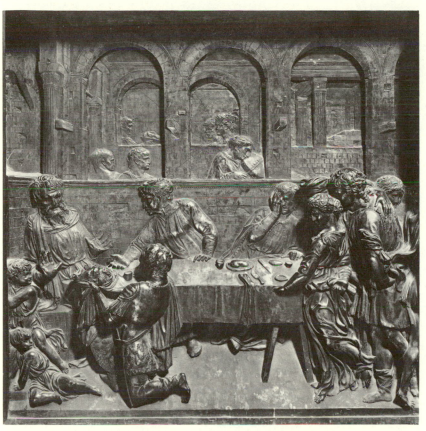

FIG. 59. Donatello, *Salome*. Siena, Baptistery, Font

FIG. 60. Donatello, Tomb of Giovanni Pecci. Siena, Cathedral

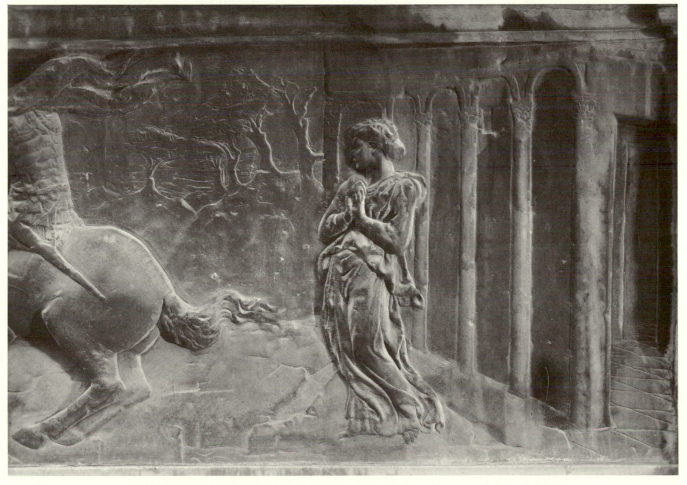

FIG. 61. Donatello, Relief of Saint George, Right half. Florence, Or San Michele

FIG. 62. Ghiberti Workshop, *God the Father*, Shutter for Ciborium from S. Egidio. Florence, Ospedale di S. Maria Nuova

FIG. 63. Window with Saint James (from cartoon by Ghiberti's Workshop). Florence, Cathedral

FIG. 64. Ghiberti, *Solomon* Panel, Ambrogio Traversari (?). Gates of Paradise

FIG. 65. Portrait of Ambrogio Traversari, *De Vita et Moribus Philosophorum*. Florence, Bibl. Medicea-Laurenziana, ms. plut. 65.22, f.1

FIG. 66. Donatello, *Giving of the Keys*. London, Victoria and Albert Museum

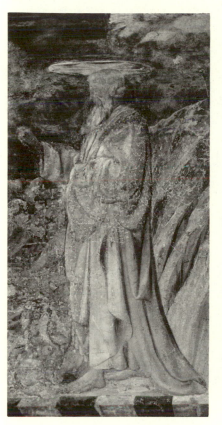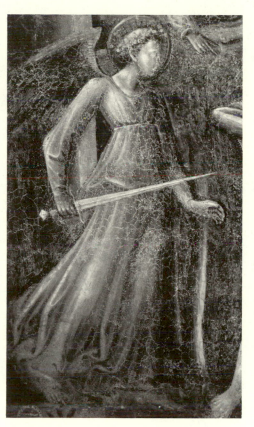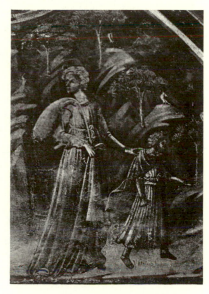

FIG. 67. Uccello, *Creation of the Animals*

FIG. 68. Uccello (?), *Expulsion from Paradise*

FIG. 69. Florentine Master, *Abraham and Hagar*

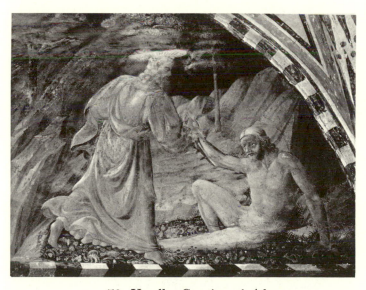

FIG. 70. Uccello, *Creation of Adam*

FIG. 71. Uccello, *Creation of Adam*, Sinopia

FIGS. 67-71. Florence, S. Maria Novella, Chiostro Verde and Capitolo del Nocentino

FIG. 72. Agnolo Gaddi, *Monk in the Desert*.
Florence, S. Croce, Castellani Chapel

FIG. 73. Taddeo Gaddi, *Christ among the Doctors*.
Florence, Accademia

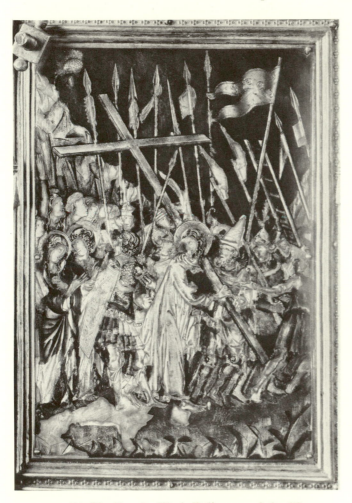

FIG. 74. Ugolino da Vieri, Reliquary of the SS.
Corporale, *Way to Calvary*. Orvieto, Cathedral

FIG. 75. Ugolino da Vieri, Reliquary of the SS.
Corporale, *Last Supper*. Orvieto, Cathedral

FIG. 76. Ambrogio Lorenzetti, *Good Government*, Detail. Siena, Palazzo Pubblico

FIG. 77. Andrea da Firenze, *Via Veritatis*, Detail.
Florence, S. Maria Novella, Spanish Chapel

FIG. 78. Francesco Traini, *Thebais*, Right half. Pisa, Camposanto

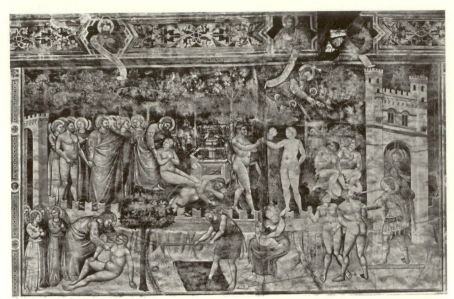

FIG. 79. Piero di Puccio, *Creation*. Pisa, Camposanto

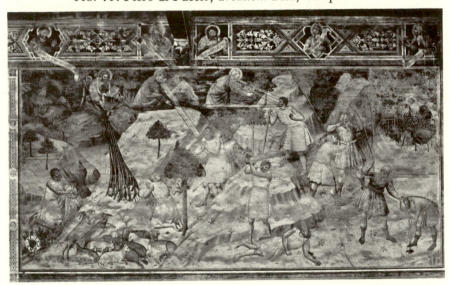

FIG. 80. Piero di Puccio, Stories of Cain, Abel, and Lamech.
Pisa, Camposanto

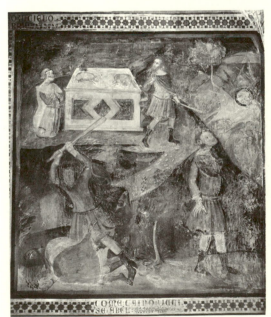

FIG. 81. *Slaying of Abel*

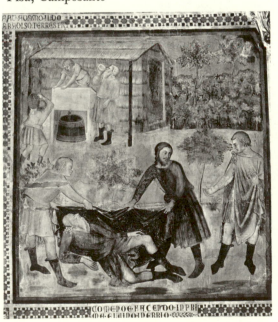

FIG. 82. *Noah's Drunkenness*

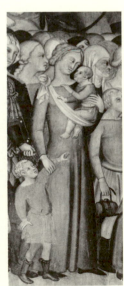

FIG. 83. *Passage
through Red Sea*

FIGS. 81-83. Bartolo di Fredi. San Gimignano, Collegiata

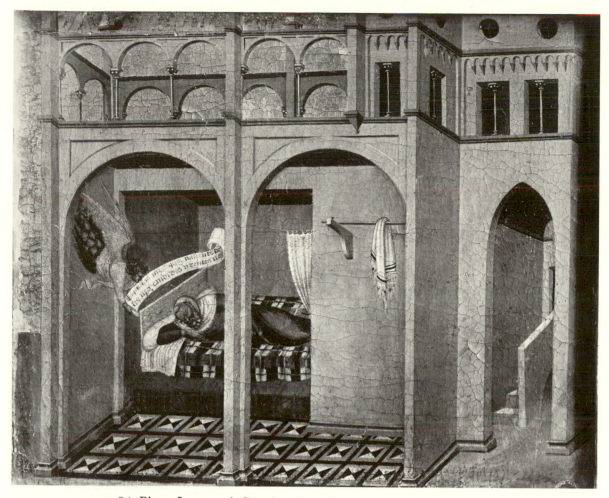

FIG. 84. Pietro Lorenzetti, Carmine Altar, Predella Panel, *Dream of Sebach*.
Siena, Pinacoteca

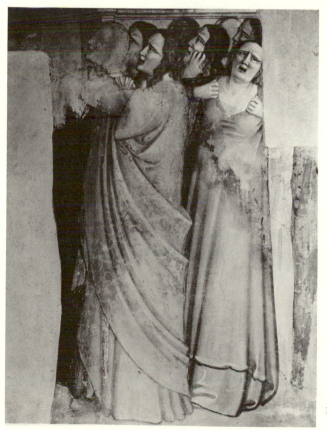

FIG. 86. School of Pietro Lorenzetti, *Coronation of the Virgin*, Eve. Montefalco, S. Agostino

FIG. 85. Maso di Banco, Sylvester Legend, *Wailing Women*. Florence, S. Croce

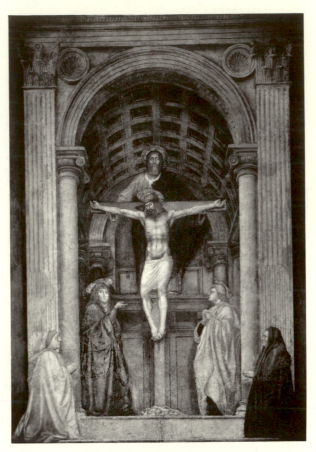

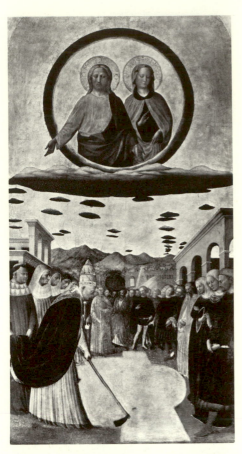

FIG. 87. Masaccio, Trinity Fresco.
Florence, S. Maria Novella

FIG. 88. Masolino, S. Maria Maggiore
Altar, *Founding of S. Maria della Neve*.
Naples, Museum

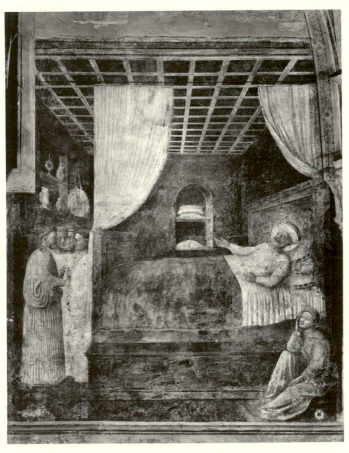

FIG. 89. Masolino, *Death of Saint Ambrose*.
Rome, S. Clemente

FIG. 90. Portal of Strozzi Chapel,
Detail. Florence, S. Trinità

FIG. 91. Augustus Altar, Garland, Detail.
Lyons

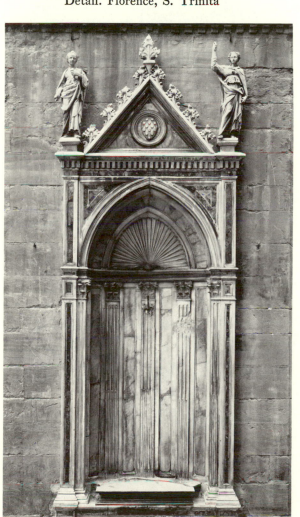

FIG. 92. Ghiberti, Niche of *Saint Matthew*.
Florence, Or San Michele

FIG. 93. Portal of Strozzi Chapel.
Florence, S. Trinità

FIG. 94. Brunelleschi, Palazzo di Parte Guelfa,
Façade. Florence

FIG. 95. Ghiberti, *Saint John the Baptist before Herod*.
Architectural Detail. Siena, Baptistery, Font

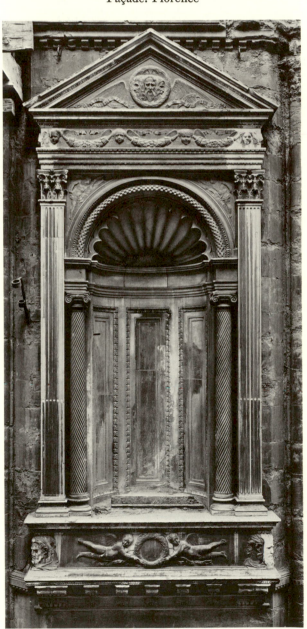

FIG. 96. Donatello, Niche of *Saint Louis*.
Florence, Or San Michele

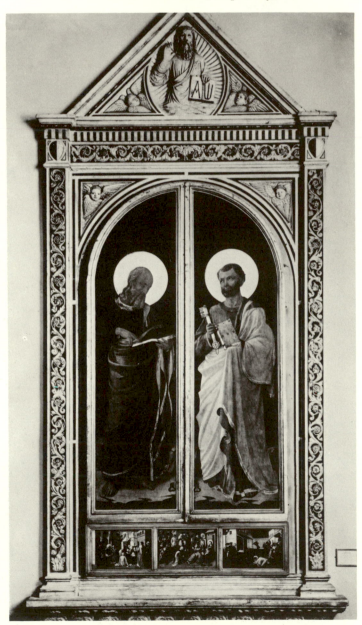

FIG. 97. Ghiberti, Linaiuoli Altar, Frame.
Florence, Museo di S. Marco

FIG. 98. Simone il Cronaca, S. Stefano Rotondo, Drawing.
Florence, Uffizi, dis. Sant. 161r

FIG. 99. Alberti, S. Sebastiano, Façade.
Mantua

FIG. 100. Luciano Laurana (?), Architectural Setting. Urbino, Palazzo Ducale

FIG. 101. Roman Pilaster, Detail. Rome,
S. Pietro, Grotte Vaticane

FIG. 102. *Niobide*. Rome, Museo Capitolino

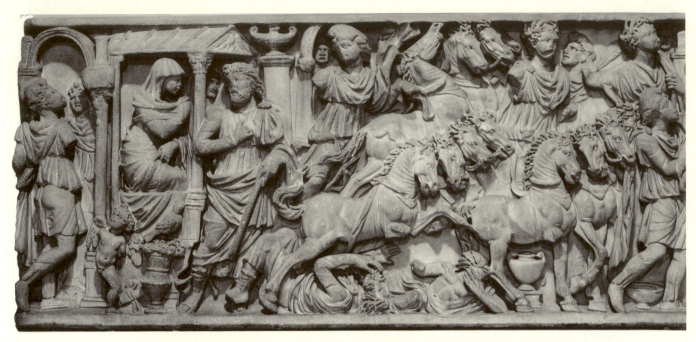

FIG. 103. Pelops Sarcophagus, Left part. Brussels, Musées Royaux

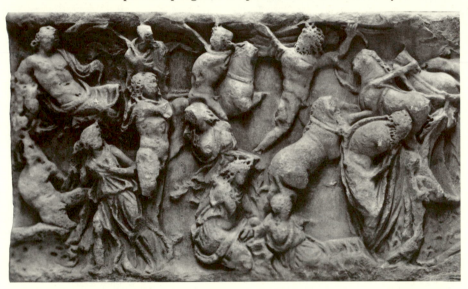

FIG. 104. Phaeton Sarcophagus, Left half. Florence, Museo dell'Opera

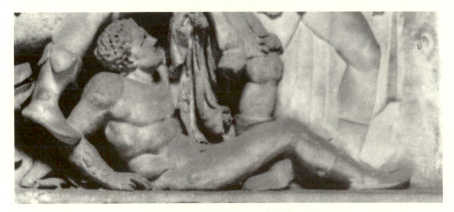

FIG. 105. Sarcophagus with *Wounding of Hippolytus*, Fallen Hunter.
Ince Blundell Hall

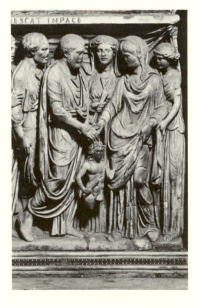

FIG. 106. Fieschi Sarcophagus, Marriage scene. Rome, S. Lorenzo, f.l.m.

FIG. 107. *Julius Caesar*, Bust. Florence, Pitti, Argenteria

FIG. 108. Antonio Rossellino Workshop (?), *Julius Caesar*, Bust. New York, Metropolitan Museum

FIG. 109. Head of Nurse

FIG. 110. Head of Hippolytus

FIG. 111. Head of Slave Girl

FIG. 112. Head of Companion of Hippolytus

FIGS. 109-112. Phaedra Sarcophagus, Pisa, Camposanto

FIG. 113. Battle Sarcophagus. Rome, Villa Borghese

FIG. 114. Bertoldo di Giovanni, Battle Relief. Florence, Bargello

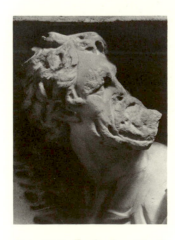 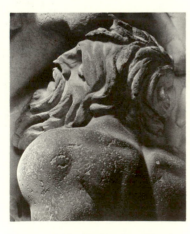 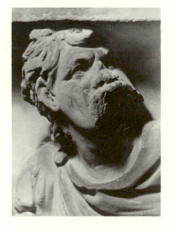 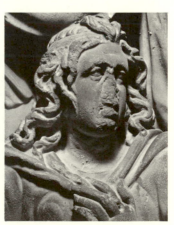

FIG. 115. Barbarian Head FIG. 116. Barbarian Head FIG. 117. Barbarian Head FIG. 118. Head of Female
 Barbarian Prisoner

FIGS. 115-118. Battle Sarcophagus. Rome, Villa Borghese

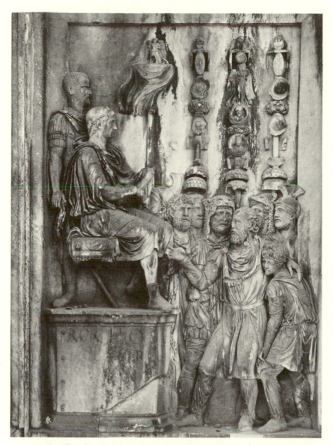

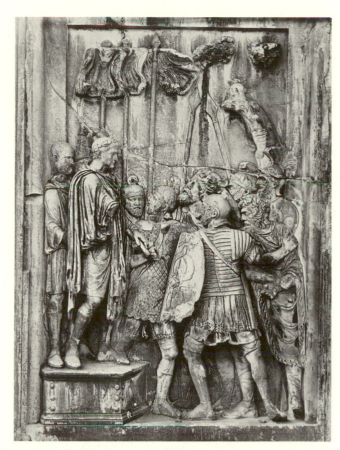

FIG. 119. Barbarian Chieftain Submitting to the Emperor

FIG. 120. Barbarian Prisoner Brought before the Emperor

FIGS. 119-120. Rome, Arch of Constantine

FIG. 121. Sarcophagus of *Dionysos Battling the Amazons*, Lid with Victories. Cortona, Cathedral

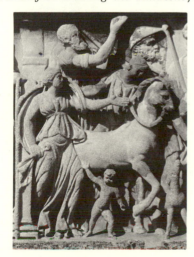

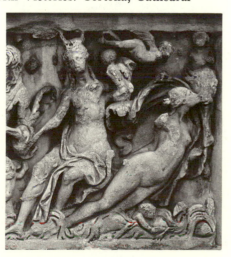

FIGS. 122-123. Adonis Sarcophagus, Details.
Rome, Palazzo Rospigliosi

FIG. 124. Marine Sarcophagus, Detail.
Rome, Vatican, Giardino della Pigna

FIGS. 125-126. Bacchic Sarcophagus from S. Maria Maggiore, Details,
Drawings. Wolfegg Sketchbook, fols. 31v, 32

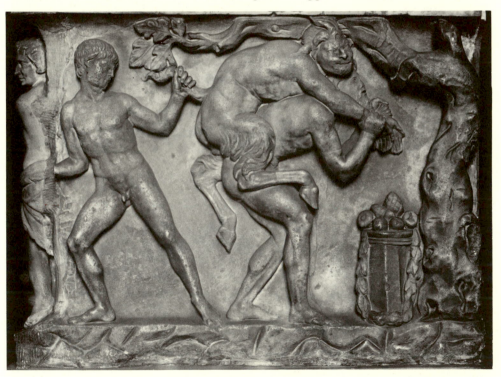

FIG. 127. Bacchic Sarcophagus from S. Maria Maggiore, Right flank.
London, British Museum

FIG. 128. Vittorio Ghiberti, Eve, Frame.
Florence, Baptistery, South Door

FIG. 129. Minerva Frieze, Detail. Rome, Forum of Nerva

FIG. 130. Plowman from (lost) Relief, Drawing.
Windsor Royal Library, Dal Pozzo Collection

FIG. 131. Trajanic Battle Relief, Detail.
Rome, Arch of Constantine

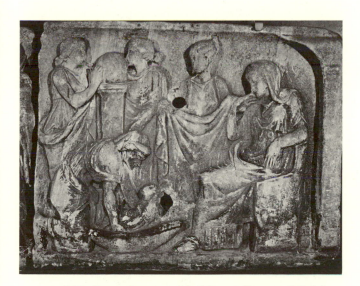

FIG. 132. Sarcophagus with *Life of Roman Official*,
Right flank, Birth of a Child.
Los Angeles, County Museum

FIG. 133. Sarcophagus with *Life of Roman Official*,
Birth of a Child from Rome, S. Pietro.
Drawing, Wolfegg Sketchbook, fol. 25v

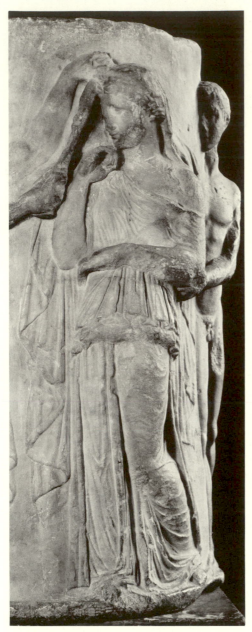

FIG. 134. Cippus with *Sacrifice of Iphigeneia*, Iphigeneia. Florence, Uffizi

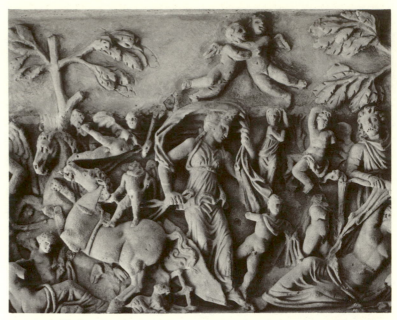

FIG. 135. Endymion Sarcophagus, Selene. Rome, Palazzo Guistiniani

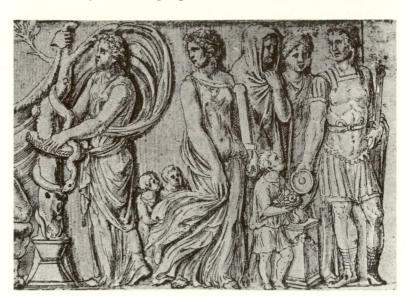

FIG. 136. Medea Sarcophagus, Medea and Children, Drawing. Coburgensis, fol. 32. Coburg, Castle, Library

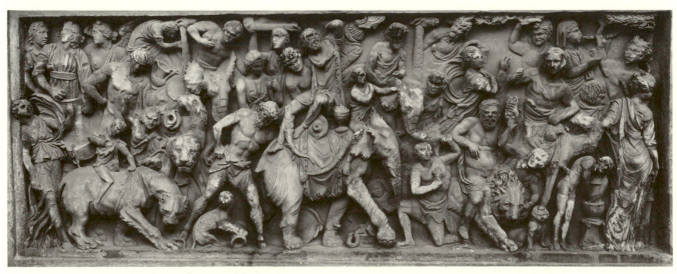

FIG. 137. Sarcophagus with *Indian Triumph of Bacchus*. Rome, Palazzo Rospigliosi

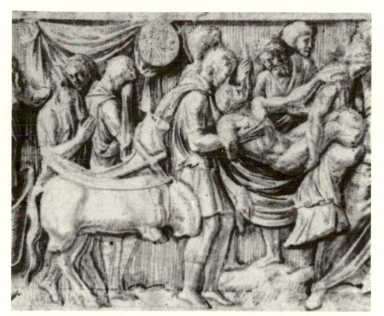

FIG. 138. Meleager Sarcophagus, *Gathering in of Meleager*, Drawing. Coburgensis, fol. 70. Coburg, Castle, Library

FIGS. 139-140. Bacchic Sarcophagus, Maenads. Windsor, Royal Library, Dal Pozzo Collection

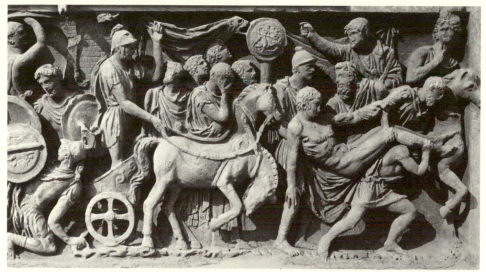

FIG. 141. Meleager Sarcophagus, *Gathering in of Meleager*. Rome, Villa Panfili

FIG. 142. Proserpina Sarcophagus, Gaia, Drawing. Wolfegg Sketchbook, fol. 37

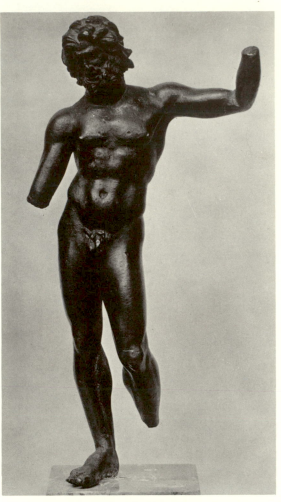

FIG. 143. *Zeus* (?), Bronze Statuette.
Munich, Private Collection (?)

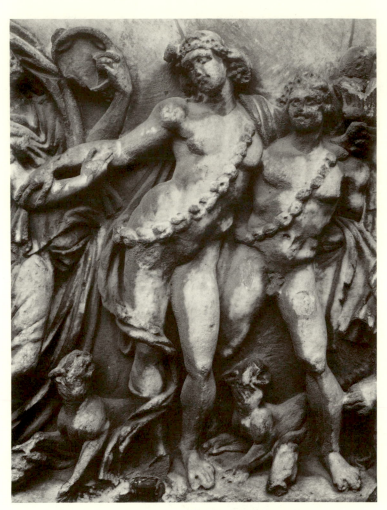

FIG. 144. Bacchic Sarcophagus, Drunken Dionysos.
Rome, Vatican, Giardino della Pigna

FIG. 145. Bacchic Sarcophagus,
Tambourine-Playing Maenad,
Coburgensis, fol. 195.
Coburg, Castle, Library

FIG. 146. Medea Sarcophagus, Children of Medea, Drawing.
Coburgensis, fol. 42. Coburg, Castle, Library